www.wadsworth.com

www.wadsworth.com is the World Wide Web site for Thomson
Wadsworth and is your direct source to dozens of online resources.

At *www.wadsworth.com* you can find out about supplements,
demonstration software, and student resources. You can also send
email to many of our authors and preview new publications and
exciting new technologies.

www.wadsworth.com
Changing the way the world learns®

CULTURE
AND VALUES

A SURVEY OF THE HUMANITIES

VOLUME TWO ∷ SIXTH EDITION

CULTURE AND VALUES

A SURVEY OF THE HUMANITIES

VOLUME TWO :: SIXTH EDITION

LAWRENCE S. CUNNINGHAM
John A. O'Brien Professor of Theology
University of Notre Dame

JOHN J. REICH
Syracuse University
Florence, Italy

THOMSON
————★————™
WADSWORTH

Australia • Canada • Mexico • Singapore • Spain
United Kingdom • United States

THOMSON
WADSWORTH

Culture and Values: A Survey of the Humanities,
Volume II, Sixth Edition
Lawrence S. Cunningham, John J. Reich

Publisher: Clark Baxter

Executive Editor: David Tatom

Art Editor: John R. Swanson

Senior Development Editor: Sharon Adams Poore

Assistant Editor: Anne Gittinger

Technology Project Manager: David Lionetti

Marketing Manager: Mark Orr

Marketing Assistant: Alexandra Tran

Marketing Communications Manager: Kelley McAllister

Project Manager, Editorial Production: Trudy Brown

Executive Art Director: Maria Epes

Print Buyer: Barbara Britton

Permissions Editor: Joohee Lee

Production Service: Lachina Publishing Services

Text Designer: Lee Anne Dollison

Photo Researcher: Sarah Evertson

Copy Editor: Ginjer Clarke

Cover Designer: John Walker

Cover Image: Joseph Stella (1879–1946), *The Voice of the City of New York Interpreted: The Bridge 1920–1922.* Oil and tempera on canvas, 88 1/2" x 54". Collection of The Newark Museum, 37.288e, New Jersey. The Newark Museum/Art Resource, NY.

Cover Printer: Phoenix Color Corp

Compositor: Lachina Publishing Services

Printer: Courier Corporation/Kendallville

Printed in the United States of America
1 2 3 4 5 6 7 09 08 07 06 05

For more information about our products, contact us at:
Thomson Learning Academic Resource Center
1-800-423-0563
For permission to use material from this text or product, submit a request online at
http://www.thomsonrights.com.
Any additional questions about permissions can be submitted by email to **thomsonrights@thomson.com.**

Library of Congress Control Number: 2005923993
Student Edition: ISBN 0-534-58229-X
Instructor's Edition: ISBN 0-495-00851-6

Thomson Higher Education
10 Davis Drive
Belmont, CA 94002-3098
USA

Asia (including India)
Thomson Learning
5 Shenton Way
#01-01 UIC Building
Singapore 068808

Australia/New Zealand
Thomson Learning Australia
102 Dodds Street
Southbank, Victoria 3006
Australia

Canada
Thomson Nelson
1120 Birchmount Road
Toronto, Ontario M1K 5G4
Canada

UK/Europe/Middle East/Africa
Thomson Learning
High Holborn House
50–51 Bedford Row
London WC1R 4LR
United Kingdom

Latin America
Thomson Learning
Seneca, 53
Colonia Polanco
11560 Mexico
D.F. Mexico

Spain (including Portugal)
Thomson Paraninfo
Calle Magallanes, 25
28015 Madrid, Spain

CONTENTS IN BRIEF

CONTENTS

PREFACE

IT is now over twenty years since we finished the manuscript which would become this textbook. In the various additions, updating, and rewriting that constitute the various editions of *Culture and Values,* we have not repented of our earliest convictions about what this book should represent. We repeat here what we said in the first edition, namely, that our desire is to present, in a chronological fashion, the most crucial landmarks of Western culture with clarity and in such a way that students might react to this tradition and its major accomplishments with the same enthusiasm as we experienced when we first encountered them and began to teach about them.

We believe that our own backgrounds have enhanced our appreciation for what we discuss in these pages. Lawrence Cunningham has degrees in philosophy, theology, literature, and humanities, while John Reich is a trained classicist, musician, and field archaeologist. Both of us have lived and lectured for extended periods in Europe. There is very little Western art or architecture discussed in this book that we have not seen firsthand.

In developing the new editions of *Culture and Values*, we have been the beneficiaries of the suggestions and criticisms of classroom teachers who have used the book.

We have also consulted closely with the editorial team at Thomson Higher Education. Our own experiences as teachers both here and abroad have also made us sensitive to new needs and refinements as we rework this book.

In this new edition we have made a number of changes: We have updated and pruned the suggested readings, brought the final chapter up to date, and made additions to the glossary. Furthermore, we have expanded some of the discussions, art representations, and readings to reflect the ever-growing retrieval of women's voices in the history of Western culture. We are also very pleased that the editorial team has obtained some newer art reproductions, redrawn the timelines, and generally used the latest in technology to make the book so attractive. The sixth edition incorporates the helpful suggestions of our reviewers, critics, and the many teachers who have noted the increasingly multicultural character of the world in which we live. We also continue to add materials from Latin America.

While it is true that the newer and ever-expanding information technologies as well as the emergence of a global sociopolitical economy may render the notion of a purely occidental culture somewhat skewed (think, for example, of the globalization of popular music), we have generally stayed within the traditional parameters of the West, although we now feel it necessary to put that Western context into a larger, more global, framework. This sixth edition is being published in the early years of a new millennium, which is an appropriate time to bring this expanded global vision into sharper focus.

One of the greatest problems we encountered in this new edition was having to decide what to leave out. Our aim is to provide some representative examples from each period, hoping that instructors would use their own predilections to fill out where we have been negligent. In that sense, to borrow the Zen concept, we are fingers pointing the way—attend to the direction and not to the finger. We refine that direction using input from instructors making those decisions and would like to acknowledge the reviewers of the sixth edition: John F. Martin, Hanover College; James W. Mock, University of Central Oklahoma; Andrew Platizky, New Jersey City University; Robert Quist, Ferris State University; Joanna Reed, Sussex County Community College; Gencie S. Rucker, Florida Community College at Jacksonville; Stephanie Satie, California State University–Northridge; Diana Major Spencer, Snow College; Trent Tomengo, Seminole Community College; and Joan Monahan Watson, Virginia Polytechnic Institute and State University.

We would especially like to acknowledge the work of Scott Douglass of Chattanooga State Technical Community College, who served as our technology consultant, provided assistance on the development of the *Culture and Values* website, and created online course materials for the book. Special thanks also go to John R. Swanson, acquisitions editor; Sharon Adams Poore, development editor; Trudy Brown, production manager; and Mark Orr, marketing manager.

FEATURES

The sixth edition of *Culture and Values* maintains many of the features that have made the book so successful.

Enhanced Illustrations. As in prior editions, the text is beautifully illustrated with over five hundred images, most of them in color. This new edition includes over ninety new images, including a photo of King Tutankhamen's golden death mask and another of the restored *Last Supper* with its unfamiliarly bright

color. Many of the images previously reproduced in the book have been replaced with higher quality photos that provide either a better view of the original artwork or a truer match to the original's color and overall appearance. A number of the line drawings have also been redrawn for better accuracy of representation and better consistency with similar drawings found in the book.

Timelines. Each chapter begins with an illustrated, two-page timeline that organizes the major events and works for each era and, where appropriate, for each major category of works discussed in the chapter (i.e., general events, literature and philosophy, art, architecture, and music). The timelines provide an instant visual reference that allows students to see the development of each type of art over the time period presented.

Boxes. Two types of boxes run throughout the book. "Voices of Their Times" boxes, taken from letters, journals, and narratives of the time period under discussion, provide students with insight into the concerns of individuals responding to the major events and ideas of the era firsthand. "Values" boxes make explicit the underlying issues or concerns unifying the works of a given era, examining their root causes and their ultimate impact on the type of art produced.

Global Coverage. Many instructors using *Culture and Values* have expressed an interest in seeing more global coverage of the humanities. Under their guidance and review, three chapters covering Asian and African cultures are in the book, and the treatment of Islamic culture remains a full chapter. In each case, the presentation focuses on the unique achievements and traditions of these cultures and their place within the broader human story.

SUPPLEMENTS

For Students

Exploring Humanities CD-ROM. This CD-ROM, included free with each new copy of the text, provides resources that make the material covered in the course come to life for students. Organized by major fields within the humanities—art, architecture, literature, philosophy, music, dance, and theater—it includes readings and documents, interactive timelines, extensive learning modules, and music flashcards. It

also includes links to such online resources as maps and other visuals, documents, a glossary of humanities terms, chronologies that place developments in the humanities in historical context, and websites of major museums.

Listening CD. This audio CD contains twenty-two musical selections discussed in the text, allowing students to hear samples of history's greatest musical achievements—from Gregorian chants, to Mozart, to Scott Joplin. The CD can be sold separately or bundled at a discount with any version of the text upon request.

Study Guide. Each chapter of this guide includes study questions; terms for students to identify and define; "Significant Works to Recognize and Remember," a review section including a ten-question self-quiz; and Web Quests that refer students to sites that expand upon chapter topics. It also includes end-of-section reviews and study cards, and tips on how to study effectively, perform research, and write papers.

The Museum Experience. This practical handbook provides everything from a primer on museum etiquette to preparation tips on how to make the visit more constructive and enjoyable. It can be sold separately or bundled FREE with new copies of the text.

Art Basics: An Illustrated Glossary and Timeline. Presented with full-color fine art images and quality line art, this brief introduction to the basic terms, styles, and time periods is a handy reference for any beginning art student. It can be sold separately or bundled FREE with new copies of the text.

Thinking and Writing in the Humanities. This supplement guides students through the process of planning, drafting, revising, and editing analytical and argument essays and research papers in the humanities.

A Practical Handbook for Writing in the Humanities. This supplement provides a concise guide to composition for students in the humanities.

InfoTrac® College Edition with InfoMarks™. An optional free bundle is available with each new text—four months of access to this online database of eighteen million full-text articles from nearly 5000 publications (including *The New York Times, Forbes,* and *USA Today*). For a tour, visit *http://www.infotrac-college.com/* and select the "InfoTrac Demo." *Journals are subject to change. Certain restrictions may apply. For additional information, consult your local Thomson representative.*

For Instructors and Students

The Thomson Wadsworth Art and Humanities Resource Center and Book Companion Website. *http://art.wadsworth.com/cunningham06/* features chapter overviews, audio glossary flashcards, self-assessment, chapter-by-chapter quizzes, a Museum Guide, line art from the text, a pronunciation guide, and other book- and discipline-specific resources.

Instructor Resources

Multimedia Manager. This package provides **digital images** from the text for use in presenting those images in your classroom using Microsoft® PowerPoint®. The package also includes an electronic Resource Integration Guide and Instructor's Manual with Test Bank.

JoinIn™ on TurningPoint.® This package provides images for personal response systems ("clickers") tailored to the text, allowing you to transform your classroom and assess your students' progress with instant in-class quizzes and polls.

Slide Set. This includes 100 slides of the text's images, maps, and line art.

WebTutor™ ToolBox for WebCT®, and Blackboard®. Preloaded with content and available via a free access code when packaged with this text, this package pairs the content of this text's book companion website with course management functionality.

THE ARTS: AN INTRODUCTION

ONE way to see the arts as a whole is to consider a widespread mutual experience: a church or synagogue service or the worship in a Buddhist monastery. Such a gathering is a celebration of written literature done, at least in part, in music in an architectural setting decorated to reflect the religious sensibilities of the community. A church service makes use of visual arts, literature, and music. While the service acts as an integrator of the arts, each art, considered separately, has its own peculiar characteristics that give it shape. The same integration may be seen, of course, in an opera or in a music video.

Music is primarily a temporal art, which is to say that there is music when there is someone to play the instruments and sing the songs. When the performance is over, the music stops.

The visual *arts* and *architecture* are spatial arts that have permanence. When a religious service is over, people may still come into the building to admire its architecture or marvel at its paintings or sculptures or look at the decorative details of the building.

Literature has a permanent quality in that it is recorded in books, although some literature is meant not to be read but to be heard. Shakespeare did not write plays for people to read, but for audiences to see and hear performed. Books nonetheless have permanence in the sense that they can be read not only in a specific context, but also at one's pleasure. Thus, to continue the religious-service example, one can read the psalms for their poetry or for devotion apart from their communal use in worship.

What we have said about the religious service applies equally to anything from a rock concert to grand opera: artworks can be seen as an integrated whole. Likewise, we can consider these arts separately. After all, people paint paintings, compose music, or write poetry to be enjoyed as discrete experiences. At other times, of course, two arts may be joined when there was no original intention to do so, as when a composer sets a poem to music or an artist finds inspiration in a literary text or, to use a more complex example, when a ballet is inspired by a literary text and is danced against the background or sets created by an artist to enhance both the dance and the text that inspired it.

However we view the arts, either separately or as integrated, one thing is clear: they are the product of human invention and human genius. When we speak of *culture,* we are not talking about something strange or "highbrow"; we are talking about something that derives from human invention. A jungle is a product of nature, but a garden is a product of culture: human ingenuity has modified the vegetative world.

In this book we discuss some of the works of human culture that have endured over the centuries. We often refer to these works as *masterpieces,* but what does the term mean? The issue is complicated because tastes and attitudes change over the centuries. Two hundred years ago the medieval cathedral was not appreciated; it was called Gothic because it was considered barbarian. Today we call such a building a masterpiece. Very roughly we can say that a masterpiece of art is any work that carries with it a surplus of meaning.

Having "surplus of meaning" means that a certain work not only reflects technical and imaginative skill, but also that its very existence sums up the best of a certain age, which spills over as a source of inspiration for further ages. As one reads through the history of the Western humanistic achievement it is clear that certain products of human genius are looked to by subsequent generations as a source of inspiration; they have a surplus of meaning. Thus the Roman achievement in architecture with the dome of the Pantheon both symbolized their skill in architecture and became a reference point for every major dome built in the West since. The dome of the Pantheon finds echoes in sixth-century Constantinople (Hagia Sophia); in fifteenth-century Florence (the Duomo); in sixteenth-century Rome (St. Peter's Basilica); and in eighteenth-century Washington, D.C. (the Capitol building).

The notion of surplus of meaning provides us with a clue as to how to study the humanistic tradition and its achievements. Admittedly simplifying, we can say that such a study has two steps that we have tried to synthesize into a whole in this book:

The Work in Itself. At this level we are asking the question of fact and raising the issue of observation: What is the work and how is it achieved? This question includes not only the basic information about, say, what kind of visual art this is (sculpture, painting, mosaic) or what its formal elements are (Is it geometric in style? bright in color? very linear? and so on), but also questions of its function: Is this work an homage to politics? for a private patron? for a church? We look at artworks, then, to ask questions about both their form and their function.

This is an important point. We may look at a painting or sculpture in a museum with great pleasure, but that pleasure would be all the more enhanced were we to see that work in its proper setting rather than as an object on display. To ask about form and function, in

short, is to ask equally about context. When reading certain literary works (such as the *Iliad* or the *Song of Roland*) we should read them aloud since, in their original form, they were written to be recited, not read silently on a page.

The Work in Relation to History. The human achievements of our common past tell us much about earlier cultures both in their differences and in their similarities. A study of the tragic plays that have survived from ancient Athens gives us a glimpse into Athenians' problems, preoccupations, and aspirations as filtered through the words of Sophocles or Euripides. From such a study we learn both about the culture of Athens and something about how the human spirit has faced the perennial issues of justice, loyalty, and duty. In that sense we are in dialogue with our ancestors across the ages. In the study of ancient culture we see the roots of our own.

To carry out such a project requires willingness to look at art and closely read literature with an eye equally to the aspect of form/function and to the past and the present. Music, however, requires a special treatment because it is the most abstract of arts (How do we speak about that which is meant not to be seen but to be heard?) and the most temporal. For that reason a somewhat more extended guide to music follows.

HOW TO LOOK AT ART

Anyone who thumbs through a standard history of art can be overwhelmed by the complexity of what is discussed. We find everything from paintings on the walls of caves and huge sculptures carved into the faces of mountains to tiny pieces of jewelry or miniature paintings. All of these are art because they were made by the human hand in an attempt to express human ideas and/or emotions. Our response to such objects depends a good deal on our own education and cultural biases. We may find some modern art ugly or stupid or bewildering. We may think of all art as highbrow or elitist despite the fact that we like certain movies (film is an art) enough to see them over and over. At first glance, art from the East may seem odd simply because we do not have the reference points with which we can judge the art good or bad.

Our lives are so bound up with art that we often fail to recognize how much we are shaped by it. We are bombarded with examples of graphic art (television commercials, magazine ads, CD jackets, displays in stores) every day; we use art to make statements about who we are and what we value in the way we decorate our rooms and in the style of our clothing. In all of these ways we manipulate artistic symbols to make statements about what we believe in, what we stand for, and how we want others to see us. The many sites on the Web bombard us with visual clues which attempt to make us stop and find out what is being offered or argued.

The history of art is nothing more than the record of how people have used their minds and imaginations to symbolize who they are and what they value. If a certain age spends enormous amounts of money to build and decorate churches (as in twelfth-century France) and another spends the same kind of money on palaces (like eighteenth-century France), we learn about what each age values the most.

The very complexity of human art makes it difficult to interpret. That difficulty increases when we are looking at art from a much different culture and/or a far different age. We may admire the massiveness of Egyptian architecture, but find it hard to appreciate why such energies were used for the cult of the dead. When confronted with the art of another age (or even our own art, for that matter), a number of questions we can ask of ourselves and of the art may lead us to greater understanding.

For What Was This Piece of Art Made? This is essentially a question of *context*. Most of the religious paintings in our museums were originally meant to be seen in churches in very specific settings. To imagine them in their original setting helps us to understand that they had a devotional purpose that is lost when they are seen on a museum wall. To ask about the original setting, then, helps us to ask further whether the painting is in fact devotional or meant as a teaching tool or to serve some other purpose.

Setting is crucial. A frescoed wall on a public building is meant to be seen by many people, while a fresco on the wall of an aristocratic home is meant for a much smaller, more elite class of viewer. The calligraphy decorating an Islamic mosque tells us much about the importance of the sacred writings of Islam. A sculpture designed for a wall niche is going to have a shape different from one designed to be seen by walking around it. Similarly, art made under official sponsorship of an authoritarian government must be read in a far different manner than art produced by underground artists who have no standing with the government. Finally, art may be purely decorative or it may have a didactic purpose, but (and here is a paradox) purely decorative art may teach us while didactic art may end up being purely decorative.

What, If Anything, Does This Piece of Art Hope to Communicate? This question is one of *intellectual* or *emotional* context. Funeral sculpture may reflect the grief of the survivors, or a desire to commemorate the achievements of the deceased, or to affirm what the survivors believe about life after death, or a combination of these purposes. If we think of art

as a variety of speech we can then inquire of any artwork: What is it saying?

An artist may strive for an ideal ("I want to paint the most beautiful woman in the world," or "I wish my painting to be taken for reality itself," or "I wish to move people to love or hate or sorrow by my sculpture"), illustrate the power of an idea, or (as in the case with most primitive art) "capture" the power of the spirit world for religious and/or magical purposes.

An artist may well produce a work simply to demonstrate inventiveness or to expand the boundaries of what art means. The story is told of Pablo Picasso's reply to a woman who said that her ten-year-old child could paint better than he. Picasso replied, "Congratulations, Madame. Your child is a genius." We know that before he was a teenager Picasso could draw and paint with photographic accuracy. He said that during his long life he tried to learn how to paint with the fresh eye and spontaneous simplicity of a child.

How Was This Piece of Art Made?

This question inquires into both the materials and the skills the artist employs to turn materials into art. Throughout this book we will speak of different artistic techniques, like bronze casting or etching or panel painting; here we make a more general point. To learn to appreciate the craft of the artist is a first step toward enjoying art for its worth as art—to developing an "eye" for art. This requires *looking* at the object as a crafted object. Thus, for example, a close examination of Michelangelo's *Pietà* shows the pure smooth beauty of marble, while his *Slaves* demonstrates the roughness of stone and the sculptor's effort to carve meaning from hard material. We might stand back to admire a painting as a whole, but then to look closely at one portion of it teaches us the subtle manipulation of color and line that creates the overall effect.

What Is the Composition of This Artwork?

This question addresses how the artist "composes" the work. Much Renaissance painting uses a pyramidal construction so that the most important figure is at the apex of the pyramid and lesser figures form the base. Some paintings presume something happening outside the picture itself (such as an unseen source of light); a cubist painting tries to render simultaneous views of an object. At other times, an artist may enhance the composition by the manipulation of color with a movement from light to dark or a stark contrast between dark and light, as in the *chiaroscuro* of Baroque painting. In all of these cases the artists intend to do something more than merely "depict" a scene; they appeal to our imaginative and intellectual powers as we enter into the picture or engage the sculpture or look at their film.

Composition, obviously, is not restricted to painting. Filmmakers compose with close-ups or tracking shots just as sculptors carve for frontal or side views of an object. Since all of these techniques are designed to make us see in a particular manner, only by thinking about composition do we begin to reflect on what the artist has done. If we do not think about composition, we tend to take an artwork at "face value" and, as a consequence, are not training our "eye." Much contemporary imaging is done by the power of mixing done on the computer.

What Elements Should We Notice about a Work of Art?

The answer to this question is a summary of what we have stated above. Without pretending to exclusivity, we should judge art on the basis of the following three aspects:

Formal elements. What kind of artwork is it? What materials are employed? What is its composition in terms of structure? In terms of pure form, how does this particular work look when compared to a similar work of the same or another artist?

Symbolic elements. What is this artwork attempting to "say"? Is its purpose didactic, propagandistic, to give pleasure, or what? How well do the formal elements contribute to the symbolic statement being attempted in the work of art?

Social elements. What is the context of this work of art? Who paid and why? Whose purposes does it serve? At this level, many different philosophies come into play. A Marxist critic might judge a work in terms of its sense of class or economic aspects, while a feminist critic might inquire whether it affirms women or acts as an agent of subjugation or exploitation.

It is possible to restrict oneself to formal criticism of an artwork (Is this well done in terms of craft and composition?), but such an approach does not do full justice to what the artist is trying to do. Conversely, to judge every work purely in terms of social theory excludes the notion of an artistic work and, as a consequence, reduces art to politics or philosophy. For a fuller appreciation of art, then, all of the elements mentioned above need to come into play.

A SPECIFIC EXERCISE

Consider Leonardo da Vinci's *Madonna of the Rocks* (Fig. 12.25).

Subject Matter: A representational depiction of the Virgin with the Christ Child and young Saint John the Baptist and angel in a rocky landscape.

Composition:

- *Foreground:* Four figures are seated along a rocky edge of land with very naturalistic plants and grasses. The Virgin is seated in the center and dominates the group. Her right hand reaches

around the young Saint John the Baptist who kneels on one knee and looks to the Christ Child seated to her front lefthand side. He is seated in a ¾-profile to the viewer and directly under the Virgin's blessing left hand. To the right is a seated angel who looks out at the viewer while pointing to St. John.

- *Middleground:* A naturalistic landscape of plants and vegetation among the rocks with a canopy of rock formations and plants that encircle the group.
- *Background:* A landscape of great depth with rock formations and valleys with light from the setting sun.

Art Elements:

- *Line, shape, light, color, texture, space, time,* and *motion*

In the *Madonna of the Rocks,* light is the most important element and affects all the other elements. The light is very dramatic and its source appears from the left as if from the setting sun. The light defines everything; it illuminates and focuses the viewer's attention on the figures. The light affects the colors and creates the warm feeling of flesh against the coldness of the rocky landscape of great depth. This use of light is called *chiaroscuro,* a contrast of very dark to very light values in the brightness of a color. Chiaroscuro creates the atmosphere, the shape and volume of the figures, and the space they occupy, a vast landscape in which real people exist.

HOW TO LISTEN TO MUSIC

The sections of this book devoted to music are designed for readers who have no special training in music theory and practice. Response to significant works of music, after all, should require no more specialized knowledge than the ability to respond to *Oedipus Rex,* say, or a Byzantine mosaic. Indeed, many millions of people buy recorded music in one form or another, or enjoy listening to it on the radio without the slightest knowledge of how the music is constructed or performed.

The gap between the simple pleasure of the listener and the complex skills of composer and performer often prevents the development of a more serious grasp of music history and its relation to the other arts. The aim of this section is to help bridge that gap without trying to provide too much technical information. After a brief survey of music's role in Western culture, we shall look at the "language" used to discuss musical works—both specific terminology, such as *sharp* and *flat,* and more general concepts, such as line and color.

Music in Western Culture

The origins of music are unknown, and neither the excavations of ancient instruments and depictions of performers nor the evidence from modern primitive societies gives any impression of its early stages. Presumably, like the early cave paintings, music served some kind of magical or ritual purpose. This is borne out by the fact that music still forms a vital part of most religious ceremonies today, from the hymns sung in Christian churches or the solo singing of the cantor in an Orthodox Jewish synagogue to the elaborate musical rituals performed in Buddhist or Shinto temples in Japan. The Old Testament makes many references to the power of music, most notably in the famous story of the battle of Jericho, and it is clear that by historical times music played an important role in Jewish life, both sacred and secular.

By the time of the Greeks, the first major Western culture to develop, music had become as much a science as an art. It retained its importance for religious rituals; in fact, according to Greek mythology the gods themselves invented it. At the same time the theoretical relationships between the various musical pitches attracted the attention of philosophers such as Pythagoras (c. 550 B.C.E.), who described the underlying unity of the universe as the "harmony of the spheres." Later fourth-century B.C.E. thinkers like Plato and Aristotle emphasized music's power to affect human feeling and behavior. Thus for the Greeks, music represented a religious, intellectual, and moral force. Once again, music is still used in our own world to affect people's feelings, whether it be the stirring sound of a march, a solemn funeral dirge, or the eroticism of much modern "pop" music (of which Plato would thoroughly have disapproved).

Virtually all of the music—and art, for that matter— that survived from the Middle Ages is religious. Popular secular music certainly existed, but since no real system of notation was invented before the eleventh century, it has disappeared without a trace. The ceremonies of both the Western and the Eastern (Byzantine) church centered around the chanting of a single musical line, a kind of music that is called *monophonic* (from the Greek "single voice"). Around the time musical notation was devised, composers began to become interested in the possibilities of notes sounding simultaneously—what we would think of as harmony. Music involving several separate lines sounding together (as in a modern string quartet or a jazz group) became popular only in the 14th century. This gradual introduction of *polyphony* ("many voices") is perhaps the single most important development in the history of music, since composers began to think not only horizontally (that is, melodically), but also vertically, or harmonically. In the process, the possibilities of musical expression were immeasurably enriched.

The Experience of Listening

"What music expresses is eternal, infinite, and ideal. It does *not* express the passion, love, or longing of this or that individual in this or that situation, but passion, love, or longing in itself; and this it presents in that unlimited variety of motivations which is the exclusive and particular characteristic of music, foreign and inexpressible in any other language" (Richard Wagner). With these words, one of the greatest of all composers described the power of music to express universal emotions. Yet for those unaccustomed to serious listening, it is precisely this breadth of experience with which it is difficult to identify. We can understand a joyful or tragic situation. Joy and tragedy themselves, though, are more difficult to comprehend.

There are a number of ways by which the experience of listening can become more rewarding and more enjoyable. Not all of them will work for everyone, but over the course of time they have proved helpful for many newcomers to the satisfactions of music.

1. *Before listening to the piece you have selected,* ask yourself some questions: What is the historical context of the music? For whom was it composed—for a general or an elite audience?

 Did the composer have a specific assignment? If the work was intended for performance in church, for example, it should sound very different from a set of dances. Sometimes the location of the performance affected the sound of the music: Composers of masses to be sung in Gothic cathedrals used the buildings' acoustical properties to emphasize the resonant qualities of their works.

 With what forces was the music to be performed? Do they correspond to those intended by the composer? Performers of medieval music, in particular, often have to reconstruct much that is missing or uncertain. Even in the case of later traditions, the original sounds can sometimes be only approximated. The superstars of the eighteenth-century world of opera were the *castrati,* male singers who had been castrated in their youth and whose soprano voices had therefore never broken; contemporaries described the sounds they produced as incomparably brilliant and flexible. The custom, which seems to us so barbaric, was abandoned in the nineteenth century, and even the most fanatic musicologist must settle for a substitute today. The case is an extreme one, but it proves that even with the best of intentions, modern performers cannot always reproduce the original sounds.

 Does the work have a text? If so, read it through before you listen to the music; it is easiest to concentrate on one thing at a time. In the case of a translation, does the version you are using capture the spirit of the original? Translators sometimes take a simple, popular lyric and make it sound archaic and obscure in order to convey the sense of "old" music. If the words do not make much sense to you, they would probably seem equally incomprehensible to the composer. Music, of all the arts, is concerned with direct communication.

 Is the piece divided into sections? If so, why? Is the relationship of the sections determined by purely musical considerations —the structure of the piece—or by external factors—the words of a song, for example, or the parts of a Mass?

 Finally, given all the above, what do you expect the music to sound like? Your preliminary thinking should have prepared you for the kind of musical experience in store for you. If it has not, go back and reconsider some of the points above.

2. *While you are listening to the music:* Concentrate as completely as you can. It is virtually impossible to gain much from music written in an unfamiliar idiom unless you give it your full attention. Read written information before you begin to listen, as you ask yourself the questions above, not *while* the music is playing. If there is a text, keep an eye on it but do not let it distract you from the music.

 Concentrating is not always easy, particularly if you are mainly used to listening to music as a background, but there are some ways in which you can help your own concentration. To avoid visual distraction, fix your eyes on some detail near you—a mark on the wall, a design in someone's dress, the cover of a book. At first this will seem artificial, but after a while your attention should be taken by the music. If you feel your concentration fading, do not pick up a magazine or gaze around; consciously force your attention back to the music and try to analyze what you are hearing. Does it correspond to your expectations? How is the composer trying to achieve an effect? By variety of instrumental color? Are any of the ideas, or tunes, repeated?

 Unlike literature or the visual arts, music occurs in the dimension of time. When you are reading, you can turn backward to check a reference or remind yourself of a character's identity. In looking at a painting, you can move from a detail to an overall view as often as you want. In music, the speed of your attention is controlled by the composer. Once you lose the thread of the discourse, you cannot regain it by going back; you must try to pick up again and follow the music as it continues— and that requires your renewed attention.

 On the other hand, in these times of easy access to recordings, the same pieces can be listened to repeatedly. Even the most experienced musicians

cannot grasp some works fully without several hearings. Indeed, one of the features that distinguishes "art" music from more "popular" works is its capacity to yield increasing rewards. On a first hearing, therefore, try to grasp the general mood and structure and note features to listen for the next time you hear the piece. Do not be discouraged if the idiom seems strange or remote, and be prepared to become familiar with a few works from each period you are studying.

As you become accustomed to serious listening, you will notice certain patterns used by composers to give form to their works. They vary according to the styles of the day, and throughout this book there are descriptions of each period's musical characteristics. In responding to the general feeling the music expresses, therefore, you should try to note the specific features that identify the time of its composition.

3. *After you have heard the piece,* ask yourself these questions: Which characteristics of the music indicated the period of its composition? Were they due to the forces employed (voices and/or instruments)? How was the piece constructed? Did the composer make use of repetition? Was there a change of mood and, if so, did the original mood return at the end? What kind of melody was used? Was it continuous or did it divide into a series of shorter phrases? If a text was involved, how did the music relate to the words? Were they audible? Did the composer intend them to be? If not, why not?

Were there aspects of the music that reminded you of the literature and visual arts of the same period? In what kind of buildings can you imagine it being performed? What does the music tell you about the society for which it was written?

Finally, ask yourself the most difficult question of all: What did the music express? Richard Wagner described the meaning of music as "foreign and inexpressible in any other language." There is no dictionary of musical meaning, and listeners must interpret for themselves what they hear. We all understand the general significance of words like *contentment* or *despair,* but music can distinguish between a million shades of each.

Concepts in Music

There is a natural tendency in talking about the arts to use terms from one artform to describe another. Thus most people would know what to expect from a "colorful" story or a painting in "quiet" shades of blue. This metaphorical use of language helps describe characteristics that are otherwise often very difficult to isolate, but some care is required to remain within the general bounds of comprehension.

Line. In music, *line* generally means the progression in time of a series of notes: the melody. A melody in music is a succession of tones related to one another to form a complete musical thought. Melodies vary in length and in shape and may be made up of several smaller parts. They may move quickly or slowly, smoothly or with strongly accented (stressed) notes. Some melodies are carefully balanced and proportional, others are irregular and asymmetrical. A melodic line dictates the basic character of a piece of music, just as lines do in a painting or the plot line does for a story or play.

Texture. The degree to which a piece of music has a thick or thin *texture* depends on the number of voices and/or instruments involved. Thus the monophonic music of the Middle Ages, with its single voice, has the thinnest texture possible. At the opposite extreme is a 19th-century opera, where half a dozen soloists, a chorus, and a large orchestra were sometimes combined. Needless to say, thickness and thinness of texture are neither good nor bad in themselves, merely simple terms of description.

Composers control the shifting texture of their works in several ways. The number of lines heard simultaneously can be increased or reduced—a full orchestral climax followed by a single flute, for example. The most important factor in the texture of the sound, however, is the number of combined independent melodic lines; this playing (or singing) together of two or more separate melodies is called *counterpoint.* Another factor influencing musical texture is the vertical arrangement of the notes: Six notes played close together low in the scale will sound thicker than six notes more widely distributed.

Color. The color, or *timbre,* of a piece of music is determined by the instruments or voices employed. Gregorian chant is monochrome, having only one line. The modern symphony orchestra has a vast range to draw upon, from the bright sound of the oboe or the trumpet to the dark, mellow sound of the cello or French horn. Different instruments used in Japanese or Chinese music will result in a quite distinct but very different timbre. Some composers have been more interested than others in exploiting the range of color instrumental combinations can produce; not surprisingly, Romantic music provides some of the most colorful examples.

Medium. The *medium* is the method of performance. Pieces can be written for solo piano, string quartet, symphony orchestra, or any other combination the composer chooses. A prime factor will be the importance of color in the work. Another is the length and seriousness of the musical material. It is difficult, although not impossible, for a piece written for solo

violin to sustain the listener's interest for half an hour. Still another is the practicality of performance. Pieces using large or unusual combinations of instruments stand less chance of being frequently programmed. In the nineteenth-century, composers often chose a medium that allowed performance in the home, thus creating a vast piano literature.

Form. *Form* is the outward, visible (or hearable) shape of a work as opposed to its substance (medium) or color. This structure can be created in a number of ways. Baroque composers worked according to the principle of unity in variety. In most Baroque movements the principal melodic idea continually recurs in the music, and the general texture remains consistent. The formal basis of much classical music is contrast, where two or more melodies of differing character (hard and soft, or brilliant and sentimental) are first laid out separately, then developed and combined, then separated again. The Romantics often pushed the notion of contrasts to extremes, although retaining the basic motions of classical form. Certain types of work dictate their own form. A composer writing a requiem mass is clearly less free to experiment with formal variation than one writing a piece for symphony orchestra. The words of a song strongly suggest the structure of the music, even if they do not impose it. Indeed, so pronounced was the Baroque sense of unity that the sung arias in Baroque operas inevitably conclude with a repetition of the words and music of the beginning, even if the character's mood or emotion has changed.

Thus music, like the other arts, involves the general concepts described above. A firm grasp of them is essential to an understanding of how the various arts have changed and developed over the centuries and how the changes are reflected in similarities—or differences— between art forms. The concept of the humanities implies that the arts did not grow and change in isolation from one another or from around the world. As this book shows, they are integrated among themselves and with the general developments of Western thought and history.

How To Read Literature

"Reading literature" conjures up visions of someone sitting in an armchair with glasses on and nose buried in a thick volume—say, Tolstoy's *War and Peace*. The plain truth is that a fair amount of the literature found in this book was never meant to be read that way at all. Once that fact is recognized, reading becomes an exercise in which different methods can serve as a great aid for both pleasure and understanding. That becomes clear when we consider various literary forms and ask ourselves how their authors originally meant them to be encountered. Let us consider some of the forms that will be studied in this volume to make the point more specifically:

Dramatic Literature. This is the most obvious genre of literature that calls for something more than reading the text quietly. Plays—ancient, medieval, Elizabethan, or modern—are meant to be acted, with living voices interpreting what the playwright wrote in the script. What seems to be strange and stilted language as we first encounter Shakespeare becomes powerful and beautiful when we hear his words spoken by someone who knows and loves language.

A further point: Until relatively recent times most dramas were played on stages nearly bare of scenery and, obviously, extremely limited in terms of lighting, theatrical devices, and the like. As a consequence, earlier texts contain a great deal of description that in the modern theater (and, even more, in a film) can be supplied by current technology. Where Shakespeare has a character say "But look, the morn in russet mangle clad/Walks o'er the dew of yon high eastward hill," a modern writer might simply instruct the lighting manager to make the sun come up.

Dramatic literature must be approached with a sense of its oral aspect as well as an awareness that the language reflects the intention of the author to have the words acted out. Dramatic language is meant to be *heard* and *seen*.

Epic. Like drama, epics have a strong oral background. It is commonplace to note that before Homer's *Iliad* took its present form, it was memorized and recited by a professional class of bards. Similarly, the *Song of Roland* was probably heard by many people and read by relatively few in the formative decades of its composition. Even epics that are more consciously literary echo the oral background of the epic; Vergil begins his elegant *Aeneid* with the words "Arms and the man I sing" not "Of Arms and the man I write." The Islamic scriptures—the Koran—is most effectively recited.

The practical conclusion to be drawn from this is that these long poetic tales take on a greater power when they are read aloud with sensitivity to their cadence.

Poetry. Under this general heading we have a very complicated subject. To approach poetry with intelligence, we need to inquire about the kind of poetry with which we are dealing. The lyrics of songs are poems, but they are better heard sung than read in a book. On the other hand, certain kinds of poems are so arranged on a page that not to see them in print is to miss a good deal of their power or charm. Furthermore, some poems are meant for the individual reader,

while others are public pieces meant for the group. There is, for example, a vast difference between a love sonnet and a biblical psalm. Both are examples of poetry, but the former expresses a private emotion while the latter most likely gets its full energy from use in worship: We can imagine a congregation singing a psalm, but not the same congregation reciting one of Petrarch's sonnets to Laura.

In poetry, then, context is all. Our appreciation of a poem is enhanced once we have discovered where the poem belongs: With music? on a page? with an aristocratic circle of intellectuals? as part of a national or ethnic or religious heritage? as propaganda or protest or to express deep emotions?

At base, however, poetry is the refined use of language. The poet is the maker of words. Our greatest appreciation of a poem comes when we say to ourselves that this could not be said better. An authentic poem cannot be edited or paraphrased or glossed. Poetic language, even in long poems, is economical. One can understand that by simple experiment: take one of Dante's portraits in the *Divine Comedy* and try to do a better job of description in fewer words. The genius of Dante (or Chaucer in the Prologue to *The Canterbury Tales*) is his ability to sketch out a fully formed person in a few stanzas.

Prose. God created humans, the writer Elie Wiesel once remarked, because he loves a good story. Narrative is as old as human history. The stories that stand behind the *Decameron* and *The Canterbury Tales* have been shown to have existed not only for centuries, but in widely different cultural milieus. Stories are told to draw out moral examples or to instruct or warn, but, by and large, stories are told because we enjoy hearing them. We read novels in order to enter into a new world and suspend the workaday world we live in, just as we watch films for the same purpose. The difference between a story and a film is that one can linger over a story, but in a film there is no "second look."

Some prose obviously is not fictional. It can be autobiographical like Augustine's *Confessions,* or it may be a philosophical essay like Jean-Paul Sartre's attempt to explain what he means by existentialism. How do we approach that kind of writing? First, with a willingness to listen to what is being said. Second, with a readiness to judge: Does this passage ring true? What objections might I make to it? and so on. Third, with an openness that says, in effect, there is something to be learned here.

A final point has to do with attitude. We live in an age in which much of what we know comes to us in very brief "sound bites" via television, and much of what we read comes to us in the disposable form of newspapers and magazines and inexpensive paperbacks. To read—*really* to read—requires that we discipline ourselves to cultivate a more leisurely approach to that art. There is merit in speed-reading the morning sports page; there is no merit in doing the same with a poem or a short story. It may take time to learn to slow down and read at a leisurely pace (leisure is the basis of culture, says Aristotle), but if we learn to do so we have taught ourselves a skill that will enrich us throughout our lives. A good thought exercise is to ask whether reading from a computer screen is a different exercise than reading from a book.

CULTURE
AND VALUES

A SURVEY OF THE HUMANITIES

VOLUME TWO ▪▪ SIXTH EDITION

	GENERAL EVENTS	LITERATURE & PHILOSOPHY	ART

FLORENTINE RENAISSANCE

THE FIRST PHASE

1400

1434

GENERAL EVENTS

15th cent. Florence center of European banking system; renaissance in exploration outside Europe begins

1417 Council of Constance ends "Great Schism"

1432 Florentines defeat Sienese at San Romano

ART

1401 Competition for North Doors of Florence Baptistery won by Ghiberti's *Sacrifice of Isaac*

1403 Ghiberti begins Baptistery doors; Brunelleschi, Donatello study Roman ruins

c. 1416–1417 Donatello, *Saint George*

1423 Fabriano, *Adoration of the Magi,* International Style altarpiece

1425 Masaccio begins frescoes for Brancacci Chapel, Santa Maria del Carmine, Florence; *Expulsion of Adam and Eve from Eden* (c. 1425)

c. 1425–c. 1452 Masaccio, *The Tribute Money* (c. 1427); Ghiberti sculpts panels for East Doors of Florence Baptistery; *The Story of Jacob and Esau* (1435)

Use of linear perspective to create three-dimensional space; naturalistic rendering of figures; return to classical ideals of beauty and proportion: Masaccio, *The Holy Trinity*, Santa Maria Novella, Florence (c. 1428)

c. 1428–1432 Donatello, *David,* first free-standing nude since antiquity

THE MEDICI ERA

GENERAL EVENTS

1434 Cosimo de' Medici becomes de facto ruler of Florence

1439–1442 Ecumenical Council of Florence deals with proposed union of Greek and Roman churches

1453 Fall of Constantinople to Turks; scholarly refugees bring Greek manuscripts to Italy

1464 Piero de' Medici takes power in Florence after death of Cosimo

1469 Lorenzo de' Medici rules city after death of Piero

1478 Pazzi conspiracy against the Medici fails

1489 Savonarola begins sermons against Florentine immorality

1492 Death of Lorenzo de' Medici

LITERATURE & PHILOSOPHY

1446–1450 Gutenberg invents movable printing type

1456 *Gutenberg Bible* printed at Mainz

1462 Cosimo de' Medici founds Platonic Academy in Florence, headed by Marsilio Ficino

1465 First Italian printing press, at Subiaco

1470–1499 Laura Cetera's humanist writings

1470–1527 Height of humanist learning

1475 *Recuyell of the Historyes of Troye,* printed by William Caxton, first book published in English

c. 1476–1477 Lorenzo de' Medici begins *Comento ad Alcuni Sonetti*

1482 Ficino, *Theologia Platonica*

1486 Pico della Mirandola, *Oration on the Dignity of Man*

1490 Lorenzo de' Medici, *The Song of Bacchus*

1491 Lorenzo de' Medici, *Laudi*

ART

1445–1450 Fra Angelico, *Annunciation,* fresco for Convent of San Marco, Florence

c. 1455 Donatello, *Saint Mary Magdalene;* Uccello, *Battle of San Romano*

1459–1463 Gozzoli, *The Journey of the Magi*

c. 1467–1483 Leonardo works in Florence

1475 The Medici commission Botticelli's *Adoration of the Magi* for Santa Maria Novella

1478–c. 1482 Botticelli, *La Primavera, The Birth of Venus, Pallas and the Centaur*

ROMAN RENAISSANCE

1494

1503

1520

GENERAL EVENTS

1494 Medici faction in exile; Savonarola becomes de facto ruler of Florence; Charles VIII of France invades Italy, beginning foreign invasions

1498 Savonarola burned at stake by order of Pope

1512 Medici power restored in Florence; Machiavelli exiled

LITERATURE & PHILOSOPHY

c. 1494 Aldus Manutius establishes Aldine Press in Venice

1496 Burning of books inspired by Savonarola

1502 Erasmus, *Enchiridion militis Christiani*

1506 Erasmus travels to Italy
1509 Erasmus, *The Praise of Folly*
1513 Machiavelli, *The Prince*
1516 Erasmus, *Greek New Testament*

ART

1498–1499 Michelangelo, *Pietá*
late 15th–early 16th cent. Leonardo, *Notebooks*
c. 1495–1498 Leonardo, *The Last Supper*
c. 1496 Botticelli burns some of his work in response to Savonarola's sermons

c. 1503–1505 Leonardo, *Mona Lisa*
1506 Ancient *Laocoön* sculpture discovered

Most dates are approximate

THE EARLY RENAISSANCE

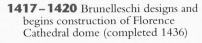

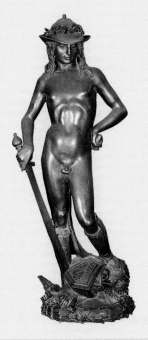

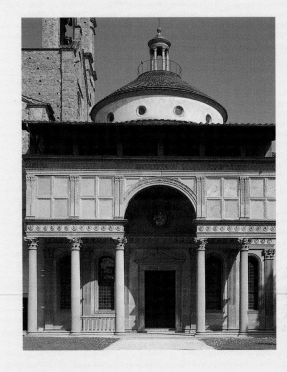

1417–1420 Brunelleschi designs and begins construction of Florence Cathedral dome (completed 1436)

1419–1426 Brunelleschi, Foundling Hospital

Use of classical order and proportion to achieve rational harmony of elements; Brunelleschi, Pazzi Chapel, Santa Croce, Florence (1430–1433)

1434 Jan Van Eyck, *Giovanni Arnolfini and His Bride*

1437–1452 Michelozzo, Convent of San Marco, Florence

1444–1459 Michelozzo, Palazzo Medici-Riccardi, Florence

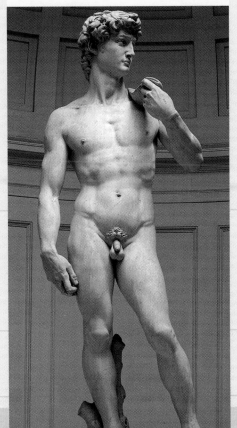

c. 1450–1500 Johannes Ockeghem, motets, chansons, masses; *Missa pro Defunctis,* earliest known polyphonic requiem mass

1479–1492 Heinrich Isaac, court composer to Medici family and organist and choirmaster at Florence Cathedral, sets Lorenzo's poems to music

c. 1489 Michelangelo begins studies in Lorenzo's sculpture garden; *Madonna of the Stairs* (1489–1492)

1501–1504 Michelangelo, *David*

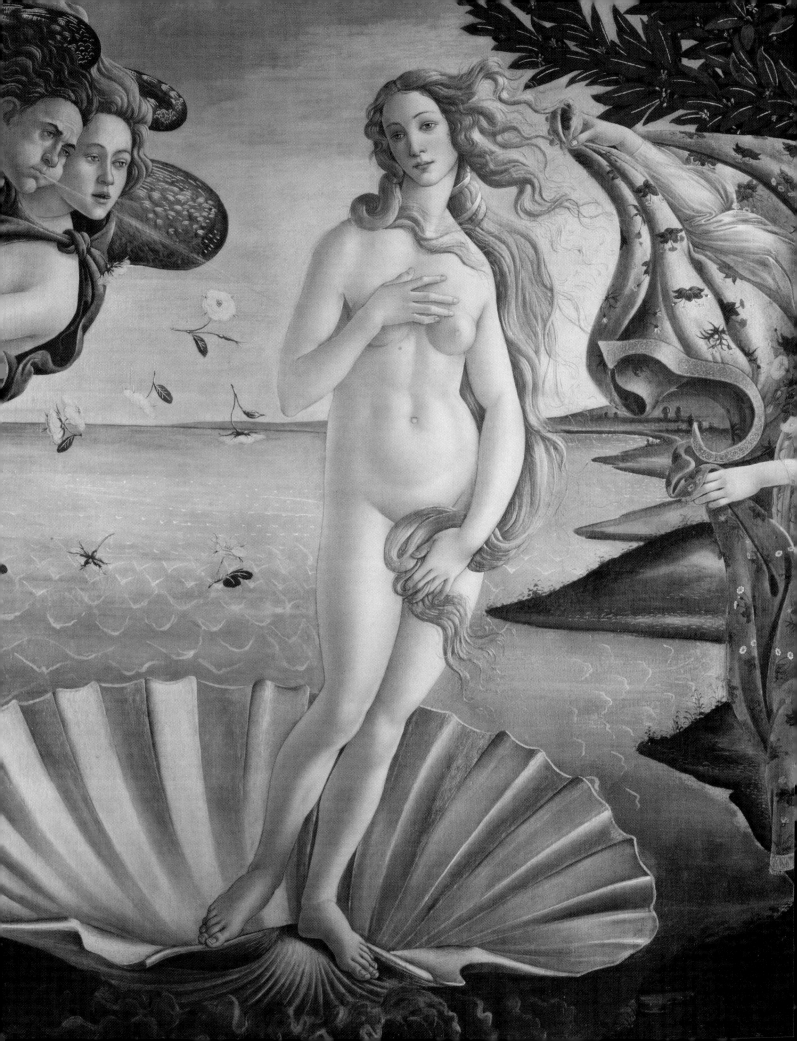

CHAPTER 12

THE EARLY RENAISSANCE

TOWARD THE RENAISSANCE

The fourteenth century was a period of great social strife and turmoil as well as a time in which new stirrings were abroad in Europe. It was the century of Dante, Petrarch, Boccaccio, and Chaucer. The entrenched scholastic approach to learning was being tempered by renewed interest in Classical literature. The long-cherished Byzantine art style was being challenged by the new realism of such Italian artists as Cimabue and Giotto in Florence, Simone Martini, and the Lorenzetti brothers, among others. Renewed interest in the world of nature was fueled by the enormous impact of Saint Francis of Assisi (1181–1226), who taught Europeans to see God in the beauty of the world and its creatures.

Europe was slowly recovering from the fearful plague-stricken years around 1348, a rebirth aided by a new growth in economics and trade. Wealth was being created by an emerging class whose claim to eminence was based less on noble blood than on ability to make money.

In the fifteenth century, the center of this new vitality was Florence in Italy. No city its size has in its day exerted more influence on culture at large than this focus of banking and commerce. From roughly the 1420s until the end of the century, a collaborative effort of thinkers, artists, and wealthy patrons enriched the city, in the process making it a magnet for all Europe. To that city and its cultural development we now turn.

THE FIRST PHASE: MASACCIO, GHIBERTI, AND BRUNELLESCHI

At the beginning of the fifteenth century, Florence had every reason to be a proud city. It stood on the main road connecting Rome with the north. Its language—known at the time as the Tuscan dialect or the Tuscan idiom—was the strongest and most developed of the Italian dialects; its linguistic power had been demon-strated more than a century earlier by Dante Alighieri and his literary successors, Petrarch and Boccaccio. The twelve great *Arti* ("trade guilds") of Florence were commercially important for the city; in addition, representatives of the seven senior **guilds** formed the body of magistrates that ruled the city from the fortresslike town hall, the Palazzo Vecchio. This "representative" government, limited though it was to the prosperous guilds, preserved Florence from the rise of the terrible city tyrants who plagued so many other Italian cities.

Florence had been one of the centers of the wool trade since the late Middle Ages. In the fifteenth century it was also the center of the European banking system. In fact, our modern banks (the word *bank* is from the Italian *banco,* which means "counter" or "table"—the place where money is exchanged) and their systems of handling money are based largely on practices developed by the Florentines. They devised advanced accounting methods, letters of credit, and a system of checks; they were the first to emphasize the importance of a stable monetary system. The gold florin minted in Florence was the standard coin in European commerce for centuries.

Great Florentine banking families made and lost fortunes in trading and banking. These families—the Strozzi, Bardi, Tornabuoni, Pazzi, and Medici—were justly famous in their own time. They, in turn, were justly proud of their wealth and their city. A visitor to Florence today walks on streets named for these families and past palaces built for them. They combined a steady sense of business conservatism with an adventuresome pursuit of wealth and fame. No great Florentine banker would have thought it odd that one of this group began his will with the words "In the name of God and profit. Amen."

For all their renown and wealth, it was not the bankers who really gave Florence its lasting fame. By some mysterious stroke of good fortune, Florence and its immediate surroundings produced, in the fifteenth century, a group of artists who revolutionized Western art to such an extent that later historians refer to the period as a time of *renaissance* ("rebirth") in the arts.

VOICES OF THEIR TIMES

Fra Savonarola

Creatures are beautiful insofar as they share in and approach the beauty of the soul. Take two women of like bodily beauty, and if one is holy and the other is evil, you will notice that the holy one is more loved by everyone than the evil one, so all eyes will rest on her.

The same is true of men. A holy man, however deformed bodily, pleases everyone because, no matter how ugly he may be, his holiness shows itself and makes everything he does gracious.

Think how beautiful the Virgin was, who was so holy. She shines forth in all she does. Saint Thomas [Aquinas] says that no one who saw her ever looked on her with evil desire, so evident was her sanctity.

But now think of the saints as they are painted in the churches of the city. Young men go about saying

"This is the Magdalen and that is Saint John," and only because the paintings in the church are modeled on them. This is a terrible thing because the things of God are undervalued.

You fill the churches with your own vanity.

Do you think that the Virgin Mary went about dressed as she is shown in paintings? I tell you she went about dressed like a poor person with simplicity and her face so covered that it was hardly seen. The same is true of Saint Elizabeth.

You would do well to destroy pictures so unsuitably conceived. You make the Virgin Mary look like a whore. How the worship of God is mocked!

From a sermon of Fra Savonarola to a congregation in the Cathedral of Florence.

The character of this revolutionary change in art is not easy to define, but we can evolve a partial definition by comparing two early fifteenth-century Florentine paintings. Sometime before 1423 a wealthy Flor- entine banker, Palla Strozzi, commissioned Gentile da Fabriano (c. 1385–1427) to paint an altarpiece for the Florentine Church of Santa Trinitá. The *Adoration of the Magi* [**FIG. 12.1**], completed in 1423, is ornately framed

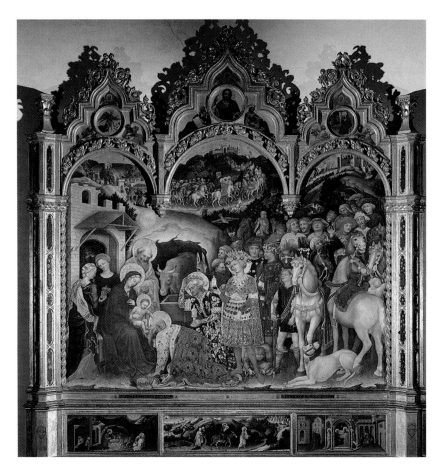

■ **12.1** Gentile da Fabriano. *Adoration of the Magi,* 1423. Altarpiece from Santa Trinita, Florence. Tempera on wood, approx. 9′11″ × 9′3″ (3.02 × 2.81 m). Galleria degli Uffizi, Florence. This painting reflects the flat two-dimensional quality of most Byzantine and medieval painting. Note the crowded composition and the highly ornate frame of the whole.

TABLE 12.1 *Major Social Events of the Fifteenth Century*

1439—Council of Florence attempts to reconcile Catholic
 and Orthodox churches
1453—End of the Hundred Years' War
1453—Constantinople (Byzantium) falls to the Turks
1469—Spain united under Ferdinand and Isabella
1485—Henry VII begins reign as first Tudor King of England
1486—First European voyage around Cape of Good Hope
1492—Columbus discovers America
1492—Last Islamic city in Spain (Granada) falls to Ferdinand
 and Isabella
1494—Spain and Portugal divide spheres of influence in the
 New World
1497—Vasco da Gama begins first voyage to India
1498—Savonarola executed in Florence

in the style of Gothic art, with evidence of influences from the miniature painting of Northern Europe and from the older painting tradition of Italy. The altarpiece is in the style called "International" because it spread far beyond the area of its origins in France. This style reflects the old-fashioned tendency to fill up the spaces of the panel, to employ the brightest colors on the palette, to use gold lavishly for halos and in the framing, and to ignore any strict proportion between the characters and the space they occupy. Gentile's altarpiece is, in fact, a strikingly beautiful painting that testifies to the lush possibilities of the conservative International Gothic style.

Only about five years later, Tommaso Guidi (1401–1428), known as Masaccio, the precocious genius of Florentine painting, painted a **fresco** for the Dominican Church of Santa Maria Novella in Florence, *The Holy Trinity* [**Fig. 12.2**], that is strikingly different from the kind of painting by Gentile. The most apparent difference is in the utilization of space. In *The Holy Trinity* the central figures of God the Father, the Holy Spirit, and the crucified Christ seem to stand in the foreground of deep three-dimensional space created by the illusionistically painted architectural framing of the Trinity. The character of the architecture is Roman, its barrel vaulting and coffering sustained by Corinthian columns and pilasters. At the sides, and slightly lower, Mary looks out at the viewer, while Saint John looks at Mary. At the edge of the scene, members of the donor family kneel in profile. The entire scene has an intense geometrical clarity based on the pyramid, with God as the apex of the triangle formed with the line of donors and saints at the ends of the baseline.

In this single fresco appear many of the characteristics of Florentine Renaissance painting that mark it off from earlier painting styles: clarity of line, a concern for mathematically precise perspective, close observation of "real people," concern for psychological states, and an uncluttered arrangement that rejects the earlier

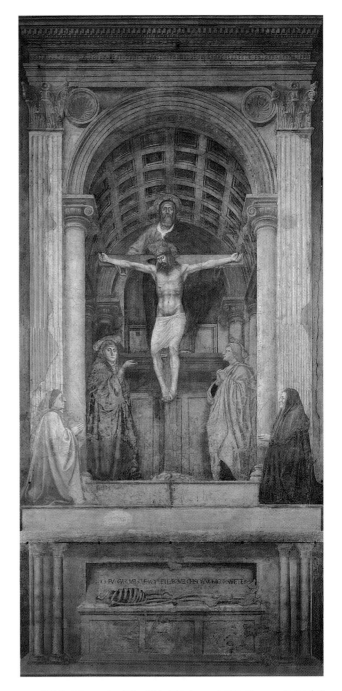

■ **12.2** Masaccio. *The Holy Trinity,* c. 1428. Fresco, 21′10½″ × 10′5″ (6.66 × 3.19 m). Santa Maria Novella, Florence. The donors of the panel kneel at bottom left and right. The Trinity, with the Holy Spirit symbolized as a dove, is set in a Classical Roman architectural frame. At the foot of the architectural frame is a skeleton representing death.

tendency in painting to produce crowded scenes to fill up all the available space.

Masaccio's earlier frescoes in the Brancacci Chapel of the Church of Santa Maria del Carmine in Florence also show his revolutionizing style. His 1427 fresco called *The Tribute Money* [**Fig. 12.3**] reflects his concern

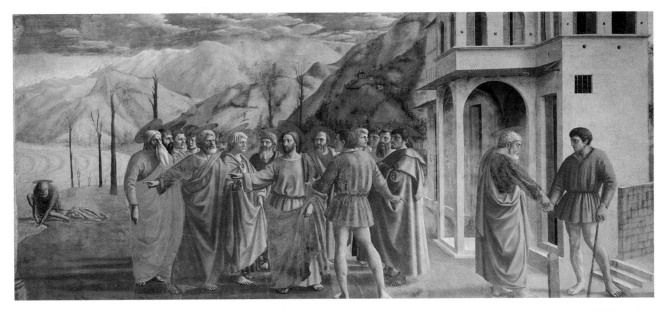

■ **12.3** Masaccio. *The Tribute Money*, c. 1427. Fresco. 8′1″ × 19′7″ (2.54 × 5.9 m). Brancacci Chapel, Santa Maria del Carmine, Florence. Three moments of the story are seen simultaneously. *Center:* Jesus instructs Peter to find the coin of tribute. *Left:* Peter finds it in the mouth of a fish. *Right:* Peter pays the tribute money. The story is in Matthew 17:24–27.

with realistic depiction of human beings. The central scene portrays Christ telling Peter that he can find the tax money for the temple in the mouth of a fish; at the left Peter recovers the coin of tribute; at the right he makes the tribute payment (Matthew 17:24–27). The clusters of figures surrounding Christ reflect a faithfulness to observed humanity that must have been startling to Masaccio's contemporaries, who had never seen anything quite like it. The figures are in a space made believable by the receding lines of the buildings to the right. The fresco of the *Expulsion of Adam and Eve from Eden* [**FIG. 12.4**] in the same chapel shows not only realism in the figures, but also a profound sense of human emotions: the shame and dismay of the first human beings as they are driven from the Garden of Paradise.

The revolutionary character of Masaccio's work was recognized in his own time. His influence on any number of Florentine painters who worked later in the century is clear. Two generations after Masaccio's death the young Michelangelo often crossed the river Arno to sketch the frescoes in the Brancacci chapel. In the next century, Giorgio Vasari (1511–1574) in his *Lives of the Artists* would judge Masaccio's influence as basic and crucial: "The superb Masaccio . . . adopted a new manner for his heads, his draperies, buildings, and nudes, his colors, and foreshortening. He thus brought into existence the modern style which, beginning during his period, has been employed by all of our artists down to the present day."

The innovative character of fifteenth-century art was not limited to painting. Significant changes were occurring in sculpture and architecture as well. A famous competition was announced in 1401 for the right to decorate the doors of the Florence Baptistery, dedicated to Saint John the Baptist and a focal point of Florentine life. The baptistery is an ancient octagonal Romanesque building which, in the fifteenth century, had such a reputation for antiquity that some thought it had originally been a Roman temple. Vasari tells us that an eminent group of artists including Lorenzo Ghiberti (1378–1455) and Filippo Brunelleschi (1377–1466) were among the competitors. Ghiberti won.

A comparison of the Brunelleschi and Ghiberti panels shows the differences between the two and allows us to infer the criteria used to judge the winner. The assigned subject for the competition was Abraham's sacrifice of Isaac (Genesis 22:1–14). Brunelleschi's version [**FIG. 12.5**] has a certain vigor, but it is a busy and crowded composition. The figures of the servants spill out of the four-leaf or quatrefoil frame, whereas the major figures (the ram, the angel, and the two principals) are in flattened two-dimensional profile with little background space.

By contrast, Ghiberti's panel on the same subject [**FIG. 12.6**] is divided dramatically by a slashing diagonal line separating the two sets of actors into clearly designated planes of action. The drastically foreshortened angel appears to be flying into the scene from deep space. Furthermore, as a close examination of the cast shows, Ghiberti's panel is a technical tour de force. Except for the figure of Isaac and Abraham's left foot (and part of the rock it rests on), the entire scene was cast as a single unit. Demonstrating his strong background as a goldsmith, Ghiberti finely modeled and skillfully finished his panel. It is a piece of fierce sentiment, mathematical perspective, and exquisite work.

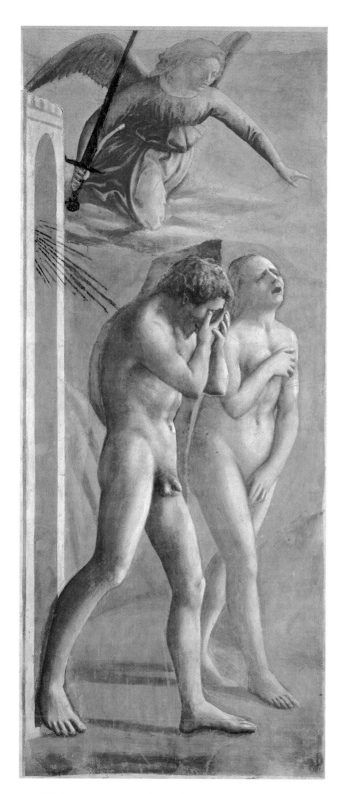

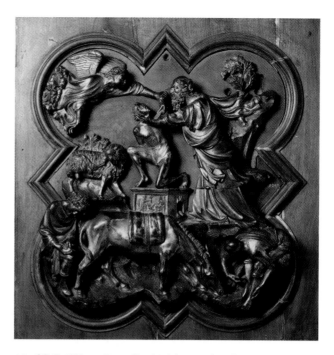

■ **12.5** Filippo Brunelleschi. *The Sacrifice of Isaac,* 1401–1402. Competition panel for the East Doors of the Baptistery of Florence. Gilt bronze relief, 21″ × 17½″ (53 × 44 cm). Museo Nazionale del Bargello, Florence. Note the figures spilling over the bottom part of the frame.

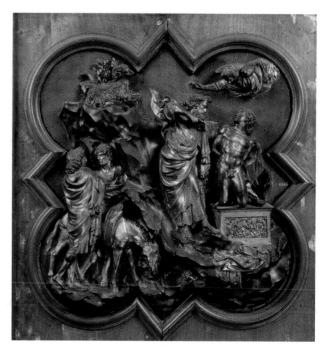

■ **12.4** Masaccio. *Expulsion of Adam and Eve from Eden,* c. 1425. Fresco, 7′¼″ × 2′11″ (2.14 × .90 m). Brancacci Chapel, Santa Maria del Carmine, Florence. The artist manages to convey both a sense of movement and a sense of the deep psychological distress and shame of the expelled couple.

■ **12.6** Lorenzo Ghiberti. *The Sacrifice of Isaac,* 1401–1402. Competition panel for the East Doors of the Baptistery of Florence. Gilt bronze relief, 21″ × 17½″ (53 × 44 cm). Museo Nazionale del Bargello, Florence. This was the winning panel in the competition.

Ghiberti worked for almost a quarter of a century on the North Doors, completing twenty panels. Just as he was finishing, the cathedral authorities commissioned him (in 1425) to execute another set of panels for the East Doors, those facing the cathedral. This commission occupied the next quarter of a century (from roughly 1425 to 1452 or 1453), and the results of these labors were so striking that Michelangelo later in the century said Ghiberti's East Doors were not unworthy to be called the "Gates of Paradise," and they are so-called to this day.

The panels of the East Doors [**FIG. 12.7**] differed radically in style and composition from the North Door panels. The Gothic style quatrefoils were replaced by more classically severe rectangular frames. The complete set of panels was framed, in turn, by a series of portrait busts of prophets and sybils.

Although Brunelleschi lost to Ghiberti in the sculpture competition of 1401, he made a major contribution to this early developmental phase of Renaissance art in another area: architecture. During his stay in Rome, where he had gone with the sculptor Donatello after the competition, he studied Roman architectural monuments. In fact, Vasari records that Brunelleschi and Donatello were reputed to be treasure hunters because of their incessant prowlings amid the ruins of the Roman Forum. These intensive studies, together with his own intuitive genius, gave Brunelleschi an idea for solving a problem then thought insoluble: how to construct the dome for the still unfinished Cathedral of Saint Mary of the Flower (Santa Maria del Fiore) in Florence.

The Cathedral of Florence had been built by Arnolfo di Cambio in the previous century over the

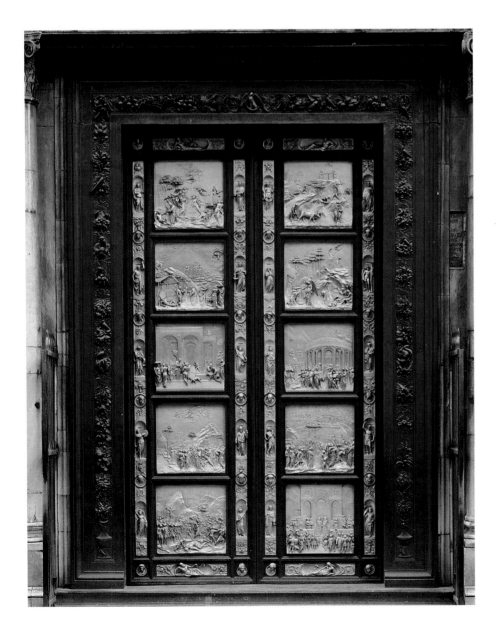

■ **12.7** Lorenzo Ghiberti, 1425–1432. East Doors ("Gates of Paradise") of the Baptistery of the Cathedral of Florence. Gilt bronze relief. Height, 17′ (5.18 m). Modern copy, ca. 1980. Original panels in Museo del Opera del Duomo, Florence.

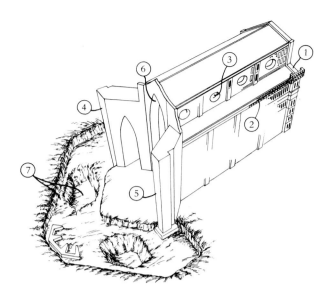

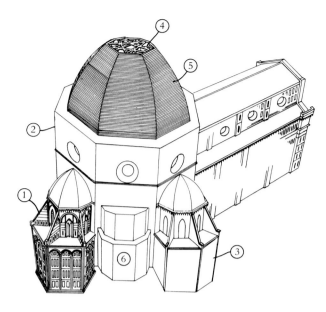

■ **12.8** Cathedral of Florence in 1390. An artist's reconstruction of the cathedral as Brunelleschi would have found it when he began his work. (1) Façade and side wall. (2) Gallery. (3) Circular windows. (4) Armature under construction. (5) Vaulting under construction. (6) Sacristy piers. (7) Excavations for buttresses.

■ **12.9** Cathedral of Florence in 1418. (1) Buttressing. (2) Completed drum (tambour). (3) Side tribunes under construction. (4) Armature under construction. (5) Vaulting under construction. (6) Sacristy piers.

remains of the older Church of Santa Reparata. In the early fifteenth century, however, the church was still unfinished, although the nave was already complete [**Fig. 12.8**]. No one had quite figured out how to span the great area without immense buttresses on the outside and supporting **armatures** on the inside. Brunelleschi worked on this problem between 1417 and 1420, trying, simultaneously, to solve the technical aspects of doming the building and convincing the skeptical cathedral overseers that it could be done. He won the day eventually, but work on the dome was not completed until 1436.

His solution, briefly, was to combine the buttressing methods of the Gothic cathedral and classical vaulting techniques that he had mastered by his careful study of the Roman Pantheon and other buildings from antiquity. By putting a smaller dome within the larger dome to support the greater weight of the outside dome, he could not only cover the great *tambour* ("drum") [**Fig. 12.9**] but also free the inside of the dome from any need for elaborate armatures or supporting structures. This dome was strong enough to support the lantern that eventually crowned the whole construction. It was a breathtaking technical achievement, as well as an aesthetic success, as any person viewing Florence from the surrounding hills can testify. Years later, writing about his own work on the dome of Saint Peter's in the Vatican, Michelangelo had Brunelleschi's dome in mind when he said "I will create your sister; bigger but no more beautiful."

The technical brilliance of Brunelleschi's dome cannot be overpraised, but his real architectural achievement lies in his building designs that break with older forms of architecture. His Foundling Hospital [**Fig. 12.10**], with its open-columned **loggias** and their graceful Corinthian pillars, arches, and **entablature,** is, despite its seeming simplicity, a highly intricate work, its proportions calculated with mathematical rigor. The building is an open departure from the heaviness of the Romanesque so common in the area of Tuscany as well as a rejection of the overly elaborate Gothic exteriors.

This same concern with Classical order, proportion, and serenity can be seen in Brunelleschi's finest work, the chapel he designed for the Pazzi family next to the Franciscan Church of Santa Croce in Florence [**Fig. 12.11**]. Its exterior evokes Roman austerity with its delicate columns, severe façade, and small dome reminiscent of the lines of Rome's Pantheon.

In this brief look at three different art forms and artists in the early fifteenth century, certain recurring words and themes give a rough descriptive outline of what the Florentine Renaissance style reflects: a concern with, and the technical ability to handle, space and volume in a believable way; a studious approach to models of art from ancient Rome; a departure from the more ethereal mode of medieval otherworldliness to a greater concern for human realism. The Florentine artistic temperament leaped over its medieval heritage (although not completely) in order to reaffirm what it considered the Classical ideal of ancient Rome and Greece.

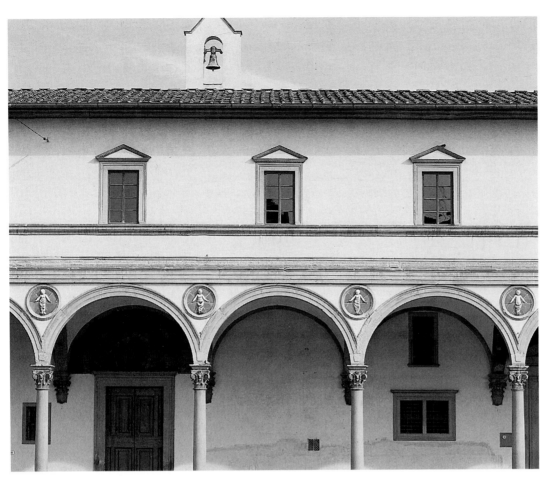

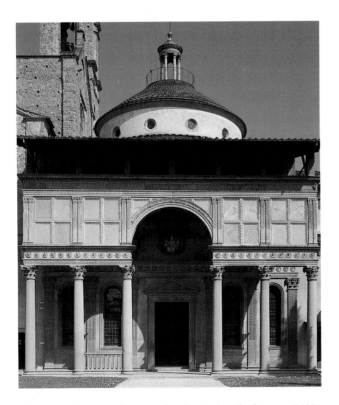

◼ **12.11** Filippo Brunelleschi. Pazzi Chapel, Florence, 1430–1433. Part of the Franciscan Church of Santa Croce can be seen in the left background.

THE MEDICI ERA

The Florentine Republic was governed by representatives of the major trade guilds. This control by a select group of people who represented commercial power and wealth inevitably led to domination by the most wealthy of the group. From 1434 until 1492, Florence was under the control of one family: the Medici.

The Medici family had old, though until then undistinguished, roots in the countryside around Florence. Their prosperity in the fifteenth century rested mainly on their immense banking fortune. By the middle of that century, Medici branch banks existed in London, Naples, Cologne, Geneva, Lyons, Basel, Avignon, Bruges, Antwerp, Lübeck, Bologna, Rome, Pisa, and Venice. The great Flemish painting by Jan van Eyck, *Giovanni Arnolfini and His Bride* [**FIG. 12.12**], in fact, commemorates van Eyck's witnessing of the marriage in 1434 of this Florentine representative of the Medici bank in Bruges. Although it is more usual to look at the painting because of its exquisite technique, its rich symbolism, and its almost microscopic concern for detail, it is also profitable to view it sociologically as a testimony to how far the influence of the Medici extended.

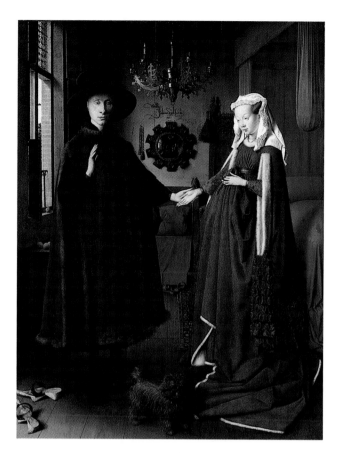

■ **12.12** Jan van Eyck. *Giovanni Arnolfini and His Bride,* 1434. Tempera and oil on wood, approx. 32″ × 23″ (81.3 × 59.7 cm). Reproduced by courtesy of the Trustees of the National Gallery, London. The artist, reflected in the mirror, stands in the doorway. The Latin words on the wall read "Jan van Eyck was here." The pair of sandals at the lower left symbolizes a sacred event; the dog is a symbol of fidelity and domestic peace.

Cosimo de' Medici

Cosimo de' Medici (de facto ruler of Florence from 1434 to 1464) was an astute banker and a highly cultivated man of letters. His closest friends were professional humanists, collectors of books, and patrons of the arts. Cosimo spent vast sums on collecting and copying ancient manuscripts. He had his copyists work in a neat cursive hand that would later be the model for the form of letters we call *italic*. His collection of books (together with those added by later members of his family) formed the core of the great humanist collection housed today in the Laurentian Library in Florence.

Although Cosimo never mastered Greek to any degree, he was intensely interested in Greek philosophy and literature. He financed the chair of Greek at the **Studium** of Florence. When Greek prelates visited Florence during the ecumenical council held in 1439 (the council sought a union between the Greek and Latin churches), Cosimo took the opportunity to seek out scholars from Constantinople in the retinue of the prelates. He was particularly struck with the brilliance of Genisthos Plethon (c. 1355–1452), who lectured on Plato. Cosimo persuaded Plethon to remain in the city to continue his lectures.

Cosimo's most significant contribution to the advancement of Greek studies was the foundation and endowment of an academy for the study of Plato. For years Cosimo and his heirs supported a priest, Marsilio Ficino, in order to allow him to translate and comment on the works of Plato. In the course of his long life (he died in 1499), Ficino translated into Latin all of Plato, Plotinus, and other Platonic thinkers. He wrote his own compendium of Platonism called the *Theologia Platonica.* These translations and commentaries had an immense influence on art and intellectual life in Italy and beyond the Alps.

Cosimo often joined his friends at a suburban villa to discuss Plato under the tutelage of Ficino. This elite group embraced Plato's ideas of striving for the ideal good and persistently searching for truth and beauty. This idealism became an important strain in Florentine culture. Ficino managed to combine his study of Plato with his own understanding of Christianity. Ficino coined the term "Platonic love"—the spiritual bond between two persons who were joined together in the contemplative search for the true, the good, and the beautiful. Cosimo, a pious man in his own right, found great consolation in this Christian Platonism of Ficino. "Come and join me as soon as you possibly can and be sure to bring with you Plato's treatise *On the Sovereign Good,*" Cosimo once wrote his protégé: "There is no pursuit to which I would devote myself more zealously than the pursuit of truth. Come then and bring with you the lyre of Orpheus."

A fiercely patriotic Florentine known to his contemporaries as *Pater Patriae* ("Father of the Homeland"), Cosimo lavished his funds on art projects to enhance the beauty of the city, at the same time glorifying his family name and atoning for his sins, especially usury (taking interest on money), by acts of generous charity. He befriended and supported many artists. He was an intimate friend and financial supporter of the greatest Florentine sculptor of the first half of the fifteenth century, Donato di Niccolò di Betto Bardi (1386–1466), known as Donatello. Donatello was an eccentric genius who cared for little besides his work; it was said that he left his fees in a basket in his studio for the free use of his apprentices or whoever else might be in need.

Even today a leisurely stroll around the historic center of Florence can, in a short time, give an idea of the tremendous range of Donatello's imaginative and artistic versatility. One need only compare his early *Saint George* [**Fig. 12.13**], fiercely tense and classically severe, to the later bronze *David* [**Fig. 12.14**]. The *Saint George* is a niche sculpture originally executed for the Church of Or San Michele, whereas the *David* is

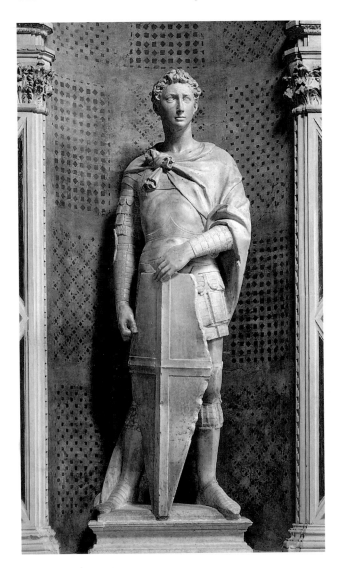

■ **12.13** Donatello. *Saint George,* 1415–1417. From Or San Michele. Marble (has been replaced by a bronze copy). Height approx. 6′10″ (2.08 m). Museo Nazionale del Bargello, Florence. Originally, the saint grasped a spear in his right hand.

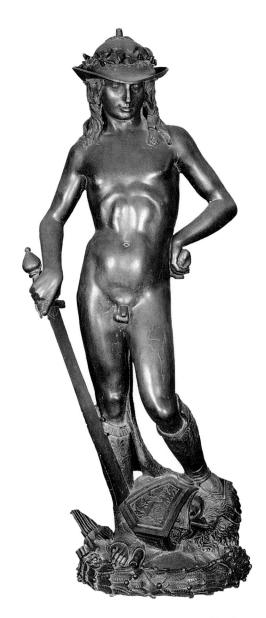

■ **12.14** Donatello. *David,* c. 1428–1432. Bronze. Height 5′2½″ (1.58 m). Museo Nazionale del Bargello, Florence. The killing of Goliath is shown at three stages in this book. Michelangelo's *David* is shown as he sees his foe (Figure 12.28). Bernini's *David* is shown in the exertion of his attack (Figure 15.8). Donatello's *David* reposes after the attack as he leans on the sword of the giant and rests his other foot on Goliath's severed head.

meant to be seen from all sides. The *David,* a near-life-size figure, is the first freestanding statue of a nude figure sculpted since Roman antiquity. It also marks a definite step in Renaissance taste: Despite its subject, it is more clearly "pagan" than biblical in spirit. The sculptor obviously wanted to show the beauty of form of this adolescent male clothed only in carefully fashioned military leg armor and a Tuscan shepherd's hat. The figure was most likely made for a garden. Some scholars have speculated that the commission was from Cosimo, although clear documentary proof is lacking.

Donatello's larger-than-life-sized wooden figure of Mary Magdalene [**FIG. 12.15**] seems light years away from the spirit of *David.* Carved around 1455, it shows the Magdalene as an ancient penitent, ravaged by time and her own life of penance. The viewer is asked to

mentally compare this older woman with the younger woman described in the Bible. The statue, then, is a profound meditation on the vanity of life, a theme lingering in Florentine culture from its medieval past and, at the same time, a hymn to the penitential spirit that made Magdalene a saint in the popular imagination.

Cosimo de' Medici had a particular fondness for the Dominican Convent of San Marco in Florence. In 1437 he asked Michelozzo (1396–1472), the architect who designed the Medici palace in Florence, to

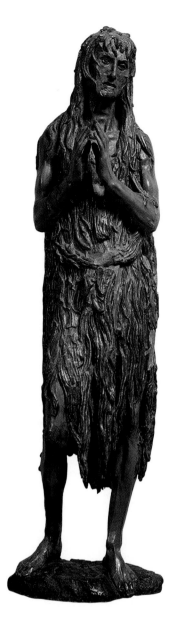

■ **12.15** Donatello. *Saint Mary Magdalene,* c. 1454–1455. Polychromed and gilded wood. Height 6′2″ (1.88 m). Museo Dell' Opera del Duomo, Florence. Cleaned and restored after flood damage in 1966, this statue now reveals some traces of the original **polychrome.** It was originally in the Baptistery of the Florence Cathedral.

rebuild the convent for the friars. One of the Dominicans who lived there was a painter of established reputation, Fra Angelico (1387–1455). When Michelozzo's renovations were done, Fra Angelico decorated many of the convent walls and most of the cells of the friars with paintings, executing many of these works under the watchful eye of Cosimo, who stayed regularly at the convent. Fra Angelico's famous *Annunciation* fresco [**FIG. 12.16**] shows his indebtedness to the artistic tradition of Masaccio: the use of architecture to frame space, a sense of realism and drama, and a close observation of the actual world.

Another painter who enjoyed the Medici largesse was Paolo Uccello (1397–1475), who created a series of three paintings for the Medici palace commemorating the earlier Battle of San Romano (1432) in which the Florentines defeated the Sienese. The paintings (now dispersed to museums in London, Florence, and Paris) show Uccello's intense fascination with perspective [**FIG. 12.17**]. The scenes are marked by slashing lines, foreshortened animals, receding backgrounds, and seemingly cluttered landscapes filled with figures of differing proportion. When the three paintings were together as a unit, they gave a panoramic sweep of the battle running across 34 feet (10.3 m) of the wall space.

Cosimo's last years were racked with chronic illness and depression brought on by the premature deaths of his son Giovanni and a favorite grandson, as well as the physical weakness of his other son, Piero. Toward the end of his life, Cosimo's wife once found him in his study with his eyes closed. She asked him why he sat in that fashion. "To get them accustomed to it," he replied. Cosimo de' Medici died on August 1, 1464. His position as head of the family and as first citizen of the city was assumed by his son Piero, called "the Gouty" in reference to the affliction of gout from which he suffered all his life.

Piero de' Medici

Piero's control over the city lasted only five years. It was a time beset by much political turmoil as well as continued artistic activity. Piero continued to support his father's old friend Donatello and maintained his patronage of Ficino's Platonic labors and his generous support of both religious and civic art and architecture.

One new painter who came under the care of Piero was Alessandro di Mariano dei Filipepi (1444–1510), known more familiarly as Sandro Botticelli. Botticelli earlier had been an apprentice of the painter Fra Filippo Lippi (c. 1406–1469), but Piero and his aristocratic wife Lucrezia Tornabuoni (a highly cultivated woman who was a religious poet) took Botticelli into their home and treated him as a family member. Botticelli stayed closely allied with the Medici for decades.

One tribute to the Medici was Botticelli's painting *Adoration of the Magi* [**FIG. 12.18**], a work commissioned for the Florentine Church of Santa Maria Novella. The Magi are shown as three generations of the Medici family; there are also portraits of Lorenzo and Giuliano, the sons of Piero. The painting was paid for by a friend of the Medici family. Many scholars believe it was a votive offering to the church in thanksgiving for the safety of the family during the political turmoil of 1466.

The theme of the Magi was a favorite of the Medici. They regularly took part in the pageants in the

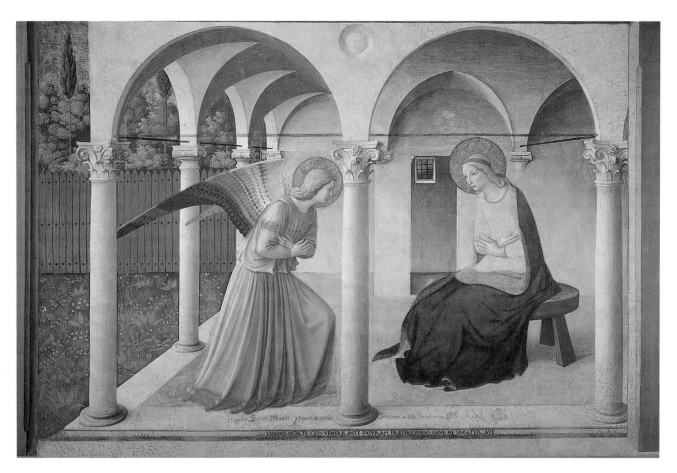

■ **12.16** Fra Angelico. *Annunciation,* 1445–1450. Fresco, 7′6″ × 10′5″ (2.29 × 3.18 m). Monastery of San Marco, Florence. Note how the architecture frames the two principal figures in the scene. Botanists can identify the flowers in the garden to the left.

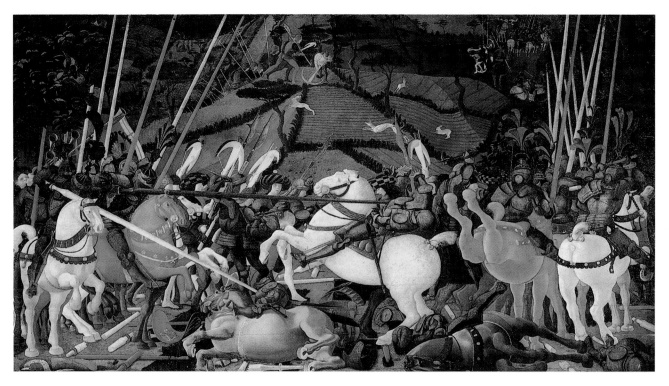

■ **12.17** Paolo Uccello. *The Battle of San Romano,* 1455. Tempera on wood, 6′10″ × 10′7″ (1.83 × 3.22 m). Galleria degli Uffizi, Florence. The upraised spears and javelins give the picture a sense of frantic complexity.

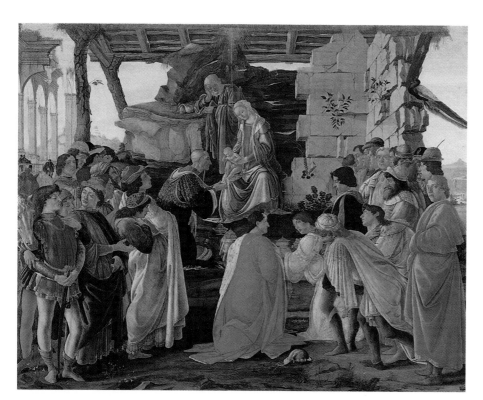

12.18 Sandro Botticelli. *Adoration of the Magi*, 1475. Tempera on wood, 3′7½″ × 4′4¾″ (1.1 × 1.34 m). Galleria degli Uffizi, Florence. Cosimo de' Medici kneels in front of the Virgin; Lorenzo is in the left foreground; Giuliano is at the right against the wall. The figure in the right foreground looking out toward the viewer is thought to be the artist.

streets of Florence celebrating the three kings on the Feast of the Epiphany (January 6). It is for that reason, one assumes, that Piero commissioned a fresco of that scene for the chapel of his own palace. The painter was Benozzo Gozzoli (1420–1495), once an apprentice of Fra Angelico. Gozzoli produced an opulent scene filled with personages of Oriental splendor modeled on the Greek scholars who had come to Florence during the ecumenical council and who stayed on to teach Greek. The fresco also included some contemporary portraits, including a self-portrait of the artist himself [**Fig. 12.19**].

Lorenzo the Magnificent

Piero de' Medici died in 1469. The mantle of power settled on the shoulders of his son Lorenzo, who accepted the responsibility with pragmatic resignation, saying, "It bodes ill for any wealthy man in Florence who doesn't control political power." Lorenzo, a rather ugly man with a high raspy voice, became the most illustrious of the family; in his own day he was known as Lorenzo il Magnifico ("the magnificent"). His accomplishments were so many and varied that the last half of the fifteenth century in Florence is often called the Laurentian Era.

Lorenzo continued the family tradition of art patronage by supporting various projects and by adding to the Medici collection of ancient gems, other antiquities, and books. He was also more directly involved in the arts. Lorenzo was an accomplished poet, but his reputation as a political and social leader has made us forget that he was an important contributor to the development of vernacular Italian poetry. He continued the sonnet tradition begun by Petrarch. One of his most ambitious projects—done in conscious imitation of Dante's *Vita Nuova*—was a long work that alternated his own sonnets with extended prose commentaries; this was the *Comento ad alcuni sonetti* (*A Commentary on Some Sonnets,* begun c. 1476–1477). In addition to this ambitious work, Lorenzo wrote hunting songs, poems for the carnival season, religious poetry, and occasional burlesque poems with a cheerfully bawdy tone.

The poem for which Lorenzo is best known is "The Song of Bacchus." Written in 1490, its opening stanzas echo the old Roman dictum of living for the present because life is short and the future is uncertain.

The Song of Bacchus

How beautiful is youth,
That flees so fleetingly by.
Let him be who chases joy
For tomorrow there is no certainty.

Look at Bacchus and Ariadne
So beautiful and much in love.
Since deceitful time flees
They are always happy.

Joyful little satyrs of the nymphs enamored,
In every cave and glade

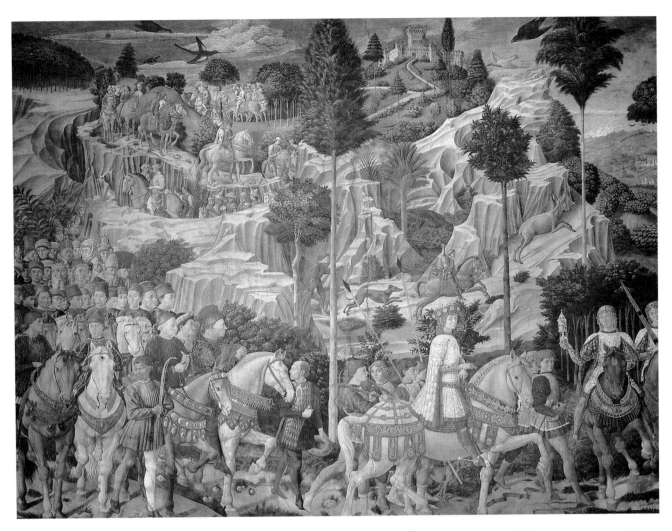

■ **12.19** Benozzo Gozzoli. *The Journey of the Magi,* 1459. Detail. Fresco. Length (entire work) 12′4½″ (3.77 m). Chapel, Palazzo Medici-Riccardi, Florence. The horseman, representing one of the Magi, is thought to be an idealized portrait of Byzantine Emperor John VII Paleologus, who visited Florence at the invitation of Cosimo de' Medici for a church council in 1439.

Have set traps by the hundred;
Now, by Bacchus intoxicated,
Dance and leap without end.

Let him be who chases joy
For tomorrow there is no certainty.

Lorenzo's interests in learning were deep. He had been tutored as a youth by Ficino and as an adult continued the habit of spending evenings with an elite group of friends and Ficino. He often took with him his friend Botticelli and a young sculptor who worked in a Medici-sponsored sculpture garden, Michelangelo Buonarroti.

The Laurentian patronage of learning was extensive. Lorenzo contributed the funds necessary to rebuild the University of Pisa and designated it the principal university of Tuscany (Galileo taught there in the next century). He continued to underwrite the study of Greek at the *Studium* of Florence.

The Greek faculty at Florence attracted students from all over Europe. This center was a principal means by which Greek learning was exported to the rest of Europe, especially to countries beyond the Alps. English scholars such as Thomas Linacre, John Colet, and William Grocyn came to Florence to study Greek and other Classical disciplines. Linacre was later to gain fame as a physician and founder of England's Royal College of Physicians. Grocyn returned to England to found the chair of Greek at Oxford. Colet used his training to become a biblical scholar and a founder of Saint Paul's School in London. The two greatest French humanists of the sixteenth century had, as young men, come under the influence of Greek learning from Italy. Guillaume Budé (died 1540) founded, under the patronage of the French kings, a library at Fontaine-bleau that was the beginning of the Bibliothèque Nationale of Paris. He also founded the Collège de France, still the most prestigious center of higher learn-

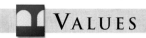

VALUES

Intellectual Synthesis

It would be a bit misleading to see the Renaissance as a naïve recovery of the Classical past. What actually occurred was a desire for *synthesis,* which is to say, a recovery of the inherited past of Greece and Rome in order to use that recovery for the needs and aspirations of the time. The first step in this synthesis required a study of the past. It is worthwhile noting how extensive that study was. It ranged from the careful observation and measurement of ancient buildings to the close study of archaeological remains from Rome like coins, carved gems, and sculpture to the humanistic work of editing texts, translating them, and providing those aids (like dictionaries, etc.) that would permit this work to go on. The synthesis came when people took what they had recovered from the past (a process called in French *ressourcement*—"going back to the sources") and transformed what they discovered to meet the needs of their own contemporary situation.

That process of synthesis needs emphasis if one is to understand what happened in, say, fifteenth-century Florence. Brunelleschi did not study Rome's Pantheon to rebuild it but as an exercise in order to better create church architecture. Ficino loved Plato but he thought that in Plato he could explain the Christian faith better than the schoolmen of an earlier period. Machiavelli and Erasmus—radically different types that we have noted in the text—loved the classics for their own sakes, but they also saw in them pragmatic clues that would help them understand contemporary problems ranging from how politics ought to be ordered to how church reform might be effected.

If one is to understand the Renaissance, it is crucial to see that the Classical past was not merely ancient history but a source for new and innovative ideas and concepts that addressed real and pertinent issues.

ing in France. Jacques Lefèvre d'Étaples had also studied in Florence and became the greatest intellectual church reformer of sixteenth-century France.

Lorenzo was less interested in painting than either his father Piero or his grandfather Cosimo. Nevertheless, some of the paintings created during his lifetime have come to epitomize the spirit of the age because of their close familial and philosophical links to Lorenzo's family. This is especially true of the work of Botticelli and, more specifically, his paintings *La Primavera* and *The Birth of Venus.*

Botticelli painted *La Primavera* (*Springtime*) [**Fig. 12.20**] for a cousin of Lorenzo named Lorenzo di' Pierfrancesco. One of the most popular paintings in Western art, *La Primavera* is an elaborate mythological **allegory** of the burgeoning fertility of the world. The allegory has never been fully explicated, but the main characters are clearly discernible: at the extreme right the wind god Zephyr pursues a nymph who is transformed into the goddess Flora (next figure), who scatters her flowers; at the left are the god Mercury and three dancing Graces. Over the Graces and the central female figure (who represents Spring) is blind Cupid ready to launch an arrow that will bring love to the one he hits. The rich carpeting of springtime flowers and the background of the orange grove provide luxuriant surroundings.

In the sixteenth century, Vasari saw *La Primavera* in Lorenzo di' Pierfrancesco's villa together with another

painting by Botticelli, *The Birth of Venus* (1480). A gentle, almost fragile work of idealized beauty, *The Birth of Venus* [**Fig. 12.21**] shows the wind gods gently stirring the sea breezes as Venus emerges from the sea and an attendant waits for her with a billowing cape. The Venus figure is inspired by the *Venus pudica* (the "Modest" Venus) figures of antiquity. The most significant aspect of the painting (and of *La Primavera*) is the impulse, motivated by Platonism, to idealize the figures. Botticelli is trying to depict not a particular woman but the essential ideal of female beauty. The Venus of this painting reflects a complex synthesis of Platonic idealism, Christian mysticism relating to the Virgin, and the Classical ideal of the female figure of Venus.

Two other artists who lived in Laurentian Florence are of worldwide significance: Leonardo da Vinci (1452–1519) and Michelangelo Buonarroti. Leonardo came from a small Tuscan town near Florence called Vinci. He lived in Florence until the 1480s, when he left for Milan; from there he moved restlessly from place to place until his death in France. Leonardo has been called *the* genius of the Renaissance not so much for what he left in the way of art (although his *Mona Lisa* [**Fig. 12.22**] and *The Last Supper* [**Fig. 12.24**] are surely among the more famous art pieces of all time) as for the things that he dreamed of doing, the problems he set himself to solve, and the phenomena he observed and set down in his *Notebooks.*

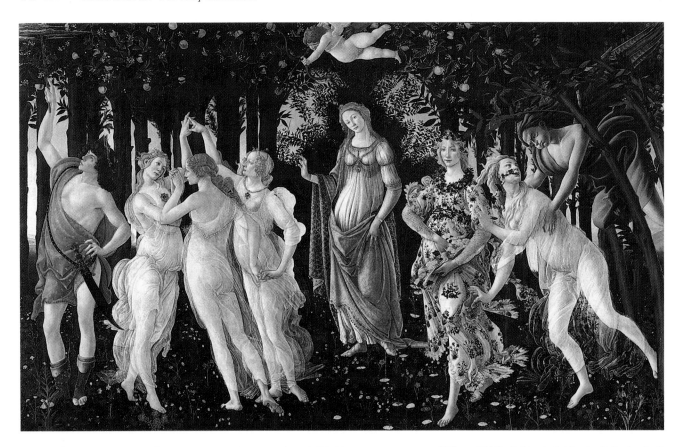

■ **12.20** Sandro Botticelli. *La Primavera (Springtime),* c. 1478. Tempera on canvas, 6′8″ × 10′4″ (2.03 × 3.14 m). Galleria degli Uffizi, Florence. This work and *The Birth of Venus* (Figure 12.21) are the best examples of Botticelli's fusion of pagan symbolism, Neo-Platonic idealism, and the quest for the ideal female.

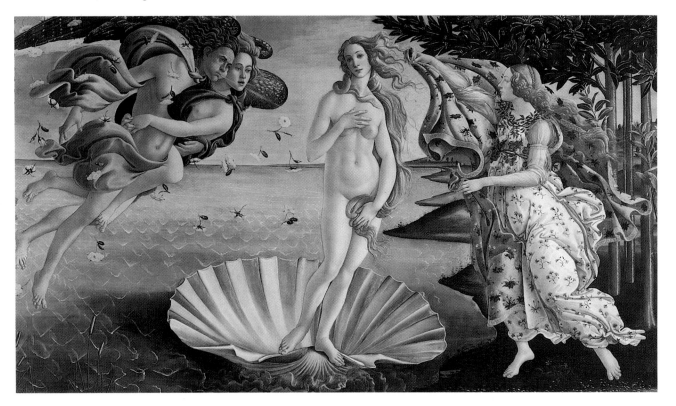

■ **12.21** Sandro Botticelli. *The Birth of Venus,* c. 1482. Tempera on canvas. Approx. 5′8″ × 9′1″ (1.72 × 2.77 m). Galleria degli Uffizi, Florence. Scholars have expended great effort to unlock the full meaning of this highly allegorical work and *La Primavera.* A comparison of the two shows some close similarity in the figures.

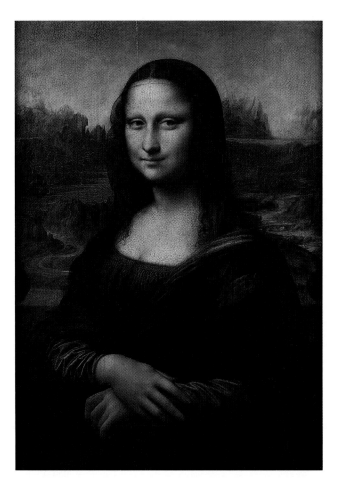

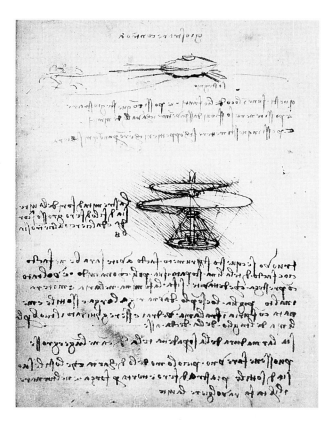

■ **12.23** Leonardo da Vinci. *Helicopter or Aerial Screw,* c. 1485–1490. Bibliothèque de l'Institut de France, Paris. Leonardo's "code writing" is decipherable only when held up to a mirror.

If we had nothing but the *Notebooks,* we would still say that Leonardo had one of humanity's most fertile minds. He left sketches for flying machines, submarines, turbines, elevators, ideal cities, and machines of almost every description [**Fig. 12.23**]. His knowledge of anatomy was unsurpassed (he came close to discovering the circulation path of blood), and his interest in the natural worlds of geology and botany was keen. The *Notebooks,* in short, reflect a restlessly searching mind that sought to understand the world and its constituent parts. Its chosen fields of inquiry are dominated by many of the characteristics common to the period: a concern with mathematics, a deep respect for the natural world, and a love for beauty.

Leonardo's *The Last Supper* [**Fig. 12.24**] is a good example of these characteristics. Leonardo chooses the moment when Jesus announces that someone at the table will betray him. The apostles are arranged in four distinct groups. The central figure of Christ is highlighted by the apostles, who either look at him or gesture toward him. Christ is haloed by the central window space behind him, with the lines of the room all converging toward that point. The painting has great emotional power even though it is mathematically one of the most perfect paintings ever executed.

Leonardo's expressive power as a painter is ably illustrated in his striking *Madonna of the Rocks* [**Fig. 12.25**], begun shortly after his arrival in Milan in 1483, a decade before he painted *The Last Supper.* The Virgin drapes her right arm over the figure of the infant Saint John the Baptist while her hand hovers in protective blessing over the Christ child. An exquisitely rendered angel points to the scene. The cavernlike space in the background would remind the perceptive viewer both of the cave at Bethlehem where Christ was born and the cave in which he would be buried. Leonardo's rendering of the jagged rocks stands in sharper relief because of the misty light in the extreme background. The particular beauty of the painting derives at least partially from the juxtaposition of the beautifully rendered persons in all their humanity with the wildly mysterious natural frame in which they are set.

The other great genius of the late fifteenth century is Michelangelo Buonarroti (1476–1564). After his early days in the sculpture garden of Lorenzo, he produced many of his greatest works in Rome (discussed

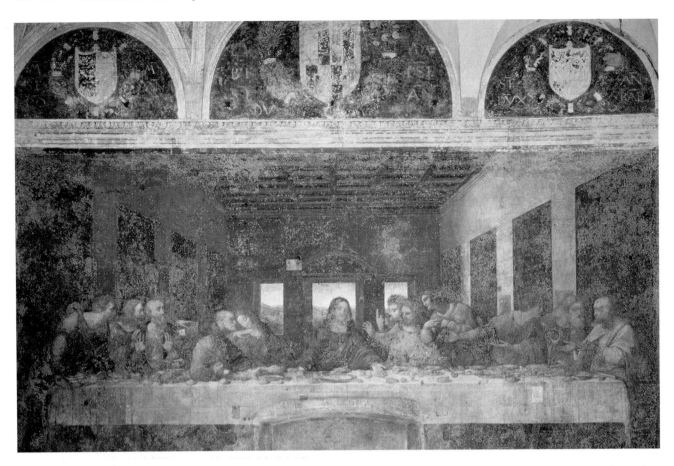

■ **12.24** Leonardo da Vinci. *The Last Supper,* 1495–1498. Fresco, 14′5″ × 28′¼″. Refectory, Santa Maria delle Grazie, Milan. Below the figure of Christ one can still see the doorway cut into the wall during the Napoleonic period by soldiers who used the monastery as a military headquarters.

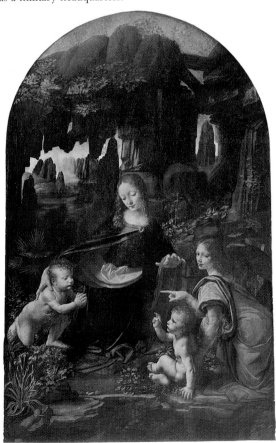

■ **12.25** Leonardo da Vinci. *Madonna of the Rocks,* begun 1483. Panel painting transferred to canvas, 78″ × 48″ (198.1 × 121.9 cm). Musée du Louvre, Paris. There is another version of this painting in London's National Gallery, but this one is thought to be completely from the hand of Leonardo. It was intended to be part of a large altarpiece, never completed, in honor of the Virgin.

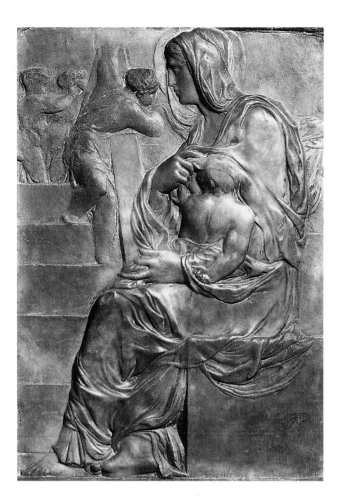

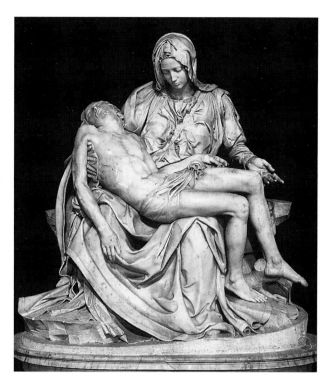

■ **12.27** Michangelo. *Pietá,* 1498–1499. Marble. Height 5′9″ (1.75 m). Saint Peter's, Vatican, Rome. One of the most "finished" of Michelangelo's sculptures, its high sheen is the result of intense polishing of the marble.

■ **12.26** Michelangelo. *Madonna of the Stairs,* 1489–1492. Marble, 21¾″ × 15¾″ (55 × 40 cm). Casa Buonarroti, Florence. A fine example of low-relief (bas-relief) carving, with its figures nearly flush to the marble surface.

in Chapter 13). However, even a few examples of his early work show both the great promise of Michelangelo's talent and some of the influences he absorbed in Florence under the Medici. The *Madonna of the Stairs* [**Fig. 12.26**], an early marble relief, reflects his study of ancient reliefs or **cameo carving** (which he may well have seen in Lorenzo's collection). By 1498, his style had matured enough for him to carve, for a French cardinal in Rome, the universally admired *Pietá* [**Fig. 12.27**], which combines his deep sensitivity with an idealism in the beauty of the Madonna's face that is reminiscent of Botticelli.

Finally, this early period of Michelangelo's work includes a sculpture that has become almost synonymous with Florence: the *David* [**Fig. 12.28**], carved in 1501–1504 from a massive piece of Carrara marble that had lain behind the cathedral in Florence since the middle of the preceding century. The sculpture's great size and its almost photographically realistic musculature combine to make it one of Michelangelo's clearest statements of idealized beauty. The statue was intended to

be seen from below with the left arm (the one touching the shoulder) facing the viewer and the right side turned back toward the cathedral. In fact, it was placed outside the Palazzo Vecchio as a symbol of the civic power of the city, where it remained until weathering and damage required its removal to a museum in the nineteenth century.

It has been said that Botticelli's paintings, the *Davids* of both Donatello and Michelangelo, and the general skepticism of a mind like Leonardo's are all symptoms of the general pagan tone of Laurentian Florence— that Athens and Rome, in short, seemed far more important to fifteenth-century Florence than did Jerusalem. There is no doubt that the Classical revival was central to Florentine culture. Neither is there any doubt that the times had little patience with, or admiration for, medieval culture. However, the notion that the Renaissance spirit marked a clean break with medieval ideals must take into account the life and career of the Dominican preacher and reformer Fra Savonarola (1452–1498).

Savonarola lived at the Convent of San Marco in Florence from 1490 until his execution in 1498. His urgent preaching against the vanities of Florence in general and the degeneracy of its art and culture in particular had an electric effect on the populace. His influence was not limited to the credulous masses or workers in the city. Lorenzo called him to his own deathbed

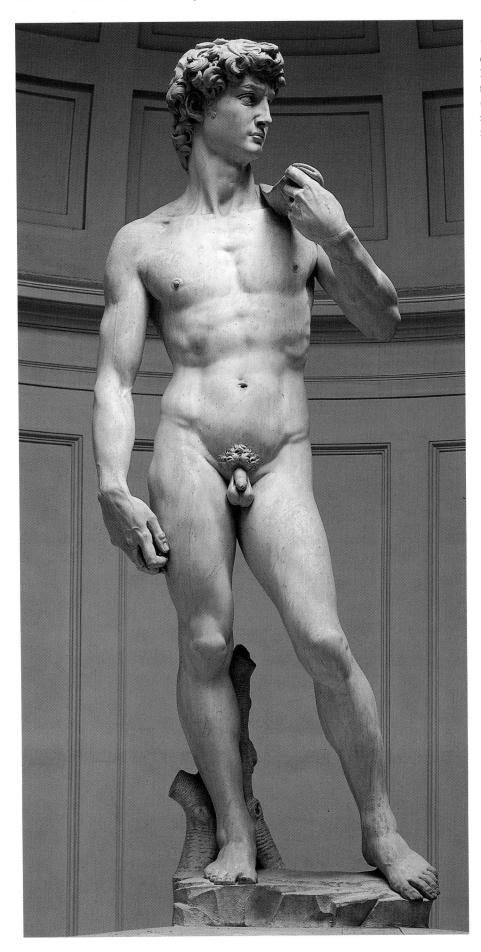

▄ **12.28** Michelangelo. *David*, 1501–1504. Marble. Height 18′ (5.49 m). Galleria dell' Accademia, Florence. Much of the weight of this figure is borne by David's right leg (with the stylized tree trunk in the rear) in a position called *contraposto* in Italian.

in 1492 to receive the last sacraments, even though Savonarola had been a bitter and open enemy of Medici control over the city. Savonarola, in fact, wanted a restored Republic with a strong ethical and theocratic base. Botticelli was so impressed by Savonarola that he burned some of his more worldly paintings, and scholars see in his last works a more profound religiosity derived from the contact with the reforming friar. Michelangelo, when an old man in Rome, told a friend that he could still hear the words of Savonarola ringing in his ears. Pico della Mirandola (1463–1494), one of the most brilliant humanists of the period, turned from his polyglot studies of Greek, Hebrew, Aramaic, and Latin to a devout life under the direction of the friar; only his early death prevented him from joining Savonarola as a friar at San Marco.

Savonarola's hold over the Florentine political order (for a brief time he was the de facto ruler of the city) ended in 1498 when he defied papal excommunication and was then strangled and burned in the public square before the Palazzo Vecchio. By that time, Lorenzo had been dead for six years and the Medici family had lost power in Florence. They were to return in the next century, but the Golden Age of Lorenzo had ended with a spasm of medieval piety. The influence of the city and its ideals had, however, already spread far beyond its boundaries.

THE CHARACTER OF RENAISSANCE HUMANISM

Jules Michelet, a nineteenth-century French historian, first coined the word *Renaissance* specifically to describe the cultural period of fifteenth-century Florence. The broad outline of this rebirth is described by the Swiss historian Jakob Burckhardt in his massive *The Civilization of the Renaissance in Italy,* published in 1860, a book that is the beginning point for any discussion of the topic. Burckhardt's thesis is simple and persuasive. European culture, he argued, was reborn in the fifteenth century after a long dormant period that extended from the fall of the Roman Empire until the beginning of the fourteenth century.

The characteristics of this new birth, Burckhardt said, were first noticeable in Italy and were the foundation blocks of the modern world. It was in late fourteenth- and fifteenth-century Italy that new ideas about the nature of the political order developed, of which the Republican government of Florence is an example, as well as the consciousness of the artist as an individual seeking personal fame. This pursuit of glory and fame was in sharp contrast to the self-effacing and world-denying attitude of the Middle Ages. Burckhardt also saw the thirst for Classical learning, the

desire to construct a humanism from that learning, and an emphasis on the good life as an intellectual repudiation of medieval religion and ethics.

Burckhardt's ideas have provoked strong reactions from historians and scholars, many of whom reject his theory as simplistic. Charles Homer Haskins, an American scholar, attacked Burckhardt's ideas in 1927 in a book the title of which gives away his line of argument: *The Renaissance of the Twelfth Century.* Haskins pointed out that everything Burckhardt said about Florentine life in the fifteenth century could be said with equal justification about Paris in the twelfth century. Furthermore (as noted in Chapter 10), scholars have also spoken of a Carolingian Renaissance identified with the court of Emperor Charlemagne.

What is the truth? Was there a genuine Renaissance in fifteenth-century Italy? Many scholars today try to mediate a position between Burckhardt and his detractors. They admit that something new was happening in the intellectual and cultural life of fifteenth-century Italy and that contemporaries were conscious of it. "May every thoughtful spirit thank God that it has been given to him to be born in this new age, so filled with hope and promise, which already enjoys a greater array of gifted persons than the world has seen in the past thousand years," wrote Matteo Palmieri, a Florentine businessman, in 1436. Yet this "new age" of which Palmieri spoke did not spring up overnight. The roots must be traced to Italy's long tradition of lay learning, the Franciscan movement of the thirteenth century, the relative absence of feudalism in Italy, and the long maintenance of Italian city life. In short, something new was happening precisely because Italy's long historical antecedents permitted it.

The question remains, however: What was new in the Renaissance? The Renaissance was surely more than a change in artistic taste or an advance in technological artistic skill. We need to go deeper. What motivated the shift in artistic taste? What fueled the personal energy that produced artistic innovation? What caused flocks of foreign scholars to cross the Alps to study in Florence and in other centers where they could absorb the "new learning"?

The answer to these questions, briefly, is this: There arose in Italy, as early as the time of Petrarch (1304–1372), but clearly in the fifteenth century, a strong conviction that humanist learning would not only ennoble and perfect the individual but could also serve as a powerful instrument for social and religious reform. Very few Renaissance humanists denied the need for God's grace, but all felt that human intellectual effort should be the first concern of anyone who wished truly to advance the good of self or society. The career of Pico della Mirandola, one of the most brilliant and gifted Florentine humanist scholars, illustrates this humanist belief.

DUCHY OF MILAN
MILAN
PADUA
VENICE
HUNGARY
ISTRIA
OTTOMAN EMPIRE
DUCHY OF SAVOY
ASTI
PIACENZA
DUCHY OF MODENA
DUCHY OF FERRARA
GENOA
BOLOGNA
VENETIAN REPUBLIC
REPUBLIC OF GENOA
DALMATIA
DUCHY OF LUCCA
PISA
FLORENCE
SIENA
STATES OF THE CHURCH
REPUBLIC OF FLORENCE
A D R I A T I C S E A
CORSICA (To Genoa)
ROME
NAPLES
SARDINIA (To Spain)
T Y R R H E N I A N S E A
KINGDOM OF THE TWO SICILIES
M E D I T E R R A N E A N S E A
PALERMO
RENAISSANCE ITALY

Pico della Mirandola

Pico della Mirandola (1463–1494) was an intimate friend of Lorenzo de' Medici and a companion of the Platonic scholar Marsilio Ficino. Precociously brilliant, Pico once bragged, not totally implausibly, that he had read every book in Italy. He was deeply involved with the intellectual life of his day.

Pico was convinced that all human learning could be synthesized in a way such as to yield basic and elementary truths. To demonstrate this, he set out to master all the systems of knowledge that then existed. He thoroughly mastered the Latin and Greek classics. He studied medieval Aristotelianism at the University of Paris and learned Arabic and the Islamic tradition. He was the first Christian in his day to take an active interest in Hebrew culture; he learned Hebrew and Aramaic and studied the **Talmud** with Jewish scholars. At the age of twenty, Pico proposed to defend at Rome his nine hundred *theses* ("intellectual propositions"), which he claimed summed up all current learning and speculation. Church leaders attacked some of his propositions as unorthodox; Pico left Rome and the debate was never held.

The preface to these theses, called the *Oration on the Dignity of Man,* has often been cited as the first and most important document of Renaissance humanism. Its central thesis is that humanity stands at the apex of creation in a way such as to create the link between the world of God and that of the creation. Pico brings his wide learning to bear on this fundamental proposition: Humanity is a great miracle. He not only calls on the traditional biblical and Classical sources but also cites, from his immense reading, the opinions of the great writers of the Jewish, Arabic, and Neo-Platonic traditions. The enthusiasm of the youthful Pico for his subject is as apparent as his desire to display his learning.

Scholars disagree on Pico's originality as a thinker. Many argue that his writings are a hodgepodge of knowledge without any genuine synthesis. There is no disagreement, however, about Pico's immense ability as a student of languages and culture to open new fields of study and, in that way, contribute much to the enthusiasm for learning in his own day. His reputation attracted students to him. The most influential of these was a German named Johann Reuchlin (1455–1522), who came to Florence to study Hebrew with Pico. After mastering that language and Greek as well,

Reuchlin went back to Germany to pursue his studies and to apply them to biblical scholarship. In the early sixteenth century he came under the influence of Martin Luther (see Chapter 14) but never joined the Reformation. Reuchlin passionately defended the legitimacy of biblical studies oriented to the original languages. When his approach was attacked in one of those periodic outbursts of anti-Semitism so characteristic of European culture of the time, Reuchlin, true to his humanist impulses, not only defended his studies as a true instrument of religious reform but also made an impassioned plea for toleration that was not characteristic of his time.

Printing Technology and the Spread of Humanism

The export of humanist learning was not restricted to the exchange of scholars between Italy and the countries to the north. Printing had been invented in the early fifteenth century, so books were becoming more accessible to the educated classes. The most famous humanist printer and publisher of the fifteenth century was Aldus Manutius (1449–1515), whose Aldine Press was in Venice, his native city (see map). Aldus was a scholar in his own right; he learned Greek from refugee scholars who settled in Venice after the fall of Constantinople in 1453. Recognizing the need for competent and reliable editions of the Classical authors, he employed professional humanists to collate and correct manuscripts. Erasmus, the greatest of the northern humanists, was, for a time, in his employ.

Aldus was also a technical innovator. He designed Greek **typefaces,** created italic type fonts (modeled after the scribal hand used for copying Florentine manuscripts), developed new inks, and obtained new paper from the nearby town of Fabriano, still a source of fine papers for artists and printmakers. His books were near pocket-size, easily portable, and inexpensive. The scope of the press's activities was huge: After 1494, Aldus (and later his son) published, in about twenty years, the complete works of Aristotle and the works of Plato, Pindar, Herodotus, Sophocles, Aristophanes, Xenophon, and Demosthenes. Aldus reissued the Latin classics in better editions and published vernacular writers like Dante and Petrarch as well as contemporary poets like Poliziano, the Florentine friend of Lorenzo.

The Aldine Press was not an isolated phenomenon. Germany, where Western printing really started, already had an active printing and publishing tradition. Johann Gutenberg (c. 1395–1468) originated the method of printing from movable type that continued to be used with virtually no change until the late nineteenth century. Gutenberg finished printing a Bible at Mainz in 1455. The first book printed in English, *The Recuyell* (collection) of the *Historyes of Troye,* was published by William Caxton in 1475. Historians have estimated that before 1500, European presses produced between six and nine million books in thirteen thousand different editions. Nearly fifty thousand of these books survive in libraries throughout the world.

This conjunction of pride in humanist learning and technology of printing had profound consequences for European culture. It permitted the wide diffusion of ideas to large numbers of people in a relatively short time. There is no doubt that vigorous intellectual movements—one thinks immediately of the Protestant Reformation—benefited immensely from printing. This communications revolution was as important for the Renaissance period as radio, film, television, and the Internet have been for our own.

Women and the Renaissance

Scholars have asked: Did women have an intellectual/artistic rebirth? It is clear that women, as the idealization of certain images and ideas, were central to the Renaissance conception of beauty (think of Botticelli's *Primavera* or *Venus*), but it is equally true that little provision was made for women to participate in the new learning that constituted the heart of humanism. A recent generation of scholars, however, has recovered for us voices that have been hitherto silent. When women did receive a humanist education it was either because they came from aristocratic families that allowed them the leisure and means to get an education or they were children of families who prized learning highly and saw nothing amiss to educate women as well as men.

A further element that helped women get an education was the rise of printing. After the popularization of the printed work, books took on a certain "mobility" that permitted women—especially those who came from wealthy or aristocratic families—to possess both books and the leisure to study them. Examples of humanistic writing coming from women in the fifteenth century almost uniformly reflect an upper-class culture.

A recently published anthology of texts (see King and Rabil in Further Reading list) by women humanists in Italy demonstrates that most came from the more illustrious families of the time. Thus Ippolita Sforza (of the Milan Sforzas) actually delivered an oration before the Renaissance humanist and Pope Pius II in 1459. Others, like Isotta Nogarola, had to swim against the tide and choose a life of letters while resisting both marriage and pressure to enter a convent. Others, like Cecilia Gonzaga, entered into convent life for the precise reason of finding the shelter and leisure to advance their studies in the new learning.

It is instructive that a determined humanist named Laura Cereta (died 1499) from Brescia continued her scholarly life throughout her mature years against a tide

of criticism from both men who were her peers and from women. Out of those struggles came two letters that were penned to answer both critics: a defense of learning aimed at male humanists and a defense of her vocation directed toward her female critics. Those two documents testify to the difficulty of her life apart from the roles expected of her in society.

TWO STYLES OF HUMANISM

In the generation after the death of Lorenzo de' Medici, the new learning made its way north, where it was most often used in attempts to reform the religious life of the area; in Italy, however, learning remained tied to more worldly matters. The double usage of humanist learning for secular and spiritual reform can be better appreciated by a brief consideration of the work of the two most important writers of the period after the golden period of the Medicean Renaissance: Niccolò Machiavelli and Desiderius Erasmus.

Machiavelli

Niccolò Machiavelli (1469–1527), trained as a humanist and active as a diplomat in Florence, was exiled from the city when the Medici reassumed power in 1512. In his exile, a few miles from the city that he had served for many years, Machiavelli wrote a political treatise on politics called *The Prince* that was published posthumously.

The Prince is often considered the first purely secular study of political theory in the West. Machiavelli's inspiration is the government of Republican Rome (B.C.E. 509–31). He sees Christianity's role in politics as a disaster that destroys the power of the state to govern. For that reason, Machiavelli asserts, the state needs to restrict the power of the church, allowing it to exercise its office only in the spiritual realm. The prince, as ruler of the state, must understand that the key to success in governing is in the exercise of power. Power is to be used with wisdom and ruthlessness. The prince, in a favorite illustration of Machiavelli, must be as sly as the fox and as brutal as the lion. Above all, the prince must not be deterred from his tasks by any consideration of morality beyond that of power and its ends. In this sense, cruelty or hypocrisy is permissible; judicious cruelty consolidates power and discourages revolution. Senseless cruelty is, however, counterproductive.

The basic theme of *The Prince* is the pragmatic use of power for state management. Previously the tradition of political theory had always invoked the transcendent authority of God to ensure the stability and legitimacy of the state. For Machiavelli it was power, not the moral law of God, that provided the state with its ultimate sanction. The final test of the successful ruler was the willingness to exercise power judiciously and freedom from the constraints of moral suasion. "A prince must not keep faith when by doing so it would be against his self-interest," Machiavelli says in one of the most famous passages from his book. His justification is "If all men were good this precept would not be a good one but as they are bad and would not observe their faith with you, so you are not bound to keep faith with them." This bold pragmatism explains why the Catholic Church put *The Prince* on its *Index of Prohibited Books* and why the adjective *Machiavellian* means, in English, "devious or unscrupulous in political dealings." Machiavelli had such a bad reputation that many sixteenth-century English plays had a stock evil character—an Italian called "Old Nick." The English phrase "to be filled with the Old Nick," meaning to be devilish, derives from Machiavelli's reputation as an immoral man. But Machiavelli's realistic pragmatism also explains why Catherine the Great of Russia and Napoleon read him with great care.

In the final analysis, however, the figure of the prince best defines a view of politics that looks to a leader who understands that power is what keeps a political person as a strong ruler. Such a leader uses a simple rule of thumb: How does one exercise power in order to retain power? Such a ruler does not appeal to eternal rules but to simple calculations: Will the exercise of power in this or that particular fashion guarantee the stability of the state? If ruthlessness or violence is needed, let there be ruthlessness or violence (or terror!). Machiavelli did not want to create a monster and he certainly did not want violence for its own sake. He did favor, however, whatever means it took to keep the state intact and powerful. That is the deepest meaning of the adjective *Machiavellian*.

Erasmus

Desiderius Erasmus (1466–1536) has been called the most important Christian humanist in Europe [**FIG. 12.29**]. Educated in Holland and at the University of Paris, Erasmus was a monk and priest who soon tired of his official church life. He became aware of humanist learning through his visits to England, where he met men like John Colet and Thomas More. Fired by their enthusiasm for the new learning, Erasmus traveled to Italy in 1506, with lengthy stays in both Rome and Venice. Thereafter he led the life of a wandering scholar, gaining immense fame as both scholar and author.

Erasmus's many books were attempts to combine Classical learning and a simple interiorized approach

■ **12.29** Albrecht Dürer. *Erasmus of Rotterdam*, 1526. Intaglio print, 9¾″ × 7½″ (25 × 19 cm). *Detail:* Writing stand and monogram. Metropolitan Museum of Art, New York (Fletcher Fund, 1919). The Latin inscription says that Erasmus was drawn from life by the artist; the Greek epigram praises the written word. The stylized letters AD are the signature letters of the artist and appear in all his engravings and prints.

to Christian living. In the *Enchiridion Militis Christiani* (1502), he attempted to spell out this Christian humanism in practical terms. The title has a typical Erasmian pun; the word *enchiridion* can mean either "handbook" or "short sword"; thus the title can mean the handbook or the short sword of the Christian knight. His *Greek New Testament* (1516) was the first attempt to edit the Greek text of the New Testament by a comparison of extant manuscripts. Because Erasmus used only three manuscripts, his version is not technically perfect, but it was a noteworthy attempt and a clear indication of how a humanist felt he could contribute to ecclesiastical work.

The most famous book written by Erasmus, *The Praise of Folly* (1509), was dashed off almost as a joke while he was a houseguest of Sir Thomas More in England. Again, the title is a pun; *Encomium Moriae* can mean either "praise of folly" or "praise of More"— Thomas More, his host. *The Praise of Folly* is a humorous work, but beneath its seemingly lighthearted spoof

of the foibles of the day there are strong denunciations of corruption, evil, ignorance, and prejudice in society. Erasmus flailed away at the makers of war (he had a strong pacifist streak), venal lawyers, and fraudulent doctors, but, above all, he bitterly attacked religious corruption: the sterility of religious scholarship and the superstitions in religious practice. Reading *The Praise of Folly* makes one wonder why Luther never won Erasmus over to the Reformation (Erasmus debated Luther, in fact). Erasmus remained in the old church, but as a bitter critic of its follies and an indefatigable proponent of its reform. Some have said that Erasmus laid the egg that Luther hatched.

This sweeping social criticism struck an obvious nerve. The book delighted not only the great Sir Thomas More (who was concerned enough about religious convictions to die for them later in the century) but also many sensitive people of the time. *The Praise of Folly* went through twenty-seven editions in the lifetime of Erasmus and outsold every other book except the Bible in the sixteenth century.

Comparing Machiavelli and Erasmus is a bit like comparing apples and potatoes, but a few points of contact can be noted that help us generalize about the meaning of the Renaissance. Both men were heavily indebted to the new learning coming out of fifteenth-century Italy. Both looked back to the great Classical heritage of the past for their models of inspiration. Both were elegant Latinists who avoided the style and thought patterns of the medieval world. Machiavelli's devotion to the Roman past was total. He saw the historic development of Christianity as a threat and stumbling block to the fine workings of the state. Erasmus, by contrast, felt that learning from the past could be wedded to the Christian tradition to create an instrument for social reform. His ideal was a Christian humanism based on this formula. It was a formula potent enough to influence thinking throughout the sixteenth century.

The tug of war between Classicism and Christianity may be one key to understanding the Renaissance. It may even help us understand something about the character of almost everything we have discussed in this chapter. The culture of the fifteenth century often was, in fact, a dialectical struggle: At times Classical ideals clashed with biblical ideals; at other times, the two managed to live either in harmony or in a temporary marriage of convenience. The strains of Classicism and Christianity interacted in complex and subtle ways. This important fact helps us understand a culture that produced, in a generation, an elegant scholar like Ficino and a firebrand like Savonarola, a pious artist like Fra Angelico and a titanic genius like Michelangelo— and a Machiavelli and an Erasmus.

MUSIC IN THE FIFTEENTH CENTURY

By the early fifteenth century, the force of the Italian *ars nova* movement in music had spent itself. The principal composers of the early Renaissance were from the North. Strong commercial links between Florence and the North ensured the exchange of ideas, and a new musical idiom that had been developed to please the ear of the prosperous merchant families of the North soon found its way to Italy.

Guillaume Dufay

Guillaume Dufay (c. 1400–1474), the most famous composer of the century, perfectly exemplifies the tendency of music to cross national boundaries. As a young man, Dufay spent several years in Italy studying music and singing in the papal choir at Rome. He later served as music teacher in the French (Burgundian) court of Charles the Good. The works he composed there included masses and motets; he was one of the first composers after Machaut to write complete settings of the Mass. His secular works include several charming *chansons* ("songs") that are free in form and expressive in nature.

Among the changes introduced into music by Dufay and his Burgundian followers (many of whom went to Italy for employment) was the secularization of the motet, a choral work that had previously used a religious text. Motets were now written for special occasions like coronations or noble marriages and the conclusions of peace treaties. Composers who could supply such motets on short notice found welcome in the courts of Renaissance Italian city-states.

Dufay was also one of the first composers to introduce a familiar folk tune into the music of the Mass, the best-known example being his use of the French folk tune *L'homme armé* (*The Man in Armor*) in a mass that is now named for it. Other composers followed suit, and the so-called *chanson masses* were composed throughout the fifteenth and sixteenth centuries. The *L'homme armé* alone was used for more than thirty different masses, including ones by such composers as Josquin and Palestrina. The intermingling of secular with religious elements is thoroughly in accordance with Renaissance ideals.

Among Dufay's most prominent pupils was the Flemish composer Johannes Ockeghem (c. 1430–1495), whose music was characterized by a smooth-flowing but complex web of contrapuntal lines generally written in a free style (the lines do not imitate one another). The resulting mood of the music is more serious than Dufay's, partly because of the intellectual complexity of the counterpoint and partly because Ockeghem sought a greater emotional expression. The combination of intellect and feeling is characteristic of the Renaissance striving for Classical balance. Ockeghem's Requiem Mass is the oldest of the genre to survive (Dufay wrote one, but it has not survived).

Music in Medici Florence

The fact that Italian composers were overshadowed by their northern contemporaries did not in any way stifle Italian interest in music. Lorenzo de' Medici founded a school of harmony that attracted musicians from many parts of Europe, and he had some skill as a lute player. Musical accompaniment enlivened the festivals and public processions of Florence. Popular dance tunes for the *saltarello* and the *pavana* have survived in lute transcriptions.

We know that the Platonist writer Marsilio Ficino played the lyre before admiring audiences, although he had intentions more serious than mere entertainment. Unlike the visual artists, who had models from Classical antiquity for inspiration, students of music had no Classical models to follow: No Greek or Roman music had survived in any significant form. Still, the ideas about music expressed by Plato and other writers fascinated Ficino and others. Greek music had been patterned after the meter of verse and its character carefully controlled by the mode in which it was composed. The Greek doctrine of ethos is still not fully understood today, but Ficino and his friends realized that Plato and Aristotle regarded music as of the highest moral (and hence political) significance. The closest they could come to imitating ancient music was to write settings of Greek and Roman texts in which they tried to follow the meter as closely as possible. Among the most popular works was Vergil's *Aeneid:* The lament of Dido was set to music by no fewer than fourteen composers in the fifteenth and sixteenth centuries.

A more popular music form was the *frottola*, probably first developed in Florence, although the earliest surviving examples come from the Renaissance court of Mantua. The *frottola* was a setting of a humorous or amorous poem for three or four parts consisting of a singer and two or three instrumentalists. Written to be performed in aristocratic circles, the *frottola* often had a simple folk quality. The gradual diffusion of *frottole* throughout Europe gave Italy a reputation for good simple melody and clear vigorous expression.

The *canto carnascialesco* ("carnival song") was a specifically Florentine form of the *frottola*. Written to be sung during the carnival season preceding Lent, such songs were very popular. Even the great Flemish

composer Heinrich Issac wrote some during his stay with Lorenzo de' Medici around 1480. With the coming of the Dominican reformer Savonarola, however, the carnivals were abolished because of their alleged licentiousness. The songs also disappeared. After the death of Savonarola, the songs were reintroduced but died out again in the sixteenth century.

SUMMARY

The main focus of this chapter is on the city of Florence in the fifteenth century. There are two basic reasons for this attention, one rooted in economics and the other in something far more difficult to define.

Florence was not a feudal city governed by a hereditary prince; it had a species of limited participatory government that was in the hands of its landed and monied individuals. It was the center of European banking in the fifteenth century and the hub of international wool and cloth trade. The vast monies in Florentine hands combined with a great sense of civic pride to give the city unparalleled opportunities for expansion and public works. The results can be seen in the explosion of building, art, sculpture, and learning that stretched throughout the century. The great banking families of Florence built and supported art to enhance their reputations, that of their cities, and partly as a form of expiation for the sin of taking interest on money (usury)—a practice forbidden by the church. We tend to view Florence today from the perspective of their generosity.

Other forces were also at work. The urban workers were exploited; they had rioted during the end of the fourteenth century and were ready for further protest. An undercurrent of medieval religiosity in the city manifested itself most conspicuously in the rise of Savonarola, who not only appealed to the common people but who also had a reputation for sanctity that could touch the lives of an educated man like Pico della Mirandola and a powerful one like Lorenzo the Magnificent. Every Florentine could visit the Duomo or see the art in the city's churches, but not everyone was equally touched by the great renaissance in ideas and art that bubbled up in Florence.

Most puzzling about Florence in this period is the sheer enormity of artistic talent it produced. Florence was not a huge city; it often portrayed itself as a David in comparison to a Roman or Milanese Goliath. Yet this relatively small city produced a tradition of art that spanned the century: In sculpture Donatello and Michelangelo bridged the generations, as did Masaccio and Botticelli in painting. Part of the explanation was native talent, but part of it also lies in the character of a city that supported the arts, nurtured artists, and enhanced civic life with beauty and learning.

KEY TERMS

Allegory In art, a genre where fictional characters symbolically represent another level of Truth

Cameo carving Small sculptures on shell or stone in which figures in relief are set off from the background of the shell or stone

Entablature In architecture, the upper part of a wall supported by a column or pillar

Fresco Painting done on fresh coats of plaster

Guild Medieval associations of artisans or tradesmen; precursors of modern trade unions

Loggia A roofed-over gallery of a building

Pietá Term used to describe depictions of Mary holding the dead Christ in her arms

Polychrome Literally "many colors," used to describe sculpture/ceramics that are painted

Studium Lecture halls for professors either in monasteries or civil establishments

Talmud The authoritative collection of ancient Jewish learning

Typeface The carved pieces of letters used by printers to assemble a page for printing. The type varied according to design (e.g., Italic or Roman).

PRONUNCIATION GUIDE

Botticelli:	Boh-tee-CHEL-ee
Brunelleschi:	Brew-ne-LESS-ki
Cosimo:	CAH-ze-mow
de' Medici:	deh MED-e-chee
Donatello:	Don-ah-TELL-oh
Dufay:	Dew-FIE
duomo:	DWO-mow
Ficino:	Fee-CHEE-no
Ghiberti:	Ghee-BAIR-tee
Lorenzo:	Lo-WREN-zo
Machiavelli:	Ma-key-ah-VEL-ee
Manutius:	Mah-KNEW-tee-us
Masaccio:	Mah-SA-cho
Pico della Mirandola:	PEE-ko dell-ah Mee-RAN-dough-la
Piero:	Pea-EH-row
Savonarola:	Sa-van-ah-ROLL-ah

EXERCISES

1. Choose one of the major paintings of this period and analyze it closely in terms of composition, gradations of color, and use of perspective.
2. List the chief problems of construction involved in raising the dome of the Florence Cathedral in an age that did not have today's building technologies.
3. To what artistic and cultural enterprises would wealthy people most likely contribute today if they had the resources and the power of a Medici family in a contemporary city?
4. What does the word *humanism* mean today and how does that meaning differ from its use in the fifteenth century? Why do some people think that the term *humanism* is a pejorative term today?
5. If Erasmus were writing today, what would be his most likely targets of satire? What are the great follies of our age?
6. What advice would a contemporary Machiavelli give a contemporary "prince" (powerful political leader)? Why do political philosophers continue to study Machiavelli?
7. Many say that computers are changing learning as radically as did printing in its age. How are computer technologies changing learning?

YOUR RESOURCES

▪ **ExploringHumanities CD-ROM**
 • Interactive Maps: Italy around 1400, Europe in the 15th Century
 • Reading Selections: Machiavelli, *The Prince*; Erasmus, *The Praise of Folly*; Vasari, *Excerpts from Life of Michaelangelo*; Vasari, *Excerpts from Life of da Vinci*
▪ **Website http://art.wadsworth.com/cunningham**
 • Chapter 12 Quiz
 • Links

FURTHER READING

Campbell, L. *Renaissance Portraits.* New Haven: Yale University Press, 1990. Survey runs from the fourteenth through the sixteenth centuries.

Dempsey, C. *The Portrayal of Love: Botticelli's* Primavera *and Humanist Culture at the time of Lorenzo the Magnificent.* Princeton, NJ: Princeton University Press, 1992. A scholarly study of a fundamental Renaissance theme.

Hale, J. R. (Ed.). *A Concise Encyclopedia of the Italian Renaissance.* New York: Oxford University Press, 1982. Excellent reference work.

Hale, J. R. *The Civilization of Europe in the Renaissance.* New York: Simon & Schuster, Touchstone, 1995. Excellent and authoritative synthetic work.

Hartt, F. *A History of Italian Renaissance Art.* London and New York: Thames & Hudson, 1970. A standard work.

Hibbert, C. *Florence: The Biography of a City.* New York: Norton, 1993. Readable and interesting.

Johnson, P. *The Renaissance.* New York: Modern Library, 2000. A short but eminently readable survey.

Kent, Dale. *Cosimo de Medici and the Florentine Renaissance.* New Haven, CT: Yale University Press, 2002. An excellent cultural study.

King, M., and A. Rabil. (Eds.). *Her Immaculate Hand: Selected Works by and about Women Humanists of Quattrocento Italy.* Binghamton, NY: Medieval and Renaissance Texts, 1983. Important anthology.

READING SELECTIONS

PICO DELLA MIRANDOLA
from ORATION ON THE DIGNITY OF MAN

These four paragraphs introduce the nine hundred theses Pico wrote to summarize his philosophy; in many ways they can stand as the position paper on Renaissance ideals. Pico argues that it is humans who stand at the apex of the world. In Pico's formulation humans, as a composite of body and soul, are the meeting point of the physical world (the body) and the spiritual (the soul) and, as a consequence, sum up the glory and potentiality of the created world.

1. I have read in the records of the Arabians, reverend Fathers, that Abdala the Saracen, when questioned as to what on this stage of the world, as it were, could be seen most worthy of wonder, replied: "There is nothing to be seen more wonderful than man." In agreement with this opinion is the saying of Hermes Trismegistus: "A great miracle, Asclepius, is man." But when I weighed the reason for these maxims, the many grounds for the excellence of human nature reported by many men failed to satisfy me—that man is the intermediary between creatures, the intimate of the gods, the king of the lower beings, by the acuteness of his senses, by the discernment of his reason, and by the light of his intelligence the interpreter of nature, the interval between fixed eternity and fleeting time, and (as the Persians say) the bond, nay, rather, the marriage song of the world, on David's testimony but little lower than the angels. Admittedly great though these reasons be, they are not the principal grounds, that is, those which may rightfully claim for themselves the privilege of the highest admiration. For why should we not admire more the angels themselves and

the blessed choirs of heaven? At last it seems to me I have come to understand why man is the most fortunate of creatures and consequently worthy of all admiration and what precisely is the rank which is his lot in the universal chain of Being—a rank to be envied not only by brutes but even by the stars and by minds beyond this world. It is a matter past faith and a wondrous one. Why should it not be? For it is on this very account that man is rightly called and judged a great miracle and a wonderful creature indeed.

2. But hear, Fathers, exactly what this rank is and, as friendly auditors, conformably to your kindness, do me this favor. God the Father, the supreme Architect, had already built this cosmic home we behold, the most sacred temple of His godhead, by the laws of His mysterious wisdom. The region above the heavens He had adorned with Intelligences, the heavenly spheres He had quickened with eternal souls, and the excrementary and filthy parts of the lower world He had filled with a multitude of animals of every kind. But, when the work was finished, the Craftsman kept wishing that there were someone to ponder the plan of so great a work, to love its beauty, and to wonder at its vastness. Therefore, when everything was done (as Moses and Timaeus bear witness), He finally took thought concerning the creation of man. But there was not among His archetypes that from which He could fashion a new offspring, nor was there in His treasurehouses anything which He might bestow on His new son as an inheritance, nor was there in the seats of all the world a place where the latter might sit to contemplate the universe. All was now complete; all things had been assigned to the highest, the middle, and the lowest orders. But in its final creation it was not the part of the Father's power to fail as though exhausted. It was not the part of His wisdom to waver in a needful matter through poverty of counsel. It was not the part of His kindly love that he who was to praise God's divine generosity in regard to others should be compelled to condemn it in regard to himself.

3. At last the best of artisans ordained that the creature to whom He had been able to give nothing proper to himself should have joint possession of whatever had been peculiar to each of the different kinds of being. He therefore took man as a creature of indeterminate nature and, assigning him a place in the middle of the world, addressed him thus: "Neither a fixed abode nor a form that is thine alone nor any function peculiar to thyself have we given thee, Adam, to the end that according to thy longing and according to thy judgment thou mayest have and possess what abode, what form, and what functions thou thyself shalt desire. The nature of all other beings is limited and constrained within the bounds of laws prescribed by Us. Thou, constrained by no limits, in accordance with thine own free will, in whose hand We have placed thee, shalt ordain for thyself the limits of thy nature. We have set thee at the world's center that thou mayest from thence more easily observe whatever is in the world. We have made thee neither of heaven nor of earth, neither mortal nor immortal, so that with freedom of choice and with honor, as though the maker and molder of thyself, thou mayest fashion thyself in whatever shape thou shalt prefer. Thou shalt have the power to degenerate into the lower forms of life, which are brutish. Thou shalt have the power, out of thy soul's judgment, to be reborn into the higher forms, which are divine."

4. O supreme generosity of God the Father, O highest and most marvelous felicity of man! To him it is granted to have whatever he chooses, to be whatever he wills. Beasts as soon as they are born (so says Lucilius) being with them from their mother's womb all they will ever possess. Spiritual beings, either from the beginning or soon thereafter, become what they are to be for ever and ever. On man when he came into life the Father conferred the seeds of all kinds and the germs of every way of life. Whatever seeds each man cultivates will grow to maturity and bear in him their own fruit. If they be vegetative, he will be like a plant. If sensitive, he will become brutish. If rational, he will grow into a heavenly being. If intellectual, he will be an angel and the son of God. And if, happy in the lot of no created thing, he withdraws into the center of his own unity, his spirit, made one with God, in the solitary darkness of God, who is set above all things, shall surpass them all. Who would not admire this our chameleon? Or who could more greatly admire aught else whatever? It is man who Asclepius of Athens, arguing from his mutability of character and from his self-transforming nature, on just grounds says was symbolized by Proteus in the mysteries. Hence those metamorphoses renowned among the Hebrews and the Pythagoreans.

Laura Cereta

from Defense of the Liberal Instruction of Women and Against Women Who Disparage Learned Women

Laura Cereta to Bibulus Sempronius: Defense of the Liberal Instruction of Women

Cereta recovered her spirits after her husband's death by immersing herself ever more deeply in her literary studies. These efforts, in turn, brought forth critics, both male and female, who, jealous of her accomplishments, belittled her work. Two principal charges were brought against her: that a woman could not be learned and that her father had written the letters for her. She turned against her critics with a ferocity at least equal to theirs. One of her surviving letters is an invective against two males whom she had known since childhood. But here we find, addressed to a man, as reasoned and thorough a defense of learned women as was penned during the Quattrocento. The letter is particularly interesting for its suggestion that the correspondent was disguising his contempt for women in singling out Cereta for praise.

The correspondent is unknown to us from other sources and may well be fictitious. Bibulus, which we have not found elsewhere among the names of this period, means "drunkard." No other letter is addressed to such a correspondent.

This translation is based on the Latin text in Tomasini, Laurae Ceretae epistolae, *pp. 187–195.*

My ears are wearied by your carping. You brashly and publicly not merely wonder but indeed lament that I am said to possess as fine a mind as nature ever bestowed upon the most learned man. You seem to think that so learned a woman has scarcely before been seen in the world. You are wrong on both counts, Sempronius, and have clearly strayed from the path of truth and disseminate falsehood. I agree that you should be grieved; indeed, you should be ashamed, for you have ceased to be a living man, but have become an animated stone; having rejected the studies which make men wise, you rot in torpid leisure. Not nature but your own soul has betrayed you, deserting virtue for the easy path of sin.

You pretend to admire me as a female prodigy, but there lurks sugared deceit in your adulation. You wait perpetually in ambush to entrap my lovely sex, and overcome by your hatred seek to trample me underfoot and dash me to the earth. It is a crafty ploy, but only a low and vulgar mind would think to halt Medusa with honey.[1] You would better

have crept up on a mole than on a wolf. For a mole with its dark vision can see nothing around it, while a wolf's eyes glow in the dark. For the wise person sees by [force of] mind, and anticipating what lies ahead, proceeds by the light of reason. For by foreknowledge the thinker scatters with knowing feet the evils which litter her path.

I would have been silent, believe me, if that savage old enmity of yours had attacked me alone. For the light of Phoebus cannot be befouled even in the mud.[2] But I cannot tolerate your having attacked my entire sex. For this reason my thirsty soul seeks revenge, my sleeping pen is aroused to literary struggle, raging anger stirs mental passions long chained by silence. With just cause I am moved to demonstrate how great a reputation for learning and virtue women have won by their inborn excellence, manifested in every age as knowledge, the [purveyor] of honor. Certain, indeed, and legitimate is our possession of this inheritance, come to us from a long eternity of ages past.

[To begin,] we read how Sabba of Ethiopia, her heart imbued with divine power, solved the prophetic mysteries of the Egyptian Salomon.[3] And the earliest writers said that Amalthea, gifted in foretelling the future, sang her prophecies around the banks of Lake Avernus, not far from Baiae. A sibyl worthy of the pagan gods, she sold books of oracles to Priscus Tarquinius.[4] The Babylonian prophetess Eriphila, her divine mind penetrating the distant future, described the fall and burning of Troy, the fortunes of the Roman Empire, and the coming birth of Christ.[5] Nicostrata also, the mother of Evander, learned both in prophecy and letters, possessed such great genius that with sixteen symbols she first taught the Latins the art of writing.[6] The fame of Inachian Isis will also remain eternal who, an Argive goddess, taught her alphabet to the Egyptians.[7] Zenobia of Egypt was so nobly learned, not only in Egyptian, but also in Greek and Latin, that she wrote histories of strange and exotic places.[8] Manto of Thebes, daughter of Tiresias, although not learned, was skilled in the arts of divination from the remains of sacrificed animals or the behavior of fire and other such Chaldaean techniques. [Examining] the fire's flames, the bird's flight, the entrails and innards of animals, she spoke with spirits and foretold future events.[9] What was the source of the great wisdom of the Tritonian Athena by which she taught so many arts to the Athenians, if not the secret writings, admired by all, of the philosopher Apollo?[10] The Greek women Philiasia and Lasthenia, splendors of learning, excite me, who often tripped up, with tricky sophistries, Plato's clever disciples.[11] Sappho of Lesbos sang to her stone-hearted lover doleful verses, echoes, I believe, of Orpheus' lyre or Apollo's lute.[12] Later, Leontia's Greek and poetic tongue dared sharply to attack, with a lively and admired style, the eloquence of Theophrastus.[13] I should not omit Proba, remarkable for her excellent command of both Greek and Latin and who, imitating Homer and Vergil, retold the stories from the Old Testament.[14] The majesty of Rome exalted the Greek Semiamira, [invited] to lecture in the Senate on laws and kings.[15] Pregnant with virtue, Rome also gave birth to Sempronia, who imposingly delivered before an assembly a fluent poem and swayed the minds of her hearers with her convincing oratory.[16] Celebrated with equal and endless praise for her eloquence was Hortensia, daughter of Hortensius, an oratrix of such power that, weeping womanly and virtuous tears, she persuaded the Triumvirs not to retaliate against women.[17] Let me add Cornificia, sister of the poet Cornificius, to whose love of letters so many skills were added that she was said to have

been nourished by waters from the Castalian spring; she wrote epigrams always sweet with Heliconian flowers.[18] I shall quickly pass by Tulliola, daughter of Cicero,[19] Terentia,[20] and Cornelia, all Roman women who attained the heights of knowledge. I shall also omit Nicolosa [Sanuto] of Bologna, Isotta Nogarola and Cassandra Fedele of our own day. All of history is full of these examples. Thus your nasty words are refuted by these arguments, which compel you to concede that nature imparts equally to all the same freedom to learn.

Only the question of the rarity of outstanding women remains to be addressed. The explanation is clear: women have been able by nature to be exceptional, but have chosen lesser goals. For some women are concerned with parting their hair correctly, adorning themselves with lovely dresses, or decorating their fingers with pearls and other gems. Others delight in mouthing carefully composed phrases, indulging in dancing, or managing spoiled puppies. Still others wish to gaze at lavish banquet tables, to rest in sleep, or, standing at mirrors, to smear their lovely faces. But those in whom a deeper integrity yearns for virtue, restrain from the start their youthful souls, reflect on higher things, harden the body with sobriety and trials, and curb their tongues, open their ears, compose their thoughts in wakeful hours, their minds in contemplation, to letters bonded to righteousness. For knowledge is not given as a gift, but [is gained] with diligence. The free mind, not shirking effort, always soars zealously toward the good, and the desire to know grows ever more wide and deep. It is because of no special holiness, therefore, that we [women] are rewarded by God the Giver with the gift of exceptional talent. Nature has generously lavished its gifts upon all people, opening to all the doors of choice through which reason sends envoys to the will, from which they learn and convey its desires. The will must choose to exercise the gift of reason.

[But] where we [women] should be forceful we are [too often] devious; where we should be confident we are insecure. [Even worse,] we are content with our condition. But you, a foolish and angry dog, have gone to earth as though frightened by wolves. Victory does not come to those who take flight. Nor does he remain safe who makes peace with the enemy; rather, when pressed, he should arm himself all the more with weapons and courage. How nauseating to see strong men pursue a weakling at bay. Hold on! Does my name alone terrify you? As I am not a barbarian in intellect and do not fight like one, what fear drives you? You flee in vain, for traps craftily-laid rout you out of every hiding place. Do you think that by hiding, a deserter [from the field of battle], you can remain undiscovered? A penitent, do you seek the only path of salvation in flight? [If you do] you should be ashamed.

I have been praised too much; showing your contempt for women, you pretend that I alone am admirable because of the good fortune of my intellect. But I, compared to other women who have won splendid renown, am but a little mousling. You disguise your envy in dissimulation, but cloak yourself in apologetic words in vain. The lie buried, the truth, dear to God, always emerges. You stumble half-blind with envy on a wrongful path that leads you from your manhood, from your duty, from God. Who, do you think, will be surprised, Bibulus, if the stricken heart of an angry girl, whom your mindless scorn has painfully wounded, will after this more violently assault your bitter words? Do you suppose, O most contemptible man on earth, that I think myself sprung [like Athena] from the head of

Jove? I am a school girl, possessed of the sleeping embers of an ordinary mind. Indeed I am too hurt, and my mind, offended, too swayed by passions, sighs, tormenting itself, conscious of the obligation to defend my sex. For absolutely everything—that which is within us and that which is without—is made weak by association with my sex.

I, therefore, who have always prized virtue, having put my private concerns aside, will polish and weary my pen against chatterboxes swelled with false glory. Trained in the arts, I shall block the paths of ambush. And I shall endeavor, by avenging arms, to sweep away the abusive infamies of noisemakers with which some disreputable and impudent men furiously, violently, and nastily rave against a woman and a republic worthy of reference. January 13 [1488]

Notes

1. Literally the text reads: "blind Medusa by dropping oil [into her eyes]."
2. Phoebus Apollo, i.e., the Sun.
3. We find no reference to an Ethiopian Sabba. But in the Old Testament Saba is Sheba and in this case would mean the Queen of Sheba, who visited the court of the Hebrew King, Solomon, posing to him certain riddles to test his proverbial wisdom (see III Kings 10; II Chronicles 9). She is believed to have come from what is now Arabia, though she is referred to in the New Testament as simply from "the south" (Matthew 12:42; Luke 11:31).
4. See Boccaccio, *Concerning Famous Women*, chap. 24.
5. See ibid., chap. 19.
6. Ibid., chap. 25.
7. Ibid., chap. 8.
8. On her and the qualities mentioned, see ibid., chap. 98.
9. Ibid., chap. 28.
10. Apollo was the god of higher aspects of civilization, among them philosophy. He was said, for example, to be the father of Plato. The reference to secret writings suggests nothing specific, perhaps a tradition associated with the Oracle at Delphi, Apollo's principal sanctuary.
11. Diogenes Laertius twice mentions Lastheneia as a disciple of Plato. Lastheneia of Mantinea is mentioned both times together with Axiothea of Philus. One reference states that they wore men's clothes, the other that they attended Plato's lectures and that Plato was derided for having an "Arcadian girl" as his pupil (3. 46; 4. 2). We find no reference to Philiasia or to the tradition that they tricked the disciples of Plato with clever sophistries.
12. Sappho (b. 612 B.C.) of Lesbos is among the most famous of Greek poets and poetesses. Her poems were collected into seven books. A number of fragments are extant. Many of these have recently been rendered into English by S. Q. Groden, *The Poems of Sappho* (Indianapolis, 1966). Cereta's source was doubtless Boccaccio, *Concerning Famous Women*, chap. 45.
13. Boccaccio, *Concerning Famous Women*, chap. 58.
14. Ibid., chap. 95.
15. Ibid., chap. 2, discusses Semiramis, a Queen of the Assyrians. We find no reference to a Greek Semiamira.
16. Ibid., chap. 74.
17. Ibid., chap. 82.
18. Ibid., chap. 84.
19. Tulliola or Tullia was born in 78 B.C. and died in 45 B.C. Cicero loved her dearly and considered building a temple to her after her death which was a turning point in his mental life. See *The Oxford Classical Dictionary*, p. 928.
20. Terentia, perhaps Cicero's wife and the mother of Tullia (above). She exercised a great influence on her husband on numerous occasions, including that of the Catiline conspiracy. The two were divorced in 46 B.C. after Cicero returned from exile. She is reputed to have lived to the age of 103. See *The Oxford Classical Dictionary*, p. 885.

Laura Cereta to Lucilia Vernacula: Against Women Who Disparage Learned Women

Not only did Cereta have to deal with carping men, she also had to contend with other women who attacked her out of envy and perhaps also because her accomplishment, so unusual for a woman, could easily be seen as socially deviant. Her departure from the norm of female existence invited resentment. This is perhaps why her tone is more violent here than in the preceding letter addressed to a man. Whereas in the preceding letter she appears to concentrate more on the issue at hand, here she focuses more on the persons involved. She regards learning as growing out of virtue, the external manifestation of an inward state. In effect she is saying that those who do not love learning have no inner direction of their own but are directed by things outside them. Thus, although virtue and learning are not the same thing, virtue will lead to learning rather than to the kinds of lives led by the women who criticize her.

This is the only letter addressed to this correspondent, who is unknown to us from other sources. Here again, the name may be fictitious. Vernacula *can mean "common slave," perhaps "hussy."*

This translation is based on the Latin text in Tomasini, Laurae Ceretae epistolae, *pp. 122–125.*

I thought their tongues should have been fine-sliced and their hearts hacked to pieces—those men whose perverted minds and inconceivable hostility [fueled by] vulgar envy so flamed that they deny, stupidly ranting, that women are able to attain eloquence in Latin. [But] I might have forgiven those pathetic men, doomed to rascality, whose patent insanity I lash with unleashed tongue. But I cannot bear the babbling and chattering women, glowing with drunkenness and wine, whose impudent words harm not only our sex but even more themselves. Empty-headed, they put their heads together and draw lots from a stockpot to elect each other [number one]; but any women who excel they seek out and destroy with the venom of their envy. A wanton and bold plea indeed for ill-fortune and unkindness! Breathing viciousness, while she strives to besmirch her better, she befouls herself; for she who does not yearn to be sinless desires [in effect] license to sin. Thus these women, lazy with sloth and insouciance, abandon themselves to an unnatural vigilance; like scarecrows hung in gardens to ward off birds, they tackle all those who come into range with a poisonous tongue. Why should it behoove me to find this barking, snorting pack of provocateurs worthy of my forbearance, when important and distinguished gentlewomen always esteem and honor me? I shall not allow the base sallies of arrogance to pass, absolved by silence, lest my silence be taken for approval or lest women leading this shameful life attract to their licentiousness crowds of fellow-sinners. Nor should anyone fault me for impatience, since even dogs are permitted to claw at pesty flies, and an infected cow must always be isolated from the healthy flock, for the best is often injured by the worst. Who would believe that a [sturdy] tree could be destroyed by tiny ants? Let them fall silent, then, these insolent little women, to whom every norm of decency is foreign; inflamed with hatred, they would noisily chew up others, [except that] mute, they are themselves chewed up within. Their inactivity of mind maddens these raving women, or rather Megaeras, who cannot bear even to hear the name of a learned woman. These are the mushy faces who, in their vehemence, now spit tedious nothings from their tight little mouths, now to the horror of those looking on spew from their lips thunderous trifles. One becomes disgusted with human failings and grows weary of these women

who, [trapped in their own mental predicament], despair of attaining possession of human arts, when they could easily do so with the application of skill and virtue. For letters are not bestowed upon us, or assigned to us by chance. Virtue only is acquired by ourselves alone; nor can those women ascend to serious knowledge who, soiled by the filth of pleasures, languidly rot in sloth. For those women the path to true knowledge is plain who see that there is certain honor in exertion, labor, and wakefulness. Farewell. November 1 [1487]

Excerpt by Laura Cereta from Her Immaculate Hand: Selected Works by and about the Women Humanists of Quattrocento Italy, *by Margaret L. King and Albert Rabil (Eds.), Second Revised Edition. © 1997 Pegasus Press, Asheville, NC 28803. Used with permission.*

NICCOLÒ MACHIAVELLI
from THE PRINCE

This selection from Machiavelli's great work on political philosophy is typical of his approach to the subject, the most notable aspect of which is an unswerving pragmatism. Machiavelli never wavers from his basic conviction that the politician (the Prince) should act on one basic principle: Is what I am doing going to work to attain my goals? Questions of morality or popularity are always secondary to the issue of how best to use power to attain one's goals and to maintain one's authority. If the Prince is to be a success, Machiavelli argues, he cannot afford to be moral if morality undermines his capacity to rule.

Chapter 15

Those Things for Which Men and Especially Princes are Praised or Censured

Now it remains to examine the wise prince's methods and conduct in dealing with subjects or with allies. And because I know that many have written about this, I fear that, when I too write about it, I shall be thought conceited, since in discussing this material I depart very far from the methods of the others. But since my purpose is to write something useful to him who comprehends it, I have decided that I must concern myself with the truth of the matter as facts show it rather than with any fanciful notion. Yet many have fancied for themselves republics and principalities that have never been seen or known to exist in reality. For there is such a difference between how men live and how they ought to live that he who abandons what is done for what ought to be done learns his destruction rather than his preservation, because any man who under all conditions insists on making it his business to be good will surely be destroyed among so many who are not good. Hence a prince, in order to hold his position, must acquire the power to be not good, and understand when to use it and when not to use it, in accord with necessity.

Omitting, then, those things about a prince that are fancied, and discussing those that are true I say that all men, when people speak of them, and especially princes, who are placed so high, are labeled with some of the following qualities that bring them either blame or praise. To wit, one is considered liberal, one stingy (I use a Tuscan word, for the *avaricious* man in our dialect is still one who tries to get property through violence; *stingy* we call him who holds back too much from using his own goods); one is considered a giver, one grasping; one cruel, one merciful; one a promise-breaker, the other truthful; one effeminate and cowardly, the other bold and spirited; one kindly, the other proud; one las-

civious, the other chaste; one reliable, the other tricky; one hard, the other tolerant; one serious, the other light-minded; one religious, the other unbelieving; and the like.

I am aware that everyone will admit that it would be most praiseworthy for a prince to exhibit such of the above-mentioned qualities as are considered good. But because no ruler can possess or fully practice them, on account of human conditions that do not permit it, he needs to be so prudent that he escapes ill repute for such vices as might take his position away from him, and that he protects himself from such as will not take it away if he can; if he cannot, with little concern he passes over the latter vices. He does not even worry about incurring reproach for those vices without which he can hardly maintain his position, because when we carefully examine the whole matter, we find some qualities that look like virtues, yet—if the prince practices them—they will be his destruction, and other qualities that look like vices, yet—if he practices them—they will bring him safety and well-being.

Chapter 16

Liberality and Stinginess

Beginning then with the first qualities mentioned above, I say that to be considered liberal is good. Nevertheless, liberality, when so practiced that you get a reputation for it, damages you, because if you exercise that quality wisely and rightfully, it is not recognized, and you do not avoid the reproach of practicing its opposite. Therefore, in order to keep up among men the name of a liberal man, you cannot neglect any kind of lavishness. Hence, invariably a prince of that sort uses up in lavish actions all his resources, and is forced in the end, if he wishes to keep up the name of a liberal man, to burden his people excessively and to be a tax-shark and to do everything he can to get money. This makes him hateful to his subjects and not much esteemed by anybody, as one who is growing poor. Hence, with such liberality having injured the many and rewarded the few, he is early affected by all troubles and is ruined early in any danger. Seeing this and trying to pull back from it, he rapidly incurs reproach as stingy.

Since, then, a prince cannot, without harming himself, make use of this virtue of liberality in such a way that it will be recognized, he does not worry, if he is prudent, about being called stingy; because in the course of time he will be thought more and more liberal, since his economy makes his income adequate; he can defend himself against anyone who makes war on him; he can carry through enterprises without burdening his people. Hence, in the end, he practices liberality toward all from whom he takes nothing, who are countless, and stinginess toward all whom he gives nothing, who are few. In our times we have not seen great things done except by those reputed stingy; the others are wiped out. Pope Julius II, although he made use of the name of a liberal man in order to gain the papacy, afterward paid no attention to keeping it up, in order to be able to make war. The present King of France carries on so many wars, without laying an excessive tax on his people, solely because his long stinginess helps pay his enormous expenses. The present King of Spain, if he were reputed liberal, would not engage in or complete so many undertakings.

Therefore, in order not to rob his subjects, in order to defend himself, in order not to grow poor and contemptible, in order not to be forced to become extortionate, a wise prince judges it of little importance to incur the name of a stingy

man, for this is one of those vices that make him reign. And if somebody says: "Caesar through his liberality attained supreme power, and many others through being and being reputed liberal have come to the highest positions," I answer: "Either you are already prince or you are on the road to gaining that position. In the first case, the kind of liberality I mean is damaging; in the second, it is very necessary to be thought liberal. Now Caesar was one of those who were trying to attain sovereignty over Rome. But if, when he had got there, he had lived on and on and had not restrained himself from such expenses, he would have destroyed his supremacy." If somebody replies: "Many have been princes and with their armies have done great things, who have been reputed exceedingly liberal," I answer you: "The prince spends either his own money and that of his subjects, or that of others. In the first case the wise prince is economical; in the second he does not omit any sort of liberality. For that prince who goes out with his armies, who lives on plunder, on booty, and on ransom, has his hands on the property of others; for him this liberality is necessary; otherwise he would not be followed by his soldiers. Of wealth that is not yours or your subjects', you can be a very lavish giver, as were Cyrus, Caesar, and Alexander, because to spend what belongs to others does not lessen your reputation but adds to it. Nothing hurts you except to spend your own money."

Moreover, nothing uses itself up as fast as does liberality; as you practice it, you lose the power to practice it, and grow either poor and despised or, to escape poverty, grasping and hated. Yet the most important danger a wise prince guards himself against is being despised and hated; and liberality brings you to both of them. So it is wiser to accept the name of a niggard, which produces reproach without hatred, than by trying for the name of freespender to incur the name of extortioner, which produces reproach with hatred.

Chapter 17

Cruelty and Mercy: Is It Better to Be Loved Than Feared, or the Reverse?

Passing on to the second of the above-mentioned qualities, I say that every sensible prince wishes to be considered merciful and not cruel. Nevertheless, he takes care not to make a bad use of such mercy. Cesare Borgia was thought cruel; nevertheless that well-known cruelty of his reorganized the Romagna, united it, brought it to peace and loyalty. If we look at this closely, we see that he was much more merciful than the Florentine people, who, to escape being called cruel, allowed the ruin of Pistoia. A wise prince, then, is not troubled about a reproach for cruelty by which he keeps his subjects united and loyal because, giving a very few examples of cruelty, he is more merciful than those who, through too much mercy, let evils continue, from which result murders or plunder, because the latter commonly harm a whole group, but those executions that come from the prince harm individuals only. The new prince—above all other princes—cannot escape being called cruel, since new governments abound in dangers. As Vergil says by the mouth of Dido, "My hard condition and the newness of my sovereignty force me to do such things, and to set guards over my boundaries far and wide."

Nevertheless, he is judicious in believing and in acting, and does not concoct fear for himself, and proceeds in such a way, moderated by prudence and kindness, that too much trust does not make him reckless and too much distrust does not make him unbearable.

This leads to a debate: Is it better to be loved than feared, or the reverse? The answer is that it is desirable to be both, but because it is difficult to join them together, it is much safer for a prince to be feared than loved, if he is to fail in one of the two. Because we can say this about men in general: they are ungrateful, changeable, simulators and dissimulators, runaways in danger, eager for gain; while you do well by them they are all yours; they offer you their blood, their property, their lives, their children, as was said above, when need is far off; but when it comes near you, they turn about. A prince who bases himself entirely on their words, if he is lacking in other preparations, falls; because friendships gained with money, not with greatness and nobility of spirit, are purchased but not possessed, and at the right times cannot be turned to account. Men have less hesitation in injuring one who makes himself loved than one who makes himself feared, for love is held by a chain of duty which, since men are bad, they break at every chance of their own profit; but fear is held by a dread of punishment that never fails you.

Nevertheless, the wise prince makes himself feared in such a way that, if he does not gain love, he escapes hatred; because to be feared and not to be hated can well be combined; this he will always achieve if he refrains from the property of his citizens and his subjects and from their women. And if he does need to take anyone's life, he does so when there is proper justification and a clear case. But above all, he refrains from the property of others, because men forget more quickly the death of a father than the loss of a father's estate. Besides, reasons for seizing property never fail, for he who is living on plunder continually finds chances for appropriating other men's goods; but on the contrary, reasons for taking life are rarer and cease sooner.

But when the prince is with his armies and has in his charge a multitude of soldiers, then it is altogether essential not to worry about being called cruel, for without such a reputation he never keeps an army united or fit for any action. Among the most striking of Hannibal's achievements is reckoned this: though he had a very large army, a mixture of countless sorts of men, led to service in foreign lands, no discord ever appeared in it, either among themselves or with their chief, whether in bad or in good fortune. This could not have resulted from anything else than his well-known inhuman cruelty, which, together with his numberless abilities, made him always respected and terrible in the soldiers' eyes; without it, his other abilities would not have been enough to get him that result. Yet historians, in this matter not very discerning, on one side admire this achievement of his and on the other condemn its main cause.

And that it is true that Hannibal's other abilities would not have been enough, can be inferred from Scipio (a man unusual indeed not merely in his own days but in all the record of known events) against whom his armies in Spain rebelled—an action that resulted from nothing else than his too great mercy, which gave his soldiers more freedom than befits military discipline. For this, he was rebuked in the Senate by Fabius Maximus, who called him the destroyer of the Roman soldiery. The Locrians, who had been ruined by a legate of his, Scipio did not avenge nor did he punish the legate's arrogance—all a result of his tolerant nature. Hence, someone who tried to apologize for him in the Senate said there were many men who knew better how not to err than how to punish errors. This tolerant nature would in time have damaged Scipio's fame and

glory, if, having it, he had kept on in supreme command; but since he lived under the Senate's control, this harmful trait of his not merely was concealed but brought him fame.

I conclude, then, reverting to being feared and loved, that since men love at their own choice and fear at the prince's choice, a wise prince takes care to base himself on what is his own, not on what is another's; he strives only to avoid hatred; as I have said.

Chapter 18

How Princes Should Keep Their Promises

How praiseworthy a prince is who keeps his promises and lives with sincerity and not with trickery everybody realizes. Nevertheless, experience in our time shows that those princes have done great things who have valued their promises little, and who have understood how to addle the brains of men with trickery; and in the end they have vanquished those who have stood upon their honesty.

You need to know, then, that there are two ways of fighting: one according to the laws, the other with force. The first is suited to man, the second to the animals; but because the first is often not sufficient, a prince must resort to the second. Therefore he needs to know well how to put to use the traits of animal and of man. This conduct is taught to princes in allegory by ancient authors, who write that Achilles and many other well-known ancient princes were given for upbringing to Chiron the Centaur, who was to guard and educate them. This does not mean anything else (this having as teacher one who is half animal and half man) than that a prince needs to know how to adopt the nature of either animal or man, for one without the other does not secure him permanence.

Since, then, a prince is necessitated to play the animal well, he chooses among the beasts the fox and the lion, because the lion does not protect himself from traps; the fox does not protect himself from the wolves. The prince must be a fox, therefore, to recognize the traps and a lion to frighten the wolves. Those who rely on the lion alone are not perceptive. By no means can a prudent ruler keep his word—and he does not—when to keep it works against himself and when the reasons that made him promise are annulled. If all men were good, this maxim would not be good, but because they are bad and do not keep their promises to you, you likewise do not have to keep yours to them. Never has a shrewd prince lacked justifying reasons to make his promise-breaking appear honorable. Of this I can give countless modern examples, showing how many treaties of peace and how many promises have been made null and empty through the dishonesty of princes. The one who knows best how to play the fox comes out best, but he must understand well how to disguise the animal's nature and must be a great simulator and dissimulator. So simple-minded are men and so controlled by immediate necessities that a prince who deceives always finds men who let themselves be deceived.

I am not willing, among fresh instances, to keep silent about one of them. Alexander VI never did anything else and never dreamed of anything else than deceiving men, yet he always found a subject to work on. Never was there a man more effective in swearing and who with stronger oaths confirmed a promise, but yet honored it less. Nonetheless, his deceptions always prospered as he hoped, because he understood well this aspect of the world.

For a prince, then, it is not necessary actually to have all the above-mentioned qualities, but it is very necessary to appear to have them. Further, I shall be so bold as to say this: that if he has them and always practices them, they are harmful; and if he appears to have them, they are useful; for example, to appear merciful, trustworthy, humane, blameless, religious—and to be so—yet to be in such measure prepared in mind that if you need to be not so, you can and do change to the contrary. And it is essential to realize this: that a prince, and above all a prince who is new, cannot practice all those things for which men are considered good, being often forced, in order to keep his position, to act contrary to truth, contrary to charity, contrary to humanity, contrary to religion. Therefore he must have a mind ready to turn in any direction as Fortune's winds and the variability of affairs require, yet, as I said above, he holds to what is right when he can but knows how to do wrong when he must.

A wise prince, then, is very careful never to let out of his mouth a single word not weighty with the above-mentioned five qualities; he appears to those who see him and hear him talk, all mercy, all faith, all integrity, all humanity, all religion. No quality does a prince more need to possess—in appearance—than this last one, because in general men judge more with their eyes than with their hands, since everybody can see but few can perceive. Everybody sees what you appear to be; few perceive what you are, and those few dare not contradict the belief of the many, who have the majesty of the government to support them. As to the actions of all men and especially those of princes, against whom charges cannot be brought in court, everybody looks at their result. So if a prince succeeds in conquering and holding this state, his means are always judged honorable and everywhere praised, because the mob is always fascinated by appearances and by the outcome of an affair; and in the world the mob is everything; the few find no room there when the many crowd together. A certain prince of the present time, whom I refrain from naming, never preaches anything except peace and truth, and to both of them he is utterly opposed. Either one, if he had practiced it, would many times have taken from him either his reputation or his power.

DESIDERIUS ERASMUS
from THE PRAISE OF FOLLY

It may be tempting to read Erasmus' satire on all manner of human follies as plain and bitter criticism. But, as in the work of all great satirists, there is a deep vein of moral outrage in these pages. Erasmus was a teacher and a reformer. He uses his biting wit not only to score against stupidity but also to improve the way people live in society.

In the same realm are those who are authors of books. All of them are highly indebted to me ["me" = the goddess Folly], especially those who blacken their pages with sheer triviality. For those who write learnedly to be criticized by a few scholars, not even ruling out a Persius or a Laelius as a judge, seem to be more pitiable than happy to men, simply because they are continuously torturing themselves. They add, they alter, they cross something out, they reinsert it,

they recopy their work, they rearrange it, they show it to friends, and they keep it for nine years; yet they still are not satisfied with it. At such a price, they buy an empty reward, namely praise—and the praise of only a handful, at that. They buy this at the great expense of long hours, no sleep, so much sweat, and so many vexations. Add also the loss of health, the deterioration of their physical appearance, the possibility of blindness or partial loss of their sight, poverty, malice, premature old age, an early death, and if you can think of more, add them to this list. The scholar feels that he has been compensated for such ills when he wins the sanction of one or two other weak-eyed scholars. But my author is crazy in a far happier way for he, without any hesitation, rapidly writes down anything that comes to his mind, his pen, or even his dreams. There is a little or no waste of paper, since he knows that if the trifles are trivial enough the majority of the readers, that is, the fools and ignoramuses, will approve of them. What is the difference if one should ignore two or three scholars, even though he may have read them? Or what weight will the censure of a few scholars carry, so long as the multitudes give it acclaim?

Actually, the wiser writers are those who put out the work of someone else as their own. By a few alterations they transfer someone else's glory to themselves, disregarding the other person's long labor and comforting themselves with the thought that even though they might be publicly convicted of plagiarism, meanwhile they shall have enjoyed the fruits and glory of authorship. It is worth one's while to observe how pleased authors are with their own works when they are popular and pointed out in a crowd—as celebrities! Their work is on display in bookstores, with three cryptic words in large type on the title page, something like a magician's spell. Ye gods! After all, what are they but words? Few people will ever hear of them, compared to the total world population, and far fewer will admire them, since people's tastes vary so, even among the common people. And why is it that the very names of the authors are often false, or stolen from the books of the ancients? One calls himself Telemachus, another Stelenus or Laertes, still another Polycrates, and another Thrasymachus. As a result, nowadays it does not matter whether you dedicate your book to a chameleon or a gourd, or simply to alpha or beta, as the philosophers do.

The most touching event is when they compliment each other and turn around in an exchange of letters, verses, and superfluities. They are fools praising fools and dunces praising dunces. The first, in the opinion of the second, is an Alcaeus, and the second, in the opinion of the first, is a Callimachus. One holds another in higher esteem than Cicero, the other finds the one more learned than Plato. Or sometimes they will choose a competitor and increase their reputation by rivaling themselves with him. As a result the public is split with opposing viewpoints, until finally, when the dispute is over, each reigns as victor and has a triumphal parade. Wise men deride this as being absolute nonsense, which is just what it is. Who will deny it? Meanwhile, our authors are leading a luxurious life because of my excellence, and they would not exchange their accomplishments for even those of Scipius. And while the scholars most certainly derive a great deal of pleasure from laughing at them, relishing to the utmost the madness of others, they themselves owe me a great deal, which they cannot deny without being most ungrateful men.

Among men of the learned professions, a most self-satisfied group of men, the lawyers may hold themselves in the highest esteem. For while they laboriously roll up the stone of Sisyphus by the force of weaving six hundred laws together at the same time, by the stacking of commentary upon commentary and opinion upon opinion regardless of how far removed from the purpose, they contrive to make their profession seem to be most difficult of all. What is actually tedious they consider brilliant. Let us include with them the logicians and sophists, a breed of men more loquacious than the famed brass kettles of Dodona. Any one of them can outtalk any twenty women. They would be happier, though, if they were just talkative and not quarrelsome as well. In fact, they are so quarrelsome that they will argue and fight over a lock of a goat's wool, absurdly losing sight of the truth in the furor of their dispute. Their egotistical love keeps them happy, and manned with but three syllogisms, they will unflinchingly argue on any subject with any man. Their mere obstinacy affords them victory, even though you place Stentor against them.

Next in line are the scientists, revered for their beards and the fur on their gowns. They feel that they are the only men with any wisdom, and all other men float about as shadows. How senilely they daydream, while they construct their countless worlds and shoot the distance to the sun, the moon, the stars, and spheres, as with a thumb and line. They postulate causes for lightning, winds, eclipses, and other inexplicable things, never hesitating for a moment, as if they had exclusive knowledge about the secrets of nature, designer of elements, or as if they visited us directly from the council of the gods. Yet all this time nature is heartily laughing at them and their conjectures. It is a sufficient argument just proving that they have good intelligence for nothing. They can never explain why they always disagree with each other on every subject. In summation, knowing nothing in general they profess to know everything in particular. They are ignorant even to themselves, and at times they do not see the ditch or stone lying across their path, because many of them are day-dreamers and are absent-minded. Yet they proclaim that they perceive ideas, universals, forms without matter, primary substances, quiddities, entities, and things so tenuous that I'm afraid that Lynceus could not see them himself. The common people are especially disdained when they bring out their triangles, quadrangles, circles, and mathematical figures of the like. They place one on top of the other and arrange them into a maze. Then they deploy some letters precisely, as if in a battle formation, and finally they reverse them. And all of this is done only to confuse those who are ignorant of their field. These scientists do not like those who predict the future from the stars, and promise even more fantastic miracles. And these fortunate men find people who believe them.

Perhaps it would be better to pass silently over the theologians. Dealing with them, since they are hot-tempered, is like crossing Lake Camarina or eating poisonous beans. They may attack me with six hundred arguments and force me to retract what I hold; for if I refuse, they will immediately declare me a heretic. By this blitz action they show a desire to terrify anyone to whom they are ill-diagnosed. No other people are so adverse to acknowledge my favors to them, yet the divines are bound to me by extraordinary obligations. These theologians are happy in their self-love, and as if they were presently inhabiting a third heaven, they look down on all men as though they were animals that crawled along the ground, coming near to pity them. They are protected by a wall of scholastic definitions, arguments, corollaries, and implicit and explicit propositions. They have

so many hideouts that not even the net of Vulcan would be able to catch them; for they back down from their distinctions, by which they also cut through the knots of an argument, as if with a double-blade ax from Tenedos; and they come forth with newly invented terms and monstrous-sounding words. Furthermore, they explain the most mysterious matters to suit themselves, for instance, the method by which the world was set in order and began, through what channels original sin has come down to us through generations, by what means, in what measure, and how long the Omnipotent Christ was in the Virgin's womb, and how accidents subsist in the Eucharist without their substance.

But those have been beaten to death down through the ages. Here are some questions that are worthy of great (and some call them) illuminated theologians, questions that will really make them think, if they should ever encounter them. Did divine generation take place at a particular time? Are there several sonships in Christ? Whether this is a possible proposition: Does God the Father hate the Son? Could God the Father have taken upon Himself the likeness of a woman, a devil, an ass, a gourd, or a piece of flint? Then how would that gourd have preached, performed miracles, or been crucified? Also, what would Peter have consecrated, if he had administered the Eucharist, while Christ's body hung on the cross? Another thought: could Christ have been said to be a man at that very moment? Will we be forbidden to eat and drink after the resurrection? (Now, while there is time, they are providing against hunger and thirst!) These intricate subtleties are infinite, and there are others that are even more subtle, concerning instances of time, notions, relations, accidents, quiddities, and entities, which no one can perceive unless, like Lynceus, he can see in the blackest darkness things that aren't there.

We must insert those maxims, rather contradictions, that, compared to the Stoic paradoxes, appear to be the most common simplicity. For instance: it is a lesser crime to cut the throats of a thousand men than to sew a stitch on a poor man's shoe on the Sabbath; it is better to want the earth to perish, body, boots, and breeches (as the saying goes), than to tell a single lie, however inconsequential. The methods that our scholastics follow only render more subtle the subtlest of subtleties; for you will more easily escape from a labyrinth than from the snares of the Realists, Nominalists, Thomists, Albertists, Occamists, and Scotists. I have not named them all, only a few of the major ones. But there is so much learning and difficulty in all of these sects that I should think the apostles themselves must have the need of some help from some other's spirit if they were to try to argue these topics with our new generation of theologians.

Paul could present faith. But when he said, "Faith is the substance of things hoped for, the evidence of things not seen," he did not define it doctorally. The same apostle, though he exemplified charity to its utmost, divided and defined it with very little logical skill in the first epistle to the Corinthians, Chapter 13. And there is no doubt that the apostles consecrated the Eucharist devoutly enough, but suppose you had questioned them about the "terminus a quo" and the "terminus ad quem," or about transubstantiation—how the body is in many places at once, and the difference between the body of Christ in heaven, on the cross, in the Eucharist at the point when transubstantiation occurs (taking note that the prayer effecting it is a discrete quantity having extension in time)—I say that they would not have answered with the same accuracy with which the pupils of Scotus distinguish and define

these matters. The apostles knew the mother of Jesus, but who among them has demonstrated philosophically just how she was preserved from the stain of original sin, as our theologians have done? Peter received the keys from One who did not commit them to an unworthy person, and yet I doubt that he ever understood—for Peter never did have a profound knowledge for the subtle—that a person who did not have knowledge could have the key to knowledge. They went everywhere baptizing people, and yet they never taught what the formal, material, efficient, and final causes of baptism were, nor did they mention that it has both a delible and indelible character. They worshipped, this is certain, but in spirit, following no other teaching than that of the gospel, "God is a spirit, and those that worship Him must do so in spirit and in truth." They seem never to have known that a picture drawn in charcoal on a wall ought to be worshipped as though it was Christ Himself, at least if it is drawn with two outstretched fingers and the hair uncombed, and has three sets of rays in the nimbus fastened to the back of the head. for who would comprehend these things had they not spent all the thirty-six years on the Physics and Metaphysics of Aristotle and the Scotists?

In the same way the apostles teach grace, and yet they never determined the difference between a grace freely given and one that makes one deserving. They urge us to do good works, but they don't separate work in general, work being done, and work that is already finished. At all times they inculcate charity, but they don't distinguish infused charity from that which is acquired, or state whether charity is an accident or a substance, created or uncreated. They abhor sin, but may I be shot if they could define sin scientifically as we know it, unless they were fortunate enough to have been instructed by the Scotists.

You could never persuade me to believe that Paul, upon whose learning others can be judged, would have condemned so many questions, disputes, genealogies, and what he called "strifes for words," if he had really been a master of those subtle topics, especially since all of the controversies at that time were merely little informal discussions. Actually, when compared with the Chrysippean subtleties of our masters, they appeared quite amateurish. And yet these masters are extremely modest; for if by chance the apostles were to have written a document carelessly or without proper knowledge of the subject, the masters would have properly interpreted what they wrote, they would not have condemned it. Therefore, they greatly respect what the apostles wrote, both because of the antiquity of the passage and their apostolic authority. And good heavens, it would almost be unjust to expect scholarly work from the apostles, for they had been told nothing about which they were writing by their Master. But if a mistake of the same kind appears in Chrysostom, Basil, or Jerome, our scholars would unhesitatingly say: "It is not accepted."

The apostles also defeated the pagan philosophers and the Jews in debates, and they are, by nature, the stubbornest of all. But they did this by using their lives as examples and by performing miracles. And, of course, they dealt with people who were not even smart enough to comprehend the most basic ideas of Scotus. Nowadays, what heathen or heretic does not immediately submit when faced with one of these cob-webbed subtleties? Unless, of course, he is either so stupid that he cannot follow them, or so impudent that he hisses them in defiance, or, possibly, so well instructed in the same ambiguities that the contest is a

draw. Then it would appear that you had matched one magician against another, or two men fighting each other with magic swords. It would amount to nothing more than reweaving Penelope's tapestry. In my humble opinion it would be much wiser for the Christians to fight off the Turks and Saracens with these brawling Scotists, stubborn Occamists, invincible Albertists, and a whole band of Sophists, rather than with the undisciplined and unwieldy battalions of soldiers with whom they have been fighting for quite some time, and without any particular favor from Mars. Then I daresay they would witness the most one sided battle that they had ever seen, and one of the greatest victories ever achieved. Who is so impassive that the shrewdness of these fighters would not excite him? And who could be so stupid that these sophistries would not quicken him? And finally, who could be so alert that they would not cloud his vision?

But you think that I say all these things as a joke. Certainly, it is no wonder, since there are some even among the divines, instructed in aural learning, who are nauseated by what they consider the petty subtleties of the theologians. There are those who abhor speaking about holy things with a smutty mouth as a kind of sacrilege and the greatest impiety. These things are to be worshipped and not expounded upon. I am speaking of the heathen's profane methods of arguing, this arrogant way that they define things, and this defiance of the majesty of sacred theology by silly and sordid terms and sentiments. And yet, for all that, the others revel and even applaud themselves in their happiness, and they are so attentive about their precious trifles, both night and day, that they don't even have enough time to read a gospel or epistle from St. Paul. And while they waste their time away in school, they think that they are upholding the universal church, which is otherwise about to crumble to ruins, by the influence of their syllogisms, in the same way that Atlas supports the heavens on his shoulders, according to the poets. You can imagine how much pleasure they derive from shaping and reshaping the Holy Scriptures, as if they were made of wax. And they insist that their own conclusions, subscribed to by a few students, are more valid than Solon's laws and preferred before a pope's decrees; and as world censors they will force a retraction of any statement that does not completely adhere both to their explicit and implicit conclusions. And they announce these conclusions as if they were oracles. "This proposition is scandalous." "This one lacks reverence." "This one tends toward heresy." "This one does not have the right ring." The inference is that neither baptism nor the gospel, Peter and Paul, St. Jerome and Augustine, no, not even the great Aristotelian Thomas, himself, can convert a Christian, unless these scholarly men give their approval. And how kind it is of them to pass judgment! Who would ever have thought, unless these wise men had instructed us, that a man who approves of both "matula putes" and "matula putet," or "ollae fervere" and "ollam fervere," as good Latin, is not a Christian? Who else would have purged the Church from treacherous errors of this sort, which no one would have ever had the occasion to read if these wise men had not published them under the great seals of their universities? Henceforth, aren't they happy while they do these things?

And furthermore, they draw exact pictures of every part of hell, as though they had spent many years in that region. They also fabricate new heavenly regions as imagination dictates, adding the biggest of all and the finest, for there must be a suitable place for the blessed souls to take their

walks, to entertain at dinner, or even to play a game of ball. Their heads are so stuffed and stretched with these and two thousand other trivialities of the same sort that I am certain Jupiter's brain was no more pregnant when he yelled for Vulcan's help to bring forth Pallas. Therefore, do not be astonished when you see one of their heads all wrapped up in swathes at a public debate, for if it wasn't it would certainly fly to pieces. I often derive much pleasure myself when these theologians, who, holding themselves in such great esteem, begin speaking in their slovenly and barbarous tongues and jabber so that no one except a jabberer can understand them, reaching a high pitch—"highest acumen," they call it. This the common man cannot attain. It is their claim that it is beyond the station of sacred discourse to be obliged to adhere to the rules of grammarians. What an amazing attribute for theologians that incorrect speech be allowed them alone! As a matter of fact they share this honor with most intellectuals. When they are addressed as "Our Masters," they feel that they are in the proximity of the gods. They feel that the term has the same religious vigor as the unspeakable four letters of the Hebrews. They say it is sacrilegious to even write MAGISTER NOSTER in small letters, and should one mistakenly utter the term, he destroys in one stroke the sublimity of the theological order.

Those who are the closest to these in happiness are generally called "the religious" or "monks," both of which are deceiving names, since for the most part they stay as far away from religion as possible and frequent every sort of place. I cannot, however, see how any life could be more gloomy than the life of these monks if I did not assist them in many ways. Though most people detest these men so much that accidentally meeting one is considered to be bad luck, the monks themselves believe that they are magnificent creatures. One of the chief benefits is that to be illiterate is to be of a high state of sanctity, and so they make sure that they are not able to read. Another is that when braying out their gospels in church they are making themselves very pleasing and satisfying to God, when in fact they are uttering these psalms as a matter of repetition rather than from their hearts. Indeed, some of these men make a good living through their uncleanliness and beggary by bellowing their petitions for food from door to door; there is not an inn, an announcement board, or a ship into which they are not accessible, here having a great advantage over other common beggars. According to them, though, they are setting an apostolic example for us by their filthiness, their ignorance, their bawdiness, and their insolence.

Moreover, it is amusing to find that they insist that everything be done in fastidious detail, as if employing the orderliness of mathematics, a small mistake in which would be a great crime. Just so many knots must be on each shoe and the shoelace may be of only one specified color; just so much lace is allowed on each habit; the girdle must be of just the right material and width; the hood of a certain shape and capacity; their hair of just so many fingers' length; and finally they can sleep only the specified number of hours per day. Can they not understand that, because of a variety of bodies and temperaments, all this equality of restrictions is in fact very unequal? Nevertheless, because of all this detail that they employ they think that they are superior to all other people. And what is more, amid all their pretense of Apostolic charity, the members of one order will denounce the members of another order clamorously because of the way in which the habit has been belted or the slightly darker color of it. You will find some among the monks who are so

strictly religious and pious that they will wear no outer clothes other than those made of Cilician goat's hair or inner garments other than the ones made of Milesian wool; some others, however, will permit linen outer garments, but they again insist on wool underneath. Members of other orders shrink from the mere touch of money as if it were poison. They do not, however, retreat from the touch of wine or of women. All derive a great deal of joy in choosing the name of their order; some prefer to call themselves Cordeliers, who are subdivided into the Coletes, the Minors, the Minims, and the Crutched; others prefer to be called Benedictines or Bernardines; while still others prefer the names Bridgetines, Augustinians, Williamists, or Jacobines—as if it were not enough to be called Christians. In short, all the different orders make sure that nothing in their lives will be uniform; nor is it so much their concern to be like Christ as it is to be unlike one another.

Many of them work so hard at protocol and at traditional fastidiousness that they think one heaven hardly a suitable reward for their labors; never recalling, however, that the time will come when Christ will demand a reckoning of that which he has prescribed, namely charity, and that he will hold their deeds of little account. One monk will then exhibit his belly filled with every kind of fish; another will profess a knowledge of over a hundred hymns. Still another will reveal a countless number of fasts that he has made, and will account for his large belly by explaining that his fasts have always been broken by a single large meal. Another will show a list of church ceremonies over which he has officiated so large that it would fill seven ships, while still another will brag that he hasn't touched any money in over sixty years unless he wore two pairs of gloves to protect his fingers. Another will take pride in the fact that he has lived a beggarly life as exampled by the filthiness and dirtiness of his hood, which even a sailor would not see fit to wear. Another will take glory in the fact that he has parasitically lived in the same spot for over fifty-five years. Another will exhibit his hoarse voice, which is a result of his diligent chanting; another, a lethargy contracted from his reclusive living; and still another, muteness as a result of his vow of silence. But Christ, interrupting their otherwise unending pleas will ask to himself, "Where does this new race of Jews come from? I recognize only one commandment that is truly mine and yet I hear nothing of it. Many years ago in the sight of all men I promised, in clear language, not through the use of parables, the inheritance of My Father to those who perform works of mercy and charity—not to those who merely wear hoods, chant prayers, or perform fasts. Nor do I reward those who acknowledge their own good works too much. Let those who think themselves holier than I, dwell in those six hundred heavens of Basilides, if they wish, or let them command those whose fastidious customs they have followed in the place of my commandments to build them a new heaven." Having heard these words and seeing that even sailors and teamsters are considered better company than they are, it should be interesting to see what looks they give each other! Yet they are, in the meantime, with my assistance, contented with their present hopes of happiness.

No one, however, even though isolated from public life, will dare to rebuke one of these monks, because through the confessional these men acquire the secrets of everyone. To be sure, they believe it a crime to publish these secrets, but they may accidentally divulge them when drinking heavily or when wishing to promote amusement by relating funny stories. The names, of course, are not revealed, because the stories are told by means of implications in most cases. In other words, if anyone offends the monks, the monks in turn will take revenge against the offender. They will reveal their enemies in public sermons by direct implications, so that everyone will know of whom they speak. And they will continue this malicious chatter until bribed to stop.

Show me any actor or charlatan you would rather watch than these monks as they drone through their sermons, trying to exemplify all the art of rhetoric that has been handed down through the ages. Good Lord! How wonderfully they gesture with their hands; how skillfully they pitch their voice; how cleverly they intone their sermons, throwing themselves about, changing facial expressions, and in the end leaving their audience in a complete state of confusion by their contradictory arguments. Yet this "art of rhetoric" is handed down with much ceremony from monk to monk, as if it required the greatest skill, craft, and ingenuity. It is forbidden for me to know this art, but I shall relate what I think are a few of its foundations. First, each oration is begun with an invocation, a device they have borrowed from the poets. Next, if charity is to be their topic, they commence their sermon with a dissertation on the Nile River in Egypt. Or they are contented to begin with Baal, the Babylonian snake god, if they intend to speak on the mystery of the cross. If fasting is their subject, they open with the twelve signs of the Zodiac; if they wish to expound faith, they initiate their sermon with the problem of squaring the circle.

I know of one notable fool—there I go again! I meant to say scholar—who was ready to expound the mystery of the Holy Trinity to a very distinguished assembly. Wishing to exhibit exceptional scholarship and to please the Divine in a special way, he embarked upon his lecture in an unheard-of manner—that is, he began by showing the relation of letters, syllables, and words; from there, he explained the agreement between nouns and verbs and nouns and adjectives. At once everyone became lost in amazement at this new approach and began to ask among themselves the question that Horace had once asked, "What is all this stink about?" As his oration progressed, however, he drew out this observation, that through the foregoing elements of grammar he could demonstrate the Holy Trinity so clearly that no mathematician could demonstrate it more understandably through his use of symbols in the sand. This fastidious monk had worked so hard on this one sermon for the previous eight months that he became blind as a mole afterward, all the keenness of his sight having given way to the sharpness of his mind. This man, to this day, however, does not regret the loss of his sight to any degree, because he believes it to have been a small price, indeed, to pay for so much glory.

I know of another monk of eighty years of age who was so scholarly that it was often said that Scotus, himself, was reborn in him. He expounded the mystery of the name of Jesus, showing with admirable subtlety that the letters of the name served to explain all that could be understood about Him. The fact that the name can be declined in three different cases—Jesus, Jesum, and Jesu—clearly illustrates the threefold nature of God. In one case the name ends with "s," this showing that He is the sum; in the second case it ends with "m," illustrating that He is the middle; and finally, in the third case we find the ending "u," this symbolizing that He is the ultimate. He amazed his audience even more when he treated the letters of the name mathematically. The name Jesus was equally divided into

two parts with an s left in the middle. He then proceeded to point out that this lone letter was ש in the Hebrew language and was pronounced Schin, or Sin, and that furthermore this Hebrew letter was a word in the Scottish dialect that means *peccatum* (Latin for sin). From the above premises he declared to his audience that this connection showed that Jesus takes away the sins of the world. His listeners, especially the theologians, were so amazed at this new approach that some of them came near to being overtaken by the same mysterious force that transformed Niobe to stone; as for my reaction, I was more inclined to imitate shoddy Priapus, who upon witnessing the nocturnal rites of Canidia and Sagona fled from the spot. And I had reason to flee, too, for when did the Greek Demosthenes or Roman Cicero ever cook up such a rhetorical insinuation as that?

These great rhetoricians insisted that any introduction that had no explicit connection with the matter of the oration was faulty, and was used only by swineherds, who had mere nature as their guide. Nevertheless, these eminent preachers hold that their preamble, as they have named it, contains its rhetorical values only insofar as it has nothing to do with the matter of the discourse, so that the listener will be asking himself, "Now what is he getting at?"

As a third step, instead of a narration they substitute the hasty explanation of some verse from a gospel, when in fact this above all other things is the part that needs to be dwelt upon. As a fourth rule, they interpret some questions of divinity through references to things that are neither in earth or in heaven. Here is where they reach the height of their theological and rhetorical ability in that they astound their audience by flowering their speech, when referring to other preachers, with such illustrious titles as Renowned Doctor, Subtle Doctor, Very Subtle Doctor, Seraphic Doctor, Holy Doctor, and Invincible Doctor. Next, they mystify their uneducated audience by their use of syllogisms, majors, minors, conclusions, corollaries, conversions, and other scholarly devices, playing on the ignorance of the crowd. And they consider all these things necessary and unique to their art.

CHAPTER 13

GENERAL EVENTS	LITERATURE & PHILOSOPHY	ART

FLORENTINE RENAISSANCE

1400

1471–1484 Reign of Pope Sixtus IV (della Rovere)

1492 Columbus discovers America

1494 Foreign invasions of Italy begin

1471–1484 Perugino, Botticelli, and others decorate Sistine Chapel side walls

1493–1506 Ancient frescoes and statues uncovered in Rome; *Laocoön* found 1506

c. 1494 Decline of Medici power in Florence causes artists to migrate to Rome

1494–1495 Dürer's first trip to Venice

c. 1494 Aldine Press established in Venice

1503

1503–1513 Reign of Pope Julius II (della Rovere)

c. 1500–1505 Giorgione, *Enthroned Madonna with Saint Liberalis and Saint Francis,* altarpiece

1505 Michelangelo called to Rome by Julius II to begin Pope's tomb; *Moses* (1513–1515), *Captives* (1527–1528)

1505–1508 Raphael works in Florence; *Madonna of the Meadows* (1505)

1508 Raphael begins frescoes for rooms in Vatican Palace; *The School of Athens,* Stanza della Segnatura (1509–1511)

1508–1511 Michelangelo, Sistine Chapel ceiling

c. 1510 Giorgione, *Fête Champêtre*

1511 Raphael, *Portrait of Julius II*

c. 1510 Decline of Venetian trade as a result of new geographic discoveries

1513–1521 Reign of Pope Leo X (dé Medici)

1517 Reformation begins in Germany with Luther's 95 Theses, challenging the practice of indulgences

1515–1547 Francis I lures Leonardo and other Italian artists to France

Painting in Venice emphasizes brilliant color and light; less linear than in Rome and Florence; Titian, *The Assumption of the Virgin* (1518)

1519 Death of Leonardo

1519–1534 Michelangelo works on Medici Chapel sculptures

1520

1523–1534 Reign of Pope Clement VII (dé Medici)

1527 Sack of Rome by Emperor Charles V

1534 Churches of Rome and England separate

1545 Council to reform Catholic Church begins at Trent

c. 1524–1534 Strozzi, poem on Michelangelo's *Night*

1527 Luther translates Bible into German

1528 Castiglione, *The Courtier,* dialogue on ideal courtly life

1550 Vasari, *Lives of the Painters*

1558–1566 Cellini, *Autobiography of Benvenuto Cellini*

1561 *The Courtier* translated into English by Sir Thomas Hoby

1520 Death of Raphael

c. 1520 Mannerism emerges as artistic style

c. 1528 Pontormo, *Deposition,* Capponi Chapel, Santa Felicitá, Florence

c. 1534 Parmigianino, *Madonna of the Long Neck*

1534–1541 Michelangelo, *The Last Judgment* fresco, Sistine Chapel

1538 Titian, *Venus of Urbino*

1603

Most dates are approximate

THE HIGH RENAISSANCE IN ITALY

	ARCHITECTURE	MUSIC

1473–1480 Sistine chapel built for Pope Sixtus IV

1473 Sistine Choir established by Sixtus IV

1486–1494 Josquin des Prez intermittently in service of Sistine Choir as composer of masses and motets; *Tu Pauperum Refugium*

1506 Pope Julius II commissions Bramante to rebuild Saint Peter's Basilica

1514 Death of Bramante; Raphael, Sangallo, and others continue work on Saint Peter's

1512 Julian Choir established by Julius II for Saint Peter's Basilica

1519–1534 Michelangelo, Medici Chapel, Church of San Lorenzo, Florence

1524 Michelangelo, Laurentian Library, Florence, begun; entrance staircase finished 1559

1527 Adrian Willaert becomes choirmaster of Saint Mark's, Venice; multiple choirs and addition of instrumental music are Venetian innovations to liturgical music

1554 Cellini casts bronze *Perseus* in Florence

1564 Death of Michelangelo

1576 Titian dies of plague

1581 Fontana, *Dead Christ*

1610 Anguissola, *Self-Portrait*

1547 Michelangelo appointed architect of Saint Peter's; apse and dome begun 1547

1567 Palestrina, *Missa Papae Marcelli*

1571–1594 Palestrina, choirmaster of Sistine Choir, in charge of musical reform for Vatican

1592 Michelangelo's dome for Saint Peter's finished by Giacomo della Porta

1603 Victoria, *Requiem Mass for the Empress Maria*

CHAPTER 13

THE HIGH RENAISSANCE IN ITALY

POPES AND PATRONAGE

Artists must work where their art is appreciated and their labors rewarded. Florence in the fifteenth century, shaped by the generous and refined **patronage** of the Medici and others, was an extremely congenial place for the talented artist. But when the political power of the Medici declined in the last decade of that century, many major artists inevitably migrated or were summoned to other centers of wealth and stability. The papal court at the Vatican in Rome was preeminently such a center.

In the fifteenth century (and even earlier), artists found rewarding work at the Vatican (see **TABLE 13.1**). Pope Sixtus IV (reigned 1471–1484) commissioned many artists who were famous in Florence—among them Ghirlandaio, Botticelli, and Perugino—to fresco the side walls of the Sistine Chapel, named for himself, as well as work on other projects that caught his artistic fancy. Not the least of these projects was the enlargement and systematization of the Vatican Library.

The period known as the High Renaissance really began, however, in 1503, when a nephew of Sixtus IV became Pope Julius II (died 1513); both were members of the della Rovere family. Pope Julius was a fiery man who did not hesitate to don full military armor over his vestments and lead his papal troops into battle. Thanks to the influence of his papal uncle, he appreciated the fine arts, indulging his artistic tastes with the same single-mindedness that characterized his military campaigns. It was Pope Julius—called by his contemporaries *il papa terribile* ("the awesome pope")—who summoned both Raphael Sanzio and Michelangelo Buonarroti to Rome.

Raphael

Raphael Sanzio (1483–1520) was born in Urbino, a center of humanist learning east of Florence dominated by the court of the Duke of Urbino. His precocious talent was first nurtured by his father, a painter, whose death in 1494 cut short the youth's education. The young Raphael then went to Perugia as an apprentice to the painter Perugino. Here his talents were quickly recognized. In 1505, at the age of twenty-two, he moved on to Florence, where he worked for three years.

During his stay in Florence, Raphael painted many madonnas in a style that has become almost synonymous with his name. The *Madonna of the Meadow* [**FIG. 13.1**] is typical. In this painting Raphael arranged his figures in a **pyramidal** configuration to create a believable and balanced space. This geometrical device, which had already been popularized by Leonardo da Vinci, was congenial to the Renaissance preoccupation with rationally ordered composition. More important than the arrangement of shapes, however, is the beautiful modeling of the human forms, especially the figures of the two children, and the genuine sweetness and warmth conveyed

TABLE 13.1 *Some Rennaisance Popes of the Sixteenth Century*

Julius II (1503–1513). Of the della Rovere family; Patron of Raphael and Michelangelo.

Leo X (1513–1521). Son of Lorenzo the Magnificent; patronized Michelangelo. Excommunicated Martin Luther.

Hadrian VI (1522–1523). Born in the Netherlands; a ferocious reformer and the last non-Italian pope until the 1970s.

Clement VII (1523–1534). Bastard grandson of Lorenzo de' Medici; commissioned the Medici tombs in Florence. Excommunicated Henry VIII. Commissioned *The Last Judgment* for the Sistine Chapel just before his death.

Paul III (1534–1549). Commissioned Michelangelo to build the Farnese Palace in Rome. Called the reform Council of Trent, which first met in 1545.

Julius III (1550–1555). Patron of the composer Palestrina. Confirmed the constitutions of the Jesuits in 1550. Appointed Michelangelo as chief architect of St. Peter's.

Marcellus II (1555). Reigned as pope twenty-two days. Palestrina composed the *Missa Papae Marcelli* in his honor.

Paul IV (1555–1559). Began the papal reaction against the Renaissance spirit. A fanatical reformer; encouraged the Inquisition and instituted the *Index of Forbidden Books* in 1557.

■ **13.1** Raphael. *Madonna of the Meadow,* 1508. Oil on panel, 44½″ × 34¼″ (113 × 87 cm). Kunsthistorisches Museum, Vienna. The infant John the Baptist kneels at the left of the picture in homage to the Christ child, who stands before his mother.

by the faces. The head of the Madonna is peaceful and luminous, while the infant Christ and Saint John convey a somewhat more playful mood. The human quality of the divine figure is Raphael's trademark.

Raphael left Florence for Rome in 1508. By the following year, Pope Julius, whom Raphael later captured in an unforgettably fine portrait, had him working in the Vatican on a variety of projects. The pope, who genuinely loved Raphael, commissioned him to decorate various rooms of his palace. Raphael spent the rest of his brief life working on these projects and filling assorted administrative posts for the papacy, including, at one time, the office of architect of Saint Peter's Basilica and at another time superintendent of the Vatican's collection of antiquities.

One of Raphael's most outstanding works—and certainly one of the most important for defining the meaning of the sixteenth-century Renaissance in Rome—is a large fresco executed in 1509–1511 on the wall of the Stanza della Segnatura, an office in the Vatican Palace where documents requiring the pope's signature were prepared. Called now the *School of Athens* [**FIG. 13.2**], the fresco is a highly symbolic homage to philosophy that complements Raphael's similar frescoes in the same room that symbolize poetry, law, and theology.

The *School of Athens* sets the great philosophers of antiquity in an immense illusionistic architectural framework that must have been at least partially inspired by the impressive ruins of Roman baths and basilicas, and perhaps by the new Saint Peter's, then under construction. Raphael's fresco depicts Roman barrel vaulting, coffered ceilings, and broad expanses not unlike the still-existing baths of ancient Rome. Occupying the center of the fresco, in places of honor framed by the receding lines of the architecture as a device to focus the viewer's eye, are the two greatest ancient Greek philosophers: Plato and Aristotle. Plato holds a copy of the *Timaeus* in one hand and with the other points to the heavens, the realm of ideal forms. Aristotle holds a copy of his *Ethics* and points to the earth, where his science of empirical observation must begin. Clustered about the two philosophers in varying poses and at various distances are other great figures of antiquity. Diogenes sprawls in front of the philosophers, while Pythagoras calculates on a slate and Ptolemy holds a globe. At the right, the idealized figure of Euclid with his compass is actually a portrait of Raphael's Roman protector, the architect Bramante. Raphael himself, in a self-portrait, looks out at the viewer at the extreme lower-right corner of the fresco.

Raphael's *School of Athens* reflects a high degree of sensitivity to ordered space, a complete ease with Classical thought, obvious inspiration from the Roman architectural past, a brilliant sense of color and form, and a love for intellectual clarity—characteristics that could sum up the Renaissance ideal. That such a fresco should adorn a room in the Vatican, the center of Christian authority, is not difficult to explain. The papal court of Julius II shared the humanist conviction that philosophy is the servant of theology and that beauty, even if derived from a pagan civilization, is a gift from God and not to be despised. To underscore this point, Raphael's homage to theology across the room, his fresco called the *Disputà,* shows in a panoramic form similar to the *School of Athens* the efforts of theologians to penetrate Divine mystery.

The *Transfiguration* was Raphael's last work, left unfinished at his death [**FIG. 13.3**]. A great scene, evenly divided between the airy transcendence of the transfigured Christ, flanked by Old Testament figures, and overpoweringly blinded apostles and the rest of the world on the darker level of the earth is still held together with a great sense of balanced activity. This painting is usually considered as one of the great moments of the Roman High Renaissance.

Michelangelo

In the lower center of Raphael's *School of Athens* is a lone figure leaning one elbow on a block of marble and scribbling, taking no notice of the exalted scene about him. Strangely isolated in his stonecutter's smock,

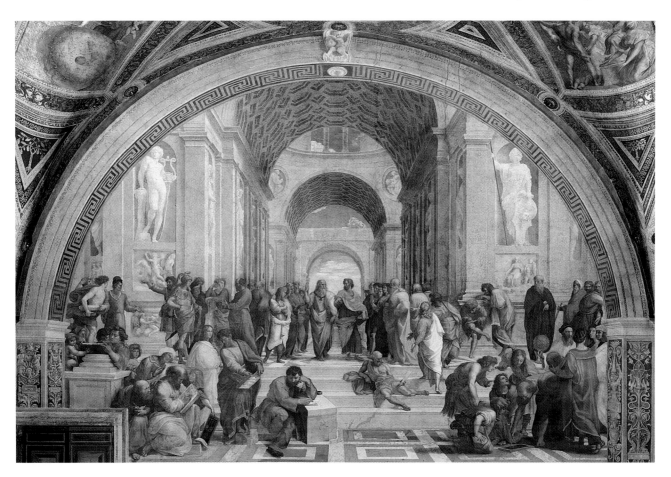

■ **13.2** Raphael. *Philosophy (School of Athens),* 1509–1511. Fresco, 26′ × 18′ (7.92 × 5.48 m). Stanza della Segnatura, Vatican Palace, Rome. The central figures represent Plato and Aristotle. The figure in the forefront is Michelangelo, with his left hand against his head.

the figure has recently been identified, at least tentatively, as Michelangelo. If this identification is correct, this is the younger artist's act of homage to the solitary genius who was working just a few yards away from him in the Sistine Chapel.

Michelangelo Buonarroti (1475–1564) was called to Rome in 1505 by Pope Julius II to create for him a monumental tomb. We have no clear sense of what the tomb was to look like, because over the years it went through at least five conceptual revisions. Certain features, however, at least in the initial stages, are definite. It was to have three levels; the bottom level was to have sculpted figures representing Victory and bound slaves. The second level was to have statues of Moses and Saint Paul as well as symbolic figures of the active and contemplative life—representative of the human striving for, and reception of, knowledge. The third level, it is assumed, was to have an effigy of the deceased pope.

The tomb of Pope Julius II was never finished. Michelangelo was interrupted in his long labors by both Pope Julius and, after the pope's death, the popes of the Medici family, who were more concerned with projects glorifying their own family. What was completed of the tomb represents a twenty-year span of frustrating delays and revised schemes. Even those finished pieces provide no sense of the whole, but they do represent some of the highest achievements of world art.

One of the finished pieces is the *Moses* [**FIG. 13.4**], begun after the death of Julius in 1513. We easily sense both the bulky physicality of Moses and the carefully modeled particulars of musculature, drapery, and hair. The fiercely inspired look on the face of Moses is appropriate for one who has just come down from Mount Sinai after seeing God. The face radiates both divine fury and divine light. It is often said of Michelangelo that his work can overwhelm the viewer with a sense of awesomeness; Italians speak of his *terribilità*. If any single statue has this awesomeness, it is the *Moses.*

The highly finished quality of the *Moses* should be compared to the roughness of the *Boboli Captives* [**FIG. 13.5**], the four figures Michelangelo worked on for the tomb of Julius in Florence in 1527–1528. There is no evidence that Michelangelo intended to leave these figures in so crude a state. Nevertheless, these magnificent works give a visual demonstration of the sculptor's methods. Michelangelo sometimes said that a living figure was concealed in a block of marble and that only the excess needed to be carved away to reveal it. The

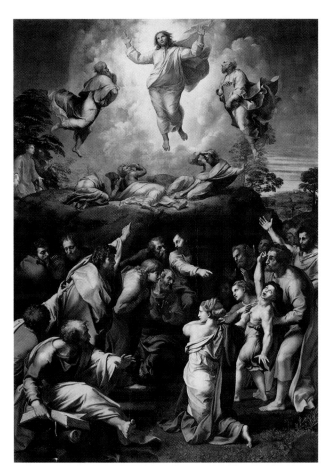

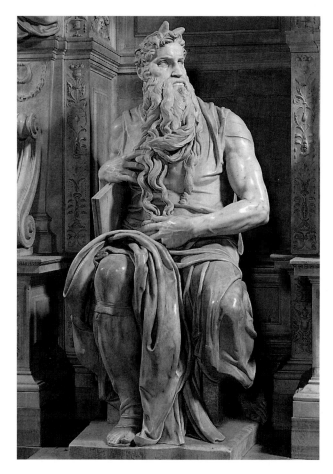

■ **13.3** Raphael. *The Transfiguration,* 1517. Tempera panel, 15′1½″ × 9′1½″ (4.6 × 2.8 m). Vatican Museum, Rome. Note how the gesturing hands "frame" the figure of Christ.

■ **13.4** Michelangelo. *Moses,* 1513–1515. Marble. Height 8′4″ (2.54 m). San Pietro in Vincoli, Rome. The horns on the head of Moses represent rays of light; the use of horns instead of rays is based on a mistranslation in the Latin Vulgate Bible.

truth of the Neo-Platonic notion that ideal form struggles to be freed from the confines of gross matter can almost be seen in these figures. A close examination reveals the bite marks of the sculptor's chisel as he worked to reveal each living figure by removing hard marble. Seldom do we have a chance, as we do here, to see the work of a great artist still unfolding.

It is not clear where the *Captives* fit into the overall plan of the tomb of Julius. It is most likely that they were meant to serve as corner supports for the bottom level of the tomb, writhing under the weight of the whole [**FIG. 13.6**]. Whatever the ultimate plan was for these figures, they are a stunning testament to the monumentally creative impulse of Michelangelo the sculptor.

Michelangelo had hardly begun work on the pope's tomb when Julius commanded him to fresco the ceiling of the Sistine Chapel to complete the work done in the previous century under Sixtus IV. But Michelangelo resisted the project (he actually fled Rome and had to be ordered back by papal edict). He considered himself a sculptor, and there were technical problems presented by the shape of the ceiling. Nevertheless, he gave in and

in three years (1508–1511) finished the ceiling [**FIG. 13.7**]. He signed it "Michelangelo, Sculptor" to remind Julius of his reluctance and his own true vocation.

The ceiling is as difficult to describe as it is to observe when standing in the Sistine Chapel. The overall organization consists of four large triangles at the corners; a series of eight triangular spaces on the outer border; an intermediate series of figures; and nine central panels (four larger than the other five), all bound together with architectural motifs and nude male figures. The corner triangles depict heroic action in the Old Testament (Judith beheading Holofernes, David slaying Goliath, Haman punished for his crimes, the rod of Moses changing into a serpent), whereas the other eight triangles depict the biblical ancestors of Jesus Christ. The ten major intermediate figures are alternating portraits of pagan sibyls (prophetesses) and Old Testament prophets. The central panels are scenes from the Book of Genesis. The one closest to the altar shows God dividing darkness from light, and the one at the other end shows the drunkenness of Noah (Genesis 9:20–27). This bare outline oversimplifies what is actually a complex, intricate design [**FIG. 13.8**].

▪ VOICES OF THEIR TIMES

Donna Vittoria and Michelangelo

Donna Vittoria Colonna to Michelangelo:

Most honored Master Michelangelo, your art has brought you such fame that you would perhaps never have believed that this fame could fade with time or through any other cause. But the heavenly light has shone into your heart and shown you that, however long earthly glory may last, it is doomed to suffer the second death.

Michelangelo's poem on this theme:

I know full well that it was a fantasy
That made me think that art could be made into
An idol or a king. Though all men do
This, they do it half-unwillingly.
The loving thoughts, so happy and so vain,
Are finished now. A double death comes near—
The one is sure, the other is a threat.

An exchange between Michelangelo's friend and spiritual adviser (for whom he made some small sculptures and drawings, according to Vasari) and the artist. She was the recipient of a number of his poems.

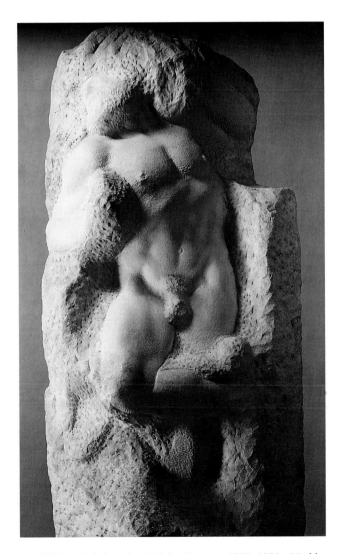

▪ **13.5** Michelangelo. *Boboli Captives,* 1527–1528. Marble, height 7′6½″ (2.3 m). Accademia, Florence. These captives once stood in the Boboli Gardens of Florence, hence their name. Note the chisel marks in the marble.

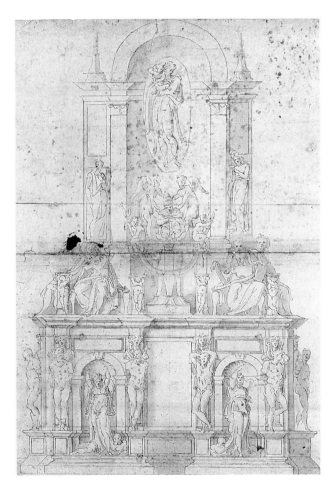

▪ **13.6** Drawing of tomb of Julius II. After Michelangelo by his pupil Giacomo Rocchetti. Brown ink, 22½″ × 15¼″ (57 × 39 cm). Kupferstichkabinett, State Museums, Berlin. This is only one of many projected plans for the tomb of Julius. Note the slaves/captives at the bottom level and Moses on the right at the second level. The semirecumbent figure of the deceased pope is supported by angelic figures, with an allegorical figure of Victory overhead in the center.

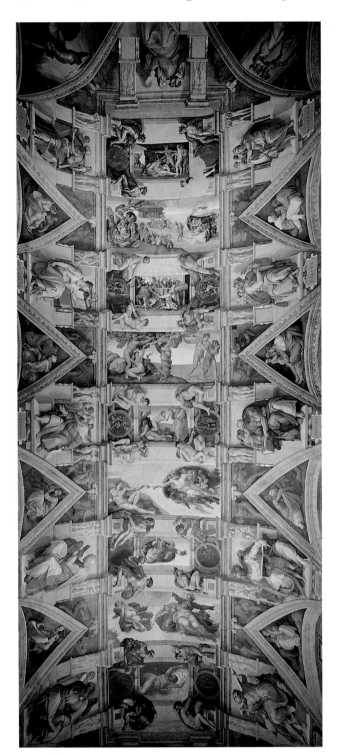

■ **13.7** Michelangelo. Ceiling of the Sistine Chapel, 1508–1511. Fresco, 44′ × 128′ (13.44 × 39.01 m). Vatican Palace, Rome.

Michelangelo conceived and executed this huge work as a single unit. Its overall meaning is a problem. The issue has engaged historians of art for generations without satisfactory resolution. Any attempt to formulate an authoritative statement must include the following elements:

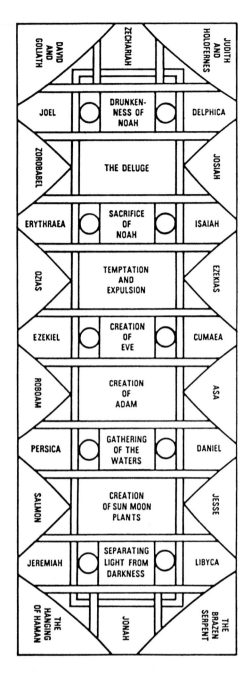

■ **13.8** Schematic drawing of the iconographic plan of the Sistine Ceiling. The corner triangles are called the *vele* ("sails").

1. Michelangelo's interest in the **Neo-Platonism** he had studied as a youth in Florence. Many writers have noted the Neo-Platonic roots of his interest in the manipulation of darkness and light (the progression of darkness to light from the outer borders to the center panels; the panel of God creating light itself); the liberation of spirit from matter (the souls represented by nudes; the drunkenness of Noah, symbolic of humanity trapped by gross matter and thereby degraded); and the numerous geometrical allusions done in triads, a triple division being much loved in Neo-Platonic number symbolism.

2. The Christian understanding of the Old Testament as a work pointing to the coming of Christ, combined with the notion that even pagan prophets were dimly prophetic figures of Christ.

3. The complex tree symbolism in seven of the nine central panels, which refer to the symbolism of the tree in the Bible (the tree of good and evil in the Genesis story, the tree of the Cross, and so forth), as well as being allusions to the pope's family name, which happened to be della Rovere ("of the oak tree").

4. The traditional theories of the relationship of the world of human wisdom (represented by the sibyls) and God's revelation (represented by the prophets).

In the panel depicting the *Creation of Adam* [**FIG. 13.9**], to cite one specific example, many of these elements come together. A majestically muscular Adam rises, as if from sleep, from the bare earth as God stretches forth His creative finger to call Adam into being. God's left arm circles a woman and child who represent simultaneously Eve and her children and, by extension, the New Eve, who is the Blessed Virgin. Adam is a prefigurement of Christ. Below Adam a youth holding a cornucopia spilling forth leaves and acorns (symbols of the della Rovere family) stands just above the Persian sibyl. Stylistically, the fresco demonstrates Michelangelo's intense involvement with masculine anatomy seen as muscular monumentality. His ability to combine great physical bulk with linear grace

and a powerful display of emotion fairly well defines the adjective *Michelangelesque,* applied to many later artists who were influenced by his style.

The full force of that Michelangelesque style can be seen in the artist's second contribution to the Sistine Chapel: *The Last Judgment,* which he painted on the wall behind the main altar between the years 1534 and 1541 [**FIG. 13.10**]. A huge fresco marking the end of the world when Christ comes back as judge, *The Last Judgment* shows the Divine Judge standing in the upper center of the scene, with the world being divided into the Dantean damned at the bottom and those who are called to glory above. Into that great scene Michelangelo poured both his own intense religious vision and a reflection of the troubled days during which he lived. It was, after all, a Rome that had already been sacked in 1527 and a church that had been riven by the Protestant Reformation in the North.

Under the patronage of popes Leo X and Clement VII—both from the Medici family—Michelangelo worked on another project, the Medici Chapel in the Florentine Church of San Lorenzo. This **chapel** is particularly interesting because Michelangelo designed and executed both the sculptures and the chapel in which they were to be placed. Although Michelangelo first conceived the project in 1519, he worked on it only in fits and starts from 1521 to 1534. He never completely finished the chapel. In 1545, some of Michelangelo's students set the statues in place.

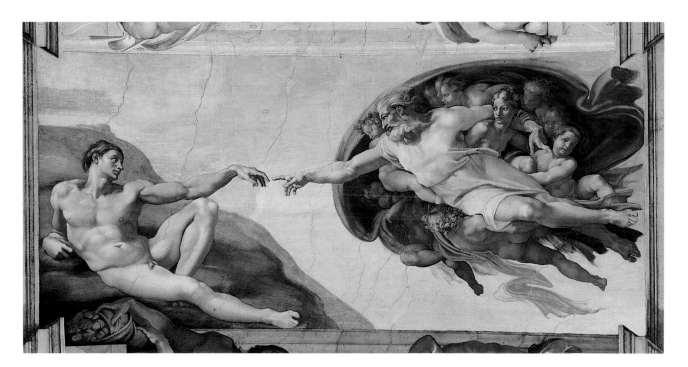

■ **13.9** Michelangelo. *Creation of Adam.* Detail of the Sistine Chapel Ceiling, 1508–1512. Fresco. Approx. 8′ × 9′2″ (2.44 × 2.8 m). Vatican Palace, Rome. Compare the figure of Adam to the figure of David (Figure 12.28) to get a sense of Michelangelo's concept of musculature.

■ **13.10** Michelangelo. *The Last Judgment*. Fresco on the altar wall of the Sistine Chapel (restored), 1534–1541. Vatican Palace, Rome. The loincloths on the figures were added later to appease the puritan sensibilities of post-Reformation Catholicism. The figure in the flayed skin of Saint Bartholomew below and to the right of Christ is a self-portrait of the painter.

The interior of the Medici Chapel [**FIG. 13.11**] echoes Brunelleschi's Pazzi Chapel with its dome, its use of a light grayish stone called *pietra serena (serena stone)*, its Classical decoration, and its chaste and severe style. The plan envisioned an altar at one end of the chapel and opposite it, at the other end, statues of the Madonna and child with saints Cosmas and Damian. The saints were the patrons of physicians, an allusion to the name *Medici*, which means "the doctor's family." At the base of these statues are buried in utter simplic-

■ **13.11** Michelangelo. Medici Chapel, 1519–1534. Church of San Lorenzo, Florence. It is not clear whether the statues of the Madonna and saints were finished by Michelangelo.

ity the bodies of Lorenzo the Magnificent and his brother Giuliano. On opposite walls are niches with idealized seated figures of relatives of Lorenzo the Magnificent, the dukes Lorenzo and Giuliano de' Medici in Roman armor. Beneath each are two symbolic figures resting on a **sarcophagus,** *Night* and *Day* and *Dawn* and *Dusk*.

This great complex, unfinished like many of Michelangelo's projects, is a brooding meditation on the shortness of life, the inevitability of death, and the Christian hope for resurrection. Both the stark decoration of the chapel and the positioning of the statues (Duke Lorenzo seems always turned to the dark with his head in shadow, whereas Duke Giuliano seems more readily to accept the light) form a mute testament to the rather pessimistic and brooding nature of their creator. When Michelangelo had finished the figure of *Night* [**Fig. 13.12**], a Florentine poet named Strozzi wrote a poem in honor of the statue, with a pun on the name Michelangelo:

> The Night you see sleeping in sweet repose
> Was carved in stone by an angel.
> Because she sleeps, she has life.
> If you do not believe this, touch her and
> She will speak.

Michelangelo, an accomplished poet in his own right, answered Strozzi's lines with a pessimistic rejoinder:

> Sleep is precious; more precious to be stone
> When evil and shame are abroad;

> It is a blessing not to see, not to hear.
> Pray, do not disturb me. Speak softly!

The New Saint Peter's

In 1506, Pope Julius II, in a gesture typical of his imperious nature, commissioned the architect Donato Bramante (1444–1514) to rebuild Saint Peter's Basilica in the Vatican. Old Saint Peter's had stood on Vatican Hill since it was first constructed more than a thousand years earlier, during the time of Roman Emperor Constantine. By the early sixteenth century it had suffered repeatedly from roof fires, structural stresses, and the simple ravages of time. In the minds of the Renaissance "moderns" it was a shaky anachronism.

Bramante's design envisioned a central domed church with a floor plan in the shape of a Greek cross with four equal arms [**Fig. 13.13**]. The dome would have been set on a columned arcade with an exterior colonnaded arcade, called a *peristyle,* on the outer perimeter of the building. Any of the four main doors was to be directly across from a *portal* ("door") on the opposite side. This central plan was not executed in Bramante's lifetime, but a small chapel he built in 1502 next to the Church of San Pietro in Montorio, Rome, may give us a clue to what Bramante had in mind. This *tempietto* ("little temple") is believed to have been done in a style similar to what Bramante wanted later for Saint Peter's.

After Bramante's death, other architects—including Raphael and Sangallo—worked on the massive project.

■ **13.12** Michelangelo. *Night*. Detail of the tomb of Giuliano de' Medici, 1519–1534. Marble. Length 6′4½″ (1.94 m). Church of San Lorenzo, Florence. The owl and the mask under the recumbent figure are emblems of night and dreams.

Both of these architects added a nave and aisles. In 1546, Michelangelo was appointed architect, because the plans previously drawn up seemed unworkable. Michelangelo returned to Bramante's plan for a central domed Greek cross church but envisioned a ribbed, arched dome somewhat after the manner of the cathedral in Florence but on a far larger scale.

The present Saint Peter's seen from the front gives us no clear sense of what Michelangelo had in mind when he drew up his plans. Michelangelo's church had a long nave and a façade added by Carlo Maderna in the early seventeenth century. The colonnaded piazza was completed under the direction of Gian Lorenzo Bernini in 1663, almost a century after Michelangelo's death. Michelangelo lived to see the completion of the **drum** that was to support his dome, which was raised some thirty years after his death by Giacomo della Porta. The best way to understand what Michelangelo intended is to view Saint Peter's from behind, from the Vatican Gardens, where one can see the great dome looming up over the arms of the Greek cross design [**FIG. 13.14**].

■ **13.13** Floor plans for the new Saint Peter's Basilica, Rome. Maderna's final additions, especially the elongated nave, narthex, and large façade, obscured Michelangelo's original design. (1) Area of papal altar under dome. (2) Transept. (3) Portal. (4) Chapel (not all are identified). (5) Apse. (6) Choir. (7) Nave. (8) Narthex. (a) Bernini's *piazza,* done in 1656.

■ **13.14** Michelangelo. Saint Peter's Basilica. View from the southwest, 1546–1564. Completed 1590 by Giacomo della Porta. The Vatican Gardens are behind the basilica, visible at the lower center of this aerial photograph. The walls mark the confines of Vatican City.

THE HIGH RENAISSANCE IN VENICE

The brilliant and dramatic outbreak of artistic activity in sixteenth-century Rome and Florence does not diminish the equally creative art being done in the Republic of Venice to the north. While Rome excelled in fresco, sculpture, and architecture, Venice was famous for its tradition of easel painting. Venice's impressive cosmopolitanism derived from its position as a maritime port and its trading tradition.

Because of the damp atmosphere of their watery city, Venetian painters quickly adopted oil painting, which had first been popularized in the north. Oil painting gave the artist unparalleled opportunities to enrich and deepen color by the application of many layers of paint. Oil painting in general, and Venetian painting in particular, placed great emphasis on the brilliance of its color and the subtlety of its light. The sunny environment of Venice, with light reflecting off the ever-present waterways, further inspired the Venetian feel for color and light. Although the generalization is subject to refinement, there is truth in the observation that Venetian painters emphasized color, whereas painters in the south were preoccupied with line. Venetian painters, like their counterparts in Northern

Europe, had an eye for close detail and a love for landscape (an ironic interest, since Venice had so little land).

Giorgione

The most celebrated and enigmatic painter in early sixteenth-century Venice was Giorgio di Castelfranco (c. 1477–1510), more commonly known as Giorgione. His large altarpiece, *Enthroned Madonna with Saints Liberalis and Francis of Assisi* [**FIG. 13.15**], painted for the cathedral of his hometown of Castelfranco, illustrates many of the characteristics of the Venetian Renaissance style. It is a highly geometric work (using the now-conventional form of the triangle with the Madonna at the apex) typical of Renaissance aesthetics of form. At the same time it shows some idiosyncratic characteristics—the luminous quality of the armor of Saint Liberalis and the minutely rendered landscape. This landscape, with its two soldiers in the bend of the road and the receding horizon, echoes painters from the north like Jan van Eyck.

Far more typical of Giorgione's work are his paintings without religious content or recognizable story line or narrative quality. Typical of these is *Le Concert Champêtre* [**FIG. 13.16**], done in the final year of the

■ **13.15** Giorgione. *Enthroned Madonna with Saints Liberalis and Francis of Assisi*, c. 1500–1505. Oil on panel, 6′6¾″ × 5′ (1.99 × 1.52 m). Cathedral, Castelfranco. Saint Francis shows the *stigmata* of Christ that he bore on his body.

VALUES

Patronage

We have noted in several places in these chapters about art *patronage* in the Renaissance period. The question is: To what end did people and/or organizations give lavish funds to sustain the various arts? The answer to that question helps us understand the social value of art.

In the earlier Renaissance, many wealthy laypersons patronized the arts to "pay back" monies earned from interest-taking, which was considered a sinful practice. A more common motive was a combination of a desire to memorialize the family name (a common custom even today), to promote civic pride, and to solidify one's standing in the community. Wealthy cities like Venice underwrote lavish art projects as a projection of civic pride and as a demonstration of power and wealth. The enormous papal expenditures in the fifteenth and sixteenth centuries reversed an earlier trend.

In the past, laypersons endowed the churches with their monies. The Renaissance popes, by contrast, used church monies to reflect the power of the papacy; to enhance the Roman claim to be the center of the church; to promote a visible form of piety; and, incidentally, to glorify the reign of the pope and his family. Visitors to the Vatican can still see the coats of arms of the families from which the popes came.

The patronage impulses of the past are not all that different from our own (although the church is hardly a central source of artistic patronage today) except that the monies that make art patronage possible come from different sources. This patronage is also the source of much social debate as our contemporaries argue the merits of state and national funding for the arts.

■ **13.16** Giorgione, *Le Concert Champêtre*, c. 1510. Oil on canvas, approx. 3′7¼″ × 4′6⅛″ (1.05 × 1.38 m). Musée du Louvre, Paris. Giorgione's robust nude figures would be much imitated by later baroque painters like Peter Paul Rubens. Giorgione died before he could finish the painting. It was completed by Titian.

painter's life. The two voluptuous nudes frame two young men who are shadowed but also glowing in their richly rendered costumes. The sky behind threatens a storm, but Giorgione counterposes the storm to a serene pastoral scene that includes a distant farmhouse and shepherds with their flock. What does the painting hope to convey? Why does one woman pour water into the well? Is the lute in the hand of one man or the recorder in the hand of the other woman a clue? We do not know. It may be an elaborate allegory on music or poetry. What is clear is that the painting is a frankly secular homage to the profane joy of life rendered with the richness and lushness of concept and color.

Titian

If Giorgione's life was short, that of his onetime apprentice Tiziano Vecelli (c. 1488–1576), known as Titian, was long. Titian brought the Venetian love for striking color to its most beautiful fulfillment. His work had an impact not only on his contemporaries but also on later baroque painters in other countries, such as Peter Paul Rubens in Antwerp and Diego Velázquez in Spain.

Titian's artistic output during seventy years of activity was huge. His reputation was such that he was lionized by popes and princes. He was a particular favorite of Holy Roman Emperor Charles V, who granted him noble rank after having summoned him on several occasions to work at the royal court. From this tremendous body of work two representative paintings, emblematic of the wide range of his abilities, provide a focus.

The huge panel painting in the Venetian Church of the Frari called *Assumption of the Virgin* [**Fig. 13.17**] shows Titian at his monumental best. The swirling color in subtly different shadings and the dramatic gestures of the principals, all of which converge on the person of the Madonna, give a feeling of vibrant upward movement; color and composition define the subject of the assumption of Mary into heaven. The energy in the panel, however, should not distract the viewer from its meticulous spatial relationships. The use of a triangular composition, the subtle shift from dark to light, the lines converging on the Madonna from both above and below are all part of carefully wrought ideas that give the work its final coherence.

Contrast this *Assumption* with Titian's work of twenty years later, the *Venus of Urbino* [**Fig. 13.18**]. The religious intensity of the *Assumption* gives way to the sensual delight of the *Venus* done in homage to feminine beauty from a purely human perspective. The architectural background, evenly divided between light and dark coloration, replaces Giorgione's natural landscapes. The lushness of the nude figure is enhanced by the richness of the brocade, the small bouquet of flowers, the little pet dog, and the circumspect maids at their tasks around a rich clothes chest in the background. The *Venus of Urbino* reflects a frank love of the human body, which is presented in a lavish artistic vocabulary.

■ **13.17** Titian. *Assumption of the Virgin*, 1516–1518. Oil on canvas, 22′6″ × 11′8″ (6.86 × 3.56 m). Church of the Frari, Venice. Note the three distinct levels in the composition of the painting.

It is obvious that Titian painted this work for an aristocratic and wealthy patron.

Tintoretto

The last of the Venetian giants was Jacopo Robusti (1518–1594), known more familiarly as Tintoretto ("little Dyer"—named for his father's occupation). After a short apprenticeship with Titian, Tintoretto worked in his own studio in Venice, a city from which he rarely strayed. It was said that over his studio door he wrote the words "The drawing of Michelangelo and the color of Titian." His most famous work was a huge cycle of frescoes done for the *Scuola* ("Confraternity") of San Rocco in Venice. He began work on the frescoes in 1564 and in 1577 was named the Scuola's official painter. The oil painting depicting *The Last Supper*

■ **13.18** Titian. *Venus of Urbino,* 1538. Oil on canvas. Approx. 3′11″ × 5′5″ (1.19 × 1.62 m). Uffizi, Florence.

[**FIG. 13.19**], done for the Church of San Giorgio Maggiore in the final years of his life, is a good example of Tintoretto's energetic and dramatic style as well as providing an opportunity for contrasting Tintoretto's work to that of Leonardo. After 1577, Tintoretto was called to decorate the ducal palace in Venice as part of a restoration project following a terrible fire. Besides allegorical work celebrating the grandeur of the city, Tintoretto and his son Domenico worked on the frescoes of the great hall of the palace contributing a huge oil painting of paradise, which is more famous for its size (it covered an eighty-foot wall) than for its beauty.

■ **13.19** Tintoretto. *The Last Supper,* 1592–1594. Oil on canvas, 12′ × 18′8″ (3.66 × 5.69 m). Chancel, San Giorgio Maggiore, Venice. Note the dramatic use of light.

MANNERISM

There is general agreement that at the end of the second decade of the sixteenth century, High Renaissance art in Italy—under severe intellectual, psychological, and cultural pressure—gave way to an art style that seemed to be an exaggeration of Renaissance form and a loosening of Renaissance intellectuality. It is not so much that a new school of artists arose but that a mood touched some artists at some point in their careers and captivated others totally. An earlier generation of art historians saw this tendency, called *Mannerism,* as a sign of decadence and decay. Scholarly opinion is less harsh today, viewing Mannerism as a distinct aesthetic to be judged on its own terms.

Mannerism is difficult to define, and the term is often used without any precise sense. The schema proposed by art historian Frederick Hartt might serve in place of a strict definition:

High Renaissance

Content:	Normal, supernormal, or ideal; appeals to universal
Narrative:	Direct, compact, comprehensible
Space:	Controlled, measured, harmonious, ideal
Composition:	Harmonious, integrated, often centralized
Proportions:	Normative, idealized
Figure:	Easily posed, with possibility of motion to new position
Color:	Balanced, controlled, harmonious
Substance:	Natural

Mannerism

Content:	Abnormal or anormal; exploits strangeness of subject uncontrolled emotion, or withdrawal
Narrative:	Elaborate, involved, abstruse
Space:	Disjointed, spasmodic, often limited to foreground plane
Composition:	Conflicting, acentral, seeks frame
Proportions:	Uncanonical, usually attenuated
Figure:	Tensely posed; confined or overextended
Color:	Contrasting, surprising
Substance:	Artificial

Using Hartt's schema we can detect Mannerist tendencies in some of Michelangelo's later work. The figures of *Night, Day, Dawn,* and *Dusk* seem to reflect the exaggerations of the Mannerist style Hartt describes. The entrance to the Laurentian Library [**Fig. 13.20**] in Florence, begun by Michelangelo in 1524 to rehouse the Medici book collection, shows some of these characteristics. Its windows are not windows, its columns support nothing, its staircases with their rounded steps seem agitated and in motion, its dominant lines break up space in odd and seemingly unresolved ways.

Mannerist characteristics show up in only some of Michelangelo's works (*The Last Judgment* fresco in the Sistine Chapel might also be analyzed in this fashion), but some of his contemporaries clearly broke with the

▪ **13.20** Michelangelo. Vestibule stairway of the Laurentian Library, San Lorenzo, Florence, begun 1524. Stairway completed 1559. This library today contains many of the books and manuscripts collected by the Medici family.

intellectual unity of the High Renaissance. Two in particular deserve some attention because they so clearly illustrate the Mannerist imagination.

Jacopo Carucci da Pontormo (1494–1557) was an eccentric and reclusive painter who had studied with Leonardo da Vinci in his youth. Pontormo's greatest painting is the *Deposition* [**FIG. 13.21**], painted around 1528 for the Church of Santa Felicità in Florence. The most striking feature of this work is its shocking colors: pinks, apple-greens, washed-out blues. It is hard to think of any other Renaissance painting to which this stunningly original and exotic work can be compared.

An even more dramatic example of the Mannerist aesthetic is by Francesco Mazzola (1503–1540), called Parmigianino. He painted the *Madonna of the Long Neck* [**FIG. 13.22**] for a church in Bologna. The gigantic proportions in the picture space are made all the more exaggerated by forcing the eye to move from the tiny prophetic figure in the background to the single column and then to the overwhelmingly large Madonna. The infant almost looks dead; in fact, his hanging left arm is reminiscent of the dead Christ in Michelangelo's *Pietà*. The Virgin's figure is rendered in a strangely elongated, almost serpentine, fashion. There is something oddly erotic and exotic about her because of the shape of her body, the long fingers, and the great curving *S* of her neck. The implied eroticism is reinforced by the partially clad figures clustered at her side.

How and under what circumstances Mannerism grew and matured is the subject of much debate. Some elements of that debate must include the intellectual and social upheavals of the time (everything from wars to the Protestant Reformation) and the human desire and need to innovate once the problems and potential of a given art style have been fully worked out. In a sense, Mannerism is a testament to the inventiveness and restlessness of the human spirit.

■ **13.21** Jacopo Carucci da Pontormo. *Deposition,* c. 1528. Oil on wood Approx. 11′ × 6′6″ (3.5 × 1.98 m). Capponi Chapel, Church of Santa Felicità, Florence. The twisted figures seem suspended in an airy space of no definite location. Note the odd palette the painter used to emphasize the horror and strangeness of the facial expression.

■ **13.22** Parmigianino. *Madonna of the Long Neck,* c. 1535. Oil on wood. Approx. 7′1″ × 4′4″ (2.15 × 1.32 m). Uffizi, Florence. Note the odd prophetic figure in the middleground of the lower right-hand corner and the elongated column in the background.

■ **13.23** Lavinia Fontana. *Dead Christ with the Symbols of the Passion,* 1581. Oil and tempera on wood panel. 10⅔″ × 41¼″ (27.0 × 36.2 cm). Rollins College, Lakeland, Florida. Note the size of the dead Christ, who is seemingly out of proportion to the other figures, while it appears to crowd the scene.

Lavinia Fontana

Daughter of an accomplished painter in Bologna, Lavinia Fontana (1552–1614) was accomplished enough that she went to Rome, where she managed to gain patronage even at the level of the papal court. Like her father she adopted the Mannerist style of painting. She had a successful career, mainly as a portrait painter, both in Bologna and later in Rome. Her work shows not only the technical skill gained in her father's studio but also in her own careful study of the works of Raphael, Michelangelo, and Parmigianino. Her prolific career was aided by her husband, Giano Paolo Zappi, who gave up his own career after they married in 1577, to aid and manage her career.

Fontana's painting of the *Dead Christ with the Symbols of the Passion* [**Fig. 13.23**] owes an obvious debt to Michelangelo's *Pietá* in the Cathedral of Florence, but the exaggerated angle of the scourging pillar juxtaposed to the cross as well as the somewhat pallid colors juxtaposed to the fierce red color of one of the robes shows the clear influence of the Mannerist palette.

Sofonisba Anguissola

In 1556, Giorgio Vasari traveled to Cremona to see the "marvels" of six sisters, children of the Anguissola family,

who were "excellent in painting, music, and *belles artes.*" The beneficiary of a humanist education at home, the most famous of these sisters was Sofonisba, who enjoyed a great degree of fame in her own lifetime. Born in 1532(?), she studied art with a minor master in Cremona. As a young woman she traveled with her father to Rome, where she most likely met Michelangelo. Sofonisba also spent time in Milan until, in 1560, she traveled to Spain as a court painter; there she met a Sicilian noble in the service of the Spanish monarch. The couple lived in Sicily, but after her husband's death she returned to Cremona. After a remarriage, she moved to Genoa (where she probably met Caravaggio) but finally went back to Palermo, Sicily, where she died in 1624 after the famous Antony Van Dyck had painted her portrait.

Sofonisba produced an enormous amount of work, which is now represented in museums around the world. Her mature work indicates how much she learned not only from the Renaissance masters but also from the *chiaroscuro* techniques of painters like Caravaggio (discussed in Chapter 15). A late self-portrait [**Fig. 13.24**] amply demonstrates her capacity for both pictorial representation and the sharp contrasts of darkness and light, which would become so important in the Baroque period.

■ **13.24** Sofonisba Anguissola. *Self-Portrait,* c. 1610. Oil on canvas, 37″ × 29½″ (94 × 75 cm). Gottfried Keller Collection, Bern, Switzerland. In her left hand a note reads: "To His Catholic Majesty; I kiss his hand. Anguissola." The portrait was an answer to a request made by Philip II of Spain.

MUSIC IN THE SIXTEENTH CENTURY

Music at the Papal Court

The emphasis in this chapter on painting, sculpture, and architecture makes it easy to forget that many of these artistic creations were intended for the service of Roman Catholic worship. It should be no surprise that fine music was subsidized and nurtured in Rome at the papal court. In fact, the active patronage of the popes for both the creation and the performance of music dates back to the earliest centuries of the papacy. Gregorian chant, after all, is considered a product of the interest of Pope Gregory and the school of Roman chant. In 1473, Pope Sixtus IV established a permanent choir for his private chapel, which came to be the most important center of Roman music. Sixtus's nephew Julius II endowed the choir for Saint Peter's, the Julian Choir.

The Sistine Choir used only male voices. Preadolescent boys sang the soprano parts, while older men—chosen by competition—sang the alto, tenor, and bass parts. The number of voices varied then from sixteen to twenty-four (the choir eventually became, and still is, much larger). The Sistine Choir sang *a cappella* (without accompaniment), although we know that the popes enjoyed instrumental music outside the confines of the church. Cellini, for example, mentions that he played instrumental motets for Pope Clement VII.

While Botticelli and Perugino were decorating the walls of the Sistine Chapel, the greatest composer of the age, Josquin des Prez (c. 1440–1521), was in the service of the Sistine Choir, composing and directing music for its members from 1486 to 1494. From his music we can get some sense of the quality and style of the music of the time.

Josquin, who was Flemish, spent only those eight years in Rome, but his influence was widely felt in musical circles. He has been called the bridge figure between the music of the Middle Ages and the Renaissance. Although he wrote madrigals and many masses in his career, it was in the motet for four voices—a form not held to traditional usage in the way masses were—that he showed his true genius for creative musical composition. Josquin has been most praised for homogeneous musical structure, a sense of balance and order, a feel for the quality of the lyrics. These are all characteristics common to the aspirations of the sixteenth-century Italian humanists. In that sense, Josquin combined the considerable musical tradition of Northern Europe with the new intellectual currents of the Italian south.

The Renaissance motet uses a sacred text sung by four voices in polyphony. Josquin divided his texts into clear divisions but disguised them by using overlapping voices so that one does not sense any break in his music. He also took considerable pains to marry his music to the obvious grammatical sense of the words while still expressing their emotional import by the use of the musical phrase. A portion of the motet *Tu Pauperum Refugium* (*Thou Refuge of the Poor*) illustrates both points clearly. The text shows the principle of overlapping (look at the intervals at which the voices enter with, for example, the end of the phrase *obdormiat in morte*). Likewise, the descending voices underscore the sense of the words *ne unquam obdormiat in morte anima mea* ("lest my soul sleep in death") in a way that to one musicologist suggests death itself is entering.

The sixteenth-century composer most identified with Rome and the Vatican is Giovanni Pierluigi da Palestrina (1525–1594). He came from the Roman hill town of Palestrina as a youth and spent the rest of his life in the capital city. At various times in his career, he was the choirmaster of the choir of Saint Peter's (the *cappella Giulia*), a singer in the Sistine Choir, and choirmaster of two other Roman basilicas (Saint John Lateran and Saint Mary Major). Finally, from 1571 until his death, he directed all music for the Vatican.

Palestrina flourished during the rather reactionary period in which the Catholic Church tried to reform itself in response to the Protestant Reformation by returning to the simpler ways of the past. It should not surprise us, then, that the more than one hundred masses he wrote were conservative. His polyphony, while a model of order, proportion, and clarity, is nonetheless closely tied to the musical tradition of the ecclesiastical past. Rarely does Palestrina move from the Gregorian roots of church music. For example, amid the polyphony of his *Missa Papae Marcelli* (*Mass in Honor of Pope Marcellus*) one can detect the traditional melodies of the Gregorian *Kyrie, Agnus Dei,* and so on. Despite that conservatism, he was an extremely influential composer whose work is still regularly heard in the Roman basilicas. His music was consciously imitated by the Spanish composer Victoria (or Vittoria, c. 1548–1611), whose motet *O Vos Omnes* is almost traditional at Holy Week Services in Rome, and by William Byrd (c. 1543–1623), who brought Palestrina's style to England.

 To hear a selection from the *Mass in Honor of Pope Marcellus (Missa Papae Marcelli),* play track 4 on the Listening CD.

Venetian Music

The essentially conservative character of Palestrina's music can be contrasted to the far more adventuresome situation in Venice, a city less touched by the ecclesiastical powers of Rome. In 1527, a Dutchman—Adrian Willaert—became choirmaster of the Church of Saint Mark. He in turn trained Andrea Gabrieli and his more famous nephew, Giovanni Gabrieli, who became the most renowned Venetian composer of the sixteenth century.

The Venetians pioneered the use of multiple choirs for their church services. Saint Mark's regularly used two choirs, called split choirs, which permitted greater variation of musical composition in that the choirs could sing to and against each other in increasingly complex patterns. The Venetians were also more inclined to add instrumental music to their liturgical repertoire. They pioneered the use of the organ for liturgical music. The independent possibilities of the organ gave rise to innovative compositions that highlighted the organ. These innovations in time became standard organ pieces: the prelude, the music played before the services began (called in Italy the *intonazione*), and the virtuoso prelude called the *toccata* (from the Italian *toccare,* "to touch"). The *toccata* was designed to feature the range of the instrument and the dexterity of the performer.

Both Roman and Venetian music were deeply influenced by the musical tradition of the North. Josquin des Prez and Adrian Willaert were, after all, both from the Low Countries. In Italy their music came in contact with the intellectual tradition of Italian humanism. Without pushing the analogy too far, it could be said that Rome gave the musician the same Renaissance sensibility that it gave the painter: a sense of proportion, classicism, and balance. The Venetian composers, much like Venetian painters of the time, were interested in color and emotion.

Contrasting Renaissance Voices

Early-sixteenth-century Renaissance culture was a study in contrasts. The period not only marked a time when some of the most refined artistic accomplishments were achieved, but it was also a period of great social upheaval. The lives of both Raphael and Leonardo ended at precisely the time Luther was struggling with the papacy. In 1527, Rome was sacked by Emperor Charles V's soldiers in an orgy of rape and violence the city had not seen since the days of the Vandals in the fifth century. It would be simplistic to reduce the period of the High Renaissance to a contrast between cool intellectual sophistication and intensely violent passion; nevertheless, it is true that two of the most interesting writers of the period in Italy do reflect rather precisely these opposing tendencies.

Castiglione

Baldassare Castiglione (1478–1529) served in the diplomatic corps of Milan, Mantua, and Urbino. He was a versatile man—a person of profound learning, equipped with physical and martial skills, and possessed of a noble and refined demeanor. Raphael's famous portrait of Castiglione [**Fig. 13.25**] faithfully reflects both Castiglione's aristocratic and intellectual qualities.

While serving at the court of Urbino from 1504 to 1516, Castiglione decided to write *The Courtier,* a task that occupied him for the next dozen years. It was finally published by the Aldine Press in Venice in 1528, a year before the author's death. In *The Courtier,* cast in the form of an extended dialogue and borrowing heavily from the style and thought of ancient writers from Plato to Cicero, Castiglione has his learned friends discuss a range of topics: the ideals of chivalry, classical virtues, the character of the true courtier, the ideals of

■ **13.25** Raphael. *Baldassare Castiglione*, c. 1514. Oil on panel, transferred to canvas, 29½″ × 25½″ (75 × 65 cm). Museé du Louvre, Paris. Raphael would have known the famous humanist through family connections in his native Urbino.

Oh, what a noble mind is here o'erthrown!
The courtier's, soldier's, scholar's eye, tongue, sword:
The expectancy and rose of the fair state,
The glass of fashion and the mould of form,
The observed of all observers . . .

The most common criticism of Castiglione's courtier is that he reflects a world that is overly refined, too aesthetically sensitive, and excessively preoccupied with the niceties of decorum and decoration. The courtier's world, in short, is the world of the wealthy, the aristocratic, and the most select of the elite. If the reader shares that criticism when reading Castiglione, the *Autobiography of Benvenuto Cellini* should prove a bracing antidote to the niceties of Castiglione.

Cellini

Benvenuto Cellini (1500–1571) was a talented Florentine goldsmith and sculptor whose life, frankly chronicled, was a seemingly never-ending panorama of violence, intrigue, quarrel, sexual excess, egotism, and political machination. His *Autobiography,* much of it dictated to a young apprentice who wrote while Cellini worked, is a vast and rambling narrative of Cellini's life from his birth to the year 1562. We read vignettes about popes and commoners, artists and soldiers, cardinals and prostitutes, assassins and artists, as well as a gallery of other characters from the Renaissance *demimonde* of Medicean Florence and papal Rome.

Above all, we meet Benvenuto Cellini, who makes no bones about his talent, his love of life, or his taste for violence. Cellini is not one of Castiglione's courtiers. Cellini fathered eight legitimate and illegitimate children; he was banished from Florence for sodomy; imprisoned for assault; fled Rome after murdering a man; and fought on the walls of the Castel Sant' Angelo in Rome during the siege of 1527 in defense of the Medici Pope Clement VII. Anyone who thinks of the Renaissance artist solely in terms of proportion, love of the Classics, Neo-Platonic philosophy, and genteel humanism is in for a shock when encountering Cellini's *Autobiography.*

One particular part of Cellini's book is interesting not for its characteristic bravado or swagger, but for its insight into the working methods of an artist. In a somewhat melodramatic account, Cellini describes the process of casting the bronze statue of Perseus that actually turned out to be his most famous work [**FIG. 13.26**]. It now stands in the Loggia dei Lanzi next to the Palazzo Vecchio in Florence.

Cellini does not belong to the first rank of sculptors, although no one has denied his skill as a craftsman. The *Perseus,* finished in 1554 for Duke Cosimo I de' Medici, is a highly refined work made more interesting because of Cellini's record of its genesis.

Platonic love. Posterity remembers Castiglione's insistent plea that the true **courtier** should be a person of humanist learning, impeccable ethics, refined courtesy, physical and martial skills, and fascinating conversation. He should not possess any of these qualities to the detriment of any other.

The *uomo universale* ("well-rounded person") should do all things with what Castiglione calls *sprezzatura.* *Sprezzatura,* which is almost impossible to translate into a single English word, means something like "effortless mastery." The courtier, unlike the pedant, wears learning lightly, while his mastery of sword and horse has none of the fierce clumsiness of the common soldier in the ranks. The courtier does everything equally well but with an air of unhurried and graceful effortlessness.

Castiglione's work was translated into English by Sir Thomas Hoby in 1561. It exercised an immense influence on what the English upper classes thought the educated gentleman should be. We can detect echoes of Castiglione in some of the plays of Ben Jonson as well as in the drama of William Shakespeare. When in *Hamlet* (III, I), for example, Ophelia cries out in horror at the lunatic behavior of Hamlet (at his loss of *sprezzatura?*), the influence of Castiglione is clear:

■ **13.26** Benvenuto Cellini. *Perseus,* 1545–1554. Bronze. Height 18′ (5.48 m). Loggia dei Lanzi, Florence. Earlier models of this statue, including a first effort in wax, are preserved in the Bargello Museum in Florence.

Although it would be overly simplistic to believe that the Renaissance caused the Reformation, it must certainly be seen as a contributing factor—as we will see in the next chapter. Even so, there is a marked shift in the atmosphere in which Michelangelo worked in Rome before 1521 and afterward, when the full force of the Protestant revolt in the North was making itself felt in Rome.

The artistic work in Rome can be contrasted profitably with that which took place in Venice during roughly the same period. The Roman Renaissance was under the patronage of the church. Venetian art and music enjoyed the same patronage source as did Florence in the preceding century: commerce and trade. Venice made its fortune from the sea: The shipping of its busy port looked to both Europe and the Middle East. It was fiercely protective of its independence (including its independence from papal Rome) and proud of its ancient traditions. Even the religious art of Venice possessed a certain freedom from the kind of art being produced in Rome in the same century because Venice had less contact with the seething ideas current in the century.

Renaissance ideas had also penetrated other areas of Italy. Florence still had its artistic life (although somewhat diminished from its great days in the fifteenth century), but provincial cities like Parma and Mantua were not without their notables. Much of this artistic activity rested in the courts of the nobility, who supplied the kind of life and leisure that made possible the courtier and the court lifestyle immortalized in the book by Castiglione. The insufficiencies of this court culture would become clear when the religious wars of the sixteenth century broke out and humanism had to confront the new realities coming from the increasingly Protestant North.

SUMMARY

Art follows patronage, as we have noted. The "high" Renaissance is summed up in the lives and works of three artists: Michelangelo, Raphael, and Leonardo da Vinci. The first two did their most famous work in the Vatican in the sixteenth century, whereas Leonardo, true to his restless spirit, sojourned there only for a time before he began his wanderings through the courts of Europe. These artists' work gives full meaning to the summation of Renaissance ideals.

When we look at the work of Raphael and Michelangelo under the patronage of the popes, we should not forget that this explosion of art and culture was taking place while a new and formidable revolution was in the making: the Protestant Reformation.

KEY TERMS

Chapel A small worship space either free standing or part of a larger church

Courtier A person who is attached to a royal court and who is trained to act appropriately

Neo-Platonism Philosophical movement ultimately derived from the work of Plato and his followers, which emphasizes the drive toward the ideal as the goal of transcending mere material reality

Patron A person or institution who supplies the financial and moral backing for artistic or literary projects

Pyramidal arrangement The manner of articulating artworks, common in the Renaissance, in which minor figures form the base and the central figure the apex of the artwork

Sarcophagus A burial container for a human body typically made from some form of stone and often ornamented both on the lid and the side panels. From the Greek words for flesh (*sarx*) and to consume (*phagein*)

Uncanonical Any form or idea that violates the agreed-on rule (canon) of the authentic or the generally accepted

5. Mannerism as an art style contains an element of exaggeration. Can you think of any art form with which we are familiar that uses exaggeration to make its point?

6. Art patronage in the sixteenth century came mainly from the church and from the wealthy. Are they equally sources of patronage today? If not, what has replaced the church as a source of art patronage today? What does that say about our culture? If so, cite examples.

PRONUNCIATION GUIDE

Bramante:	Bra-MAHN-tay
Buonarroti:	Bwon-ah-ROH-tee
Castiglione:	KAS-til-YOH-nay
Cellini:	Che-LEE-nee
Le Concert Champêtre:	Leh Kon-CER Sham-PET-reh
Giorgione:	Jor-JOAN-eh
Laurentian:	Law-WREN-shen
Palestrina:	Pal-es-TRIN-ah
Parmigianino:	PAR-me-jan-EE-no
Pontormo:	Pon-TOR-mo
sprezzatura:	spreh-tza-TOUR-ah
Strozzi:	STROH-tzee
tempietto:	tem-PYET-toe
Titian:	TEA-shan

YOUR RESOURCES

- ▶ **ExploringHumanities CD-ROM**
 - Interactive Maps: Renaissance Florence, Rome with Renaissance and the Baroque Monuments
 - Interactive Module: Explore a Renaissance Painting
 - Reading Selections: *The Courtier*
- ▶ **Website http://art.wadsworth.com/cunningham**
 - Chapter 13 Quiz
 - Links
- ▶ **Audio CD**
 - Palestrina: *Missa Papae Marcelli, Credo*

EXERCISES

1. If you were to transpose Raphael's *School of Athens* into a contemporary setting, what kind of architecture would you use to frame the scene and whom would you include among the personages in the picture?

2. Critics use the adjective *Michelangeloesque*. Now that you have studied his work, what does that adjective mean to you? Give an all-inclusive definition of the term.

3. Michelangelo's Medici Chapel represents the artist's best attempt to express a permanent tribute to the dead. How does it differ in spirit from such monuments today? (You might begin by comparing it to the Vietnam Memorial in Washington, D.C., or some other such public monument.)

4. Castiglione's concept of *sprezzatura* was an attempt to summarize the ideal of the educated courtier. Is there a word or phrase that would best sum up the character of the well-rounded person today? Do we have a similar ideal? If so, how would you characterize it? If not, why not?

FURTHER READING

Grafton, A. (Ed.). *Rome Reborn: The Vatican Library and Renaissance Culture*. New Haven, CT: Yale University Press, 1994. Excellent interdisciplinary study.

Kelly, J. N. D. (Ed.). *The Oxford Dictionary of Popes*. New York: Oxford University Press, 1986. A handy reference work.

King, Ross. *Michelangelo & the Pope's Ceiling*. New York: Walker Publishing, 2003. An interesting study of two strong and determined personalities.

Logan, O. *Culture and Society in Venice*. New York: Scribner's, 1972. Engaging and readable.

Partner, P. *Renaissance Rome: 1550–1559*. Berkeley: University of California Press, 1976. Cultural history at its best.

Perlingieri, I. *Sofonisba Anguissola: The First Great Woman Artist of the Renaissance*. New York: Rizzoli, 1992. Excellent text and illustrations.

Stinger, C. *The Renaissance in Rome*. Bloomington: University of Indiana Press, 1985. A readable volume.

Turner, A. R. *Inventing Leonardo*. New York: Knopf, 1993. Valuable on the artist and his times.

READING SELECTIONS

BALDASSARE CASTIGLIONE
from THE COURTIER

This chapter deals with the position of women in the courtly life of Renaissance Italy. Remember that this was an aristocratic setting in which the discussion of women reflects none of the popular prejudice or social conservatism of ordinary sixteenth-century life. One strikingly modern note sounds in this selection when the Magnifico argues that women imitate men not because of masculine superiority but because they desire to "gain their freedom and shake off the tyranny that men have imposed on them by their one-sided authority."

On Women

"Leaving aside, therefore, those virtues of the mind which she must have in common with the courtier, such as prudence, magnanimity, continence and many others besides, and also the qualities that are common to all kinds of women, such as goodness and discretion, the ability to take good care, if she is married, of her husband's belongings and house and children, and the virtues belonging to a good mother, I say that the lady who is at Court should properly have, before all else, a certain pleasing affability whereby she will know how to entertain graciously every kind of man with charming and honest conversation, suited to the time and the place and the rank of the person with whom she is talking. And her serene and modest behavior, and the candor that ought to inform all her actions, should be accompanied by a quick and vivacious spirit by which she shows her freedom from boorishness; but with such a virtuous manner that she makes herself thought no less chaste, prudent and benign than she is pleasing, witty and discreet. Thus she must observe a certain difficult mean, composed as it were of contrasting qualities, and take care not to stray beyond certain fixed limits. Nor in her desire to be thought chaste and virtuous, should she appear withdrawn or run off if she dislikes the company she finds herself in or thinks the conversation improper. For it might easily be thought that she was pretending to be straitlaced simply to hide something she feared others could find out about her; and in any case, unsociable manners are always deplorable. Nor again, in order to prove herself free and easy, should she talk immodestly or practice a certain unrestrained and excessive familiarity or the kind of behavior that leads people to suppose of her what is perhaps untrue. If she happens to find herself present at such talk, she should listen to it with a slight blush of shame. Moreover, she should avoid an error into which I have seen many women fall, namely, eagerly talking and listening to someone speaking evil of others. For those women who when they hear of the immodest behavior of other women grow hot and bothered and pretend it is unbelievable and that to them an unchaste woman is simply a monster, in showing that they think this is such an enormous crime, suggest that they might be committing it themselves. And those who go about continually prying into the love affairs of other women, relating them in such detail and with such pleasure, appear to be envious and anxious that everyone should know how the matter stands lest by mistake the same thing should be imputed to them; and so they laugh in a certain way, with various mannerisms which betray the pleasure they feel. As a result, although men seem ready enough to listen, they nearly always form a bad opinion of them and hold them in very little respect, and they imagine that the mannerisms they affect are meant to lead them on; and then often they do go so far that the women concerned deservedly fall into ill repute, and finally they come to esteem them so little that they do not care to be with them and in fact regard them with distaste. On the other hand, there is no man so profligate and brash that he does not respect those women who are considered to be chaste and virtuous; for in a woman a serious disposition enhanced by virtue and discernment acts as a shield against insolence and beastliness of arrogant men; and thus we see that a word, a laugh or an act of kindness, however small, coming from an honest woman is more universally appreciated than all the blandishments and caresses of those who without reserve display their lack of shame, and who, if they are not unchaste, with their wanton laughter, loquacity, brashness and scurrilous behavior of this sort, certainly appear to be.

"And then, since words are idle and childish unless they are concerned with some subject of importance, the lady at Court as well as being able to recognize the rank of the person with whom she is talking should possess a knowledge of many subjects; and when she is speaking she should know how to choose topics suitable for the kind of person she is addressing, and she should be careful about sometimes saying something unwittingly that may give offense. She ought to be on her guard lest she arouse distaste by praising herself indiscreetly or being too tedious. She should not introduce serious subjects into light-hearted conversation, or jests and jokes into a discussion about serious things. She should not be inept in pretending to know what she does not know, but should seek modestly to win credit for knowing what she does, and, as was said, she should always avoid affectation. In this way she will be adorned with good manners; she will take part in the recreations suitable for a woman with supreme grace; and her conversation will be fluent, and extremely reserved, decent and charming. Thus she will be not only loved but also revered by all and perhaps worthy to stand comparison with our courtier as regards qualities both of mind and body."

Having said this, the Magnifico fell silent and seemed to be sunk in reflection, as if he had finished what he had to say. And then signor Gaspare said:

"You have indeed, signor Magnifico, beautifully adorned his lady and made her of excellent character. Nevertheless, it seems to me that you have been speaking largely in generalities and have mentioned qualities so impressive that I think you were ashamed to spell them out; and, in the way people sometimes hanker after things that are impossible and miraculous, rather than explain them you have simply wished them into existence. So I should like you to explain what kind of recreations are suitable for a lady at Court, and in what way she ought to converse, and what are the many subjects you say it is fitting for her to know about; and also whether you mean that the prudence, magnanimity, purity and so many other qualities you mentioned are to help her merely in managing her home, and her family and children (though this was not to be her chief occupation) or rather in her conversation and in the graceful practice of those various activities. And now for heaven's sake be careful not to set those poor virtues such degraded tasks that they come to feel ashamed!"

The Magnifico laughed and said:

"You still cannot help displaying your ill-will towards women, signor Gaspare. But I was truly convinced that I had said enough, and especially to an audience such as this; for I hardly think there is anyone here who does not know, as far

as recreation is concerned, that it is not becoming for women to handle weapons, ride, play the game of tennis, wrestle or take part in other sports that are suitable for men."

Then the Unico Aretino remarked: "Among the ancients women used to wrestle naked with men; but we have lost that excellent practice, along with many others."

Cesare Gonzaga added: "And in my time I have seen women play tennis, handle weapons, ride, hunt and take part in nearly all the sports that a knight can enjoy."

The Magnifico replied: "Since I may fashion this lady my own way, I do not want her to indulge in these robust and manly exertions, and, moreover, even those that are suited to a woman I should like her to practice very circumspectly and with the gentle delicacy we have said is appropriate to her. For example, when she is dancing I should not wish to see her use movements that are too forceful and energetic, nor, when she is singing or playing a musical instrument, to use those abrupt and frequent diminuendos that are ingenious but not beautiful. And I suggest that she should choose instruments suited to her purpose. Imagine what an ungainly sight it would be to have a woman playing drums, fifes, trumpets or other instruments of that sort; and this is simply because their stridency buries and destroys the sweet gentleness which embellishes everything a woman does. So when she is about to dance or make music of any kind, she should first have to be coaxed a little, and should begin with a certain shyness, suggesting the dignified modesty that brazen women cannot understand. She should always dress herself correctly, and wear clothes that do not make her seem vain and frivolous. But since women are permitted to pay more attention to beauty than men, as indeed they should, and since there are various kinds of beauty, this lady of ours ought to be able to judge what kind of garments enhance her grace and are most appropriate for whatever she intends to undertake, and then make her choice. When she knows that her looks are bright and gay, she should enhance them by letting her movements, words and dress incline towards gaiety; and another woman who feels that her nature is gentle and serious should match it in appearance. Likewise she should modify the way she dresses depending on whether she is a little stouter or thinner than normal, or fair or dark, though in as subtle a way as possible; and keeping herself all the while dainty and pretty, she should avoid giving the impression that she is going to great pains.

"Now since signor Gaspare also asks what are the many things a lady at Court should know about, how she ought to converse, and whether her virtues should be such as to contribute to her conversation, I declare that I want her to understand what these gentlemen have said the courtier himself ought to know; and as for the activities we have said are unbecoming to her, I want her at least to have the understanding that people can have of things they do not practice themselves; and this so that she may know how to value and praise the gentlemen concerned in all fairness, according to their merits. And, to repeat in just a few words something of what has already been said, I want this lady to be knowledgeable about literature and painting, to know how to dance and play games, adding a discreet modesty and the ability to give a good impression of herself to the other principles that have been taught the courtier. And so when she is talking or laughing, playing or jesting, no matter what, she will always be most graceful, and she will converse in a suitable manner with whomever she happens to meet, making use of agreeable witticisms and jokes. And although continence, magnanimity, temperance, fortitude of spirit, prudence and the other virtues may not appear to be relevant in her social encounters with others, I want her to be adorned with these as well, not so much for the sake of good company, though they play a part in this too, as to make her truly virtuous, and so that her virtues, shining through everything she does, may make her worthy of honor."

"I am quite surprised," said signor Gaspare with a laugh, "that since you endow women with letters, continence, magnanimity and temperance, you do not want them to govern cities as well, and to make laws and lead armies, while the men stay at home to cook and spin."

The Magnifico replied, also laughing: "Perhaps that would not be so bad, either."

Then he added: "Do you not know that Plato, who was certainly no great friend of women, put them in charge of the city and gave all the military duties to the men? Don't you think that we might find many women just as capable of governing cities and armies as men? But I have not imposed these duties on them, since I am fashioning a Court lady and not a queen. I'm fully aware that you would like by implication to repeat the slander that signor Ottaviano made against women yesterday, namely, that they are most imperfect creatures, incapable of any virtuous act, worth very little and quite without dignity compared with men. But truly both you and he would be very much in error if you really thought this."

Then signor Gaspare said: "I don't want to repeat things that have been said already; but you are trying hard to make me say something that would hurt the feelings of these ladies, in order to make them my enemies, just as you are seeking to win their favor by deceitful flattery. However, they are so much more sensible than other women that they love the truth, even if it is not all that much to their credit, more than false praises; nor are they aggrieved if anyone maintains that men are of greater dignity, and they will admit that you have made some fantastic claims and attributed to the Court lady ridiculous and impossible qualities and so many virtues that Socrates and Cato and all the philosophers in the world are as nothing in comparison. And to tell the truth I wonder that you haven't been ashamed to go to such exaggerated lengths. For it should have been quite enough for you to make this lady beautiful, discreet, pure and affable, and able to entertain in an innocent manner with dancing, music, games, laughter, witticisms and the other things that are in daily evidence at Court. But to wish to give her an understanding of everything in the world and to attribute to her qualities that have rarely been seen in men, even throughout the centuries, is something one can neither tolerate nor bear listening to. That women are imperfect creatures and therefore of less dignity than men and incapable of practicing the virtues practiced by men, I would certainly not claim now, for the worthiness of these ladies here would be enough to give me the lie; however, I do say that very learned men have written that since Nature always plans and aims at absolute perfection she would, if possible, constantly bring forth men; and when a woman is born this is a mistake or defect, and contrary to Nature's wishes. This is also the case when someone is both blind, or lame, or with some other defect, as again with trees, when so many fruits fail to ripen. Nevertheless, since the blame for the defects of women must be attributed to Nature, who has made them what they are, we ought not to despise them or to fail to give them the respect which is their due. But to esteem them to be more than they are seems to me to be manifestly wrong."

The Magnifico Giuliano waited for signor Gaspare to continue, but seeing that he remained silent he remarked:

"It appears to me that you have advanced a very feeble argument for the imperfection of women. And, although this is not perhaps the right time to go into subtleties, my answer, based both on a reliable authority and on the simple truth, is

that the substance of anything whatsoever cannot receive of itself either more or less; thus just as one stone cannot, as far as its essence is concerned, be more perfectly stone than another stone, nor one piece of wood more perfectly wood than another piece, so one man cannot be more perfectly man than another; and so, as far as their formal substance is concerned, the male cannot be more perfect than the female, since both the one and the other are included under the species man, and they differ in their accidents and not their essence. You may then say that man is more perfect than woman if not as regards essence then at least as regards accidents; and to this I reply that these accidents must be the properties either of the body or of the mind. Now if you mean the body, because man is more robust, more quick and agile, and more able to endure toil, I say that this is an argument of very little validity since among men themselves those who possess these qualities more than others are not more highly regarded on that account; and even in warfare, when for the most part the work to be done demands exertion and strength, the strongest are not the most highly esteemed. If you mean the mind, I say that everything men can understand, women can too; and where a man's intellect can penetrate, so along with it can a woman's."

After pausing for a moment, the Magnifico then added with a laugh:

"Do you not know that this proposition is held in philosophy: namely, that those who are weak in body are able in mind? So there can be no doubt that being weaker in body women are abler in mind and more capable of speculative thought than men."

Then he continued: "But apart from this, since you have said that I should argue from their acts as to the perfection of the one and the other, I say that if you will consider the operations of Nature, you will find that she produces women the way they are not by chance but adapted to the necessary end; for although she makes them gentle in body and placid in spirit, and with many other qualities opposite to those of men, yet the attributes of the one and the other tend towards the same beneficial end. For just as their gentle frailty makes women less courageous, so it makes them more cautious; and thus the mother nourishes her children, whereas the father instructs them and with his strength wins outside the home what his wife, no less commendably, conserves with diligence and care. Therefore if you study ancient and modern history (although men have always been very sparing in their praises of women) you will find that women as well as men have constantly given proof of their worth; and also that there have been some women who have waged wars and won glorious victories, governed kingdoms with the greatest prudence and justice, and done all that men have done. As for learning, cannot you recall reading of many women who knew philosophy, of others who have been consummate poets, others who prosecuted, accused and defended before judges with great eloquence? It would take too long to talk of the work they have done with their hands, nor is there any need for me to provide examples of it. So if in essential substance men are no more perfect than women, neither are they as regards accidents; and apart from theory this is quite clear in practice. And so I cannot see how you define this perfection of theirs.

"Now you said that Nature's intention is always to produce the most perfect things, and therefore she would if possible always produce men, and that women are the result of some mistake or defect rather than of intention. But I can only say that I deny this completely. You cannot possibly argue that Nature does not intend to produce the women without whom the human race cannot be preserved, which is something that Nature desires above everything else. For by means of the union of male and female, she produces children, who then return the benefits received in childhood by supporting their parents when they are old; then they renew them when they themselves have children, from whom they expect to receive in their old age what they bestowed on their own parents when they were young. In this way Nature, as if moving in a circle, fills out eternity and confers immortality on mortals. And since woman is as necessary to this process as man, I do not see how it can be that one is more the fruit of mere chance than the other. It is certainly true that Nature always intends to produce the most perfect things, and therefore always intends to produce the species man, though not male rather than female; and indeed, if Nature always produced males this would be imperfection: for just as there results from body and soul a composite nobler than its parts, namely, man himself, so from the union of male and female there results a composite that preserves the human species, and without which its parts would perish. Thus male and female always go naturally together, and one cannot exist without the other. So by very definition we cannot call anything male unless it has its female counterpart, or anything female if it has no male counterpart. And since one sex alone shows imperfection, the ancient theologians attribute both sexes to God. For this reason, Orpheus said that Jove was both male and female in His own likeness; and very often when the poets speak of the gods they confuse the sex."

Then signor Gaspare said: "I do not wish us to go into such subtleties because these ladies would not understand them; and though I were to refute you with excellent arguments, they would still think that I was wrong, or pretend to at least; and they would at once give a verdict in their own favor. However, since we have made a beginning, I shall say only that, as you know, it is the opinion of very learned men that man is as the form and woman as the matter, and therefore just as the form is more perfect than matter, and indeed it gives it its being, so man is far more perfect than woman. And I recall having once heard that a great philosopher in certain of his *Problems* asks: Why is it that a woman always naturally loves the man to whom she first gave herself in love? And on the contrary, why is it that a man detests the woman who first coupled with him in that way? And in giving his explanation he affirms that this is because in the sexual act the woman is perfected by the man, whereas the man is made imperfect, and that everyone naturally loves what makes him perfect and detests what makes him imperfect. Moreover, another convincing argument for the perfection of man and the imperfection of woman is that without exception every woman wants to be a man, by reason of a certain instinct that teaches her to desire her own perfection."

The Magnifico Giuliano at once replied:

"The poor creatures do not wish to become men in order to make themselves more perfect but to gain their freedom and shake off the tyranny that men have imposed on them by their one-sided authority. Besides the analogy you give of matter and form is not always applicable; for woman is not perfected by man in the way that matter is perfected by form. To be sure, matter receives its being from form, and cannot exist without it; and indeed the more material a form is, the more imperfect it is, and it is most perfect when separated from matter. On the other hand, woman does not receive her being from man but rather perfects him just as she is perfected by him, and thus both join together for the purpose of procreation which neither can ensure alone. Moreover, I shall attribute woman's enduring love for the man with whom she has first been, and man's detestation for the first woman he possesses, not to what is alleged by your philosopher in his *Problems* but to the resolution and constancy of women

and the inconstancy of men. And for this, there are natural reasons: for because of its hot nature, the male sex possesses the qualities of lightness, movement and inconstancy, whereas from its coldness, the female sex derives its steadfast gravity and calm and is therefore more susceptible."

At this point, signora Emilia turned to the Magnifico to say:

"In heaven's name, leave all this business of matter and form and male and female for once, and speak in a way that you can be understood. We heard and understood quite well all the evil said about us by signor Ottaviano and signor Gaspare, but now we can't at all understand your way of defending us. So it seems to me that what you are saying is beside the point and merely leaves in everyone's mind the bad impression of us given by these enemies of ours."

"Do not call us that," said signor Gaspare, "for your real enemy is the Magnifico who, by praising women falsely, suggests they cannot be praised honestly."

Then the Magnifico Giuliano continued: "Do not doubt, madam, that an answer will be found for everything. But I don't want to abuse men as gratuitously as they have abused women; and if there were anyone here who happened to write these discussions down, I should not wish it to be thought later on, in some place where the concepts of matter and form might be understood, that the arguments and criticisms of signor Gaspare had not been refuted."

"I don't see," said signor Gaspare, "how on this point you can deny that man's natural qualities make him more perfect than woman, since women are cold in temperament and men are hot. For warmth is far nobler and more perfect than cold, since it is active and productive; and, as you know, the heavens shed warmth on the earth rather than coldness, which plays no part in the work of Nature. And so I believe that the coldness of women is the reason why they are cowardly and timid."

"So you still want to pursue these sophistries," replied the Magnifico Giuliano, "though I warn you that you get the worst of it every time. Just listen to this, and you'll understand why. I concede that in itself warmth is more perfect than cold; but this is not therefore the case with things that are mixed and composite, since if it were so the warmer any particular substance was the more perfect it would be, whereas in fact temperate bodies are the most perfect. Let me inform you also that women are cold in temperament only in comparison with men. In themselves, because of their excessive warmth, men are far from temperate; but in themselves women are temperate, or at least more nearly temperate than men, since they possess, in proportion to their natural warmth, a degree of moisture which in men, because of their excessive aridity, soon evaporates without trace. The coldness which women possess also counters and moderates their natural warmth, and brings it far nearer to a temperate condition; whereas in men excessive warmth soon brings their natural heat to the highest point where for lack of sustenance it dies away. And thus since men dry out more than women in the act of procreation they invariably do not live so long; and therefore we can attribute another perfection to women, namely, that enjoying longer life than men they fulfill far better than men the intention of Nature. As for the warmth that is shed on us from the heavens, I have nothing to say, since it has only its name in common with what we are talking about and preserving as it does all things beneath the orb of the moon, both warm and cold, it cannot be opposed to coldness. But the timidity of women, though it betrays a degree of imperfection, has a noble origin in the subtlety and readiness of their senses which convey images very speedily to the mind, because of which they are easily moved by external things. Very often you will

find men who have no fear of death or anything else and yet cannot be called courageous, since they fail to recognize danger and rush headlong without another thought along the path they have chosen. This is the result of a certain obtuse insensitivity; and a fool cannot be called brave. Indeed, true greatness of soul springs from a deliberate choice and free resolve to act in a certain way and to set honor and duty above every possible risk, and from being so stout-hearted even in the face of death, that one's faculties do not fail or falter but perform their functions in speech and thought as if they were completely untroubled. We have seen and heard of great men of this sort, and also of many women, both in recent centuries and in the ancient world, who no less than men have shown greatness in spirit and have performed deeds worthy of infinite praise."

"On Women" from *The Book of the Courtier* by Baldesar Castiglione, translated by George Bull (Penguin Classics, 1967). Copyright © George Bull, 1967. Reprinted by permission of the publisher, Penguin Books, Ltd.

BENVENUTO CELLINI
from THE AUTOBIOGRAPHY

This selection recalls Cellini's casting of the bronze statue of Perseus that now stands in the Piazza della Signoria in Florence. The reader quickly hears a common note Cellini strikes throughout this work: his own powerful ego. If there ever was a story of the self—an autobiography—this work is it. Cellini has no doubts about either his talent or his genius and, in this case—as the finished work clearly demonstrates—he has reason for his self-assurance.

Casting PERSEUS

Then one morning when I was preparing some little chisels for my work a very fine steel splinter flew into my right eye and buried itself so deeply in the pupil that I found it impossible to get out. I thought for certain that I would lose the sight of that eye. After a few days I sent for the surgeon, Raffaello dé Pilli, who took two live pigeons, made me lie on my back on a table, and then holding the pigeons opened with a small knife one of the large veins they have in the wings. As a result the blood poured out into my eye: I felt immediate relief, and in under two days the steel splinter came out and my sight was unimpeded and improved.

As the feast of St. Lucy fell three days later, I made a golden eye out of a French crown piece and had it offered to the saint by one of my six nieces, the daughter of my sister Liperata, who was about ten years old. I gave thanks with her to God and to St. Lucy. For a while I was reluctant to work on the Narcissus. But, in the difficult circumstances I mentioned, I continued with the Perseus, with the idea of finishing it and then clearing off out of Florence.

I had cast the Medusa—and it came out very well—and then very hopefully I brought the Perseus towards completion. I had already covered it in wax, and I promised myself that it would succeed in bronze as well as the Medusa had. The wax Perseus made a very impressive sight, and the Duke thought it extremely beautiful. It may be that someone had given him to believe that it could not come out so well in bronze, or perhaps that was his own opinion, but anyhow he came along to my house more frequently than he used to, and on one of his visits he said:

"Benvenuto, this figure can't succeed in bronze, because the rules of art don't permit it."

I strongly resented what his Excellency said.

"My lord," I replied, "I'm aware that your Most Illustrious Excellency has little faith in me, and I imagine this

comes of your putting too much trust in those who say so much evil of me, or perhaps it's because you don't understand the matter."

He hardly let me finish before exclaiming: "I claim to understand and I do understand, only too well."

"Yes," I answered, "like a patron, but not like an artist. If your Excellency understood the matter as you believe you do, you'd trust in me on the evidence of the fine bronze bust I made of you: that large bust of your Excellency that has been sent to Elba. And you'd trust me because of my having restored the beautiful Ganymede in marble; a thing I did with extreme difficulty and which called for much more exertion than if I had made it myself from scratch: and because of my having cast the Medusa, which is here now in your Excellency's presence; and casting that was extraordinarily difficult, seeing that I have done what no other master of this devilish art has ever done before. Look, my lord, I have rebuilt the furnace and made it very different from any other. Besides the many variations and clever refinements that it has, I've constructed two outlets for the bronze: that was the only possible way of ensuring the success of this difficult, twisted figure. It only succeeded so well because of my inventiveness and shrewdness, and no other artist ever thought it possible.

"Be certain of this, my lord, that the only reason for my succeeding so well with all the important and difficult work I did in France for that marvelous King Francis was because of the great encouragement I drew from his generous allowances and from the way that he met my request for workmen— there were times when I made use of more than forty, all of my own choice. That was why I made so much in so short a time. Now, my lord, believe what I say, and let me have the assistance I need, since I have every hope of finishing a work that will please you. But if your Excellency discourages me and refuses the assistance I need, I can't produce good results, and neither could anyone else no matter who."

The Duke had to force himself to stay and listen to my arguments; he was turning now one way and now another, and, as for me, I was sunk in despair, and I was suffering agonies as I began to recall the fine circumstances I had been in [when] in France.

All at once the Duke said: "Now tell me, Benvenuto, how can you possibly succeed with this beautiful head of Medusa, way up there in the hand of the Perseus?"

Straight away I replied: "Now see, my lord: if your Excellency understood this art as you claim to then you wouldn't be worried about that head not succeeding; but you'd be right to be anxious about the right foot, which is so far down."

At this, half in anger, the Duke suddenly turned to some noblemen who were with him and said:

"I believe the man does it from self-conceit, contradicting everything."

Then all at once he turned toward me with an almost mocking expression that was imitated by the others, and he said:

"I'm ready to wait patiently and listen to the arguments you can think up to convince me."

"I shall give such convincing ones," I said, "that your Excellency will understand only too well."

Then I began: "You know, my lord, the nature of fire is such that it tends upwards, and because this is so I promise you that the head of Medusa will come out very well. But seeing that fire does not descend I shall have to force it down six cubits by artificial means: and for that very cogent reason I tell your Excellency that the foot can't possibly succeed, though it will be easy for me to do it again."

"Well then," said the Duke, "why didn't you take precautions to make sure the foot comes out in the way you say the head will?"

"I would have had to make the furnace much bigger," I replied, "and build in it a conduit as wide as my leg, and then the weight of the hot metal would have enabled me to bring it down. As it is, the conduit now descends those six cubits I mentioned before down to the feet, but it's no thicker than two fingers. It was not worth the expense of changing it, because I can easily repair the fault. But when my mould has filled up more than halfway, as I hope it will, then the fire will mount upwards, according to its nature, and the head of the Perseus, as well as that of Medusa, will come out perfectly. You may be sure of that."

After I had expounded these cogent arguments and endless others which it would take me too long to write down here, the Duke moved off shaking his head.

Left to myself in this way, I regained my self-confidence and rid myself of all those troublesome thoughts that used to torment me from time to time, often driving me to bitterly tearful regret that I had ever quit France, even though it had been to go on a charitable mission to Florence, my beloved birthplace, to help out my six nieces. I now fully realized that it was this that had been at the root of all my misfortunes, but all the same I told myself that when my Perseus that I had already begun was finished, all my hardships would give way to tremendous happiness and prosperity.

So with renewed strength and all the resources I had both in my limbs and my pocket (though I had very little money left) I made a start by ordering several loads of wood from the pine forest at Serristori, near Monte Lupo. While waiting for them to arrive I clothed my Perseus with the clays I had prepared some months previously in order to ensure that they would be properly seasoned. When I had made its clay tunic, as it is called, I carefully armed it, enclosed it with iron supports, and began to draw off the wax by means of a slow fire. It came out through the air vents I had made—the more of which there are, the better a mould fills. After I had finished drawing off the wax, I built round my Perseus a funnel-shaped furnace. It was built, that is, round the mould itself, and was made of bricks piled on top of the other, with a great many gaps for the fire to escape more easily. Then I began to lay on wood, in fairly small amounts, keeping the fire going for two days and nights.

When all the wax was gone and the mould well baked, I at once began to dig the pit in which to bury it, observing all the rules that my art demands. That done, I took the mould and carefully raised it up by pulleys and strong ropes, finally suspending it an arm's length above the furnace, so that it hung down just as I wanted it above the middle of the pit. Very, very slowly I lowered it to the bottom of the furnace and set it in exact position with the utmost care: and then, having finished that delicate operation, I began to bank it up with the earth I had dug out. As I built this up, layer by layer, I left a number of air holes by means of little tubes of terracotta of the kind used for drawing off water and similar purposes. When I saw that it was perfectly set up, that all was well as far as covering it and putting those tubes in position was concerned, and that the workmen had grasped what my method was—very different from those used by all the others in my profession—I felt confident that I could rely on them, and I turned my attention to the furnace.

I had had it filled with a great many blocks of copper and other bronze scraps, which were placed according to the rules of our art, that is, so piled up that the flames would be able to play through them, heat the metal more quickly, and melt it down. Then, very excitedly, I ordered the furnace to be set alight.

The pine logs were heaped on, and what with the greasy resin from the wood and the excellence of my furnace, everything went so merrily that I was soon rushing from

one side to another, exerting myself so much that I became worn out. But I forced myself to carry on.

To add to the difficulties, the workshop caught fire and we were terrified that the roof might fall in on us, and at the same time the furnace began to cool off because of the rain and wind that swept in at me from the garden.

I struggled against these infuriating accidents for several hours, but the strain was more than even my strong constitution could bear, and I was suddenly attacked by a bout of fever—the fiercest you can possibly imagine—and was forced to throw myself on to my bed.

Very upset, forcing myself away from the work, I gave instructions to my assistants, of whom there were ten or more, including bronze-founders, craftsmen, ordinary laborers, and the men from my own workshop. Among the last was Bernardino Mannellini of Mugello, whom I had trained for a number of years; and I gave him special orders.

"Now look, my dear Bernardino," I said, "do exactly as I've shown you, and be very quick about it as the metal will soon be ready. You can't make any mistakes—these fine fellows will hurry up with the channels and you yourself will easily be able to drive in the two plugs with these iron hooks. Then the mould will certainly fill beautifully. As for myself, I've never felt so ill in my life. I'm sure it will make an end of me in a few hours."

And then, very miserably, I left them and went to bed.

As soon as I was settled, I told my housemaids to bring into the workshop enough food and drink for everyone, and I added that I myself would certainly be dead by the next day. They tried to cheer me up, insisting that my grave illness would soon pass and was only the result of excessive tiredness. Then I spent two hours fighting off the fever, which all the time increased in violence, and I kept shouting out: "I'm dying!"

Although my housekeeper, the best in the world, an extraordinarily worthy and lovable woman called Fiore of Castel del Reio, continually scolded me for being so miserable, she tended to all my wants with tremendous devotion. But when she realized how very ill I was, and how low my spirits had fallen, for all her unflagging courage she could not keep back her tears, though even then she did her best to prevent my noticing them.

In the middle of this dreadful suffering I caught sight of someone making his way into my room. His body was all twisted, just like a capital *S*, and he began to moan in a voice full of gloom, like a priest consoling a prisoner about to be executed.

"Poor Benvenuto! Your work is all ruined—there's no hope left!"

On hearing the wretch talk like that I let out a howl that could have been heard echoing from the farthest planet, sprang out of bed, seized my clothes, and began to dress. My servants, my boy, and everyone else who rushed up to help me found themselves treated to kicks and blows, and I grumbled furiously at them:

"The jealous traitors! This is deliberate treachery—but I swear by God I'll get to the root of it. Before I die I'll leave such an account of myself that the whole world will be dumbfounded!"

As soon as I was dressed, I set out for the workshop in a very nasty frame of mind, and there I found the men I had left in such high spirits all standing round with an air of astonished dejection.

"Come along now," I said, "listen to me. As you either couldn't or wouldn't follow the instructions I left you, obey me now that I'm here with you to direct my work in person. I don't want any objections—we need work now, not advice."

At this, a certain Alessandro Lastricati cried out:

"Look here, Benvenuto, what you want done is beyond the powers of art. It's simply impossible."

When I heard him say that I turned on him so furiously and with such a murderous glint in my eye that he and all the others shouted out together:

"All right then, let's have your orders. We'll obey you in everything while there's still life in us."

And I think they showed this devotion because they expected me to fall down dead at any minute.

I went at once to inspect the furnace, and I found that the metal had all curdled, had caked as they say. I ordered two of the hands to go over to Capretta, who kept a butcher's shop, for a load of young oak that had been dried out a year or more before and had been offered me by his wife, Ginevra. When they carried in the first armfuls I began to stuff them under the grate. The oak that I used, by the way, burns much more fiercely than any other kind of wood, and so alder or pinewood, which are slower burning, is generally preferred for work such as casting artillery. Then, when it was licked by those terrible flames, you should have seen how that curdled metal began to glow and sparkle!

Meanwhile I hurried on with the channels and also sent some men up to the roof to fight the fire that had begun to rage more fiercely because of the greater heat from the furnace down below. Finally I had some boards and carpets and other hangings set up to keep out the rain that was blowing in from the garden.

As soon as all that terrible confusion was straightened out, I began roaring: "Bring it here! Take it there!" And when they saw the metal beginning to melt my whole band of assistants were so keen to help that each one of them was as good as three men put together.

Then I had someone bring me a lump of pewter, weighing about sixty pounds, which I threw inside the furnace on to the caked metal. By this means, and by piling on the fuel and stirring with pokers and iron bars, the metal soon became molten. And when I saw that despite the despair of all my ignorant assistants that I had brought a corpse back to life, I was so reinvigorated that I quite forgot the fever that had put the fear of death into me.

At this point there was a sudden explosion and a tremendous flash of fire, as if a thunderbolt had been hurled in our midst. Everyone, not least myself, was struck with unexpected terror. When the glare and noise had died away, we stared at each other, and then realized that the cover of the furnace had cracked open and that the bronze was pouring out. I hastily opened the mouths of the mould and at the same time drove in the two plugs.

Then, seeing that the metal was not running as easily as it should, I realized that the alloy must have been consumed in that terrific heat. So I sent for all my pewter plates, bowls, and salvers, which numbered about two hundred, and put them one by one in front of the channels, throwing some straight into the furnace. When they saw how beautifully the bronze was melting and the mould filling up, everyone grew excited. They all ran up smiling to help me, and fell over themselves to answer my calls, while I—now in one place, now another—issued instructions, gave a hand with the work, and cried out loud: "O God, who by infinite power raised Yourself from the dead and ascended into heaven!" And then in an instant my mould was filled. So I knelt down and thanked God with all my heart.

Then I turned to a plate of salad that was there on some bench or other, and with a good appetite ate and drank with all my band of helpers. Afterwards I went to bed, healthy

and happy, since it was two hours off dawn, and so sweetly did I sleep that it was as if I hadn't a thing wrong with me. Without a word from me that good servant of mine had prepared a fat capon, and so when I got up—near dinner time—she came to me smiling and said:

"Now then, is this the man who thought he was going to die? I believe the blows and kicks you gave us last night, with you so enraged and in such a devilish temper, made your nasty fever frightened that it would come in for a beating as well, and so it ran away."

Then all my poor servants, no longer burdened by anxiety and toil, immediately went out to replace those pewter vessels and plates with the same number of earthenware pots, and we all dined happily. I never remember in my life having dined in better spirits or with a keener appetite.

After dinner all those who had assisted came to visit me; they rejoiced with me, thanking God for what had happened and saying that they had learnt and seen how to do things that other masters held to be impossible. I was a little boastful and inclined to show off about it, and so I preened myself a little. Then I put my hand in my purse and paid them all to their satisfaction.

My mortal enemy, that bad man Pier Francesco Riccio, the Duke's majordomo, was very diligent in trying to find out how everything had gone: those two whom I strongly suspected of being responsible for the metal's curdling told him that I obviously wasn't human but rather some powerful fiend, since I had done the impossible, and some things which even a devil would have found baffling.

They greatly exaggerated what had happened—perhaps to excuse themselves—and without delay, the majordomo wrote repeating it all to the Duke who was at Pisa, making the story even more dramatic and marvelous than he had heard it.

I left the cast to cool off for two days and then very, very slowly, I began to uncover it. The first thing that I found was the head of Medusa, which had come out beautifully because of the air vents, just as I had said to the Duke that the nature of fire was to ascend. Then I began uncovering the rest, and came to the other head—that is the head of the Perseus—which had also succeeded beautifully. This came as much more of a surprise because, as can be seen, it's a good deal lower than the Medusa.

The mouths of the mould were placed above the head of the Perseus, and by the shoulders, and I found that all the bronze there was in my furnace had been used up in completing the head of the Perseus. It was astonishing to find that there was not the slightest trace of metal left in the channels, nor on the other hand was the statue incomplete. This was so amazing that it seemed a certain miracle, with everything controlled and arranged by God.

I carried on happily with the uncovering, and without exception I found everything perfect until I reached the foot of the right leg on which it rests. There I discovered that the heel was perfectly formed, and continuing farther I found it all complete: on the one hand, I rejoiced very much, but on the other I was half disgruntled if only because I had told the Duke that it could not come out. But then on finishing the uncovering I found that the toes of the foot had not come out: and not only the toes, because there was missing a small part above the toes as well, so that just under a half was missing. Although this meant a little more work I was very glad of it, merely because I could show the Duke that I knew my business. Although much more of the foot had come out than I had expected, the reason for this was that—with all that had taken place—the metal had been hotter than it would have been, and at the same time I had had to help it out with the alloy in the way I described, and with those pewter vessels—something no one else had ever done before.

Seeing that the work was so successful I immediately went to Pisa to find my Duke. He welcomed me as graciously as you can imagine, and the Duchess did the same. Although their majordomo had sent them news about everything, it seemed to their Excellencies far more of a stupendous and marvelous experience to hear me tell of it in person. When I came to the foot of the Perseus which had not come out—just as I had predicted to his Excellency—he was filled with astonishment and he described to the Duchess how I had told him this beforehand. Seeing how pleasantly my patrons were treating me I begged the Duke's permission to go to Rome. He gave me leave, with great kindness, and told me to return quickly and finish his Perseus; and he also gave me letters recommending me to his ambassador, who was Averardo Serristori: these were the first years of Pope Julius dé Monti.

From *The Autobiography of Benvenuto Cellini*, translated by George Bull (Penguin Classics, 1956). Copyright © George Bull, 1956. Reprinted by permission of Penguin Books, Ltd.

CHAPTER 14

	GENERAL EVENTS	LITERATURE & PHILOSOPHY	ART
1494			**1494–1495** Dürer visits Italy
1500	**1498** da Gama lands in India		
GENESIS OF THE REFORMATION	**1515–1547** Reign of Francis I in France	**1506–1532** Ariosto active in Italy	**1500** Dürer, *Self-Portrait*
		1509 Erasmus, *The Praise of Folly*	**early 16th cent.** Italian Renaissance art and thought spread northward
	1517 Reformation begins in Germany with Luther's 95 Theses, challenging the practice of indulgences	**1516** More, *Utopia*	**c. 1505–1510** Bosch, *Garden of Earthly Delights,* triptych
	1519–1556 Reign of Charles V as Holy Roman Emperor		**1508–1511** Dürer, *Adoration of the Trinity*
	1521 Excommunication of Luther by Pope Leo X	**1521** Luther begins translation of Bible into German, published 1534	**1513** Dürer, *Knight, Death and the Devil,* engraving
	1524–1525 Peasants' War in Germany	**1524** Erasmus, *De Libero Arbitrio (On Free Will)*	**1515** Grünewald, *Isenheim Altarpiece*
1525	**1525** Francis I defeated by Charles V at Pavia	**1525** Luther, *De Servo Arbitrio (On the Bondage of the Will)*	**1525** Altdorfer, *Landscape,* early example of pure landscape painting
SPREAD OF PROTESTANTISM			**1528** Dürer, *Four Books on Human Proportions*
	1527 Sack of Rome by Charles V		**1529** Altdorfer, *Battle of Alexander and Darius*
			c. 1530 Clouet, *Portrait of Francis I*
	1534 Henry VIII founds Anglican Church in England when Parliament passes Act of Supremacy	**1530** Budé persuades Francis I to found Collège de France as center for humanism	**c. 1530–1550** Sacred art denounced as idolatry by reforming iconoclasts
			c. 1533–1540 Decorations by Rosso Fiorentino for Palace at Fontainebleau
		16th cent. Humanism spreads, along with interest in scientific inquiry; availability of books increases literacy	**1539–1540** Holbein the Younger, *Portrait of Henry VIII in Wedding Dress*
	1539 Society of Jesus (Jesuits) founded by Saint Ignatius of Loyola		**1540–1543** Cellini, *The Saltcellar,* commissioned by Francis I
	1545–1564 Council of Trent initiates Counter-Reformation under Jesuit guidance	**1543** Copernicus, *On the Revolution of Celestial Bodies;* Vesalius, *Seven Books on the Structure of the Human Body*	
1550	**1550–1555** Wars between Lutheran and Catholic princes in Germany; ended by Peace of Augsburg in 1555		
GROWTH OF COUNTER-REFORMATION	**1556** Retirement of Charles V		
	1556–1598 Reign of Philip II in Spain and Netherlands		
	1558–1603 Reign of Elizabeth in England	**1559** Pope Paul IV publishes first Index of Prohibited Books	**c. 1562–1567** Bruegel the Elder, *The Triumph of Death, Hunters in the Snow, Peasant Wedding*
	1572 Saint Bartholomew's Day Massacre in France		
1575	**1581** United Provinces of Netherlands declare independence from Spain	**1580** Montaigne's first *Essays*	
RELIGIOUS AND NATIONALISTIC UNREST		**c. 1587** Marlowe, *Tamburlaine,* tragedy	
	1585 England sends troops to support Netherlands against Spain	**1590** Sidney, *Arcadia*	
		1590–1596 Spenser, *The Faerie Queene,* allegorical epic	
	1588 Philip's Spanish Armada defeated by English	**1590–1610** Drama at height in Elizabethan England	
	1598 Edict of Nantes establishes religious toleration in France	**1593** Marlowe, *Dr. Faustus,* tragedy	
	1600 British found East India Tea Company	**late 16th–early 17th cent.** Cervantes active in Spain, Jonson in England, Tasso in Italy	**c. 1600** Patronage for sacred art wanes in Reformation countries, flourishes in Counter-Reformation countries
	1602 Dueling banned in France	**c. 1600** Shakespeare, *Hamlet*	
	1607 English found colony of Virginia in New World	**c. 1604–1605** Shakespeare, *Othello, King Lear, Macbeth*	
	1609 Independence of Netherlands recognized by Spain	**1611** *Authorized Version* of Bible	
1620		**1620** Francis Bacon, *Novum Organum*	

Most dates are approximate

	ARCHITECTURE	MUSIC

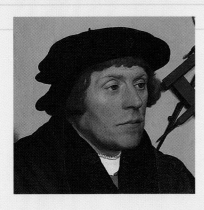

Vernacular hymns stressed by Reformers; musical elements in Protestant services simplified by Luther to increase comprehension

1506 Rebuilding of Saint Peter's Basilica, Rome, begins

c. 1510 Isaac and Sendl active in Northern Europe

1519 Château de Chambord built by Francis I

c. 1520 Marot and Janequin compose *chansons*

c. 1525–1530 *Ein' Feste Burg Ist Unser' Gott (A Mighty Fortress Is Our God)*

1544 Gregorian chant is basis for first English-language litany in England

1549 Merbecke, *The Boke of Common Praier Noted*

1548–1549 Goujon, *Fountain of the Innocents,* Louvre, Paris

1546 Lescot and Goujon, Square Court of Louvre, begun

c. 1550 Reformation ends building of elaborate churches in Protestant countries

c. 1570 Tallis, English court organist, composes *Lamentations of Jeremiah*

1588 *Musica Transalpina* translated into English

c. 1590 Hilliard, *Portrait of a Youth,* miniature

1591 Byrd, *My Ladye Nevells Booke*

late 16th–early 17th cent. English madrigals by Byrd, Morley, and Weelkes follow Italian models; ayres by Dowland

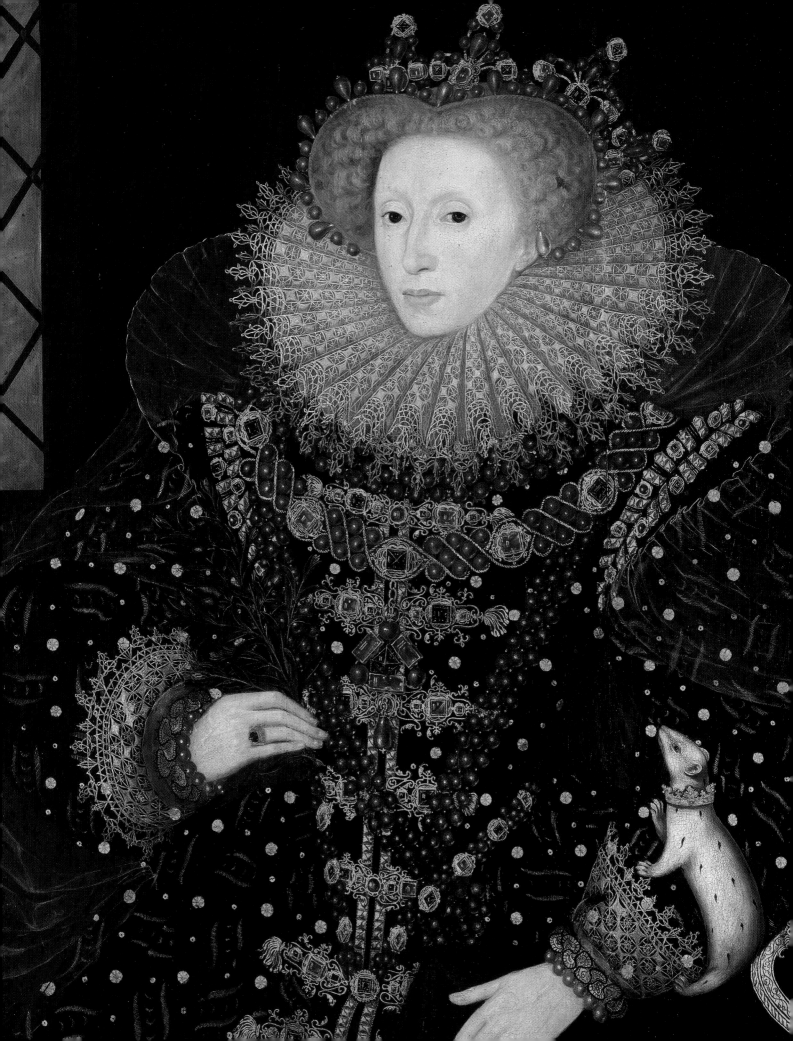

CHAPTER 14

THE RENAISSANCE IN THE NORTH

The ideas and artistic styles that developed in Italy during the fifteenth and sixteenth centuries produced immense changes in the cultural life of England, France, Germany, and the Netherlands. As the Renaissance spread beyond the Alps, the new humanism it carried roused Northern Europe from its conservative intellectual patterns and offered an alternative to traditional religious doctrines. The infusion of Italian ideas produced a new breadth of vision that was responsible for some of the greatest northern painting and for important developments in music. By the end of the sixteenth century, under the influence of humanism, a brilliant cultural life had developed in Elizabethan England, where Renaissance English drama achieved its greatest glory in the work of William Shakespeare.

This was not the first time Northern Europe and Italy had come into contact. During the fourteenth century, a style of late-Gothic painting reflecting the grace and elegance of courtly life on both sides of the Alps had developed. Known as the International Style, it was popular in both Italy and Northern Europe. Furthermore, as early as the beginning of that century, German scholars who had traveled to Italy to study returned home with a new enthusiasm for classical antiquity. Nor was the northern Renaissance merely based on Italian ideas, the wholesale adoption by Northern European artists of foreign ways and styles. Northern artists drew on a rich native past and were able to incorporate exciting new ideas from Italy into their own vision of the world. One of the chief characteristics of northern Renaissance art, in fact, was its emphasis on individualism; painters like Albrecht Dürer and Albrecht Altdorfer are as different from each other as they are from the Italian artists who initially influenced them.

The spread of Italian Renaissance ideas to the north was in many respects political rather than cultural. Throughout most of the sixteenth century, the great monarchs of Northern Europe vied with one another for political and military control over the states of Italy and, in the process, were brought into contact with the latest developments in Italian artistic and intellectual

life, and often based their own courts on Italian models. Francis I, who ruled France from 1515 to 1547, made a deliberate attempt to expose French culture to Italian influences by doing everything he could to attract Italian artists to the French court; among those who came were Leonardo da Vinci, Andrea del Sarto (1486–1530), and Benvenuto Cellini [**FIG. 14.1**]. Francis and his successors also esteemed literature and scholarship highly. Francis's sister, Marguerite of Navarre, a writer of considerable gifts, became the center of an intellectual circle that included many of the finest minds of the age.

The history of Germany is intimately bound up with that of the Hapsburg family. In the first half of the sixteenth century, the same Hapsburg king who ruled Germany (under the old name of the Holy Roman Empire) with the title of Charles V ruled Spain under the title of Charles I. Charles was the principal competitor of Francis I for political domination of Italy, and although his interest in the arts was less cultivated than that of his rival, his conquests brought Italian culture to both Spain and the north [**FIG. 14.2**]. On his abdication (1556) he divided his vast territories between his brother Ferdinand and his son Philip. The Austrian and Spanish branches of the Hapsburg family remained the principal powers in Europe until the 1650s.

For most of the Renaissance, England remained under the dominion of a single family—the Tudors—whose last representative was Elizabeth I. Like her fellow rulers, in the course of her long reign (1558–1603) Elizabeth established her court as a center of art and learning. Although the influence of Italian models on the visual arts was less marked in England than elsewhere, revived interest in Classical antiquity and the new humanism it inspired is reflected in the works of Shakespeare and other Elizabethan writers.

Although the art of the great northern centers drew heavily on Italy for inspiration, another factor was equally important. The sixteenth century was a period of almost unparalleled intellectual tumult, in which traditional ideas on religion and the nature of the universe were shaken and often permanently changed. Many of the revolutionary movements of the age were

■ **14.1** Benvenuto Cellini. *The Saltcellar of Francis I,* 1539–1543. Gold, 10¼″ × 13⅛″ (26 × 33 cm). Kunsthistorisches Museum, Vienna. The male figure is Sea; the female is Land. "Both figures were seated with their legs interlaced, just as the arms of the sea run into the land," said Cellini. The sculptor had fled to the French court after the sack of Rome in 1527.

in fact northern in origin, and not surprisingly they had a profound effect on the art, music, and literature being produced in the same place and time. While northern artists were being influenced by the styles of their fellow artists south of the Alps, their cultural world was being equally shaped by theologians and scientists closer to home. The intellectual developments of this world form a necessary background to its artistic achievements.

THE REFORMATION

On the eve of All Saints' Day in 1517, a German Augustinian friar, Martin Luther (1483–1546), tacked on the door of the collegiate Church of Wittenberg a parchment containing ninety-five **theses** (academic proposi-

tions) written in Latin—the usual procedure for advertising an academic debate [**FIG. 14.3**]. Luther's theses constituted an attack on the Roman Catholic doctrine of **indulgences** (forgiveness of punishment for sins, usually obtained either through good works or prayers along with the payment of an appropriate sum of money); this was a timely topic because an indulgence was currently being preached near Wittenberg to help raise funds for the rebuilding of Saint Peter's in Rome.

Luther's act touched off a controversy that went far beyond academic debate. For the next few years there were arguments among theologians, while Luther received emissaries and directives from the Vatican as well as official warnings from the pope. Luther did not waver in his criticisms. On June 15, 1520, Pope Leo X (Giovanni de' Medici, son of Lorenzo the Magnificent) condemned Luther's teaching as heretical and, on January 3, 1521, excommunicated him from the Catholic Church. The Protestant Reformation had been born.

■ **14.3** Lucas Cranach. *Portrait of Martin Luther*, c. 1526. Oil on panel, 15″ × 9″ (38 × 24 cm). Galleria degli Uffizi, Florence. Around the time this portrait was painted, Luther—seen here wearing austere black—married Katharina von Bora, a former nun; they had six children.

■ **14.2** Leone Leoni. *Bust of Emperor Charles V,* 1533–1555. Bronze. Height 44″ (112 cm). Kunsthistorisches Museum, Vienna. The sculptor deliberately portrayed the German ruler as a Roman emperor, thus associating Charles with both Italy and Classical antiquity. Note the eagle at the base, symbol of imperial rule since Roman times.

Luther's reformation principles began to be applied in churches throughout Germany, and a rapid and widespread outbreak of other reforming movements was touched off by Luther's example. By 1523, radical reformers far more iconoclastic than Luther began to agitate for a purer Christianity free from any trace of "popery." These radical reformers are often called **anabaptists** ("baptized again") because of their insistence on adult baptism even if baptism had been performed in infancy. Many of these anabaptist groups had radical social and political ideas, including pacifism and the refusal to take oaths or participate in civil government, which appealed to the discontent of the lower classes. One outcome was the Peasants' War in Germany, which was put down with ferocious bloodshed in 1525.

The Reformation was not confined to Germany. In 1523, Zurich, Switzerland, accepted the reformation ideal for its churches. Under the leadership of Ulrich Zwingli (1484–1531), Zurich, and later Berne and Basel, adopted Luther's reforms, including the abolition of statues and images and the right of the clergy to marry (abolishing celibacy). In addition, the list of sacraments was greatly reduced and modified to include only baptism and the Lord's Supper (communion). In Geneva, John Calvin (1509–1564) preached a brand of Protestantism even more extreme than that of either Luther or Zwingli. Calvin's doctrines soon spread north to the British Isles, especially Scotland, under the Calvinist John Knox, and west to the Low Countries, especially Holland. In England, King Henry VIII (born 1491, reigned 1509–1547), formerly a stout opponent of Lutheranism, broke with Rome in 1534 because the

VOICES OF THEIR TIMES

Katherine Zell

Many of the Reformation's most active figures were women. Katherine Zell (1497–1562) was the wife of Matthew Zell, one of the first priests to demonstrate his break from the church by marrying. When he died, Katherine continued his teaching and pastoral work. She wrote this letter in 1558 to an old friend who was suffering from leprosy:

> My dear Lord Felix, since we have known each other for a full thirty years I am moved to visit you in your long and frightful illness. I have not been able to come as often as I would like, because of the load here for the poor and the sick, but you have been ever in my thoughts. We have often talked of how you have been stricken, cut off from rank, office, from your wife and friends, from all dealings with the world which recoils

from your loathsome disease and leaves you in utter loneliness. At first you were bitter and utterly cast down till God gave you strength and patience, and now you are able to thank him that out of love he has taught you to bear the cross. Because I know that your illness weighs upon you daily and may easily cause you again to fall into despair and rebelliousness, I have gathered some passages which may make your yoke light in the spirit, though not in the flesh. I have written meditations on the 51st Psalm: "Have mercy upon me, O God, according to thy loving-kindness," and the 130th, "Out of the depths have I cried unto thee, O Lord." And then on the Lord's Prayer and the Creed.

Letter by Katherine Zell, reprinted from *Women of the Reformation in Germany and Italy* by Roland H. Bainton, © 1971 Augsburg Fortress Press.

pope refused to grant him an annulment from his first wife, Katherine of Aragon [**FIG. 14.4**]. In that same year (1534), Henry issued the Act of Supremacy, declaring the English sovereign head of the church in England.

By the middle of the sixteenth century, Europe—for centuries solidly under the authority of the Church of Rome—was therefore divided in a way that has remained essentially unaltered. Spain and Portugal, Italy, most of France, southern Germany, Austria, parts of Eastern Europe (Poland, Hungary, and parts of the Balkans), and Ireland remained Catholic, whereas most of Switzerland, the British Isles, all of Scandinavia, northern and eastern Germany, and other parts of Eastern Europe gradually switched to Protestantism (see "Religious Divisions in Europe c. 1600").

Causes of the Reformation

What conditions permitted this rapid and revolutionary upheaval in Europe? The standard answer is that the medieval church was so riddled with corruption and incompetence that it was like a house of cards waiting to be toppled. This answer, while containing some truth, is not totally satisfactory because it does not explain why the Reformation did not occur a century earlier, when similar or worse conditions prevailed. Why had the Reformation not taken place during the fourteenth century, when there were such additional factors as plague, schisms, and wars as well as incipient reformers clamoring for change? The exact conditions that permitted the Reformation to happen are difficult to pinpoint, but any explanation must take into account several elements that were clearly emerging in the sixteenth century.

First, there was a rising sense of nationalism in Europe combined with increasing resentment at the economic and political demands made by the papacy, many of which ignored the rights of individual coun-

■ **14.4** Hans Holbein the Younger. *Henry VIII in Wedding Dress,* 1540. Oil on panel, 32½″ × 29″ (83 × 74 cm). Galleria Barberini, Rome. Weddings were not uncommon events in Henry's life. This wedding, when he was in his 49th year, as the inscription says, was probably the ill-fated one to his fourth wife, Anne of Cleves (see Figure 14.25).

RELIGIOUS DIVISIONS IN EUROPE C. 1600

☐ Catholicism	☐ Anglicanism
▨ Orthodox Christianity	▨ Calvinism
	▨ Lutheranism

(Religious minorities are not represented)

0 400 Miles

0 400 Kilometers

tries. Thus Luther's insistence that the German rulers reform the church because the church was impotent to do so appealed to both economic and nationalistic self-interests.

Second, the idea of reform in the church had actually been maturing for centuries, with outcries against abuses and pleas for change. Some of the great humanists who were contemporaries of Luther—including Erasmus of Rotterdam, Thomas More in England, and Jacques Lefèvre d'Étaples in France—had also pilloried the excesses of the church. These men, and many of their followers and devoted readers, yearned for a deeper, more interior piety, free from the excessive pomp and ceremony that characterized so much of popular medieval religion. Luther's emphasis on personal conversion and his rejection of much of the ecclesiastical superstructure of Catholicism appealed to

the sensibilities of many people. That the reformers to the left of Luther demanded even more rejection of Catholic practices shows how widespread was the desire for change.

Third, several other factors clustered around the two already mentioned. The low moral and intellectual condition of much of the clergy was a scandal; the wealth and lands of the monastic and episcopal lords were envied. In short, many related economic and political factors fed the impulses of the Reformation.

Renaissance Humanism and the Reformation

The relationship between Renaissance humanism and the Protestant Reformation is significant if complex.

With the single exception of John Calvin, none of the major church reformers were professional humanists, although all came into contact with the movement. Luther had no early contact with the "new learning," even though he utilized its fruits. Nevertheless, humanism as far back as the time of Petrarch shared many intellectual and cultural sentiments with the Reformation. We should note these similarities before treating the wide differences between the two movements.

The reformers and the humanists shared several religious aversions. They were both fiercely critical of monasticism, the decadent character of popular devotion to the saints, the low intellectual preparation of the clergy, and the general venality and corruption of the higher clergy, especially the papal **curia**—the body of tribunals and assemblies through which the pope governed the church.

Both the humanists and the reformers felt that the scholastic theology of the universities had degenerated into quibbling arguments, meaningless discussions, and dry academic exercises bereft of any intellectual or spiritual significance. In a common reaction, both rejected the scholastics of the medieval universities in favor of Christian writers of an earlier age. John Calvin's reverence in the sixteenth century for the writings of the early Christian church father and philosopher Augustine (354–430) echoed the equal devotion of Petrarch in the fourteenth century.

Humanists and reformers alike spearheaded a move toward a better understanding of the Bible based not on the authority of theological interpretation but on close, critical scrutiny of the text, preferably in the original Hebrew and Greek. Mastery of the three biblical languages (Latin, Greek, and Hebrew) was considered so important in the sixteenth century that schools were founded especially for the specific purpose of instruction in them. Some famous academic institutions, including Corpus Christi College, Oxford; the University of Alcalá, Spain; and the Collège de France in Paris, were founded for that purpose. Luther's own University of Wittenberg had three chairs for the study of biblical languages.

We can see the connection between humanist learning and the Reformation more clearly by noting some aspects of Luther's great translation of the Bible into German. Although there had been many earlier vernacular translations into German, Luther's, which he began in 1521, was the first produced entirely from the original languages, and the texts he used illuminate the contribution of humanist learning. For the New Testament, he used the critical Greek edition prepared by Erasmus. For the Book of Psalms, he used a text published in Hebrew by the humanist printer Froben at Basel in 1516. The other Hebrew texts were rendered from a Hebrew version published by Italian Jewish scholars who worked in the Italian cities of Soncino and Brescia. His translations of the Apocrypha (books not found in the Hebrew canon) utilized the Greek edition of the Apocrypha printed in 1518 by Aldus Manutius at his press in Venice. As an aid for his labors, Luther made abundant use of grammars and glossaries published by the humanist scholar Johann Reuchlin.

In short, Luther's great achievement was possible only because much of the groundwork had already been laid by a generation of humanist philologists. This scholarly tradition endured. In 1611, when the translators of the famous English King James Version wrote their preface to the Bible, they noted that they had consulted commentaries and translations as well as translations or versions in Chaldee, Hebrew, Syriac, Greek, Latin, Spanish, French, Italian, and Dutch.

Although there were similarities and mutual influences between humanists and reformers, there were also vast differences. Two are of particular importance. The first relates to concepts of the nature of humanity. The humanist program was rooted in the notion of human perfectibility. This was as true of the Florentine humanists with their strong Platonic bias as it was of northern humanists like Erasmus. The humanists placed great emphasis on the profoundly Greek (or, more accurately, Socratic) notion that education can produce a moral person. Both humanist learning and humanist education had a strong ethical bias: learning improves and ennobles. The reformers, by contrast, felt that humanity was hopelessly mired in sin and could only be raised from that condition by the freely offered grace of God. For the reformers, the humanists' position that education could perfect a person undercut the notion of a sinful humanity in need of redemption.

The contrast between these two points of view is most clearly evident in a polemical debate between Luther and Erasmus on the nature of the human will. In a 1524 treatise called *De Libero Arbitrio (On Free Will)*, Erasmus defended the notion that human effort cooperates in the process of sanctification and salvation. Luther answered in 1525 with a famous tract titled *De Servo Arbitrio (On the Bondage of the Will)*. The titles of the two pamphlets provide a shorthand description of the severe tension existing between the two viewpoints. A second difference between the humanists and the reformers begins with the humanist notion that behind all religious systems lies a universal truth that can be detected by a careful study of religious texts. Pico della Mirandola, for example, believed that the essential truth of Christianity could be detected in Talmudic, Platonic, Greek, and Latin authors. He felt that a sort of universal religion could be constructed from a close application of humanist scholarship to all areas of religion. The reformers, on the other hand, held to a simple yet unshakable dictum: *Scriptura sola* ("the Bible alone"). While the reformers were ready to use humanist methods to investigate the sacred text, they were adamant in their conviction that only the Bible held God's revelation to humanity.

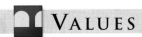

VALUES

Reform

It is almost too obvious, but one would have to say that the predominant value that energized Western Europe in the first half of the sixteenth century was the desire for religious *reform*. This impulse manifested in different ways, but the acting out of the reform impulse would have great sociopolitical effects in Europe and in the newly discovered lands of the New World.

This desire for reform was an explicit motivating impulse in the work of the northern humanists who believed that their scholarly labors of biblical translation and the recovery of early Christian classics would be a vehicle by which the Christian life of Europe would be invigorated. The humanists of the North believed in reform by scholarship.

The great Protestant reformers did not set out to start new churches. Their goal was to get back to an earlier, less corrupt, kind of Christianity that would reform Christian life. The close contact between Calvin's reform of Geneva and the city's political life was an attempt not only to reinvigorate religious faith but also to provide a different model of governance in civil affairs.

The Catholic response to Protestantism is often called a "counterreformation" but, in fact, it was a genuinely internal reformation clarifying both its own beliefs and triggering new religious impulses

within. The various reactive strategies of Catholicism to the rise of the Protestant world all derived from a deep sense that the church needed a thorough reformation.

The reforming impulses early in the century eventually solidified into discrete church bodies: the Anglicans in England; Presbyterians in Scotland; Calvinists in parts of Switzerland and Holland; Catholicism in the Mediterranean countries; and Lutheranism in parts of Germany and Scandinavia. Like all reforming movements, that of the sixteenth century eventually formed institutions ready and waiting for a time when new reforming impulses would be required.

Already evident in this period was a new spirit in scientific investigation, which would sweep away the older authority-based approach to scientific questions in favor of an empirical, investigative mode that would not only revolutionize science but also create the need for new reformations in church life. In the rise of the experimental sciences we can see, in the deepest meaning of the word, a reformation of intellectual life coming alive in the culture of the time, a reformation that would show itself to be, in time, antagonistic to the religious reforms of the first part of the century.

As a result of the translation of the Bible into the vernacular language of millions of Northern Europeans, Reformation theologians were able to stress the Scriptures as the foundation of their teachings. Luther and Calvin further encouraged lay education, urging their followers to read the Bible themselves and find there—and only there—Christian truth. In interpreting what they read, individuals were to be guided by no official religious authority but were to make their own judgment following their own consciences. This doctrine is known as "universal priesthood," because it denies a special authority to the clergy. All of these teachings, although primarily theological, were to have profound and long-range cultural impacts.

We can see that there was an intense positive and negative interaction between humanism and the Reformation—a movement energized by books in general and the Bible in particular. The intensely literary preoccupations of fourteenth- and fifteenth-century humanism provided a background and impetus for the sixteenth-century Reformation. As a philosophical and cultural system, however, humanism was in general too

optimistic and ecumenical for the more orthodox reformers. In the latter sixteenth century, humanism as a worldview found a congenial outlook in the Christian humanism of Cervantes and the gentle skepticism of Montaigne, but in Reformation circles it was used only as an intellectual instrument for other ends.

Cultural Significance of the Reformation

Cultural historians have attributed a great deal of significance to the Reformation. Some have argued, for example, that with its strong emphasis on individuals and their religious rights, the Reformation was a harbinger of the modern political world. However, with equal plausibility one could make the case that with its strong emphasis on social discipline and its biblical authoritarianism, the Reformation was the last great spasm of the medieval world. Likewise, in a famous **thesis** developed in the early twentieth century by the German sociologist Max Weber, Calvinism was seen as

the seedbed and moving force of modern capitalism. Weber's proposition has lingered in our vocabulary in phrases like "work ethic" or "Puritan ethic," although most scholars now see it as more provocative than provable. Regardless of the scholarly debates about these large questions, there are other, more clearly defined ways in which the Protestant Reformation changed the course of Western culture.

First, the Reformation gave a definite impetus to the already growing use of books in Europe. The strong emphasis on the reading and study of the Bible produced inevitable concern for increased literacy. Luther, for example, wanted education to be provided free to children from all classes in Germany.

The central place of the Bible in religious life made an immense impact on the literary culture of the time. Luther's Bible in Germany and the King James Version in England exercised an inestimable influence on the very shape of the language spoken by their readers. In other countries touched by the Reformation the literary influence of the translated Bible was absolutely fundamental. In the Scandinavian countries, vernacular literature really began with translations of the Bible. In Finland, a more extreme example, Finnish was used as a written language for the first time in translating the Bible.

The Bible was not the only book to see widespread diffusion in this period. Books, pamphlets, and treatises crisscrossed Europe as the often intricate theological battles were waged for one or another theological position. It is not accidental that the Council of Trent (1545–1564), a prime instrument of the Catholic counterreform, stringently legislated the manner in which copies of the Bible were to be translated and distributed. The fact that the infamous *Index* (a list of forbidden books) was instituted by the Catholic Church at this time is evidence that the clerical leadership recognized the immense power of books. The number of books circulating during this period is staggering. Between 1517 and 1520 (even before his break with Rome) Luther's various writings sold about three hundred thousand copies in Europe.

None of this would, of course, have been possible before the Reformation for the simple reason that printing did not exist in Europe. The invention of the printing press and movable type revolutionized Renaissance culture north and south of the Alps in the same way that films, radio, television, and the Internet changed the twentieth century [**Fig. 14.5**]. There were two important side effects. The early availability of "book learning" undermined the dominance of universities, which had acted as the traditional guardians and spreaders of knowledge. Also, Latin began to lose its position as the only language for scholarship, because many of the new readers could not read or write it. Luther grasped the implications of the spread of liter-

■ **14.5** Portion of a page from the Gutenberg Bible, 1455. Rare Books and Manuscript Division, New York Public Library. The Latin text of the Lord's Prayer (Matthew 6:9–13) begins on the fourth line with *Pater noster*. The first edition of this Bible printed at Mainz probably consisted of no more than 150 copies.

acy fully, and his use of it to advance his cause was imitated countless times in the centuries that followed.

A second cultural fact about the Reformation, closely allied to the first, is also noteworthy. The reformers placed great emphasis on the Word. Besides reading and listening there was also singing, and the reformers—especially Luther—stressed vernacular hymns. Hymns were seen as both a means of praise and an instrument of instruction. Luther was a hymn writer of note. The famous *Ein' Feste Burg Ist Unser' Gott (A Mighty Fortress Is Our God),* one of the best-loved hymns in Christianity, is generally attributed to him [**Fig. 14.6**]. The German musical tradition, which ultimately led to Johann Sebastian Bach in the seventeenth century, was very much the product of the Lutheran tradition of hymnody.

On the other hand, the sixteenth-century reformers had little need or sympathy for painting and sculpture. They were in fact militantly iconoclastic. One of the hallmarks of the first reformers was their denunciation of paintings, statues, and other visual representations as forms of papist idolatry. The net result of this iconoclastic spirit was that, by the beginning of the seventeenth century, patronage for the sacred visual arts had virtually died out in countries where the Reformation was strong. With the single exception of Rembrandt (and this exception is gigantic), it is difficult to name

any first-rate painter or sculptor who worked from a Reformation religious perspective after the sixteenth century, although much secular art was produced.

The attitude of the sixteenth-century reformers toward the older tradition of the visual arts may best be summed up by the Church of Saint Peter in Geneva, Switzerland. Formerly a Romanesque Catholic cathedral of the twelfth century, Saint Peter's became Calvin's own church. The stained glass was removed, the walls whitewashed, the statues and crucifixes taken away, and a pulpit placed where the high altar once stood. The Church of Saint Peter is a thoroughly reformed church, a building whose entire function is for the hearing of the preached and read word. Gone is the older notion (represented, for example, by the Cathedral of Chartres) of the church reflecting the otherworldly vision of heaven in the richness of its art. Reformation culture was in short an *aural,* not a *visual,* culture.

INTELLECTUAL DEVELOPMENTS

Montaigne's Essays

Michel Eyquem de Montaigne (1533–1593) came from a wealthy Bordeaux family. His father, who had been in Italy and was heavily influenced by Renaissance ideas, provided his son with a fine early education. Montaigne spoke nothing but Latin with his tutor when he was a child, so that when he went to school at age six he spoke Latin not only fluently but with a certain elegance. His later education (he studied law for a time) was a keen disappointment to him because of its pedantic narrowness. After a few years of public service,

in 1571 Montaigne retired with his family to a rural estate to write and study. He remained there, with the exception of a few years traveling and some further time of public service, until his death.

The times were not happy. France was split over the religious issue, as was Montaigne's own family. He remained a Catholic, but his mother and sisters became Protestants. Only a year after his retirement came the terrible Saint Bartholomew's Day Massacre (August 24, 1572), in which thousands of French Protestants were slaughtered in a bloodbath unequaled in France since the days of the Hundred Years' War. In the face of this violence and religious bigotry, Montaigne returned to a study of the classics and wrote out his ideas for consolation.

Montaigne's method was to write on a widely variegated list of topics gleaned either from his readings or from his own experiences. He called these short meditations **essays.** Our modern form of the essay is rooted in Montaigne's first use of the genre in Europe. The large numbers of short essays Montaigne wrote share certain qualities characteristic of a mind wearied by the violence and religious bigotry of the time: a sense of stoic calmness (derived from his study of Cicero and Seneca), a tendency to moralize (in the best sense of that abused word) from his experiences, a generous nondogmatism, a vague sense of world-weariness.

The Growth of Science

The sixteenth century was not merely a turning point in the history of religions, it was also a decisive age in the history of science. In earlier times a scientist was likely enough to be an ingenious tinkerer with elaborate

inventions who dabbled in alchemy, astrology, and magic [**FIG. 14.7**]. The new Renaissance scientist, a person of wide learning with a special interest in mathematics and philosophy, would develop bold and revolutionary ideas but always subject them to the test of practical experience [**FIG. 14.8**].

The age produced many advances in science. In England alone William Gilbert (1540–1603) discovered that the earth was a large magnet the pole of which points approximately north; Sir William Harvey (1578–1657) solved the problem of how the blood could "circulate"—get from the arteries to the veins and return to the heart—by postulating the existence of the then-undiscovered channels we now call "capillaries"; John Napier (1550–1615) discovered the practical mathematical tool called the **logarithm,** which greatly reduced the time and effort needed to solve difficult equations.

Elsewhere in Europe, the German Paracelsus (1493–1541) laid the foundations of modern medicine by his decisive rejection of traditional practices. Although his own theories were soon rejected, his insistence on observation and inquiry had important consequences, one of which can be seen in the work of Andreas Vesalius (1514–1564), who was born in Brussels and studied in Padua. Vesalius's *De humani corporis fabrica (Seven Books on the Structure of the Human Body),* published in 1543, comprise a complete anatomical treatise, illustrating in minute detail and with impressive accuracy the human form [**FIG. 14.9**].

The philosophical representative of the "new science" was Francis Bacon (1561–1626), who combined an active and somewhat disreputable political career with the writing of works intended to demolish tra-ditional scientific views. The chief of these books was the *Novum Organum (New Organon,* 1620), which aimed to free science from the two-thousand-year-old grasp of Aristotle while at the same time warning against the unrestrained use of untested hypotheses. Science and religion came into direct conflict in the work of the Polish astronomer Nicholaus Copernicus (1473–1543), who studied at the universities of Cracow and Bologna. In 1543, the same year Vesalius's work appeared, Copernicus published *De Revolutionibus orbium coelastium (On the Revolutions of Celestial Bodies),* a treatise in which he denied that the sun and the planets revolve around the earth, and reverted instead to a long-dead Greek theory that the earth and planets orbit the sun. Catholic and Protestant theologians for once found themselves united in their refusal to accept an explanation of the universe that seemed to contradict the teaching of the Bible, but Copernicus's work, though not a complete break with the past, provided stimulus for Galileo's astronomical discoveries in the following century.

Additionally, the general principle behind Copernicus's method had important repercussions for the entire history of science. Up to his time, scientists had taken the position that, with certain exceptions, reality is as it appears to be. If the sun appears to revolve about the earth, that appearance is a "given" in nature, not to be questioned. Copernicus questioned the assumption, claiming that it was equally plausible to take the earth's mobility as a given, because everything that had been explainable in the old way was fully explainable in the new (see **TABLE 14.1**). Copernicus's position on scientific matters was thus the equivalent of Luther's stand on the fallibility of the church.

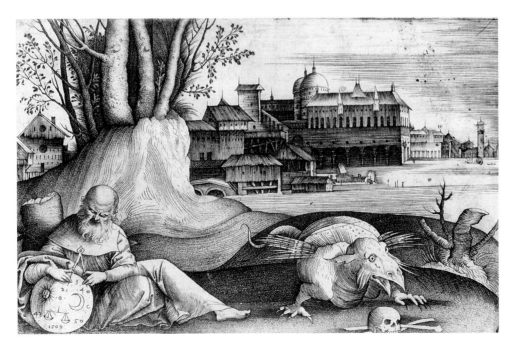

■ **14.7** Giulio Campagnola. *The Astrologer,* 1509. Engraving, 3¾″ × 6″ (9.5 × 15 cm). British Museum, London (reproduced by courtesy of the Trustees). The old-fashioned astrologer is shown with the paraphernalia of his craft, immersed in mystical speculation and apparently accompanied by his pet monster.

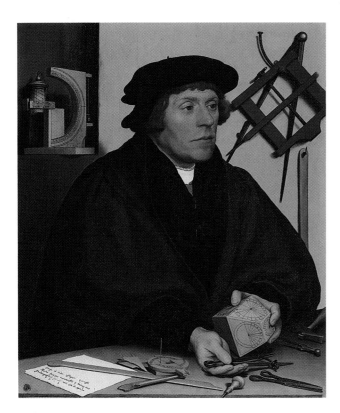

■ **14.8** Hans Holbein the Younger. *Nikolaus Kratzer,* 1528. Tempera on panel, 32″ × 26″ (83 × 67 cm). Louvre, Paris. The new scientists are represented here by Kratzer, official astronomer to the court of Henry VIII and a friend of Dürer. The tools used in the calculation he is making are devised for maximum precision, and the room in which Kratzer is working is equipped as a library.

■ **14.9** Andreas Vesalius. "Third Musculature Table" from *De humani corporis fabrica,* Brussels, 1543. National Library of Medicine, Bethesda, Maryland. Although the work was chiefly intended to have a scientific value, Vesalius has set his figure into a scene showing a landscape and, in the distance, evidence of human construction. By placing the human in the foreground, towering over the rest of the scene, Vesalius emphasizes the Humanists' view of the central importance of humanity.

THE VISUAL ARTS IN NORTHERN EUROPE

Painting in Germany: Dürer, Grünewald, Altdorfer

The conflict between Italian humanism, with its belief in human perfectibility, and the Reformation, which emphasized sin and the need for prayer, is reflected in the art of the greatest German painters of the early sixteenth century. It might even be said that the intellectual and religious battles of the times stimulated German art to its highest achievements, for both Albrecht Dürer (1471–1528) and Matthias Grünewald (c. 1470–1528) are, in very different ways, towering figures in the development of European painting. Despite his sympathy with Luther's beliefs, Dürer was strongly influenced by Italian artistic styles and, through Italian models, by Classical ideas. Grünewald, on the other hand, rejected almost all Renaissance innovations and turned instead to traditional northern religious themes, treating them with new passion and emotion. Other artists, meanwhile, chose not to wrestle with the problems of the times. Some, including

Albrecht Altdorfer (1480–1538), preferred to stand back and create a worldview of their own.

Dürer was born in Nuremberg, the son of a goldsmith. Even as a child he showed remarkable skill in drawing. His father apprenticed him to a wood engraver, and in 1494 to 1495—after finishing his training—Dürer made the first of two visits to Italy. There he saw for the first time the new technique of **linear perspective** (where all parallel lines converge at a single vanishing point) and came into contact with the growing interest in human anatomy. Quite as important as these technical discoveries, however, was his perception of a new function for the artist. The traditional German—indeed, medieval—view of the artist

TABLE 14.1 *Principal Discoveries and Inventions in the Sixteenth Century*

1486	Diaz rounds Cape of Good Hope
1492	Columbus discovers America
1493–1541	Paracelsus pioneers the use of chemicals to treat disease
1513	Balboa sights the Pacific Ocean
1516	Portuguese ships reach China
1520–1522	First circumnavigation of globe by Magellan
1530–1543	Copernicus refutes geocentric view of universe
1533	Gemma Frisius invents principle of triangulation in surveying
1542	Leonhart Fuchs publishes herbal guide to medicine
1543	Vesalius publishes anatomical treatise
1546	Agricola publishes guide to metallurgy
1569	Mercator devises system of mapmaking
1572	Tycho Brahe observes first supernova and produces first modern star catalogue
1582	Pope Gregory XIII reforms the calendar
c. 1600	First refracting telescope constructed in Holland
1600	William Gilbert publishes treatise on magnetism

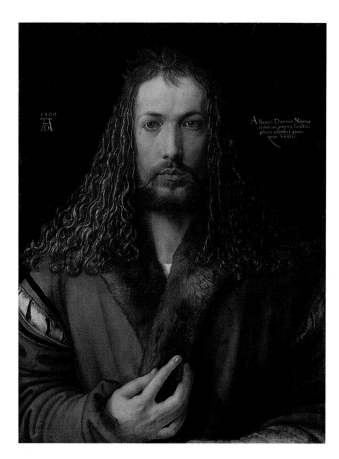

■ **14.10** Albrecht Dürer. *Self-Portrait,* 1500. Panel, 25⅝″ × 18⅞″ (64 × 48 cm). Alte Pinakothek, Munich. The frontal pose and solemn gaze convey Dürer's belief in the seriousness of his calling. The artist's characteristic signature stands to the upper left, with the date, 1500, above it.

was as an artisan whose task was humbly, if expertly, to reproduce God's creations.

Dürer adopted Renaissance humanism's concept of the artist as an inspired genius, creating a unique personal world. It is not by chance that a first glance at his *Self-Portrait* of 1500 [**FIG. 14.10**] suggests a Christlike figure rather than a prosperous German painter of the turn of the century. The effect is intentional. The lofty gaze of the eyes underlines the solemn, almost religious nature of the artist's vision, while the prominent hand draws attention to his use of the pen and the brush to communicate it to us.

In his paintings, Dürer shows a fondness for precise and complex line drawing rather than the softer use of mass and color typical of Italian art. In fact, much of his greatest work appears in the more linear **woodcuts** and **engravings.** In 1498, Dürer published a series of fifteen woodcuts illustrating the Revelation of Saint John, known as the Apocalypse series. Woodcut engravings are produced by drawing a design on a block of soft wood, then cutting away the surrounding wood to leave the lines of the drawing standing in relief. The blocks of wood can then be coated with ink and used to print an impression on paper.

In the hands of Dürer this relatively simple technique was raised to new heights of expressiveness, as in his depiction of Saint Michael's fight against the dragon from the Apocalypse series [**FIG. 14.11**]. In the upper part of the scene, Michael and other angels—all with long hair curiously like Dürer's own—do battle with a gruesome horde of fiends, while the peaceful German landscape below seems untouched by the cosmic fight in progress. Dürer's vision of an apocalyptic struggle between good and evil reflected the spirit of the time,

and copies of the Apocalypse series sold in large quantities. Growing discontent with the church was, as we have seen, one of the causes of Luther's Reformation; the general sense of forthcoming trouble and upheaval gave Dürer's woodcuts a particular aptness.

The medium of *line engraving* was also one to which Dürer brought an unsurpassed subtlety and expressiveness. Unlike a woodblock, where the artist can complete the drawing before cutting away any material, the copper plate from which a line engraving is printed has to be incised directly with the lines of the design by means of a sharp-pointed steel instrument called a **burin.** The richness of effect Dürer achieved in this extremely difficult medium, as in his engraving of *The Fall of Man (Adam and Eve)* [**FIG. 14.12**], is almost incredible. The engraving further demonstrates not only his technical brilliance but also the source of much of his artistic inspiration. The carefully shaded bodies of Adam and Eve reflect the influence of contemporary Italian ideals of beauty, while the proportions of the figures are derived from Classical literary sources. Dürer made up for the lack of actual Greek

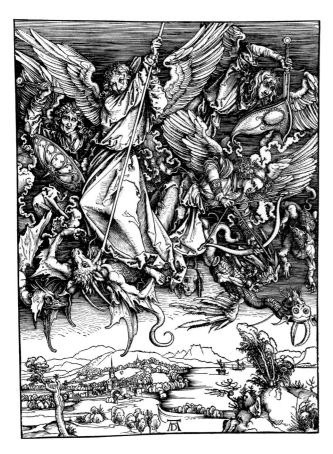

■ **14.11** Albrecht Dürer. "Saint Michael Fighting the Dragon," from the *Apocalypse* series, 1498. Woodcut, 15½″ × 11⅛″ (39 × 28 cm). British Museum, London (reproduced by courtesy of the Trustees). Note the contrast between the violence of Saint Michael's struggle in the upper part and the tranquil scene below, with the calm waters of its harbor.

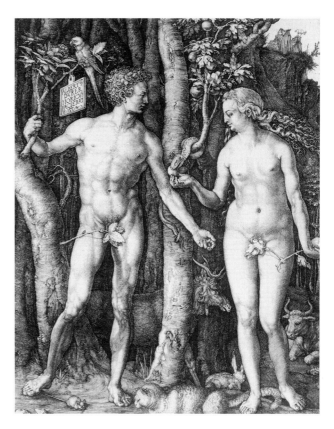

■ **14.12** Albrecht Dürer. *The Fall of Man (Adam and Eve)*, 1504. Engraving, 9⅞″ × 7⅝″ (25 × 19 cm). Centennial Gift of Landon T. Clay. Courtesy of Museum of Fine Arts, Boston. The animals represent the sins and diseases that resulted from Adam and Eve's eating of the tree of knowledge: the cat, pride and cruelty; the ox, gluttony and sloth. The detailed anatomy of the human figures marks a return to Classical models.

and Roman sculpture in Germany by a careful reading of ancient authors, from whom he derived a system of proportion for the human figure.

Dürer returned to Italy in 1505 and spent most of his two-year stay in Venice, discussing theoretical and practical aspects of Renaissance art with Bellini and other Venetian artists. It was inevitable that the rich color characteristic of Venetian painting would make an impression on him, and many of his works of this period (1505–1507) try to outdo even the Venetians in splendor.

His renewed interest in painting was, however, brief. For most of the remainder of his life he devoted himself to engraving and to writing theoretical works on art. Between 1513 and 1515, Dürer produced his three greatest engravings. The earliest of these, *Knight, Death, and the Devil* [**Fig. 14.13**], again reflects contemporary religious preoccupation with its symbolic use of the Christian knight accompanied by a dog who represents untiring devotion, and beset by the temptations of the devil (in a particularly untempting guise, it

must be admitted). Neither this fearsome creature nor the appearance of Death, armed with an hourglass, can shake the knight's steadfast gaze.

By the end of his life, Dürer was acknowledged as one of the great figures of his time. Like Luther, he used the new possibilities of the printing press to disseminate his ideas. At the time of his death, Dürer was working on *Libri IV De Humani Corporis Proportionibus (Four Books on Human Proportions)*. This work (in Latin), aimed to accomplish for art what Vesalius's did for medicine. It was inspired by two of the great intellectual concerns of the Renaissance: a return to Classical ideals of beauty and proportion, and a new quest for knowledge and scientific precision.

Although the work of Grünewald represents the other high point in German Renaissance art, little is known about his life. Only in the twentieth century did we discover his real name, Mathis Gothart Neithart; the date of his birth and the early years of his career are still a mystery. Grünewald seems to have worked for a while at the court of the Cardinal Archbishop of Mainz,

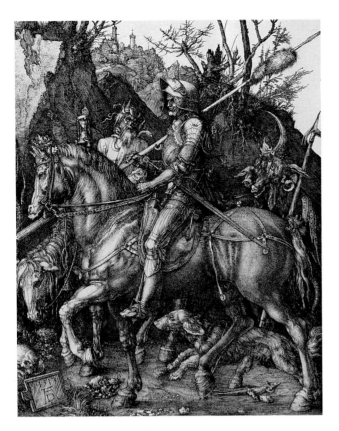

■ **14.13** Albrecht Dürer. *Knight, Death, and the Devil,* 1513. Engraving, 9⅝″ × 7⅜″ (24 × 18 cm). The Metropolitan Museum of Art, New York, Harris Brisbane Dick Fund, 1943. The knight's calm determination reflects Dürer's confidence in the ability of the devout Christian to resist temptation. This engraving may have been inspired by Erasmus's *Handbook of the Christian Knight.*

but in the 1525 Peasants' War he sided with the German peasants in their revolt against the injustices of their rulers, after which his enthusiasm for Luther's new ideas kept him from returning to the cardinal's service. He retired to Halle, where he died in 1528.

What we know about his political and religious sympathies—his support for the oppressed and for the ideals of the Reformation—is borne out by the characteristics of his paintings. Unlike Dürer, Grünewald never visited Italy and showed no interest in the new styles developed there. The Renaissance concept of ideal beauty and the humanist interest in Classical antiquity left him unmoved. Instead, he turned repeatedly to the traditional religious themes of German medieval art, bringing to them a passionate, almost violent intensity that must at least in part reflect the religious heart-searchings of the times. Yet it would be a mistake to view Grünewald's unforgettable images as merely another product of the spirit of the age, for an artist capable of so unique and personal a vision is in the last analysis inspired by factors that cannot be explained in historical terms. All that can safely be said is that no artist, before or since, has depicted the Cru-

cifixion as a more searing tragedy or Christ's Resurrection as more radiantly triumphant.

Both of these scenes occur in Grünewald's greatest work, the Isenheim Altarpiece (completed in 1515), which was commissioned for the church of a hospital run by members of the Order of Saint Anthony. The folding panels are painted with scenes and figures appropriate to its location, including saints associated with the curing of disease and events in the life of Saint Anthony. In particular, the patients who contemplated the altarpiece were expected to meditate on Christ's Crucifixion and Resurrection and derive from them comfort for their own sufferings.

In his painting of Christ in the *Crucifixion* panel [**FIG. 14.14**], Grünewald uses numerous details to depict the intensity of Christ's anguish—from his straining hands frozen in the agony of death, to the thorns stuck in his festering body, to the huge iron spike that pins his feet to the cross.

It is difficult to imagine anything further from the Italian Renaissance and its concepts of ideal beauty than this tortured image. Grünewald reveals an equal lack of interest in Renaissance or Classical theories of proportion or perspective. The figure of Christ, for example, is not related in size to the other figures—it dominates the panel—as a glance at the comparative size of the hands will show. Yet the sheer horror of this scene only throws into greater relief the triumph of the Resurrection [**FIG. 14.15**]. Christ seems almost to have exploded out of the tomb in a great burst of light that dazzles the viewers as well as the soldiers stumbling below. No greater contrast can be imagined than that between the drooping body on the cross and this soaring, weightless image that suggests a hope of similar resurrection to the sufferers in the hospital.

The drama of Grünewald's spiritual images is in strong contrast to the quiet, poetic calm of the work of Albrecht Altdorfer. Although closer in style to Grünewald than to Dürer, Altdorfer found his favorite subject not in religious themes but in landscapes. *Danube Landscape Near Regensburg* [**FIG. 14.16**], probably dating from around 1525, is one of the first examples in the Western tradition of a painting without a single human figure. From the time of the Greeks, art had served to tell a story—sacred or secular—or to illustrate some aspect of human behavior. Now for the first time the contemplation of the beauties of nature was in itself deemed a worthy subject for an artist. In this painting, Altdorfer depicts a kind of ideal beauty very different from Dürer's *The Fall of Man* (see Figure 14.12) but no less moving. Part of his inspiration may have come from the landscapes that can be seen in the background of paintings by Venetian artists like Giorgione, although there is no evidence that Altdorfer ever visited Italy. Even if he had, his sympathy with the forces of nature, its light and scale and sense of life, seems more directly inspired by actual contact.

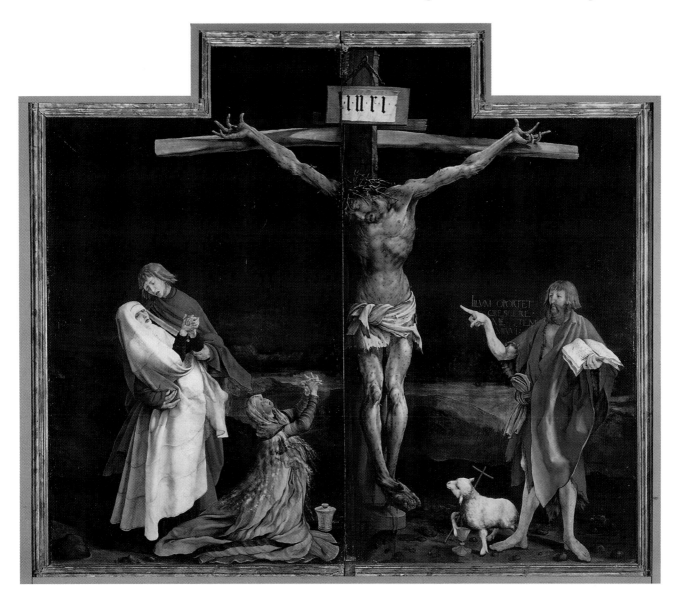

■ **14.14** Matthias Grünewald. *Crucifixion* from the Isenheim Altarpiece (exterior), completed 1515. Panel (with framing) 9′9½″ × 10′9″ (2.98 × 3.28 m). Musée d'Unterlinden, Colmar. Behind Mary Magdalene, who kneels in grief, stand Mary and John; on the other side, John the Baptist points to Christ's sacrifice. Beside him, in Latin, are inscribed the words, "He must increase, but I must decrease." Above Christ are the initial letters of the Latin words meaning "Jesus of Nazareth, King of the Jews."

PAINTING IN THE NETHERLANDS: BOSCH AND BRUEGEL

The two greatest Netherlandish painters of the Renaissance, Hieronymus Bosch (c. 1450–1516) and Pieter Bruegel (1525–1569), are linked both by their pessimistic view of human nature and by their use of satire to express it. Bosch furthermore drew on an apparently inexhaustible imagination to create a fantasy world that alternately fascinates and repels as the eye wanders from one bizarre scene to another. Although modern observers have interpreted Bosch's work in a variety of ways, it is generally agreed that, contrary to appearances, he was in fact a deeply religious painter. His chief subject is human folly in its innumerable forms, his theme that the inevitable punishment of sin is Hell. Salvation is possible through Christ, but few, according to Bosch, have the sense to look for it. His paintings show us the consequences.

Almost nothing is known of Bosch's life, so his body of work must speak for itself. The most elaborate in its fantasy is a **triptych** (a three-paneled painting) known as the *Garden of Earthly Delights* [**FIG. 14.17, 14.17A**], which was probably finished around 1510. Into it are crowded hundreds of nude figures engaged in activities that range from the unimaginable to the indescribable, all in pursuit of erotic pleasure. The movement from the apparently innocent scene of the creation of Eve on the left to the fires of hell on the right

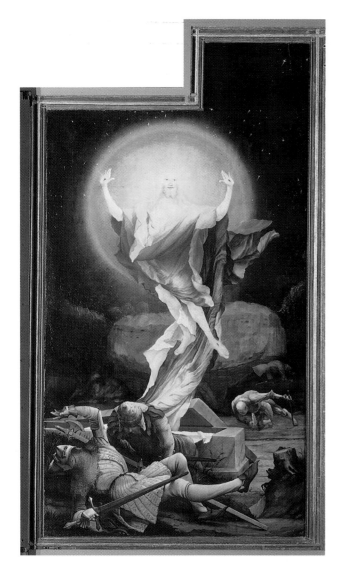

■ **14.16** Albrecht Altdorfer. *Danube Landscape Near Regensburg*, c. 1522–1525. Panel, 11″ × 8⅝″ (28 × 22 cm). Alte Pinakothek, Münich. The only traces of human existence here are the road and the distant castle to which it leads.

■ **14.15** Matthias Grünewald. *Resurrection* from the Isenheim Altarpiece (first opening). Completed 1515. Panel, 8′2½″ × 3′1½″ (2.45 × .93 m). Musée d'Unterlinden, Colmar. Note the absence of any natural setting and the confused perspective, which give the scene an otherworldly quality. The artist contrasts the soaring figure of Christ with the soldiers tumbling down in shock at the vision.

illustrates Bosch's belief that the pleasures of the body lead to damnation along a road of increasing depravity. Even in the Garden of Eden we sense what is to come, as Adam sits up with excited enthusiasm on being presented with the naked Eve, while God seems to eye him nervously.

The bright world of the middle panel, in which the pallid, rubbery figures seem to arrange themselves (and one another) in every conceivable position and permutation, gives way on the right to a hallucinatory vision of eternal damnation. Bosch's symbolism is too complex and too private to permit a detailed understanding of the scene, yet his general message is clear enough: Hell is not terrifying so much as it is sordid and pathetic. The frantic scenes of activity are as senseless and futile as those of worldly existence, but in hell their monstrous nature becomes fully apparent.

The sources of Bosch's inspiration in this and his other work are unknown. Many of his demons and fantastic animals seem related to similar manifestations of evil depicted in medieval art, but no medieval artist ever devised a vision such as this or possessed the technique to execute it. To modern eyes some of Bosch's creations, like the human-headed monster on the right-hand panel turning both face and rear toward us, seem to prefigure the surrealist art of the twentieth century. There is a danger, however, in applying labels from the art of later times to that of an earlier period. Bosch must be allowed to stand on his own as one of the great originals in the history of painting.

Pieter Bruegel, often called the Elder to distinguish him from his son of the same name, represents the culmination of Renaissance art in the Netherlands. Like Bosch, his work is often fantastic, and his crowded canvases are frequently filled with scenes of grotesque activity. Some of his paintings suggest that he shared Bosch's view of the apparent futility of human existence and the prevalence of sin. In many of his pictures, however, the scenic backgrounds reveal a love and understanding of nature very different from

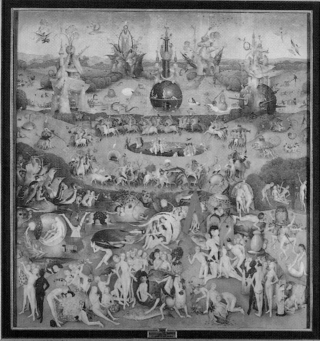

■ **14.17** Hieronymus Bosch. *Garden of Earthly Delights,* c. 1505–1510. Panel center 7′2⅝″ × 6′4¾″ (2.2 × 1.95 m), each wing 7′2⅝″ × 3′2¼″ (2.2 × .97 m). Prado, Madrid. Perhaps surprisingly, this catalog of the sins of the flesh was among the favorite works of the gloomy King Philip II of Spain.

■ **14.17a** Hieronymus Bosch. *Garden of Earthly Delights,* c. 1505–1510. Panel detail. Right wing 7′2⅝″ × 3′2½″ (2.2 × .97 m). Prado, Madrid. Note the violence of the imagery in Bosch's Hell. A lute and harp, symbols of heavenly music, are used as instruments of torture, while below a gambler is pinned to his table. Meanwhile, in the background, the fires of Hell blaze.

Bosch's weird worldview and represent one of the keys to understanding his work. For Bruegel, the full range of human activity formed part of a world in which there existed an underlying order. The beauty of nature forms the background not only to his pictures but actually to the lives of us all, he seems to say; by seeing ourselves as part of the natural cycle of existence we can avoid the folly of sin. If this interpretation of his work is correct, it places Bruegel with the humanists who believed in the possibilities for human good, and some evidence suggests that his friends did include members of a group of humanist philosophers active at Antwerp.

Although Bruegel's best-known paintings are scenes of peasant life, it is a mistake to think of him as unsophisticated. On the contrary, during the final years of his life, which he spent in Brussels, he was familiar with many of the leading scholars of the day and seems to have been a man of considerable culture. He certainly traveled to Italy, where he was apparently unaffected by the art but deeply impressed by the beauty of the landscape. Back home, he may well have supported the move to free the Netherlands from

Spanish rule; some of his paintings seem to contain allusions to Spanish cruelties.

Bruegel's vision is so rich and understanding of the range of human experience that it almost rivals that of Shakespeare, who was born in 1564, five years before Bruegel's death. In his great painting *The Triumph of Death* [**Fig. 14.18**], Bruegel looks with uncompromising honesty at the universal phenomenon of death, which comes eventually to all: rich and powerful or poor and hopeless. Unlike Bosch, who reminds us that the righteous (if there are any) will be saved, Bruegel seems to offer no hope. Yet the same artist painted the *Peasant Wedding Feast* [**Fig. 14.19**], a scene of cheerful celebration. True, Bruegel's peasants find pleasure in simple rather than sophisticated delights, in this case chiefly food and drink, but he reminds us that some are luckier than others. The little boy in the foreground, so completely engrossed in licking up every last delicious morsel of food, is counterbalanced by the bagpiper who looks wistfully and wanly over his shoulder at the tray of pies nearby. Nor should we be too hasty to view Bruegel's peasants as unthinking creatures, content with

a brutish existence. The bride certainly does not seem either bright or beautiful, but she radiates happiness, and the general air of merriment is attractive.

Bruegel's most profound statements are perhaps to be found in a cycle of paintings intended to illustrate the months of the year, rather like the *Très Riches Heures* of the Limbourg brothers a century earlier (not shown). Bruegel completed only five, including the magnificent *Hunters in the Snow* (1565) [**Fig. 14.20**]. In the background tower lofty peaks representing Bruegel's memory of the Alps, seen on his trip to Italy. From the weary hunters in the foreground, a line of barren trees leads the eye to fields of snow where peasants are hard at work. The scene can hardly be called a happy one, but neither is it unhappy. There is an inevitability in the way humans, animals, birds, and nature are all bound together into a unity, expressive of a sense of order and purpose. The lesson of Italian humanism has been translated into a very different language, spoken with a highly individual accent, but Bruegel's northern scene seems in its own way inspired by a similar regard for human dignity.

■ **14.18** Pieter Bruegel the Elder. *The Triumph of Death,* c. 1562–1564. Oil on panel, 3′10″ × 5′3¾″ (1.17 × 1.62 m). Prado, Madrid. Note the huge coffin on the right into which the dead are being piled, guarded by rows of skeleton-soldiers. Nobody is spared, not even the king in the lower left-hand corner.

▪ **14.19** Pieter Bruegel the Elder. *Peasant Wedding Feast,* 1566–1567. Oil on panel, 3′8⅞″ × 5′4⅛″ (1.14 × 1.63 m). Kunsthistorisches Museum, Vienna. The composition of this painting is based on the diagonal line of the receding table that leads the eye past the bride and the bagpiper to the back of the room. The small boy in the foreground, licking his fingers, is a typical example of Breugel's ability to make his scenes come to life.

ART AND ARCHITECTURE IN FRANCE

France of the sixteenth century bears little resemblance to the artistic achievements of Germany and the Netherlands. The influence of Italian art on France was so strong, due in great part to the actual presence at the French court of Italian artists, that French painting was almost completely overwhelmed. The only native artist of note was Jean Clouet (c. 1485–1541), who was retained by Francis I chiefly to serve as his official portrait painter. Among the many portraits of the king attributed to Clouet is one of around 1530 [**FIG. 14.21**] that does full justice to the sensual but calculating character of his master.

More interesting than French painting during the sixteenth century is French architecture. The series of luxurious châteaux that Francis I had built along the valley of the river Loire combined the airiness of the earlier French Gothic style with decorative motifs imported from Italian Renaissance architecture. The result was buildings like the beautiful Château de Chambord [**FIG. 14.22**].

The love of decoration shown by the builders of Chambord emerges even more strongly as a feature of French architectural style in the design of the Square Court of the Louvre [**FIG. 14.23**]. This structure was begun in 1546 by the architect Pierre Lescot (1510–1578) and the sculptor Jean Goujon (c. 1510–1568), working for once without Italian guidance. The façade of the court is a compendium of Classical forms, from the window moldings to the Corinthian columns to the decorative motifs. The total effect, however, is very different from Italian buildings using the same features. Instead of being grand or awe-inspiring, the building seems graceful and harmonious, perhaps even a little fussy, and the emphasis on decoration became a prominent characteristic of French art in the following two centuries.

■ **14.20** Pieter Bruegel the Elder. *Hunters in the Snow,* 1565. Oil on wood. Approx. 46″ × 64″ (116.8 × 162.6 cm). Kunsthistorisches Museum, Vienna. Note Bruegel's careful use of color to suggest a cold, clear, sunless day. From his first crossing of the Alps in the 1530s, Bruegel was inspired by mountain scenery, and it reappeared throughout his work. In this painting, the panoramic sweep from the foreground to the lofty peaks behind makes the scene appear a microcosm of human existence. Thus Bruegel's "world landscapes" or *Weltlandsschaften* are both literal depictions of scenes from nature and symbolic representations of the relationship between human beings and the world around them.

ART IN ELIZABETHAN ENGLAND

Throughout the sixteenth century, English political and cultural life followed a path notably different from that of continental Europe, as it did so often in its previous history. The social unrest that had marked the latter Middle Ages in England was finally ended in 1485 by the accession of Henry VII, the first king of the Tudor Dynasty. For the entire sixteenth century, England enjoyed a new stability and commercial prosperity on the basis of which it began to play an increasingly active role in international politics. Henry VIII's final break with the Catholic Church in 1534 led to the later development of ties between England

■ **14.21** Jean Clouet. *Francis I,* c. 1525–1530. Tempera and oil on wood. Approx. 38″ × 29″ (96 × 74 cm). Louvre, Paris. This famous work is now thought to be by an unknown artist rather than by Clouet, but its style is similar to that of his many official portraits of the king. For all the apparent relaxation of the king's pose, his hand is on the handle of his dagger, ready for use.

■ **14.22** Château de Chambord, France, begun 1519. The turrets and pinnacles are reminiscent of French medieval architecture: compare the background on the "May" page of the *Tres Riches Heures* (11.19). The central block, though, and much of the decorative detail suggest Italian Renaissance models.

■ **14.23** Pierre Lescot and Jean Goujon. Façade of the Square Court of the Louvre, Paris, begun 1546. The architectural and sculptural decoration is Italian in origin but used here as typically French elaborate ornamentation. On the first floor, the use of arches is reminiscent of ancient Roman architecture.

and the other countries of the Reformation, particularly the Netherlands. When years of tension between the Netherlanders and their Spanish rulers finally broke out into open rebellion, England (then ruled by Queen Elizabeth I) supplied help secretly. Relations between Elizabeth and Spanish King Philip II were already strained, and English interference in the Spanish Netherlands was unlikely to help. In 1585, a new Spanish campaign of repression in the Netherlands, coupled with the threat of a Spanish invasion of England, drove the queen to resort to more open action—she sent six thousand troops to fight alongside the Netherlanders. Their presence proved decisive.

Philip's anger at his defeat and at the progress of the campaign for an independent Netherlands was turned in fury against England. The massive Spanish Armada—the largest fleet the world had ever seen—was ready early in 1588 and sailed majestically north, only to be met by a fleet of lighter, faster English ships commanded by Sir Francis Drake. The rest is part history, part legend. Even before the expedition sailed, Drake had "singed the beard of the King of Spain" by sailing into Cadiz harbor and setting fire to some of the Spanish galleons anchored there. What was left of the Armada reached the English Channel, where it was destroyed, partly by superior English tactics and partly by a huge storm promptly dubbed (by the victors, at least) the "Protestant Wind." The subsequent tales told of English valor and daring brought a new luster to the closing years of the Elizabethan Age [**FIG. 14.24**]. In view of England's self-appointed position as bulwark of Protestantism against the Catholic Church in general and Spain in particular, it is hardly surprising that Renaissance ideas developed south of the Alps took some time to affect English culture. Few Italian artists were tempted to work at the English court or, for that matter, were likely to be invited. Furthermore, England's geographic position inevitably cut it off from intellectual developments in continental Europe and produced a kind of psychological insularity that was bolstered in the late sixteenth century by a wave of national pride. The finest expression of this is probably to be found in the lines William Shakespeare put into the mouth of John of Gaunt in Act II, scene I of *Richard II,* a play written some six years after the defeat of the Spanish Armada:

> This royal throne of kings, this sceptered isle,
> This earth of majesty, this seat of Mars,
> This other Eden, demi-Paradise,
> This fortress built by Nature for herself
> Against infection and the hand of war,
> This happy breed of men, this little world,
> This precious stone set in the silver sea,
> Which serves it in the office of a wall
> Or as a moat defensive to a house
> Against the envy of less happier lands—
> This blessed plot, this earth, this realm,
> this England. . . .

■ **14.24** Nicholas Hilliard (?). *Ermine Portrait of Queen Elizabeth I,* 1585. Oil on canvas, 41¾″ × 35″ (106 × 89 cm). Hatfield House, England (collection of the Marquess of Salisbury). The ermine on the queen's sleeve is a symbol of virginity. The portrait as a whole is a symbol of her majesty, not intended to show her actual appearance.

On the other hand, the same spirit of nationalism was bound to produce a somewhat narrow-minded rejection of new ideas from outside. English sculpture and painting suffered as a result. The only foreign painter to work in England was a northerner, Hans Holbein the Younger (1497/98–1543), whose portrait of Henry VIII appears earlier in this chapter (see Figure 14.4). A magnificent portraitist, Holbein was sent by Henry to paint prospective brides so that the king could make his choice with at least some idea of their appearance—an effective if rather tedious method before photography. It must be added that the artist seems to have done his work rather too well, since his picture of *Anne of Cleves* [**FIG. 14.25**] inspired Henry to marry the princess only to divorce her within six months, contemptuously dismissing her as his "Flanders Mare."

Apart from Holbein, English artists were virtually cut off from the new ideas current elsewhere. The only English painter of note during the sixteenth century was Nicholas Hilliard (1547–1619), best known for his miniatures, small portraits often painted in watercolor. The finest is of an unidentified young man who has something of the poetic melancholy of a Shakespearean lover [**FIG. 14.26**]. When Hilliard turned to larger works, specifically to portraits of Queen Elizabeth, he was inevitably inhibited by his monarch's demand for a

■ **14.25** Hans Holbein the Younger. *Anne of Cleves,* c. 1539–1540. Vellum applied to canvas, 25⅝″ × 18⅞″ (65 × 48 cm). Louvre, Paris. After viewing this portrait, Henry VIII sent for Anne of Cleves and made her his fourth queen. Note the formal pose and suitably modest downturned gaze.

painting that would look regal and imposing rather than realistic. The result, *Ermine Portrait of Queen Elizabeth I* (see Figure 14.24), is a symbolic representation of majesty rather than a mere portrait.

MUSIC OF THE NORTHERN RENAISSANCE

As in the visual arts, the Renaissance produced major stylistic changes in the development of music, but, in general, musical development in the Renaissance was marked by a less severe break with medieval custom than was the case with the visual arts. Although sixteenth-century European composers began to increase the complexity of their style, frequently using polyphony, they continued to use forms developed in the High Middle Ages and the early Renaissance. In religious music, the motet remained popular, set to a religious text. Composers also continued to write *madrigals* (songs for three or more solo voices based generally on secular poems). For the most part these were intended for performance at home, and elaborate, interweaving polyphonic lines often tested the skill of the singers. The difficulty of the parts often made it necessary for the singers to be accompanied instrumentally. This increasing complexity produced a significant change in the character of madrigals, which were especially popular in Elizabethan England. Nonetheless, sixteenth-century musicians were recognizably the heirs of their thirteenth- and fourteenth-century predecessors.

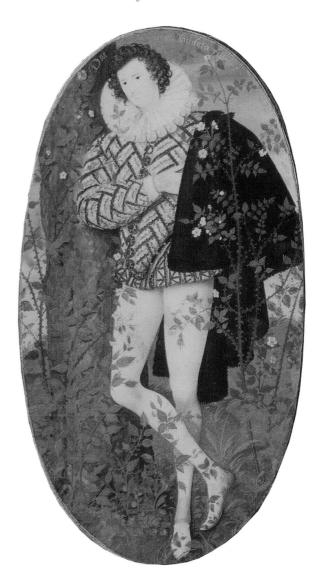

■ **14.26** Nicholas Hilliard. *Portrait of a Youth,* c. 1590. Parchment, 5⅜″ × 2¾″ (14 × 7 cm). Victoria and Albert Museum, London, Crown copyright. The thorns of the wild rose growing in the foreground may represent friendship in adversity. (The miniature is shown here at almost its actual size.)

Music in France and Germany

The madrigal form was originally devised in Italy for the entertainment of courtly circles. By the early sixteenth century, French composers, inspired by such lyric poets as Clement Marot (1496–1544), were writing

more popular songs known as **chansons.** The best-known composer of chansons was Clement Janequin (c. 1485–c. 1560), who was famous for building his works around a narrative program. In "La Guerre" ("The War") the music imitates the sound of shouting soldiers, fanfares, and rattling guns; other songs feature street cries and birdsong. Frequently repeated notes and the use of nonsense syllables help give Janequin's music great rhythmic vitality, although it lacks the harmonic richness of Italian madrigals.

The same tendency to appeal to a general public characterized German and Flemish songs of the period with texts that were Romantic, military, or sometimes even political in character. Among the great masters of the period was the Flemish composer Heinrich Isaac (c. 1450–1517), who composed songs in Italian and French as well as in German. His style ranges from simple chordlike settings to elaborately interweaving lines that imitate one another. Isaac's pupil, the German Ludwig Sendl (c. 1486–c. 1542), was, if anything, more prolific than his teacher; his music is generally less complex and graceful—almost wistful—in mood.

Elizabethan Music

English music suffered far less than the visual arts from the cultural isolationism of Elizabethan England; the Elizabethan Age, in fact, marks one of the high points in its history. Almost two hundred years earlier, the English musician John Dunstable (c. 1385–1453) had been one of the leading composers in Europe. By bringing English music into the mainstream of continental developments, Dunstable helped prepare the way for his Elizabethan successors. Several other factors were also responsible for the flourishing state of English music.

To begin with, in England there had always been a greater interest in music than in the visual arts. Also, the self-imposed ban on the importation of foreign artworks and styles did not extend to printed music, with the result that by the early years of the reign of Elizabeth, Italian secular music began to circulate in English musical circles. A volume of Italian songs in translation was published in 1588 under the title *Musica Transalpina (Music from Across the Alps).*

As for sacred music, when Henry VIII broke away from the pope he was not at all ready to convert wholeheartedly to Lutheranism or Calvinism and discard those parts of the liturgy that were sung. The services, psalms, and hymns the new Anglican Church had to devise generally (although by no means invariably) used English rather than Latin texts, echoing Luther's use of the vernacular, but continued for the most part to follow Catholic models. Thus, when the first official version of the English Litany was issued in 1544 by Archbishop of Canterbury Thomas Cranmer,

it used the traditional Gregorian chant, simplified so that only one note was allocated to each syllable of the text. This innovation preserved the flavor of the original music, while making it easier for a listener to follow the meaning of the words and thereby participate more directly in the worship. The tendency to simplify is also visible, literally [**FIG. 14.27**], in the first published musical setting of the words of *The Boke of Common Praier Noted (The Book of Common Prayer Set to Music),* which appeared in 1549. This first musical edition by John Merbecke (c. 1510–c. 1585) again used only one note for each syllable, and his settings followed the normal accentuation of the English words. This work is still used by the Episcopal Church.

In more elaborate music the effects of the Reformation were even less evident. Most of the professional composers of the day had after all been brought up in a Catholic musical tradition, and while the split with Rome affected religious dogma (and permitted Henry to marry and divorce at will), it did not alter their freedom to compose religious music as they wished. They continued to write pieces that alternated and combined the two chief styles of the day: blocks of chords in which every voice moved at the same time and the elaborate interweaving of voices known as **counterpoint.**

The musical forms also remained unchanged except in name. Among the most popular compositions throughout Europe were motets, the words of which were often in Latin. English composers continued to write works of this kind but used English texts and called them **anthems.** A piece that used the full choir throughout was called a *full anthem* and one containing passages for solo voice or voices a *verse anthem.* English musicians nevertheless did not entirely abandon the

■ **14.27** John Merbecke. *The Boke of Common Praier Noted.* British Library, London (reproduced by courtesy of the Trustees). The Lord's Prayer is on the left page and part of the right page. The words are in English, but note the Latin title "Agnus Dei" ("Lamb of God") retained on the right page.

use of Latin. Some of the greatest figures of the period continued to write settings of Latin texts as well as ones in the vernacular.

The dual nature of Elizabethan music is well illustrated by the career of Thomas Tallis (c. 1505–1585), who spent more than forty years of his life as organist of the Chapel Royal at the English court. Although his official duties required him to compose works for formal Protestant occasions, he also wrote Latin motets and Catholic masses. Tallis was above all a master of counterpoint, bringing the technique of combining and interweaving several vocal lines to a new height of complexity in one of his motets, *Spem in Alium (Hope in Another),* written for no less than forty voices, each moving independently. In his anthems, however, he adopted a simpler style with a greater use of chord passages, so that the listener could follow at least part of the English text. His last works combine both techniques to achieve a highly expressive, even emotional effect, as in his setting of the *Lamentations of Jeremiah.*

Among Tallis's many pupils was William Byrd (c. 1543–1623), the most versatile of Elizabethan composers and one of the greatest in the history of English music. Like Tallis, he produced both Protestant and Catholic church music, writing three Latin masses and four English services, including the so-called Great Service for five voices. Byrd also composed secular vocal and instrumental music, including a particularly beautiful elegy for voice and strings, *Ye Sacred Muses,* inspired by the death of Tallis. The concluding bars, setting the words "Tallis is dead and music dies," demonstrate his ability to achieve considerable emotional pathos with simple means, in this case the rise of an octave in the next-to-last bar:

And mu———————— sic dies, And— mu— sic dies.

Much of Byrd's instrumental music was written for the **virginal,** an early keyboard instrument in the form of an oblong box small enough to be placed on a table or held in the player's lap. It was once believed that the instrument was so-called because of its popularity at the court of Elizabeth, the self-styled Virgin Queen, but references have been found to the name before her time, and its true origin is unknown. Forty-two pieces written for the virginal by Byrd were copied down in 1591 in an album known as *My Ladye Nevells Booke.* They include dances, variations, and fantasias and form a rich compendium of Byrd's range of style.

Byrd also wrote madrigals. The madrigal began in Italy, where the words were as important as the music, and Italian composers often chose poems that reflected the Renaissance interest in Classical antiquity. The English madrigal was less concerned with Renaissance ideas of refinement than with the expression of emo-

tional extremes. Many of the madrigals of Thomas Morley (1557–1602) are lighthearted in tone and fast moving, using refrains such as "Fa-la-la." Among the best known are settings of popular verses rather than literary texts: "Sing We and Chaunt It" and "Now Is the Month of Maying." These were not intended for an elite but for domestic performance by an increasingly prosperous middle class. Other madrigals were more serious, even mournful. Both Morley and his younger contemporary Thomas Weelkes (c. 1575–1623) composed madrigals in memory of Henry Noel, an amateur musician who was a favorite at the court of Queen Elizabeth. Weelkes's piece "Noel, Adieu" is striking for its use of extreme dissonance to express grief. In the following bars, the clash of C against C# seems strikingly modern in its harshness:

 To hear a performance of "Now Is the Month of Maying," play track 5 on the Listening CD.

The most melancholy works of all Elizabethan music are the **ayres** (simple songs for one voice accompanied by either other voices or instruments) of John Dowland (1562–1626)—the rare example of an Elizabethan musician who traveled widely. Irish by birth, Dowland visited France, Germany, and Italy and even worked for a while at the court of King Christian IV of Denmark; ultimately, he settled in England.

Dowland was the greatest virtuoso of his day on the lute (a plucked string instrument that is a relative of the guitar), and he used it to accompany his ayres. Dowland's gloomy temperament was given full expression both in the ayres and in his solo pieces for lute, most of which are as obsessively depressed and woeful as Morley's madrigals are determinedly cheerful. Popular in his own day, in more recent times Dowland's music has undergone something of a revival with the growth of interest in the guitar and other similar instruments.

English Literature: Shakespeare

English literature in the sixteenth century, unlike the visual arts and to a greater extent even than music, was strongly affected by new currents of Renaissance thought. One reason for this is purely practical. Soon after the invention of printing in Germany (see Figure 14.5), William Caxton (c. 1421–1491) introduced the

printing press into England and, during the first half of the sixteenth century, books became increasingly plentiful and cheap. With the spread of literature an increased literacy developed, and the new readers were anxious to keep in touch with all the latest ideas of their day. The development of humanism in England undoubtedly influenced Erasmus of Rotterdam, who was brought into contact with humanist ideas during his visits there. In addition to teaching at Cambridge, Erasmus formed a warm personal friendship with the English statesman Sir Thomas More (1478–1535), who became Lord Chancellor in 1529.

More's *Utopia,* a philosophical romance in Latin describing an ideal world resembling that of Plato's *Republic,* was written under Erasmus's influence and was firmly based on humanistic ideals. Once introduced, these ideas caught on, and so did the use of Classical or Italian models to express them. Sir Philip Sidney (1554–1586), the dashing youth who has been described as Castiglione's courtier come to life, wrote a series of sonnets in imitation of Petrarch, and a romance, *Arcadia,* of the kind made popular in Italy by Lodovico Ariosto (1474–1533). Edmund Spenser (1552–1599), the greatest nondramatic poet of Elizabethan England, was also influenced by Ariosto and by Torquato Tasso (1544–1595), Ariosto's Italian successor in the production of massive epic poems. In *The Faerie Queene,* Spenser combined the romance of Ariosto and the Christian allegory of Tasso to create an immensely complex epic. Its chivalrous hero, the Knight of the Red Cross, represents both Christianity and, through his resemblance to Saint George, England. At the same time, the tests he undergoes make him a Renaissance version of the medieval figure of Everyman. The epic takes place in the imaginary land of Faerie, where the knight's path is frequently blocked by dragons, witches, wizards, and other magical creatures. All of this mythological paraphernalia not only advances the plot but also provides a series of allegorical observations on moral and political questions of the day. The result has, in general, been more admired than read.

The greatest of all English achievements in the Renaissance were in drama. The Classical models of English drama were the Latin tragedies of Seneca and the comedies of Plautus and Terence, which, with the introduction of printing, became more frequently read and performed. These ancient Roman plays created a taste for the theater that English dramatists began to satisfy in increasing quantities. At the same time, the increasing prosperity and leisure that created a demand for new madrigals produced a growing audience for drama. To satisfy this audience, traveling groups of actors began to form, often attaching themselves to the household of a noble who acted as their patron. These companies gave performances in public places, especially the courtyards of inns. When the first permanent theater buildings were constructed, their architects imitated the form of the inn courtyards, with roofs open to the sky and galleries around the sides. The stage generally consisted of a large platform jutting out into the center of the open area known as the **pit** or **ground** [FIG. 14.28].

The design of these theaters allowed—indeed encouraged—people of all classes to attend performances regularly because the price of admission varied for different parts of the theater. The more prosperous spectators sat in the galleries, where they had a clear view of the stage, while the poorer spectators stood on the ground around the stage. Dramatists and actors soon learned to please these so-called **groundlings** by appealing to their taste for noise and spectacle.

Not all performances were given in public before so democratic an audience. The most successful companies were invited to entertain Queen Elizabeth and her court. The plays written for these state occasions were generally more sophisticated in both content and style than those written for the general public. The works written for the court of James I, Elizabeth's successor, are among the most elaborate of all. In general, English drama developed from a relatively popular entertainment in the mid-sixteenth century to a more formal artificial one in the early seventeenth century. It is probably no coincidence that the greatest of all Elizabethan dramatists, Shakespeare and Marlowe, wrote their best works at about the midpoint in this development, from about 1590 to 1610. Their plays reflect the increasing appreciation and demand for real poetry and high intellectual content without losing the "common touch" that has given their work its continual appeal.

Christopher Marlowe (1564–1593) was born two months before Shakespeare. Had he not been killed in a fight over a tavern bill at age twenty-nine, he might well have equaled Shakespeare's mighty achievements. It is certainly true that by the same age Shakespeare had written relatively little of importance, whereas Marlowe's works include the monumental two-part *Tamburlaine,* a vast tragic drama that explores the limits of human power; exuberant erotic verse like his *Hero and Leander;* and his greatest masterpiece, *Dr. Faustus.* Marlowe's use of blank verse for dramatic expression was imitated by virtually every other Elizabethan playwright, including Shakespeare. It consists of nonrhyming iambic pentameter lines of five metrical feet in which each foot has two syllables, and the second foot generally bears the rhythmic stress. In style, Marlowe's work reflects the passion and violence of his own life, with heroes striving to achieve the unachievable by overcoming all limits, only to be defeated by destiny.

Regret at the loss of what Marlowe might have written had he lived longer is balanced by gratitude for the many works William Shakespeare (1564–1616) left us. Shakespeare [FIG. 14.29] is universally acknowledged as the greatest writer in the English language,

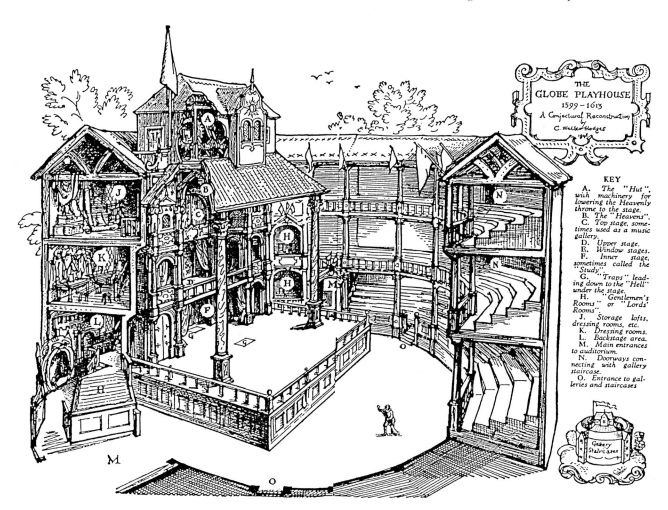

■ **14.28** The Globe Playhouse, London, 1599–1613. This conjectural reconstruction by C. Walter Hodges shows the playhouse during the years when *Hamlet, King Lear,* and other Shakespearean plays were first performed there.

and one of the greatest in any tongue. His position is best summarized in the words of his leading contemporary and rival playwright Ben Jonson (1572–1637): "He was not of an age, but for all time!"

Surprisingly little is known about Shakespeare's life. He was born at Stratford-upon-Avon; his early years and education seem to have been typical of provincial England, although no details are known. In 1582, he married Anne Hathaway, and over the following three years the couple had three children. By 1592, Shakespeare was established in London as an actor and playwright. Exactly how he became involved in the theater and what he did from 1585 to 1592 remain a mystery. From the beginning of his time in London, Shakespeare was associated with the leading theatrical company of the day—the Lord Chamberlain's Men—which changed its name to the King's Men at the accession of James I in 1603.

Shakespeare's earliest plays followed the example of Classical models in being carefully constructed, although their plots sometimes seem unnecessarily overcomplicated. In *The Comedy of Errors* (1592–1593), for example, Shakespeare combined two plays by the Roman comic writer Plautus (c. B.C.E. 254–184) to create a series of situations replete with mistaken identities and general confusion. The careful manipulation of plot in the early plays is achieved at the expense of characterization, and the poetry tends to use artificial literary devices. Even Shakespeare's first great tragedy, *Romeo and Juliet* (1595), is not altogether free from an excessive use of puns and plays on words, although the psychological depiction of the young lovers is convincing and the play contains some magnificent passages.

The comedies of the next few years, including both *The Merchant of Venice* (c. 1596) and *Twelfth Night* (c. 1600), are more lyrical. The brilliant wit of the earlier plays is often replaced by a kind of wistful melancholy. *Twelfth Night* is, in fact, often regarded as Shakespeare's supreme achievement in the field of comedy. Although the plot hinges on a series of well-worn comic devices—mistaken identities, separated twins, and so on—the characters are as vivid and individual as in any of his plays. Furthermore, the work's principal subject, romantic love, is shown from an almost

■ 14.29 Title page of the First Folio. The first collected edition of Shakespeare's works, which was prepared by two of the playwright's fellow actors, London, 1623. Rare books and manuscripts division, New York Public Library. So little is known of Shakespeare's life or appearance that it is difficult to judge the accuracy of this image. Certainly the text of the edition is badly flawed in places.

infinite number of viewpoints. Yet at the same time Shakespeare was attracted to historical subjects, generally drawn from English history, as in *Henry IV*, Parts I and II (1597–1598), but also from Roman history, as in *Julius Caesar*.

Julius Caesar (1599) is notable for several reasons. It shows that Shakespeare shared the renewed interest of his contemporaries in Classical antiquity. It is, in fact, based directly on the *Lives* of Caesar, Brutus, and Marc Antony by the Greek historian Plutarch (c. 46–127 C.E.), which had appeared in a new translation by Sir Thomas North in 1579. *Julius Caesar* also illustrates Shakespeare's growing interest in psychological motivation rather than simple sequencing of events.

The playwright tells us not so much what his characters do as why they do it, using the **soliloquy** (a kind of speech in which characters utter their thoughts aloud, without addressing them to anyone else), and

thereby revealing to the audience the inner workings of the characters' minds. The use of this device becomes increasingly common in Shakespeare's supreme achievements, the series of tragedies he wrote between 1600 and 1605: *Hamlet* (c. 1600), *Othello* (c. 1604), *King Lear* (c. 1605), and *Macbeth* (c. 1605). In dramatic truth, poetic beauty, and profundity of meaning, these four plays achieve an artistic perfection equaled only by the tragic dramas of Classical Greece. Through his protagonists, Shakespeare explores the great problems of human existence—the many forms of love, the possibilities and consequences of human error, the mystery of death—with a subtlety and yet a directness that remain miraculous through countless readings or performances and continue to provide inspiration to artists and writers. Shakespeare's later plays explore new directions. *Antony and Cleopatra* (c. 1607–1608) returns to Plutarch and to ancient Rome, but with a new richness and magnificence of language. The conciseness of his great tragedies is replaced by a delight in the sound of words, and the play contains some of the most musical of all Shakespearean verse. His last works examine the borderline between tragedy and comedy with a sophistication that was perhaps intended to satisfy the new aristocratic audience of the court of King James I. *The Tempest* (1611), set on an enchanted island, blends high romance and low comedy to create a world of fantasy unlike that of any of his other plays.

In the year he wrote *The Tempest*, Shakespeare left London and retired to Stratford to live out the remaining years of his life in comparative prosperity. Although he continued to write, it is tempting to see in the lines he gave to Prospero toward the end of *The Tempest* (IV, I, 148–158) his own farewell to the theater, and to the world he created for it:

> Our revels now are ended. These our actors,
> As I foretold you, were all spirits, and
> Are melted into air, into thin air.
> And, like the baseless fabric of this vision,
> The cloud-capped towers, the gorgeous palaces,
> The solemn temples, the great globe itself—
> Yea, all which it inherit—shall dissolve
> And, like this insubstantial pageant faded,
> Leave not a rack behind. We are such stuff
> As dreams are made on, and our little life
> Is rounded with a sleep.

SUMMARY

The Cultural Consequences of the Reformation The political and cultural life of Northern Europe was profoundly changed by the Reformation. After centuries of domination by the Church of Rome, many northern countries gradually switched to one of the various forms of Protestantism, whose ideas and teachings

were rapidly spread by the use of the newly invented printing press. The consequences of this division did much to shape modern Europe, while the success of the Reformation movement directly stimulated the counterreformation of the seventeenth century.

Printing and Literature The growth of literacy both north and south of the Alps made possible by the easy availability of books produced a vast new reading public. Among the new literary forms to be introduced was that of the essay, first used by Montaigne. Epic poems were also popular; the works of Lodovico Ariosto and Torquato Tasso circulated widely and were imitated by many writers, including Edmund Spenser. The revival of interest in Classical drama produced a new and enthusiastic audience for plays; those written by Elizabethan dramatists like Christopher Marlowe combined high poetic and intellectual quality with popular appeal. The supreme achievement in English literature of the time and perhaps of all time may be found in the works of William Shakespeare. Furthermore, in an age when the importance of education was emphasized, many advances in science were made and important scientific publications appeared. These included Vesalius's work on anatomy and Copernicus's revolutionary astronomical theories.

Painting in Germany: Dürer and Grünewald In the visual arts the sixteenth century saw the spread of Italian Renaissance ideas northward. In some cases they were carried by Italian artists like Benvenuto Cellini, who went to work in France. Some major northern artists, like Albrecht Dürer, actually traveled to Italy. Dürer's art was strongly influenced by Italian theories of perspective, proportion, and color, although he retained a strong interest in line typical of northern art. But not all of his contemporaries showed the same interest in Italian styles. Matthias Grünewald's paintings do not show Renaissance concerns for humanism and ideal beauty; instead, they draw on traditional medieval German art to project the artist's own passionate religious beliefs, formed against the background of the bitter conflict of the Peasants' War.

Painting in the Netherlands: Bosch and Bruegel The two leading Netherlandish artists of the century, Hieronymus Bosch and Pieter Bruegel the Elder, were also influenced by contemporary religious ideas. Their work has other characteristics in common: a pessimistic attitude toward human nature and the use of satire—yet the final effect is very different. Bosch's paintings are complex and bizarre; Bruegel shows a broader range of interest in human activities, together with a love of nature.

Elsewhere in Northern Europe artistic inspiration was more fitful. The only English painter of note was the miniaturist Nicholas Hilliard, while in France the principal achievements were in the field of architecture. Even in Germany and the Netherlands, by the end of the century the Reformation movement's unsympathetic attitude toward the visual arts had produced a virtual end to official patronage for religious art.

Musical Developments in Reformation Europe Music was central to Reformation practice: Luther was a hymn writer of note. In England, after Henry VIII broke with Rome to form the Anglican Church, the hymns devised by the new church generally followed Reformation practice by using texts in the vernacular rather than in Latin. The music, however, retained the complexity of the Italian style; as a result, the religious works of musicians like Tallis and Byrd are among the finest of northern Renaissance compositions.

Secular music also had a wide following throughout Northern Europe, particularly as the printing of music became increasingly common. The form of the madrigal, originally devised in Italy, spread to France, Germany, the Netherlands, and England. Many of the works of the leading composers of the day, including the French Clement Janequin and the Flemish Heinrich Isaac, were intended for a popular audience and dealt with Romantic or military themes.

Thus the combination of new Renaissance artistic ideas and new Reformation religious teachings roused Northern Europe from its conservative traditions and stimulated a series of vital cultural developments.

KEY TERMS

Anabaptists Radical Reformers who insisted on adult baptism even for those who had been baptized in infancy (the word means "those baptized again")

Anthem A musical composition written for choir (sometimes with solo voices added), the text of which is in English

Ayres Simple English songs written for one singer and accompaniment

Burin Sharp-pointed steel instrument used for incising the lines for an engraving

Chanson Popular French song

Counterpoint Two or more distinct melodic lines sung or played at the same time

Curia The body of tribunals and assemblies through which the pope governed the church

Engraving Process of incising lines on a copper plate, which is then printed to produce an impression (itself also known as an engraving)

Essay A short literary work, generally in prose, dealing with a specific topic

Ground, Groundlings The part of an Elizabethan theater where the spectators stood. These poorer members of the audience became known as the *groundlings*. The ground was sometimes called the *pit*.

Index List of forbidden books that was issued by the Catholic Church

Indulgences Forgiveness of sins in return for prayer, good works, and/or money

Linear perspective A system of perspective in which all parallel lines converge at a single vanishing point

Logarithm Table of numbers that simplifies mathematical calculation by substituting addition and subtraction for multiplication and division

Pit See *ground*

Soliloquy Speech made by characters in a play who utter their thoughts aloud, without addressing them to any other character

Thesis Academic proposition that seeks to prove the truth of a statement

Triptych Painting consisting of three separate panels

Virginal Early keyboard instrument small enough to be placed on a table

Woodcut A work produced by cutting away parts of a wooden block, which is then inked and printed

PRONUNCIATION GUIDE

Altdorfer:	ALT-door-fer
Apocalypse:	Ah-POC-a-lips
Bosch:	BOSH
Bruegel:	BROY-gull
Byrd:	BIRD
Chambord:	Sham-BORE
chanson:	shans-ON
Copernicus:	Cop-EARN-ik-us
Dürer:	DUE-rer
Grünewald:	GROON-ee-vald
Gutenberg:	GOOT-en-burg
Holbein:	HOLE-bine
Isenheim:	IZ-en-hime
Janequin:	ZHAN-u-can
Loire:	LWAR
Luther:	LOO-ther
Montaigne:	Mont-ANE
polyphonic:	pol-i-FON-ic

EXERCISES

1. Discuss the career of Albrecht Dürer and compare his work to that of his contemporaries in Germany and Italy.
2. What were the principal causes of the Reformation? What was its impact on the development of the arts?
3. Describe the effect of the spread of humanism in Northern Europe. What part was played by the invention of printing?
4. What are the main features of musical development during the sixteenth century? Discuss the relationship between sacred and secular music.
5. Describe Shakespeare's development as a dramatist and analyze the plot of one of his plays.

YOUR RESOURCES

❖ **ExploringHumanities CD-ROM**
- Interactive Module: Empires of Art
- Reading Selections: Montaigne, *Of Cannibals;* Shakespeare Modules: *A Midsummer Night's Dream, Henry IV, The Merry Wives of Windsor, Twelfth Night, Hamlet, Othello, King Lear, The Tempest*

❖ **Website http://art.wadsworth.com/cunningham**
- Chapter 14 Quiz
- Links

❖ **Audio CD**
- Morley: *Now is the Month of Maying*

FURTHER READING

Ackroyd, Peter. *The Life of Thomas More.* New York: Random House, 1998. Written by a novelist, this provides a vivid picture of one of the most turbulent periods in English history.

Blunt, Anthony. *Art and Architecture in France, 1500–1700.* Rev. ed. New Haven, CT: Yale University Press, 1999. A masterly survey of the field, written by one of its greatest scholars.

Brown, Howard Mayer, and Louise K. Stein. *Music in the Renaissance.* Upper Saddle River, NJ: Prentice Hall, 1999.

Cameron, E. *The European Reformation.* Oxford: Oxford University Press, 1991. A scholarly and readable survey of Reformation history and culture.

Campbell, L. *The Fifteenth Century Netherlandish Schools.* London: National Gallery Publications, 1998. A fully illustrated description of one of the great collections of early Netherlandish art.

Harbison, C. *The Mirror of the Artist: Northern Renaissance Art in its Historical Context.* New York: Harry Abrams, 1995. A study of the social and cultural background to the art of the period. Excellent illustrations.

Hillerbrand, H. (Ed.) *The Oxford Encyclopedia of the Reformation.* (4 vols.). New York: Oxford University Press, 1996. A mine of information on any aspect of the Reformation, an authoritative reference work.

Landau, David, and Peter Parshall. *The Renaissance Print.* New Haven, CT: Yale University Press, 1994. An introduction to the early developments of a new artistic medium, with useful illustrations.

Rose, M. B. *Women in the Middle Ages and the Renaissance.* Syracuse, NY: Syracuse University Press, 1986. An anthology of readings that brings together a great deal of remarkable material and casts light on a subject that has only recently begun to be studied in its own right.

READING SELECTIONS

MICHEL EYQUEM DE MONTAIGNE
OF CANNIBALS

This essay reflects Montaigne's horror at the lack of civility in a culture that incessantly wars over religion as he contrasts so-called primitive people (reports of native peoples poured into Europe in this period as explorers wrote of their adventures in the New World) to the "civilized" people of his own time and place. Montaigne's somewhat Romantic view of the "cannibals" reminds us of the tendency of European—culture especially in the following century—to praise the "noble savage" as a vehicle for social anid political criticism.

When King Pyrrhus passed over into Italy, after studying the formation of the army that the Romans sent to meet him, he said: "I do not know what barbarians these are" (for so the Greeks called all foreign nations), "but the formation of this army that I see is not at all barbarous." The Greeks said as much of the army that Flaminius brought into their country, and so did Philip, seeing from a knoll the order and distribution of the Roman camp, in his kingdom, under Publius Sulpicius Galba. That is how we should beware of clinging to common opinions, and judge things by reason's way, not by popular say.

I had with me for a long time a man who had lived for ten or twelve years in that other world which was discovered in our century, in the place where Villegaignon landed, and which he called Antarctic France.[1] This discovery of a boundless country seems worthy of consideration. I don't know if I can guarantee that some other such discovery will not be made in the future, so many personages greater than ourselves having been mistaken about this one. I am afraid we have eyes bigger than our stomachs, and more curiosity than capacity. We embrace everything, but we clasp only wind.

Plato brings in Solon, telling how he had learned from the priests of the city of Saïs in Egypt that in days of old, before the Flood, there was a great island named Atlantis, right at the mouth of the Straits of Gibraltar, which contained more countries than Africa and Asia put together, and that the kings of that country, who not only possessed that island but had stretched out so far on the mainland that they held the breadth of Africa as far as Egypt, and the length of Europe as far as Tuscany, attempted to step over into Asia and subjugate all the nations that border on the Mediterranean, as far as the gulf of the Black Sea; and to accomplish this, crossed the Spains, Gaul, Italy, as far as Greece, where the Athenians checked them; but that some time after, both the Athenians and themselves and their island were swallowed up by the Flood.

It is quite likely that that phenomenal havoc of waters made amazing changes in the habitations of the earth, as people maintain that the sea cut off Sicily from Italy—

> 'Tis said an earthquake once asunder tore
> These lands with dreadful havoc, which before
> Formed but one land, one shore,
>
> [Vergil]

—Cyprus from Syria, the island of Euboea from the mainland of Boeotia; and elsewhere joined lands that were divided, filling the channels between them with sand and mud:

> A sterile marsh, long fit for rowing, now
> Feeds neighbor towns, and feels the heavy plow.
>
> [Horace]

But there appears little likelihood that that island was the new world which we have just discovered; for it almost touched Spain, and it would be an incredible result of a flood to have forced it away as far as it is, more than twelve hundred leagues; besides, the travels of the moderns have already almost revealed that it is not an island, but a mainland connected with the East Indies on one side, and elsewhere with the lands under the two poles; or, if it is separated from them, it is by so narrow a strait and interval that it does not deserve to be called an island on that account.

It seems that there are movements, some natural, others feverish, in these great bodies, just as in our own. When I consider the inroads that my river, the Dordogne, is making in my lifetime into the right bank in its descent, and that in twenty years it has gained so much ground and stolen away the foundations of several buildings, I clearly see that this is an extraordinary disturbance; for if it had always gone at this rate, or was to do so in the future, the face of the world would be turned topsy-turvy. But rivers are subject to changes: now they overflow in one direction, now in another, now they keep to their course. I do not speak of the sudden inundations whose causes are manifest. In Médoc, along the seashore, my brother, the Sieur d'Arsac, can see an estate of his buried under the sands that the sea vomits in front of it; the tops of some buildings are still visible; his rents and domains have changed into very thin pasturage. The inhabitants say that for some time the sea has been pushing toward them so hard that they have lost four leagues of land. These sands are its harbingers; and we see great dunes of moving sand that march half a league ahead of it and gain territory.

The other testimony of antiquity with which some would connect this discovery is in Aristotle, at least if that little book *Of Unheard-of Wonders* is by him. He there relates that certain Carthaginians, having set out upon the Atlantic Ocean from the Straits of Gibraltar, and sailed a long time, had at last discovered a great fertile island, all clothed in woods and watered by great deep rivers, far remote from any mainland; and that they, and others since, attracted by the goodness and fertility of the soil, went there with their wives and children, and began to settle there. The lords of Carthage, seeing that their country was gradually becoming depopulated, expressly forbade anyone to go there any more, on pain of death, and drove out these new inhabitants, fearing, it is said, that in course of time they might come to multiply so greatly as to supplant themselves and ruin their state. This story of Aristotle does not fit our new lands any better than the other.

This man I had was a simple crude fellow[2]—a character fit to bear true witness; for clever people observe more things and more curiously, but they interpret them; and to lend weight and conviction to their interpretation, they cannot help altering history a little. They never show you the things as they are, but bend and disguise them according to the way they have seen them; and to give credence to their judgment and attract you to it, they are prone to add something

to their matter to stretch it out and amplify it. We need a man either very honest, or so simple that he has not the stuff to build up false inventions and give them plausibility; and wedded to no theory. Such was my man; and besides this, he has at various times brought sailors and merchants, whom he had known on that trip, to see me. So I content myself with his information, without inquiring what the cosmographers say about it.

We ought to have topographers who would give us an exact account of the places where they have been. But because they have this advantage over us that they have seen Palestine, they want to enjoy the privilege of telling us news about all the rest of the world. I would like everyone to write what he knows, and as much as he knows, not only in this, but in all other subjects; for a man may have some special knowledge and experience of the nature of a river or a fountain, who in other matters knows only what everybody knows. However, to circulate this little scrap of knowledge, he will undertake to write down the whole of physics. From this vice spring many great abuses.

Now, to return to my subject, I think there is nothing barbarous and savage in this nation, from what I have been told, except that each man calls barbarism whatever is not his own practice; for indeed it seems we have no other test of truth and reason than the example and pattern of the opinions and customs of the country we live in. *There* is always the perfect religion, the perfect government, the perfect and accomplished usage in all things. Those people are wild, just as we call wild the fruits that Nature has produced by herself and in her normal course; whereas really it is those that we have changed artificially and led astray from the common order, that we should rather call wild. In the former the genuine, most useful and natural virtues and properties are alive and vigorous, which we have debased in the latter, and have only adapted to the pleasure of our corrupted taste. And yet for all that, the savor and delicacy of some uncultivated fruits of those countries is quite as excellent, even to our taste, as that of our own. It is not reasonable that art should win the place of honor over our great and powerful mother Nature. We have so overloaded the beauty and richness of her works by our inventions that we have quite smothered her. Yet wherever she shines forth in her purity, she wonderfully puts to shame our vain and frivolous attempts:

> Ivy comes readier without our care;
> In lonely caves the arbutus grows more fair;
> No art with artless bird-song can compare.
>
> [Propertius]

All our efforts cannot even succeed in reproducing the nest of the tiniest little bird, its contexture, its beauty and convenience; nor even the web of the puny spider. All things, says Plato, are produced by nature, by chance, or by art; the greatest and most beautiful by one or the other of the first two, the least and most imperfect by the last.

These nations, then, seem to me barbarous in this sense, that they have been fashioned very little by the human mind, and are still very close to their original naturalness. The laws of nature still rule them, very little corrupted by ours; but they are in such a state of purity that I am sometimes vexed that knowledge of them did not come earlier, in the days when there were men able to judge them better than we. I am sorry that Lycurgus and Plato did not have this knowledge; for it seems to me that what we actually see in these nations surpasses not only all the pictures in which poets have embellished the golden age, and all their ingenuity in imagining a happy state of man, but also the conception and the very desire of philosophy. They could not imagine a naturalness so pure and simple as that which we see by experience; nor could they believe that our society can be maintained with so little artifice and human solder. This is a nation, I should say to Plato, in which there is no sort of traffic, no knowledge of letters, no science of numbers, no name for a magistrate or for political superiority, no custom of servitude, no riches or poverty, no contracts, no successions, no partitions, no occupations but leisure ones, no care for any but common kinship, no clothes, no agriculture, no metal, no use of wine or corn. The very words that signify lying, treachery, dissimulation, avarice, envy, belittling, pardon, unheard of. How far from this perfection would he find the republic that he imagined: *Men fresh sprung from the gods* [Seneca].

> These manners nature first ordained.
>
> [Vergil]

For the rest, they live in a country with a very pleasant and temperate climate, so that according to my witnesses you rarely see a sick man there; and they have assured me that they never saw one palsied, bleary-eyed, toothless, or bent with age. They are settled along the sea and shut in on the land side by great high mountains, with a stretch about a hundred leagues wide in between. They have a great abundance of fish and flesh which bear no resemblance to ours, and they eat them with no other artifice than cooking. The first man who rode a horse there, though he had had dealings with them on several other trips, so horrified them in this posture that they shot him dead with arrows before they could recognize him.

Their buildings are very long, with a capacity of two or three hundred souls, covered with the bark of great trees, the strips fastened to the ground at one end and supporting and leaning on one another at the top, in the manner of some of our barns, whose covering hangs down to the ground and acts as a side. They have wood so hard that they cut with it and make of it their swords and grills to cook their food. Their beds are of a cotton weave, hung from the roof like those in our ships, each man having his own; for the wives sleep apart from their husbands.

They get up with the sun, and eat right after they get up, for the whole day, having no other meal than that one. They do not drink then, as Suidas tells us of some other Eastern peoples, who drank apart from meals; but they drink several times a day, and to capacity. Their drink is made of some root, and is of the color of our claret wines. They only drink it lukewarm. This beverage keeps only two or three days; it has a slightly sharp taste, is not at all heady, good for the stomach, and laxative for those who are not used to it; it is a very pleasant drink for anyone who is accustomed to it. In place of bread they use a certain white substance like preserved coriander. I have tried it; it tastes sweet and a little flat.

The whole day is spent in dancing. The younger men go to hunt animals with bows. Some of the women busy themselves meanwhile in warming their drink, which is their chief duty. Some one of the old men, in the morning before they begin to eat, preaches to the whole barnful in common, walking from one end to the other, and repeating one single sentence several times until he has completed the circuit (for the buildings are fully a hundred paces long). He recommends to them only two things: valor against the enemy and love for their wives. And they never fail to point out this obligation, as their refrain, that it is their wives who keep their drink warm and seasoned.

There may be seen in several places, including my own house, the shape of their beds, of their ropes, of their

wooden swords and the bracelets with which they cover their wrists in combats, and of the big canes, open at one end, by whose sound they keep time in their dances. They are close shaven all over, and shave themselves much more cleanly than we, with nothing but a wooden or stone razor. They believe that souls are immortal, and that those who have deserved well of the gods are lodged in that part of heaven where the sun rises, and the damned in the west.

They have some sort of priests and prophets, who very rarely appear before the people, having their home in the mountains. On their arrival there is a great feast and solemn assembly of several villages—each barn, as I have described it, makes up a village, and they are about one French league from each other. This prophet speaks to them in public, exhorting them to virtue and their duty; but their whole ethical science contains only these two articles: resoluteness in war and affection for their wives. This man prophesies to them things to come and the results they are to expect from their undertakings, and urges them to war or holds them back from it; but this is on the condition that when he fails to prophesy correctly, and if things turn out otherwise than he has predicted, he is cut into a thousand pieces if they catch him, and condemned as a false prophet. For this reason, the prophet who has once been mistaken is never seen again.

Divination is a gift of God; that is why it should be a punishable imposture to abuse it. Among the Scythians, when the soothsayers failed to hit the mark, they were laid, chained hand and foot, on carts full of heather and drawn by oxen, on which they were burned. Those who handle matters subject to the conduct of human capacity are excusable if they do the best they can. But these others, who come and trick us with assurances of an extraordinary faculty that is beyond our ken, should they not be punished for not making good their promise, and for the temerity of their imposture?

They have their wars with the nations beyond the mountains, further inland, to which they go quite naked, with no other arms than bows or wooden swords pointed at one end, in the manner of the tongues of our boar spears. It is marvelous what firmness they show in their combats, which never end but in slaughter and bloodshed; for as for routs and terror, they do not know what that means.

Each man brings back as his trophy the head of the enemy he has killed, and sets it up at the entrance to his dwelling. After treating their prisoners well for a long time with all the hospitality they can think of, the captor of each one calls a great assembly of his acquaintances. He ties a rope to one of the prisoner's arms, by the end of which he holds him, a few steps away, for fear of being hurt, and gives his dearest friend the other arm to hold in the same way; and these two, in the presence of the whole assembly, dispatch him with their swords. This done, they roast him and eat him in common and send some pieces to their absent friends. This is not, as people think, for nourishment, as of old the Scythians used to do; it is to betoken an extreme revenge. And the proof of this is that having perceived that the Portuguese, who had joined forces with their adversaries, inflicted a different kind of death on them when they took them prisoner, which was to bury them up to the waist, shoot the rest of their bodies full of arrows, and afterwards hang them; they thought that these people from the other world, being men who had sown the knowledge of many vices among their neighbors and were much greater masters than themselves in every sort of wickedness, did not adopt this sort of vengeance without some reason, and that it must be more painful than their own; so they began to give up their old method and follow this one.

I am not sorry that we notice the barbarous horror of such acts, but I am heartily sorry that, judging their faults rightly, we should be so blind to our own. I think there is more barbarity in eating a man alive than in eating him dead, in tearing by tortures and the rack a body still full of feeling, in roasting him bit by bit, having him bitten and mangled by dogs and swine (as we have not only read but seen within fresh memory, not among ancient enemies, but among neighbors and fellow citizens, and what is worse, on the pretext of piety and religion) than in roasting and eating him after he is dead.

Indeed, Chrysippus and Zeno, heads of the Stoic sect, thought that there was nothing wrong in using our carcasses for any purpose in case of need, and getting nourishment from them; just as our ancestors, being besieged by Caesar in the city of Alésia, resolved to relieve the famine of this siege with the bodies of the old men, women, and other people useless for fighting.

> The Gascons once, 'tis said, their life renewed
> By eating of such food.
>
> [Juvenal]

And physicians do not fear to use human flesh in all sorts of ways for our health, applying it either inwardly or outwardly. But there never was any opinion so diseased as to excuse treachery, disloyalty, tyranny, and cruelty, which are our common vices.

Then we may well call these people barbarians, in respect to the rules of reason, but not in respect to ourselves, who surpass them in every kind of barbarity.

Their warfare is wholly noble and generous, and as excusable and beautiful as this human disease can be; its only basis among them is the jealousy of valor. They are not fighting for the conquest of new lands, for they still enjoy that natural abundance that provides them without toil and trouble with all necessary things in such profusion that they have no wish to enlarge their boundaries. They are still in that happy state of desiring only as much as their natural needs demand; anything beyond that is superfluous to them.

They generally call each other thus: those of the same age, brothers; those who are younger, children; and the old men are fathers to all the others. These leave to their heirs in common the full possession of their property, without division or any other title at all than just the one that Nature gives to her creatures in bringing them into the world.

If their neighbors cross the mountains to come and attack them, and win victory over them, the gain of the victor is glory, and the advantage of having proven the master in valor and virtue; for otherwise they have no use for the goods of the vanquished, and they return to their own country, where they have no lack of anything necessary, nor yet lack of that great thing, the knowledge of how to enjoy their condition happily and be content with it. These do the same in their turn. They demand of their prisoners no other ransom than their confession and acknowledgment of being vanquished. But there is not one in a whole century who does not choose to die rather than to relax a single bit, by word or look, from the grandeur of an invincible courage; you do not see one who does not choose to be killed and eaten rather than so much as ask not to be. They treat them very freely, so that life may be all the dearer to them, and usually talk to them of the threats of their coming death, the torments they will have to suffer, the preparations that are being made for that purpose, the cutting up of their limbs, and the feast that will be made at their expense. All this is done for the sole purpose of extorting from their lips some weak or base word, or making them want to flee, so as to

gain the advantage of having terrified them and broken down their firmness. For indeed, if you take it the right way, it is in this point alone that true victory lies:

It is no victory
Unless the vanquished foe admits your mastery.
[Claudian]

The Hungarians, very bellicose fighters, did not in olden times pursue their advantage beyond putting the enemy at their mercy. For having wrung this confession from him, they let him go unharmed, unransomed, except, at most, for making him give his word never again to take arms against them.

We win quite enough advantages over our enemies that are borrowed advantages, not really our own. It is the quality of a porter, not of valor, to have sturdier arms and legs; agility is a dead and corporal quality; it is a stroke of luck to make our enemy stumble, or dazzle his eyes by the light of the sun; it is a trick of art and science, which may be found in a worthless coward, to be an able fencer. The worth and value of a man is in his heart and his will; there lies his real honor. Valor is the strength, not of legs and arms, but of heart and soul; it does not consist in the worth of our horse, or our weapons, but in our own. He who falls obstinate in his courage, *if he has fallen, he fights on his knees* [Seneca]. He who relaxes none of his assurance for any danger of imminent death; who, giving up his soul, still looks firmly and scornfully at his enemy, he is beaten not by us, but by fortune; he is killed, not conquered.

The most valiant are sometimes the most unfortunate. Thus there are triumphant defeats that rival victories. Nor did those four sister victories, the fairest that the sun ever beheld with his eyes—Salamis, Plataea, Mycale, and Sicily—ever dare match all their combined glory against the glory of the annihilation of King Leonidas and his men at the pass of Thermopylae.

Who ever hastened with more glorious and ambitious desire to win a battle than Captain Ischolas to lose one? Who ever secured his safety more ingeniously and painstakingly than he did his destruction? He was charged to defend a certain pass in the Peloponnesus against the Arcadians. In order to do so, finding himself quite powerless in view of the nature of the place and the inequality of the forces, and making up his mind that all who confronted the enemy would necessarily have to remain on the field; on the other hand, deeming it unworthy both of his own virtue and magnanimity and of the name of a Lacedaemonian to fail in his charge, he took a middle course between these two extremes, in this way. The youngest and fittest of his band he preserved for the defense and service of their country, and sent them home; and with those whose loss was less vital, he determined to hold this pass, and by their death to make the enemy buy their entry as dearly as he could. And so it turned out. For being presently surrounded on all sides by the Arcadians, after slaughtering a larger number of them, he and his men were all put to the sword. Is there a trophy dedicated to victors that would not be more due to these vanquished? The role of true victory is in fighting, not in coming off safely; and the honor of valor consists in combating, not in beating.

To return to our story. These prisoners are so far from giving in, in spite of all that is done to them, that on the contrary, during the two or three months that they are kept, they wear a gay expression; they urge their captors to hurry and put them to the test; they defy them, insult them, reproach them with their cowardice and the number of battles lost to their men.

I have a song composed by a prisoner which contains this challenge, that they should all come boldly and gather to dine off him, for they will be eating at the same time their own fathers and grandfathers, who have served to feed and nourish his body. "These muscles," he says, "this flesh and these veins are your own, poor fools that you are. You do not recognize that the substance of your ancestors' limbs is still contained in them? Savor them well; you will find in them the taste of your own flesh." An idea that certainly does not smack of barbarity. Those that paint these people dying, and who show the execution, portray the prisoner spitting in the face of his slayers and making faces at them. Indeed, to the last gasp they never stop braving and defying them by word and look. Truly here are real savages by our standards; for either they must be thoroughly so, or we must be; there is an amazing distance between their character and ours.

The men there have several wives, and the higher their reputation for valor, the more wives they have. It is a remarkably beautiful thing about their marriages that the same jealousy our wives have to keep us from the affection and favors of other women, theirs have to win this for them. Being more concerned for their husbands' honor than for anything else, they strive and worry to have as many companions as they can, since that is a sign of their husband's valor.

Our wives will cry "Miracle!"; but it is not. It is a properly matrimonial virtue, but one of the highest order. And in the Bible, Leah, Rachel, Sarah, and Jacob's wives gave their beautiful handmaids to their husbands; and Livia seconded the appetites of Augustus, to her own disadvantage; and Stratonice, the wife of King Deiotarus, not only lent her husband for his use a very beautiful young chambermaid in her service, but carefully brought up her children, and backed them up to succeed to their father's estates.

And lest it be thought that all this is done through a simple and servile bondage to usage and through the pressure of the authority of their ancient customs, without reasoning or judgment, and because their minds are so stupid that they cannot take any other course, I must cite some examples of their capacity. Besides the warlike song I have just quoted, I have another, a love song, which begins in this vein: "Adder, stay; stay, adder, that from the pattern of your coloring my sister may draw the model and the workmanship of a rich girdle that I may give to my love; so may your beauty and your disposition be forever preferred to all other serpents." This first couplet is the refrain of the song. Now I am familiar enough with poetry to be a judge of this: that not only is there nothing barbarous in this fancy, but that it is altogether Anacreontic. Their language, moreover, is a soft language, with an agreeable sound, somewhat like Greek in its endings.

Three of these men, not knowing how much their repose and happiness will pay some day for the knowledge of the corruptions of this side of the ocean, and that of this intercourse will come their ruin, which I suppose is already well advanced—poor wretches, to have let themselves be tricked by the desire for new things, and to have left the serenity of their own sky to come and see ours—were at Rouen, at the time when the late King Charles the Ninth[3] was there. The King talked to them for a long time; they were shown our ways, our pomp, the form of a fine city. After that someone asked their opinion, and wanted to know what they had found most amazing. They replied that there were three things, of which I have forgotten the third, and I am very sorry for it; but I still remember two of them. They said that in the first place they thought it very strange that so many grown men, bearded, strong, and armed, who were around the King (it is likely that they were talking about the Swiss of his guard) should submit to obey a child, and that one of them was not chosen to command instead; secondly (they have a way in their language of speaking of men as halves of one another), that they had noticed that there were among

us men full and gorged with all sorts of good things, and that their other halves were beggars at their doors, emaciated with hunger and poverty; and they thought it strange that these needy halves could suffer such an injustice, and did not take the others by the throat, or set fire to their houses.

I had a long talk with one of them; but I had an interpreter who followed my meaning so badly, and who was so hindered by his stupidity in taking in my ideas, that I could get hardly any satisfaction from the man. When I asked him what profit he gained from his superior position among his people (for he was a captain, and our sailors called him king), he told me that it was to march foremost in war. How many men followed him? He pointed to a piece of ground, to signify as many as such a space could hold; it might have been four or five thousand men. Did all this authority expire with the war? He said that this much remained, that when he visited the villages dependent on him, they made paths for him through the underbrush by which he might pass quite comfortably.

All this is not too bad. But wait! They don't wear trousers.

Notes

[1] In Brazil, in 1557.
[2] The traveler Montaigne spoke of at the beginning of the chapter.
[3] In 1562.

MARTIN LUTHER
ENCHIRIDION[1]

The Small Catechism *is a brief compendium of the faith of the Lutheran Reformation written for ordinary people.*

The Small Catechism

Grace, mercy, and peace in Jesus Christ, our Lord, from Martin Luther to all faithful, godly pastors and preachers.

The deplorable conditions which I recently encountered when I was a visitor[2] constrained me to prepare this brief and simple catechism or statement of Christian teaching. Good God, what wretchedness I beheld! The common people, especially those who live in the country, have no knowledge whatever of Christian teaching, and unfortunately many pastors are quite incompetent and unfitted for teaching. Although the people are supposed to be Christian, are baptized, and receive the holy sacrament, they do not know the Lord's Prayer, the Creed, or the Ten Commandments,[3] they live as if they were pigs and irrational beasts, and now that the Gospel has been restored they have mastered the fine art of abusing liberty.

How will you bishops answer for it before Christ that you have so shamefully neglected the people and paid no attention at all to the duties of your office? May you escape punishment for this! You withhold the cup in the Lord's Supper and insist on the observance of human laws, yet you do not take the slightest interest in teaching the people the Lord's Prayer, the Creed, the Ten Commandments, or a single part of the Word of God. Woe to you forever!

I therefore beg of you for God's sake, my beloved brethren who are pastors and preachers, that you take the duties of your office seriously, that you have pity on the people who are entrusted to your care, and that you help me to teach the catechism to the people, especially those who are young. Let those who lack the qualifications to do better

at least take this booklet and these forms and read them to the people word for word in this manner:

In the first place, the preacher should take the utmost care to avoid changes or variations in the text and wording of the Ten Commandments, the Creed, the Lord's Prayer, the sacraments, etc. On the contrary, he should adopt one form, adhere to it, and use it repeatedly year after year. Young and inexperienced people must be instructed on the basis of a uniform, fixed text and form. They are easily confused if a teacher employs one form now and another form—perhaps with the intention of making improvements—later on. In this way all the time and labor will be lost.

This was well understood by our good fathers, who were accustomed to use the same form in teaching the Lord's Prayer, the Creed, and the Ten Commandments. We, too, should teach these things to the young and unlearned in such a way that we do not alter a single syllable or recite the catechism differently from year to year. Choose the form that pleases you, therefore, and adhere to it henceforth. When you preach to intelligent and educated people, you are at liberty to exhibit your learning and to discuss these topics from different angles and in such a variety of ways as you may be capable of. But when you are teaching the young, adhere to a fixed and unchanging form and method. Begin by teaching them the Ten Commandments, the Creed, the Lord's Prayer, etc., following the text word for word so that the young may repeat these things after you and retain them in their memory.

If any refuse to receive your instruction, tell them that they deny Christ and are no Christians. They should not be admitted to the sacrament, be accepted as sponsors in Baptism, or be allowed to participate in any Christian privileges.[4] On the contrary, they should be turned over to the pope and his officials,[5] and even to the devil himself. In addition, parents and employers should refuse to furnish them with food and drink and should notify them that the prince is disposed to banish such rude people from his land.

Although we cannot and should not compel anyone to believe, we should nevertheless insist that the people learn to know how to distinguish between right and wrong according to the standards of those among whom they live and make their living.[6] For anyone who desires to reside in a city is bound to know and observe the laws under whose protection he lives, no matter whether he is a believer or, at heart, a scoundrel or knave.

In the second place, after the people have become familiar with the text, teach them what it means. For this purpose, take the explanations in this booklet, or choose any other brief and fixed explanations which you may prefer, and adhere to them without changing a single syllable, as stated above with reference to the text. Moreover, allow yourself ample time, for it is not necessary to take up all the parts at once. They can be presented one at a time. When the learners have a proper understanding of the First Commandment, proceed to the Second Commandment, and so on. Otherwise they will be so overwhelmed that they will hardly remember anything at all.

In the third place, after you have thus taught this brief catechism, take up a large catechism[7] so that the people may have a richer and fuller understanding. Expound every commandment, petition, and part, pointing out their respective obligations, benefits, dangers, advantages, and disadvantages, as you will find all of this treated at length in the many books written for this purpose. Lay the greatest weight on those commandments or other parts which seem to require special attention among the people where you are. For example, the Seventh Commandment, which treats of stealing, must be emphasized when instructing laborers and shopkeepers, and even farmers and servants, for many of

these are guilty of dishonesty and thievery.[8] So, too, the Fourth Commandment must be stressed when instructing children and the common people in order that they may be encouraged to be orderly, faithful, obedient, and peaceful. Always adduce many examples from the Scriptures to show how God punished and blessed.

You should also take pains to urge governing authorities and parents to rule wisely and educate their children. They must be shown that they are obliged to do so, and that they are guilty of damnable sin if they do not do so, for by such neglect they undermine and lay waste both the kingdom of God and the kingdom of the world and are the worst enemies of God and man. Make very plain to them the shocking evils they introduce when they refuse their aid in the training of children to become pastors, preachers, notaries, etc., and tell them that God will inflict awful punishments on them for these sins. It is necessary to preach about such things. The extent to which parents and governing authorities sin in this respect is beyond telling. The devil also has a horrible purpose in mind.

Finally, now that the people are freed from the tyranny of the pope, they are unwilling to receive the sacrament and they treat it with contempt. Here, too, there is need of exhortation, but with this understanding: No one is to be compelled to believe or to receive the sacrament, no law is to be made concerning it, and no time or place should be appointed for it. We should so preach that, of their own accord and without any law, the people will desire the sacrament and, as it were, compel us pastors to administer it to them. This can be done by telling them: It is to be feared that anyone who does not desire to receive the sacrament at least three or four times a year despises the sacrament and is no Christian, just as he is no Christian who does not hear and believe the Gospel. Christ did not say, "Omit this," or "Despise this," but he said, "Do this, as often as you drink it," etc.[9] Surely he wishes that this be done and not that it be omitted and despised. "*Do* this," he said.

He who does not highly esteem the sacrament suggests thereby that he has no sin, no flesh, no devil, no world, no death, no hell. That is to say, he believes in none of these, although he is deeply immersed in them and is held captive by the devil. On the other hand, he suggests that he needs no grace, no life, no paradise, no heaven, no Christ, no God, nothing good at all. For if he believed that he was involved in so much that is evil and was in need of so much that is good, he would not neglect the sacrament in which aid is afforded against such evil and in which such good is bestowed. It is not necessary to compel him by any law to receive the sacrament, for he will hasten to it of his own accord, he will feel constrained to receive it, he will insist that you administer it to him.

Accordingly you are not to make a law of this, as the pope has done. All you need to do is clearly to set forth the advantage and disadvantage, the benefit and loss, the blessing and danger connected with this sacrament. Then the people will come of their own accord without compulsion on your part. But if they refuse to come, let them be, and tell them that those who do not feel and acknowledge their great need and God's gracious help belong to the devil. If you do not give such admonitions, or if you adopt odious laws on the subject, it is your own fault if the people treat the sacrament with contempt. How can they be other than negligent if you fail to do your duty and remain silent. So it is up to you, dear pastor and preacher! Our office has become something different from what it was under the pope. It is now a ministry of grace and salvation. It subjects us to greater burdens and labors, dangers and temptations, with little reward or gratitude from the world. But Christ himself will be our reward if

we labor faithfully. The Father of all grace grant it! To him be praise and thanks forever, through Christ, our Lord. Amen.

From *Martin Luther's Basic Theological Writings*, edited by Timothy L. Lull, copyright © 1989 Augsburg Fortress. Used by permission of Augsburg Fortress.

Notes

[1] Greek: manual or handbook.
[2] Luther visited congregations in Electoral Saxony and Meissen between Oct. 22, 1528, and Jan. 9, 1529.
[3] This is the order in which these materials appeared in late medieval manuals.
[4] Cf. *Large Catechism*, Short Preface, 1–5.
[5] Diocesan judges who decided disciplinary and other cases; now often called vicar-generals.
[6] Cf. *Large Catechism*, Short Preface, 2.
[7] Luther here refers not only to his own *Large Catechism* but also to other treatments of the traditional parts of the catechism. See the reference to "many books" in the next sentence.
[8] Cf. *Large Catechism*, Ten Commandments, 225, 226.
[9] I Cor. 11:25.

[I]

THE TEN COMMANDMENTS

IN THE PLAIN FORM IN WHICH THE HEAD OF THE FAMILY SHALL TEACH THEM TO HIS HOUSEHOLD[1]

The First

"You shall have no other gods." [2]
 What does this mean?
 Answer: We should fear,[3] love, and trust in God above all things.

The Second

"You shall not take the name of the Lord your God in vain." [4]
 What does this mean?
 Answer: We should fear and love God, and so[5] we should not use his name to curse, swear,[6] practice magic, lie, or deceive, but in every time of need call upon him, pray to him, praise him, and give him thanks.

The Third

"Remember the Sabbath day,[7] to keep it holy."
 What does this mean?
 Answer: We should fear and love God, and so we should not despise his Word and the preaching of the same, but deem it holy and gladly hear and learn it.

The Fourth

"Honor your father and your mother."
 What does this mean?
 Answer: We should fear and love God, and so we should not despise our parents and superiors, nor provoke them to anger, but honor, serve, obey, love, and esteem them.

The Fifth

"You shall not kill."
 What does this mean?
 Answer: We should fear and love God, and we should not endanger our neighbor's life, nor cause him any harm, but help and befriend him in every necessity of life.

The Sixth

"You shall not commit adultery."
 What does this mean?

Answer: We should fear and love God, and so we should lead a chaste and pure life in word and deed, each one loving and honoring his wife or her husband.

The Seventh

"You shall not steal."
What does this mean?

Answer: We should fear and love God, and so we should not rob our neighbor of his money or property, nor bring them into our possession by dishonest trade or by dealing in shoddy wares, but help him to improve and protect his income and property.

The Eighth

"You shall not bear false witness against your neighbor."
What does this mean?

Answer: We should fear and love God, and so we should not tell lies about our neighbor, nor betray, slander, or defame him, but should apologize for him, speak well of him, and interpret charitably all that he does.

The Ninth

"You shall not covet your neighbor's house."
What does this mean?

Answer: We should fear and love God, and so we should not seek by craftiness to gain possession of our neighbor's inheritance or home, nor to obtain them under pretext of legal right, but be of service and help to him so that he may keep what is his.

The Tenth

"You shall not covet your neighbor's wife, or his manservant, or his maidservant, or his ox, or his ass,[8] or anything that is your neighbor's."
What does this mean?

Answer: We should fear and love God, and so we should not abduct, estrange, or entice away our neighbor's wife, servants, or cattle, but encourage them to remain and discharge their duty to him.

Conclusion

What does God declare concerning all these commandments?

Answer: He says, "I the Lord your God am a jealous God, visiting the iniquity of the fathers upon the children to the third and the fourth generation of those who hate me, but showing steadfast love to thousands of those who love me and keep my commandments."

What does this mean?

Answer: God threatens to punish all who transgress these commandments. We should therefore fear his wrath and not disobey these commandments. On the other hand, he promises grace and every blessing to all who keep them. We should therefore love him, trust in him, and cheerfully do what he has commanded.

Notes

[1] Latin title: *Small Catechism for the Use of Children in School. How, in a very Plain Form, Schoolmasters Should Teach the Ten Commandments to their Pupils.*

[2] The Nuremberg editions of 1531 and 1558 read: "I am the Lord your God. You shall have no other gods before me." In some editions since the sixteenth century "I am the Lord your God" was printed separately as an introduction to the entire Decalogue. The Ten Commandments are from Exod. 20:2–17 and Deut. 5:6–21.

[3] On filial and servile fear see Apology, XII, 38.

[4] The Nuremberg editions of 1531 and 1558 add: "for the Lord will not hold him guiltless who takes his name in vain."

[5] On the translation of *dass* see M. Reu in *Kirchliche Zeitschrift*, L (1926), pp. 626–689.

[6] For the meaning of "swear" see *Large Catechism*, Ten Commandments, 66.

[7] Luther's German word *Feiertag* means day of rest, and this is the original Hebrew meaning of Sabbath, the term employed in the Latin text. The Jewish observance of Saturday is not enjoined here, nor a Sabbatarian observance of Sunday; cf. Augsburg Confession, XXVIII, 57–60; *Large Catechism*, Ten Commandments, 79–82.

[8] For "or his ox, or his ass" Luther's German text reads "or his cattle." The Latin text employs the fuller expression.

II

The Creed

IN THE PLAIN FORM IN WHICH THE HEAD OF THE FAMILY SHALL TEACH IT TO HIS HOUSEHOLD[1]

The First Article: Creation

"I believe in God, the Father almighty, maker of heaven and earth."
What does this mean?

Answer: I believe that God has created me and all that exists; that he has given me and still sustains my body and soul, all my limbs and senses, my reason and all the faculties of my mind, together with food and clothing, house and home, family and property; that he provides me daily and abundantly with all the necessities of life, protects me from all danger, and preserves me from all evil. All this he does out of his pure, fatherly, and divine goodness and mercy, without any merit or worthiness on my part. For all of this I am bound to thank, praise, serve, and obey him. This is most certainly true.

The Second Article: Redemption

"And in Jesus Christ, his only son, our Lord: who was conceived by the Holy Spirit, born of the virgin Mary, suffered under Pontius Pilate, was crucified, dead, and buried: he descended into hell, the third day he rose from the dead, he ascended into heaven, and is seated on the right hand of God, the Father almighty, whence he shall come to judge the living and the dead."
What does this mean?

Answer: I believe that Jesus Christ, true God, begotten of the Father from eternity, and also true man, born of the virgin Mary, is my Lord, who has redeemed me, a lost and condemned creature, delivered me and freed me from all sins, from death, and from the power of the devil, not with silver and gold but with his holy and precious blood and with his innocent sufferings and death, in order that I may be his, live under him in his kingdom, and serve him in everlasting righteousness, innocence, and blessedness, even as he is risen from the dead and lives and reigns to all eternity. This is most certainly true.

The Third Article: Sanctification

"I believe in the Holy Spirit, the holy Christian church, the communion of saints, the forgiveness of sins, the resurrection of the body, and the life everlasting. Amen."
What does this mean?

Answer: I believe that by my own reason or strength I cannot believe in Jesus Christ, my Lord, or come to him. But the Holy Spirit has called me through the Gospel, enlightened me with his gifts, and sanctified and preserved me in

true faith, just as he calls, gathers, enlightens, and sanctifies the whole Christian church on earth and preserves it in union with Jesus Christ in the one true faith. In this Christian church he daily and abundantly forgives all my sins, and the sins of all believers, and on the last day he will raise me and all the dead and will grant eternal life to me and to all who believe in Christ. This is most certainly true.

Notes

[1] Latin text: *How, in a very Plain Form, Schoolmasters Should Teach the Apostles' Creed to their Pupils.*

III

THE LORD'S PRAYER

IN THE PLAIN FORM IN WHICH THE HEAD OF THE FAMILY SHALL TEACH IT TO HIS HOUSEHOLD[1]

Introduction

"Our Father who art in heaven." [2]
What does this mean?
Answer: Here God would encourage us to believe that he is truly our Father and we are truly his children in order that we may approach him boldly and confidently in prayer, even as beloved children approach their dear father.

The First Petition

"Hallowed be thy name."
What does this mean?
Answer: To be sure, God's name is holy in itself, but we pray in this petition that it may also be holy for us.
How is this done?
Answer: When the Word of God is taught clearly and purely and we, as children of God, lead holy lives in accordance with it. Help us to do this, dear Father in heaven! But whoever teaches and lives otherwise than as the Word of God teaches, profanes the name of God among us. From this preserve us, heavenly Father!

The Second Petition

"Thy kingdom come."
What does this mean?
Answer: To be sure, the kingdom of God comes of itself, without our prayer, but we pray in this petition that it may also come to us.
How is this done?
Answer: When the heavenly Father gives us his Holy Spirit so that by his grace we may believe in his holy Word and live a godly life, both here in time and hereafter forever.

The Third Petition

"Thy will be done, on earth as it is in heaven."
What does this mean?
Answer: To be sure, the good and gracious will of God is done without our prayer, but we pray in this petition that it may also be done by us.
How is this done?
Answer: When God curbs and destroys every evil counsel and purpose of the devil, of this world, and of our flesh which would hinder us from hallowing his name and prevent the coming of his kingdom, and when he strengthens us and keeps us steadfast in his Word and in faith even to the end. This is his good and gracious will.

The Fourth Petition

"Give us this day our daily bread."
What does this mean?
Answer: To be sure, God provides daily bread, even to the wicked, without our prayer, but we pray in this petition that God may make us aware of his gifts and enable us to receive our daily bread with thanksgiving.
What is meant by daily bread?
Answer: Everything required to satisfy our bodily needs, such as food and clothing, house and home, fields and flocks, money and property; a pious spouse and good children, trustworthy servants, godly and faithful rulers, good government; seasonal weather, peace and health, order and honor; true friends, faithful neighbors, and the like.

The Fifth Petition

"And forgive us our debts, as we have also forgiven our debtors."
What does this mean?
Answer: We pray in this petition that our heavenly Father may not look upon our sins, and on their account deny our prayers, for we neither merit nor deserve those things for which we pray. Although we sin daily and deserve nothing but punishment, we nevertheless pray that God may grant us all things by his grace. And assuredly we on our part will heartily forgive and cheerfully do good to those who may sin against us.

The Sixth Petition

"And lead us not into temptation."
What does this mean?
Answer: God tempts no one to sin, but we pray in this petition that God may so guard and preserve us that the devil, the world, and our flesh may not deceive us or mislead us into unbelief, despair, and other great and shameful sins, but that, although we may be so tempted, we may finally prevail and gain the victory.

The Seventh Petition

"But deliver us from evil."
What does this mean?
Answer: We pray in this petition, as in a summary, that our Father in heaven may deliver us from all manner of evil, whether it affect body or soul, property or reputation, and that at last, when the hour of death comes, he may grant us a blessed end and graciously take us from this world of sorrow to himself in heaven.

Conclusion

"Amen." [3]
What does this mean?
Answer: It means that I should be assured that such petitions are acceptable to our heavenly Father and are heard by him, for he himself commanded us to pray like this and promised to hear us. "Amen, amen" means "Yes, yes, it shall be so."

Notes

[1] Latin title: *How, in a very Plain Form, Schoolmasters Should Teach the Lord's Prayer to their Pupils.*
[2] The "introduction" to the Lord's Prayer was not prepared by Luther until 1531. It does not appear in the Latin text, which begins with the First Petition. The text of the Prayer is from Matt. 6:9–13.
[3] The Nuremberg edition of 1558, and many later editions, inserted "For thine is the kingdom, and the power, and the glory, for ever and ever" before "Amen."

IV

THE SACRAMENT OF HOLY COMMUNION

IN THE PLAIN FORM IN WHICH THE HEAD OF THE FAMILY
SHALL TEACH IT TO HIS HOUSEHOLD[1]

First

What is Baptism?

Answer: Baptism is not merely water, but it is water used according to God's command and connected with God's Word.

What is this Word of God?

Answer: As recorded in Matthew 28:19, our Lord Christ said, "Go therefore and make disciples of all nations, baptizing them in the name of the Father and of the Son and of the Holy Spirit."

Second

What gifts or benefits does Baptism bestow?

Answer: It effects forgiveness of sins, delivers from death and the devil, and grants eternal salvation to all who believe, as the Word and promise of God declare.

What is this Word and promise of God?

Answer: As recorded in Mark 16:16, our Lord Christ said, "He who believes and is baptized will be saved; but he who does not believe will be condemned."

Third

How can water produce such great effects?

Answer: It is not the water that produces these effects, but the Word of God connected with the water, and our faith which relies on the Word of God connected with the water. For without the Word of God that water is merely water and no Baptism. But when connected with the Word of God it is a Baptism, that is, a gracious water of life and a washing of regeneration in the Holy Spirit, as St. Paul wrote to Titus (3:5–8), "He saved us by the washing of regeneration and renewal in the Holy Spirit, which he poured out upon us richly through Jesus Christ our Saviour, so that we might be justified by his grace and become heirs in hope of eternal life. The saying is sure."

Fourth

What does such baptizing with water signify?

Answer: It signifies that the old Adam in us, together with all sins and evil lusts, should be drowned by daily sorrow and repentance and be put to death, and that the new man should come forth daily and rise up, cleansed and righteous, to live forever in God's presence.

Where is this written?

Answer: In Romans 6:4, St. Paul wrote, "We were buried therefore with him by baptism into death, so that as Christ was raised from the dead by the glory of the Father, we too might walk in newness of life."

Notes

[1] Latin title: *How, in a very Plain Form, Schoolmasters Should Teach the Sacrament of Baptism to their Pupils.*

V

CONFESSION AND ABSOLUTION

HOW PLAIN PEOPLE ARE TO BE TAUGHT TO CONFESS[1]

What is confession?

Answer: Confession consists of two parts. One is that we confess our sins. The other is that we receive absolution or forgiveness from the confessor as from God himself, by no means doubting but firmly believing that our sins are thereby forgiven before God in heaven.

What sins should we confess?

Answer: Before God we should acknowledge that we are guilty of all manner of sins, even those of which we are not aware, as we do in the Lord's Prayer. Before the confessor, however, we should confess only those sins of which we have knowledge and which trouble us.

What are such sins?

Answer: Reflect on your condition in the light of the Ten Commandments: whether you are a father or mother, a son or daughter, a master or servant; whether you have been disobedient, unfaithful, lazy, ill-tempered, or quarrelsome; whether you have harmed anyone by word or deed; and whether you have stolen, neglected, or wasted anything, or done other evil.

Please give me a brief form of confession.

Answer: You should say to the confessor: "Dear Pastor, please hear my confession and declare that my sins are forgiven for God's sake."

"Proceed."

"I, a poor sinner, confess before God that I am guilty of all sins. In particular I confess in your presence that, as a manservant or maidservant, etc., I am unfaithful to my master, for here and there I have not done what I was told. I have made my master angry, caused him to curse, neglected to do my duty, and caused him to suffer loss. I have also been immodest in word and deed. I have quarreled with my equals. I have grumbled and sworn at my mistress, etc. For all this I am sorry and pray for grace. I mean to do better."

A master or mistress may say: "In particular I confess in your presence that I have not been faithful in training my children, servants, and wife to the glory of God. I have cursed. I have set a bad example by my immodest language and actions. I have injured my neighbor by speaking evil of him, overcharging him, giving him inferior goods and short measure." Masters and mistresses should add whatever else they have done contrary to God's commandments and to their action in life, etc.

If, however, anyone does not feel that his conscience is burdened by such or by greater sins, he should not worry, nor should he search for and invent other sins, for this would turn confession into torture;[2] he should simply mention one or two sins of which he is aware. For example, "In particular I confess that I once cursed. On one occasion I also spoke indecently. And I neglected this or that," etc. Let this suffice.

If you have knowledge of no sin at all (which is quite unlikely), you should mention none in particular, but receive forgiveness upon the general confession[3] which you make to God in the presence of the confessor.

Then the confessor shall say: "God be merciful to you and strengthen your faith. Amen."

Again he shall say: "Do you believe that this forgiveness is the forgiveness of God?"

Answer: "Yes, I do."

Then he shall say: "Be it done for you as you have believed.[4] According to the command of our Lord Jesus Christ, I forgive you your sins in the name of the Father and of the Son and of the Holy Spirit. Amen. Go in peace." [5]

A confessor will know additional passages of the Scriptures with which to comfort and to strengthen the faith of those whose consciences are heavily burdened or who are distressed and sorely tried. This is intended simply as an ordinary form of confession for plain people.

Notes

[1] In 1531 this section replaced the earlier "A Short Method of Confessing" (1529), *WA*, 30I: 343–45. Luther intended confession especially for those who were about to receive Communion.

[2] Luther was here alluding to the medieval practice of confession; see also Smalcald Articles, Pt. II, Art. III, 19.

[3] See article "General Confession" in *New Schaff-Herzog Encyclopedia of Religious Knowledge*, IV, 449. Cf. Smalcald Articles, Pt. III, Art. III, 13.

[4] Matt. 8:13.

[5] Mark 5:34; Luke 7:50; 8:48.

VI

THE SACRAMENT OF THE ALTAR

IN THE PLAIN FORM IN WHICH THE HEAD OF THE FAMILY SHALL TEACH IT TO HIS HOUSEHOLD[1]

What is the Sacrament of the Altar?

Answer: Instituted by Christ himself, it is the true body and blood of our Lord Jesus Christ, under the bread and wine, given to us Christians to eat and drink.

Where is this written?

Answer: The holy evangelists Matthew, Mark, and Luke, and also St. Paul, write thus: "Our Lord Jesus Christ, on the night when he was betrayed, took bread, and when he had given thanks, he broke it, and gave it to the disciples and said, 'Take, eat; this is my body which is given for you. Do this in remembrance of me.' In the same way also he took the cup, after supper, and when he had given thanks he gave it to them, saying, 'Drink of it, all of you. This cup is the new covenant in my blood, which is poured out for many for the forgiveness of sins. Do this, as often as you drink it, in remembrance of me.'"[2]

What is the benefit of such eating and drinking?

Answer: We are told in the words "for you" and "for the forgiveness of sins." By these words the forgiveness of sins, life, and salvation are given to us in the sacrament, for where there is forgiveness of sins, there are also life and salvation.

How can bodily eating and drinking produce such great effects?

Answer: The eating and drinking do not in themselves produce them, but the words "for you" and "for the forgiveness of sins." These words, when accompanied by the bodily eating and drinking, are the chief thing in the sacrament, and he who believes these words has what they say and declare: the forgiveness of sins.

Who, then, receives this sacrament worthily?

Answer: Fasting and bodily preparation are a good external discipline, but he is truly worthy and well prepared who believes these words: "for you" and "for the forgiveness of sins." On the other hand, he who does not believe these words, or doubts them, is unworthy and unprepared, for the words "for you" require truly believing hearts.

Notes

[1] Latin title: *How, in a very Plain Form, Schoolmasters Should Teach the Sacrament of the Altar to their Pupils.*

[2] A conflation of texts from I Cor. 11:23–25; Matt. 26:26–28; Mark 14:22–24; Luke 22:19, 20. Cf. *Large Catechism*, Sacrament of the Altar, 3.

VII

MORNING AND EVENING PRAYERS

HOW THE HEAD OF THE FAMILY SHALL TEACH HIS HOUSE-HOLD TO SAY MORNING AND EVENING PRAYERS[1]

In the morning, when you rise, make the sign of the cross and say, "In the name of God, the Father, the Son, and the Holy Spirit. Amen."

Then, kneeling or standing, say the Apostles' Creed and the Lord's Prayer. Then you may say this prayer:

"I give Thee thanks, heavenly Father, through thy dear Son Jesus Christ, that Thou hast protected me through the night from all harm and danger. I beseech Thee to keep me this day, too, from all sin and evil, that in all my thoughts, words, and deeds I may please Thee. Into thy hands I commend my body and soul and all that is mine. Let the holy angel have charge of me, that the wicked one may have no power over me. Amen."

After singing a hymn (possibly a hymn on the Ten Commandments)[2] or whatever your devotion may suggest, you should go to your work joyfully.

In the evening, when you retire, make the sign of the cross and say, "In the name of God, the Father, the Son, and the Holy Spirit. Amen."

Then, kneeling or standing, say the Apostles' Creed and the Lord's Prayer. Then you may say this prayer:

"I give Thee thanks, heavenly Father, through thy dear Son Jesus Christ, that Thou hast this day graciously protected me. I beseech Thee to forgive all my sin and the wrong which I have done. Graciously protect me during the coming night. Into thy hands I commend my body and soul and all that is mine. Let thy holy angels have charge of me, that the wicked one may have no power over me. Amen."

Then quickly lie down and sleep in peace.

Notes

[1] Latin title: *How, in a very Plain Form, Schoolmasters Should Teach their Pupils to Say their Prayers in the Morning and in the Evening.* (The material in this section was adapted from the Roman Breviary.)

[2] See *Large Catechism*, Short Preface, 25.

VIII

GRACE AT TABLE

HOW THE HEAD OF THE FAMILY SHALL TEACH HIS HOUSEHOLD TO OFFER BLESSING AND THANKSGIVING AT TABLE[1]

Blessing before Eating

When children and the whole household gather at the table, they should reverently fold their hands and say:

"The eyes of all look to Thee, O Lord, and Thou givest them their food in due season. Thou openest thy hand; Thou satisfiest the desire of every living thing."[2]

(It is to be observed that "satisfying the desire of every living thing" means that all creatures receive enough to eat to make them joyful and of good cheer. Greed and anxiety about food prevent such satisfaction.)

Then the Lord's Prayer should be said, and afterwards this prayer:

"Lord God, heavenly Father, bless us, and these thy gifts which of thy bountiful goodness Thou hast bestowed on us, through Jesus Christ our Lord. Amen."

Thanksgiving after Eating

After eating, likewise, they should fold their hands reverently and say:

"O give thanks to the Lord, for he is good; for his steadfast love endures forever. He gives to the beasts their food, and to the young ravens which cry. His delight is not in the strength of the horse, nor his pleasure in the legs of a man; but the Lord takes pleasure in those who fear him, in those who hope in his steadfast love."[3]

Then the Lord's Prayer should be said, and afterwards this prayer:

"We give Thee thanks, Lord God, our Father, for all thy benefits, through Jesus Christ our Lord, who lives and reigns forever. Amen."

Notes

[1] Latin title: *How, in Plain Form, Schoolmasters Should Teach their Pupils to Offer Blessing and Thanksgiving at Table.* (The material in this section was adapted from the Roman Breviary.)

[2] Ps. 145:15, 16. The gloss which follows, here given in parentheses, was intended to explain the meaning of *Wohlgefallen* or *benedictio* in the German and Latin translations of the Psalm.

[3] Ps. 106:1, 136:26; 147:9–11.

IX

TABLE OF DUTIES

CONSISTING OF CERTAIN PASSAGES OF THE SCRIPTURES, SELECTED FOR VARIOUS ESTATES AND CONDITIONS OF MEN, BY WHICH THEY MAY BE ADMONISHED TO DO THEIR RESPECTIVE DUTIES[1]

Bishops, Pastors, and Preachers

"A bishop must be above reproach, married only once, temperate, sensible, dignified, hospitable, an apt teacher, no drunkard, not violent but gentle, not quarrelsome, and no lover of money. He must manage his own household well, keeping his children submissive and respectful in every way. He must not be a recent convert," etc. (I Tim. 3:2–6).

Duties Christians Owe Their Teachers and Pastors[2]

"Remain in the same house, eating and drinking what they provide, for the laborer deserves his wages" (Luke 10:7). "The Lord commanded that those who proclaim the gospel should get their living by the gospel" (I Cor. 9:14). "Let him who is taught the word share all good things with him who teaches. Do not be deceived; God is not mocked" (Gal. 6:6, 7). "Let the elders who rule well be considered worthy of double honor, especially those who labor in preaching and teaching; for the scripture says, 'You shall not muzzle an ox when it is treading out the grain,' and 'The laborer deserves his wages,'" (I Tim. 5:17, 18). "We beseech you, brethren, to respect those who labor among you and are over you in the Lord and admonish you, and to esteem them very highly in love because of their work. Be at peace among yourselves" (I Thess. 5:12, 13). "Obey your leaders and submit to them; for they are keeping watch over your souls, as men who will have to give account. Let them do this joyfully, and not sadly, for that would be of no advantage to you" (Heb. 13:17).

Governing Authorities[3]

"Let every person be subject to the governing authorities. For there is no authority except from God, and those that exist have been instituted by God. Therefore he who resists the authorities resists what God has appointed, and those who resist will incur judgment. He who is in authority does not bear the sword in vain; he is the servant of God to execute his wrath on the wrongdoer" (Rom. 13:1–4).

Duties Subjects Owe Governing Authorities

"Render therefore to Caesar the things that are Caesar's, and to God the things that are God's" (Matt. 22:21). "Let every person be subject to the governing authorities. Therefore one must be subject, not only to avoid God's wrath but also for the sake of conscience. For the same reason you also pay taxes, for the authorities are ministers of God, attending to this very thing. Pay all of them their dues, taxes to whom taxes are due, revenue to whom revenue is due, respect to whom respect is due, honor to whom honor is due" (Rom. 13:1, 5–7). "I urge that supplications, prayers, intercessions, and thanksgivings be made for all men, for kings and all who are in high positions, that we may lead a quiet and peaceable life, godly and respectful in every way" (I Tim. 2:1, 2). "Remind them to be submissive to rulers and authorities, to be obedient, to be ready for any honest work" (Tit. 3:1). "Be subject for the Lord's sake to every human institution, whether it be to the emperor as supreme, or to governors as sent by him to punish those who do wrong and to praise those who do right" (I Pet. 2:13, 14).

Husbands

"You husbands, live considerately with your wives, bestowing honor on the woman as the weaker sex, since you are joint heirs of the grace of life, in order that your prayers not be hindered" (I Pet. 3:7). "Husbands, love your wives, and do not be harsh with them" (Col. 3:19).

Wives

"You wives, be submissive to your husbands, as Sarah obeyed Abraham, calling him lord. And you are now her children if you do right and let nothing terrify you" (I Pet. 3:1, 6).

Parents

"Fathers, do not provoke your children to anger, lest they become discouraged, but bring them up in the discipline and instruction of the Lord" (Eph. 6:4; Col. 3:21).

Children

"Children, obey your parents in the Lord, for this is right. 'Honor your father and mother' (this is the first commandment with a promise) 'that it may be well with you and that you may live long on the earth'" (Eph. 6:1–3).

Laborers and Servants, Male and Female

"Be obedient to those who are your earthly masters, with fear and trembling, with singleness of heart, as to Christ; not in the way of eye-service, as men-pleasers, but as servants of Christ, doing the will of God from the heart, rendering service with a good will as to the Lord and not to men, knowing that whatever good anyone does, he will receive the same again from the Lord, whether he is a slave or free" (Eph. 6:5–8).

Masters and Mistresses

"Masters, do the same to them, and forbear threatening, knowing that he who is both their Master and yours is in heaven, and that there is no partiality with him" (Eph. 6:9).

Young Persons in General

"You that are younger, be subject to the elders. Clothe yourselves, all of you, with humility toward one another, for 'God opposes the proud, but gives grace to the humble.' Humble yourselves therefore under the mighty hand of God, that in due time he may exalt you" (I Pet. 5:5, 6).

Widows

"She who is a real widow, and is left all alone, has set her hope on God and continues in supplication and prayers night and day; whereas she who is self-indulgent is dead even while she lives" (I Tim. 5:5, 6).

Christians in General

"The commandments are summed up in this sentence, 'You shall love your neighbor as yourself'" (Rom. 13:9). "I urge that supplications, prayers, intercessions, and thanksgivings be made for all men" (I Tim. 2:1).

> Let each his lesson learn with care
> And all the household well will fare.[4]

Notes

[1] This table of duties was probably suggested to Luther by John Gerson's *Tractatus de modo vivendi omnium fidelium*.

[2] This section was not prepared by Luther, but was later taken up into the *Small Catechism*, probably with Luther's consent. The passages from Luke 10 and I Thess. 5 are not included in the Latin text.

[3] This section was not prepared by Luther, but was later taken up into the *Small Catechism*, probably with Luther's consent.

[4] On this rhyme by Luther see WA, 35:580.

HAMLET, PRINCE OF DENMARK

WILLIAM SHAKESPEARE

Probably none of Shakespeare's works has been discussed more than Hamlet. *It would be possible to make a case for* King Lear *or even* Othello *as a greater work of art, but* Hamlet *presents problems that intrigue at so many different levels as to justify its reputation as the most famous play ever written. To the scholar, the critic, the psychiatrist, the actor, the lover of the theater, every performance of* Hamlet *represents a challenge to their powers of interpretation, and every reading presents the possibility of coming to grips with its central question: Why is Hamlet unable to make up his mind and do something?*

The theme of the play was familiar to Elizabethan audiences. It belongs to a category known as revenge tragedy, in which the hero discovers that a close relative has been murdered, experiences considerable trouble in identifying the murderer, and, after overcoming numerous obstacles, finally succeeds in avenging the death by killing the murderer. Other violent elements were usually thrown in, including mad scenes and ghosts. The plays generally ended in a welter of blood. A good example of a revenge tragedy is The Spanish Tragedy *of Thomas Kyd (1558–1594), who also wrote a now lost version of the* Hamlet *story that may have influenced Shakespeare's.*

Hamlet is a revenge tragedy with a number of important differences, however. Hamlet has no need to investigate the cause of his father's death, since his father's ghost communicates directly to him both the fact and method of his murder. Nor does he need to search for the identity of the murderer, his uncle, whom he has in any case already suspected. The only obstacles in the way of his revenge are ones he creates himself. Although Hamlet does indeed eventually avenge his father's death he does so at the price of the lives of his mother, the girl he loves, her father and brother, and himself. If Hamlet had only taken action at the time he first learned the truth, as any other hero might have done, all the agony of the closing scenes would have been avoided.*

A partial explanation of Hamlet's *fascination for the modern reader lies precisely in the fact that Hamlet is not a conventional hero, but represents instead a type sometimes called* antiheroic. *Certainly it is true that throughout the play Hamlet is aware of the difficulties of existence rather than the possibilities it presents. His mood is not so much of melancholy as of disillusionment. The disgust he feels at his mother's unseemly haste to remarry within two months of her husband's death gives him a newly pessimistic perspective on human relationships, which he extends to all aspects of life.*

The pessimism with which Hamlet contemplates existence extends to nonexistence as well, both in the great soliloquy "To be, or not to be" (see Act III) and in the graveyard scene at the beginning of Act V. At the side of the grave destined for Ophelia, who has been driven to madness and suicide by Hamlet's callous treatment of her love for him, the fact of death, hitherto veiled beneath layers of poetic and philosophical reflection, suddenly becomes real and neither Hamlet nor Shakespeare hesitates to stare it in the face. The bleakness of the vision, coupled with the down-to-earth reactions of the gravediggers, is reminiscent of Bruegel's The Triumph of Death *[see Figure 14.18] with its skeletons and peasant folk.*

Hamlet is by no means the only character of interest in the play or his vengeance the only issue. His relationships with his mother Gertrude and Ophelia provide further insights into human behavior. Gertrude is shown as good-natured but weak, led astray by her inability to resist temptation (especially sexual temptation). In the gentle Ophelia, destroyed by her own innocence, Shakespeare produced one of his most touching creations. Her father Polonius stands alongside the great comic figures of Shakespearean drama while retaining a curious dignity. Even the courtiers Rosencrantz and Guildenstern and the odious Osric are given personalities of their own.

Nonetheless it is Hamlet himself who continues to attract our interest and curiosity. The reasons for his indecisiveness have been discussed again and again. External circumstances, religious or moral scruples, simple lack of nerve, excessive tendency to intellectualize, and psychological instability have all been suggested. All can be defended, but none is by itself totally convincing. It has even been said that most analyses of Hamlet *are inappropriate because they look at the play from a modern rather than an Elizabethan point of view and try to find subtleties of which Shakespeare never dreamed. Why can we not, some critics argue, see* Hamlet *as an exceptional revenge tragedy given a pessimistic twist and expressed in superb poetic language?*

Such a position would seem to underrate both Shakespeare and his audience, but we can agree at least about the language. To a viewer or reader coming to the play for the first time, or returning to it after a long absence, perhaps nothing is more astonishing than the way in which so many of the lines are already familiar. They seem to have become part of the way in which we think and speak. It is difficult to remember the first time we heard the words "To be, or not to be," so much are they a part of our cultural heritage. The familiarity of phrase after phrase—"Fraility, thy name is woman"; "to thine own self be true"; "though this be madness, yet there is method in it"—illustrates that no play of Shakespeare has had a more universal appeal than the one which, paradoxically, presents the greatest enigmas.

PERSONS REPRESENTED

CLAUDIUS, *King of Denmark*
HAMLET, *son to the late, and nephew to the present,* King
FORTINBRAS, *Prince of Norway*
POLONIUS, *Lord Chamberlain*
HORATIO, *friend to Hamlet*
LAERTES, *son to Polonius*
VOLTIMAND
CORNELIUS
ROSENCRANTZ *courtiers*

GUILDENSTERN
OSRIC
A GENTLEMAN
A PRIEST
MARCELLUS *officers*
BERNARDO
FRANCISCO, *a solider*
REYNALDO, *servant to Polonius*
PLAYERS
TWO CLOWNS, *grave-diggers*
A CAPTAIN
ENGLISH AMBASSADORS
GHOST *of Hamlet's father*
GERTRUDE, *Queen of Denmark and mother to Hamlet*
OPHELIA, *daughter of Polonius*
LORDS, LADIES, OFFICERS, SOLDIERS, SAILORS, MES-
SENGERS, AND OTHER ATTENDANTS

SCENE: ELSINORE

Act I

Scene I. *A platform before the castle.*

FRANCISCO AT HIS POST. ENTER TO HIM BERNARDO.

BERNARDO Who's there?
FRANCISCO Nay, answer me: stand, and unfold[1] yourself.
BERNARDO Long live the king!
FRANCISCO Bernardo?
BERNARDO He.
FRANCISCO You come most carefully upon your hour.
BERNARDO 'Tis now struck twelve: get thee to bed,
 Francisco.
FRANCISCO For this relief much thanks: 'tis bitter cold,
 And I am sick at heart.
BERNARDO Have you had quiet guard?
FRANCISCO Not a mouse stirring.
BERNARDO Well, good night. If you do meet Horatio and
 Marcellus, The rivals[2] of my watch, bid them make
 haste.
FRANCISCO I think I hear them.— Stand, ho! who is there? 11

ENTER HORATIO AND MARCELLUS.

HORATIO Friends to this ground.
MARCELLUS And liegemen to the Dane.[3]
FRANCISCO Give you good night.
MARCELLUS O, farewell, honest soldier: Who hath
 relieved you?
FRANCISCO Bernardo hath my place. Give you good night.

EXIT FRANCISCO.

MARCELLUS Holla! Bernardo!
BERNARDO Say,—What, is Horatio there?
HORATIO A piece of him.
BERNARDO Welcome, Horatio; welcome, good Marcellus.
MARCELLUS What, has this thing appeared again tonight?
BERNARDO I have seen nothing.
MARCELLUS Horatio says, 'tis but our fantasy; 20
 And will not let belief take hold of him,
 Touching this dreaded sight, twice seen of us:
 Therefore I have entreated him along
 With us to watch the minutes of this night;
 That if again this apparition come,
 He may approve[4] our eyes and speak to it.
HORATIO Tush, tush, 'twill not appear.

BERNARDO Sit down a while;
 And let us once again assail your ears,
 That are so fortified against our story,
 What we have two nights seen.
HORATIO Well, sit we down,
 And let us hear Bernardo speak of this.
BERNARDO —Last night of all, 32
 When yon same star that's westward from the pole,
 Had made his course to illume that part of heaven
 Where now it burns, Marcellus and myself,
 The bell then beating one,—

ENTER GHOST.

MARCELLUS Peace, break thee off; look, where it comes
 again!
BERNARDO In the same figure, like the king that's dead.
MARCELLUS Thou art a scholar, speak to it, Horatio.
BERNARDO Looks 'a[5] not like the king? mark it, Horatio. 40
HORATIO Most like: it harrows me with fear and wonder.
BERNARDO It would be spoke to.
MARCELLUS Speak to it, Horatio.
HORATIO What art thou, that usurp'st this time of night,
 Together with that fair and warlike form
 In which the majesty of buried Denmark
 Did sometimes march? by heaven I charge thee, speak!
MARCELLUS It is offended.
BERNARDO See, it stalks away!
HORATIO Stay! speak, speak! I charge thee, speak!

EXIT GHOST.

MARCELLUS 'Tis gone, and will not answer.
BERNARDO How now, Horatio! you tremble and
 look pale: 50
 Is not this something more than fantasy?
 What think you on't?
HORATIO Before my God, I might not this believe,
 Without the sensible and true avouch
 Of mine own eyes.
MARCELLUS Is it not like the king?
HORATIO As thou art to thyself:
 Such was the very armour he had on
 When he the ambitious Norway[6] combated;
 So frowned he once, when, in an angry parle,[7]
 He smote the sledded pole-axe on the ice. 60
 'Tis strange.
MARCELLUS Thus twice before, and jump[8] at this
 dead hour,
 With martial stalk hath he gone by our watch.
HORATIO In what particular thought to work I know not;
 But, in the gross and scope of mine opinion,
 This bodes some strange eruption to our state.
MARCELLUS Good now, sit down, and tell me, he
 that knows,
 Why this same strict and most observant watch
 So nightly toils the subject of the land?
 And why such daily cast of brazen cannon, 70
 And foreign mart for implements of war:
 Why such impress of shipwrights, whose sore task
 Does not divide the Sunday from the week:
 What might be toward that this sweaty haste
 Doth make the night joint-labourer with the day;
 Who is't that can inform me?
HORATIO That can I;
 At least the whisper goes so. Our last king,
 Whose image even but now appeared to us,

Was, as you know, by Fortinbras of Norway,
Thereto pricked on by a most emulate pride,
Dared to the combat; in which our valiant Hamlet—
For so this side of our known world esteemed him—
Did slay this Fortinbras; who, by a sealed compact,
Well ratified by law and heraldry,
Did forfeit, with his life, all those his lands,
Which he stood seized of, to the conqueror:
Against the which a moiety competent
Was gaged[9] by our king; which had returned
To the inheritance of Fortinbras,
Had he been vanquisher; as, by the same comart[10] 90
And carriage of the article designed,
His fell to Hamlet. Now, sir, young Fortinbras,
Of unapproved mettle hot and full,
Hath in the skirts[11] of Norway here and there
Sharked up a list of lawless resolutes,
For food and diet, to some enterprise
That hath a stomach in't: which is no other—
As it doth well appear unto our state,—
But to recover of us, by strong hand,
And terms compulsatory, those foresaid lands 100
So by his father lost: and this, I take it,
Is the main motive of our preparations;
The source of this our watch; and the chief head
Of this post-haste and romage[12] in the land.
BERNARDO I think it be no other but e'en so.
 Well may it sort, that this portentous figure
 Comes armed through our watch, so like the king
 That was and is the question of these wars.
HORATIO A mote it is to trouble the mind's eye.
 In the most high and palmy state of Rome, 110
 A little ere the mightiest Julius fell,
 The graves stood tenantless, and the sheeted dead
 Did squeak and gibber in the Roman streets:
 As stars with trains of fire and dews of blood,
 Disasters in the sun; and the moist star,
 Upon whose influence Neptune's empire stands,
 Was sick almost to doomsday with eclipse:
 And even the like precurse of fierce events,
 As harbingers preceding still the fates,
 And prologue to the omen coming on, 120
 Have heaven and earth together demonstrated
 Unto our climatures[13] and countrymen.—

RE-ENTER GHOST.

But soft; behold! lo, where it comes again!
I'll cross it, though it blast me.—Stay, illusion!
If thou hast any sound, or use of voice,
Speak to me:
If there be any good thing to be done,
That may to thee do ease and grace to me,
Speak to me:
If thou art privy to thy country's fate, 130
Which, happily, foreknowing may avoid,
O, speak!
Or if thou hast uphoarded in thy life
Extorted treasure in the womb of earth,
For which, they say, you spirits oft walk in death,

THE COCK CROWS.

Speak of it: stay, and speak.—Stop it, Marcellus.
MARCELLUS Shall I strike at it with my partizan?[14]
HORATIO Do, if it will not stand.
BERNARDO 'Tis here!

HORATIO 'Tis here!
MARCELLUS 'Tis gone! 80

EXIT GHOST.

 We do it wrong, being so majestical, 140
 To offer it the show of violence;
 For it is, as the air, invulnerable,
 And our vain blows malicious mockery.
BERNARDO It was about to speak, when the cock crew.
HORATIO And then it started like a guilty thing
 Upon a fearful summons. I have heard,
 The cock, that is the trumpet to the morn,
 Doth with his lofty and shrill-sounding throat
 Awake the god of day, and at his warning,
 Whether in sea or fire, in earth or air, 150
 The extravagant and erring spirit hies
 To his confine: and of the truth herein
 This present object made probation.
MARCELLUS It faded on the crowing of the cock.
 Some say that ever 'gainst that season comes
 Wherein our Saviour's birth is celebrated,
 The bird of dawning singeth all night long:
 And then, they say, no spirit dare stir abroad,
 The nights are wholesome, then no planets strike,
 No fairy takes, nor witch hath power to charm, 160
 So hallowed and so gracious is the time.
HORATIO So have I heard, and do in part believe it.
 But, look, the morn, in russet mantle clad,
 Walks o'er the dew of yon high eastward hill.
 Break we our watch up; and by my advice,
 Let us impart what we have seen to-night
 Unto young Hamlet: for, upon my life,
 This spirit, dumb to us, will speak to him:
 Do you consent we shall acquaint him with it,
 As needful in our loves, fitting our duty? 170
MARCELLUS Let's do't, I pray: and I this morning know
 Where we shall find him most convenient.

EXEUNT.

Notes

[1] reveal
[2] partners
[3] loyal subjects of the Danish king
[4] confirm
[5] he
[6] king of Norway
[7] parley
[8] just
[9] pledged
[10] agreement
[11] borders
[12] bustle
[13] regions
[14] pike (a type of spear)

Scene II. *A room of state in the castle.*

 FLOURISH. ENTER THE KING, QUEEN, HAMLET, POLONIUS,
LAERTES, VOLTIMAND, CORNELIUS, LORDS, AND ATTENDANTS.

KING Though yet of Hamlet our dear brother's death
 The memory be green, and that it us befitted
 To bear our hearts in grief and our whole kingdom
 To be contracted in one brow of woe;
 Yet so far hath discretion fought with nature,

That we with wisest sorrow think on him,
Together with remembrance of ourselves.
Therefore our sometime sister, now our queen,
The imperial jointress[1] to this warlike state,
Have we, as 'twere, with a defeated joy, 10
With an auspicious and a dropping eye;
With mirth in funeral and with dirge in marriage
In equal scale weighing delight and dole,
Taken to wife: nor have we herein barred
Your better wisdoms, which have freely gone
With this affair along. For all, our thanks.
Now follows, that you know, young Fortinbras,
Holding a weak supposal of our worth;
Or thinking by our late dear brother's death,
Our state to be disjoint and out of frame, 20
Colleagued with this dream of his advantage,
He hath not failed to pester us with message,
Importing the surrender of those lands
Lost by his father, with all bands of law,
To our most valiant brother. So much for him.
Now for ourself, and for this time of meeting;
Thus much the business is: we have here writ
To Norway, uncle of young Fortinbras,—
Who, impotent and bed-rid, scarcely hears
Of this his nephew's purpose,—to suppress 30
His further gait herein; in that the levies,
The lists and full proportions,[2] are all made
Out of his subject: and we here dispatch
You, good Cornelius, and you, Voltimand,
For bearers of this greeting to old Norway;
Giving to you no further personal power
To business with the king more than the scope
Of these delated articles[3] allow.
 Farewell, and let your haste commend your duty.
CORNELIUS, VOLTIMAND In that, and all things, will we
 show our duty. 40
KING We doubt it nothing; heartily farewell.

 EXEUNT VOLTIMAND AND CORNELIUS.

 And now, Laertes, what's the news with you?
 You told us of some suit; what is't, Laertes?
 You cannot speak of reason to the Dane,
 And lose your voice: what wouldst thou beg, Laertes,
 That shall not be my offer, not thy asking?
 The head is not more native to the heart,
 The hand more instrumental to the mouth,
 Than is the throne of Denmark to thy father.
 What wouldst thou have, Laertes? 50
LAERTES My dread lord,
 Your leave and favour to return to France;
 From whence though willingly I came to Denmark,
 To show my duty in your coronation;
 Yet now, I must confess, that duty done,
 My thoughts and wishes bend again toward France,
 And bow them to your gracious leave and pardon.
KING Have you your father's leave? What says Polonius?
POLONIUS He hath, my lord, wrung from me my slow
 leave,
 By laboursome petition; and at last,
 Upon his will I sealed my hard consent: 60
 I do beseech you, give him leave to go.
KING Take thy fair hour, Laertes; time be thine,
 And thy best graces spend it at thy will!
 But now, my cousin Hamlet, and my son,—
HAMLET *[Aside]* A little more than kin, and less than kind.

KING How is it that the clouds still hang on you?
HAMLET Not so, my lord, I am too much i' the sun.
QUEEN Good Hamlet, cast thy nighted colour off,
 And let thine eye look like a friend on Denmark,
 Do not, for ever, with thy vailed[4] lids 70
 Seek for thy noble father in the dust.
 Thou know'st, 'tis common; all that lives must die,
 Passing through nature to eternity.
HAMLET Ay, madam, it is common.
QUEEN If it be,
 Why seems it so particular with thee?
HAMLET "Seems," madam! nay, it is; I know not seems."
 'Tis not alone my inky cloak, good mother,
 Nor customary suits of solemn black,
 Nor windy suspiration of forced breath,
 No, nor the fruitful river in the eye, 80
 Nor the dejected haviour of the visage,
 Together with all forms, moods, shows of grief,
 That can denote me truly: these indeed seem,
 For they are actions that a man might play:
 But I have that within which passes show;
 These, but the trappings and the suits of woe.
KING 'Tis sweet and commendable in your nature, Hamlet,
 To give these mourning duties to your father:
 But, you must know, your father lost a father;
 That father lost his; and the survivor bound 90
 In filial obligation for some term
 To do obsequious sorrow: but to persever
 In obstinate condolement[5] is a course
 Of impious stubbornness; 'tis unmanly grief:
 It shows a will most incorrect to heaven;
 A heart unfortified, a mind impatient,
 An understanding simple and unschooled:
 For what we know must be and is as common
 As any the most vulgar thing to sense,
 Why should we, in our peevish opposition, 100
 Take it to heart? Fie! 'tis a fault to heaven,
 A fault against the dead, a fault to nature,
 To reason most absurd, whose common theme
 Is death of fathers, and who still hath cried,
 From the first corse[6] till he that died to-day,
 "This must be so." We pray you, throw to earth
 This unprevailing woe, and think of us
 As of a father: for let the world take note,
 You are the most immediate to our throne,
 And with no less nobility of love, 110
 Than that which dearest father bears his son,
 Do I impart toward you. For your intent
 In going back to school in Wittenberg,
 It is most retrograde to our desire:
 And we beseech you, bend you to remain
 Here, in the cheer and comfort of our eye,
 Our chiefest courtier, cousin, and our son.
QUEEN Let not thy mother lose her prayers, Hamlet;
 I pray thee, stay with us; go not to Wittenberg.
HAMLET I shall in all my best obey you, madam. 120
KING Why, 'tis a loving and a fair reply;
 Be as ourself in Denmark. Madam, come;
 This gentle and unforced accord of Hamlet
 Sits smiling to my heart: in grace whereof,
 No jocund health that Denmark drinks to-day,
 But the great cannon to the clouds shall tell;
 And the king's rouse the heaven shall bruit[7] again,
 Re-speaking earthly thunder. Come away.

 EXEUNT ALL BUT HAMLET.

HAMLET O, that this too too solid flesh would melt,
 Thaw and resolve itself into a dew!
 Or that the Everlasting had not fixed
 His canon[8] 'gainst self-slaughter! O God! O God!
 How weary, stale, flat, and unprofitable
 Seem to me all the uses of this world!
 Fie on't! ah, fie! 'tis an unweeded garden,
 That grows to seed; things rank and gross in nature,
 Possess it merely. That it should come to this!
 But two months dead! nay, not so much, not two;
 So excellent a king; that was, to this,
 Hyperion[9] to a satyr: so loving to my mother, 140
 That he might not beteem[10] the winds of heaven
 Visit her face too roughly. Heaven and earth!
 Must I remember? why, she would hang on him,
 As if increase of appetite had grown
 By what it fed on: and yet, within a month,—
 Let me not think on't;—frailty, thy name is woman!—
 A little month; or ere those shoes were old,
 With which she followed my poor father's body,
 Like Niobe,[11] all tears;—why she, even she,— 150
 O God! a beast, that wants discourse of reason,
 Would have mourned longer,—married with my uncle,
 My father's brother, but no more like my father,
 Than I to Hercules. Within a month?
 Ere yet the salt of most unrighteous tears
 Had left the flushing in her galled eyes,
 She married. O, most wicked speed, to post[12]
 With such dexterity to incestuous sheets!
 It is not, nor it cannot come to, good;—
 But break, my heart: for I must hold my tongue!

 ENTER HORATIO, MARCELLUS, BERNARDO.

HORATIO Hail to your lordship!
HAMLET I am glad to see you well: 160
 Horatio,—or I do forget myself.
HORATIO The same, my lord, and your poor servant ever.
HAMLET Sir, my good friend; I'll change that name
 with you.
 And what makes you from Wittenberg,
 Horatio?—
 Marcellus?
MARCELLUS My good lord,—
HAMLET I am very glad to see you; good even, sir,—
 But what, in faith, make you from Wittenberg?
HORATIO A truant disposition, good my lord.
HAMLET I would not hear your enemy say so,
 Nor shall you do mine ear that violence, 170
 To make it truster of your own report
 Against yourself: I know you are no truant.
 But what is your affair in Elsinore?
 We'll teach you to drink deep, ere you depart.
HORATIO My lord, I came to see your father's funeral.
HAMLET I pray thee, do not mock me, fellow-student;
 I think it was to see my mother's wedding.
HORATIO Indeed, my lord, it followed hard upon.
HAMLET Thrift, thrift, Horatio! the funeral baked meats
 Did coldly furnish forth the marriage tables. 180
 Would I had met my dearest foe in heaven
 Or ever I had ever seen that day, Horatio!—
 My father,—methinks I see my father.
HORATIO Where, my lord?
HAMLET In my mind's eye, Horatio.
HORATIO I saw him once, 'a was a goodly king.
HAMLET 'A was a man, take him for all in all,
 I shall not look upon his like again.

HORATIO My lord, I think I saw him yesternight.
HAMLET Saw! who? 130
HORATIO My lord, the king your father. 190
HAMLET The king my father!
HORATIO Season your admiration for a while
 With an attent ear, till I may deliver,
 Upon the witness of these gentlemen,
 This marvel to you.
HAMLET For God's love; let me hear.
HORATIO Two nights together had these gentlemen,
 Marcellus and Bernardo, on their watch,
 In the dead waste and middle of the night,
 Been thus encountered. A figure like your father,
 Armed at point, exactly, cap-a-pe,[13]
 Appears before them, and with solemn march, 200
 Goes slow and stately by them; thrice he walked,
 By their oppressed and fear-surprised eyes,
 Within his truncheon's length; whilst they, distilled
 Almost to jelly with the act of fear,
 Stand dumb, and speak not to him. This to me
 In dreadful[14] secrecy impart they did;
 And I with them the third night kept the watch:
 Where, as they had delivered, both in time,
 Form of the thing, each word made true and good,
 The apparition comes. I knew your father; 210
 These hands are not more like.
HAMLET But where was this?
MARCELLUS My lord, upon the platform where we
 watched.
HAMLET Did you not speak to it?
HORATIO My lord, I did;
 But answer made it none: yet once, methought,
 It lifted up its head and did address
 Itself to motion, like as it would speak:
 But even then the morning cock crew loud,
 And at the sound it shrank in haste away,
 And vanished from our sight.
HAMLET 'Tis very strange.
HORATIO As I do live, my honoured lord, 'tis true;
 And we did think it writ down in our duty, 220
 To let you know of it.
HAMLET Indeed, indeed, sirs, but this troubles me.
 Hold you the watch to-night?
MARCELLUS, BERNARDO We do, my lord.
HAMLET Armed, say you?
ALL Armed, my lord.
HAMLET From top to toe?
ALL My lord, from head to foot.
HAMLET Then saw you not his face?
HORATIO O, yes, my lord; he wore his beaver[15] up.
HAMLET What, looked he frowningly?
HORATIO A countenance more in sorrow than in anger. 230
HAMLET Pale or red?
HORATIO Nay, very pale.
HAMLET And fixed his eyes upon you?
HORATIO Most constantly.
HAMLET I would I had been there.
HORATIO It would have much amazed you.
HAMLET Very like, very like. Stayed it long?
HORATIO While one with moderate haste might tell a
 hundred.
MARCELLUS, BERNARDO Longer, longer.
HORATIO Not when I saw't.
HAMLET His beard was grizzled, no?
HORATIO It was, as I have seen it in his life,
 A sable silvered.

HAMLET I will watch to-night; 240
 Perchance, 'twill walk again.
HORATIO I warrant it will.
HAMLET If it assume my noble father's person,
 I'll speak to it, though hell itself should gape
 And bid me hold my peace. I pray you all,
 If you have hitherto concealed this sight,
 Let it be tenable in your silence still,
 And whatsoever else shall hap to-night,
 Give it an understanding, but no tongue;
 I will requite your loves. So, fare you well:
 Upon the platform, 'twixt eleven and twelve, 250
 I'll visit you.
ALL Our duty to your honour.
HAMLET Your loves, as mine to you: farewell.

<center>EXEUNT ALL BUT HAMLET.</center>

 My father's spirit in arms! all is not well;
 I doubt some foul play: would the night were come!
 Till then sit still, my soul; foul deeds will rise,
 Though all the earth o'erwhelm them, to men's eyes.

<center>EXIT.</center>

Notes

1 partner
2 provisions
3 detailed documents
4 lowered
5 mourning
6 corpse
7 noisily proclaim
8 law
9 the sun god, a symbol of ideal beauty
10 allow
11 a mother who, according to the Greek myth, wept so profusely at the
 death of her children that she was turned to stone by the gods
12 hasten
13 head to foot
14 fearful
15 visor, face guard

Scene III. *A room in* POLONIUS' *house.*

<center>ENTER LAERTES AND OPHELIA.</center>

LAERTES My necessaries are embarked; farewell:
 And, sister, as the winds give benefit,
 And convoy is assistant, do not sleep,
 But let me hear from you.
OPHELIA Do you doubt that?
LAERTES For Hamlet, and the trifling of his favour,
 Hold it a fashion, and a toy in blood,
 A violet in the youth of primy[1] nature,
 Forward, not permanent, sweet, not lasting,
 The perfume and suppliance[2] of a minute;
 No more.
OPHELIA No more but so?
LAERTES Think it no more: 10
 For nature crescent[3] does not grow alone
 In thews and bulk; but, as this temple waxes,
 The inward service of the mind and soul
 Grows wide withal. Perhaps he loves you now;
 And now no soil nor cautel[4] doth besmirch
 The virtue of his will: but, you must fear,
 His greatness weighed, his will is not his own;
 For he himself is subject to his birth:

He may not, as unvalued persons do,
 Carve for himself, for on his choice depends, 20
 The safety and health of this whole state,
 And therefore must his choice be circumscribed
 Unto the voice and yielding of that body
 Whereof he is the head. Then if he says he loves you,
 It fits your wisdom so far to believe it
 As he in his particular act and place
 May give his saying deed; which is not further,
 Than the main voice of Denmark goes withal.
 Then weigh what loss your honour may sustain,
 If with too credent ear you list his songs, 30
 Or lose your heart, or your chaste treasure open
 To his unmastered importunity.
 Fear it, Ophelia, fear it, my dear sister,
 And keep you in the rear of your affection,
 Out of the shot and danger of desire.
 The chariest maid is prodigal enough,
 If she unmask her beauty to the moon:
 Virtue itself 'scapes not calumnious strokes:
 The canker galls the infants of the spring
 Too oft before their buttons[5] be disclosed, 40
 And in the morn and liquid dew of youth
 Contagious blastments are most imminent.
 Be wary then: best safety lies in fear;
 Youth to itself rebels, though none else near.
OPHELIA I shall the effect of this good lesson keep,
 As watchman to my heart. But, good my brother,
 Do not, as some ungracious pastors do,
 Show me the steep and thorny way to heaven,
 Whiles, like a puffed and reckless libertine,
 Himself the primrose path of dalliance treads 50
 And recks not his own rede.[6]
LAERTES O, fear me not.
 I stay too long; but here my father comes.

<center>ENTER POLONIUS.</center>

 A double blessing is a double grace;
 Occasion smiles upon a second leave.
POLONIUS Yet here, Laertes! aboard, aboard, for shame!
 The wind sits in the shoulder of your sail,
 And you are stayed for. There; my blessing with thee!

<center>LAYING HIS HAND ON LAERTES' HEAD.</center>

 And these few precepts in thy memory
 Look thou character.[7] Give thy thoughts no tongue,
 Nor any unproportioned thought his act. 60
 Be thou familiar, but by no means vulgar.
 The friends thou hast, and their adoption tried,
 Grapple them to thy soul with hoops of steel;
 But do not dull thy palm with entertainment
 Of each new-hatched, unfledged comrade.
 Beware
 Of entrance to a quarrel: but, being in,
 Bear't that the opposed may beware of thee.
 Give every man thine ear, but few thy voice:
 Take each man's censure, but reserve thy judgement.
 Costly thy habit as thy purse can buy, 70
 But not expressed in fancy; rich, not gaudy:
 For the apparel oft proclaims the man;
 And they in France of the best rank and station
 Are most select and generous, chief in that.
 Neither a borrower nor a lender be:
 For loan oft loses both itself and friend,
 And borrowing dulls the edge of husbandry.
 This above all: to thine ownself be true,

And it must follow, as the night the day,
Thou canst not then be false to any man.
Farewell; my blessing season this in thee!
LAERTES Most humbly do I take my leave, my lord.
POLONIUS The time invites you; go, your servants tend.
LAERTES Farewell, Ophelia, and remember well
 What I have said to you.
OPHELIA 'Tis in my memory locked,
 And you yourself shall keep the key of it.
LAERTES Farewell.

EXIT LAERTES.

POLONIUS What is't, Ophelia, he hath said to you?
OPHELIA So please you, something touching the Lord
 Hamlet.
POLONIUS Marry, well bethought:
 'Tis told me, he hath very oft of late
 Given private time to you, and you yourself
 Have of your audience been most free and bounteous;
 If it be so,—as so 'tis put on me,
 And that in way of caution,—I must tell you,
 You do not understand yourself so clearly,
 As it behoves my daughter and your honour.
 What is between you? give me up the truth.
OPHELIA He hath, my lord, of late, made many tenders
 Of his affection to me.
POLONIUS Affection! pooh! you speak like a green girl,
 Unsifted in such perilous circumstance.
 Do you believe his "tenders," as you call them?
OPHELIA I do not know, my lord, what I should think.
POLONIUS Marry, I'll teach you: think yourself a baby;
 That you have ta'en his tenders for true pay,
 Which are not sterling. Tender yourself more dearly;
 Or,—not to crack the wind of the poor phrase,
 Running it thus,—you'll tender me a fool.
OPHELIA My lord, he hath importuned me with love
 In honourable fashion.
POLONIUS Ay, "fashion" you may call it; go to, go to.
OPHELIA And hath given countenance to his speech,
 my lord,
 With almost all the vows of heaven.
POLONIUS Ay, springes to catch woodcocks.[8] I do know,
 When the blood burns, how prodigal the soul
 Lends the tongue vows: these blazes, daughter,
 Giving more light than heat, extinct in both,
 Even in their promise, as it is a-making,
 You must not take for fire. From this time
 Be something scanter of your maiden presence;
 Set your entreatments at a higher rate,
 Than a command to parley. For Lord Hamlet,
 Believe so much in him, that he is young;
 And with a larger tether may he walk,
 Than may be given you; in few, Ophelia,
 Do not believe his vows; for they are brokers,
 Not of that dye which their investments show,
 But mere implorators of unholy suits,
 Breathing like sanctified and pious bawds,
 The better to beguile. This is for all;
 I would not, in plain terms, from this time forth,
 Have you so slander any moment's leisure,
 As to give words or talk with the Lord Hamlet.
 Look to't, I charge you; come your ways.
OPHELIA I shall obey, my lord.

EXEUNT.

Notes

80

[1] springlike
[2] occupation
[3] growing
[4] deceit
[5] buds
[6] does not heed his own advice
[7] inscribe
[8] traps to catch stupid birds

Scene IV. *The platform.*

ENTER HAMLET, HORATIO, AND MARCELLUS.

HAMLET The air bites shrewdly; it is very cold.
HORATIO It is a nipping and an eager air.
HAMLET What hour now?
HORATIO I think it lacks of twelve.
MARCELLUS No, it is struck.
HORATIO Indeed? I heard it not; it then draws near the
 season,
 Wherein the spirit held his wont to walk.

A FLOURISH OF TRUMPETS, AND ORDNANCE SHOT OFF, WITHIN.

 What does this mean, my lord?
HAMLET The king doth wake to-night and takes his rouse,
 Keeps wassail and the swaggering up-spring reels;
 And as he drains his draughts of Rhenish down,
 The kettle-drum and trumpet thus bray out
 The triumph of his pledge.
HORATIO Is it a custom?
HAMLET Ay, marry, is't:
 But to my mind, though I am native here,
 And to the manner born, it is a custom
 More honoured in the breach than the observance.
 This heavy-headed revel east and west
 Makes us traduced and taxed of other nations:
 They clepe[1] us drunkards, and with swinish phrase
 Soil our addition;[2] and indeed it takes
 From our achievements, though performed at height,
 The pith and marrow of our attribute.
 So, oft it chances in particular men,
 That for some vicious mole of nature in them,
 As, in their birth,—wherein they are not guilty
 Since nature cannot choose his origin,—
 By the o'ergrowth of some complexion,
 Oft breaking down the pales[3] and forts of reason;
 Or by some habit that too much o'erleavens
 The form of plausive[4] manners; that these men,—
 Carrying, I say, the stamp of one defect;
 Being nature's livery, or fortune's star,—
 His virtues else—be they as pure as grace,
 As infinite as man may undergo,—
 Shall in the general censure take corruption
 From that particular fault: the dram of eale
 Doth all the noble substance of a doubt,
 To his own scandal.

ENTER GHOST.

HORATIO Look, my lord, it comes!
HAMLET Angels and ministers of grace defend us!
 Be thou a spirit of health or goblin damned,
 Bring with thee airs from heaven or blasts from hell,

90

100

110

120

130

10

20

30

40

Be thy intents wicked or charitable,
Thou com'st in such a questionable shape,
That I will speak to thee; I'll call thee Hamlet,
King, father; royal Dane, O, answer me!
Let me not burst in ignorance; but tell
Why thy canonized bones, hearsed in death
Have burst their cerements;⁵ why the sepulchre,
Wherein we saw thee quietly in-urned,
Hath oped his ponderous and marble jaws, 50
To cast thee up again. What may this mean,
That thou, dead corse, again, in complete steel,
Revisit'st thus the glimpses of the moon,
Making night hideous; and we fools of nature
So horridly to shake our disposition,
With thoughts beyond the reaches of our souls?
Say, why is this? wherefore? what should we do?

GHOST BECKONS HAMLET.

HORATIO It beckons you to go away with it,
As if it some impartments⁶ did desire
To you alone.
MARCELLUS Look, with what courteous action 60
It waves you to a more removed ground:
But do not go with it.
HORATIO No, by no means.
HAMLET It will not speak; then I will follow it.
HORATIO Do not, my lord.
HAMLET Why, what should be the fear?
I do not set my life at a pin's fee;
And for my soul, what can it do to that,
Being a thing immortal as itself?
It waves me forth again: I'll follow it.
HORATIO What if it tempt you toward the flood, my lord,
Or to the dreadful summit of the cliff 70
That beetles o'er his base into the sea,
And there assume some other horrible form,
Which might deprive your sovereignty of reason,
And draw you into madness? think of it:
The very place puts toys of desperation,
Without more motive, into every brain,
That looks so many fathoms to the sea
And hears it roar beneath.
HAMLET It waves me still.
Go on; I'll follow thee. 79
MARCELLUS You shall not go, my lord.
HAMLET Hold off your hands!
HORATIO Be ruled; you shall not go.
HAMLET My fate cries out,
And makes each petty artery in this body
As hardy as the Nemean lion's⁷ nerve.

GHOST BECKONS.

Still am I called:—unhand me, gentlemen;

BREAKING FROM THEM.

By heaven, I'll make a ghost of him that lets me:
I say, away!—Go on, I'll follow thee.

EXEUNT GHOST AND HAMLET.

HORATIO He waxes desperate with imagination.
MARCELLUS Let's follow; 'tis not fit thus to obey him.
HORATIO Have after.—To what issue will this come?

MARCELLUS Something is rotten in the state of Denmark. 90
HORATIO Heaven will direct it.
MARCELLUS Nay, let's follow him.

EXEUNT.

Notes

¹ call
² reputation
³ enclosures
⁴ pleasing
⁵ shroud
⁶ communication
⁷ mythical lion killed by the Greek hero Hercules

Scene V. *Another part of the platform.*

ENTER GHOST AND HAMLET.

HAMLET Where wilt thou lead me? speak,
I'll go no further.
GHOST Mark me.
HAMLET I will.
GHOST My hour is almost come,
When I to sulphurous and tormenting flames
Must render up myself.
HAMLET Alas, poor ghost!
GHOST Pity me not, but lend thy serious hearing
To what I shall unfold.
HAMLET Speak; I am bound to hear.
GHOST So art thou to revenge, when thou shalt hear.
HAMLET What?
GHOST I am thy father's spirit;
Doomed for a certain term to walk the night;
And for the day confined to fast in fires, 10
Till the foul crimes done in my days of nature
Are burnt and purged away. But that I am forbid
To tell the secrets of my prison-house,
I could a tale unfold whose lightest word
Would harrow up thy soul, freeze thy young blood,
Make thy two eyes, like stars, start from their spheres,
Thy knotted and combined locks to part,
And each particular hair to stand on end,
Like quills upon the fretful porpentine,¹
But this eternal blazon must not be 20
To ears of flesh and blood. List, list, O list!
If thou didst ever thy dear father love—
HAMLET O God!
GHOST Revenge his foul and most unnatural murder.
HAMLET Murder?
GHOST Murder, most foul, as in the best it is,
But this most foul, strange, and unnatural.
HAMLET Haste me to know't; that I, with wings as swift
As meditation or the thoughts of love,
May sweep to my revenge.
GHOST I find thee apt;
And duller shouldst thou be than the fat weed
That roots itself in ease on Lethe² wharf, 30
Wouldst thou not stir in this. Now Hamlet, hear:
'Tis given out, that, sleeping in mine orchard,
A serpent stung me; so the whole ear of Denmark
Is by a forged process of my death
Rankly abused: but know, thou noble youth,
The serpent that did sting thy father's life,
Now wears his crown.

HAMLET O my prophetic soul! my uncle!
GHOST Ay, that incestuous, that adulterate beast,
 With witchcraft of his wit, with traitorous gifts,—
 O wicked wit and gifts, that have the power 40
 So to seduce!—won to his shameful lust
 The will of my most seeming-virtuous queen:
 O Hamlet, what a falling-off was there!
 From me, whose love was of that dignity,
 That it went hand in hand even with the vow
 I made to her in marriage; and to decline
 Upon a wretch, whose natural gifts were poor
 To those of mine!
 But virtue, as it never will be moved,
 Though lewdness court it in a shape of heaven;
 So lust, though to a radiant angel linked, 50
 Will sort itself in a celestial bed,
 And prey on garbage.
 But, soft! methinks I scent the morning air;
 Brief let me be. Sleeping within my orchard
 My custom always in the afternoon,
 Upon my secure hour thy uncle stole,
 With juice of cursed hebenon[3] in a vial,
 And in the porches of mine ears did pour
 The leperous distilment; whose effect
 Holds such an enmity with blood of man, 60
 That swift as quicksilver it courses through
 The natural gates and alleys of the body;
 And with a sudden vigour it doth posset[4]
 And curd, like eager[5] droppings into milk,
 The thin and wholesome blood: so did it mine;
 And a most instant tetter[6] barked about,
 Most lazar-like,[7] with vile and loathsome crust,
 All my smooth body.
 Thus was I, sleeping, by a brother's hand,
 Of life, of crown, and queen, at once dispatched; 70
 Cut off even in the blossoms of my sin,
 Unhouseled, disappointed, unaneled;[8]
 No reckoning made, but sent to my account
 With all my imperfections on my head:
 O, horrible! O, horrible! most horrible!
 If thou hast nature in thee, bear it not;
 Let not the royal bed of Denmark be
 A couch for luxury and damned incest,
 But, howsoever thou pursuest this act,
 Taint not thy mind, nor let thy soul contrive 80
 Against thy mother aught; leave her to heaven,
 And to those thorns that in her bosom lodge,
 To prick and sting her. Fare thee well at once!
 The glow-worm shows the matin[9] to be near,
 And 'gins to pale his uneffectual fire:
 Adieu, adieu, adieu! remember me.

<div align="center">EXIT.</div>

HAMLET O all you host of heaven! O earth! What else?
 And shall I couple hell? O fie! Hold, hold, my heart;
 And you, my sinews, grow not instant old,
 But bear me stiffly up.—Remember thee? 90
 Ay, thou poor ghost, whiles memory holds a seat
 In this distracted globe. Remember thee?
 Yea, from the table of my memory
 I'll wipe away all trivial fond records,
 All saws of books, all forms, all pressures part,
 That youth and observation copied there;
 And thy commandment all alone shall live
 Within the book and volume of my brain,
 Unmixed with baser matter: yes, by heaven! 100

 O most pernicious woman!
 O villain, villain, smiling, damned villain!
 My tables, meet it is I set it down,
 That one may smile, and smile, and be a villain;
 At least I'm sure it may be so in Denmark;

<div align="center">WRITING.</div>

 So, uncle, there you are. Now to my word;
 It is, "Adieu, adieu! remember me."
 I have sworn't.
HORATIO [*Within*] My lord, my lord—
MARCELLUS [*Within*] Lord Hamlet—
HORATIO [*Within*] Heaven secure him!
MARCELLUS [*Within*] So be it!
HORATIO [*Within*] Illo, ho, ho, my lord! 109
HAMLET Hillo, ho, ho, boy! come, bird, come.

<div align="center">ENTER HORATIO AND MARCELLUS.</div>

MARCELLUS How is't, my noble lord?
HORATIO What news, my lord?
HAMLET O, wonderful!
HORATIO Good my lord, tell it.
HAMLET No, you will reveal it.
HORATIO Not I, my lord, by heaven.
MARCELLUS Nor I, my lord.
HAMLET How say you then; would heart of man once
 think it?
 But you'll be secret—
HORATIO, MARCELLUS Ay, by heaven, my lord.
HAMLET There's ne'er a villain dwelling in all Denmark
 But he's an arrant knave.
HORATIO There needs no ghost, my lord, come from
 the grave
 To tell us this.
HAMLET Why, right; you are i' the right;
 And so, without more circumstance at all, 121
 I hold it fit that we shake hands and part;
 You, as your business and desire shall point you;
 For every man hath business and desire,
 Such as it is; and for my own poor part,
 Look you, I'll go pray.
HORATIO These are but wild and whirling words, my lord.
HAMLET I'm sorry they offend you, heartily;
 Yes, faith, heartily.
HORATIO There's no offence, my lord.
HAMLET Yes, by Saint Patrick, but there is, Horatio, 130
 And much offence too. Touching this vision here,
 It is an honest ghost, that let me tell you;
 For your desire to know what is between us,
 O'ermaster it as you may. And now, good friends,
 As you are friends, scholars, and soldiers,
 Give me one poor request.
HORATIO What is't my lord? we will.
HAMLET Never make known what you have seen tonight.
HORATIO, MARCELLUS My lord, we will not.
HAMLET Nay, but swear't.
HORATIO In faith, My lord, not I.
MARCELLUS Nor I, my lord, in faith. 140
HAMLET Upon my sword.
MARCELLUS We have sworn, my lord, already.
HAMLET Indeed, upon my sword, indeed.
GHOST [*Beneath*] Swear.
HAMLET Ha, ha, boy! say'st thou so? art thou there, true-
 penny?[10]
 Come on; you hear this fellow in the cellarage;
 Consent to swear.

HORATIO Propose the oath, my lord.

HAMLET Never to speak of this that you have seen.
 Swear by my sword.

GHOST [*Beneath*] Swear.

HAMLET *Hic et ubique?*[11] then we'll shift our ground—
 Come hither, gentlemen, 150
 And lay your hands again upon my sword:
 Never to speak of this that you have heard,
 Swear by my sword.

GHOST [*Beneath*] Swear.

HAMLET Well said, old mole! canst work i' the ground
 so fast?
 A worthy pioneer![12] Once more remove, good friends.

HORATIO O day and night, but this is wondrous strange!

HAMLET And therefore as a stranger give it welcome.
 There are more things in heaven and earth, Horatio, 160
 Than are dreamt of in your philosophy. But come;
 Here, as before, never, so help you mercy,
 How strange or odd soe'er I bear myself,
 As I perchance hereafter shall think meet
 To put an antic disposition on,
 That you, at such times seeing me, never shall
 With arms encumbered thus, or this head-shake,
 Or by pronouncing of some doubtful phrase,
 As, "Well, well, we know," or "We could, and if we
 would,"
 Or, "If we list to speak," or, "There be, and if they might," 170
 Or such ambiguous giving out, to note
 That you know aught of me: this not to do,
 So grace and mercy at your most need help you.
 Swear!

GHOST [*Beneath*] Swear!

HAMLET Rest, rest, perturbed spirit! So, gentlemen,
 With all my love I do commend me to you:
 And what so poor a man as Hamlet is
 May do, to express his love and friending to you,
 God willing, shall not lack. Let us go in together;
 And still your fingers on your lips, I pray. 180
 The time is out of joint;—O cursed spite,
 That ever I was born to set it right!—
 Nay, come, let's go together.

EXEUNT.

Notes

[1] timid porcupine
[2] river of forgetfulness in Hades
[3] a poisonous plant
[4] curdle
[5] acid
[6] scab
[7] leperlike
[8] without taking communion, unabsolved, without extreme unction
[9] morning
[10] honest fellow
[11] here and everywhere
[12] miner

ACT II

Scene I. *A room in* POLONIUS' *house.*

ENTER POLONIUS AND REYNALDO.

POLONIUS Give him this money and these notes,
 Reynaldo.

REYNALDO I will, my lord.

POLONIUS You shall do marvellous wisely, good Reynaldo,
 Before you visit him, to make inquire
 Of his behaviour.

REYNALDO My lord, I did intend it.

POLONIUS Marry, well said, very well said. Look you, sir.
 Inquire me first what Danskers[1] are in Paris,
 And how, and who; what means, and where they keep;
 What company, at what expense; and finding
 By this encompassment and drift of question, 10
 That they do know my son, come you more nearer
 Than your particular demands will touch it:
 Take you, as 'twere, some distant knowledge of him,
 As thus, "I know his father and his friends,
 And in part him." Do you mark this, Reynaldo?

REYNALDO Ay, very well, my lord.

POLONIUS "And in part, him; but," you may say,
 "not well:
 But if't be he I mean, he's very wild,
 Addicted" so and so; and there put on him
 What forgeries you please; marry, none so rank 20
 As may dishonour him; take heed of that:
 But, sir, such wanton, wild, and usual slips,
 As are companions noted and most known
 To youth and liberty.

REYNALDO As gaming, my lord.

POLONIUS Ay, or drinking, fencing, swearing,
 Quarrelling, drabbing:[2] you may go so far.

REYNALDO My lord, that would dishonour him.

POLONIUS Faith, no; as you may season it in the charge.
 You must not put another scandal on him,
 That he is open to incontinency; 30
 That's not my meaning: but breathe his faults so quaintly
 That they may seem the taints of liberty:
 The flash and outbreak of a fiery mind;
 A savageness in unreclaimed blood,
 Of general assault.[3]

REYNALDO But, my good lord,—

POLONIUS Wherefore should you do this?

REYNALDO Ay, my lord, I would know that.

POLONIUS Marry, sir, here's my drift;
 And, I believe, it is a fetch of warrant:
 You laying these slight sullies on my son,
 As 'twere a thing a little soiled i' the working, 40
 Mark you, your party in converse, him you would sound,
 Having ever seen in the prenominate crimes,
 The youth you breathe of guilty, be assured,
 He closes with you in this consequence:
 "Good sir," or so; or, "friend," or "gentleman,"—
 According to the phrase or the addition,
 Of man and country.

REYNALDO Very good, my lord.

POLONIUS And then, sir, does 'a[4] this,—'a does—
 what was
 I about to say? By the mass, I was about to say
 something: where did I leave? 50

REYNALDO At "closes in the consequence," at "friend
 or so," and "gentleman."

POLONIUS At "closes in the consequence," ay, marry;
 He closes thus: "I know the gentleman;
 I saw him yesterday, or t' other day,
 Or then, or then, with such, or such, and, as you say,
 There was a-gaming, there o'ertook in's rouse:
 There falling out at tennis;" or perchance,
 "I saw him enter such a house of sale"
 Videlicet,[5] a brothel, or so forth. See you now; 60
 Your bait of falsehood takes this carp of truth:

And thus do we of wisdom and of reach,
With windlasses and with assays of bias,
By indirections find direction out;
So, by my former lecture and advice,
Shall you my son. You have me, have you not?
REYNALDO My lord, I have.
POLONIUS God b'uy ye; fare ye well.
REYNALDO Good, my lord!
POLONIUS Observe his inclination in yourself.
REYNALDO I shall, my lord. 70
POLONIUS And let him ply his music.
REYNALDO Well, my lord.
POLONIUS Farewell!

EXIT.

ENTER OPHELIA.

How now, Ophelia? what's the matter?
OPHELIA O, my lord, my lord, I have been so affrighted!
POLONIUS With what, i' the name of God?
OPHELIA My lord, as I was sewing in my closet,
Lord Hamlet, with his doublet all unbraced:[6]
No hat upon his head: his stockings fouled,
Ungartered, and down-gyved[7] to his ankle;
Pale as his shirt; his knees knocking each other;
And with a look so piteous in purport, 80
As if he had been loosed out of hell,
To speak of horrors, he comes before me.
POLONIUS Mad for thy love?
OPHELIA My lord, I do not know,
But truly I do fear it.
POLONIUS What said he?
OPHELIA He took me by the wrist, and held me hard;
Then goes he to the length of all his arm,
And with his other hand thus o'er his brow,
He falls to such perusal of my face,
As he would draw it. Long stayed he so;
At last, a little shaking of mine arm, 90
And thrice his head thus waving up and down,
He raised a sigh so piteous and profound,
As it did seem to shatter all his bulk,
And end his being: that done, he lets me go:
And with his head over his shoulder turned
He seemed to find his way without his eyes;
For out o' doors he went without their help,
And to the last bended their light on me.
POLONIUS Come, go with me; I will go seek the king.
This is the very ecstasy of love; 100
Whose violent property fordoes itself,
And leads the will to desperate undertakings,
As oft as any passion under heaven,
That does afflict our natures. I am sorry,—
What, have you given him any hard words of late?
OPHELIA No, my good lord, but, as you did command,
I did repel his letters, and denied
His access to me.
POLONIUS That hath made him mad.
I am sorry that with better heed and judgment,
I had not quoted him: I feared he did but trifle 110
And meant to wrack thee; but, beshrew my jealousy!
By heaven, it is as proper to our age
To cast beyond ourselves in our opinions
As it is common for the younger sort
To lack discretion. Come, go we to the king:
This must be known; which, being kept close,
 might move
More grief to hide than hate to utter love.
Come!

EXEUNT.

Notes

1 Danes
2 womanizing
3 common to all
4 he
5 namely
6 jacket completely unfastened
7 hanging down like fetters

Scene II. *A room in the castle.*

FLOURISH. ENTER KING, QUEEN, ROSENCRANTZ,
GUILDENSTERN, AND ATTENDANTS.

KING Welcome, dear Rosencrantz and Guildenstern!
Moreover that we much did long to see you,
The need we have to use you did provoke
Our hasty sending. Something have you heard
Of Hamlet's transformation: so I call it,
Sith[1] nor the exterior nor the inward man
Resembles that it was. What it should be,
More than his father's death, that thus hath put him
So much from the understanding of himself,
I cannot dream of. I entreat you both, 10
That, being of so young days brought up with him,
And sith so neighboured to his youth and humour,[2]
That you vouchsafe your rest here in our court
Some little time; so by your companies
To draw him on to pleasures, and to gather,
So much as from occasion you may glean,
Whether aught to us unknown afflicts him thus,
That, opened, lies within our remedy.
QUEEN Good gentlemen, he hath much talked of you;
And sure I am two men there are not living 20
To whom he more adheres. If it will please you
To show us so much gentry[3] and good will,
As to expend your time with us a while,
For the supply and profit of our hope,
Your visitation shall receive such thanks
As fits a king's remembrance.
ROSENCRANTZ Both your majesties
Might, by the sovereign power you have of us,
Put your dread pleasures more into command
Than to entreaty.
GUILDENSTERN But we both obey,
And here give up ourselves, in the full bent, 30
To lay our service freely at your feet,
To be commanded.
KING Thanks, Rosencrantz and gentle Guildenstern.
QUEEN Thanks, Guildenstern and gentle Rosencrantz:
And I beseech you instantly to visit
My too much changed son. Go, some of you,
And bring these gentlemen where Hamlet is.
GUILDENSTERN Heavens make our presence and our
 practices,
Pleasant and helpful to him!
QUEEN Ay, amen!

EXEUNT ROSENCRANTZ, GUILDENSTERN,
AND SOME ATTENDANTS.

ENTER POLONIUS.

POLONIUS The ambassadors from Norway, my good lord,
are joyfully returned. 40
KING Thou still hast been the father of good news.
POLONIUS Have I, my lord? Assure you, my good
liege, I hold my duty, as I hold my soul,

Both to my God and to my gracious king:
And I do think, or else this brain of mine
Hunts not the trail of policy so sure
As I have used to do, that I have found
The very cause of Hamlet's lunacy.
KING O, speak of that; that I do long to hear. 50
POLONIUS Give first admittance to the ambassadors;
My news shall be the fruit to that great feast.
KING Thyself do grace to them, and bring them in.

EXIT POLONIUS.

He tells me, my dear Gertrude, that he hath found
The head and source of all your son's distemper.
QUEEN I doubt it is no other but the main;
His father's death, and our o'erhasty marriage.
KING Well, we shall sift him.—

RE-ENTER POLONIUS, WITH VOLTIMAND AND CORNELIUS.

Welcome, my good friends!
Say, Voltimand, what from our brother Norway?
VOLTIMAND Most fair return of greetings and desires. 60
Upon our first, he sent out to suppress
His nephew's levies, which to him appeared
To be a preparation 'gainst the Polack;
But better looked into, he truly found
It was against your highness: whereat, grieved
That so his sickness, age, and impotence,
Was falsely borne in hand, sends out arrests
On Fortinbras, which he, in brief, obeys,
Receives rebuke from Norway, and, in fine,[4]
Makes vow before his uncle never more 70
To give the assay of arms against your majesty.
Whereon old Norway, overcome with joy,
Gives him three thousand crowns in annual fee
And his commission to employ those soldiers,
So levied as before, against the Polack:
With an entreaty, herein further shown,

GIVES A PAPER.

That it might please you to give quiet pass
Through your dominions for this enterprise;
On such regards of safety and allowance,
As therein are set down.
KING It likes us well; 80
And at our more considered time, we'll read,
Answer, and think upon this business.
Meantime we thank you for your well-took labour:
Go to your rest; at night we'll feast together:
Most welcome home!

EXEUNT VOLTIMAND AND CORNELIUS.

POLONIUS This business is well ended.
My liege, and madam, to expostulate
What majesty should be, what duty is,
Why day is day, night night, and time is time,
Were nothing but to waste night, day, and time.
Therefore, since brevity is the soul of wit, 90
And tediousness the limbs and outward flourishes,
I will be brief. Your noble son is mad:
Mad call I it: for, to define true madness,
What is't but to be nothing else but mad?
But let that go.
QUEEN More matter, with less art.
POLONIUS Madam, I swear, I use no art at all.
That he is mad, 'tis true; 'tis true 'tis pity;
And pity 'tis 'tis true: a foolish figure;[5]
But farewell it, for I will use no art.

Mad let us grant him then: and now remains, 100
That we find out the cause of this effect;
Or rather say, the cause of this defect,
For this effect defective comes by cause:
Thus it remains and the remainder thus.
Perpend.[6]
I have a daughter; have, while she is mine;
Who in her duty and obedience, mark,
Hath given me this: now gather and surmise.

READS.

—*To the celestial, and my soul's idol, the most beautified*
Ophelia,"— 110
That's an ill phrase, a vile phrase; *"beautified"* is
a vile phrase, but you shall hear. Thus:
[*Reads*] *"These. In her excellent white bosom, these."*
QUEEN Came this from Hamlet to her?
POLONIUS Good madam, stay awhile; I will be faithful.
[*Reads*] *"Doubt thou, the stars are fire;*
Doubt that the sun doth move;
Doubt truth to be a liar;
But never doubt, I love.
"O dear Ophelia, I am ill at these numbers; I have 120
not heart to reckon my groans: but that I love thee best, O most
best, believe it. Adieu.
"Thine evermore, most dear lady, whilst
this machine is to him, Hamlet."
This in obedience hath my daughter shown me:
And more above, hath his solicitings,
As they fell out by time, by means, and place,
All given to mine ear.
KING But how hath she
Received his love?
POLONIUS What do you think of me?
KING As of a man faithful and honourable. 130
POLONIUS I would fain prove so. But what might you
think,
When I had seen this hot love on the wing,
As I perceived it, I must tell you that,
Before my daughter told me, what might you,
Or my dear majesty your queen here, think,
If I had played the desk or table-book,[7]
Or given my heart a working, mute and dumb;
Or looked upon this love with idle sight;
What might you think? No, I went round to work,
And my young mistress thus I did bespeak; 140
"Lord Hamlet is a prince out of thy star;[8]
This must not be:" and then I prescripts gave her,
That she should lock herself from his resort,
Admit no messengers, receive no tokens
Which done, she took the fruits of my advice;
And he repelled, a short tale to make,
Fell into a sadness, then into a fast,
Thence to a watch, thence into a weakness,
Thence to a lightness, and by this declension
Into the madness wherein now he raves 150
And all we mourn for.
KING Do you think 'tis this?
QUEEN It may be, very like.
POLONIUS Hath there been such a time, I'd fain know that,
That I have positively said "'tis so,"
When it proved otherwise?
KING Not that I know.
POLONIUS [*Pointing to his head, and shoulder*] Take
this from this, if this be otherwise.
of circumstances lead me, I will find

Where truth is hid, though it were hid indeed
Within the centre.

KING How may we try it further?

POLONIUS You know, sometimes he walks four hours together, 160
Here in the lobby.

QUEEN So he does, indeed.

POLONIUS At such time I'll loose my daughter to him;
Be you and I behind an arras[9] then;
Mark the encounter: if he love her not,
And be not from his reason fallen thereon,
Let me be no assistant for a state,
But keep a farm and carters.

KING We will try it.

QUEEN But, look, where sadly the poor wretch comes reading.

POLONIUS Away, I do beseech you, both away;
I'll board him presently:—O, give me leave.— 170

EXEUNT KING, QUEEN, AND ATTENDANTS.

ENTER HAMLET, READING.

How does my good Lord Hamlet?

HAMLET Well, God-a-mercy.

POLONIUS Do you know me, my lord?

HAMLET Excellent well; you are a fishmonger.[10]

POLONIUS Not I, my lord.

HAMLET Then I would you were so honest a man.

POLONIUS Honest, my lord?

HAMLET Ay, sir; to be honest, as this world goes, is to be one man picked out of ten thousand.

POLONIUS That's very true, my lord. 180

HAMLET For if the sun breed maggots in a dead dog, being a good kissing carrion,—Have you a daughter?

POLONIUS I have, my lord.

HAMLET Let her not walk i' the sun: conception is a blessing; but not as your daughter may conceive,—friend, look to't.

POLONIUS How say you by that? *[Aside]* Still harping on my daughter: yet he knew me not at first; 'a said I was a fishmonger: 'a is far gone, far gone: and truly in my youth I suffered much extremity for love; very near this. I'll speak to him again.—What do you read, my lord? 192

HAMLET Words, words, words!

POLONIUS What is the matter, my lord?

HAMLET Between who?

POLONIUS I mean the matter that you read, my lord?

HAMLET Slanders, sir: For the satiricial rogue says here that old men have grey beards, that their faces are wrinkled, their eyes purging thick amber and plum-tree gum, and that they have a plentiful lack of wit, to-gether with most weak hams: all which, sir, though I most powerfully and potently believe, yet I hold it not honesty to have it thus set down; for you yourself, sir, should be old as I am, if like a crab you could go backward. 205

POLONIUS Though this be madness, yet there is method in't. *[Aside]* Will you walk out of the air, my lord?

HAMLET Into my grave?

POLONIUS Indeed, that is out of the air.—How pregnant[11] sometimes his replies are! a happiness that often madness hits on, which reason and sanity could not so prosperously be delivered of. I will leave him, and suddenly contrive the means of meeting between him and my daughter.—My honourable lord, I will most humbly take my leave of you.

HAMLET You cannot, sir, take from me any thing that I will more willingly part withal; except my life, except my life, except my life. 220

POLONIUS Fare you well, my lord.

HAMLET These tedious old fools!

ENTER ROSENCRANTZ AND GUILDENSTERN.

POLONIUS You go to seek the Lord Hamlet; there he is.

ROSENCRANTZ *[To* POLONIUS*]* God save you, sir!

EXIT POLONIUS.

GUILDENSTERN My honoured lord!—

ROSENCRANTZ My most dear lord!

HAMLET My excellent good friends! How dost thou, Guildenstern? Ah, Rosencrantz! Good lads, how do ye both? 230

ROSENCRANTZ As the indifferent children of the earth.

GUILDENSTERN Happy, in that we are not overhappy; on fortune's cap we are not the very button.

HAMLET Nor the soles of her shoe?

ROSENCRANTZ Neither, my lord.

HAMLET Then you live about her waist, or in the middle of her favours?

GUILDENSTERN Faith, her privates we. 240

HAMLET In the secret parts of fortune? O, most true; she is a strumpet. What's the news?

ROSENCRANTZ None, my lord; but that the world's grown honest.

HAMLET Then is dooms-day near: but your news is not true. Let me question more in particular: what have you, my good friends, deserved at the hands of fortune, that she sends you to prison hither?

GUILDENSTERN Prison, my lord?

HAMLET Denmark's a prison. 250

ROSENCRANTZ Then is the world one.

HAMLET A goodly one; in which there are many confines, wards,[12] and dungeons; Denmark being one o' the worst.

ROSENCRANTZ We think not so, my lord.

HAMLET Why, then 'tis none to you: for there is nothing either good or bad but thinking makes it so: to me it is a prison.

ROSENCRANTZ Why, then your ambition makes it one; 'tis too narrow for your mind. 260

HAMLET O God, I could be bounded in a nutshell, and count myself a king of infinite space; were it not that I have bad dreams.

GUILDENSTERN Which dreams, indeed, are ambition; for the very substance of the ambitious is merely the shadow of a dream.

HAMLET A dream itself is but a shadow.

ROSENCRANTZ Truly, and I hold ambition of so airy and light a quality that it is but a shadow's shadow. 270

HAMLET Then are our beggars bodies; and our monarchs and outstretched heroes the beggars' shadows. Shall we to the court? for, by my fay,[13] I cannot reason.

ROSENCRANTZ, GUILDENSTERN We'll wait upon you.

HAMLET No such matter: I will not sort you with the rest of my servants; for, to speak to you like an honest man, I am most dreadfully attended. But, in the beaten way of friendship, what make you at Elsinore? 280

ROSENCRANTZ To visit you, my lord; no other occasion.

HAMLET Beggar that I am, I am even poor in thanks; but I thank you: and sure, dear friends, my thanks are too dear a halfpenny. Were you not sent for? Is it your own inclining? Is it a free visitation? Come, deal justly with me: come, come; nay, speak.

GUILDENSTERN What should we say, my lord?

HAMLET Why anything, but to the purpose. You were sent for; and there is a kind of confession in your looks, which your modesties have not craft enough to colour. I know, the good king and queen have sent for you. 293

ROSENCRANTZ To what end, my lord?

HAMLET That you must teach me. But let me conjure you, by the rights of our fellowship, by the consonancy of our youth, by the obligation of our ever-preserved love, and by what more dear a better proposer could charge you withal, be even and direct with me, whether you were sent for, or no. 301

ROSENCRANTZ *[To* GUILDENSTERN*]* What say you?

HAMLET *[Aside]* Nay, then I have an eye of you.—If you love me, hold not off.

GUILDENSTERN My lord, we were sent for.

HAMLET I will tell you why; so shall my anticipation prevent your discovery, and your secrecy to the king and queen moult no feather. I have of late, but wherefore, I know not, lost all my mirth, forgone all custom of exercises: and indeed, it goes so heavily with my disposition that this goodly frame, the earth, seems to me a sterile promontory; this most excellent canopy, the air, look you, this brave o'erhanging firmament, this majestical roof fretted with golden fire, why, it appears no other thing to me than a foul and pestilent congregation of vapours. What a piece of work is a man! how noble in reason! how infinite in faculty! in form and moving, how express[14] and admirable! in action, how like an angel! in apprehension, how like a god! the beauty of the world! the paragon of animals! And yet, to me, what is this quintessence of dust? man delights not me; no, nor woman neither, though by your smiling you seem to say so. 325

ROSENCRANTZ My lord, there was no such stuff in my thoughts.

HAMLET Why did you laugh then, when I said, "Man delights not me"?

ROSENCRANTZ To think, my lord, if you delight not in man, what lenten[15] entertainment the players shall receive from you: we coted[16] them on the way; and hither are they coming, to offer you service.

HAMLET He that plays the king shall be welcome; his majesty shall have tribute of me: the adventurous knight shall use his foil and target: the lover shall not sigh gratis; the humorous man shall end his part in peace: the clown shall make those laugh whose lungs are tickle o' the sere,[17] and the lady shall say her mind freely, or the blank verse shall halt for 't. What players are they? 342

ROSENCRANTZ Even those you were wont to take such delight in, the tragedians of the city.

HAMLET How chances it they travel? their residence, both in reputation and profit, was better both ways.

ROSENCRANTZ I think their inhibition comes by the means of the late innovation.

HAMLET Do they hold the same estimation they did when I was in the city? Are they so followed?

ROSENCRANTZ No indeed, they are not.

HAMLET How comes it? Do they grow rusty?

ROSENCRANTZ Nay, their endeavour keeps in the wonted pace: but there is, sir, an aerie[18] of children, little eyases, that cry out on the top of question and are most tyrannically clapped for 't: these are now the fashion, and so berattle the common stages,—so they call them,—that many wearing rapiers are afraid of goose quills, and dare scarce come thither. 361

HAMLET What, are they children? who maintains 'em? how are they escoted?[19] Will they pursue the quality[20] no longer than they can sing? will they not say afterwards, if they should grow themselves to common players,—as it is most like, if their means are not better,—their writers do them wrong, to make them exclaim against their own succession?

ROSENCRANTZ Faith, there has been much to-do on both sides; and the nation holds it no sin to tarre[21] them to controversy; there was for a while no money bid for argument, unless the poet and the player went to cuffs in the question. 374

HAMLET Is't possible?

GUILDENSTERN O, there has been much throwing about of brains.

HAMLET Do the boys carry it away?

ROSENCRANTZ Ay, that they do, my lord; Hercules and his load too. 380

HAMLET It is not very strange; for my uncle is king of Denmark; and those that would make mows at him while my father lived, give twenty, forty, fifty, an hundred ducats a-piece, for his picture in little. 'Sblood, there is something in this more than natural, if philosophy could find it out.

FLOURISH OF TRUMPETS WITHIN.

GUILDENSTERN There are the players.

HAMLET Gentlemen, you are welcome to Elsinore. Your hands, come: the appurtenance of welcome is fashion and ceremony: let me comply with you in this garb, lest my extent[22] to the players, which, I tell you, must show fairly outwards, should more appear like entertainment than yours. You are welcome: but my uncle-father and aunt-mother are deceived. 395

GUILDENSTERN In what, my dear lord?

HAMLET I am but mad north-north-west: when the wind is southerly, I know a hawk from a handsaw.

ENTER POLONIUS.

POLONIUS Well be with you, gentlemen!

HAMLET Hark you, Guildenstern,—and you too;—at each ear a hearer; that great baby you see there is not yet out of his swaddling clouts.

ROSENCRANTZ Happily, he's the second time come to them; for, they say, an old man is twice a child.

HAMLET I will prophesy he comes to tell me of the players; mark it.—You say right, sir: o' Monday morning; 'twas so, indeed.

POLONIUS My lord, I have news to tell you.

HAMLET My lord, I have news to tell you. When Roscius[23] was an actor in Rome,— 410

POLONIUS The actors are come hither, my lord.

HAMLET Buz, buz!

POLONIUS Upon mine honour,—

HAMLET Then came each actor on his ass,—

POLONIUS The best actors in the world, either for tragedy,
 comedy, history, pastoral, pastoral-comical, historical-
 pastoral, tragical-historical, tragical-comical-
 historical-pastoral, scene individable, or poem un-
 limited: Seneca[24] cannot be too heavy, nor Plautus[25]
 too light. For the law of writ and the liberty, these are
 the only men.

HAMLET O Jephthah, judge of Israel, what a treasure
 hadst thou!

POLONIUS What a treasure had he, my lord?

HAMLET Why—
 "One fair daughter, and no more,
 The which he loved passing well."

POLONIUS [*Aside*] Still on my daughter.

HAMLET Am I not i' the right, old Jephthah?

POLONIUS If you call me Jephthah, my lord, I have a
 daughter, that I love passing well.

HAMLET Nay, that follows not.

POLONIUS What follows then, my lord?

HAMLET Why,
 "As by lot, God wot," and then you know,
 "It came to pass, as most like it was,"—the first row of
 the pious chanson will show you more: for look,
 where my abridgments come.

<center>ENTER FOUR OR FIVE PLAYERS.</center>

 You are welcome, masters; welcome all. I am glad to see
 thee well. Welcome, good friends.—O, my old friend!
 Thy face is valanced[26] since I saw thee last: com'st
 thou to beard me in Denmark?—What! my young
 lady and mistress! By'r lady, your ladyship is nearer to
 heaven, than when I saw you last, by the altitude of a
 chopine.[27] Pray God, your voice, like a piece of
 uncurrent gold, be not cracked within the ring.—
 Masters, you are all welcome. We'll e'en to't like
 French falconers, fly at any thing we see: we'll have a
 speech straight: come, give us a taste of your quality;
 come, a passionate speech.

FIRST PLAYER What speech, my good lord?

HAMLET I heard thee speak me a speech once, but it was
 never acted; or, if it was, not above once; for the play,
 I remember, pleased not the million; 'twas caviare to
 the general: but it was, as I received it, and others,
 whose judgments, in such matters, cried in the top of
 mine, an excellent play, well digested in the scenes, set
 down with as much modesty as cunning. I remember,
 one said, there were no sallets[28] in the lines to make
 the matter savoury, nor no matter in the phrase that
 might indict the author of affection; but called it an
 honest method, as wholesome as sweet, and by very
 much more handsome than fine. One speech in it I
 chiefly loved: 'twas Æneas' tale to Dido; and there-
 about of it especially, where he speaks of Priam's
 slaughter. If it live in your memory, begin at this line;
 let me see, let me see;—
 "The rugged Pyrrhus, like the Hyrcanian beast,"[29]—
 'tis not so; it begins with "Pyrrhus.
 "The rugged Pyrrhus, he, whose sable arms,
 Black as his purpose, did the night resemble
 When he lay couched in the ominous horse,
 Hath now this dread and black complexion smeared
 With heraldry more dismal; head to foot
 Now is he total gules; horridly tricked[30]
 With blood of fathers, mothers, daughters, sons,
 Baked and impasted with the parching streets,
 That lend a tyrannous and damned light
 To their lords' murther: roasted in wrath and fire,

421

431

452

470

481

And thus o'er-sized with coagulate gore,
With eyes like carbuncles, the hellish Pyrrhus
Old grandsire Priam seeks."
So, proceed you.

POLONIUS 'Fore God, my lord, well spoken; with good
 accent and good discretion.

FIRST PLAYER "Anon he finds him
 Striking too short at Greeks; his antique sword,
 Rebellious to his arm, lies where it falls,
 Repugnant to command: unequal matched,
 Pyrrhus at Priam drives; in rage strikes wide;
 But with the whiff and wind of his fell sword
 The unnerved father falls. Then senseless Ilium,
 Seeming to feel this blow, with flaming top
 Stoops to his base; and with a hideous crash
 Takes prisoner Pyrrhus' ear: for, lo! his sword,
 Which was declining on the milky head
 Of reverend Priam, seemed i' the air to stick:
 So, as a painted tyrant, Pyrrhus stood,
 And, like a neutral to his will and matter,
 Did nothing.
 But as we often see, against some storm,
 A silence in the heavens, the rack[31] stand still,
 The bold winds speechless and the orb below
 As hush as death, anon the dreadful thunder
 Doth rend the region: so after Pyrrhus' pause
 Aroused vengeance sets him new a-work;
 And never did the cyclops hammer fall
 On Mars's armour, forged for proof eterne,
 with less remorse than Pyrrhus' bleeding sword
 Now falls on Priam.—
 Out, out, thou strumpet, Fortune! All you gods,
 In general synod[32] take away her power;
 Break all the spokes and fellies[33] from her wheel,
 And bowl the round nave[34] down the hill of heaven,
 As low as to the fiends."

POLONIUS This is too long.

HAMLET It shall to the barber's with your beard.—Prithee,
 say on: he's for a jig, or a tale of bawdry, or he sleeps:
 say on: come to Hecuba.

FIRST PLAYER "But who, O who, had seen the mobled[35]
 queen—"

HAMLET "The mobled queen?"

POLONIUS That's good: "mobled queen" is good.

FIRST PLAYER "Run barefoot up and down, threatening
 the flames
 With bisson rheum;[36] a clout[37] about that head,
 Where late the diadem stood; and for a robe,
 About her lank and all o'er-teemed loins,
 A blanket, in the alarm of fear caught up;
 Who this had seen, with tongue in venom steeped,
 'Gainst Fortune's state would treason have pronounced;
 But if the gods themselves did see her then,
 When she saw Pyrrhus make malicious sport
 In mincing with his sword her husband's limbs,
 The instant burst of clamour that she made,—
 Unless things mortal move them not at all,—
 Would have made milch the burning eyes of heaven,
 And passion in the gods."

POLONIUS Look, whether he has not turned his colour and
 has tears in's eyes.—Pray you, no more.

HAMLET 'Tis well; I'll have thee speak out the rest soon.—
 Good my lord, will you see the players well
 bestowed?[38] Do you hear, let them be well used; for
 they are the abstract and brief chronicles of the time:
 after your death you were better have a bad epitaph
 than their ill report while you live.

491

501

510

524

540

POLONIUS My lord, I will use them according to their
 desert. 551
HAMLET God's bodikins, man, much better! Use every
 man after his desert, and who should scape whip-
 ping? Use them after your own honour and dignity:
 the less they deserve, the more merit is in your bounty.
 Take them in.
POLONIUS Come, sirs.
HAMLET Follow him, friends: we'll hear a play tomorrow.
 [Exit POLONIUS *with all the* PLAYERS *but the* FIRST.*]* Dost
 thou hear me, old friend; can you play "The Murder
 of Gonzago"? 561
FIRST PLAYER Ay, my lord.
HAMLET We'll ha't to-morrow night. You could, for a need,
 study a speech of some dozen or sixteen lines, which I
 would set down, and insert in't?, could you not?
FIRST PLAYER Ay, my lord.
HAMLET Very well. Follow that lord; and look you mock
 him not. *[Exit* PLAYER*]* My good friends,
 [To ROSENCRANTZ *and* GUILDENSTERN*]* I'll leave you till
 night; you are welcome to Elsinore. 571
ROSENCRANTZ Good my lord!
HAMLET Ay, so, God b'uy ye. *[Exeunt* ROSENCRANTZ *and*
 GUILDENSTERN.*]* Now I am alone.
 O what a rogue and peasant slave am I!
 Is it not monstrous that this player here,
 But in a fiction, in a dream of passion,
 Could force his soul so to his own conceit[39]
 That from her working, all his visage wanned;
 Tears in his eyes, distraction in's aspect, 580
 A broken voice, and his whole function suiting
 With forms to his conceit? And all for nothing!
 For Hecuba!
 What's Hecuba to him, or he to Hecuba,
 That he should weep for her? What would he do,
 Had he the motive and the cue for passion
 That I have? He would drown the stage with tears,
 And cleave the general ear with horrid speech,
 Make mad the guilty and appal the free,
 Confound the ignorant, and amaze indeed 590
 The very faculties of eyes and ears. Yet I,
 A dull and muddy-mettled rascal, peak,
 Like John-a-dreams, unpregnant of my cause,
 And can say nothing; no, not for a king,
 Upon whose property, and most dear life,
 A damned defeat was made. Am I a coward?
 Who calls me villain? breaks my pate across?
 Plucks off my beard, and blows it in my face?
 Tweaks me by the nose? gives me the lie i' the throat,
 As deep as to the lungs? Who does me this? 600
 Ha! 'swounds, I should take it: for it cannot be,
 But I am pigeon-livered, and lack gall
 To make oppression bitter; or, ere this,
 I should ha' fatted all the region kites[40]
 With this slave's offal: bloody, bawdy villain!
 Remorseless, treacherous, lecherous, kindless villain!
 O vengeance!
 Why, what an ass am I! This is most brave;
 That I, the son of the dear father murdered, 609
 Prompted to my revenge by heaven and hell,
 Must, like a whore, unpack my heart with words,
 And fall a-cursing, like a very drab,[41]
 A scullion!
 Fie upon't! foh! About, my brain! Hum, I have heard
 That guilty creatures, sitting at a play,
 Have by the very cunning of the scene,
 Been struck so to the soul that presently

 They have proclaimed their malefactions;
 For murder, though it have no tongue, will speak
 With most miraculous organ. I'll have these players 620
 Play something like the murder of my father
 Before mine uncle: I'll observe his looks;
 I'll tent[42] him to the quick; if he but blench,
 I know my course. The spirit that I have seen
 May be the devil: and the devil hath power
 To assume a pleasing shape; yea, and perhaps
 Out of my weakness and my melancholy,
 As he is very potent with such spirits,
 Abuses me to damn me. I'll have grounds
 More relative than this. The play's the thing 630
 Wherein I'll catch the conscience of the king.

<div align="center">EXIT.</div>

Notes

[1] since
[2] behavior
[3] courtesy
[4] finally
[5] rhetorical device
[6] consider carefully
[7] had kept secrets
[8] sphere
[9] tapestry hanging in front of a wall
[10] dealer in fish (slang for a procurer)
[11] meaningful
[12] cells
[13] faith
[14] exact
[15] scanty
[16] overtook
[17] on hair trigger
[18] nest
[19] financially supported
[20] acting profession
[21] incite
[22] behavior
[23] famous comic actor in ancient Rome
[24] Roman tragic dramatist
[25] Roman comic dramatist
[26] fringed with a beard
[27] thick-soled shoe
[28] salads, spicy jests
[29] tiger (Hyrcania was in Asia and notorious for its wild animals)
[30] all red, horridly adorned
[31] clouds
[32] council
[33] rims
[34] hub
[35] muffled
[36] blinding tears
[37] rag
[38] housed
[39] imagination
[40] scavenger birds
[41] prostitute
[42] probe

ACT III

Scene I. *A room in the castle.*

<div align="center">ENTER KING, QUEEN, POLONIUS, OPHELIA,
ROSENCRANTZ, AND GUILDENSTERN.</div>

KING And can you, by no drift of conference,
 Get from him why he puts on this confusion,
 Grating so harshly all his days of quiet
 With turbulent and dangerous lunacy?

ROSENCRANTZ He does confess he feels himself
 distracted,
 But from what cause 'a will by no means speak.
GUILDENSTERN Nor do we find him forward to be
 sounded,
 But, with a crafty madness, keeps aloof,
 When we would bring him on to some confession
 Of his true state.
QUEEN Did he receive you well? 10
ROSENCRANTZ Most like a gentleman.
GUILDENSTERN But with much forcing of his disposition.
ROSENCRANTZ Niggard of question, but of our demands.
 Most free in his reply.
QUEEN Did you assay[1] him to any pastime?
ROSENCRANTZ Madam, it so fell out that certain players
 We o'er-raught[2] on the way: of these we told him,
 And there did seem in him a kind of joy
 To hear of it: they are here about the court
 And, as I think, they have already order 20
 This night to play before him.
POLONIUS 'Tis most true;
 And he beseeched me to entreat your majesties
 To hear and see the matter.
KING With all my heart;
 And it doth much content me to hear him so inclined.—
 Good gentlemen, give him a further edge,
 And drive his purpose on to these delights.
ROSENCRANTZ We shall, my lord.

 EXEUNT ROSENCRANTZ AND GUILDENSTERN.

KING Sweet Gertrude, leave us too:
 For we have closely sent for Hamlet hither,
 That he, as 'twere by accident, may here
 Affront Ophelia. Her father, and myself, 30
 Will so bestow ourselves that, seeing unseen,
 We may of their encounter frankly judge,
 And gather by him, as he is behaved,
 If't be the affliction of his love or no
 That thus he suffers for.
QUEEN I shall obey you.—
 And for your part, Ophelia, I do wish
 That your good beauties be the happy cause
 Of Hamlet's wildness; so shall I hope your virtues
 Will bring him to his wonted way again,
 To both your honours.
OPHELIA Madam, I wish it may. 40
POLONIUS Ophelia, walk you here.—Gracious, so
 please you,
 We will bestow ourselves. *[To* OPHELIA*]* Read on this book;
 That show of such an exercise may colour
 Your loneliness. We are oft to blame in this,—
 'Tis too much proved,—that with devotion's visage,
 And pious action we do sugar o'er
 The devil himself.
KING *[Aside]* O, 'tis too true!
 How smart a lash that speech doth give my conscience!
 The harlot's cheek, beautied with plastering art,
 Is not more ugly to the thing that helps it, 50
 Than is my deed to my most painted word.
 O heavy burthen!
POLONIUS I hear him coming; let's withdraw, my lord.

 EXEUNT KING AND POLONIUS.

 ENTER HAMLET.

HAMLET To be; or not to be,—that is the question:
 Whether 'tis nobler in the mind to suffer
 The slings and arrows of outrageous fortune,
 Or to take arms against a sea of troubles,
 And by opposing end them? To die,—to sleep,—
 No more; and by a sleep to say we end
 The heartache, and the thousand natural shocks 60
 That flesh is heir to,—'tis a consummation
 Devoutly to be wished. To die;—to sleep;—
 To sleep! perchance to dream;—ay, there's the rub;
 For in that sleep of death what dreams may come,
 When we have shuffled off this mortal coil,
 Must give us pause: there's the respect,
 That makes calamity of so long life:
 For who would bear the whips and scorns of time,
 The oppressor's wrong, the proud man's contumely,
 The pangs of disprized love, the law's delay, 70
 The insolence of office, and the spurns
 That patient merit of the unworthy takes,
 When he himself might his quietus[3] make
 With a bare bodkin?[4] Who would fardels[5] bear,
 To grunt and sweat under a weary life,
 But that the dread of something after death,
 The undiscovered country, from whose bourne[6]
 No traveller returns, puzzles the will,
 And makes us rather bear those ills we have
 Than fly to others that we know not of? 80
 Thus conscience does make cowards of us all;
 And thus the native hue of resolution
 Is sicklied o'er with the pale cast[7] of thought;
 And enterprises of great pitch[8] and moment,
 With this regard their currents turn awry
 And lose the name of action. Soft you now!
 The fair Ophelia?—Nymph, in thy orisons[9]
 Be all my sins remembered.
OPHELIA Good my lord,
 How does your honour for this many a day?
HAMLET I humbly thank you; well, well, well. 90
OPHELIA My lord, I have remembrances of yours,
 That I have longed long to re-deliver;
 I pray you, now receive them.
HAMLET No, not I; I never gave you aught.
OPHELIA My honoured lord, you know right well you did;
 And with them words of so sweet breath composed
 As made these things more rich: their perfume lost,
 Take these again; for to the noble mind,
 Rich gifts wax poor, when givers prove unkind.
 There, my lord. 100
HAMLET Ha, ah! are you honest?
OPHELIA My lord?
HAMLET Are you fair?
OPHELIA What means your lordship?
HAMLET That if you be honest and fair, your honesty
 should admit no discourse to your beauty.
OPHELIA Could beauty, my lord, have better commerce
 than with honesty?
HAMLET Ay, truly; for the power of beauty will sooner
 transform honesty from what it is to a bawd,[10] than
 the force of honesty can translate beauty into his like-
 ness: this was sometime a paradox, but now the time
 gives it proof. I did love you once. 114
OPHELIA Indeed, my lord, you made me believe so.
HAMLET You should not have believed me: for virtue can-
 not so inoculate our old stock, but we shall relish of it;
 I loved you not.

OPHELIA I was the more deceived.

HAMLET Get thee to a nunnery; why wouldst thou be a
breeder of sinners? I am myself indifferent honest; but
yet I could accuse me of such things that it were better
my mother had not borne me: I am very proud, re-
vengeful, ambitious; with more offences at my beck
than I have thoughts to put them in, imagination to
give them shape, or time to act them in. What should
such fellows as I do crawling between heaven and
earth? We are arrant knaves all; believe none of us. Go
thy ways to a nunnery. Where's your father? 130

OPHELIA At home, my lord.

HAMLET Let the doors be shut upon him, that he may play
the fool no where but in's own house. Farewell.

OPHELIA O, help him, you sweet heavens!

HAMLET If thou dost marry, I'll give thee this plague for
thy dowry: be thou as chaste as ice, as pure as snow,
thou shalt not escape calumny. Get thee to a nunnery,
go; farewell. Or, if thou wilt needs marry, marry a fool;
for wise men know well enough what monsters you
make of them. To a nunnery, go; and quickly too.
Farewell. 142

OPHELIA O heavenly powers, restore him!

HAMLET I have heard of your paintings too, well enough.
God hath given you one face, and you make your-
selves another; you jig, you amble, and you lisp, and
nickname God's creatures, and make your wanton-
ness your ignorance. Go to, I'll no more on't; it hath
made me mad. I say, we will have no moe[11] marriage:
those that are married already, all but one, shall live;
the rest shall keep as they are. To a nunnery, go.

EXIT HAMLET.

OPHELIA O, what a noble mind is here o'erthrown! 153
The courtier's, soldier's, scholar's, eye, tongue, sword:
The expectancy and rose of the fair state,
The glass of fashion, and the mould of form,
The observed of all observers, quite, quite down!
And I, of ladies most deject and wretched,
That sucked the honey of his music-vows,
Now see that noble and most sovereign reason,
Like sweet bells jangled, out of time and harsh;
That unmatched form and stature of blown youth, 162
Blasted with ectasy:[12] O, woe is me!
To have seen what I have seen, see what I see!

RE-ENTER KING AND POLONIUS.

KING Love! his affections do not that way tend;
Nor what he spake, though it lacked form a little,
Was not like madness. There's something in his soul,
O'er which his melancholy sits on brood;
And I do doubt the hatch and the disclose,
Will be some danger: which for to prevent, 170
I have in quick determination
Thus set it down: he shall with speed to England,
For the demand of our neglected tribute:
Haply the seas and countries different
With variable objects shall expel
This something-settled matter in his heart,
Whereon his brains still beating puts him thus
From fashion of himself. What think you on't?

POLONIUS It shall do well; but yet do I believe,
The origin and commencement of his grief
Sprung from neglected love.—How now, Ophelia? 181

You need not tell us what Lord Hamlet said;
We heard it all.—My Lord, do as you please;
But, if you hold it fit, after the play,
Let his queen mother all alone entreat him
To show his grief; let her be round with him;
And I'll be placed, so please you, in the ear
Of all their conference. If she find him not, 188
To England send him, or confine him where
Your wisdom best shall think.

KING It shall be so;
Madness in great ones must not unwatched go.

EXEUNT.

Notes

[1] tempt
[2] overtook
[3] full discharge (a legal term)
[4] dagger
[5] burdens
[6] regions
[7] color
[8] height
[9] prayers
[10] procurer
[11] more
[12] madness

Scene II. *A hall in the same.*

ENTER HAMLET AND PLAYERS.

HAMLET Speak the speech, I pray you, as I pronounced it
to you, trippingly on the tongue: but if you mouth it,
as many of our players do, I had as lief the town-crier
spoke my lines. Nor do not saw the air too much with
your hand, thus: but use all gently: for in the very tor-
rent, tempest, and, as I may say, whirlwind of your
passion, you must acquire and beget a temperance
that may give it smoothness. O, it offends me to the
soul, to hear a robustious periwig-pated fellow tear a
passion to tatters, to very rags, to split the ears of the
groundlings;[1] who, for the most part, are capable of
nothing but inexplicable dumb-shows and noise: I
would have such a fellow whipped for o'erdoing
Termagant; it out-herods Herod:[2] pray you, avoid it.

FIRST PLAYER I warrant your honour.

HAMLET Be not too tame neither, but let your own discre-
tion be your tutor: suit the action to the word, the
word to the action; with this special observance, that
you o'er-step not the modesty of nature; for anything
so overdone is from the purpose of playing, whose
end, both at the first and now, was and is, to hold, as
'twere, the mirror up to nature; to show virtue her
own feature, scorn her own image, and the very age
and body of the time his form and pressure. Now this
overdone, or come tardy off, though it make the un-
skilful laugh, cannot but make the judicious grieve;
the censure of the which one must in your allowance
o'er-weigh a whole theatre of others. O, there be play-
ers that I have seen play, and heard others praise, and
that highly, not to speak it profanely, that neither
having the accent of Christians nor the gait of Chris-
tian, pagan, nor man, have so strutted and bellowed,
that I have thought some of nature's journeymen had
made them, and not made them well, they imitated
humanity so abominably. 39

FIRST PLAYER I hope we have reformed that indifferently[3] with us, sir.

HAMLET O, reform it altogether. And let those that play your clowns speak no more than is set down for them; for there be of them that will themselves laugh, to set on some quantity of barren spectators to laugh too, though in the mean time some necessary question of the play be then to be considered: that's villainous; and shows a most pitiful ambition in the fool that uses it. Go, make you ready.—

EXEUNT PLAYERS.

ENTER POLONIUS, ROSENCRANTZ, AND GUILDENSTERN.

How now, my lord? will the king hear this piece of work? 51

POLONIUS And the queen too, and that presently.

HAMLET Bid the players make haste.

EXIT POLONIUS.

Will you two help to hasten them?

BOTH We will, my lord.

EXEUNT ROSENCRANTZ AND GUILDENSTERN.

HAMLET What, ho! Horatio!

ENTER HORATIO.

HORATIO Here, sweet lord, at your service.

HAMLET Horatio, thou art e'en as just a man
As e'er my conversation coped withal.

HORATIO O, my dear lord,—

HAMLET Nay, do not think I flatter: 60
For what advancement may I hope from thee,
That no revenue hast but thy good spirits,
To feed and clothe thee? Why should the poor be
 flattered?
No, let the candied[4] tongue lick absurd pomp,
And crook the pregnant hinges of the knee
Where thrift may follow fawning. Dost thou hear?
Since my dear soul was mistress of her choice,
And could of men distinguish, her election
Hath sealed thee for herself: for thou hast been
As one, in suffering all, that suffers nothing; 70
A man that fortune's buffets and rewards
Hath ta'en with equal thanks: and blest are those,
Whose blood and judgment are so well commingled,
That they are not a pipe for fortune's finger
To sound what stop she please. Give me that man
That is not passion's slave, and I will wear him
In my heart's core, ay, in my heart of heart,
As I do thee. Something too much of this.
There is a play to-night before the king;
One scene of it comes near the circumstance 80
Which I have told thee of my father's death.
I prithee, when thou seest that act a-foot,
Even with the very comment of my soul
Observe my uncle: if his occulted[5] guilt
Do not itself unkennel in one speech,
It is a damned ghost that we have seen;
And my imaginations are as foul
As Vulcan's stithy.[6] Give him heedful note:
For I mine eyes will rivet to his face;
And after we will both our judgments join 90
To censure of his seeming.

HORATIO Well, my lord:
If he steal aught the whilst this play is playing,
And scape detecting, I will pay the theft.

HAMLET They are coming to the play; I must be idle:
Get you a place.

DANISH MARCH. FLOURISH. ENTER KING, QUEEN, POLONIUS, OPHELIA, ROSENCRANTZ, GUILDENSTERN, AND OTHER LORDS.

ATTENDANT, WITH THE GUARD, CARRYING TORCHES.

KING How fares our cousin Hamlet?

HAMLET Excellent, i' faith; of the chameleon's dish:[7] I eat the air, promise-crammed: you cannot feed capons so.

KING I have nothing with this answer, Hamlet; these words are not mine. 101

HAMLET No, nor mine now. [*To* POLONIUS]
My lord, you played once i' the university, you say?

POLONIUS That I did, my lord, and was accounted a good actor.

HAMLET And what did you enact?

POLONIUS I did enact Julius Caesar: I was killed i' the Capitol: Brutus killed me.

HAMLET It was a brute part of him to kill so capital a calf there.—Be the players ready? 111

ROSENCRANTZ Ay, my lord; they stay upon your patience.

QUEEN Come hither, my dear Hamlet, sit by me.

HAMLET No, good mother, here's metal more attractive.

POLONIUS [*To the* KING] O ho! do you mark that?

HAMLET Lady, shall I lie in your lap?

LYING DOWN AT OPHELIA'S FEET.

OPHELIA No, my lord.

HAMLET I mean, my head upon your lap? 120

OPHELIA Ay, my lord.

HAMLET Do you think I meant country matters?

OPHELIA I think nothing, my lord.

HAMLET That's a fair thought to lie between maids' legs.

OPHELIA What is, my lord?

HAMLET Nothing.

OPHELIA You are merry, my lord.

HAMLET Who, I?

OPHELIA Ay, my lord. 130

HAMLET O God! your only jig-maker. What should a man do but be merry? for, look you, how cheerfully my mother looks, and my father died within's two hours.

OPHELIA Nay, 'tis twice two months, my lord.

HAMLET So long? Nay, then let the devil wear black, for I'll have a suit of sables. O heavens! die two months ago, and not forgotten yet? Then there's hope a great man's memory may outlive his life half a year: but, by'r lady, 'a must build churches then: or else shall 'a suffer not thinking on, with the hobby-horse; whose epitaph is, "For, O, for, O, the hobby-horse is forgot." 143

HAUTBOYS PLAY. THE DUMB SHOW ENTERS.

ENTER A KING AND A QUEEN, VERY LOVINGLY; THE QUEEN EMBRACING HIM, AND HE HER. SHE KNEELS, AND MAKES SHOW OF PROTESTATION UNTO HIM. HE TAKES HER UP, AND DECLINES HIS HEAD UPON HER NECK: LAYS HIM DOWN UPON A BANK OF FLOWERS; SHE, SEEING HIM ASLEEP, LEAVES HIM. ANON COMES IN A FELLOW, TAKES OFF HIS CROWN, KISSES IT, AND POURS POISON IN THE KING'S EARS, AND EXIT. THE QUEEN RETURNS; FINDS THE KING DEAD, AND MAKES PASSIONATE ACTION. THE POISONER, WITH SOME TWO OR THREE MUTES, COMES IN AGAIN, SEEMING TO LAMENT WITH HER. THE DEAD BODY IS CARRIED AWAY. THE POISONER WOOS THE QUEEN WITH GIFTS; SHE SEEMS LOTH AND UNWILLING A WHILE, BUT, IN THE END ACCEPTS HIS LOVE.

EXEUNT.

OPHELIA What means this, my lord?

HAMLET Marry, this is miching mallecho;[8] it means mischief.

OPHELIA Belike this show imports the argument of
 the play?

 ENTER PROLOGUE.

HAMLET We shall know by this fellow: the players cannot
 keep counsel; they'll tell all. 150
OPHELIA Will he tell us what this show meant?
HAMLET Ay, or any show that you'll show him: be not you
 ashamed to show, he'll not shame to tell you what it
 means.
OPHELIA You are naught, you are naught; I'll mark
 the play.
PROLOGUE For us, and for our tragedy
 Here stooping to your clemency,
 We beg your hearing patiently.
HAMLET Is this a prologue, or the posy of a ring?
OPHELIA 'Tis brief, my lord. 161
HAMLET As woman's love.

 ENTER TWO PLAYERS, KING AND QUEEN.

PLAYER KING Full thirty times hath Phoebus' cart[9]
 gone round
 Neptune's salt wash[10] and Tellus'[11] orbed ground,
 And thirty dozen moons with borrowed sheen,
 About the world have times twelve thirties been,
 Since love our hearts and Hymen did our hands,
 Unite commutual in most sacred bands.
PLAYER QUEEN So many journeys may the sun and moon
 Make us again count o'er ere love be done! 170
 But, woe is me, you are so sick of late,
 So far from cheer and from your former state,
 That I distrust you. Yet, though I distrust,
 Discomfort you, my lord, it nothing must;
 For women's fear and love hold quantity,
 In neither aught, or in extremity.
 Now, what my love is, proof hath made you know;
 And as my love is sized, my fear is so.
 Where love is great, the littlest doubts are fear;
 Where little fears grow great, great love grows there. 180
PLAYER KING 'Faith, I must leave thee, love, and
 shortly too;
 My operant[12] powers my functions leave to do:
 And thou shalt live in this fair world behind,
 Honoured, beloved; and haply one as kind
 For husband shalt thou—
PLAYER QUEEN O, confound the rest!
 Such love must needs be treason in my breast:
 In second husband let me be accurst!
 None wed the second but who killed the first.
HAMLET *[Aside]* Wormwood,[13] wormwood.
PLAYER QUEEN The instances that second marriage move, 190
 Are base respects of thrift, but none of love;
 A second time I kill my husband dead,
 When second husband kisses me in bed.
PLAYER KING I do believe you think what now you speak;
 But what we do determine oft we break.
 Purpose is but the slave to memory,
 Of violent birth but poor validity:
 Which now, like fruit unripe, sticks on the tree,
 But fall unshaken when they mellow be.
 Most necessary 'tis that we forget 200
 To pay ourselves what to ourselves is debt:
 What to ourselves in passion we propose,
 The passion ending, doth the purpose lose.
 The violence of either grief or joy
 Their own enactures[14] with themselves destroy:
 Where joy most revels, grief doth most lament;
 Grief joys, joy grieves, on slender accident.

 This world is not for aye, nor 'tis not strange,
 That even our loves should with our fortunes change,
 For 'tis a question left us yet to prove, 210
 Whether love lead fortune or else fortune love.
 The great man down, you mark his favourite flies;
 The poor advanced makes friends of enemies;
 And hitherto doth love on fortune tend:
 For who not needs shall never lack a friend,
 And who in want a hollow friend doth try
 Directly seasons him his enemy.
 But, orderly to end where I begun,
 Our wills and fates do so contrary run,
 That our devices still are overthrown, 220
 Our thoughts are ours, their ends none of our own;
 So think thou wilt no second husband wed;
 But die thy thoughts when thy first lord is dead.
PLAYER QUEEN Nor earth to me give food nor heaven
 light!
 Sport and repose lock from me, day and night!
 To desperation turn my trust and hope!
 And anchor's[15] cheer in prison be my scope!
 Each opposite, that blanks the face of joy,
 Meet what I would have well and it destroy!
 Both here and hence pursue me lasting strife,
 If, once a widow, ever I be wife! 231
HAMLET *[To* OPHELIA*]* If she should break it now!
PLAYER KING 'Tis deeply sworn. Sweet, leave me here
 awhile;
 My spirits grow dull, and fain I would beguile
 The tedious day with sleep.

 SLEEPS.

PLAYER QUEEN Sleep rock thy brain
 And never come mischance between us twain!

 EXIT.

HAMLET Madam, how like you this play?
QUEEN The lady doth protest too much, methinks.
HAMLET O, but she'll keep her word.
KING Have you heard the argument? Is there no
 offence in't? 240
HAMLET No, no, they do but jest, poison in jest; no offence
 i' the world.
KING What do you call the play?
HAMLET "The Mouse-trap." Marry, how? Tropically. This
 play is the image of a murder done in Vienna: Gon-
 zago is the Duke's name; his wife, Baptista: you shall
 see anon; 'tis a knavish piece of work: but what o'
 that? your majesty, and we that have free souls, it
 touches us not: let the galled jade wince,[16] our withers
 are unwrung.—

 ENTER LUCIANUS.

 This is one Lucianus, nephew to the king. 251
OPHELIA You are as good as a chorus, my lord.
HAMLET I could interpret between you and your love, if I
 could see the puppets dallying.
OPHELIA You are keen, my lord, you are keen.
HAMLET It would cost you a groaning, to take off my edge.
OPHELIA Still better and worse.
HAMLET So you mistake your husbands.—Begin,
 murderer. Pox, leave thy damnable faces, and
 begin. Come; 261
 "the croaking raven
 Doth bellow for revenge."
LUCIANUS Thoughts black, hands apt, drugs fit, and time
 agreeing;

Confederate season, else no creature seeing;
Thou mixture rank, of midnight weeds collected,
With Hecate's[17] ban thrice blasted, thrice infected,
Thy natural magic and dire property,
On wholesome life usurp immediately.

POURS THE POISON IN THE SLEEPER'S EAR.

HAMLET 'A poisons him i' the garden for his estate. His
 name's Gonzago; the story is extant, and writ in very
 choice Italian: you shall see anon, how the murderer
 gets the love of Gonzago's wife. 273
OPHELIA The king rises.
HAMLET What, frighted with false fire!
QUEEN How fares my lord?
POLONIUS Give o'er the play.
KING Give me some light.—Away!
ALL Lights, lights, lights!

EXEUNT ALL BUT HAMLET AND HORATIO.

HAMLET Why, let the strucken deer go weep, 280
 The hart ungalled play:
 For some must watch, while some must sleep;
 Thus runs the world away.
 Would not this, sir, and a forest of feathers,—if the rest of
 my fortunes turn Turk with me,—with two Provincial
 roses on my razed[18] shoes, get me a fellowship in a
 cry[19] of players, sir?
HORATIO Half a share.
HAMLET A whole one, I.
 For thou dost know, O Damon dear, 290
 This realm dismantled was
 Of Jove himself; and now reigns here
 A very, very—pajock.[20]
HORATIO You might have rhymed.
HAMLET O good Horatio, I'll take the ghost's word for a
 thousand pound. Didst perceive?
HORATIO Very well, my lord.
HAMLET Upon the talk of the poisoning,—
HORATIO I did very well note him.
HAMLET Ah, ha! Come, some music! come, the
 recorders!— 301
 For if the king like not the comedy,
 Why then, belike,—he likes it not, perdy.[21]

ENTER ROSENCRANTZ AND GUILDENSTERN.

 Come, some music.
GUILDENSTERN Good my lord, vouchsafe me a word
 with you.
HAMLET Sir, a whole history.
GUILDENSTERN The king, sir,—
HAMLET Ay, sir, what of him?
GUILDENSTERN Is, in his retirement marvellous
 distempered. 311
HAMLET With drink, sir?
GUILDENSTERN No, my lord, rather with choler.
HAMLET Your wisdom should show itself more richer to
 signify this to the doctor; for, for me to put him to his
 purgation would perhaps plunge him into far more
 choler.
GUILDENSTERN Good my lord, put your discourse into
 some frame, and start not so wildly from my affair. 320
HAMLET I am tame, sir; pronounce.
GUILDENSTERN The queen, your mother, in most great
 affliction of spirit, hath sent me to you.
HAMLET You are welcome.
GUILDENSTERN Nay, good my lord, this courtesy is not of
 the right breed. If it shall please you to make me a

wholesome answer, I will do your mother's com-
mandment: if not, your pardon and my return shall be
the end of my business.
HAMLET Sir, I cannot. 330
GUILDENSTERN What, my lord?
HAMLET Make you a wholesome answer; my wit's
 diseased: but, sir, such answers as I can make, you
 shall command; or rather, as you say, my mother:
 therefore no more but to the matter; my mother,
 you say,—
ROSENCRANTZ Then thus she says: your behaviour hath
 struck her into amazement and admiration.[22]
HAMLET O wonderful son, that can so 'stonish a mother!
 But is there no sequel at the heels of this mother's
 admiration? Impart. 341
ROSENCRANTZ She desires to speak with you in her
 closet, ere you go to bed.
HAMLET We shall obey, were she ten times our mother.
 Have you any further trade with us?
ROSENCRANTZ My lord, you once did love me.
HAMLET And do still, by these pickers and stealers.[23]
ROSENCRANTZ Good my lord, what is your cause of dis-
 temper? you do surely bar the door upon your own
 liberty, if you deny your griefs to your friend. 351
HAMLET Sir, I lack advancement.
ROSENCRANTZ How can that be, when you have the
 voice of the king himself for your succession in
 Denmark?
HAMLET Ay, sir, but "while the grass grows,"— the
 proverb is something musty.

RE-ENTER PLAYERS, WITH RECORDERS.

 O, the recorders! let me see one.—To withdraw with
 you:—why do you go about to recover the wind of
 me, as if you would drive me into a toil?[24]
GUILDENSTERN O, my lord, if my duty be too bold, my
 love is too unmannerly. 362
HAMLET I do not well understand that. Will you play upon
 this pipe?
GUILDENSTERN My lord, I cannot.
HAMLET I pray you.
GUILDENSTERN Believe me, I cannot.
HAMLET I do beseech you.
GUILDENSTERN I know no touch of it, my lord.
HAMLET It is as easy as lying: govern these ventages[25] with
 your fingers and thumb, give it breath with your
 mouth, and it will discourse most eloquent music.
 Look you, these are the stops. 373
GUILDENSTERN But these cannot I command to any
 utterance of harmony; I have not the skill.
HAMLET Why, look you now, how unworthy a thing you
 make of me! You would play upon me: you would
 seem to know my stops; you would pluck out the
 heart of my mystery; you would sound me from my
 lowest note to the top of my compass: and there is
 much music, excellent voice, in this little organ; yet
 cannot you make it speak.—'Sblood, do you think I
 am easier to be played on than a pipe? Call me what
 instrument you will, though you can fret me, you
 cannot play upon me.— 386

RE-ENTER POLONIUS.

 God bless you, sir!
POLONIUS My lord, the queen would speak with you, and
 presently.
HAMLET Do you see yonder cloud that's almost in shape
 of a camel?

POLONIUS By the mass, and 'tis like a camel, indeed.
HAMLET Methinks it is like a weasel.
POLONIUS It is backed like a weasel.
HAMLET Or like a whale?
POLONIUS Very like a whale.
HAMLET Then will I come to my mother by and by.—They
 fool me to the top of my bent.—I will come by and by.
POLONIUS I will say so.

<center>EXIT POLONIUS.</center>

HAMLET "By and by" is easily said.—Leave me, friends. 402

<center>EXEUNT ALL BUT HAMLET.</center>

'Tis now the very witching time of night;
When churchyards yawn, and hell itself breathes out
Contagion to this world: now could I drink hot blood,
And do such bitter business as the day
Would quake to look on. Soft! now to my mother.—
O, heart, lose not thy nature; let not ever
The soul of Nero[26] enter this form bosom:
Let me be cruel, not unnatural:
I will speak daggers to her, but use none;
My tongue and soul in this be hypocrites: 410
How in my words soever she be shent,[27]
To give them seals never, my soul, consent!

<center>EXIT.</center>

Notes

[1] those who stood in the pit of the theater
[2] characters in the old mystery plays
[3] tolerably
[4] flattering
[5] hidden
[6] smithy
[7] air, on which chameleons were believed to live
[8] sneaking mischief
[9] the sun's chariot
[10] the sea
[11] Roman goddess of the earth
[12] active
[13] a bitter herb
[14] acts
[15] anchorite's, hermit's
[16] chapped horse wince
[17] the goddess of witchcraft
[18] ornamented with slashes
[19] company
[20] peacock
[21] by God (French: *par dieu*)
[22] wonder
[23] hands
[24] trap
[25] vents, stops on a recorder
[26] Roman emperor who murdered his mother
[27] rebuked

Scene III. *A room in the castle.*

<center>ENTER KING, ROSENCRANTZ, AND GUILDENSTERN.</center>

KING I like him not, nor stands it safe with us
 To let his madness range. Therefore prepare you;
 I your commission will forthwith dispatch,
 And he to England shall along with you;
 The terms of our estate may not endure
 Hazard so near us as doth hourly grow
 Out of his brows.
GUILDENSTERN We will ourselves provide:
 Most holy and religious fear it is,
 To keep those many many bodies safe,
 That live and feed upon your majesty. 10
ROSENCRANTZ The single and peculiar life is bound
 With all the strength and armour of the mind
 To keep itself from noyance; but much more
 That spirit upon whose weal depends and rests
 The lives of many. The cease of majesty[1]
 Dies not alone, but like a gulf[2] doth draw
 What's near it with it: it is a massy wheel,
 Fixed on the summit of the highest mount,
 To whose huge spokes ten thousand lesser things
 Are mortised and adjoined; which, when it falls, 20
 Each small annexment, petty consequence,
 Attends the boisterous ruin. Never alone
 Did the king sigh, but with a general groan.
KING Arm you, I pray you, to this speedy voyage;
 For we will fetters put upon this fear,
 Which now goes too free-footed.
ROSENCRANTZ, GUILDENSTERN We will haste us.

<center>EXEUNT ROSENCRANTZ AND GUILDENSTERN.</center>

<center>ENTER POLONIUS.</center>

POLONIUS My lord, he's going to his mother's closet:
 Behind the arras I'll convey myself,
 To hear the process; I'll warrant she'll tax him home;
 And, as you said, and wisely was it said, 30
 Tis meet that some more audience than a mother,
 Since nature makes them partial, should o'erhear
 The speech of vantage. Fare you well, my liege:
 I'll call upon you ere you go to bed,
 And tell you what I know.
KING Thanks, dear my lord.

<center>EXIT POLONIUS.</center>

O, my offence is rank, it smells to heaven;
It hath the primal eldest curse[3] upon't,
A brother's murder!—Pray can I not,
Though inclination be as sharp as will; 39
My stronger guilt defeats my strong intent,
And, like a man to double business bound,
I stand in pause where I shall first begin,
And both neglect. What if this cursed hand
Were thicker than itself with brother's blood?
Is there not rain enough in the sweet heavens,
To wash it white as snow? Whereto serves mercy
But to confront the visage of offence?
And what's in prayer but this two-fold force,
To be forestalled ere we come to fall, 49
Or pardoned being down? Then I'll look up;
My fault is past. But, O, what form of prayer
Can serve my turn? "Forgive me my foul murder!"—
That cannot be, since I am still possessed
Of those effects for which I did the murder,
My crown, mine own ambition and my queen.
May one be pardoned and retain the offence?
In the corrupted currents of this world,
Offence's gilded hand may shove by justice;
And oft 'tis seen the wicked prize itself
Buys out the law: but 'tis not so above: 60
There is no shuffling, there the action lies
In his true nature; and we ourselves compelled,
Even to the teeth and forehead of our faults,
To give in evidence. What then? what rests?
Try what repentance can. What can it not?

Yet what can it, when one can not repent?
O wretched state! O bosom, black as death!
O limed[4] soul, that struggling to be free,
Art more engaged! Help, angels! make assay!
Bow, stubborn knees, and, heart with strings of steel, 70
Be soft as sinews of the new-born babe!
All may be well.

RETIRES AND KNEELS.

ENTER HAMLET.

HAMLET How might I do it pat, now he is praying;
And now I'll do't; and so he goes to heaven:
And so am I revenged? That would be, scanned:
A villain kills my father; and for that,
I, his sole son, do this same villain send
To heaven.
O, this is hire and salary, not revenge.
He took my father grossly, full of bread, 80
With all his crimes broad blown, as flush[5] as May;
And how his audit stands who knows save heaven?
But in our circumstance and course of thought,
'Tis heavy with him: and am I then revenged,
To take him in the purging of his soul,
When he is fit and seasoned for his passage?
No!
Up, sword, and know thou a more horrid hent;[6]
When he is drunk asleep, or in his rage,
Or in the incestuous pleasure of his bed; 90
At gaming, swearing; or about some act
That has no relish of salvation in't:
Then trip him, that his heels may kick at heaven;
And that his soul may be damned and black
As hell, whereto it goes. My mother stays:—
This physic but prolongs thy sickly days.

EXIT.

KING *[Rising]* My words fly up, my thoughts remain below;
Words without thoughts never to heaven go.

EXIT.

Notes

[1] end (death) of a king
[2] whirlpool
[3] curse of Cain, who killed Abel
[4] trapped (birdlime is a sticky substance spread on boughs to snare birds)
[5] vigorous
[6] grasp (here, time for seizing)

Scene IV. *The queen's closet.*

ENTER QUEEN AND POLONIUS.

POLONIUS 'A will come straight. Look you lay home
to him:
Tell him his pranks have been too broad to bear with,
And that your grace hath screened and stood between
Much heat and him. I'll silence me e'en here.
Pray you, be round with him.
HAMLET *[Within]* Mother! mother! mother!
QUEEN I'll warrant you;
Fear me not. Withdraw, I hear him coming.

POLONIUS HIDES HIMSELF.

ENTER HAMLET.

HAMLET Now, mother; what's the matter?

QUEEN Hamlet, thou hast thy father much offended.
HAMLET Mother, you have my father much offended. 10
QUEEN Come, come, you answer with an idle tongue.
HAMLET Go, go, you question with a wicked tongue.
QUEEN Why, how now, Hamlet?
HAMLET What's the matter now?
QUEEN Have you forgot me?
HAMLET No, by the rood,[1] no so:
You are the queen, your husband's brother's wife;
And would it were not so!—you are my mother.
QUEEN Nay, then I'll set those to you that can speak.
HAMLET Come, come, and sit you down; you shall not
budge;
You go not till I set you up a glass[2]
Where you may see the inmost part of you. 20
QUEEN What wilt thou do? thou wilt not murder me? Help,
help, oh!
POLONIUS *[Behind]* What, ho! help, help, help!
HAMLET How now! a rat? Dead, for a ducat, dead.

DRAWS. HAMLET MAKES A PASS THROUGH THE ARRAS.

POLONIUS *[Behind]* O, I am slain!

FALLS AND DIES.

QUEEN O me, what hast thou done?
HAMLET Nay, I know not: is it the king?

LIFTS UP THE ARRAS, AND DRAWS FORTH POLONIUS.

QUEEN O, what a rash and bloody deed is this!
HAMLET A bloody deed! almost as bad, good mother,
As kill a king, and marry with his brother.
QUEEN As kill a king!
HAMLET Ay, lady, 'twas my word.—
[To POLONIUS]
Thou wretched, rash, intruding fool, farewell! 30
I took thee for thy better; take thy fortune;
Thou find'st, to be too busy is some danger.—
Leave wringing of your hands. Peace! sit you down,
And let me wring your heart: for so I shall,
If it be made of penetrable stuff;
If damned custom have not brazed it so,
That it is proof and bulwark against sense.
QUEEN What have I done, that thou darest wag thy tongue
In noise so rude against me?
HAMLET Such an act,
That blurs the grace and blush of modesty, 40
Calls virtue hypocrite, takes off the rose
From the fair forehead of an innocent love,
And sets a blister there; makes marriage vows
As false as dicers' oaths; O, such a deed
As from the body of contraction[3] plucks
The very soul, and sweet religion makes
A rhapsody of words: heaven's face doth glow;
Yea, this solidity and compound mass,
With heated visage, as against the doom,
Is thought-sick at the act.
QUEEN Ay me, what act, 50
That roars so loud and thunders in the index?[4]
HAMLET Look here, upon this picture, and on this,
The counterfeit presentment of two brothers.
See what a grace was seated on this brow:
Hyperion's curls; the front of Jove himself;
An eye like Mars, to threaten and command;
A station, like the herald Mercury,
New-lighted on a heaven-kissing hill;
A combination and a form indeed,

Where every god did seem to set his seal 60
To give the world assurance of a man:
This was your husband. Look you now, what follows:
Here is your husband; like a mildewed ear,
Blasting his wholesome brother. Have you eyes?
Could you on this fair mountain leave to feed,
And batten on this moor? Ha! have you eyes?
You cannot call it love, for at your age
The hey-day in the blood is tame, it's humble,
And waits upon the judgment: and what judgment
Would step from this to this? Sense sure you have, 70
Else could you not have motion: but sure that sense
Is apoplexed: for madness would not err,
Nor sense to ecstasy was ne'er so thralled,
But it reserved some quantity of choice,
To serve in such a difference. What devil was't,
That thus hath cozened you at hoodman-blind?[5]
Eyes without feeling, feeling without sight,
Ears without hands or eyes, smelling sans[6] all,
Or but a sickly part of one true sense
Could not so mope. 80
O shame! where is thy blush? Rebellious hell,
If thou canst mutine in a matron's bones,
To flaming youth let virtue be as wax,
And melt in her own fire: proclaim no shame,
When the compulsive ardour gives the charge,
Since frost itself as actively doth burn,
And reason panders will.
QUEEN O Hamlet, speak no more:
Thou turn'st my very eyes into my soul;
And there I see such black and grained spots,
As will not leave their tinct.[7]
HAMLET Nay, but to live 90
In the rank of sweat of an enseamed bed,
Stewed in corruption, honeying and making love
Over the nasty sty;—
QUEEN O, speak to me no more;
These words like daggers enter in mine ears.
No more, sweet Hamlet!
HAMLET A murderer and a villain:
A slave that is not twentieth part the tithe[8]
Of your precedent lord: a vice of kings:
A cutpurse of the empire and the rule;
that from a shelf the precious diadem stole,
And put it in his pocket!
QUEEN No more! 100
HAMLET A king of shreds and patches:—

ENTER GHOST.

Save me, and hover o'er me with your wings,
You heavenly guards!—What would you, gracious
 figure?
QUEEN Alas! he's mad!
HAMLET Do you not come your tardy son to chide,
That, lapsed in time and passion, lets go by
The important acting of your dread command?
O, say!
GHOST Do not forget. This visitation
Is but to whet thy almost blunted purpose.
But, look, amazement on thy mother sits: 110
O, step between her and her fighting soul;
Conceit in weakest bodies strongest works:
Speak to her, Hamlet.
HAMLET How is it with you, lady?
QUEEN Alas, how is't with you,
That you do bend your eye on vacancy,
And with the incorporal air do hold discourse?

Forth at your eyes your spirits wildly peep;
And as the sleeping soldiers in the alarm,
Your bedded hair,[9] like life in excrements,
Starts up and stands on end. O gentle son, 120
Upon the heat and flame of thy distemper
Sprinkle cool patience. Whereon do you look?
HAMLET On him, on him! Look you, how pale he glares!
His form and cause conjoined, preaching to stones,
Would make them capable.—Do not look upon me;
Lest, with this piteous action you convert
My stern effects: then what I have to do
Will want true colour! tears perchance for blood.
QUEEN To whom do you speak this?
HAMLET Do you see nothing there?
QUEEN Nothing at all; yet all that is I see. 130
HAMLET Nor did you nothing hear?
QUEEN No, nothing but ourselves.
HAMLET Why, look you there! look, how it steals away!
My father, in his habit as he lived!
Look, where he goes, even now, out at the portal!

EXIT GHOST.

QUEEN This is the very coinage of your brain:
This bodiless creation ecstasy
Is very cunning in.
HAMLET "Ecstasy!"
My pulse, as yours, doth temperately keep time,
And makes as healthful music: it is not madness
That I have uttered: bring me to the test, 140
And I the matter will re-word, which madness
Would gambol from. Mother, for love of grace,
Lay not that flattering unction to your soul,
That not your trespass but my madness speaks:
It will but skin and film the ulcerous place,
Whiles rank corruption, mining[10] all within,
Infects unseen. Confess yourself to heaven;
Repent what's past, avoid what is to come;
And do not spread the compost on the weeds,
To make them ranker. Forgive me this my virtue, 150
For in the fatness of these pursy[11] times,
Virtue itself of vice must pardon beg,
Yea, courb and woo for leave to do him good.
QUEEN O Hamlet, thou hast cleft my heart in twain.
HAMLET O, throw away the worser part of it,
And live the purer with the other half.
Good night: but go not to mine uncle's bed;
Assume a virtue, if you have it not.
That monster, custom, who all sense doth eat,
Of habits devil, is angel yet in this, 160
That to the use of actions fair and good
He likewise gives a frock or livery,
That aptly is put on. Refrain to-night,
And that shall lend a kind of easiness
To the next abstinence: the next more easy;
For use almost can change the stamp of nature,
And either master the devil, or throw him out
With wondrous potency. Once more, good night:
And when you are desirous to be blessed,
I'll blessing beg of you.—For this same lord, 169

[POINTING TO POLONIUS]

I do repent: but heaven hath pleased it so,
To punish me with this, and this with me,
That I must be their scourge and minister.
I will bestow him, and will answer well
The death I gave him. So again, good night!
I must be cruel, only to be kind:

Thus bad begins and worse remains behind.
One word more, good lady.
QUEEN What shall I do?
HAMLET Not this, by no means, that I bid you do:
 Let the bloat king tempt you again to bed; 180
 Pinch wanton on your cheek; call you his mouse;
 And let him, for a pair of reechy[12] kisses,
 Or paddling in your neck with his damned fingers,
 Make you to ravel all this matter out,
 That I essentially am not in madness,
 But mad in craft. 'Twere good you let him know:
 For who, that's but a queen, fair, sober, wise,
 Would from a paddock,[13] from a bat, a gib,[14]
 Such dear concernings hide? who would do so?
 No, in despite of sense and secrecy, 190
 Unpeg the basket on the house's top,
 Let the birds fly, and like the famous ape,
 To try conclusions, in the basket creep,
 And break your own neck down.
QUEEN Be thou assured, if words be made of breath,
 And breath of life, I have no life to breathe
 What thou hast said to me.
HAMLET I must to England; you know that?
QUEEN Alack, I had forgot; 'tis so concluded on.
HAMLET There's letters sealed: and my two school-fellows, 200
 Whom I will trust as I will adders fanged,
 They bear the mandate; they must sweep my way,
 And marshal me to knavery. Let it work;
 For 'tis the sport to have the engineer
 Hoist with his own petard:[15] and't shall go hard
 But I will delve one yard below their mines,
 And blow them at the moon: O, 'tis most sweet,
 When in one line two crafts directly meet.
 This man shall set me packing:
 I'll lug the guts into the neighbour room. 210
 Mother, good night. Indeed, this counsellor
 Is now most still, most secret, and most grave
 Who was in life a foolish prating knave.
 Come, sir, to draw toward an end with you:
 Good night, mother.

EXEUNT SEVERALLY; HAMLET
DRAGGING IN THE BODY OF POLONIUS.

Notes

[1] cross
[2] mirror
[3] marriage contract
[4] prologue
[5] blindman's buff
[6] without
[7] color
[8] tenth part
[9] flattened hairs
[10] undermining
[11] bloated
[12] foul
[13] toad
[14] tomcat
[15] bomb

ACT IV

Scene I. *A room in the castle.*

ENTER KING, QUEEN, ROSENCRANTZ, AND GUILDENSTERN.

KING There's matter in these sighs: these profound heaves
 You must translate: 'tis fit we understand them.
 Where is your son?

QUEEN Bestow this place on us a little while.—

EXEUNT ROSENCRANTZ AND GUILDENSTERN.

 Ah, my good lord, what have I seen to-night!
KING What, Gertrude? How does Hamlet?
QUEEN Mad as the sea and wind, when both contend
 Which is the mightier: in his lawless fit,
 Behind the arras hearing something stir,
 Whips out his rapier, cries "A rat! a rat!" 10
 And in his brainish apprehension kills
 The unseen good old man.
KING O heavy deed!
 It had been so with us, had we been there:
 His liberty is full of threats to all,
 To you yourself, to us, to every one.
 Alas, how shall this bloody deed be answered?
 It will be laid to us, whose providence
 Should have kept short, restrained, and out of haunt,
 This mad young man: but, so much was our love,
 We would not understand what was most fit, 20
 But, like the owner of a foul disease,
 To keep it from divulging, let it feed
 Even on the pith of life. Where is he gone?
QUEEN To draw apart the body he hath killed:
 O'er whom his very madness, like some ore
 Among a mineral of metals base,
 Shows itself pure. 'A weeps for what is done.
KING O, Gertrude, come away!
 The sun no sooner shall the mountains touch,
 But we will ship him hence: and this vile deed
 We must, with all our majesty and skill, 31
 Both countenance and excuse.—Ho!
 Guildenstern!

RE-ENTER ROSENCRANTZ AND GUILDENSTERN.

 Friends both, go join you with some further aid:
 Hamlet in madness hath Polonius slain,
 And from his mother's closet hath he dragged him.
 Go seek him out; speak fair, and bring the body
 Into the chapel. I pray you haste in this.

EXEUNT ROSENCRANTZ AND GUILDENSTERN.

 Come, Gertrude, we'll call up our wisest friends;
 And let them know, both what we mean to do,
 And what's untimely done: so, haply, slander, 40
 Whose whisper o'er the world's diameter,
 As level as the cannon to his blank[1]
 Transports his poisoned shot, may miss our name,
 And hit the woundless air. O, come away!
 My soul is full of discord and dismay.

EXEUNT.

Notes

[1] center of a target

Scene II. *Another room in the castle.*

ENTER HAMLET.

HAMLET Safely stowed,—
ROSENCRANTZ, GUILDENSTERN [*Within*] Hamlet! Lord
 Hamlet!
HAMLET But soft, what noise? who calls on Hamlet?
 O, here they come.

ENTER ROSENCRANTZ AND GUILDENSTERN.

ROSENCRANTZ What have you done, my lord, with the
 dead body?
HAMLET Compound it with dust, whereto 'tis kin.
ROSENCRANTZ Tell us where 'tis, that we may take it
 thence, 10
 And bear it to the chapel.
HAMLET Do not believe it.
ROSENCRANTZ Believe what?
HAMLET That I can keep your counsel, and not mine own.
 Besides, to be demanded of a sponge, what replica-
 tion[1] should be made by the son of a king?
ROSENCRANTZ Take you me for a sponge, my lord?
HAMLET Ay, sir; that soaks up the king's countenance, his
 rewards, his authorities. But such officers do the king
 best service in the end: he keeps them, like an ape, in
 the corner of his jaw; first mouthed, to be last swal-
 lowed: when he needs what you have gleaned, it is
 but squeezing you, and, sponge, you shall be dry
 again. 24
ROSENCRANTZ I understand you not, my lord.
HAMLET I am glad of it: a knavish speech sleeps in a
 foolish ear.
ROSENCRANTZ My lord, you must tell us where the body
 is, and go with us to the king.
HAMLET The body is with the king, but the king is not
 with the body. The king is a thing—
GUILDENSTERN "A thing," my lord?
HAMLET Of nothing: bring me to him. Hide fox, and all
 after. 34

<div align="center">EXEUNT.</div>

Notes

[1] reply

Scene III. *Another room in the castle.*

<div align="center">ENTER KING, ATTENDED.</div>

KING I have sent to seek him, and to find the body.
 How dangerous is it that this man goes loose!
 Yet must not we put the strong law on him:
 He's loved of the distracted multitude,
 Who like not in their judgment, but their eyes;
 And where 'tis so, the offender's scourge is weighed,
 But never the offence. To bear all smooth and even,
 This sudden sending him away must seem
 Deliberate pause: diseases desperate grown
 By desperate appliance are relieved, 10
 Or not at all.—

<div align="center">ENTER ROSENCRANTZ.</div>

 How now! what hath befallen?
ROSENCRANTZ Where the dead body is bestowed, my lord,
 We cannot get from him.
KING But where is he?
ROSENCRANTZ Without, my lord; guarded, to know your
 pleasure.
KING Bring him before us.
ROSENCRANTZ Ho, Guildenstern! bring in my lord.

<div align="center">ENTER HAMLET AND GUILDENSTERN.</div>

KING Now, Hamlet, where's Polonius?
HAMLET At supper. 20
KING "At supper"? where?
HAMLET Not where he eats, but where 'a is eaten: a certain
 convocation of politic[1] worms are e'en at him. Your
 worm is your only emperor for diet. We fat all

creatures else to fat us, and we fat ourselves for mag-
gots. Your fat king, and your lean beggar, is but
variable service, two dishes, but to one table; that's
the end.
KING Alas, alas!
HAMLET A man may fish with the worm that hath eat of a
 king, and eat of the fish that hath fed of that worm. 32
KING What dost thou mean by this?
HAMLET Nothing but to show you how a king may go a
 progress[2] through the guts of a beggar.
KING Where is Polonius?
HAMLET In heaven; send thither to see: if your messenger
 find him not there, seek him i' the other place your-
 self. But if, indeed, you find him not within this
 month, you shall nose him as you go up the stairs into
 the lobby. 41
KING [*To some* ATTENDANTS] Go seek him there.
HAMLET 'A will stay till you come.

<div align="center">EXEUNT ATTENDANTS.</div>

KING Hamlet, this deed of thine, for thine especial safety,
 Which we do tender,[3] as we dearly grieve
 For that which thou hast done, must send thee hence
 With fiery quickness: therefore prepare thyself;
 The bark is ready and the wind at help,
 The associates tend,[4] and everything is bent
 For England.
HAMLET For England?
KING Ay, Hamlet.
HAMLET Good. 50
KING So is it, if thou knew'st our purposes.
HAMLET I see a cherub that sees them.—But, come; for
 England!—Farewell, dear mother.
KING Thy loving father, Hamlet.
HAMLET My mother: father and mother is man and wife;
 man and wife is one flesh, and so, my mother.—
 Come, for England.

<div align="center">EXIT.</div>

KING Follow him at foot; tempt him with speed aboard;
 Delay it not; I'll have him hence to-night:
 Away! for everything is sealed and done 60
 That else leans on the affair: pray you, make haste.

<div align="center">EXEUNT ROSENCRANTZ AND GUILDENSTERN.</div>

 And England, if my love thou hold'st at aught,—
 As my great power thereof may give thee sense;
 Since yet thy cicatrice,[5] looks raw and red
 After the Danish sword, and thy free awe
 Pays homage to us,—thou mayst not coldly set
 Our sovereign process; which imports at full,
 By letters congruing to that effect,
 The present death of Hamlet. Do it, England;
 for like the hectic[6] in my blood he rages, 70
 And thou must cure me: till I know 'tis done,
 Howe'er my haps,[7] my joys were ne'er begun.

<div align="center">EXIT.</div>

Notes

[1] statesmanlike
[2] royal journey
[3] hold dear
[4] wait
[5] scar
[6] fever
[7] fortune

Scene IV. *A plain in Denmark.*

ENTER FORTINBRAS, A CAPTAIN AND SOLDIERS, MARCHING.

FORTINBRAS Go, captain, from me greet the Danish king;
 Tell him that, by his licence, Fortinbras
 Claims the conveyance of a promised march
 Over his kingdom. You know the rendezvous.
 If that his majesty would aught with us,
 We shall express our duty in his eye;
 And let him know so.
CAPTAIN I will do't, my lord.
FORTINBRAS Go softly on.

EXEUNT FORTINBRAS AND SOLDIERS.

ENTER HAMLET, ROSENCRANTZ, GUILDENSTERN, ETC.

HAMLET Good sir, whose powers are these?
CAPTAIN They are of Norway, sir. 10
HAMLET How purposed, sir, I pray you?
CAPTAIN Against some part of Poland.
HAMLET Who commands them, sir?
CAPTAIN The nephew to old Norway, Fortinbras.
HAMLET Goes it against the main of Poland, sir,
 Or for some frontier?
CAPTAIN Truly to speak, and with no addition,
 We go to gain a little patch of ground,
 That hath in it no profit but the name.
 To pay five ducats, five, I would not farm it; 20
 Nor will it yield to Norway, or the Pole,
 A ranker[1] rate, should it be sold in fee.[2]
HAMLET Why, then the Polack never will defend it.
CAPTAIN Yes, 'tis already garrisoned.
HAMLET Two thousand souls and twenty thousand ducats
 Will not debate the question of this straw:
 This is the imposthume[3] of much wealth and peace;
 That inward breaks, and shows no cause without 28
 Why the man dies. — I humbly thank you, sir.
CAPTAIN God b'uy you, sir.

EXIT.

ROSENCRANTZ Will't please you go, my lord?
HAMLET I will be with you straight. Go a little before.

EXEUNT ALL EXCEPT HAMLET.

 How all occasions do inform against me,
 And spur my dull revenge! What is a man,
 If his chief good and market of his time
 Be but to sleep and feed? a beast, no more.
 Sure, he that made us with such large discourse,
 Looking before and after, gave us not
 That capability and godlike reason
 To fust[4] in us unused. Now, whether it be
 Bestial oblivion, or some craven scruple 40
 Of thinking too precisely on the event, —
 A thought which, quartered, hath but one part wisdom
 And ever three parts coward, — I do not know
 Why yet I live to say, "This thing's to do;"
 Sith I have cause, and will, and strength, and means,
 To do't. Examples, gross as earth, exhort me:
 Witness this army, of such mass and charge,
 Led by a delicate and tender prince,
 Whose spirit, with divine ambition puffed,
 Makes mouths at the invisible event; 50
 Exposing what is mortal and unsure
 To all that fortune, death, and danger dare,
 Even for an egg-shell. Rightly to be great,

Is not to stir without great argument,
 But greatly to find quarrel in a straw
 When honour's at the stake. How stand I then,
 That have a father killed, a mother stained,
 Excitements of my reason and my blood,
 And let all sleep while to my shame I see,
 The imminent death of twenty thousand men, 60
 That for a fantasy and trick of fame,
 Go to their graves like beds, fight for a plot
 Whereon the numbers cannot try the cause,
 Which is not tomb enough and continent,[5]
 To hide the slain? O, from this time forth,
 My thoughts be bloody, or be nothing worth?

EXIT.

Notes

[1] higher
[2] outright
[3] abscess, ulcer
[4] grow moldy
[5] container

Scene V. *A room in the castle.*

ENTER QUEEN, HORATIO, AND A GENTLEMAN.

QUEEN I will not speak with her.
GENTLEMAN She is importunate, indeed, distract;
 Her mood will needs be pitied.
QUEEN What would she have?
GENTLEMAN She speaks much of her father; says
 she hears,
 There's tricks i' the world; and hems and beats her heart;
 Spurns enviously at straws; speaks things in doubt,
 That carry but half sense: her speech is nothing,
 Yet the unshaped use of it doth move
 The hearers to collection; they aim at it,
 And botch the words up fit to their own thoughts; 10
 Which, as her winks and nods and gestures yield them,
 Indeed would make one think there might be thought,
 Though nothing sure, yet much unhappily.
HORATIO 'Twere good she were spoken with, for she
 may strew
 Dangerous conjectures in ill-breeding minds.
QUEEN Let her come in.

EXIT HORATIO.

 To my sick soul, as sin's true nature is,
 Each toy seems prologue to some great amiss:
 So full of artless jealousy is guilt,
 It spills itself in fearing to be spilt. 20

RE-ENTER HORATIO WITH OPHELIA.

OPHELIA Where is the beauteous majesty of Denmark?
QUEEN How now, Ophelia?
OPHELIA [*Sings*] *How should I your true love know*
 From another
 By his cockle hat
 And his sandal shoon.[1]
QUEEN Alas, sweet lady, what imports this song?
OPHELIA Say you? nay, pray you, mark.
 He is dead and gone, lady,
 He is dead and gone; 30
 At his head a grass-green turf,
 At his heels a stone.
 O, ho!

QUEEN Nay, but Ophelia,—
OPHELIA Pray you, mark.
 [Sings] White his shroud as the mountain snow.

ENTER KING.

QUEEN Alas, look here, my lord.
OPHELIA *[Sings]* Larded[2] with sweet flowers:
 Which bewept to the grave did not go,
 With true-love showers.
KING How do you, pretty lady?
OPHELIA Well, God dild[3] you! They say the owl was a
 baker's daughter. Lord, we know what we are, but
 know not what we may be. God be at your table! 43
KING *[Aside]* Conceit[4] upon her father.
OPHELIA Pray you, let us have no words of this; but when
 they ask you what it means, say you this:
 [Sings] To-morrow is Saint Valentine's day,
 All in the morning bedtime,
 And I a maid at your window,
 To be your Valentine: 50
 Then up he rose, and donned his clothes
 And dupped[5] the chamber-door;
 Let in the maid, that out a maid
 Never departed more.
KING Pretty Ophelia!
OPHELIA Indeed, la, without an oath, I'll make an end on't:
 [Sings] By Gis,[6] and by Saint Charity,
 Alack, and fie for shame!
 Young men will do't, if they come to't; 60
 By cock, they are to blame.
 Quoth she, before you tumbled me,
 You promised me to wed:
 [He answers:] So would I ha' done, by yonder sun,
 And thou hadst not come to my bed.
KING How long hath she been thus?
OPHELIA I hope, all will be well. We must be patient: but I
 cannot choose but weep, to think they should lay him
 i' the cold ground. My brother shall know of it; and so
 I thank you for your good counsel.—Come, my
 coach!—
 Good night, ladies; good night, sweet ladies; good night,
 good night.

EXIT.

KING Follow her close; give her good watch, I pray you.

EXIT HORATIO.

O, this is the poison of deep grief; it springs
All from her father's death. O Gertrude,
Gertrude, 75
When sorrows come, they come not single spies,
But in battalions! First, her father slain;
Next, your son gone; and he most violent author
Of this own just remove: the people muddied,
Thick and unwholesome in thoughts and whispers, 80
For good Polonius' death; and we have done
but greenly,[7]
In hugger-mugger[8] to inter him; poor Ophelia
Divided from herself and her fair judgment
Without the which we are pictures, or mere beasts;
Last, and as much containing as all these,
Her brother is in secret come from France:
Feeds on his wonder, keeps himself in clouds,
And wants not buzzers to infect his ear
With pestilent speeches of his father's death;

Wherein necessity, of matter beggared, 90
Will nothing stick our person to arraign
In ear and ear. O my dear Gertrude, this,
Like to a murdering-piece, in many places
Gives me superfluous death.

A NOISE WITHIN.

QUEEN Alack! what noise is this?
KING Where are my Switzers?[9] Let them guard the door.

ENTER A GENTLEMAN.

What is the matter?
GENTLEMAN Save yourself, my lord;
 The ocean, overpeering of his list,[10]
 Eats not the flats with more impetuous haste,
 Than young Laertes, in a riotous head,
 O'erbears your officers. The rabble call him lord; 100
 And, as the world were now but to begin,
 Antiquity forgot, custom not known,
 The ratifiers and props of every word,
 They cry, "Choose we; Laertes shall be king!"
 Caps, hands, and tongues, applaud it to the clouds,
 "Laertes shall be king, Laertes king!"
QUEEN How cheerfully on the false trail they cry!
 O, this is counter, you false Danish dogs!

NOISE WITHIN.

KING The doors are broke.

ENTER LAERTES, ARMED; DANES FOLLOWING.

LAERTES Where is the king?—Sirs, stand you all without. 110
DANES No, let's come in.
LAERTES I pray you, give me leave.
DANES We will, we will.

THEY RETIRE WITHOUT THE DOOR.

LAERTES I thank you. Keep the door.—O thou vile king,
 Give me my father!
QUEEN Calmly, good Laertes.
LAERTES That drop of blood that's calm, proclaims me
 bastard;
 Cries cuckold to may father; brands the harlot
 Even here, between the chaste unsmirched brow
 Of my true mother.
KING What is the cause, Laertes,
 That thy rebellion looks so giant-like?
 Let him go, Gertrude; do not fear our person; 120
 There's such divinity doth hedge a king,
 That treason can but peep to what it would,
 Acts little of his will. Tell me, Laertes,
 Why thou art thus incensed.—Let him go,
 Gertrude.—
 Speak, man.
LAERTES Where's my father?
KING Dead.
QUEEN But not by him.
KING Let him demand his fill.
LAERTES How came he dead? I'll not be juggled with.
 To hell, allegiance! vows, to the blackest devil!
 Conscience and grace, to the profoundest pit!
 I dare damnation. To this point I stand: 130
 That both the worlds I give to negligence,
 Let come what comes; only I'll be revenged
 Most throughly for my father.
KING Who shall stay you?

LAERTES My will, not all the world:
 And for my means, I'll husband them so well,
 They shall go far with little.
KING Good Laertes,
 If you desire to know the certainty
 Of your dear father's death, is't writ in your revenge,
 That, swoopstake,[11] you will draw both friend and foe,
 Winner and loser? 140
LAERTES None but his enemies.
KING Will you know them then?
LAERTES To his good friends thus wide I'll ope my arms;
 And, like the kind life-rendering pelican,[12]
 Repast[13] them with my blood.
KING Why, now you speak
 Like a good child and a true gentleman.
 That I am guiltless of your father's death,
 And am most sensibly in grief for it,
 It shall as level to your judgment pierce,
 As day does to your eye.
DANES [*Within*] Let her come in.
LAERTES How now! what noise is that? 150

ENTER OPHELIA.

 O heat, dry up my brains! tears, seven times salt,
 Burn out the sense and virtue of mine eye!—
 By heaven, thy madness shall be paid with weight,
 Till our scale turn the beam. O rose of May!
 Dear maid, kind sister, sweet Ophelia!—
 O heavens! is't possible a young maid's wits
 Should be as mortal as an old man's life?
 Nature is fine in love, and where 'tis fine,
 It sends some precious instance of itself
 After the thing it loves. 160
OPHELIA [*Sings*] *They bore him barefaced on the bier;*
 Hey non nonny, nonny, hey nonny;
 And on his grave rains many a tear.—
 Fare you well, my dove!
LAERTES Hadst thou thy wits, and didst persuade revenge,
 It could not move thus.
OPHELIA You must sing, *Down-a-down, and you call him a-*
 down-a. O, how the wheel becomes it!
 It is the false steward, that stole his master's daughter.
LAERTES This nothing's more than matter. 170
OPHELIA There's rosemary, that's for remembrance; pray
 you, love, remember: and there is pansies, that's for
 thoughts.
LAERTES A document in madness; thoughts and remem-
 brance fitted.
OPHELIA There's fennel for you, and columbines: there's
 rue for you; and here's some for me: we may call it
 herb of grace o'Sundays: oh, you must wear your rue
 with a difference. There's a daisy: I would give you
 some violets; but they withered all, when my father
 died: they say 'a made a good end,— 182
 [*Sings*] *For bonny sweet Robin is all my joy.*
LAERTES Thought and affliction, passion, hell itself,
 She turns to favour and to prettiness.
OPHELIA [*Sings*] *And will 'a not come again?*
 And will 'a not come again?
 No, no, he is dead,
 Go to thy death-bed,
 He never will come again. 190
 His beard was as white as snow,
 All flaxen was his poll:
 He is gone, he is gone,
 And we cast away moan;

God ha' mercy on his soul!
 And of all Christian souls, I pray God.—God b'uy you!

EXIT OPHELIA.

LAERTES Do you see this, O God?
KING Laertes, I must commune with your grief,
 Or you deny me right. Go but apart,
 Make choice of whom your wisest friends you will, 200
 And they shall hear and judge 'twixt you and me.
 If by direct or by collateral hand
 They find us touched,[14] we will our kingdom give,
 Our crown, our life, and all that we call ours,
 To you in satisfaction. But if not,
 Be you content to lend your patience to us,
 And we shall jointly labour with your soul
 To give it due content.
LAERTES Let this be so;
 His means of death, his obscure burial—
 No trophy, sword, not hatchment[15] o'er his bones, 210
 No noble rite nor formal ostentation,—
 Cry to be heard, as 'twere from heaven to earth,
 That I must call't in question.
KING So you shall;
 And where the offence is let the great axe fall.
 I pray you, go with me.

EXEUNT.

Notes

[1] shoes
[2] decorated
[3] yield, i.e., reward
[4] brooding
[5] opened
[6] contraction of "Jesus"
[7] foolishly
[8] secret haste
[9] Swiss guards
[10] shore
[11] in a clean sweep
[12] the pelican was thought to feed its young with its own blood
[13] feed
[14] implicated
[15] tablet bearing the coat of arms of the dead

Scene VI. *Another room in the castle.*

ENTER HORATIO AND A SERVANT.

HORATIO What are they that would speak with me?
SERVANT Sea-faring men, sir; they say, they have letters for
 you.
HORATIO Let them come in.—

EXIT SERVANT.

 I do not know from what part of the world
 I should be greeted, if not from Lord Hamlet.

ENTER SAILORS.

1 SAILOR God bless you, sir.
HORATIO Let him bless thee too.
1 SAILOR 'A shall, sir, and't please him. There's a letter for
 you, sir; it comes from the ambassador that was
 bound for England; if your name be Horatio, as I am
 let to know it is. 13
HORATIO [*Reads*] *Horatio, when thou shalt have overlooked*
 this, give these fellows some means to the king; they have
 letters for him. Ere we were two days old at sea, a pirate of

*very warlike appointment gave us chase. Finding ourselves
too slow of sail, we put on a compelled valour; in the grap-
ple I boarded them: on the instant, they got clear of our ship;
so I alone became their prisoner. They have dealt with me
like thieves of mercy; but they knew what they did; I am to
do a good turn for them. Let the king have the letters I have
sent; and repair thou to me with as much speed as thou
wouldst fly death. I have words to speak in thine ear will
make thee dumb; yet are they much too light for the bore of
the matter. These good fellows will bring thee where I am.
Rosencrantz and Guildenstern hold their course for En-
gland; of them I have much to tell thee. Farewell.* 30
He that thou knowest thine, Hamlet.

Come, I will give you way for these your letters;
And do 't the speedier, that you may direct me
To him from whom you brought them.

<div align="center">EXEUNT.</div>

Scene VII. *Another room in the castle.*

<div align="center">ENTER KING AND LAERTES.</div>

KING Now must your conscience my acquittance seal,
 And you must put me in your heart for friend;
 Sith you have heard, and with a knowing ear,
 That he which hath your noble father slain,
 Pursued my life.
LAERTES It well appears: but tell me
 Why you proceeded not against these feats,
 So crimeful and so capital in nature,
 As by your safety, greatness, wisdom, all things else,
 You mainly were stirred up.
KING O, for two special reasons; 10
 Which may to you, perhaps, seem much unsinewed,
 And yet to me they are strong. The queen, his mother,
 Lives almost by his looks; and for myself,—
 My virtue or my plague, be it either which,—
 She's so conjunctive to my life and soul,
 That, as the star moves not but in his sphere,
 I could not but by her. The other motive,
 Why to a public count I might not go,
 Is the great love the general gender[1] bear him:
 Who, dipping all his faults in their affection,
 Would, like the spring that turneth wood to stone, 20
 Convert his gyves[2] to graces; so that my arrows,
 Too slightly timbered for so loud a wind,
 Would have reverted to my bow again,
 And not where I had aimed them.
LAERTES And so have I a noble father lost;
 A sister driven into desperate terms,
 Whose worth, if praises may go back again,
 Stood challenger on mount of all the age
 For her perfections. But my revenge will come.
KING Break not your sleeps for that: you must not think 30
 That we are made of stuff so flat and dull
 That we can let our beard be shook with danger
 And think it pastime. You shortly shall hear more:
 I loved your father, and we love ourself;
 And that, I hope, will teach you to imagine,—
 How now? what news?

<div align="center">ENTER A MESSENGER.</div>

MESSENGER Letters, my lord, from Hamlet:
 These to your majesty; this to the queen.
KING From Hamlet! who brought them?
MESSENGER Sailors, my lord, they say: I saw them not.
 They were given me by Claudio; he received them 40
 Of him that brought them.

KING Laertes, you shall hear them.
 Leave us.

<div align="center">EXIT MESSENGER.</div>

[Reads] High and mighty, You shall know, I am set naked on
 your kingdom. To-morrow shall I beg leave to see your
 kingly eyes: when I shall, first asking your pardon there-
 unto, recount the occasion of my sudden and more strange
 return. Hamlet.
What should this mean? Are all the rest come back?
 Or is it some abuse, and no such thing?
LAERTES Know you the hand?
KING 'Tis Hamlet's character.[3] "Naked,"—
 And, in a postscript here, he says, "alone":
 Can you advise me? 52
LAERTES I'm lost in it, my lord. But let him come:
 It warms the very sickness in my heart,
 That I shall live and tell him to his teeth,
 "Thus didest thou."
KING If it be so, Laertes,—
 As how should it be so? how otherwise?—
 Will you be ruled by me?
LAERTES Ay, my lord:
 So you will not o'er-rule me to a peace.
KING To thine own peace. If he be now returned, 60
 As checking at his voyage, and that he means
 No more to undertake it, I will work him
 To an exploit now ripe in my device,
 Under the which he shall not choose but fall;
 And for his death no wind of blame shall breathe;
 But even his mother shall uncharge the practice,
 And call it accident.
LAERTES My lord, I will be ruled:
 The rather, if you could devise it so,
 That I might be the organ.
KING It falls right.
 You have been talked of since your travel much, 70
 And that in Hamlet's hearing, for a quality
 Wherein, they say, you shine: your sum of parts
 Did not together pluck such envy from him,
 As did that one, and that, in my regard,
 Of the unworthiest siege.[4]
LAERTES What part is that, my lord?
KING A very riband in the cap of youth,
 Yet needful too; for youth no less becomes
 The light and careless livery that it wears,
 Than settled age his sables and his weeds,
 Importing health and graveness. Two months since, 80
 Here was a gentleman of Normandy;—
 I have seen myself, and served against the French,
 And they can well on horseback: but this gallant
 Had witchcraft in 't; he grew unto his seat,
 And to such wondrous doing brought his horse,
 As he had been incorpsed and demi-natured
 With the brave beast. So far he topped my thought
 That I, in forgery of shapes and tricks,
 Come short of what he did.
LAERTES A Norman, was 't?
KING A Norman.
LAERTES Upon my life, Lamord.
KING The very same.
LAERTES I know him well: he is the brooch indeed, 91
 And gem of all the nation.
KING He made confession of you,
 And gave you such a masterly report,
 For art and exercise in your defence,

And for your rapier most especially,
That he cried out, 'twould be a sight indeed,
If one could match you: the scrimers[5] of their nation,
He swore, had neither motion, guard, nor eye,
If you opposed them. Sir, this report of his 100
Did Hamlet so envenom with his envy,
That he could nothing do, but wish and beg
Your sudden coming o'er, to play with him.
Now, out of this,—

LAERTES What out of this, my lord?

KING Laertes, was your father dear to you?
 Or are you like the painting of a sorrow,
 A face without a heart?

LAERTES Why ask you this?

KING Not that I think you did not love your father;
 But that I know love is begun by time;
 And that I see, in passages of proof, 110
 Time qualifies the spark and fire of it.
 There lives within the very flame of love
 A kind of wick or snuff that will abate it;
 And nothing is at a like goodness still;
 For goodness, growing to a plurisy,[6]
 Dies in his own too-much: that we would do,
 We should do when we would; for this "would" changes
 And hath abatements and delays as many,
 As there are tongues, are hands, are accidents,
 And then this "should" is like a spendthrift sigh, 120
 That hurts by easing. But, to the quick[7] o' the ulcer:
 Hamlet comes back: what would you undertake,
 To show yourself your father's son in deed
 More than in words?

LAERTES To cut his throat i' the church.

KING No place, indeed, should murder sanctuarize;
 Revenge should have no bounds. But, good Laertes,
 Will you do this, keep close within your chamber?
 Hamlet returned shall know you are come home:
 We'll put on those shall praise your excellence,
 And set a double varnish on the fame 130
 The Frenchman gave you, bring you, in fine,[8] together,
 And wager on your heads: he, being remiss,
 Most generous and free from all contriving,
 Will not peruse the foils, so that with ease,
 Or with a little shuffling, you may choose
 A sword unbated,[9] and in a pass of practice,
 Requite him for your father.

LAERTES I will do't:
 And for that purpose I'll anoint my sword.
 I bought an unction of a mountebank,[10]
 So mortal that but dip a knife in it, 140
 Where it draws blood no cataplasm[11] so rare,
 Collected from all simples[12] that have virtue
 Under the moon, can save the thing from death
 That is but scratched withal: I'll touch my point
 With this contagion, that if I gall him slightly
 It may be death.

KING Let's further think of this;
 Weigh what convenience both of time and means,
 May fit us to our shape. If this should fail,
 And that our drift look through our bad performance,
 'Twere better not assayed; therefore this project 150
 Should have a back or second, that might hold
 If this should blast in proof. Soft!—let me see!—
 We'll make a solemn wager on your cunnings;
 I ha't: when in your motion you are hot and dry,—

As make your bouts more violent to that end,—
And that he calls for drink, I'll have prepared him
A chalice for the nonce;[13] whereon but sipping,
If he by chance escape your venomed stuck,[14]
Our purpose may hold there. But stay, what noise?—

<div align="center">ENTER QUEEN.</div>

 How now, sweet queen? 160

QUEEN One woe doth tread upon another's heel,
 So fast they follow. Your sister's drowned,
 Laertes.

LAERTES "Drowned"! O, where?

QUEEN There is a willow grows aslant a brook,
 That shows his hoar leaves in the glassy stream;
 There with fantastic garlands did she come
 Of crow-flowers, nettles, daisies, and long purples,
 That liberal shepherds give a grosser name,
 But our cold maids do dead men's fingers call them:
 There, on the pendent boughs her coronet weeds 170
 Clambering to hang, an envious sliver broke;
 When down the weedy trophies and herself
 Fell in the weeping brook. Her clothes spread wide,
 And, mermaid-like, a while they bore her up:
 Which time she chanted snatches of old tunes,
 As one incapable of her own distress,
 Or like a creature native and indued[15]
 Unto that element: but long it could not be,
 Till that her garments, heavy with their drink,
 Pulled the poor wretch from her melodious lay 180
 To muddy death.

LAERTES Alas then, she is drowned?

QUEEN Drowned, drowned.

LAERTES Too much of water hast thou, poor Ophelia,
 And therefore I forbid my tears: but yet
 It is our trick, nature her custom holds,
 Let shame say what it will: when these are gone,
 The woman will be out.—Adieu, my lord;
 I have a speech of fire that fain would blaze,
 But that this folly douts it.

<div align="center">EXIT.</div>

KING Let's follow, Gertrude;
 How much I had to do to calm his rage! 190
 Now fear I this will give it start again;
 Therefore let's follow.

<div align="center">EXEUNT.</div>

Notes

[1] common people
[2] letters
[3] handwriting
[4] rank
[5] fencers
[6] excess
[7] sensitive flesh
[8] finally
[9] not blunted
[10] quack
[11] poultice
[12] medicinal herbs
[13] occasion
[14] thrust
[15] in harmony with

ACT V

Scene I. *A churchyard.*

ENTER TWO CLOWNS, WITH SPADES, ETC.

1 CLOWN Is she to be buried in Christian burial when she wilfully seeks her own salvation?

2 CLOWN I tell thee she is; and therefore make her grave straight: the crowner[1] hath sate on her, and finds it Christian burial.

1 CLOWN How can that be, unless she drowned herself in her own defence?

2 CLOWN Why, 'tis found so.

1 CLOWN It must be *se offendendo;*[2] it cannot be else. For here lies the point: if I drown myself wittingly, it argues an act, and an act hath three branches; it is, to act, to do, and to perform: argal,[3] she drowned herself wittingly. 13

2 CLOWN Nay, but hear you, goodman delver,—

1 CLOWN Give me leave. Here lies the water; good: here stands the man; good: if the man go to this water and drown himself, it is, will he, nill he, he goes; mark you that; but if the water come to him and drown him, he drowns not himself: argal, he that is not guilty of his own death shortens not his own life. 21

2 CLOWN But is this law?

1 CLOWN Ay, marry is't; crowner's quest[4] law.

2 CLOWN Will you ha' the truth on't? If this had not been a gentlewoman, she should have been buried out o' Christian burial.

1 CLOWN Why, there thou say'st: and the more pity, that great folk should have countenance in this world to drown or hang themselves more than their even Christen. Come, my spade. There is no ancient gentlemen but gardeners, ditchers, and grave-makers; they hold up Adam's profession.

2 CLOWN Was he a gentleman? 33

1 CLOWN 'A was the first that ever bore arms.

2 CLOWN Why, he had none.

1 CLOWN What, art a heathen? How dost thou understand the scripture? The scripture says "Adam digged"; could he dig without arms? I'll put another question to thee: if thou answerest me not to the purpose, confess thyself— 40

2 CLOWN Go to.

1 CLOWN What is he, that builds stronger than either the mason, the shipwright, or the carpenter?

2 CLOWN The gallows-maker; for that frame outlives a thousand tenants.

1 CLOWN I like thy wit well, in good faith; the gallows does well: but how does it well? it does well to those that do ill: now thou dost ill to say, the gallows is built stronger than the church; argal, the gallows may do well to thee. To't again; come.

2 CLOWN "Who builds stronger than a mason, a shipwright, or a carpenter?" 52

1 CLOWN Ay, tell me that, and unyoke.

2 CLOWN Marry, now I can tell.

1 CLOWN To't.

2 CLOWN Mass,[5] I cannot tell.

ENTER HAMLET AND HORATIO AT A DISTANCE.

1 CLOWN Cudgel thy brains no more about it, for your dull ass will not mend his pace with beating, and when you are asked this question next, say "a grave-maker;" the house that he makes lasts till doomsday. Go, get thee to Yaughan; fetch me a stoup[6] of liquor. 62

EXIT 2 CLOWN. 1 CLOWN DIGS, AND SINGS.

In youth, when I did love, did love,
Methought it was very sweet,
To contract, O, the time, for, ah, my behove[7]
O, methought, there was nothing meet.

HAMLET Has this fellow no feeling of his business, that he sings at grave-making?

HORATIO Custom hath made it in him a property of easiness. 70

HAMLET 'Tis e'en so: the hand of little employment hath the daintier sense.

1 CLOWN *But age with his stealing steps,*
Hath clawed me in his clutch,
And hath shipped me intil the land,
As if I had never been such.

THROWS UP A SKULL.

HAMLET That skull had a tongue in it, and could sing once: how the knave jowls[8] it to the ground as if 'twere Cain's jaw-bone, that did the first murder! This might be the pate of a politician, which this ass now o'er-reaches; one that could circumvent God, might it not? 82

HORATIO It might, my lord.

HAMLET Or of a courtier, which could say, "Good-morrow, sweet lord! How dost thou, good Lord?" This might be my lord Such-a-one, that praised my lord Such-a-one's horse, when he meant to beg it; might it not?

HORATIO Ay, my lord.

HAMLET Why, e'en so: and now my Lady Worm's; chapless,[9] and knocked about the mazzard[10] with a sexton's spade: here's fine revolution, and we had the trick to see't. Did these bones cost no more the breeding, but to play at loggats[11] with 'em? mine ache to think on't. 95

1 CLOWN [*Sings.*] *A pick-axe, and a spade, a spade,*
For and a shrouding sheet:
O, a pit of clay for to be made
For such a guest is meet.

THROWS UP A SKULL.

HAMLET There's another; why may not that be the skull of a lawyer? Where be his quiddits[12] now, his quillets,[13] his cases, his tenures,[14] and his tricks? why does he suffer this rude knave now to knock him about the sconce[15] with a dirty shovel, and will not tell him of his action of battery? Hum! This fellow might be in's time a great buyer of land, with his statutes, his recognizances, his fines, his double vouchers, his recoveries: is this the fine[16] of his fines and the recovery of his recoveries, to have his fine pate full of fine dirt? will his vouchers vouch him no more of his purchases, and double ones too, than the length and breadth of a pair of indentures? The very conveyances of his lands will hardly lie in this box; and must the inheritor himself have no more, ha? 115

HORATIO Not a jot more, my lord.

HAMLET Is not parchment made of sheep-skins?

HORATIO Ay, my lord, and of calf-skins.

HAMLET They are sheep and calves which seek out assurance in that. I will speak to this fellow.—Whose grave's this, sirrah? 121

1 CLOWN Mine, sir.—
 [*Sings*] *O, a pit of clay for to be made*
 For such a guest is meet.

HAMLET I think it be thine, indeed, for thou liest in't.

1 CLOWN You lie out on't, sir, and therefore it is not yours:
 for my part, I do not lie in't, and yet it is mine.

HAMLET Thou dost lie in't, to be in't, and say it is thine: 'tis
 for the dead, not for the quick;[17] therefore thou liest. 131

1 CLOWN 'Tis a quick lie, sir; 'twill away again, from me
 to you.

HAMLET What man dost thou dig it for?

1 CLOWN For no man, sir.

HAMLET What woman then?

1 CLOWN For none neither.

HAMLET Who is to be buried in't?

1 CLOWN One that was a woman, sir; but, rest her soul,
 she's dead. 140

HAMLET How absolute the knave is! we must speak by the
 card or equivocation will undo us. By the lord,
 Horatio, these three years I have taken note of it; the
 age is grown so picked[18] that the toe of the peasant
 comes so near the heel of the courtier, he galls his
 kibe.[19]—How long hast thou been grave-maker?

1 CLOWN Of all the days i' the year, I came to't that day
 that our last king Hamlet o'ercame Fortinbras.

HAMLET How long is that since? 150

1 CLOWN Cannot you tell that? every fool can tell that: it
 was the very day that young Hamlet was born: he that
 is mad, and sent into England.

HAMLET Ay, marry; why was he sent into England?

1 CLOWN Why, because 'a was mad: 'a shall recover his
 wits there; or, if 'a do not, 'tis no great matter there!

HAMLET Why?

1 CLOWN 'Twill not be seen in him; there the men are as
 mad as he. 160

HAMLET How came he mad?

1 CLOWN Very strangely, they say.

HAMLET How "strangely"?

1 CLOWN Faith, e'en with losing his wits.

HAMLET Upon what ground?

1 CLOWN Why, here in Denmark. I have been sexton here,
 man and boy, thirty years.

HAMLET How long will a man lie i' the earth ere he rot?

1 CLOWN Faith, if 'a be not rotten before 'a die,—as we
 have many pocky corses[20] now-a-days, that will scarce
 hold the laying in,—'a will last you some eight year or
 nine year: a tanner will last you nine year. 174

HAMLET Why he more than another?

1 CLOWN Why, sir, his hide is so tanned with his trade, that
 'a will keep out water a great while; and your water is
 a sore decayer of your whoreson dead body. Here's a
 skull now: this skull has lain in the earth three-and-
 twenty years. 180

HAMLET Whose was it?

1 CLOWN A whoreson mad fellow's it was; whose do you
 think it was?

HAMLET Nay, I know not.

1 CLOWN A pestilence on him for a mad rogue! 'a poured a
 flagon of Rhenish on my head once. This same skull,
 sir, was Yorick's skull, the king's jester.

HAMLET This?

1 CLOWN E'en that. 190

HAMLET Let me see. Alas, poor Yorick!—I knew him,
 Horatio; a fellow of infinite jest, of most excellent
 fancy: he hath borne me on his back a thousand times;
 and now how abhorred in my imagination it is! my

gorge rises at it. Here hung those lips that I have
kissed I know not how oft. Where be your gibes now?
your gambols? your songs? your flashes of merriment,
that were wont to set the table on a roar? Not one now,
to mock your own grinning? quite chapfallen? Now
get you to my lady's chamber, and tell her, let her
paint an inch thick, to this favour she must come; make
her laugh at that.—Prithee, Horatio, tell me one thing. 204

HORATIO What's that, my lord?

HAMLET Dost thou think Alexander looked o' this fashion
 i' the earth?

HORATIO E'en so.

HAMLET And smelt so? puh!
 Throws down the skull.

HORATIO E'en so, my lord. 210

HAMLET To what base uses we may return, Horatio!
 Why may not imagination trace the noble dust of
 Alexander, till he find it stopping a bung-hole?

HORATIO 'Twere to consider too curiously, to consider so.

HAMLET No, faith, not a jot; but to follow him thither with
 modesty enough and likelihood to lead it; as thus;
 Alexander died, Alexander was buried, Alexander
 returneth to dust; the dust is earth; of earth we make
 loam: and why of that loam, whereto he was
 converted, might they not stop a beer-barrel? 222
 Imperious Caesar, dead, and turned to clay,
 Might stop a hole to keep the wind away:
 O that that earth, which kept the world in awe,
 Should patch a wall to expel the winter's flaw.[21]
 But soft! but soft! aside! here comes the king.

ENTER PRIESTS, ETC. IN PROCESSION;
THE CORPSE OF OPHELIA, LAERTES, AND
MOURNERS FOLLOWING IT; KING, QUEEN, THEIR TRAINS, ETC.

 The queen, the courtiers: who is this they follow?
 And with such maimed rites? This doth betoken
 The corse they follow did with desperate hand
 Fordo it own life; 'twas of some estate.[22]
 Couch[23] we a while, and mark. 232

RETIRING WITH HORATIO.

LAERTES What ceremony else?

HAMLET This is Laertes, a very noble youth: mark.

LAERTES What ceremony else?

1 PRIEST Her obsequies have been as far enlarged
 As we have warrantise: her death was doubtful;
 And, but that great command o'ersways the order,
 She should in ground unsanctified have lodged
 Till the last trumpet; for charitable prayers,
 Shards,[24] flints, and pebbles should be thrown on her, 242
 Yet here she is allowed her virgin crants,[25]
 Her maiden strewments, and the bringing home
 Of bell and burial.

LAERTES Must there no more be done?

1 PRIEST No more be done;
 We should profane the service of the dead,
 To sing a *requiem* and such rest to her,
 As to peace-parted souls.

LAERTES Lay her i' the earth;—
 And from her fair and unpolluted flesh
 May violets spring! I tell thee, churlish priest, 250
 A ministering angel shall my sister be,
 When thou liest howling.

HAMLET What, the fair Ophelia?

QUEEN Sweets to the sweet: farewell!

SCATTERING FLOWERS.

I hoped thou shouldst have been my Hamlet's wife.
I thought thy bride-bed to have decked, sweet maid,
And not t' have strewed thy grave.
LAERTES O, treble woe
Fall ten times treble on that cursed head,
Whose wicked deed thy most ingenious sense
Deprived thee of!—Hold off the earth a while,
Till I have caught her once more in mine arms.

LEAPS INTO THE GRAVE.

Now pile your dust upon the quick and dead,
Till of this flat a mountain you have made
To o'er-top old Pelion[26] or the skyish head
Of blue Olympus. 264
HAMLET [*Advancing*] What is he whose grief
Bears such an emphasis? whose phrase of sorrow
Conjures the wandering stars, and makes them stand
Like wonder-wounded hearers? This is I,
Hamlet the Dane!

LEAPS INTO THE GRAVE.

LAERTES The devil take thy soul! 270

GRAPPLING WITH HIM.

HAMLET Thou pray'st not well.
I prithee, take thy fingers from my throat;
For, though I am not splenetive[27] and rash,
Yet have I something in me dangerous,
Which let thy wisdom fear. Hold off thy hand.
KING Pluck them asunder.
QUEEN Hamlet, Hamlet!
ALL Gentlemen,—
HORATIO Good my lord, be quiet.

THE ATTENDANTS PART THEM, AND
THEY COME OUT OF THE GRAVE.

HAMLET Why, I will fight with him upon this theme, 280
Until my eyelids will no longer wag.
QUEEN O my son, what theme?
HAMLET I loved Ophelia; forty thousand brothers
Could not, with all their quantity of love,
Make up my sum.—What wilt thou do for her?
KING O, he is mad, Laertes.
QUEEN For love of God, forbear him.
HAMLET 'Swounds show me what thou'lt do:
Woo't weep? woo't fight? woo't fast? woo't tear thyself?
Woo't drink up eisil?[28] eat a crocodile? 290
I'll do't. Dost thou come here to whine?
To outface me with leaping in her grave?
Be buried quick with her, and so will I.
And, if thou prate of mountains, let them throw
Millions of acres on us, till our ground,
Singeing his pate against the burning zone,
Make Ossa like a wart! Nay, an thou'lt mouth,
I'll rant as well as thou.
QUEEN This is mere madness:
And thus a while the fit will work on him;
Anon, as patient as the female dove, 300
When that her golden couplets are disclosed,
His silence will sit drooping.
HAMLET Hear you, sir;
What is the reason that you use me thus?
I loved you ever.—But it is no matter;
Let Hercules himself do what he may,
The cat will mew, and dog will have his day.

EXIT.

KING I pray thee, good Horatio, wait upon him.—

EXIT HORATIO.

[*To* LAERTES] Strengthen your patience in our last night's
speech;
We'll put the matter to the present push.—
Good Gertrude, set some watch over your son.— 310
This grave shall have a living monument:
An hour of quiet shortly shall we see;
Till then, in patience our proceeding be.

EXEUNT.

Notes

[1] coroner
[2] offending herself (parody of *se defendendo,* a legal term meaning "in self-defense")
[3] parody of Latin *ergo,* "therefore"
[4] inquest
[5] by the mass
[6] tankard
[7] advantage
[8] hurls
[9] lacking the lower jaw
[10] head
[11] a game in which small pieces of wood were thrown at an object
[12] subtle distinctions
[13] time arguments
[14] legal means of holding land
[15] head
[16] end
[17] living
[18] refined
[19] sore on the back of the heel
[20] pock-marked corpses
[21] gust
[22] high rank
[23] hide
[24] broken pieces of pottery
[25] garlands
[26] one of two mountains (the other is Ossa, 1. 297) which, according to Greek mythology, the giants piled on top of one another in order to reach heaven and fight the gods
[27] fiery
[28] vinegar

Scene II. *A hall in the castle.*

ENTER HAMLET AND HORATIO.

HAMLET So much for this, sir: now shall you see the other;
You do remember all the circumstance?
HORATIO Remember it, my lord!
HAMLET Sir, in my heart there was a kind of fighting,
That would not let me sleep: methought I lay
Worse than the mutines in the bilboes.[1]
Rashly,—
And praised be rashness for it, let us know,
Our indiscretion sometimes serves us well
When our deep plots do pall; and that should learn us
There's divinity that shapes our ends, 10
Rough-hew them how we will.
HORATIO That is most certain.
HAMLET —Up from my cabin,
My sea-gown scarfed about me, in the dark
Groped I to find out them: had my desire,
Fingered their packet, and in fine withdrew
To mine own room again; making so bold,

My fears forgetting manners, to unfold
Their grand commission; where I found, Horatio,—
O royal knavery! an exact command,
Larded[2] with many several sorts of reasons, 20
Importing Denmark's health and England's too,
With, ho! such bugs and goblins in my life,
That, on the supervise, no leisure bated,
No, not to stay the grinding of the axe,
My head should be strook off.
HORATIO Is't possible?
HAMLET Here's the commission; read it at more leisure.
 But wilt thou hear me how I did proceed?
HORATIO I beseech you.
HAMLET Being thus benetted round with villanies,—
 Ere I could make a prologue to my brains, 30
 They had begun the play, I sat me down;
 Devised a new commission; wrote it fair:
 I once did hold it, as our statists[3] do,
 A baseness to write fair, and laboured much
 How to forget that learning; but, sir, now
 It did me yeoman's service. Wilt thou know
 The effect of what I wrote?
HORATIO Ay, good my lord.
HAMLET An earnest conjuration from the king,
 As England was his faithful tributary;
 As love between them like the palm might flourish, 40
 As peace should still her wheaten garland wear
 And stand a comma[4] 'tween their amities,
 And many such like "Ases" of great charge
 That on the view and knowing of these contents,
 Without debatement further, more, or less,
 He should the bearers put to sudden death,
 Not shriving[5]-time allowed.
HORATIO How was this sealed?
HAMLET Why, even in that was heaven ordinant;
 I had my father's signet in my purse,
 Which was the model of that Danish seal: 50
 Folded the writ up in form of the other;
 Subscribed it; gave't the impression; placed it safely,
 The changeling never known. Now, the next day
 Was our sea-fight: and what to this was sequent
 Thou know'st already.
HORATIO So Guildenstern and Rosencrantz go to't.
HAMLET Why, man, they did make love to this
 employment;
 They are not near my conscience; their defeat
 Does by their own insinuation grow:
 'Tis dangerous when the baser nature comes 60
 Between the pass and fell incensed points
 Of mighty opposites.
HORATIO Why, what a king is this!
HAMLET Does it not, think'st thee, stand me now upon—
 he that hath killed my king, and whored my mother;
 Popped in between the election and my hopes;
 Thrown out his angle[6] for my proper life,
 And with such cozenage[7]—isn't not perfect conscience
 To quit him with this arm? and is't not to be damned,
 To let this canker of our nature come
 In further evil? 70
HORATIO It must be shortly known to him from England
 What is the issue of the business there.
HAMLET It will be short: the interim is mine;
 And a man's life no more than to say "One."
 But I am very sorry, good Horatio,
 That to Laertes I forgot myself;
 For by the image of my cause, I see
 The portraiture of his: I'll court his favours:

 But, sure, the bravery of his grief did put me
 Into a towering passion.
HORATIO Peace! who comes here?

ENTER OSRIC.

OSRIC Your lordship is right welcome back to Denmark. 82
HAMLET I humbly thank you, sir.—Dost know this
 water-fly?
HORATIO No, my good lord.
HAMLET Thy state is the more gracious: for 'tis a vice to
 know him. He hath much land, and fertile; let a beast
 be lord of beasts, and his crib shall stand at the king's
 mess:[8] 'tis a chough,[9] but, as I say, spacious in the
 possession of dirt. 90
OSRIC Sweet lord, if your lordship were at leisure, I should
 impart a thing to you from his majesty.
HAMLET I will receive it with all diligence of spirit. Put
 your bonnet to his right use; 'tis for the head.
OSRIC I thank your lordship, it is very hot.
HAMLET No, believe me, 'tis very cold; the wind is
 northerly.
OSRIC It is indifferent cold, my lord, indeed.
HAMLET But yet methinks it is very sultry and hot for my
 complexion. 100
OSRIC Exceedingly, my lord; it is very sultry,—as 'twere,—I
 cannot tell how. But, my lord, his majesty bade me
 signify to you, that 'a has laid a great wager on your
 head. Sir, this is the matter.
HAMLET I beseech you, remember—

HAMLET MOVES HIM TO PUT ON HIS HAT.

OSRIC Nay, in good faith; for mine ease, in good faith. Sir,
 here is newly come to court Laertes: believe me, an
 absolute gentleman, full of most excellent differences,
 of very soft society, and great showing: indeed, to
 speak feelingly of him, he is the card or calendar of
 gentry, for you shall find in him the continent of what
 part a gentleman would see. 113
HAMLET Sir, his definement suffers no perdition in you;
 though, I know, to divide him inventorially would
 dizzy the arithmetic of memory, and yet but yaw
 neither, in respect of his quick sail. But, in the verity of
 extolment, I take him to be a soul of great article, and
 his infusion of such dearth and rareness, as, to make
 true diction of him, his semblable is his mirror, and,
 who else would trace him, his umbrage,[10] noth-
 ing more. 122
OSRIC Your lordship speaks most infallibly of him.
HAMLET The concernancy,[11] sir? why do we wrap the gen-
 tleman in our more rawer breath?
OSRIC Sir?
HORATIO Is't not possible to understand in another
 tongue? You will do't, sir, really.
HAMLET What imports the nomination of this gentleman? 130
OSRIC Of Laertes?
HORATIO His purse is empty already; all's golden words
 are spent.
HAMLET Of him, sir.
OSRIC I know you are not ignorant—
HAMLET I would you did, sir; yet, in faith, if you did, it
 would not much approve me. Well, sir.
OSRIC You are not ignorant of what excellence Laertes is. 139
HAMLET I dare not confess that, lest I should compare with
 him in excellence; but, to know a man well, were to
 know himself.
OSRIC I mean, sir, for his weapon; but in the imputation
 laid on him by them, in his meed[12] he's unfellowed.

HAMLET What's his weapon?

OSRIC Rapier and dagger.

HAMLET That's two of his weapons: but, well.

OSRIC The king, sir, hath wagered with him six Barbary horses: against the which he has imponed, as I take it, six French rapiers and poniards, with their assigns, as girdle, hangers,[13] and so: three of the carriages, in faith, are very dear to fancy, very responsive to the hilts, most delicate carriages, and of very liberal conceit. 155

HAMLET What call you the carriages?

HORATIO I knew you must be edified by the margent, ere you had done.

OSRIC The carriages, sir, are the hangers.

HAMLET The phrase would be more germane to the matter if we could carry cannon by our sides: I would it might be hangers till then.

But, on: six Barbary horses against six French swords, their assigns, and three liberal-conceited carriages; that's the French bet against the Danish. Why is this "imponed," as you call it? 166

OSRIC The king, sir, hath laid, sir, that in a dozen passes between yourself and him, he shall not exceed you three hits; he hath laid on twelve for nine; and it would come to immediate trial, if your lordship would vouchsafe the answer.

HAMLET How, if I answer "no"?

OSRIC I mean, my lord, the opposition of your person in trial.

HAMLET Sir, I will walk here in the hall; if it please his majesty, 'tis the breathing time of day with me: let the foils be brought; the gentleman willing, and the king hold his purpose, I will win for him if I can; if not, I will gain nothing but my shame and the odd hits. 180

OSRIC Shall I re-deliver you e'en so?

HAMLET To this effect, sir, after what flourish your nature will.

OSRIC I commend my duty to your lordship.

EXIT.

HAMLET Yours, yours. He does well to commend it himself; there are no tongues else for's turn.

HORATIO This lapwing runs away with the shell on his head.

HAMLET He did comply with his dug, before he sucked it. Thus has he, and many more of the same bevy that I know the drossy age dotes on, only got the tune of the time and outward habit of encounter; a kind of yesty[14] collection, which carries them through and through the most fond and winnowed opinions; and do but blow them to their trial, the bubbles are out. 196

ENTER A LORD.

LORD My lord, his majesty commended him to you by young Osric, who brings back to him, that you attend him in the hall: he sends to know if your pleasure hold to play with Laertes, or that you will take longer time. 201

HAMLET I am constant to my purposes; they follow the king's pleasure; if his fitness speaks, mine is ready: now or whensoever, provided I be so able as now.

LORD The king, and queen, and all are coming down.

HAMLET In happy time.

LORD The queen desires you to use some gentle entertainment to Laertes, before you fall to play.

HAMLET She well instructs me.

EXIT LORD.

HORATIO You will lose this wager, my lord. 212

HAMLET I do not think so; since he went into France, I have been in continual practice; I shall win at the odds. But thou wouldst not think, how ill all's here about my heart: but it is no matter.

HORATIO Nay, good my lord,—

HAMLET It is but foolery; but it is such a kind of gain-giving[15] as would perhaps trouble a woman.

HORATIO If your mind dislike anything, obey it. I will forestal their repair hither, and say you are not fit. 222

HAMLET Not a whit; we defy augury; there's a special providence in the fall of a sparrow. If it be now, 'tis not to come; if it be not to come, it will be now; if it be not now, yet it will come: the readiness is all. Since no man of aught he leaves, knows, what is't to leave betimes? Let be.

ENTER KING, QUEEN, LAERTES, AND LORDS, OSRIC,
AND OTHER ATTENDANTS WITH FOILS AND GAUNTLETS:
A TABLE AND FLAGONS OF WINE ON IT.

KING Come, Hamlet, come, and take this hand from me. 230

THE KING PUTS THE HAND OF LAERTES INTO THAT OF HAMLET.

HAMLET Give me your pardon, sir: I have done you wrong;
But pardon't, as you are a gentleman.
—This presence[16] knows,
And you must needs have heard, how I am punished
With a sore distraction. What I have done,
That might your nature, honour, and exception
Roughly awake, I here proclaim was madness.
Was't Hamlet wronged Laertes? Never, Hamlet:
If Hamlet from himself be ta'en away,
And, when he's not himself, does wrong Laertes, 240
Then Hamlet does it not; Hamlet denies it.
Who does it then? His madness: if't be so,
Hamlet is of the faction that is wronged;
His madness is poor Hamlet's enemy.
—Sir, in this audience,
Let my disclaiming from a purposed evil
Free me so far in your most generous thoughts,
That I have shot mine arrow o'er the house,
And hurt my brother.

LAERTES I am satisfied in nature,
Whose motive, in this case, should stir me most
To my revenge; but in my terms of honour,
I stand aloof, and will no reconcilement, 252
Till by some elder masters of known honour
I have a voice and precedent of peace,
To keep my name ungored. But till that time
I do receive your offered love like love,
And will not wrong it.

HAMLET I embrace it freely,
And will this brother's wager frankly play.—
Give us the foils. Come on.

LAERTES Come, one for me.

HAMLET I'll be your foil, Laertes; in mine ignorance 260
Your skill shall, like a star i' the darkest night,
Stick fiery off indeed.

LAERTES You mock me, sir.

HAMLET No, by this hand.

KING Give them the foils, young Osric.—Cousin Hamlet,
You know the wager?

HAMLET Very well, my lord;
Your grace hath laid the odds o' the weaker side.

KING I do not fear it: I have seen you both.
But since he is bettered, we have therefore odds.

LAERTES This is too heavy, let me see another.
HAMLET This likes me well. These foils have all a length? 270
OSRIC Ay, my good lord.

THEY PREPARE TO PLAY.

KING Set me the stoups of wine upon that table.—
If Hamlet give the first or second hit,
Or quit[17] in answer of the third exchange,
Let all the battlements their ordnance fire;
The king shall drink to Hamlet's better breath;
And in the cup an union[18] shall he throw,
Richer than that which four successive kings
In Denmark's crown have worn. Give me the cups;
And let the kettle[19] to the trumpet speak, 280
The trumpet to the cannoneer without,
The cannons to the heavens, the heaven to earth,
"Now the king drinks to Hamlet."—Come, begin;—
And you, the judges, bear a wary eye.
HAMLET Come on, sir.
LAERTES Come, my lord.

THEY PLAY.

HAMLET One.
LAERTES No.
HAMLET Judgment.
OSRIC A hit, a very palpable hit.
LAERTES Well; again.
KING Stay, give me drink: Hamlet, this pearl is thine;
Here's to thy health. Give him the cup.

TRUMPETS SOUND; AND CANNON SHOT OFF WITHIN.

HAMLET I'll play this bout first, set it by awhile.—
Come.—[*They play*] Another hit. What say you?
LAERTES A touch, a touch, I do confess. 291
KING Our son shall win.
QUEEN He's fat, and scant of breath.—
Here, Hamlet, take my napkin, rub thy brows:
The queen carouses to thy fortune, Hamlet.
HAMLET Good, madam.
KING Gertrude, do not drink.
QUEEN I will, my lord; I pray you, pardon me.
KING [*Aside*] It is the poisoned cup! it is too late!
HAMLET I dare not drink yet, madam; by and by.
QUEEN Come, let me wipe thy face. 299
LAERTES My lord, I'll hit him now.
KING I do not think't.
LAERTES [*Aside*] And yet 'tis almost against my conscience.
HAMLET Come, for the third, Laertes: you but dally;
I pray you, pass with your best violence;
I am afeard you make a wanton of me.
LAERTES Say you so? come on.

THEY PLAY.

OSRIC Nothing neither way.
LAERTES Have at you now!

LAERTES WOUNDS HAMLET; THEN, IN SCUFFLING,
THEY CHANGE RAPIERS, AND HAMLET WOUNDS LAERTES.

KING Part them, they are incensed.
HAMLET Nay, come again.

THE QUEEN FALLS.

OSRIC Look to the queen there, ho!
HORATIO They bleed on both sides,—How is it, my lord? 311
OSRIC How is't, Laertes?

LAERTES Why, as a woodcock to mine own springe,[20]
Osric;
I am justly killed with mine own treachery.
HAMLET How does the queen?
KING She swounds[21] to see them bleed.
QUEEN No, no, the drink, the drink,—O my dear Ham-
let,—
The drink, the drink;—I am poisoned!

DIES.

HAMLET O villainy! Ho! Let the door be locked:
Treachery! seek it out.

LAERTES FALLS.

LAERTES It is here, Hamlet, Hamlet, thou art slain;
No medicine in the world can do thee good,
In thee there is not half an hour of life;
The treacherous instrument is in thy hand, 322
Unbated and envenomed: the foul practice
Hath turned itself on me; lo, here I lie,
Never to rise again; thy mother's poisoned;
I can no more, the king—the king's to blame.
HAMLET The point envenomed too! then, venom, to
thy work.

STABS THE KING.

ALL Treason! treason!
KING O, yet defend me, friends; I am but hurt.
HAMLET Here, thou incestuous, murderous, damned Dane, 331
Drink off this potion. Is thy union here?
Follow my mother!

KING DIES.

LAERTES He is justly served;
It is a poison tempered by himself.—
Exchange forgiveness with me, noble Hamlet:
Mine and my father's death come not upon thee,
Nor thine on me!

DIES.

HAMLET Heaven make thee free of it! I follow thee.— 338
I am dead, Horatio.—Wretched queen, adieu!—
You that look pale and tremble at this chance,
That are but mutes[22] or audience to this act,
Had I but time, as this fell sergeant, death,
Is strict in his arrest, O, I could tell you—
But let it be.—Horatio, I am dead;
Thou livest; report me and my cause aright
To the unsatisfied.
HORATIO Never believe it;
I am more an antique Roman[23] than a Dane;
Here's yet some liquor left.
HAMLET As thou'rt a man,
Give me the cup; let go; by heaven I'll have't.
O, good Horatio, what a wounded name,
Things standing thus unknown, shall live behind me! 351
If thou didst ever hold me in thy heart,
Absent thee from felicity a while,
And in this harsh world draw thy breath in pain,
To tell my story.—

MARCH AFAR OFF, AND SHOT WITHIN.

What warlike noise is this?
OSRIC Young Fortinbras, with conquest come from Poland,
To the ambassadors of England gives
This warlike volley.

HAMLET O, I die, Horatio;
 The potent poison quite o'er-crows my spirit;
 I cannot live to hear the news from England.
 But I do prophesy the election lights
 On Fortinbras; he has my dying voice;
 So tell him, with the occurrents,[24] more and less,
 Which have solicited—the rest is silence.

<div align="center">DIES.</div>

HORATIO Now cracks a noble heart.—Good night, sweet
 prince,
 And flights of angels sing thee to thy rest!
 Why does the drum come hither?

<div align="center">MARCH WITHIN.</div>

<div align="center">ENTER FORTINBRAS, THE ENGLISH AMBASSADORS,
WITH DRUM, COLOURS, AND ATTENDANTS.</div>

FORTINBRAS Where is this sight?
HORATIO What is it ye would see?
 If aught of woe or wonder, cease your search.
FORTINBRAS This quarry[25] cries on havoc.—O proud
 death!
 What feast is toward in thine eternal cell,
 That thou so many princes, at a shot,
 So bloodily hast strook?
1 AMBASSADOR The sight is dismal;
 And our affairs from England come too late:
 The ears are senseless that should give us hearing,
 To tell him his commandment is fulfilled,
 That Rosencrantz and Guildenstern are dead.
 Where should we have our thanks?
HORATIO Not from his mouth,
 Had it the ability of life to thank you;
 He never gave commandment for their death.
 But since, so jump[26] upon this bloody question,
 You from the Polack wars, and you from England
 Are here arrived, give order that these bodies
 High on a stage be placed to the view;
 And let me speak to the yet unknowing world,
 How these things came about: so shall you hear
 Of carnal, bloody, and unnatural acts,
 Of accidental judgments, casual slaughters,
 Of deaths put on by cunning, and forced cause;
 And, in this upshot, purposes mistook
 Fallen on the inventors' heads. All this can I
 Truly deliver.
FORTINBRAS Let us haste to hear it,
 And call the noblest to the audience.

361

370

379

390

 For me, with sorrow I embrace my fortune;
 I have some rights of memory in this kingdom,
 Which now to claim my vantage doth invite me.
HORATIO Of that I shall have always cause to speak,
 And from his mouth whose voice will draw on more:
 But let this same be presently performed,
 E'en while men's minds are wild; lest more mischance,
 On plots and errors, happen.
FORTINBRAS Let four captains
 Bear Hamlet, like a soldier, to the stage;
 For he was likely, had he been put on,
 To have proved most royally: and, for his passage,
 The soldiers' music and the rites of war
 Speak loudly for him.—
 Take up the bodies.—Such a sight as this
 Becomes the field, but here shows much amiss.
 Go, bid the soldiers shoot.

400

<div align="center">A DEAD MARCH.</div>

<div align="center">EXEUNT, BEARING OFF THE BODIES; AFTER WHICH
A PEAL OF ORDNANCE IS SHOT OFF.</div>

Notes

[1] mutineers in fetters
[2] enriched
[3] statesmen
[4] link
[5] absolution
[6] fishing line
[7] trickery
[8] table
[9] jackdaw, chatterer
[10] shadow
[11] meaning
[12] merit
[13] straps hanging the sword to the belt
[14] frothy
[15] misgiving
[16] royal assembly
[17] hit back
[18] pearl
[19] kettledrum
[20] snare
[21] swoons
[22] performers who have no lines to speak
[23] reference to the old Roman fashion of suicide
[24] occurrences
[25] heap of slain bodies
[26] precisely

CHAPTER 15

	GENERAL EVENTS	LITERATURE & PHILOSOPHY	ART
1560			
DECLINE OF SPANISH POWER	**1603–1625** Reign of James I in England **1609** Holland and Flanders given virtual independence in truce with Spain **1610–1643** Reign of Louis XIII in France; Marie de' Medici is regent during his minority	**1565** Teresa of Avila, *Autobiography* **1582–1584** John of the Cross, *The Dark Night* **1605–1615** Cervantes, *Don Quixote* **1611** Publication of *Authorized Version* of Bible, commissioned by King James I	**1595–1600** El Greco, *The Baptism of Christ* **1597–1604** Caravaggio and the Carracci at work in Rome **c. 1600–1602** Caravaggio, *The Doubting of Thomas, The Calling of Saint Matthew, The Martyrdom of Saint Matthew* **1604** A. Carracci, *The Flight into Egypt*; decorations for Palazzo Farnese Galleria completed **1616** Hals, *Banquet of the Officers of the Saint George Militia Company* **c. 1618** Rubens, *The Rape of the Daughters of Leucippus*
1618			
THIRTY YEARS' WAR	**1618** Thirty Years' War begins in Germany **1620** English Pilgrims land at Plymouth **1621–1665** Reign of Philip IV in Spain **1643** Five-year-old Louis XIV ascends throne of France under regency of his mother **1648** Peace of Westphalia	**1621** Donne appointed Dean of Saint Paul's, London **1632** Galileo, founder of modern physics, submits *Dialogue Concerning the Two Chief World Systems* to Pope Urban VIII; is tried and condemned in 1633 **1637** Descartes, "Father of Modern Philosophy," publishes *Discourse on Method* **1638** Galileo, *Dialogues Concerning Two New Sciences* **c. 1640** French Classical comedy and tragedy at height **1640–1643** Corneille, *Horace, Polyeucte*, tragedies **1641** Descartes, *Meditations* **1646** Crashaw, *Steps to the Temple*	**c. 1620** Artemisia Gentileschi, *Judith and Holofernes* **1622–1625** Rubens paints cycle of 24 paintings glorifying Marie de' Medici; Bernini, *The Rape of Proserpine* **1623** Bernini, *David;* Velázquez appointed court painter to Philip IV **c. 1625** Van Dyck, *Portrait of the Marchesa Cataneo* **1627** Caravaggio's influence spreads northward when Louis XIII summons Vouet back from Rome to become court artist **c. 1630** A. Gentileschi, *Self-Portrait as "La Pittura"* **1631** Claude Le Lorrain, *Mill on a River* **1632** Van Dyck court painter to Charles I **c. 1639** Ribera, *The Martyrdom of Saint Bartholomew* **1642** Rembrandt, *The Night Watch* **1645–1652** Bernini, *Saint Teresa in Ecstasy*
1649			
PURITAN RULE	**1649** Execution of Charles I of England; Cromwell rules 1649–1658	**c. 1650** Locke active in England, Pascal in France, Spinoza in Holland **1651** Hobbes, *Leviathan* **c. 1659–1699** Poet and dramatist John Dryden active in England	**c. 1650** Poussin, *The Arcadian Shepherds;* Georges de La Tour, *Saint Sebastian Attended by Saint Irene* **1656** Velázquez, *Las Meninas*
1660			
AGE OF LOUIS XIV AND XV	**1660** Restoration of monarchy in England under Charles II **1661** Louis XIV assumes full control of France **1682** Louis XIV moves court to newly remodeled Versailles **1688** Parliamentary enemies of James II invite William of Orange to invade England **1689** Declaration of Rights establishes English constitutional government; William and Mary rule **1715** Louis XIV dies after 72-year reign; Louis XV ascends throne	**1664** Molière, *Tartuffe,* comedy **1667** Milton, *Paradise Lost,* epic poem in tradition of Homer and Vergil **1677** Racine, *Phèdre,* tragedy **1690** Locke, *Concerning Human Understanding* **1694** Voltaire born in Paris	**1662–1664** Vermeer, *Woman Reading a Letter* **1669** Death of Rembrandt; last *Self-Portrait* **1701** Rigaud, *Louis XIV*
1774			

Most dates are approximate

THE BAROQUE WORLD

ARCHITECTURE	MUSIC

late 16th cent. Birth of opera in Florence, development of *monody*

1594–1595 Peri, *Dafne,* first play set to music, performed in Florence

1600 Peri, *Euridice*

Opera, concerto grosso, oratorio, cantata, and sonata established as musical forms; virtuoso tradition begins

1607 Monteverdi, *L'Orfeo*

1619 Schütz, *Psalms of David*

Retention of classical vocabulary of Renaissance but on grandiose scale; civic planning and private-house construction also prevalent because of rise of middle classes

1629 Bernini appointed official architect of Saint Peter's, Rome

1631–1687 Longhena, Santa Maria della Salute, Venice

1634 Frescobaldi active at Rome

1638–1641 Borromini, Church of San Carlo alle Quattro Fontane, Rome; façade added 1665–1667

1652 Lully enters service of Louis XIV

1663 Bernini, piazza and colonnades for Saint Peter's, Rome; church proper completed by Carlo Maderno 1607–1615

1669–1685 Le Vau and Hardouin-Mansart, Garden façade Versailles

1678 Le Brun and Hardouin-Mansart begin Hall of Mirrors, Palace of Versailles

1668 Buxtehude becomes organist at Lübeck

1674 Lully's *Alceste* first performed at Versailles

1685 Births of Bach, Handel, Scarlatti

c. 1720 Vivaldi, *The Four Seasons,* violin concertos

1721 J. S. Bach, *Brandenburg Concertos*

1723 Bach appointed Kantor of St. Thomas', Leipzig

1729 J. S. Bach, *St. Matthew Passion*

c. 1735 Rameau, *Les Indes Galantes*

1742 Handel's *Messiah* first performed

CHAPTER 15

THE BAROQUE WORLD

THE COUNTER-REFORMATION SPIRIT

By about 1600 the intellectual and artistic movements of the Renaissance and Reformation had taken a new turn. Although the cultural activity of the following hundred and fifty years was the natural outgrowth of earlier developments, the difference in spirit—already signaled by the middle of the sixteenth century—was striking.

The chief agent of this new spirit was the Roman Catholic Church. After its initial shock at the success of Protestantism, the Catholic Church decided that the best defense was a well-planned attack. Switching to the offensive, the church relied in great measure on new religious orders like the Jesuits to lead the movement known as the Counter-Reformation. Putting behind them the anxieties of the past, the chief representatives of the Counter-Reformation gave voice to a renewed spirit of confidence in the universality of the church and the authority of its teachings.

The official position of the church was newly stated at the Council of Trent, which met sporadically from 1545 to 1563. Under the leadership of Pope Paul III, the council redefined Catholic doctrines and reaffirmed those dogmas that Protestantism had challenged. Transubstantiation, the apostolic succession of the priesthood, the belief in purgatory, and the rule of celibacy for the clergy were all confirmed as essential to the Catholic system of faith. The pope remained as monarchical ruler of the church. At the same time, the council tried to eliminate abuses by the clergy and to tighten discipline. Bishops and priests could no longer hold more than one benefice, and theological seminaries were set up in every diocese to improve the educational level of the priesthood.

One of the key instruments in the campaign to reestablish the authority of the church was the Society of Jesus, an order of priests and brothers dedicated to the defense of the faith. The order was founded in 1534 by Ignatius Loyola (1491–1556), a Spanish nobleman. After spending the first part of his career as a soldier,

Loyola converted to the religious life after suffering a serious wound. His *Spiritual Exercises* (begun 1522–1523) express a mystical, even morbid spirit of introspection, inspired by visions of Satan, Jesus, and the Trinity. A similarly heightened spiritual sense and attempt to describe mystical experiences occurs in the writings of other Spanish Catholics of the Counter-Reformation, most notably Saint Teresa of Avila (1515–1582) and Saint John of the Cross (1542–1591); the latter wrote powerfully of the soul's emergence from the "dark night" to attain union with God.

The order that Loyola founded soon became the most militant of the various religious movements to appear during the sixteenth century. Its members, the Jesuits, fought not with swords or guns, but with eloquence and the power of persuasion. The Jesuits were organized on the model of a military company, led by a general as their chief commander, and required to exercise iron discipline. Their duty was simple: to promote the teachings of the church unquestioningly—Loyola taught that if the church ruled that black was white, its followers were obliged to believe it. They reinforced this position by their vigorous missionary work throughout Europe, the Americas, and the Far East, while improving educational institutions throughout Catholic Europe.

At the same time, the Council of Trent called on artists to remind Catholics of the power and splendor of their religion by commissioning a massive quantity of works of art dedicated to underlining the chief principles of Counter-Reformation teachings. Now it was the task of religious leaders and, under their guidance, of the artists to make this position known to the faithful. New emphasis was placed on clarity and directness. The impression of the church's triumphant resurgence was further reinforced by a new emphasis on material splendor and glory. In Rome, the construction of lavish churches was crowned by the completion at last of Saint Peter's and the addition of Bernini's spectacular **piazza** ("square") in front of it [**FIG. 15.1**], while throughout Catholic Europe there developed a rich and ornate art that could do justice to the new demands for expressive power and spectacle.

▪ **15.1** Aerial view of Saint Peter's, Rome. Height of façade 147′ (44.81 m), width 374′ (114 m). The nave and façade were finished by Carlo Maderna (1556–1629) between 1606 and 1612, and the colonnades around the square were built between 1656 and 1663 to Bernini's design. The completion of Saint Peter's was one of the first great achievements of baroque architecture.

The term used to describe the new style, at first in derision but since the nineteenth century simply as a convenient label, is *baroque*. The word's origins are obscure. It may be related to the Portuguese *barroco* ("an irregularly shaped pearl") or perhaps to *baroco* (an Italian term used to describe a complicated problem in medieval logic). In any case, baroque came to be applied in general to anything elaborate and fanciful, in particular to the artistic style of the seventeenth and early eighteenth centuries.

Although strictly speaking *baroque* is a term applied only to the visual arts, it is frequently used to describe the entire cultural achievement of the age. To extend its use to literature, music, and even intellectual developments of the same period inevitably implies that all the arts of the Baroque period had certain characteristics in common. In fact, a close comparison between the visual arts, music, and literature of the seventeenth and early eighteenth centuries does reveal some shared ideas and attitudes. It is important to remember from the outset, however, that this artistic unity is by no means obvious. A first glance at the cultural range of the period actually reveals an astonishing variety of styles, developing individually in widely separated places and subject to very different political and social pressures.

In this respect the Baroque period marks a significant break with the Renaissance, when Italy had been the center of virtually all artistic development. Despite the impact of the Counter-Reformation, the Reformation had begun an irreversible process of decentralization. By the beginning of the seventeenth century, although Rome was still the artistic capital of Europe, important cultural changes were taking place elsewhere. The economic growth of countries like Holland and England, and the increasing power of France, produced a series of artistic styles that developed locally rather than being imported wholesale from south of the Alps. Throughout Northern Europe the rise of the middle class continued to create a new public for the arts, which in turn affected the development of painting, architecture, and music. For the first time European culture began to spread across the Atlantic, carried to the Americas by Counter-Reformation missionaries.

The much greater geographic spread of artistic achievement was accompanied by the creation of new artistic forms in response to new religious and social pressures. In music, for instance, the seventeenth century saw the birth of **opera** and of new kinds of instrumental music, including works for orchestra like the **concerto grosso.** Painters continued to depict scenes from the Bible and from Classical mythology,

but they turned increasingly to other subjects including portraits, landscapes, and scenes from everyday life. Architects constructed private townhouses and started to take an interest in civic planning instead of devoting themselves exclusively to churches and palaces.

A similar richness and variety can be found in the philosophical and scientific thought of the period, which managed temporarily to reconcile its own pursuit of scientific truth with traditional theological and political attitudes. By the end of the seventeenth century, however, the practical discoveries of science had begun to undermine long-accepted ideas and to lay the basis for the new skepticism that came to dominate the eighteenth century.

It would be unwise to look for broad general principles operating in an age of such dynamic and varied change. Nonetheless, to understand and appreciate the Baroque spirit as it appears in the individual arts, it is helpful to bear in mind the chief assumptions and preoccupations shared by most baroque artists. Whatever the medium in which they worked, baroque artists were united in their commitment to strong emotional statements, psychological exploration, and the invention of new and daring techniques.

Perhaps the most striking of these is the expression of intense emotions. During the Renaissance, artists had generally tried to achieve the calm balance and order they thought of as typically Classical. During the Baroque period, artists were attracted by extremes of feeling—sometimes these strong emotions were personal. Painters and poets alike tried to look into their own souls and reveal by color or word the depths of their own psychic and spiritual experience. More often artists tried to convey intense religious emotions. In each case, far from avoiding painful or extremely emotional states as subjects, their works sought out and explored them.

This concern with emotion produced in its turn an interest in what came to be called *psychology*. Baroque artists attempted to explain how and why their subjects felt as strongly as they did by representing their emotional states as vividly and analytically as possible. This is particularly evident in seventeenth-century opera and drama, where music in the one case and words in the other were used to depict the precise state of mind of the characters.

The desire to express the inexpressible required the invention of new techniques. As a result, baroque art placed great emphasis on virtuosity. Sculptors and painters achieved astonishing realism in the way in which they handled their media. Stone was carved in a way such as to give the effect of thin, flowing drapery, while seventeenth-century painters found ways to reproduce complex effects of light and shade (see **TABLE 15.1**). Baroque writers often used elaborate imagery and complicated grammatical structure to express intense emotional states. In music, both composers and

TABLE 15.1 *Characteristics and Examples of Baroque Art*

CHARACTERISTIC	EXAMPLE
Emotionalism	Caravaggio, *The Martyrdom of Saint Matthew* [15.3]
	Rubens, *The Rape of the Daughters of Leucippus* [15.25]
Illusionism	Bernini, *David* [15.8]
	Rembrandt, *The Night Watch* [15.30]
Splendor	Bernini, Saint Peter's Square [15.1]
	Palace of Versailles [15.18, 15.19]
	Carracci, *The Triumph of Bacchus and Ariadne* [15.6]
Light and Shade	Caravaggio, *The Calling of Saint Matthew* [15.2]
	de La Tour, *The Lamentation over Saint Sebastian* [15.12]
	Velázquez, *Las Meninas* [15.23]
	Vermeer, *Woman Reading a Letter* [15.29]
Movement	Borromini, Façade for San Carlo alle Quattro [15.11]
	El Greco, *Burial of Count Orgaz* [15.21]
Religious Fervor	El Greco, *Martyrdom of Saint Maurice and the Theban Legion* [15.20]
	Ribera, *The Martyrdom of Saint Bartholomew* [15.22]
Domestic Intimacy	Caravaggio, *Madonna of Loreto* [15.4]
	Rubens, *Hélène Fourment and Her Children* [15.24]
	Rembrandt, *Jacob Blessing the Sons of Joseph* [15.32]

performers began to develop new virtuoso skills; composers in their ability to write works of greater and greater complexity, and performers in their ability to sing or play music in the new style. In fact some pieces, like **toccatas** (free-form rhapsodies for keyboard), were principally intended to allow instrumentalists to demonstrate their technique, thus inaugurating the tradition of the virtuoso performer that reached a climax in the nineteenth century.

THE VISUAL ARTS IN THE BAROQUE PERIOD

Painting in Rome: Caravaggio and the Carracci

The foundations of baroque style, which was to dominate much of European painting for one hundred and fifty years, were laid in Rome around 1600 by two artists whose works at first glance seem to have little in common. Michelangelo Merisi (1573–1610), better known

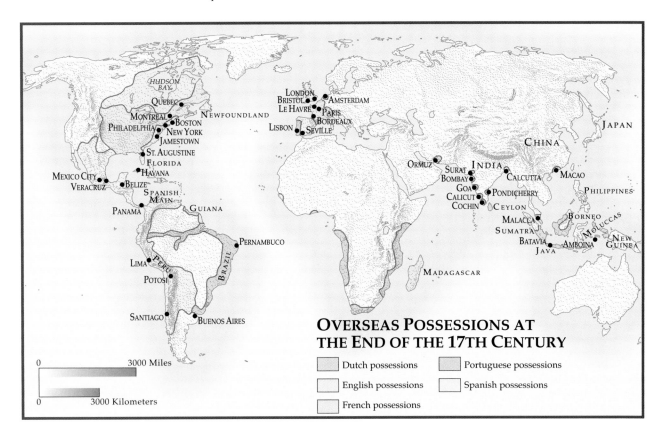

OVERSEAS POSSESSIONS AT THE END OF THE 17TH CENTURY

Dutch possessions

English possessions

French possessions

Portuguese possessions

Spanish possessions

as Caravaggio, the name of his hometown in northern Italy, explored the darker aspects of life and death in some of the most naturalistic and dramatic pictures ever painted. Annibale Carracci (1560–1609) preferred to paint light and elegant depictions of the loves of gods and goddesses and charming landscapes. That both artists exerted an immense influence on their successors says something for the extreme range of baroque painting. Of the two painters, Caravaggio was certainly the more controversial in his day. His own lifestyle did little to recommend him to the aristocratic and ecclesiastical patrons on whom he depended. From his first arrival in Rome (around 1590), Caravaggio seems to have lived an unconventional and violent life, in continual trouble with the police, and alienating potential friends by his savage temper.

Any chances Caravaggio had for establishing himself successfully in Rome were brought to an abrupt end in 1606 when he quarreled violently with an opponent in a tennis match and stabbed him to death. He avoided punishment only by fleeing to Naples and then to Malta, where he was thrown into prison for attacking a police officer. Escaping, he made his way to Sicily and then back to Naples, where he yet again got involved in a violent quarrel, this time in a sleazy inn. Seriously wounded, he heard of the possibility of a pardon if he were to return to Rome, but on the journey back he died of a fever (brought on, it was said, by a final attack

of rage at some sailors he mistakenly thought had robbed him). The pardon from the pope arrived a few days later. The spirit of rebellion that governed Caravaggio's life can be seen in his art. In his depiction of religious scenes he refused to accept either the traditional idealizing versions of earlier artists or the Counter-Reformation demands for magnificent display. Furthermore, instead of placing his figures in an elaborate setting in accordance with Counter-Reformation principles, Caravaggio surrounded them with shadows, a device that emphasizes the drama of the scene and the poverty of the participants.

Caravaggio's preference for **chiaroscuro** (extreme contrasts between light and dark) was one of the aspects of his style most imitated by later painters. When not handled by a master, the use of heavy shadows surrounding brightly lit figures in the foreground tends to become artificial and overtheatrical, but in Caravaggio's work it always serves a true dramatic purpose. In his painting *The Calling of Saint Matthew* [**FIG. 15.2**], one of three pictures painted between 1597 and 1603 for the Contarelli Chapel in the Church of San Luigi dei Francesi at Rome—Caravaggio's first important Roman commission—the stern hand of Jesus summoning the future apostle is emphasized by the beam of light that reveals the card players at the table; Matthew, awed and fearful, tries to shrink back into the darkness.

▪ **15.2** Caravaggio. *The Calling of Saint Matthew*, c. 1597–1601. Oil on canvas, 11'1" × 11'5" (3.38 × 1.48 m). Contarelli Chapel, San Luigi dei Francesi, Rome. The artist produces a highly dramatic effect by having the bright light emanating from the half-hidden figure of Jesus (to the right) strike the head of Matthew. The future saint draws back from the glare in fear.

In his painting of *The Martyrdom of Saint Matthew* [**FIG. 15.3**], Caravaggio used his own experience of suffering to portray the scene with painful realism; the painting tells us as much about the reactions of the onlookers as about Matthew. They range from the sadistic violence of the executioner to the apparent indifference of the figures in shadow on the left; only the angel swooping down with the palm of martyrdom relieves the brutality and pessimism of the scene.

It would be a mistake to think of Caravaggio's work as lacking tenderness. In the *Madonna of Loreto* [**FIG. 15.4**], he shows us not the remote grace of a Botticelli Virgin or the sweet, calm beauty of a Raphael Madonna but a simple Roman mother. As she stands gravely on the doorstep of her backstreet house where the plaster is falling away from the walls, two humble pilgrims fall to their knees in confident prayer. They raise their loving faces to the Virgin and Christ child while turning toward us their muddy, travel-stained feet. It is perhaps not surprising that some of Caravaggio's contemporaries, brought up on the elegant and well-nourished Madonnas and worshipers of the Renaissance and surrounded by the splendor of Counter-Reformation art, should have found pictures like these disrespectful and lacking in devotion. It should be equally unsurprising

that once the initial shock wore off, the honesty and truth of Caravaggio's vision made a profound impact on both artists and the public.

Among the painters working in Rome who fell under the spell of Caravaggio's works was Orazio Gentileschi (1563–1639), who was born in Pisa and studied in Florence. Much impressed by Caravaggio's dramatic naturalism and concern for psychological truth, Gentileschi based his own style on that of his younger contemporary. Since he spent the last eighteen years of his life traveling and living in Northern Europe, first in France and then in England, he played an important part in spreading a knowledge of Caravaggio's style outside Italy. At the same time, he handed on his enthusiasm to a painter nearer home—his own daughter Artemisia (1592–1652/1653).

Artemisia Gentileschi has been described as the first woman in the history of the Western world to make a significant contribution to the art of her time. The question of why so few women achieved eminence in the visual arts before recent times is a complicated one, and the chief answers are principally social and economic rather than aesthetic. Certainly, Artemisia was typical of the few women painters of the Renaissance and Baroque periods who did become famous in

■ **15.3** Caravaggio. *The Martyrdom of Saint Matthew,* c. 1602. Oil on canvas, 10′9″ × 11′6″ (3.3 × 3.5 m). Contarelli Chapel, San Luigi dei Francesi, Rome. Note the violent contrasts of light, which highlight the saint and his executioner. The deeply moved onlooker at the very back of the scene is, according to one tradition, a self-portrait of the artist.

that she was the daughter of a painter and therefore at home in the world of art and artists.

Gentileschi's most famous painting is *Judith and Holofernes* [**FIG. 15.5**]. Done in chiaroscuro, the painting conveys a tremendous sense of violence as Judith and her maid loom over the drastically foreshortened body of Holofernes. There is a stark contrast between the realistic violence of the beheading and the sensual richness of the silken bed, jewelry, and cunning drapery. It is not inconceivable that the painter, a rape victim in her youth, poured her own passionate protest into this painting of a woman taking retribution against a

would-be defiler. This work depicts a scene from the biblical story of the Jewish heroine Judith, who used her charms to save her people from an invading Assyrian army; she won the confidence of its general, Holofernes, and then beheaded him in the privacy of his tent.

It is a far cry from the dark, emotional world of Caravaggio and his followers to the brilliant, idealized world of Annibale Carracci, his brother Agostino, and his cousin Ludovico, all often spoken of collectively as the Carracci. The most gifted member of this Bolognese family was Annibale, whose earliest important

▪ **15.4** Caravaggio. *Madonna of Loreto,* 1604. Oil on canvas, 8′6½″ × 4′10½″ (2.6 × 1.5 m). Cavaletti Chapel, San Agostino, Rome. The shabby clothes show the poverty of the two pilgrims. The light that illuminates their faces seems to shine directly from the Madonna and Child.

▪ **15.5** Artemisia Gentileschi. *Judith and Holofernes,* c. 1620. Oil on canvas, 78⅓″ × 64″ (199 × 162.5 cm). Galleria degli Uffizi, Florence. Gentileschi has chosen to show the moment when the sword slices into Holophernes' neck. The blow requires the combined force of Judith and her attendant, as the blood spurts out of the wound. Note the influence of Caravaggio in the dark background and dramatic effect of light on the three figures.

work in Rome—the decoration of the **galleria** (formal reception hall) of the Palazzo Farnese—was painted between 1597 and 1604, precisely the years when Caravaggio was working on the Contarelli Chapel. The many scenes in the galleria constitute a fresco cycle based on Greek and Roman mythology, depicting the loves of the gods, including *The Triumph of Bacchus and Ariadne* [**Fig. 15.6**]. The sense of exuberant life and movement and the mood of unrestrained sensual celebration seem farthest removed from Caravaggio's somber paintings, yet both artists share the baroque love of extreme emotion, and both show the same concern for realism of detail.

The same blend of ideal proportion and realistic detail emerges in Annibale's landscape paintings, of which the best known is probably *The Flight into Egypt*

[**Fig. 15.7**]. The scene is the countryside around Rome, with the river Tiber in the foreground and the Alban hills in the distance. The tiny human figures are carefully related in proportion to this natural setting, precisely balanced by the distant castle, and located just at the meeting point of the diagonal lines formed by the flock of sheep and the river. As a result, we perceive a sense of idyllic Classical order while being convinced of the reality of the landscape.

Roman Baroque Sculpture and Architecture: Bernini and Borromini

The most influential of all Italian baroque artists of the Counter-Reformation was a sculptor and architect, not a painter. The sculptural achievement of Gian Lorenzo Bernini (1598–1680), of seemingly unlimited range of expression and unbelievable technical virtuosity, continued to influence sculptors until the nineteenth century; as the chief architect of Counter-Reformation

◼ **15.6** Annibale Carracci. *The Triumph of Bacchus and Ariadne,* 1597–1600, Fresco. Farnese Palace, Rome. The god's chariot, drawn by tigers, is accompanied by a wild procession of cupids, nymphs, and satyrs. The sense of movement is created by the distorted poses of many of the figures.

Rome, he permanently changed the face of that venerable city.

Born the son of a Florentine sculptor in Naples, Bernini showed signs of his extraordinary abilities at an early age. One of his first important works, a statue of *David* [**FIG. 15.8**], seems to have been deliberately intended to evoke comparison with works by his illustrious predecessors. Unlike the *David* of Donatello (see Figure 12.14) or Michelangelo (see Figure 12.28), which show the subject in repose, Bernini's figure is definitely in the midst of action. From the bitten lips to the muscular tension of the arms to the final detail of the clenched toes of the right foot, this David seems

to personify energy, almost exploding through space. Bernini gives the figure additional expressive power by his deep cuts in the stone, producing a strong contrast between light and dark. In its expression of violent emotion, its communication of the psychological state of its subject, and its virtuoso technique, this David is a truly baroque figure.

Some of Bernini's sculptures depict his aristocratic patrons with the same mastery he applied to spectacular subjects. The bust of Cardinal Scipione Borghese [**FIG. 15.9**], with its quizzical expression and almost uncanny sense of movement, conveys the personality of the sitter with sympathy and subtlety. Most of his finest master-

◼ **15.7** Annibale Carracci. *The Flight into Egypt,* 1603–1604. Oil on canvas, 4′ × 7′6″ (.9 × 2.3 m). Galleria Doria-Pamphili, Rome. Despite the Holy Family in the center foreground, the painting is not so much religious as it is a depiction of the landscape around Rome. Note how skilfully the artist adapts his composition to the semi-circular shape of the canvas.

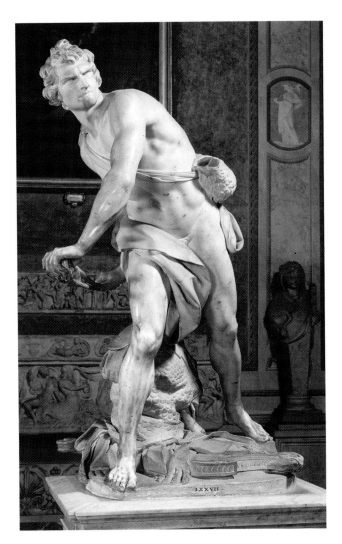

■ **15.8** Gian Lorenzo Bernini. *David,* 1623. Marble. Life size, height 5′6¼″ (1.7 m). Galleria Borghese, Rome. It is said that Bernini carved the face while looking at his own in a mirror. The expression reinforces the tension of the pose, with straining leg and foot muscles.

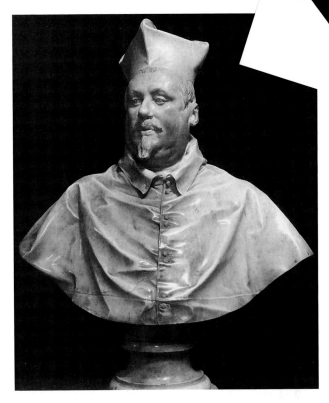

■ **15.9** Gian Lorenzo Bernini. *Cardinal Scipione Borghese,* 1632. Marble. Height 30¾″ (78 cm). Galleria Borghese, Rome. Breaking with the tradition of Renaissance portraiture, which showed the subject in repose, Bernini portrays the cardinal, his first patron, with a sense of lively movement. Note the rippling effect of the drapery, which hides the fact that it is carved from stone.

pieces, however, deal with religious themes, and draw their inspiration from Counter-Reformation teachings.

The most spectacular of these is *Saint Teresa in Ecstasy,* which uses a combination of architecture, sculpture, and natural light to convey the saint's ecstatic vision of an angel [**Fig. 15.10**]. Gilded bronze shafts of light are further illuminated by light from a concealed window, as Saint Teresa, torn by violent emotion, awaits the blow of the angel, about to pierce her to the heart.

Works such as these would have been more than sufficient to guarantee Bernini's immortality, but his architectural achievements are equally impressive. The physical appearance of baroque Rome was enriched by numerous Bernini fountains, Bernini palaces, and Bernini churches. Most important of all was his work on Saint Peter's, where he created in front of the basilica a vast piazza with its oval colonnade, central obelisk,

and fountains—an ensemble (see Figure 15.1) that rivals in grandeur even the fora of Imperial Rome.

Bernini's expansive personality and his success in obtaining important commissions brought him tragically if inevitably into conflict with the other great architect of baroque Rome: Francesco Borromini (1599–1667). Brooding and melancholy much of the time, Borromini spent most of his career in constant competition with his brilliant rival and finally committed suicide (see Voices of Their Times box, this chapter). Whereas Bernini was concerned with the broad sweep of a design and grandiose effects, Borromini concentrated on elaborate details and highly complex structures.

Borromini's greatest and most influential achievement was the church of San Carlo alle Quattro Fontane. The inside, designed between 1638 and 1641, was his first important work; the façade, which he added in 1665–1667, was his last [**Fig. 15.11**]. On a relatively small exterior wall space, Borromini has placed a wide range of decorative elements—columns, niches, arches, statues—while the façade flows in sinuous curves. The almost obsessive elaboration of design is in strong contrast to the clarity of many of Bernini's

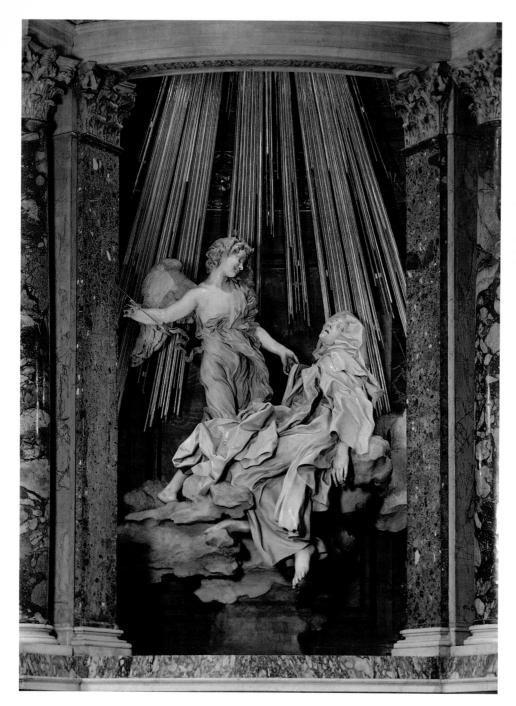

■ **15.10** Gian Lorenzo Bernini. *Saint Teresa in Ecstasy,* 1645–1652. Marble. Height of group 11'6" (3.5 m). Cornaro Chapel, Santa Maria della Vittoria, Rome. One of the supreme masterpieces of baroque art, this famous work shows Bernini's virtuoso skill in the expression of heightened religious emotion. Note the contrast between the light texture of the angel's robe and the heavier weight of the saint's costume, as she seems to swoon before our eyes.

buildings, but its ornateness represents another baroque approach to architecture, one that was to have a continual appeal.

BAROQUE ART IN FRANCE AND SPAIN

In general, the more extravagant aspects of Italian baroque art never appealed greatly to French taste, which preferred elegance to display and restraint to emotion. The conservative nature of French art found expression before the end of the century in the foundation of the Académie des Beaux-Arts (Academy of the Fine Arts). The first of the special exhibitions organized by the academy took place in 1667, under the patronage of Louis XIV. Both then and through the succeeding centuries, academy members saw their function as the defense of traditional standards and values rather than the encouragement of revolutionary new developments. Their innate conservatism affected both the works selected for exhibition and those awarded prizes. The tension between these self-appointed guardians of

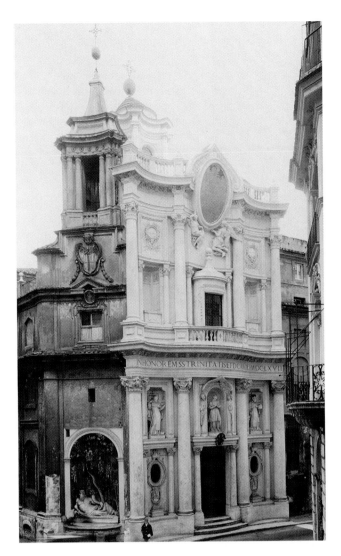

■ **15.12** Georges de La Tour. *The Lamentation over Saint Sebastian,* 1645. Oil on canvas, approx. 5′3″ × 4′3″ (1.6 × 1.3 m). Gemäldegalerie Staatliche Museen. Preussischer Kulturbesitz, Berlin. The influence of Caravaggio is obvious. Nevertheless, the simplification of details and the distaste for violence (there is no blood around the arrow) are typical of the restraint of de La Tour's paintings.

■ **15.11** Francesco Borromini. Façade of San Carlo alle Quattro Fontane, Rome. Begun 1638, façade finished 1667. Length 52′ (15.86 m), width 34′ (10.36 m), width of façade 38′ (11.58 m). The curves and countercurves of the façade, together with the rich, almost cluttered, decoration, mark a deliberate rejection of the Classical style.

tradition and those artists who revolted against established ideas lasted well into the nineteenth century.

The closest parallel in French baroque painting to the intensity of Caravaggio is found in the strangely moving paintings of Georges de La Tour (1590–1652), whose candlelit scenes and humbly dressed figures are reminiscent of some aspects of the Italian's work. Yet the mood of such paintings as *The Lamentation over Saint Sebastian* [**Fig. 15.12**] is far more restrained—the emotions are not stressed.

The greatest French painter of the seventeenth century, Nicolas Poussin (c. 1594–1665), echoed this French preference for restraint when he decisively rejected the innovations of Caravaggio, whose works he claimed to detest. He saw his own work as a kind

of protest against the excesses of the baroque; a strong dislike of his Roman contemporaries did not, however, prevent Poussin from spending most of his life in Rome. It may seem strange that so French an artist should have chosen to live in Italy, but what drew him there was the art of ancient, not baroque, Rome. Poussin's only real and enduring enthusiasm was for the world of Classical antiquity. His friends in Rome included the leading antiquarians of the day, and his paintings often express a nostalgic yearning for a long-vanished past.

Among Poussin's most poignant early works is *Et in Arcadia Ego* [**Fig. 15.13**], in which four country dwellers gather at a large stone tomb in an idyllic landscape. The inscription they struggle intently to decipher says Et in Arcadia Ego ("I am also in Arcadia"), a reminder that death exists even in the midst of such beauty and apparent simple charm. (Arcadia, although an actual region in Greece, was also used to refer to an imaginary land of perfect peace and beauty.) That charm is not altogether so simple, however. Poussin's rustic shepherds and casually dressed shepherdess seem to have stepped

■ **15.13** Nicolas Poussin. *Et in Arcadia Ego,* c. 1630. Oil on canvas, approx. 40″ × 32″ (102 × 81 cm). The Devonshire Collection, Chatsworth Settlement. Although influenced by Classical sources, this early version of the subject has a poetical character that owes much to the art of Titian.

directly from some actual antique scene, such as Poussin often incorporated into his paintings, while the rich landscape is reminiscent of Venetian painting. The entire work therefore represents not so much the authentic representation of an actual past as the imaginative creation of a world that never really existed.

As his career developed, Poussin's style changed. The poetry of his earlier work was replaced by a grandeur that sometimes verges on stiffness. The *Rape of the Sabine Women* [**Fig. 15.14**] is conceived on a massive scale and deals with a highly dramatic subject, yet the desperate women and violent Roman soldiers seem almost frozen in motion. Every figure is depicted clearly and precisely, as in Carracci's *The Triumph of Bacchus and Ariadne* (see Figure 15.6), yet with none of the exuberance of the earlier artist. The artificial, contrived air is deliberate.

By the end of his life, Poussin had returned to the simplicity of his earlier style, but it was drained of any trace of emotion. Another version of the subject of *Et in Arcadia Ego* [**Fig. 15.15**], painted some ten years later, provides a revealing contrast. The same four figures study the same tomb, but in a mood of deep stillness. Gone is the urgency of the earlier painting and much of the poetry. In its place, Poussin creates a mood of philosophical calm and tries to recapture the lofty spirit of antiquity, most notably in the noble brow and solemn stance of the shepherdess. Compensating for the loss of warmth is the transcendent beauty of the image.

Even had Poussin been prepared to leave Rome and return to the French court, the austere nature of his art would hardly have served to glorify that most autocratic and magnificent of monarchs, Louis XIV (born 1638, reigned 1643–1715). For the most part, the king had only second-rate artists available to him at court. Like Poussin, the other great French painter of the

▪ **15.14** Nicolas Poussin. *Rape of the Sabine Women,* c. 1634. Oil on canvas, 60⅞″ × 82⅝″ (154.6 × 209.9 cm). Metropolitan Museum of Art, New York, Harris Brisband Dick Fund, 1946. At the time of this painting, Poussin was strongly influenced by the ancient sculptures he had studied in Rome, most notably in the careful depiction of the musculature of his figures.

▪ **15.15** Nicolas Poussin. *Et in Arcadia Ego,* 1638–1639. Oil on canvas, 33½″ × 47⅝″ (85 × 121 cm). Louvre, Paris. When compared to Figure 15.13, an earlier version, this treatment is found to be calmer and less dramatic. The group is seen from the front rather than diagonally, and both faces and poses are deliberately unemotional.

day—Claude Gellée (called Claude Le Lorrain, 1600–1682)—spent most of his life in Rome, and was only interested in painting landscapes [**Fig. 15.16**].

Although most official court painters achieved only mediocre respectability, an exception must be made for Hyacinthe Rigaud (1659–1743), whose stunning portrait of Louis XIV [**Fig. 15.17**] epitomizes baroque grandeur. It would be difficult to claim the intellectual vigor of Poussin or the emotional honesty of Caravag-

gio for this frankly flattering image of majesty. The stilted pose and gorgeous robes may even suggest an element of exaggeration, almost of parody; yet a glance at the king's sagging face and stony gaze immediately puts such an idea to rest. Rigaud has captured his patron's outward splendor while not hiding his increasing weakness, due in great part to his decadent lifestyle. The signs of physical collapse are visible—*Et in Versailles Ego.*

■ **15.16** Claude Gellée (called Le Lorrain). French (worked in Rome), 1600–1682. *Mill on a River*, 1631. Oil on canvas, 24¼″ × 33¼″ (61.5 × 84.5 cm). Museum of Fine Arts, Boston (Seth K. Sweetser Fund). Although this is one of Lorrain's early paintings, it already shows his ability to create a sense of infinite space and depth, in part by calculated contrasts between light and dark.

Louis XIV's most lasting artistic achievement was a new center for the court—the Palace of Versailles—built a few miles outside Paris [**Fig. 15.18**]. The history of its construction is long and complicated, and the final result betrays some of the uncertainties that went into its planning.

Louis XIV, an acute politician and astute judge of human psychology, was well aware of the fact that the aristocratic courtiers who surrounded him were likely to turn on him if he showed the faintest sign of weakness or hesitation. By constructing an elaborate setting at Versailles in which he could consciously act out the role of Grand Monarch, Louis conveyed the image of himself as supreme ruler and thereby retained his mastery over the aristocracy.

The Palace of Versailles was therefore conceived by the king in political terms. The architects' task, both inside and out, was to create a building that would illustrate Louis XIV's symbolic concept of himself as the Sun King. Thus, each morning the king would rise from his bed, make his way past the assembled court through the Hall of Mirrors [**Fig. 15.19**] where the seventeen huge mirrors reflected both the daylight and his own splendor, and enter the gardens along the main wing of the palace—laid out in an east-west axis to follow the path of the sun. At the same time both the palace and its gardens, which extend behind it for some two miles, were required to provide an appropriate setting for the balls, feasts, and fireworks displays organized there.

Given the grandiose symbolism of the ground plan and interior decorations, the actual appearance of the outside of the Palace of Versailles, with its rows of

■ **15.17** Hyacinthe Rigaud. *Louis XIV*, 1701. Louvre, Paris, 9′7⅞″ × 6′4″ (2.77 × 1.94 m). Louis was sixty-three when this portrait was painted. The swirling ermine-lined robes are a mark of the king's swagger. The ballet pose of his feet is a reminder of the popularity of dancing at the French court.

■ **15.18** Aerial view, Palace of Versailles, begun 1669, and a small portion of the surrounding park. Width of palace 1935′ (589.79 m). The chief architects for the last stage of construction at Versailles were Louis le Vau (1612–1670) and Jules Hardouin-Mansart (1646–1708). Although the external decoration of the palace is Classical in style, the massive scale is characteristic of baroque architecture.

■ **15.19** Jules Hardouin-Mansart and Charles Lebrun. *Galerie des Glaces (Hall of Mirrors)*, Palace of Versailles. Begun 1676. Length 240′ (73.15 m), width 34′ (10.36 m), height 43′ (13.11 m). The interior decoration was by Charles Lebrun (1619–1690), who borrowed the idea of a ceiling frescoed with mythological scenes from Carracci's painted ceiling in the Farnese Palace (see Figure 15.6).

Ionic columns, is surprisingly modest. The simplicity of design and decoration is another demonstration of the French ability to combine the extremes of baroque art with a more Classical spirit.

The Spanish reaction to the baroque was very different. Strong religious emotion had always been a characteristic of Spanish Catholicism, and the new possibilities presented by baroque painting were foreshadowed in the work of the greatest painter active in Spain in the late sixteenth century, El Greco "the Greek" (1541–1614). Domenikos Theotokopoulos (El Greco's birth name) was born on the Greek island of Crete, which at the time was under Venetian rule. He apparently traveled to Venice, where he was influenced by Titian, and to Rome. It is not known why he went to Spain, but El Greco is recorded as having lived in Toledo from 1577 until his death.

Although he tried to obtain court patronage, the violence of contrasts in his work—clashes of color, scale, and emotion—did not appeal to official taste: his first royal commission, the *Martyrdom of Saint Maurice and the Theban Legion* [**Fig. 15.20**], was his last. The painting illustrates the theme of moral responsibility and choice. The Roman soldier Maurice, faced with a conflict between the demands of Roman law and of his Christian faith, chooses the latter, together with his

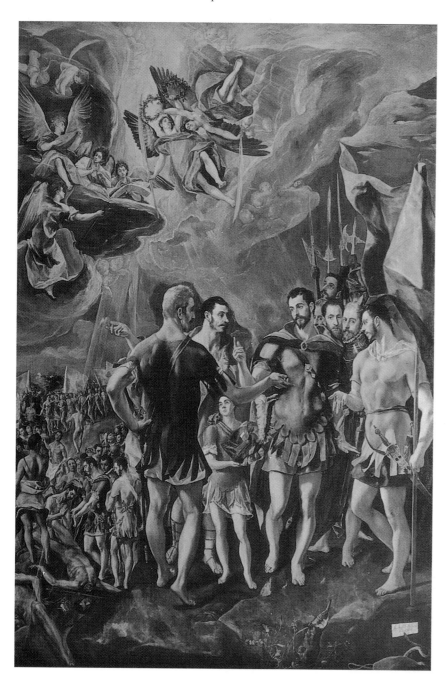

■ **15.20** El Greco. *Martyrdom of Saint Maurice and the Theban Legion,* 1581–1584. Oil on canvas, 14′6″ × 9′10″ (4.42 × 3 m). Escorial Palace, Madrid. The saint is facing the viewer, pointing up toward the heavenly vision he sees. The elongated figures and bright colors are reminiscent of Italian Mannerists like Pontormo (see Figure 13.21), but El Greco's arrangement of his figures is much more irregular.

fellow Theban and Christian legionnaires. The hallucinatory brightness of the colors is probably derived from Italian Mannerist painting of earlier in the sixteenth century, as are the elongated proportions, but the effect—underlined by the asymmetrical composition—is incomparably more fierce and disturbing.

In the absence of court patronage, El Greco produced many of his works for Toledo, his city of residence. Among the most spectacular is the *Burial of Court Orgaz* [**Fig. 15.21**], a local benefactor who was rewarded for his generosity by the appearance of Saint Augustine and Saint Stephen at his funeral in 1323. They can be seen in the lower center of the painting, burying the count while his soul rises; the small boy

dressed in black in the left-hand corner is the artist's eight-year-old son, identified by an inscription. The rich, heavy robes of the saints are balanced by the swirling drapery of the heavenly figures above, while the material and spiritual worlds are clearly separated by a row of grave, brooding local dignitaries.

The same religious fervor appears in the work of José de Ribera (1591–1652) but is expressed in a far more naturalistic style. Like Caravaggio, Ribera used peasants in his religious scenes, which were painted with strong contrasts of light and dark. In his *The Martyrdom of Saint Bartholomew* [**Fig. 15.22**], Ribera spares us nothing in the way of realism as the saint is hauled into position to be flayed. The muscular brutality of his

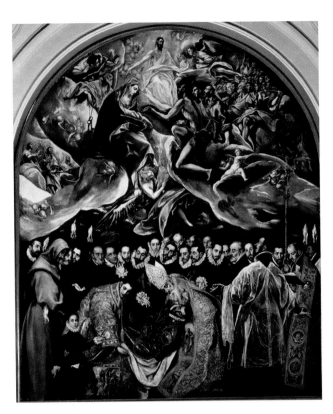

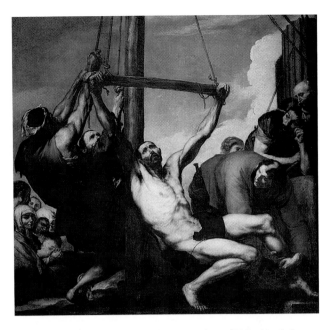

■ **15.22** José de Ribera. *The Martyrdom of Saint Bartholomew,* c. 1639. Oil on canvas, 92″ × 92″ (2.34 × 2.34 m). Museo del Prado, Madrid. Unlike La Tour (see Figure 15.12), Ribera refuses to soften the subject by idealizing his figures. The saint has nothing to distinguish him from his executioners, nor is there any sign of heavenly intervention, as there is in Caravaggio's *Martyrdom of St. Matthew* (see Figure 15.3).

■ **15.21** El Greco. *Burial of Count Orgaz,* 1586. Oil on canvas, 16′ × 11′10″ (4.88 × 3.61 m). San Tomé, Toledo. Note the elongated proportions of the figures in the heavens and the color contrasts between the upper and lower sections of the painting. This division is accentuated by the relatively straightforward composition of the burial scene, with the figures arranged in a row, which is in strong contrast to the swirling scene in Heaven.

executioners and the sense of impending physical agony are almost masochistic in their vividness. Only in the compassionate faces of some onlookers do we find any relief from the torment of the scene.

Although paintings like Ribera's are representative of much of Spanish baroque art, the work of Diego Velázquez (1599–1660), the greatest Spanish painter of the Baroque period, is very different in spirit. Velázquez used his superlative technique to depict scenes brimming with life, preferring the court of Phillip IV (where he spent much of his career) and the lives of ordinary people to religious or mythological subjects.

The finest and most complex work of Velázquez is *Las Meninas (The Maids of Honor)* [**Fig. 15.23**]. Unlike Louis XIV, the Spanish king was fortunate enough to have one of the greatest painters in history to preserve the memory of his court. It is to Philip IV's credit that he treated Velázquez with respect and honor. In return, Velázquez produced several superb portraits of the monarch and his family. *Las Meninas* is an evocation of life in the royal palace. The scene is Velázquez's own studio there; the five-year-old Princess Margarita has

come with her two maids to visit the painter at work on a huge painting that must surely be *Las Meninas* itself. Despite the size of the picture, the mood is quiet, even intimate: two figures in casual conversation, a sleepy dog, a passing court official who raises a curtain at the back to peer into the room. Yet so subtle is Velázquez's use of color that we feel the presence of the room as a three-dimensional space filled with light—now bright, now shadowy. The reality of details like the little princess's hair or dress never distracts from the overall unity of color and composition. That Velázquez was justifiably proud of his abilities is shown by the two distinguished visitors whose presence is felt rather than seen, reflected as they are in the mirror hanging on the back wall: the king and queen come to honor the artist by visiting him in his own studio.

BAROQUE ART IN NORTHERN EUROPE

Most baroque art produced in Northern Europe was intended for a middle-class rather than an aristocratic audience, as in Italy, France, and Spain. Before examining the effects of this, however, we must look at two notable exceptions, Peter Paul Rubens (1577–1640)

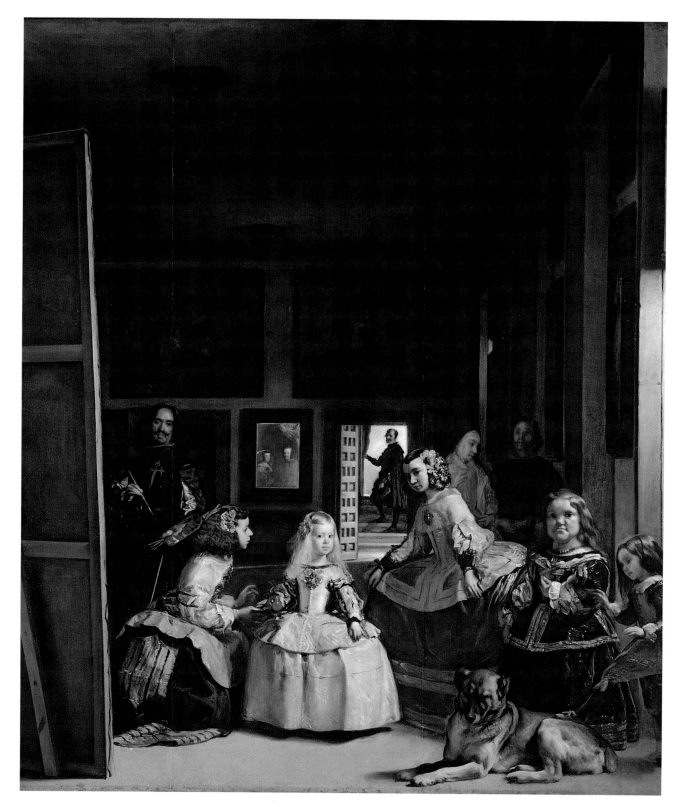

■ **15.23** Diego Velázquez. *Las Meninas (The Maids of Honor),* 1656. Oil on canvas, 10′5″ × 9′ (3.18 × 2.74 m). Museo del Prado, Madrid. The red cross on the artist's breast, symbol of the noble Order of Santiago, was painted there by the king's command after Velázquez's death. Velázquez regarded his nomination to the order in 1658 as recognition of both his own nobility and that of his art. He thus became one of the first victors in the war that artists had waged ever since the Renaissance for a social status equal to that of their patrons. Throughout the sixteenth and seventeenth centuries, their aristocratic and ecclesiastical employers regarded them as little better than servants; only by the end of the eighteenth century were artists and musicians able to assert their social and political independence.

▐ VOICES OF THEIR TIMES

Giambattista Passeri

In this passage the seventeenth-century painter and biographer Giambattista Passeri describes the suicide of Francesco Borromini. In the summer of 1667, tormented by Bernini's triumphant successes, Borromini

... was assailed again with even greater violence by hypochondria which reduced him within a few days to such a state that nobody recognized him any more for Borromini, so haggard had his body become, and so frightening his face. He twisted his mouth in a thousand horrid ways, rolled his eyes from time to time in a fearful manner, and sometimes would roar and tremble like an irate lion. His nephew [Bernardo] consulted doctors, heard the advice of friends, and had him visited several times by priests. All agreed that he should never be left alone, nor be allowed any occasion for working, and that one should try to make him sleep at all costs, so that his spirit might calm down. This was the precise order which the servants received from his nephew and which they carried out. But instead of improving, his illness grew worse. Finding that he was never obeyed, as all he asked for was refused him; he imagined that this was done in order to annoy him rather than for his good, so that his restlessness increased and as time passed his hypochondria changed into

pains in his chest, asthma, and a sort of intermittent frenzy. One evening, during the height of summer, he had at last thrown himself into his bed, but after barely an hour's sleep he woke up again, called the servant on duty, and asked for a light and writing material.

Told by the servant that these had been forbidden him by the doctors and his nephew, he went back to bed and tried to sleep. But unable to do so in those hot and sultry hours, he started to toss agitatedly about as usual, until he was heard to exclaim "When will you stop afflicting me, O dismal thoughts? When will my mind cease being agitated? When will all these woes leave me? . . . What am I still doing in this cruel and execrable life?" He rose in a fury and ran to a sword which, unhappily for him and through carelessness of those who served him, had been on a table, and letting himself barbarously fall on the point was pierced from front to back. The servant rushed in at the noise and seeing the terrible spectacle called others for help, and so, half-dead and covered in blood, he was put back to bed. Knowing then that he had really reached the end of his life, he called for the confessor and made his will.

and his assistant and later rival, Anthony van Dyck (1599–1641), both Flemish by birth.

Rubens is often called the most universal of painters because he produced with apparent ease an almost inexhaustible stream of work of all kinds—religious subjects, portraits, landscapes, mythological scenes—all on the grandest of scales. He must certainly have been among the most active artists in history: in addition to running the workshop used for the production of his commissions, he pursued a career in diplomacy, which involved considerable traveling throughout Europe, and still had time for academic study. He is said to have spoken and written six modern languages and to have read Latin fluently. He was also versed in theology. Furthermore, in contrast to solitary and gloomy figures like Caravaggio and Borromini, Rubens seems to have been contented in his personal life. After the death of his first wife he remarried at age fifty-three, a girl of sixteen, Hélène Fourment, with whom he spent an ecstatically happy ten years before his death. The paintings of his last decade are among the most intimate and tender of all artistic tributes to married love, as shown in *Hélène Fourment and her Children* [**FIG. 15.24**].

For the most part, however, intimacy is not the quality most characteristic of Rubens' art. Generally his pictures convey something of the restless energy of his life. In *The Rape of the Daughters of Leucippus* [**FIG. 15.25**], every part of the painting is filled with movement as the mortal women, divine riders, and even the horses are drawn into a single pulsating spiral. The sense of action, so characteristic of Rubens' paintings, is in strong contrast to the frozen movement of Poussin's depiction of a similar episode (see Figure 15.14). Equally typical of the artist is his frank delight in the women's sensuous nudity and ample proportions—the slender grace of other artists' nudes was not at all to Rubens' taste.

Perhaps the most extraordinary achievement of Rubens' remarkable career was his fulfillment of a commission from Marie de' Medici, widow of Henry IV and mother of Louis XIII, to decorate an entire gallery with paintings illustrating her life. In a mere three years, from 1622 to 1625, he created twenty-four enormous paintings commemorating the chief events in which she played a part, with greater flattery than truth. The splendid *Journey of Marie de' Medici* [**FIG. 15.26**] shows

■ **15.24** Peter Paul Rubens. *Hélène Fourment and Her Children,* 1636–1637. Oil on canvas, 44½″ × 32¼″ (118 × 85 cm). Louvre, Paris. In this affectionate portrait of his young wife and two of their children, Rubens achieves a sense of immediacy and freshness by the lightness of his touch: the details of the chair and background are only lightly sketched in.

the magnificently attired queen on horseback at the Battle of Ponts-de-Cé, accompanied by the spirit of Power, while Fame and Glory flutter around her head. It hardly matters that the queen's forces were ignominiously defeated in the battle, so convincingly triumphant does her image appear.

Paintings on this scale required the help of assistants, and there is no doubt that in Rubens' workshop much of the preliminary work was done by his staff. One of the many artists employed for this purpose eventually became as much in demand for portraits of the aristocracy as his former master. Anthony van Dyck spent two years (1618–1620) with Rubens before beginning his career as an independent artist. Although from time to time he painted religious subjects, his fame rests on his formal portraits, many of

which were produced during the years he spent in Italy and England.

Van Dyck's refined taste equipped him for satisfying the demands of his noble patrons that they be shown as they thought they looked rather than as they actually were. It is certainly difficult to believe that any real-life figure could have had quite the haughty bearing and lofty dignity of the Marchesa Cataneo [**FIG. 15.27**] in van Dyck's portrait of her, although the Genoese nobility of which she was a member was known for its arrogance.

International celebrities like Rubens and van Dyck, at home at the courts of all Europe, were far from typical of northern artists. Painters in the Netherlands in particular found themselves in a very different situation from their colleagues elsewhere. The two most lucrative

■ **15.25** Peter Paul Rubens. *The Rape of the Daughters of Leucippus*, c. 1618. Oil on canvas, 7′3″ × 6′10″ (2.21 × 2.08 m). Alte Pinakothek, Munich. According to the Greek legend, Castor and Pollux, twin sons of Zeus, carried off King Leucippus's two daughters, who had been betrothed to their cousins. The myth here becomes symbolic of physical passion. Note the ample forms of the two women; this physique has come to be called "Rubensesque."

sources of commissions—the church and the aristocracy—were unavailable to them because the Dutch Calvinist Church followed the post-Reformation practice of forbidding the use of images in church, and because Holland had never had its own powerful hereditary nobility. Painters therefore depended on the tastes and demands of the open market.

One highly profitable source of income for Dutch artists in the seventeenth century was the group portrait, in particular that of a militia or civic guard company. These bands of soldiers had originally served a practical purpose in the defense of their country, but their regular reunions tended to be social gatherings, chiefly for the purpose of eating and drinking. A group of war veterans today would hire a photographer to commemorate their annual reunion; the militia companies engaged the services of a portrait painter. If they were lucky or rich enough they might even get Frans Hals (c. 1580–1666), whose group por-

traits capture the individuality of each of the participants while conveying the general convivial spirit of the occasion [**FIG. 15.28**]. Hals was certainly not the most imaginative or inventive of artists, but his sheer ability to paint, using broad dynamic brush strokes and cleverly organized compositions, makes his work some of the most attractive of that period.

Very different in spirit was Jan Vermeer (1632–1675), who worked almost unknown in the city of Delft and whose art was virtually forgotten after his death. Rediscovered in the nineteenth century, it is now regarded as second only to Rembrandt's for depth of feeling. At first sight this may seem surprising, because Vermeer's subjects are rather limited in scope. A woman reading a letter [**FIG. 15.29**], girls sewing or playing music—through such intimate scenes Vermeer reveals qualities of inner contemplation and repose that are virtually unique in the entire history of art. Unlike Hals, with his loose style, Vermeer built up his forms

■ **15.26** Peter Paul Rubens. *The Journey of Marie de' Medici*, 1622–1625. Oil on canvas, 14'11" × 9'6" (3.94 × 2.95 m). Louvre, Paris. This painting focuses on the triumphant figure of the queen. As in many of his large works, Rubens probably painted the important sections and left other parts to his assistants.

■ **15.27** Anthony van Dyck. *Marchesa Elena Grimaldi, Wife of Marchese Nicola Cataneo*, c. 1623. Oil on canvas, 97" × 68" (2.46 × 1.72 m). National Gallery of Art, Washington (Widener Collection, 1942). Painted fairly early in van Dyck's career during a stay in Genoa, the portrait emphasizes the aristocratic bearing of its subject by somber colors and an artificial setting, which accentuates her grandeur.

by applying the paint in the form of tiny dots of color and then rendering the details with careful precision. Like Velázquez's *Las Meninas* (see Figure 15.23), his paintings are dominated by light so palpable as to seem to surround the figures with its presence. However, where Velázquez's canvas is suffused with a warm, Mediterranean glow, Vermeer's paintings capture the coolness and clarity of northern light. The perfection of his compositions creates a mood of stillness so complete that mundane activities take on a totally unexpected concentration and become endowed with a heightened sense of importance.

Rembrandt van Rijn (1606–1669) is one of the most deeply loved of all painters. No summary of his achievements can begin to do it justice. Born in Leiden in the Netherlands, he spent a short time at the university there before beginning his studies as a painter. The early part of his career was spent in Amsterdam, where he moved in 1631 and soon became known as a fashionable portrait painter. His life was that of any successful man of the time, happily married, living in his own fine house.

Rembrandt's interest in spiritual matters and the eternal problems of existence, however, coupled with his researches into new artistic techniques, seem to have prevented his settling down for long to a bourgeois existence of this kind. The artistic turning point of his career came in 1642, the year of the death of his wife, when he finished the painting known as *The Night Watch* [**FIG. 15.30**]. Although ostensibly the same kind of group portrait as Hals' *Banquet of the Officers of the Civic Guard* (see Figure 15.28), it is composed with much greater complexity and subtlety. The arrange-

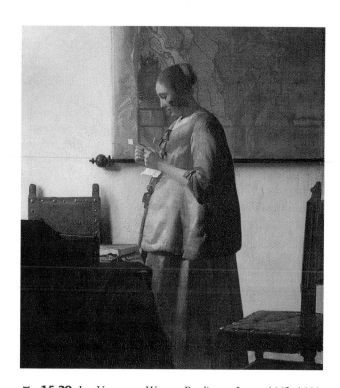

■ **15.28** Frans Hals. *Banquet of the Officers of the Civic Guard of Saint George at Haarlem,* 1616. Oil on canvas, 5′8¼″ × 10′6⅜″ (1.75 × 3.24 m). Frans Halsmuseum, Haarlem. The diagonal lines of the curtains, banner, and sashes help bind the painting together and make it at the same time both a series of individual portraits and a single unified composition.

ment of the figures and the sense of depth show how far Rembrandt was outdistancing his contemporaries.

The price Rembrandt paid for his genius was growing neglect, which by 1656 had brought bankruptcy. The less his work appealed to the public of his day, the more Rembrandt retreated into his own spiritual world. About 1645 he set up house with Hendrickje Stoffels, although he never married her, and his unconventional behavior succeeded in alienating him still further from his contemporaries. The faithful Hendrickje, however, together with Titus, Rembrandt's son by his first marriage, helped put his financial affairs in some sort of order. Her death in 1663 left him desolate, and its effect on him is visible in some of his last self-portraits [**Fig. 15.31**].

Throughout his life Rembrandt had sought self-understanding by painting a series of portraits of himself, charting his inner journey through the increasingly tragic events of his life. Without self-pity or pretense he analyzed his own feelings and recorded them with a dispassion that might be called merely clinical if its principal achievement were not the revelation of a human soul. By the time of Hendrickje's death, which was followed in 1668 by that of Titus, Rembrandt was producing self-portraits that evoke not so much sympathy for his sufferings as awe at their truth. The inexorable physical decay, the universal fate, is accompanied by a growth in spiritual awareness that

■ **15.29** Jan Vermeer. *Woman Reading a Letter,* 1662–1664. Oil on canvas, 18⅛″ × 15¼″ (46 × 39 cm). Rijksmuseum, Amsterdam. Much of the sense of balance and repose that Vermeer conveys is achieved by his careful color contrasts between blue and yellow and the repetition of rectangular surfaces such as the table, chairbacks, and the map of the Netherlands on the wall.

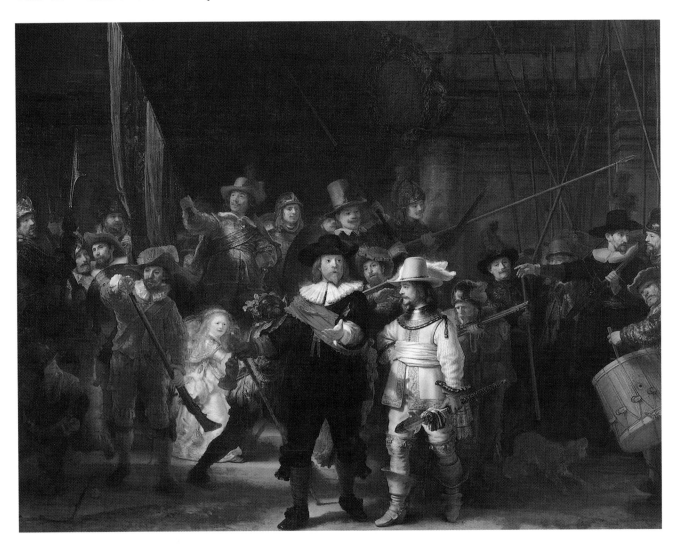

■ **15.30** Rembrandt. *The Sortie of Captain Frans Banning Cocq's Company of the Civic Guard (The Night Watch)*, 1642. Oil on canvas, 11′9½″ × 14′2½″ (3.63 × 4.37 m). Rijksmuseum, Amsterdam. Recent cleaning has revealed that the painting's popular name, though conveniently brief, is inaccurate. Far from being submerged in darkness, the principal figures were originally bathed in light and painted in glowing colors.

must have at least in part come from Rembrandt's life-long meditation on the Scriptures.

Rembrandt used contrast between light and darkness to achieve dramatic and emotional effect in all his work. Light also served to build composition and to create depth in his paintings and etchings. In the paintings, he often built up layers of paint to create a richness of color and sense of texture unmatched by any of his contemporaries. In his etchings and engravings, he developed ways of varying the lines to produce a similarly elaborate surface. A supremely baroque

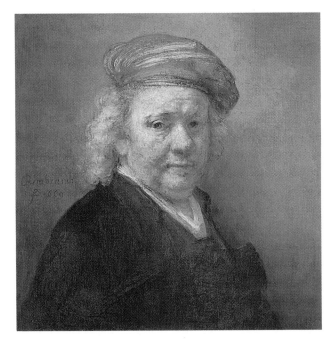

■ **15.31** Rembrandt. *Old Self-Portrait,* 1669. Oil on canvas, 23¼″ × 20¾″ (59 × 53 cm). Mauritshuis, The Hague. In this, his last self-portrait painted a few months before his death, the artist seems drained of all emotion, his expression resigned, and gaze fixed.

artist, Rembrandt always used his mastery of composition and texture to deepen and enhance the emotional power of the image.

In the final years of his life, Rembrandt turned increasingly to biblical subjects, always using them to explore some aspect of human feelings. In *Jacob Blessing the Sons of Joseph* [**Fig. 15.32**] all the tenderness of family affection is expressed in the juxtaposition of the heads of the old man and his son, whose expression of love is surpassed only by that of his wife as she gazes almost unseeingly at her sons. The depth of emotion and the dark shadows mark that school of baroque painting initiated by Caravaggio, yet it seems almost an impertinence to categorize so universal a statement. Through this painting Rembrandt seems to offer us a deep spiritual comfort for the tragic nature of human destiny revealed by the self-portraits.

BAROQUE MUSIC

Although the history of music is as long as that of the other arts, the earliest music with which most modern music lovers are on familiar ground is that of the Baroque period. It is safe to say that many thousands of listeners have tapped their feet to the rhythm of a baroque concerto without knowing or caring anything about its historical context, and with good reason: Baroque music, with its strong emphasis on rhyth-

mic vitality and attractive melody, is easy to respond to with pleasure. Furthermore, in the person of Johann Sebastian Bach, the Baroque period produced one of the greatest geniuses in the history of music, one who shared Rembrandt's ability to communicate profound experience on the broadest level.

The qualities that make baroque music popular today were responsible for its original success: Composers of the Baroque period were the first since Classical antiquity to write large quantities of music intended for the pleasure of listeners as well as the glory of God. The polyphonic music of the Middle Ages and the Renaissance, with its interweaving of many musical lines, had enabled composers like Machaut or Palestrina to praise the Lord on the highest level of intellectual achievement, but the result was a musical style far above the heads of most of their contemporary listeners. The Council of Trent, in accordance with Counter-Reformation principles, had even considered prohibiting polyphony in religious works in order to make church music more accessible to the average congregation before finally deciding that this would be too extreme a measure. For once, the objectives of Reformation and Counter-Reformation coincided, for Luther had already simplified the musical elements in Protestant services for the same reason (see Chapter 14).

The time was therefore ripe for a general move toward sacred music with a wider and more universal appeal. Since at the same time the demand for secular

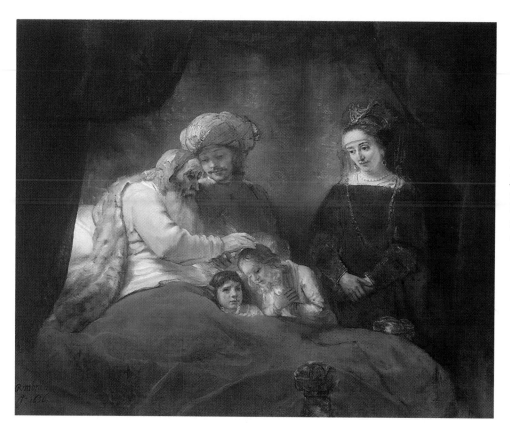

▪ **15.32** Rembrandt. *Jacob Blessing the Sons of Joseph,* 1656. Oil on canvas, 5′8¼″ × 6′9″ (1.75 × 2.1 m). Staatliche Kunstsammlungen Kassel, Galerie Alte Meister, GK 249. In his very personal version of the biblical story, painted the year of his financial collapse, Rembrandt includes Asenath, Joseph's wife. Although she is not mentioned in the text, her presence here emphasizes the family nature of the occasion.

music was growing, it is not surprising that composers soon developed a style sufficiently attractive and flexible not only for the creation of masses and other liturgical works, but also of instrumental and vocal music that could be played and listened to at home [FIG. 15.33].

The Birth of Opera

Perhaps the major artistic innovation of the seventeenth century was a new form of musical entertainment that had been formulated at the beginning of the Baroque period: opera. This consisted of a play in which the text was sung rather than spoken. Throughout the seventeenth century the taste for opera and operatic music swept Europe, attracting aristocratic and middle-class listeners alike. In the process, the public appetite for music with which it could identify grew even greater. Small wonder that twentieth-century listeners have found pleasure and delight in music written to provide our baroque predecessors with precisely these satisfactions.

Like much else of beauty, opera was born in Florence. Ironically enough, an art form that was to become so popular in so short a time was originally conceived of in lofty intellectual terms. Toward the end of the sixteenth century, a group of thinkers, poets, and musicians began to meet regularly at the house of a wealthy Florentine noble, Count Giovanni Bardi. This group, known as the Florentine *Camerata,* objected strongly to the way in which the polyphonic style in vocal music reduced the text to incomprehensible nonsense. They looked back nostalgically to the time of the Greeks, when almost every word of Greek tragedy was both sung and accompanied by instruments, yet remained perfectly understandable to the spectators. Greek music was lost forever, but at least the group could revive what they considered its essence.

The result was the introduction of a musical form known as **monody,** or **recitative,** which consisted of the free declamation of a single vocal line with a simple instrumental accompaniment for support. Thus listeners could follow the text with ease. The addition of music also gave an emotional intensity not present in simple spoken verse, thus satisfying the baroque interest in heightened emotion.

Although in theory monody could be used for either sacred or secular works, its dramatic potential was obvious. In the winter of 1594–1595 the first play set to music, Jacopo Peri's *Dafne,* was performed in Florence. Its subject was drawn from Classical mythology and dealt with Apollo's pursuit of the mortal girl Daphne, who turned into a laurel tree to elude him. In the words of a spectator, "The pleasure and amazement of those present were beyond expression." *Dafne* is now lost, but another work of Peri, *Euridice,* has survived to become the earliest extant opera. It too was based on a Greek myth, that of Orpheus and Eurydice. The first performance took place in 1600, again in Florence, at the wedding of Henry IV of France to the

■ **15.33** Pieter de Hooch. *Portrait of a Family Making Music,* 1683. Oil on canvas, 39″ × 47″ (99 × 119 cm). Cleveland Museum of Art. (Gift of Hanna Fund, 51,355.) Some prosperous Dutch citizens are relaxing by performing and listening to music.

same Marie de' Medici whom Rubens was to portray a generation later (see Figure 15.26).

It is no coincidence that both of Peri's works as well as many that followed were written on Classical subjects, because the Camerata had taken its initial inspiration from Greek drama. The story of Orpheus and Eurydice, furthermore, had a special appeal for composers, because it told how the musician Orpheus was able to soften the heart of the King of the Underworld by his music and thereby win back his wife Eurydice from the dead. The theme was treated many times in the music of the following four hundred years, yet no subsequent version is more moving or psychologically convincing than the one by Claudio Monteverdi (1567–1643), the first great genius in the history of opera.

Monteverdi's *L'Orfeo* was first performed in 1607. Its composer brought to the new form not only a complete understanding of the possibilities of monody but in addition an impressive mastery of traditional polyphonic forms such as the madrigal. Equally important for the success of his work was Monteverdi's remarkable dramatic instinct and his ability to transform emotion into musical terms. The contrast between the pastoral gaiety of the first act of L'Orfeo, depicting the happy couple's love, and the scene in the second act in which Orpheus is brought the news of his wife's death is achieved with marvelous expressive power.

 To hear a selection from Monteverdi's *L'Orfeo,* play track 6 on the Listening CD.

In *L'Orfeo,* his first opera, Monteverdi was able to breathe real life into the academic principles of the Florentine Camerata, but the work was written for his noble employer, the Duke of Mantua, and intended for a limited aristocratic public. Monteverdi lived long enough to see the new dramatic form achieve widespread popularity at all levels of society throughout Europe. It did not take long for a taste for Italian opera to spread to Germany and Austria and then to England where, by the end of the century, Italian singers dominated the London stage. The French showed their usual unwillingness to adopt a foreign invention wholesale; nonetheless, the leading composer at the court of Louis XIV was a Florentine who tactfully changed his name from Giovanni Battista Lulli to Jean Baptiste Lully (1632–1687). His stately tragedies, which were performed throughout Europe, incorporated long sections of ballet, a custom continued by his most illustrious successor, Jean Philippe Rameau (1683–1764).

Opera won its largest public in Italy proper. In Venice alone, where Monteverdi spent the last thirty years of his life, at least sixteen theaters were built between 1637—when the first public opera house was opened— and the end of the century. As in the Elizabethan the-ater (see Figure 14.28), the design of these opera houses separated the upper ranks of society, who sat in the boxes, from the ordinary citizens—the groundlings.

There is a notable similarity, too, between Elizabethan drama and opera in the way they responded to growing popularity. Just as the groundlings of Shakespeare's day demanded ever more sensational and melodramatic entertainment, so the increasingly demanding and vociferous opera public required new ways of being satisfied. The two chief means by which these desires were met became a feature of most operas written during the following century. The first was the provision of lavish stage spectacles involving mechanical cloud machines that descended from above and disgorged singers and dancers, complex lighting effects that gave the illusion that the stage was being engulfed by fire, apparently magical transformations, and so on—baroque extravagance at its most extreme. The second was a move away from the declamatory recitative of the earliest operas to self-contained musical "numbers" known as **arias.** (In the case of both opera and many other musical forms, we continue to use technical terms like aria in their Italian form—a demonstration of the crucial role played by Italy, and in particular Florence, in the history of music.) The function of music as servant of the drama was beginning to change. Beauty of melody and the technical virtuosity of the singers became the glory of baroque opera, although at the expense of dramatic truth.

Baroque Instrumental and Vocal Music: Johann Sebastian Bach

The development of opera permitted the dramatic retelling of mythological or historical tales. Sacred texts as stories derived from the Bible were set to music in a form known as the **oratorio,** which had begun to appear toward the end of the sixteenth century. One of the baroque masters of the oratorio was the Italian Giacomo Carissimi (1605–1674), whose works, based on well-known biblical episodes, include *The Judgment of Solomon* and *Job.* By the dramatic use of the chorus, simple textures, and driving rhythms, Carissimi created an effect of strength and power that late-twentieth-century listeners have begun to rediscover.

The concept of the public performance of religious works, rather than secular operas, made a special appeal to Protestant Germans. Heinrich Schütz (1585–1672) wrote a wide variety of oratorios and other sacred works. In his early *Psalms of David* (1619), Schütz combined the choral technique of Renaissance composers like Gabrieli with the vividness and drama of the madrigal. His setting of *The Seven Last Words of Christ* (1645–1646) uses soloists, chorus, and instruments to create a complex sequence of narrative sections (recitatives), vocal ensembles, and choruses. Among his last works are three settings of the Passion, the events

of the last days of the life of Jesus, in the accounts given by Matthew, Luke, and John. Written in 1666, these works revert to the style of a century earlier, with none of the instrumental coloring generally typical of baroque music, both sacred and secular.

Schütz is, in fact, one of the few great baroque composers who, so far as is known, never wrote any purely instrumental music. The fact is all the more striking because the Baroque period was notable for the emergence of independent instrumental compositions unrelated to texts of any kind. Girolamo Frescobaldi (1583–1643), the greatest organ virtuoso of his day—he was organist at Saint Peter's in Rome—wrote a series of rhapsodic fantasies known as toccatas that combined extreme technical complexity with emotional and dramatic expression. His slightly earlier Dutch contemporary Jan Pieterszoon Sweelinck (1562–1621), organist at Amsterdam, built sets of variations out of different settings of a chorale melody or hymn tune. The writing of **chorale variations,** as this type of piece became known, became popular throughout the Baroque period.

The Danish Dietrich Buxtehude (1637–1707), who spent most of his career in Germany, combined the brilliance of the toccata form with the use of a chorale theme in his chorale fantasies. Starting with a simple hymn melody, he composed free-form rhapsodies that are almost improvisational in style. His suites for **harpsichord** (the keyboard instrument that was a primary forerunner of the modern piano) include movements in variation form, various dances, slow lyric pieces, and other forms; like other composers of his day, Buxtehude used the keyboard suite as a kind of compendium of musical forms.

One of the greatest composers of the late Baroque period was Domenico Scarlatti (1685–1757). The greatest virtuoso of his day on the harpsichord, Scarlatti wrote hundreds of **sonatas** (short instrumental pieces) for it and laid the foundation for modern keyboard techniques.

Scarlatti's contemporary Georg Frideric Handel (1685–1759) was born in Halle, Germany, christened with the name he later changed to George Frederick Handel when he settled in England and became a naturalized citizen. London was to prove the scene of his greatest successes, among them *Messiah,* first performed in Dublin in 1742. This oratorio is among the most familiar of all baroque musical masterpieces, and its most famous section is the *Hallelujah Chorus.*

 To hear the *Hallelujah Chorus* from Handel's *Messiah,* play track 7 on the Listening CD.

Handel also wrote operas, including a series of masterpieces in Italian that were written for performance in England. Among their greatest glories are the arias, which are permeated by Handel's rich melodic sense; one of the most famous is "Ombra mai fu" from *Xerxes,* often called the "Largo." His best-known orchestral works are probably *The Water Music* and *The Music for the Royal Fireworks,* both originally designed for outdoor performance. Written for a large number of instruments, they were later rearranged for regular concerts.

In the year that saw the births of both Scarlatti and Handel, Johann Sebastian Bach (1685–1750) was born in Eisenach, Germany, into a family that had already been producing musicians for more than a century. With the exception of opera, which, as a devout Lutheran, did not interest him, Bach mastered every musical form of the time, pouring forth some of the most intellectually rigorous and spiritually profound music ever created.

It is among the more remarkable achievements in the history of the arts that most of Bach's music was produced under conditions of grinding toil as organist and choir director in relatively provincial German towns. Even Leipzig—where Bach spent twenty-seven years (from 1723 to his death) as **kantor** ("music director") at the school attached to Saint Thomas's Church—was far removed from the glittering centers of European culture where most artistic developments were taking place. As a result, Bach was little known as a composer during his lifetime and virtually forgotten after his death; only in the nineteenth century did his body of work become known and published. He has since taken his place at the head of the Western musical tradition as the figure who raised the art of polyphony to its highest level.

If the sheer quantity of music Bach wrote is stupefying, so is the complexity of his musical thought. Among the styles he preferred was the **fugue** (derived from the Latin word for "flight"). In the course of a fugue a single theme is passed from voice to voice or instrument to instrument (generally four in number), each imitating the principal theme in turn. The theme thus becomes combined with itself and, in the process, the composer creates a seamless web of sound in which each musical part is equally important; this technique is called *counterpoint (contrapunctum).* Bach's ability to endow this highly intellectual technique with emotional power is little short of miraculous. The range of emotions Bach's fugues cover can best be appreciated by sampling his two books of twenty-four preludes and fugues each, known collectively as *The Well-Tempered Clavier.* Each of the forty-eight preludes and fugues creates its own mood while remaining logically organized according to contrapuntal technique.

Many of Bach's important works are permeated by a single concern: the expression of his deep religious faith. A significant number were written in his capacity as director of music at Saint Thomas's for performance in the church throughout the year. Organ music, masses, oratorios, motets; in all of these he could use

music to glorify God and to explore the deeper mysteries of Christianity. His **chorale preludes** consist of variations on chorales and use familiar and well-loved songs as the basis for a kind of musical improvisation. He wrote some two hundred **cantatas** (short oratorios) made up of sections of declamatory recitative and lyrical arias, which contain an almost inexhaustible range of religious emotions, from joyful celebrations of life to profound meditations on death. Most overwhelming of all is his setting of the *Saint Matthew Passion,* the story of the trial and crucifixion of Jesus as recorded in the Gospel of Matthew. In this immense work, Bach asserted his Lutheranism by using the German rather than the Latin translation of the Gospel and by incorporating Lutheran chorales. The use of self-contained arias is Italian, though, and the spirit of deep religious commitment and dramatic fervor can only be described as universal.

It would be a mistake to think of Bach as somehow unworldly and touched only by religious emotions. Certainly his own life had its share of domestic happiness and tragedy. His parents died when he was ten, leaving him to be brought up by an elder brother, who treated him with less than complete kindness. At the age of fifteen, Bach jumped at the chance to leave home and become a choirboy in the little town of Luneberg. He spent the next few years moving from place to place, perfecting his skills as organist, violinist, and composer.

In 1707 Bach married his cousin, Maria Barbara Bach, who bore him seven children, of whom four died in infancy. Bach was always devoted to his family, and the loss of these children, followed by the death of his wife in 1720, made a deep impression on him. It may have been to provide a mother for his three surviving sons that he remarried in 1721. At any event, his new wife, Anna Magdalena, proved a loving companion, bearing him thirteen more children and helping him with the preparation and copying of his music. One of the shortest but most touching of Bach's works is the little song, "Bist du bei mir," which has survived, copied out in her notebook. The words are: "As long as you are with me I could face my death and eternal rest with joy. How peaceful would my end be if your beautiful hands could close my faithful eyes." (Some scholars now believe that the song may have originally been written by G. H. Stölzel, a contemporary musician whom Bach much admired.)

The move to Leipzig in 1723 was dictated at least in part by the need to provide suitable schooling for his children, although it also offered the stability and security Bach seems to have required. The subsequent years of continual work took their toll, however. Bach's sight had never been good, and the incessant copying of manuscripts produced a continual deterioration. In 1749, Bach was persuaded to undergo two disastrous operations, which left him totally blind. A few months later his sight was suddenly restored, but within ten days he died of apoplexy (stroke).

Although most of Bach's works are on religious themes, the best known of all, the six *Brandenburg Concertos,* were written for the private entertainment of a minor prince, the Margrave of Brandenburg. Their form follows the Italian *concerto grosso,* an orchestral composition in three **movements** (sections): fast-slow-fast. The form had been pioneered by the Venetian composer Antonio Vivaldi (c. 1676–1741), who delighted in strong contrasts between the orchestra, generally made up of string instruments and a solo instrument, often a violin, but sometimes a flute, bassoon, or other wind instrument. Vivaldi's most often performed work is a set of four violin concertos known as *The Four Seasons,* which illustrate in sound a set of four poems describing the characteristics of the annual cycle of the seasons. The one for Spring, for example, describes the happy songs and dances with which the season is celebrated. Four of Bach's six *Brandenburg Concertos* use a group of solo instruments, although the group differs from work to work. The whole set forms a kind of compendium of the possibilities of instrumental color, a true virtuoso achievement requiring equal virtuosity in performance. The musical mood is light, as befits works written primarily for entertainment, but Bach was incapable of writing music without depth, and the slow movements in particular are strikingly beautiful.

 To hear a movement from the Spring concerto from Vivaldi's *Four Seasons,* play track 8 on the Listening CD.

The *Second Brandenburg Concerto* is written for solo trumpet, recorder, oboe, and violin accompanied by a string orchestra. The first movement combines all of these to produce a brilliant rhythmic effect as the solo instruments now emerge from the orchestra, now rejoin it. The melodic line avoids short themes. Instead, as in much baroque music, the melodies are long, elaborate patterns that seem to spread and evolve, having much of the ornateness of baroque art. It does not require the ability to read music to see as well as hear how the opening theme of the Second Brandenburg Concerto forms an unbroken line of sound, rising and falling and doubling back as it luxuriantly spreads itself out.

The slow second movement forms a tranquil and meditative interlude. The brilliant tone of the trumpet would be inappropriate here and Bach therefore omits it, leaving the recorder, oboe, and violin quietly to intertwine in a delicate web of sound. After its enforced silence, the trumpet seems to burst out irrepressibly at the beginning of the third movement, claiming the right to set the mood of limitless energy that carries the work to its conclusion.

 To hear the last movement of Bach's *Brandenburg Concerto No. 2*, play track 9 on the Listening CD.

PHILOSOPHY AND SCIENCE IN THE BAROQUE PERIOD

Throughout the seventeenth century, philosophy—like the visual arts—continued to extend and intensify ideas first developed in the Renaissance by pushing them to new extremes. With the spread of humanism, the sixteenth century had seen a growing spirit of philosophical and scientific inquiry. In the Baroque period, that fresh approach to the world and its phenomena was expressed in clear and consistent terms for the first time since the Greeks. It might be said, in fact, that if the Renaissance marked the birth of modern philosophy, the seventeenth century signaled its coming of age.

Briefly stated, the chief difference between the intellectual attitudes of the medieval period and those inaugurated by the Renaissance was a turning away from the contemplation of the absolute and eternal to a study of the particular and the perceivable. Philosophy ceased to be the preserve of the theologians and instead became an independent discipline, no longer prepared to accept a supernatural or divine explanation for the world and human existence.

For better or worse, we are still living with the consequences of this momentous change. The importance of objective truth, objectively demonstrated, lies at the heart of all scientific method and most modern philosophy. Yet great thinkers before the Renaissance, such as Thomas Aquinas (1225–1274), had also asked questions in an attempt to understand the world and its workings. How did seventeenth-century scientists and philosophers differ from their predecessors in dealing with age-old problems?

The basic difference lay in their approach. When, for example, Aquinas was concerned with the theory of motion, he discussed it in abstract, metaphysical terms. Armed with his copy of Aristotle, he claimed that "motion exists because things which are in a state

of potentiality seek to actualize themselves." When Galileo wanted to study motion and learn how bodies move in time and space, he climbed to the top of the Leaning Tower of Pisa and dropped weights to watch them fall. It would be difficult to imagine a more dramatic rejection of abstract generalization in favor of objective demonstration (see **TABLE 15.2**).

Galileo

The life and work of Galileo Galilei (1564–1642) are typical both of the progress made by science in the seventeenth century and of the problems it encountered. Galileo changed the scientific world in two ways: first, as the stargazer who claimed that his observations through the telescope proved Copernicus right, for which statement he was tried and condemned by the Inquisition; and second, as the founder of modern physics. Although he is probably better known for his work in astronomy, from the scientific point of view his contribution to physics is more important.

Born in Pisa, Galileo inherited from his father Vincenzo, who had been one of the original members of the Florentine Camerata, a lively prose style and a fondness for music. As a student at the University of Padua from 1581 to 1592, he began to study medicine but soon changed to mathematics. After a few months back in Pisa, he took a position at the University of Padua as professor of mathematics, remaining there from 1592 to 1600.

In Padua, Galileo designed and built his own telescopes [**FIG. 15.34**] and saw for the first time the craters of the moon, sunspots, the phases of Venus, and other phenomena that showed that the universe is in a constant state of change, as Copernicus had claimed. From the time of Aristotle, however, it had been a firm belief that the heavens were unalterable, representing perfection of form and movement. Galileo's discoveries thus disproved what had been a basic philosophical princi-

TABLE 15.2 *Principal Scientific Discoveries of the Seventeenth Century*

1609	Kepler announces his first two laws of planetary motion
1614	Napier invents logarithms
1632	Galileo publishes *Dialogue Concerning the Two Chief World Systems*
1643	Torricelli invents the barometer
1660	Boyle formulates his law of gas pressure
1675	Royal Observatory founded at Greenwich, England
1687	Isaac Newton publishes his account of the principle of gravity
1710	Leibnitz invents new notations of calculus
1717	Fahrenheit invents system of measuring temperature

■ **15.34** Galileo Galilei. Telescopes, 1609. Museum of Science, Florence. After his death near Florence in 1642, many of Galileo's instruments, including these telescopes, were collected and preserved. The Museum of Science in Florence, where they can now be seen, was one of the earliest museums to be devoted to scientific rather than artistic works.

ple for 2000 years and so outraged a professor of philosophy at Padua that he refused to shake his own prejudices by having a look through a telescope for himself.

The more triumphantly Galileo proclaimed his findings, the more he found himself involved in something beyond mere scientific controversy. His real opponent was the church, which had officially adopted the Ptolemaic view of the universe: that the earth formed the center of the universe around which the sun, moon, and planets circled. This theory accorded well with the Bible, which seemed to suggest that the sun moves rather than the earth; for the church, the Bible naturally took precedence over any reasoning or speculation independent of theology. Galileo, however, considered ecclesiastical officials incompetent to evaluate scientific matters and refused to give way. When he began to claim publicly that his discoveries had proved

what Copernicus had theorized but could not validate, the church initiated a case against him on the grounds of heresy.

Galileo had meanwhile returned to his beloved Pisa, where he found himself in considerable danger from the Inquisition. In 1615, he left for Rome to defend his position in the presence of Pope Paul V. He failed and, as a result, was censured and prohibited from spreading the Copernican theory either by teaching or publication.

In 1632, Galileo returned to the attack when a former friend was elected pope. He submitted to Pope Urban VIII a *Dialogue Concerning the Two Chief World Systems,* having carefully chosen the dialogue form so that he could put ideas into the mouths of other characters and thereby claim that they were not his own. Once more, under pressure from the Jesuits, Galileo was summoned to Rome. In 1633, he was put on trial after spending several months in prison. His pleas of old age and poor health won no sympathy from the tribunal. He was made to recant and humiliate himself publicly and was sentenced to prison for the rest of his life. (It might well have appealed to Galileo's sense of bitter irony that three hundred forty-seven years later, in 1980, Pope John Paul II, a fellow countryman of the Polish Copernicus, ordered the case to be reopened so that belated justice might be done.)

Influential friends managed to secure Galileo a relatively comfortable house arrest in his villa just outside Florence, and he retired there to work on physics. His last and most important scientific work, *Dialogues Concerning Two New Sciences,* was published in 1638. In it he examined many long-standing problems, including that of motion, always basing his conclusions on practical experiment and observation. In the process he established the outlines of many areas of modern physics.

In all his work Galileo set forth a new way of approaching scientific problems. Instead of trying to understand the final cause or cosmic purpose of natural events and phenomena, he tried to explain their character and the manner in which they came about. He changed the question from why? to what? and how?

Descartes

Scientific investigation could not solve every problem of human existence. While it could try to explain and interpret objective phenomena, there remained other more subjective areas of experience involving ethical and spiritual questions. The Counter-Reformation on the one hand and the Protestant churches on the other claimed to have discovered the answers. The debates nevertheless continued, most notably in the writings of the French philosopher René Descartes

VALUES

Scientific Truth

Many factors contributed to the growth of science in the seventeenth century. Among them were the spread of education, the discovery of the Americas, explorations in Asia and Africa, and the development of urban life. Perhaps the most important of all was a growing skepticism in traditional religious beliefs, induced by the violent wars of religion provoked by the Reformation and Counter-Reformation.

One of the leading figures in the scientific revolution, Francis Bacon (1561–1626), wrote that scientists should follow the example of Columbus, and think all things possible until all things could be tested. This emphasis on the "empirical faculty"—learning based on experience—is a method of drawing general conclusions from particular observations. Medieval thinkers, relying on the examples of Aristotle and Ptolemy, had devised general theories and then looked for specific examples to confirm them. Scientific truth sought to reason in the opposite way: start from the specific and use it to establish a general theory, a process known as **induction.** Above all, the new scientists took nothing for granted and regarded no opinion as "settled and immovable."

The search for objective, scientific truth required the invention of new instruments. Galileo's telescope allowed him to study the sky and revolutionize astronomy. Other researchers used another form of optical instrument—the microscope—to analyze blood and describe bacteria. The invention of the thermometer and barometer made it possible to perform atmospheric experiments.

With the increasing circulation of knowledge, scientists could spread and test their ideas. An international scientific community began to develop, stimulated by the formation of academies and learned societies. The most influential were the Royal Society for Improving Natural Knowledge, founded in London in 1662, and the French Académie des Sciences, founded in 1666. By means of published accounts and private correspondence, scientists were able to see how their own discoveries related to other fields.

Although the study of natural science does not involve questions of theology or philosophy, the growing interest in finding rational explanations for natural phenomena led to a change in views of religion. Most early scientists continued to believe in God but abandoned the medieval view of the deity as incomprehensible Creator and Judge. Rather, they saw God as the builder of a world-machine, which He then put into motion. Humans could come to understand how the machine worked, but only if they used their powers of reason to establish scientific truth.

(1596–1650), often called the "Father of Modern Philosophy" [**FIG. 15.35**].

In many ways Descartes' philosophical position was symptomatic of his age. He was educated at a Jesuit school but found traditional theological teaching unsatisfactory. Turning to science and mathematics, he began a lifelong search for reliable evidence in his quest to distinguish truth from falsehood. Attacking philosophical problems, his prime concern was to establish criteria for defining reality. His chief published works, the *Discourse on Method* (1637) and the *Meditations* (1641), contain a step-by-step account of how he arrived at his conclusions.

According to Descartes, the first essential in the search for truth was to make a fresh start by refusing to believe anything that could not be decisively proved to be true. This required that he doubt all of his previously held beliefs, including the evidence of his own senses. By stripping away all uncertainties he reached a basis of indubitable certainty on which he could build: that he existed. The very act of doubting proved that

he was a thinking being. As he put it in a famous phrase in his second *Meditation,* "Cogito, ergo sum" ("I think, therefore I am").

From this foundation Descartes proceeded to reconstruct the world he had taken to pieces by considering the nature of material objects. He was guided by the principle that whatever is clearly and distinctly perceived must exist. He was aware at the same time that our perceptions of the exact nature of these objects are extremely likely to be incorrect and misleading. When, for example, we look at the sun we see it as a very small disk, although the sun is really an immense globe. We must be careful, therefore, not to assume that our perceptions are bound to be accurate. All that they demonstrate is the simple existence of the object in question.

If the idea of the sun comes from the perception, however inaccurate, of something that actually exists, what of God? Is the idea of a divine being imagined or based on truth? Descartes concluded that the very fact that we who are imperfect and doubting can con-

■ **15.35** Frans Hals. *René Descartes*. Oil on panel. Statens Museum for Kunst (Royal Museum of Fine Arts), Copenhagen. The great French philosopher spent many years in Holland, where his ideas found a receptive audience and where Hals painted this portrait.

ceive of a perfect God proves that our conception is based on a reality. In other words, who could ever have imagined God unless God existed? At the center of the Cartesian philosophical system, therefore, lay the belief in a perfect being, not necessarily to be identified with the God of the Old and New Testaments, who had created a world permeated by perfect (that is, mathematical) principles.

At first, this may seem inconsistent with Descartes' position as the founder of modern rational thought. It may seem even stranger that, just at the time when scientific investigators like Galileo were explaining natural phenomena without recourse to divine intervention, Descartes succeeded in proving to his own satisfaction the undeniable existence of a divine being. Yet a more careful look at Descartes' method reveals that both he and Galileo shared the same fundamental confidence in the rational powers of human beings.

Hobbes and Locke

Although Galileo and Descartes represent the major trends in seventeenth-century thought, other impor-

tant figures made their own individual contributions. Descartes' fellow countryman Blaise Pascal (1623–1662), for example, launched a strong attack on the Jesuits while providing his own somewhat eccentric defense of Christianity. A more mystical approach to religion was that of the Dutch philosopher Baruch Spinoza (1632–1677), whose concept of the ideal unity of nature later made a strong appeal to nineteenth-century Romantics. The English philosopher Thomas Hobbes (1588–1679), however, had little in common with any of his contemporaries—as he was frequently at pains to make plain. For Hobbes, truth lay only in material things: "All that is real is material, and what is not material is not real."

Hobbes is thus one of the first modern proponents of **materialism** and, like many of his materialist successors, was interested in solving political rather than philosophical problems. Born in the year of the Spanish Armada, Hobbes lived through the turbulent English Civil War, a period marked by constant instability and political confusion. Perhaps in consequence, he developed an enthusiasm for the authority of the law, as represented by the king, that verges on totalitarianism.

Hobbes' political philosophy finds its fullest statement in his book *Leviathan*, first published in 1651. The theory of society that he describes there totally denies the existence in the universe of any divinely established morality. (Hobbes never denied the existence of God, not wishing to outrage public and ecclesiastical opinion unnecessarily, although he might as well have.) According to Hobbes, all laws are created by humans to protect themselves from one another—a necessary precaution in view of human greed and violence. Organized society in consequence is arrived at when individuals give up their personal liberty in order to achieve security. As a result, the ideal state is that in which there is the greatest security, specifically one ruled by an absolute ruler.

From its first appearance *Leviathan* created a scandal; it has been subjected to continual attack ever since. Hobbes managed to offend both of the chief participants in the intellectual debates of the day: the theologians, by telling them that their doctrines were irrelevant and their terminology "insignificant sound"; and the rationalists, by claiming that human beings, far from being capable of the highest intellectual achievements, are dangerous and aggressive creatures who need to be saved from themselves. Hobbes' pessimism and the extreme nature of his position have won him few wholehearted supporters in the centuries since his death. Yet many modern readers, like others in the time since *Leviathan* first appeared, must reluctantly admit that there is at least a grain of truth in his picture of society, which can be attested to by personal experience and observation. At the very least, his political philosophy is valuable as a diagnosis and a warning of some aspects of human potential virtually all of his

contemporaries and many of his successors have preferred to ignore.

The leading English thinker of the generation following Hobbes was John Locke (1632–1704), whose work helped pave the way for the European Enlightenment. The son of a country attorney, his education followed traditional Classical lines, but the young Locke was more interested in medicine and the new experimental sciences. In 1666, he became physician and secretary to the future Earl of Shaftesbury, who encouraged Locke's interest in political philosophy.

In his first works, Locke explored the subjects of property and trade, and the role of the monarch in a modern state. He then turned to more general questions: What is the nature of ideas? How do we get them? and What are the limitations of human knowledge? His most influential work, *An Essay Concerning Human Understanding,* appeared in 1690. In it he argued against a theory of innate ideas, proposing instead that our ideas derive from our perceptions. Thus, our notions and characters are based on our own individual sense impressions and on our reflections on them, not on inherited values. Rejecting traditional metaphors and metaphysics, Locke advocated an antimonarchical, property-oriented political philosophy, in which ideas served as a kind of personal property.

For his successors in the eighteenth century, Locke seemed to have set human nature free from the control of divine authority. Humans were no longer perceived as the victims of innate original sin or the accidents of birth, but instead derived their ideas and personalities from their experiences. Like many of the spokesmen of the Enlightenment, Voltaire acknowledged the importance of Locke's ideas, while few modern students of education or theory of knowledge have failed to be influenced by him.

LITERATURE IN THE SEVENTEENTH CENTURY

French Baroque Comedy and Tragedy

It is hardly surprising that the Baroque age, which put so high a premium on the expression of dramatic emotion, should have been an important period in the development of the theater. In France in particular, three of the greatest names in the history of drama were active simultaneously, all of them benefiting at one point or another from the patronage of Louis XIV.

Molière was the stage name of Jean Baptiste Poquelin (1622–1673), who was the creator of a new theatrical form, French baroque comedy. Having first made his reputation as an actor, he turned to the writing of drama as a means of deflating pretense and

pomposity. In his best works, the deceptions or delusions of the principal characters are revealed for what they are with good humor and considerable understanding of human foibles, but dramatic truth is never sacrificed to mere comic effect. Unlike so many comic creations, Molière's characters remain believable. Jourdain, the good-natured social climber of *Le Bourgeois Gentilhomme,* and Harpagon, the absurd miser of *L'Avare,* are by no means mere symbols of their respective vices but victims of those vices, albeit willing ones. Even the unpleasant Tartuffe in the play of that name is a living character with his own brand of hypocrisy.

Classical motifs play a strong part in the works of the two greatest tragic dramatists of the age: Pierre Corneille (1606–1684) and Jean Racine (1639–1699). Corneille created, as counterpart to Molière's comedy, French baroque tragedy. Most of his plays take as their theme an event in Classical history or mythology, which is often used to express eternal truths about human behavior. The themes of patriotism, as in *Horace,* or martyrdom, as in *Polyeucte,* are certainly as relevant today as they were in seventeenth-century France or in ancient Greece or Rome. However, most people's response to Corneille's treatment of subjects such as these is probably conditioned by the degree to which they enjoy the cut and thrust of rhetorical debate.

Racine may well provide for many modern readers an easier entry into the world of French baroque tragedy. Although for the most part he followed the dramatic form and framework established by Corneille, he used it to explore different areas of human experience. His recurrent theme is self-destruction: the inability to control one's own jealousy, passion, or ambition and the resulting inability, as tragic as it is inevitable, to survive its effects. Furthermore, in plays like *Phèdre,* he explored the psychological state of mind of his principal characters, probing for the same kind of understanding of motivation that Monteverdi tried to achieve in music.

The Novel in Spain: Cervantes

By the middle of the sixteenth century, the writing of fiction in Spain had begun to take a characteristic form that was to influence future European fiction. The **picaresque novel** (in Spanish *pícaro* means "rogue" or "knave") was a Spanish invention; books of this genre tell a story that revolves around a rogue or adventurer. The earliest example is *Lazarillo de Tormes,* which appeared anonymously in 1554. Its hero, Lazarillo, is brought up among beggars and thieves, and many of the episodes serve as an excuse to satirize priests and church officials—so much so, in fact, that the Inquisition ordered parts omitted in later printings. Unlike prose being written elsewhere at the time, the

style is colloquial, even racy, and heavy with irony.

Although *Don Quixote,* by general agreement the greatest novel in the Spanish language, has picaresque elements, its style and subject are both far more subtle and complex. Miguel de Cervantes Saavedra (1547–1616), its author, set out to satirize medieval tales of chivalry and romance by inventing a character—Don Quixote—who is an amiable elderly gentleman looking for the chivalry of storybooks in real life. This apparently simple idea takes on almost infinite levels of meaning, as Don Quixote pursues his ideals, in general without much success, in a world with little time for romance or honor. In his adventures, which bring him into contact with all levels of Spanish society, he is accompanied by his squire Sancho Panza, whose shrewd practicality serves as a foil for his own unworldliness.

The structure of the novel is as leisurely and seemingly as rambling as the Don's wanderings. Yet the various episodes are linked by the constant confrontation between reality and illusion, the real world and that of the imagination. Thus at one level the book becomes a meditation on the relationship between art and life. By the end of his life, Don Quixote has learned painfully that his noble aspirations cannot be reconciled with the realities of the world, and he dies disillusioned. In the last part of the book, where the humor of the hero's mishaps does not conceal their pathos, Cervantes reaches that rare height of artistry where comedy and tragedy are indistinguishable.

The English Metaphysical Poets

In England, the pinnacle of dramatic expression had been reached by the turn of the century in the works of Shakespeare, and nothing remotely comparable was to follow. The literary form that proved most productive during the seventeenth century was that of lyric poetry, probably because of its ability to express personal emotions, although the single greatest English work of the age was John Milton's epic poem *Paradise Lost.*

It may well be argued that the most important of all literary achievements of the seventeenth century was not an original artistic creation but a translation. It is difficult to know precisely how to categorize the Authorized Version of the Bible, commissioned by King James I and first published in 1611, often called the only great work of literature ever produced by a committee. The fifty-four scholars and translators who worked on the task deliberately tried to create a "biblical" style that would transcend the tone of English as it was then generally used. Their success can be measured by the immense influence the King James Bible has had on speakers and writers of English ever since (see Chapter 14). It remained the Authorized Version for English-speaking people until the late nineteenth century, when it was revised in light of the new developments in biblical studies.

Of all seventeenth-century literary figures, the group known as the metaphysical poets, with their concern to give intellectual expression to emotional experience, make a particular appeal to modern readers. As is often pointed out, the label **metaphysical** is highly misleading for two reasons. In the first place, it suggests an organized group of poets consciously following a common style. It is true that the earliest poet to write in the metaphysical style, John Donne (1572–1631), exerted a strong influence on a whole generation of younger poets, but there never existed any unified group or school. (Some scholars would, in fact, classify Donne's style as *Mannerist.*)

Second, *metaphysical* seems to imply that the principal subject of their poetry was philosophical speculation on abstruse questions. It is certainly true that the metaphysical poets were interested in ideas and that they used complex forms of expression and a rich vocabulary to express them. The chief subject of their poems was not philosophy, however, but themselves—particularly their own emotions.

Yet this concern with self-analysis should not suggest a limitation of vision. Some critics have ranked Donne as second only to the Shakespeare of the Sonnets in range and depth of expression. Donne's intellectual brilliance and his love of paradox and ambiguity make his poetry sometimes difficult to follow. Donne always avoided the conventional, either in word or thought, while the swift changes of mood within a single short poem from light banter to the utmost seriousness can confuse the careless reader. Although it sometimes takes patience to unravel his full meaning, the effort is more than amply rewarded by contact with one of the most daring and honest of poets.

Donne's poems took on widely differing areas of human experience, ranging from some of the most passionate and frank discussions of sexual love ever penned to profound meditations on human mortality and the nature of the soul. Born a Catholic, he traveled widely as a young man and seems to have led a hectic and exciting life. He abandoned Catholicism, perhaps in part to improve his chances of success in Protestant England and, in 1601, on the threshold of a successful career in public life, entered Parliament. The same year, however, he secretly married his patron's sixteen-year-old niece, Anne More. Her father had him dismissed and even imprisoned for a few days, and Donne's career never recovered from the disgrace.

Although Donne's marriage proved a happy one, its early years were clouded by debt, ill health, and frustration. In 1615, at the urging of friends, he finally joined the Anglican Church and entered the ministry. As a preacher he soon became known as among the greatest of his day. By 1621, Donne was appointed to one of the most prestigious positions in London: Dean

of Saint Paul's. During his last years he became increasingly obsessed with death. After a serious illness in the spring of 1631, he preached his own funeral sermon and died within a few weeks.

Thus the successful worldliness of the early years gave way to the growing somberness of his later career. We might expect a similar progression from light to darkness in his work, yet throughout his life the two forces of physical passion and religious intensity seem to have been equally dominant, with the result that in much of his poetry each is sometimes used to express the other.

The poems of Donne's younger contemporary, Richard Crashaw (1613–1649), blend extreme emotion and religious fervor in a way that is completely typical of much baroque art. Yet Crashaw serves as a reminder of the danger of combining groups of artists under a single label, because although he shares many points in common with the other metaphysical poets, his work as a whole strikes a unique note.

There can be little doubt that Crashaw's obsessive preoccupation with pain and suffering has more than a touch of masochism and that his religious fervor is extreme even by baroque standards. Some of the intensity is doubtless a result of his violent rejection of his father's Puritanism and his own enthusiastic conversion to Catholicism. Stylistically Crashaw owed much to the influence of the flamboyant Italian baroque poet Giambattista Marino (1569–1625), whose virtuoso literary devices he imitated. Yet the eroticism that so often tinges his spiritual fervor gives a highly individual air to his work.

Milton's Heroic Vision

While the past hundred years have seen a growing appreciation for Donne and his followers, the reputation of John Milton has undergone some notable ups and downs. Revered in the centuries following his death, Milton's work came under fire in the early years of the twentieth century from major poets such as T. S. Eliot and Ezra Pound, who claimed that his influence on his successors had been pernicious and led much of subsequent English poetry astray. Now that the dust of these attacks has settled, Milton has resumed his place as one of the greatest of English poets. The power of his spiritual vision, coupled with his heroic attempt to wrestle with the great problems of human existence, seems in fact to speak directly to the uncertainties of our own time.

Milton's life was fraught with controversy. An outstanding student with astonishing facility in languages, he spent his early years traveling widely in Europe and in the composition of relatively lightweight verse—lightweight, that is, when compared to what was to come. Among his most entertaining early works are the companion poems "L'Allegro" and "Il Penseroso," which compare the cheerful and the contemplative character, to appropriate scenery. They were probably written in 1632, following his graduation from Cambridge.

By 1640, however, he had become involved in the tricky issues raised by the English Civil War and the related problems of church government. He launched into the fray with a series of radical pamphlets that advocated, among other things, divorce on the grounds of incompatibility. (It is presumably no coincidence that his own wife had left him six weeks after their marriage.) His growing support for Oliver Cromwell and the Puritan cause won him an influential position at home but considerable enmity in continental Europe, where he was seen as the defender of those who had ordered the execution of King Charles I in 1649. The strain of his secretarial and diplomatic duties during the following years destroyed his eyesight, but although completely blind, he continued to work with the help of assistants.

When Charles II was restored to power (in 1660), Milton lost his position and was fortunate not to lose his life or liberty. Retired to private life, he spent his remaining years in the composition of three massive works: *Paradise Lost* (1667), *Paradise Regained* (1671), and *Samson Agonistes* (1671).

By almost universal agreement, Milton's most important, if not most accessible, work is *Paradise Lost,* composed in the early 1660s and published in 1667. It was intended as an account of the fall of Adam and Eve, and its avowed purpose was to "justify the ways of God to men." The epic is in twelve books (originally ten, but Milton later revised the divisions), written in blank verse.

Milton's language and imagery present an almost inexhaustible combination of biblical and Classical reference. From the very first lines of Book I, where the poet calls on a Classical Muse to help him tell the tale of The Fall, the two great Western cultural traditions are inextricably linked. Like Bach, Milton represents the summation of these traditions. In his work, Renaissance and Reformation meet and blend to create the most complete statement in English of Christian humanism, the philosophical reconciliation of humanist principles with Christian doctrine. To the Renaissance Milton owed his grounding in the Classics. In composing *Paradise Lost,* an epic poem that touches on the whole range of human experience, he was deliberately inviting comparison to Homer and Vergil. His language is also classical in its inspiration, with its long, grammatically complex sentences and preference for abstract terms. Yet his deeply felt Christianity and his emphasis on human guilt and repentance mark him as a product of the Reformation. Furthermore, although he may have tried to transcend the limitations of his own age, he was as much a child of

his time as any of the other artists discussed in this chapter. The dramatic fervor of Bernini, the spiritual certainty of Bach, the psychological insight of Monteverdi, the humanity of Rembrandt—all have their place in Milton's work and mark him, too, as an essentially baroque figure.

SUMMARY

The Counter-Reformation If the history and culture of the sixteenth century were profoundly affected by the Reformation, the prime element to influence those of the seventeenth century was the Counter-Reformation, the Catholic Church's campaign to regain its authority and influence. By clarifying and forcefully asserting their teaching, backed up with a vigorous program of missionary work, church leaders aimed to present a positive and optimistic appearance that would eliminate past discords.

Counter-Reformation Art Among the resources used by Counter-Reformation reformers were the arts. Imposing architectural complexes like Saint Peter's Square in Rome, paintings and sculptures, music and verse could all reinforce the glory of the church. In some cases, works were commissioned officially; in others, artists responded individually to the spirit of the times. Bernini's *Saint Teresa in Ecstasy,* a statue that reflects the artist's own devout faith, was commissioned for the church in Rome in which it still stands. Richard Crashaw's poetry represents a more personal response to the religious ideas of his day.

The Rise of Science For all the importance of religion, the seventeenth century was also marked by significant developments in philosophy and science. Galileo, the father of modern physics, revolutionized astronomy by proving Copernicus's claims of the previous century correct. Thinkers like Descartes and Hobbes, instead of accepting official church teachings, tried to examine the problems of human existence by their own intellectual approaches. Descartes was the founder of modern rational thought (although a believer in a supreme being); Hobbes was the first modern materialist.

The Arts in the Baroque Period The principal artistic style of the seventeenth century was the *baroque,* a term originally used for the visual arts but also applied by extension to the other arts of the period. Although the baroque style was created in Italy, it spread quickly throughout Europe and was even carried to the New World by missionaries. Baroque art is marked by a wide range of achievements, but there are several common features. Artists in the seventeenth century were concerned with expressing strong emotions, either religious or personal. This in turn led to an interest in exploring human behavior from a psychological point of view. With the new subjects came new techniques, many of which emphasized the virtuosity of the artist. These in turn led to the invention of new forms: for example, in music that of opera, and in painting that of landscape scenes.

Baroque Painting Two artists created the chief characteristics of baroque painting in Rome around 1600. Caravaggio's work is emotional and dominated by strong contrasts of light and darkness. Annibale Carracci painted scenes of movement and splendor, many on Classical themes. Both strongly influenced their contemporaries and successors.

Caravaggio's use of light was the forerunner of the work of artists as diverse as the Spaniard Velázquez and the Dutchman Vermeer, while Carracci's choice of classical subjects was followed by the French Poussin. The two greatest painters of Northern Europe—Rembrandt and Rubens—were also influenced by the ideas of their day. Rembrandt used strong contrasts of light and dark to paint deeply felt religious scenes as well as the self-portraits that explore his own inner emotions. Rubens, one of the most versatile of artists, ranged from mythological subjects to historical paintings like the Marie de' Medici cycle to intimate personal portraits.

Baroque Architecture Although the seventeenth century saw architects increasingly employed in designing private houses, most of the principal building projects were public. At Rome the leading architect was Bernini, also one of the greatest sculptors of the age, whose churches, fountains, and piazzas changed the face of the city. In his sculpture, Bernini drew on virtually all the themes of Counter-Reformation art, including mythological and religious works and vividly characterized portraits. The other great building project of the century was the palace built for Louis XIV at Versailles, where the splendor of the Sun King was reflected in the grandiose decoration scheme.

Music in the Counter-Reformation In music, as in the visual arts, the Baroque period was one of experimentation and high achievement. Counter-Reformation policy required that music for church use should be easily understood and appreciated, as was already the case in the Protestant countries of Northern Europe. At the same time, there was a growing demand for secular music for performance both in public and at home.

The Birth of Opera One of the most important innovations of the seventeenth century was opera. The first opera was performed just before 1600 in Florence, and by the middle of the century, opera houses were being built throughout Europe to house the new art form. The first great composer of operas was the Italian Monteverdi, whose *L'Orfeo* is the earliest opera still performed. Among later musicians of the period to write works for the theater was the German Georg Frideric Handel, many of whose operas were composed to Italian texts for performance in England.

Bach and Handel Handel also wrote oratorios (sacred dramas performed without any staging); the most famous of all oratorios is his *Messiah*. The oratorio was a form with a special appeal for Protestant Germans; among its leading exponents was Heinrich Schütz. The greatest of all Lutheran composers, Johann Sebastian Bach, wrote masterpieces in just about every musical form other than opera. Like many of the leading artists of the age, Bach produced works inspired by deep religious faith as well as pieces like the *Brandenburg Concertos* composed for private entertainment.

Baroque Literature The baroque interest in emotion and drama, exemplified by the invention of opera, led to important developments in writing for the theater as well as in the style of poetic composition and the invention of new literary forms. In France, the comedies of Molière and the tragedies of Corneille and Racine, written in part under the patronage of Louis XIV, illustrate the dramatic range of the period. The religious fervor of the English metaphysical poets is yet another sign of baroque artists' concern with questions of faith and belief. The more practical problems involved in reconciling ideals with the realities of life are described in *Don Quixote,* one of the first great novels in Western literature. The most monumental of all literary works of the seventeenth century, Milton's *Paradise Lost,* aimed to combine the principles of Renaissance humanism with Christian teaching. Its drama, spirituality, and psychological insight mark it as a truly baroque masterpiece.

For all the immense range of baroque art and culture, its principal lines were drawn by reactions to the Counter-Reformation. Furthermore, paradoxically enough, by the end of the seventeenth century, a movement that had been inspired by opposition to the Reformation had accomplished many of the aims of the earlier reformers. Through art, music, and literature both artists and their audiences were made more familiar with questions of religious faith and more sensitive to aspects of human experience.

KEY TERMS

Aria A solo song in an opera, oratorio, or cantata, which often gives the singer a chance to display technical skill

Cantata Short oratorios, alternating arias and recitative

Chiaroscuro In painting, extreme contrasts between dark and light

Chorale prelude Piece of instrumental music that uses a familiar hymn or sacred song as the basis of an improvisation

Chorale variation Piece of instrumental music consisting of a set of variations on a familiar hymn or sacred song

Concerto grosso A composition for orchestra, generally in three movements: fast-slow-fast

Fugue Piece of music in which the same themes are repeated and combined in counterpoint

Galleria (In a Baroque Palace) Formal reception hall

Harpsichord Keyboard instrument, the forerunner of the modern piano

Induction A system of reasoning that starts from a specific case and tries to use it to establish a general theory

Kantor Music director of a church choir (and often of a school attached to the church)

Materialism Belief that nothing exists except material things

Metaphysical Term used (confusingly) to describe a group of seventeenth-century English poets

Monody See *recitative*

Movement In music, a self-contained section of a longer work

Opera A dramatic performance in which the text is sung rather than spoken

Oratorio Sacred drama performed without action, scenery, or costume, generally in a church or concert hall

Piazza The Italian word for a city square or market place

Picaresque novel Novel telling a story involving a rogue or adventurer

Recitative The free declaration of a vocal line, with only a simple instrumental accompaniment for support. The inventors of opera, who thought they were reviving ancient Greek tragedy, used the Greek term: *monody.*

Sonata In the seventeenth century, a short instrumental piece. Over time, the term came to be used for an instrumental piece in several movements.

Toccata An instrumental composition combining extreme technical complexity and dramatic expression

PRONUNCIATION GUIDE

Annibale Carracci:	Ann-IB-a-lay Car-AHCH-ee
Baroque:	Bar-OAK
Borromini:	Bo-roe-MEE-ni
Caravaggio:	Ca-ra-VAJ-o
Cervantes:	Ser-VAN-teez
concerto grosso:	con-CHAIR-towe GRO-sew
Corneille:	Cor-NAY
Descartes:	Day-CART
Donne:	DUN
Don Quixote:	Don Ki-HOTE-ee
Galileo:	Ga-li-LAY-owe
Gentileschi:	Gen-ti-LESS-key

Lorrain:	Lor-ANN
Molière:	Mo-li-AIR
Monteverdi:	Mon-te-VAIR-di
Orfeo:	Or-FAY-owe
piazza:	pi-AT-sa
Racine:	Rah-SEEN
Rameau:	Ram-OWE
Rembrandt van Rijn:	REM-brant van RHINE
Rubens:	RUE-buns
Schütz:	SHUETS
Sweelinck:	SVAY-link
Theotokopoulos:	They-ot-ok-OP-ou-loss
toccata:	to-CA-ta
Velázquez:	Ve-LASS-kes
Vermeer:	Vur-MERE
Versailles:	Ver-SIGH

EXERCISES

1. What characteristics are common to all the arts in the Baroque period? Give examples.
2. Compare the paintings of Caravaggio and Rembrandt with regard to subject matter and use of contrasts in light.
3. Describe the birth and early development of opera.
4. What were the principal scientific and philosophical movements of the seventeenth century? To what extent were they the result of external historical factors?
5. Discuss the treatment of religious subjects by baroque artists, writers, and musicians. How does it contrast with that of the Renaissance?

YOUR RESOURCES

▪ **ExploringHumanities CD-ROM**
 • Interactive Map: Europe at the Onset of the Thirty Years' War
 • Reading Selections: Cervantes, *Don Quixote,* Part I; Milton, *Paradise Lost,* Book I; Bacon, *Novum Organum;* Bunyon, *Pilgrim's Progress;* Descartes, *Discourse on Method;* Descartes, *Principles of Philosophy*
▪ **Website http://art.wadsworth.com/cunningham**
 • Chapter 15 Quiz
 • Links
▪ **Audio CD**
 • Monteverdi: *Quel sguardo sdegnosetto*
 • Handel: *The Messiah, Hallelujah Chorus*
 • Vivaldi: *Four Seasons, "Spring" Allegro*
 • Bach: *Brandenburg Concerto No. 2, Allegro Assai*

FURTHER READING

Adams, L. S. *Key Monuments of the Baroque.* Denver: Westview Press, 1999. A valuable collection both for an overview and for the study of individual works.

Boyd, M. ed. *Oxford Composer Companions: J. S. Bach.* New York: Oxford University Press, 1999. A comprehensive guide to practically every aspect of Bach's life and work, including his influence on later composers.

Brook, Stephen, ed. *Opera: A Penguin Anthology.* New York: Penguin, 1996. An anthology of writing about operatic history and practice, with a fair number of backstage anecdotes.

Brown, J. *The Golden Age of Painting in Spain.* New Haven, CT: Yale University Press, 1991. An authoritative survey of an enormously rich field.

Chastel, Andre. *French Art: The Ancien Regime, 1620–1775.* New York: Flammarion, 1996. A masterly survey that includes the period covered in the following chapter. Beautifully illustrated.

Franits, W. *Looking at Seventeenth-Century Dutch Art: Realism Reconsidered.* Cambridge: Cambridge University Press, 1997. A study of Dutch painting that takes a new look at some traditional views.

Machamer, Peter, ed. *The Cambridge Companion to Galileo.* New York: Cambridge University Press, 1998. A series of essays discussing a wide variety of aspects of Galileo's work and relating it to the culture of his times.

Muller, Sheila D., ed. *Dutch Art: An Encyclopedia.* New York: Garland Publishers, 1997. A handy reference work filled with useful information on artists, patrons, and the culture of the times.

North, M. *Art and Commerce in the Dutch Golden Age.* New Haven, CT: Yale University Press, 1997. This interesting study of the relationship between comerce and the arts emphasizes economic factors rather than cultural ones.

Price, Curtis, ed. *Music and Society: The Early Baroque Era.* Upper Saddle River, NJ: Prentice Hall, 1994. A series of essays discussing the social and cultural context of Baroque music, organized by city (Rome, Florence, Vienna, London, etc.).

Rodis-Lewis, Genevieve, trans. Jane Marie Todd. *Descartes: His Life and Thought.* Ithaca, NY: Cornell University Press, 1998. An excellent introduction to one of the most influential thinkers of his times.

Schama, Simon. *Rembrandt's Eyes.* New York: Penguin, 1999. A marvelously rich meditation on Rembrandt and his world, which combines meticulous critical analysis with a sympathetic vision of the world of seventeenth-century Holland.

READING SELECTIONS

THOMAS HOBBES
from LEVIATHAN

Hobbes' philosophical masterpiece describes the life of humans in their natural state as "solitary, poor, nasty, brutish, and short." The only remedy lies in the imposition of social order, if possible in the form of an absolute monarchy. In this chapter, Hobbes' cynical view of human motivation is expressed in a tone of cool irony, which blends wit and detachment.

Part I, Chapter XIII

Of the Natural Condition of Mankind, As Concerning Their Felicity and Misery

Nature hath made men so equal in the faculties of body and mind as that though there be found one man sometimes manifestly stronger in body, or of quicker mind than another, yet when all is reckoned together, the difference between man and man is not so considerable as that one man can thereupon claim to himself any benefit to which another may not pretend as well as he. For as to the strength of body, the weakest has strength enough to kill the strongest, either by secret machination, or by confederacy with others that are in the same danger with himself.

And as to the faculties of the mind, setting aside the arts grounded upon words, and especially that skill of proceeding upon general and infallible rules, called science, which very few have, and but in few things, as being not a native faculty, born with us, nor attained, as prudence, while we look after somewhat else, I find yet a greater equality amongst men than that of strength. For prudence is but experience; which equal time equally bestows on all men, in those things they equally apply themselves unto. That which may perhaps make such equality incredible is but a vain conceit of one's own wisdom, which almost all men think they have in a greater degree than the vulgar; that is, than all men but themselves and a few others, whom by fame or for concurring with themselves they approve. For such is the nature of men, that howsoever they may acknowledge many others to be more witty or more eloquent or more learned, yet they will hardly believe there be many so wise as themselves. For they see their own wit at hand, and other men's at a distance. But this proveth rather that men are in that point equal, than unequal. For there is not ordinarily a greater sign of the equal distribution of anything than that every man is contented with his share.

From this equality of ability ariseth equality of hope in the attaining of our ends. And therefore if any two men desire the same thing, which nevertheless they cannot both enjoy, they become enemies; and in the way to their end (which is principally their own conservation, and sometimes their delectation only), endeavor to destroy or subdue one another. And from hence it comes to pass, that where an invader hath no more to fear than another man's single power, if one plant, sow, build or possess a convenient seat, others may probably be expected to come prepared with forces united to dispossess and deprive him, not only of the fruit of his labor, but also of his life or liberty. And the invader again is in the like danger of another.

And from this diffidence of one another, there is no way for any man to secure himself so reasonable as anticipation; that is, by force or wiles to master the persons of all men he can, so long till he see no other power great enough to endanger him; and this is no more than his own conservation requireth, and is generally allowed. Also because there be some, that taking pleasure in contemplating their own power in the acts of conquest, which they pursue farther than their security requires; if others, that otherwise would be glad to be at ease within modest bounds, should not by invasion increase their power, they would not be able, long time, by standing only on their defense, to subsist. And by consequence, such augmentation of dominion over men, being necessary to a man's conservation, it ought to be allowed him.

Again, men have no pleasure, but on the contrary a great deal of grief, in keeping company, where there is no power able to overawe them all: For every man looketh that his companion should value him at the same rate he sets upon himself; and upon all signs of contempt or undervaluing, naturally endeavors, as far as he dares (which amongst them that have no common power to keep them in quiet, is far enough to make them destroy each other), to extort a greater value from his contemners, by damage; and from others, by the example.

So that in the nature of man, we find three principal causes of quarrel. First, competition; second, diffidence; third, glory.

The first maketh men invade for gain; the second, for safety; and the third, for reputation. The first use violence, to make themselves masters of other men's persons, wives, children, and cattle; the second, to defend them; the third, for trifles, as a word, a smile, a different opinion, and any other sign of undervalue, either direct in their persons, or by reflection in their kindred, their friends, their nation, their profession, or their name.

Hereby it is manifest, that during the time men live without a common power to keep them all in awe, they are in that condition which is called war; and such a war as is of every man, against every man. For war consisteth not in battle only or the act of fighting; but in a tract of time, wherein the will to contend by battle is sufficiently known; and therefore the notion of time is to be considered in the nature of war, as it is in the nature of weather. For as the nature of foul weather lieth not in a shower or two of rain, but in an inclination thereto of many days together; so the nature of war consisteth not in actual fighting, but in the known disposition thereto during all the time there is no assurance to the contrary. All other time is peace.

Whatsoever therefore is consequent to a time of war, where every man is enemy to every man, the same is consequent to the time wherein men live without other security than what their own strength and their own invention shall furnish them withal. In such condition there is no place for industry, because the fruit thereof is uncertain, and consequently no culture of the earth; no navigation, nor use of the commodities that may be imported by sea; no commodious building; no instruments of moving and removing such things as require much force; no knowledge of the face of the earth; no account of time; no arts; no letters; no society; and, which is worst of all, continual fear, and danger of violent death; and the life of man, solitary, poor, nasty, brutish, and short.

It may seem strange to some man that has not well weighed these things, that nature should thus dissociate and render men apt to invade and destroy one another; and he may therefore, not trusting to this inference made from the passions, desire perhaps to have the same confirmed by experience. Let him therefore consider with himself; when taking a journey, he arms himself, and seeks to go well accompanied; when going to sleep, he locks his doors; when even in his house he locks his chests; and then when he knows

there be laws and public officers, armed, to revenge all injuries shall be done him; what opinion he has of his fellow-subjects, when he rides armed; of his fellow-citizens, when he locks his doors; and of his children and servants, when he locks his chests. Does he not there as much accuse mankind by his actions as I do by my words? But neither of us accuse man's nature in it. The desires and other passions of man are in themselves no sin. No more are the actions that proceed from those passions, till they know a law that forbids them; which till laws be made they cannot know; nor can any law be made till they have agreed upon the person that shall make it.

It may peradventure [perhaps; perchance] be thought there was never such a time nor condition of war as this; and I believe it was never generally so over all the world; but there are many places where they live so now. For the savage people in many places of America, except the government of small families, the concord whereof dependeth on natural lust, have no government at all, and live at this day in that brutish manner, as I said before. Howsoever, it may be perceived what manner of life there would be, where there were no common power to fear, by the manner of life which men that have formerly lived under a peaceful government use to degenerate into in a civil war.

But though there had never been any time wherein particular men were in a condition of war one against another, yet in all times, kings and persons of sovereign authority, because of their independence, are in continual jealousies, and in the state and posture of gladiators; having their weapons pointing, and their eyes fixed on one another; that is, their forts, garrisons, and guns, upon the frontiers of their kingdoms; and continual spies upon their neighbors; which is a posture of war. But because they uphold thereby the industry of their subjects, there does not follow from it that misery which accompanies the liberty of particular men.

To this war of every man against every man, this also is consequent, that nothing can be unjust. The notions of right and wrong, justice and injustice, have there no place. Where there is no common power, there is no law; where no law, no injustice. Force and fraud are in war the two cardinal virtues. Justice and injustice are none of the faculties neither of the body nor mind. If they were, they might be in a man that were alone in the world, as well as his senses and passions. They are qualities that relate to men in society, not in solitude. It is consequent also to the same condition that there be no propriety, no dominion, no "mine" and "thine" distinct; but only that to be every man's that he can get; and for so long as he can keep it. And thus much for the ill condition which every man by mere nature is actually placed in; though with a possibility to come out of it, consisting partly in the passions, partly in his reason.

The passions that incline men to peace are fear of death, desire of such things as are necessary to commodious living, and a hope by their industry to obtain them. And reason suggesteth convenient articles of peace, upon which men may be drawn to agreement. These articles are they which otherwise are called the laws of nature. . . .

JOHN LOCKE
from AN ESSAY CONCERNING HUMAN UNDERSTANDING, BOOK I

Book I of Locke's most important work deals with the nature of ideas. Arguing against the notion of innate ideas, Locke propounds the theory that knowledge depends on perception. In later sections, he discusses the nature of language and argues that it consists of a series of counters put in motion by associative ideas. By the end of his essay, he claims that the knowledge of each of us is limited to the sense impressions we have accumulated, and to our interpretation of them. Thus we should not believe ourselves inescapably trapped by divine preordination or the accidents of birth.

Book I: Of Innate Notions

Chapter I: Introduction

1. Since it is the *understanding* that sets man above the rest of sensible beings, and gives him all the advantage and dominion which he has over them; it is certainly a subject, even for its nobleness, worth our labor to inquire into. The understanding, like the eye, whilst it makes us see and perceive all other things, takes no notice of itself; and it requires art and pains to set it at a distance and make it its own object. But whatever be the difficulties that lie in the way of this inquiry; whatever it be that keeps us so much in the dark to ourselves; sure I am that all the light we can let in upon our minds, all the acquaintance we can make with our own understandings, will not only be very pleasant, but bring us great advantage, in directing our thoughts in the search of other things.

2. This, therefore, being my purpose—to inquire into the original, certainty, and extent of human knowledge, together with grounds and degrees of belief, opinion, and assent—I shall not at present meddle with the physical consideration of the mind; or trouble myself to examine wherein its essence consists; or by what motions of our spirits or alterations of our bodies we come to have any sensation by our organs, or any *ideas* in our understandings; and whether those *ideas* do in their formation, any or all of them, depend on matter or not. These are speculations which, however curious and entertaining, I shall decline, as lying out of my way in the design I am now upon. It shall suffice to my present purpose, to consider the discerning faculties of a man, as they are employed about the objects which they have to do with. And I shall imagine I have not wholly misemployed myself in the thoughts I shall have on this occasion, if, in this historical, plain method, I can give any account of the ways whereby our understandings come to attain those notions of things we have, and can set down any measures of the certainty of our knowledge; or the grounds of those persuasions which are to be found amongst men, so various, different, and wholly contradictory; and yet asserted somewhere or other with such assurance and confidence that he that shall take a view of the opinions of mankind, observe their opposition, and at the same time consider the fondness and devotion wherewith they are embraced, the resolution and eagerness wherewith they are maintained, may perhaps have reason to suspect, that either there is no such thing as truth at all, or that mankind hath no sufficient means to attain a certain knowledge of it . . .

5. For though the comprehension of our understandings comes exceeding short of the vast extent of things, yet we shall have cause enough to magnify the bountiful Author of our being, for that proportion and degree of knowledge he has bestowed on us, so far above all the rest of the inhabitants of this our mansion. Men have reason to be well satisfied with what God hath thought fit for them, since he hath given them (as St. Peter says) πάντα πρὸς ζωὴν καὶ εὐσέβειαν, whatsoever is necessary for the conveniences of life and information of virtue; and has put within the reach of their discovery, the comfortable provision for this life, and the way that leads to a better. How short soever their knowledge may come of an universal or

perfect comprehension of whatsoever is, yet it secures their great concernments, that they have light enough to lead them to the knowledge of their Maker, and the sight of their own duties. Men may find matter sufficient to busy their heads and employ their hands with variety, delight and satisfaction, if they will not boldly quarrel with their own constitution, and throw away the blessings their hands are filled with, because they are not big enough to grasp everything. We shall not have much reason to complain of the narrowness of our minds, if we will but employ them about what may be of use to us; for of that they are very capable. And it will be an unpardonable as well as childish peevishness, if we undervalue the advantages of our knowledge, and neglect to improve it to the ends for which it was given us, because there are some things that are set out of the reach of it. It will be no excuse to an idle and untoward servant, who would not attend his business by candlelight, to plead that he had not broad sunshine. The Candle that is set up in us shines bright enough for all our purposes. The discoveries we can make with this ought to satisfy us; and we shall then use our understandings right, when we entertain all objects in that way and proportion that they are suited to our faculties, and upon those grounds they are capable of being proposed to us; and not peremptorily or intemperately require demonstration, and demand certainty, where probability only is to be had, and which is sufficient to govern all our concernments. If we will disbelieve everything, because we cannot certainly know all things, we shall do much-what as wisely as he who would not use his legs, but sit still and perish because he had no wings to fly.

Chapter II: No Innate Principles in the Mind

1. It is an established opinion amongst some men, that there are in the understanding certain *innate principles;* some primary notions, κοιναὶ ἔννοιαι, characters, as it were stamped upon the mind of man; which the soul receives in its very first being, and brings into the world with it.

It would be sufficient to convince unprejudiced readers of the falseness of this supposition, if I should only show (as I hope I shall in the following parts of this Discourse) how men, barely by the use of their natural faculties, may attain to all the knowledge they have, without the help of any innate impressions; and may arrive at certainty, without any such original notions or principles. For I imagine any one will easily grant that it would be impertinent to suppose the ideas of colors innate in a creature to whom God hath given sight, and a power to receive them by the eyes from external objects; and no less unreasonable would it be to attribute several truths to the impressions of nature, and innate characters, when we may observe in ourselves faculties fit to attain as easy and certain knowledge of them as if they were originally imprinted on the mind.

2. There is nothing more commonly taken for granted than that there are certain principles, both speculative and practical (for they speak of both), universally agreed upon by all mankind: which therefore, they argue, must needs be the constant impressions which the souls of men receive in their first beings, and which they bring into the world with them, as necessarily and really as they do any of their inherent faculties. . . .

4. But, which is worse, this argument of universal consent, which is made use of to prove innate principles, seems to me a demonstration that there are none such: because, there are none to which all mankind give an universal as-

sent. I shall begin with the speculative, and instance in those magnified principles of demonstration, "Whatsoever is, is," and "It is impossible for the same thing to be and not to be"; which of all others, I think have the most allowed title to innate. But yet I take liberty to say, that these propositions are so far from having an universal assent, that there are a great part of mankind to whom they are not so much as known. . . .

6. To avoid this it is usually answered, that all men know and assent to them, *when they come to the use of reason;* and this is enough to prove them innate. I answer:

7. Doubtful expressions, that have scarce any signification, go for clear reasons to those who, being prepossessed, take not the pains to examine even what they themselves say. For, to apply this answer with any tolerable sense to our present purpose, it must signify one of these two things: either that as soon as men come to the use of reason these supposed native inscriptions come to be known and observed by them; or else, that the use and exercise of men's reason assists them in the discovery of these principles, and certainly makes them known to them.

Chapter III: No Innate Practical Principles

1. If those speculative Maxims, whereof we discoursed in the foregoing chapter, have not an actual universal assent from all mankind, as we there proved, it is much more visible concerning *practical* Principles, that they come short of an universal reception: and I think it will be hard to instance any one moral rule which can pretend to so general and ready an assent as, "What is, is," or to be so manifest a truth as this, that "It is impossible for the same thing to be and not to be." Whereby it is evident that they are further removed from a title to be innate; and the doubt of their being native impressions on the mind is stronger against those moral principles than the others. Not that it brings their truth at all in question. They are equally true, though not equally evident. Those speculative maxims carry their own evidence with them: but moral principles require reasoning and discourse, and some exercise of the mind, to discover the certainty of their truth. They lie not open as natural characters engraved on the mind; which, if any such were, they must needs be visible b themselves, and by their own light be certain and known to everybody. But this is no derogation to their truth and certainty; no more than it is to the truth or certainty of the three angles of a triangle being equal to two right ones: because it is not so evident as "The whole is bigger than a part," nor so apt to be assented to at first hearing. It may suffice that these moral rules are capable of demonstration; and therefore it is our own fault if we come not to a certain knowledge of them. But the ignorance wherein many men are of them, and the slowness of assent wherewith others receive them, are manifest proofs that they are not innate, and such as offer themselves to their view without searching.

2. Whether there be any such moral principles, wherein all men do agree, I appeal to any who have been but moderately conversant in the history of mankind and looked abroad beyond the smoke of their own chimneys. Where is that practical truth that is universally received, without doubt or question as it must be if innate? *Justice,* and keeping of contracts, is that which most men seem to agree in. This is a principle which is thought to extend itself to the dens of thieves, and the confederacies of the greatest villains; and they who have gone furthest towards the putting

off of humanity itself, keep faith and rules of justice one with another. I grant that outlaws themselves do this one amongst another: but it is without receiving these as the innate laws of nature. They practice them as rules of convenience within their own communities: but it is impossible to conceive that he embraces justice as a practical principle, who acts fairly with his fellow highwayman, and at the same time plunders or kills the next honest man he meets with. Justice and truth are the common ties of society; and therefore even outlaws and robbers, who break with all the world besides, must keep faith and rules of equity amongst themselves; or else they cannot hold together. But will any one say, that those that live by fraud or rapine have innate principles of truth and justice which they allow and assent to?

RICHARD CRASHAW
ON THE WOUNDS OF OUR CRUCIFIED LORD

Crashaw's religious poetry, intense even by baroque standards, often fuses fervor and eroticism. In this poem, composed as if spoken by a weeping Mary Magdalen, the image of Christ's wounds as mouths blends with the image of Mary's tears and kisses, just as the wounds and kisses themselves literally blend.

O these wakeful wounds of thine!
 Are they Mouthes? or are they eyes?
Be they Mouthes, or be they eyne,
 Each bleeding part some one supplies.

Lo! a mouth, whose full-bloom'd lips
 At too deare a rate are roses.
Lo! a blood-shot eye! that weepes
 And many a cruell teare discloses.

O thou that on this foot hast laid
 Many a kisse, and many a Teare. 10
Now thou shal't have all repaid.
 Whatsoe're thy charges were.

This foot hath got a Mouth and lippes,
 To pay the sweet summe of thy kisses:
To pay thy Teares, and Eye that weeps
 In stead of Teares such Gems as this is.

The difference only this appeares.
 (Nor can the change offend)
The debt is paid in Ruby-Teares,
 Which thou in Pearles did'st lend. 20

JOHN DONNE
THE CANONIZATION

Donne's poetry, like Crashaw's, contains both religious and erotic elements. In "The Canonization" the first three verses express with mounting passion the intensity of the poet's love. The climactic image of the phoenix, the mythological bird that died only to rise from its own ashes, is especially powerful, since in the sixteenth and seventeenth centuries to die often connoted the consummation of the physical act of love. Yet when Donne wants to cap even this image he turns to the language of religion, in the picture of the two lovers canonized.

For Godsake, hold your tongue, and let me
 love,

Or chide my palsy, or my gout,
My five gray hairs, or ruined fortune flout.
 With wealth your state, your mind with
 arts improve.
 Take you a course, get you a place,
 Observe his honor, or his grace,
Or the King's real, or his stamped face
 Contemplate; what you will, approve,
 So you will let me love.

Alas, alas, who's injured by my love? 10
 What merchant's ships have my sighs
 drowned?
Who says my tears have overflowed his
 ground?
 When did my colds a forward spring
 remove?
 When did the heats which my veins fill
 Add one more to the plaguy bill?
Soldiers find wars, and lawyers find out still
 Litigious men, which quarrels move,
 Though she and I do love.

Call us what you will, we are made such
 by love;
 Call her one, me another fly, 20
We're tapers too, and at our own cost die,
 And we in us find the eagle and the dove.
 The phoenix riddle hath more wit
 By us; we two being one, are it.
So, to one neutral thing both sexes fit.
 We die and rise the same, and prove
 Mysterious by this love.
We can die by it, if not live by love,
 And if unfit for tombs and hearse
Our legend be, it will be fit for verse; 30
 And if no piece of chronicle we prove,
 We'll build in sonnets pretty rooms;
 As well a well-wrought urn becomes
The greatest ashes, as half-acre tombs.

 And by these hymns, all shall approve
 Us *canonized* for Love.
And thus invoke us: "You, whom reverend
 love
 Made one another's hermitage;
You, to whom love was peace, that now is
 rage;
Who did the whole world's soul extract, 40
 and drove
 Into the glasses of your eyes
 (So made such mirrors, and such spies,
That they did all to you epitomize)
 Countries, towns, courts: beg from above
 A pattern of your love!"

MOLIÈRE (JEAN BAPTISTE POQUELIN)
from TARTUFFE, ACT III

Tartuffe, the central character of Molière's play, is a sensual man who hypocritically pretends to be a religious ascetic. Although most people see through his deceit, he manages to fool Orgon, a wealthy Parisian, who is so taken in by Tartuffe's pose that he decides to leave his fortune to him. In order to open Orgon's eyes to the truth—and to protect their own interests—his wife, Elmire,

and his son, Damis, decide to expose Tartuffe as a fraud. Dorine, the maid, hides Damis in a cupboard from which he can watch Elmire and Tartuffe together. As Damis and Elmire suspected he would, Tartuffe proceeds to try to seduce Elmire. Damis bursts out of hiding and, when Orgon enters, denounces Tartuffe to his father. Yet even this is not sufficient to convince the stubborn old man, and Tartuffe's clever protestations of guilt turn Orgon's anger against his son. The scene ends with Tartuffe triumphant, about to be adopted as Orgon's son.

As the play continues, Tartuffe returns to the assault of Elmire's honor, only to be caught by Orgon himself. Not only does he show no regret for his actions, he also takes immediate possession of Orgon's property and tries to have him evicted from his own house. At the very last moment Tartuffe is arrested and Orgon saved, but only by a sudden and completely unexpected royal decree. If this were real life and not a comedy, Molière seems to be saying, Tartuffe would probably get away with his diabolical scheme.

In Act III of the play we see Tartuffe in all his poses, as well as in his revelation of his true nature to Elmire. Molière brilliantly conveys the reactions of the various characters to Tartuffe while making the situation only too believable. Tartuffe's fake piety would have had a particular significance for an age in which religion was taken very seriously.

Scene 1. DAMIS, DORINE

DAMIS May lightning strike me even as I speak,
 May all men call me cowardly and weak,
 If any fear or scruple holds me back
 From settling things, at once, with that great quack!
DORINE Now, don't give way to violent emotion. 5
 Your father's merely talked about this notion,
 And words and deeds are far from being one.
 Much that is talked about is never done.
DAMIS No, I must stop that scoundrel's machinations;
 I'll go and tell him off; I'm out of patience. 10
DORINE Do calm down and be practical. I had rather
 My mistress dealt with him—and with your father.
 She has some influence with Tartuffe, I've noted.
 He hangs upon her words, seems most devoted,
 And may, indeed, be smitten by her charm. 15
 Pray Heaven it's true! 'Twould do our cause no harm.
 She sent for him, just now, to sound him out
 On this affair you're so incensed about;
 She'll find out where he stands, and tell him, too,
 What dreadful strife and trouble will ensue 20
 If he lends countenance to your father's plan.
 I couldn't get in to see him, but his man
 Says that he's almost finished with his prayers.
 Go, now. I'll catch him when he comes downstairs.
DAMIS I want to hear this conference, and I will. 25
DORINE No, they must be alone.
DAMIS Oh, I'll keep still.
DORINE Not you. I know your temper. You'd start a brawl,
 And shout and stamp your foot and spoil it all.
 Go on.
DAMIS I won't; I have a perfect right . . . 30
DORINE Lord, you're a nuisance! He's coming; get out of
 sight.

 [DAMIS CONCEALS HIMSELF IN A CLOSET
 AT THE REAR OF THE STAGE.]

Scene 2. TARTUFF, DORINE

TARTUFFE [*Observing* DORINE, *and calling to his manservant offstage*] Hang up my hair-shirt, put my scourge in
 place,
 And pray, Laurent, for Heaven's perpetual grace.
 I'm going to the prison now, to share
 My last few coins with the poor wretches there.
DORINE [*Aside*] Dear God, what affectation! What a fake! 5
TARTUFFE You wished to see me?
DORINE Yes . . .
TARTUFFE [*Taking a handkerchief from his pocket*] For
 mercy's sake,
 Please take this handkerchief, before you speak.
DORINE What?
TARTUFFE Cover that bosom, girl, The flesh is weak,
 And unclean thoughts are difficult to control.
 Such sights as that can undermine the soul. 10
DORINE Your soul, it seems, has very poor defenses,
 And flesh makes quite an impact on your senses.
 It's strange that you're so easily excited;
 My own desires are not so soon ignited,
 And if I saw you naked as a beast, 15
 Not all your hide would tempt me in the least.
TARTUFFE Girl, speak more modestly; unless you do,
 I shall be forced to take my leave of you.
DORINE Oh, no, it's I who must be on my way;
 I've just one little message to convey. 20
 Madame is coming down, and begs you, Sir,
 To wait and have a word or two with her.
TARTUFFE Gladly.
DORINE [*Aside*] That had a softening effect!
 I think my guess about him was correct.
TARTUFFE Will she be long?
DORINE No: that's her step I hear. 25
 Ah, here she is, and I shall disappear.

Scene 3. ELMIRE, TARTUFFE

TARTUFFE May Heaven, whose infinite goodness we
 adore,
 Preserve your body and soul forevermore,
 And bless your days, and answer thus the plea
 Of one who is its humblest votary.
ELMIRE I thank you for that pious wish. But please, 5
 Do take a chair and let's be more at ease.

 [THEY SIT DOWN.]

TARTUFFE I trust that you are once more well and strong?
ELMIRE Oh, yes: the fever didn't last for long.
TARTUFFE My prayers are too unworthy, I am sure,
 To have gained from Heaven this most gracious cure; 10
 But lately, Madam, my every supplication
 Has had for object your recuperation.
ELMIRE You shouldn't have troubled so. I don't deserve it.
TARTUFFE Your health is priceless, Madam, and to pre-
 serve it
 I'd gladly give my own, in all sincerity. 15
ELMIRE Sir, you outdo us all in Christian charity.
 You've been most kind. I count myself your debtor.
TARTUFFE 'Twas nothing, Madam. I long to serve you
 better.
ELMIRE There's a private matter I'm anxious to discuss.
 I'm glad there's no one here to hinder us. 20

TARTUFFE I too am glad; it floods my heart with bliss
 To find myself alone with you like this.
 For just this chance I've prayed with all my power
 But prayed in vain, until this happy hour.
ELMIRE This won't take long, Sir, and I hope you'll be 25
 Entirely frank and unconstrained with me.
TARTUFFE Indeed, there's nothing I had rather do
 Than bare my inmost heart and soul to you.
 First, let me say that what remarks I've made
 About the constant visits you are paid 30
 Were prompted not by any mean emotion,
 But rather by a pure and deep devotion,
 A fervent zeal . . .
ELMIRE No need for explanation.
 Your sole concern, I'm sure, was my salvation.
TARTUFFE [*Taking* ELMIRE's *hand and pressing her*
 fingertips]
 Quite so; and such great fervor do I feel . . . 35
ELMIRE Ooh! Please! You're pinching.
TARTUFFE 'Twas from excess of zeal.
 I never meant to cause you pain, I swear.
 I'd rather . . .

 [HE PLACES HIS HAND ON ELMIRE'S KNEE.]

ELMIRE What can your hand be doing there?
TARTUFFE Feeling your gown: what soft, fine-woven stuff!
ELMIRE Please, I'm extremely ticklish. That's enough. 40

[SHE DRAWS HER CHAIR AWAY; TARTUFFE PULLS HIS AFTER HER.]

TARTUFFE [*Fondling the lace collar of her gown*]
 My, my, what lovely lacework on your dress!
 The workmanship's miraculous, no less.
 I've not seen anything to equal it.
ELMIRE Yes, quite. But let's talk business for a bit.
 They say my husband means to break his word 45
 And give his daughter to you, Sir. Had you heard?
TARTUFFE He did once mention it. But I confess
 I dream of quite a different happiness.
 It's elsewhere, Madam, that my eyes discern
 The promise of that bliss for which I yearn. 50
ELMIRE I see: you care for nothing here below.
TARTUFFE Ah, well my heart's not made of stone,
 you know.
ELMIRE All your desires mount heavenward, I'm sure,
 In scorn of all that's earthly and impure.
TARTUFFE A love of heavenly beauty does not preclude 55
 A proper love for earthly pulchritude;
 Our senses are quite rightly captivated
 By perfect works our Maker has created.
 Some glory clings to all that Heaven has made;
 In you, all Heaven's marvels are displayed. 60
 On that fair face, such beauties have been lavished,
 The eyes are dazzled and the heart is ravished;
 How could I look on you, O flawless creature,
 And not adore the Author of all Nature,
 Feeling a love both passionate and pure 65
 For you, his triumph of self-portraiture?
 At first, I trembled lest that love should be
 A subtle snare that Hell had laid for me;
 I vowed to flee the sight of you, eschewing
 A rapture that might prove my soul's undoing; 70
 But soon, fair being, I became aware
 That my deep passion could be made to square
 With rectitude, and with my bounden duty,

 I thereupon surrendered to your beauty.
 It is, I know, presumptuous on my part 75
 To bring you this poor offering of my heart,
 And it is not my merit, Heaven knows,
 But your compassion on which my hopes repose.
 You are my peace, my solace, my salvation;
 On you depends my bliss or desolation; 80
 I bide your judgment and, as you think best,
 I shall be either miserable or blest.
ELMIRE Your declaration is most gallant, Sir,
 But don't you think it's out of character?
 You'd have done better to restrain your passion 85
 And think before you spoke in such a fashion.
 It ill becomes a pious man like you . . .
TARTUFFE I may be pious, but I'm human too:
 With your celestial charms before his eyes,
 A man has not the power to be wise. 90
 I know such words sound strangely, coming from me,
 But I'm no angel, nor was meant to be,
 And if you blame my passion, you must needs
 Reproach as well the charms on which it feeds.
 Your loveliness I had no sooner seen 95
 Than you became my soul's unrivalled queen;
 Before your seraph glance, divinely sweet,
 My heart's defenses crumbled in defeat,
 And nothing fasting, prayer, or tears might do
 Could stay my spirit from adoring you. 100
 My eyes, my sighs have told you in the past
 What now my lips make bold to say at last,
 And if, in your great goodness, you will deign
 To look upon your slave, and ease his pain,
 If, in compassion for my soul's distress, 105
 You'll stoop to comfort my unworthiness,
 I'll raise to you, in thanks for that sweet manna,
 An endless hymn, an infinite hosanna.
 With me, of course, there need be no anxiety,
 No fear of scandal or of notoriety. 110
 These young court gallants, whom all the ladies fancy,
 Are vain in speech, in action rash and chancy;
 When they succeed in love, the world soon knows it;
 No favor's granted them but they disclose it
 And by the looseness of their tongues profane 115
 The very altar where their hearts have lain.
 Men of my sort, however, love discreetly,
 And one may trust our reticence completely.
 My keen concern for my good name insures
 The absolute security of yours; 120
 In short, I offer you, my dear Elmire,
 Love without scandal, pleasure without fear.
ELMIRE I've heard your well-turned speeches to the end,
 And what you urge I clearly apprehend,
 Aren't you afraid that I may take a notion 125
 To tell my husband of your warm devotion,
 And that, supposing he were duly told,
 His feelings toward you might grow rather cold?
TARTUFFE I know, dear lady, that your exceeding charity
 Will lead your heart to pardon my temerity; 130
 That you'll excuse my violent affection
 As human weakness, human imperfection;
 And that O fairest! you will bear in mind
 That I'm but flesh and blood, and am not blind.
ELMIRE Some women might do otherwise, perhaps, 135
 But I shall be discreet about your lapse;
 I'll tell my husband nothing of what's occurred

If, in return, you'll give your solemn word
To advocate as forcefully as you can
The marriage of Valère and Mariane, 140
Renouncing all desire to dispossess
Another of his rightful happiness.
And . . .

Scene 4. DAMIS, ELMIRE, TARTUFFE

DAMIS *[Emerging from the closet where he has been hiding]*
No! We'll not hush up this vile affair;
I heard it all inside that closet there,
Where Heaven, in order to confound the pride
Of this great rascal, prompted me to hide.
Ah, now I have my long-awaited chance 5
To punish his deceit and arrogance,
And give my father clear and shocking proof
Of the black character of his dear Tartuffe.
ELMIRE As no, Damis; I'll be content if he
Will study to deserve my leniency. 10
I've promised silence don't make me break my word;
To make a scandal would be too absurd.
Good wives laugh off such trifles, and forget them;
Why should they tell their husbands, and upset them?
DAMIS You have your reasons for taking such a course, 15
And I have reasons, too, of equal force.
To spare him now would be insanely wrong.
I've swallowed my just wrath for far too long
And watched this insolent bigot bringing strife
And bitterness into our family life. 20
Too long he's meddled in my father's affairs,
Thwarting my marriage-hopes, and poor Valère's.
It's high time that my father was undeceived,
And now I've proof that can't be disbelieved
Proof that was furnished me by Heaven above. 25
It's too good not to take advantage of.
This is my chance, and I deserve to lose it
If, for one moment, I hesitate to use it.
ELMIRE Damis . . .
DAMIS No, I must do what I think right.
Madam, my heart is bursting with delight, 30
And, say whatever you will, I'll not consent
To lose the sweet revenge on which I'm bent.
I'll settle matters without more ado;
And here, most opportunely, is my cue.

Scene 5. ORGON, DAMIS, TARTUFFE, ELMIRE

DAMIS Father, I'm glad you've joined us. Let us advise you
Of some fresh news which doubtless will surprise you.
You've just now been repaid with interest
For all your loving-kindness to our guest.
He's proved his warm and grateful feelings toward you; 5
It's with a pair of horns he would reward you.
Yes, I surprised him with your wife, and heard
His whole adulterous offer, every word.
She, with her all too gentle disposition,
Would not have told you of his proposition; 10
But I shall not make terms with brazen lechery,
And feel that not to tell you would be treachery.
ELMIRE And I hold that one's husband's peace of mind
Should not be spoilt by tattle of this kind.
One's honor doesn't require it: to be proficient 15

In keeping men at bay is quite sufficient.
These are my sentiments, and I wish, Damis,
That you had heeded me and held your peace.

Scene 6. ORGON, DAMIS, TARTUFFE

ORGON Can it be true, this dreadful thing I hear?
TARTUFFE Yes, Brother, I'm a wicked man, I fear:
A wretched sinner, all depraved and twisted,
The greatest villain that has ever existed.
My life's one heap of crimes, which grows each minute; 5
There's naught but foulness and corruption in it;
And I perceive that Heaven, outraged by me,
Has chosen this occasion to mortify me.
Charge me with any deed you wish to name;
I'll not defend myself, but take the blame. 10
Believe what you are told, and drive Tartuffe
Like some base criminal from beneath your roof;
Yes, drive me hence, and with a parting curse:
I shan't protest, for I deserve far worse.
ORGON *[To DAMIS]* Ah, you deceitful boy, how dare you try 15
To stain his purity with so foul a lie?
DAMIS What! Are you taken in by such a bluff?
Did you not hear . . . ?
ORGON Enough, you rogue, enough!
TARTUFFE Ah, Brother, let him speak: you're being
unjust.
Believe his story; the boy deserves your trust. 20
Why, after all, should you have faith in me?
How can you know what I might do, or be?
Is it on my good actions that you base
Your favor? Do you trust my pious face?
Ah, no, don't be deceived by hollow shows; 25
I'm far, alas, from being what men suppose;
Though the world takes me for a man of worth,
I'm truly the most worthless man on earth.
[To DAMIS]
Yes, my dear son, speak out now: call me the chief
Of sinners, a wretch, a murderer, a thief; 30
Load me with all the names men most abhor;
I'll not complain, I've earned them all, and more;
I'll kneel here while you pour them on my head
As a just punishment for the life I've led.
ORGON *[To TARTUFFE]* This is too much, dear Brother.
[To DAMIS] Have you no heart?
DAMIS Are you so hoodwinked by this rascal's
art . . . ? 35
ORGON Be still, you monster.
[To TARTUFFE] Brother, I pray you, rise.
[To DAMIS] Villain!
DAMIS But . . .
ORGON Silence!
DAMIS Can't you realize . . . ?
ORGON Just one word more, and I'll tear you limb
from limb.
TARTUFFE In God's name, Brother, don't be harsh
with him. 40
I'd rather far be tortured at the stake
Than see him bear one scratch for my poor sake.
ORGON *[To DAMIS]* Ingrate!
TARTUFFE If I must beg you, on bended knee,
To pardon him . . .
ORGON *[Falling to his knees, addressing TARTUFFE]*
Such goodness cannot be!
[To DAMIS] Now, there's true charity!
DAMIS What, you . . . ?

ORGON Villain, be still! 45
 I know your motives; I know you wish him ill:
 Yes, all of you wife, children, servants, all
 Conspire against him and desire his fall,
 Employing every shameful trick you can
 To alienate me from this saintly man. 50
 Ah, but the more you seek to drive him away,
 The more I'll do to keep him. Without delay,
 I'll spite this household and confound its pride
 By giving him my daughter as his bride.
DAMIS You're going to force her to accept his hand? 55
ORGON Yes, and this very night, d'you understand?
 I shall defy you all, and make it clear
 That I'm the one who gives the orders here.
 Come, wretch, kneel down and clasp his blessed feet,
 And ask his pardon for your black deceit. 60
DAMIS I ask that swindler's pardon? Why, I'd rather . . .
ORGON So! You insult him, and defy your father!
 A stick! A stick! *[To* TARTUFFE*]* No, no release me, do.
 [To DAMIS*]* Out of my house this minute! Be off with you,
 And never dare set foot in it again. 65
DAMIS Well, I shall go, but . . .
ORGON Well, go quickly, then.
 I disinherit you; an empty purse
 Is all you'll get from me except my curse!

Scene 7. ORGON, TARTUFFE

ORGON How he blasphemed your goodness!
 What a son!
TARTUFFE Forgive him, Lord, as I've already done.
 [To ORGON*]* You can't know how it hurts when some-
 one tries
 To blacken me in my dear Brother's eyes.
ORGON Ahh!
TARTUFFE The mere thought of such ingratitude 5
 Plunges my soul into so dark a mood . . .
 Such horror grips my heart . . . I gasp for breath,
 And cannot speak, and feel myself near death.
ORGON *[He runs, in tears, to the door through which he has
 just driven his son.]*
 You blackguard! Why did I spare you? Why did I not
 Break you in little pieces on the spot? 10
 Compose yourself, and don't be hurt, dear friend.
TARTUFFE These scenes, these dreadful quarrels, have got
 to end.
 I've much upset your household, and I perceive
 That the best thing will be for me to leave.
ORGON What are you saying!
TARTUFFE They're all against me here; 15
 They'd have you think me false and insincere.
ORGON Ah, what of that? Have I ceased believing in you?
TARTUFFE Their adverse talk will certainly continue,
 And charges which you now repudiate
 You may find credible at a later date. 20
ORGON No, Brother, never.
TARTUFFE Brother, a wife can sway
 Her husband's mind in many a subtle way.
ORGON No, no.
TARTUFFE To leave at once is the solution;
 Thus only can I end their persecution.
ORGON No, no, I'll not allow it; you shall remain. 25
TARTUFFE Ah, well; 'twill mean much martyrdom
 and pain,
 But if you wish it . . .

ORGON Ah! 45
TARTUFFE Enough; so be it.
 But one thing must be settled, as I see it.
 For your dear honor, and for our friendship's sake,
 There's one precaution I feel bound to take. 30
 I shall avoid your wife, and keep away . . .
ORGON No, you shall not, 'whatever they may say.
 It pleases me to vex them, and for spite
 I'd have them see you with her day and night.
 What's more, I'm going to drive them to despair 35
 By making you my only son and heir;
 This very day, I'll give to you alone
 Clear deed and title to everything I own.
 A dear, good friend and son-in-law-to-be
 Is more than wife, or child, or kin to me. 40
 Will you accept my offer, dearest son?
TARTUFFE In all things, let the will of Heaven be done.
ORGON Poor fellow! Come, we'll go draw up the deed.
 Then let them burst with disappointed greed!

Miguel de Cervantes Saavedra
from The Adventures of Don Quixote: Part II, Chapters 10 and 11

These two chapters, from the beginning of the second half of the story, illustrate some of the many layers of meaning in Cervantes' novel. The two heroes are hidden outside the town of El Toboso, where they have come in search of Don Quixote's ideal (and imaginary) mistress, Dulcinea. Sancho, who realizes the absurdity of the quest, pretends to recognize a passing peasant girl as the beloved Dulcinea. Don Quixote can see immediately that the girl is plain, poorly dressed, and riding on a donkey, yet Sancho's conviction— as well as his own need to be convinced—persuades him to greet her as his beautiful mistress. But how to reconcile her appearance with her noble identity? The Don rushes to the conclusion that some malign, persecuting enchanter has bewitched him; as a result he cannot see the real Dulcinea on her magnificent horse, but only a rough girl on an ass. Thus he sees the truth yet invents his own interpretation of it.

The two travelers then meet up with a band of actors dressed as the characters they play: Death, Cupid, the Emperor, and so on. The resulting confusion between reality and illusion, with its implicit questioning of the nature of role-playing, has significance far beyond the man of la Mancha and his delusions.

In both of these episodes, Cervantes touches on profound questions of identity and truth, yet his style is always easy, even conversational. The narrator's apparent detachment adds to the touching effect of the Don's madness.

Chapter X. *In which is related the device Sancho adopted to enchant the Lady Dulcinea, and other incidents as comical as they are true.*

When the author of this great history comes to recount the contents of this chapter, he says that he would have liked to pass it over in silence, through fear of disbelief. For Don Quixote's delusions here reach the greatest imaginable

bounds and limits, and even exceed them, great as they are, by two bowshots. But finally he wrote the deeds down, although with fear and misgivings, just as our knight performed them. without adding or subtracting one atom of truth from the history, or taking into account any accusations of lying that might be laid against him. And he was right, for truth, though it may run thin, never breaks, and always flows over the lie like oil over water. So, continuing his history, he says that as soon as Don Quixote had hidden himself in the thicket, or oak wood, or forest, beside great El Toboso, he ordered Sancho to go back to the city, and not return to his presence without first speaking to his lady on his behalf, and begging her to be so good as to allow herself to be seen by her captive knight, and to deign to bestow her blessing on him, so that he might hope thereby to meet with the highest success in all his encounters and arduous enterprises. Sancho undertook to do as he was commanded, and to bring his master as favorable a reply as he had brought the first time.

"Go, my son," said Don Quixote, "and do not be confused when you find yourself before the light of the sun of beauty you are going to seek. How much more fortunate you are than all other squires in the world! Bear in your mind, and let it not escape you, the manner of your reception; whether she changes color whilst you are delivering her my message; whether she is stirred or troubled on hearing my name; whether she shifts from her cushion, should you, by chance, find her seated on the rich dais of her authority. If she is standing, watch whether she rests first on one foot and then on the other; whether she repeats her reply to you two or three times; whether she changes from mild to harsh, from cruel to amorous; whether she raises her hand to her hair to smooth it, although it is not untidy. In fact, my son, watch all her actions and movements; because, if you relate them to me as they were, I shall deduce what she keeps concealed in the secret places of her heart as far as concerns the matter of my love. For you must know, Sancho, if you do not know already, that between lovers the outward actions and movements they reveal when their loves are under discussion are most certain messengers, bearing news of what is going on in their innermost souls. Go, friend, and may better fortune than mine guide you, and send you better success than I expect, waiting between fear and hope in this bitter solitude where you leave me."

"I'll go, and come back quickly," said Sancho. "Cheer up that little heart of yours, dear master, for it must be no bigger now than a hazel nut.

Remember the saying that a stout heart breaks bad luck; and where there are no flitches there are no hooks; and they say, too, where you least expect it, out jumps the hare. This I say because now that it's day I hope to find my lady's palaces or castles where I least expect them, even though we didn't find them last night: and once found, leave me to deal with her alone."

"Indeed, Sancho," said Don Quixote, "you always bring in your proverbs very much to the purpose of our business. May God give me as good luck in my ventures as you have in your sayings."

At these words Sancho turned away and gave Dapple the stick; and Don Quixote stayed on horseback, resting in his stirrups and leaning on his lance, full of sad and troubled fancies, with which we will leave him and go with Sancho Panza, who parted from his master no less troubled and

thoughtful than he. So much so that scarcely had he come out of the wood than he turned round and, seeing that Don Quixote was out of sight, dismounted from his ass. Then, sitting down at the foot of a tree, he began to commune with himself to this effect:

"Now, let us learn, brother Sancho, where your worship is going. Are you going after some ass you have lost? No, certainly not. Then what are you going to look for? I am going to look, as you might say, for nothing, for a Princess, and in her the sun of beauty and all heaven besides.

And where do you expect to find this thing you speak of, Sancho? Where? In the great city of El Toboso. Very well, and on whose behalf are you going to see her? On behalf of the famous knight Don Quixote de la Mancha, who rights wrongs, gives meat to the thirsty, and drink to the hungry. All this is right enough. Now, do you know her house? My master says it will be some royal palace or proud castle. And have you by any chance ever seen her? No, neither I nor my master have ever seen her. And, if the people of El Toboso knew that you are here for the purpose of enticing away their Princesses and disturbing their ladies, do you think it would be right and proper for them to come and give you such a basting as would grind your ribs to powder and not leave you a whole bone in your body? Yes, they would be absolutely in the right, if they did not consider that I am under orders, and that

You are a messenger, my friend
And so deserve no blame.

"Don't rely on that, Sancho, for the Manchegans are honest people and very hot-tempered, and they won't stand tickling from anyone. God's truth, if they smell you, you're in for bad luck. Chuck it up, you son of a bitch, and let someone else catch it. No, you won't find me searching for a cat with three legs for someone else's pleasure. What's more, looking for Dulcinea up and down El Toboso will be like looking for little Maria in Ravenna, or the Bachelor in Salamanca. It's the Devil, the Devil himself who has put me into this business. The Devil and no other!"

This colloquy Sancho held with himself, and it led him to the following conclusion: "Well, now, there's a remedy for everything except death, beneath whose yoke we must all pass, willy-nilly, at the end of our lives. I have seen from countless signs that this master of mine is a raving lunatic who ought to be tied up—and me, I can't be much better, for since I follow him and serve him, I'm more of a fool than he—if the proverb is true that says: tell me what company you keep and I will tell you what you are; and that other one too: not with whom you are born but with whom you feed. Well, he's mad—that he is—and it's the kind of madness that generally mistakes one thing for another, and thinks white black and black white, as was clear when he said that the windmills were giants and the friars' mules dromedaries, and the flocks of sheep hostile armies, and many other things to this tune. So it won't be very difficult to make him believe that the first peasant girl I run across about here is the lady Dulcinea. If he doesn't believe it I'll swear, and if he swears I'll outswear him, and if he sticks to it I shall stick to it harder, so that, come what may, my word shall always stand up to his. Perhaps if I hold out I shall put an end to his sending me on any more of these errands, seeing what poor answers I bring back. Or perhaps he'll think, as I fancy he will, that one of those wicked enchanters who, he says, have a grudge against him, has changed her shape to vex and spite him."

With these thoughts Sancho quieted his conscience, reckoning the business as good as settled. And there he waited till afternoon, to convince Don Quixote that he had had time to go to El Toboso and back. And so well did everything turn out that when he got up to mount Dapple he saw three peasant girls coming in his direction, riding on three young asses or fillies—our author does not tell us which—though it is more credible that they were she-asses, as these are the ordinary mounts of village women; but as nothing much hangs on it, there is no reason to stop and clear up the point. To continue—as soon as Sancho saw the girls, he went back at a canter to look for his master and found him, sighing and uttering countless amorous lamentations. But as soon as Don Quixote saw him, he cried: "What luck, Sancho? Shall I mark this day with a white stone or with a black?"

"It'll be better," replied Sancho, "for your worship to mark it in red chalk, like college lists, to be plainly seen by all who look."

"At that rate," said Don Quixote, "you bring good news."

"So good," answered Sancho, "that your worship has nothing more to do than to spur Rocinante and go out into the open to see the lady

Dulcinea del Toboso, who is coming to meet your worship with two of her damsels."

"Holy Father! What is that you say, Sancho my friend?" cried Don Quixote. "See that you do not deceive me, or seek to cheer my real sadness with false joys."

"What could I gain by deceiving your worship?" replied Sancho. "Especially as you are so near to discovering the truth of my report. Spur on, sir, come, and you'll see the Princess, our mistress, coming dressed and adorned—to be brief, as befits her. Her maidens and she are one blaze of gold, all ropes of pearls, all diamonds, all rubies, all brocade of more than ten gold strands; their hair loose on their shoulders, like so many sunrays sporting in the wind and what's more, they are riding on three piebald nackneys, the finest to be seen.

"Hackneys you mean, Sancho."

"There is very little difference," replied Sancho, "between nackneys and hackneys. But let them come on whatever they may, they are the bravest ladies you could wish for, especially the Princess Dulcinea, my lady, who dazzles the senses."

"Let us go, Sancho my son," replied Don Quixote, "and as a reward for this news, as unexpected as it is welcome, I grant you the best spoil I shall gain in the first adventure that befalls me; and, if that does not content you, I grant you the fillies that my three mares will bear me this year, for you know that I left them to foal on our village common."

"The fillies for me," cried Sancho, "for it's not too certain that the spoils of the first adventure will be good ones."

At this point they came out of the wood and discovered the three village girls close at hand. Don Quixote cast his eye all along the El Toboso road, and seeing nothing but the three peasant girls, asked Sancho in great perplexity whether he had left the ladies outside the city.

"How outside the city?" he answered. "Can it be that your worship's eyes are in the back of your head that you don't see that these are they, coming along shining like the very sun at noon?"

"I can see nothing, Sancho," said Don Quixote, "but three village girls on three donkeys."

"Now God deliver me from the Devil," replied Sancho. "It is possible that three hackneys or whatever they're called, as white as driven snow, look to your worship like asses? Good Lord, if that's the truth, may my beard be plucked out."

"But I tell you, Sancho my friend," said Don Quixote, "that it is as true that they are asses, or she-asses, as that I am Don Quixote and you Sancho Panza. At least, they look so to me."

"Hush, sir!" said Sancho. "Don't say such a thing, but wipe those eyes of yours, and come and do homage to the mistress of your thoughts, who is drawing near."

As he spoke he rode forward to receive the three village girls, and dismounting from Dapple, took one of the girls' asses by the bridle and sank on both knees to the ground, saying: "Queen and Princess and Duchess of beauty, may your Highness and Mightiness deign to receive into your grace and good liking your captive knight, who stands here, turned to marble stone, all troubled and unnerved at finding himself in your magnificent presence. I am Sancho Panza, his squire, and he is the travel-weary knight, Don Quixote de la Mancha, called also by the name of the Knight of the Sad Countenance."

By this time Don Quixote had fallen on his knees beside Sancho, and was staring, with his eyes starting out of his head and a puzzled look on his face, at the person whom Sancho called Queen and Lady. And as he could see nothing in her but a country girl, and not a very handsome one at that, she being round-faced and flat-nosed, he was bewildered and amazed, and did not dare to open his lips. The village girls were equally astonished at seeing these two men, so different in appearance, down on their knees and preventing their companion from going forward. But the girl they had stopped broke the silence by crying roughly and angrily: "Get out of the way, confound you, and let us pass.

We're in a hurry."

To which Sancho replied: "O Princess and world-famous Lady of El Toboso! How is it that your magnanimous heart is not softened when you see the column and prop of knight errantry kneeling before your sublimated presence?"

On hearing this, one of the two others exclaimed: "Wait till I get my hands on you, you great ass! See how these petty gentry come and make fun of us village girls, as if we couldn't give them as good as they bring! Get on your way, and let us get on ours. You had better!"

"Rise, Sancho," said Don Quixote at this; "for I see that Fortune, unsatisfied with the ill already done me, has closed all roads by which any comfort may come to this wretched soul I bear in my body. And you, O perfection of all desire! Pinnacle of human gentleness! Sole remedy of this afflicted heart, that adores you! Now that the malignant enchanter persecutes me, and has put clouds and cataracts into my eyes, and for them alone, and for no others, has changed and transformed the peerless beauty of your countenance into the semblance of a poor peasant girl, if he has not at the same time turned mine into the appearance of some specter to make it abominable to your sight, do not refuse to look at me softly and amorously, perceiving in this submission and prostration, which I make before your deformed beauty, the humility with which my soul adores you."

"Tell that to my grandmother!" replied the girl. "Do you think I want to listen to that nonsense? Get out of the way and let us go on, and we'll thank you."

Sancho moved off and let her pass, delighted at having got well out of his fix. And no sooner did the girl who had played the part of Dulcinea find herself free than she prodded her

nackney with the point of a stick she carried, and set off at a trot across the field. But when the she-ass felt the point of the stick, which pained her more than usual, she began to plunge so wildly that my lady Dulcinea came off upon the ground. When Don Quixote saw this accident he rushed to pick her up, and Sancho to adjust and strap on the packsaddle, which had slipped under the ass's belly. But when the saddle was adjusted and Don Quixote was about to lift his enchanted mistress in his arms and place her on her ass, the lady picked herself up from the ground and spared him the trouble. For, stepping back a little, she took a short run, and resting both her hands on the ass's rump, swung her body into the saddle, lighter than a hawk, and sat astride like a man.

At which Sancho exclaimed: "By St. Roque, the lady, our mistress, is lighter than a falcon, and she could train the nimblest Cordovan or Mexican to mount like a jockey. She was over the crupper of the saddle in one jump, and now without spurs she's making that hackney gallop like a zebra. And her maidens are not much behind her. They're all going like the wind."

And so they were, for once Dulcinea was mounted, they all spurred after her and dashed away at full speed, without once looking behind them till they had gone almost two miles. Don Quixote followed them with his eyes, and, when he saw that they had disappeared, turned to Sancho and said:

"Do you see now what a spite the enchanters have against me, Sancho? See to what extremes the malice and hatred they bear me extend, for they have sought to deprive me of the happiness I should have enjoyed in seeing my mistress in her true person. In truth, I was born a very pattern for the unfortunate, and to be a target and mark for the arrows of adversity. You must observe also, Sancho, that these traitors were not satisfied with changing and transforming my Dulcinea, but transformed her and changed her into a figure as low and ugly as that peasant girl's. And they have deprived her too of something most proper to great ladies, which is the sweet smell they have from always moving among ambergris and flowers. For I must tell you, Sancho, that when I went to help my Dulcinea on to her hackney—as you say it was, though it seemed a she-ass to me—I got such a whiff of raw garlic as stank me out and poisoned me to the heart."

"Oh, the curs!" cried Sancho at this. "Oh, wretched and spiteful enchanters! I should like to see you strung up by the gills like pilchards on a reed. Wise you are and powerful and much evil you do! It should be enough for you, ruffians, to have changed the pearls of my lady's eyes into corktree galls, and her hair of purest gold into red ox tail bristles, and all her features, in fact, from good to bad, without meddling with her smell. For from that at least we have gathered what lay concealed beneath that ugly crust. Though, to tell you the truth, I never saw her ugliness, but only her beauty, which was enhanced and perfected by a mole she had on her right lip, like a moustache, with seven or eight red hairs like threads of gold more than nine inches long."

"To judge from the mole," said Don Quixote, "by the correspondence there is between those on the face and those on the body, Dulcinea must have another on the fleshy part of her thigh, on the same side as the one on her face. But hairs of the length you indicate are very long for moles."

"But I can assure your worship," replied Sancho, "that there they were, as if they had been born with her."

"I believe it, friend," said Don Quixote, "for nature has put nothing on Dulcinea which is not perfect and well-finished. And so, if she had a hundred moles like the one you speak of on her, they would not be moles, but moons and shining stars. But tell me, Sancho, that which appeared to me to be a pack-saddle and which you set straight—was it a plain saddle or a side-saddle?"

"It was just a lady's saddle," replied Sancho, "with an outdoor covering so rich that it was worth half a kingdom."

"And to think that I did not see all this, Sancho!" cried Don Quixote, "Now I say once more—and I will repeat it a thousand times—I am the most unfortunate of men."

And that rascal Sancho had all he could do to hide his amusement on hearing this crazy talk from his master, whom he had so beautifully deceived. In the end, after much further conversation between the pair, they mounted their beasts once more, and followed the road to Saragossa, where they expected to arrive in time to be present at a solemn festival which is held every year in that illustrious city. But before they got there certain things happened to them, so many, so important, and so novel that they deserve to be written down and read, as will be seen hereafter.

Chapter XI. *Of the strange Adventure which befell the valorous Don Quixote with the Car or Wagon of the Parliament of Death.*

Very much downcast Don Quixote went on his way, pondering on the evil trick the enchanters had played on him in turning his lady Dulcinea into the foul shape of a village girl, and he could think of no remedy he could take to restore her to her original state. These thoughts took him so much out of himself that he gave Rocinante the reins without noticing it. And his horse, feeling the liberty he was given, lingered at each step to browse the green grass, which grew thickly in those fields. But Sancho roused his master from his musing by saying:

"Sir, griefs were not made for beasts but for men. Yet if men feel them too deeply they turn to beasts. Pull yourself together, your worship, and come to your senses and pick up Rocinante's reins. Cheer up and wake up, and show that gay spirit knights errant should have. What the devil is it? What despondency is this? Are we here or in France? Let all the Dulcineas in the world go to Old Nick, for the well-being of a single knight errant is worth more than all the enchantments and transformations on earth."

"Hush, Sancho," replied Don Quixote with more spirit than might have been expected. "Hush, I say, and speak no more blasphemies against that enchanted lady. For I alone am to blame for her misfortune and disaster. From the envy the wicked bear me springs her sad plight."

"And so say I," answered Sancho, "who saw her and can still see her now. What heart is there that would not weep?"

"You may well say that, Sancho," replied Don Quixote, "since you saw her in the perfect fullness of her beauty, for the enchantment did not go so far as to disturb your vision or conceal her beauty from you. Against me alone, against my eyes, was directed the power of their venom.

But for all that, Sancho, one thing occurs to me: you described her beauty to me badly. For, if I remember rightly, you said that she had eyes like pearls, and eyes like pearls suit a sea-bream better than a lady. According to my belief, Dulcinea's eyes must be green emeralds, full and large, with twin

rainbows to serve them for eyebrows. So take these pearls from her eyes and transfer them to her teeth, for no doubt you got mixed up, Sancho, taking her teeth for her eyes."

"Anything's possible," replied Sancho, "for her beauty confused me, as her ugliness did your worship. But let's leave it all in God's hands.

For He knows all things that happen in this vale of tears, in this wicked world of ours, where there's hardly anything to be found without a tincture of evil, deceit and roguery in it. But one thing troubles me, dear master, more than all the rest: I can't think what we're to do when your worship conquers a giant or another knight and commands him to go and present himself before the beauteous Dulcinea. Where is he to find her, that poor giant or that poor miserable conquered knight? I seem to see them wandering about El Toboso, gaping like dummies, in search of my lady Dulcinea; and even if they meet her in the middle of the street they won't know her any more than they would my father."

"Perhaps, Sancho," answered Don Quixote, "the enchantment will not extend so far as to deprive vanquished and presented giants and knights of the power to recognize Dulcinea. But we will make the experiment with one or two of the first I conquer. We will send them with orders to return and give me an account of their fortunes in this respect, and so discover whether they can see her or not."

"Yes, sir," said Sancho; "that seems a good idea to me. By that trick we shall find out what we want to, and if it proves that she is only disguised from your worship, the misfortunes will be more yours than hers. But so long as the lady Dulcinea has her health and happiness, we in these parts will make shift to put up with it as best we can. We'll seek our adventures and leave Time to look after hers; for Time's the best doctor for such ailments and for worse."

Don Quixote was about to reply to Sancho, but he was interrupted by a wagon, which came out across the road loaded with some of the strangest shapes imaginable. Driving the mules and acting as carter was an ugly demon, and the wagon itself was open to the sky, without tilt or hurdle roof. The first figure which presented itself before Don Quixote's eyes was Death himself with a human face. Beside him stood an angel with large painted wings. On one side was an Emperor with a crown on his head, apparently of gold. At the feet of Death was the God they call Cupid, without his bandage over his eyes, but with his bow, his quiver and his arrows. There was also a knight in complete armor, except that he wore no helmet or headpiece, but a hat instead adorned with multi-colored plumes. And there were other personages differing in dress and appearance. The sudden vision of this assembly threw Don Quixote into some degree of alarm, and struck fear into Sancho's heart. But soon the knight's spirits mounted with the belief that there was some new and perilous adventure presenting itself; and with this idea in his head, and his heart ready to encounter any sort of danger, he took up his position in front of the cart, and cried in a loud and threatening voice:

"Carter, coachman, devil, or whatever you may be, tell me instantly who you are, where you are going, and who are the people you are driving in your coach, which looks more like Charon's bark than an ordinary cart."

To which the Devil, stopping the cart, politely replied: "Sir, we're players of Angulo El Malo's company. We've been acting this morning in a village which lies behind that hill for it's Corpus Christi week. Our piece is called *The Parliament of Death;* and we have to perform this evening, in that village which you can see over there. So because it's quite near, and to spare ourselves the trouble of taking off our clothes and dressing again, we are travelling in the costumes we act in. That young man there plays Death. The other fellow's the Angel. That lady, who is the manager's wife, is the Queen. This man plays the Soldier. That man's the Emperor. And I'm the Devil and one of the chief characters in the piece, for I play the principal parts in this company. If your worship wants to know anything more about us, ask me. I can tell you every detail, for being the Devil I'm up to everything."

"On the faith of a knight errant," answered Don Quixote, "when I saw this cart I imagined that some great adventure was presenting itself to me. But now I declare that appearances are not always to be trusted. Go, in God's name, good people, and hold your festival; and think whether you have any request to make of me. If I can do you any service I gladly and willingly will do so, for from my boyhood I have been a lover of pantomimes, and in my youth I was always a glutton for comedies."

Now, whilst they were engaged in this conversation, as Fate would have it, one of the company caught them up, dressed in motley with a lot of bells about him, and carrying three full blown ox-bladders on the end of a stick. When this clown came up to Don Quixote, he began to fence with his stick, to beat the ground with his bladders, and leap into the air to the sound of his bells; and this evil apparition so scared Rocinante that he took the bit between his teeth, and started to gallop across the field with more speed than the bones of his anatomy promised; nor was Don Quixote strong enough to stop him. Then, realizing that his master was in danger of being thrown off, Sancho jumped down from Dapple and ran in all haste to his assistance. But when he got up to him he was already on the ground, and beside him lay Rocinante, who had fallen with his master for such was the usual upshot of the knight's exploits and Rocinante's high spirits.

But no sooner had Sancho left his own mount to help Don Quixote than the dancing devil jumped on to Dapple, and dealt him a slap with the bladders, whereat, startled by the noise rather than by the pain of the blows, the ass went flying off across country towards the village where the festival was to take place. Sancho watched Dapple's flight and his master's fall, undecided which of the two calls to attend to first.

But finally, good squire and good servant that he was, love of his master prevailed over affection for his ass, though each time he saw the bladders rise in the air and fall on his Dapple's rump, he felt the pains and terrors of death, for he would rather have had those blows fall on his own eyeballs than on the least hair of his ass's tail. In this sad state of perplexity he arrived where Don Quixote lay in a great deal worse plight than he cared to see him in and, helping him on to Rocinante, he said: "Sir, the Devil's carried Dapple off."

"What Devil?" asked Don Quixote.

"The one with the bladders," replied Sancho.

"Then I shall get him back," said Don Quixote, "even if he were to lock him up in the deepest and darkest dungeons of Hell. Follow me, Sancho. For the waggon goes slowly, and I will take its mules to make up for the loss of Dapple."

"There's no need to go to that trouble, sir," said Sancho. "Cool your anger, your worship, for it looks to me as if the

Devil has let Dapple go and is off to his own haunts again."

And so indeed he was. For when the Devil had given an imitation of Don Quixote and Rocinante by tumbling off Dapple he set off to the village on foot, and the ass came back to his master.

"All the same," said Don Quixote, "it will be as well to visit that demon's impoliteness on one of those in the wagon, perhaps on the Emperor himself."

"Put that thought out of your head, your worship," answered Sancho. "Take my advice and never meddle with play-actors, for they're a favored race. I've seen an actor taken up for a couple of murders and get off scot-free. As they're a merry lot and give pleasure, I would have your worship know that everybody sides with them and protects them, aids them, and esteems them, particularly if they belong to the King's companies and have a charter. And all of them, or most of them, look like princes when they have their costumes and make-up on."

"For all that," answered Don Quixote, "that player devil shall not go away applauding himself, even if the whole human race favors him."

And as he spoke, he turned toward the wagon, which was now very close to the village, calling out loudly, as he rode: "Halt! Stop, merry and festive crew! For I would teach you how to treat asses and animals which serve as mounts to the squires of knights errant."

So loudly did Don Quixote shout that those in the wagon heard and understood him; and judging from his words the purpose of their speaker, Death promptly jumped out of the wagon, and after him the Emperor, the Demon-driver, and the Angel; nor did the Queen or the god Cupid stay behind. Then they all loaded themselves with stones and took up their positions in a row, waiting to receive Don Quixote with the edges of their pebbles. But when he saw them drawn up in so gallant a squadron, with their arms raised in the act of discharging this powerful volley of stones, he reined Rocinante in, and began to consider how to set upon them with least peril to his person. While he was thus checked Sancho came up and, seeing him drawn up to attack that well-ordered squadron, said:

"It would be the height of madness to attempt such an enterprise. Consider, your worship, that there is no defensive armor in the world against the rain of these fellows' bullets, unless you could ram yourself into a brass bell and hide. And you must consider too, master, that it is rashness and not valor for a single man to attack an army with Death in its ranks, Emperors in person fighting in it, and assisted by good and bad angels. What's more, if this isn't reason enough to persuade you to stay quiet, consider that it's a positive fact that although they look like Kings, Princes and Emperors, there isn't a single knight errant among the whole lot of them there."

"Now, Sancho," said Don Quixote, "you have certainly hit on a consideration which should deflect me from my determination. I cannot and must not draw my sword, as I have told you on many occasions before now, against anyone who is not a knight. It rests with you therefore, Sancho, if you wish to take revenge for the injury done to your Dapple; and I will help you from here with words of salutary counsel."

"There's no reason, sir, to take revenge on anyone," replied Sancho, "for it's not right for a good Christian to avenge his injuries. What's more I shall persuade Dapple to leave his cause in my hands, and it's my intention to live peacefully all the days of life that Heaven grants me."

"Since that is your decision," answered Don Quixote, "good Sancho, wise Sancho, Christian Sancho, honest Sancho, let us leave these phantoms and return to our quest for better and more substantial adventures. For I'm sure that this is the sort of country that can't fail to provide us with many and most miraculous ones."

Then he turned Rocinante, Sancho went to catch his Dapple, and Death and all his flying squadron returned to their wagon and continued their journey. And this was the happy ending of the encounter with the waggon of Death, thanks to the healthy advice which Sancho Panza gave his master.

From *The Adventures of Don Quixote* by Miguel de Cervantes Saavedra, translated by J. M. Cohen, © 1950 by J. M. Cohen. Published by Penguin Books, Ltd. Reproduced by permission of Penguin Books, Ltd.

JOHN MILTON

from PARADISE LOST, BOOK I

The reader who approaches Book I by itself must bear in mind the perhaps obvious but important fact that it represents only the introduction to a cosmic struggle on a massive scale. The events of the book prefigure the eventual fall of Adam and Eve and are dominated by the figure of Satan, who is depicted in language so powerful as to seem almost heroic. His defiance of God's punishment in lines 94 to 111 has been compared by some critics to Prometheus' defiance in the face of the threats of Zeus and subsequent punishment at the hands of the father of the Greek gods. The description of his kingdom in lines 670 to 798 is of epic grandeur. Yet Milton leaves no doubt that the grandeur is fatally flawed. In lines 158 to 165 Satan himself reminds us that in Hell "ever to do ill [is] our sole delight." To see Satan as the hero of the epic, a kind of underdog, victim of the divine tyranny, is to misinterpret Milton. Satan is a courageous and formidable opponent, but neither quality is inconsistent with the utmost evil.

Milton's language and imagery present an almost inexhaustible combination of biblical and Classical reference. From the very first lines of Book I, where the poet calls upon a Classical Muse to help him tell the tale of The Fall, *the two great Western cultural traditions are inextricably linked. Toward the end of the book, for example, we learn that the chief architect of both Heaven and Hell was none other than the Greek god Hephaistos, the Roman Vulcan (lines 732–751). Much of the poetic effect is gained by Milton's love of exotic or romantic names from ancient sources, many of them obscure. He would, of course, have hoped that his readers could identify them all and understand the references; but the modern reader may be somewhat comforted to find that the sheer musical value of lines like 406 to 411, or 582 to 587 is considerable without regard to their detailed significance. The richness of effect is in keeping with the lavishness of much of baroque art.*

Book I of Paradise Lost *therefore provides an introduction to many aspects of the entire epic. It partially conceals the true nature of the conflict between good and evil and fails to introduce us to Adam and Eve. Yet a reading of even this small part of the whole work makes it absolutely clear why Milton so profoundly affected successive generations of poets.*

After Milton, English literature was never the same again.

The Argument

This First Book proposes, first in brief, the whole subject Man's disobedience, and the loss thereupon of Paradise, wherein he was placed; then touches the prime cause of his fall the Serpent, or rather Satan in the Serpent; who, revolting

from God, and drawing to his side many legions of Angels, was, by the command of God, driven out of Heaven, with all his crew, into the great Deep. Which action passed over, the Poem hastens into the midst of things; presenting Satan, with his Angels, now fallen into Hell—described here not in the Center (for heaven and earth may be supposed as yet not made, certainly not yet accursed), but in a place of utter darkness, [most fitly] called Chaos. Here Satan, with his Angels lying on the burning lake, thunderstruck and astonished, after a certain space recovers, as from confusion; calls up him who, next in order and dignity, lay by him: they confer of their miserable fall. Satan awakens all his legions, who lay till then in the same manner confounded. They rise: their numbers; array of battle: their chief leaders named, according to the idols known afterwards in Canaan and the countries adjoining. To these Satan directs his speech; comforts them with hope yet of regaining Heaven; but tells them, lastly, of a new world and new kind of creature to be created, according to an ancient prophecy, or report, in Heaven—for that Angels were long before this visible creation was the opinion of many ancient Fathers. To find out the truth of this prophecy, and what to determine thereon, he refers to a full council. What his associates thence attempt. Pandemonium, the palace of Satan, rises, suddenly built out of the Deep: The infernal Peers there sit in council.

> Of Man's first disobedience, and the fruit
> Of that forbidden tree whose mortal taste
> Brought death into the World, and all our woe,
> With loss of Eden, till one greater Man
> Restore us, and regain the blissful seat,
> Sing, Heavenly Muse, that, on the secret top
> Of Oreb, or of Sinai, didst inspire
> That shepherd who first taught the chosen seed
> In the beginning how the heavens and earth
> Rose out of Chaos: or, if Sion hill 10
> Delight thee more, and Siloa's brook that flowed
> Fast by the oracle of God, I thence
> Invoke thy aid to my adventurous song,
> That with no middle flight intends to soar
> Above the Aonian mount, while it pursues
> Things unattempted yet in prose or rhyme.
> And chiefly Thou, O Spirit, that dost prefer
> Before all temples the upright heart and pure.
> Instruct me, for Thou know'st; Thou from the first
> Wast present, and, with mighty wings outspread, 20
> Dove-like sat'st brooding on the vast Abyss,
> And mad'st it pregnant: what in me is dark
> Illumine, what is low raise and support;
> That, to the height of this great argument,
> I may assert Eternal Providence,
> And justify the ways of God to men.
> Say first—for heaven hides nothing from thy view.
> Nor the deep tract of Hell—say first what cause
> Favored of Heaven so highly, to fall off 30
> From their Creator, and transgress his will
> For one restraint, lords of the World besides.
> Who first seduced them to that foul revolt?
> The infernal Serpent; he it was whose guile,
> Stirred up with envy and revenge, deceived
> The mother of mankind, what time his pride
> Had cast him out from Heaven, with all his host
> Of rebel Angels, by whose aid, aspiring
> To set himself in glory above his peers,

> He trusted to have equaled the Most High, 40
> If he opposed, and, with ambitious aim
> Against the throne and monarchy of God,
> Raised impious war in Heaven and battle proud,
> With vain attempt. Him the Almighty Power
> Hurled headlong flaming from the ethereal sky,
> With hideous ruin and combustion, down
> To bottomless perdition, there to dwell
> In adamantine chains and penal fire,
> Who durst defy the Omnipotent to arms.
> Nine times the space that measures day and night 50
> To mortal men, he, with his horrid crew,
> Lay vanquished, rolling in the fiery gulf,
> Confounded, though immortal. But his doom
> Reserved him to more wrath; for now the thought
> Both of lost happiness and lasting pain
> Torments him: round he throws his baleful eyes,
> That witnessed huge affliction and dismay,
> Mixed with obdurate pride and steadfast hate.
> At once, as far as Angel's ken, he views
> The dismal situation waste and wild. 60
> A dungeon horrible, on all sides round,
> As one great furnace flamed; yet from those flames
> No light; but rather darkness visible
> Served only to discover sights of woe,
> Regions of sorrow, doleful shades, where peace
> And rest can never dwell, hope never comes
> That comes to all, but torture without end
> Still urges, and a fiery deluge, fed
> With ever-burning sulfur unconsumed.
> Such place Eternal Justice had prepared 70
> For those rebellious; here their prison ordained
> In utter darkness, and their portion set,
> As far removed from God and light of Heaven
> As from the center thrice to the utmost pole.
> Oh how unlike the place from whence they fell!
> There the companions of his fall, o'erwhelmed
> With floods and whirlwinds of tempestuous fire,
> He soon discerns; and, weltering by his side.
> next himself in power, and next in crime,
> Long after known in Palestine, and named 80
> BEËLZEBUB. To whom the Arch-Enemy,
> And thence in Heaven called SATAN, with bold words
> Breaking the horrid silence, thus began:—
> "If thou beest he but Oh how fallen! how changed
> From him!—who, in the happy realms of light,
> Clothed with transcendent brightness, didst outshine
> Myriads, though bright if he whom mutual league,
> United thoughts and counsels, equal hope
> And hazard in the glorious enterprise,
> Joined with me once, now misery hath joined 90
> In equal ruin; into what pit thou seest
> From what height fallen: so much the stronger proved
> He with his thunder: and till then who knew
> The force of those dire arms? Yet not for those,
> Nor what the potent Victor in his rage
> Can else inflict, do I repent, or change,
> Though changed in outward luster, that fixt mind,
> And high disdain from sense of injured merit,
> That with the Mightiest raised me to contend,
> And to the fierce contention brought along 100
> Innumerable force of Spirits armed,
> That durst dislike his reign, and, me preferring,
> His utmost power with adverse power opposed

In dubious battle on the plains of heaven,
And shook his throne. What though the field be lost?
All is not lost—the unconquerable will,
And study of revenge, immortal hate,
And courage never to submit or yield:
And what is else not to be overcome.
That glory never shall his wrath or might 110
Extort from me. To bow and sue for grace
With suppliant knee, and deify his power
Who, from the terror of this arm, so late
Doubted his empire—that were low indeed;
That were an ignominy and shame beneath
This downfall; since, by fate, the strength of Gods,
And this empyreal substance, cannot fail;
Since, through experience of this great event,
In arms not worse, in foresight much advanced,
We may with more successful hope resolve 120
To wage by force or guile eternal war,
Irreconcilable to our grand Foe,
Who now triumphs, and in the excess of joy
Sole reigning holds the tyranny of Heaven."
So spake the apostate Angel, though in pain,
Vaunting aloud, but racked with deep despair;
And him thus answered soon his bold compeer:—
"O Prince, O Chief of many thronèd Powers
That led the embattled Seraphim to war
Under thy conduct, and, in dreadful deeds 130
Fearless, endangered Heaven's perpetual King,
And put to proof his high supremacy,
Whether upheld by strength, or chance, or fate!
Too well I see and rue the dire event
That, with sad overthrow and foul defeat,
Hath lost us Heaven, and all this mighty host
In horrible destruction laid thus low,
As far as Gods and heavenly Essences
Can perish: for the mind and spirit remains
Invincible, and vigor soon returns, 140
Though all our glory extinct, and happy state
Here swallowed up in endless misery.
But what if He our Conqueror (whom I now
Of force believe almighty, since no less
Than such could have o'erpowered such force as ours)
Have left us this our spirit and strength entire,
Strongly to suffer and support our pains,
That we may so suffice his vengeful ire
Or do him mightier service as his thralls
By right of war, whate'er his business be, 150
Here in the heart of Hell to work in fire,
Or do his errands in the gloomy Deep?
What can it then avail though yet we feel
Strength undiminished, or eternal being
To undergo eternal punishment?"
Whereto with speedy words the Arch-Fiend replied:—
"Fallen Cherub, to be weak is miserable,
Doing or suffering: but of this be sure—
To do aught good never will be our task,
But ever to do ill our sole delight, 160
As being the contrary to His high will
Whom we resist. If then his providence
Out of our evil seek to bring forth good,
Our labor must be to pervert that end,
And out of good still to find means of evil;
Which ofttimes may succeed so as perhaps
Shall grieve him, if I fail not, and disturb
His inmost counsels from their destined aim.

But see? the angry Victor hath recalled
His ministers of vengeance and pursuit 170
Back to the gates of Heaven: the sulphurous hail,
Shot after us in storm, o'erblown hath laid
The fiery surge that from the precipice
Of Heaven received us falling; and the thunder,
Winged with red lightning and impetuous rage,
Perhaps hath spent his shafts, and ceases now
To bellow through the vast and boundless Deep.
Let us not slip the occasion, whether scorn
Or satiate fury yield it from our Foe.
Seest thou yon dreary plain, forlorn and wild, 180
The seat of desolation, void of light,
Save what the glimmering of these livid flames
Casts pale and dreadful? Thither let us tend
From off the tossing of these fiery waves;
There rest, if any rest can harbor there;
And, reassembling our afflicted powers,
Consult how we may henceforth most offend
Our enemy, our own loss how repair,
How overcome this dire calamity,
What reinforcement we may gain from hope, 190
If not what resolution from despair."
Thus Satan, talking to his nearest mate,
With head uplift above the wave, and eyes
That sparkling blazed; his other parts besides
Prone on the flood, extended long and large
Lay floating many a rood, in bulk as huge
As whom the fables name of monstrous size,
Titanian or Earth-born, that warred on Jove,
Briareos or Typhon, whom the den
By ancient Tarsus held, or that sea-beast 200
Leviathan, which God of all his works
Created hugest that swim the ocean-stream.
Him, haply slumbering on the Norway foam,
The pilot of some small night-foundered skiff,
Deeming some island, oft, as seamen tell,
With fixed anchor in his scaly rind,
Moors by his side under the lee, while night
Invests the sea, and wished morn delays.
So stretched out huge in length the Arch-Fiend lay,
Chained on the burning lake; nor ever thence 210
Had risen, or heaved his head, but that the will
And high permission of all-ruling Heaven
Left him at large to his own dark designs,
That with reiterated crimes he might
Heap on himself damnation, while he sought
Evil to others, and enraged might see
How all his malice served but to bring forth
Infinite goodness, grace, and mercy, shown
On Man by him seduced, but on himself
Treble confusion, wrath, and vengeance poured, 220
Forthwith upright he rears from off the pool
His mighty stature; on each hand the flames
Driven backward slope their pointing spires, and, rolled
In billows, leave i' the midst a horrid vale.
Then with expanded wings he steers his flight
Aloft, incumbent on the dusky air,
That felt unusual weight; till on dry land
He lights—if it were land that ever burned
With solid, as the lake with liquid fire,
And such appeared in hue as when the force 230
Of subterranean wind transports a hill
Torn from Pelorus, or the shattered side
Of thundering Ætna, whose combustible

And fuelled entrails, thence conceiving fire,
Sublimed with mineral fury, aid the winds,
And leave a singed bottom all involved
With stench and smoke. Such resting found the sole
Of unblest feet. Him followed his next mate;
Both glorying to have scaped the Stygian flood
As gods, and by their own recovered strength, 240
Not by the sufferance of supernal power.
"Is this the region, this the soil, the clime,"
Said then the lost Archangel, "this the seat
That we must change for Heaven?—this mourn-
 ful gloom
For that celestial light? Be it so, since He
Who now is sovereign can dispose and bid
What shall be right: farthest from Him is best,
Whom reason hath equaled; force hath made supreme
Above his equals. Farewell, happy fields,
Where joy for ever dwells! Hail, horrors! hail, 250
Infernal World! and thou, profoundest Hell,
Receive thy new possessor—one who brings
A mind not to be changed by place or time.
The mind is its own place, and in itself
Can make a Heaven of Hell, a Hell of Heaven.
What matter where, if I be still the same,
And what I should be, all but less than he
Whom thunder hath made greater? Here at least
We shall be free; the Almighty hath not built
Here for his envy, will not drive us hence: 260
Here we may reign secure; and, in my choice,
To reign is worth ambition, though in Hell:
Better to reign in Hell than serve in Heaven.
But wherefore let we then our faithful friends,
The associates and co-partners of our loss,
Lie thus astonished on the oblivious pool,
And call them not to share with us their part
In this unhappy mansion, or once more
With rallied arms to try what may be yet
Regained in Heaven, or what more lost in Hell?" 270
So Satan spoke; and him Beëlzebub
Thus answered:—"Leader of those armies bright
Which, but the Omnipotent, none could have foiled!
If once they hear that voice, their liveliest pledge
Of hope in fears and dangers—heard so oft
In worst extremes, and on the perilous edge
Of battle, when it raged, in all assaults
Their surest signal—they will soon resume
New courage and revive, though now they lie
Groveling and prostrate on yon lake of fire, 280
As we erewhile, astounded and amazed;
No wonder, fallen such a pernicious height!"
He scarce had ceased when the superior Fiend
Was moving toward the shore; his ponderous shield,
Ethereal temper, massy, large, and round,
Behind him cast. The broad circumference
Hung on his shoulders like the moon, whose orb
Through optic glass the Tuscan artist views
At evening, from the top of Fiesolé,
Or in Valdarno, to descry new lands, 290
Rivers, or mountains, in her spotty globe.
His spear—to equal which the tallest pine
Hewn on Norwegian hills, to be the mast
Of some great ammiral, were but a wand—
He walked with, to support uneasy steps
Over the burning marle, not like those steps
On Heaven's azure; and the torrid clime

Smote on him sore besides, vaulted with fire.
Nathless he so endured, till on the beach
Of that inflamèd sea he stood, and called 300
His legions—Angel Forms, who lay entranced
Thick as autumnal leaves that strow the brooks
In Vallombrosa, where the Etrurian shades
High over-arched embower; or scattered sedge
Afloat, when with fierce winds Orion armed
Hath vexed the Red-Sea coast, whose waves o'erthrew
Busiris and his Memphian chivalry,
While with perfidious hatred they pursued
The sojourners of Goshen, who beheld
From the safe shore their floating carcasses 310
And broken chariot-wheels. So thick bestrown,
Abject and lost, lay these, covering the flood,
Under amazement of their hideous change.
He called so loud that all the hollow deep
Of Hell resounded:—"Princes, Potentates,
Warriors, the Flower of heaven—once yours; now lost,
If such astonishment as this can seize
Eternal Spirits! Or have ye chosen this place
After the toil of battle to repose
Your wearied virtue, for the ease you find 320
To slumber here, as in the vales of Heaven?
Or in this abject posture have ye sworn
To adore the Conqueror, who now beholds
Cherub and Seraph rolling in the flood
With scattered arms and ensigns, till anon
His swift pursuers from Heaven-gates discern
The advantage, and, descending, tread us down
Thus drooping, or with linked thunderbolts
transfix us to the bottom of this gulf?—
Awake, arise, or be for ever fallen!" 330
They heard, and were abashed, and up they sprung
Upon the wing, as when men wont to watch,
On duty sleeping found by whom they dread,
Rouse and bestir themselves ere well awake.
Nor did they not perceive the evil plight
In which they were, or the fierce pains not feel;
Yet to their General's voice they soon obeyed
Innumerable. As when the potent rod
Of Amram's son, in Egypt's evil day,
Waved round the coast, up-called a pitchy cloud 340
Of locusts, warping on the eastern wind,
That o'er the realm of impious Pharaoh hung
Like Night, and darkened all the land of Nile;
So numberless were those bad Angels seen
Hovering on wing under the cope of Hell,
'Twixt upper, nether, and surrounding fires;
Till, as a signal given, the uplifted spear
Of their great Sultan waving to direct
Their course, in even balance down they light
On the firm brimstone, and fill all the plain: 350
A multitude like which the populous North
Poured never from her frozen loins to pass
Rhene or the Danaw, when her barbarous sons
Came like a deluge on the South, and spread
Beneath Gibraltar to the Libyan sands.
Forthwith, from every squadron and each band,
The heads and leaders thither haste where stood
Their great Commander—godlike Shapes, and Forms
Excelling human; princely Dignities;
And Powers that erst in Heaven sat on thrones, 360
Though of their names in Heavenly records now
Be no memorial, blotted out and razed

By their rebellion from the Books of Life.
Nor had they yet among the sons of Eve
Got them new names, till, wandering o'er the earth,
Through God's high sufferance for the trial of man.
By falsities and lies the greatest part
Of mankind they corrupted to forsake
God their Creator, and the invisible
Glory of Him that made them to transform 370
Oft to the image of a brute, adorned
With gay religions full of pomp and gold,
And devils to adore for deities:
Then were they known to men by various names,
And various idols through the Heathen World.
Say, Muse, their names then known, who first, who last,
Roused from the slumber on that fiery couch,
At their great Emperor's call, as next in worth
Came singly where he stood on the bare strand,
While the promiscuous crowd stood yet aloof. 380
The chief were those who, from the pit of Hell
Roaming to seek their prey on Earth, durst fix
Their seats, long after, next the seat of God,
Their altars by His altar, gods adored
Among the nations round, and durst abide
Jehovah thundering out of Sion, throned
Between the Cherubim; yea, often placed
Within His sanctuary itself their shrines,
Abomination; and with cursed things
His holy rites and solemn feasts profaned, 390
And with their darkness durst affront His light.
First, *Moloch,* horrid king, besmeared with blood
Of human sacrifice, and parents' tears;
Though, for the noise of drums and timbrels loud,
Their children's cries unheard that passed through fire
To his grim idol. Him the Ammonite
Worshiped in Rabba and her watery plain,
In Argob and in Basan, to the stream
Of utmost Arnon. Nor content with such
Audacious neighborhood, the wisest heart 400
Of Solomon he led by fraud to build
His temple right against the temple of God
On that opprobrious hill, and made his grove
The pleasant valley of Hinnom, Tophet thence
And black Gehenna called, the type of Hell.
Next *Chemos,* the obscene dread of Moab's sons,
From Aroar to Nebo and the wild
Of southmost Abarim; in Hesebon
And Horonaim, Seon's realm, beyond
The flowery dale of Sibma clad with vines, 410
And Elealé—to the Asphaltic Pool:
Peor his other name, when he enticed
Israel in Sittim, on their march from Nile,
To do him wanton rites, which cost them woe.
Yet thence his lustful orgies he enlarged
Even to that hill of scandal, by the grove
Of Moloch homicide, lust hard by hate,
Till good Josiah drove them hence to Hell.
With these came they who, from the bordering flood
Of old Euphrates to the brook that parts 420
Egypt from Syrian ground, had general names
Of *Baalim* and *Ashtaroth*—those male,
These feminine. For Spirits, when they please,
Can either sex assume, or both; so soft
And uncompounded is their essence pure,
Not tied or manacled with joint or limb,
Nor founded on the brittle strength of bones,

Like cumbrous flesh; but, in what shape they choose,
Dilated or condensed, bright or obscure,
Can execute their aery purposes, 430
And works of love or enmity fulfil.
For those the race of Israel oft forsook
Their Living Strength, and unfrequented left
His righteous altar, bowing lowly down
To bestial gods; for which their heads, as low
Bowed down in battle, sunk before the spear
Of despicable foes. With these in troop
Came *Astoreth,* whom the Phoenicians called
Astarte, queen of heaven, with crescent horns;
To whose bright image nightly by the moon 440
Sidonian virgins paid their vows and songs;
In Sion also not unsung, where stood
Her temple on the offensive mountain, built
By that uxorious king whose heart, though large,
Beguiled by fair idolatresses, fell
To idols foul. *Thammuz* came next behind,
Whose annual wound in Lebanon allured
The Syrian damsels to lament his fate
In amorous ditties all a summer's day,
While smooth Adonis from his native rock 450
Ran purple to the sea, supposed with blood
Of Thammuz yearly wounded: the love-tale
Infected Sion's daughters with like heat,
Whose wanton passions in the sacred porch
Ezekiel saw, when, by the vision led,
His eye surveyed the dark idolatries
Of alienated Judah. Next came one
Who mourned in earnest, when the captive ark
Maimed his brute image, head and hands lopt off,
In his own temple, on the grunsel-edge, 460
Where he fell flat and shamed his worshipers:
Dagon his name, sea-monster, upward man
And downward fish; yet had his temple high
Reared in Azotus, dreaded through the coast
Of Palestine, in Gath and Ascalon,
And Accaron and Gaza's frontier bounds.
Him followed *Rimmon,* whose delightful seat
Was fair Damascus, on the fertile banks
Of Abbana and Pharphar, lucid streams.
He also against the house of God was bold: 470
A leper once he lost, and gained a king—
Ahaz, his sottish conqueror, whom he drew
God's altar to disparage and displace
For one of Syrian mode, whereon to burn
His odious offerings, and adore the gods
Whom he had vanquished. After these appeared
A crew who, under names of old renown—
Osiris, Isis, Orus, and their train—
With monstrous shapes and sorceries abused
Fanatic Egypt and her priests to seek 480
Their wandering gods disguised in brutish forms
Rather than human. Nor did Israel scape
The infection, when their borrowed gold composed
The calf in Oreb; and the rebel king
Doubled that sin in Bethel and in Dan,
Likening his Maker to the grazed ox—
Jehovah, who, in one night, when he passed
From Egypt marching, equaled with one stroke
Both her first-born and all her bleating gods.
Belial came last; than whom a spirit more lewd
Fell not from Heaven, or more gross to love 491
Vice for itself. To him no temple stood

Or altar smoked; yet who more oft than he
In temples and at altars, when the priest
Turns atheist, as did Eli's sons, who filled
With lust and violence the house of God?
In courts and palaces he also reigns,
And in luxurious cities, where the noise
Of riot ascends above their loftiest towers,
And injury and outrage; and, when night 500
Darkens the streets, then wander forth the sons
Of Belial, flown with insolence and wine.
Witness the streets of Sodom, and that night
In Gibeah, when the hospitable door
Exposed a matron, to avoid worse rape.
These were the prime in order and in might:
The rest were long to tell; though far renowned
The Ionian gods—of Javan's issue held
Gods, yet confessed later than Heaven and Earth,
Their boasted parents;—*Titan,* Heaven's first-born 510
With his enormous brood, and birthright seized
By younger *Saturn:* he from mightier Jove,
His own and Rhea's son, like measure found;
So *Jove* usurping reigned. These, first in Crete
And Ida known, thence on the snowy top
Of cold Olympus ruled the middle air,
Their highest heaven; or on the Delphian cliff,
Or in Dodona, and through all the bounds
Of Doric land; or who with Saturn old
Fled over Adria to the Hesperian fields, 520
And o'er the Celtic roamed the utmost Isles.
All these and more came flocking; but with looks
Downcast and damp; yet such wherein appeared
Obscure some glimpse of joy to have found their Chief
Not in despair, to have found themselves not lost
In loss itself; which on his countenance cast
Like doubtful hue. But he, his wonted pride
Soon recollecting, with high words, that bore
Semblance of worth, not substance, gently raised
Their fainting courage, and dispelled their fears; 530
Then straight commands that, at the warlike sound
Of trumpets loud and clarions, be upreared
His mighty standard. That proud honor claimed
Azazel as his right, a Cherub tall:
Who forthwith from the glittering staff unfurled
The imperial ensign; which, full high advanced,
Shone like a meteor streaming to the wind,
With gems and golden luster rich emblazed,
Seraphic arms and trophies; all the while
Sonorous metal blowing martial sounds: 540
At which the universal host up-sent
A shout that tore Hell's concave, and beyond
Frighted the reign of Chaos and old Night.
All in a moment through the gloom were seen
Ten thousand banners rise into the air,
With orient colors waving: with them rose
A forest huge of spears; and thronging helms
Appeared, and serried shields in thick array
Of depth immeasurable. Anon they move
In perfect phalanx to the Dorian mood 550
Of flutes and soft recorders—such as raised
To height of noblest temper heroes old
Arming to battle, and instead of rage
Deliberate valor breathed, firm, and unmoved
With dread of death to flight or foul retreat;
Nor wanting power to mitigate and swage
With solemn touches troubled thoughts, and chase

Anguish and doubt and fear and sorrow and pain
From mortal or immortal minds. Thus they,
Breathing united force with fixed thought, 560
Moved on in silence to soft pipes that charmed
Their painful steps o'er the burnt soil. And now
Advanced in view they stand—a horrid front
Of dreadful length and dazzling arms, in guise
Of warriors old, with ordered spear and shield,
Awaiting what command their mighty Chief
Had to impose. He through the armed files
Darts his experienced eye, and soon traverse
The whole battalion views—their order due,
Their visages and stature as of gods; 570
Their number last he sums. And now his heart
Distends with pride, and, hardening in his strength,
Glories: for never, since created Man,
Met such embodied force as, named with these,
Could merit more than that small infantry
Warred on by cranes—though all the giant brood
Of Phlegra with the heroic race were joined
That fought at Thebes and Ilium, on each side
Mixed with auxiliar gods; and what resounds
In fable or romance of Uther's son, 580
Begirt with British and Armoric knights;
And all who since, baptized or infidel,
Jousted in Aspramont, or Montalban,
Damasco, or Marocco, or Trebisond,
Or whom Biserta sent from Afric shore
When Charlemagne with all his peerage fell
By Fontarabia. Thus far these beyond
Compare of mortal prowess, yet observed
Their dread Commander. He, above the rest
In shape and gesture proudly eminent, 590
Stood like a tower. His form had yet not lost
All her original brightness, nor appeared
Less than Archangel ruined, and the excess
Of glory obscured: as when the sun new-risen
Looks through the horizontal misty air
Shorn of his beams, or, from behind the moon.
In dim eclipse, disastrous twilight sheds
On half the nations, and with fear of change
Perplexes monarchs. Darkened so, yet shone
Above them all the Archangel: but his face 600
Deep scars of thunder had entrenched, and care
Sat on his faded cheek, but under brows
Of dauntless courage, and considerate pride
Waiting revenge. Cruel his eye, but cast
Signs of remorse and passion, to behold
The fellows of his crime, the follower's rather
(Far other once beheld in bliss), condemned
For ever now to have their lot in pain—
Millions of Spirits for his fault amerced
Of Heaven, and from eternal splendors flung 610
For his revolt—yet faithful how they stood,
Their glory withered; as, when heaven's fire
Hath scathed the forest oaks or mountain pines,
With singed top their stately growth, though bare,
Stands on the blasted heath. He now prepared
To speak; whereat their doubled ranks they bend
From wing to wing, and half enclose him round
With all his peers: Attention held them mute.
Thrice he assayed, and thrice, in spite of scorn,
Tears, such as Angels weep, burst forth: at last 620
Words interwove with sighs found out their way:—
"O myriads of immortal Spirits! O Powers

Matchless, but with the Almighty!—and that strife
Was not inglorious, though the event was dire,
As this place testifies, and this dire change,
Hateful to utter. But what power of mind,
Foreseeing or presaging, from the depth
Of knowledge past or present, could have feared
How such united force of gods, how such
As stood like these, could ever know repulse? 630
For who can yet believe, though after loss,
That all these puissant legions, whose exile
Hath emptied Heaven, shall fail to re-ascend,
Self-raised, and re-possess their native seat?
For me, be witness all the host of heaven,
If counsels different, or danger shunned
By me, have lost our hopes. But he who reigns
Monarch in Heaven till then as one secure
Sat on his throne, upheld by old repute,
Consent or custom, and his regal state 640
Put forth at full, but still his strength concealed—
Which tempted our attempt, and wrought our fall.
Henceforth his might we know, and know our own.
So as not either to provoke, or dread
New war provoked: our better part remains
To work in close design, by fraud or guile,
What force effected not; that he no less
At length from us may find, Who overcomes
By forth hath overcome but half his foe.
Space may produce new Worlds; whereof so rife 650
There went a fame in Heaven that He ere long
Intended to create, and therein plant
A generation whom his choice regard
Should favor equal to the Sons of Heaven.
Thither, if but to pry, shall be perhaps
Our first eruption—thither, or elsewhere;
For this infernal pit shall never hold
Celestial Spirits in bondage, nor the Abyss
Long under darkness cover. But these thoughts
Full counsel must mature. Peace is despaired; 660
For who can think submission? War, then, war
Open or understood, must be resolved."
He spake; and, to confirm his words, out-flew
Millions of flaming swords, drawn from the thighs
Of mighty Cherubim; the sudden blaze
Far round illumined Hell. Highly they raged
Against the Highest, and fierce with grasped arms
Clashed on their sounding shields the din of war,
Hurling defiance toward the vault of Heaven.
There stood a hill not far, whose grisly top 670
Belched fire and rolling smoke; the rest entire
Shone with a glossy scurf—undoubted sign
That in his womb was hid metallic ore,
The work of sulfur. Thither, winged with speed.
A numerous brigade hastened: as when bands
Of pioneers, with spade and pickaxe armed,
Forerun the royal camp, to trench a field,
Or cast a rampart. Mammon led them on—
Mammon, the least erected Spirit that fell
From Heaven; for even in Heaven his looks and thoughts 680
Were always downward bent, admiring more
The riches of Heaven's pavement, trodden gold,
Than aught divine or holy else enjoyed
In vision beatific. By him first
Men also, and by his suggestion taught,
Ransacked the Center, and with impious hands
Rifled the bowels of their mother Earth

For treasures better hid. Soon had his crew
Opened into the hill a spacious wound,
And digged out ribs of gold. Let none admire 690
That riches grow in Hell; that soil may best
Deserve the precious bane. And here let those
Who boast in mortal things, and wondering tell
Of Babel, and the works of Memphian kings,
Learn how their greatest monuments of fame,
And strength, and art, are easily outdone
By Spirits reprobate, and in an hour
What in an age they, with incessant toil
And hands innumerable, scarce perform.
Nigh on the plain, in many cells prepared, 700
That underneath had veins of liquid fire
Sluiced from the lake, a second multitude
With wondrous art founded the massy ore,
Severing each kind, and scummed the bullion-dross.
A third as soon had formed within the ground
A various mould, and from the boiling cells
By strange conveyance filled each hollow nook;
As in an organ, from one blast of wind,
To many a row of pipes the sound-board breathes.
Anon out of the earth a fabric huge 710
Rose like an exhalation, with the sound
Of dulcet symphonies and voices sweet—
Built like a temple, where pilasters round
Were set, and Doric pillars overlaid
With golden architrave; nor did there want
Cornice or frieze, with bossy sculptures graven:
The roof was fretted gold. Not Babylon
Nor great Alcairo such magnificence
Equaled in all their glories, to enshrine
Belus or Serapis their gods, or seat 720
Their kings, when Egypt with Assyria strove
In wealth and luxury. The ascending pile
Stood fixed her stately height; and straight the doors,
Opening their brazen folds, discover, wide
Within, her ample spaces o'er the smooth
And level pavement: from the archèd roof,
Pendent by subtle magic, many a row
Of starry lamps and blazing cressets, fed
With naphtha and asphaltus, yielded light
As from a sky. The hasty multitude 730
Admiring entered; and the work some praise,
And some the architect. His hand was known
In Heaven by many a towered structure high,
Where scepterd Angels held their residence,
And sat as Princes, whom the supreme King
Exalted to such power, and gave to rule,
Each in his hierarchy, the Orders bright.
Nor was his name unheard or unadored
In ancient Greece; and in Ausonian land
Men called him Mulciber; and how he fell 740
From Heaven they fabled, thrown by angry Jove
Sheer o'er the crystal battlements: from morn
To noon he fell, from noon to dewy eve,
A summer's day, and with the setting sun
Dropt from the zenith like a falling star,
On Lemnos, the Ægæan isle. Thus they relate,
Erring; for he with this rebellious rout
Fell long before; nor aught availed him now
To have built in Heaven high towers; nor did he scape
By all his engines, but was headlong sent, 750
With his industrious crew, to build in Hell.
Meanwhile the wingèd Heralds, by command

Of sovereign power, with awful ceremony
And trumpet's sound, throughout the host proclaim
A solemn council forthwith to be held
At Pandemonium, the high capital
Of Satan and his peers. Their summons called
From every band and squarèd regiment
By place or choice the worthiest: they anon
With hundreds and with thousands trooping came 760
Attended. All access was thronged; the gates
And porches wide, but chief the spacious hall
(Though like a covered field, where champions bold
Wont ride in armed, and at the Soldan's chair
Defied the best of Panim chivalry
To mortal combat, or career with lance),
Thick swarmed, both on the ground and in the air,
Brushed with the hiss of rustling wings. As bees
In spring-time, when the Sun with Taurus rides,
Pour forth their populous youth about the hive 770
In clusters; they among fresh dews and flowers
Fly to and fro, or on the smoothèd plank,
The suburb of their straw-built citadel,
New rubbed with balm, expatiate, and confer
Their state affairs: so thick the aery crowd
Swarmed and were straitened; till, the signal given,
Behold a wonder! They but now who seemed

In bigness to surpass Earth's giant sons,
Now less than smallest dwarfs, in narrow room
Throng numberless—like that pygmean race 780
Beyond the Indian mount; or faery elves,
Whose midnight revels, by a forest-side
Or fountain, some belated peasant sees,
Or dreams he sees, while overhead the Moon
Sits arbitress, and nearer to the Earth
Wheels her pale course: they, on their mirth and dance
Intent, with jocund music charm his ear;
At once with joy and fear his heart rebounds.
Thus incorporeal Spirits to smallest forms
Reduced their shapes immense, and were at large, 790
Though without number still, amidst the hall
Of that infernal court. But far within.
And in their own dimensions like themselves,
The great Seraphic Lords and Cherubim
In close recess and secret conclave sat,
A thousand demi-gods on golden seats,
Frequent and full. After short silence then,
And summons read, the great consult began.

"The Argument" from *John Milton: Paradise Lost* by Roy Flannagan, ©
1993 by Roy Flannagan.

CHAPTER 16

	GENERAL EVENTS	LITERATURE & PHILOSOPHY	ART

<table>
<tr><td rowspan="2">1700</td></tr><tr></tr>
</table>

1700

DAWN OF THE ENLIGHTENMENT

GENERAL EVENTS	LITERATURE & PHILOSOPHY	ART
1710–c. 1795 Rise of Prussia and Russia	**1711** Pope, *Essay on Criticism*	
1715 Death of Louis XIV	**1712** Pope, *The Rape of the Lock,* mock-heroic epic	**c. 1715** Rococo style emerges in France
1715–1774 Reign of Louis XV in France	**18th cent.** Translations of classical authors; Pope's *Iliad* (1713–1720), *Odyssey* (1725–1726)	**1717** Watteau, *Pilgrimage to Cythera*
	1726 Swift, *Gulliver's Travels;* Voltaire exiled from France (returns 1729)	
	1729 Swift, *A Modest Proposal*	**c. 1730** Carriera, *Anna Sofia d'Este, Princess of Modena*
	1733–1734 Pope, *Essay on Man*	
	1734 Voltaire, *Lettres philosophiques*	
	1739 Hume, *Treatise of Human Nature*	

1740

AGE OF ENLIGHTENED DESPOTS

GENERAL EVENTS	LITERATURE & PHILOSOPHY	ART
1740–1786 Reign of Frederick the Great in Prussia	**1750–1753** Voltaire at court of Frederick the Great in Potsdam	**1743–1745** Hogarth paints satirical series, *Marriage à la Mode*
	1751–1772 Diderot's *Encyclopédie* includes writings by Montesquieu and J. J. Rousseau	**1748** Excavations begin at Pompeii; interest in ancient classical styles increases
	1758–1778 Voltaire sets up own court in Ferney	Sculpture more virtuosic than profound; Queirolo, *Deception Unmasked* (after 1752)
1773–1814 Jesuits disbanded	**1759** Voltaire, *Candide*	**1754** Boucher, *Cupid a Captive*
1774–1792 Reign of Louis XVI and Marie Antoinette in France	**1762** J. J. Rousseau, *The Social Contract, Emile*	**c. 1765** Gainsborough, *Mary, Countess Howe*
1776 American Declaration of Independence	**1772** Political writer Thomas Paine meets Benjamin Franklin in London	**1769** Tiepolo, *The Immaculate Conception,* rococo style applied to religious subject
1778–1783 American War of Independence	**1776** In Philadelphia, Paine publishes *Common Sense,* series of pamphlets	**1771** Houdon, *Diderot*
	1776–1788 Gibbon, *History of the Decline and Fall of the Roman Empire*	**1773** Fragonard, *Love Letters;* Reynolds, *Three Ladies Adorning a Term of Hymen,* influenced by classical and Renaissance models
		c. 1776 Vanvitelli, *The Great Cascade,* fountains at castle of Caserta near Naples
		1784–1785 David, *Oath of the Horatii,* establishes official style of revolutionary art
1788 Collapse of French economy; riots in Paris		**c. 1785** Gainsborough, *Haymaker and Sleeping Girl*

1789

REVOLUTIONARY AND NAPOLEONIC WARS

GENERAL EVENTS	LITERATURE & PHILOSOPHY	ART
1789 French Revolution begins; new American Constitution		**c. 1790** Houdon, *George Washington,* statue
1793 Execution of Louis XVI	**1792** Paine, *The Rights of Man*	
1793–1795 Reign of Terror in France		
1799–1804 Napoleon rules France as consul		**1800** David, *Napoleon Crossing the Alps*
1804–1814 Napoleon rules France as emperor		**1808** Canova, *Pauline Bonaparte Borghese as Venus Victorious*

1815

Most dates are approximate

THE EIGHTEENTH CENTURY: FROM ROCOCO TO REVOLUTION

ARCHITECTURE	MUSIC

c. 1700–1730 Couperin leading composer of *style galant* music at French court

1732 Boffrand begins Hôtel de Soubise, Paris; rococo style applied to room decoration

1743 Henry Hoare begins to lay out classical-inspired park at Stourhead

1750 Death of J. S. Bach

c. 1750 C. P. E. Bach chief representative of emotional *empfindsamkeit* at court of Frederick the Great

1743–1772 Neumann, Vierzehnheiligen Pilgrim Church near Bamberg

1750–1800 Development of classical style and symphonic form

1752 J. J. Rousseau, *Le Devin du Village,* opera

1755–1792 Soufflot converts church of Sainte Geneviève into the Pantheon, neoclassical memorial for dead of French Revolution

1759 Death of Handel

1761 Haydn ("Father of the Symphony") begins 30-year service with Esterhazys

1785–1796 Jefferson's state capitol, Richmond, Virginia, modeled on ancient Roman Maison Carrée at Nimes

1786 First performance of Mozart's *The Marriage of Figaro,* opera based on Beaumarchais play

1788 Mozart, *Symphony No. 40 in g minor*

1791 Mozart, *Piano Concerto 27 in B flat;* opera *The Magic Flute*

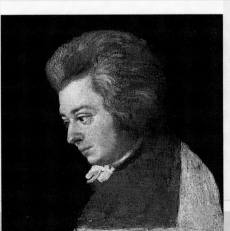

1791–1795 Haydn composes 12 symphonies during visits to London, *Symphony No. 104 in D Major* (1795)

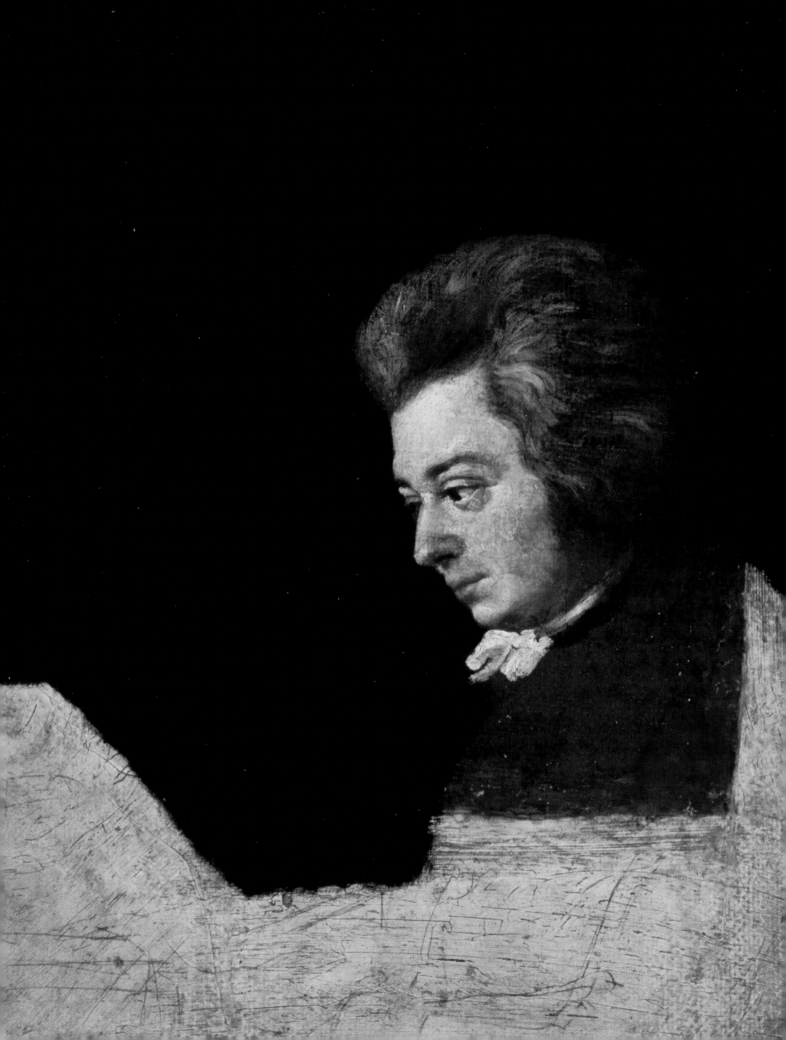

CHAPTER 16

THE EIGHTEENTH CENTURY:
FROM ROCOCO TO REVOLUTION

AGE OF DIVERSITY

Even the most determined cultural historians, fully armed with neat labels for successive stages of Western cultural development, acknowledge serious difficulty in categorizing the eighteenth century. Although it has often been called the Age of Enlightenment or the Age of Reason, these labels—which do in fact describe some of its aspects—fail to encompass the full spirit of the age.

From one perspective, the eighteenth century was an age of optimism. It had trust in science and in the power of human reason, belief in a natural order, and an overriding faith in the theory of progress that the world was better than it had ever been and was bound to get better still. Looked at from another perspective, however, the eighteenth century was marked by pervasive resentment and dissatisfaction with established society. By its end, criticism and the press for reform had actually grown into a desire for violent change, producing the American and then the French revolutions. Furthermore, even these two apparently contradictory views—of unqualified optimism and extreme discontent—do not cover all aspects of eighteenth-century culture. For example, one of the most popular artistic styles of the period, the rococo, was characterized by frivolity and lightheartedness. Rococo artists deliberately aimed to create a fantasy world of pleasure into which their patrons could escape from the problems around them.

The eighteenth century, then, presents an immense variety of artistic and intellectual ideas, seemingly contradictory yet in fact coexistent. Each style or idea seems far easier to grasp and categorize by itself than as part of an overall pattern of cultural development. Nevertheless, it is possible to discern at least one characteristic that links together some of the diverse artistic achievements of the century: a conscious engagement with social issues. An opera such as Wolfgang Amadeus Mozart's *The Marriage of Figaro,* a series of satiric paintings of daily life such as William Hogarth's *Marriage à la Mode,* a mock epic poem such as Alexander Pope's *The Rape of the Lock,* and evolutionary ideas such as those of Jean-Jacques Rousseau are all examples of ways in which artists and thinkers joined with political leaders to effect social change.

Meanwhile, artists who supported the establishment and resisted change were equally engaged in social issues. They too used their art to express and defend their position. François Boucher's portraits of his wealthy aristocratic patrons, for example, often show them in the guises of Greek gods and goddesses, thus imparting a sense of glamour and importance to an aristocracy that was soon to be fighting for its survival.

The contrast between revolutionaries and conservatives lasted right to the eve of the French Revolution. Jacques-Louis David's famous painting *Oath of the Horatii* (1784–1785) [**FIG. 16.1**], a clarion call to action and resolve, was painted in the same year as Thomas Gainsborough's idealized picture of a *Haymaker and Sleeping Girl* [**FIG. 16.2**]. The former, in keeping with the spirit of the times, prefigures the mood of revolution. The latter turns its back on reality, evoking a nostalgic vision of love among the haystacks. In so doing it reinforces the aristocracy's refusal to see the working classes as real people with serious problems of their own. The same contrast occurs in the literature of the age; the conservative stance of Pope or Swift is very different from the views of Enlightenment figures such as Voltaire or Rousseau.

The eighteenth century opened with Louis XIV still strutting down the Hall of Mirrors at the Palace of Versailles, but his death in 1715 marked the beginning of the end of absolute monarchy. Although most of Europe continued to be ruled by hereditary kings, the former emphasis on splendor and privilege was leavened with a new concern for the welfare of the ordinary citizen. Rulers such as Frederick the Great of Prussia (ruled 1740–1786) were no less determined than their predecessors to retain all power in their own hands, but they no longer thought of their kingdoms as private possessions to be manipulated for personal pleasure. Instead, they regarded them as trusts, which required them to show a sense of duty and responsibility. They built

■ **16.1** Jacques–Louis David, 1784–1785. *Oath of the Horatii.* Oil on canvas, 10′10″ × 14′ (3.3 × 4.25 m). Louvre, Paris. The story of the Horatii, three brothers who swore an oath to defend Rome even at the cost of their lives, is used here to extol patriotism. Painted only five years before the French Revolution, David's work established the official style of revolutionary art.

new roads, drained marshes, and reorganized legal and bureaucratic systems along rational lines (see **TABLE 16.1**).

Because of their greater concern for the welfare of their people, these new more liberal kings, often known as **enlightened despots,** undoubtedly postponed for a while the growing demand for change. Inevitably, however, by drawing attention to the injustices of the past, they stimulated an appetite for reform that they were in no position to satisfy. Furthermore, for all their claims—Frederick the Great, for example, described himself as "first servant of the state"—their regimes remained essentially autocratic.

THE VISUAL ARTS IN THE EIGHTEENTH CENTURY

The Rococo Style

Despite the changing social climate of the time, most eighteenth-century artists still depended on the aristocracy for commissions. The baroque style had partially evolved to satisfy just these patrons, and throughout the early part of the eighteenth century, many artists continued to produce works following baroque precedents. Yet, despite the continued fondness for the baroque characteristics of richness and elaboration, there was a significant change of emphasis. The new enlightened despots and their courts had less time for pomposity or excessive grandeur. They wanted not so much to be glorified as entertained. In France, too, the death of Louis XIV served as an excuse to escape the

■ **16.2** Thomas Gainsborough. *Haymaker and Sleeping Girl (Mushroom Girl),* c. 1785. Oil on canvas, 89½″ × 59″ (227.3 × 149.9 cm). Museum of Fine Arts, Boston (Theresa B. Hopkins and Seth K. Sweetser Fund). These charming and elegant peasants, neither of whom looks exactly ravaged by hard work in the fields, represent the artificial world of rococo art.

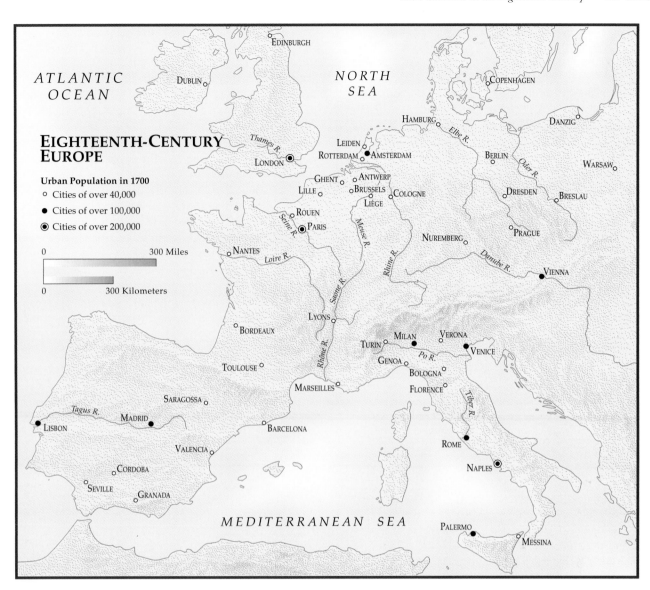

ATLANTIC OCEAN

NORTH SEA

EIGHTEENTH-CENTURY EUROPE

Urban Population in 1700

○ Cities of over 40,000
● Cities of over 100,000
◎ Cities of over 200,000

0 300 Miles

0 300 Kilometers

MEDITERRANEAN SEA

TABLE 16.1 *European Rulers in the Eighteenth Century*

Enlightened Despots

Frederick II of Prussia	1740–1786[a]
Catherine the Great of Russia	1762–1796
Gustavus III of Sweden	1771–1792
Charles III of Spain	1759–1788
Joseph II of Austria	1780–1790

Rulers Bound by Parliamentary Government[b]

George I of England	1714–1727
George II of England	1727–1760
George III of England	1760–1820

Aristocratic Rulers

Louis XV of France	1715–1774
Louis XVI of France	1774–1792

[a] All dates are those of reigns.
[b] English political life was dominated not by the kings but by two powerful prime ministers: Robert Walpole and William Pitt.

oppressive ceremony of life at the Palace of Versailles; the French court moved back to Paris to live in elegant comfort.

The artistic style that developed to meet these new, less grandiose needs first reached its maturity in France. It is generally called *rococo,* a word derived from the French word *rocaille,* which means a kind of elaborate decoration of rocks and shells that often adorned the grottoes of baroque gardens. Rococo art was conceived of as antibaroque, a contrast to the weighty grandeur of seventeenth-century art. It makes plentiful use of shell motifs, along with other decorative elements such as scrolls and ribbons, to produce an overall impression of lightness and gaiety. The subject matter is rarely serious, often frivolous, with strong emphasis on romantic dalliance and the pursuit of pleasure.

The style is graceful and harmonious, in contrast to the flamboyant, dramatic effects of much baroque art. It might be said that whereas baroque artists preached or declaimed to their public, rococo art was the equivalent

of polite, civilized conversation. The eighteenth century was an age of polite society: a time of letter writing, chamber music, dancing. Clearly, such pastimes only represented one aspect of eighteenth-century life, and the revolutions that shook Europe and the European colonies of North America at the end of the century called on a very different artistic style, the Neo-Classical, discussed in the following section. Neo-Classical artists rejected baroque extravagance and rococo charm in favor of dignity and austerity.

Critics have often said that the only purpose of rococo art was to provide pleasure, but this is a somewhat incomplete view of its social role. The rococo style was for the most part aimed at an aristocratic audience; its grace and charm served the important purpose of shielding this class from the growing problems of the real world. The elegant picnics, the graceful lovers, the Venuses triumphant represent an almost frighteningly unrealistic view of life, and one that met

with disapproval from Enlightenment thinkers who were anxious to promote social change. Yet even the sternest moralist can hardly fail to respond to the enticing fantasy existence that the best of rococo art presents. In a sense, the knowledge that the whole rococo world was to be so completely swept away imparts an added (and, it must be admitted, unintentional) poignancy to its art. The existence of all those fragile ladies and their refined suitors was to be cut short by the guillotine.

The first and probably the greatest French rococo painter, Jean Antoine Watteau (1684–1721), seems to have felt instinctively the transitory and impermanent world he depicted. Watteau is best known for his paintings of ***fêtes galantes*** (elegant outdoor festivals attended by courtly figures dressed in the height of fashion). Yet the charming scenes are always touched with a mood of nostalgia that often verges on melancholy. In *Pilgrimage to Cythera* [**FIG. 16.3**], for instance,

■ **16.3** Jean Antoine Watteau. *Return from Cythera,* 1717. Oil on canvas, 4′3″ × 6′4½″ (1.3 × 1.94 m). Schloss Charlottenburg, Berlin. One ancient Greek tradition claimed the isle of Cythera as the birthplace of Venus, goddess of love. Thus, the island became symbolic of ideal, tender love. Note that the mood of nostalgia and farewell is conveyed not only by the autumnal colors but also by the late-afternoon light that washes over the scene.

the handsome young couples are returning home (despite the traditional title of the painting) from a visit to Cythera, the island sacred to Venus and to love. As they leave, a few of them gaze wistfully over their shoulders at the idyllic life they must leave behind, symbolized by the statue of Venus. Watteau thus emphasizes the moment of renunciation, underscoring the sense of departure and farewell by the autumnal colors of the landscape.

François Boucher (1703–1770), the other leading French rococo painter, was also influenced by Rubens. Lacking the restraint or poetry of Watteau, Boucher's paintings carry Rubens' theme of voluptuous beauty to an extreme. His canvases often seem to consist of little beyond mounds of pink flesh, as in *Cupid a Captive* [**Fig. 16.4**]. It would certainly be difficult to find profundity of intellectual content in most of his work, the purpose of which is to depict only one aspect of human existence. His visions of erotic delights are frankly intended to arouse other than aesthetic feelings.

Among Boucher's pupils was Jean Honoré Fragonard (1732–1806), the last of the great French rococo painters, who lived long enough to see all demand for rococo art disappear with the coming of the French Revolution. Although his figures are generally more clothed than those of Boucher, they are no less erotic. Even more than his master, Fragonard was able to use landscape to accentuate the mood of romance. In *Love Letters* [**Fig. 16.5**], for example, the couple flirting in the foreground is surrounded by a jungle of trees and bushes that seems to impart a heady, humid air to the apparently innocent confrontation. The end of Fragonard's career is a reminder of how much eighteenth-century artists were affected by contemporary historical developments. When his aristocratic patrons either died or fled France during the Revolution, he was reduced to complete poverty. It was perhaps because Fragonard supported the ideals of the Revolution, despite its disastrous effect on his personal life, that Jacques-Louis David, one of the Revolution's chief artistic arbiters, found him a job in the Museums Service. The last representative of the rococo tradition died poor and in obscurity as a minor official in the new French Republic.

Taken together, the three leading representatives of rococo painting provide a picture of the fantasy life of eighteenth-century aristocratic society. The work of other rococo artists, however, gives us a clearer impression of what life was really like in that aristocratic world. The Venetian artist Rosalba Carriera (1675–1757) traveled widely throughout Europe producing large numbers of portraits in the rather unusual medium of **pastel**—dry sticks of color that leave a soft, powdery hue when rubbed on paper. The medium is delicate, but so, unfortunately, are the works executed in it, because the powder smudges easily and tends to

■ **16.4** François Boucher. *Cupid a Captive*, 1754. Oil on canvas, 5′5″ × 2′9″ (1.64 × .83 m). Wallace Collection, London (reproduced by courtesy of the Trustees). Venus is seen in a relaxed and playful mood as she teases her little son by dangling his quiver of arrows above his head. Nonetheless, the presence of her seductive nymphs reminds us that she is not simply the goddess of motherly love.

drop off if the paper is shaken. It is unlikely that Carriera was concerned with conveying psychological depths. Her chief aim was to provide her subjects flattering likenesses that reinforced their own favorable visions of themselves. Works like her portrait of *Anna Sofia d'Este, Princess of Modena* [**Fig. 16.6**] emphasize the

■ **16.5** Jean Honoré Fragonard. *Love Letters,* 1773. Oil on canvas, 10′5″ × 7′1″ (3.17 × 2.17 m). Copyright Frick Collection, New York. Fragonard's style is far more free and less precise than Boucher's. Compare the hazy, atmospheric landscape of this painting to the background of *Cupid a Captive* (see Figure 16.4). The statue on the pedestal to the right is, appropriately, of Venus and Cupid.

■ **16.6** Rosalba Carriera. *Anna Sofia d'Este, Princess of Modena,* c. 1730. Pastel. Galleria degli Uffizi, Florence. The pale elegance of the subject is typical of most of Carriera's aristocratic sitters, as is the charming untidiness of her dress. Note how the delicate colors of the pastels convincingly reproduce the tones of the sitter's skin.

delicacy, charm, and sensuality of eighteenth-century society beauties.

English art in the eighteenth century was also notable for its aristocratic portraits. The more extreme elements of rococo eroticism had little appeal to the English nobility, but the artists who were commissioned to paint their portraits could hardly help being influenced by the style of their day. Thomas Gainsborough (1727–1788), who together with Sir Joshua Reynolds (1723–1792) dominated the English art of the time, even studied for a while with a pupil of Boucher. At a time when rococo art had already fallen into disfavor in France, Gainsborough was still producing paintings like *Haymaker and Sleeping Girl* (see Figure 16.2), an idealizing rococo vision that recalls the world of Fragonard, although he went on to develop his own unique style, especially in his conversation pieces. Gainsborough's chief reputation, however, was made by his landscapes and portraits. Most of the portraits are set against a landscape background, as in the case of *Mary, Countess Howe* [**FIG. 16.7**]. In this

painting, setting and costume are reminiscent of Watteau, but the dignified pose and cool gaze of the subject suggest that she had other than romantic thoughts in mind. There is no lack of poetry in the scene, though, and the resplendent shimmer of the countess's dress is set off perfectly by the more somber tones of the background. Portraits and landscapes lend themselves naturally to rococo treatment, but what of religious art? One of the few painters who tried to apply rococo principles to religious subjects was the Venetian painter Giovanni Battista Tiepolo (1696–1770). Many of Tiepolo's most ambitious and best-known works are decorations for the ceilings of churches and palaces, for which projects he was helped by assistants. A more personal work is his painting *The Immaculate Conception* [**FIG. 16.8**]. The light colors and chubby cherubs of Boucher and the haughty assurance of Gainsborough's society ladies are here applied to the life of the Virgin Mary.

Rococo sculptors were, for the most part, more concerned with displaying their virtuosity in works aimed at a brilliant effect than with exploring finer

■ **16.7** Thomas Gainsborough. *Mary, Countess Howe*, c. 1765. Oil on canvas, 8′ × 5′ (2.59 × 1.52 m). London County Council, Kenwood House (Iveagh Bequest). The wild background and threatening sky set off the subject, but their artificiality is shown by her shoes—hardly appropriate for a walk in the country. Gainsborough was famous for his ability to paint fabric: note the contrast between the heavy silk dress and the lacy sleeves.

■ **16.8** Giovanni Battista Tiepolo. *The Immaculate Conception*, 1769. Oil on canvas, 9′2″ × 5′ (2.79 × 1.52 m). Museo del Prado, Madrid. The sense of weightlessness and the wonderful cloud effects are both typical of Tiepolo's style.

shades of meaning. For instance, the figure of *Deception Unmasked* [**Fig. 16.9**] by the Genoese sculptor Francesco Queirolo (1704–1762) theoretically has serious religious significance; in practice its principal purpose is to dazzle us with the sculptor's skill at rendering such details as the elaborate net in which Deception hides.

Rococo architecture likewise was principally concerned with delighting the eye rather than inspiring noble sentiments. It is most successful in decorative interiors like those of the Hôtel de Soubise in Paris [**Fig. 16.10**], where the encrustation of ornament flows from the ceiling down onto the walls, concealing the break between them.

One region of Europe in which the rococo style did exert a powerful influence on religious architecture was southern Germany and Austria. Throughout the seven-

teenth century, a series of wars in that area had discouraged the construction of new churches or public buildings; with the return of relatively stable conditions in the German states, new building again became possible. By one of those fortunate chances in the history of the arts, the fantasy and complexity of the rococo style provided a perfect complement to the new mood of exuberance. The result is a series of churches that is among the happiest of all rococo achievements.

The leading architect of the day was Balthazar Neumann (1687–1753), who had begun his career as an engineer and artillery officer. Among the many palaces and churches he designed, none is more spectacular than the Vierzehnheiligen ("fourteen saints")

16.9 Francesco Queirolo. *Deception Unmasked,* after 1752. Marble. Height approx. 5'8" (1.75 m). Cappella Sansevero, Santa Maria della Pietá di Sangro, Naples. The figure is a Christian sinner freeing himself, with the help of an angel, from the net of deception. Both figure and net are carved from a single piece of stone.

near Bamberg. The relative simplicity of the exterior deliberately leaves the visitor unprepared for the spaciousness and elaborate decoration of the interior [**FIG. 16.11**], with its rows of windows and irregularly placed columns. As in the Hôtel de Soubise, the joint between the ceiling and walls is hidden by a fresco that, together with its border, spills downward in a series of gracious curves. It is not difficult to imagine what John Calvin would have said of such an interior, but if a church can be allowed to be a place of light and joy, Neumann's design succeeds admirably.

Neo-Classical Art

For all its importance, the rococo style was not the only style to influence eighteenth-century artists. The other principal artistic movement of the age was Neo-Classicism, which increased in popularity as the appeal of the rococo declined.

There were good historical reasons for the rise of Neo-Classicism. The excavation of the buried cities of Herculaneum and Pompeii, beginning in 1711 and 1748, respectively, evoked immense interest in the art of classical antiquity in general and that of Rome in particular. The wall paintings from Pompeian villas of the first century A.D. were copied by countless visitors to the excavations, and reports of the finds were published throughout Europe. The German scholar Johannes Winckelmann (1717–1768), who is sometimes called the Father of Archaeology, played a major part in creat-

16.10 Germain Boffrand. Salon de la Princesse, Hôtel de Soubise, Paris. c. 1737–1740. Oval 33' × 26' (10.06 × 7.92 m). Painting by Natoire, sculpture by J. B. Lemoine. The decoration is typical of the rococo style. The shape of the room, the paintings that flow from ceiling to walls, and the reflections in the mirrors all create an impression of light and grace.

■ **16.11** Balthazar Neumann. Nave and high altar of Vierzehnheiligen Pilgrim Church, near Bamberg, Germany, 1743–1772. This view of the interior shows the high altar at the back of the nave (center) and part of the oval altar in the middle of the church (left). The oval altar, the ***Gnadenaltar*** ("Mercy Altar"), is a mark of the pilgrimage churches of southern Germany and Austria. Its shape is echoed in the oval ceiling paintings. The architect deliberately rejected the soaring straight lines of Gothic architecture and the balance of symmetry of the Renaissance style in favor of an intricate interweaving of surfaces, solid volumes, and empty spaces.

ing a new awareness of the importance of classical art; in many of his writings he encouraged his contemporaries not only to admire ancient masterpieces but to imitate them (see **TABLE 16.2**).

Furthermore, the aims and ideals of the Roman Republic—freedom, opposition to tyranny, valor—held a special appeal for eighteenth-century republican politicians, and the evocation of Classical models became a characteristic of the art of the French Revolution. The painter who best represents the official revolutionary style is Jacques-Louis David (1748–1825). His *Oath of the Horatii* (see Figure 16.1) draws not only on a story of ancient Roman civic virtue but also on a knowledge of ancient dress and armor derived from excavations of Pompeii and elsewhere. The simplicity of its message—the importance of united opposition to tyranny—is expressed by the simple austerity of its

style and composition, a far cry from the lush, effete world of Fragonard. David used the same lofty grandeur to depict Napoleon soon after his accession to power [**FIG. 16.12**], although there is considerable if unintentional irony in the use of the revolutionary style to represent the military dictator.

The austere poses and orderly decorations of ancient art came as a refreshing change for those artists who, regardless of politics, were tired of the excesses of the baroque and rococo styles. One of the most notable painters to introduce a Neo-Classical sense of statuesque calmness into his works was Sir Joshua Reynolds, Gainsborough's chief rival in England. *Three Ladies Adorning a Term of Hymen* [**FIG. 16.13**] shows three fashionable ladies-about-town in the guise of figures from Greek mythology. Their static poses seem derived from actual ancient statues. The Classical bust

■ **16.12** Jacques-Louis David. *Napoleon Crossing the Alps,* 1800. Oil on canvas, 8′10″ × 7′7″ (2.44 × 2.31 m), National Museum, Versailles. After he took his army across the Alps, Napoleon surprised and defeated an Austrian army. His calm, controlled figure guiding a wildly rearing horse is symbolic of his own vision of himself as bringing order to postrevolutionary France.

■ **16.13** Sir Joshua Reynolds. *Three Ladies Adorning a Term of Hymen,* 1773. Oil on canvas, 7'8″ × 10'4½″ (2.34 × 2.90 m). Tate Gallery, London (reproduced by courtesy of the Trustees). A term is a pillar topped with a bust, in this case of Hymen, god of marriage. Reynolds introduced a marriage theme because the fiancé of one of the ladies, who were daughters of Sir William Montgomery, commissioned the painting. The Neo-Classical composition was deliberately chosen by the artist because it gave him "an opportunity of introducing a variety of graceful historical attitudes."

and antique vessel on the right are evidence of a careful attempt to imitate ancient models. Even the stool at center is based on examples found at Pompeii.

Although the rococo and Neo-Classical styles dominated most of eighteenth-century painting, a few important artists avoided both the escapism of the one and the idealism of the other to provide a more truthful picture of the age. The work of William Hogarth, for example, presents its own individual view of aristocratic society in the eighteenth century.

As a master of line, color, and composition, Hogarth was in no way inferior to such contemporaries as Fragonard or Gainsborough, but he used his skills to paint a series of "moral subjects" that satirized the same patrons his colleagues aimed to entertain and to flatter. In his series of paintings called *Marriage à la Mode,* Hogarth illustrated the consequences of a loveless marriage between an impoverished earl and the daughter of a wealthy city merchant who wants to improve his social position. By the second scene in the series, *Shortly After the Marriage* [**Fig. 16.14**], matters have already begun to deteriorate.

The principal Neo-Classical sculptors—the Italian Antonio Canova (1757–1822) and the Frenchman Jean Antoine Houdon (1741–1829)—succeeded in using Classical models with real imagination and creativity (see Figure 16.21 and Figure 16.23). Canova's portrait, *Pauline Bonaparte Borghese as Venus Victorious* [**Fig. 16.15**], depicts Napoleon's sister with an idealized Classical beauty as she reclines on a couch modeled on

one found at Pompeii. The cool worldly elegance of the figure, however, is Canova's own contribution.

For serious projects such as major public buildings, architects tended to follow Classical models, as in the portico of the Pantheon in Paris [**Fig. 16.16**], the design of which uses Classical proportions. As might have been expected, the architects of the American Revolution

TABLE 16.2 *The Rediscovery of Classical Antiquity in the Eighteenth Century*

1711	First excavations at Herculaneum
1734	Society of Dilettanti formed in London to encourage exploration
1748	First excavations at Pompeii
1753	Robert Wood and James Dawkins publish *The Ruins of Palmyra*
1757	Wood and Dawkins publish *The Ruins of Baalbec*
1762	James Stuart and Nicholas Revett publish the first volume of *The Antiquities of Athens*
1764	Robert Adam publishes *The Ruins of the Palace of Diocletian at Spalato;* Johannes Winckelmann publishes *History of Ancient Art*
1769	Richard Chandler and William Pars publish the first volume of *The Antiquities of Ionia*
1772	The Hamilton collection of Greek vases purchased by the British Museum
1785	Richard Colt Hoare explores Etruscan sites in Tuscany
1801	Lord Elgin receives Turkish permission to work on the Parthenon in Athens

■ **16.14** William Hogarth. *Shortly After the Marriage,* from *Marriage à la Mode,* c. 1745. Oil on canvas, 28″ × 36″ (68 × 89 cm). National Gallery, London (reproduced by courtesy of the Trustees). Although he achieved his effects through laughter, Hogarth had the serious moral purpose of attacking the corruption and hypocrisy of his day. The young husband, exhausted from his night out, shows his empty trouser pockets, while the small dog sniffs suspiciously at the woman's cap hanging from his coat pocket.

■ **16.15** Antonio Canova. *Pauline Bonaparte Borghese as Venus Victorious,* 1808. Marble. Life size, length 6′6″ (1.98 m). Galleria Borghese, Rome. Canova's blend of simplicity and grace was widely imitated by European and American sculptors throughout the nineteenth century. The apple is the apple of discord, inscribed "to the fairest." According to legend, the goddesses Aphrodite (Venus), Hera, and Athena each offered a tempting bribe to the Trojan Paris, who was to award the apple to one of them. Paris chose Venus, who had promised him the most beautiful of women. The result was the Trojan War, which began when Paris abducted his prize, Helen, wife of a Greek king.

also turned to classical precedents when they constructed their new public buildings. Thomas Jefferson's State Capitol at Richmond [**FIG. 16.17**], for example, shows a conscious rejection of the rococo and all it stood for in favor of the austere world (as it seemed to him) of ancient Rome.

CLASSICAL MUSIC

For the most part, music in the eighteenth century followed the example of literature in retaining a serious purpose, and was relatively untouched by the mood of the rococo style. At the French court, however, there was a demand for elegant, lighthearted music to serve as entertainment. The leading composer in this ***style gallant*** was François Couperin (1668–1733), whose many compositions for keyboard emphasize grace and delicacy at the expense of the rhythmic drive and intellectual rigor of the best of baroque music. Elsewhere in Europe, listeners continued to prefer music that expressed emotion. At the court of Frederick the Great (an accomplished performer and composer), for example, a musical style known as ***empfindsamkeit*** ("sensitiveness") developed.

❖ **16.16** Germain Soufflot. Pantheon (Sainte Geneviève), Paris, 1755–1792. Originally built as the Church of Sainte Geneviève, the building was converted into a memorial to the illustrious dead at the time of the French Revolution. The architect studied in Rome for a time; the columns and pediment were inspired by ancient Roman temples.

The chief exponent of this expressive style was Carl Philipp Emanuel (hereafter referred to as C. P. E.) Bach (1714–1788), a son of Johann Sebastian Bach. His works have considerable emotional range and depth; their rich harmonies and contrasting moods opened up new musical possibilities. Like all his contemporaries, C. P. E. Bach was searching for a formal structure with which to organize them. A single piece or movement from a baroque work had first established a single mood and then explored it fully, whether it be joyful, meditative, or tragic. Now composers were developing a musical organization that would allow them to place different emotions side-by-side, contrast these, and thereby achieve expressive variety.

By the middle of the eighteenth century, a musical style developed that made possible this new range of expression. It is usually called *classical,* although the term is also used in a more general sense, which can be confusing. It would be as well to begin by carefully distinguishing between these two usages.

In its general sense, the term *classical* is frequently used to distinguish so-called serious music from popular, so that all music likely to be met with in a concert hall or opera house, no matter what its age, is labeled "classical." One reason this distinction is confusing is that for many composers before our own time, there was essentially no difference between serious and popular music. They used the same musical style and techniques for a formal composition to be listened to attentively by an audience of music lovers, as for a religious work to be performed in church, or for dance music or background music for a party or festive occasion. Furthermore, used in this sense, classical tells us nothing significant about the music itself or its period or form. It does not even describe its mood, because many pieces of "classical" or "serious" music were in fact deliberately written to provide light entertainment.

The more precise and technical meaning of "classical" as it relates to music denotes a musical style that was in use from the second half of the eighteenth century and reached its fulfillment in the works of Franz Joseph Haydn (1732–1809) and Wolfgang Amadeus Mozart (1756–1791). It evolved in answer to new musical needs the baroque style could not satisfy and lasted until the early years of the nineteenth century, when it in turn gave way to the romantic style. The figure chiefly responsible for the change from classical

❖ **16.17** Thomas Jefferson. State Capitol, Richmond, Virginia, 1785–1796. Like the Pantheon, Jefferson's building was modeled on a Roman temple, the Maison Carrée at Nîmes, but the austere spirit of the American Revolution prompted Jefferson to replace the elaborate Corinthian capitals of the original with simpler Ionic ones.

to romantic music was Ludwig van Beethoven (1770–1827). Although his musical roots were firmly in the classical style, he is more appropriately seen as a representative of the new romantic age and will be discussed in Chapter 17.

It is no coincidence that the classical style in music developed at much the same time as painters, architects, and poets were turning to Greek and Roman models, because the aims of classical music and Neo-Classical art and literature were similar. After the almost obsessive exuberance and display of the Baroque period, the characteristic qualities of ancient art—balance, clarity, intellectual weight—seemed especially appealing. The eighteenth-century composer, however, faced a problem that differed from that of the artist or writer. Unlike literature or the visual arts, ancient music has disappeared almost without trace. As a result, the classical style in music had to be newly invented to express ancient concepts of balance and order. In addition, it had to combine these intellectual principles with the no-less-important ability to express a wide range of emotion. Haydn and Mozart were the two supreme masters of the classical style because of their complete command of the possibilities of the new idiom within which they wrote.

The Classical Symphony

The most popular medium in the classical period was instrumental music. In extended orchestral works, **symphonies,** divided into several self-contained sections called **movements,** composers were most completely able to express classical principles.

One reason for this was the new standardization of instrumental combinations. In the Baroque period, composers such as Bach had felt free to combine instruments into unusual groups that varied from composition to composition. Each of Bach's *Brandenburg Concertos* was written for a different set of solo instruments. By about 1750, however, most instrumental music was written for a standard orchestra, the nucleus of which was formed by the string instruments: violins (generally divided into two groups known as first and second), violas, cellos, and double basses. To the strings were added wind instruments, almost always the oboe and bassoon and fairly frequently the flute; the clarinet began to be introduced gradually and, by about 1780, had become a regular member of the orchestra. The only brass instrument commonly included was the French horn. Trumpets, along with the **timpani** or **kettle drums,** were reserved for reinforcing volume or rhythm. Trombones were never used in classical symphonies until Beethoven did so [**FIG. 16.18**].

Orchestras made up of these instruments were capable of rich and varied sound combinations ideally suited to the new classical form of the symphony. In general, the classical symphony has four movements (as opposed to the baroque concerto's three): a first, relatively fast one, usually the most complex in form; then a slow, lyrical movement, often songlike; a third movement in the form of a **minuet** (a stately dance); and a final movement, which brings the entire work to a spirited and usually cheerful conclusion. As time went on, the length and complexity of the movements grew, and many of Haydn's later symphonies last for nearly half an hour. In most cases, however, the most elaborate musical "argument" was always reserved for the first movement, presumably because during it the listeners were freshest and most able to concentrate.

The structure almost invariably chosen for the first movement of a classical symphony was that called **sonata form.** Because sonata form was not only one of the chief features of classical style but also a principle of musical organization that remained popular throughout the nineteenth century, it merits our attention in some detail. The term is actually rather confusing, because the word *sonata* is used to describe a work in several movements (like a symphony) but written for one or two instruments rather than for an orchestra. Thus, a piano sonata is a piece for solo piano, a violin sonata is a piece for violin and an accompanying instrument, almost always a piano, and so on. A symphony is, in fact, a sonata for orchestra.

The term "sonata form," however, does not, as might be reasonably expected, describe the form of a sonata but a particular kind of musical organization frequently found in the first movement of both symphonies and sonatas as well as other instrumental combinations like string quartets (two violins, viola, and cello). Because first movements are generally played at a fast **tempo** ("speed"), the term **sonata allegro form** is also sometimes used. (The Italian word *allegro* means "fast"; Italian terms are traditionally used in music, as we have seen.)

Unlike baroque music, with its unity based on the use of a single continually expanding theme, sonata form is dominated by the idea of contrasts. The first of the three main sections of a sonata form movement is called the **exposition,** because it sets out, or "exposes," the musical material. This consists of at least two **themes,** or groups of themes, that differ from one another in melody, rhythm, and key. They represent, so to speak, the two principal characters in the drama. If the first theme is lively, the second may be thoughtful or melancholy; or a strong marchlike first theme may be followed by a gentle, romantic second one. During the exposition, the first of these themes (or "subjects," as they are often called) is stated, followed by a linking passage leading to the second subject and a conclusion that rounds off the exposition.

During the course of the movement, it is of the utmost importance that listeners be able to remember these themes and identify them when they reappear. To

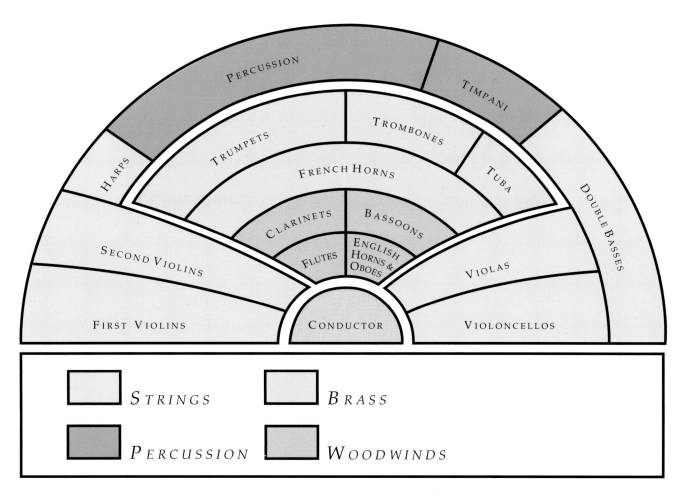

■ **16.18** Plan of the layout of a modern symphony orchestra.

help make this task easier, classical composers replaced the long, flowing lines of baroque melodies with much shorter tunes, often consisting of only a few notes, comparatively easy to recognize when they recur. The difference between baroque and classical melody is clearly visible even on paper. Compare, for example, the continuous pattern of the melodic line in Chapter 15, from Bach's *Brandenburg Concerto No. 2,* with the following theme from Mozart's *Symphony No. 40 in g minor.* The tune consists basically of a group of three notes (a) repeated three times to produce a melodic phrase (b). This procedure is then repeated three more times to impress it firmly on one's memory.

Just in case their listeners were still not perfectly famil-iar with the basic material of a movement, composers reinforced it by repeating the entire exposition note for note.

In the second section of a sonata form movement, the **development,** the themes stated in the exposition are changed and varied in whatever way the composer's imagination suggests. One part of the first subject is often detached and treated on its own, passing up and down the orchestra, now loud, now soft, as happens in the first movement of Mozart's *Symphony No. 40* to the notes above (a). Sometimes different themes will be combined and played simultaneously. In almost all cases the music passes through a wide variety of keys and moods. In the process the composer sheds new light on what have by now become familiar ideas.

At the end of the development, the original themes return to their original form for the third section of the movement, the **recapitulation** ("repeated" theme). The first section is recapitulated with both first and second subjects now in the same key. In this way the conflict implicit in the development section is resolved. A final **coda** (or "tailpiece"; coda is the Italian word for "tail") is sometimes added to bring the movement to a suitably firm conclusion.

Sonata form embodies many of the classical principles of balance, order, and control. The recapitulation, which carefully balances the exposition, and the breaking down of the material in the development and its subsequent reassembling both emphasize the sense of structure behind a sonata form movement. Both the first and last movements of Mozart's *Symphony No. 40* demonstrate how the sonata form can be used to create music of extreme dramatic power.

 To hear the last movement of Mozart's *Symphony No. 40,* play track 10 on the Listening CD.

Haydn

The long and immensely productive career of Franz Joseph Haydn spanned a period of great change in both artistic and social terms. Born in Rohrau on the Austro-Hungarian border, he sang as a child in the choir of Saint Stephen's Cathedral in Vienna. After scraping together a living for a few precarious years, in 1761 he entered the service of a wealthy nobleman, Prince Esterhazy.

Haydn began work for the prince on the same terms as any carpenter, cook, or artisan in his master's employ. That he was a creative artist was irrelevant, because social distinctions were made on grounds of wealth or birth, not talent. By the time he left the Esterhazy family almost thirty years later, the aristocracy was competing for the privilege of entertaining him! The world was changing; in the course of two visits to London, Haydn found himself feted and honored, and during his last years in Vienna he was among the most famous figures in Europe. Thus Haydn was one of the first musicians to attain a high social position solely on the strength of his genius. His success signaled the new relationship between the artist and society that was to characterize the nineteenth century.

In personal terms, Haydn seems to have been little affected by his fame. During the long years of service to Prince Esterhazy and his descendants, Haydn used the enforced isolation of the palace where he lived to experiment with all of the musical forms available to him. In addition to operas, string quartets, piano sonatas, and hundreds of other pieces, Haydn wrote more than one hundred symphonies that exploit almost every conceivable variation on sonata and other classical forms, winning him the nickname "Father of the Symphony." During his visits to London (in 1791–1792 and 1794–1795), he wrote his last twelve symphonies, which are often known as the "London" Symphonies. Although less obviously experimental than his earlier works, they contain perhaps the finest of all his orchestral music; the slow movements in particular manage to express the greatest seriousness and profundity without tragedy or gloom.

Mozart

In 1781, in his fiftieth year and at the height of his powers, Haydn met a young man about whom he was to say a little while later to the young man's father: "Before God and as an honest man, I tell you that your son is the greatest composer known to me either in person or by name." Many of us, for whom the music of Wolfgang Amadeus Mozart represents a continual source of inspiration and joy and a comforting reminder of the heights the human spirit can attain, would see no reason to revise Haydn's judgment [**Fig. 16.19**].

Although Mozart's life, in contrast to Haydn's, was to prove one of growing disappointments and setbacks, his early years were comparatively happy. During his childhood he showed extraordinary musical ability. By age six he could already play the violin and piano and had begun to compose. His father Leopold, a professional musician in the service of the Archbishop of Salzburg, where the family lived, took Wolfgang on a seemingly never-ending series of trips throughout Europe to exhibit his son's musical prowess. The effect of constant travel on the boy's health and temperament can be imagined, but during these trips he became exposed to the most sophisticated and varied musical ideas of the day; the universality of his own musical style must in part be the result of the wide range of

■ **16.19** Joseph Lange. *Mozart at the Pianoforte,* 1789. Oil on canvas, 13½″ × 11½″ (35 × 30 cm). Mozart Museum, Salzburg. This unfinished portrait shows the composer for once without the wig that was customarily worn at the time. Mozart must have liked the painting because he had a copy made and sent to his father.

influences he was able to assimilate, from the **style galant** of the rococo to the Renaissance polyphonies he heard in Rome. From time to time father and son would return to Salzburg, where by this time they both held appointments at the court of the archbishop.

In 1772, the old archbishop died. His successor, Hieronymus Colloredo, was far less willing to allow his two leading musicians to come and go as they pleased. Artistic independence of the kind Haydn was to achieve was still in the future, and the following ten years were marked by continued quarreling between Mozart and his aristocratic employer. Finally, in 1781, when Mozart could take no more and asked the archbishop for his freedom, he was literally kicked out the palace door. From 1781 to 1791, Mozart spent the last years of his life in Vienna, trying in vain to find a permanent position while writing some of the most sublime masterpieces in the history of music. When he died at age thirty-five, he was buried in a pauper's grave.

The relationship between an artist's life and work is always fascinating. In Mozart's case it raises particular problems. We might expect that continual frustration, poverty, and depression would have left its mark on his music, yet it is a grave mistake to look for autobiographical self-expression in the work of an artist who devoted his life to achieving perfection in his art. In general, Mozart's music reflects only the highest and most noble of human aspirations. Perhaps more than any other artist in any medium, Mozart combines ease and grace with profound learning in his art to come as near to ideal beauty as anything can. Nevertheless, his music remains profoundly human. We are reminded many times not of Mozart's own suffering but of the tragic nature of life itself.

A year before his death, Mozart wrote the last of his great series of concertos for solo piano and orchestra, the *Piano Concerto No. 27 in B flat,* K. 595 (Mozart's works are generally listed according to the catalog first made by Köchel; hence the letter *K* that precedes the catalogue numbers). The wonderful slow movement of this work expresses, with a profundity no less moving for its utter simplicity, the resignation of one for whom the beauty of life is perpetually tinged with sadness. We can only marvel at so direct a statement of so universal a truth.

The need to earn a living, coupled with the inexhaustibility of his inspiration, drew from Mozart works in almost every conceivable category. Symphonies, concertos, masses, sonatas, and string quartets are only some of the forms he enriched. Many admirers of Mozart would choose his operas, however, if faced with a decision as to what to save if all else were to be lost. Furthermore, his operas provide the clearest picture of his historical position.

Mozart's opera *The Marriage of Figaro* is based on a play of the same name by the French dramatist Pierre-Augustin Beaumarchais (1732–1799). Although a comedy, the play, which was first performed in 1784, contains serious overtones. The plot is too complicated to permit even a brief summary, but among the characters are a lecherous and deceitful, though charming, Count; his deceived wife, the Countess; her maid, Susanna, who puts up a determined resistance against the Count's advances; and Susanna's husband-to-be, Figaro, who finally manages to outwit and embarrass the would-be seducer of his future wife, who is also his own employer [**Fig. 16.20**]. In other words, the heroes of the play are the servants and the villain their

■ **16.20** *The Marriage of Figaro.* Metropolitan Opera, New York, 1975. In this scene from Act II of Mozart's opera, the Count (on the right) is trying to assert his aristocratic authority against the combined arguments of his wife (left), Susanna (second from right), and Figaro (third from right). The singers are Evelyn Lear as the Countess, Wolfgang Brendel as the Count, Judith Blegen as Susanna, and Justino Diaz as Figaro.

master. Written as it was on the eve of the French Revolution, Beaumarchais's play was interpreted rightly as an attack on the morals of the ruling classes and a warning that the lower classes would fight back. Beaumarchais was firmly associated with the moves toward social and political change; he was an early supporter of the American Revolution and helped organize French support for the insurgent colonists.

Mozart's opera was first performed in 1786. It retains the spirit of protest in the original but adds a sense of humanity and subtlety perhaps only music can bring. No one suffered more than Mozart from the highhandedness of the aristocracy, yet when *The Marriage of Figaro* gives voice to the growing mood of revolution, it does so as a protest against the abuse of human rights rather than in a spirit of personal resentment. In the first act, Figaro's aria "Se vuol' ballare" expresses the pent-up frustration of generations of men and women who had endured injustices and who could take no more. The musical form and expression is still restrained, indeed classical, but Mozart pours into it the feelings of the age.

Mozart's ability to create characters who seem real, with whose feelings we can identify, reaches its height in the Countess. Ignored and duped by her husband, the laughingstock of those around her, she expresses the conflicting emotions of a woman torn between resentment and deep attachment. Her aria in the third act, "Dove sono," begins with a recitative in which she vents her bitterness. Gradually it melts into a slow and meditative section in which she asks herself what went wrong: "Where are those happy moments of sweetness and pleasure, where did they go, those vows of a deceiving tongue?" The poignant theme to which these words are set returns toward the end of the slow section to provide one of the most affective moments in all opera. Mozart's gift for expressing human behavior at its most noble is conveyed in the aria's final section, where the Countess decides, despite everything, to try to win back her husband's love. Thus, in seven or eight minutes, we have been carried from despair to hope, and Mozart has combined his revelation of a human heart with music that by itself is of extraordinary beauty.

The opera as a whole is far richer than discussion of these two arias can suggest. For instance, among the other characters is one of the composer's most memorable creations, the pageboy Cherubino, whose aria "Non so più" epitomizes the breathless, agonizing joy of adolescent love. An accomplishment of another kind is exemplified by the **ensembles** (scenes in which a large number of characters are involved). Here Mozart combines clarity of musical and dramatic action while advancing the plot at a breakneck pace.

The Marriage of Figaro expresses at the same time the spirit of its age and the universality of human nature, a truly classical achievement. Equally impressively, it illu-

minates the personal emotions of individual people, and through them teaches us about our own reactions to life and its problems. As one distinguished writer has put it, in this work Mozart has added to the world's understanding of people—of human nature.

LITERATURE IN THE EIGHTEENTH CENTURY

Intellectual Developments

While painters, poets, and musicians were reflecting the changing moods of the eighteenth century in their art, social and political philosophers were examining the problems of contemporary society more systematically. Individual thinkers frequently alternated between optimism and despair, because awareness of the greatness of which human beings were capable was always qualified by the perception of the sorry state of the world. The broad range of diagnosis and/or proposed solutions makes it difficult to generalize on the nature of eighteenth-century intellectual life, but two contrasting trends can be discerned. A few writers, notably Jonathan Swift, reacted to the problems of the age with deep pessimism, bitterly opposing the view that human nature is basically good. Others, convinced that progress was possible, sought to devise new systems of intellectual, social, or political organization. Rational humanists like Diderot and political philosophers like Rousseau based their arguments on an optimistic view of human nature. However, Voltaire, the best known of all eighteenth-century thinkers, fitted into neither of these two categories—rather, he moved from one to the other. The answer he finally proposed to the problems of existence is as applicable to the world of today as it was to that of the eighteenth century, although perhaps no more welcome.

The renewed interest in Classical culture, visible in the portraits by Sir Joshua Reynolds and buildings like the Pantheon, also made a strong impression on literature. French writers like Racine had already based works on Classical models, and the fables of Jean de La Fontaine (1621–1695) drew freely on Aesop and other Greek and Roman sources. Elsewhere in Europe throughout the eighteenth century, poets continued to produce works on Classical themes, from the plays of Pietro Metastasio (1698–1782) in Italy to the lyric poetry of Friedrich von Schiller (1759–1805) in Germany.

The appeal of Neo-Classical literature was particularly strong in England, where major Greek and Roman works like Homer's *Iliad* and *Odyssey* or Vergil's *Aeneid* had long been widely read and admired. In the seventeenth century, Milton's *Paradise Lost* had represented a deliberate attempt to create an equally monumental

VOICES OF THEIR TIMES

Horace Walpole

A Visit to the Court of Louis XV

The English writer and connoisseur Horace Walpole (1717–1797) has been presented to the king and queen and describes the encounter to a friend.

You perceive that I have been presented. The Queen took great notice of me; none of the rest said a syllable.

You are let into the king's bedchamber just as he has put on his shirt; he dresses and talks good-humoredly to a few, glares at strangers, goes to mass, to dinner, and a-hunting. The good old Queen, who is like Lady Primrose in the face, and Queen Caroline in the immensity of her cap, is at her dressing-table, attended by two or three old ladies, who are languishing to be in Abraham's bosom, as the only man's bosom to whom they can hope for admittance. Thence you go to the Dauphin, for all is done in an hour. He scarce stays a minute; indeed, poor creature; he is a ghost, and cannot possibly last three months. The Dauphiness is in her bedchamber, but dressed and standing; looks cross, is not civil, and has the true Westphalian grace and accents.

The four Mesdames, who are clumsy, plump old wenches, with a bad likeness to their father, stand in a bedchamber in a row, with black cloaks and knitting-bags, looking good-humored, not knowing what to say, and wriggling as if they wanted to make water. This ceremony too is very short; then you are carried to the Dauphin's three boys, who you may be sure only bow and stare. The Duke of Berry looks weak and weakeyed: the Count de Provence is a fine boy; the Count d'Artois well enough. The whole concludes with seeing the Dauphin's little girl dine, who is as round and as fat as a pudding.

From *The Letters of Horace Walpole*, P. Cunningham, ed. London, 1892.

epic poem in English. Before the eighteenth century, however, several important works, including the tragedies of Aeschylus, had never been translated into English.

The upsurge of enthusiasm for Classical literature that characterized the eighteenth-century English literary scene had two chief effects: Poets and scholars began to translate or retranslate the most important Classical authors; and creative writers began to produce original works in Classical forms, deal with Classical themes, and include Classical references. The general reading public was by now expected to understand and appreciate both the ancient masterpieces and modern works inspired by them.

The principal English writers formed a group calling themselves Augustans. The name reveals the degree to which these writers admired and modeled themselves on the Augustan poets of ancient Rome. In 27 A.D., the victory of the first Roman emperor Augustus ended the chaos of civil war in Rome and brought peace and stability to the Roman world. The principal poets of Rome's Augustan Age, writers like Vergil and Horace, had subsequently commemorated Augustus's achievement in works intended for a sophisticated public. In the same way in England the restoration to power of King Charles II (in 1660) seemed to some of his contemporaries a return to order and civilization after the tumultuous English Civil War. The founders of the English Augustan movement, writers like John Dryden (1631–1700), explored not only the historical parallel by glorifying English achievement under the monarchy but also the literary one by imitating the highly polished style of the Roman Augustan poets in works intended for an aristocratic audience. He also translated the works of Vergil, Juvenal, and other Roman poets into English.

Pope's Rococo Satires Alexander Pope (1688–1744), the greatest English poet of the eighteenth century, was one of the Augustans, yet the lightness and elegance of his wit reflect the rococo spirit of the age.

His genius lay precisely in his awareness that the dry bones of Classical learning needed to have life breathed into them. The spirit that would awaken art in his own time, as it had done for the ancient writers, was that of Nature—not in the sense of the natural world but in the sense of that which is universal and unchanging in human experience. Pope's conception of the vastness and truth of human experience given form and meaning by rules first devised in the ancient past represents eighteenth-century thought at its most constructive.

Like Watteau, Pope suffered throughout his life from ill health. At age twelve, an attack of spinal tuberculosis left him permanently crippled. Perhaps in compensation he soon developed the passion for reading and for the beauty of the world around him that shines through his work. A Catholic in a Protestant country, he was unable to establish a career in public life or obtain public patronage for his literary work. As a result he was forced to support himself entirely by writing and translating. Pope's literary reputation was

first made by the *Essay on Criticism,* but he won economic independence by producing highly successful translations of Homer's *Iliad* (1713–1720) and *Odyssey* (1721–1726) and an edition of the works of Shakespeare (1725). With the money he earned from these endeavors, he abandoned commercial publishing and confined himself, for the most part, to his house on the river Thames at Twickenham, where he spent the rest of his life writing, entertaining friends, and indulging his fondness for gardening.

Pope's range as a poet was considerable, but his greatest achievements were in the characteristically rococo medium of **satire.** Like his fellow countryman Hogarth, Pope's awareness of the heights to which humans can rise was coupled with an acute sense of the frequency of their failure to do so. In the long poem *Essay on Man* (1733–1734), for example, Pope combines Christian and humanist teaching in a characteristically eighteenth-century manner to express his philosophical position with regard to the preeminent place occupied by human beings in the divine scheme of life. He is at his best, however, when applying his principles to practical situations and uncovering human folly. Pope's reverence for order and reason made him the implacable foe of those who in his eyes were responsible for the declining political morality and artistic standards of the day. It is sometimes said that Pope's satire is tinged with personal hostility. In fact, a series of literary and social squabbles marked his life, suggesting that he was not always motivated by the highest ideals; nonetheless, in his poetry he nearly always based his moral judgments on what he described as "the strong antipathy of good to bad," a standard he applied with courage and wit.

Swift's Savage Indignation Perhaps the darkest of all visions of human nature in the eighteenth century was that of Jonathan Swift (1667–1745). In a letter to Alexander Pope he made it clear that, whatever his affection for individuals, he hated the human race as a whole. According to Swift, human beings were not to be defined automatically as rational animals, as so many eighteenth-century thinkers believed, but as animals capable of reason. It was precisely because so many of them failed to live up to their capabilities that Swift turned his "savage indignation" against them into bitter satire, never more so than when the misuse of reason served "to aggravate man's natural corruptions" and provide him with new ones.

Swift was in a position to observe at close quarters the political and social struggles of the times. Born in Dublin, for much of his life he played an active part in supporting Irish resistance to English rule. After studying at Trinity College, Dublin, he went to England and (in 1694) was ordained a priest in the Anglican Church. For the next few years he moved back and forth between England and Ireland, taking a leading role in

the political controversies of the day by publishing articles and pamphlets that in general, were strongly conservative.

A fervent supporter of the monarchy and of the Anglican Church, Swift had good reason to hope that his advocacy of their cause would win him a position of high rank. In 1713, this hope was partially realized with his appointment as Dean of Saint Patrick's Cathedral in Dublin. Any chances he had of receiving an English bishopric were destroyed in 1714 by the death of Queen Anne and the subsequent dismissal of his political friends from power.

Swift spent the remainder of his life in Ireland, cut off from the mainstream of political and cultural life. Here he increasingly emerged as a publicist for the Irish cause. During his final years his mind began to fail, but not before he had composed the epitaph under which he lies buried in Saint Patrick's Cathedral: *Ubi saeva indignatio ulterius cor lacerare nequit* ("He has gone where savage indignation can tear his heart no more").

During his years in Ireland, Swift wrote his best-known work, *Gulliver's Travels,* first published in 1726. In a sense *Gulliver's Travels* has been a victim of its own popularity, because its surprising success as a work for young readers has distracted attention from the author's real purpose: to satirize human behavior. (It says much for the eighteenth century's richness that it could produce two writers working in the same genre—the satirists Swift and Pope—with such differing results.) The first two of Gulliver's four voyages, to the miniature land of Lilliput and to Brobdingnag, the land of giants, are the best known. In these sections the harshness of Swift's satire is to some extent masked by the charm and wit of the narrative. In the voyage to the land of the Houyhnhnms, however, Swift draws a bitter contrast between the Houyhnhnms, a race of horses whose behavior is governed by reason, and their slaves the Yahoos, human in form but bestial in behavior. As expressed by the Yahoos, Swift's vision of the depths to which human beings can sink is profoundly pessimistic. His insistence on their deep moral and intellectual flaws is in strong contrast to the rational humanism of many of his contemporaries, who believed in the innate dignity and worth of human beings.

Yet even the Yahoos do not represent Swift's most bitter satire. It took his experience of the direct consequences of "man's inhumanity to man" to draw from his pen a short pamphlet, *A Modest Proposal for Preventing the Children of Poor People in Ireland from Being a Burden to Their Parents or Country, and for Making Them Beneficial to the Public,* the title of which is generally abbreviated to *A Modest Proposal.* First published in 1729, this brilliant and shocking work was inspired by the poverty and suffering of a large sector of Ireland's population. Even today the nature of the supposedly benevolent author's "modest proposal" can take the

reader's breath away, both by the calmness with which it is offered and by the devastatingly quiet logic with which its implications are explained. All the irony of which this master satirist was capable is here used to express anger and disgust at injustice and the apparent inevitability of human suffering. Although Swift was writing in response to a particular historical situation, the deep compassion for the poor and oppressed that inspired him transcends its time. Our own world has certainly not lost the need for it.

Rational Humanism: The Encyclopedists Belief in the essential goodness of human nature and the possibility of progress, which had first been expressed by the humanists of the Renaissance, continued to find supporters throughout the eighteenth century. The enormous scientific and technical achievements of the two centuries since the time of Erasmus tended to confirm the opinions of those who took a positive view of human capabilities. It was in order to provide a rational basis for this positive humanism that the French thinker and writer Denis Diderot (1713–1784) [**Fig. 16.21**] conceived the project of preparing a vast encyclopedia that would describe the state of contemporary science, technology, and thought and provide a system for the classification of knowledge.

Work on the *Encyclopédie*, as it is generally called, began in 1747; the last of its seventeen volumes appeared in 1765. By its conclusion, what had begun as a compendium of information had become the statement of a philosophical position: that the extent of human powers and achievements conclusively demonstrates that humans are rational beings. The implication of this position is that any political or religious system seeking to control the minds of individuals is to be condemned. It is hardly surprising, therefore, that some years before the conclusion of the project, the *Encyclopédie* had been banned by decree of Louis XV; the last volumes were published clandestinely.

In religious terms, the *Encyclopédie* took a position of considerable skepticism, advocating freedom of conscience and belief. Politically, however, its position was less extreme and less consistent. One of the most distinguished philosophers to contribute political articles was Charles-Louis Montesquieu (1689–1755), whose own aristocratic origins may have helped mold his relatively conservative views. Both in the *Encyclopédie* and in his own writings, Montesquieu advocated the retention of a monarchy, with powers divided between the king and a series of "intermediate bodies" that included parliament, aristocratic organizations, the middle class, and even the church. By distributing power in this way, Montesquieu hoped to achieve a workable system of "checks and balances," thereby eliminating the possibility of a central dictatorial government. His ideas proved particularly interesting to the authors of the Constitution of the United States.

■ **16.21** Jean Antoine Houdon. *Denis Diderot*, 1771. Terra cotta. Height 16″ (41 cm). Louvre, Paris. Unlike most official portraiture of the eighteenth century, Houdon's work aims to reveal the character of his sitters. Here he vividly conveys Diderot's humanity and quizzical humor.

A very different point of view was espoused by another contributor to the *Encyclopédie*, Jean Jacques Rousseau (1712–1778), whose own quarrelsome and neurotic character played a considerable part in influencing his political philosophy. Diderot had originally commissioned Rousseau to produce some articles on music, since the latter was an accomplished composer (his opera *Le Devin du Village* is still performed occasionally). After violently quarreling with Diderot and others, however, Rousseau spent much of an unhappy and restless life writing philosophical treatises and novels that expressed his political convictions. Briefly stated, Rousseau believed that the natural goodness of the human race had been corrupted by the growth of civilization and that the freedom of the individual had been destroyed by the growth of society. For Rousseau, humans were good and society was bad.

Rousseau's praise of the simple virtues like unselfishness and kindness and his high regard for natural human feelings have identified his philosophy with a belief in the "noble savage," but this phrase is misleading. Far from advocating a return to primitive existence in some nonexistent Garden of Eden, Rousseau passionately strove to create a new social order. In *The Social Contract* (1762), he tried to describe the basis of his ideal state in terms of the General Will of the people, which would delegate authority to individual organs of government, although neither most of his readers nor Rousseau seemed clear on how this General Will should operate.

Although Rousseau's writings express a complex political philosophy, most of his readers were more interested in his emphasis on spontaneous feeling than in his political theories. His contempt for the superficial and the artificial, and his praise for simple and direct relationships between individuals, did a great deal to help demolish the principles of aristocracy and continue to inspire believers in human equality.

Voltaire's Philosophical Cynicism: *Candide* It may seem extravagant to claim that the life and work of François Marie-Arouet (1694–1778), best known to us as Voltaire (one of his pen names), can summarize the events of a period as complex as the eighteenth century. That the claim can be not only advanced but also supported is some measure of the breadth of his genius. A writer of poems, plays, novels, and history; a student of science, philosophy, and politics; a man who spent time at the courts of Louis XV and Frederick the Great but also served a prison sentence; a defender of religious and political freedom who simultaneously supported enlightened despotism, Voltaire was above all a man *engagé*—one committed to the concerns of his age [**FIG. 16.22**].

After being educated by the Jesuits, he began to publish writings in the satirical style he was to use throughout his life. His belief that the aristocratic society of the times was unjust must have received strong confirmation when his critical position earned him first a year in jail and then, in 1726, exile from France. Voltaire chose to go to England, where he found a system of government that seemed to him far more liberal and just than that of the French. On his return home in 1729 he discussed the advantages of English political life in his *Lettres philosophiques,* published in 1734, and escaped from the scandal and possibility of arrest that his work created by spending the next ten years in the country.

In 1744, Voltaire was finally tempted back to the French court but found little in its formal and artificial life to stimulate him. He discovered a more congenial atmosphere at the court of Frederick the Great at Potsdam, where he spent the years from 1750 to 1753. Frederick's warm welcome and considerable intellectual

■ **16.22** Jean Baptiste Pigalle. *Voltaire,* 1770–1776. Marble. Height 4′9⅜″ (1.47 m). Louvre, Paris. This most unusual statue of the great philosopher places a powerful head on the torso of an old man. The head was modeled from life when Voltaire was seventy-six; the body is based on that of a Roman statue. The statue seems to represent the triumph of the spirit over the frailty of the body.

stature must have come as an agreeable change from the sterile ceremony of the French court, and the two men soon established a close friendship. It seems, however, that Potsdam was not big enough to contain two such powerful intellects and temperaments. After a couple of years, Voltaire quarreled with his patron and once again abandoned sophisticated life for that of the country.

In 1758, Voltaire finally settled in the village of Ferney, where he set up his own court. Here the greatest names in Europe—intellectuals, artists, politicians—made the pilgrimage to talk and, above all, listen to the sage of Ferney, while he published work after work, each of which was distributed throughout Europe. Only in 1778, the year of his death, did Voltaire return to Paris, where the excitement brought on by a hero's welcome proved too much for his failing strength.

It is difficult to summarize the philosophy of a man who touched on so many subjects. Nevertheless, one theme recurs continually in Voltaire's writings: the importance of freedom of thought. Voltaire's greatest hatred was reserved for intolerance and bigotry; in letter after letter he ended with the phrase he made famous, *Écrasez l'infâme* ("Crush the infamous thing"). The "infamous thing" is superstition, which breeds fanaticism and persecution. Those Voltaire judged chiefly responsible for superstition were the Christians—Catholic and Protestant alike.

Voltaire vehemently attacked the traditional view of the Bible as the inspired word of God. He claimed that it contained a mass of anecdotes and contradictions totally irrelevant to the modern world and that the disputes arising from it, which had divided Christians for centuries, were absurd and pointless. Yet Voltaire was far from being an atheist. He was a firm believer in a God who had created the world, but whose worship could not be tied directly to one religion or another: "The only book that needs to be read is the great book of nature." Only natural religion and morality would end prejudice and ignorance.

Voltaire's negative criticisms of human absurdity are more convincing than his positive views on a universal natural morality. It is difficult not to feel at times that even Voltaire had only the vaguest ideas of what natural morality really meant. In fact, in *Candide* (1759), his best-known work, he reaches a much less optimistic conclusion. *Candide* was written with the avowed purpose of ridiculing the optimism of the German philosopher Gottfried von Leibnitz (1646–1716), who believed that "everything is for the best in the best of all possible worlds." Because both intellect and experience teach that this is far from the case, Voltaire chose to demonstrate the folly of unreasonable optimism, as well as the cruelty and stupidity of the human race, by subjecting his hero Candide to a barrage of disasters and suffering.

THE LATE EIGHTEENTH CENTURY: TIME OF REVOLUTION

Throughout the eighteenth century, Europe continued to prosper economically. The growth of trade and industry, particularly in Britain, France, and Holland, led to several significant changes in the lifestyles of increasing numbers of people. Technological improvements in coal mining and iron casting began to lay the foundations for the Industrial Revolution of the nineteenth century. The circulation of more books and newspapers increased general awareness of the issues of the day. As states began to accumulate more revenue, they increased both the size of their armies and the number of those in government employ. The Baroque period had seen the exploitation of imported goods and spices from Asia and gold from Latin America; the eighteenth century was marked by the development of trade with North America and the Caribbean.

Amid such vast changes, it was hardly possible that the systems of government should remain unaffected. Thinkers like Rousseau and Voltaire began to question the hitherto unquestioned right of the wealthy aristocracy to rule throughout Europe. In Britain, both at home and in the colonies, power was gradually transferred from the king to Parliament. Prussia, Austria, and Russia were ruled by so-called enlightened despots, as we have seen.

In France, however, the center of much of the intellectual pressure for change, the despots were not even enlightened. Louis XV, who ruled from 1715 to 1774, showed little interest in the affairs of his subjects or the details of government. The remark often attributed to him, *Après moi le déluge* ("After me the flood"), suggests that he was fully aware of the consequences of his indifference. Subsequent events fully justified his prediction, yet throughout his long reign he remained either unwilling or unable to follow the example of his fellow European sovereigns and impose some order on government. By the time his grandson Louis XVI succeeded him in 1774, the damage was done. Furthermore, the new king's continued reliance on the traditional aristocratic class, into whose hands he put wealth and political power, offended both the rising middle class and the peasants.

When in 1788 the collapse of the French economy was accompanied by a disastrous harvest and consequent steep rise in the cost of food in the first phase of the revolution, riots broke out in Paris and in rural districts. In reaction to the ensuing violence "The Declaration of the Rights of Man and Citizen," which asserted the universal right to "liberty, property, security, and resistance to oppression," was passed on August 26, 1789. Its opening section clearly shows the influence of the American Declaration of Independence.

from The Declaration of the Rights of Man

The representatives of the French people, organized in National Assembly, considering that ignorance, forgetfulness, or contempt of the rights of man are the sole causes of public misfortunes and of the corruption of governments, have resolved to set forth in a solemn declaration the natural, inalienable, and sacred rights of man, in order that such declaration, continually before all members of the social body, may be a perpetual reminder of their rights and duties; in order that the acts of the legislative power and those of the executive power may constantly be compared to the aim of every political institution and may accordingly be more respected; in order that the demands of the citizens, founded henceforth upon simple and incontestable principles, may always be directed toward the maintenance of the Constitution and the welfare of all.

Accordingly, the National Assembly recognizes and proclaims, in the presence and under the auspices of the Supreme Being, the following rights of man and citizen.

1. Men are born and remain free and equal in rights; social distinctions may be based only on general usefulness.
2. The aim of every political association is the preservation of the natural and inalienable rights of man; these rights are liberty, property, security, and resistance to oppression.
3. The source of all sovereignty resides essentially in the nation; no group, no individual may exercise authority not emanating expressly therefrom.
4. Liberty consists of the power to do whatever is not injurious to others; thus the enjoyment of the natural rights of every man has for its limits only those that assure other members of society the enjoyment of those same rights; such limits may be determined only by law.
5. The law has the right to forbid only actions which are injurious to society. Whatever is not forbidden by law may not be prevented, and no one may be constrained to do what it does not prescribe.
6. Law is the expression of the general will; all citizens have the right to concur personally, or through their representatives, in its formation; it must be the same for all, whether it protects or punishes. All citizens, being equal before it, are equally admissible to all public offices, positions, and employments, according to their capacity, and without other distinction than that of virtues and talents.

Declarations alone hardly sufficed, however; after two and a half years of continual political bickering and unrest, the revolution entered its second phase. On September 20, 1792, the National Convention was assembled. One of its first tasks was to try Louis XVI, now deposed and imprisoned for treason. After unanimously finding him guilty, the convention was divided on whether to execute him. He was finally condemned to the guillotine by a vote of 361 to 360 and beheaded forthwith. The resulting Reign of Terror lasted until 1795. During it, utopian theories of a republic based on liberty, equality, and fraternity were ruthlessly put into practice. The revolutionary leaders cold-bloodedly eliminated all opponents, real or potential, and created massive upheaval throughout all levels of French society.

The principal political group in the convention, the Jacobins, was at first led by Maximilien Robespierre (1758–1794). One of the most controversial figures of the revolution, Robespierre is viewed by some as a demagogue and bloodthirsty fanatic, by others as a fiery idealist and ardent democrat; his vigorous commitment to revolutionary change is disputed by no one. Following Rousseau's belief in the virtues of natural human feelings, Robespierre aimed to establish a "republic of virtue," made up democratically of honest citizens.

In order to implement these goals, revolutionary courts were established, which tried and generally sentenced to death those perceived as the enemies of the revolution. The impression that the Reign of Terror was aimed principally at the old aristocracy is incorrect. Only nobles suspected of political agitation were arrested, and the vast majority of the guillotine's victims—some 70 percent—were rebellious peasants and workers. Neither were revolutionary leaders immune. Georges-Jacques Danton (1759–1794), one of the earliest spokesmen of the revolution and one of Robespierre's principal political rivals, was executed in March 1794 along with some of his followers.

Throughout the rest of Europe, events in France were followed with horrified attention. Austria and Prussia were joined by England, Spain, and several smaller states in a war against the revolutionary government. After suffering initial defeat, the French enlarged and reorganized their army and succeeded in driving back the allied troops at the Battle of Fleurus in June 1794. Paradoxically, the military victory, far from reinforcing Robespierre's authority, provided his opponents the strength to eliminate him; he was declared an outlaw on July 27, 1794, and guillotined the next day.

By the spring of the following year, the country was in economic chaos and Paris was torn by street rioting. Many of those who had originally been in favor of revolutionary change, including businessmen and landowning peasants, realized that whatever the virtues of democracy, constitutional government was essential. In reply to these pressures the convention produced a new constitution, known as the Directory. This first formally established French republic lasted only until 1799, when political stability returned to France with the military dictatorship of Napoleon Bonaparte.

Although the French Revolution was an obvious consequence of extreme historical pressures, many of its leaders were additionally inspired by the successful outcome of another revolution: that of the Americans against their British rulers. More specifically, the Americans had rebelled against not the British king but the British parliament. In eighteenth-century England the king was given little chance to be enlightened or otherwise, because supreme power was concentrated in the legislative assembly, which ruled both England and, by its appointees, British territories abroad. A series of economic measures enacted by Parliament succeeded in thoroughly rousing American resentment. The story of what followed the Declaration of Independence of July 4, 1776, is too involved to be summarized here. Its result was the signing of a peace treaty in 1783 and the inauguration of the new American Constitution in 1789.

Although the Declaration of Independence was certainly not intended as a work of literature, its author, generally assumed to be Thomas Jefferson, was as suc-

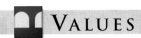

VALUES

Revolution

The eighteenth century saw a series of vast upheavals in patterns of European life that had remained constant since late medieval times. The Renaissance and the subsequent Reformation and Counter-Reformation had laid the intellectual bases for the change. The eighteenth century was marked by their consequences. One revolution was in economic affairs. As a result of exploration and colonization, international trade and commerce increased, which enriched ever-growing numbers of middle-class citizens and their families. On the other hand, the endless wars of the seventeenth century left national governments deeply in debt. In England, the state introduced paper money for the first time in an attempt to restore financial stability. The transfer of wealth from the public sector to private hands encouraged speculation. Spectacular financial collapses of private companies—the most notorious was that of the South Sea Company—produced panic and revolutionary changes in banking systems.

Another revolution, perhaps in the long run the most important of all, was the development of industry. The Industrial Revolution, which reached its climax in the mid-nineteenth century, had its origins a century earlier. The invention of new machines, particularly in the textile industry, led to the establishment of factories, which in turn produced the growth of urban life. New mining techniques turned coal into big business. New technologies revolutionized modes of travel that had been virtually unchanged since Roman times.

At the same time, the complex structure of international diplomatic relations that had existed for centuries began to collapse. Although France remained the leading European power, its economy and internal stability were undermined by the refusal of its ruling class to admit change, and Britain became the richest country in the world. The dominant powers of Renaissance Europe and the Age of Exploration—Spain, Portugal, the city-states of Italy—were in decline, while important new players appeared on the scene: Prussia under the Hohenzollerns, the Russia of Peter the Great.

Impatience with the ways of the Old Regime, together with the desire for revolutionary political and social change, found expression in the writings of Enlightenment figures such as Voltaire. By the end of the eighteenth century, many people throughout Europe were increasingly frustrated by living in continual political and social deprivation. As a result, they took to the streets in direct physical action.

The American Revolution undermined the power of the monarchy in Britain, and speeded up the collapse of the Old Regime in France. The French Revolution petered out in the years of Napoleonic rule but marked a watershed in Western history and culture: ever since the late eighteenth century, governments have had to reckon with intellectual protest and direct political action by their citizens.

cessful as any of the literary figures of the eighteenth century in expressing the more optimistic views of the age. The principles enshrined in the document assume that human beings are capable of achieving political and social freedom. Positive belief in equality and justice is expressed in universal terms like *man* and *nature*—universal for their day, that is—typical of eighteenth-century enlightened thought [**Fig. 16.23**].

from The Declaration of Independence

When in the Course of human events, it becomes necessary for one people to dissolve the political bonds which have connected them with another, and to assume among the Powers of the earth, the separate and equal station to which the Laws of Nature and of Nature's God entitle them, a decent respect to the opinions of mankind requires that they should declare the causes which impel them to the separation.

We hold these truths to be self-evident, that all men are created equal, that they are endowed by their Creator with certain unalienable Rights, that among these are Life, Liberty and the pursuit of Happiness. That to secure these rights, Governments are instituted among Men, deriving their just powers from the consent of the governed. That whenever any Form of Government becomes destructive of these ends, it is the Right of the People to alter or to abolish it, and to institute new Government, laying its foundation on such principles and organizing its powers in such form, as to them shall seem most likely to effect their Safety and Happiness. Prudence, indeed, will dictate that Governments long established should not be changed for light and transient causes; and accordingly all experience hath shown, that mankind are more disposed to suffer, while evils are sufferable, than to right themselves by abolishing the forms to which they are accustomed. But when a long train of abuses and usurpations, pursuing invariably the same Object, evinces a

■ **16.23** Jean Antoine Houdon. *George Washington,* 1778. Marble. Height 6′8″ (2.03 m). Virginia State Capitol, Richmond (courtesy of the Virginia State Library). The sculptor has emphasized the dignity and lofty calm of the first president.

design to reduce them under absolute Despotism, it is their right, it is their duty, to throw off such Government, and to provide new Guards for their future security. Such has been the patient sufferance of these Colonies; and such is now the necessity which constrains them to alter their former Systems of Government. The history of the present King of Great Britain is a history of repeated injuries and usurpations, all having in direct object the establishment of an absolute Tyranny over these States.

SUMMARY

Monarchy in the Eighteenth Century The eighteenth century marked the passage in European life from the old aristocratic order to the beginnings of modern society. When the age began, Louis XIV was still firmly entrenched; before the century ended, Louis XVI and his wife had been executed by the National Convention of the French Revolution—itself inspired, in theory at least, by the American Revolution of a few years earlier.

Elsewhere in Europe enlightened despots like Frederick the Great of Prussia responded to the growing restlessness of their subjects by reorganizing government and improving living conditions. Frederick's court even became one of the leading cultural and intellectual centers of the time; C. P. E. Bach directed the music there and Voltaire spent two years as Frederick's guest.

Rococo Art In the visual arts the principal style to emerge from the baroque splendors of the previous century was the rococo. Lighter and less grandiose, it was wonderfully suited to the civilized amenities of aristocratic life. The chief rococo painters were French and Italian—appropriately enough, because rulers both in France and in the kingdoms of Italy made few concessions to the growing demands for reform. In architecture, the builders of Parisian private houses such as the Hôtel de Soubise indulged their taste for fanciful decoration, while the rococo churches of southern Germany and Austria represent some of the happiest of all eighteenth-century achievements.

The Neo-Classical Style The other important artistic style of the period was the Neo-Classical. Inspired by the increasing quantities of ancient art being excavated at Pompeii and elsewhere, artists began to turn to the style and subjects of Classical antiquity, which provided a refreshing contrast to the theatricality of baroque and the artificiality of rococo. Furthermore, in the history of the Roman Republic (at least as they perceived it) revolutionary artists of the later eighteenth century found a vehicle for expressing their battle for freedom. In many cases painters incorporated into their works discoveries from the various excavations in progress: the French Jacques-Louis David in his paintings for the revolution as well as the English Joshua Reynolds in his portraits of society women.

Ancient sculpture provided a stimulus to some of the leading artists of the day, most notably the Italian Antonio Canova and the French Jean Antoine Houdon. Both of them worked principally during and after the revolutions; Houdon even produced a Neo-Classical statue of George Washington. Washington and the other leaders of the American Revolution turned naturally to classical architecture for their public build-

ings. Among the finest examples is Thomas Jefferson's State Capitol at Richmond.

Music in the Eighteenth Century: Haydn and Mozart

In music the emotional style of baroque composers began to give way to a new way of organizing musical forms. By the mid-eighteenth century, the classical style was beginning to evolve, and the two greatest composers of the age—Franz Joseph Haydn and Wolfgang Amadeus Mozart (both Austrian)—used it to write their symphonies, concertos, and sonatas. Most of these works employed sonata form, a system of musical composition involving contrasts rather than the unity of baroque music. Haydn's hundred or so symphonies show an almost infinitely endless exploration of the possibilities offered by sonata form while also reflecting the evolution of the modern symphony orchestra. His own personal career furthermore illustrates the changing status of the artist: After years of serving in the household of an aristocratic family, he became transformed by his compositions into one of the most famous men in Europe.

Mozart's relations with his noble employers were far less happy. His music, however, transcends the difficulties of his life and achieves the supreme blend of eighteenth-century art's two chief concerns: beauty and learning. Like Haydn, he explored the possibilities of sonata form and also wrote several operas that remain among the best-loved of all musical works for the stage. *The Marriage of Figaro* illustrates Mozart's genius for expressing universal human emotions in music, while in its story it reflects the revolutionary mood of the times.

Eighteenth-Century Literature: History and Satire

Like music, the literature of the eighteenth century was generally serious. Many writers avoided the lightness of the rococo, preferring to produce works based on Classical models or themes. They included the Italian dramatist Metastasio. An exception is provided by the satirical writings of Alexander Pope, which poke fun at the pretensions of eighteenth-century society, although many of Pope's other works are Neo-Classical in style. Other writers used satire, in itself a characteristically rococo medium, as a bitter weapon against human folly. Jonathan Swift's writings present an indictment of his fellow humans that offers little hope for their improvement.

The Encyclopedists

The French Encyclopedists offered a more optimistic point of view. Denis Diderot and most of his colleagues believed in the essential goodness of human nature and the possibility of progress, and their *Encyclopédie* was intended to exalt the power of reason. Not all of the contributors agreed on this goal, however. Jean Jacques Rousseau claimed that society was an evil that corrupted essential human goodness and called for a new social order. Yet all of the leading intellectuals of the day, including the greatest of them all, Voltaire, were united in urging the need for radical social change. In novels, pamphlets, plays, and countless other publications, Voltaire attacked traditional religion and urged the importance of freedom of thought.

By the end of the century, the battle for freedom had plunged France into chaos and demonstrated to the whole of Europe that the old social order had come to an end. The following century was to see the struggle to forge a new society.

KEY TERMS

Allegro The Italian word for "fast," used to indicate the speed at which a piece of music should be played

Coda The Italian word for "tail"; the concluding section of a sonata form movement

Development The central section of a sonata form movement, in which a composer changes and combines the themes stated in the opening **exposition**

Empfindsamkeit The German word for "sensitiveness." In music, the term was used to describe the emotional music popular in the mid-eighteenth century.

Enlightened despots Eighteenth-century rulers who, while retaining full powers, sought the welfare of their subjects

Ensemble In opera, a scene in which several characters sing simultaneously

Exposition The opening section of a sonata form movement, setting out its main themes

Fetes galantes In the eighteenth century, elegant festivals or parties, held outdoors

Gnadenaltar The German word for "Mercy Altar," generally found in pilgrimage churches in southern Germany and Austria

Kettle drums A kind of drum that can be tuned to a specific pitch (note); known in Italian as *timpani*

Minuet A French seventeenth-century dance, the rhythm of which came to be used in the third movement of eighteenth-century sonatas and symphonies

Movement A self-contained section of a musical work made up of several separate movements; the Classical symphony had four.

Pastel Dry sticks of colored chalk that leave a soft, powdery hue when rubbed on paper

Recapitulation The third section of a sonata form movement, which restates the themes heard in the first section, the *exposition*

Satire The use of ridicule and sarcasm to expose and discourage what the author considers folly or even more serious shortcomings; popular in eighteenth-century literature

Sonata Generally, from the eighteenth century on, a piece of music for one or two instruments (piano sonata for solo piano, violin sonata for violin and piano, etc.) in several self-contained movements

Sonata form, sonata allegro form A musical form evolved during the eighteenth century that became the basis of the first movement (and sometimes also the last) of a *sonata*

Style galant A style of elegant, lighthearted music popular in France in the early eighteenth century

Symphony A musical work in several self-contained movements, written for full orchestra; essentially a *sonata* for orchestra

Tempo The Italian word for "time": the speed, indicated by the composer, at which a piece of music should be performed

Theme A short musical idea, or tune, which a composer can then vary and develop

Timpani See *kettle drums*

2. Describe the principles of sonata form and compare it to musical form in the Baroque period.

3. What were the main schools of philosophical thought in eighteenth-century France? How are these expressed in the writings of Voltaire?

4. Describe the use of satire in the works of Pope and Swift. What are the authors' aims, and how successful are they?

5. How were the social and political developments that led to the French Revolution reflected in the arts?

YOUR RESOURCES

■ **ExploringHumanities CD-ROM**
 • Reading Selections: Swift, *Gulliver's Travels;* Voltaire, *Candide*
■ **Website http://art.wadsworth.com/cunningham**
 • Chapter 16 Quiz
 • Links
■ **Audio CD**
 • Mozart: *Symphony No. 40, IV*

PRONUNCIATION GUIDE

Beaumarchais:	Boe-mar-SHAY
Boucher:	Boo-SHAY
Candide:	Can-DEED
Cherubino:	Ke-ru-BEEN-owe
Cythera:	SITH-er-a
David:	Da-VEED
Diderot:	Di-der-OWE
Fragonard:	Fra-gone-ARE
Haydn:	HI-dn
Montesquieu:	Mont-es-KEW
Mozart:	MOTE-sart
Neumann:	NOY-man
Robespierre:	Robe-spee-AIR
rococo:	ro-co-COWE
Rousseau:	Rue-SEW
timpani:	TIM-pan-ee
Vierzehnheiligen:	Fear-tsayn-HI-li-gen
Voltaire:	Vol-TARE
Watteau:	Wat-OWE
Winckelmann:	VIN-kel-man

EXERCISES

1. Compare and contrast the rococo and Neo-Classical styles in the visual arts, illustrating your answer with reference to specific works of art.

FURTHER READING

Bermingham, Ann. *Landscape and Ideology: The English Rustic Tradition, 1740–1850.* Berkeley: University of California Press, 1986. A study of English landscape painting from the Rococo to the height of the Victorian age. Well illustrated.

Chartier, R. *The Cultural Origins of the French Revolution.* Durham, NC: Duke University Press, 1991. An important study of the intellectual and cultural forces that shaped the eighteenth century in Western Europe.

Conisbee, Philip. *Painting in Eighteenth-Century France.* Ithaca, NY: Phaidon/Cornell University Press, 1981. A beautifully illustrated account of the art produced during the period covered by this chapter.

Garrioch, D. *Neighborhood and Community in Paris, 1740–1790.* Cambridge: Cambridge University Press, 1986. This book provides a fascinating study of the daily lives of the residents in various parts of Paris in the years leading to the outbreak of the French Revolution.

Levey, M. *Painting and Sculpture in France, 1700–1789* (new ed.). New Haven, CT: Yale University Press, 1993. This well-illustrated book provides an excellent introduction to a rich field; good bibliographies.

Osborne, C. *The Complete Operas of Mozart: A Critical Guide.* London: Victor Gollancz, 1992. A useful guide to all of Mozart's stage works.

Roche, Daniel, trans. Arthur Goldhammer. *France in the Enlightenment.* Cambridge, MA: Harvard University Press, 1998. An account of both high and popular culture in eighteenth-century France.

Roston, M. *Changing Perspectives in Literature and the Visual Arts, 1650–1820.* Princeton, NJ: Princeton University Press, 1990. This valuable study takes a comparative look at the arts over a period extending from the later Baroque to the early stages of Romanticism.

Sklar, J. *Montesquieu.* Oxford: Oxford University Press, 1987. An excellent study of the life and work of a key eighteenth-century figure.

Varriano, J. *Italian Baroque and Rococo Architecture.* New York: Oxford University Press, 1986. A good survey of seventeenth- and eighteenth-century Italian architectural developments.

READING SELECTIONS

ALEXANDER POPE

The following epigram illustrates the delicacy and precision of Pope's wit.

Engraved on the collar of a dog which I gave to his Royal Highness

> I am his Highness' dog at Kew;
> Pray tell me, sir, whose dog are you?

from ESSAY ON MAN, *Epistle I*

Far more serious in its intent is Pope's Essay on Man, *which takes the form of four verse letters (or epistles) to his friend Henry Bolingbroke. The first of these, reproduced below, discusses the part that evil plays in a world created by God, and tries to describe the divinely appointed social order. Pope expresses his conclusions in the epistle's last words: "Whatever is, is right." Later sections of the poem are concerned with how humans should act in a world where evil exists.*

Awake, my St. John! leave all meaner things
To low ambition, and the pride of Kings.
Let us (since Life can little more supply
Than just to look about us and to die)
Expatiate free o'er all this scene of Man; 5
A mighty maze! but not without a plan;
A Wild, where weeds and flow'rs promiscuous shoot,
Or Garden, tempting with forbidden fruit.
Together let us beat this ample field,
Try what the open, what the covert yield; 10
The latent tracts, the giddy heights explore
Of all who blindly creep, or sightless soar;
Eye Nature's walks, shoot Folly as it flies,
And catch the Manners living as they rise;
Laugh where we must, be candid where we can; 15
'But vindicate the ways of God to Man.
 I. Say first, of God above, or Man below,
What can we reason, but from what we know?
Of Man what see we, but his station here,
From which to reason, or to which refer? 20
Thro' worlds unnumber'd tho' the God be known,

'Tis ours to trace him only in our own.
He, who thro' vast immensity can pierce,
See worlds on worlds compose one universe,
Observe how system into system runs, 25
What other planets circle other suns,
What vary'd being peoples ev'ry star,
May tell why Heav'n has made us as we are.
But of this frame the bearings, and the ties,
The strong connections, nice dependencies, 30
Gradations just, has thy pervading soul
Look'd thro'? or can a part contain the whole?
 Is the great chain, that draws all to agree,
And drawn supports, upheld by God, or thee? 34
 II. Presumptuous Man! the reason wouldst thou find,
Why form'd so weak, so little, and so blind!
First, if thou canst, the harder reason guess,
Why form'd no weaker, blinder, and no less!
Ask of thy mother earth, why oaks are made
Taller or stronger than the weeds they shade? 40
Or ask of yonder argent fields above,
Why JOVE's Satellites are less than JOVE?
 Of Systems possible, if 'tis confest
That Wisdom infinite must form the best,
Where all must full or not coherent be, 45
And all that rises, rise in due degree;
Then, in the scale of reas'ning life, 'tis plain
There must be, somewhere, such a rank as Man;
And all the question (wrangle e'er so long)
Is only this, if God has plac'd him wrong? 50
 Respecting Man, whatever wrong we call,
May, must be right, as relative to all.
In human works, tho' labour'd on with pain,
A thousand movements scarce one purpose gain;
In God's, one single can its end produce; 55
Yet serves to second too some other use.
So Man, who here seems principal alone,
Perhaps acts second to some sphere unknown,
Touches some wheel, or verges to some goal;
'Tis but a part we see, and not a whole. 60
 When the proud steed shall know why Man restrains
His fiery course, or drives him o'er the plains;
When the dull Ox, why now he breaks the clod,
Is now a victim, and now Ægypt's God:
Then shall Man's pride and dullness comprehend 65
His actions', passions', being's, use and end;
Why doing, suff'ring, check'd, impell'd; and why
This hour a slave, the next a deity.
 Then say not Man's imperfect, Heav'n in fault;
Say rather, Man's as perfect as he ought; 70
His knowledge measur'd to his state and place,
His time a moment, and a point his space.
If to be perfect in a certain sphere,
What matter, soon or late, or here or there?
The blest today is as completely so, 75
As who began a thousand years ago.
 III. Heav'n from all creatures hides the book of Fate,
All but the page prescrib'd, their present state;
From brutes what men, from men what spirits know:
Or who could suffer Being here below? 80
The lamb thy riot dooms to bleed to-day,
Had he thy Reason, would he skip and play?
Pleas'd to the last, he crops the flow'ry food,
And licks the hand just rais'd to shed his blood.
Oh blindness to the future! kindly giv'n, 85
That each may fill the circle mark'd by Heav'n;
Who sees with equal eye, as God of all,
A hero perish, or a sparrow fall,

Atoms or systems into ruin hurl'd,
And now a bubble burst, and now a world. 90

 Hope humbly then; with trembling pinions soar;
Wait the great teacher Death, and God adore!
What future bliss, he gives not thee to know,
But gives that Hope to be thy blessing now.
Hope springs eternal in the human breast: 95
Man never Is, but always To be blest:
The soul, uneasy and confin'd from home,
Rests and expatiates in a life to come.
 Lo! the poor Indian, whose untutor'd mind
Sees God in clouds, or hears him in the wind; 100
His soul proud Science never taught to stray
Far as the solar walk, or milky way;
Yet simple Nature to his hope has giv'n,
Behind the cloud-topt hill, an humbler heav'n;
Some safer world in depth of woods embrac'd, 105
Some happier island in the watry waste,
Where slaves once more their native land behold,
No fiends torment, no Christians thirst for gold!
To Be, contents his natural desire,
He asks no Angel's wing, no Seraph's fire; 110
But thinks, admitted to that equal sky,
His faithful dog shall bear him company,
 IV. Go, wiser thou! and in thy scale of sense
Weigh thy Opinion against Providence;
Call Imperfection what thou fancy'st such, 115
Say, here he gives too little, there too much;
Destroy all creatures for thy sport or gust,
Yet cry, If Man's unhappy, God's unjust;
If Man alone ingross not Heav'n's high care,
Alone made perfect here, immortal there: 120
Snatch from his hand the balance and the rod,
Rejudge his justice, be the GOD of GOD!
 In Pride, in reas'ning Pride, our error lies;
All quit their sphere, and rush into the skies.
Pride still is aiming at the blest abodes, 125
Men would be Angels, Angels would be Gods.
Aspiring to be Gods, if Angels fell,
Aspiring to be Angels, Men rebel;
And who but wishes to invert the laws
Of ORDER, sins against th' Eternal Cause. 130
 V. Ask for what end the heav'nly bodies shine,
Earth for whose use? Pride answers, 'Tis for mine:
For me kind Nature wakes her genial pow'r,
Suckles each herb, and spreads out ev'ry flow'r;
Annual for me, the grape, the rose renew 135
The juice nectareous, and the balmy dew;
For me, the mine a thousand treasures brings;
For me, health gushes from a thousand springs;
Seas roll to waft me, suns to light me rise;
My foot-stool earth, my canopy the skies.' 140
 But errs not Nature from this gracious end,
From burning suns when livid deaths descend,
When earthquakes swallow, or when tempests
 sweep
Towns to one grave, whole nations to the deep?
'No ('tis reply'd) the first Almighty Cause 145
Acts not by partial, but by gen'ral laws;
Th' exceptions few; some change since all began,
And what created perfect?'—Why then Man?
If the great end be human Happiness,
Then Nature deviates; and can Man do less? 150
As much that end a constant course requires
Of show'rs and sunshine, as of Man's desires;
As much eternal springs and cloudless skies,
As Men for ever temp'rate, calm, and wise.
If plagues or earthquakes break not Heav'n's design, 155

Why then a Borgia, or a Catiline?
Who knows but he, whose hand the light'ning forms,
Who heaves old Ocean, and who wings the storms,
Pours fierce Ambition in a Caesar's mind,
Or turns young Ammon loose to scourge mankind? 160
From pride, from pride, our very reas'ning springs;
Account for moral as for nat'ral things:
Why charge we Heav'n in those, in these acquit?
In both, to reason right is to submit.
 Better for Us, perhaps, it might appear, 165
Were there all harmony, all virtue here;
That never air or ocean felt the wind;
That never passion discompos'd the mind:
But all subsists by elemental strife;
And Passions are the elements of Life. 170
The gen'ral ORDER, since the whole began,
Is kept in Nature, and is kept in Man.
 VI. What would this Man? Now upward will
 he soar,
And little less than Angel, would be more;
Now looking downwards, just as griev'd appears 175
To want the strength of bulls, the fur of bears.
Made for his use all creatures if he call,
Say what their use, had he the pow'rs of all?
Nature to these, without profusion kind,
The proper organs, proper pow'rs assign'd; 180
Each seeming want compensated of course,
Here with degrees of swiftness, there of force;
All in exact proportion to the state;
Nothing to add, and nothing to abate.
Each beast, each insect, happy in its own; 185
Is Heav'n unkind to Man, and Man alone?
Shall he alone, whom rational we call,
Be pleas'd with nothing, if not bless'd with all?
 The bliss of Man (could Pride that blessing find)
Is not to act or think beyond mankind; 190
No pow'rs of body or of soul to share,
But what his nature and his state can bear.
Why has not Man a microscopic eye?
For this plain reason, Man is not a Fly.
Say what the use, were finer optics giv'n, 195
T' inspect a mite, not comprehend the heav'n?
Or touch, if trembling alive all o'er,
To smart and agonize at ev'ry pore?
Or quick effluvia darting thro' the brain,
Die of a rose in aromatic pain? 200
If nature thunder'd in his op'ning ears,
And stunn'd him with the music of the spheres,
How would he wish that Heav'n had left him still
The whisp'ring Zephyr, and the purling rill?
Who finds not Providence all good and wise, 205
Alike in what it gives, and what it denies?
 VII. Far as Creation's ample range extends,
The scale of sensual, mental pow'rs ascends:
Mark how it mounts, to Man's imperial race,
From the green myriads in the peopled grass: 210
What modes of sight betwixt each wide extreme,
The mole's dim curtain, and the lynx's beam:
Of smell, the headlong lioness between,
And hound sagacious on the tainted green:
Of hearing, from the life that fills the flood, 215
To that which warbles thro' the vernal wood:
The spider's touch, how exquisitely fine!
Feels at each thread, and lives along the line:
In the nice bee, what sense so subtly true
From pois'nous herbs extracts the healing dew: 220
How Instinct varies in the grov'ling swine,
Compar'd, half-reas'ning elephant, with thine:

'Twixt that, and Reason, what a nice barrier;
For ever sep'rate, yet for ever near!
Remembrance and Reflection how ally'd;
What thin partitions Sense from Thought divide:
And Middle natures, how they long to join,
Yet never pass th' insuperable line!
Without this just gradation, could they be
Subjected these to those, or all to thee?
The pow'rs of all subdu'd by thee alone,
Is not thy Reason all these pow'rs in one?
 VIII. See, thro' this air, this ocean, and this earth,
All matter quick, and bursting into birth.
Above, how high progressive life may go!
Around, how wide! how deep extend below!
Vast chain of being, which from God began,
Natures µthereal, human, angel, man,
Beast, bird, fish, insect! what no eye can see,
No glass can reach! from Infinite to thee,
From thee to Nothing!—On superior pow'rs
Were we to press, inferior might on ours:
Or in the full creation leave a void,
Where, one step broken, the great scale's destroy'd:
From Nature's chain whatever link you strike,
Tenth or ten thousandth, breaks the chain alike.

 And if each system in gradation roll,
Alike essential to th' amazing whole;
The least confusion but in one, not all
That system only, but the whole must fall.
Let Earth unbalanc'd from her orbit fly,
Planets and Suns run lawless thro' the sky,
Let ruling Angels from their spheres be hurl'd,
Being on being wreck'd, and world on world,
Heav'n's whole foundations to their center nod,
And Nature tremble to the throne of God:
All this dread ORDER break—for whom? for thee?
Vile worm!—oh Madness, Pride, Impiety!
 IX. What if the foot, ordain'd the dust to tread,
Or hand to toil, aspir'd to be the head?
What if the head, the eye, or ear repin'd
To serve mere engines to the ruling Mind?
Just as absurd for any part to claim
To be another, in this gen'ral frame:
Just as absurd, to mourn the tasks or pains
The great directing MIND OF ALL ordains.
All are but parts of one stupendous whole,
Whose body, Nature is, and God the soul;
That, chang'd thro' all, and yet in all the same,
Great in the earth, as in th' µthereal frame,
Warms in the sun, refreshes in the breeze,
Glows in the stars, and blossoms in the trees,
Lives thro' all life, extends thro' all extent,
Spreads undivided, operates unspent,
Breathes in our soul, informs our mortal part,
As full, as perfect, in a hair as heart;
As full, as perfect, in vile Man that mourns,
As the rapt Seraph that adores and burns;
To him no high, no low, no great, no small;
He fills, he bounds, connects, and equals all.
 X. Cease then, nor Order Imperfection name:
Our proper bliss depends on what we blame.
Know thy own point: This kind, this due degree
Of blindness, weakness, Heav'n bestows on thee.
Submit—In this, or any other sphere,
Secure to be as blest as thou canst bear:
Safe in the hand of one disposing Pow'r,
Or in the natal, or the mortal hour.
All Nature is but Art, unknown to thee;
All Chance, Direction, which thou canst not see;

225 All Discord, Harmony, not understood;
All partial Evil, universal Good:
And, spite of Pride, in erring Reason's spite,
One truth is clear, 'Whatever is, is RIGHT.'

JONATHAN SWIFT
from A MODEST PROPOSAL

In frustration at the widespread starvation of the poor in Ireland and the general indifference on the part of those better off, Swift wrote a savage masterpiece. His proposed final solution to the problem of overpopulation and undernourishment is simple: The rich should eat the poor. In relentlessly working out the implications of his ironic proposal, Swift identifies human cruelties and weaknesses with deadly truth. The essay has been described as a "lucid nightmare." Swift would certainly not have been surprised to learn that the conditions of abject poverty he describes are still present in large areas of the world.

It is a melancholy object to those who walk through this great town or travel in the country, when they see the streets, the roads, and cabin doors, crowded with beggars of the female-sex, followed by three, four, or six children, all in rags and importuning every passenger for an alms. These mothers, instead of being able to work for their honest livelihood, are forced to employ all their time in strolling to beg sustenance for their helpless infants, who, as they grow up, either turn thieves for want of work, or leave their dear native country to fight for the Pretender in Spain, or sell themselves to the Barbadoes.

 I think it is agreed by all parties that this prodigious number of children in the arms, or on the backs, or at the heels of their mothers, and frequently of their fathers, is in the present deplorable state of the kingdom a very great additional grievance; and therefore whoever could find out a fair, cheap, and easy method of making these children sound, useful members of the commonwealth would deserve so well of the public as to have his statue set up for a preserver of the nation.

 But my intention is very far from being confined to provide only for the children of professed beggars; it is of a much greater extent, and shall take in the whole number of infants at a certain age who are born of parents in effect as little able to support them as those who demand our charity in the streets.

 As to my own part, having turned my thoughts for many years upon this important subject, and maturely weighed the several schemes of other projectors, I have always found them grossly mistaken in their computation. It is true, a child just dropped from its dam may be supported by her milk for a solar year, with little other nourishment; at most not above the value of two shillings, which the mother may certainly get, or the value in scraps, by her lawful occupation of begging; and it is exactly at one year old that I propose to provide for them in such a manner as instead of being a charge upon their parents or the parish, or wanting food and raiment for the rest of their lives, they shall on the contrary contribute to the feeding, and partly to the clothing, of many thousands.

 There is likewise another great advantage in my scheme, that it will prevent those voluntary abortions, and that horrid practice of women murdering their bastard children, alas, too frequent among us, sacrificing the poor innocent babes, I doubt, more to avoid the expense than the shame, which would move tears and pity in the most savage and inhuman breast.

 The number of souls in this kingdom being usually reckoned one million and a half, of these I calculate there may be

about two hundred thousand couples whose wives are breeders; from which number I subtract thirty thousand couples who are able to maintain their own children, although I apprehend there cannot be so many under the present distresses of the kingdom; but this being granted, there will remain an hundred and seventy thousand breeders. I again subtract fifty thousand for those women who miscarry, or whose children die by accident or disease within the year. There only remain an hundred and twenty thousand children of poor parents annually born. The question therefore is, how this number shall be reared and provided for, which, as I have already said, under the present situation of affairs, is utterly impossible by all the methods hitherto proposed. For we can neither employ them in handicraft or agriculture; we neither build houses (I mean in the country) nor cultivate land. They can very seldom pick up a livelihood by stealing till they arrive at six years old, except where they are of towardly parts: although I confess they learn the rudiments much earlier, during which time they can however be looked upon only as probationers, as I have been informed by a principal gentleman in the county of Cavan, who protested to me that he never knew above one or two instances under the age of six, even in a part of the kingdom so renowned for the quickest proficiency in that art.

I am assured by our merchants that a boy or a girl before twelve years old is no salable commodity; and even when they come to this age they will not yield above three pounds, or three pounds and half a crown at most on the Exchange; which cannot turn to account either to the parents or the kingdom, the charge of nutriment and rags having been at least four times that value.

I shall now therefore humbly propose my own thoughts, which I hope will not be liable to the least objection.

I have been assured by a very knowing American of my acquaintance in London, that a young healthy child well nursed is at a year old a most delicious, nourishing, and wholesome food, whether stewed, roasted, baked, or boiled; and I make no doubt that it will equally serve in a fricasse or a ragout.

I do therefore humbly offer it to public consideration that of the hundred and twenty thousand children, already computed, twenty thousand may be reserved for breed, whereof only one fourth part to be males, which is more than we allow to sheep, black cattle, or swine; and my reason is that these children are seldom the fruits of marriage, a circumstance not much regarded by our savages, therefore one male will be sufficient to serve four females. That the remaining hundred thousand may at a year old be offered in sale to the persons of quality and fortune through the kingdom, always advising the mother to let them suck plentifully in the last month, so as to render them plump and fat for a good table. A child will make two dishes at an entertainment for friends; and when the family dines alone, the fore or hind quarter will make a reasonable dish, and seasoned with a little pepper or salt will be very good boiled on the fourth day, especially in winter.

I have reckoned upon a medium that a child just born will weigh twelve pounds, and in a solar year if tolerably nursed increaseth to twenty-eight pounds.

I grant this food will be somewhat dear, and therefore very proper for landlords, who, as they have already devoured most of the parents, seem to have the best title to the children.

Infant's flesh will be in season throughout the year, but more plentiful in March, and a little before and after. For we are told by a grave author, an eminent French physician [Rabelais], that fish being a prolific diet, there are more children born in Roman Catholic countries about nine months after Lent than at any other season; therefore, reckoning a year after Lent, the markets will be more glutted than usual, because the number of popish infants is at least three to one in this kingdom; and therefore it will have one other collateral advantage, by lessening the number of Papists among us.

I have already computed the charge of nursing a beggar's child (in which list I reckon all cottagers, laborers, and four fifths of the farmers) to be about two shillings per annum, rags included; and I believe no gentleman would repine to give ten shillings for the carcass of a good fat child, which, as I have said, will make four dishes of excellent nutritive meat, when he hath only some particular friend or his own family to dine with him. Thus the squire will learn to be a good landlord, and grow popular among the tenants; the mother will have eight shillings net profit, and be fit for work till she produces another child.

Those who are more thrifty (as I must confess the times require) may flay the carcass; the skin of which artificially dressed will make admirable gloves for ladies and summer boots for fine gentlemen.

As to our city of Dublin, shambles may be appointed for this purpose in the most convenient parts of it, and butchers we may be assured will not be wanting; although I rather recommend buying the children alive, and dressing them hot from the knife as we do roasting pigs.

A very worthy person, a true lover of his country, and whose virtues I highly esteem, was lately pleased in discoursing on this matter to offer a refinement upon my scheme. He said that many gentlemen of this kingdom, having of late destroyed their deer, he conceived that the want of venison might be well supplied by the bodies of young lads and maidens, not exceeding fourteen years of age nor under twelve, so great a number of both sexes in every county being now ready to starve for want of work and service; and these to be disposed of by their parents, if alive, or otherwise by their nearest relations. But with due deference to so excellent a friend and so deserving a patriot, I cannot be altogether in his sentiments; for as to the males, my American acquaintance assured me from frequent experience that their flesh was generally tough and lean, like that of our schoolboys, by continual exercise, and their taste disagreeable; and to fatten them, would not answer the charge. Then as to the females, it would, I think with humble submission, be a loss to the public, because they soon would become breeders themselves: and besides, it is not improbable that some scrupulous people might be apt to censure such a practice (although indeed very unjustly) as little bordering upon cruelty; which, I confess, hath always been with me the strongest objection against any project, how well soever intended.

But in order to justify my friend, he confessed that this expedient was put into his head by the famous Psalmanazar, a native of the island Formosa, who came from thence to London above twenty years ago, and in conversation told my friend that in his country when any young person happened to be put to death, the executioner sold the carcass to persons of quality as a prime dainty; and that in his time the body of a plump girl of fifteen, who was crucified for an attempt to poison the emperor, was sold to his Imperial Majesty's prime minister of state, and other great mandarins of the court, in joints from the gibbet, at four hundred crowns. Neither indeed can I deny that if the same use were made of several plump young girls in this town, who without one single groat to their fortunes cannot stir abroad without a chair, and appear at the playhouse and assemblies in foreign fineries which they never will pay for, the kingdom would not be the worse.

Some persons of a desponding spirit are in great concern about that vast number of poor people who are aged, diseased, or maimed, and I have been desired to employ my thoughts what course may be taken to ease the nation of so grievous an encumbrance. But I am not in the least pain upon that matter, because it is very well known that they are every day dying and rotting by cold and famine, and filth and vermin, as fast as can be reasonably expected. And as to the younger laborers, they are now in almost as hopeful a condition. They cannot get work, and consequently pine away for want of nourishment to a degree that if at any time they are accidentally hired to common labor, they have not strength to perform it; and thus the country and themselves are happily delivered from the evils to come.

I have too long digressed, and therefore shall return to my subject. I think the advantages by the proposal which I have made are obvious and many, as well as of the highest importance.

For first, as I have already observed, it would greatly lessen the number of Papists, with whom we are yearly overrun, being the principal breeders of the nation as well as our most dangerous enemies; and who stay at home on purpose to deliver the kingdom to the Pretender, hoping to take their advantage by the absence of so many good Protestants, who have chosen rather to leave their country than to stay at home and pay tithes against their conscience to an Episcopal curate.

Secondly, the poorer tenants will have something valuable of their own, which by law may be made liable to distress, and help to pay their landlord's rent, their corn and cattle being already seized and money a thing unknown.

Thirdly, whereas the maintenance of an hundred thousand children, from two years old and upwards, cannot be computed at less than ten shillings a piece per annum, the nation's stock will be thereby increased fifty thousand pounds per annum, besides the profit of a new dish introduced to the tables of all gentlemen of fortune in the kingdom who have any refinement in taste. And the money will circulate among ourselves, the goods being entirely of our own growth and manufacture.

Fourthly, the constant breeders, besides the gain of eight shillings sterling per annum by the sale of their children, will be rid of the charge of maintaining them after the first year.

Fifthly, this food would likewise bring great custom to taverns, where the vintners will certainly be so prudent as to procure the best receipts for dressing it to perfection, and consequently have their houses frequented by all the fine gentlemen, who justly value themselves upon their knowledge in good eating; and a skillful cook, who understands how to oblige his guests, will contrive to make it as expensive as they please.

Sixthly, this would be a great inducement to marriage, which all wise nations have either encouraged by rewards or enforced by laws and penalties. It would increase the care and tenderness of mothers toward their children, when they were sure of a settlement for life to the poor babes, provided in some sort by the public, to their annual profit instead of expense. We should see an honest emulation among the married women, which of them could bring the fattest child to the market. Men would become as fond of their wives during the time of their pregnancy as they are now of their mares in foal, their cows in calf, or sows when they are ready to farrow; nor offer to beat or kick them (as is too frequent a practice) for fear of a miscarriage.

Many other advantages might be enumerated. For instance, the addition of some thousand carcasses in our exportation of barreled beef, the propagation of swine's flesh, and improvement in the art of making good bacon, so much wanted among us by the great destruction of pigs, too frequent at our tables, which are no way comparable in taste of magnificence to a well-grown, fat, yearling child, which roasted whole will make a considerable figure at a lord mayor's feast or any other public entertainment. But this and many others I omit, being studious of brevity.

Supposing that one thousand families in this city would be constant customers for infants' flesh, besides others who might have it at merry meetings, particularly weddings and christenings, I compute that Dublin would take off annually about twenty thousands carcasses, and the rest of the kingdom (where probably they will be sold somewhat cheaper) the remaining eighty thousand.

I can think of no one objection that will possibly be raised against this proposal, unless it should be urged that the number of people will be thereby much lessened in the kingdom. This I freely own, and it was indeed one principal design in offering it to the world. I desire the reader will observe, that I calculate my remedy for this one individual kingdom of Ireland and for no other that ever was, is, or I think ever can be upon earth. Therefore let no man talk to me of other expedients: of taxing our absentees at five shillings a pound: of using neither clothes nor household furniture except what is of our own growth and manufacture: of utterly rejecting the materials and instruments that promote foreign luxury: of curing the expensiveness of pride, vanity, idleness, and gaming in our women: of introducing a vein of parsimony, prudence, and temperance: of learning to love our country, in the want of which we differ even from Laplanders and the inhabitants of Topinamboo: of quitting our animosities and factions, nor acting any longer like the Jews, who were murdering one another at the very moment their city was taken: of being a little cautious not to sell our country and conscience for nothing: of teaching landlords to have at least one degree of mercy toward their tenants: lastly, of putting a spirit of honesty, industry, and skill into our shopkeepers; who, if a resolution could now be taken to buy only our native goods, would immediately unite to cheat and exact upon us in the price, the measure, and the goodness, nor could ever yet be brought to make one fair proposal of just dealing, though often and earnestly invited to it.

Therefore I repeat, let no man talk to me of these and the like expedients, till he hath at least some glimpse of hope that there will ever be some hearty and sincere attempt to put them in practice.

But as to myself, having been wearied out for many years with offering vain, idle, visionary thoughts, and at length utterly despairing of success, I fortunately fell upon this proposal, which, as it is wholly new, so it hath something solid and real, of no expense and little trouble, full in our own power and whereby we can incur no danger in disobliging England. For this kind of commodity will not bear exportation, the flesh being of too tender a consistence to admit a long continuance in salt, although perhaps I could name a country which would be glad to eat up our whole nation without it.

After all, I am not so violently bent upon my own opinion as to reject any offer proposed by wise men, which shall be found equally innocent, cheap, easy, and effectual. But before something of that kind shall be advanced in contradiction to my scheme, and offering a better, I desire the author or authors will be pleased maturely to consider two points. First, as things now stand, how they will be able to find food and raiment for an hundred thousands useless mouths and backs. And secondly, there being a round million of creatures in human figure throughout this kingdom, whose sole subsistence put into a common stock would

leave them in debt two millions of pounds sterling, adding those who are beggars by profession to the bulk of farmers, cottagers, and laborers, with their wives and children who are beggars in effect; I desire those politicians who dislike my overture, and may perhaps be so bold to attempt an answer, that they will first ask the parents of these mortals whether they would not at this day think it a great happiness to have been sold for food at a year old in the manner I prescribe, and thereby have avoided such a perpetual scene of misfortunes as they have since gone through by the oppression of landlords, the impossibility of paying rent without money or trade, the want of common sustenance, with neither house nor clothes to cover them from the inclemencies of the weather, and the most inevitable prospect of entailing the like or greater miseries upon their breed forever.

I profess, in the sincerity of my heart, that I have not the least personal interest in endeavoring to promote this necessary work, having no other motive than the public good of my country, by advancing our trade, providing for infants, relieving the poor, and giving some pleasure to the rich. I have no children by which I can propose to get a single penny; the youngest being nine years old, and my wife past childbearing.

JEAN JACQUES ROUSSEAU
from EMILE

Rousseau's didactic novel Emile *first appeared in 1762. A landmark in the history of educational thought, the book's criticism of traditional educational methods earned its author the disapproval of the French parliament. In the following passage, Rousseau analyzes the nature of his own existence and sensations, and sets out his view of religion.*

My child, do not look to me for learned speeches or profound arguments. I am no great philosopher, nor do I desire to be one. I have, however, a certain amount of commonsense and a constant devotion to truth. I have no wish to argue with you nor even to convince you; it is enough for me to show you, in all simplicity of heart, what I really think. Consult your own heart while I speak; that is all I ask. If I am mistaken, I am honestly mistaken, and therefore my error will not be counted to me as a crime; if you, too, are honestly mistaken, there is no great harm done. If I am right, we are both endowed with reason, we have both the same motive for listening to the voice of reason. Why should not you think as I do?

By birth I was a peasant and poor; to till the ground was my portion; but my parents thought it a finer thing that I should learn to get my living as a priest and they found means to send me to college. . . . I learned what was taught me, I said what I was told to say, I promised all that was required, and I became a priest. But I soon discovered that when I promised not to be a man, I had promised more than I could perform.

Conscience, they tell us, is the creature of prejudice, but I know from experience that conscience persists in following the order of nature in spite of all the laws of man. . . . My good youth, nature has not yet appealed to your senses; may you long remain in this happy state when her voice is the voice of innocence. Remember that to anticipate her teaching is to offend more deeply against her than to resist her teaching; you must first learn to resist, that you may know when to yield without wrong-doing.

From my youth up I had reverenced the married state as the first and most sacred institution of nature. . . .

This very resolution proved my ruin. My respect for marriage led to the discovery of my misconduct. . . . The scandal must be expiated; I was arrested, suspended, and dismissed; I was the victim of my scruples rather than

of my incontinence, and I had reason to believe, from the reproaches which accompanied my disgrace, that one can often escape punishment by being guilty of a worse fault.

A thoughtful mind soon learns from such experiences. I found my former ideas of justice, honesty, and every duty of man overturned by these painful events, and day by day I was losing my hold on one or another of the opinions I had accepted.

I was in the state of doubt and uncertainty which Descartes considers essential to the search for truth. It is a state which cannot continue, it is disquieting and painful; only vicious tendencies and an idle heart can keep us in that state. . . .

I pondered, therefore, on the sad fate of mortals, adrift upon this sea of human opinions, without compass or rudder, and abandoned to their stormy passions with no guide but an inexperienced pilot who does not know whence he comes or whither he is going. I said to myself, "I love truth, I seek her, and cannot find her. Show me truth and I will hold her fast; why does she hide her face from the eager heart that would fain worship her?"

My perplexity was increased by the fact that I had been brought up in a church which decides everything and permits no doubts, so that having rejected one article of faith I was forced to reject the rest; . . .

I consulted the philosophers, I searched their books and examined their various theories; I found them all alike proud, assertive, dogmatic, professing, even in their so-called skepticism, to know everything, proving nothing, scoffing at each other. . . .

I suppose this prodigious diversity of opinion is caused, in the first place, by the weakness of the human intellect; and, in the second, by pride. . . . The one thing we do not know is the limit of the knowable. We prefer to trust to chance and to believe what is not true, rather than to own that not one of us can see what really is. A fragment of some vast whole whose bounds are beyond our gaze, a fragment abandoned by its Creator to our foolish quarrels, we are vain enough to want to determine the nature of that whole and our own relations with regard to it.

The first thing I learned from these considerations was to restrict my inquiries to what directly concerned myself, to rest in profound ignorance of everything else, and not even to trouble myself to doubt anything beyond what I required to know.

I also realized that the philosophers, far from ridding me of my vain doubts, only multiplied the doubts that tormented me and failed to remove any one of them. So I chose another guide and said, "Let me follow the Inner Light; it will not lead me so far astray as others have done, or if it does it will be my own fault, and I shall not go so far wrong if I follow my own illusions as if I trusted to their deceits."

But who am I? What right have I to decide? What is it that determines my judgments? If they are inevitable, if they are the results of the impressions I receive, I am wasting my strength in such inquiries; they would be made or not without any interference of mine. I must therefore first turn my eyes upon myself to acquaint myself with the instrument I desire to use, and to discover how far it is reliable.

I exist, and I have senses through which I receive impressions. This is the first truth that strikes me and I am forced to accept it. Have I any independent knowledge of my existence, or am I only aware of it through my sensations? This is my first difficulty, and so far I cannot solve it. For I continually experience sensations, either directly or indirectly through memory, so how can I know if the feeling of self is something beyond these sensations or if it can exist independently of them?

My sensations take place in myself, for they make me aware of my own existence; but their cause is outside me, for

they affect me whether I have any reason for them or not, and they are produced or destroyed independently of me. So I clearly perceive that my sensation, which is within me, and its cause or its object, which is outside me, are different things.

Thus, not only do I exist, but other entities exist also, that is to say, the objects of my sensations; and even if these objects are merely ideas, still these ideas are not me.

But everything outside myself, everything which acts upon my senses, I call matter, and all the particles of matter which I suppose to be united into separate entities I call bodies. Thus all the disputes of the idealists and the realists have no meaning for me; their distinctions between the appearance and the reality of bodies are wholly fanciful.

I am now as convinced of the existence of the universe as of my own. I next consider the objects of my sensations, and I find that I have the power of comparing them, so I perceive that I am endowed with an active force of which I was not previously aware.

To perceive is to feel; to compare is to judge; to judge and to feel are not the same. Through sensation objects present themselves to me separately and singly as they are in nature; by comparing them I rearrange them, I shift them so to speak, I place one upon another to decide whether they are alike or different, or more generally to find out their relations. To my mind, the distinctive faculty of an active or intelligent being is the power of understanding this word *is*. I seek in vain in the merely sensitive entity that intelligent force which compares and judges; I can find no trace of it in its nature. This passive entity will be aware of each object separately, it will even be aware of the whole formed by the two together, but having no power to place them side by side it can never compare them, it can never form a judgment with regard to them.

To see two things at once is not to see their relations nor to judge of their differences; to perceive several objects, one beyond the other, is not to relate them. I may have at the same moment an idea of a big stick and a little stick without comparing them, without judging that one is less than the other, just as I can see my whole hand without counting my fingers. These comparative ideas, greater, smaller, together with number ideas of one, two, etc., are certainly not sensations, although my mind only produces them when my sensations occur.

We are told that a sensitive being distinguishes sensations from each other by the inherent differences in the sensations; this requires explanation. When the sensations are different, the sensitive being distinguishes them by their differences; when they are alike, he distinguishes them because he is aware of them one beyond the other. Otherwise, how could he distinguish between two equal objects simultaneously experienced? He would necessarily confound the two objects and take them for one object, especially under a system which professed that the representative sensations of space have no extension.

When we become aware of the two sensations to be compared, their impression is made, each object is perceived, both are perceived, but for all that their relation is not perceived. If the judgment of this relation were merely a sensation, and came to me solely from the object itself, my judgments would never be mistaken, for it is never untrue that I feel what I feel.

Why then am I mistaken as to the relation between these two sticks, especially when they are not parallel? Why, for example, do I say the small stick is a third of the large, when it is only a quarter? Why is the picture, which is the sensation, unlike its model which is the object? It is because I am active when I judge, because the operation of comparison is at fault; because my understanding, which judges of relations, mingles its errors with the truth of sensations, which only reveal to me things.

Add to this a consideration which will, I feel sure, appeal to you when you have thought about it: it is this—If we were purely passive in the use of our senses, there would be no communication between them; it would be impossible to know that the body we are touching and the touch we are looking at is the same. Either we should never perceive anything outside ourselves, or there would be for us five substances perceptible by the senses, whose identity we should have no means of perceiving.

This power of my mind which brings my sensations together and compares them may be called by any name; let it be called attention, meditation, reflection, or what you will; it is still true that it is in me and not in things, that it is I alone who produce it, though I only produce it when I receive an impression from things. Though I am compelled to feel or not to feel, I am free to examine more or less what I feel.

Being now, so to speak, sure of myself, I begin to look at things outside myself, and I behold myself with a sort of shudder flung at random into this vast universe, plunged as it were into the vast number of entities, knowing nothing of what they are in themselves or in relation to me. I study them, I observe them; . . .

I believe, therefore, that there is a will which sets the universe in motion and gives life to nature. This is my first dogma, or the first article of my creed. . . .

Let us compare the special ends, the means, the ordered relations of every kind, then let us listen to the inner voice of feeling; what healthy mind can reject its evidence? Unless the eyes are blinded by prejudices, can they fail to see that the visible order of the universe proclaims a supreme intelligence? What sophisms must be brought together before we fail to understand the harmony of existence and the wonderful cooperation of every part for the maintenance of the rest? . . .

In vain do those who deny the unity of intention manifested in the relations of all the parts of this great whole, in vain do they conceal their nonsense under abstractions, coordinations, general principles, symbolic expressions; whatever they do I find it impossible to conceive of a system of entities so firmly ordered unless I believe in an intelligence that orders them. It is not in my power to believe that passive and dead matter can have brought forth living and feeling beings, that blind chance has brought forth intelligent beings, that that which does not think has brought forth thinking beings.

I believe, therefore, that the world is governed by a wise and powerful will; I see it or rather I feel it, and it is a great thing to know this. But has this same world always existed, or has it been created? Is there one source of all things? Are there two or many? What is their nature? I know not; and what concern is it of mine? When these things become of importance to me I will try to learn them; till then I abjure these idle speculations, which may trouble my peace, but cannot affect my conduct nor be comprehended by my reason.

Recollect that I am not preaching my own opinion but explaining it. Whether matter is eternal or created, whether its origin is passive or not, it is still certain that the whole is one, and that it proclaims a single intelligence; for I see nothing that is not part of the same ordered system, nothing which does not cooperate to the same end, namely, the conservation of all within the established order. This being who wills and can perform his will, this being active through his own power, this being, whoever he may be, who moves the universe and orders all things, is what I call God. To this name I add the ideas of intelligence, power, will, which I have brought together, and that of kindness which is their necessary consequence; but for all this I know no more of the being to which I ascribe them. He hides himself alike from my senses and my understanding; the more I think of him, the more perplexed I am; I know full well that he exists, and that he exists of himself alone; I know that my existence depends

on his, and that every thing I know depends upon him also. I see God everywhere in his works; I feel him within myself; I behold him all around me; but if I try to ponder him himself, if I try to find out where he is, what he is, what is his substance, he escapes me and my troubled spirit finds nothing.

"Emile" by Jean Jacques Rousseau from *Introduction to Contemporary Civilization in the West, Vol. 1*, Third Edition, translated by Barbara Foxley. Copyright 1960 Columbia University Press. Reprinted by permission.

VOLTAIRE

from CANDIDE *or* OPTIMISM

Candide is a simple young man of charm and courage who at an early age has been subjected to the opinions of his tutor, Dr. Pangloss. According to Dr. Pangloss, who is a parody of the rational philosophers of the day, everything that happens is bound to happen for the best, be it rape, murder, or earthquake. In a famous scene in Chapter 5, Candide and Pangloss become involved in an actual historical event, the disastrous earthquake that destroyed most of Lisbon in 1755. When called upon to help the injured, the learned doctor meditates instead on the causes and effects of the earthquake and duly comes to the conclusion that if Lisbon and its inhabitants were destroyed, it had to be so, and therefore was all for the best.

It is, incidentally, typical of the breadth of Voltaire's satire that in the very first sentence of the next chapter he turns from philosophical optimism to an attack on religious superstition and fanaticism, when he describes the decision taken to find some victims injured in the earthquake and burn them alive as a means of averting further disasters. That this decision is made by the University of Coimbra, supposedly an establishment of reason, is of course an extra twist of the knife on Voltaire's part.

Among the chosen victims is Candide himself; by the time he has escaped even he, innocent follower of his tutor's precepts, is beginning to have serious doubts. When he hears of the disasters that have befallen his childhood sweetheart Cunegonde and the old lady who is her companion, the absurdity of philosophical optimism bcomes clear. Much of the rest of the book is devoted to underlining precisely how absurd it is and exploring alternative schools of thought. Candide travels from Spain to the New World and back to Europe, and wherever he goes finds nothing but evil, stupidity, and ignorance.

In the course of his travels Candide decides to find a companion and joins up with Martin, an old scholar who represents the opposite philosophical viewpoint from that of Dr. Pangloss: total pessimism. The two travel to Venice and then to Constantinople, where Candide and his once-beloved Cunegonde are reunited.

By the end of his journeys Candide has had a chance to think about the optimism of Dr. Pangloss and the pessimism of his friend Martin and to compare them both to real life. The conclusion he reaches is expressed in the book's final words, "we must cultivate our gardens." The world is a cruel place where human life is of little account, but to give way to total pessimism is fruitless. Instead, we should try to find some limited activity we can perform well. By succeeding in this small task we can construct a little island of peace and sanity in a hostile world.

The reader who expects to find fully developed characters and a convincing plot in Candide *is likely to be severely disappointed. Voltaire's aim is to teach, and to this end he manipulates the narrative to make his points as powerfully as possible. This does not mean that he does not write entertainingly, however; indeed,* Candide *is probably one of the most enjoyable of the great literary works. With inexhaustible imagination and dry wit, Voltaire even succeeds in making us laugh at the impossible disasters he invents and the absurd reactions of his characters to them, since, given the choice of laughter or tears at the injustices of life, he chooses the former. Nonetheless, the message of the work is far from comforting. It is a measure of Voltaire's courage that his final advice to "cultivate our gardens" manages to extract something positive from the despair masked by his humor and irony.*

The two long selections that follow are not intended to present every twist and turn of the plot but to convey something of the flavor and spirit of the whole. The first selection (chapters 1–13) sees the story well on its way, with Candide separated from Cunegonde, reunited with her and separated yet again, while Voltaire takes on an assortment of targets that includes the aristocracy, the law, war, religious intolerance and hypocrisy, and, of course, Dr. Pangloss. The episode of the old woman and her story, furthermore, contains some of Voltaire's most bizarre inventions. The note of suspense on which Chapter 13 closes is typical of much of the rest of the book, where characters are placed in an impossible situation from which they find a highly unlikely means of escape.

How Candide was brought up in a noble castle and how he was expelled from the same

In the castle of Baron Thunder-ten-tronckh in Westphalia there lived a youth, endowed by Nature with the most gentle character. His face was the expression of his soul. His judgment was quite honest and he was extremely simple-minded; and this was the reason, I think, that he was named Candide. Old servants in the house suspected that he was the son of the Baron's sister and a decent honest gentleman of the neighborhood, whom this young lady would never marry because he could only prove seventy-one quarterings, and the rest of his genealogical tree was lost, owing to the injuries of time. The Baron was one of the most powerful lords in Westphalia, for his castle possessed a door and windows. His Great Hall was even decorated with a piece of tapestry. The dogs in his stable-yards formed a pack of hounds when necessary; his grooms were his huntsmen; the village curate was his Grand Almoner. They all called him "My Lord," and laughed heartily at his stories. The Baroness weighed about three hundred and fifty pounds, was therefore greatly respected, and did the honors of the house with a dignity which rendered her still more respectable. Her daughter Cunegonde, age seventeen, was rosy-cheeked, fresh, plump and tempting. The Baron's son appeared in every respect worthy of his father. The tutor Pangloss was the oracle of the house, and little Candide followed his lessons with all the candor of his age and character. Pangloss taught metaphysico-theologo-cosmo-lonigology. He proved admirably that there is no effect without a cause and that in this best of all possible worlds, My Lord the Baron's castle was the best of castles and his wife the best of all possible Baronesses. "'Tis demonstrated," said he, "that things cannot be otherwise; for, since everything is made for an end, everything is necessarily for the best end. Observe that noses were made to wear spectacles; and so we have spectacles. Legs were visibly instituted to be breeched, and we have breeches. Stones were formed to be quarried and to build castles; and My Lord has a very noble castle; the greatest Baron in the province should have the best house; and as pigs were made to be eaten, we eat pork all the year round; consequently, those who have asserted that all is well talk nonsense; they ought to have said that all is for the best." Candide listened attentively and believed innocently; for he thought Mademoiselle Cunegonde extremely beautiful, although he was never bold enough to tell her so. He decided that after the happiness of being born Baron of Thunder-ten-tronckh, the second degree of happiness was to be Mademoiselle Cunegonde; the third to see her every day; and the fourth to listen to Doctor Pangloss, the greatest philosopher of the province and therefore of the whole world. One day when Cunegonde was walking near the castle, in a little wood which was called The Park, she observed Doctor Pangloss in the bushes, giving a lesson in experimental physics to her mother's waiting-maid, a very pretty and docile brunette. Mademoiselle Cunegonde had a great inclination for science and watched breathlessly the reiterated experiments she wit-

nessed; she observed clearly the Doctor's sufficient reason, the effects and the causes, and returned home very much excited, pensive, filled with the desire of learning, reflecting that she might be the sufficient reason of young Candide and that he might be hers. On her way back to the castle she met Candide and blushed; Candide also blushed. She bade him good-morning in a hesitating voice; Candide replied without knowing what he was saying. Next day, when they left the table after dinner, Cunegonde and Candide found themselves behind a screen; Cunegonde dropped her handkerchief, Candide picked it up; she innocently held his hand; the young man innocently kissed the young lady's hand with remarkable vivacity, tenderness and grace; their lips met, their eyes sparkled, their knees trembled, their hands wandered. Baron Thunder-ten-tronckh passed near the screen, and, observing this cause and effect, expelled Candide from the castle by kicking him in the backside frequently and hard. Cunegonde swooned; when she recovered her senses, the Baroness slapped her in the face; and all was in consternation in the noblest and most agreeable of all possible castles.

II

What happened to Candide among the Bulgarians

Candide, expelled from the earthly paradise, wandered for a long time without knowing where he was going, turning up his eyes to Heaven, gazing back frequently at the noblest of castles which held the most beautiful of young Baronesses; he lay down to sleep supperless between two furrows in the open fields; it snowed heavily in large flakes. The next morning the shivering Candide, penniless, dying of cold and exhaustion, dragged himself towards the neighboring town, which was called Waldberghoff-trarbk-dikdorff. He halted sadly at the door of an inn. Two men dressed in blue noticed him. "Comrade," said one, "there's a well-built young man of the right height." They went up to Candide and very civilly invited him to dinner. "Gentlemen," said Candide with charming modesty, "you do me a great honor, but I have no money to pay my share." "Ah, sir," said one of the men in blue, "persons of your figure and merit never pay anything; are you not five feet five tall?" "Yes, gentlemen," said he, bowing, "that is my height." "Ah, sir, come to table; we will not only pay your expenses, we will never allow a man like you to be short of money; men were only made to help each other." "You are in the right," said Candide, "that is what Doctor Pangloss was always telling me, and I see that everything is for the best." They begged him to accept a few crowns, he took them and wished to give them an I O U; they refused to take it and all sat down to table. "Do you not love tenderly. . . ." "Oh, yes," said he. "I love Mademoiselle Cunegonde tenderly." "No," said one of the gentlemen. "We were asking if you do not tenderly love the King of the Bulgarians." "Not a bit," said he, "for I have never seen him." "What! He is the most charming of Kings, and you must drink his health." "Oh, gladly, gentlemen." And he drank. "That is sufficient," he was told. "You are now the support, the aid, the defender, the hero of the Bulgarians; your fortune is made and your glory assured." They immediately put irons on his legs and took him to a regiment. He was made to turn to the right and left, to raise the ramrod and return the ramrod, to take aim, to fire, to march double time, and he was given thirty strokes with a stick; the next day he drilled not quite so badly, and received only twenty strokes; the day after, he only had ten and was looked on as a prodigy by his comrades. Candide was completely mystified and could not make out how he was a hero. One fine spring day he thought he would take a walk, going straight ahead, in the belief that to use his legs as he pleased was a privilege of the human species as well as of animals. He had

not gone two leagues when four other heroes, each six feet tall, fell upon him, bound him and dragged him back to a cell. He was asked by his judges whether he would rather be thrashed thirty-six times by the whole regiment or receive a dozen lead bullets at once in his brain. Although he protested that men's wills are free and that he wanted neither one nor the other, he had to make a choice; by virtue of that gift of God which is called *liberty*, he determined to run the gauntlet thirty-six times and actually did so twice. There were two thousand men in the regiment. That made four thousand strokes which laid bare the muscles and nerves from his neck to his backside. As they were about to proceed to a third turn, Candide, utterly exhausted, begged as a favor that they would be so kind as to smash his head; he obtained this favor; they bound his eyes and he was made to kneel down. At that moment the King of the Bulgarians came by and inquired the victim's crime; and as this King was possessed of a vast genius, he perceived from what he learned about Candide that he was a young metaphysician very ignorant in worldly matters, and therefore pardoned him with a clemency which will be praised in all newspapers and all ages. An honest surgeon healed Candide in three weeks with the ointments recommended by Dioscorides. He had already regained a little skin and could walk when the King of the Bulgarians went to war with the King of the Abares.

III

How Candide escaped from the Bulgarians and what became of him

Nothing could be smarter, more splendid, more brilliant, better drawn up than the two armies. Trumpets, fifes, hautboys, drums, cannons, formed a harmony such as has never been heard even in hell. The cannons first of all laid flat about six thousand men on each side; then the musketry removed from the best of worlds some nine or ten thousand blackguards who infested its surface. The bayonet also was the sufficient reason for the death of some thousands of men. The whole might amount to thirty thousand souls. Candide, who trembled like a philosopher, hid himself as well as he could during this heroic butchery. At last, while the two Kings each commanded a Te Deum in his camp, Candide decided to go elsewhere to reason about effects and causes. He clambered over heaps of dead and dying men and reached a neighboring village, which was in ashes; it was an Abare village which the Bulgarians had burned in accordance with international law. Here, old men dazed with blows watched the dying agonies of their murdered wives who clutched their children to their bleeding breasts; there, disemboweled girls who had been made to satisfy the natural appetites of heroes gasped their last sighs; others, half-burned, begged to be put to death. Brains were scattered on the ground among dismembered arms and legs. Candide fled to another village as fast as he could; it belonged to the Bulgarians, and Abarian heroes had treated it in the same way. Candide, stumbling over quivering limbs or across ruins, at last escaped from the theatre of war, carrying a little food in his knapsack, and never forgetting Mademoiselle Cunegonde. His provisions were all gone when he reached Holland; but, having heard that everyone in that country was rich and a Christian, he had no doubt at all but that he would be as well treated as he had been in the Baron's castle before he had been expelled on account of Mademoiselle Cunegonde's pretty eyes. He asked alms of several grave persons, who all replied that if he continued in that way he would be shut up in a house of correction to teach him how to live. He then addressed himself to a man who had been discoursing on charity in a large assembly for an hour on end. This orator, glancing at him askance, said: "What are you

doing here? Are you for the good cause?" "There is no effect without a cause," said Candide modestly. "Everything is necessarily linked up and arranged for the best. It was necessary that I should be expelled from the company of Mademoiselle Cunegonde, that I ran the gauntlet, and that I beg my bread until I can earn it; all this could not have happened differently." "My friend," said the orator, "do you believe that the Pope is anti-Christ?" "I had never heard so before," said Candide, "but whether he is or isn't, I am starving." "You don't deserve to eat," said the other. "Hence, rascal; hence, you wretch; and never come near me again." The orator's wife thrust her head out of the window and seeing a man who did not believe that the Pope was anti-Christ, she poured on his head a full . . . O Heavens! To what excess religious zeal is carried by ladies! A man who had not been baptized, an honest Anabaptist named Jacques, saw the cruel and ignominious treatment of one of his brothers, a featherless two-legged creature with a soul; he took him home, cleaned him up, gave him bread and beer, presented him with two florins, and even offered to teach him to work at the manufacture of Persian stuffs which are made in Holland. Candide threw himself at the man's feet, exclaiming: "Doctor Pangloss was right in telling me that all is for the best in this world, for I am vastly more touched by your extreme generosity than by the harshness of the gentlemen in the black cloak, and his good lady." The next day when he walked out he met a beggar covered with sores, dull-eyed, with the end of his nose fallen away, his mouth awry, his teeth black, who talked huskily, was tormented with a violent cough and spat out a tooth at every cough.

IV

How Candide met his old master in philosophy, Doctor Pangloss, and what happened

Candide, moved even more by compassion than by horror, gave this horrible beggar the two florins he had received from the honest Anabaptist, Jacques. The phantom gazed fixedly at him, shed tears and threw its arms round his neck. Candide recoiled in terror. "Alas!" said the wretch to the other wretch, "don't you recognize your dear Pangloss?" "What do I hear? You, my dear master! You, in this horrible state! What misfortune has happened to you! Why are you no longer in the noblest of castles? What has become of Mademoiselle Cunegonde, the pearl of young ladies, the masterpiece of Nature?" "I am exhausted," said Pangloss. Candide immediately took him to the Anabaptist's stable where he gave him a little bread to eat; and when Pangloss had recovered: "Well!" said he, "Cunegonde?" "Dead," replied the other. At this word Candide swooned; his friend restored him to his senses with a little bad vinegar which happened to be in the stable. Candide opened his eyes. "Cunegonde dead! Ah! best of worlds, where are you? But what illness did she die of? Was it because she saw me kicked out of her father's noble castle?" "No," said Pangloss. "She was disemboweled by Bulgarian soldiers, after having been raped to the limit of possibility; they broke the Baron's head when he tried to defend her; the Baroness was cut to pieces; my poor pupil was treated exactly like his sister; and as to the castle, there is not one stone standing on another, not a barn, not a sheep, not a duck, not a tree; but we were well avenged, for the Abares did exactly the same to a neighboring barony which belonged to a Bulgarian Lord." At this, Candide swooned again; but, having recovered and having said all that he ought to say, he inquired the cause and effect, the sufficient reason which had reduced Pangloss to so piteous a state. "Alas!" said Pangloss, "'tis love; love, the consoler of the human race, the preserver of the universe, the soul of all tender creatures, gentle love," "Alas!" said Candide. "I am

acquainted with this love, this sovereign of hearts, this soul of our soul; it has never brought me anything but one kiss and twenty kicks in the backside. How could this beautiful cause produce in you so abominable an effect?" Pangloss replied as follows: "My dear Candide! You remember Paquette, the maid-servant of our august Baroness; in her arms I enjoyed the delights of Paradise which have produced the tortures of Hell by which you see I am devoured; she was infected and perhaps is dead. Paquette received this present from a most learned monk, who had it from the source; for he received it from an old countess, who had it from a cavalry captain, who owed it to a marchioness, who derived it from a page, who had received it from a Jesuit, who, when a novice, had it in a direct line from one of the companions of Christopher Columbus. For my part, I shall not give it to anyone, for I am dying." "O Pangloss!" exclaimed Candide, "this is a strange genealogy! Wasn't the devil at the root of it?" "Not at all," replied that great man. "It was something indispensable in this best of worlds, a necessary ingredient; for, if Columbus in an island of America had not caught this disease, which poisons the source of generation, and often indeed prevents generation, we should not have chocolate and cochineal; it must also be noticed that hitherto in our continent this disease is peculiar to us, like theological disputes. The Turks, the Indians, the Persians, the Chinese, the Siamese and the Japanese are not yet familiar with it; but there is a sufficient reason why they in their turn should become familiar with it in a few centuries. Meanwhile, it has made marvelous progress among us, and especially in those large armies composed of honest, well-bred stipendiaries who decide the destiny of States; it may be asserted that when thirty thousand men fight a pitched battle against an equal number of troops, there are about twenty thousand with the pox on either side." "Admirable!" said Candide. "But you must get cured." "How can I?" said Pangloss. "I haven't a sou, my friend, and in the whole extent of this globe, you cannot be bled or receive an enema without paying or without someone paying for you." This last speech determined Candide; he went and threw himself at the feet of his charitable Anabaptist, Jacques, and drew so touching a picture of the state to which his friend was reduced that the good easy man did not hesitate to succor Pangloss; he had him cured at his own expense. In this cure Pangloss only lost one eye and one ear. He could write well and knew arithmetic perfectly. The Anabaptist made him his bookkeeper. At the end of two months he was compelled to go to Lisbon on business and took his two philosophers on the boat with him. Pangloss explained to him how everything was for the best. Jacques was not of this opinion. "Men," said he, "must have corrupted nature a little, for they were not born wolves, and they have become wolves. God did not give them twenty-four-pounder cannons or bayonets, and they have made bayonets and cannons to destroy each other. I might bring bankruptcies into the account and Justice which seizes the goods of bankrupts in order to deprive the creditors of them." "It was all indispensable," replied the one-eyed doctor, "and private misfortunes make the public good, so that the more private misfortunes there are, the more everything is well," While he was reasoning, the air grew dark, the winds blew from the four quarters of the globe and the ship was attacked by the most horrible tempest in sight of the port of Lisbon.

V

Storm, shipwreck, earthquake, and what happened to Doctor Pangloss, to Candide and the Anabaptist Jacques

Half the enfeebled passengers, suffering from that inconceivable anguish which the rolling of a ship causes in the nerves and in all the humors of bodies shaken in contrary

directions, did not retain strength enough even to trouble about the danger. The other half screamed and prayed; the sails were torn, the masts broken, the vessel leaking. Those worked who could, no one cooperated, no one commanded. The Anabaptist tried to help the crew a little; he was on the main-deck; a furious sailor struck him violently and stretched him on the deck; but the blow he delivered gave the sailor so violent a shock that he fell head-first out of the ship. He remained hanging and clinging to part of the broken mast. The good Jacques ran to his aid, helped him to climb back, and from the effort he made was flung into the sea in full view of the sailor, who allowed him to drown without condescending even to look at him. Candide came up, saw his benefactor reappear for a moment and then be engulfed for ever. He tried to throw himself after him into the sea; he was prevented by the philosopher Pangloss, who proved to him that the Bay of Lisbon had been expressly created for the Anabaptist to be drowned in it. While he was proving this a priori, the vessel sank, and every one perished except Pangloss, Candide and the brutal sailor who had drowned the virtuous Anabaptist; the blackguard swam successfully to the shore and Pangloss and Candide were carried there on a plank. When they had recovered a little, they walked toward Lisbon; they had a little money by the help of which they hoped to be saved from hunger after having escaped the storm. Weeping the death of their benefactor, they had scarcely set foot in the town when they felt the earth tremble under their feet; the sea rose in foaming masses in the port and smashed the ships which rode at anchor. Whirlwinds of flame and ashes covered the streets and squares; the houses collapsed, the roofs were thrown upon the foundations, and the foundations were scattered; thirty thousand inhabitants of every age and both sexes were crushed under the ruins. Whistling and swearing, the sailor said: "There'll be something to pick up here." "What can be the sufficient reason for this phenomenon?" said Pangloss. "It is the last day!" cried Candide. The sailor immediately ran among the debris, dared death to find money, found it, seized it, got drunk, and having slept off his wine, purchased the favors of the first woman of good-will he met on the ruins of the houses and among the dead and dying. Pangloss, however, pulled him by the sleeve. "My friend," said he, "this is not well, you are disregarding universal reason, you choose the wrong time." "Blood and 'ounds!" he retorted. "I am a sailor and I was born in Batavia; four times have I stamped on the crucifix during four voyages to Japan; you have found the right man for your universal reason!" Candide had been hurt by some falling stones; he lay in the street covered with debris. He said to Pangloss: "Alas! Get me a little wine and oil; I am dying." "This earthquake is not a new thing," replied Pangloss. "The town of Lima felt the same shocks in America last year; similar causes produce similar effects; there must certainly be a train of sulphur underground from Lima to Lisbon." "Nothing is more probable," replied Candide; "but, for God's sake, a little oil and wine." "What do you mean, probable?" replied the philosopher; "I maintain that it is proved." Candide lost consciousness, and Pangloss brought him a little water from a neighboring fountain. Next day they found a little food as they wandered among the ruins and regained a little strength. Afterwards they worked like others to help the inhabitants who had escaped death. Some citizens they had assisted gave them as good a dinner as could be expected in such a disaster; true, it was a dreary meal; the hosts watered their bread with their tears, but Pangloss consoled them by assuring them that things could not be otherwise. "For," said he, "all this is for the best; for, if there is a volcano at Lisbon, it cannot be anywhere else; for it is impossible that things should not be where they are; for all is well." A little, dark man, a familiar of the Inquisition, who sat beside him, politely took up the conversation, and said: "Apparently, you do not believe in original sin; for, if everything is for the best, there was neither fall nor punishment." "I most humbly beg your excellency's pardon," replied Pangloss still more politely, "for the fall of man and the curse necessarily entered into the best of all possible worlds." "Then you do not believe in free-will?" said the familiar. "Your excellency will pardon me," said Pangloss; "free-will can exist with absolute necessity; for it was necessary that we should be free; for in short, limited will . . ." Pangloss was in the middle of his phrase when the familiar nodded to his armed attendant who was pouring out port or Oporto wine for him.

VI

How a splendid **audo-da-fé** *was held to prevent earthquakes and how Candide was flogged*

After the earthquake which destroyed three-quarters of Lisbon, the wise men of that country could discover no more efficacious way of preventing a total ruin than by giving the people a splendid *auto-da-fé*. It was decided by the university of Coimbra that the sight of several persons being slowly burned in great ceremony is an infallible secret for preventing earthquakes. Consequently they had arrested a Biscayan convicted of having married his fellow-godmother, and two Portuguese who, when eating a chicken, had thrown away the fat; after dinner they came and bound Doctor Pangloss and his disciple Candide, one because he had spoken and the other because he had listened with an air of approbation; they were both carried separately to extremely cool apartments, where there was never any discomfort from the sun; a week afterwards each was dressed in a sanbenito and their heads were ornamented with paper mitres. Candide's mitre and sanbenito were painted with flames upside down and with devils who had neither tails nor claws; but Pangloss's devils had claws and tails, and his flames were upright. Dressed in this manner they marched in procession and listened to a most pathetic sermon, followed by lovely plainsong music. Candide was flogged in time to the music, while the singing went on; the Biscayan and the two men who had not wanted to eat fat were burned, and Pangloss was hanged, although this is not the custom. The very same day, the earth shook again with a terrible clamor. Candide, terrified, dumbfounded, bewildered, covered with blood, quivered from head to foot, said to himself: "If this is the best of all possible worlds, what are the others? Let it pass that I was flogged, for I was flogged by the Bulgarians, but, O my dear Pangloss! The greatest of philosophers! Must I see you hanged without knowing why! O my dear Anabaptist! The best of men! Was it necessary that you should be drowned in port! O Mademoiselle Cunegonde! The pearl of women! Was it necessary that your belly should be slit!" He was returning, scarcely able to support himself, preached at, flogged, absolved and blessed, when an old woman accosted him and said: "Courage, my son, follow me."

VII

How an old woman took care of Candide and how he regained that which he loved

Candide did not take courage, but he followed the old woman to a hovel; she gave him a pot of ointment to rub on, and left him food and drink; she pointed out a fairly clean bed; near the bed there was a suit of clothes. "Eat, drink, sleep," she said, "and may our Lady of Atocha, my Lord Saint Anthony of Padua and my Lord Saint James of Compostella take care of you; I shall come back tomorrow." Candide, still amazed by all he had seen, by all he had suffered, and still more by the old woman's charity, tried to kiss her hand. "'Tis not my hand you should kiss," said the old woman, "I shall come back tomorrow. Rub on the ointment, eat and sleep." In

spite of all his misfortune, Candide ate and went to sleep. Next day the old woman brought him breakfast, examined his back and smeared him with another ointment; later she brought him dinner, and returned in the evening with supper. The next day she went through the same ceremony. "Who are you?" Candide kept asking her. "Who has inspired you with so much kindness? How can I thank you?" The good woman never made any reply; she returned in the evening but without any supper. "Come with me," said she, "and do not speak a word." She took him by the arm and walked into the country with him for about a quarter of a mile; they came to an isolated house, surrounded with gardens and canals. The old woman knocked at a little door. It was opened; she led Candide up a back stairway into a gilded apartment, left him on a brocaded sofa, shut the door and went away. Candide thought he was dreaming, and felt that his whole life was a bad dream and the present moment an agreeable dream. The old woman soon reappeared; she was supporting with some difficulty a trembling woman of majestic stature, glittering with precious stones and covered with a veil. "Remove the veil," said the old woman to Candide. The young man advanced and lifted the veil with a timid hand. What a moment! What a surprise! He thought he saw Mademoiselle Cunegonde, in fact he was looking at her, it was she herself. His strength failed him, he could not utter a word and fell at her feet. Cunegonde fell on the sofa. The old woman dosed them with distilled waters; they recovered their senses and began to speak: at first they uttered only broken words, questions and answers at cross purposes, sighs, tears, exclamations. The old woman advised them to make less noise and left them alone. "What! Is it you?" said Candide. "You are alive, and I find you here in Portugal! Then you were not raped? Your belly was not slit, as the philosopher Pangloss assured me?" "Yes, indeed," said the fair Cunegonde; "but those two accidents are not always fatal." "But your father and mother were killed?" "'Tis only too true," said Cunegonde, weeping. "And your brother?" "My brother was killed too." "And why are you in Portugal? And how did you know I was here? And by what strange adventure have you brought me to this house?" "I will tell you everything," replied the lady, "but first of all you must tell me everything that has happened to you since the innocent kiss you gave me and the kicks you received." Candide obeyed with profound respect; and, although he was bewildered, although his voice was weak and trembling, although his back was still a little painful, he related in the most natural manner all he had endured since the moment of their separation. Cunegonde raised her eyes to heaven; she shed tears at the death of the good Anabaptist and Pangloss, after which she spoke as follows to Candide, who did not miss a word and devoured her with his eyes.

VIII

Cunegonde's story

"I was fast asleep in bed when it pleased Heaven to send the Bulgarians to our noble castle of Thunder-ten-tronckh; they murdered my father and brother and cut my mother to pieces. A large Bulgarian six feet tall, seeing that I had swooned at the spectacle, began to rape me; this brought me to, I recovered my senses, I screamed, I struggled, I bit, I scratched, I tried to tear out the big Bulgarian's eyes, not knowing that what was happening in my father's castle was a matter of custom; the brute stabbed me with a knife in the left side where I still have the scar." "Alas! I hope I shall see it," said the naive Candide. "You shall see it," said Cunegonde, "but let me go on." "Go on," said Candide. She took up the thread of her story as follows: "A Bulgarian captain came in, saw me covered with blood, and the soldier did not disturb himself. The captain was angry at the brute's lack of

respect to him, and killed him on my body. Afterwards, he had me bandaged and took me to his billet as a prisoner of war. I washed the few shirts he had and did the cooking; I must admit he thought me very pretty; and I will not deny that he was very well built and that his skin was white and soft; otherwise he had little wit and little philosophy; it was plain that he had not been brought up by Dr. Pangloss. At the end of three months he lost all his money and got tired of me; he sold me to a Jew named Don Issachar, who traded in Holland and Portugal and had a passion for women. This Jew devoted himself to my person but he could not triumph over it; I resisted him better than the Bulgarian soldier; a lady of honor may be raped once, but it strengthens her virtue. In order to subdue me, the Jew brought me to this country house. Up till then I believed that there was nothing on earth so splendid as the castle of Thunder-ten-tronckh; I was undeceived. One day the Grand Inquisitor noticed me at Mass; he ogled me continually and sent a message that he wished to speak to me on secret affairs. I was taken to his palace; I informed him of my birth; he pointed out how much it was beneath my rank to belong to an Israelite. A proposition was made on his behalf to Don Issachar to give me up to His Lordship. Don Issachar, who is the court banker and a man of influence, would not agree. The Inquisitor threatened him with an *auto-da-fé*. At last the Jew was frightened and made a bargain whereby the house and I belong to both in common. The Jew has Mondays, Wednesdays and the Sabbath day, and the Inquisitor has the other days of the week. This arrangement has lasted for six months. It has not been without quarrels; for it has often been debated whether the night between Saturday and Sunday belonged to the old law or the new. For my part, I have hitherto resisted them both; and I think that is the reason why they still love me. At last My Lord the Inquisitor was pleased to arrange an *auto-da-fé* to remove the scourge of earthquakes and to intimidate Don Issachar. He honored me with an invitation. I had an excellent seat; and refreshments were served to the ladies between the Mass and the execution. I was indeed horror-stricken when I saw the burning of the two Jews and the honest Biscayan who had married his fellow-godmother; but what was my surprise, my terror, my anguish, when I saw in a sanbenito and under a mitre a face which resembled Pangloss's! I rubbed my eyes, I looked carefully, I saw him hanged; and I fainted. I had scarcely recovered my senses when I saw you stripped naked; that was the height of horror, of consternation, of grief and despair. I will frankly tell you that your skin is even whiter and of a more perfect tint than that of my Bulgarian captain. This spectacle redoubled all the feelings which crushed and devoured me. I exclaimed, I tried to say: 'Stop, Barbarians!' but my voice failed and my cries would have been useless. When you had been well flogged, I said to myself: 'How does it happen that the charming Candide and the wise Pangloss are in Lisbon, the one to receive a hundred lashes, and the other to be hanged, by order of My Lord the Inquisitor, whose darling I am? Pangloss deceived me cruelly when he said that all is for the best in the world.' I was agitated, distracted, sometimes beside myself and sometimes ready to die of faintness, and my head was filled with the massacre of my father, of my mother, of my brother, the insolence of my horrid Bulgarian soldier, the gash he gave me, my slavery, my life as a kitchen-wench, my Bulgarian captain, my horrid Don Issachar, my abominable Inquisitor, the hanging of Dr. Pangloss, that long *miserere* in counterpoint during which you were flogged, and above all the kiss I gave you behind the screen that day when I saw you for the last time. I praised God for bringing you back to me through so many trials, I ordered my old woman to take care of you and to bring you here as soon as she could. She has carried out my commission very well; I have enjoyed the inexpressible

pleasure of seeing you again, of listening to you, and of speaking to you. You must be very hungry; I have a good appetite; let us begin by having supper." Both sat down to supper; and after supper they returned to the handsome sofa we have already mentioned; they were still there when Signor Don Issachar, one of the masters of the house, arrived. It was the day of the Sabbath. He came to enjoy his rights and to express his tender love.

IX

What happened to Cunegonde, to Candide, to the Grand Inquisitor and to a Jew

This Issachar was the most choleric Hebrew who had been seen in Israel since the Babylonian captivity. "What!" said he. "Bitch of a Galilean, isn't it enough to have the Inquisitor? Must this scoundrel share with me too?" So saying, he drew a long dagger which he always carried and, thinking that his adversary was unarmed, threw himself upon Candide; but our good Westphalian had received an excellent sword from the old woman along with his suit of clothes. He drew his sword, and although he had a most gentle character, laid the Israelite stone-dead on the floor at the feet of the fair Cunegonde. "Holy Virgin!" she exclaimed, "what will become of us? A man killed in my house! If the police come we are lost." "If Pangloss had not been hanged," said Candide, "he would have given us good advice in this extremity, for he was a great philosopher. In default of him, let us consult the old woman." She was extremely prudent and was beginning to give her advice when another little door opened. It was an hour after midnight, and Sunday was beginning. This day belonged to My Lord the Inquisitor. He came in and saw the flogged Candide sword in hand, a corpse lying on the ground, Cunegonde in terror, and the old woman giving advice. At this moment, here is what happened in Candide's soul and the manner of his reasoning: "If this holy man calls for help, he will infallibly have me burned; he might do as much to Cunegonde; he had me pitilessly lashed; he is my rival; I am in the mood to kill, there is no room for hesitation." His reasoning was clear and swift; and, without giving the Inquisitor time to recover from his surprise, he pierced him through and through and cast him beside the Jew. "Here's another," said Cunegonde. "There is no chance of mercy; we are excommunicated, our last hour has come. How does it happen that you, who were born so mild, should kill a Jew and a prelate in two minutes?" "My dear young lady," replied Candide, "when a man is in love, jealous, and has been flogged by the Inquisition, he is beside himself." The old woman then spoke up and said: "In the stable are three Andalusian horses, with their saddles and bridles; let the brave Candide prepare them; mademoiselle has moidores [Portuguese gold coins] and diamonds; let us mount quickly, although I can only sit on one buttock, and go to Cadiz; the weather is beautifully fine, and it is most pleasant to travel in the coolness of the night." Candide immediately saddled the three horses. Cunegonde, the old woman and he rode thirty miles without stopping. While they were riding away, the Holy Hermandad arrived at the house; My Lord was buried in a splendid church and Issachar was thrown into a sewer. Candide, Cunegonde and the old woman had already reached the little town of Avacena in the midst of the mountains of the Sierra Morena; and they talked in their inn as follows.

X

How Candide, Cunegonde and the old woman arrived at Cadiz in great distress, and how they embarked

"Who can have stolen my pistoles and my diamonds?" said Cunegonde, weeping. "How shall we live? What shall we do? Where shall we find Inquisitors and Jews to give me others?" "Alas!" said the old woman, "I strongly suspect a reverend Franciscan father who slept in the same inn at Badajoz with us: Heaven forbid that I should judge rashly! But he twice came into our room and left long before we did." "Alas!" said Candide, "the good Pangloss often proved to me that this world's goods are common to all men and that every one has an equal right to them. According to these principles the monk should have left us enough to continue our journey. Have you nothing left then, my fair Cunegonde?" "Not a maravedi," said she. "What are we to do?" said Candide. "Sell one of the horses," said the old woman. "I will ride postilion behind Mademoiselle Cunegonde, although I can only sit on one buttock, and we will get to Cadiz." In the same hotel there was a Benedictine friar. He bought the horse very cheap. Candide, Cunegonde and the old woman passed through Lucena. Chillas, Lebrixa, and at last reached Cadiz. A fleet was there being equipped and troops were being raised to bring to reason the reverend Jesuit fathers of Paraguay, who were accused of causing the revolt of one of their tribes against the kings of Spain and Portugal near the town of Sacramento. Candide, having served with the Bulgarians, went through the Bulgarian drill before the general of the little army with so much grace, celerity, skill, pride and agility, that he was given the command of an infantry company. He was now a captain; he embarked with Mademoiselle Cunegonde, the old woman, two servants, and the two Andalusian horses which had belonged to the Grand Inquisitor of Portugal. During the voyage they had many discussions about the philosophy of poor Pangloss. "We are going to a new world," said Candide, "and no doubt it is there that everything is for the best; for it must be admitted that one might lament a little over the physical and moral happenings in our own world." "I love you with all my heart," said Cunegonde, "but my soul is still shocked by what I have seen and undergone." "All will be well," replied Candide, "the sea in this new world already is better than the seas of our Europe; it is calmer and the winds are more constant. It is certainly the new world which is the best of all possible worlds." "God grant it!" said Cunegonde, "but I have been so horribly unhappy in mine that my heart is nearly closed to hope." "You complain," said the old woman to them. "Alas! you have not endured such misfortunes as mine." Cunegonde almost laughed and thought it most amusing of the old woman to assert that she was more unfortunate. "Alas! my dear," said she, "unless you have been raped by two Bulgarians, stabbed twice in the belly, have had two castles destroyed, two fathers and mothers murdered before your eyes, and have seen two of your lovers flogged in an *auto-da-fé*, I do not see how you can surpass me; moreover, I was born a Baroness with seventy-two quarterings and I have been a kitchen wench." "You do not know my birth," said the old woman, "and if I showed you my backside you would not talk as you do and you would suspend your judgment." This speech aroused intense curiosity in the minds of Cunegonde and Candide. And the old woman spoke as follows.

XI

The old woman's story

"My eyes were not always bloodshot and red-rimmed; my nose did not always touch my chin and I was not always a servant. I am the daughter of Pope Urban X and the Princess of Palestrina. Until I was fourteen I was brought up in a palace to which all the castles of your German Barons would not have served as stables; and one of my dresses cost more than all the magnificence of Westphalia. I increased in beauty, in grace, in talents, among pleasures, respect and hopes; already I inspired love, my breasts were forming; and

what breasts! White, firm, carved like those of the Venus de´ Medici. And what eyes! What eyelids! What black eyebrows! What fire shone from my two eye-balls, and dimmed the glitter of the stars, as the local poets pointed out to me. The women who dressed and undressed me fell into ecstasy when they beheld me in front and behind; and all the men would have liked to be in their place. I was betrothed to a ruling prince of Massa-Carrara. What a prince! As beautiful as I was, formed of gentleness and charms, brilliantly witty and burning with love; I loved him with a first love, idolatrously and extravagantly. The marriage ceremonies were arranged with unheard-of pomp and magnificence; there were continual fêtes, revels and comic operas; all Italy wrote sonnets for me and not a good one among them. I reached the moment of my happiness when an old marchioness who had been my prince's mistress invited him to take chocolate with her; less than two hours afterwards he died in horrible convulsions; but that is only a trifle. My mother was in despair, though less distressed than I, and wished to absent herself for a time from a place so disastrous. She had a most beautiful estate near Gaeta; we embarked on a galley, gilded like the altar of St. Peter's at Rome. A Salle pirate swooped down and boarded us; our soldiers defended us like soldiers of the Pope; they threw down their arms, fell on their knees and asked the pirates for absolution in *articulo mortis*. They were immediately stripped as naked as monkeys and my mother, our ladies of honor and myself as well. The diligence with which these gentlemen strip people is truly admirable; but I was still more surprised by their inserting a finger in a place belonging to all of us where women usually only allow the end of a syringe. This appeared to me a very strange ceremony; but that is how we judge everything when we leave our own country. I soon learned that it was to find out if we had hidden any diamonds there; 'tis a custom established from time immemorial among the civilized nations who roam the seas.

"I have learned that the religious Knights of Malta never fail in it when they capture Turks and Turkish women; this is an international law which has never been broken. I will not tell you how hard it is for a young princess to be taken with her mother as a slave to Morocco; you will also guess all we had to endure in the pirates' ship. My mother was still very beautiful; our ladies of honor, even our waiting-maids possessed more charms than could be found in all Africa; and I was ravishing, I was beauty, grace itself, and I was a virgin; I did not remain so long; the flower which had been reserved for the handsome prince of Massa-Carrara was ravished from me by a pirate captain; he was an abominable Negro who thought he was doing me a great honor. The Princess of Palestrina and I must indeed have been strong to bear up against all we endured before our arrival in Morocco! But let that pass; these things are so common that they are not worth mentioning. Morocco was swimming in blood when we arrived. The fifty sons of the Emperor Muley Ismael had each a faction; and this produced fifty civil wars, of blacks against blacks, browns against browns, mulatoes against mulatoes. There was continual carnage throughout the whole extent of the empire. Scarcely had we landed when the blacks of a party hostile to that of my pirate arrived with the purpose of depriving him of his booty. After the diamonds and the gold, we were the most valuable possessions. I witnessed a fight such as is never seen in your European climates. The blood of the northern peoples is not sufficiently ardent; their madness for women does not reach the point which is common in Africa. The Europeans seem to have milk in their veins; but vitriol and fire flow in the veins of the inhabitants of Mount Atlas and the neighboring countries. They fought with the fury of the lions, tigers and serpents of the country to determine who

should have us. A Moor grasped my mother by the right arm, my captain's lieutenant held her by the left arm; a Moorish soldier held one leg and one of our pirates seized the other. In a moment nearly all our women were seized in the same way by four soldiers. My captain kept me hidden behind him; he had a scimitar in his hand and killed everybody who opposed his fury. I saw my mother and all our Italian women torn to pieces, gashed, massacred by the monsters who disputed them. The prisoners, my companions, those who had captured them, soldiers, sailors, blacks, browns, whites, mulatoes and finally my captain were all killed and I remained expiring on a heap of corpses. As everyone knows, such scenes go on in an area of more than three hundred square leagues and yet no one ever fails to recite the five daily prayers ordered by Mahomet. With great difficulty I extricated myself from the bloody heaps of corpses and dragged myself to the foot of a large orange-tree on the bank of a stream; there I fell down with terror, weariness, horror, despair and hunger. Soon afterwards, my exhausted senses fell into a sleep which was more like a swoon than repose. I was in this state of weakness and insensibility between life and death when I felt myself oppressed by something which moved on my body. I opened my eyes and saw a white man of good appearance who was sighing and muttering between his teeth: *O che sciagura d'essere senza coglioni!*

XII

Continuation of the old woman's misfortunes

"Amazed and delighted to hear my native language, and not less surprised at the words spoken by this man, I replied that there were greater misfortunes than that of which he complained. In a few words I informed him of the horrors I had undergone and then swooned again. He carried me to a neighboring house, had me put to bed, gave me food, waited on me, consoled me, flattered me, told me he had never seen anyone so beautiful as I, and that he had never so much regretted that which no one could give back to him. 'I was born at Naples,' he said, 'and every year they make two or three thousand children there into capons; some die of it, others acquire voices more beautiful than women's, and others become the governors of States. This operation was performed upon me with very great success and I was a musician in the chapel of the Princess of Palestrina.' 'Of my mother,' I exclaimed. 'Of your mother!' cried he, weeping 'What! Are you that young princess I brought up to the age of six and who even then gave promise of being as beautiful as you are?' 'I am! my mother is four hundred yards from here, cut into quarters under a heap of corpses . . .' I related all that had happened to me; he also told me his adventures and informed me how he had been sent to the King of Morocco by a Christian power to make a treaty with that monarch whereby he was supplied with powder, cannons and ships to help to exterminate the commerce of other Christians. 'My mission is accomplished,' said this honest eunuch, 'I am about to embark at Ceuta and I will take you back to Italy. *Ma che sciagura d'essere senza coglioni!*' I thanked him with tears of gratitude; and instead of taking me back to Italy he conducted me to Algiers and sold me to the Dey. I had scarcely been sold when the plague which had gone through Africa, Asia and Europe, broke out furiously in Algiers. You have seen earthquakes; but have you ever seen the plague?" "Never," replied the Baroness. "If you had," replied the old woman, "you would admit that it is much worse than an earthquake. It is very common in Africa; I caught it. Imagine the situation of a Pope's daughter age fifteen, who in three months had undergone poverty and slavery, had been raped nearly every day, had seen her mother

cut into four pieces, had undergone hunger and war, and was now dying of the plague in Algiers. However, I did not die; but my eunuch and the Dey and almost all the seraglio of Algiers perished. When the first ravages of this frightful plague were over, the Dey's slaves went sold. A merchant bought me and carried me to Tunis; he sold me to another merchant who resold me at Tripoli; from Tripoli I was resold to Alexandria, from Alexandria re-sold to Smyrna; from Smyrna to Constantinople. I was finally bought by an Aga of the Janizaries, who was soon ordered to defend Azov against the Russians who were besieging it. The Aga, who was a man of great gallantry, took his whole seraglio with him, and lodged us in a little fort on the Islands of Palus-Maeotis, guarded by two black eunuchs and twenty soldiers. He killed a prodigious number of Russians but they returned the compliment as well. Azov was given up to fire and blood, neither sex nor age was pardoned; only our little fort remained; and the enemy tried to reduce it by starving us. The twenty Janizaries had sworn never to surrender us. The extremities of hunger to which they were reduced forced them to eat our two eunuchs for fear of breaking their oath. Some days later they resolved to eat the women. We had with us a most pious and compassionate Imam who delivered a fine sermon to them by which he persuaded them not to kill us altogether. 'Cut,' said he, 'only one buttock from each of these ladies and you will have an excellent meal; if you have to return, there will still be as much left in a few days; Heaven will be pleased at so charitable action and you will be saved.' He was very eloquent and persuaded them. This horrible operation was performed upon us; the Imam anointed us with the same balm that is used for children who have just been circumcised; we were all at the point of death. Scarcely had the Janizaries finished the meal we had supplied when the Russians arrived in flat-bottomed boats; not a Janizary escaped. The Russians paid no attention to the state we were in. There are French doctors everywhere; one of them who was very skillful, took care of us; he healed us and I shall remember all my life that, when my wounds were cured, he made propositions to me. For the rest, he told us all to cheer up; he told us that the same thing had happened in several sieges and that it was a law of war. As soon as my companions could walk they were sent to Moscow. I fell to the lot of a Boyar who made me his gardener and gave me twenty lashes a day. But at the end of two years the lord was broken on the wheel with thirty other Boyars owing to some court disturbance, and I profited by this adventure; I fled; I crossed all Russia; for a long time I was servant in an inn at Riga, then at Rostock, at Wismar, at Leipzig, at Cassel, at Utrecht, at Leyden, at the Hague, at Rotterdam; I have grown old in misery and in shame, with only half a backside, always remembering that I was the daughter of a Pope; a hundred times I wanted to kill myself but I still loved life. This ridiculous weakness is perhaps the most disastrous of our inclinations; for is there anything sillier than to desire to bear continually a burden one always wishes to throw on the ground; to look upon oneself with horror and yet to cling to oneself; in short, to caress the serpent which devours us until he has eaten our heart? In the countries it has been my fate to traverse and in the inns where I have served I have seen a prodigious number of people who hated their lives; but I have only seen twelve who voluntarily put an end to their misery: three Negroes, four Englishmen, four Genevans and a German professor named Robeck. I ended up as servant to the Jew, Don Issachar; he placed me in your service, my fair young lady; I attached myself to your fate and have been more occupied with your adventures than with my own. I should never even have spoken of my misfortunes, if you had not piqued me a little and if it had not been the custom on board ship to tell stories to pass the time. In short, Mademoiselle, I have had experience, I know the world; provide yourself with an entertainment, make each passenger tell you his story; and if there is one who has not often cursed his life, who has not often said to himself that he was the most unfortunate of men, throw me headfirst into the sea."

XIII

How Candide was obliged to separate from the fair Cunegonde and the old woman

The fair Cunegonde, having heard the old woman's story, treated her with all the politeness due to a person of her rank and merit. She accepted the proposition and persuaded all the passengers one after the other to tell her their adventures. She and Candide admitted that the old woman was right. "It was most unfortunate," said Candide, "that the wise Pangloss was hanged contrary to custom at an *auto-da-fé*, he would have said admirable things about the physical and moral evils which cover the earth and the sea, and I should feel myself strong enough to urge a few objections with all due respect." While each of the passengers was telling his story the ship proceeded on its way. They arrived at Buenos Ayres. Cunegonde, Captain Candide and the old woman went to call on the governor, Don Fernando d'Ibaraa y Figueora y Mascarenes y Lampourdos y Souza. This gentleman had the pride befitting a man who owned so many names. He talked to men with a most noble disdain, turning his nose up so far, raising his voice so pitilessly, assuming so imposing a tone, affecting so lofty a carriage, that all who addressed him were tempted to give him a thrashing. He had a furious passion for women. Cunegonde seemed to him the most beautiful woman he had ever seen. The first thing he did was to ask if she were the Captain's wife. The air with which he asked this question alarmed Candide; he did not dare say that she was his wife, because as a matter of fact she was not; he dared not say she was his sister, because she was not that either; and though this official lie was formerly extremely fashionable among the ancients, and might be useful to the moderns, his soul was too pure to depart from truth. "Mademoiselle Cunegonde," said he, "is about to do me the honor of marrying me, and we beg your excellency to be present at the wedding." Don Fernando d'Ibaraa y Figuerora y Mascarenes y Lampourdos y Souza twisted his moustache, smiled bitterly and ordered Captain Candide to go and inspect his company. Candide obeyed; the governor remained with Mademoiselle Cunegonde. He declared his passion, vowed that the next day he would marry her publicly, or otherwise, as it might please her charms. Cunegonde asked for a quarter of an hour to collect herself, to consult the old woman and to make up her mind. The old woman said to Cunegonde: "You have seventy-two quarterings and you haven't a shilling; it is in your power to be the wife of the greatest Lord in South America, who has an exceedingly fine moustache; is it for you to pride yourself on a rigid fidelity? You have been raped by Bulgarians, a Jew and an Inquisitor have enjoyed your good graces; misfortunes confer certain rights. If I were in your place, I confess I should not have the least scruple in marrying the governor and making Captain Candide's fortune." While the old woman was speaking with all that prudence which comes from age and experience, they saw a small ship come into the harbor; an Alcayde and some Alguazils were on board, and this is what had happened. The old woman had guessed correctly that it was a long-sleeved monk who stole Cunegonde's money and jewels at Badajoz, when she was flying in all haste with Candide. The monk tried to sell some of the gems to a jeweler. The merchant

recognized them as the property of the Grand Inquisitor. Before the monk was hanged he confessed that he had stolen them; he described the persons and the direction they were taking. The flight of Cunegonde and Candide was already known. They were followed to Cadiz; without any waste of time a vessel was sent in pursuit of them. The vessel was already in the harbor at Buenos Ayres. The rumor spread that an Alcayde was about to land and that he was in pursuit of the murderers of His Lordship the Grand Inquisitor. The prudent old woman saw in a moment what was about to be done. "You cannot escape," she said to Cunegonde, "and you have nothing to fear; you did not kill His Lordship; moreover, the governor is in love with you and will not allow you to be maltreated; stay here." She ran to Candide at once. "Fly," said she, "or in an hour's time you will be burned." There was not a moment to lose; but how could he leave Cunegonde and where could he take refuge?

By the beginning of Chapter 26, where our second selection opens, Candide has lost both Cunegonde and his personal servant Cacambo but gained Martin, his pessimistic friend. After his reunion with Cacambo and their extraordinary experience at the inn he sets out for Constantinople and Cunegonde, while Voltaire begins to pull the threads of his narrative together. Both Dr. Pangloss and Cunegonde's brother turn up yet again, the doctor still refusing to budge from his philosophical position. The lovers' meeting in Chapter 29 is handled with typical cynicism, while the last chapter reassesses the views on life we have heard. It ends with Candide's resigned but by no means hopeless conclusion.

XXVI

How Candide and Martin supped with six strangers and who they were

One evening when Candide and Martin were going to sit down to table with the strangers who lodged in the same hotel, a man with a face the color of soot came up to him from behind and, taking him by the arm, said: "Get ready to come with us, and do not fail." He turned round and saw Cacambo. Only the sight of Cunegonde could have surprised and pleased him more. He was almost wild with joy. He embraced his dear friend. "Cunegonde is here, of course? Where is she? Take me to her, let me die of joy with her." "Cunegonde is not here," said Cacambo. "She is in Constantinople." "Heavens! In Constantinople! But were she in China, I would y to her; let us start at once." "We will start after supper," replied Cacambo. "I cannot tell you any more; I am a slave, and my master is waiting for me; I must go and serve him at table! Do not say anything; eat your supper and be in readiness." Candide, torn between joy and grief, charmed to see his faithful agent again, amazed to see him a slave, filled with the idea of seeing his mistress again, with turmoil in his heart, agitation in his mind, sat down to table with Martin (who met every strange occurrence with the same calmness), and with six strangers, who had come to spend the Carnival at Venice. Cacambo, who acted as butler to one of the strangers, bent down to his master's head towards the end of the meal and said: "Sire, your Majesty can leave when you wish, the ship is ready." After saying this, Cacambo withdrew. The guests looked at each other with surprise without saying a word, when another servant came up to his master and said: "Sire, your Majesty's post-chaise is at Padua, and the boat is ready." The master made a sign and the servant departed. Once more all the guests looked at each other, and the general surprise doubled. A third servant went up to the third stranger and said: "Sire, believe me, your Majesty cannot remain here any longer; I will prepare everything." And he immediately disappeared. Candide and Martin had no doubt that this was a Carnival masquerade. A fourth servant said to the fourth master: "Your Majesty can leave when you wish." And he went out like the others. The fifth servant spoke similarly to the fifth master. But the sixth servant spoke differently to the sixth stranger who was next to Candide, and said: "Faith, sire, they will not give your Majesty any more credit nor me either, and we may very likely be jailed to-night, both of us; I am going to look to my own affairs, good-bye." When the servants had all gone, the six strangers, Candide and Martin remained in profound silence. At last it was broken by Candide. "Gentlemen," said he, "this is a curious jest. How is it you are all kings? I confess that neither Martin nor I are kings." Cacambo's master then gravely spoke and said in Italian: "I am not jesting, my name is Achmet III. For several years I was Sultan; I dethroned my brother; my nephew dethroned me; they cut off the heads of my viziers; I am ending my days in the old seraglio; my nephew, Sultan Mahmoud, sometimes allows me to travel for my health, and I have come to spend the Carnival at Venice." A young man who sat next to Achmet spoke after him and said: "My name is Ivan; I was Emperor of all the Russias; I was dethroned in my cradle; my father and mother were imprisoned and I was brought up in prison; I sometimes have permission to travel, accompanied by those who guard me, and I have come to spend the Carnival at Venice." The third said: "I am Charles Edward, King of England; my father gave up his rights to the throne to me and I fought a war to assert them; the hearts of eight hundred of my adherents were torn out and dashed in their faces. I have been in prison; I am going to Rome to visit the King, my father, who is dethroned like my grandfather and me; and I have come to spend the Carnival at Venice." The fourth then spoke and said: "I am the King of Poland; the chance of war deprived me of my hereditary states; my father endured the same reverse of fortune; I am resigned to Providence like the Sultan Achmet, the Emperor Ivan and King Charles Edward, to whom God grant long life; and I have come to spend the Carnival at Venice." The fifth said: "I also am the King of Poland: I have lost my kingdom twice; but Providence has given me another state in which I have been able to do more good than all the kings of the Sarmatians together have been ever able to do on the banks of the Vistula; I also am resigned to Providence and I have come to spend the Carnival at Venice." It was now for the sixth monarch to speak. "Gentlemen," said he, "I am not so eminent as you; but I have been a king like anyone else. I am Theodore; I was elected King of Corsica; I have been called Your Majesty and now I am barely called Sir. I have coined money and do not own a farthing; I have had two Secretaries of State and now have scarcely a valet; I have occupied a throne and for a long time lay on straw in a London prison. I am much afraid I shall be treated in the same way here, although I have come, like your Majesties, to spend the Carnival at Venice." The five other kings listened to this speech with a noble compassion. Each of them gave King Theodore twenty sequins to buy clothes and shirts; Candide presented him with a diamond worth two thousand sequins. "Who is this man," said the five kings, "who is able to give a hundred times as much as any of us, and who gives it?" As they were leaving the table, there came to the same hotel four serene highnesses who had also lost their states in the chance of war, and who had come to spend the rest of the Carnival at Venice; but Candide did not even notice these newcomers. He could think of nothing but of going to Constantinople to find his dear Cunegonde.

XXVII

Candide's voyage to Constantinople

The faithful Cacambo had already spoken to the Turkish captain who was to take Sultan Achmet back to Constantinople and had obtained permission for Candide and Mar-

tin to come on board. They both entered this ship after having prostrated themselves before his miserable Highness. On the way, Candide said to Martin: "So we have just supped with six dethroned kings! And among those six kings there was one to whom I gave charity. Perhaps there are many other princes still more unfortunate. Now, I have only lost a hundred sheep and I am hastening to Cunegonde's arms. My dear Martin, once more, Pangloss was right, all is well." "I hope so," said Martin. "But," said Candide, "this is a very singular experience we have just had at Venice. Nobody has ever seen or heard of six dethroned kings supping together in a tavern." "'Tis no more extraordinary," said Martin, "than most of the things which have happened to us. It is very common for kings to be dethroned; and as to the honor we have had of supping with them, 'tis a trifle not deserving our attention." Scarcely had Candide entered the ship when he threw his arms round the neck of the old valet, of his friend Cacambo. "Well!" said he, "what is Cunegonde doing? Is she still a marvel of beauty? Does she still love me? How is she? Of course you have bought her a palace in Constantinople?" "My dear master," replied Cacambo, "Cunegonde is washing dishes on the banks of Propontis for a prince who possesses very few dishes; she is a slave in the house of a former sovereign named Ragotsky, who receives in his refuge three crowns a day from the Grand Turk; but what is even sadder is that she has lost her beauty and has become horribly ugly." "Ah! beautiful or ugly," said Candide, "I am a man of honor and my duty is to love her always. But how can she be reduced to so abject a condition with the five or six millions you carried off?" "Ah!" said Cacambo, "did I not have to give two millions to Senor Don Fernando d'Ibaraa y Figueora y Mascarenes y Lampourdos y Souza, Governor of Buenos Ayres, for permission to bring away Mademoiselle Cunegonde? And did not a pirate bravely strip us of all the rest? And did not this pirate take us to Cape Matapan, to Milo, to Nicaria, to Samos, to Petra, to the Dardanelles, to Marmora, to Scutari? Cunegonde and the old woman are servants to the prince I mentioned, and I am slave to the dethroned Sultan." "What a chain of terrible calamities!" said Candide. "But after all, I still have a few diamonds; I shall easily deliver Cunegonde. What a pity she has become so ugly." Then turning to Martin, he said: "Who do you think is the most to be pitied, the Sultan Achmet, the Emperor Ivan, King Charles Edward, or me?" "I do not know at all," said Martin. "I should have to be in your hearts to know." "Ah!" said Candide, "if Pangloss were here he would know and would tell us." "I do not know," said Martin, "what scales your Pangloss would use to weigh the misfortunes of men and to estimate their sufferings. All I presume is that there are millions of men on the earth a hundred times more to be pitied than King Charles Edward, the Emperor Ivan and the Sultan Achmet." "That may very well be," said Candide. In a few days they reached the Black Sea channel. Candide began by paying a high ransom for Cacambo and, without wasting time, he went on board a galley with his companions bound for the shores of Propontis, in order to find Cunegonde however ugly she might be. Among the galley slaves were two convicts who rowed very badly and from time to time the Levantine captain applied several strokes of a bull's pizzle to their naked shoulders. From a natural feeling of pity Candide watched them more attentively than the other galley slaves and went up to them. Some features of their disfigured faces appeared to him to have some resemblance to Pangloss and the wretched Jesuit, the Baron, Mademoiselle Cunegonde's brother. This idea disturbed and saddened him. He looked at them still more carefully. "Truly," said he to Cacambo, "if I had not seen Doctor Pangloss hanged, and if I had not been so unfortunate as to kill the Baron, I should think they were rowing in this galley." At the words Baron and Pan-

gloss, the two convicts gave a loud cry, stopped on their seats and dropped their oars. The Levantine captain ran up to them and the lashes with the bull's pizzle were redoubled. "Stop! Stop, sir!" cried Candide. "I will give you as much money as you want." "What! Is it Candide?" said one of the convicts. "What! Is it Candide?" said the other. "Is it a dream?" said Candide. "Am I awake? Am I in this galley? Is that my Lord the Baron whom I killed? Is that Doctor Pangloss whom I saw hanged?" "It is, it is," they replied. "What! Is that the great philosopher?" said Martin. "Ah! sir," said Candide to the Levantine captain, "how much money do you want for My Lord Thunder-ten-tronckh, one of the first Barons of the empire, and for Dr. Pangloss, the most profound metaphysician of Germany?" "Dog of a Christian," replied the Levantine captain, "since these two dogs of Christian convicts are Barons and metaphysicians, which no doubt is a high rank in their country, you shall pay me fifty thousand sequins." "You shall have them, sir. Row back to Constantinople like lightning and you shall be paid at once. But, no, take me to Mademoiselle Cunegonde." The captain, at Candide's first offer had already turned the bow towards the town, and rowed there more swiftly than a bird cleaves the air. Candide embraced the Baron and Pangloss a hundred times. "How was it I did not kill you, my dear Baron? And, my dear Pangloss, how do you happen to be alive after having been hanged? And why are you both in a Turkish galley?" "Is it really true that my dear sister is in this country?" said the Baron. "Yes," replied Cacambo. "So once more I see my dear Candide!" cried Pangloss. Candide introduced Martin and Cacambo. They all embraced and all talked at the same time. The galley flew; already they were in the harbor. They sent for a Jew, and Candide sold him for fifty thousand sequins a diamond worth a hundred thousand, for which he swore by Abraham he could not give any more. The ransom of the Baron and Pangloss was immediately paid. Pangloss threw himself at the feet of his liberator and bathed them with tears; the other thanked him with a nod and promised to repay the money at the first opportunity. "But is it possible that my sister is in Turkey?" said he. "Nothing is so possible," replied Cacambo, "since she washes the dishes of a prince of Transylvania." They immediately sent for two Jews: Candide sold some more diamonds; and they all set out in another galley to rescue Cunegonde.

XXVIII

What happened to Candide, to Cunegonde, to Pangloss, to Martin, etc.

"Pardon once more," said Candide to the Baron, "pardon me, reverend father, for having thrust my sword through your body." "Let us say no more about it," said the Baron. "I admit I was a little too sharp; but since you wish to know how it was you saw me in a galley, I must tell you that after my wound was healed by the brother apothecary of the college, I was attacked and carried off by a Spanish raiding party; I was imprisoned in Buenos Ayres at the time when my sister had just left. I asked to return to the Vicar-General in Rome. I was ordered to Constantinople to act as almoner to the Ambassador of France. A week after I had taken up my office I met towards evening a very handsome young page of the Sultan. It was very hot; the young man wished to bathe; I took the opportunity to bathe also. I did not know that it was a most serious crime for a Christian to be found naked with a young Mahometan. A cadi sentenced me to a hundred strokes on the soles of my feet and condemned me to the galley. I do not think a more horrible injustice has ever been committed. But I should very much like to know why my sister is in the kitchen of a Transylvanian sovereign living in exile among the Turks." "But, my dear Pangloss," said

Candide, "how does it happen that I see you once more?" "It is true," said Pangloss, "that you saw me hanged; and in the natural course of events I should have been burned. But you remember, it poured with rain when they were going to roast me; the storm was so violent that they despaired of lighting the fire; I was hanged because they could do nothing better; a surgeon bought my body, carried me home and dissected me. He first made a crucial incision in me from the navel to the collarbone. Nobody could have been worse hanged than I was. The executioner of the holy Inquisition, who was a sub-deacon, was marvelously skillful in burning people, but he was not used to hanging them; the rope was wet and did not slide easily and it was knotted; in short, I still breathed. The crucial incision caused me to utter so loud a scream that the surgeon fell over backwards and, thinking he was dissecting the devil, fled away in terror and fell down the staircase in his flight. His wife ran in from another room at the noise; she saw me stretched out on the table with my crucial incision; she was still more frightened than her husband, fled, and fell on top of him. When they had recovered a little, I heard the surgeon's wife say to the surgeon: 'My dear, what were you thinking of, to dissect a heretic? Don't you know the devil always possesses them? I will go and get a priest at once to exorcise him.' At this I shuddered and collected the little strength I had left to shout: 'Have pity on me!' At last the Portuguese barber grew bolder; he sewed up my skin; his wife even took care of me, and at the end of a fortnight I was able to walk again. The barber found me a situation and made me lackey to a Knight of Malta who was going to Venice; but, as my master had no money to pay me wages, I entered the service of a Venetian merchant and followed him to Constantinople. One day I took it into my head to enter a mosque: there was nobody there except an old Imam and a very pretty young devotee who was reciting her prayers; her breasts were entirely uncovered; between them she wore a bunch of tulips, roses, anemones, ranunculus, hyacinths and auriculas; she dropped her bunch of flowers; I picked it up and returned it to her with a most respectful alacrity. I was so long putting them back that the Imam grew angry and, seeing I was a Christian, called for help. I was taken to the cadi, who sentenced me to receive a hundred strokes on the soles of my feet and sent me to the galleys. I was chained on the same seat and in the same galley as My Lord the Baron. In this galley there were four young men from Marseilles, five Neapolitan priests and two monks from Corfu, who assured us that similar accidents occurred every day. His Lordship the Baron claimed that he had suffered a greater injustice than I; and I claimed that it was much more permissible to replace a bunch of flowers between a woman's breasts than to be naked with one of the Sultan's pages. We argued continually, and every day received twenty strokes of the bull's pizzle, when the chain of events of this universe led you to our galley and you ransomed us." "Well! my dear Pangloss," said Candide, "when you were hanged, dissected, stunned with blows and made to row in the galleys, did you always think that everything was for the best in this world?" "I am still of my first opinion," replied Pangloss, "for after all I am a philosopher; and it would be unbecoming for me to recant, since Leibnitz could not be in the wrong and preestablished harmony is the finest thing imaginable like the plenum and subtle matter."

XXIX

How Candide found Cunegonde and the old woman again

While Candide, the Baron, Pangloss, Martin and Cacambo were relating their adventures, reasoning upon contingent or noncontingent events of the universe, arguing about effects and causes, moral and physical evil, free will and necessity, and the consolations to be found in the Turkish galleys, they came to the house of the Transylvanian prince on the shores of Propontis. The first objects which met their sight were Cunegonde and the old woman hanging out towels to dry on the line. At this sight the Baron grew pale. Candide, that tender lover, seeing his fair Cunegonde sunburned, blear-eyed, flat-breasted, with wrinkles round her eyes and red, chapped arms, recoiled three paces in horror, and then advanced from mere politeness. She embraced Candide and her brother. They embraced the old woman; Candide bought them both. In the neighborhood was a little farm; the old woman suggested that Candide should buy it, until some better fate befell the group. Cunegonde did not know that she had become ugly, for nobody had told her so; she reminded Candide of his promises in so peremptory a tone that the good Candide dared not refuse her. He therefore informed the Baron that he was about to marry his sister. "Never," said the Baron, "will I endure such baseness on her part and such insolence on yours; nobody shall ever reproach me with this infamy; my sister's children could never enter the noble assemblies of Germany. No, my sister shall never marry anyone but a Baron of the Empire." Cunegonde threw herself at his feet and bathed him in tears; but he was inflexible. "Madman," said Candide, "I rescued you from the galleys, I paid your ransom and your sister's; she was washing dishes here, she is ugly, I am so kind as to make her my wife, and you pretend to oppose me! I should kill you again if I listened to my anger." "You may kill me again," said the Baron, "but you shall never marry my sister while I am alive."

XXX

Conclusion

At the bottom of his heart Candide had not the least wish to marry Cunegonde. But the Baron's extreme impertinence determined him to complete the marriage, and Cunegonde urged it so warmly that he could not retract. He consulted Pangloss, Martin and the faithful Cacambo. Pangloss wrote an excellent memorandum by which he proved that the Baron had no rights over his sister and that by all the laws of the empire she could make a left-handed marriage with Candide. Martin advised that the Baron should be thrown into the sea; Cacambo decided that he should be returned to the Levantine captain and sent back to the galleys, after which he could be returned by the first ship to the Vicar-General at Rome. This was thought to be very good advice; the old woman approved it; they said nothing to the sister; the plan was carried out with the aid of a little money and they had the pleasure of duping a Jesuit and punishing the pride of a German Baron.

It would be natural to suppose that when, after so many disasters, Candide was married to his mistress, and living with the philosopher Pangloss, the philosopher Martin, the prudent Cacambo and the old woman, having brought back so many diamonds from the country of the ancient Incas, he would lead the most pleasant life imaginable. But he was so cheated by the Jews that he had nothing left but his little farm; his wife, growing uglier every day, became shrewish and unendurable; the old woman was ailing and even more bad-tempered than Cunegonde. Cacambo, who worked in the garden and then went to Constantinople to sell vegetables, was overworked and cursed his fate. Pangloss was in despair because he did not shine in some German university. As for Martin, he was firmly convinced that people are

equally uncomfortable everywhere; he accepted things patiently. Candide, Martin and Pangloss sometimes argued about metaphysics and morals. From the windows of the farm they often watched the ships going by, filled with effendis, pashas, and cadis, who were being exiled to Lemnos, to Mitylene and Erzerum. They saw other cadis, other pashas and other effendis coming back to take the place of the exiles and to be exiled in their turn. They saw the neatly impaled heads which were taken to the Sublime Porte. These sights redoubled their discussions; and when they were not arguing, the boredom was so excessive that one day the old woman dared to say to them: "I should like to know which is worse, to be raped a hundred times by Negro pirates, to have a buttock cut off, to run the gauntlet among the Bulgarians, to be whipped and flogged in an *auto-da-fé*, to be dissected, to row in a galley, in short, to endure all the miseries through which we have passed, or to remain here doing nothing?" "'Tis a great question," said Candide.

These remarks led to new reflections, and Martin especially concluded that man was born to live in the convulsions of distress or in the lethargy of boredom. Candide did not agree, but he asserted nothing. Pangloss confessed that he had always suffered horribly; but, having once maintained that everything was for the best, he had continued to maintain it without believing it.

One thing confirmed Martin in his detestable principles, made Candide hesitate more than ever, and embarrassed Pangloss. And it was this. One day there came to their farm Paquette and Friar Giroflée, who were in the most extreme misery; they had soon wasted their three thousand piastres, had left each other, made up, quarreled again, been put in prison, escaped, and finally Friar Giroflée had turned Turk. Paquette continued her occupation everywhere and now earned nothing by it. "I foresaw," said Martin to Candide, "that your gifts would soon be wasted and would only make them the more miserable. You and Cacambo were once bloated with millions of piastres and you are no happier than Friar Giroflée and Paquette." "Ah! Ha!" said Pangloss to Paquette, "so Heaven brings you back to us, my dear child? Do you know that you cost me the end of my nose, an eye and an ear! What a plight you are in! Ah! What a world this is!" This new occurrence caused them to philosophize more than ever.

In the neighborhood there lived a very famous Dervish, who was supposed to be the best philosopher in Turkey; they went to consult him; Pangloss was the spokesman and said: "Master, we have come to beg you to tell us why so strange an animal as man was ever created." "What has it to do with you?" said the Dervish, "Is it your business?" "But, reverend father," said Candide, "there is a horrible amount of evil in the world." "What does it matter," said the Dervish, "whether there is evil or good? When his highness sends a ship to Egypt, does he worry about the comfort or discomfort of the rats in the ship?" "Then what should we do?" said Pangloss. "Hold your tongue," said the Dervish. "I flattered myself." said Pangloss, "that I should discuss with you effects and causes, this best of all possible worlds, the origin of evil, the nature of the soul and preestablished harmony." At these words the Dervish slammed the door in their faces.

During this conversation the news went round that at Constantinople two viziers and the mufti had been strangled and several of their friends impaled. This catastrophe made a prodigious noise everywhere for several hours. As Pangloss, Candide and Martin were returning to their little farm, they came upon an old man who was taking the air under a bower of orange-trees at his door. Pangloss, who was as curious as he was argumentative, asked him what

was the name of the mufti who had just been strangled. "I do not know," replied the old man. "I have never known the name of any mufti or of any vizier. I am entirely ignorant of the occurrence you mention; I presume that in general those who meddle with public affairs sometimes perish miserably and that they deserve it; but I never inquire what is going on in Constantinople; I content myself with sending there for sale the produce of the garden I cultivate." Having spoken thus, he took the strangers into his house. His two daughters and his two sons presented them with several kinds of sherbet which they made themselves, caymac flavored with candied citron peel, oranges, lemons, limes, pineapples, dates, pistachios and Mocha coffee which had not been mixed with the bad coffee of Batavia and the Isles. After which this good Mussulman's two daughters perfumed the beards of Candide, Pangloss and Martin. "You must have a vast and magnificent estate?" said Candide to the Turk. "I have only twenty acres," replied the Turk. "I cultivate them with my children; and work keeps at bay three great evils: boredom, vice and need."

As Candide returned to his farm he reflected deeply on the Turk's remarks. He said to Pangloss and Martin: "That good old man seems to me to have chosen an existence preferable by far to that of the six kings with whom we had the honor to sup." "Exalted rank," said Pangloss, "is very dangerous, according to the testimony of all philosophers; for Eglon, King of the Moabites, was murdered by Ehud; Absolom was hanged by the hair and pierced by three darts; King Nadab, son of Jeroboam, was killed by Baasha; King Elah by Zimri; Ahaziah by Jehu; Athaliah by Jehoiada; the Kings Jehoiakim, Jeconiah and Zedekiah were made slaves. You know in what manner died Croesus, Astyages, Darius, Denys of Syracuse, Pyrrhus, Perseus, Hannibal, Jugurtha, Ariovistus, Caesar, Pompey, Nero, Otho, Vitellius, Domitian, Richard II of England, Edward II, Henry VI, Richard III, Mary Stuart, Charles I, the three Henrys of France, the Emperor Henry IV. You know . . ." "I also know," said Candide, "that we should cultivate our garden." "You are right," said Pangloss, "for, when man was placed in the Garden of Eden, he was placed there *ut operaretur eum*, to dress it and to keep it; which proves that man was not born for idleness." "Let us work without theorizing," said Martin, "'tis the only way to make life endurable."

The whole small fraternity entered into this praiseworthy plan, and each started to make use of his talents. The little farm yielded well. Cunegonde was indeed very ugly, but she became an excellent pastry-cook; Paquette embroidered; the old woman took care of the linen. Even Friar Giroflée performed some service; he was a very good carpenter and even became a man of honor; and Pangloss sometimes said to Candide: "All events are linked up in this best of all possible worlds; for, if you had not been expelled from a noble castle, by hard kicks in your backside for love of Mademoiselle Cunegonde, if you had not been clapped into the Inquisition, if you had not wandered about America on foot, if you had not stuck your sword in the Baron, if you had not lost all your sheep from the land of Eldorado, you would not be eating candied citrons and pistachios here." "That's well said," replied Candide, "but we must cultivate our garden."

From *Candide and Other Writings* by Voltaire, edited by Haskell M. Block, copyright © 1956 and renewed 1984 by Random House, Inc. Used by permission of Random House, Inc.

	GENERAL EVENTS	LITERATURE & PHILOSOPHY	ART
1765		**1773** Goethe leads *Sturm und Drang* movement against Neo–Classicism **1774** Goethe, *The Sorrows of Young Werther*	**c.1774** Copley leaves Boston to study in England **1784–1785** David, *Oath of the Horatii*
1789 REVOLUTIONARY AND NAPOLEONIC WARS	**1789** French Revolution begins **1793–1795** Reign of Terror in France **1799–1804** Napoleon rules France as consul **1804–1814** Napoleon rules France as emperor **1812** Failure of Napoleon's Russian campaign **1814** Napoleon exiled to Elba; Stephenson's first locomotive **1814–1815** Congress of Vienna	**1790** Kant, *Critique of Judgment*, expounding Transcendental Idealism **1794** Blake, "London" **1798** Wordsworth, "Tintern Abbey" **1807–1830** Philosophy of Hegel published in Germany **1808** Goethe's *Faust*, Part I	**1799** David, *The Battle of the Romans and the Sabines*. Goya becomes court painter to Charles IV of Spain; *The Family of Charles IV* (1800) **19th cent.** Romantic emphasis on emotion, nature, exotic images, faraway lands **1814** Goya, *Execution of the Madrileños on May 3, 1808*, a retreat from idealism in art
1815 GROWTH OF INDUSTRIALIZATION	**1815** Napoleon escapes Elba; defeated at Battle of Waterloo **1815–1850** Industrialization of England **1816** Wreck of French vessel *Medusa* **1821** Death of Napoleon **1821–1829** Greek War of Independence against Turks **1830–1860** Industrialization of France and Belgium **1837–1901** Reign of Queen Victoria in England **1840–1870** Industrialization of Germany	**1819** Schopenhauer, *The World as Will and Idea*; Keats, *Ode to a Nightingale* **c. 1820** English romantic peak **1820** Shelley, *Prometheus Unbound* **1821** Byron, *Don Juan* **1824** Byron dies in Greece **1829–1847** Balzac, *The Human Comedy*, 90 realistic novels **1832** Goethe, *Faust*, Part II **1836–1860** Transcendentalist movement in New England **1837–1838** Dickens, *Oliver Twist* **1840** Poe, *Tales of the Grotesque* **1846** Sand, *Lucrezia Floriani* **1847** E. Brontë, *Wuthering Heights*	**1818–1819** Géricault, *Raft of the Medusa*, first exhibited 1819 **1820–1822** Goya paints nightmare scenes on walls of his house; *Saturn Devouring One of His Sons* **1824** Delacroix, *Massacre at Chios* **1826** Delacroix, *The Death of Sardanapalus* **c. 1830** Social realism follows romanticism; Daumier, *The Legislative Belly* (1834) **1836** Constable, *Stoke-by-Nayland* **1844** Turner, *Rain, Steam, and Speed* **c. 1847** Development of national styles. American artists influenced by Transcendentalism; Cole, *Genesee Scenery* (1847)
1848 AGE OF NATIONALISM	**1848** Revolutionary uprisings throughout Europe **1860–1870** Unification of Italy **1861–1865** American Civil War **1866–1871** Unified Germany **1867** Canada granted dominion status; British Factory Act gives workers Saturday afternoons off **1869** First transcontinental railroad completed in America	**1848** Marx, *Communist Manifesto* **1851** Melville, *Moby Dick* **1854** Thoreau, *Walden* **1855** First edition of Whitman's *Leaves of Grass* **1856–1857** Flaubert, *Madame Bovary* **1859** Darwin publishes theory of evolution, *On the Origin of Species by Means of Natural Selection* **1862** Hugo, *Les Misérables* **1863–1869** Tolstoy, *War and Peace*	**1855** Courbet, *The Studio: A Real Allegory of the Last Seven Years of My Life* **c. 1860** American luminist painting develops; Heade, *Lake George* (1862)
1870	**1876** Bell patents the telephone **1888** Pasteur Institute founded in Paris	**1873–1877** Tolstoy, *Anna Karenina* **1890** Dickinson's poems first published, four years after her death	**1870** Homer, *Eaglehead, Manchester, Massachusetts* **1870** Corot, *Ville d'Avray* **c. 1880** Eakins uses photography and scientific techniques in search for realism; *The Swimming Hole* (1885)
1900			

Most dates are approximate

THE ROMANTIC ERA

ARCHITECTURE	MUSIC

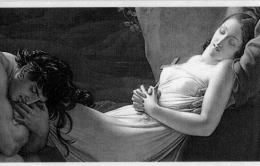

1788 Mozart composes last three symphonies

1785–1796 Jefferson, State Capitol, Richmond, Virginia

1795 Debut of Beethoven as pianist

Development from classical to romantic music most evident in work of Beethoven; *Pathetique Sonata* (1799)

1804 First performance of Beethoven's *Eroica Symphony,* originally meant to honor Napoleon

1808 Girodet-Trioson, *The Entombment of Atala,* inspired by Chateaubriand's romantic novel *Atala*

1810 Friedrich, *Cloister Graveyard in the Snow*

1811 Ingres, *Jupiter and Thetis*

1814 Beethoven's opera *Fidelio* performed

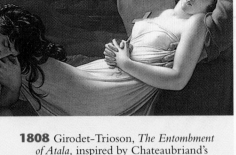

19th cent. Sequence of revival styles: neoclassical, neo-Gothic, neo-Renaissance; forms affected by growth of industry and technology

c. 1815–1828 Schubert creates genre of art song *(lied),* setting to music poetry of Goethe, Schiller, others
1822 Schubert, "Unfinished" *Symphony*
1824 First performance of Beethoven's *Symphony No. 9;* finale is choral version of Schiller's "Ode to Joy"
1830 Berlioz, *Fantastic Symphony*
1831 Bellini's *bel canto* opera *Norma* performed
1835 Donizetti, *Lucia di Lammermoor*
c. 1835–c. 1845 Virtuoso performance at peak; brilliant composer-performers create works of immense technical difficulty: Chopin, *Piano Sonata in b minor,* Op. 35 (1839)
1839 Chopin completes *Twenty-Four Preludes,* Op. 28
1842 Verdi's *Nabucco* performed; symbolic of Italians' suffering under Austrian rule

1836 Barry and Pugin begin neo-Gothic Houses of Parliament, London

1846 Berlioz, *The Damnation of Faust*

1851–1874 Wagner, *The Ring of the Nibelung;* first staged at new Bayreuth opera house 1876

1853 First performances of Verdi's *Il Trovatore* and *La Traviata,* the latter based on Dumas' novel *The Lady of the Camelias*

1865 Wagner experiments with harmony in *Tristan and Isolde*

1861–1875 Garnier, Opéra, Paris

1865 Reynaud, Gare du Nord, Paris

1874 First production of Moussorgsky's opera *Boris Godunov* in St. Petersburg
1876 Brahms, *Symphony No. 1 in c minor*
1882 Wagner, *Parsifal*
1887 Verdi, *Otello;* Bruckner begins *Symphony No. 8 in c minor*

CHAPTER 17

THE ROMANTIC ERA

THE CONCERNS OF ROMANTICISM

The tide of revolution that swept away much of the old political order in Europe and America in the last quarter of the eighteenth century had momentous consequences for the arts. Both the American and the French revolutions had in fact used art as a means of expressing their spiritual rejection of the aristocratic society against which they were physically rebelling, and both had adopted the Neo-Classical style to do so. Jacques-Louis David's images of stern Roman virtue (see Figure 16.1) and Jefferson's evocation of the simple grandeur of Classical architecture (see Figure 16.17) represented, as it were, the revolutionaries' view of themselves and their accomplishments. Neo-Classicism, however, barely survived into the beginning of the nineteenth century. The movement that replaced it, Romanticism, eventually dominated virtually every aspect of nineteenth-century artistic achievement.

The essence of Romanticism is particularly difficult to describe because it is far more concerned with broad general attitudes than with specific stylistic features. Painters, writers, and musicians in the nineteenth century shared several concerns in their approach to their art. First was the important emphasis they placed on personal feelings and their expression. Ironically enough, the revolutionary movements that had encouraged artists to rebel against the conventional styles of the early eighteenth century had proved too restricting and conventional.

Second, emphasis on emotion rather than intellect led to the expression of subjective rather than objective visions; after all, the emotions known best are those we have experienced. The Romantics used art to explore and dissect their own personal hopes and fears (more often the latter) rather than as a means to arrive at some general truth.

This in turn produced a third attitude of Romanticism—its love of the fantastic and the exotic—which made it possible to probe more deeply into an individual's creative imagination. Dreams, for example, were a way of releasing the mind from the constraints of everyday experience and bringing to the surface those dark visions reason had submerged, as the Spanish artist Francisco Goya shows us unforgettably in a famous etching [**Fig. 17.1**]. Artists felt free to invent their own dream worlds. Some chose to reconstruct such ages long past as the medieval period, which was particularly popular (Britain's Houses of Parliament [**Fig. 17.2**] were begun in 1836 in the Gothic style of six centuries earlier). Others preferred to imagine remote and exotic lands and dreamed of life in the mysterious Orient or on a primitive desert island. Still others simply trusted to the powers of their imagination and invented a fantasy world of their own.

A fourth characteristic of much Romantic art is a mystical attachment to the world of nature that was also the result of the search for new sensations. Painters turned increasingly to landscape, composers sought to evoke the rustling of leaves in a forest or the noise of a storm, and poets tried to express their sense of union with the natural world. Most eighteenth-century artists had turned to nature in search of order and reason. In the nineteenth century, the wild unpredictability of nature would be emphasized, depicted neither objectively nor realistically but as a mirror of the artist's individual emotions. At the same time, the romantic communion with nature expressed a rejection of the Classical notion of a world centered on human activity.

These attitudes, and the new imaginative and creative power they unleashed, had two different but equally important effects on the relationship between the artist and society. On the one hand, many creative artists became increasingly alienated from their public. Whereas they had once filled a precise role in providing entertainment or satisfying political and religious demands, now their self-expressive works met no particular needs except their own.

On the other hand, an increasing number of artists sought to express the national characteristics of their people via art. Abandoning the common artistic language of earlier periods and instead developing local styles that used traditional folk elements, artists were able to stimulate (and in some cases to initiate) the

■ **17.1** Francisco Goya. *Los Caprichos,* plate 43: *El sueño de la razón produce monstruos (The Sleep of Reason Produces Monsters),* 1797–1798. Etching and aquatint, 8″ × 6″ (216 × 152 mm). The Metropolitan Museum of Art, New York, gift of M. Knoedler and Co., 1918 [18.64(43)]. The precise meaning of the work is not clear, but it evidently represents the inability of reason to banish monstrous thoughts. Its title is written on the desk below the student, who sleeps with his head on his textbooks.

growth of national consciousness and the demand for national independence (see map, "Europe in 1848"). This was particularly effective in the Russian and Austrian empires (which incorporated many nationalities) and even in America, which had always been only on the fringe of the European cultural tradition, but it also became an increasingly strong tendency in the art of France and Italy, countries that had hitherto shared the same general culture. Thus while some artists were retreating into a private world of their own creation, others were in the forefront of the social and political movements of their own age (**TABLE 17.1**).

THE INTELLECTUAL BACKGROUND

It might be expected that a movement like Romanticism, which placed a high value on the feelings of the moment at the expense of conscious reason, would remain relatively unaffected by intellectual principles. Notwithstanding, several Romantic artists did in fact draw inspiration from contemporary philosophy. A rapid survey of the chief intellectual developments of the nineteenth century therefore provides a background to the artistic ones.

The ideas that proved most attractive to the Romantic imagination had developed in Germany at the end of the eighteenth century. Their chief spokesman was Immanuel Kant (1724–1804), whose *Critique of Judgment* (1790) defined the pleasure we derive from art as "disinterested satisfaction." Kant conceived of art as uniting opposite principles. It unites the general with the particular, for example, and reason with the imagination. For Kant, the only analogy for the way in which art is at the same time useless and yet useful was to be found in the world of nature.

Even more influential than Kant was Georg Wilhelm Friedrich Hegel (1770–1831), whose ideas continued to affect attitudes toward art and artistic criti-

■ **17.2** Charles Barry and A. W. N. Pugin. Houses of Parliament, London, 1836–1860. Length 940′ (286.51 m). The relative symmetry of the façade is broken only by the placing of the towers—Gothic in style, as is the decorative detail.

TABLE 17.1 *Principal Characteristics of the Romantic Movement*

The Expression of Personal Feelings

Chopin, *Preludes*
Goya, *The Family of Charles IV* [17.11]
Goethe, *The Sorrows of Young Werther*

Self-Analysis

Berlioz, *Fantastic Symphony*
Poetry of Keats
Whitman, *Leaves of Grass*

Love of the Fantastic and Exotic

Music and performances of Paganini
Girodet-Trioson, *The Entombment of Atala* [17.13]
Delacroix, *The Death of Sardanapalus* [17.16]

Interest in Nature

Beethoven, *Pastoral Symphony*
Constable, *Hay Wain* [17.23]
Poetry of Wordsworth
Emerson, *The American Scholar*

Nationalism and Political Commitment

Verdi, *Nabucco*
Smetana, *My Fatherland*
Goya, *Execution of the Madrileños* [17.10]
Byron's support of the Greeks

Erotic Love and the Eternal Feminine

Goethe, *Faust,* Part II
Wagner, *Tristan and Isolde*

cism into the twentieth century. Like Kant, Hegel stressed art's ability to reconcile and make sense of opposites, and to provide a **synthesis** of the two opposing components of human existence, called **thesis** (pure, infinite being) and **antithesis** (the world of nature). This process, he held, applied to the workings of the mind and also to the workings of world history, through the development and realization of what he called the "World Spirit." Hegel's influence on his successors lay less in the details of his philosophical system than in his acceptance of divergences and his attempt to reconcile them. The search for a way to combine differences, to permit the widest variety of experience, is still the basis of much contemporary thinking about the arts.

Both Kant and Hegel developed their ideas in the relatively optimistic intellectual climate of the late eighteenth and early nineteenth centuries, and their approach both to art and to existence is basically positive. A different position was that of Arthur Schopenhauer (1788–1860), whose major work, *The World as Will and Idea* (1819), expresses the belief that the dominating will, or power, in the world is evil. At the time of its appearance, Schopenhauer's work made little impression, largely because of the popularity of Kant's

and Hegel's idealism. Schopenhauer did not help matters by launching a bitter personal attack on Hegel. But the failure of the nationalist uprisings of 1848 in many parts of Europe produced a growing mood of pessimism and gloom, against which background Schopenhauer's vision of a world condemned perpetually to be ravaged by strife and misery seemed more convincing. Thus, his philosophy, if it did not mold the Romantic movement, came to reflect its growing despondency.

It must be admitted that many of the major developments in nineteenth-century thought had little direct impact on the contemporary arts. The most influential of all nineteenth-century philosophers was probably Karl Marx (1818–1883), whose belief in the inherent evil of capitalism and in the historical inevitability of a proletarian revolution was powerfully expressed in his *Communist Manifesto* (1848).

Marx's belief that revolution was both unavoidable and necessary was based at least in part on his own observation of working conditions in industrial England, where his friend and fellow communist Friedrich Engels (1820–1895) had inherited a textile factory. Marx and Engels both believed that the factory workers, although creating wealth for the middle classes, derived no personal benefit. Living in overcrowded, unsanitary conditions, the workers were deprived of any effective political power and only kept quiet by the drug of religion, which offered them the false hope of rewards in a future life. The plight of the working classes seemed to Marx to transcend all national boundaries and create a universal proletariat who could only achieve freedom through revolution: "Workers of the world, unite! You have nothing to lose but your chains!" The drive to political action was underpinned by Marx's economic philosophy, with its emphasis on the value of labor and, more generally, on the supreme importance of economic and social conditions as the true moving forces behind historical events. This so-called materialist concept of history was to have worldwide repercussions in the century that followed Marx's death. More contemporary writers such as Bertolt Brecht (1898–1956) have embraced Marxist principles, and Marxist critics have developed a school of aesthetic criticism that applies standards based on Marxist doctrines. During the nineteenth and early twentieth centuries, however, Marx's influence was exclusively social and political.

Marx clearly laid out his views on the arts. Art has the ability to contribute to important social and political changes, and is thus a determining factor in history. Neither is artistic output limited to the upper or more prosperous social classes; according to the "principle of uneven development," a higher social order does not necessarily produce a correspondingly high artistic achievement. Capitalism is, in fact, hostile to artistic development because of its obsession with money and profit. As for styles, the only one appropriate for the

EUROPE IN 1848

— Boundaries of German Confederation

● Centers of Revolution

class struggle and the new state is realism, which would be understood by the widest audience. Lenin inherited and developed this doctrine further when he ordered that art should be a specific "reflection" of reality, and used the party to enforce the official cultural policy.

The nineteenth century saw vast changes in the lives of millions of people, as industrial development and scientific progress overthrew centuries-old ways. The railroad, using engines powered by steam, first appeared in 1825 between Stockton and Darlington in England. By 1850, there were 6000 miles of track in Britain, 3000 in Germany, 2000 in France, and the beginnings of a rail system in Austria, Italy, and Russia. The economic impact was overwhelming. The railroad represented a new industry that fulfilled a universal need; it provided jobs and offered opportunities for capital investment. At the same time, it increased the demand for coal and iron.

Industry soon overtook agriculture as the source of national wealth. With the growth of mass production in factories, the cities connected by rail became vast urban centers, attracting wholesale migration from the countryside. The number of persons living in cities rose dramatically. The population of Turin, in northern Italy, was 86,000 in 1800, 137,000 by 1850, and more than 200,000 by 1860. Half of Britain's inhabitants lived in cities by 1850, the first time in history that this was true for any large society. The results were by no means always pleasant; one Londoner described his city in the 1820s as "a wilderness of human beings."

In science, constant research brought a host of new discoveries. Experiments in magnetism and electricity advanced physics. Using new chemical elements, the French chemist Louis Pasteur (1822–1895) explored the process of fermentation and invented "pasteurization"— a discovery that helped improve the safety of food. Equally beneficial was Pasteur's demonstration that dis-

ease is spread by living but invisible (to the naked eye, at least) germs, which can be combated by vaccination and the sterilization of medical equipment.

No single book affected nineteenth-century readers more powerfully than *On the Origin of Species by Means of Natural Selection* by Charles Robert Darwin (1809–1882), which appeared in 1859. As a student at Cambridge, in 1831 Darwin was offered the post of naturalist aboard the H.M.S. *Beagle,* a ship ready to embark on a surveying expedition around the world. In the course of the voyage, Darwin studied geological formations, fossils, and the distribution of plant and animal types. On examining his material, Darwin became convinced that species were not fixed categories, as had always been held, but were instead capable of variation. Drawing on the population theories of Malthus, and the geological studies of Sir Charles Lyell, Darwin developed his theory of evolution as an attempt to explain the changes, disappearances, and new appearances of various species.

According to Darwin, animals and plants evolve by a process of **natural selection** (he chose the term to contrast it with the "artificial selection" used by animal breeders). Over time, some variations of each species survive while others die out. Those likely to survive are those best suited to prevailing environmental conditions—a process called by one of Darwin's followers "the survival of the fittest." Changes in the environment would lead to adjustments within the species. The first publication of this theory appeared in 1858, in the form of a short scientific paper; *On the Origin of Species* appeared a year later. In 1871, Darwin published *The Descent of Man,* in which he claimed that the human race is descended from an animal of the anthropoid group.

The impact of both books was spectacular. Their author quietly continued his research and tried to avoid the popular controversy surrounding his work. Church leaders thundered their denunciations of a theory that utterly contradicted the notion that humans, along with everything else, had been created by God in accordance with a divine plan. Scientists and free-thinkers stoutly defended Darwin, often enlarging his claims. Others held that the development of modern capitalism and industrial society represented a clear demonstration of the "survival of the fittest," although Darwin never endorsed this "Social Darwinism" (see **TABLE 17.2**).

Achievements in science and technology are reflected to a certain extent in Romantic art, although chiefly from a negative point of view. The growing industrialization of life in the great cities, and the effect of inventions like the railway train on urban architecture stimulated a "back-to-nature" movement, as Romanticism provided an escape from the grim realities of urbanization and industrialization. Furthermore, at a time when many people felt submerged and depersonalized in overcrowded cities, the Romantic

TABLE 17.2 *Nineteenth-Century Scientific and Technological Developments*

1814	Stephenson builds first locomotive
1821	Faraday discovers principle of electric dynamo
1825	Erie Canal opened in the United States; First railway completed (England)
1839	Daguerre introduces his process of photography
1844	Morse perfects the telegraph
1853	First International Exhibition of Industry (New York)
1858	Transatlantic cable begun (completed 1866)
1859	Darwin publishes *On the Origin of Species;* First oil well drilled (in Pennsylvania)
1867	Nobel invents dynamite
1869	Transcontinental railway completed in the United States; Suez Canal opened
1876	Bell patents the telephone
1879	Edison invents the electric light
1885	First internal combustion engines using gasoline

emphasis on the individual and on self-analysis found an appreciative audience. Many artists contrasted the growing problems of urban life with an idyllic (and highly imaginative) picture of rustic bliss.

Scientific ideas had something of the same negative effect on nineteenth-century artists. The English Victorian writers (so-called after Queen Victoria, who reigned from 1837 to 1901) responded to the growing scientific materialism of the age.

Although few were, strictly speaking, Romantics, much of their resistance to progress in science and industry and their portrayal of its evil effects has its roots in the Romantic tradition.

MUSIC IN THE ROMANTIC ERA

Beethoven

For many of the Romantics, music was the supreme art. Free from the intellectual concepts involved in language and the physical limits inherent in the visual arts, it was capable of the most wholehearted and intuitive expression of emotion. Ludwig van Beethoven (1770–1827), widely regarded as the pioneer of musical Romanticism, also manifested many characteristically Romantic attitudes—such as love of nature, passionate belief in the freedom of the individual, and fiery temperament—so it is not surprising that he has come to be regarded as the prototype of the Romantic artist [**FIG. 17.3**]. When Beethoven wrote proudly to one of his most loyal aristocratic supporters, "There will always be thousands of princes, but there is only one Beethoven," he spoke for a new generation of creators. When he used the last movement of his *Symphony No. 9* to preach the doctrine of universal brotherhood, he inspired countless ordinary listeners by his fervor. Even today familiarity with Beethoven's music

❖ **17.3** Ferdinand Georg Waldmuller. *Ludwig van Beethoven,* 1823, 28″ × 22¾″ (72 × 58 cm). Painting now lost. Painted a year before the first performance of Beethoven's *Symphony No. 9 in d minor,* the portrait emphasizes the composer's stubborn independence by both the set of the mouth and the casual, even untidy, dress and hair. Beethoven, who became irascible in his latter years, allowed the artist only one sitting for his portrait commissioned by one of his music publishers.

has not dulled its ability to give dramatic expression to the noblest of human sentiments.

Although Beethoven's music served as the springboard for the Romantic movement in music, his own roots were deep in the classical tradition. He pushed classicism to the limits through use of the sonata allegro form. In spirit, furthermore, his work is representative of the Age of Enlightenment and the revolutionary mood of the turn of the century, as is proved by both the words and music of his opera *Fidelio*. A complex and many-sided genius, Beethoven transcended the achievements of the age in which he was born and set the musical tone for the nineteenth century.

Beethoven was born in Bonn, Germany, where he received his musical training from his father, an alcoholic. Beethoven's father saw the possibility of producing a musical prodigy in his son and forced him to practice hours at the keyboard, often locking him in his room and beating him on his return from drinking bouts. All possibilities of a happy family life were brought to an end in 1787 by the death of Beethoven's mother and his father's subsequent decline into

advanced alcoholism. Beethoven sought compensation in the home of the von Breuning family, where he acted as private tutor. It was there that he met other musicians and artists and developed a love of literature that he kept throughout his life. He also struck up a friendship with a local minor aristocrat, Count Waldstein, who remained his devoted admirer until the composer's death.

In 1792 Waldstein was one of the aristocrats who helped Beethoven go to Vienna to study with Haydn, who was then regarded as the greatest composer of his day; but although Haydn agreed to give him lessons, the young Beethoven's impatience and suspicion, and Haydn's deficiencies as a teacher, did not make for a happy relationship. Nevertheless, many of the works Beethoven wrote during his first years in Vienna are essentially classical in both form and spirit; only by the end of the century had he begun to extend the emotional range of his music.

One of the first pieces to express the characteristically Beethovenian spirit of rebellion against fate and the determination to struggle on is his *Piano Sonata No. 8 in c minor,* Op. 13, generally known as the *Pathétique*. The first movement begins with a slow introduction, but unlike similar introductions in the classical music of Haydn, it sets the emotional tone of the entire piece rather than merely capturing the listener's attention. As is so often the case, the significance of Beethoven's music is as easy to grasp on hearing as it is difficult to express in words. The heavy, foreboding chords seem to try to pull themselves up, only to fall back again and again in defeat, until finally they culminate in a burst of defiant energy that sets the main allegro ("fast") portion of this movement on its stormy way. Just before the end of the movement, the ghost of the slow introduction returns briefly, as if to emphasize the odds against which the struggle has been—and will be—waged.

The sublime slow middle movement finds a sense of peace absent so far from the music, and the final movement appears to arrive at a synthesis between the drama of the opening and the hushed beauty of the slow movement. Yet in the end Beethoven storms to a sudden fiery conclusion, and the work leaves us with the same sense of struggle with which it began.

To hear the last movement of this sonata, *Pathétique,* play track 11 on the Listening CD.

It is important to understand precisely how Beethoven used music in a new and revolutionary way. Other composers had written music to express emotion long before Beethoven's time, from Bach's outpouring of religious fervor to Mozart's evocation of human joy and sorrow. What is different about Beethoven is that his emotion is autobiographical. His

music tells us how he feels, what his succession of moods is, and what conclusion he reaches. It does other things at the same time, and at this early stage in his career for the most part it self-consciously follows classical principles of construction, but the vivid communication of personal emotions is its prime concern. That Beethoven's range was not limited to anger and frustration is immediately demonstrated by the beautiful and consoling middle slow movement of the *Pathétique* with its lyrical main theme, but the final movement returns to turbulent passion.

Parallels for the turbulent style of the *Pathétique* can be found in other contemporary arts, especially literature, but although to some extent Beethoven was responding to the climate of the times, there can be no doubt that he was also expressing a personal reaction to the terrible tragedy that had begun to afflict him as early as 1796. In that year, the first symptoms of his deafness began to appear; by 1798, his hearing had grown very weak; and by 1802, he was virtually totally deaf.

Nonetheless, although obviously affected by his condition, Beethoven's music was not exclusively concerned with his own fate. The same heroic attitude with which he faced his personal problems was also given universal expression, never more stupendously than in the *Symphony No. 3 in E flat,* Op. 55, subtitled the *Eroica,* the "Heroic Symphony." As early as 1799, the French ambassador to Vienna had suggested that Beethoven write a symphony in honor of Napoleon Bonaparte. At the time Napoleon was widely regarded as a popular hero who had triumphed over his humble origins to rise to power as a champion of liberty and democracy. Beethoven's own democratic temperament made him one of Napoleon's many admirers. The symphony was duly begun, but in 1804—the year of its completion—Napoleon had himself crowned emperor. When Beethoven heard the news, he angrily crossed out Napoleon's name on the title page. The first printed edition, which appeared in 1806, bore only the dedication "to celebrate the memory of a great man."

It would be a mistake to view the *Eroica* as merely a portrait of Napoleon. Rather, inspired by what he saw as the heroic stature of the French leader, Beethoven created his own heroic world in sound, in a work of vast dimensions. The first movement alone lasts for almost as long as many a classical symphony. Its complicated structure requires considerable concentration on the part of the listener. The form is basically the old classical sonata allegro form (see Chapter 16), but on a much grander scale and with a wealth of musical ideas. Yet the principal theme of the movement, which the cellos announce at the beginning, after two hammering, impatient chords demand our attention, is of a rocklike sturdiness and simplicity:

Beethoven's genius emerges as he uses this and other similarly straightforward ideas to build his mighty structure. Throughout the first movement his use of harmony and, in particular, discord, adds to the emotional impact, especially in the middle of the development section, where slashing dissonances seem to tear apart the orchestra. His classical grounding emerges in the recapitulation, where the infinite variety of the development section gives way to a restored sense of unity; the movement ends triumphantly with a long and thrilling coda. The formal structure is recognizably classical, but the intensity of expression, depth of personal commitment, and heroic defiance are all totally Romantic.

The second movement of the *Eroica* is a worthy successor to the first. A funeral march on the same massive scale, it alternates a mood of epic tragedy—which has been compared, in terms of impact, with the works of the Greek playwright Aeschylus—with rays of consolation that at times achieve a transcendental exaltation. Although the many subtleties of construction deserve the closest attention, even a first hearing will reveal the grandeur of Beethoven's conception.

The third and fourth movements relax the tension. For the third, Beethoven replaces the stately minuet of the classical symphony with a **scherzo**—the word literally means "joke" and is used to describe a fast-moving, generally lighthearted piece of music. Beethoven's introduction of this kind of music, which in his hands often has something of the crude flavor of a peasant dance, is another illustration of his "democratization" of the symphony. The last movement is a brilliant and energetic series of variations on a theme Beethoven had composed a few years earlier for a ballet he had written on the subject (from Classic mythology) of Prometheus, who defied the ancient gods by giving mortals the gift of fire, for which he was punished by Zeus—a final reference to the heroic mood of the entire work.

Many of the ideas and ideals that permeate the *Eroica* reappear throughout Beethoven's work. His love of liberty and hatred of oppression are expressed in his only opera, *Fidelio,* which describes how a faithful wife rescues her husband who has been unjustly imprisoned for his political views. A good performance of *Fidelio* is still one of the most uplifting and exalting experiences music has to offer. The concept of triumph over fate recurs in his best-known symphony, *No. 5,* Op. 67. The first movement is built on a short theme, which Beethoven likened to his "shaking a fist" against destiny. His ability to build a massive, driving symphonic structure on this brief motif shows the composer at his most inspired.

 To hear the first movement of Beethoven's *Symphony No. 5,* play track 12 on the Listening CD.

His *Symphony No. 6, Op. 68,* called the *Pastoral,* consists of a Romantic evocation of nature and the emotions it arouses, while the *Symphony No. 9, Op. 125,* is perhaps the most complete statement of the human striving to conquer all obstacles and win through to universal peace and joy. In it Beethoven introduced a chorus and soloists to give voice to the "Ode to Joy" by his compatriot Friedrich von Schiller (1759–1805). The symphony represents the most complete artistic vindication of Kant's Transcendental Idealism. It is also one of the most influential works of the entire Romantic movement.

Instrumental Music after Beethoven

After Beethoven, music could never again return to its former mood of classical objectivity. Although Beethoven's music may remain unsurpassed for its universalization of individual emotion, his successors tried—and in large measure succeeded—to find new ways to express their own feelings. Among the first to follow Beethoven was Hector Berlioz (1803–1869), the most distinguished French Romantic composer who produced, among other typically Romantic works, the *Fantastic Symphony,* which describes the hallucinations of an opium-induced dream, and *The Damnation of Faust,* a setting of Part One of Goethe's work. In both of these, Berlioz used the full Romantic apparatus of dreams, witches, demons, and the grotesque to lay bare the artist's innermost feelings. The last movement of the *Fantastic Symphony* depicts the funeral of the dreamer, who has seen his own execution in the preceding movement. The scene is that of a "Witches' Sabbath," and the music begins with the gradual assembly of the cackling old witches. The theme that earlier represented the dreamer's lover appears in a horribly distorted form, and at the climax of the tumult the brass instruments blare out the old Gregorian Chant theme of the **dies irae** ("day of wrath"), which forms part of the traditional Catholic requiem mass.

 To hear the last movement of Berlioz's *Fantastic Symphony,* play track 13 on the Listening CD.

A highly intimate and poetic form of Romantic self-revelation is the music of Franz Schubert (1797–1828), who explored in the few years before his premature death the new possibilities opened up by Beethoven in a wide range of musical forms. In general, Schubert was happiest when working on a small scale, as evidenced by his more than six hundred **Lieder** ("songs"), which are an inexhaustible store of musical and emotional expression.

On the whole, the more rhetorical nature of the symphonic form appealed to Schubert less, although the wonderful *Symphony No. 8 in b minor,* called the *Unfinished Symphony* because he only completed two movements, combines great poetic feeling with a genuine sense of drama. His finest instrumental music was written for small groups of instruments. The two *Trios for Piano, Violin, and Cello,* Op. 99 and 100, are rich in the heavenly melodies that seemed to come to him so easily; the second, slow movement of the *Trio in E flat,* Op. 100, touches profound depths of romantic expression. Like the slow movement of Mozart's *Piano Concerto No. 27* in B flat (see Chapter 16), its extreme beauty is tinged with an unutterable sorrow. But whereas Mozart seems to speak for humanity at large, Schubert moves us most deeply by communicating his own personal feelings.

Most nineteenth-century composers followed Beethoven in using the symphony as the vehicle for their most serious musical ideas. Robert Schumann (1810–1856) and his student Johannes Brahms (1833–1897) regarded the symphonic form as the most lofty means of musical expression, and each as a result wrote only four symphonies. Brahms did not even dare to write a symphony until he was forty-four and is said to have felt the presence of Beethoven's works "like the tramp of a giant" behind him. When it finally appeared, Brahms' *Symphony No. 1 in c minor,* Op. 68, was inevitably compared to Beethoven's symphonies. Although Brahms' strong sense of form and conservative style won him the hostility of the arch-Romantics of the day, other critics hailed him as the true successor to Beethoven.

Both responses were, of course, extreme. Brahms' music certainly is Romantic with its emphasis on warm melody and a passion no less present for being held tightly in rein—but far from echoing the heaven-storming mood of many of the symphonies of his great predecessor, Brahms was really more at home in a relaxed vein. Although the *Symphony No. 1* begins with a gesture of defiant grandeur akin to Beethoven's, the first movement ends by fading dreamily into a glowing tranquility. The lovely slow movement is followed not by a scherzo but by a quiet and graceful **intermezzo** ("interlude"), and only in the last movement are we returned to the mood of the opening.

Closer to the more cosmic mood of the Beethoven symphonies are the nine symphonies of Anton Bruckner (1824–1896). A deeply religious man imbued with a romantic attachment to the beauties of nature, Bruckner combined his devout Catholicism and mystical vision in music of epic grandeur. It has often been remarked that Bruckner's music requires time and patience on the listener's part. His pace is leisurely and he creates huge structures in sound that demand our full concentration if we are to appreciate their "architecture." There is no lack of incidental beauty, however, and the rewards are immense. No other composer has been able to convey quite the tone of mystical exalta-

tion that Bruckner achieves, above all in the slow movements of his last three symphonies. The **adagio** movement from the *Symphony No. 8 in c minor,* for instance, moves from the desolate Romanticism of its opening theme to a mighty, blazing climax as thrilling and stirring as anything in nineteenth-century music.

The Age of the Virtuosos

Beethoven's emphasis on the primacy of the artist inspired another series of Romantic composers to move in a different direction from that of the symphony. Beethoven had first made his reputation as a brilliant pianist, and much of his music—both for piano and for other instruments—was of considerable technical difficulty. As composers began to demand greater and greater feats of virtuosity from their performers, performing artists came to attract more attention. Singers had already, in the eighteenth century, commanded high fees and attracted crowds of fanatical admirers, and they continued to do so. Now, however, they were joined by instrumental virtuosos, some of whom were also highly successful composers.

The life of Frédéric Chopin (1810–1849) seems almost too Romantic to be true [**Fig. 17.4**]. Both in his piano performances and in the music he composed, he united the aristocratic fire of his native Poland with the elegance and sophistication of Paris, where he spent much of his life. His concerts created a sensation throughout Europe, while his piano works exploited (if they did not always create) new musical forms like the **nocturne**—a short piano piece in which an expressive, if often melancholy, melody floats over a murmuring accompaniment. Chopin is characteristically Romantic in his use of music to express his own personal emotions. The structure of works like the twenty-four **Preludes,** Op. 28, is dictated not by formal considerations but by the feeling of the moment. Thus the first three take us from excited agitation to brooding melancholy to bubbling high spirits in just over three minutes.

In private, Chopin's life was dominated by a much-talked-about liaison with the leading French woman author of the day, George Sand (1804–1876). His early death from tuberculosis put the final Romantic touch to the life of a composer who has been described as the soul of the piano.

Franz Liszt (1811–1886) shared Chopin's brilliant skill at the keyboard and joined to it his own more robust temperament. A natural Romantic, Liszt ran the gamut of Romantic themes and experiences. After beginning his career as a handsome, impetuous young rebel, the idol of the salons of Paris, he conducted several well-publicized affairs and ended up by turning to the consolations of religion. His vast musical output includes some of the most difficult of all piano works

▪ **17.4** Eugène Delacroix. *Frederic Chopin,* 1838. Oil on canvas, 18″ × 15″ (45 × 38 cm). Musée Louvre, Paris. Delacroix's portrait of his friend captures Chopin's Romantic introspection. Delacroix was a great lover of music, although perhaps surprisingly the great Romantic painter preferred Mozart to Beethoven.

(many of them inspired by the beauties of nature), two symphonies on the characteristically Romantic subjects of Faust and Dante (with special emphasis, in the latter case, on the *Inferno*), and a host of pieces that use the folk tunes of his native Hungary.

Assessment of Liszt's true musical stature is difficult. He was probably a better composer than his present reputation suggests, although not so great a one as his contemporaries (and he) thought. As a virtuoso performer even *he* takes second place to Nicolò Paganini (1782–1840), the greatest violinist of the age, if not of all time.

Like Chopin and Liszt, Paganini also composed, but his public performances won him his amazing reputation. So apparently impossible were the technical feats he so casually executed that rumor spread that, like Faust, he had sold his soul to the devil. This typically Romantic exaggeration was, of course, assiduously encouraged by Paganini, who cultivated a suitably ghoulish appearance to enhance his public image. Nothing more clearly illustrates the nineteenth century's obsession with music as emotional expression (in this case, diabolical) than the fact that Paganini's concerts earned him both honors throughout Europe and a considerable fortune.

Musical Nationalism

Both Chopin and Liszt introduced the music of their native lands into their works, Chopin in his **mazurkas** and **polonaises** (traditional Polish dances) and Liszt in his *Hungarian Rhapsodies.* For the most part, however, they adapted their musical styles to the prevailing international fashions of the day.

Other composers placed greater emphasis on their native musical traditions. In Russia, a group of five composers (Moussorgsky, Balakirev, Borodin, Cui, and Rimsky-Korsakov) consciously set out to exploit their rich musical heritage. The greatest of the five was Modest Moussorgsky (1839–1881), whose opera *Boris Godunov* (1874) is based on an episode in Russian history. It makes full use of Russian folksongs and religious music in telling the story of Tsar Boris Godunov, who rises to power by killing the true heir to the throne. Although Boris is the opera's single most important character, the work is really dominated by the chorus, which represents the Russian people. Moussorgsky powerfully depicts their changing emotions, from bewilderment to awe to fear to rage, and in so doing gives voice to the feelings of his nation.

Elsewhere in Eastern Europe composers were finding similar inspiration in national themes and folk music. The Czech composer Bedrich Smetana (1824–1884), who aligned himself with his native Bohemia in the uprising against Austrian rule in 1848, composed a set of seven pieces for orchestra under the collective title of *Má Vlast (My Fatherland).* The best known, *Vltava (The Moldau),* depicts the course of the river Vltava as it flows from its source through the countryside to the capital city of Prague. His fellow countryman Antonin Dvorák (1841–1904) also drew on the rich tradition of folk music in works like his *Slavonic Dances,* colorful settings of Czech folktunes.

Opera in Italy: Verdi

Throughout the nineteenth century, opera achieved new heights of popularity in Europe, and "operamania" began to spread to America, where opera houses opened in New York (1854) and Chicago (1865). On both sides of the Atlantic, opera house stages are still dominated by the works of the two nineteenth-century giants: the Italian Giuseppe Verdi and the German Richard Wagner.

When Giuseppe Verdi (1813–1901) began his career, the Italian opera-going public was interested in beautiful and brilliant singing rather than realism of plot or action. This love of what is often called **bel canto** ("beautiful singing") should not be misunderstood. Composers like Gaetano Donizetti (1797–1848) and Vincenzo Bellini (1801–1835) used their music to express sincere and deep emotions and even drama, but the emotional expression was achieved primarily by means of song and not by a convincing dramatic situation. The plots of their operas serve only as an excuse for the music; thus characters in *bel canto* operas are frequently given to fits of madness in order to give musical expression to deep emotion. Within the necessary framework provided by the plot, a great singer, inspired by great music, could use the magic of the human voice to communicate a dramatic emotion that transcended the time and place of the action. Under the inspiration of Verdi and Wagner, however, opera began to move in a different direction. The subjects composers chose remained larger than life, but dramatic credibility became increasingly important.

Beginning in the 1950s, however, many music lovers began to discover a rich source of musical beauty and even drama in a work like Bellini's *Norma,* first performed in 1831. The revival and subsequent popularity of much early-nineteenth-century opera is largely the result of the performances and recordings of Maria Callas [**Fig. 17.5**], whose enormous talent showed how a superb interpreter could bring such works to life.

■ **17.5** Maria Callas as Norma in Bellini's opera of the same title, Covent Garden, London, 1957. The Greek-American Maria Callas (1923–1977), one of the great sopranos of the twentieth century, made her professional debut in Verona in 1947. Her first appearances at La Scala, Milan; Covent Garden, London; and the Metropolitan Opera, New York followed in 1950, 1952, and 1956, respectively.

Following her example, other singers turned to *bel canto* opera, with the result that performances of *Norma* and of Donizetti's best-known opera, *Lucia di Lammermoor* (1835), have become a regular feature of modern operatic life, while lesser-known works are revived in increasing numbers.

The revival of *bel canto* works has certainly not been at the expense of Verdi, perhaps the best-loved of all opera composers. His works showed a new concern for dramatic and psychological truth. Even in his early operas like *Nabucco* (1842) or *Luisa Miller* (1849), Verdi was able to give convincing expression to human relationships. At the same time, his music became associated with the growing nationalist movement in Italy. *Nabucco,* for example, deals ostensibly with the captivity of the Jews in Babylon and their oppression by Nebuchadnezzar, but the plight of the Jews became symbolic of the Italians' suffering under Austrian rule. The chorus the captives sing as they think of happier days, "Va, pensiero . . ." ("Fly, thought, on golden wings, go settle on the slopes and hills where the soft breezes of our native land smell gentle and mild"), became a kind of theme song for the Italian nationalist movement, the Risorgimento, largely because of the inspiring yet nostalgic quality of Verdi's tune.

Verdi's musical and dramatic powers reached their first great climax in three major masterpieces—*Rigoletto* (1851), *Il Trovatore* (1853), and *La Traviata* (1853)—which remain among the most popular of all operas. They are very different in subject and atmosphere. *Il Trovatore* is perhaps the most traditional in approach, with its gory and involved plot centering around the troubadour Manrico and its abundance of superb melodies. In *Rigoletto,* Verdi achieved one of his most convincing character portrayals in the hunchback court jester Rigoletto, who is forced to suppress his human feelings and play the fool to his vicious and lecherous master, the Duke of Mantua. With *La Traviata* based on Dumas' play *La dame aux camélias (The Lady of the Camelias),* Verdi broke new ground in the history of opera by dealing with contemporary life rather than a historical or mythological subject.

The principal character of *La Traviata* is Violetta, a popular courtesan in Paris, who falls in love with Alfredo Germont, a young man from the provinces, and decides to give up her sophisticated life in the capital for country bliss. Her reputation follows her there, however, in the form of Alfredo's father. In a long and emotional encounter, he persuades her to abandon his son and put an end to the disgrace she is bringing on his family [**FIG. 17.6**]. Violetta, who is aware that she is suffering from a fatal illness, returns alone to the cruel glitter of her life in Paris. By the end of the opera, her money gone, she lies dying in poverty and solitude. At this tragic moment Verdi gives her one of his most moving arias, "Addio del passato" ("Goodbye bright dreams of the past"), as she thinks

■ **17.6** *La Traviata.* Metropolitan Opera, New York, 1981. *La Traviata* was first produced in New York in 1856. Many noted sopranos have sung the role of Violetta, including Maria Callas (Figure 17.5).

back over her earlier life. Alfredo, who has finally learned of the sacrifice she has made for his sake, rushes to find her, only to arrive for a final farewell—Violetta dies in his arms.

 To hear Violetta's aria from Act I of Verdi's *La Traviata,* play track 14 on the Listening CD.

Throughout the latter part of his career, Verdi's powers continued to develop and enrich, until in 1887 he produced in *Otello,* a version of Shakespeare's tragedy of the same name, perhaps the supreme work in the entire Italian operatic tradition. From the first shattering chord that opens the first act to Otello's heartbreaking death at the end of the last, Verdi rose to the Shakespearean challenge with music of unsurpassed eloquence. In a work that is so consistently inspired, it seems invidious to pick out highlights, but the ecstatic love duet of Act I between Otello and Desdemona deserves mention as one of the noblest and most moving of all depictions of romantic passion.

Opera in Germany: Wagner

The impact of Richard Wagner (1813–1883) on his times went far beyond the opera house. Not only did

his works change the course of the history of music, but many of his ideas also had a profound effect on writers and painters [**FIG. 17.7**]. This truly revolutionary figure even became actively involved with the revolutionary uprisings of 1848 and spent several years in exile in Switzerland.

It is difficult to summarize the variety of Wagner's ideas, which ranged from art to politics to vegetarianism and are not noted for their tolerance. Behind many of his writings on opera and drama lay the concept that the most powerful form of artistic expression was one that united all the arts—music, painting, poetry, movement—in a single work of art, the **Gesamtkunstwerk** ("complete artwork"). To illustrate this theory, Wagner wrote both the words and music of what he called "music dramas" and even designed and built a special theater for their performance at Bayreuth, where they are still performed every year at the Bayreuth Festival.

Several characteristics link all of Wagner's mature works. First, he abolished the old separation between *recitatives* (in which the action was advanced) and arias, duets, or other individual musical numbers (which held up the action). Wagner's music flowed continuously from the beginning to the end of each act with no pauses. Second, he eliminated the vocal display and virtuosity that had been traditional in opera. Wagner roles are certainly not easy to sing, but their difficulties are always for dramatic reasons and not to show off a singer's skill. Third, he put a new emphasis on the orchestra, which not only accompanied the singers but

also provided a rich musical argument of its own. This was enhanced by his fourth contribution, the famous device of the **leitmotiv** ("leading motif"), which consisted of giving each of the principal characters, ideas, and even objects an individual theme of his, her, or its own. By recalling these themes and by combining them or changing them, Wagner achieved highly complex dramatic and psychological effects.

Wagner generally drew his subjects from German mythology. By peopling his stage with heroes, gods, giants, magic swans, and the like, he aimed to create universal dramas that would express universal emotions. In his most monumental achievement, *The Ring of the Nibelung,* written between 1851 and 1874, he even represented the end of the world. *The Ring* consists of four separate music dramas: *The Rhinegold, The Valkyrie, Siegfried,* and *The Twilight of the Gods,* the plot of which defies summary. In music of incredible richness, Wagner depicted not only the actions and reactions of his characters but also the wonders of nature. In *Siegfried,* for example, we hear the rustling of the forest and the songs of woodbirds, while throughout *The Ring* and especially in the well-known "Rhine Journey" from *The Twilight of the Gods,* the mighty river Rhine sounds throughout the score. At the same time, *The Ring* has several philosophical and political messages, many of which are derived from Schopenhauer. One of its main themes is that power corrupts, while Wagner also adopted Goethe's idea of redemption by a woman in the final resolution of the drama.

■ **17.7** Wilhelm Beckmann. *Richard Wagner at His Home in Bayreuth,* 1880. Oil on canvas, 4'¾" × 5'1⅝" (1.25 × 1.58 m). Richard Wagner Museum, Triebschen-Luzern, Switzerland. Characteristically, Wagner is holding forth to his wife and friends, in this case Liszt in his garb as Abbot and the author Hans von Wolzogen. At lower left are some stage designs for Wagner's final work: *Parsifal.*

The second opera in the cycle, *The Valkyrie,* introduces the Valkyries, the warrior daughters of the god Wotan. Wagner uses the leitmotiv, which represents them throughout *The Ring* in the stormy *Ride of the Valkyries,* describing their ride through the sky bearing the bodies of dead heroes.

 To hear Wagner's *The Ride of the Valkyries,* play track 15 on the Listening CD.

No brief discussion can begin to do justice to so stupendous a work. It is probably easier to see Wagner's genius in operation by looking at a work on small scale, a single self-contained music drama—albeit one of some four hours' duration. *Tristan and Isolde* was first performed in 1865, and its first notes opened a new musical era. Its subject is the overwhelming love of the English knight Tristan and the Irish princess Isolde, so great that the pair betray his dearest friend and lord and her husband, King Mark of Cornwall, and so overpowering that it can achieve its complete fulfillment only in death.

Wagner's typically Romantic preoccupation with love and death may seem morbid and farfetched, but under the sway of his intoxicating music it is difficult to resist. The sense of passion awakened but unfulfilled is expressed in the famous opening bars of the Prelude, with their theme that yearns upward and the discords that dissolve into one another only to hang unresolved in the air:

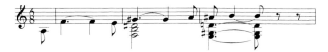

The music imparts no sense of settled harmony or clear direction. This lack of **tonality,** used here for dramatic purpose, was to have a considerable influence on modern music.

The core of *Tristan and Isolde* is the long love scene at the heart of the second act, where the music reaches heights of erotic ecstasy too potent for some listeners. Whereas Verdi's love duet in *Otello* presents two noble spirits responding to one another with deep feeling but with dignity, Wagner's characters are racked by passions they cannot begin to control. If ever music expressed what neither words nor images could depict, it is in the overwhelming physical emotion of this scene [**FIG. 17.8**]. The pulsating orchestra and surging voices of the lovers build up an almost unbearable tension that Wagner suddenly breaks with the arrival of

■ **17.8** Scene from *Tristan and Isolde,* Act I, the Bayreuth staging designed by Wagner's grandson, Wieland Wagner (1981). First mounted in 1962, the production starred Wolfgang Windgassen and Birgit Nilsson as the lovers. The abstract sets and complex lighting have influenced much stage design since then. The scene here shows Isolde's arrival in Cornwall. In the foreground the lovers are forcibly separated by their attendants, while, behind, the ship on which Isolde arrived, together with its crew is dimly visible in the shadows.

King Mark. Once again, as in the Prelude, fulfillment is denied both to the lovers and to us.

That fulfillment is reached only at the end of the work in Isolde's "Liebestod" ("Love Death"). Tristan has died, and over his body Isolde begins to sing a kind of incantation. She imagines she sees the spirit of her beloved, and in obscure, broken words describes the bliss of union in death before sinking lifeless upon him. Although the "Liebestod" does make its full effect when heard at the end of the entire work, even out of context the emotional power of the music as it rises to its climax can hardly fail to affect the sensitive listener.

ROMANTIC ART

Painting at the Turn of the Century: Goya

Just as Beethoven and his Romantic successors rejected the idealizing and universal qualities of classical music to achieve a more intense and personal communication, painters also began to abandon the lofty, remote world of Neo-Classical art for more vivid images. In the case of painting, however, the question of style was far more related to political developments. We have already seen in Chapter 16 that Neo-Classicism had become, as it were, the official artistic dress of the French Revolution, so it was not easy for a painter working in France, which was still the center of artistic life, to suddenly abandon the revolutionary style. The

problem is particularly visible in the works of Jacques-Louis David (1748–1825), whose *Oath of the Horatii* (see Figure 16.1) had been inspired by the prerevolutionary longing for austere Republican virtue.

By the end of the revolution, David had come to appreciate the advantages of peace; his painting *The Battle of the Romans and the Sabines of 1799* [FIG. 17.9] expresses his desire for an end to violence and bloodshed. The subject is drawn from Roman mythology and focuses on that moment when Hersilia, wife of the Roman leader Romulus, interrupts the battle between Romans and Sabines and begs for an end to war. Its significance is precisely the reverse of the *Oath of the Horatii*. In place of a masculine call to arms and sacrifice, David shows his heroine making an impassioned plea for peace. The style, however, remains firmly Neo-Classical, not only in the choice of subject but also in its execution. For all the weapons and armor, there is no sign of actual physical violence. The two opponents, with their heroic figures and noble brows, are idealized along typical Neo-Classical lines. The emotional gestures of Hersilia and others are also stylized and frozen. The painting is powerful, but it depicts a concept rather than individual human feelings.

The contrast between the Neo-Classical representation of the horrors of war and a Romantic treatment of the same theme can be seen by comparing David's painting to *Execution of the Madrileños on May 3, 1808* [FIG. 17.10] by Francisco Goya (1746–1828). In Goya's painting, nothing is idealized. The horror and the terror of the victims, their faceless executioners, the blood streaming in the dust all combine to create an almost

■ **17.9** Jacques–Louis David. *The Battle of the Romans and the Sabines,* 1799. Oil on canvas, 12′5″ × 16′9″ (3.8 × 5.1 m). Louvre, Paris. David may have intended his depiction of feminine virtue as a tribute to his wife, who left him when he voted for the execution of Louis XVI but returned to him when he was imprisoned for a time.

■ **17.10** Francisco Goya. *Execution of the Madrileños on May 3, 1808,* 1814. Oil on canvas, 8′8¾″ × 11′3¾″ (2.66 × 3.45 m). Museo del Prado, Madrid. The painting shows the execution of a group of citizens of Madrid who had demonstrated against the French occupation by Napoleon's troops. The Spanish government commissioned the painting after the expulsion of the French army.

unbearable image of protest against human cruelty. Goya's painting is Romantic because it conveys to us his own personal emotions at the thought of the executions and because, great artist that he was, his emotions become our own.

As Beethoven convinces us of the necessity to struggle against the injustices of human beings and of fate by his own passionate commitment, so Goya by his intensity urges us to condemn the atrocities of war. Furthermore, both Beethoven and Goya shared a common sympathy with the oppressed and a hatred of tyranny. The soldiers firing their bayoneted guns in Goya's painting were serving in the army of Napoleon; the event shown took place some four years after Beethoven had seen the danger Napoleon presented to the cause of liberty and had erased his name from the *Eroica.*

It was easier for an artist outside France to abandon the artistic language of Neo-Classicism for more direct ways of communication. Although from 1824 to his death Goya lived in France, he was born in Spain and spent most of his working life there. Removed from the mainstream of artistic life, he seems never to have been attracted by the Neo-Classical style. Some of his first paintings were influenced by the rococo style of Tiepolo (see Figure 16.8), who was in Spain from 1762 until 1770, but his own introspective nature and the strength of his feelings seem to have driven Goya to find more direct means of expression. Personal suffering may have played a part also, because Goya, like Beethoven, became totally deaf.

In 1799, Goya became official painter to King Charles IV of Spain and was commissioned to produce a series of formal court portraits. The most famous of these, *The Family of Charles IV* [**Fig. 17.11**], was deliberately modeled on Velázquez's *Las Meninas* (see Figure 15.23). Goya shows us the royal family—king, queen, children, and grandchildren—in the artist's studio, where they have come to visit. The comparison he intends us to make between his own painting and that of his distinguished predecessor is devastating. At first glance, Goya's painting may seem just another official portrait, but it does not take a viewer long to realize that something is wrong at the court of Spain. Instead of grace and elegance, Goya's patrons radiate arrogance, vanity, and stupidity. The king and queen, in particular, are especially unappealing.

The effect of Goya's painting is not so much one of realism as of personal comment, although there is every reason to believe that the queen was in fact as ugly as she appears here. The artist is communicating his own feelings of disgust at the emptiness—indeed the evil—of court life. That he does so through the medium of an official court portrait that is itself a parody of one of the most famous of all court portraits is an intentional irony.

Even at the time of his official court paintings, Goya was obsessed by the darker side of life. His engraving *The Sleep of Reason Produces Monsters* (see Figure 17.1) foreshadowed the work of his last years. Between 1820 and 1822, Goya covered the walls of his own house with paintings that depict a nightmare world of horror

17.11 Francisco Goya. *The Family of Charles IV,* 1800. Oil on canvas, 9′2″ × 11′ (2.79 × 3.35 m). Museo del Prado, Madrid. In this scathing portrayal of the Spanish royal family, the artist depicts himself working quietly at the far left. The French writer Alphonse Daudet said the painting showed "the grocer and his family who have just won top prize in the lottery."

and despair. *Saturn Devouring One of His Sons* [**Fig. 17.12**] uses a Classical myth to portray the god of time in the act of destroying humanity, but the treatment owes nothing to Neo-Classicism. No simple stylistic label seems adequate to describe so personal a vision. The intensity of expression, the fantastic nature of the subject, and the mood of introspection are all typically Romantic, yet the totality transcends its components. No one but Goya has ever expressed a vision of human existence in quite these terms.

Painting and Architecture in France: Romantics and Realists

Although the events of the French Revolution and Napoleon's subsequent dictatorship had an immediate impact on artists, writers, and musicians outside France, their effect on French artists was more complex. As we have seen earlier in this chapter, David was never able to throw off the influence of Neo-Classicism, and his immediate successors had a hard time finding a style that could do justice to romantic themes while remaining within Neo-Classical limits. One solution was offered by Anne Louis Girodet-Trioson (1767–1824), whose painting *The Entombment of Atala* [**Fig. 17.13**] depicts a highly Romantic subject acted out, as it were, by Classical figures.

The subject is from a popular novel by the French Romantic novelist René de Chateaubriand (1768–1848) and depicts the burial of its heroine, Atala, in the American wilderness where the book is set. The other figures are her Indian lover, Choctas, and a priest from a nearby mission in the Florida swamps. The story of the painting therefore contains just about every conceivable element of Romanticism: an exotic location, emphasis on personal emotion, the theme of unfulfilled love. Girodet provides for his characters a Romantic setting, with its dramatic light and mysterious jungle background, but the figures are idealized in a thoroughly Classical way. Atala's wan beauty and elegant drapery and the muscular nudity of her lover are obviously reminiscent of Classical models. Only the mysterious figure of the old priest provides a hint of Romantic gloom.

It took a real-life disaster and a major national scandal to inspire the first genuinely romantic French painting. In 1816, a French government vessel, the *Medusa,* bound for Africa with an incompetent political appointee as captain, was wrecked in a storm. The one hundred forty-nine passengers and crewmembers were crowded onto a hastily improvised raft that drifted for days under the equatorial sun. Hunger, thirst, madness, and even, it was rumored, cannibalism had reduced the survivors to fifteen by the time the raft was finally sighted.

▪ **17.12** Francisco Goya. *Saturn Devouring One of His Sons,* 1819–1823. Detail of a detached fresco on canvas. Full size approx. 57″ × 32″ (144.8 × 81.3 cm). Museo del Prado, Madrid. The painting originally decorated a wall in Goya's country house, La Quinta del Sordo ("Deaf Man's Villa").

The young French painter Jean Louis André Théodore Géricault (1791–1824), whose original enthusiasm for Napoleon had been replaced by adherence to the liberal cause, depicted the moment of the sighting of the raft in his painting *Raft of the Medusa* [**FIG. 17.14**]. Horror at the suffering of the victims and anger at the corruption and incompetence of the ship's officers (and their political supporters) inspired a work that, from its first exhibition in 1819, created a sensa-

tion in artistic circles. Even the general public flocked to see a painting that illustrated contemporary events so dramatically. In the process they became exposed to the principles of Romantic painting. Géricault's work deliberately rejects the ideal beauty of Classical models. The agonizing torment of the survivors is powerfully rendered, and the dramatic use of lighting underlines the intense emotions of the scene.

When Géricault died following a fall from a horse, the cause of Romanticism was taken up by his young friend and admirer, Ferdinand Victor Eugéne Delacroix (1798–1863), whose name has become synonymous with Romantic painting. Although the subjects of many of his paintings involve violent emotions, Delacroix seems to have been aloof and reserved. He never married or for that matter formed any lasting relationship. His *Journal* reveals him as a man constantly stimulated by ideas and experience, but he preferred to live his life through his art—a true Romantic. Among his few close friends was Chopin; his portrait of the composer (see Figure 17.4) seems to symbolize the introspective creative vision of the romantic artist.

Like his mentor Géricault, Delacroix supported the liberal movements of the day. His painting *Massacre at Chios* [**FIG. 17.15**] depicted a particularly brutal event in the Greek War of Independence. In 1824, the year in which Lord Byron died while supporting the Greek cause, the Turks massacred some 90 percent of the population of the Greek island of Chios, and Delacroix's painting on the subject was intended to rouse popular indignation. It certainly roused the indignation of the traditional artists of the day, one of whom dubbed it "the massacre of painting," principally because of its revolutionary use of color. Whereas David and other Neo-Classical painters had drawn their forms and then filled them in with color, Delacroix used color to create form. The result is a much more fluid use of paint.

Lord Byron figures again in another of Delacroix's best-known paintings, because it was on one of the poet's works that the artist based *The Death of Sardanapalus* [**FIG. 17.16**]. The Assyrian king, faced with the destruction of his palace by the Medes, decided to prevent his enemies from enjoying his possessions after his death by ordering that his wives, horses, and dogs be killed and their bodies piled up, together with his treasures, at the foot of the funeral pyre he intended for himself. The opulent, violent theme is treated with appropriate drama; the savage brutality of the foreground contrasts with the lonely, brooding figure of the king reclining on his couch above. Over the entire scene, however, hovers an air of unreality, even of fantasy, as if Delacroix is trying to convey not so much the sufferings of the victims as the intensity of his own imagination.

Although with Delacroix's advocacy Romanticism acquired a vast popular following, not all French artists

◾ **17.13** Anne Louis Girodet-Trioson. *The Entombment of Atala,* 1808. Oil on canvas, 6′11¾″ × 8′9″ (2.13 × 2.67 m). Louvre, Paris. The anti-Classical nature of the subject is emphasized by the Christian symbolism of the two crosses, one on Atala's breast and the other rather improbably placed high in the jungle outside the cave.

◾ **17.14** Jean Louis André Théodore Géricault. *Raft of the Medusa,* 1818. Oil on canvas, 16′1¼″ × 23′6″ (4.91 × 7.16 m). Louvre, Paris. Note the careful composition of this huge work, built around a line that leads from the bottom-left corner to the top right, where a survivor desperately waves his shirt.

▪ **17.15** Eugéne Delacroix. *Massacre at Chios,* 1824. Oil on canvas, 13′7″ × 11′10″ (4.19 × 3.64 m). Louvre, Paris. Rather than depict a single scene, the painter chose to combine several episodes, contrasting the static misery of the figures on the left with a swirl of activity on the right.

▪ **17.16** Eugéne Delacroix. *The Death of Sardanapalus, 1826.* Oil on canvas, 12′1″ × 16′3″ (3.68 × 4.95 m). Louvre, Paris. This painting makes no attempt to achieve archaeological accuracy but instead concentrates on exploiting the violence and cruelty of the story. Delacroix called this work *Massacre No. 2,* a reference to his earlier painting, the *Massacre at Chios* (Figure 17.15). Although this suggests a certain detachment on the artist's part, there is no lack of energy or commitment in the free, almost violent, brush strokes.

joined the Romantic cause. A fierce and bitter rear-guard action was fought by the leading Neo-Classical proponents, headed by Jean Auguste Dominique Ingres (1780–1867), who was, in his own different way, as great a painter as Delacroix. The self-appointed defender of Classicism, Ingres once said of Delacroix that "his art is the complete expression of an incomplete intelligence." Characteristically, his war against Romantic painting was waged vindictively and on the most personal terms.

Now that the dust has settled, however, it becomes clear that Ingres, far from religiously adhering to Classical doctrines, was unable to suppress a Romantic streak. His extraordinary painting *Jupiter and Thetis* [**FIG. 17.17**] deals with an event from Homer's *Iliad* and shows Thetis, the mother of Achilles, begging the father of gods and mortals to avenge an insult by the Greek commander Agamemnon to her son by allowing the Trojans to be victorious. The subject may be Classical, but Ingres's treatment of it is strikingly personal, even bizarre.

Sensuality blends with an almost hallucinatory sharpness of detail to create a memorable if curiously disturbing image. Even in his more conventional portraits [**FIG. 17.18**], Ingres's stupendous technique endows subject and setting with an effect that is the reverse of academic. The style that in the end succeeded in replacing the full-blown romanticism of Delacroix and his followers was not that of the Neo-Classical school, with its emphasis on idealism, but a style that stressed precisely the reverse qualities. The greatest French painters of the second half of the nineteenth century were Realists, who used the everyday events of the world around them to express their views of life. One of the first Realist artists was Honoré Daumier (1808–1879), who followed the example of Goya in using his work to criticize the evils of society in general and government in particular. In *Le Ventre Legislatif (The Legislative Belly)* [**FIG. 17.19**], Daumier produced a powerful image of the greed and corrup-

■ **17.17** Jean Auguste Dominique Ingres. *Jupiter and Thetis,* 1811. Oil on canvas, 10′10″ × 8′5″ (3.3 × 2.57 m). Musée Granet, Aix-en-Provence, France. The figure of Jupiter, with his youthful face surrounded by a vast wreath of beard and hair, is highly unconventional. Thetis's arms and throat are purposely distorted to emphasize her supplication.

■ **17.18** Jean Auguste Dominique Ingres. *La Comtesse d'Haussonville,* 1845. Oil on canvas, 4′5″ × 3′¼″ (1.36 × .92 m). Frick Collection, New York. The artist seems to have been more interested in his subject's dress, which is marvelously painted, than in her personality. The reflection in the mirror reinforces the highly polished air of the painting.

tion of political opportunists that has lost neither its bitterness nor, unfortunately, its relevance.

Equally political was the realism of Gustave Courbet (1819–1877), a fervent champion of the working class, whose ability to identify with ordinary people won him the label of Socialist. Courbet tried to correct this political impression of his artistic and philosophical position in a vast and not entirely successful allegorical work, *The Studio: A Real Allegory of the Last Seven Years of My Life* [**FIG. 17.20**]. Like Goya's royal portrait (see

■ **17.20** Gustave Courbet. *The Studio: A Real Allegory of the Last Seven Years of My Life*, 1855. Oil on canvas, 11′9¾″ × 19′6⅝″ (3.6 × 5.96 m). Louvre, Paris. Although most of the figures can be convincingly identified as symbols or real people, no one has ever satisfactorily explained the small boy admiring Courbet's work or the cat at his feet.

Figure 17.11), the painting deliberately evokes memories of Velázquez's *Las Meninas* (see Figure 15.23), although the artist is now placed firmly in the center of the picture, hard at work on a landscape, inspired by a nude model who may represent Realism or Truth. The various other figures symbolize the forces that made up Courbet's world. There is some doubt as to the precise identification of many of them, and it is not even clear that Courbet had any single allegory in mind. The total effect of the confusion, unintentional though it may be, is to underline the essentially Romantic origins of Courbet's egocentric vision.

Neither Romanticism nor its realistic vision made much impression on architectural styles in nineteenth-century France. French architects retained a fondness for classical forms and abandoned them only to revive the styles of the Renaissance. In some of the public buildings designed to meet the needs of the age, however, the elaborate decoration uses Classical elements to achieve an ornateness of effect that is not very far from the opulent splendor of Delacroix's *Death of Sardanapalus* (see Figure 17.16).

The most ornate of all nineteenth-century French buildings was the Paris Opera [**FIG. 17.21**] of Charles Garnier (1824–1898). The new opera house had to be sufficiently large to accommodate the growing public for opera and sufficiently ostentatious to satisfy its taste. Garnier's building, designed in 1861 and finally opened in 1875, uses Classical ornamentation like Corinthian columns and huge winged Victories, but

the total effect is highly un-Classical, a riot of confusion that would surely have appalled Classical and Renaissance architects alike.

Painting in Germany and England

Unlike their French counterparts, Romantic artists in both Germany and England were particularly attracted by the possibilities offered by landscape painting. The emotional range of their work illustrates once again the versatility of the Romantic style. The German painter Caspar David Friedrich (1774–1840) seems to have drawn some of his Gothic gloom from a tradition that had been strong in Germany since the Middle Ages, although he uses it to Romantic effect. His *Cloister Graveyard in the Snow* [**FIG. 17.22**], in fact, illustrates several Romantic preoccupations, with its ruined medieval architecture and melancholy dreamlike atmosphere.

The English painter John Constable (1776–1837), on the other hand, shared the deep and warm love of nature expressed by Wordsworth. His paintings convey not only the physical beauties of the landscape but also a sense of the less tangible aspects of the natural world. In *Hay Wain* [**FIG. 17.23**], for example, we not only see the peaceful rustic scene, with its squat, comforting house on the left, but we also can even sense that light and quality of atmosphere, prompted by the billowing clouds that, responsible for the fertility of the countryside, seem about to release their moisture.

■ **17.21** Charles Garnier. Opéra, Paris, 1861–1875, at dusk. The incredibly rich and complex ornamentation has earned this style of architecture the label Neo-Baroque.

■ **17.22** Caspar David Friedrich. *Cloister Graveyard in the Snow*, 1810. Oil on canvas, 3′11⅝″ × 5′10″ (1.21 × 1.78 m). Formerly Nationalgalerie Berlin. (Painting destroyed during World War II.) The vast bare trees in the foreground and the ruined Gothic abbey behind emphasize the insignificance of the human figures.

■ **17.23** John Constable. *Hay Wain*, 1821. Oil on canvas, 4′3″ × 6′1″ (1.28 × 1.85 m). The National Gallery, London (reproduced by courtesy of the Trustees). Note Constable's bold use of color, which impressed Delacroix.

Constable's use of color pales besides that of his contemporary, Joseph Mallord William Turner (1775–1851). In a sense, the precise subjects of Turner's paintings are irrelevant. All his mature works use light, color, and movement to represent a cosmic union of the elements in which earth, sky, fire, and water dissolve into one another and every trace of the material world disappears. His technique is seen at its most characteristic in The *Slave Ship* [**Fig. 17.24**].

Like Géricault's *Raft of the Medusa* (see Figure 17.14), Turner's *Slave Ship* deals with a social disgrace of the time; in this case, the horrifyingly common habit of the captains of slave ships to jettison their entire human cargo if an epidemic broke out. Turner only incidentally illustrates his specific subject—the detail of drowning figures in the lower-right corner seems to have been added as an afterthought—and concentrates instead on conveying his vision of the grandeur and mystery of the universe.

Literature in the Nineteenth Century

Goethe

The towering figure of Johann Wolfgang von Goethe (1749–1832) spans the transition from Neo-Classicism to Romanticism in literature like a colossus. So great was the range of his genius that in the course of a long and immensely productive life he wrote in a bewildering variety of disciplines. One of the first writers to rebel against the principles of Neo-Classicism, Goethe used both poetry and prose to express the most turbulent emotions; yet he continued to produce work written according to Neo-Classical principles of clarity and balance until his final years, when he expressed in his writing a profound if abstruse symbolism.

Although the vein of Romanticism is only one of many that runs through Goethe's work, it is an impor-

■ **17.24** Joseph Mallord William Turner. *The Slave Ship*, 1840. Oil on canvas, 35¾″ × 48¼″ (90.8 × 122.6 cm). Museum of Fine Arts, Boston (Henry Lillie Pierce Fund). The title of this painting is an abbreviation of a longer one: *Slavers Throwing Overboard the Dead and Dying; Typhoon Coming On*. Turner includes a horrifying detail at lower center: the chains still binding the slaves whose desperate hands show above the water. Note the extreme contrast between Turner's interpretation of color and light and that of the American luminists as shown in Heade's painting (Figure 17.31).

tant one. As a young man Goethe studied law, first at Leipzig and then at Strassburg, where by 1770 he was already writing lyric poetry of astonishing directness and spontaneity. By 1773, he was acknowledged as the leader of the literary movement known as **Sturm und Drang** ("Storm and Stress"). This German manifestation of Romanticism rebelled against the formal structure and order of Neo-Classicism, replacing it with an emphasis on originality, imagination, and feelings. Its chief subjects were nature, primitive emotions, and protest against established authority. Although the Sturm und Drang movement was originally confined to literature, its precepts were felt elsewhere. For instance, it was partly under the inspiration of this movement that Beethoven developed his fiery style.

The climax of this period in Goethe's life is represented by his novel *The Sorrows of Young Werther* (1774), which describes how an idealistic young man comes to feel increasingly disillusioned and frustrated by life, develops a hopeless passion for a happily married woman, and ends his agony by putting a bullet through his head. All of these events but the last were autobiographical. Instead of committing suicide, Goethe left town and turned his life experiences into the novel that won him international fame. Not surprisingly it became a key work of the Romantic movement. Young men began to dress in the blue jacket and yellow trousers Werther is described as wearing, and some, disappointed in love, even committed suicide with copies of the book in their pockets—a dramatic if regrettable illustration of Goethe's ability to communicate his own emotions to others [**Fig. 17.25**].

The years around the turn of the century found Goethe extending the range of his output. Along with such plays as the Classical drama *Iphigenia in Tauris,* which expressed his belief in purity and sincere humanity, were stormy works like *Egmont,* inspired by the idea that human life is controlled by demonic forces. The work for which Goethe is probably best known, *Faust,* was begun at about the turn of the century, although its composition took many years. Part One was published in 1808, and Part Two was only finished in 1832, shortly before his death.

The subject of Dr. Faustus and his pact with the devil had been treated before in literature, notably in the play by Christopher Marlowe. The theme was guaranteed to appeal to Romantic sensibilities with its elements of the mysterious and fantastic and, in Part One, Goethe put additional stress on the human emotions involved. The chief victim of Faust's lust for experience and power is the pure and innocent Gretchen, whom he callously seduces and then abandons. She becomes deranged as a result. At the end of Part One of *Faust,* Gretchen is accused of the murder of her illegitimate child, condemned to death, and executed. Moving from irony to wit to profound compassion, the rich tapestry

■ **17.25** Tony Johannot. Illustration for a later edition of *The Sorrows of Young Werther,* 1852. By permission of the Houghton Library, Harvard University. The hero has just declared his hopeless passion for Charlotte.

of Part One shows Goethe, like Beethoven and Goya, on the side of suffering humanity.

Part Two of *Faust* is very different. Its theme, expressed symbolically through Faust's pact with the devil, is nothing less than the destiny of Western culture. Our civilization's unceasing activity and thirst for new experiences inevitably produces error and suffering; at the same time, it is the result of the divine spark within us and will, in the end, guarantee our salvation. In his choice of the agent of this salvation, Goethe established one of the other great themes of Romanticism, the Eternal Feminine. Faust is finally redeemed by the divine love of Gretchen, who leads him upward to salvation.

Romantic Poetry

English Romantic poetry of the first half of the nineteenth century represents a peak in the history of English literature. Its chief writers, generally known as the Romantic poets, touched on several themes characteristic of the age. William Wordsworth's deep love of the

country–led him to explore the relationship between human beings and the world of nature; Percy Bysshe Shelley and George Gordon, Lord Byron (hereafter called Lord Byron), probed the more passionate, even demonic aspects of existence; and John Keats expressed his own sensitive responses to the eternal problems of art, life, and death. William Wordsworth (1770–1850), often called the founder of the Romantic movement in English poetry, clearly described his aims and ideals in his critical writings. For Wordsworth, the poet was a person with special gifts, "endowed with more lively sensibility, more enthusiasm and tenderness, who has a greater knowledge of human nature, and a more comprehensive soul" than ordinary people.

Rejecting artificiality and stylization, Wordsworth aimed to make his poetry communicate directly in easily comprehensible terms. His principal theme was the relation between human beings and nature, which he explored by thinking back calmly on experiences that had earlier produced a violent emotional reaction: his famous "emotion recollected in tranquility."

Wordsworth's emotion recollected in tranquility is in strong contrast to the poetry of Lord Byron (1788–1824), who filled both his life and work with the same moody, passionate frenzy of activity [**Fig. 17.26**]. Much

■ **17.26** Thomas Phillips. *Lord Byron in Albanian Costume,* 1814. Oil on canvas, 29½″ × 24½″ (75 × 62 cm). National Portrait Gallery, London. Byron is shown during his first visit to Greece, dressed for the role of Romantic sympathizer with exotic lands and peoples.

of his time was spent wandering throughout Europe, where he became a living symbol of the unconventional, homeless, tormented Romantic hero who has come to be called Byronic after him. Much of his flamboyant behavior was no doubt calculated to produce the effect it did, but his personality must have been striking for no less a figure than Goethe to describe him as "a personality of such eminence as has never been before and is not likely to come again." Byron's sincere commitment to struggles for liberty—like the Greek war of independence against the Turks—can be judged by the fact that he died while on military duty in Greece.

Percy Bysshe Shelley (1792–1822), who like Byron spent many of his most creative years in Italy, lived a life of continual turmoil. After being expelled from Oxford for publishing his atheistic views, he espoused the cause of anarchy and eloped with the daughter of one of its chief philosophical advocates. The consequent public scandal, coupled with ill health and critical hostility toward his work, gave him a sense of bitterness and pessimism that lasted until his death by drowning.

Shelley's brilliant mind and restless temperament produced poetry that united extremes of feeling, veering from the highest pitch of exultant joy to the most extreme despondency. His belief in the possibility of human perfection is expressed in his greatest work, *Prometheus Unbound* (1820), where the means of salvation is love—the love of human beings for one another expressed in the last movement of Beethoven's *Ninth Symphony*—rather than the redeeming female love of Goethe and Wagner. His most accessible works, however, are probably the short lyrics in which he seized a fleeting moment of human emotion and captured it by his poetic imagination.

Even Shelley's sensitivity to the poetic beauty of language was surpassed by that of John Keats (1795–1821), whose life, clouded by unhappy love and the tuberculosis that killed him so tragically young, inspired poetry of rare poignance and sensitivity. In his *Odes* (lyric poems of strong feeling), in particular, Keats conveys both the glory and the tragedy of human existence and dwells almost longingly on the peace of death. In the wonderful "Ode to a Nightingale," the song of a bird comes to represent a permanent beauty beyond human grasp. The sensuous images, the intensity of emotion, and the flowing rhythm join to produce a magical effect.

The Novel

Although great novels have been written in our own time, the nineteenth century probably marked the high point in the creation of fiction. Increase in liter-

acy and a rise in the general level of education resulted in a public that was eager for entertainment and instruction, and the success of such writers as Charles Dickens and Leo Tolstoy was largely the result of their ability to combine the two. The best of nineteenth-century novels were those rare phenomena: great works of art that achieved popularity in their own day. Many of these are still able to enthrall modern readers with their humanity and insight.

Most of the leading novelists of the mid-nineteenth century wrote within a tradition of Realism that came gradually to replace the more self-centered vision of Romanticism. Instead of describing an imaginary world of their own creation, they looked outward to find inspiration in the day-to-day events of real life. The increasing social problems produced by industrial and urban development produced not merely a lament for the spirit of the times but also a passionate desire for the power to change them as well. In some cases, writers were able to combine the Romantic style with a social conscience, as in the case of the French novelist Victor Hugo (1802–1885), whose *Les Misérables* (1862) describes the plight of the miserable victims of society's injustices. The hero of the novel, Jean Valjean, is an ex-convict who is rehabilitated through the agency of human sympathy and pity. Hugo provides graphic descriptions of the squalor and suffering of the poor, but his high-flown rhetorical style is essentially Romantic.

Increasingly, however, writers found that they could best do justice to the problems of existence by adopting a more naturalistic style and describing their characters' lives in realistic terms. One of the most subtle attacks on contemporary values is *Madame Bovary* (1856–1857) by Gustave Flaubert (1821–1880). Flaubert's contempt for bourgeois society finds expression in his portrait of Emma Bovary, who tries to discover in her own provincial life the romantic love she reads about in novels. Her shoddy affairs and increasing debts lead to an inevitably dramatic conclusion. Flaubert is at his best when portraying the banality of Emma's everyday existence.

Honoré de Balzac (1779–1850) was the most versatile of all French novelists. He created a series of some ninety novels and stories, under the general title of *The Human Comedy,* in which many of the same characters appear more than once. Above all a Realist, Balzac depicted the social and political currents of his time while imposing on them a sense of artistic unity. His novels are immensely addictive. The reader who finds in one of them a reference to characters or events described in another novel hastens there to be led on to a third, and so on. Balzac thus succeeds in creating a fictional world that seems, by a characteristically Romantic paradox, more real than historical reality.

Among the leading literary figures of Balzac's Paris, and a personal friend of Balzac, was the remarkable Aurore Dupin (1804–1876), better known by her pseudonym George Sand. This redoubtable defender of women's rights and attacker of male privilege used her novels to wage war on many of the accepted conventions of society. In her first novel, *Lélia* (1833), she attacked, among other institutions, the church, marriage, the laws of property, and the double standard of morality whereby women were condemned for doing what was condoned for men.

Unconventional in her own life, Sand became the lover of Chopin, with whom she lived from 1838 to 1847. Her autobiographical novel *Lucrezia Floriani* (1846) chronicles as thinly disguised fiction the remarkable course of this relationship, albeit very much from its author's point of view.

If France was one of the great centers of nineteenth-century fiction, another was Russia, where Leo Tolstoy (1828–1910) produced, among other works, two huge novels of international stature: *War and Peace* (1863–1869) and *Anna Karenina* (1873–1877). The first is mainly set against the background of Napoleon's invasion of Russia in 1812. Among the vast array of characters is the Rostov family, aristocratic but far from wealthy, who, together with their acquaintances, have their lives permanently altered by the great historical events through which they live. Tolstoy even emphasizes the way in which the course of the war affects his characters by combining figures he created for the novel with real historical personages, including Napoleon, and allowing them to meet.

At the heart of the novel is the young and impressionable Natasha Rostov, whose own confused love life seems to reflect the confusion of the times. Yet its philosophy is profoundly optimistic, despite the tragedies of Natasha's own life and the horrors of war that surround her. Her final survival and triumph represent the glorification of the irrational forces of life, which she symbolizes as the "natural person," over sophisticated and rational civilization. Tolstoy's high regard for irrationality and contempt for reason link him with other nineteenth-century Romantics, and his ability to analyze character through the presentation of emotionally significant detail and to sweep the reader up in the panorama of historical events make *War and Peace* the most important work of Russian Realistic fiction.

Toward the end of his life, Tolstoy gave up his successful career and happy family life to undertake a mystical search for the secret of universal love. Renouncing his property, he began to wear peasant dress and went to work in the fields, although at the time of his death he was still searching in vain for peace. Russia's other great novelist, Fyodor Dostoyevsky (1821–1881), although he died before Tolstoy, had far more in common with the late nineteenth century than with the Romantic movement, and he is accordingly discussed in Chapter 18.

VOICES OF THEIR TIMES

Isabella Bird Meets a Mountain Man

Isabella Bird (1831–1904), the English travel writer, meets Rocky Mountain Jim in Colorado in 1873: "a man who any woman might love, but who no sane woman would marry." A tireless traveler throughout America, Asia, and Australia, Isabella finally did settle down for a while and marry; her husband observed that he "had only one formidable rival in Isabella's heart, and that is the high Table Land of Central Asia."

Roused by the growling of the dog, his owner came out, a broad, thickset man, about the middle height, with an old cap on his head, and wearing a gray hunting-suit much the worse for wear (almost falling to pieces, in fact), a digger's scarf knotted round his waist, a knife in his belt, and a bosom friend, a revolver, sticking out of the breast pocket of his coat; his feet, which were very small, were bare, except for some dilapidated moccasins made of horse hide. The marvel was how his clothes hung together, and on him. The scarf round his waist must have had something to do with it. His face was remarkable. He is a man about 45, and must have been strikingly handsome. He has large gray-blue eyes, deeply set, with well-marked eyebrows, a handsome aquiline nose, and a very handsome mouth. His face was smooth shaven except for a dense moustache and imperial [a pointed beard]. Tawny hair,

in thin uncared for curls, fell from under his hunter's cap and over his collar. One eye was entirely gone, and the loss made one side of the face repulsive, while the other might have been modeled in marble. "Desperado" was written in large letters all over him. I almost repented of having sought his acquaintance.

His first impulse was to swear at the dog, but on seeing a lady he contented himself with kicking him, and coming up to me he raised his cap, showing as he did so a magnificently formed brow and head, and in a cultured tone of voice asked if there were anything he could do for me? I asked for some water, and he brought some in a battered tin, gracefully apologizing for not having anything more presentable. We entered into conversation, and as he spoke I forgot both his reputation and appearance, for his manner was that of a chivalrous gentleman, his accent refined, and his language easy and elegant. I inquired about some beavers' paws which were drying, and in a moment they hung on the horn of my saddle. Apropos of the wild animals of the region, he told me that the loss of his eye was owing to a recent encounter with a grizzly bear, which after giving him a death hug, tearing him all over, breaking his arm and scratching out his eye, had left him for dead.

From *A Lady's Life in the Rocky Mountains* (London, 1879); reprinted by Virago Press (London, 1982).

The riches of the English nineteenth-century novel are almost unlimited. They range from the profoundly intellectual and absorbing works of George Eliot, the pen name of Mary Ann Evans (1819–1880), to *Wuthering Heights* (1847), the only novel by Emily Brontë (1818–1848) and one of the most dramatic and passionate pieces of fiction ever written. The book's brilliant evocation of atmosphere and violent emotion produces a shattering effect. Like the two already mentioned, many of the leading novelists of the time were women, and the variety of their works soon puts to flight any facile notions about the feminine approach to literature. Elizabeth Gaskell (1810–1865), for example, was one of the leading social critics of the day; her novels study the effects of industrialization on the poor.

If one figure stands out in the field of the English novel, it is Charles Dickens (1812–1870), who was immensely popular during his lifetime and has been widely read ever since. It is regrettable that one of Dickens' best-known novels, *A Tale of Two Cities* (1859), is one of his least characteristic, because its melodra-

matic and not totally successful historical reconstruction of the French Revolution may have deterred potential readers from exploring the wealth of humor, emotion, and imagination in his more successful books. Each of Dickens' novels and short stories creates its own world, peopled by an incredible array of characters individualized by their tics and quirks of personality. Dickens' ability to move us from laughter to tears and back again gives his work a continual human appeal, although it has won him the censure of some of the more severe critics.

Throughout his life, Dickens was an active campaigner against social injustices and used his books to focus on individual institutions and their evil effects. *Oliver Twist* (1837–1838) attacked the treatment of the poor in workhouses and revealed Dickens' view of crime as the manifestation of a general failing in society [FIG. 17.27]. In *Hard Times* (1854) he turned, like Gaskell, to the evils of industrialization and pointed out some of the harm that misguided attempts at education can do.

■ **17.28** John Singleton Copley. *Nathaniel Hurd,* 1765. Oil on canvas, 30″ × 25½″ (76 × 65 cm). Cleveland Museum of Art (Gift of the John Huntington Art and Polytechnic Trust). In this portrait of a friend, Copley avoids technical tricks. The result is an attractive simplicity of style that still allows him to reveal something of the subject's personality.

THE ROMANTIC ERA IN AMERICA

The early history of the arts in America was intimately linked to developments in Europe. England, in particular, by virtue of its common tongue and political connections, exerted an influence on literature and painting that even the War of Independence did not end. American writers sought publishers and readers there and modeled their style on that of English writers. American painters went to London to study, sometimes with less than happy results. John Singleton Copley (1738–1815), for example, produced a series of portraits in a simple, direct style of his own [**FIG. 17.28**] before leaving Boston for England, where he fell victim to Sir Joshua Reynolds' grand manner (see Figure 16.13). Of American music we cannot say much, because the earliest American composers confined their attention to settings of hymns and patriotic songs. A recognizably American musical tradition of composition did not develop before the end of the nineteenth century, although much earlier European performers found a vast and enthusiastic musical public in the course of their American tours [**FIG. 17.29**].

In the case of literature and the visual arts, the French Revolution provided a change of direction, for revolutionary ties inevitably resulted in the importation of Neo-Classicism into America. With the dawning of the Romantic era, however, American artists began to develop for the first time an authentic voice of their own. In many cases they still owed much to European examples. The tradition of the expatriate American artist who left home to study in Europe and remained there had been firmly established by the eighteenth century. Throughout the nineteenth century, writers like Washington Irving (1783–1859) and painters like Thomas Eakins (1844–1916) continued to bring back to America themes and styles they had acquired during their European travels. Something about the nature of Romanticism, however, with its emphasis on the individual, seemed to fire the American imagination. The Romantic love of the remote and mysterious reached a peak in the macabre stories of Edgar Allan Poe (1809–1849). For the first time, in the Romantic era American artists began to produce work that was both a genuine product of their native land and at the same time of international stature.

■ **17.29** Nathaniel Currier. *First Appearance of Jenny Lind in America: At Castle Garden, Sept. 11, 1850.* Lithograph detail. J. Clarence Davies Collection, Museum of the City of New York. The great soprano, inevitably known as the Swedish Nightingale, made a highly successful tour of America under the management of P. T. Barnum in 1850–1851, during which she earned the staggering sum of $120,000 (multiply by ten for present value). At this first appearance in New York, the total receipts were $26,238. Nathaniel Currier (1813–1888) and James Merritt Ives (1824–1895), who became his partner in 1857, were lithographers who sold thousands of hand-colored prints that show many aspects of nineteenth-century American life.

American Literature

In a land where daily existence was lived so close to the wildness and beauty of nature, the Romantic attachment to the natural world was bound to make a special appeal. The Romantic concept of the transcendental unity of humans and nature was quickly taken up in the early nineteenth century by a group of American writers who even called themselves the **Transcendentalists.** Borrowing ideas from Kant and from his English followers such as Coleridge and Wordsworth, they developed notions of an order of truth that transcends what we can perceive by our physical senses and that unites the entire world. One of their leading representatives, Ralph Waldo Emerson (1803–1882), underlined the particular importance of the natural world for American writers in his essay "The American Scholar," first published in 1837. In calling for the development of a national literature, Emerson laid down as a necessary condition for its success that his compatriots should draw their inspiration from the

wonders of their own country. A few years later he was to write: "America is a poem in our eyes; its ample geography dazzles the imagination, and it will not wait long for metres."

Emerson always tried to make his own work "smell of pines and resound with the hum of insects," but although his ideas have exerted a profound effect on the development of American culture, Emerson was a better thinker than creative artist. Far more successful as a literary practitioner of Transcendentalist principles was Henry David Thoreau (1817–1862), whose masterpiece *Walden* (1854) uses his day-to-day experiences as he lived in solitude on the shore of Walden Pond to draw general conclusions about the nature of existence. Thoreau's passionate support of the freedom of the individual led him to be active in the antislavery movement and, by the end of his life, he had moved from belief in passive resistance to open advocacy of violence against slavery.

Ideas of freedom, tolerance, and spiritual unity reached their most complete poetic expression in the

VALUES

Nationalism

One of the consequences of the rise of the cities and growing political consciousness was the development of nationalism: the identification of individuals with a nation-state, with its own culture and history. In the past, the units of which people felt a part were either smaller (a local region) or larger (a religious organization or a social class). In many cases, the nations with which people began to identify were either broken up into separate small states, as in the case of the future Germany and Italy, or formed part of a larger state: Hungary, Austria, and Serbia were all under the rule of the Hapsburg Empire, with Austria dominating the rest.

The period from 1848 to 1914 was one in which the struggle for national independence marked political and social life and left a strong impact on European culture. The arts, in fact, became one of the chief ways in which nationalists sought to stimulate a sense of peoples' awareness of their national roots. One of the basic factors that distinguished the Hungarians or the Czechs from their Austrian rulers was their language, and patriotic leaders fought for the right to use their own language in schools, government, and legal proceedings. In Hungary, the result was the creation by Austria of the Dual Monarchy in 1867, which allowed Hungarian speakers to have their own systems of education and public life. A year later, the Hapsburgs granted a similar independence to minorities living there: Poles, Czechs, Slovaks, Romanians, and others.

In Germany and Italy, the reverse process operated. Although most Italians spoke a dialect of the same language, they had been ruled for centuries by a bewildering array of outside powers. In Sicily alone, Arabs, French, Spaniards, and English were only some of the occupiers who had succeeded one another. The architects of Italian unity used the existence of a common language, which went back to the poet Dante, to forge a sense of national identity.

The arts also played their part. Nationalist composers used folktunes, sometimes real and sometimes invented, to underscore a sense of national consciousness. In the visual arts, painters illustrated historical events and sculptors portrayed patriotic leaders. While the newly formed nations aimed to create an independent national culture, the great powers reinforced their own identities. Russian composers turned away from Western models to underline their Slavic roots, while in Britain the artists and writers of the Victorian Age depicted the glories (and, in some cases, the horrors) of their nation.

The consequences of the rise of national consciousness dominated the twentieth century and are still with us today. The age of world war was inaugurated by competition between nation-states, and the last half of the twentieth century saw the collapse and regrouping of many of the countries created in the first half. Among the casualties are the former Czechoslovakia and Yugoslavia. The struggle of minorities to win their own nationhood remains a cause of bloodshed. The Basques of northern Spain and the Corsican separatists are just two examples. In both cases, language and the arts continue to serve as weapons in the struggle.

works of America's first great poet, Walt Whitman (1819–1892). His first important collection of poems was published in 1855 under the title *Leaves of Grass*. From then until his death he produced edition after edition, retaining the same title but gradually adding many new poems and revising the old ones. Whitman was defiantly, even aggressively, an American poet, yet the central theme of most of his work was the importance of the individual. The contradiction this involves serves as a reminder of the essentially Romantic character of Whitman's mission since, by describing the details of his own feelings and reactions, he hoped to communicate a sense of the essential oneness of the human condition. Much of the time the sheer vitality and flow of his language helps make his experiences our own, although many of his earlier readers were horrified at the explicit sexual descriptions in some of his poems. Above all, Whitman was a fiery defender of freedom and democracy. His vision of the human race united with itself and with the universe had a special significance for the late twentieth century that continues.

Emily Dickinson (1830–1881) was as private in her life and work as Whitman was public in his. Only seven of her poems appeared in print during her lifetime, and the first complete edition was published as late as 1958. Yet, today, few American poets are better known or better loved. Her work tries to create a balance between passion and the prompting of reason, while her interest in psychological experience appeals to modern readers. Many, too, are attracted by her desire for a secure

religious faith, equaled only by her stubborn skepticism. The essential optimism of the Transcendentalists, especially as interpreted by Whitman, is absent from the work of the two great American novelists of the nineteenth century: Nathaniel Hawthorne (1804–1864) and Herman Melville (1819–1891).

Hawthorne in particular was deeply concerned with the apparently ineradicable evil in a society dedicated to progress. In *The Scarlet Letter* (1850), his first major success, and in many of his short stories, he explored the conflicts between traditional values and the drive for change.

Melville imitated Hawthorne's example in combining realism with allegory and in dealing with profound moral issues. His subjects and style are both very different, however. *Moby Dick* (1851), his masterpiece, is often hailed as the greatest of all American works of fiction. It shares with Goethe's *Faust* the theme of the search for truth and self-discovery, which Melville works out by using the metaphor of the New England whaling industry. Both Melville and Hawthorne were at their greatest when using uniquely American settings and characters to shed light on universal human experience.

American Painting

Under the influence of the Transcendentalists, landscape painting in America took on a new significance. Emerson reminded the artist who set out to paint a natural scene that "landscape has a beauty for his eye because it expresses a thought which to him is good, and this because the same power which sees through his eyes is seen in that spectacle." Natural beauty, in other words, is moral beauty, and both demonstrate the Transcendental unity of the universe.

The earliest painters of landscapes intended to glorify the wonders of nature are known collectively as the Hudson River School. The foundations of their style were laid by Thomas Cole (1801–1848), born in England, whose later paintings combine grandeur of effect with accurate observation of details. His *Genesee Scenery* [**FIG. 17.30**] is particularly successful in capturing a sense of atmosphere and presence.

By midcentury, a new approach to landscape painting had developed. Generally called **luminism,** it aimed to provide the sense of artistic anonymity Emerson and other Transcendentalists demanded. In a way this is the exact antithesis of Romanticism. Instead of sharing with the viewer their own reactions, the luminists tried by realism to eliminate their own presence and let nothing stand between the viewer and the scenes. Yet the results, far from achieving only a photographic realism, have an utterly characteristic and haunting beauty that has no real parallel in European

▪ **17.30** Thomas Cole. *Genesee Scenery (Landscape with Waterfall),* 1847. Oil on canvas, 51″ × 39½″ (1.2 × 1 m). Museum of Art, Rhode Island School of Design, Providence (Jesse Metcalf Fund). One of Cole's last works, this shows a meticulous care for detail that is never allowed to detract from the broad sweep of the view. Note the tiny figure on the bridge over the waterfall, the only sign of human existence in the painting.

art of the time. The painting *Lake George* [**FIG. 17.31**] by Martin J. Heade (1819–1904), one of the leading luminists, seems almost to foreshadow the Surrealist art of the twentieth century.

The two great American painters of the latter nineteenth century—Winslow Homer (1836–1910) and Thomas Eakins (1844–1916)—both used the luminist approach to realism as a basis for their own individual styles. In the case of Homer, the realism of his early paintings was largely the result of his work as a documentary artist, recording the events of the Civil War. His style underwent a notable change as he became exposed to contemporary French Impressionist painting (discussed in Chapter 18). His mysterious *Eagle Head* [**FIG. 17.32**] is certainly far more than a naturalistic depiction of three women and a dog on a beach. By the way in which he has positioned the figures, Homer suggests rather than spells out greater emotional depths than initially meet the eye. The sense of restrained drama occurs elsewhere in his work, while

▣ **17.31** Martin Johnson Heade. *Lake George,* 1862. Oil on canvas, 26″ × 49¾″ (68 × 126.3 cm). Museum of Fine Arts, Boston (bequest of Maxim Karolik). Note the smooth surface of the painting, which reveals no trace of the artist's brush strokes, and the extreme precision of the rendering of the rocks at right.

▣ **17.32** Winslow Homer. *Eagle Head, Manchester, Massachusetts,* 1870. Oil on canvas, 26″ × 38″ (66 × 96.5 cm). Metropolitan Museum of Art, New York (gift of Mrs. William F. Milton, 1923). This painting, produced after Homer's visit to France, shows a new, more Impressionistic approach to light and sea.

❖ **17.33** Thomas Eakins. *The Swimming Hole,* 1885. Oil on canvas, 27⅜″ × 36⅜″ (69.5 × 92.4 cm). Amon Carter Museum, Fort Worth, Texas, acquired by the Friends of Art, Fort Worth Art Association, 1925. Presented to the Amon Carter Museum, 1990, by the Modern Art Museum of Fort Worth through grants and donations from the Amon G. Carter Foundation, the Sid W. Richardson Foundation, the Anne Burnett and Charles Tandy Foundation, Capital Cities/ABC Foundation, *Fort Worth Star-Telegram,* The R. D. and Joan Dale Hubbard Foundation, and the people of Fort Worth. Eakins painted figures directly from models placed in poses from Greek sculpture in order to try to see nature as the Greeks saw it, but without the Greeks' idealization. The figure swimming in the bottom-right-hand corner is Eakins.

the sea became a growing obsession with him and provided virtually the only subject of his last works.

Thomas Eakins used Realism as a means of achieving objective truth. His pursuit of scientific accuracy led him to make a particular study of the possibilities of photography. Animals and, more particularly, humans in motion continually fascinated him. This trait can be observed in *The Swimming Hole* [**FIG. 17.33**], where the variety of poses and actions produces a series of individual anatomical studies rather than a unified picture.

In his own day Eakins' blunt insistence on accuracy of perception did not endear him to a public that demanded more glamorous art. Yet if many of his works seem essentially anti-Romantic in spirit, foreshadowing as they do the age of mechanical precision, in his portraits he returns to the Romantic tradition of expressing emotions by depicting them. The sitter in *Miss Van Buren* [**FIG. 17.34**], as in most of his portraits,

turns her eyes away from us, rapt in profound inner contemplation. The artist's own emotional response to the mood of his subject is made visible in his painting.

Painters such as Homer and Eakins, like Whitman and other writers discussed here, are important in the history of American culture not only for the value of their individual works. Their achievements demonstrated that American society could at last produce creative figures capable of absorbing the European cultural experience without losing their individuality.

SUMMARY

The Rise of Nationalism The revolutionary changes that ushered in the nineteenth century, and that were to continue throughout it, profoundly affected society

■ **17.34** Thomas Eakins. *Miss Van Buren,* c. 1889–1891. Oil on canvas, 45″ × 32″ (114 × 81 cm). Phillips Collection, Washington, D.C. Note how, in contrast to the portraits by Ingres (Figure 17.18) and Copley (Figure 17.28), Eakins achieves deep feeling and sensitivity by the angle of his subject's head and her position in the chair.

and culture. The industrialization of Europe produced vast changes in the lifestyles of millions of people. The Greek struggle for independence, the unification of Italy and of Germany, and the nationalist revolutionary uprisings of 1848 in many parts of Europe all radically changed the balance of power and the nature of society. The same period further saw the gradual assertion of the United States, tested and tried by its own civil war, as one of the leading Western nations. By the end of the nineteenth century, America had not only established itself as a world power, but it had also produced artists, writers, and musicians who created works with an authentically American spirit.

Intellectual Ferment: Darwin and Marx A period of such widespread change was naturally also one of major intellectual ferment. The political philosophy of Karl Marx and the scientific speculations of Charles Darwin, influential in their day, remain powerful and controversial in the present. The optimism of Immanuel Kant and Friedrich Hegel and the pessimism of Arthur Schopenhauer were reflected in numerous works of art.

Romanticism in the Arts The artistic movement that developed alongside these ideas was Romanticism. The Romantics, for all their divergences, shared several common concerns. They sought to express their personal feelings in their works rather than search for some kind of abstract philosophical or religious "truth." They were attracted by the fantastic and the exotic and by worlds remote in time (the Middle Ages) or in place (the mysterious Orient). Many of them felt a special regard for nature, in the context of which human achievement seemed so reduced. For some, on

the other hand, the new age of industry and technology was exotic and exciting. Many Romantic artists identified with the nationalist movements of the times and either supported their own country's fight for freedom (as in the case of Verdi) or championed the cause of others (as did Lord Byron).

Beethoven and His Successors In music the transition from the Classical to the Romantic style can be heard in the works of Ludwig van Beethoven. With roots deep in the Classical tradition, Beethoven used music to express emotion in a revolutionary way, pushing traditional forms like the sonata to their limits. Typical of the age is his concern with freedom, which appears in *Fidelio* (his only opera), and human unity, as expressed in the last movement of the *Ninth Symphony.*

Many of Beethoven's successors in the field of instrumental music continued to use symphonic forms for their major works. Among the leading symphonists of the century were Hector Berlioz, Johannes Brahms, and Anton Bruckner. Other composers—Franz Schubert and Robert Schumann—although they wrote symphonies, were more at home in the intimate world of songs and chamber music. The Romantic emphasis on personal feelings and the display of emotion encouraged the development of another characteristic of nineteenth-century music: the virtuoso composer-performer.

Frédéric Chopin, Franz Liszt, and Niccolò Paganini all won international fame performing their own works. The nationalist spirit of the times was especially appealing to musicians who could draw on a rich tradition of folk music. The Russian Modest Moussorgsky and the Czech Bedrich Smetana both wrote works using national themes and folktunes.

Wagner and Verdi The world of opera was dominated by two giants: Giuseppe Verdi and Richard Wagner. The former took the forms of early-nineteenth-century opera and used them to create powerful and dramatic masterpieces. An enthusiastic supporter of Italy's nationalist movement, Verdi never abandoned the basic elements of the Italian operatic tradition—expressive melody and vital rhythm—but he infused these with new dramatic truth. Wagner's quest for "music drama" led him in a different direction. His work breaks with the operatic tradition of individual musical numbers; the music, in which the orchestra plays an important part, runs continuously from the beginning to the end of each act. In addition, the use of leading motifs to represent characters or ideas makes possible complex dramatic effects. Wagner's works revolutionized the development of both operatic and nonoperatic music, and his theoretical writings on music and much else made him one of the nineteenth century's leading cultural figures.

Romanticism and Realism in Nineteenth-Century Painting Just as Beethoven spanned the transition from Classical to Romantic in music, so Francisco Goya, some of whose early works were painted in the rococo style, produced some of the most powerful of Romantic paintings. His concern with justice and liberty, as illustrated in *Execution of the Madrileños on May 3, 1808,* and with the world of dreams, as in *The Sleep of Reason Produces Monsters,* was prototypical of much Romantic art.

In France, painters were divided into two camps. The fully committed Romantics included Théodore Géricault, also concerned to point out injustice, and Eugéne Delacroix, whose work touched on virtually every aspect of romanticism: nationalism, exoticism, eroticism. The other school was that of the Realists. Honoré Daumier's way of combating the corruption of his day was to portray it as graphically as possible. In the meantime, Ingres waged his campaign against both progressive movements by continuing to paint in the academic Neo-Classical style of the preceding century—or at least his version of it.

The World of Nature Painters in England and Germany were particularly attracted by the Romantic love of nature. Caspar David Friedrich used the grandeur of the natural world to underline the transitoriness of human achievement, while in John Constable's landscapes there is greater harmony between people and their surroundings. Joseph M. W. Turner, Constable's contemporary, falls into a category by himself. Although many of his subjects were Romantic, his use of form and color make light and movement the real themes of his paintings.

From Neo-Classicism to Romanticism in Literature: Goethe In literature no figure dominated his time more than Johann Wolfgang von Goethe, the German poet, dramatist, and novelist. One of the first writers to break the fetters of Neo-Classicism, he nonetheless continued to produce Neo-Classical works as well as more Romantic ones. The scale of his writings runs from the most intimate love lyrics to the monumental two parts of his *Faust* drama.

The Romantic Poets and the Novel The work of the English Romantic poets William Wordsworth, Percy Bysshe Shelley, John Keats, and Lord Byron touched on all the principal Romantic themes. Other English writers used the novel as a means of expressing their concern with social issues, as in the case of Charles Dickens, or their absorption with strong emotion, as did Emily Brontë. Indeed, the nineteenth century was the great age of the novel, with Honoré de Balzac and Gustave Flaubert writing in France and above all Leo Tolstoy in Russia.

The Nineteenth Century in America The Romantic Era was the first period in which American artists cre-

ated their own original styles rather than borrow them from Europe. Love of nature inspired writers like Henry David Thoreau and painters like Thomas Cole. The description of strong emotions, often personal ones, characterizes the poetry of Walt Whitman and many of the paintings of Winslow Homer. Thomas Eakins, with his interest in Realism, used a nineteenth-century invention that had an enormous impact on the visual arts: photography.

By the end of the century the audience for art of all kinds had expanded immeasurably. No longer commissioned by the church or the aristocracy, artworks expressed the hopes and fears of individual artists and of humanity at large. Furthermore, as the revolutionaries of the eighteenth century had dreamed, they had helped bring about social change.

Key Terms

Adagio The Italian word for "very slow;" used by composers to indicate the speed at which music should be played.

Antithesis See *synthesis*

Bel canto Italian for "beautiful singing;" term applied to a school of early nineteenth-century opera

Gesamtkunstwerk German term invented by Wagner meaning "complete art work" to describe his combination of music, poetry, the visual arts and movement in a single work.

Intermezzo The Italian word for "interlude." Originally used to describe a short musical piece between two longer ones, or between two acts of an opera, it became used by some Romantic composers to describe a short independent composition.

Lieder The German word for "songs," generally used to describe songs set to a German text

Luminism School of landscape painting that developed in mid-nineteenth-century America

Mazurka A Polish folk-dance in fast triple time

Natural selection According to Charles Darwin, the process of evolution by which some variations of each species die out, while others survive

Nocturne Short, dreamy piece of music, generally for solo piano. Invented by the Irish composer John Field, it was popularized by Chopin.

Polonaise A stately Polish processional dance, frequently performed at weddings and public ceremonies

Prelude Originally a short opening section of a longer piece (it was used in this way by Bach). Composers in the Romantic era also used it to describe a short independent piece.

Scherzo The Italian word for "joke." Beethoven first employed the term for the third, more light-hearted movement of his symphonies, and composers continued to use it either to describe a similar movement in a symphony or for an independent piece.

Sturm und Drang German for "Storm and Stress." A late-eighteenth-century German literary school that rejected Neo-Classicism and emphasized emotions and protest against established authority.

Synthesis A philosophical theory developed by Hegel, which aimed to achieve a balance between *thesis*, the world of humans, which he called "pure, infinite being," and *antithesis*, the world of nature.

Thesis See *synthesis*

Tonality The characteristic of most music written between the seventeenth and twentieth centuries to be anchored around a fixed key and mode (i.e., major or minor), from which it can move but to which it eventually returns

Transcendentalists An American literary school of the nineteenth century that emphasized the transcendental unity of humans and nature

Pronunciation Guide

Balzac:	Bal-ZAK
Berlioz:	BARE-li-owes
Bruckner:	BROOK-ner
Chios:	KEY-os
Chopin:	Show-PAN
Courbet:	Coor-BAY
Daumier:	Doe-MYAY
Delacroix:	De-la-KRWA
Eakins:	ACHE-ins
Fidelio:	Fi-DAY-li-owe
Géricault:	Jay-rick-OWE
Goethe:	GUR-te
Ingres:	ANG
Kant:	CANT
leitmotiv:	LITE-mow-teef
Liebestod:	LEE-bis-tote
Liszt:	LIST
Moussorgsky:	Mus-ORG-ski
Nabucco:	Na-BOO-ko
Sardanapalus:	Sar-dan-AP-al-us
scherzo:	SCARE-tsow
Schopenhauer:	SHOWP-en-how-er
Thoreau:	Thoh-ROW
Traviata:	Tra-vi-AH-ta
Wagner:	VAHG-ner
Waldstein:	VALD-stine

YOUR RESOURCES

* **ExploringHumanities CD-ROM**
 * Reading Selections: Balzac, *Old Goriot;* Keats, selected works; Dickens, *Hard Times;* Darwin, *On the Origin of the Species*
* **Website http://art.wadsworth.com/cunningham**
 * Chapter 17 Quiz
 * Links
* **Audio CD**
 * Beethoven: *Piano Sonata in C minor, Op. 13 "Pathetique,"* III
 * Beethoven: *Symphony No. 5,* I
 * Berlioz: *Symphonie Fantastique,* V
 * Verdi: *La Traviata*-Act One aria, *Ah Fors'e lui*
 * Wagner: *The Ride of the Valkyries*

EXERCISES

1. Analyze the elements of the Romantic style and compare its effect on the various arts.
2. Discuss the career of Beethoven and assess his influence on the development of music in the nineteenth century.
3. What were the principal schools of French Romantic painting? Who were their leaders? What kinds of subjects did they choose? Explain why.
4. Which factors—historical, cultural, social—favored the popularity of the novel in the nineteenth century? How do they compare to present conditions? What is the current status of the novel?
5. Discuss the American contribution to the Romantic movement.

FURTHER READING

Ackroyd, P. *Dickens.* London: Minerva Press, 1991. A magnificently realized rounded portrait of the great novelist by an author who is one of the leading novelists of our times.

Barker, Juliet. *The Brontës.* London, Phoenix Books, 1995. A thoughtful biography of some of the most beloved writers of the nineteenth century, which meticulously examines, and in many cases dismisses, many of the standard accounts of the Brontë sisters.

Cairns, D. *Berlioz: The Making of an Artist.* London: Sphere Books, 1989. See comments below.

Cairns, D. *Berlioz: Servitude and Greatness.* New York: Penguin, 1999. In this book and its predecessor (see above), Cairns provides an astonishingly vivid picture of nineteenth-century cultural life. We meet several figures including Delacroix and Ingres, Flaubert and George Sand, and musicians Rossini, Verdi, and Wagner.

Chu, Petra ten-Doesschate. *Nineteenth-Century European Art.* New York: Abrams, 2003. A fine recent survey with excellent illustrations.

Cooper, Barry. *Beethoven.* New York: Oxford University Press, 2000. An important recent study of Beethoven and his music, written as a continuous chronological narrative, combining the composer's life and works.

Davidoff, L., and C. Hall. (1991). *Family Fortunes: Men and Women of the English Middle Class, 1780–1850.* Chicago: University of Chicago Press, 1991. An important study of social developments during a crucial period in the evolution of the modern world.

Eisenmann, S. E. *Nineteenth-Century Art: A Critical History.* New York: Thames & Hudson, 1994. A good general survey, with excellent illustrations.

Eisler, Benita. *Byron: Child of Passion, Fool of Fame.* New York: Penguin, 1999. A spellbinding account of the supreme embodiment of Romanticism, which untangles Byron's tortuous love life, while providing valuable comments on his poetry.

Magee, Brian. *The Tristan Chord: Wagner and Philosophy.* New York: Henry Holt, 2000. In examining Wagner's philosophy, this fascinating book discusses many of the important intellectual developments of the nineteenth century—from revolutionary socialism to Schopenhauer.

Miller, A. L. *The Empire of the Eye: Landscape Representation and American Colonial Politics.* Ithaca, NY: Cornell University Press, 1993. An absorbing study of the way in which art served as a political instrument in the American expansion westward and the subsequent forging of national unity.

Newbold, Brian. *Schubert: The Music and the Man.* London: Gollancz, 1999. An eloquent introduction to Schubert and his world, describing his tragically short life and illuminating the richness of the music.

Porterfield, Todd. *The Allure of Empire: Art in the Service of French Imperialism 1798–1836.* Princeton, NJ: Princeton University Press, 1998. A study of art in the Napoleonic and post-Napoleonic years and the part it played in the political developments of the period.

Robb, Graham. *Victor Hugo.* London: Macmillan, 1998. An exciting account of what must have been an exciting life, told against the background of tumultuous events: the Revolutions of 1830 and 1848, and the rise and fall of Napoleon III.

READING SELECTIONS

KARL MARX AND FRIEDRICH ENGELS
from THE COMMUNIST MANIFESTO

The Communist Manifesto was written jointly by Marx and Engels in 1848, to serve as a program for a secret workingmen's society, the Communist League, but subsequently became the core of all Communist doctrine. The translation that appears below was done by Samuel F. Moore under the supervision of Engels.

Proletarians and Communists

In what relation do the Communists stand to the proletarians as a whole?

The Communists do not form a separate party opposed to other working-class parties.

They have no interests separate and apart from those of the proletariat as a whole.

They do not set up any sectarian principles of their own, by which to shape and mould the proletarian movement.

The Communists are distinguished from the other working-class parties by this only: 1. In the national struggles of the proletarians of the different countries, they point out and bring to the front the common interests of the entire proletariat independently of all nationality. 2. In the various stages of development which the struggle of the working class against the bourgeoisie has to pass through, they always and everywhere represent the interests of the movement as a whole.

The Communists, therefore, are on the one hand, practically, the most advanced and resolute section of the working-class parties of every country, that section which pushes forward all others; on the other hand, theoretically, they have over the great mass of the proletariat the advantage of clearly understanding the line of march, the conditions, and the ultimate general results of the proletarian movement.

The immediate aim of the Communists is the same as that of all the other proletarian parties; formation of the proletariat into a class, overthrow of the bourgeois supremacy, conquest of political power by the proletariat.

The theoretical conclusions of the Communists are in no way based on ideas or principles that have been invented, or discovered, by this or that would-be universal reformer.

They merely express, in general terms, actual relations springing from an existing class struggle, from a historical movement going on under our very eyes. The abolition of existing property relations is not at all a distinctive feature of Communism.

All property relations in the past have continually been subject to historical change consequent upon the change in historical conditions.

The French Revolution, for example, abolished feudal property in favor of bourgeois property.

The distinguishing feature of Communism is not the abolition of property generally, but the abolition of bourgeois property. But modern bourgeois private property is the final and most complete expression of the system of producing and appropriating products, that is based on class antagonism, on the exploitation of the many by the few.

In this sense, the theory of the Communists may be summed up in the single sentence: Abolition of private property.

We Communists have been reproached with the desire of abolishing the right of personally acquiring property as the fruit of a man's own labor, which property is alleged to be the ground work of all personal freedom, activity and independence.

Hard-won, self-acquired, self-earned property! Do you mean the property of the petty artisan and of the small peasant, a form of property that preceded the bourgeois form? There is no need to abolish that; the development of industry has to a great extent already destroyed it, and is still destroying it daily.

Or do you mean modern bourgeois private property?

But does wage-labor create any property for the laborer? Not a bit. It creates capital, i.e., that kind of property which exploits wage-labor, and which cannot increase except upon condition of getting a new supply of wage-labor for fresh exploitation. Property, in its present form, is based on the antagonism of capital and wage-labor. Let us examine both sides of this antagonism.

To be a capitalist, is to have not only a purely personal, but a social status in production. Capital is a collective product, and only by the united action of many members, nay, in the last resort, only by the united action of all members of society, can it be set in motion.

Capital is therefore not a personal, it is a social power.

When, therefore, capital is converted into common property, into the property of all members of society, personal property is not thereby transformed into social property. It is only the social character of the property that is changed. It loses its class-character. . . .

Abolition of the family! Even the most radical flare up at this infamous proposal of the Communists.

On what foundation is the present family, the bourgeois family, based? On capital, on private gain. In its completely developed form this family exists only among the bourgeoisie. But this state of things finds its complement in the practical absence of the family among the proletarians, and in public prostitution.

The bourgeois family will vanish as a matter of course when its complement vanishes, and both will vanish with the vanishing of capital.

Do you charge us with wanting to stop the exploitation of children by their parents? To this crime we plead guilty.

But, you will say, we destroy the most hallowed of relations, when we replace home education by social.

And your education! Is not that also social, and determined by the social conditions under which you educate, by the intervention, direct or indirect, of society by means of schools, etc.? The Communists have not invented the intervention of society in education; they do but seek to alter the character of that intervention, and to rescue education from the influence of the ruling class.

The bourgeois clap-trap about the family and education, about the hallowed co-relation of parent and child, becomes all the more disgusting, the more, by the action of Modern Industry, all family ties among the proletarians are torn asunder, and their children transformed into simple articles of commerce and instruments of labor.

But you Communists would introduce community of women, screams the whole bourgeoisie in chorus.

The bourgeois sees in his wife a mere instrument of production. He hears that the instruments of production are to be exploited in common, and, naturally, can come to no other conclusion, than that the lot of being common to all will likewise fall to the women.

He has not even a suspicion that the real point aimed at is to do away with the status of women as mere instruments of production.

For the rest, nothing is more ridiculous than the virtuous indignation of our bourgeois at the community of women which, they pretend, is to be openly and officially established by the Communists. The Communists have no need to introduce community of women; it has existed almost from time immemorial.

Our bourgeois, not content with having the wives and daughters of their proletarians at their disposal, not to speak of common prostitutes, take the greatest pleasure in seducing each other's wives.

Bourgeois marriage is in reality a system of wives in common and thus, at the most, what the Communists might possibly be reproached with, is that they desire to introduce, in substitution for a hypocritically concealed, an openly legalized community of women. For the rest, it is self-evident, that the abolition of the present system of production must bring with it the abolition of the community of women

springing from that system, i.e., of prostitution both public and private.

The Communists are further reproached with desiring to abolish countries and nationalities.

The working men have no country. We cannot take from them what they have not got. Since the proletariat must first of all acquire political supremacy, must rise to be the leading class of the nation, must constitute itself the nation, it is, so far, itself national, though not in the bourgeois sense of the word.

National differences, and antagonisms between peoples, are daily more and more vanishing, owing to the development of the bourgeoisie, to freedom of commerce, to the world-market, to uniformity in the mode of production and in the conditions of life corresponding thereto.

The supremacy of the proletariat will cause them to vanish still faster. United action, of the leading civilized countries at least, is one of the first conditions for the emancipation of the proletariat.

In proportion as the exploitation of one individual by another is put an end to, the exploitation of one nation by another will also be put an end to. In proportion as the antagonism between classes within the nation vanishes, the hostility of one nation to another will come to an end.

The charges against Communism made from a religious, a philosophical, and generally, from an ideological standpoint, are not deserving of serious examination.

Does it require deep intuition to comprehend that man's ideas, views, and conceptions, in one word, man's consciousness, changes with every change in the conditions of his material existence, in his social relations and in his social life?

What else does the history of ideas prove, than that intellectual production changes in character in proportion as material production is changed? The ruling ideas of each age have ever been the ideas of its ruling class.

When people speak of ideas that revolutionize society, they do but express the fact, that within the old society, the elements of a new one have been created, and that the dissolution of the old ideas keeps even pace with the dissolution of the old conditions of existence. . . .

The Communists turn their attention chiefly to Germany, because that country is on the eve of a bourgeois revolution, that is bound to be carried out under more advanced conditions of European civilization, and with a more developed proletariat, than that of England was in the seventeenth, and of France in the eighteenth century, and because the bourgeois revolution in Germany will be but the prelude to an immediately following proletarian revolution.

In short, the Communists everywhere support every revolutionary movement against the existing social and political order of things.

In all these movements they bring to the front, as the leading question in each, the property question, no matter what its degree of development at the time.

Finally, they labor everywhere for the union and agreement of the democratic parties of all countries.

The Communists disdain to conceal their views and aims. They openly declare that their ends can be attained only by the forcible overthrow of all existing social conditions. Let the ruling classes tremble at a Communistic revolution. The proletarians have nothing to lose but their chains. They have a world to win.

Working men of all countries, unite!

WILLIAM WORDSWORTH
TINTERN ABBEY

The principal theme of Wordsworth's poetry—the relation between humans and nature—emerges in "Lines Composed a Few Miles Above Tintern Abbey on Revisiting the Banks of the Wye During a Tour," written in 1798, which describes the poet's reactions in his return to the place he had visited five years earlier. After describing the scene, he recalls the joy its memory has brought to him in the intervening years (lines 23–49). This in turn brings to mind the passage of time in his own life (lines 65–88) and the importance that the beauty of nature has always had for him (lines 88–111). The last part of the poem shows ho his love of nature has illuminated his relationships with other human beings, in this case his beloved sister. The complete thought processes are expressed in the simplest language. In contrast to such eighteenth-century poets as Alexander Pope the words are straightforward and there are no learned biblical, classical, or even literary references.

Five years have past: five summers, with the length
Of five long winters! and again I hear
These waters, rolling from their mountain-springs
With a soft inland murmur.—Once again
Do I behold these steep and lofty cliffs,
That on a wild secluded scene impress
Thoughts of more deep seclusion: and connect
The landscape with the quiet of the sky.
The day is come when I again repose
Here, under this dark sycamore, and view　　　　　　10
These plots of cottage-ground, these orchard-tufts,
Which at this season, with their unripe fruits,
Are clad in one green hue, and lose themselves
'Mid groves and copses. Once again I see
These hedge-rows, hardly hedge-rows, little lines
Of sportive wood run wild: these pastoral farms,
Green to the very door; and wreaths of smoke
Sent up, in silence, from among the trees!
With some uncertain notice, as might seem
Of vagrant dwellers in the houseless woods,　　　　20
Or of some Hermit's cave, where by his fire
The Hermit sits alone.
　　　　These beauteous forms,
Through a long absence, have not been to me
As is a landscape to a blind man's eye:
But oft, in lonely rooms, and 'mid the din
Of towns and cities, I have owed to them.
In hours of weariness, sensations sweet,
Felt in the blood, and felt along the heart;
And passing even into my purer mind.　　　　　　30
With tranquil restoration:—feelings too
Of unremembered pleasure: such, perhaps,
As have no slight or trivial influence
On that best portion of a good man's life,
His little, nameless, unremembered, acts
Of kindness and of love. Nor less, I trust,
To them I may have owed another gift,
Of aspect more sublime; that blessed mood,
In which the burthen [burden] of the mystery,
In which the heavy and the weary weight　　　　　40
Of all this unintelligible world,
Is lightened:—that serene and blessed mood,
In which the affections gently lead us on,—
Until, the breath of this corporeal frame
And even the motion of our human blood
Almost suspended, we are laid asleep
In body, and become a living soul:
While with an eye made quiet by the power
Of harmony, and the deep power of joy,
We see into the life of things.　　　　　　　　　50
　　　　If this
Be but a vain belief, yet, oh! how oft—
In darkness and amid the many shapes
Of joyless daylight; when the fretful stir
Unprofitable, and the fever of the world,
Have hung upon the beatings of my heart—

How oft, in spirit, have I turned to thee,
O sylvan Wye! thou wanderer thro' the woods,
How often has my spirit turned to thee!
And now, with gleams of half-extinguished thought,
With many recognitions dim and faint,　　　　　　　　　60
And somewhat of a sad perplexity,
The picture of the mind revives again:
While here I stand, not only with the sense
Of present pleasure, but with pleasing thoughts
That in this moment there is life and food
For future years. And so I dare to hope,
Though changed, no doubt, from what I was when first
I came among these hills; when like a roe
I bounded o'er the mountains, by the sides
Of the deep rivers, and the lonely streams,
Wherever nature led: more like a man　　　　　　　　　70
Flying from something that he dreads than one
Who sought the thing he loved. For nature then
(The coarser pleasures of my boyish days,
And their glad animal movements all gone by)
To me was all in all.—I cannot paint
What then I was. The sounding cataract
Haunted me like a passion: the tall rock,
The mountain, and the deep and gloomy wood,
Their colors and their forms, were then to me
An appetite; a feeling and a love,　　　　　　　　　　80
That had no need of a remoter charm,
By thought supplied, nor any interest
Unborrowed from the eye.—That time is past,
And all its aching joys are now no more,
And all its dizzy raptures. Not for this
Faint I, nor mourn nor murmur; other gifts
Have followed; for such loss, I would believe,
Abundant recompense. For I have learned
To look on nature, not as in the hour
Of thoughtless youth; but hearing oftentimes　　　　　90
The still, sad music of humanity,
Nor harsh nor grating, though of ample power
To chasten and subdue. And I have felt
A presence that disturbs me with the joy
Of elevated thoughts; a sense sublime
Of something far more deeply interfused,
Whose dwelling is the light of setting suns,
And the round ocean and the living air,
And the blue sky, and in the mind of man:
A motion and a spirit, that impels　　　　　　　　　　100
All thinking things, all objects of all thought,
And rolls through all things. Therefore am I still
A lover of the meadows and the woods,
And mountains; and of all that we behold
From this green earth; of all the mighty world
Of eye, and ear,—both what they half create,
And what perceive; well pleased to recognize
In nature and the language of the sense
The anchor of my purest thoughts, the nurse,
The guide, the guardian of my heart, and soul　　　110
Of all my moral being.
　　　　　　Nor perchance,
If I were not thus taught, should I the more
Suffer my genial spirits to decay:
For thou art with me here upon the banks
Of this fair river; thou my dearest Friend,
My dear, dear Friend; and in thy voice I catch
The language of my former heart, and read
My former pleasures in the shooting lights
Of thy wild eyes. Oh! yet a little while
May I behold in thee what I was once,　　　　　　　120
My dear, dear Sister! and this prayer I make,
Knowing that Nature never did betray

The heart that loved her; 'tis her privilege,
Through all the years of this our life, to lead
From joy to joy: for she can so inform
The mind that is within us, so impress
With quietness and beauty, and so feed
With lofty thoughts, that neither evil tongues,
Rash judgments, nor the sneers of selfish men,
Nor greetings where no kindness is, nor all　　　　130
The dreary intercourse of daily life,
Shall e'er prevail against us, or disturb
Our cheerful faith, that all which we behold
Is full of blessings. Therefore let the moon
Shine on thee in thy solitary walk;
And let the misty mountain-winds be free
To blow against thee; and, in after years,
When these wild ecstasies shall be matured
Into a sober pleasure; when thy mind
Shall be a mansion for all lovely forms,　　　　　　140
Thy memory be as a dwelling-place
For all sweet sounds and harmonies; oh! then,
If solitude, or fear, or pain, or grief,
Should be thy portion, with what healing thoughts
Of tender joy wilt thou remember me,
And these my exhortations! Nor, perchance—
If I should be where I no more can hear
Thy voice, nor catch from thy wild eyes these gleams
Of past existence—wilt thou then forget
That on the banks of this delightful stream　　　　150
We stood together; and that I, so long
A worshipper of Nature, hither came
Unwearied in that service: rather say
With warmer love—oh! with far deeper zeal
Of holier love. Nor wilt thou then forget
That after many wanderings, many years
Of absence, these steep woods and lofty cliffs,
And this green pastoral landscape, were to me
More dear, both for themselves and for thy sake!

PERCY BYSSHE SHELLEY

The first of these two poems illustrates Shelley's ability to capture intense emotions by the use of the simplest of language. Without any overstatement and with direct, uncomplicated images the poem makes an impression out of all proportion to its length.

In the second poem, Shelley sounds deeper and more resonant chords. Ozymandias was the Greek name for the mighty Egyptian Pharaoh Ramses II, and Shelley uses the image of his shattered statue to symbolize the impermanence of human achievement.

To——

Music, when soft voices die,
Vibrates in the memory;
Odors, when sweet violets sicken,
Live within the sense they quicken.
Rose leaves, when the rose is dead,
Are heaped for the beloved's bed;
And so thy thoughts, when thou art gone,
Love itself shall slumber on.

Ozymandias

I met a traveler from an antique land
Who said: Two vast and trunkless legs of stone
Stand in the desert . . . Near them, on the sand,
Half sunk, a shattered visage lies, whose frown,
And wrinkled lip, and sneer of cold command,
Tell that its sculptor well those passions read
Which yet survive, stamped on these lifeless things
The hand that mocked them and the heart that fed:

And on the pedestal these words appear:
"My name is Ozymandias, king of kings: 10
Look on my works, ye Mighty, and despair!"
Nothing beside remains. Round the decay
Of that colossal wreck, boundless and bare
The lone and level sands stretch far away.

JOHN KEATS
ODE TO A NIGHTINGALE

Keats wrote this poem while living in Hampstead (London), and his companion, Charles Brown, left an account of the circumstances of its composition: "In the spring of 1819 a nightingale had built her nest near my house. Keats felt a tranquil and continual joy in her song; and one morning he took his chair from the breakfast table to the grass plot under a plum-tree where he sat for two or three hours. When he came into the house, I perceived he had some scraps of paper in his hand. . . ."

The song of the bird serves as inspiration for a meditation on the nature of human experience. The poem begins in despondency as Keats (only age twenty-four, but already stricken by tuberculosis) broods on life's sorrows. As he muses, the immortal song and the beauty of nature is represents console him, bringing comfort and release, and he accepts his tragic fate. He died less than two years later.

I

My heart aches, and a drowsy numbness pains
My sense, as though of hemlock I had drunk,
Or emptied some dull opiate to the drains
One minute past, and Lethe-wards had sunk:
'Tis not through envy of thy happy lot,
But being too happy in thine happiness,—
That thou, light-winged Dryad of the trees,
In some melodious plot
Of beechen green, and shadows numberless,
Singest of summer in full-throated ease. 10

II

O, for a draught of vintage! that hath been
Cool'd a long age in the deep-delved earth,

Tasting of Flora and the country green,
Dance, and Provençal song, and sunburnt mirth!
O for a beaker full of the warm South,
Full of the true, the blushful Hippocrene,
With beaded bubbles winking at the brim,
And purple-stainèd mouth;
That I might drink, and leave the world unseen,
And with thee fade away into the forest dim: 20

III

Fade far away, dissolve, and quite forget
What thou among the leaves hast never known,
The weariness, the fever, and the fret
Here, where men sit and hear each other groan;
Where palsy shakes a few, sad, last gray hairs,
Where youth grows pale, and spectre-thin, and dies;
Where but to think is to be full of sorrow
And leaden-eyed despairs,
Where Beauty cannot keep her lustrous eyes,
Or new Love pine at them beyond tomorrow. 30

IV

Away! away! for I will fly to thee,
Not charioted by Bacchus and his pards [leopards],
But on the viewless wings of Poesy,
Though the dull brain perplexes and retards:

Already with thee! tender is the night,
And haply the Queen-Moon is on her throne,
Cluster'd around by all her starry Fays;
But here there is no light,
Save what from heaven is with the breezes blown
Through verdurous glooms and winding mossy ways. 40

V

I cannot see what flowers are at my feet,
Nor what soft incense hangs upon the boughs,
But, in embalmed darkness, guess each sweet
Wherewith the seasonable month endows
The grass, the thicket, and the fruit-tree wild;
White hawthorn, and the pastoral eglantine;
Fast fading violets cover'd up in leaves;
And mid-May's eldest child,
The coming musk-rose, full of dewy wine,
The murmurous haunt of flies on summer eves. 50

VI

Darkling I listen: and, for many a time
I have been half in love with easeful Death,
Call'd him soft names in many a musèd rhyme,
To take into the air my quiet breath;
Now more than ever seems it rich to die,
To cease upon the midnight with no pain,
While thou art pouring forth thy soul abroad
In such an ecstasy!
Still wouldst thou sing, and I have ears in vain—
To thy high requiem become a sod. 60

VII

Thou wast not born for death, immortal Bird!
No hungry generations tread thee down;
The voice I hear this passing night was heard
In ancient days by emperor and clown:
Perhaps the self-same song that found a path
Through the sad heart of Ruth, when, sick for home,
She stood in tears amid the alien corn;
The same that oft-times hath
Charm'd magic casements, opening on the foam
Of perilous seas, in faery lands forlorn. 70

VIII

Forlorn! the very word is like a bell
To toll me back from thee to my sole self!
Adieu! the fancy cannot cheat so well
As she is fam'd to do, deceiving elf.
Adieu! adieu! thy plaintive anthem fades
Past the near meadows, over the still stream,
Up the hill-side; and now 'tis buried deep
In the next valley-glades.
Was it a vision, or a waking dream?
Fled is that music:—Do I wake or sleep? 80

CHARLES DICKENS
from OLIVER TWIST, *Chapters 1 and 2*

Although Dickens also wrote short stories, he needed the large canvas of the novel to do justice to his genius. The opening chapters of Oliver Twist, *which appeared in serial form between 1837 and 1839, reveal the author's passionate anger at the conditions of the poor and underprivileged. The publication of this and other novels by Dickens played a significant part in arousing public indignation, and led to reform of institutions like the workhouse. The last scene in this extract, in which Oliver asks for more, provides a powerful instance of Dickens' ability to find an unforgettable image, while the blend of comedy and anger is also characteristically Dickensian.*

Chapter I

Treats of the Place where Oliver Twist was Born; and of the Circumstances attending his Birth

Among other public buildings in a certain town, which for many reasons it will be prudent to refrain from mentioning, and to which I will assign no fictitious name, there is one anciently common to most towns, great or small; to wit, a workhouse: and in this workhouse was born: on a day and date which I need not trouble myself to repeat, inasmuch as it can be of no possible consequence to the reader, in this stage of the business at all events: the item of mortality whose name is prefixed to the head of this chapter.

For a long time after it was ushered into this world of sorrow and trouble, by the parish surgeon, it remained a matter of considerable doubt whether the child would survive to bear any name at all, in which case it is somewhat more than probable that these memoirs would never have appeared; or, if they had, that being comprised within a couple of pages, they would have possessed the inestimable merit of being the most concise and faithful specimen of biography, extant in the literature of any age or country.

Although I am not disposed to maintain that the being born in a workhouse, is in itself the most fortunate and enviable circumstance that can possibly befall a human being, I do mean to say that in this particular instance, it was the best thing for Oliver Twist that could by possibility have occurred. The fact is, that there was considerable difficulty in inducing Oliver to take upon himself the office of respiration—a troublesome practice, but one which custom has rendered necessary to our easy existence; and for some time he lay gasping on a little flock mattress, rather unequally poised between this world and the next: the balance being decidedly in favor of the latter. Now, if, during this brief period, Oliver had been surrounded by careful grandmothers, anxious aunts, experienced nurses, and doctors of profound wisdom, he would most inevitably and indubitably have been killed in no time. There being nobody by, however, but a pauper old woman, who was rendered rather misty by an unwonted allowance of beer; and a parish surgeon who did such matters by contract; Oliver and Nature fought out the point between them. The result was, that, after a few struggles, Oliver breathed, sneezed, and proceeded to advertise to the inmates of the workhouse the fact of a new burden having been imposed upon the parish, by setting up as loud a cry as could reasonably have been expected from a male infant who had not been possessed of that very useful appendage, a voice, for a much longer space of time than three minutes and a quarter.

As Oliver gave this first proof of the free and proper action of his lungs, the patchwork coverlet which was carelessly flung over the iron bedstead, rustled; the pale face of a young woman was raised feebly from the pillow; and a faint voice imperfectly articulated the words, "Let me see the child, and die."

The surgeon had been sitting with his face turned towards the fire: giving the palms of his hands a warm and a rub alternately. As the young woman spoke, he rose, and advancing to the bed's head, said, with more kindness than might have been expected of him:

"Oh, you must not talk about dying yet."

"Lor' bless her dear heart, no!" interposed the nurse, hastily depositing in her pocket a green glass bottle, the contents of which she had been tasting in a corner with evident satisfaction. "Lor' bless her dear heart, when she has lived as long as I have, sir, and had thirteen children of her own, and all on 'em dead except two, and them in the wurkus with me, she'll know better than to take on in that way, bless her dear heart!

Think what it is to be a mother, there's a dear young lamb, do."

Apparently this consolatory perspective of a mother's prospect failed in producing its due effect. The patient shook her head, and stretched out her hand towards the child.

The surgeon deposited it in her arms. She imprinted her cold white lips passionately on its forehead; passed her hands over her face; gazed wildly round; shuddered; fell back and died. They chafed her breast, hands, and temples; but the blood had stopped for ever. They talked of hope and comfort. They had been strangers too long.

"It's all over, Mrs. Thingummy!" said the surgeon at last.

"Ah, poor dear, so it is!" said the nurse, picking up the cork of the green bottle, which had fallen out on the pillow, as she stooped to take up the child. "Poor dear!"

"You needn't mind sending up to me, if the child cries, nurse," said the surgeon, putting on his gloves with great deliberation. "It's very likely it *will* be troublesome. Give it a little gruel if it is." He put on his hat, and, pausing by the bedside on his way to the door, added "She was a good-looking girl, too; where did she come from?"

"She was brought here last night," replied the old woman, "by the overseer's order. She was found lying in the street. She had walked some distance, for her shoes were worn to pieces; but where she came from, or where she was going to, nobody knows."

The surgeon leaned over the body, and raised the left hand. "The old story," he said, shaking his head; "no wedding-ring, I see. Ah! Good night!"

The medical gentleman walked away to dinner; and the nurse, having once more applied herself to the green bottle, sat down on a low chair before the fire, and proceeded to dress the infant.

What an excellent example of the power of dress, young Oliver Twist was! Wrapped in the blanket which had hitherto formed his only covering, he might have been the child of a nobleman or a beggar; it would have been hard for the haughtiest stranger to have assigned him his proper station in society. But now that he was enveloped in the old calico robes which had grown yellow in the same service, he was badged and ticketed, and fell into his place at once—a parish child—the orphan of a workhouse—the humble, half-starved drudge—to be cuffed and buffeted through the world—despised by all, and pitied by none.

Oliver cried lustily. If he could have known that he was an orphan, left to the tender mercies of church wardens and overseers, perhaps he would have cried the louder.

Chapter II

Treats of Oliver Twist's Growth, Education, and Board

For the next eight or ten months, Oliver was the victim of a systematic course of treachery and deception. He was brought up by hand. The hungry and destitute situation of the infant orphan was duly reported by the workhouse authorities to the parish authorities. The parish authorities inquired with dignity of the workhouse authorities whether there was no female then domiciled "in the house" who was in a situation to impart to Oliver Twist the consolation and nourishment of which he stood in need. The workhouse authorities replied with humility, that there was not. Upon this, the parish authorities magnanimously and humanely resolved, that Oliver should be "farmed," or, in other words, that he should be dispatched to a branch-workhouse some three miles off, where twenty or thirty other juvenile offenders against the poor-laws, rolled about the floor all day, without the inconvenience of too much food or too much clothing, under the parental superintendence of an elderly female, who received the culprits at and for the consideration of

sevenpence-halfpenny per small head per week. Sevenpence-halfpenny's worth per week is a good round diet for a child; a great deal may be got for sevenpence-halfpenny, quite enough to overload its stomach, and make it uncomfortable. The elderly female was a woman of wisdom and experience; she knew what was good for children; and she had a very accurate perception of what was good for herself. So, she appropriated the greater part of the weekly stipend to her own use, and consigned the rising parochial generation to even a shorter allowance than was originally provided for them. Thereby finding in the lowest depth a deeper still; and proving herself a very great experimental philosopher.

Everybody knows the story of another experimental philosopher who had a great theory about a horse being able to live without eating, and who demonstrated it so well, that he got his own horse down to a straw a day, and would unquestionably have rendered him a very spirited and rampageous animal on nothing at all, if he had not died, just four-and-twenty hours before he was to have had his first comfortable bait of air. Unfortunately for the experimental philosophy of the female to whose protecting care Oliver Twist was delivered over, a similar result usually attended the operation of *her* system; for at the very moment when a child had contrived to exist upon the smallest possible portion of the weakest possible food, it did perversely happen in eight and a half cases out of ten, either that it sickened from want and cold, or fell into the fire from neglect, or got half-smothered by accident; in any one of which cases, the miserable little being was usually summoned into another world, and there gathered to the fathers it had never known in this.

Occasionally, when there was some more than usually interesting inquest upon a parish child, who had been overlooked in turning up a bedstead, or inadvertently scalded to death when there happened to be a washing—though the latter accident was very scarce, anything approaching to a washing being of rare occurrence in the farm—the jury would take it into their heads to ask troublesome questions, or the parishioners would rebelliously affix their signatures to a remonstrance. But these impertinences were speedily checked by the evidence of the surgeon, and the testimony of the beadle; the former of whom had always opened the body and found nothing inside (which was very probable indeed), and the latter of whom invariably swore whatever the parish wanted; which was very self-devotional. Besides, the board made periodical pilgrimages to the farm, and always sent the beadle the day before, to say they were going. The children were neat and clean to behold, when *they* went; and what more would the people have!

It cannot be expected that this system of farming would produce any very extraordinary or luxuriant crop. Oliver Twist's ninth birthday found him a pale thin child, somewhat diminutive in stature, and decidedly small in circumference. But nature or inheritance had implanted a good sturdy spirit in Oliver's breast. It had had plenty of room to expand, thanks to the spare diet of the establishment; and perhaps to the circumstance may be attributed his having any ninth birthday at all. Be this as it may, however, it *was* his ninth birthday; and he was keeping it in the coal-cellar with a select party of two other young gentlemen, who, after participating with him in a sound thrashing, had been locked up therein for atrociously presuming to be hungry, when Mrs. Mann, the good lady of the house, was unexpectedly startled by the apparition of Mr. Bumble, the beadle, striving to undo the wicket of the garden-gate.

"Goodness gracious! Is that you, Mr. Bumble, Sir?" said Mrs. Mann, thrusting her head out of the window in well-affected ecstasies of joy.

"(Susan, take Oliver and them two brats up stairs and wash 'em directly.)—My heart alive! Mr. Bumble, how glad I am to see you, surely!"

Now, Mr. Bumble was a fat man, and a choleric; so, instead of responding to this open-hearted salutation in a kindred spirit, he gave the little wicket a tremendous shake, and then bestowed upon it a kick which could have emanated from no leg but a beadle's.

"Lor', only think," said Mrs. Mann, running out—for the three boys had been removed by this time—"only think of that! That I should have forgotten that the gate was bolted on the inside, on account of them dear children! Walk in, Sir; walk in, pray, Mr. Bumble, do, Sir."

Although this invitation was accompanied with a curtsey that might have softened the heart of a churchwarden, it by no means mollified the beadle.

"Do you think this respectful or proper conduct, Mrs. Mann," inquired Mr. Bumble, grasping his cane, "to keep the parish officers a waiting at your garden-gate, when they come here upon parochial business connected with the parochial orphans? Are you aweer, Mrs. Mann, that you are, as I may say, a parochial delegate, and a stipendiary?"

"I'm sure, Mr. Bumble, that I was only a telling one or two of the dear children as is so fond of you, that it was you a coming," replied Mrs. Mann with great humility.

Mr. Bumble had a great idea of his oratorical powers and his importance. He had displayed the one, and vindicated the other. He relaxed.

"Well, well, Mrs. Mann," he replied in a calmer tone; "it may be as you say; it may be. Lead the way in, Mrs. Mann, for I come on business, and have something to say."

Mrs. Mann ushered the beadle into a small parlor with a brick floor; placed a seat for him; and officiously deposited his cocked hat and cane on the table before him. Mr. Bumble wiped from his forehead the perspiration which his walk had engendered, glanced complacently at the cocked hat, and smiled. Yes, he smiled. Beadles are but men; and Mr. Bumble smiled.

"Now don't you be offended at what I'm going to say," observed Mrs. Mann, with captivating sweetness. "You've had a long walk, you know, or I wouldn't mention it. Now, will you take a little drop of somethink, Mr. Bumble?"

"Not a drop. Not a drop," said Mr. Bumble, waving his right hand in a dignified, but placid manner.

"I think you will," said Mrs. Mann, who had noticed the tone of the refusal, and the gesture that had accompanied it. "Just a leetle drop, with a little cold water, and a lump of sugar."

Mr. Bumble coughed.

"Now, just a leetle," said Mrs. Mann persuasively.

"What is it?" inquired the beadle.

"Why, it's what I'm obliged to keep a little of in the house, to put into the blessed infants' Daffy, when they ain't well, Mr. Bumble," replied Mrs. Mann as she opened a corner cupboard, and took down a bottle and glass. "It's gin. I'll not deceive you, Mr. B. It's gin."

"Do you give the children Daffy, Mrs. Mann?" inquired Bumble, following with his eyes the interesting process of mixing.

"Ah, bless 'em, that I do, dear as it is," replied the nurse. "I couldn't see 'em suffer before my very eyes, you know, Sir."

"No," said Mr. Bumble approvingly; "no, you could not. You are a humane woman, Mrs. Mann." (Here she set down the glass.) "I shall take a early opportunity of mentioning it to the board, Mrs. Mann." (He drew it towards him.) "You feel as a mother, Mrs. Mann." (He stirred the gin-and-water.) "I—I drink your health with cheerfulness, Mrs. Mann;" and he swallowed half of it.

"And now about business," said the beadle, taking out a leathern pocket-book. "The child that was half-baptized Oliver Twist, is nine year old today."

"Bless him!" interposed Mrs. Mann, inflaming her left eye with the corner of her apron.

"And notwithstanding a offered reward of ten pound, which was afterwards increased to twenty pound. Notwithstanding the most superlative, and, I may say, supernat'ral exertions on the part of this parish," said Bumble, "we have never been able to discover who is his father, or what was his mother's settlement, name, or condition."

Mrs. Mann raised her hands in astonishment; but added, after a moment's reflection, "How comes he to have any name at all, then?"

The beadle drew himself up with great pride, and said, "I inwented it."

"You, Mr. Bumble!"

"I, Mrs. Mann. We name our fondlins in alphabetical order. The last was a S,—Swubble, I named him. This was a T,—Twist, I named *him*. The next one as comes will be Unwin; and the next Vilkins. I have got names ready made to the end of the alphabet, and all the way through it again, when we come to Z."

"Why, you are quite a literary character, Sir!" said Mrs. Mann.

"Well, well," said the beadle, evidently gratified with the compliment; "perhaps I may be. Perhaps I may be, Mrs. Mann." He finished the gin-and-water, and added, "Oliver being now too old to remain here, the board have determined to have him back into the house. I have come out myself to take him there. So let me see him at once."

"I'll fetch him directly," said Mrs. Mann, leaving the room for that purpose. Oliver, having had by this time as much of the outer coat of dirt which encrusted his face and hands, removed, as could be scrubbed off in one washing, was led into the room by his benevolent protectress.

"Make a bow to the gentleman, Oliver," said Mrs. Mann.

Oliver made a bow, which was divided between the beadle on the chair, and the cocked-hat on the table.

"Will you go along with me, Oliver?" said Mr. Bumble, in a majestic voice.

Oliver was about to say that he would go along with anybody with great readiness, when, glancing upwards, he caught sight of Mrs. Mann, who had got behind the beadle's chair, and was shaking her fist at him with a furious countenance. He took the hint at once, for the first had been too often impressed upon his body not to be deeply impressed upon his recollection.

"Will *she* go with me?" inquired poor Oliver.

"No, she can't," replied Mr. Bumble. "But she'll come and see you sometimes."

This was no very great consolation to the child. Young as he was, however, he had sense enough to make a feint of feeling great regret at going away. It was no very difficult matter for the boy to call the tears into his eyes. Hunger and recent ill-usage are great assistants if you want to cry; and Oliver cried very naturally indeed. Mrs. Mann gave him a thousand embraces, and, what Oliver wanted a great deal more, a piece of bread and butter, lest he should seem too hungry when he got to the workhouse. With the slice of bread in his hand, and the little brown-cloth parish cap on his head, Oliver was then led away by Mr. Bumble from the wretched home where one kind word or look had never lighted the gloom of his infant years. And yet he burst into an agony of childish grief, as the cottage-gate closed after him. Wretched as were the little companions in misery he was leaving behind, they were the only friends he had ever known; and a sense of his loneliness in the great wide world, sank into the child's heart for the first time.

Mr. Bumble walked on with long strides; little Oliver, firmly grasping his gold-laced cuff, trotted beside him, inquiring at the end of every quarter of a mile whether they were "nearly there." To these interrogations, Mr. Bumble returned very brief and snappish replies; for the temporary blandness which gin-and-water awakens in some bosoms had by this time evaporated; and he was once again a beadle.

Oliver had not been within the walls of the workhouse a quarter of an hour, and had scarcely completed the demolition of a second slice of bread, when Mr. Bumble, who had handed him over to the care of an old woman, returned; and, telling him it was a board night, informed him that the board had said he was to appear before it forthwith.

Not having a very clearly defined notion of what a live board was, Oliver was rather astounded by this intelligence, and was not quite certain whether he ought to laugh or cry. He had no time to think about the matter, however; for Mr. Bumble gave him a tap on the head, with his cane, to wake him up: and another on the back to make him lively: and bidding him follow, conducted him into a large whitewashed room, where eight or ten fat gentlemen were sitting round a table. At the top of the table, seated in an arm-chair rather higher than the rest, was a particularly fat gentleman with a very round, red face.

"Bow to the board," said Bumble. Oliver brushed away two or three tears that were lingering in his eyes; and seeing no board but the table, fortunately bowed to that.

"What's your name, boy?" said the gentleman in the high chair.

Oliver was frightened at the sight of so many gentlemen, which made him tremble: and the beadle gave him another tap behind, which made him cry. These two causes made him answer in a very low and hesitating voice; whereupon a gentleman in a white waistcoat said he was a fool. Which was a capital way of raising his spirits, and putting him quite at his ease.

"Boy," said the gentleman in the high chair, "listen to me. You know you're an orphan, I suppose?"

"What's that, Sir?" inquired poor Oliver.

"The boy *is* a fool—I thought he was," said the gentleman in the white waistcoat.

"Hush!" said the gentleman who had spoken first. "You know you've got no father or mother, and that you were brought here by the parish, don't you?"

"Yes, Sir," replied Oliver, weeping bitterly.

"What are you crying for?" inquired the gentleman in the white waistcoat? And to be sure, it was very extraordinary. What *could* the boy be crying for?

"I hope you say your prayers every night," said another gentleman in a gruff voice; "and pray for the people who feed you, and take care of you—like a Christian."

"Yes, Sir," stammered the boy. The gentleman who spoke last was unconsciously right. It would have been very like a Christian, and a marvelously good Christian too, if Oliver had prayed for the people who fed and took care of *him*. But he hadn't, because nobody had taught him.

"Well! You have come here to be educated, and taught a useful trade," said the red-faced gentleman in the high chair.

"So you'll begin to pick oakum tomorrow morning at six o'clock," added the surly one in the white waistcoat.

For the combination of both these blessings in the one simple process of picking oakum, Oliver bowed low by the direction of the beadle, and was then hurried away to a large ward: where, on a rough hard bed, he sobbed himself to sleep. What a noble illustration of the tender laws of England! They let the paupers go to sleep!

Poor Oliver! He little thought, as he lay sleeping in happy unconsciousness of all around him, that the board had that very day arrived at a decision which would exercise the most material influence over all his future fortunes. But they had. And this was it:—

The members of this board were very sage, deep, philosophical men; and when they came to turn their attention to the workhouse, they found out at once, what ordinary folks would never have discovered—the poor people liked it! It was a regular place of public entertainment for the poorer classes; a tavern where there was nothing to pay; a public breakfast, dinner, tea, and supper all the year round; a brick and mortar elysium, where it was all play and no work. "Oho!" said the board, looking very knowing; "we are the fellows to set this to rights; we'll stop it all, in no time." So, they established the rule, that all poor people should have the alternative (for they would compel nobody, not they), of being starved by a gradual process in the house, or by a quick one out of it. With this view, they contracted with the works to lay on an unlimited supply of water; and with a corn-factor to supply periodically small quantities of oatmeal; and issued three meals of thin gruel a day, with an onion twice a week, and half a roll on Sundays. They made a great many other wise and humane regulations, having reference to the ladies, which it is not necessary to repeat; kindly undertook to divorce poor married people, in consequence of the great expense of a suit in Doctors' Commons; and, instead of compelling a man to support his family, as they theretofore had done, took his family away from him, and made him a bachelor! There is no saying how many applicants for relief under these last two heads, might have started up in all classes of society, if it had not been coupled with the workhouse; but the board were long-headed men, and had provided for this difficulty. The relief was inseparable from the workhouse and the gruel; and that frightened people.

For the first six months after Oliver Twist was removed, the system was in full operation. It was rather expensive at first, in consequence of the increase in the undertaker's bill, and the necessity of taking in the clothes of all the paupers, which fluttered loosely on their wasted, shrunken forms, after a week or two's gruel. But the number of workhouse inmates got thin as well as the paupers; and the board were in ecstasies.

The room in which the boys were fed, was a large stone hall, with a copper at one end: out of which the master, dressed in an apron for the purpose, and assisted by one or two women, ladled the gruel at mealtimes. Of this festive composition each boy had one porringer, and no more—except on occasions of great public rejoicing, when he had two ounces and a quarter of bread besides. The bowls never wanted washing. The boys polished them with their spoons till they shown again; and when they had performed this operation (which never took very long, the spoons being nearly as large as the bowls), they would sit staring at the copper, with such eager eyes, as if they could have devoured the very bricks of which it was composed; employing themselves, meanwhile, in sucking their fingers most assiduously, with the view of catching up any stray splashes of gruel that might have been cast thereon. Boys have generally excellent appetites. Oliver Twist and his companions suffered the tortures of slow starvation for three months; at last they got so voracious and wild with hunger, that one boy, who was tall for his age, and hadn't been used to that sort of thing (for his father had kept a small cookshop), hinted darkly to his companions, that unless he had another basin of gruel *per diem*, he was afraid he might some night happen to eat the boy who slept next him, who happened to be a weakly youth of tender age. He

had a wild, hungry eye; and they implicitly believed him. A council was held; lots were cast who should walk up to the master after supper that evening, and ask for more; and it fell to Oliver Twist.

The evening arrived; the boys took their places. The master, in his cook's uniform, stationed himself at the copper; his pauper assistants ranged themselves behind him; the gruel was served out; and a long grace was said over the short commons. The gruel disappeared; the boys whispered each other, and winked at Oliver; while his next neighbors nudged him. Child as he was, he was desperate with hunger, and reckless with misery. He rose from the table; and advancing to the master, basin and spoon in hand, said: somewhat alarmed at his own temerity:

"Please, Sir, I want some more."

The master was a fat, healthy man; but he turned very pale. He gazed in stupefied astonishment on the small rebel for some seconds, and then clung for support to the copper. The assistants were paralyzed with wonder; the boys with fear.

"What!" said the master at length, in a faint voice.

"Please, Sir," replied Oliver, "I want some more."

The master aimed a blow at Oliver's head with the ladle; pinioned him in his arms; and shrieked aloud for the beadle.

The board were sitting in solemn conclave, when Mr. Bumble rushed into the room in great excitement, and addressing the gentleman in the high chair, said,

"Mr. Limbkins, I beg your pardon, Sir! Oliver Twist has asked for more!"

There was a general start. Horror was depicted on every countenance.

"For *more!*" said Mr. Limbkins. "Compose yourself, Bumble, and answer me distinctly. Do I understand that he asked for more, after he had eaten the supper allotted by the dietary?"

"He did, Sir," replied Bumble.

"That boy will be hung," said the gentleman in the white waistcoat. "I know that boy will be hung."

Nobody controverted the prophetic gentleman's opinion. An animated discussion took place. Oliver was ordered into instant confinement; and a bill was next morning pasted on the outside of the gate, offering a reward of five pounds to anybody who would take Oliver Twist off the hands of the parish. In other words, five pounds and Oliver Twist were offered to any man or woman who wanted an apprentice to any trade, business or calling.

"I never was more convinced of anything in my life," said the gentleman in the white waistcoat, as he knocked at the gate and read the bill next morning: "I never was more convinced of anything in my life, than I am, that that boy will come to be hung."

As I purpose to show in the sequel whether the white-waistcoated gentleman was right or not, I should perhaps mar the interest of this narrative (supposing it to possess any at all), if I ventured to hint, just yet, whether the life of Oliver Twist had this violent termination or no.

LEO TOLSTOY
"THE THREE HERMITS"

Tolstoy is best known for his vast historical novel, War and Peace, *but throughout his life he also wrote short stories. The following story, which dates to the end of his career, shows Tolstoy's interest in the spiritual, represented by the three hermits who transcend conventional religion. Tolstoy himself spent his last years in a mystical search for enlightenment, "leaving this worldly life in order to live out my days in peace and solitude."*

*And in praying use not vain repetitions, as the Gentiles do:
for they think that they shall be heard for their much speak-
ing. Be not therefore like them; for your Father knoweth
what things ye have need of, before ye ask Him.*

Matthew vi: 7,8.

A Bishop was sailing from Archangel to the Solovétsk Monastery, and on the same vessel were a number of pilgrims on their way to visit the shrines at that place. The voyage was a smooth one. The wind favorable and the weather fair. The pilgrims lay on deck, eating, or sat in groups talking to one another. The Bishop, too, came on deck, and as he was pacing up and down he noticed a group of men standing near the prow and listening to a fisherman, who was pointing to the sea and telling them something. The Bishop stopped, and looked in the direction in which the man was pointing. He could see nothing, however, but the sea glistening in the sunshine. He drew nearer to listen, but when the man saw him, he took off his cap and was silent. The rest of the people also took off their caps and bowed.

"Do not let me disturb you, friends," said the Bishop. "I came to hear what this good man was saying."

"The fisherman was telling us about the hermits," replied one, a tradesman, rather bolder than the rest.

"What hermits?" asked the Bishop, going to the side of the vessel and seating himself on a box. "Tell me about them. I should like to hear. What were you pointing at?"

"Why, that little island you can just see over there," answered the man, pointing to a spot ahead and a little to the right. "That is the island where the hermits live for the salvation of their souls."

"Where is the island?" asked the Bishop. "I see nothing."

"There, in the distance, if you will please look along my hand. Do you see that little cloud? Below it, and a bit to the left, there is just a faint streak. That is the island."

The Bishop looked carefully, but his unaccustomed eyes could make out nothing but the water shimmering in the sun.

"I cannot see it," he said. "But who are the hermits that live there?"

"They are holy men," answered the fisherman. "I had long heard tell of them, but never chanced to see them myself till the year before last."

And the fisherman related how once, when he was out fishing, he had been stranded at night upon that island, not knowing where he was.

In the morning, as he wandered about the island, he came across an earth hut, and met an old man standing near it. Presently two others came out, and after having fed him and dried his things, they helped him mend his boat.

"And what are they like?" asked the Bishop.

"One is a small man and his back is bent. He wears a priest's cassock and is very old; he must be more than a hundred, I should say. He is so old that the white of his beard is taking a greenish tinge, but he is always smiling, and his face is as bright as an angel's from heaven. The second is taller, but he also is very old. He wears a tattered peasant coat. His beard is broad, and of a yellowish gray color. He is a strong man. Before I had time to help him, he turned my boat over as if it were only a pail. He too is kindly and cheerful. The third is tall, and has a beard as white as snow and reaching to his knees. He is stern, with overhanging eyebrows; and he wears nothing but a piece of matting tied round his waist."

"And did they speak to you?" asked the Bishop.

"For the most part they did everything in silence, and spoke but little even to one another. One of them would just give a glance, and the others would understand him. I asked the tallest whether they had lived there long. He frowned, and muttered something as if he were angry; but the oldest one took his hand and smiled, and then the tall one was quiet. The oldest one only said: 'Have mercy upon us,' and smiled."

While the fisherman was talking, the ship had drawn nearer to the island.

"There, now you can see it plainly, if your Lordship will please to look," said the tradesman, pointing with his hand.

The Bishop looked, and now he really saw a dark streak—which was the island. Having looked at it a while, he left the prow of the vessel, and going to the stern, asked the helmsman:

"What island is that?"

"That one," replied the man, "has no name. There are many such in this sea."

"Is it true that there are hermits who live there for the salvation of their souls?"

"So it is said, your Lordship, but I don't know if it's true. Fishermen say they have seen them; but of course they may only be spinning yarns."

"I should like to land on the island and see these men," said the Bishop. "How could I manage it?"

"The ship cannot get close to the island," replied the helmsman, "but you might be rowed there in a boat. You had better speak to the captain."

The captain was sent for and came.

"I should like to see these hermits," said the Bishop. "Could I not be rowed ashore?"

The captain tried to dissuade him.

"Of course it could be done," said he, "but we should lose much time. And if I might venture to say so to your Lordship, the old men are not worth your pains. I have heard say that they are foolish old fellows, who understand nothing, and never speak a word, any more than the fish in the sea."

"I wish to see them," said the Bishop, "and I will pay you for your trouble and loss of time. Please let me have a boat."

There was no help for it; so the order was given. The sailors trimmed the sails, the steersman put up the helm, and the ship's course was set for the island. A chair was placed at the prow for the Bishop, and he sat there, looking ahead. The passengers all collected at the prow, and gazed at the island. Those who had the sharpest eyes could presently make out the rocks on it, and then a mud hut was seen. At last one man saw the hermits themselves. The captain brought a telescope and, after looking through it, handed it to the Bishop.

"It's right enough. There are three men standing on the shore. There, a little to the right of that big rock."

The Bishop took the telescope, got it into position, and he saw the three men: a tall one, a shorter one, and one very small and bent, standing on the shore and holding each other by the hand.

The captain turned to the Bishop.

"The vessel can get no nearer in than this, your Lordship. If you wish to go ashore, we must ask you to go in the boat, while we anchor here."

The cable was quickly let out; the anchor cast, and the sails furled. There was a jerk, and the vessel shook. Then, a boat having been lowered, the oarsmen jumped in, and the Bishop descended the ladder and took his seat. The men pulled at their oars and the boat moved rapidly towards the island. When they came within a stone's throw, they saw three old men: a tall one with only a piece of matting tied round his waist: a shorter one in a tattered peasant coat, and a very old one bent with age and wearing an old cassock—all three standing hand in hand.

The oarsmen pulled in to the shore, and held on with the boathook while the Bishop got out.

The old men bowed to him, and he gave them his blessing, at which they bowed still lower. Then the Bishop began to speak to them.

"I have heard," he said, "that you, godly men, live here saving your own souls and praying to our Lord Christ for your fellow men. I, an unworthy servant of Christ, am called, by God's mercy, to keep and teach His flock. I wished to see you, servants of God, and to do what I can to teach you, also."

The old men looked at each other smiling, but remained silent.

"Tell me," said the Bishop, "what you are doing to save your souls, and how you serve God on this island."

The second hermit sighed, and looked at the oldest, the very ancient one. The latter smiled, and said:

"We do not know how to serve God. We only serve and support ourselves, servant of God."

"But how do you pray to God?" asked the Bishop.

"We pray in this way," replied the hermit. "Three are ye, three are we, have mercy upon us."

And when the old man said this, all three raised their eyes to heaven, and repeated:

"Three are ye, three are we, have mercy upon us!"

The Bishop smiled.

"You have evidently heard something about the Holy Trinity," said he. "But you do not pray aright. You have won my affection, godly men. I see you wish to please the Lord, but you do not know how to serve Him. That is not the way to pray; but listen to me, and I will teach you. I will teach you, not a way of my own, but the way in which God in the Holy Scriptures has commanded all men to pray to Him."

And the Bishop began explaining to the hermits how God had revealed Himself to men; telling them of God the Father, and God the Son, and God the Holy Ghost.

"God the Son came down to the earth," said he, "to save men, and this is how He taught us all to pray. Listen, and repeat after me: 'Our Father.'"

And the first old man repeated after him, "Our Father," and the second said, "Our Father," and the third said, "Our Father."

"Which art in heaven," continued the Bishop.

The first hermit repeated, "Which art in heaven," but the second blundered over the words, and the tall hermit could not say them properly.

His hair had grown over his mouth so that he could not speak plainly. The very old hermit, having no teeth, also mumbled indistinctly.

The Bishop repeated the words again, and the old men repeated them after him. The Bishop sat down on a stone, and the old men stood before him, watching his mouth, and repeating the words as he uttered them. And all day long the Bishop labored, saying a word twenty, thirty, a hundred times over, and the old men repeated it after him. They blundered, and he corrected them, and made them begin again.

The Bishop did not leave off till he had taught them the whole of the Lord's Prayer so that they could not only repeat it after him, but could say it by themselves. The middle one was the first to know it, and to repeat the whole of it alone. The Bishop made him say it again and again, and at last the others could say it too.

It was getting dark and the moon was appearing over the water, before the Bishop rose to return to the vessel. When he took leave of the old men they all bowed down to the ground before him. He raised them, and kissed each of them, telling them to pray as he had taught them.

Then he got into the boat and returned to the ship.

And as he sat in the boat and was rowed to the ship he could hear the three voices of the hermits loudly repeating the Lord's Prayer. As the boat drew near the vessel their voices could no longer be heard, but they could still be seen in the moonlight, standing as he had left them on the shore, the shortest in the middle, the tallest on the right, the middle one on the left. As soon as the Bishop had reached the vessel and got on board, the anchor was weighed and the sails unfurled. The wind filled them and the ship sailed away, and the Bishop took a seat in the stern and watched the island they had left. For a time he could still see the hermits, but presently they disappeared from sight, though the island was still visible. At last it too vanished, and only the sea was to be seen, rippling in the moonlight.

The pilgrims lay down to sleep, and all was quiet on deck. The Bishop did not wish to sleep, but sat alone at the stern, gazing at the sea where the island was no longer visible, and thinking of the good old men. He thought how pleased they had been to learn the Lord's Prayer; and he thanked God for having sent him to teach and help such godly men.

So the Bishop sat, thinking, and gazing at the sea where the island had disappeared. And the moonlight flickered before his eyes, sparkling, now here, now there, upon the waves. Suddenly he saw something white and shining, on the bright path which the moon cast across the sea.

Was it a seagull, or the little gleaming sail of some small boat? The Bishop fixed his eyes on it, wondering.

"It must be a boat sailing after us," thought he, "but it is overtaking us very rapidly. It was far, far away a minute ago, but now it is much nearer. It cannot be a boat, for I can see no sail; but whatever it may be, it is following us and catching us up."

And he could not make out what it was. Not a boat, nor a bird, nor a fish! It was too large for a man, and besides a man could not be out there in the midst of the sea. The Bishop rose, and said to the helmsman:

"Look there, what is that, my friend? What is it?" the Bishop repeated, though he could now see plainly what it was—the three hermits running upon the water, all gleaming white, their gray beards shining, and approaching the ship as quickly as though it were not moving.

The steersman looked, and let go the helm in terror.

"Oh, Lord! The hermits are running after us on the water as though it were dry land!"

The passengers, hearing him, jumped up and crowded to the stern. They saw the hermits coming along hand in hand, and the two outer ones beckoning the ship to stop. All three were gliding along upon the water without moving their feet. Before the ship could be stopped, the hermits had reached it, and raising their heads, all three as with one voice, began to say:

"We have forgotten your teaching, servant of God. As long as we kept repeating it we remembered, but when we stopped saying it for a time, a word dropped out, and now it has all gone to pieces. We can remember nothing of it. Teach us again."

The Bishop crossed himself, and leaning over the ship's side, said:

"Your own prayer will reach the Lord, men of God. It is not for me to teach you. Pray for us sinners."

And the Bishop bowed low before the old men; and they turned and went back across the sea. And a light shone until daybreak on the spot where they were lost to sight.

EDGAR ALLAN POE
"THE OVAL PORTRAIT"

Poe's first Tales of the Grotesque *were written as parodies—or so he claimed. Certainly the following story compresses an astonishing number of Romantic elements into a couple of pages: the*

gloomy castle, the mysterious picture seen by candlelight, the "vague and quaint" words of explanation, and the dramatic revelation of the story's last words. Yet if there is an element of self-consciousness in Poe's technique—every phrase adds another touch of mystery—few readers can resist the compelling atmosphere he creates.

The chateau in which my valet had ventured to make forcible entrance, rather than permit me, in my desperately wounded condition, to pass a night in the open air, was one of those piles of commingled gloom and grandeur which have so long frowned among the Apennines, not less in fact than in the fancy of Mrs. Radcliffe. To all appearance it had been temporarily and very lately abandoned. We established ourselves in one of the smallest and least sumptuously furnished apartments. It lay in a remote turret of the building. Its decorations were rich, yet tattered and antique. Its walls were hung with tapestry and bedecked with manifold and multiform armorial trophies, together with an unusually great number of very spirited modern paintings in frames of rich golden arabesque. In these paintings, which depended from the walls not only in their main surfaces, but in very many nooks which the bizarre architecture of the chateau rendered necessary—in these paintings my incipient delirium, perhaps, had caused me to take deep interest; so that I bade Pedro to close the heavy shutters of the room, since it was already night, to light the tongues of a tall candelabrum which stood by the head of the bed, and to throw open far and wide the fringed curtains of black velvet which enveloped the bed itself. I wished all this done that I might resign myself, if not to sleep, at least alternately to the contemplation of these pictures, and the perusal of a small volume which had been found upon the pillow, and which purported to criticize and explain them.

Long, long I read—and devoutly, devotedly I gazed. Rapidly and gloriously the hours flew by and the deep midnight came. The position of the candelabrum displeased me, and outreaching my hand with difficulty, rather than disturb my slumbering valet, I placed it so as to throw its rays more fully upon the book.

But the action produced an effect altogether unanticipated. The rays of the numerous candles (for there were many) now fell within a niche of the room which had hitherto been thrown into deep shade by one of the bed-posts. I thus saw in vivid light a picture all unnoticed before. It was the portrait of a young girl just ripening into womanhood. I glanced at the painting hurriedly, and then closed my eyes. Why I did this was not at first apparent even to my own perception. But while my lids remained thus shut, I ran over in my mind my reason for so shutting them.

It was an impulsive movement to gain time for thought, to make sure that my vision had not deceived me, to calm and subdue my fancy for a more sober and more certain gaze. In a very few moments I again looked fixedly at the painting.

That I now saw aright I could not and would not doubt; for the first flashing of the candles upon that canvas had seemed to dissipate the dreamy stupor which was stealing over my senses, and to startle me at once into waking life.

The portrait, as I have already said, was that of a young girl. It was a mere head and shoulders, done in what is technically termed a vignette manner, much in the style of the favorite heads of Sully. The arms, the bosom, and even the ends of the radiant hair melted imperceptibly into the vague yet deep shadow which formed the background of the whole. The frame was oval, richly gilded and filagreed in Moresque. As a thing of art nothing could be more admirable than the painting itself. But it could have been neither the execution of the work, nor the immortal beauty of the countenance, which had so suddenly and so vehemently moved me. Least of all, could it have been that my fancy, shaken from its half slumber, had mistaken the head for that of a living person. I saw at once that the peculiarities of the design, of the vignetting, and of the frame, must have instantly dispelled such idea—must have prevented even its momentary entertainment. Thinking earnestly upon these points, I remained, for an hour perhaps, half sitting, half reclining, with my vision riveted upon the portrait. At length, satisfied with the true secret of its effect, I fell back within the bed. I had found the spell of the picture in an absolute *life-likeness* of expression, which, at first startling, finally confounded, subdued, and appalled me. With deep and reverent awe I replaced the candelabrum in its former position. The cause of my deep agitation being thus shut from view, I sought eagerly the volume which discussed the paintings and their histories. Turning to the number which designated the oval portrait, I there read the vague and quaint words which follow:

She was a maiden of rarest beauty, and not more lovely than full of glee. And evil was the hour when she saw, and loved, and wedded the painter. He, passionate, studious, austere, and having already a bride in his Art: she a maiden of rarest beauty and not more lovely than full of glee; all light and smiles, and frolicsome as the young fawn; loving and cherishing all things; hating only the Art which was her rival; dreading only the palette and brushes and other untoward instruments which deprived her of the countenance of her lover. It was thus a terrible thing for this lady to hear the painter speak of his desire to portray even his young bride. But she was humble and obedient, and sat meekly for many weeks in the dark high turret-chamber where the light dripped upon the pale canvas only from overhead. But he, the painter, took glory in his work, which went on from hour to hour, and from day to day. And he was a passionate and wild, and moody man, who became lost in reveries; so that he *would* not see the light which fell so ghastly in that lone turret withered the health and the spirits of his bride, who pined visibly to all but him. Yet she smiled on and still on, uncomplainingly, because she saw that the painter (who has high renown) took a fervid and burning pleasure in his task, and wrought day and night to depict her who so loved him, yet who grew daily more dispirited and weak. And in sooth some who beheld the portrait spoke of its resemblance in low words, as of a mighty marvel, and a proof not less of the power of the painter than of his deep love for her whom he depicted so surpassingly well. But at length, as the labor drew nearer to its conclusion, there were admitted none into the turret; for the painter had grown wild with the ardor of his work, and turned his eyes from the canvas rarely, even to regard the countenance of his wife. And he *would* not see that the tints which he spread upon the canvas were drawn from the cheeks of her who sat beside him. And when many weeks had passed, and but little remained to do, save one brush upon the mouth and one tint upon the eye, the spirit of the lady again flickered up as the flame within the socket of the lamp. And then the brush was given, and then the tint was placed; and for one moment, the painter stood entranced before the work which he had wrought; but in the next, while he yet gazed, he grew tremulous and very pallid, and aghast, and crying with a loud voice, "This is indeed *Life* itself!" turned suddenly to regard his beloved—*She was dead.*

WALT WHITMAN
LEAVES OF GRASS, *Five Poems from* SONGS OF PARTING

The second and third of these poems date to 1865, the others to the 1860 edition of Leaves of Grass. *Between them they illustrate many of the characteristics of Whitman's poetry. The mood*

is optimistic, even when the poet contemplates his own end. America, with its Manifest Destiny, symbolizes hope for the world. Even the tragedy of the Civil War can teach a positive lesson.

The style is rhetorical, and Whitman uses the device of repetition to hammer home his message. Place names are given a magic ring. We are reminded again and again that these are songs, while always in the forefront is the poet himself, the ever-present I.

As the Time Draws Nigh

As the time draws nigh glooming a cloud,
A dread beyond of I know not what darkens me.

I shall go forth,
I shall traverse the States awhile, but I cannot tell whither
 or how long,
Perhaps soon some day or night while I am singing my
 voice will suddenly cease.

O book, O chants! must all then amount to but this?
Must we barely arrive at this beginning of us?—and yet
 it is enough, O soul;
O soul, we have positively appear'd—that is enough.

Years of the Modern

Years of the modern! years of the unperform'd!
Your horizon rises, I see it parting away for more august
 dramas,
I see not America only, not only Liberty's nation but other
 nations preparing,
I see tremendous entrances and exits, new combinations,
 the solidarity of races,
I see that force advancing with irresistible power on the
 world's stage,
(Have the old forces, the old wars, played their parts? are
 the acts suitable to them closed?)
I see Freedom, completely arm'd and victorious and very
 haughty, with Law on one side and Peace on the
 other,
A stupendous trio all issuing forth against the idea of
 caste;
What historic denouements are these we so rapidly
 approach?
I see men marching and countermarching by swift
 millions, 10
I see the frontiers and boundaries of the old aristocracies
 broken,
I see the landmarks of European kings removed,
I see this day the People beginning their landmarks, (all
 others give way;)
Never were such sharp questions ask'd as this day,
Never was average man, his soul, more energetic, more
 like a God,

Lo, how he urges and urges, leaving the masses no rest!
His daring foot is on land and sea everywhere, he
 colonizes the Pacific, the archipelagoes,
With the steamship, the electric telegraph, the newspaper,
 the wholesale engines of war,
With these and the world-spreading factories he inter-
 links all geography, all lands;
What whispers are these O lands, running ahead of you,
 passing under the seas? 20
Are all nations communing? is there going to be but one
 heart to the globe?
Is humanity forming en-masse? for lo, tyrants tremble,
 crowns grow dim,
The earth, restive, confronts a new era, perhaps a general
 divine war,

No one knows what will happen next, such portents fill
 the days and nights;
Years prophetical! the space ahead as I walk, as I vainly
 try to pierce it, is full of phantoms,
Unborn deeds, things soon to be, project their shapes
 around me,
This incredible rush and heat, this strange ecstatic fever
 of dreams O years!
Your dreams O years, how they penetrate through me! (I
 know not whether I sleep or wake;)
The perform'd America and Europe grow dim, retiring in
 shadow behind me,
The unperform'd, more gigantic than ever, advance,
 advance upon me. 30

Ashes of Soldiers

Ashes of soldiers South or North,
As I muse retrospective murmuring a chant in thought,
The war resumes, again to my sense your shapes,
And again the advance of the armies.

Noiseless as mists and vapors,
From their graves in the trenches ascending,
From cemeteries all through Virginia and Tennessee,
From every point of the compass out of the countless
 graves,
In wafted clouds, in myriads large, or squads of twos or
 threes or single ones they come,
And silently gather round me. 10

Now sound no note O trumpeters,
Not at the head of my cavalry parading on spirited
 horses,
With sabers drawn and glistening, and carbines by their
 thighs, (ah my brave horsemen!
My handsome tan-faced horsemen! what life, what joy
 and pride,
With all the perils were yours.)

Nor you drummers, neither at reveillé at dawn,
Nor the long roll alarming the camp, nor even the
 muffled beat for a burial,
Nothing from you this time O drummers bearing my
 warlike drums.

But aside from these and the marts of wealth and the
 crowded promenade,
Admitting around me comrades close unseen by the rest
 and voiceless, 20
The slain elate and alive again, the dust and debris alive,
I chant this chant of my silent soul in the name of all dead
 soldiers.
Faces so pale with wondrous eyes, very dear, gather
 closer yet,
Draw close, but speak not.

Phantoms of countless lost,
Invisible to the rest henceforth become my companions,
Follow me ever—desert me not while I live.
Sweet are the blooming cheeks of the living— sweet are
 the musical voices sounding,
But sweet, ah sweet, are the dead with their silent eyes.

Dearest comrades, all is over and long gone, 30
But love is not over—and what love, O comrades
Perfume from battle-fields rising, up from the foetor
 arising.
Perfume therefore my chant, O love, immortal love,
Give me to bathe the memories of all dead soldiers,
Shroud them, embalm them, cover them all over with
 tender pride.

Perfume all—make all wholesome,
Make these ashes to nourish and blossom,
O love, solve all, fructify all with the last chemistry.
Give me exhaustless, make me a fountain,
That I exhale love from me wherever I go like a moist
 perennial dew, 40
For the ashes of all dead soldiers South or North.

Thoughts

1

Of these years I sing,
How they pass and how pass'd through convuls'd pains,
 as through parturitions,
How America illustrates birth, muscular youth, the
 promise, the sure fulfilment, the absolute success,
 despite of people—illustrates evil as well as good,
The vehement struggle so fierce for unity in one's-self;
How many hold despairingly yet to the models departed,
 caste, myths, obedience, compulsion, and to
 infidelity,
How few see the arrived models, the athletes, the Western
 States, or see freedom or spirituality, or hold any
 faith in results,
(But I see the athletes, and I see the results of the war
 glorious and inevitable, and they again leading to
 other results.)

How the great cities appear—how the Democratic
 masses, turbulent, willful, as I love them,
How the whirl, the context, the wrestle of evil with good,
 the sounding and resounding, keep on and on,
How society waits unform'd, and is for a while 10
 between things ended and things begun,
How America is the continent of glories, and of the
 triumph of freedom and of the Democracies, and
 of the fruits of society, and of all that is begun,
And how the States are complete in themselves— and
 how all triumphs and glories are complete in them-
 selves, to lead onward,
And how these of mine and of the States will in their turn
 be convuls'd, and serve other parturitions and
 transitions,

And how all people, sights, combinations, the democratic
 masses too, serve—and how every fact, and war
 itself, with all its horrors, serves,
And how now or at any time each serves the exquisite
 transition of death.

2

Of seeds dropping into the ground, of births,
Of the steady concentration of America, inland, upward,
 to impregnable and swarming places,
Of what Indiana, Kentucky, Arkansas, and the rest, are
 to be,
Of what a few years will show there in Nebraska,
 Colorado, Nevada, and the rest,
(Or afar, mounting the Northern Pacific to Sitka or
 Alaska,)
Of what the feuilage of America is the preparation for—
 and of what all sights, North, South, East and
 West are,
Of this Union welded in blood, of the solemn price paid,
 of the unnamed lost ever present in my mind;
Of the temporary use of materials for identity's sake,
Of the present, passing, departing—of the growth of
 completer men than any yet,

Of all sloping down there where the fresh free giver the
 mother, the Mississippi flows, 10
Of mighty inland cities yet unsurvey'd and
 unsuspected,
Of the new and good names, of the modern develop-
 ments, of inalienable homesteads,
Of a free and original life there, of simple diet and clean
 and sweet blood,
Of litheness, majestic faces, clear eyes, and perfect
 physique there,
Of immense spiritual results future years far West, each
 side of the Anahuacs,
Of these songs, well understood there, (being made for
 that area,)
Of the native scorn of grossness and gain there,
(O it lurks in me night and day what is gain after all to
 savageness and freedom?)

Song at Sunset

Splendor of ended day floating and filling me,
Hour prophetic, hour resuming the past,
Inflating my throat, you divine average,
You earth and life till the last ray gleams I sing.

Open mouth of my soul uttering gladness,
Eyes of my soul seeing perfection,
Natural life of me faithfully praising things,
Corroborating forever the triumph of things.

Illustrious every one!
Illustrious what we name space, sphere of unnumber'd
 spirits, 10
Illustrious the mystery of motion in all beings, even the
 tiniest insect,
Illustrious the attribute of speech, the senses,
 the body,
Illustrious the passing light—illustrious the pale reflec-
 tion on the new moon in the western sky,
Illustrious whatever I see or hear or touch, to the last.

Good in all,
In the satisfaction and aplomb of animals,
In the annual return of the seasons,
In the hilarity of youth,
In the strength and flush of manhood,
In the grandeur and exquisiteness of old age, 20
In the superb vistas of death.

Wonderful to depart!
Wonderful to be here!
The heart, to jet the all-alike and innocent blood!
To breathe the air, how delicious!
To speak—to walk—to seize something by the hand!
To prepare for sleep, for bed, to look on my rose-color'd
 flesh!
To be conscious of my body, so satisfied, so large!
To be this incredible God I am!
To have gone forth among other Gods, these men and
 women I love. 30

Wonderful how I celebrate you and myself!
How my thoughts play subtly at the spectacles around!
How the clouds pass silently overhead!
How the earth darts on and on! and how the sun, moon,
 stars, dart on and on!
How the water sports and sings! (surely it is alive!)
How the trees rise and stand up, with strong trunks, with
 branches and leaves!
(Surely there is something more in each of the trees, some
 living soul.)

O amazement of things—even the least particle!
O spirituality of things!
O strain musical flowing through ages and continents,
 now reaching me and America! 40
I take your strong chords, intersperse them, and cheer-
 fully pass them forward.

I too carol the sun, usher'd or at noon, or as now, setting,
I too throb to the brain and beauty of the earth and of all
 the growths of the earth,
I too have felt the resistless call of myself.

As I steam'd down the Mississippi,
As I wander'd over the prairies,
As I have lived, as I have look'd through my windows
 my eyes,
As I went forth in the morning, as I beheld the light
 breaking in the east,
As I bathed on the beach of the Eastern Sea, and again on
 the beach of Western Sea,
As I roam'd the streets of inland Chicago, whatever
 streets I have roam'd, 50
Or cities or silent woods, or even amid the sights of war,
Wherever I have been I have charged myself with con-
 tentment and triumph.

I sing to the last the equalities modern or old,
I sing the endless finalés of things,
I say Nature continues, glory continues,
I praise with electric voice,
For I do not see one imperfection in the universe,
And I do not see one cause or result lamentable at last in
 the universe.

O setting sun! though the time has come,
I still warble under you, if none else does, unmitigated
 adoration. 60

EMILY DICKINSON
SIX POEMS

Feeling no pressure to publish, Dickinson developed a personal style which was remarkably free, intense, and idiomatic. Among her sources of inspiration were hymns and popular jingles. The following poems are short and easy to grasp, but have a power and emotional force out of all proportion to their simple form. Dickinson had the ability to find an image and make it vivid—the jewel in the second poem, the slanting light in the third. Yet her recurring theme is complex: the effect that our awareness of death has on our lives. For all the moments of happiness or hope, her vision is essentially a bleak one.

(125)

For each ecstatic
We must an anguish pay
In keen and quivering ratio
To the ecstasy.

For each beloved hour
Sharp pittances of years—
Bitter contested farthings
And Coffers heaped with Tears!
(c. 1859)

(245)

I held a Jewel in my fingers—
And went to sleep—
The day was warm, and winds were prosy—
I said "'Twill keep"

I woke—and chid my honest fingers,
The Gem was gone—
And now, an Amethyst remembrance
Is all I own.
(c. 1861)

(258)

There's a certain Slant of light,
Winter Afternoons—
That oppresses, like the Heft
Of Cathedral Tunes—

Heavenly Hurt, it gives us—
We can find no scar,
But internal difference,
Where the Meanings are—

None may teach it—Any—
'Tis the Seal Despair 10
An imperial Affliction
Sent us of the Air—

When it comes, the Landscape listens—
Shadows—hold their breath—
When it goes, 'tis like the Distance
On the look of Death—
(c. 1861)

(529)

I'm sorry for the Dead—Today—
It's such congenial times
Old Neighbors have at fences—
It's time o' year for Hay.

And Broad—Sunburned Acquaintance
Discourse between the Toil—
And laugh, a homely species
That makes the Fences smile—

It seems so straight to lie away
From all the noise of Fields— 10
The busy Carts—the fragrant Cocks—
The Mower's Metre—Steals

A Trouble lest they're homesick—
Those Farmers—and their Wives
Set Separate from the Farming—
And all the Neighbors' lives—

A Wonder if the Sepulchre
Don't feel a lonesome way—
When Men—and Boys—and Carts—and June,
Go down the Fields to "Hay"— 20
(c. 1862)

(712)

Because I could not stop for Death—
He kindly stopped for me—

The Carriage held but just Ourselves—
And Immortality.

We slowly drove—He knew no haste
And I had put away
My labor and my leisure too,
For His Civility—

We passed the School, where Children strove
At Recess—in the Ring—　　　　　　　　　10
We passed the Fields of Gazing Grain—
We passed the Setting Sun—

Or rather—He passed Us—
The Dews drew quivering and chill—
For only Gossamer, my Gown—
My Tippet—only Tulle—

We paused before a House that seemed
A Swelling of the Ground—
The Roof was scarcely visible—
The Cornice—in the Ground—　　　　　　20

Since then—'tis Centuries—and yet
Feels shorter than the Day
I first surmised the Horses' Heads
Were toward Eternity—
(c. 1863)

(760)

Elysium is as far as to
The very nearest Room
If in that Room a Friend await
Felicity or Doom—

What fortitude the Soul contains,
That it can so endure
The accent of a coming Foot—
The opening of a Door—
(c. 1882)

Reprinted by permission of the publishers and the Trustees of Amherst College from *The Poems of Emily Dickinson*, Thomas H. Johnston, editor, Cambridge, MA: The Belknap Press of Harvard University Press. Copyright 1951, 1955, 1979 by the President and Fellows of Harvard College.

	GENERAL EVENTS	LITERATURE & PHILOSOPHY	ART
1860			
			1863 Manet exhibits *Le Déjeuner sur l'Herbe* to public outrage
GROWTH OF BIG BUSINESS		**1866** Dostoyevsky, *Crime and Punishment*	**1869–1872** Degas, *Degas' Father Listening to Lorenzo Pagans Singing*
			1874 Impressionism emerges when Monet and others exhibit at Café Guerbois, Paris; *Impression: Sunrise* (1872)
		1870–1914 New areas explored in writing: impact of subconscious on human behavior, the role of women	**1875** Monet, *Red Boats at Argenteuil*
			1876 Renoir, *Le Moulin de la Galette*
	1876 Speech first transmitted through telephone by Alexander Graham Bell		**c. 1880** Postimpressionists reject impressionism
		1879 First performance of Ibsen's realistic drama, *A Doll's House*	**1882** Manet, *A Bar at the Folies-Bergère*
	1880–1914 Height of European colonialism	**1881** Death of Dostoyevsky	**1884–1886** Seurat, *A Sunday on La Grande Jatte*
		1883–1892 Nietzsche, *Thus Spoke Zarathustra*	**c. 1885** Protocubist experiments of Cézanne; *Still Life with Commode*
			1886 Rodin, *The Kiss*; Degas, *The Tub*
	1886 Dedication of Statue of Liberty, presented by France to America		**1888** van Gogh, *The Night Café*
	1889 International League of Socialist Parties founded		**1889** van Gogh, *The Starry Night*; Cassatt, *Mother and Child*
1890			
HEIGHT OF EUROPEAN COLONIALISM	**1890–1914** Industrialization of Russia	**1891** Shaw, drama critic for *Saturday Review*, champions Ibsen	**1891** Gauguin, *Ia Orana Maria*; Mary Cassatt's first solo exhibition in Paris
		1893 Wilde, *Salome*	**1893** Munch, *The Scream*; Rodin begins *Monument to Balzac*
		1894 Kate Chopin, *The Story of an Hour*	**1894–1898** Kollwitz, *March of the Weavers*, etching based on Hauptmann play
	1899–1902 Boer War	**1899** Kate Chopin, *The Awakening*	
1900			
RISE OF GERMAN MILITARY POWER	**1901** Death of Queen Victoria of England; reign of Edward VII begins; first message sent over Marconi's transatlantic wireless telegraph	**1900** Freud, *Interpretation of Dreams*	**c. 1904–1906** Cézanne paints last series of landscapes depicting *Mont Sainte-Victoire*
	1903 Wright brothers make first airplane flight		**1903–1913** German expressionist movement *Die Brücke*
	1904 Russo–Japanese War	**1904** Death of Chekhov	
	1905 First Revolution breaks out in Russia; Einstein formulates theory of relativity; first motion-picture theater opens in Pittsburgh		**1905** First Fauve exhibition in Paris; Matisse, *The Joy of Life* (1905–1906)
	1908 Model T touring car introduced by Ford		**1907–1914** Picasso and Braque develop cubism in Paris
	1911 Revolution in China establishes republic	**1913** Publication of *Swann's Way*, first volume of Proust's *Remembrance of Things Past*; final volume published posthumously (1927)	**1911** Matisse, *The Red Studio*; German expressionist group *Der Blaue Reiter* formed
	1914 World War I begins		
1914			

Most dates are approximate

ARCHITECTURE	MUSIC

1883 Birth of Gropius

1886 R. Strauss begins tone poem *Don Juan*

1890–1891 Sullivan, Wainwright Building, St. Louis, first skyscraper

1893 Tchaikovsky, *Pathetique Symphony,* precedes composer's suicide. Mahler's *Symphony No. 1 in D* marks transition from romantic to modern music

1894 Debussy, musical impressionist, composes *Prélude à l'après-midi d'un faune*

1895 R. Strauss, *Till Eulenspiegel*

1896 Puccini champions verismo in Italian opera; *La Bohème*

1899 R. Strauss, *A Hero's Life*

1900–1904 Puccini, *Tosca; Madama Butterfly*

1905 First performance of R. Strauss' opera *Salome,* based on Wilde's play; Debussy, *La Mer*

1905–1907 Gaudí, Casa Milá, Barcelona

1908 Schönberg, *Three Piano Pieces,* Op. 11, first major atonal work

1909 Nolde, *Pentecost;* Rodin, *Portrait of Mahler*

1909 Robie House, Chicago, Frank Lloyd Wright's first big success

1909–1910 Mahler, *Symphony No. 9*

1910–1913 Stravinsky composes *The Firebird, Petrouchka, Rite of Spring* for Diaghilev's Ballet Russe in Paris

1912 Heckel, *Two Men at a Table (To Dostoyevsky)*

1911–1915 R. Strauss, *Alpine Symphony*

1912 Schönberg, *Pierrot Lunaire*

1913 Ravel composes *Daphnis and Chloe* for Diaghilev

CHAPTER 18

TOWARD THE MODERN ERA: 1870–1914

istance lends perspective in human experience. The more intimately we are affected by events, the more difficult it is to evaluate them objectively. Looking back, we can see that the world in which we live—with its great hopes and even greater fears—began to take its present shape in the early years of the twentieth century. World War I (1914–1918) marked an end to almost three thousand years of European political and cultural supremacy as well as the beginning of a world in which events in any corner of the globe could—and still do—have immense consequences for good or ill for the entire human race. The effects on the humanities of so vast a change in direction are the subject of Chapters 21 and 22. Here we will consider some of the causes and early symptoms of the change.

Although the period in which the modern world was formed is the historical era that directly affects our daily lives, our cultural traditions go back to ancient Greece and Rome. Yet even if the cataclysmic events of the twentieth century did not destroy the value of centuries of accumulated experience, we naturally feel more intimately linked to the generation of our parents and grandparents than to the more distant generations of ancestors of which we are also the product. Nevertheless, our parents and grandparents are the people whose nearness to us in time and emotional impact makes them and their world more difficult to understand objectively.

Our own responses to the increasing complexity of historical forces during the formative stages of modern culture are still so confused that it is helpful to turn to the reactions of individual artists and thinkers who lived through the times and can to some extent interpret them to us. Furthermore, within the relatively limited sphere of artistic creativity we can observe at work forces that also operated on a much larger scale. As so often in the history of Western civilization, the arts provide a direct and powerful, if incomplete, expression of the spirit of an age. It may even be that the enduring importance of the humanities as a reflection of the human condition is one of the few aspects

of Western civilization to survive a century of global turmoil and help us now in the twenty-first century.

THE GROWING UNREST

By the last quarter of the nineteenth century there was a widespread if unfocused feeling in Europe that life could not continue as before. Social and political revolutions had replaced the old monarchies with more nearly equitable forms of government. Scientific and technological developments had affected millions of ordinary people, bringing them improved standards of living and a more congenial existence. As a result, a new mood of cheerfulness began to make itself felt in the great cities of Europe; in Paris, for example, the period became known as the **belle époque** ("beautiful age").

But the apparent gaiety was only superficial. The price of the immense changes that made it possible had been unrest and violence, and the forces that had been built to achieve them remained in existence. Thus, in a period of nominal peace, most of the leading countries in Europe were maintaining huge armies and introducing compulsory military service. Long before 1914, a growing mood of frustration led many people to assume that sooner or later war would break out—a belief that certainly did not help to avert it [**FIG. 18.1**].

The many historical causes of this mood are beyond the scope of this book, but some of the more important underlying factors are easy enough to perceive. First, the growth of democratic systems of government had taught increasing numbers of people that they had a right to share in the material benefits made possible by the Industrial Revolution. Discontent grew on all sides. In the richest countries in Europe—France, England, and Germany—the poor compared their lot to that of the more affluent. Simultaneously, in the poorer European countries, including Ireland, Spain, Portugal, and all of Eastern Europe, everyone looked with envy toward their wealthier neighbors. Even more significantly, those vast continents that the empire-building

■ **18.1** Ludwig Meidner. *The Eve of War,* 1914. Stadtische Kunsthalle, Recklinghausen. The distorted faces and violent, heaving composition reflect the spirit of a world on the point of collapse. Note that the artist has dated the work precisely: "beginning of August 1914" is written in the bottom right-hand corner.

European powers were introducing to European civilization for the first time, including parts of Africa, Asia, and South America, began increasingly to resent European domination.

Second, the scientific progress that made possible improvements in people's lives created problems of its own. New medical advances reduced the rate of infant mortality, cured hitherto fatal diseases, and prolonged life expectancy. As a result, populations in most of Europe soared to record levels, creating food and housing shortages. New forms of transport and industrial processes brought vast numbers of workers to the cities. Consequently, the lives of many people were uprooted and their daily existence became anonymous and impersonal.

Third, the growth of a world financial market, primarily dependent on the value of gold, gave new power to the forces of big business. In turn, the rise of capitalism, fiercely opposed by the growing forces of socialism [**FIG. 18.2**], provoked the development of trade unions to protect the workers' interests.

Finally, at a time when so many political and social forces were pitted against one another there seemed to be no certainty on which to fall back. Religion had lost its hold over intellectual circles by the eighteenth century and, by the end of the nineteenth century, strong religious faith and its manifestation in church attendance began to fall drastically at all levels of society. The newly developing fields of anthropology and psychology, far from replacing religion, provided fresh controversy with their radically different explanations of human life and behavior.

■ **18.2** Käthe Kollwitz. *March of the Weavers,* from *The Weavers Cycle,* 1897. Etching, $8\frac{3}{8}'' \times 11\frac{5}{8}''$ (21 × 29 cm). University of Michigan Museum of Art, Ann Arbor, 1956/1.21. This print is based on a play, *The Weavers,* by the German playwright Gerhart Hauptmann (1862–1946), dealing with the misery and helplessness of both workers and owners in the industrial age. The axes and mattocks in the workers' hands point to the coming violence.

In a state of such potential explosiveness it is hardly surprising that a major collapse of the fabric of European civilization seemed inevitable. Only in America, where hundreds of thousands of Europeans emigrated in the hope of making a new start, did optimism seem possible [**Fig. 18.3**]. Events were moving at so fast a pace that few thinkers were able to detach themselves from

their times and develop a philosophical basis for dealing with them. One of the few who did was Friedrich Wilhelm Nietzsche (1844–1900), whose ominous diagnosis of the state of Western civilization in *Thus Spoke Zarathustra* (1883–1892) and other works led him to propose drastic remedies.

For Nietzsche, Christianity was a slave religion, extolling feeble virtues such as compassion and self-sacrifice, the greatest curse of Western civilization. He viewed democracy as little better, calling it the rule of the mediocre masses. The only valid life force, according to Nietzsche, is the "will to power"—that energy that casts off all moral restraints in its pursuit of independence. Anything that contributes to power is good. Society can only improve if strong and bold individuals who can survive the loss of illusions, by the free assertion of the will, establish new values of nobility and goodness. Nietzsche called this superior individual an **Übermensch** (literally "overperson"). Like Schopenhauer in the early nineteenth century (see Chapter 17), Nietzsche is valuable principally for the way in which he anticipated future ideas rather than because he was the leader of a movement. Unfortunately, his concepts were later taken up and distorted by many would-be world rulers of the twentieth century, most notoriously the leaders of Nazi Germany.

Cut adrift from the security of religion or philosophy, the arts responded to the restless mood of the times by searching for new subjects and styles, which often challenged principles that had been accepted for centuries. In music, traditional concepts of harmony and rhythm were first radically extended and then, by some composers at least, completely discarded. In literature, new areas of experience were explored, including the impact of the subconscious on human behavior, and traditional attitudes like the role of women were examined afresh. In the visual arts, the Impressionists found a totally new way of looking at the world, which in turn opened up other exciting new fields of artistic expression. Whatever their defects, the formative years of the modern world were certainly not dull with respect to the arts.

■ **18.3** Frédéric-Auguste Bartholdi. *Statue of Liberty (Liberty Enlightening the World)*. Constructed and erected in Paris, 1876–1884; disassembled, shipped to New York, re-erected, dedicated 1886. Hammered copper sheets over iron trusswork and armature; height of figure 151′ (46 m), total height, including pedestal, above sea level 306′ (93 m). This famous monument, which still dominates New York's harbor, became the symbol to European immigrants in the late nineteenth century of the welcome they would find in the New World. The colossal statue (the head alone is 13′6″, or 4.4 m, high) was a gift from France to the United States. It was designed by the French sculptor Frédéric-Auguste Bartholdi (1834–1904); its supporting framework was designed by the French engineer Gustave Eiffel (1832–1923), known mainly for his Eiffel Tower in Paris, France's national monument, completed in 1889.

NEW MOVEMENTS IN THE VISUAL ARTS

Something of the feverish activity in the visual arts during this period can be gauged by the sheer number of movements and styles that followed one another in rapid succession: Impressionism, post-Impressionism, Fauvism, and Expressionism, culminating in the birth of Cubism around the time of World War I. Cubism is discussed in Chapter 21 because of its effects on the whole of twentieth-century art, but all of the other

movements form important stages in the transition from traditional artistic styles to present-day art, much of which rejects any attempt at Realism in favor of abstract values of line, shape, and color. An understanding of their significance is thus a necessary prerequisite for a full appreciation of modern abstract art. Quite apart from their historical interest, however, the artistic movements of the late nineteenth and twentieth centuries have much visual pleasure to offer.

As so often in the past, the center of artistic activity was Paris, where Édouard Manet (1832–1883) created a sensation in 1863 with his painting *Le Déjeuner sur l'Herbe (Luncheon on the Grass)* [**FIG. 18.4**]. Public outcry was directed against the subject of the painting: a female nude among two fully clothed young men and another clothed female figure. Other artists had combined nude females and clothed males before in a single picture, but Manet's scene has a particular air of reality; the way the unclad young woman stares out from the canvas and the two smartly dressed young men appear nonchalantly indifferent to her condition can still take the spectator by surprise. The true break with tradition, however, lay not in the picture's subject but its style. The artist is much less interested in telling us what his characters are doing than in showing us how he sees them and their surroundings. Instead of representing them as rounded, three-dimensional forms, he has painted them as a series of broad, flat areas in which the brilliance of color is unmuted. In creating this style, Manet laid the philosophical foundations that made Impressionism possible.

The massive, almost monumental human form reappears in one of Manet's last paintings, *A Bar at the Folies-Bergére* of 1882 [**FIG. 18.5**], where the barmaid amid her bottles and dishes presents the same solid appearance as the nude in *Déjeuner.* If we glance over her shoulder, however, and look into the mirror as it reflects her back and the crowded scene of which we have temporarily become a part, the style changes. The sharp outlines and fully defined forms of the foreground are replaced by a blur of shapes and colors that conveys the general impression of a crowded theater without reproducing specific details. A comparison between the background of the two pictures makes it clear that between 1863 and 1881, something drastic had occurred in the way painters looked at scenes and then reproduced them.

Impressionism

In 1874, a group of young artists organized an exhibition of their work during conversations at the Café Guerbois in Paris. Their unconventional approach to art and their contempt for traditional methods meant that normal avenues of publicity were closed to them; they hoped that the exhibition would succeed in bringing their work to public attention. It certainly did! One of the paintings, *Impression: Sunrise* [**FIG. 18.6**] by Claude Monet (1840–1926), particularly scandalized the more conventional critics, some of whom derisively borrowed its title and nicknamed the whole

■ **18.4** Édouard Manet. *Le Déjeuner sur l'Herbe,* 1863. Oil on canvas, 7′3⅜″ × 8′10⅜″ (2.15 × 2.7 m). Musée d'Orsay, Paris. Manet probably based the landscape on sketches made outdoors but painted the figures from models in his studio, something a careful look at the painting seems to confirm.

■ **18.5** Édouard Manet. *A Bar at the Folies-Bergère,* 1882. Oil on canvas, approx. 37″ × 51″ (.95 × 1.3 m). The Courtauld Institute Galleries, London (Courtauld Collection). Note the Impressionistic way in which Manet painted the girl's top-hatted customer, reflected in the mirror at right.

■ **18.6** Claude Monet. *Impression: Sunrise,* 1872. Oil on canvas, 19½″ × 14½″ (50 × 62 cm). Musée Marmottan, Paris. Although this was the painting after which the Impressionist movement was named, its use of Impressionistic techniques is relatively undeveloped compared to Figure 18.7 and Figure 18.8.

group Impressionists. Within a few years the Impressionists had revolutionized European painting.

Although Impressionism seemed at the time to represent a radical break with the past, it first developed out of yet another attempt to achieve greater realism, a tradition that had begun at the dawn of the Renaissance with Giotto. The Impressionists concentrated, however, on realism of light and color rather than realism of form and sought to reproduce—with utmost fidelity—the literal impression an object made on their eyes. If, for example, we look at a house or a human face from a distance, we automatically interpret it on the basis of our mental knowledge, and "see" details that are not truly visible. Impressionist painters tried to banish all such interpretations from their art and to paint with an "innocent eye." In *Red Boats at Argenteuil*

[FIG. 18.7], Monet recorded all of the colors he saw in the water and the reflections of the boats without trying to blend them together conventionally (or intellectually). The result is not a painting of boats at anchor but a representation of the instantaneous impact on the eye of the lights and colors of those boats; that is, what the artist saw rather than what he knew.

Throughout his long career, Monet retained a total fidelity to visual perception. His fellow painter Paul Cézanne (1839–1906) is said to have called him "only an eye, but my God what an eye!" Monet's preoccupation with the effects of light and color reached its most complete expression in his numerous paintings of water lilies in his garden. In version after version he tried to capture in paint the effect of the shimmering, everchanging appearance of water, leaves, and blossoms. The result, as in the *Water Lilies* of 1920–1921 [FIG. 18.8], reproduces not so much the actual appearance of Monet's lily pond as an abstract symphony of glowing colors and reflecting lights. Paradoxically, the most complete devotion to naturalism was to pave the way for abstraction and for what we know as "modern art."

Monet's art represents Impressionism in its purest form. Other painters, while preserving its general principles, devised variants on it. Pierre Auguste Renoir (1841–1919) shared Monet's interest in reproducing the effects of light in patches of color, but he brought to his subjects a human interest that derived from his own joy in life. It is a refreshing change, in fact, to find an artist whose work consistently explored the beauty of the world around him rather than the great problems of human existence. Neither was Renoir's interest limited, as was Monet's, to the wonders of nature. His most enduring love was for women as symbols of life; in his paintings, they radiate an immense warmth and charm. His painting of *Le Moulin de la Galette* [FIG. 18.9], a popular Parisian restaurant and dance hall, captures the spirit of the crowd by means of the same fragmentary patches of color Manet used in the background of *A Bar at the Folies-Bergère* (see Figure 18.5), but Renoir adds his own sense of happy activity. The group in the foreground is particularly touching, with its sympathetic depiction of adolescent love. The boy leans impetuously forward, while the girl who has attracted his attention leans back and looks gravely yet seductively into his face, restrained by the protective

■ **18.7** Claude Monet. *Red Boats at Argenteuil,* 1875. Oil on canvas, 24″ × 32⅜″ (61.9 × 82.4 cm). Courtesy of the Harvard University Art Museum. Fogg Art Museum (bequest—Collection of Maurice Wertheim, Class of 1906). Painted the year after the first Impressionist exhibition in Paris, this work shows Monet's characteristic way of combining separate colors to reproduce the effect of light.

■ **18.8** Claude Monet. *Nymphéas (Water Lilies)*, 1920–1921. Oil on canvas, 6′6″ × 19′7″ (1.98 × 5.97 m). The Carnegie Museum of Art, Pittsburgh (acquired through the generosity of Mrs. Alan M. Scaife, 1962). This is one of several huge paintings (in this case almost 20′ long) that Monet produced in the garden of his house in Giverny. Note the contrast with his *Red Boats at Argenteuil* of forty-five years earlier (Figure 18.7); in *Water Lilies* there is a different attitude toward realism of form. The greatly enlarged detail at right gives an idea of Monet's technique—one that looks simple at first glance but actually results from many separate, complex decisions. In every case, the artist was guided by purely visual factors rather than formal or intellectual ones.

■ **18.9** (Pierre) Auguste Renoir. *Le Moulin de la Galette*, 1876. Oil on canvas, approx. 51″ × 68″ (129.5 × 172.7 cm). Louvre, Paris. By using small patches of color, Renoir achieves the impression of dappled sunlight filtering through the trees. The general mood of pleasure tinged with a certain wistful nostalgia is typical of the *belle époque*.

arm of an older companion. Although the encounter may be commonplace, Renoir endows it with a significance and a humanity far different from Monet's more austere, if more literal, vision of the world by setting it against the warmth and movement of the background.

Unlike many other Impressionists, Renoir traveled widely throughout Europe in order to see the paintings of the great Renaissance and Baroque masters. The influence of artists like Raphael, Velázquez, and Rubens is visible in his work. This combination of an Impressionistic approach to color with a more traditional attitude toward form and composition emerges in *Two Girls at the Piano* [**FIG. 18.10**], where the girls' arms have a genuine sense of roundness and weight. This painting is no mere visual exercise—Renoir endows his figures with a sense of self-assurance that only emphasizes their vulnerability.

The artist Edgar Hilaire Germain Degas (1834–1917) shared Renoir's interest in people, but unlike Renoir (who emphasized the positive side of life) he simply reported what he saw, stressing neither the good nor the bad. By showing us intimate moments in

other people's lives, revealed by a momentary gesture or expression, his frankness, far from being heartless, as some of his critics have claimed, conveys the universality of human experience. Although Degas exhibited with the Impressionists and, like them, chose to paint scenes from the everyday events of life, his psychological penetration distinguishes his art from their more literal approach to painting. Even the Impressionist principle of capturing a scene spontaneously, in action, becomes in Degas's hands a powerful means of expression. One of the themes he turned to again and again was ballet, perhaps because of the range of movement it involved, although he also often underlined the gulf between the Romantic façade of ballet and its down-to-earth reality. In *The Rehearsal* [**FIG. 18.11**] we are left in no doubt that neither ballet nor ballet dancers are entirely glamorous. Degas's point of view is emphasized by the unusual vantage point from which the stage is shown: close to and from a position high up on the side. Far from coldly observing and reproducing the scene, Degas creates an instant bond between us and the hard-worked dancers, based on our perception of them as human beings.

Degas's honesty won him the reputation of being a mysogynist because many of his representations of female nudes lack the idealizing qualities of Renoir's and other painters' works. In a series of pastels he shows women caught unawares in simple, natural poses. *The Tub* [**FIG. 18.12**], with its unusual angle of vision, shows why these were sometimes called "key-hole visions." Far from posing, his subjects seem to be spied on while they are engrossed in the most intimate and natural activities.

One of Degas's closest friends was the American artist Mary Cassatt (1844–1926), who, after overcoming strong opposition from her father, settled in Europe to pursue an artistic career. Like Degas, Cassatt painted spontaneous scenes from daily life, particularly situations involving mothers and children. *Mother and Child* [**FIG. 18.13**] shows the mother turned away from us and a child who is saved from sentimentality by his complete unawareness of our presence. Cassatt never married, but there is no reason to think that her paintings of children were created out of frustration. She seems to have had a rich and happy life, and her championship of the Impressionist cause among her American friends led to many of them buying and taking home Impressionist works. Cassatt's artist friends had much to thank her for, and so do the curators of many American museums and galleries, which have inherited collections of Impressionist paintings.

Another member of the same circle was Berthe Morisot (1841–1895). In 1868, Morisot met Manet and they became warm friends; a few years later she married his younger brother. An active member of the Impressionist group, she exhibited works in almost all their shows.

■ **18.10** (Pierre) Auguste Renoir. *Two Girls at the Piano,* 1892. Oil on canvas, 45½″ × 34½″ (116 × 90 cm). Museé d'Orsay, Paris. The position of the two girls, one leaning forward and resting her arm on the shoulder of the other, is almost exactly the same as that of the woman and the girl in the center of Figure 18.9; this position seems to have appealed to Renoir as a gesture of affection.

■ **18.11** Edgar Degas. *The Rehearsal*, 1874. Oil on canvas, 26″ × 32¼″ (66 × 82 cm). Musée d'Orsay, Paris. Degas's careful observation extends even to the director of the ballet troupe at the right-hand edge of the stage, hat almost over his eyes, holding the back of his chair.

■ **18.12** Edgar Degas. *The Tub*, c. 1886. Pastel, 27⅝″ (70 cm) square. Hill-Stead Museum, Farmington, Connecticut. The beautiful simplicity of Degas's drawing gives an impression of action glimpsed momentarily, as if by one passing by. As in Figure 18.11, Degas chooses to visualize the scene from an unusual angle; here the figure is viewed from above.

■ **18.13** Mary Cassatt. *Mother and Child*, c. 1889. Oil on canvas, 29″ × 23½″ (74 × 60 cm). Cincinnati Art Museum (John J. Emery Endowment, 1928). By turning the mother's face away, the artist concentrates attention on the child, an effect enhanced by the vague background.

Morisot's work has often been labeled "feminine," both by her contemporaries and by more recent critics. Like Cassatt, a close friend, she often painted women and children. Yet she also produced works of considerable breadth. *View of Paris from the Trocadero* [**Fig. 18.14**] presents a panoramic view of the city. The sense of light and atmosphere is conveyed by loose, fluid brushstrokes. The figures in the foreground do not seem part of any story or incident but help focus the scale of the view, which is seen as if from a height.

The impact of Impressionism on sculptors was inevitably limited, because many of its principles depended on color and light and could only be applied in paint. Nevertheless, the greatest sculptor of the age (according to many, the greatest since Bernini), Auguste François René Rodin (1840–1917), reproduced in bronze something of the Impressionist love of shifting forms and light and shadow. His remarkable figure of Balzac [**Fig. 18.15**] demonstrates the irregularity of surface by which Rodin converted two-dimensional Impressionist effects to a three-dimensional format. It also reveals one of the ways in which he differed from his Impressionist contemporaries, because his themes are generally massive and dramatic rather than drawn from everyday life. The statue of Balzac shows the great novelist possessed by creative inspiration, rather than his actual physical appearance. The subject of this sculpture is really the violent force of genius, a concept

also illustrated in Rodin's portrayal of the composer Gustav Mahler (see Figure 18.31), and Rodin conveys it with almost elemental power. It should perhaps not be surprising that critics of the day were unprepared for such burning intensity. One of them dubbed the statue a "toad in a sack," but in retrospect, Rodin breathed new life into sculpture. The "primitive" grandeur of his images formed a powerful attraction for future sculptors.

In general, Rodin's works in marble are less Impressionistic than those in bronze, but his famous *The Kiss* [**Fig. 18.16**] achieves something of Renoir's blurred sensuality by the soft texture of the stone and the smooth transitions between the forms of the figures. Yet even though Rodin at times seems to strive for an Impressionistic surface effect, the drama and full-blooded commitment of many of his works show the inadequacy of stylistic labels. We can only describe Rodin as a sculptor who used the Impressionist style in works that foreshadow modern developments; that is, as a great original.

Post-Impressionism

As a stylistic category, **post-Impressionism** is one of the least helpful or descriptive terms in art history. The artists who are generally grouped together under it

■ **18.14** Berthe Morisot. *View of Paris from the Trocadero,* 1872. Oil on canvas, 18⅛″ × 32¹/₁₆″ (46.3 × 81.3 cm). Santa Barbara Museum of Art, California (gift of Mrs. Hugh N. Kirkland). The separation between the various planes of the view produces an effect of breadth and tranquility. Note the depictions of human activity—the boat on the river, the horse and carriage—which help bring the scene to life.

■ **18.15** Auguste Rodin. *Monument to Balzac,* 1897–1898. Bronze (cast 1954), 9′3″ × 48¼″ × 41″ (282 × 122.5 × 104.2 cm). The Museum of Modern Art, New York. Presented in memory of Curt Valentin by his friends. Unlike most sculptors who worked in bronze, Rodin avoided a smooth surface by roughening and gouging the metal.

■ **18.16** Auguste Rodin. *The Kiss,* 1886. Marble. Height 6′2″ (1.9 m). Musée Rodin, Paris. As in his Balzac statue, the artist uses the texture of the material to enhance the appearance of his work, but the smooth, slightly blurred surface of the marble here, in contrast to the rough surface of the portrait, produces a glowing effect.

have as their only real common characteristic a rejection of Impressionism for new approaches to painting. All of them arrived at their own individual styles. Their grouping together is therefore more a matter of historical convenience than critical judgment. The scientific precision of Georges Pierre Seurat (1859–1891), for example, whose paintings, based on the geometric relationship of forms in space, are made up of thousands of tiny dots of paint applied according to strict theories of color [**Fig. 18.17**], has little in common with the flamboyant and exotic art of (Eugéne Henri) Paul Gauguin (1848–1903). Particularly in his last paintings, based on his experiences in Tahiti, Gauguin attacked primitive subjects in a highly sophisticated manner, producing results like *Ia Orana Maria* [**Fig. 18.18**], which may attract or repel viewers but rarely leave them indifferent.

The greatest post-Impressionist painter was Paul Cézanne. It would be difficult to overestimate the revolutionary quality of Cézanne's art, which has been

compared to that of the proto-Renaissance Florentine painter Giotto as an influence on Western art. Cézanne's innovations ended the six-hundred-year attempt since Giotto's time to reproduce nature in painting. In place of nature Cézanne looked for order; or rather he tried to impose order on nature, without worrying if the results were realistic. It is not easy to comprehend or express in intellectual terms the character of Cézanne's vision, although, as so often in the arts, the works speak for themselves. He claimed that he wanted to "make of Impressionism something solid and durable," and many of his paintings have a monumental air; they convey the mass and weight, in terms of both shape and color of his subject matter, rather than its literal physical appearance. His *Still Life with Commode* [**Fig. 18.19**] does not try to show how the fruit, vase, and cloth really look or reproduce their actual relationship to one another. On the contrary, the painter has deliberately distorted the surface of the table and oversimplified the shapes of the objects to

■ **18.17** Georges Seurat. *A Sunday on La Grande Jatte,* 1884–1886. Oil on canvas, 6′9″ × 10′3⁄8″ (207.5 × 308 cm). The Art Institute of Chicago (Helen Birch Bartlett Memorial Collection), 1926.224. For all the casual activity in this scene of strollers in a park on an island in the river Seine, Seurat's remarkable sense of form endows it with an air of formality. Both shape and color (applied in minute dots) are rigorously ordered.

■ **18.18** Paul Gauguin. *Ia Orana Maria,* 1891. Oil on canvas, 44¾″ × 34½″ (113.7 × 87.7 cm). Metropolitan Museum of Art, New York (Bequest of Samuel A. Lewisohn, 1951). The title means "We hail thee, Mary"; the painting shows a Tahitian Madonna and child being worshiped by two women with an angel standing behind them. The whole scene presents a fusion of Western spiritual values and the simple beauty of primitive Polynesian life.

■ **18.19** Paul Cézanne. *Still Life with Commode,* c. 1887–1888. Oil on canvas, 25½″ × 31¾″ (65.1 × 80.8 cm). Harvard Museum of Art. Fogg Art Museum (bequest—Collection of Maurice Wertheim, Class of 1906). So painstakingly did the artist work on the precise arrangement of the objects in his still life and on their depiction that the fruit usually rotted long before a painting was complete.

achieve a totally satisfying composition. Abstract considerations, in other words, take precedence over fidelity to nature. Cézanne believed that all forms in nature are based on the cone, the sphere, and the cylinder, and he shapes and balances the forms to make them conform to this notion using vigorous, rhythmical brush strokes. In the process, a simple plate of fruit takes on a quality that can only be called massive.

The miracle of Cézanne's paintings is that for all their concern with ideal order, they are still vibrantly alive. *Mont Sainte-Victoire* [**FIG. 18.20**] is one of several versions Cézanne painted of the same scene, visible from his studio window. Perhaps the contrast between the peaceful countryside and the grandeur of the mountain beyond partially explains the scene's appeal to him. He produced the transition from foreground to background and up to the sky by the wonderful manipulation of planes of pure color. It illustrates his claim that he tried to give the style of Impressionism a more solid appearance by giving his shapes a more continuous surface, an effect produced by broad brushstrokes. Yet the painting equally conveys the vivid colors of a Mediterranean landscape, with particular details refined away to leave behind the pure essence of all its beauty.

Nothing could be in greater contrast to Cézanne's ordered world than the tormented vision of Vincent van Gogh (1853–1890), the tragedy of whose life found its expression in his work. The autobiographical nature of van Gogh's painting, together with its passionate feelings, has a special appeal to modern sensibilities. In fairness to van Gogh, however, we should remember that by giving expression to his desperate emotions the artist was, however briefly, triumphing over them. Furthermore, in a way that only the arts make possible, the suffering of a grim, even bizarre life

■ **18.20** Paul Cézanne. *Mont Sainte-Victoire,* 1904–1906. Oil on canvas, 28⅞″ × 36¼″ (73 × 92 cm). Philadelphia Museum of Art (George W. Elkins Collection). The reduction of the elements in the landscape to flat planes and the avoidance of the effect of perspective give the painting a sense of concentrated intensity.

became transformed into a profound if admittedly partial statement on the human condition. Desperate ecstasy and passionate frenzy are not emotions common to most people, yet *The Starry Night* [FIG. **18.21**] communicates them immediately and unforgettably.

The momentum of swirling, flickering forms in *The Starry Night* is intoxicating, but for the most part van Gogh's vision of the world was profoundly pessimistic. *The Night Café* [FIG. **18.22**] was described by the artist as "one of the ugliest I have done," but the ugliness was deliberate. Van Gogh's subject was "the terrible passions of humanity," expressed by the harsh contrasts between red, green, and yellow, which were intended to convey the idea that "the café is a place where one can ruin oneself, go mad, or commit a crime."

Much of van Gogh's pessimism was undoubtedly the result of the unhappy circumstances of his own life, but it is tempting to place it in the wider context of his times and see it also as a terrifying manifestation of the growing social and spiritual alienation of society in the late nineteenth century. That van Gogh was actually aware of this is shown by a remark he made about his *Portrait of Dr. Gachet* [FIG. **18.23**], the physician who treated him in his last illness. He had painted the doctor, he said, with the "heartbroken expression of our times."

Fauvism and Expressionism

By the early years of the twentieth century, the violent mood of the times had intensified still further, and artists continued to express this in their art. The impact of post-Impressionists like van Gogh inspired several

■ **18.21** Vincent van Gogh. *The Starry Night,* 1889. Oil on canvas, 29″ × 36¼″ (73.7 × 92.1 cm). Collection, The Museum of Modern Art, New York (acquired through the Lillie P. Bliss Bequest). The impression of irresistible movement is the result of the artist's careful use of line and shape. The scene is dominated by vertical spirals formed by the cypress trees and horizontal ones in the sky, which create a sense of rushing speed.

▪ **18.22** Vincent van Gogh. *The Night Café,* 1888. Oil on canvas, 28½″ × 36¼″ (72 × 92 cm). Yale University Art Gallery, New Haven, Connecticut (bequest of Stephen C. Clark). Compare the lack of perspective in Cézanne's *Mont Sainte-Victoire* (Figure 18.20) to the highly exaggerated perspective used by van Gogh here to achieve a sense of violent intensity.

▪ **18.23** Vincent van Gogh. *Portrait of Dr. Gachet,* 1890. Oil on canvas, 26¼″ × 22½″ (67 × 57 cm). Private collection, Japan. Gachet was an amateur artist and friend of van Gogh who often provided medical treatment for his painter acquaintances without taking any fee. Mentally ill and in despair, van Gogh committed suicide while staying with Gachet.

new movements—the most important of which was **Fauvism.** This developed in France, and **Expressionism,** which reached its high point in the same period, developed in Germany (see **TABLE 18.1**).

The origin of the term "fauvism" reveals much of its character. In 1905, a group of artists exhibited paintings that broke so violently with tradition in their use of color and form that a critic described the painters as "*les fauves*" ("the wild beasts"). These painters had little in common apart from their desire to discard all traditional values; not surprisingly, the group broke up after a short while, but one of their number, Henri Matisse (1869–1954), became a major force in twentieth-century art.

Henri Matisse was the leading spirit of the Fauves. His works are filled with the bold accents and brilliant color typical of Fauvist art. Yet the flowing images of Matisse's paintings strike an individual note, expressing a mood of optimism and festivity curiously at odds with the times. One of his first important paintings, *The Joy of Life* [**FIG. 18.24**], shows fields and trees in bright sunlight, where men and women are sleeping, dancing, and making music and love. It is difficult to think of any work of art further removed from the anguish of the years immediately preceding World War I than this image of innocent joy painted between 1905 and 1906.

Matisse was saved from the gloom of his contemporaries by his sheer pleasure in seeing and painting; his work communicates the delight of visual sensation

■ **18.24** Henri Matisse. *The Joy of Life,* 1905–1906. Oil on canvas, 5′8″ × 7′9¾″ (1.74 × 2.38 cm). Barnes Foundation, BF No. 719, Merion Station, Pennsylvania. By varying the sizes of the figures without regard to the relationship of one group to another, the artist accentuates the sense of dreamlike unreality. Note Matisse's characteristically simple, flowing lines.

eloquently. His still-life paintings, like those of Cézanne, sacrifice Realism in effective and satisfying design, but his use of color and the distortion of the natural rela-

TABLE 18.1 *Principal Characteristics of Fauvism and Expressionism*

FAUVISM

Violent, startling color contrasts

Paintings reflect the effect of visual contact on the psyche

Nature interpreted and subjected to the spirit of the artists

Composition a decorative arrangement of elements to express the artist's feelings

Technique deliberately crude to disturb the form of objects

No effect of light or depth

Art for art's sake

EXPRESSIONISM

Brilliant, clashing colors

Paintings reflect mysticism, self-examination, speculation on the infinite

Nature used to interpret the universe

Composition: distorted forms in a controlled space, derived from late Gothic woodcut tradition

Technique influenced by medieval art and the primitivistic art of Africa and Oceania

No use of traditional perspective

Art to convey emotional or psychological truth

tionships of the objects he paints are even greater than Cézanne's. In *The Red Studio* [**FIG. 18.25**], every form is clearly recognizable but touched by the painter's unique vision. It is as if Matisse compels us to look through his eyes and see familiar objects suddenly take on new, vibrant life.

Matisse's sunny view of the world was very unusual, however. In northern Europe, particularly, increasing social and political tensions inspired a group of artists generally known as Expressionists to produce works that are at best gloomy and foreboding, sometimes chilling.

The forerunner of Expressionist art was the Norwegian painter Edvard Munch (1863–1944), whose influence on German painting was comparable to that of Cézanne's on French. The morbid insecurity that characterized Munch's own temperament emerges with horrifying force in his best-known work, *The Scream* [**FIG. 18.26**], from which the lonely figure's cry seems to reverberate visibly through space. This painting is more than autobiographical, however, because it reflects a tendency on the part of Norwegian and other Scandinavian artists and writers to explore social and psychological problems. Elsewhere in Europe the Spanish architect Antonio Gaudí (1852–1926) applied the same artistic principles to his buildings, with often startling results. His Casa Milá [**FIG. 18.27**], an apartment house in Barcelona, like *The Scream,* uses restless, waving lines that seem to undulate as we look. The sense of disturbance is continued by the spiraling chimneys, although Gaudí's intention was neither to upset nor necessarily to protest.

▪ **18.25** Henri Matisse. *The Red Studio,* Issy-les-Molineaux, 1911. Oil on canvas, 71¼″ × 7′2¼″ (1.81 × 2.19 m). Collection, The Museum of Modern Art, New York (Mrs. Simon Guggenheim Fund). The paintings and small sculptures in the studio are actual works by Matisse; they show the brilliant colors typical of Fauve art.

▪ **18.26** Edvard Munch. *The Scream,* 1893. Oil on cardboard, 35½″ × 28¾″ (91 × 74 cm). Nasjonalgalleriet, Oslo. Munch once said, "I hear the scream in nature," and in this painting the anguish of the human figure seems to be echoed by the entire world around. Munch painted several versions of the subject. The one illustrated here was stolen several years ago and subsequently recovered. Another version was stolen in 2004 and is still missing.

By 1905, Expressionist artists in Germany were using the bold, undisguised brushstrokes and vivid colors of Fauvism to paint subjects with more than a touch of Munch's torment. The German Expressionists, many of them grouped in "schools" with such names as **Die Brücke** ("*The Bridge*") and **Der Blaue Reiter** ("*The Blue Rider*"), were relatively untouched by the intellectual and technical explorations of their contemporaries elsewhere. Instead, they were concerned with the emotional impact that a work could produce on the viewer. They were fascinated by the power of color to express mood, ideas, and emotion. They wanted their art to affect not only the eye but also the viewer's inner sense. When they succeeded, as they often did, their works aroused strong emotions.

One of their principal themes was alienation and loneliness, so it is not surprising that they often turned to the writings of Dostoyevsky for inspiration. *Two Men at a Table* [**Fig. 18.28**], by Erich Heckel (1883–1970), is in fact subtitled *To Dostoyevsky.*

Emil Nolde (1867–1956), who identified himself with Die Brücke after 1906, was one of the few Expressionists to paint biblical scenes. To these he brought his own ecstatic, barbaric intensity. *Pentecost* [**Fig. 18.29**] shows the apostles seated around the table literally burning with inspiration; the tongues of flame of the biblical account are visible above their heads. Their faces have a masklike simplicity, but the huge eyes and heavy eyebrows convey frighteningly intense emotion. The image is far more disturbing than inspiring. Even in a religious context, Expressionist art touches chords of alarm, and hysteria, unhappily appropriate to the times.

◼ **18.27** Antonio Gaudí. Casa Milá, Barcelona, 1907. Note the rough surface of the stone and the absence of any straight lines.

◼ **18.28** Erich Heckel. *Two Men at a Table (To Dostoyevsky)*, 1912. Oil on canvas, 97 × 120 cm. Kunsthalle, Hamburg. The two figures seem separated from one another by doubt and distrust, each wrapped up in his own isolation. Behind them is a distorted image of the crucified Christ.

■ **18.29** Emil Nolde. *Pentecost*, 1909. Oil on canvas, 2'8" × 3'6" (87 × 107 cm). Staatliche Musseen Preussischer Kulturbesitz, Nationalgalerie, Berlin. The broad, simplified faces and the powerful gestures of Christ in the center and of the two apostles clasping hands impart to the scene a concentration of emotional intensity.

NEW STYLES IN MUSIC

Impressionism had forced both artists and public to think afresh about painting and seeing; by the early years of the twentieth century, musicians and music lovers were also to have many of their preconceptions challenged. Not only were traditional forms like the symphony either discarded or handled in a radical new way, but even the basic ingredients of musical expression, *melody, harmony,* and *rhythm,* were subject to startling new developments. Few periods in the history of music are in fact more packed with change than those between 1870 and 1914, which saw a fresh approach to symphonic form, the rise of a musical version of Impressionism, and the revolutionary innovations of the two giants of modern music: Schönberg and Stravinsky.

Orchestral Music at the Turn of the Nineteenth Century

Although many extended orchestral works written in the last years of the nineteenth century and the early twentieth century were called symphonies by their composers, they would hardly have been recognizable as such to Haydn or Beethoven. The custom of varying the traditional number and content of symphonic movements had already begun during the Romantic period; Berlioz had written his *Fantastic Symphony* as early as 1829 (see Chapter 17). Nonetheless, by the turn of the century, so-called symphonies were being written that had little in common with one another, much less the Classic symphonic tradition.

The driving force behind many of these works was the urge to communicate something beyond purely musical values. From the time of the ancient Greeks, many composers attempted to write instrumental music that told a story or described some event, including Vivaldi and his *Four Seasons* and Beethoven in his curious work known as the *Battle Symphony.* By the midnineteenth century, however, composers had begun to devise elaborate *programs* (plots), which their music would then describe. Music of this kind is generally known as **program music,** the first great exponent of which was Liszt (see Chapter 17), who wrote works with titles such as *Hamlet, Orpheus,* and *The Battle of the Huns,* for which he invented the generic description **symphonic poem.**

The principle behind program music is no better or worse than many another. The success of any individual piece depends naturally on the degree to which narrative and musical interest can be combined. There are, to be sure, some cases where a composer has been carried away by eagerness for realism. Ottorino Respighi (1879–1936), for example, incorporated the sound of a nightingale by including a record player and a recording of live birdsong in his *Pines of Rome* (1924).

No one was more successful at writing convincing program symphonies and symphonic poems (**tone poems,** as he called them) than the German composer Richard Strauss (1864–1949). One of his first successful tone poems, *Don Juan,* begun in 1886, deals

VALUES

Colonialism

The transition, beginning around 1500, from the world of the late Middle Ages to the dawn of the modern era was largely the result of European expansion overseas, with the vast economic developments that it brought. From the mid-nineteenth century, this search for new territories abroad became transformed into the drive to win Imperial possessions, and the history of the past two centuries has seen the rise and subsequent collapse of European colonial empires. In the process, European dominance has given way to a global culture in which the destinies of all parts of the world are linked. Technological changes, weapons of mass destruction, and, in the past few years, rapid progress in electronic communication have all in different ways helped build the "global village."

In the course of the twentieth century, struggles for independence in many parts of the world led to the notion of Imperialism, one of the chief motivating forces in nineteenth-century politics and culture, acquiring strongly negative associations. Its original impetus came from economic, political, and psychological considerations. In the first place, conquest of overseas territories and peoples provided a source of raw material and abundant cheap labor. At the same time, the colonies became centers for investment and thereby absorbed surplus capital, which accumulated as the capitalist system began to grow—a point made by one of the fiercest opponents of both capitalism and imperialism: Lenin.

Politically, Imperialism provided a means whereby the leading European powers could continue their rivalries outside Europe. At the beginning of the nineteenth century, at the Congress of Vienna of 1815, the delegates had created a political "balance of power," whereby no state was able to dominate. Each country had its own national sovereignty and could maintain independence of action, which meant that none could achieve superiority in Europe. Now, by conquering more and richer territory in Africa and Asia, Western European colonizers could try to surpass one another.

No less important was the psychological factor. With the rise of nationalism, national pride became a powerful factor in determining political and military decisions. Furthermore, with the growth of anonymous cities, some form of heroic achievement abroad could bring personal glory, as well as give those less advantaged a chance to improve their lot. A further factor, as European possessions abroad began to accumulate, was that of strategy. By taking a well-located port or island, its conquerors could open up new territories, or hold on to what they had—or even block a rival.

At least some of the drive for empire also involved fewer self-interest factors. Many conquerors claimed, and some surely believed, that their motives were to "spread civilization"—in its European form, at least. Missionaries accompanied most colonial expeditions, and colonial governments tried to outlaw those local customs that appalled their administrators: cannibalism, child marriage, nakedness. The physical conditions and education of the local populations often improved, although rulers resisted most calls for self-government.

The eventual result was that the colonized peoples slowly began to fight for their own independence. In the process, the zeal of nineteenth-century colonizers began to be regarded as arrogant and self-serving, rather than heroic and altruistic. Like many other values in history, however, colonialism should be seen in its historical context to be fairly judged.

with the familiar story of the compulsive Spanish lover from a characteristically late-nineteenth-century point of view. Instead of the unrepentant Don Giovanni of Mozart or Byron's amused (and amusing) Don Juan, Strauss presents a man striving to overcome the bonds of human nature, only to be driven by failure and despair to suicide. The music, gorgeously orchestrated for a vast array of instruments, moves in bursts of passion, from the surging splendor of its opening to a bleak and shuddering conclusion.

Strauss was not limited to grand and tragic subjects. *Till Eulenspiegel* tells the story of a notorious practical joker and swindler and is one of the most successful examples of humor in music. Even when Till goes too far in his pranks and ends up on the gallows (vividly depicted by Strauss's orchestration), the music returns to a cheerful conclusion.

One of Strauss's most remarkable works, and one that clearly demonstrates the new attitude toward symphonic form, is his *Alpine Symphony,* written between 1911 and 1915. In one huge movement lasting some fifty minutes it describes a mountain-climbing expedition, detailing the adventures on the way (with waterfalls, cowbells, glaciers all in the music) and, at its cli-

max, the arrival on the summit. The final section depicts the descent, during which a violent storm breaks out, and the music finally sinks to rest in the peace with which it opened. All this may sound more like a movie's soundtrack than a serious piece of music, but skeptical listeners should try the *Alpine Symphony* for themselves. It is as far from conventional notions of a symphony as Cézanne's painting of *Mont Sainte-Victoire* (see Figure 18.20) is from a conventional landscape, but genius makes its own rules. Strauss's work should be taken on its own terms.

Not surprisingly, a composer capable of such exuberant imagination was also fully at home in the opera house. Several of Strauss's operas are among the greatest of all twentieth-century contributions to the repertoire. In some, he was clearly influenced by the prevailingly gloomy and morbid mood of German Expressionist art. His first big success, for example, was a setting of the English writer Oscar Wilde's play *Salome*, based on the biblical story, first performed to a horrified audience in 1905. After one performance (in 1907) at the Metropolitan Opera House in New York, it was banned in the United States for almost thirty years. The final scene provides a frightening yet curiously moving depiction of erotic depravity, as Salome kisses the lips of the severed head of John the Baptist. This subject had been gruesomely represented by the German Expressionist painter Lovis Corinth (1858–1925) in 1899 [**Fig. 18.30**].

Works like *Don Juan* and the *Alpine Symphony* deal with stories we know or describe events with which we are familiar. In other cases, Strauss took as his subject his own life, and a few of his pieces, including the *Domestic Symphony* and the somewhat immodestly titled *Ein Heldenleben (Hero's Life)*, are frankly autobiographical. In this he was following a custom that had become increasingly popular in the late nineteenth century—the composition of music concerned with the detailed revelation of its composer's inner emotional life.

One of the first musicians to make his personal emotions the basis for a symphony was the late-Romantic composer Peter Ilych Tchaikovsky (1840–1893), whose *Symphony No. 6 in b minor*, known as the *Pathétique*, was written in the year of his death. An early draft outline of its "story" was found among his papers, describing its "impulsive passion, confidence, eagerness for activity," followed by love and disappointments, and finally collapse and death. It is now believed that the Russian composer's death from cholera was not, as used to be thought, accidental, but deliberate suicide. The reasons are still not clear, but they perhaps related to a potentially scandalous love affair in high places with which Tchaikovsky had become involved. In the light of this information, the *Pathétique* takes on new poignancy. Its last movement sinks mournfully into silence after a series of climaxes that seem to protest bitterly if vainly against the injustices of life.

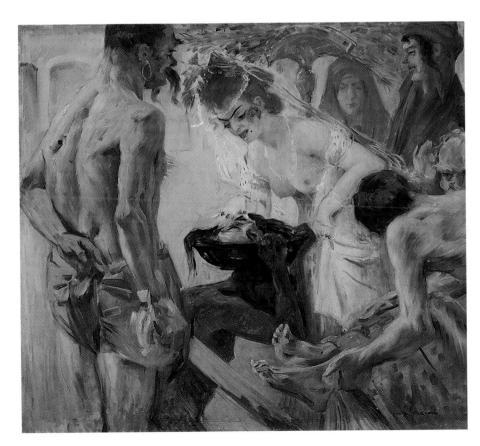

■ **18.30** Lovis Corinth. *Salome*, 1899. Oil on canvas, 29½″ × 33″ (76.2 × 83.3 cm). Courtesy of Busch-Reisinger Museum, Harvard University (gift of Hans H. A. Meyn). Note the strikingly modern look of Salome, with her heavy eye makeup and lipstick, here representing the degeneracy of the artist's own times.

VOICES OF THEIR TIMES

Gustav Mahler

A letter from Mahler to his wife Alma, reporting on a meeting with Richard Strauss. Mahler had heard *Salome,* and was impressed. The *she* in the second sentence is Pauline, Strauss's wife.

Berlin, January 190-

My dear, good Almschili;

Yesterday afternoon I went to see Strauss. She met me at the door with pst! pst! Richard is sleeping, pulled me into her (very slovenly) boudoir, where her old mama was sitting over some mess (not coffee) and filled me full of nonsensical chatter about various financial and sexual occurrences of the last two years, in the meantime asking hastily about a thousand and one things without waiting for a reply, would not let me go under any circumstances, told me that yesterday morning Richard had had a very exhausting rehearsal in Leipzig, then returned to Berlin and conducted Götterdämmerung in the evening, and this afternoon, worn to a frazzle, he had gone to sleep, and she was carefully guarding his sleep. I was dumbfounded.

Suddenly she burst out: "Now we have to wake up the rascal!" Without my being able to prevent it, she pulled me with both her fists into his room and yelled at him in a very loud voice: "Get up, Gustav is here!"

(For an hour I was Gustav—then suddenly Herr Direktor again.) Strauss got up, smiled patiently, and then we went back to a very animated discussion of all that sheer bilge. Later we had tea and they brought me back to my hotel in their automobile, after arranging for me to take lunch with them at noon Saturday.

There I found two tickets for parquet seats in the first row for *Salome* and I took Berliner along. The performance was excellent in every respect—orchestrally, vocally, and scenically it was pure Kitsch and Stoll, and again it made an extraordinary impression on me. It is an extremely clever, very powerful piece, which certainly belongs among the most significant of our time! Beneath a heap of rubbish an infernal fire lives and burns in it—not just fireworks.

That's the way it is with Strauss's whole personality and it's difficult to separate the wheat from the chaff. But I had felt tremendous respect for the whole manifestation and this was confirmed again. I was tremendously pleased. I go the whole hog on that. Yesterday Blech conducted—excellently. Saturday Strauss is conducting and I am going again. Destinn was magnificent; the Jochanaan [Berger] very fine. The others, so-so. The orchestra really superb.

Letter of Gustav Mahler to his wife from *Letters of Composers* by G. Norman and M. L. Shrifte.

The revelation of a composer's life and emotions through his music reached its most complete expression in the works of Gustav Mahler (1860–1911). Until around 1960, the centenary of his birth in Bohemia, Mahler's music was almost unknown and he was generally derided as unoriginal and overambitious. Now that he has become one of the most frequently performed and recorded of composers, we can begin to appreciate his true worth and learn the danger of hasty judgments.

The world of Mahler's symphonies is filled with his own anxieties, triumphs, hopes, and fears, but it also illuminates our own problem-ridden age. It may well be that Mahler speaks so convincingly and so movingly to a growing number of ordinary music lovers because his music touches on areas of human experience that were unexplored before his time and increasingly significant to ours. In purely musical terms, however, Mahler can now be seen as a profoundly original genius. Like Rodin, who produced a marvelous portrait of him [**FIG. 18.31**], Mahler stands as both the last major figure of the nineteenth century in his field and a pioneer in the modern world. Mahler's innovations won him the scorn of earlier listeners: his deliberate use of popular, banal tunes, for example, and the abrupt changes of mood in his music. A symphony, he once said, should be like the world; it should contain everything. His own nine completed symphonies (he left a tenth unfinished), and *Das Lied von der Erde (The Song of the Earth)*, a symphony for two singers and orchestra, certainly contain just about every human emotion.

As early as the *Symphony No. 1 in D,* we can hear the highly individual characteristics of Mahler's music. The third movement of the symphony is a funeral march, but its wry, ironic tone is totally unlike any other in the history of music. The movement opens with the mournful sound of a solo double bass playing the old round "Frère Jacques," which is then taken up by the rest of the orchestra. There are sudden bursts of trite nostalgia and violent aggression until the mood gradually changes to one of genuine tenderness. After a gentle middle section, the movement returns to the bizarre and unsettling spirit of the opening.

By the end of his life, Mahler was writing far less optimistic music than his *Symphony No. 1,* which—despite its third-movement funeral march—concludes with a long finale ending in a blaze of triumphant

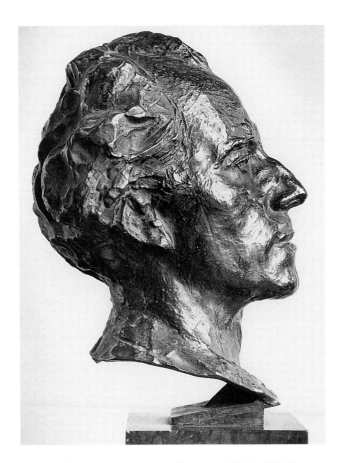

■ **18.31** (Pierre) Auguste Rodin. *Gustav Mahler,* 1909. Bronze. Height 13″ (34 cm). Musée Rodin, Paris. As in his *Monument to Balzac* (Figure 18.15), Rodin deliberately roughened the surface of the bronze for dramatic effect. In this case Mahler's hollow cheeks and intense gaze are powerfully suggested.

glory. Mahler's last completed works, *The Song of the Earth* and *Symphony No. 9,* composed under the shadow of fatal heart disease and impending death, express all of the beauty of the world together with the sorrow and ultimate resignation of one who has to leave it. The final movement of the *Symphony No. 9,* in particular, is a uniquely eloquent statement of courage in the face of human dissolution. Opening with a long, slow theme of great passion and nobility, the movement gradually fades away as the music dissolves into fragments and finally sinks into silence. Like all of Mahler's music, and like the paintings of van Gogh or Munch, the *Symphony No. 9* does not turn its back on the ugliness and tragedy of life, but Mahler, unlike many of his contemporaries, was able to see beyond these realities and express something of the painful joy of human existence. Perhaps this is why his music has become so revered today.

Impressionism in Music

At about the same time painters in France were developing the style we call Impressionist, Claude Debussy

(1862–1918), a young French composer, began to break new musical ground. Abandoning the concept of the development of themes in a systematic musical argument, which lies behind classical sonata form and Romantic symphonic structure, he aimed for a constantly changing flow of sound. Instead of dealing with human emotions, Debussy's music evoked the atmosphere of nature: the wind and rain and the sea. The emphasis on shifting tone colors led inevitably to comparisons to Impressionist painting. Like Monet or Renoir, he avoided grand, dramatic subjects in favor of ephemeral, intangible sensations and replaced Romantic opulence with refinement.

These comparisons should nevertheless not be exaggerated. Debussy and the Impressionists shared a strong reaction against tradition in general and the Romantic tradition in particular, in response to which they created a radically new approach to their respective arts, but Impressionism permanently changed the history of painting, while the only really successful Impressionist composer was Debussy. Later musicians borrowed some of Debussy's musical devices, including his highly fluid harmony and frequent dissonances, but Debussy never really founded a school. The chief developments in twentieth-century music after Debussy took a different direction, summed up rather unsympathetically by the French poet Jean Cocteau (1891–1963): "After music with the silk brush, music with the axe." These developments represent a more determined break with tradition than the refined style of Debussy. With the passing of time, Debussy's musical style appears increasingly to represent the last gasp of Romanticism rather than the dawn of a new era.

Whatever his historical position, Debussy was without doubt one of the great creative musical figures of his time. He is at his best and most Impressionist in orchestral works like *La Mer (The Sea),* which Debussy called symphonic sketches—a rather curious term that shows the composer for once willing to accept a traditional label. This marine counterpart of Strauss's *Alpine Symphony* is in three movements, the titles of which ("From Dawn to Noon on the Sea," "Play of the Waves," and "Dialogue of the Wind and the Sea") describe the general atmosphere that concerned Debussy rather than literal sounds. There are no birdcalls or thunderclaps in the music; instead the continual ebb and flow of the music suggest the mood of a seascape. The second movement, for example, depicts the sparkling sunlight on the waves by means of delicate, flashing violin scales punctuated by bright flecks of sound color from the wind instruments. It is scarcely possible to resist a comparison with the shimmering colors of Monet's *Water Lilies* (see Figure 18.8).

Elsewhere, Debussy's music is less explicitly descriptive. His piano music, among his finest compositions, shows an incredible sensitivity to the range of sound effects that instrument can achieve. Many of his pieces

have descriptive titles—"Footsteps in the Snow," "The Girl with the Flaxen Hair," and so on—but these were often added after their composition as the obligatory touch of musical Impressionism. Sometimes they were even suggested by Debussy's friends as their own personal reactions to his music. His *Claire de Lune (Moonlight)* is a case in point. The tranquil calm of the music might well convey to some listeners the beauty of a moonlit night, but the piece can equally be enjoyed as a musical experience in its own right.

 To hear Debussy's *Claire de Lune,* play track 16 on the Listening CD.

The only composer to make wholehearted use of Debussy's Impressionistic style was his fellow countryman Maurice Joseph Ravel (1875–1937), who, however, added a highly individual quality of his own. Ravel was far more concerned with classical form and balance than Debussy. His musical god was Mozart, and something of the limpid clarity of Mozart's music can be heard in many of his pieces, although certainly not in the all-too-familiar *Bolero*. His lovely *Piano Concerto in G* alternates a Mozartian delicacy and grace with an exuberance born of Ravel's encounters with jazz. Even in his most overtly Impressionistic moments, like the scene in his ballet *Daphnis and Chloe* that describes dawn rising, he retains an elegance and verve that differs distinctly from the veiled and muted tones of Debussy.

The Search for a New Musical Language

In 1908, the Austrian composer Arnold Schönberg (1874–1951) wrote his *Three Piano Pieces,* Op. 11, in which he was "conscious of having broken all restrictions" of past musical traditions. After their first performance one critic described them as "pointless ugliness" and "perversion." In 1913, the first performance of *The Rite of Spring,* a ballet by the Russian-born composer Igor Fyodorovich Stravinsky (1882–1971), was given in Paris, where he was then living. It was greeted with hissing, stamping, and yelling, and Stravinsky was accused of the "destruction of music as an art." Stravinsky and Schönberg are today justly hailed as the founders of modern music, but we can agree with their opponents in at least one respect: their revolutionary innovations permanently changed the course of musical development.

It is a measure of their achievement that today listeners find *The Rite of Spring* exciting, even explosive, but perfectly approachable. If Stravinsky's ballet score has lost its power to shock and horrify, it is principally because we have become accustomed to music written

in its shadow. *The Rite of Spring* has created its own musical tradition, one without which present-day music at all levels of popularity would be unthinkable. Schönberg's effect has been less widespread and subtler; nonetheless, no serious composer writing since his time has been able to ignore his music. It is significant that Stravinsky, who originally seemed to be taking music down a radically different "path to destruction," eventually adopted principles of composition based on Schönberg's methods.

As is true of all apparently revolutionary breaks with the past, Stravinsky and Schönberg were really only pushing to extreme conclusions developments that had been under way for some time. Traditional harmony had been collapsing since the time of Wagner, and Schönberg only dealt it a deathblow by his innovations. Wagner's *Tristan and Isolde* had opened with a series of chords that were not firmly rooted in any key and had no particular sense of direction (see Chapter 17), a device Wagner used to express the poetic concept of restless yearning. Other composers followed him in rejecting the concept of a fixed harmonic center from which the music might stray so long as it returned there, replacing it with a much more fluid use of harmony. (Debussy, in his attempts to go beyond the bounds of conventional harmony, often combined chords and constructed themes to avoid the sense of a tonal center; the result can be heard in the wandering, unsettled quality of much of his music.)

Schönberg believed that the time had come to abandon a harmonic (or tonal) system that had served music well for more than three hundred years but had simply become worn out. He therefore began to write **atonal** music, which deliberately avoided traditional chords and harmonies. Thus Schönberg's **atonality** was a natural consequence of earlier musical developments. At the same time, it was fully in accordance with the spirit of the times. The sense of a growing rejection of traditional values, culminating in a decisive and violent break with the past, can be felt not only in the arts but also in the political and social life of Europe; Schönberg's drastic abandonment of centuries of musical tradition prefigured by only a few years the far more drastic abandonment of centuries of tradition brought about by World War I.

There is another sense in which Schönberg's innovations correspond to contemporary developments. One of the principal effects of atonality is a mood of instability—even disturbance—which lends itself to the same kind of morbid themes that attracted Expressionist painters. In fact, many of Schönberg's early atonal works deal with such themes. Schönberg was a painter of some ability and generally worked in an Expressionist style.

One of Schönberg's most extraordinary pieces is *Pierrot Lunaire,* finished in 1912, a setting of twenty-

one poems for woman's voice and small instrumental group. The poems describe the bizarre experiences of their hero, Pierrot, who is an Expressionist version of the eternal clown, and their mood is grotesque and at times demonic. The eighth poem, for example, describes a crowd of gigantic black moths flying down to block out the sunlight, while in the eleventh, titled "Red Mass," Pierrot holds his own heart in his blood-stained fingers to use as a "horrible red sacrificial wafer." Schönberg's music clothes these verses in appropriately fantastic and macabre music. The effect is enhanced by the fact that the singer is instructed to speak the words at specific pitches. This device of **Sprechstimme** ("voiced speech"), invented by Schönberg for *Pierrot Lunaire,* is difficult to execute, but when it is done properly by a skilled performer, it imparts a wistfully dreamlike quality to the music.

The first poem, *Mondestrunken* (literally "Moon-drunk"), sets the mood for the whole cycle; the moon returns as a symbol in several later songs. The poet, his eyes drunk with wine and moonlight, seeks inspiration in the beauty of the night.

 To hear *Mondestrunken* from Schönberg's *Pierrot Lunaire,* play track 17 on the Listening CD.

The freedom atonality permitted the composer became something of a liability and, by the 1920s, Schönberg replaced it with a system of composition as rigid as any earlier method in the history of music. His famous **twelve-tone technique** uses the twelve notes of the chromatic scale (on the piano, all of the black and white notes in a single octave), which are carefully arranged in a **row** or **series,** the latter term having given rise to the name **serialism** to describe the technique. The basic row, together with variant forms, then serves as the basis for a movement or even an entire work, with the order of the notes remaining always the same. The following example presents the row used in the first movement of Schönberg's *Piano Suite,* Op. 25, together with three of its variant forms. No. 1 is the row, No. 2 its **inversion** (that is, the notes are separated by the same distance but in the opposite direction, down instead of up, and up instead of down), No. 3 is the row **retrograde** or backward, and No. 4 the inversion of this backward form, known as **retrograde inversion.**

Just as with program music, the only fair way to judge the twelve-tone technique is by its results. Not all works written using it are masterpieces, but we can hardly expect them to be. It is not a system that appeals to all composers or brings out the best in them, but few systems ever have universal application. Some of Schönberg's own twelve-tone works, including his unfinished opera *Moses and Aaron* and the *Violin Concerto* of 1934, demonstrate that serial music can be both beautiful and moving. The twenty-first century will decide whether the system has permanent and enduring value.

Like *Pierrot Lunaire,* Stravinsky's *The Rite of Spring* deals with a violent theme. It is subtitled *Pictures from Pagan Russia* and describes a springtime ritual culminating in the sacrifice of a chosen human victim. Whereas Schönberg jettisoned traditional harmony, Stravinsky used a new approach to rhythm as the basis of his piece. Constantly changing, immensely complex, and frequently violent, his rhythmic patterns convey a sense of barbaric frenzy that is enhanced by the weight of sound obtained from the use of a vast orchestra. There are some more peaceful moments, notably the nostalgic opening section, but in general the impression is of intense exhilaration. Something of the rhythmic vitality of *The Rite of Spring* can be seen in this brief extract from the final orgiastic dance. The same melodic fragment is repeated, but in a constantly fluctuating rhythm that changes almost from bar to bar. Yet elsewhere in the work, Stravinsky obtains an equal sense of excitement from repeating the same rhythm obsessively, while violently stressing some of the notes, as in the *Dance of the Adolescents;* coming shortly after the quiet introduction, the music seems suddenly to explode.

 To hear the *Dance of the Adolescents* from Stravinsky's *The Rite of Spring,* play track 18 on the Listening CD.

The Rite of Spring was the last of three ballets (the others were *The Firebird* and *Petrouchka*) that Stravinsky based on Russian folk subjects [**FIG. 18.32**]. In the years following World War I, he wrote music in a wide variety of styles, absorbing influences as varied as Bach, Tchaikovsky, and jazz. Yet a characteristically Stravinskian flavor pervades all of his best works, with the result that his music is almost always instantly recognizable. Short, expressive melodies and unceasing rhythmic vitality, both evident in *The Rite of Spring,* recur in

❖ **18.32** Vaslav Nijinsky as the puppet Petrouchka in Igor Stravinsky's ballet of that name, as choreographed by Michel Fokine and performed by the Ballet Russe. Paris, 1911. New York Public Library at Lincoln Center (Roger Pryor Dodge Collection). Nijinsky (1890–1950), a Russian, was one of the greatest dancers of all time. Fokine (1880–1942), also a Russian, was a choreographer who broke new ground in the ballet just as the Impressionists did in art and music.

works like the *Symphony in Three Movements* in 1945. Even when, in the 1950s, he finally adopted the technique of serialism, he retained his own unique musical personality. Stravinsky is a peculiarly twentieth-century cultural phenomenon, an artist uprooted from his homeland, cut off (by choice) from his cultural heritage, and exposed to a barrage of influences and counterinfluences. That he never lost his sense of personal identity or his belief in the enduring value of art made him a twentieth-century hero.

NEW SUBJECTS FOR LITERATURE

Psychological Insights in the Novel

At the end of the nineteenth century, many writers were still as concerned with exploring the nature of their own individual existences as they had been when the century began. In fact, the first years of the twentieth century saw an increasing interest in the effect of the subconscious on human behavior, a result largely of the work of the Austrian psychoanalyst Sigmund Freud (1856–1939); the general conclusions Freud reached are discussed in Chapter 21. In many ways his interest in the part played by individual frustrations, repressions, and neuroses (particularly sexual) in creating personality was prefigured in the writing of two of the greatest novelists of the late nineteenth century: Fyodor Dostoyevsky (1821–1881) and Marcel Proust (1871–1922).

Self-knowledge played a major part in Dostoyevsky's work, and his concern for psychological truth led him into a profound study of his characters' subconscious motives. His empathy for human suffering derived in part from his identification with Russian Orthodox Christianity, with its emphasis on suffering as a means to salvation. Although well aware of social injustices, he was more concerned with their effect on the individual soul than on society as a whole. His books present a vivid picture of the Russia of his day, with characters at all levels of society brought brilliantly to life. Nevertheless, he was able to combine realism of perception with a deep psychological understanding of the workings of the human heart. Few artists have presented so convincing a picture of individuals struggling between good and evil.

The temptation to evil forms a principal theme of one of his most powerful works, *Crime and Punishment*. In it Dostoyevsky tells the story of a poor student, Raskolnikov, whose growing feeling of alienation from his fellow human beings leads to a belief that he is superior to society and above conventional morality. To prove this to himself, Raskolnikov decides to commit an act of defiance: the murder of a defenseless old woman, not for gain but as a demonstration of his own power.

He murders the old woman and also her younger sister, who catches him in the act. Crime is followed immediately, however, not by the punishment of the law but by the punishment of his own conscience. Guilt and remorse cut him off even farther from human contact until finally, in utter despair and on the verge of madness, he goes to the police and confesses to the murder. Here and in his other works, Dostoyevsky underlines the terrible dangers of intellectual arrogance. The world he portrays is essentially cruel, one in which simplicity and self-awareness are the

only weapons against human evil, and suffering is a necessary price paid for victory.

If Dostoyevsky used violence to depict his worldview, his contemporary and fellow Russian Anton Pavlovich Chekhov (1860–1904) used irony and satire to show the passivity and emptiness of his characters. In plays and short stories, Chekhov paints a provincial world whose residents dream of escape, filled with a frustrated longing for action. The three sisters who are the chief characters in the play of that name never manage to achieve their ambition to go "To Moscow, to Moscow!" In stories such as "The Lady with the Dog," Chekhov uses apparent triviality to express profound understanding, whereas in "The Bet" he ironically challenges most of our basic values.

One of the most influential of all modern writers was the French novelist Marcel Proust. Proust's youth was spent in the fashionable world of Parisian high society, where he entertained lavishly and mixed with the leading figures of the day while writing elegant if superficial poems and stories. The death of his father in 1903 and of his mother in 1905 brought about a complete change. He retired to his house in Paris and rarely left his soundproofed bedroom, where he wrote the vast work for which he is famous, *Remembrance of Things Past*. The first volume appeared in 1913; the eighth and last volume was not published until 1927, five years after his death.

It is difficult to do justice to this amazing work. The lengthy story is told in the first person by a narrator who, though never named, obviously has much in common with Proust. The story's entire concern is to recall the narrator's past life—from earliest childhood to middle age—by bringing to mind the people, places, things, and events that have affected him. In the course of the narrator's journey back into his past, he realizes that all of it lies hidden inside him and that the tiniest circumstance—a scent, a taste, the appearance of someone's hair—can trigger a whole chain of memory associations. By the end of the final volume the narrator has decided to preserve the recollection of his past life by making it permanent in the form of a book—the book the reader has just finished.

Proust's awareness of the importance of the subconscious and his illustration of the way in which it can be unlocked have had a great appeal to modern writers, as has his **stream of consciousness** style, which appears to reproduce his thought processes as they actually occur rather than as edited by a writer for logical connections and development. Furthermore, as we follow Proust's (or the narrator's) careful and painstaking resurrection of his past, it is important to remember that his purpose is far more than a mere intellectual exercise. By recalling the past we bring it back to life in a literal sense. Memory is our most powerful weapon against death.

Responses to a Changing Society: The Role of Women

Not all writers in the late nineteenth and early twentieth centuries devoted themselves to the kind of psychological investigation found in the works of Dostoyevsky and Proust. The larger question of the nature of society continued to attract the attention of more socially conscious writers who explored the widening range of problems created by industrial life as well as a whole new series of social issues (see **TABLE 18.2**).

One of the most significant aspects of the development of the modern world has been the changing role of women in family life and in society at large. The issue of women's right to vote was bitterly fought in the early years of the twentieth century, and not until 1918 in Great Britain and 1920 in the United States were women permitted to participate in the electoral process. On a more personal basis, the growing availability and frequency of divorce began to cause many women (and men) to rethink the nature of the marriage tie. The pace of women's emancipation from the stock role assigned to them over centuries was extremely slow, and the process is far from complete. A beginning had to be made somewhere, however, and it is only fitting that a period characterized by cultural and political change should also be marked by social change in this most fundamental of areas.

TABLE 18.2 *Social and Intellectual Developments: 1870–1914*

1875	German Social Democratic party founded
1879	Edison invents electric light bulb
1881	Pasteur and Koch prove "germ theory" of disease
1883	Social insurance initiated by Bismarck in Germany
1888	Brazil abolishes slavery, the last nation to do so
1889	International league of socialist parties founded, the so-called Second International
1894–1906	Dreyfus affair in France reveals widespread anti-Semitism and leads to separation of church and state
1895	Roentgen discovers x-rays; Marconi invents wireless telegraphy
1900	Freud publishes *The Interpretation of Dreams*
1903	Wright brothers make first flight with power-driven plane
1905	Einstein formulates theory of relativity; Revolution in Russia fails to produce significant social change
1906–1911	Social insurance and parliamentary reform enacted in Britain
1909	Ford produces assembly-line-made automobiles
1911	Revolution in China establishes republic; Rutherford formulates theory of positively charged atomic nucleus

In the same way Dickens had led the drive against industrial oppression and exploitation in the mid-nineteenth century, writers of the late nineteenth and early twentieth centuries not only reflected feminist concerns but actively promoted them as well. They tackled a range of problems so vast that we can do no more than look at just one area, marriage, through the eyes of two writers of the late nineteenth century. One of them, Henrik Ibsen (1828–1906), was the most famous playwright of his day and a figure of international renown. The other, Kate Chopin (1851–1904), was ignored in her own lifetime even in her native America.

Ibsen was born in Norway, although he spent much of his time in Italy. Most of his mature plays deal with the conventions of society and their consequences, generally tragic. Although many are technically set in Norway, their significance was intended to be universal. The problems Ibsen explored were frequently ones regarded as taboo, including venereal disease, incest, and insanity. The realistic format of the plays brought issues like these home to his audience with shocking force. At first derided, Ibsen eventually became a key figure in the development of drama, particularly in the English-speaking world, where his work was championed by George Bernard Shaw (1856–1950), who later inherited Ibsen's mantle as a progressive social critic.

In one of his first important plays, *A Doll's House* (1879), Ibsen dealt with the issue of women's rights. The principal characters, Torvald Helmer and his wife Nora, have been married for eight years, apparently happily enough. Early in their marriage, however, before Helmer had become a prosperous lawyer, Nora had secretly borrowed some money from Krogstad, a friend, to pay for her husband's medical treatment; she had told Torvald that the money came from her father because Helmer was too proud to borrow. As the play opens, Krogstad, to whom Nora is still in debt, threatens to blackmail her if she does not persuade Helmer to find him a job. When she refuses to do so, Krogstad duly writes a letter to Helmer revealing the truth. Helmer recoils in horror at his wife's deception. The matter of the money is eventually settled by other means and Helmer eventually forgives Nora, but not before the experience has given her a new and unforgettable insight into her relationship with her husband. In the final scene, she walks out the door, slams it, and leaves him forever.

Nora decides to abandon her husband on two grounds. In the first place, she realizes how small a part she plays in her husband's real life. As she says, "Ever since the first day we met, we have never exchanged so much as one serious word about serious things." The superficiality of their relationship horrifies her. In the second place, Helmer's inability to rise to the challenge presented by the discovery of his wife's deception and

prove his love for her by claiming that it was he who had borrowed and failed to repay the debt diminishes him in Nora's eyes. Ibsen tries to express what he sees as an essential difference between men and women when, in reply to Helmer's statement "One doesn't sacrifice one's honor for love's sake," Nora replies, "Millions of women have done so." Nora's decision not to be her husband's childish plaything—to leave the doll's house in which she was the doll—was so contrary to accepted social behavior that one noted critic remarked: "That slammed door reverberated across the roof of the world."

In comparison to the towering figure of Ibsen, the American writer Kate Chopin found few readers in her own lifetime; even today she is not widely known. Only recently have critics begun to do justice to the fine construction and rich psychological insight of her novel *The Awakening*, denounced as immoral and banned when first published in 1899. Its principal theme is the oppressive role women are forced to play in family life. Edna, its heroine, like Nora in *A Doll's House*, resents the meaninglessness of her relationship with her husband and the tedium of her daily existence. Her only escape is to yield to her sexual drives and find freedom not in slamming the door behind her but by throwing herself into a passionate if unloving affair.

In her short stories, Chopin dealt with the same kind of problem, but with greater delicacy and often with a wry humor. Frequently on the smallest of scales, these stories examine the prison that marriage seems so often to represent. In the course of a couple of pages, Chopin exposes an all-too-common area of human experience and, like Ibsen, touches a chord that rings as true now as it did at the turn of the century.

SUMMARY

The Coming of World War The last years of the nineteenth century saw the threat of war gathering with increasing speed over Europe. The gap between the prosperous and the poor, the growth of the forces of big business, and overcrowding and food shortages in the cities all tended to create a climate of unease that the rivalries of the major European powers exacerbated. Many emigrated to America in search of a new start. For the philosopher Friedrich Nietzsche, only drastic remedies could prevent the collapse of Western civilization.

Impressionist Painting In each of the arts, the years leading up to World War I were marked by far-reaching changes. In the case of painting, the Impressionist school developed in Paris. Foreshadowed in the work of Édouard Manet, Impressionist art represented a new

way of looking at the world. Painters like Claude Monet, Auguste Renoir, and Berthe Morisot reproduced what they saw rather than visually interpret their subjects. The depiction of light and atmosphere became increasingly important. The figure studies of Edgar Degas and Mary Cassatt avoided the careful poses of earlier times in favor of natural, intimate scenes.

The Post-Impressionists The various schools that developed out of Impressionism are collectively known as post-Impressionist, although they have little in common with one another. Among the leading artists were Paul Gauguin, with his love of exotic subjects, and Vincent van Gogh, whose deeply moving images have made him perhaps the best known of all nineteenth-century painters. In historical terms, the most important figure was probably Paul Cézanne: His works are the first since the dawn of the Renaissance to eliminate perspective and impose order on nature rather than try to reproduce it.

Expressionism and the Fauves In the early years of the twentieth century, two movements began to emerge: Fauvism and Expressionism—the former in France and the latter in Germany and Scandinavia. Both emphasized bright colors and violent emotions, and the works of Edvard Munch and other Expressionists are generally tormented in spirit. Henri Matisse, the leading Fauve artist, however, produced works that are joyous and optimistic; he was to become a major force in twentieth-century painting.

Orchestral Music at the Turn of the Nineteenth Century Composers of orchestral music in the late nineteenth and early twentieth centuries turned increasingly to the rich language of post-Wagnerian harmony and instrumentation to express either extramusical "programs" or to compose "autobiographical" works. The leading figures of the period included Richard Strauss and Gustav Mahler. Many of Strauss's operas have held the stage since their first performances, while his tone poems use a vast orchestra either to tell a story (as in *Don Juan*) or to describe his own life (*Domestic Symphony*). Mahler's symphonies, neglected in the composer's lifetime, have come to represent some of the highest achievements of the symphonic tradition. Openly autobiographical, they reflect at the same time the universal human problems of loss and anxiety.

In France, the music of Claude Debussy and, to a lesser extent, Maurice Ravel, set out to achieve the musical equivalent of Impressionism. In works like *La Mer*, Debussy used new harmonic combinations to render the atmosphere of a seascape.

New Approaches to Music: Schönberg and Stravinsky The experiments of composers like Mahler and Debussy at least retained many of the traditional musical forms and modes of expression, although they vastly extended them. In the early years of the twentieth century, Arnold Schönberg and Igor Stravinsky

wrote works that represented a significant break with the past. Schönberg's atonal and, later, serial music sought to replace the traditional harmonic structure of Western musical style with a new freedom, albeit one limited by the serial system. In *The Rite of Spring* and other works, Stravinsky revealed a new approach to rhythm. Both composers profoundly influenced the development of twentieth-century music.

Literature and the Subconscious Like other arts, literature also underwent revolutionary change in the latter decades of the nineteenth century. In the hands of Fyodor Dostoyevsky and Marcel Proust, the novel became a vehicle to reveal the effects of the subconscious on human behavior. In Dostoyevsky's books, self-knowledge and psychological truth are combined to explore the nature of human suffering. Proust's massive exploration of the past not only seeks to uncover his own memories, but it also deals with the nature of time. Both writers, along with many of their contemporaries, joined painters and musicians in pushing their art to its limits in order to extend its range of expression.

Writers and the Changing Role of Women A more traditional aim of literature was to effect social change. At a time when society was becoming aware of the changing role of women in the modern world, writers aimed to explore the implications for marriage and the family of the gradual emancipation of women and the increasing availability of divorce. The plays of Henrik Ibsen not only described the issues of his day, including feminist ones, but they were also intended to open up discussion of topics—venereal disease, incest—that his middle-class audience would have preferred to ignore.

With the outbreak of war in 1914, the arts were wrenched from their traditional lines of development to express the anxieties of the age. Nothing—in art, culture, politics, or society—was ever to return to its former state.

KEY TERMS

Atonality Music that lacks a traditional harmonic (or tonal) center
Belle époque French for "Beautiful age." Used to describe the growing prosperity of the late nineteenth century.
Blaue Reiter, Brucke Two of the schools of German Expressionist painting
Expressionism Early twentieth-century style of painting, popular in Germany, which aimed to use color and theme to express the growing social and political tensions of the times
Fauvism Early twentieth-century style of painting in France, using violent extremes of color and form
Inversion See *serialism*

Post-Impressionism General term for varying styles of painting, mainly in France, which developed after the Impressionist movement

Program music Music which illustrates a story or program

Retrograde inversion See *serialism*

Row See *serialism*

Serialism, Twelve-tone technique A system of musical composition invented by Schönberg, based on an arrangement of the twelve notes of the chromatic scale, which remains fixed during a piece of music. In strict serialism, the only variations of this *row* or *series* permitted are *inversion* (the row turned upside down), *retrograde* (the row turned backward), and *retrograde inversion* (the backwards version of the row turned upside down).

Series See *serialism*

Sprechstimme A device invented by Schönberg whereby a singer "speaks" musical notes rather than singing them in traditional style

Symphonic Poem, Tone Poem A piece of *program music* that tells a story in sound

Twelve-tone technique See *serialism*

Übermensch Term invented by Nietzsche to describe a "superior human"

PRONUNCIATION GUIDE

belle époque:	bell ep-OCK
Cézanne:	Say-ZAN
Degas:	De-GA
Dostoyevsky:	Doh-stoy-EV-ski
Gauguin:	Go-GAN
Ibsen:	IB-sun
Manet:	Ma-NAY
Monet:	Mo-NAY
Morisot:	Mo-ri-SEW
Munch:	MOONK
Nietzsche:	NEE-che
Proust:	PROOST
Renoir:	Ren-WAAR
Rodin:	Roe-DAN
Schönberg:	SHURN-burg
Till Eulenspiegel:	Til OY-lin-shpee-gull
van Gogh:	van GO

EXERCISES

1. Assess the impact of political and philosophical developments on the arts in the late nineteenth century.

2. Describe the goals and achievements of the Impressionist movement in painting. How do you account for the enormous popularity of Impressionist art ever since?

3. How did Arnold Schönberg's music break with the past? How does his serial system function? What is its purpose?

4. In what ways is the changing role of women reflected in art and literature at the turn of the century?

5. Compare the fiction of Dostoyevsky and Proust. How does it differ from earlier nineteenth-century novels discussed in Chapter 17?

YOUR RESOURCES

▪ **ExploringHumanities CD-ROM**
 - Interactive Modules: Comparing Modern Art, Aspects of Modernism
 - Reading Selections: Freud, *Interpretaton of Dreams;* Shaw, *Man and Superman*

▪ **Website http://art.wadsworth.com/cunningham**
 - Chapter 18 Quiz
 - Links

▪ **Audio CD**
 - Debussy: *Claire de Lune*
 - Schönberg: *Pierrot Lunaire, "Mondestrunken"*
 - Stravinsky: *Le Sacre du Printemps, Danse des adolescentes*

FURTHER READING

Antliff, Mark. *Cultural Politics and the Parisian Avant-Garde.* Princeton, NJ: Princeton University Press, 1993. Sets the artistic movements of the late nineteenth century into a more general political and social context.

Broude, N. *Impressionism: A Feminist Reading.* New York: Rizzoli, 1991. A refreshing look at some familiar works, with very good illustrations.

Franklin, P. *The Life of Mahler.* New York: Cambridge University Press, 1997. A fine biography that places Mahler's life and music in the context of the cultural conflicts of his era.

Fried, M. *Manet's Modernism, or, The Face of Painting in the 1860s.* Chicago: University of Chicago Press, 1996. An important book that analyzes the artistic conditions leading to the birth of Impressionism.

Garb, Tamar. *Bodies of Modernity: Figure and Flesh in Fin-de Siecle France.* New York: Thames and Hud-

son, 1998. A short, well-illustrated account of the essential background to the development of Modernism in art.

Hamilton, George H. *Painting and Sculpture in Europe, 1880–1940*, 6th ed. New Haven, CT: Yale University Press, 1993. An authoritative survey, which continues the story up to World War II.

Jensen, R. *Marketing Modernism in fin-de-siecle Europe.* Princeton, NJ: Princeton University Press, 1994. A fascinating and unusual perspective on European art at the end of the nineteenth century.

Joseph, Charles M. *Stravinsky Inside Out.* New Haven, CT: Yale University Press, 2001. An interesting study of the composer, which uses a great deal of unpublished material (e.g., letters, documents, film) to focus on Stravinsky's place in the culture of the twentieth century.

Kennedy, M. *Richard Strauss: Man, Musician, Enigma.* New York: Cambridge University Press, 1999. One of the latest studies of Strauss and his music. Kennedy deals relatively sympathetically with Strauss's controversial relationship with the Nazis.

Mainardi, Patricia. *The End of the Salon: Art and State in the Early Third Republic.* Cambridge: Cambridge University Press, 1993. A revealing study of the social and political tensions underlying the birth of the Modernist movement.

Smith, P. *Impressionism: Beneath the Surface.* New York: Harry N. Abrams, 1995. An interesting and beautifully illustrated study of Impressionist art.

Tadier, J-Y., trans. Euan Cameron. *Marcel Proust: A Life.* New York: Viking, 2000. An authoritative study of Proust's life and works from the leading French Proust scholar.

READING SELECTIONS

ANTON CHEKHOV
THE BET

Many readers of this famous story have asked about the wager it describes: "Who won?" Whichever of the two suffers the most, their plight underlines Chekhov's concern for the human condition and the isolation and sense of futility that have become part of the modern condition. The last sentence adds a final note of typical Chekhovian irony.

I

It was a dark autumn night. The old banker was pacing from corner to corner of his study, recalling to his mind the party he gave in the autumn fifteen years before. There were many clever people at the party and much interesting conversation. They talked among other things of capital punishment. The guests, among them not a few scholars and journalists, for the most part disapproved of capital punishment. They found it obsolete as a means of punishment, unfitted to a Christian State and immoral. Some of them thought that capital punishment should be replaced universally by life imprisonment.

"I don't agree with you," said the host. "I myself have experienced neither capital punishment nor life imprisonment, but if one may judge *a priori*, then in my opinion capital punishment is more moral and more humane than imprisonment. Execution kills instantly, life imprisonment kills by degrees. Who is the more humane executioner, one who kills you in a few seconds or one who draws the life out of you incessantly, for years?"

"They're both equally immoral," remarked one of the guests, "because their purpose is the same, to take away life. The State is not God. It has no right to take away that which it cannot give back, if it should so desire."

Among the company was a lawyer, a young man of about twenty-five. On being asked his opinion, he said:

"Capital punishment and life imprisonment are equally immoral; but if I were offered the choice between them, I would certainly choose the second. It's better to live somehow than not to live at all."

There ensued a lively discussion. The banker, who was then younger and more nervous, suddenly lost his temper, banged his fist on the table, and turning to the young lawyer, cried out:

"It's a lie. I bet you two million you wouldn't stick in a cell even for five years."

"If you mean it seriously," replied the lawyer, "then I bet I'll stay not five but fifteen."

"Fifteen! Done!" cried the banker. "Gentlemen, I stake two million."

"Agreed. You stake two million, I my freedom," said the lawyer.

So this wild, ridiculous bet came to pass. The banker, who at that time had too many millions to count, spoiled and capricious, was beside himself with rapture. During supper he said to the lawyer jokingly:

"Come to your senses, young man, before it's too late. Two million are nothing to me, but you stand to lose three or four of the best years of your life. I say three or four, because you'll never stick it out any longer. Don't forget either, you unhappy man, that voluntary is much heavier enforced imprisonment. The idea that you have the right to free yourself at any moment will poison the whole of your life in the cell. I pity you."

And now the banker, pacing from corner to corner, recalled all this and asked himself:

"Why did I make this bet? What's the good? The lawyer loses fifteen years of his life and I throw away two million. Will it convince people that capital punishment is worse or better than imprisonment for life? No, no! All stuff and rubbish. On my part, it was the caprice of a well-fed man; on the lawyer's pure greed of gold."

He recollected further what happened after the evening party. It was decided that the lawyer must undergo his imprisonment under the strictest observation, in a garden wing of the banker's house. It was agreed that during the period he would be deprived of the right to cross the threshold, to see living people, to hear human voices, and to receive letters and newspapers. He was permitted to have a musical instrument, to read books, to write letters, to drink wine and

smoke tobacco. By the agreement he could communicate, but only in silence, with the outside world through a little window specially constructed for this purpose. Everything necessary, books, music, wine, he could receive in any quantity by sending a note through the window. The agreement provided for all the minutest details, which made the confinement strictly solitary, and it obliged the lawyer to remain exactly fifteen years from twelve o'clock of November 14th, 1870, to twelve o'clock of November 14th, 1885. The least attempt on his part to violate the conditions, to escape if only for two minutes before the time, freed the banker from the obligation to pay him the two million.

During the first year of imprisonment, the lawyer, as far as it was possible to judge from his short notes, suffered terribly from loneliness and boredom. From his wing day and night came the sound of the piano. He rejected wine and tobacco. "Wine," he wrote, "excites desires, and desires are the chief foes of a prisoner; besides, nothing is more boring than to drink good wine alone, and tobacco spoils the air in his room."

During the first year the lawyer was sent books of a light character; novels with a complicated love interest, stories of crime and fantasy, comedies, and so on.

In the second year the piano was heard no longer and the lawyer asked only for classics. In the fifth year, music was heard again, and the prisoner asked for wine. Those who watched him said that during the whole of that year he was only eating, drinking, and lying on his bed.

He yawned often and talked angrily to himself. Books he did not read. Sometimes at night he would sit down to write. He would write for a long time and tear it all up in the morning. More than once he was heard to weep.

In the second half of the sixth year, the prisoner began zealously to study languages, philosophy, and history. He fell on these subjects so hungrily that the banker hardly had time to get books enough for him. In the space of four years about six hundred volumes were bought at his request. It was while that passion lasted that the banker received the following letter from the prisoner: "My dear gaoler, I am writing these lines in six languages. Show them to experts. Let them read them. If they do not find one single mistake, I beg you to give orders to have a gun fired off in the garden. By the noise I shall know that my efforts have not been in vain. The geniuses of all ages and countries speak in different languages; but in them all burns the same flame. Oh, if you knew my heavenly happiness now that I can understand them!" The prisoner's desire was fulfilled. Two shots were fired in the garden by the banker's order.

Later on, after the tenth year, the lawyer sat immovable before his table and read only the New Testament. The banker found it strange that a man who in four years had mastered six hundred erudite volumes, should have spent nearly a year in reading one book, easy to understand and by no means thick. The New Testament was then replaced by the history of religions and theology.

During the last two years of his confinement the prisoner read an extraordinary amount, quite haphazard. Now he would apply himself to the natural sciences, then he would read Byron or Shakespeare. Notes used to come from him in which he asked to be sent at the same time a book on chemistry, a textbook of medicine, a novel, and some treatise on philosophy or theology. He read as though he were swimming in the sea among broken pieces of wreckage, and in his desire to save his life was eagerly grasping one piece after another.

II

The banker recalled all this, and thought:

"Tomorrow at twelve o'clock he receives his freedom. Under the agreement, I shall have to pay him two million. If I pay, it's all over with me. I am ruined forever . . ."

Fifteen years before he had too many millions to count, but now he was afraid to ask himself which he had more of, money or debts.

Gambling on the Stock Exchange, risky speculation, and the recklessness of which he could not rid himself even in old age, had gradually brought his business to decay; and the fearless, self-confident, proud man of business had become an ordinary banker, trembling at every rise and fall in the market.

"That cursed bet," murmured the old man clutching his head in despair. . . . "Why didn't the man die? He's only forty years old. He will take away my last farthing, marry, enjoy life, gamble on the exchange, and I will look on like an envious beggar and hear the same words from him every day: 'I'm obliged to you for the happiness of my life. Let me help you.' No. it's too much! The only escape from bankruptcy and disgrace—is that the man should die."

The clock had just struck three. The banker was listening. In the house every one was asleep, and one could hear only the frozen trees whining outside the windows. Trying to make no sound, he took out of his safe the key of the door which had not been opened for fifteen years, put on his overcoat, and went out of the house. The garden was dark and cold. It was raining. A damp, penetrating wind howled in the garden and gave the trees no rest. Though he strained his eyes, the banker could see neither the ground, nor the white statues, nor the garden wing, nor the trees. Approaching the garden wing, he called the watchman twice. There was no answer. Evidently the watchman had taken shelter from the bad weather and was now asleep somewhere in the kitchen or the greenhouse.

"If I have the courage to fulfill my intention," thought the old man, "the suspicion will fall on the watchman first of all."

In the darkness he groped for the steps and the door and entered the hall of the garden wing, then poked his way into a narrow passage and struck a match. Not a soul was there. Someone's bed, with no bedclothes on it, stood there, and an iron stove loomed dark in the corner. The seals on the door that led into the prisoner's room were unbroken.

When the match went out, the old man, trembling from agitation, peeped into the little window.

In the prisoner's room a candle was burning dimly. The prisoner himself sat by the table. Only his back, the hair on his head and his hands were visible. Open books were strewn about on the table, the two chairs, and on the carpet near the table.

Five minutes passed and the prisoner never once stirred. Fifteen years' confinement had taught him to sit motionless. The banker tapped on the window with his finger, but the prisoner made no movement in reply. Then the banker cautiously tore the seals from the door and put the key into the lock. The rusty lock gave a hoarse groan and the door creaked. The banker expected instantly to hear a cry of surprise and the sound of steps. Three minutes passed and it was as quiet as it had been before. He made up his mind to enter.

Before the table sat a man, unlike an ordinary human being. It was a skeleton, with tight-drawn skin, with long curly hair like a woman's, and a shaggy beard. The color of his

face was yellow, of an earthy shade; the cheeks were sunken, the back long and narrow, and the hand upon which he leaned his hairy head was so lean and skinny that is was painful to look upon. His hair was already silvering with gray, and no one who glanced at the senile emaciation of the face would have believed that he was only forty years old. On the table, before his bent head, lay a sheet of paper on which something was written in a tiny hand.

"Poor devil," thought the banker, "he's asleep and probably seeing millions in his dreams. I have only to take and throw this half-dead thing on the bed, smother him a moment with the pillow, and the most careful examination will find no trace of unnatural death. But, first, let us read what he has written here."

The banker took the sheet from the table and read:

"Tomorrow at twelve o'clock midnight, I shall obtain my freedom and the right to mix with people. But before I leave this room and see the sun I think it necessary to say a few words to you. On my own clear conscience and before God who sees me I declare to you that I despise freedom, life, health, and all that your books call the blessings of the world.

"For fifteen years I have diligently studied earthly life. True, I saw neither the earth nor the people, but in your books I drank fragrant wine, sang songs, hunted deer and wild boar in the forests, loved women. . . . And beautiful women, like clouds ethereal, created by the magic of your poets' genius, visited me by night and whispered to me wonderful tales, which made my head drunken. In your books I climbed the summits of Elburz and Mont Blanc and saw from there how the sun rose in the morning, and in the evening suffused the sky, the ocean, and the mountain ridges with a purple gold. I saw from there how above me lightning glimmered cleaving the clouds; I saw green forests, fields, rivers, lakes, cities; I heard sirens singing, and the playing of the pipes of Pan; I touched the wings of beautiful devils who came flying to me to speak of God. . . . In your books I cast myself into bottomless abysses, worked miracles, burned cities to the ground, preached new religions, conquered whole countries. . . .

"Your books gave me wisdom. All that unwearying human thought created in the centuries is compressed to a little lump in my skull. I know that I am cleverer than you all.

"And I despise your books, despise all worldly blessings and wisdom. Everything is void, frail, visionary and delusive as a mirage. Though you be proud and wise and beautiful, yet will death wipe you from the face of the earth like the mice underground; and your posterity, your history, and the immortality of your men of genius will be as frozen slag, burnt down together with the terrestrial globe.

"You are mad, and gone the wrong way. You take falsehood for truth and ugliness for beauty. You would marvel if suddenly apple and orange trees should bear frogs and lizards instead of fruit, and if roses should begin to breathe the odor of a sweating horse. So do I marvel at you, who have bartered heaven for earth. I do not want to understand you.

"That I may show you in deed my contempt for that by which you live, I waive the two million of which I once dreamed as of paradise, and which I now despise. That I may deprive myself of my right to it, I shall come out from here five minutes before the stipulated term, and thus shall violate the agreement."

When he had read, the banker put the sheet on the table, kissed the head of the strange man, and began to weep. He went out of the wing.

Never at any other time, not even after his terrible losses on the exchange, had he felt such contempt for himself as now. Coming home, he lay down on his bed, but agitation and tears kept him a long time from sleeping. . . .

The next morning the poor watchman came running to him and told him that they had seen the man who lived in the wing climb through the window into the garden. He had gone to the gate and disappeared. The banker instantly went with his servants to the wing and established the escape of his prisoner. To avoid unnecessary rumors he took the paper with the renunciation from the table and, on his return, locked it in his safe.

HENRIK IBSEN
from A DOLL'S HOUSE, *Act III, final scene*

In this famous scene Ibsen, through the words of his character Nora, challenges many of the nineteenth century's most cherished illusions about marriage and the family. The insights Nora has gained into her husband's nature and the quality of their relationship mean nothing to Helmer when she tries to explain them to him. In the course of the dialogue the two struggle in mutual incomprehension as Nora describes her feelings of alienation and Helmer continues to respond with astonishment to the idea of his wife being concerned with "serious thoughts." By the end she leaves because she "can't spend the night in a strange man's house."

Ibsen has sometimes been accused of writing "problem plays" in which the ideas are more important than the characters. It is certainly true that Nora and Helmer are chiefly concerned with articulating their points of view. Yet amid the heated arguments both of them emerge as individuals. With great difficulty Helmer gradually begins to understand something of Nora's anguish. As for Nora, the whole of her past life is unforgettably described in the metaphor she uses to sum it up, which gives the play its name: a doll's house.

[THE ACTION TAKES PLACE LATE AT NIGHT, IN THE HELMERS' LIVING ROOM. NORA, INSTEAD OF GOING TO BED, HAS SUDDENLY REAPPEARED IN EVERYDAY CLOTHES.]

HELMER . . . What's all this? I thought you were going to bed. You've changed your dress?
NORA Yes, Torvald; I've changed my dress.
HELMER But what for? At this hour?
NORA I shan't sleep tonight.
HELMER But, Nora dear—
NORA [*looking at her watch*] It's not so very late—Sit down. Torvald; we have a lot to talk about.

[SHE SITS AT ONE SIDE OF THE TABLE.]

HELMER Nora—what does this mean? Why that stern expression? 10
NORA Sit down. It'll take some time. I have a lot to say to you.

[HELMER SITS AT THE OTHER SIDE OF THE TABLE.]

HELMER You frighten me, Nora. I don't understand you.
NORA No, that's just it. You don't understand me; and I have never understood you either—until tonight. No, don't interrupt me. Just listen to what I have to say. This is to be a final settlement, Torvald.
HELMER How do you mean?
NORA [*after a short silence*] Doesn't anything 20
special strike you as we sit here like this?

HELMER I don't think so—why?

NORA It doesn't occur to you, does it, that though we've been married for eight years, this is the first time that we two—man and wife—have sat down for a serious talk?

HELMER What do you mean by serious?

NORA During eight whole years, no—more than that—ever since the first day we met—we have never exchanged so much as one serious word about serious things.

HELMER Why should I perpetually burden you with all my cares and problems? How could you possibly help me to solve them?

NORA I'm not talking about cares and problems. I'm simply saying we've never once sat down seriously and tried to get to the bottom of anything.

HELMER But, Nora, darling—why should you be concerned with serious thoughts?

NORA That's the whole point! You've never understood me—A great injustice has been done me, Torvald; first by Father, and then by you.

HELMER What a thing to say! No two people on earth could ever have loved you more than we have!

NORA *[shaking her head]* You never loved me. You just thought it was fun to be in love with me.

HELMER This is fantastic!

NORA Perhaps. But it's true all the same. While I was still at home I used to hear Father airing his opinions and they became my opinions; or if I didn't happen to agree, I kept it to myself—he would have been displeased otherwise. He used to call me his doll-baby, and played with me as I played with my dolls. Then I came to live in your house—

HELMER What an expression to use about our marriage!

NORA *[undisturbed]* I mean—from Father's hands I passed into yours. You arranged everything according to your tastes, and I acquired the same tastes, or I pretended to—I'm not sure which—a little of both, perhaps. Looking back on it all, it seems to me I've lived here like a beggar, from hand to mouth. I've lived by performing tricks for you, Torvald. But that's the way you wanted it. You and Father have done me a great wrong. You've prevented me from becoming a real person.

HELMER Nora, how can you be so ungrateful and unreasonable! Haven't you been happy here?

NORA No, never. I thought I was; but I wasn't really.

HELMER Not—not happy!

NORA No, only merry. You've always been so kind to me. But our home has never been anything but a play-room. I've been your doll-wife, just as at home I was Papa's doll-child. And the children in turn, have been my dolls. I thought it fun when you played games with me, just as they thought it fun when I played games with them. And that's been our marriage, Torvald.

HELMER There may be a grain of truth in what you say, even though it is distorted and exaggerated. From now on things will be different. Playtime is over now; tomorrow lessons begin!

NORA Whose lessons? Mine, or the children's?

HELMER Both, if you wish it, Nora, dear.

NORA Torvald, I'm afraid you're not the man to teach me to be a real wife to you.

HELMER How can you say that?

NORA And I'm certainly not fit to teach the children.

HELMER Nora!

NORA Didn't you just say, a moment ago, you didn't dare trust them to me?

HELMER That was in the excitement of the moment! You mustn't take it so seriously!

NORA But you were quite right, Torvald. That job is beyond me; there's another job I must do first: I must try and educate myself. You could never help me to do that; I must do it quite alone. So, you see that's why I'm going to leave you.

HELMER *[jumping up]* What did you say—?

NORA I shall never get to know myself—I shall never learn to face reality—unless I stand alone. So I can't stay with you any longer.

HELMER Nora! Nora!

NORA I am going at once. I'm sure Kristine will let me stay with her tonight—

HELMER But, Nora—this is madness! I shan't allow you to do this. I shall forbid it!

NORA You no longer have the power to forbid me anything. I'll only take a few things with me—those that belong to me. I shall never again accept anything from you.

HELMER Have you lost your senses?

NORA Tomorrow I'll go home—to what was my home, I mean. It might be easier for me there, to find something to do.

HELMER You talk like an ignorant child, Nora—!

NORA Yes. That's just why I must educate myself.

HELMER To leave hour home—to leave your husband, and your children! What do you suppose people would say to that?

NORA It makes no difference. This is something I must do.

HELMER It's inconceivable? Don't you realize you'd be betraying your most sacred duty?

NORA What do you consider that to be?

HELMER Your duty toward your husband and your children—I surely don't have to tell you that!

NORA I've another duty just as sacred.

HELMER Nonsense! What duty do you mean?

NORA My duty toward myself.

HELMER Remember—before all else you are a wife and mother.

NORA I don't believe that anymore. I believe that before all else I am a human being, just as you are—or at least that I should try and become one. I know that most people would agree with you, Torvald—and that's what they say in books. But I can no longer be satisfied with what most people say or what they write in books. I must think things out for myself—get clear about them.

HELMER Surely your position in your home is clear enough? Have you no sense of religion? Isn't that an infallible guide to you?

NORA But don't you see, Torvald—I don't really know what religion is.

HELMER Nora! How *can* you!

NORA All I know about it is what Pastor Hansen told me when I was confirmed. He taught me what he thought religion was—said it was *this*

and *that*. As soon as I get away by myself, I shall have to look into that matter too, try and decide whether what he taught me was right—or whether it's right for *me*, at least.

HELMER A nice way for a young woman to talk! It's unheard of! If religion means nothing to you, I'll appeal to your conscience; you must have some sense of ethics, I suppose? Answer me! Or have you none?

NORA It's hard for me to answer you, Torvald. I don't think I know—all these things bewilder me. But I do know that I think quite differently from you about them. I've discovered that the law, for instance, is quite different from what I had imagined; but I find it hard to believe it can be right. It seems it's criminal for a woman to try and spare her old, sick, father, or save her husband's life! I can't agree with that.

HELMER You talk like a child. You have no understanding of the society we live in.

NORA No, I haven't. But I'm going to try and learn. I want to find out which of us is right—society or I.

HELMER You are ill, Nora; you have a touch of fever; you're quite beside yourself.

NORA I've never felt so sure—so clear-headed—as I do tonight.

HELMER "Sure and clear-headed" enough to leave your husband and your children?

NORA Yes.

HELMER Then there is only one explanation possible.

NORA What?

HELMER You don't love me any more.

NORA No; that is just it.

HELMER Nora!—What are you saying!

NORA It makes me so unhappy, Torvald; for you've always been so kind to me. But I can't help it. I don't love you anymore.

HELMER [*mastering himself with difficulty*] You feel "sure and clear-headed" about this too?

NORA Yes, utterly sure. That's why I can't stay here any longer.

HELMER And can you tell me how I lost your love?

NORA Yes, I can tell you. It was tonight—when the wonderful thing didn't happen; I knew then you weren't the man I always thought you were.

HELMER I don't understand.

NORA For eight years I've been waiting patiently; I knew, of course, that such things don't happen every day. Then, when this trouble came to me—I thought to myself: Now! Now the wonderful thing will happen! All the time Krogstad's letter was out there in the box, it never occurred to me for a single moment that you'd think of submitting to his conditions. I was absolutely convinced that you'd defy him—that you'd tell him to publish the thing to all the world; and that then—

HELMER You mean you thought I'd let my wife be publicly dishonored and disgraced?

NORA No. What I thought you'd do, was to take the blame upon yourself.

HELMER Nora—!

NORA I know! You think I never would have accepted such a sacrifice. Of course I wouldn't! But my word would have meant nothing against

yours. That was the wonderful thing I hoped for, Torvald, hoped for with such terror. And it was to prevent that, that I chose to kill myself.

HELMER I'd gladly work for you day and night, Nora—go through suffering and want, if need be—but one doesn't sacrifice one's honor for love's sake.

NORA Millions of women have done so.

HELMER You think and talk like a silly child.

NORA Perhaps. But you neither think nor talk like the man I want to share my life with. When you'd recovered from your fright—and you never thought of me, only of yourself—when you had nothing more to fear—you behaved as though none of this had happened. I was your little lark again, your little doll—whom you would have to guard more carefully than ever, because she was so weak and frail. [*stands up*] At that moment it suddenly dawned on me that I had been living here for eight years with a stranger and that I'd borne him three children. I can't bear to think about it! I could tear myself to pieces!

HELMER [*sadly*] I see, Nora—I understand; there's suddenly a great void between us—Is there no way to bridge it?

NORA Feeling as I do now, Torvald—I could never be a wife to you.

HELMER But, if I were to change? Don't you think I'm capable of that?

NORA Perhaps—when you no longer have your doll to play with.

HELMER It's inconceivable! I can't part with you, Nora. I can't endure the thought.

NORA [*going into room on the right*] All the more reason it should happen.

[SHE COMES BACK WITH OUTDOOR THINGS AND A SMALL TRAVELING BAG, WHICH SHE PLACES ON A CHAIR.]

HELMER But not at once, Nora—not now! At least wait till tomorrow.

NORA [*putting on cloak*] I can't spend the night in a strange man's house.

HELMER Couldn't we go on living here together? As brother and sister, if you like—as friends.

NORA [*fastening her hat*] You know very well that wouldn't last, Torvald. [*puts on the shawl*] Goodbye. I won't go in and see the children. I know they're in better hands than mine. Being what I am—how can I be of any use to them?

HELMER But surely, some day, Nora—?

NORA How can I tell? How do I know what sort of person I'll become?

HELMER You are my wife, Nora, now and always!

NORA Listen to me, Torvald—I've always heard that when a wife deliberately leaves her husband as I am leaving you, he is legally freed from all responsibility toward her. At any rate, I release you now from all responsibility. You mustn't feel yourself bound, any more than I shall. There must be complete freedom on both sides. Here is your ring. Now give me mine.

HELMER That too?

NORA That too.

HELMER Here it is.

NORA So—it's all over now. Here are the keys.

The servants know how to run the house—
better than I do. I'll ask Kristine to come
by tomorrow, after I've left town; there are a
few things I brought with me from home; she'll
pack them up and send them on to me.

HELMER You really mean it's over, Nora? *Really*
over? You'll never think of me again?

NORA I expect I shall often think of you; of you—
and the children, and this house.

HELMER May I write to you?

NORA No—never. You mustn't! Please!

HELMER At least, let me send you—

NORA Nothing!

HELMER But, you'll let me help you, Nora—

NORA No, I say! I can't accept anything from strangers.

HELMER Must I always be a stranger to you,
Nora?

NORA *[taking her traveling bag]* Yes. Unless it were to
happen—the most wonderful thing of all—

HELMER What?

NORA Unless we both could change so that—Oh,
Torvald! I no longer believe in miracles, you see!

HELMER Tell me! Let me believe! Unless we both
could change so that—?

NORA So that our life together might truly be a
marriage. Good-bye.

[SHE GOES OUT BY THE HALL DOOR.]

HELMER *[sinks into a chair by the door with his face in his
hands]* Nora! Nora! *[he looks around the room and
rises]* She is gone! How empty it all seems! *[a hope
springs up in him]* The most wonderful thing
of all—?

[FROM BELOW IS HEARD THE REVERBERATION OF A HEAVY
DOOR CLOSING.]

CURTAIN

From Act III of *A Doll's House* by Henrik Ibsen, translated by Eva Le Galli-
enne in *Six Plays by Henrik Ibsen*, © 1957 Eva Le Gallienne. Reprinted by
permission of International Creative Management, Inc.

KATE CHOPIN

THE STORY OF AN HOUR

*This story illustrates several aspects of Chopin's narrative art.
Most of it consists of a stream-of-consciousness account of Mrs.
Mallard's thoughts, but at the very end there is a sudden switch to
objective observation—except, of course, that we know that the
observation is wrong. The ability to think the unthinkable is char-
acteristically bold. The ironies in the tale are many-layered. Fi-
nally the proportions are perfect, and brevity serves to reinforce the
story's considerable impact.*

Knowing that Mrs. Mallard was afflicted with a heart trou-
ble, great care was taken to break to her as gently as possible
the news of her husband's death.

It was her sister Josephine who told her, in broken sen-
tences; veiled hints that revealed in half concealing. Her
husband's friend Richards was there, too, near her. It was he

who had been in the newspaper office when intelligence of
the railroad disaster was received, with Brently Mallard's
name leading the list of "killed." He had only taken the time
to assure himself of its truth by a second telegram, and had
hastened to forestall any less careful, less tender friend in
bearing the sad message.

280 She did not hear the story as many women have heard
the same, with a paralyzed inability to accept its signifi-
cance. She wept at once, with sudden, wild abandonment, in
her sister's arms. When the storm of grief had spent itself
she went away to her room alone. She would have no one
follow her.

There stood, facing the open window, a comfortable,
roomy armchair. Into this she sank, pressed down by a
physical exhaustion that haunted her body and seemed to
reach into her soul.

She could see in the open square before her house the
tops of trees that were all aquiver with the new spring life.
290 The delicious breath of rain was in the air. In the street be-
low a peddler was crying his wares. The notes of a distant
song which some one was singing reached her faintly, and
countless sparrows were twittering in the eaves.

There were patches of blue sky showing here and there
through the clouds that had met and piled one above the
other in the west facing her window.

She sat with her head thrown back upon the cushion of
the chair, quite motionless, except when a sob came up into
her throat and shook her, as a child who has cried itself to
sleep continues to sob in its dreams.

She was young, with a fair, calm face, whose lines be-
spoke repression and even a certain strength. But now there
was a dull stare in her eyes, whose gaze was fixed away off
300 yonder on one of those patches of blue sky. It was not a
glance of reflection, but rather indicated a suspension of in-
telligent thought.

There was something coming to her and she was waiting
for it, fearfully. What was it? She did not know; it was too
subtle and elusive to name. But she felt it, creeping out of
the sky, reaching toward her through the sounds, the scents,
the color that filled the air.

Now her bosom rose and fell tumultuously. She was be-
ginning to recognize this thing that was approaching to
possess her, and she was striving to beat it back with her
will—as powerless as her two white slender hands would
have been.

When she abandoned herself a little whispered word es-
caped her slightly parted lips. She said it over and over un-
der her breath: "free, free, free!" The vacant stare and the
look of terror that had followed it went from her eyes. They
stayed keen and bright. Her pulses beat fast, and the cours-
ing blood warmed and relaxed every inch of her body.

She did not stop to ask if it were or were not a monstrous
joy that held her. A clear and exalted perception enabled her
to dismiss the suggestion as trivial.

She knew that she would weep again when she saw the
kind, tender hands folded in death; the face that had never
looked save with love upon her, fixed and gray and dead.
But she saw beyond that bitter moment a long procession of
years to come that would belong to her absolutely. And she
opened and spread her arms out to them in welcome.

There would be no one to live for her during those com-
ing years; she would live for herself. There would be no
powerful will bending hers in that blind persistence with

which men and women believe they have a right to impose a private will upon a fellow-creature. A kind intention or a cruel intention made the act seem no less a crime as she looked upon it in that brief moment of illumination.

And yet she had loved him—sometimes. Often she had not. What did it matter! What could love, the unsolved mystery, count for in face of this possession of self-assertion which she suddenly recognized as the strongest impulse of her being!

"Free! Body and soul free!" she kept whispering.

Josephine was kneeling before the closed door with her lips to the keyhole, imploring for admission. "Louise, open the door! I beg; open the door—you will make yourself ill. What are you doing, Louise? For heaven's sake open the door."

"Go away. I am not making myself ill." No; she was drinking in a very elixir of life through that open window.

Her fancy was running riot along those days ahead of her. Spring days, and summer days, and all sorts of days that would be her own. She breathed a quick prayer that life might be long. It was only yesterday she had thought with a shudder that life might be long.

She arose at length and opened the door to her sister's importunities. There was a feverish triumph in her eyes, and she carried herself unwittingly like a goddess of Victory. She clasped her sister's waist, and together they descended the stairs. Richards stood waiting for them at the bottom.

Someone was opening the front door with a latchkey. It was Brently Mallard who entered, a little travel-stained, composedly carrying his grip-sack and umbrella. He had been far from the scene of the accident, and did not even know there had been one. He stood amazed at Josephine's piercing cry; at Richards' quick motion to screen him from the view of his wife.

But Richards was too late.

When the doctors came they said she had died of heart disease—of joy that kills.

CHAPTER 19

GENERAL EVENTS	LITERATURE & PHILOSOPHY	ART & ARCHITECTURE

INDIA

1192 Sultanate of Delhi establishes first major seat of Muslim power in India		
1500–1700 The Mughal Empire in India	Akbar commissions a new language, Urdu, to establish a common language for the empire	Under the Mughal emperors, secular art forms develop depicting realistic portraits and historical events
1526 Afghanistan chieftan Babur (1483–1530) wins control of northern India		
Babur's grandson Akbar (1542–1605) extends Muslim rule to most of India		
Aurangzeb (1618–1707), last significant Mughal emperor, orders systematic destruction of Hindu works	Hindu poet Tulsi Das (1532?–1623) writes the Sanskrit epic "The Holy Lake of the Acts of Rama"	Taj Mahal built by Shah Jehan (1632–1649)

1764 India falls under the virtual control of the British East India	Prem Cand (1880–1936) Indian novelist and short-story writer	
1800 British control of India made official		
1885 Founding of India's National Congress party		
1914–1917 World War I	In *The Apu Trilogy,* and other works, Indian filmmaker Satyajit Ray (1921–1992) tells about the lives of ordinary people, using the details of everyday life to give a general impression of their culture	
1917 Mohandas Gandhi (1869–1948) leads postwar campaign for Indian independence, espousing "Satyagraha" or nonviolent civil disobedience		
1939–1945 World War II		
1948 Gandhi assassinated by Hindu extremist		
1950 End of British rule		

Timeline scale (left): 1100, 1200, 1300, 1400, 1500, 1600, 1700, 1800, 1900, 2000

Most dates are approximate

INDIA, CHINA, AND JAPAN: FROM THE MEDIEVAL TO THE MODERN WORLD

GENERAL EVENTS	LITERATURE & PHILOSOPHY	ART & ARCHITECTURE
	CHINA	

GENERAL EVENTS	LITERATURE & PHILOSOPHY	ART & ARCHITECTURE
1279 Mongols invade China, seizing Beijing		**1200s** Construction of imperial capital Beijing, including the Forbidden City, follows conservative plan
1368–1644 Ming Dynasty Confucianism with its emphasis on obedience and loyalty to authorities develops under the Ming Dynasty	Confucianism results in both a rigid conservatism in existing forms and an explosion of experimentation in new artistic forms	Ming Dynasty produces vases of exceptional quality
		1400 Landscape provides a new subject for painters
	1500 First collections of "Hua-Pen," works based on the oral traditions of traveling storytellers appear *Chin P'ing Mei,* one of the first novels to focus on daily life rather than the fantastic or epic stories of tradition *Monkey,* by Wu Ch'eng-en (c. 1501–1580), relates the legends and tales of the travels of Tripitaka, an actual Buddhist priest	
1644–1911 Qing Dynasty Kang (1654–1722) establishes the Grand Council to solidify his power with local bureaucratic structures **1669** Ferdinand Verbiest (1623–1688), a westerner, becomes head of the Beijing Astronomical Bureau **1689** Treaty with Peter the Great limits Russian expansion into China; British East India Company arrives in China	Painter Shitao introduces a more vigorous line in landscape painting	
1800 Chinese independence threatened by traders importing opium **1839–1842** Opium War results when China resists western efforts to import opium Conditions in China result in widespread unrest and rebellion **1851–1864** Tai Ping Rebellion		
1900–1901 Boxer Rebellion results in full western control of China **1911** Sun Yat-sen (1866–1925) and the Republican army defeat the monarchy Chiang Kai-shek (1887–1975) leads the Kuomintang, authoritarian regime initially intended to result in democratic rule **1949** Mao Tse-tung (1893–1976) Chinese communist party leader assumes power	After World War II virtually all art either glorifies communism or vilifies previous regimes	Like the other arts, Chinese film was rigidly controlled by the Communist Party; recent filmmakers like Zhang Yimou (b. 1951) have been able to present stories of a more personal nature; his films *Raise the Red Lantern* (1951) and *The Story of Qiu Ju* (1992), for example, highlight the social system in China with special attention on hardships faced by women

	GENERAL EVENTS	LITERATURE & PHILOSOPHY	ART & ARCHITECTURE

JAPAN

200

Agricultural communities based on tribal chiefs develop in Japan

780

THE HEIAN PERIOD

780 Heian, present-day Kyoto, becomes new capital and stable center of government

Fujiwara Michinaga (966–1027) serves as regent to the royal family

Japanese develop their own system of writing

No plays, which combine ritual and slapstick elements to tell traditional stories, develop

Lady Murasaki Shikibu (c. 980–1030) writes *The Tale of Genji,* based on her experiences at the Heian court; it becomes the most famous literary work of its day

The "pillow-book" or diaries of Sei Shonagon (c. 1000) also survive from this era

The Tale of Genji

1185

1185 The Period of Feudal Rule

The city of Kakamura becomes a more aggressive rival to the capital at Kyoto, marking the beginning of feudal rule under a new warrior class of *samurai* serving under the military command of the *shogūn*

1274, 1281 Successive waves of Mongol invasion

1450

1467–1568 Age of the Warring States

1590 Hideyoshi (1537–1598) reunites Japan

1603

THE EDO PERIOD

Tokugawa (1543–1616) creates a new capital at Edo, the modern Tokyo

1853 Commodore Matthew Perry arrives, intent on opening Japan to American trade

Basho (1644–1694), a great poet of the age, develops the *haiku*

Ihara Saikaku (1642–1693) becomes famous for his novels, including "Life of an Amorous Woman"

In "The Love Suicide at Amijima" and other works, Chikamatsu Monzaemon (1653–1725) contributes to the new dramatic form *kabuki,* which draws on real life for material

Japanese artists continue to develop traditional Chinese models for landscape painting

Hokusai Katsushika (1760–1849) explores the popular new medium of woodblock

1868

1868 The Meiji

Japan begins a vast program of modernization under the Meji emperors

By 1905 Japan has industrialized successfully enough to defeat the Russians in the Russo–Japanese War

1900

1914–1917 World War I

1939–1945 World War II

1950

1952 End of American occupation of Japan

1950s, acclaimed Japanese film director Akira Kurosawa (1910–1998) directs *Rashomon* and *Seven Samurai;* his career continues well into the 80s with *Kagemusha* and *Ran,* reflecting the influence of such classic American filmmakers as John Ford

2000

Most dates are approximate

CHAPTER 19

INDIA, CHINA, AND JAPAN: FROM THE MEDIEVAL TO THE MODERN WORLD

At the time the medieval era in Western Europe was nearing its end, two principal regions in southeast Asia—India and China—underwent lasting changes as a result of outside invaders. The third, Japan, maintained its cultural isolation from the rest of the world until the nineteenth century. All three regions eventually came into contact with Western culture.

INDIA: FROM MUGHAL CONQUEST TO BRITISH RULE

With the decline of Buddhism and the fall of the Gupta Empire, India separated into a series of kingdoms, many of which were ruled by **rajputs.** For the most part, these local rulers were descendants of warriors from Central Asia, who had converted to Hinduism and claimed membership in the warrior caste. Their constant feuding prevented the formation of a thriving economy or stable government and left India vulnerable to conquest by an outside force—that of the Muslims.

The first major seat of Muslim power was at Delhi, where Turkish forces established a sultanate (a Muslim kingdom ruled by a sultan) in 1192. Although it fell to successive waves of invaders, the Sultanate of Delhi established Islam as a new force in the subcontinent; it was strongest in the northwest—the Indus Valley—a region that centuries later broke away from India to become the Islamic Republic of Pakistan after World War II.

THE MUGHAL EMPIRE

In 1526, Babur (1483–1530), an Afghanistan chieftain, led his troops into India, and in a short time won control over most of northern India. His grandson, Akbar (1542–1605), further extended Muslim rule to cover most of India and Afghanistan. Akbar's kingdom was called the **Mughal** (the Persian word for "Mongol") Empire and lasted until the British took control of India in the eighteenth century.

Unlike earlier raiders bent on plunder, both Akbar and his grandfather intended from the outset that the land they conquered should become a center for civilization. Akbar was famous not only for his courage and military prowess, but also as a book collector and patron of the arts. Unlike Muslim rulers elsewhere, Akbar made no attempt to impose the Islamic faith on his subjects. He married a Hindu princess and allowed Hindu women at his court to practice their religion openly. In order to provide a common language for all his subjects, Akbar commissioned scholars to create a blend of Hindi (hitherto the most widely spoken language in India) with Arabic and Persian. The new language, called **Urdu,** is, together with Hindi and English, one of India's three official languages today.

Under Akbar's successors, the Mughal Empire expanded further to include all of the subcontinent except for the extreme southern tip. During the first half of the seventeenth century, patronage of the arts reached new heights, as Mughal architects and painters devised a new style that, like the Urdu language, combined aspects of the Hindu tradition with Persian and other Muslim elements.

Mughal Art

The most visible remains of Mughal rule in India were left by Mughal architects. Mosques, palaces, walled cities, and forts all show traditional Indian techniques combined with new innovations from Arabic architecture. Among the most important of these innovations are the dome, pointed arch, and **minaret** ("tower"); this last feature formed a vital element in the construction of mosques, Islam's most important religious architectural form. The most famous of Mughal buildings—and one of the best known anywhere in the world—is the Taj Mahal at Agra, built by order of Shah Jehan (1592–1666) during the years 1632–1649 [**FIG. 19.1**].

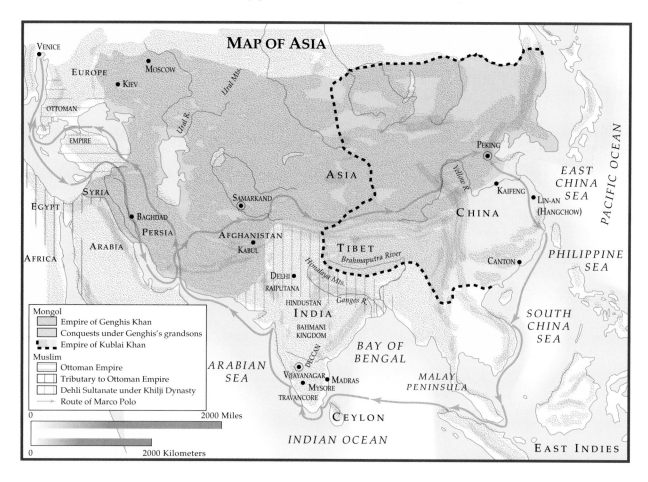

MAP OF ASIA

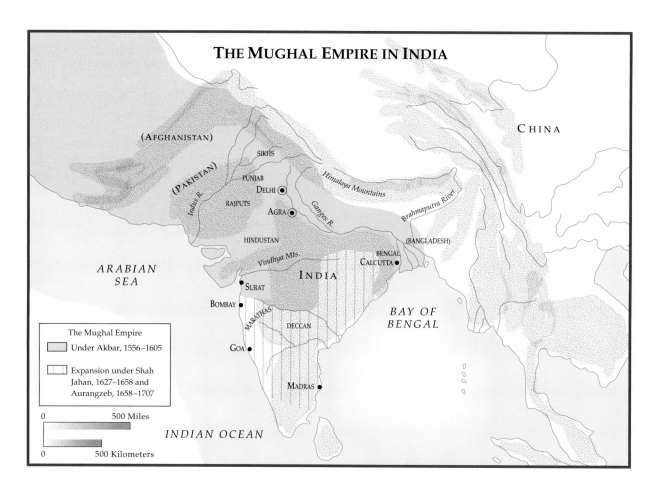

THE MUGHAL EMPIRE IN INDIA

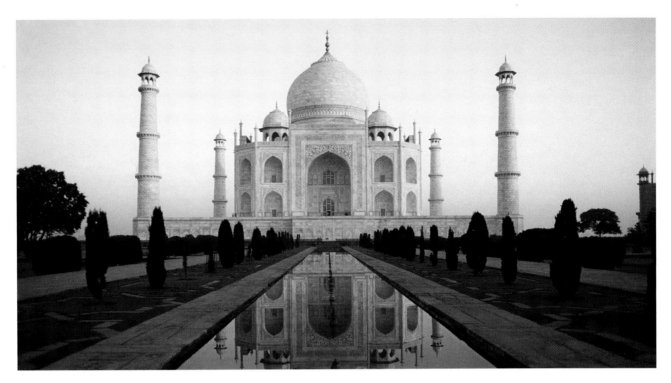

■ **19.1** The Taj Mahal at Agra. Built 1632–1649, at the command of Shah Jehan, as the tomb for his favorite wife (it eventually served as the Shah's own tomb). Much of the building's visual effect comes from its proportions: the height of the central structure is equal to its width, and the dome and the façade on which it sits are the same height.

The shah commissioned the Taj Mahal as a tomb and monument for his beloved wife Banu Begam, the mother of fourteen of his children, a woman as renowned for her charity as for her beauty. The dome, towers, and landscaping—in particular the use of water—are all typical Mughal features. Together with the elaborate decorations, or arabesques, they make the Taj Mahal seem an eternal symbol of the queen, "radiant in her youthful beauty, who still lingers on the riverbanks, at early morn, in the glowing midday sun, or in the silver moonlight."

Virtually all Mughal painting is in the form of book illustrations or miniature paintings that were collected in portfolios. Unlike earlier Hindu and Buddhist art, Mughal painting is secular. It shows scenes of courtly life, including—for the first time in Indian art—realistic portraits [**Fig. 19.2**], and often depicts historical events [**Fig. 19.3**]. As in the case of Mughal architecture, the overwhelming influence comes from Persian art of the period. A new art form in India also drew inspiration from Persian models, that of **calligraphy**, which was often combined with miniature paintings. Very few earlier Sanskrit or Hindu texts contained illustrations. By contrast, Mughal artists made full use of the decorative possibilities of Arabic or Persian script [**Fig. 19.4**].

Literature and the production of fine books was highly esteemed by Mughal aristocrats. Babur, the founder of Mughal rule, wrote his autobiography, the *Babur-nama,* in Eastern Turkish. It is still regarded as one of the finest examples of Turkish prose literature. His successor, Homayun (ruled 1530–1540; 1555–1556) was so devoted to books that when he rode into battle he took with him part of his library, carried on camelback.

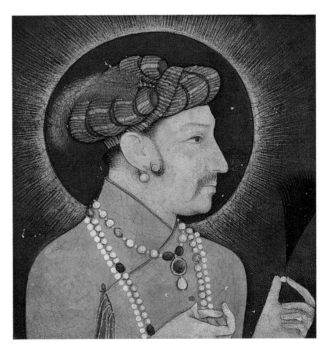

■ **19.2** Portrait of Jahangir (1569–1627), who ruled as Mughal emperor from 1605–1627. Painting on paper, 1⁹⁄₁₂″ × 1⁷⁄₁₆″ (17 × 17 cm). Museum of Fine Arts, Boston. Jahangir's reign was notable for the contacts he established with Europe, and among the many objects acquired by the Mughal court were prints and portraits.

■ **19.4** Sultan-Muhammad, the court of Gayumars, detail of folio 20 verso of the *Shahnama* of Shah Tahmasp, from Tabriz, Iran. c. 1525–1535. Ink, watercolor, and gold on paper, full page c. 1′1″ × 9″ (31.8 by 22.3 cm.). Prince Sadruddin Aga Khan Collection, Geneva. The page shows Gayumars, the legendary first ruler of Iran, seated on a mountain top, presiding over his court. Note the leopard skins worn by his courtiers, and the written text that accompanies the image.

■ **19.3** Basawan and Chatar Muni. *Akbar and the Elephant Hawai.* Folio 22 from the *Akbarnama (History of Akbar)* by Abul Fazl, c. 1590. Opaque watercolor on paper, 1′1⅞″ × 8¾″ (32.5 by 22 cm.). Victoria and Albert Museum, London. The painting depicts an actual event that took place when Akbar was 19. An elephant he rode charged after another elephant and broke a bridge resting on boats. The emperor is shown successfully maintaining control over his beast—a symbol of his success in governing the state.

Homayun also wrote poetry, using the Persian, rather than Turkish language. Mughal tolerance allowed Hindu writers to continue to write works in their own language and on traditional themes. The poet Tulsi Das (1532?–1623), drawing on the Sanskrit epic, the *Ramayana,* produced *Ramcaritmanas (The Holy Lake of the Acts of Rama)*, a work that combines monotheism with traditional Hindu polytheism and is still widely read.

The End of Mughal Rule and the Arrival of the British

The religious tolerance of the early Mughal rulers eroded over time. The last significant Mughal emperor, Aurangzeb (1618–1707), destroyed Hindu temples and increased his Hindu subjects' taxes. For the first time,

Hindus serving in the imperial bureaucracy had to convert to Islam. Another factor contributing to the collapse of Mughal power was the rise of a new religion, related to Hinduism, but with no caste system: Sikhism. The Sikhs combined Hindu rituals with a highly activistic approach, forming a military brotherhood that succeeded in setting up an independent state of their own, which lasted until 1849. In that same year, British forces had won control over the rest of India.

Throughout the eighteenth century, the British and French had fought their battle for colonial supremacy on Indian soil. The British East India Trading Company began its operations as early as 1600, and the superiority of British naval forces assured them victory over other European rivals—first Portugal, then France. By 1764, although India was theoretically made up of separate kingdoms, including a Sikh state and a much-reduced Mughal Empire, in practice government was in British hands, first under the East India Company

and then, by 1800, directly under the British government. For the next century and a half, India was the "Jewel in the Crown" of the British Empire.

THE RISE OF NATIONALISM

Throughout the early years of the twentieth century, many of those colonized by the chief European powers began to strive for self-rule. In India, the battle began in 1885 with the founding of India's National Congress party. During World War I, three million Indian soldiers fought in British armies. This brought about further impetus, and a postwar campaign for India's independence was led by Mohandas Gandhi (1869–1948). First in South Africa, and then—after 1915 in India—Gandhi developed the principle of **Satyagraha** ("nonviolent civil disobedience"). Born a Brahmin (the highest Hindu caste), Gandhi opposed the caste system, to the delight of the poor and India's Muslims, while maintaining Hindu backing by praising religious tradition. Pressure for independence grew during the 1930s and, by the end of World War II, Britain had no choice but to withdraw. Despite Gandhi's efforts to unite Hindus and Muslims—a policy that led to his assassination in 1948 by a Hindu extremist—Britain had played its own part in encouraging Hindu-Muslim tension, and the subcontinent split into the Republic of India (predominantly Hindu) and the Republic of Pakistan (mostly Muslim).

One of the effects of the struggle for self-rule was to create a generation of Indian authors who, writing in both their own languages and in English, sought to draw attention to their country's plight. They include the novelist and short-story writer Prem Cand (1880–1936) and, most famously, Rabindranath Tagore (1861–1941). In 1913, Tagore won the Nobel Prize for literature; he also painted and composed music, including India's first national anthem, and founded a school and a university. Tagore's writing and teaching stressed that national freedom was meaningless without personal freedom and that true authority comes only from basic humanity. The tradition of Indian writers using English for their works continued throughout the twentieth century, and at the beginning of the twenty-first century many of the leading novelists of the day who write in English—Salman Rushdie, Vikram Seth, and many others—are Indian.

CHINESE CULTURE UNDER IMPERIAL RULE

China retained a central government for most of its history. For the period from 1368 to the Republican Revolution of 1911, two dynasties controlled Chinese political and cultural life: the Ming (1368–1644) and the Qing (1644–1911). As in India, European traders established operations in China—the British East India Company arrived in 1689. Portuguese Jesuit missionaries had been established in the preceding century, using Macao (leased by the emperor to Portugal) as their base [**FIG. 19.5**]. Unlike the Indian experience, however, where the European colonial powers fought out their wars on Indian soil, China remained virtually untouched by the West, and Macao remained the only port of entry for non-Chinese until the nineteenth century. Thus the central government was able to maintain tight control over the arrival of both people and ideas. This encouraged the stability of the state bureaucracy and the social structure, but did little to encourage trade or manufacturing. As a result, the rapid increase in population between 1600 and 1800—from around one hundred fifty million to some three hundred million—led inevitably to widespread poverty and political unrest, conditions that Western colonial powers were quick to exploit during the nineteenth century, culminating in the Republican Revolution of 1911.

■ **19.5** Painting of a Belgian Jesuit missionary, dressed in traditional Chinese costume. China, seventeenth century. Note that for the Chinese the missionary is associated not with religious teaching, but with science and mathematics. He holds a telescope, while a globe and a compass are on the table beside him, and other instruments stand on the ground.

THE MING EMPIRE
Fourteenth to seventeenth centuries

The Arts under the Ming Dynasty

In 1279, the urban society created in China under the T'ang and Sung dynasties fell under the control of Mongol invaders from Central Asia. It took almost a century for resentment of foreign occupation, coupled with a series of disastrous floods, to provoke a widespread peasants' revolt. One of the rebels' leaders seized the Mongol capital, Beijing, and in 1368 declared himself the first emperor of the Ming Dynasty.

Under the Ming emperors, China enjoyed an extended period of political and economic stability and cultural enrichment. The basis for all aspects of life was Confucianism in its most traditional form. The importance of obedience and loyalty to the authorities became paramount, both within the individual family, headed by the father, and in the state as a whole, headed by the emperor, the Son of Heaven, who ruled as the "father" of his country. The effect of this conservatism on the arts was twofold. Those fields that had been cultivated in the past remained little changed; one Ming writer observed that since the early writers on Confucius had discovered everything worth knowing, it was unnecessary to write any more scholarly works. Furthermore, writers and painters tackling traditional themes tended to imitate past models. As a result, the Ming period saw the invention of new artistic forms, in which creative artists felt free to experiment.

The most popular new literary genres were the novel and the short story. The latter, known as **Hua-Pen,** were often based on the oral tales of professional traveling storytellers, or at any rate aimed to give that impression. They included verses inserted into the prose narrative, audience reaction, and the use of the speech of the streets. Traditional Buddhist subjects

were combined with scenes from everyday life. The earliest collections of Hua-Pen date to the sixteenth century, although many of these had probably circulated for more than a century.

One of the first novels to focus on daily life rather than extraordinary events is the anonymous *Chin P'ing Mei.* This story chronicles the lurid career of the licentious Hsi-men. The society it describes is driven mainly by lust, greed, and vanity, although its author makes no attempt to moralize. The book owed its immediate and continuing popularity to its openly erotic episodes. Another novel to achieve a large readership, particularly among children, is *Monkey,* written by Wu Ch'eng-en (c. 1501–1580). Describing the journey to India of a Buddhist priest, Tripitaka, it uses centuries-old tales and legends. Tripitaka is an historical figure who actually made a pilgrimage to India in the seventh century. By the tenth century, his travels had already inspired an entire cycle of fantastic tales, which by the beginning of the Ming Dynasty were the subject of stage plays. Wu Ch'eng-en thus had a mass of material to draw on for his long fairy tale. The real hero of the story is not Tripitaka but his assistant, Monkey, whose magical powers and craftiness enable the two travelers to overcome all obstacles—both natural and supernatural—and complete their journey. The story combines fantasy, folklore, and history, together with strong elements of satire. The absurd bureaucratic behavior of the gods is clearly intended to poke fun at the complexity of the Chinese state bureaucracy. Tripitaka represents a kind of Chinese "Everyman," blundering along through the various problems he has to face, whereas Monkey represents the ingenuity of human intelligence. One of Tripitaka's other fellow pilgrims, Pigsy, personifies human physical desires and brute strength. None of these layers of meaning are allowed to interfere with the narrative drive and the richness of the various adventures encountered by the pilgrims.

In the visual arts, landscape provided a new subject for painters. Early Ming Dynasty works take traditional human subjects—a scholar and his companion, together with a crane, for example—and place them in a natural setting [**Fig. 19.6**]. A century later, in a painting by Shen Zhou, the human subject is barely visible, overwhelmed by the grandeur of the mountain scenery [**Fig. 19.7**]. Like many other individuals of the period, Shen Zhou was a gentleman-scholar rather than a professional artist. One of the differences between art in China and in the West was that the Chinese paid no particular respect to professional artists, who mainly worked on decorative projects. Ideas such as the Renaissance notion of the inspired genius who produces a masterpiece did not form part of the Chinese aesthetic. Amateurs, who considered themselves above "mere" technique, were the most admired of painters.

Another way in which the arts in China differed from those in the West was that the Chinese did not distinguish between the major art forms—painting, sculp-

■ **19.6** Ming Dynasty painting showing scholar and crane sailing home, fifteenth century. Nelson Atkins Museum, Kansas City, Missouri. *Landscape Album: Five leaves by Shen Chou, One Leaf by Wen.* Note the importance of landscape. The broad river sweeps toward the distant mountain peaks, while the scholar contemplates the grandeur of nature.

ture, architecture—and the so-called decorative arts: painted pottery and calligraphy, for example. The same gentleman-scholar who could produce a landscape would also pride himself on his elegant handwriting. Both of the paintings illustrated here (see Figure 19.6 and Figure 19.7) include examples of calligraphy, a practice unimaginable in Western art of the same period.

■ **19.7** Shen Zhou. *Poet on a Mountaintop.* Ming Dynasty, c. 1500. Painting mounted as a handscroll. Ink and color on paper, 15¼″ × 23¾″ (38.1 × 60.2 cm). Nelson Atkins Museum, Kansas City, Missouri. One of the leading painters of the Ming Dynasty, Shen Zhou came from a family of painters and scholars. Here he takes even further (compare 19.6) the sense of human insignificance in the vastness of the natural world. The tiny figure atop the mountain is suspended between the sky and the fog rolling in below.

Chinese connoisseurs had always prized and collected painted ceramicware, and potters of the Ming Dynasty produced vases of exceptional quality [**FIG. 19.8**]. Pieces

■ **19.8** Arrow vase with Persian inscriptions and floral scrolls. China, Ming Dynasty (1368–1644). Porcelain with underglaze blue decoration, width ¾″ (10.7 cm). Severance and Greta Millikin Collection, 1964.170. The Cleveland Museum of Art. The blue on white is typical of much Ming ware, although the arabesque designs seen here suggest that the piece was intended for export.

of decorated porcelain began increasingly to circulate in the West, taken there by traders and missionaries. These transported pieces added a new word to the English language for high-quality pottery: **china.**

While artists working in the fields of literature and painting could experiment and invent new forms, architects were tied far more closely to the traditions of Confucianism, particularly if they were working on official projects. Nowhere is this more clearly visible than in the construction of Beijing as Imperial capital. It was originally laid out in a rectangular plan during the thirteenth century, by order of the Mongol King Kublai Khan (c. 1216–1294). We have a description of how it then looked from perhaps the most famous travel writer of all time, Marco Polo (c. 1254–1324), who arrived in China in 1275 and spent time there as an envoy of Kublai Khan. When the Chinese succeeded in driving out the Mongols, they retained Beijing as Imperial capital; the city was reconstructed early in the Ming Dynasty, at the beginning of the fifteenth century.

The chief buildings, including the emperor's residence—known as the Forbidden City—and the main government offices, or Imperial City, were laid out on a grid plan with a north-south axis, to the north of the rest of the city. All of these buildings faced south, with their backs to the direction that symbolized evil: the

Mongol invasion. This was just one more example to the Chinese of the fact that north represented misfortune. The Forbidden City stood to the extreme north of the complex, so that the emperor, like the northerly Pole star, could overlook his subjects [**FIG. 19.9**]. A series of gateways and courtyards led from the main entrance, the southern Gate of Heavenly Peace (which now gives its name to the vast square in front of the buildings, "Tiananmen") to the heart of the palace, the Hall of Supreme Harmony, where the emperor held audiences and performed special rituals. Thus the entire complex represented traditional symbolic values.

The general attitude toward cultural development during the Ming Dynasty can be summed up in a phrase frequently used by Ming-period scholars: "change within tradition." The result was to produce a culture—and also a society—that was stable but that lacked dynamic development. The preeminence of gentleman-scholars, artists, and bureaucrats, rather than professionals, inevitably led to economic decline. By the early seventeenth century, as the bureaucracy became increasingly corrupt and the emperors began to lose control, rebellions and banditry became rampant and, in 1628, a popular uprising drove the last Ming emperor to hang himself. The resulting confusion attracted invaders from the south, who soon established a new dynasty, the Qing, the last royal house to rule China.

■ **19.9** Hall of Supreme Harmony. The Forbidden City, Beijing. The Forbidden City served both as private residence for the emperor and as the setting for his official appearances. The Hall of Supreme Harmony served as the throne room, set as it is on a high platform with marble staircases. The throne, inside, was set on another high dais.

VOICES OF THEIR TIMES

The Emperor of China Studies Western Mathematics

Chinese Emperor Kang Hsi Muses on His Contacts with Western Ideas

I realized, too, that Western Mathematics has its uses. I first grew interested in this subject shortly after I came to the throne, during the confrontations between the Jesuit Adam Schall and his Chinese critic, Yang Kuang-hsien, when the two men argued the merits of their respective techniques by the Wumen gate, and none of the great officials there knew what was going on. Schall died in prison, but after I had learned something about astronomy I pardoned his friend Verbiest in 1669 and gave him an official position, promoting him in 1682. In 1687, I let the newly arrived Jesuit Fontaney and the others come to Beijing, although they had come to China illegally on a Chinese merchant vessel and the Board of Rites had recommended their depor-

tation; and throughout the 1680s I discussed Western skills in Manchu with Verbiest, and I made Grimaldi and Pereira learn the language as well, so they could converse with me.

After the treaty of Nerchinsk had been signed with the Russians, I ordered the Jesuits Thomas, Gerbillon, and Bouvet to study Manchu also, and to compose treatises in that language on Western arithmetic and the geometry of Euclid. In the early 1690s, I often worked several hours a day with them. With Verbiest I had examined each stage of the forging of cannons, and made him build a water fountain that operated in conjunction with an organ, and erect a windmill in the court.

From *Emperor of China* by Jonathan D. Spence, copyright © 1974 by Jonathan D. Spence. Used by permission of Alfred A. Knopf, a division of Random House, Inc.

THE QING DYNASTY: CHINA AND THE WESTERN POWERS

The new Qing rulers, who came from Manchuria, were foreigners in the eyes of most Chinese. Although they maintained their own army, they had to rely on the established bureaucracy for the day-to-day running of the empire. One of the early Qing emperors, Kang Hsi (1654–1722), set up a grand council to supervise the bureaucrats, and succeeded in interweaving local and central administration. These measures strengthened the power of the emperor. Simultaneously, Kang Hsi began to make tentative contacts abroad. In 1689, he signed a treaty with Peter the Great of Russia, to set limits on the expanding Russian Empire, and encouraged the introduction—carefully controlled—of Western arts and education. The Jesuit missionary Matteo Ricci (1552–1610) had already studied Chinese in order to familiarize some of those at court with Western mathematics, geography, and astronomy. Kang Hsi employed other Jesuits as mapmakers and took Jesuit physicians with him on his travels. Some Westerners even received appointments at court. The Flemish missionary and astronomer Ferdinand Verbiest (1623–1688) became head of Beijing's Astronomical Bureau in 1669 and played a part in helping to determine the Chinese-Russian border. When, however, the pope sent an ambassador to ask if a permanent papal legation could be set up in Beijing (in part, probably, to keep an eye on the Jesuits), the emperor refused permission and required all resident Jesuits to sign a declaration stating that they understood and accepted the definition of Confucianism and ancestral rituals as formulated by Kang Hsi.

In cultural terms, however, China remained stagnant. Technological methods remained basic [**FIG. 19.10**]. Artistic works followed old formulas, often on a more lavish scale, with the studied elegance of earlier

■ **19.10** A Chinese papermaker dipping a bamboo frame into pulp, which is then spread thinly across the frame to dry. The Chinese had been the first to develop the technique of printing on paper: the earliest known manufacture of individual characters that could be combined and stamped on paper occurred in China as early as the eleventh century. As this illustration shows, however, at a time when Western Europe was undergoing the Industrial Revolution, the Chinese continued to use traditional methods.

■ **19.11** Dish with lobed rim. Qing Dynasty, c. 1700. White porcelain with overglaze, 1′2″ in diameter (40 cm). The Percival David Foundation of Chinese Art, London. The colors are made of enamels. The three central figures, Fu, Lu, and Shou, are the gods of happiness, success, and longevity, respectively. The cranes and deer around the rim were believed to have long lives and were thus also symbols of good fortune.

Ming ware replaced by the use of multicolored techniques [**FIG. 19.11**]. A few painters tried to reestablish the vigor of former days. The painter Shitao stressed the vitality of line, as can be seen in his landscape scene showing a hut in the mountains [**FIG. 19.12**], which is far more vigorous than the landscapes of the Ming period.

By 1800, Chinese independence was beginning to come under threat. As Western traders established themselves in India and other parts of Asia, they recognized the potential for profit at home as demand rose for Chinese tea, fine vases, silks, and exotic works of art. Trade, however, depended on exchange, and foreign merchants could find little in the way of Western products to interest the Chinese. Silver and gold would have been acceptable, but the British, who were the chief traders, had no intention of damaging their balance of trade by incurring trade deficits. British merchants, therefore, began importing large quantities of opium from India into China. The Chinese, well aware of the harmful effects of the drug, made little use of it. The Chinese government, therefore, attempted to prevent its importation; the emperor even addressed a personal appeal to Queen Victoria, which she ignored.

When (in 1839) the Chinese tried to block the introduction of opium, the result was outright war. The Opium War of 1839–1842, in which the British used

■ **19.12** Shitao. *Landscape.* Qing Dynasty, late seventeenth century. Album leaf, ink, and colors on paper, 9″ × 11″ (30 × 33 cm). C. C. Wang Collection, New York. The painter Shitao became a Buddhist monk at the age of 20. By contrast with earlier landscape artists (compare Figures 19.6 and 19.7), the natural world he paints is less a passive, lofty setting and more of a place of action: note the spiky trees and the rushing water.

their vastly superior naval power to blockade the entire coast, forced the Chinese to open up a string of ports along their coast, including Canton and Shanghai, thereby ending their isolation. Quite apart from their bitter resentment at the introduction of a drug that soon became widely used (importation rose from six thousand cases in 1820 to one hundred thousand in 1880), the Chinese also had to face the arrival of other Westerners—France and the United States, among others. One of the results of all this turmoil was a series of internal rebellions, which the Chinese authorities could only put down by humiliatingly having to ask the invading foreigners for help. During the Tai Ping Rebellion (1851–1864), a Franco-British force occupied Beijing, drove out the emperor, and burned down the Summer Palace.

When the central government grew increasingly ineffectual, the foreign trading powers benefited from a weak central authority that depended on them for the little influence it possessed. The utter unconcern of these foreign traders and settlers for the culture they were invading is evidenced by the design of an English church built in Shanghai in the late nineteenth century [**Fig. 19.13**]. With the suppression of the bloody Boxer Rebellion of 1900–1901, the Western powers took virtual control, constructing railways and opening up river traffic to all parts of the interior.

In 1911, republicans led by Sun Yat-sen (1866–1925) finally brought down the monarchy, but the collapse of centuries-old institutions created decades of chaos, complicated by two world wars. Two chief movements struggled for power in China. The Kuomintang, led by Chiang Kai-shek (1887–1975), offered authoritarian rule, which was supposed to evolve into a form of

■ **19.13** Photograph of an English church built in Shanghai in the late nineteenth century. Note the complete disregard of the English community for the culture surrounding them: they built a church that makes no pretense to fit into its context.

democracy. The other group, the Chinese Communist Party, aimed to follow the example of Russia's Bolshevik movement and was led by Mao Tse-tung (1893–1976). The communists came to power in 1949. Virtually all of the art produced under communist rule either exhorts the party (under Mao especially) [**Fig. 19.14**] or reminds its viewers of the horrors of earlier times [**Fig. 19.15**].

THE ART AND CULTURE OF JAPAN

Early Japanese History and Culture

Archaeological evidence suggests that although early settlers in Japan had developed agricultural communities by C.E. 200, these were based on tribal chiefs; each tribal group had its own god, thought of as an ancestor. Around 400, one of these communities was sufficiently sophisticated to bring in scribes from Korea to keep records, because no system of writing as yet existed in Japan. The original chief city had been Nara, laid out in 706 in imitation of Chinese urban design. Less than a century later, however, the various settlements, now much expanded, came together in a new capital, Kyoto (then known as Heian), which remained a center of stable government and economic growth until 1185.

Although early Japanese religious thought owed much to the influences of Buddhism and Confucianism, the native Japanese religion was **Shintoism.** This involved not only worship of the spirits of nature—including the all-important rice god—and a complex series of rituals, but also the imperial cult; that is, the ruling emperor and his ancestors were worshiped as divine. The tension between Shintoism and the influence of Chinese Buddhism always remained an important factor in Japanese religious life. The move from Nara to Kyoto was in part to escape from the domination of Nara's Buddhist priests.

During this period, the Japanese developed their own writing system, partly based on the Chinese system. Poetry was popular, and as urban centers grew, various forms of theater became common. Perhaps the best known is the **no** play, in which dancers enact dramatic stories combined with ritual and slapstick [**Fig. 19.16**]. The most famous literary work of the age was *The Tale of Genji,* written by Lady Murasaki Shikibu (c. 980–1030). Murasaki lived during the so-called Fujiwara period, one dominated by members of that family; the most important, Fujiwara Michinaga, ruled as regent from 966 to 1027.

Murasaki's father held a minor position at court. She married and had children, but when her husband died and her father was transferred to the provinces, Murasaki took a position in the service of Empress Akiko. The diary she wrote during her years at court

■ **19.14** A vast statue of Chairman Mao, the center of celebrations of National Day in China, October 2, 1966. c. 36′ (12 m). The statue is being carried by some of the paraders as they march through Tiananmen Square. In the background is the Forbidden City.

■ **19.15** Sculptured scene of rent collection in pre-Communist days, with the peasants kneeling before their masters. Clay, life-size, 1965. Dayi, Sichuan Province, China. The scene forms part of a much larger work, incorporating 114 life-size figures, which depicts the horrors of precommunist times. Here the weary peasants deposit their produce to pay their taxes to the haughty landlord, who is leaning back arrogantly in his chair.

gives precious insight into life there. Basically serious-minded, Murasaki had little time for the frivolity of many of her contemporaries. By a remarkable chance, another diary of the same period has also survived, kept by Sei Shonagon (active c. 1000). Sei Shonagon's work takes the form of a **pillow-book**—a collection of her notes and observations on the day's events that are often malicious and sometimes indelicate, forming an interesting contrast with the more straitlaced Murasaki.

Murasaki's enduring fame is based on her novel, *The Tale of Genji*. One of the great achievements of Japanese literature, the book describes the amorous adventures of Prince Genji, set against a court background very similar to that in which Murasaki herself moved. She writes with great delicacy and an underlying melancholy, often underlined by descriptions of nature. The autumnal winds, swift-flowing rivers, snow in winter—all serve as background to the book's more poignant scenes. One of the unintentional effects of Murasaki's psychological subtlety is to reveal the gulf between the aesthetic sensibilities of the aristocratic elite at court and the lives of the peasants, the overwhelming majority of the population. It seems that life at court consisted of music and love affairs, poetry recitations, and apt quotations from the classics. The art of the same period shares this otherworldly quality. A scene illustrating an episode from *The Tale of Genji* shows the hero with his beloved shortly before her death. To the left, in the garden, a weeping tree adds to the autumnal gloom [**Fig. 19.17**].

▪ **19.16** Portrait of an actor in a *no* play. The pinned hairstyle suggests the male actor is playing a female role. All of the performers in *no* plays were male; as here, they used traditional wooden masks. They combined speech, singing, dance, and mime.

▪ **19.17** Scene from *The Tale of Genji*. Late Heian period, first half of twelfth century. Handscroll. Ink and color on paper, 8⅝″ high (28 cm). Goto Art Museum, Tokyo. Note the bent branches of the willow tree in the garden, to the left, a sign of mourning, and the generally muted colors.

The Period of Feudal Rule

As the increasingly remote court life of Kyoto led to internal rivalry, in 1185 a new, more aggressive center developed at Kakamura. The emperor now combined legal and administrative duties with military command, creating a new office—**samurai-dokoro**—which gave him control of all of Japan's warriors (**samurai** is the Japanese name for a professional warrior). His title was Seiitaishogun ("barbarian-suppressing commander-in-chief"), later shortened to **shogun.** This newly enhanced warrior class dominated Japanese culture sufficiently enough to defeat two waves of Mongol invaders (in 1274 and 1281). Bands of warriors followed their aristocratic leader, who was in turn bound to the emperor—a system not unlike the feudal system developing independently in Western Europe around the same period.

Over time, the local **daimyo** ("warlords") began to assert their own authority against that of the shogun, and the years 1467 to 1568 are known as the Age of the Warring States. With the introduction of firearms first obtained from Portuguese traders, and then manufactured in Japan, individual daimyo began to build their own fortified centers, and the authority of the central government grew ever weaker. The Portuguese guns may have increased the influence of individual warriors, but they undercut the traditional samurai fighting style and raised the problem of outside influence in a society that had been virtually closed to the outside world for centuries. Fighting between the various warlords was finally ended under two powerful leaders, Hideyoshi (1537–1598), who once more united Japan by 1590, and Tokugawa (1543–1616), who created a new capital in 1603 at Edo (present-day Tokyo). Members of the Tokugawa family ruled there until 1868.

The Edo Period

Artists in the Edo period produced a wide variety of work, catering to the needs of an increasingly urban and sophisticated population. The landscape scenes of Chinese gentleman-scholars (see Figure 19.6 and Figure 19.7) proved a popular influence, but the Japanese versions used gentler colors. Both vegetation and background mountains are more abstract, giving a dreamlike quality to the view [**FIG. 19.18**]. Other artists aimed to combine the richness of color of traditional Japanese art with the precision in description of Western artists, as in the gorgeous silk painting *Peacocks and Peonies* [**FIG. 19.19**]. Woodblock, a popular new medium, made possible the making of multiple copies for a growing number of collectors. The most famous artist in this field was Hokusai Katsushika (1760–1849), whose image of a wave crashing in the foreground, while a diminutive but enduring Mount Fuji appears at the center of the

■ **19.18** Yosa Buson. *Cuckoo Flying over New Verdure.* Edo period, late eighteenth century. Hanging scroll. Ink and color on silk, 5′1½″ × 2′7¼″ (1.33 m × 89 cm). Hiraki Ukiyoe Museum, Yokohama. Buson, who also wrote haiku verse, brought his own delicate touch to landscape painting. Although influenced by Chinese art, his scenes are gentler and less precise. Here the trees in the foreground seem swallowed up in mist.

background, is one of the most familiar of all Japanese works of art [**FIG. 19.20**].

Japanese writers of the Edo period made major contributions in poetry, fiction, and dramatic writing. The greatest poet of the age was Basho (1644–1694), who developed one of the most important Japanese verse forms, the **haiku** (originally called hokku). This consists of three lines of five, seven, and five syllables, respectively. Haiku typically uses an image, often drawn from nature, to evoke or suggest a feeling or mood. Basho spent most of his life either in retreat or on solitary journeys, writing poems that evoke entire

■ 19.19 Maruyama Okyo. *Peacocks and Peonies.* Edo period, 1776. Hanging scroll. Color on silk, 4′3⅓″ × 2′2⅞″ (1.25 m × 68 cm). Imperial Household Collection, Tokyo. The care with which the artist depicts the bird's plumage and the flowers in the foreground was probably influenced by Western models.

landscapes by the telling selection of the crucial details. In this way, he aimed to provide a poetic equivalent of the flash of enlightenment that a meditating Buddhist hoped to achieve. Basho was a devout Buddhist, with a

■ 19.20 Hokusai Katsushika. *The Great Wave off Kanagawa.* Togukawa period, c. 1831. Polychrome woodblock print, 9⅞″ × 14⅝″ (25.5 × 37.1 cm). This is one of a series of woodblocks called *Thirty-Six Views of Mount Fuji;* the mountain can be seen in the distance. Note the two boats, whose crews are trying to negotiate the perilous sea.

special interest in Zen Buddhism. (Zen, which avoided images, rituals, and sacred texts, and stressed contemplation and meditation, had a great influence on Japanese culture.)

Basho's contemporary, Ihara Saikaku (1642–1693), also wrote poetry, but was chiefly famous for his novels. Many of these follow the various adventures of their heroes and heroines rather in the manner of *The Tale of Genji* to which they form a middle-class equivalent. *Life of an Amorous Woman,* for example, is narrated by an old woman as she looks back over her life from the Buddhist retreat to which she has retired. Beginning as a high-class prostitute, she gradually declined to a mere streetwalker and eventually scraped a living from the few occupations open to women. The overt eroticism is in strong contrast with Lady Murasaki's delicacy and emerges in Saikaku's other writings, which include a collection of tales about male homosexual love. Similar themes of love among the bourgeois merchant classes inspire the plays of Chikamatsu Monzaemon (1653–1725). One of the most famous is *The Love Suicide at Amijima,* which describes the life and eventual death of a paper merchant, ruined by his hopeless love for a prostitute. The earlier *no* dramas had enacted traditional stories, passed down from generation to generation. This new form of drama, based on real-life incidents, is called **kabuki,** and grew increasingly popular despite government opposition.

At the end of the Edo period, Japan was thrust into contact with the Western powers. In 1853, the famous American naval expedition of Commodore Matthew Calbraith Perry arrived in Edo Bay and insisted, under threat of bombardment, that Americans be allowed to trade. Britain, Russia, and Holland soon followed. The ensuing contest between conservatives and reformers was soon won by the latter, when a new emperor ascended to the throne in 1867.

MODERN JAPAN: THE MEIJI

The new Emperor Mitsuhito's reign (1817–1912), known as the **Meiji** ("enlightened government"), introduced a radical program of reform, abolished feudalism, and quickly built a strong central government. A new army, modeled on the German system, was formed. A parliament, consisting of an upper and a lower house, served under the emperor. Banks, railways, and a merchant marine all permitted Japan to industrialize at a speed that far outstripped India or China and, by 1905, Japan could claim military victory over a European opponent in the Russo-Japanese War. Yet although the tumultuous events of the twentieth century brought ever-increasing globalization of culture and economies, Japanese artists have continued to work in ways inherited from the past. As in China,

high-quality ceramic manufacture has always been a feature of artistic production, and the tradition continues, with contemporary artists adapting new styles and techniques to old art forms [**FIG. 19.21**].

SUMMARY

The Mughal Empire Muslim forces had arrived in northwest India in the thirteenth century, but with the conquest of large parts of the subcontinent by the Mughal general Babur in 1526, most of India came under the rule of the Mughals for the following two and a half centuries. The Mughal Empire, both under Babur and his grandson Akbar, established an organized system of administration, which devoted considerable effort to cultural achievement and aimed to promote unity. The emperors did not impose the Islamic religion on their Hindu subjects and introduced a new language, Urdu, which combined elements of Arabic and Persian with the Hindi language spoken most commonly in India before their arrival.

Mughal Art The art of the Mughal period similarly aimed to combine elements of preexisting Indian styles with Arabic and, above all, Persian characteristics. Buildings such as the Taj Mahal introduced forms of dome, arch, and tower that were commonly used in Islamic architecture. Mughal painters depicted scenes from real life and portraits, rather than restricting themselves to religious subjects, as earlier Hindu and Buddhist artists had done. The emperors highly valued

■ **19.21** Hamada Shoji. Large bowl, 1962. Black trails on translucent glaze, 5⅞″ × 1′10½″ (14 × 74 cm). National Museum of Modern Art, Kyoto. The Japanese have retained their love for traditional ceramics. This bowl is made of stoneware, rather than the finer porcelain of Chinese pottery, and its simple, apparently casual decoration emphasizes its relationship to folk art and craft.

literature, both collecting books and writing their own works. At the same time, Hindu writers continued to produce religious texts in their own language.

The End of Mughal Rule and the Arrival of the British Toward the end of the Mughal period, later emperors proved less tolerant, and local resistance led to the collapse of the empire. At the same time, European traders began to assert ever greater influence. The leaders in this were the British, who defeated European rivals and during the eighteenth century won virtual political and economic control over the separate states into which India had once again fallen.

The Rise of Nationalism With the formation of the Indian National Congress Party toward the end of the nineteenth century, India was one of the first colonized nations to begin the struggle for independence. Throughout the 1920s and 1930s, Mohandas Gandhi played a major role in leading this cause, with his policy of nonviolent civil disobedience. Many leading Indian writers of the day used English to introduce India's problems to a wider audience. Finally, following World War II, British rule ended, although one of the consequences was the partition of the subcontinent into mainly Hindu India and the new Muslim state of Pakistan. The mass population transfers that accompanied partition involved millions of deaths on both sides.

Chinese Culture under Imperial Rule Following the centuries of confusion caused by the Mongol invasions, China once again came under central rule. The two dynasties to govern China from the fourteenth century to modern times were the Ming (1368–1644) and the Qing (1644–1911).

The Arts under Ming Rule With the restoration of imperial rule came a return to traditional Confucian values and familiar artistic forms. One of the effects was to encourage artists in search of new ideas to invent or develop new artistic forms. Writers turned to the short story, based on everyday life, or to the novel. In some cases, as in the novel *Monkey,* the author could use what seemed pure fantasy to satirize aspects of contemporary political life. Painters, many of whom were gentleman-scholars rather than professionals, depicted landscapes in which individual humans were dwarfed by the grandeur of nature. The major building project of the age was the construction of the Imperial palace—the Forbidden City—at Beijing; the Mongols had made Beijing their capital, and the Ming emperors retained it as such.

The Qing Dynasty: China and the West When the Ming Dynasty finally collapsed, invaders from northeast China, Manchuria, set up the Qing Dynasty, the last to rule China before modern times. Early Qing rulers succeeded in limiting contacts with Western traders, although Jesuit missionaries succeeded in establishing limited contacts, not the least of which was at the Imperial court, where they managed to introduce some Western technology and culture. In general, however,

the Qing period saw growing stagnation, with artists continuing to repeat familiar subjects.

By the nineteenth century, China was under growing pressure to allow trade with outside powers. The Opium War of 1839–1842, in which the British compelled the Chinese to accept increasing quantities of a drug whose harmful effects were well known to both sides, led to the opening of Chinese markets to other Western nations, including France and the United States. As internal revolutionaries fought against the collapse of traditional ways in China—first in the Taiping Rebellion of 1851–1864 and then in the Boxer Rebellion of 1900–1901—the last Qing rulers were forced to turn to the outside powers who were the cause of the revolts to help crush them. By 1911, mass dissatisfaction led to the end of millennia of Imperial rule. The republic that followed saw its own share of bloody conflict before the establishment of the Communist Chinese Peoples' Republic in 1949.

The Arts and Culture of Japan: Early Japanese History and Culture The early history of Japan seems to have been mainly agricultural, but over time settlements grew in size, and the first Japanese capital was founded at Nara (c. 700). Although Buddhism played an important role in influencing Japanese culture throughout its history, the religion native to Japan was Shintoism, essentially a form of nature worship. Shintoism differs from other Asian religions, however, in its belief in the divine nature of the emperor, descended from the sun goddess. In the early ninth century, Japan's capital moved to Kyoto, where a rich and elaborate court life developed, with much emphasis on elegance and formal ritual. One of the most revealing sources of information about the artificiality and ceremony of the court is the novel by Lady Murasaki, *The Tale of Genji.*

The Period of Feudal Rule In an attempt to counteract what was seen as the weakness of Imperial rule at Kyoto, a new administrative center was set up (in 1185) at Kakamura. Japanese soldiers were formed into a new warrior class of samurai, under the military command of the shogun. Individual warrior bands owed their loyalty to their own warlords, who in turn were subject to the emperor. Over time, this system degenerated into fighting between rival groups—a period of violence exacerbated by the importation of firearms from the Portuguese.

The Edo Period Peace was only restored by a strong leadership that transferred the capital once again, this time to Tokyo (Edo). With renewed central government, Japan began to develop an increasingly sophisticated urban culture, and the Edo period was one in which the arts flourished. Painters produced works inspired by a host of outside styles, from traditional Chinese landscape scenes to Western realistic depictions of people and animals. Novelists and storytellers drew on contemporary everyday life, rather than the artificial world of the Imperial court. Poets, of whom the most popular was Basho, invented a new form of short poem, the haiku, derived in part from the inspiration of Zen Buddhism, which aimed to provide the enlightenment of sudden insight derived from the world of nature.

Modern Japan: The Meiji Beginning in 1868, under the Meiji emperors, Japan began a hasty program of modernization. Catapulted into the modern world by the arrival of Commodore Matthew Perry's American fleet in 1853, Japan soon began to acquire the infrastructure of an industrial economy. These changes, together with reforms in education, politics, and communications allowed Japan, in its first hostile encounter with a European power in the Russo-Japanese War of 1905–1906, to prove victorious. By the end of the twentieth century, of all the cultures of Asia, Japan was the one best capable of competing with the West on equal terms.

Postscript: A Note on Asian Film One of the most direct and enjoyable means of access to an unknown culture is by way of its films. In the case of the cultures of Southeast Asia, movies made since World War II provide an especially rich source of information. In China, government censorship meant that for much of the postwar period, filmmakers had little choice but to echo the official party line. But in recent years, independent directors have been able to create works that reflect their own vision. Perhaps the best-known of Chinese directors is Zhang Yimou, whose films include *Raise the Red Lantern* and *The Story of Qiu Ju,* both of which give a vivid impression of the social system existing in China, with special attention to the hardships of women.

In the case of India and Japan, two directors in particular—the Indian Satyajit Ray (b. 1921) and the Japanese Akira Kurosawa (1910–1998)—have made films that many movie critics consider as among the greatest ever produced, and they are already classics of the medium.

Ray was born into a prosperous Bengali family and studied art as a young man. His films aim to show the lives of ordinary people and use the details of their everyday existence to give a more general impression of the culture of which they form a part. His best-known work is probably *The Apu Trilogy,* three films that tell the story of a young Bengali boy growing to maturity: *The Song of the Road (Pather Panchali)* of 1955, *The Unvanquished (Aparajito)* of 1957, and *The World of Apu* of 1958. Taken together, the three movies, with specially composed background music played by Ravi Shankar, provide an unforgettably moving impression of coming of age in both rural and urban India and point out the similarities between a culture that at first seems so remote from life in the West in the twenty-first century. A later Ray film, *The Home and the World* (1984), sets a romantic love triangle against the background of

the early years of the twentieth century, with its scheming and treacherous British rulers.

The greatest Japanese filmmaker—Kurosawa—is, if anything, even more highly esteemed. Influenced by American movies, in particular those of John Ford, Kurosawa brought his own insights to bear on a wide range of human situations and historical periods. The first of his films to catch international attention was *Rashomon* (1950), a study in human perception and memory. This was followed by *Seven Samurai* (1954), which brilliantly re-creates the lives—and deaths—of Japanese feudal warriors and has been listed as one of the ten greatest films of all time. This film was later remade as an American film, *The Magnificent Seven*. A later historical epic, set in the sixteenth century, is *Kagemusha* (1980), which explores the notion of identity: a petty thief, who resembles the dying warlord of a powerful clan, takes over as leader and gradually assumes the character of the man he is pretending to be. One critic writing of Kurosawa referred to the "Shakespearean cast of his genius"; two of his most dramatic films are based on works by Shakespeare: *Throne of Blood* (1957), based on *Macbeth*, and *Ran* (1985), Kurosawa's version of *King Lear*. The latter is a movie of immense power, profoundly pessimistic in tone.

KEY TERMS

Calligraphy Literally, fine handwriting; the cultivating of writing as an art form

China The name of the country, which became used to describe its most famous export

Daimyo Japanese warlords

Haiku Japanese verse form consisting of three lines of five, seven, and five syllables

Hua-Pen Chinese short stories

Kabuki Japanese drama, aimed at a wider public than **No** drama, and often based on real-life incidents

Meiji Literally, "enlightened government." The period beginning in 1868 during which feudalism was abolished and a strong central government established.

Minaret Tower of a mosque, from where the call to prayer is chanted

Mughal The Persian word for "Mongol." It is used to describe the period of Muslim rule in India.

No (or **Noh**) Traditional Japanese drama, generally based on stories passed down from generation to generation, involving acting, song, dance, and mime

Pillow-book Japanese literary form consisting of a diary describing the day's events, often of an erotic nature

Rajput Rulers of local Indian kingdoms following the fall of the Gupta Empire

Samurai Japanese professional warrior

Samurai-dokoro Office held by Japanese emperor, giving him command over all Japan's professional warriors

Satyagraha Nonviolent civil disobedience; a form of protest against British rule in India devised by Gandhi

Shintoism Native Japanese religion, combining reverence for nature spirits and worship of the emperor and his ancestors

Shogun Official title of the Japanese emperor

Urdu New language, based on Hindi, Arabic, and Persian, created during the reign of Akbar

PRONUNCIATION GUIDE

Aurangzeb:	Our-ANG-zeb
Basho:	BAH-SHOW
Beijing:	Bay-JING
daimyo:	DIME-yo
Genji:	GHEN-ji
Heian:	HAY-an
Hokusai:	HOE-COO-SIGH
Kublai Khan:	KOO-bli KON
Kurosawa:	KOO-ro-SAH-wa
Macao:	Ma-COW
Matteo Ricci:	Mat-A-owe RICH-ee
Meiji:	MAY-ji
Mohandas Gandhi:	Moe-HAN-das GAN-di
Mughal:	MOO-gal
Murasaki:	MOOR-a-SAR-ki
Qing:	CHING
Rabindranath Tagore:	Ra-BIN-dra-nath Ta-GORE
Ramayana:	RA-MA-YA-NA
Saikaku:	SIGH-KAY-KOO
samurai:	SAM-oo-rye
shogun:	SHOW-GUN
Sikh:	SEEK
Tokugawa:	TOH-KOO-GAH-WAH
Tripitaka:	Tri-pi-TAH-ka
Urdu:	OOR-do
Verbiest:	Ver-BEAST

EXERCISES

1. What effect did contact with Western civilization have on the cultures of India, China, and Japan? How did it differ in each case?

2. What were the lasting results of the Mughal conquest of India for the history of the subcontinent?

3. Urdu is just one of many attempts to construct a new language. What others have been tried? Why did Urdu succeed? Why did others fail?

4. What are the outstanding features of Marco Polo's account of his travels? Which other travelers left descriptions of their travels in Asia before modern times?

5. Why has Zen Buddhism become popular in the West in modern times? What are its chief characteristics?

6. Lady Murasaki is a rare example of a woman artist before the nineteenth century, either in Western or Asian culture. Why have there been so few? Why did such a high proportion of those few write rather than paint or compose music?

YOUR RESOURCES

■ **ExploringHumanities CD-ROM**
 • Interactive Map: Early Japan, Modern Japan
 • Architectural Basics: Chinese Construction Methods and Principles
■ **Website http://art.wadsworth.com/cunningham**
 • Chapter 19 Quiz
 • Links

FURTHER READING

Asher, Catherine B. *Architecture of Mughal India.* New York: Cambridge University Press, 1992. A fine study of one of the chief legacies of Mughal India.

Barnhart, R. M. *Painters of the Great Ming: The Imperial Court and the Zen School.* Dallas, TX: Dallas Museum of Art, 1993. This well-illustrated account provides a cultural context for Ming painting.

Beach, M. C. *Mughal and Rajput Painting.* Cambridge: Cambridge University Press, 1992. An excellent survey, with superb illustrations.

Clunas, C. *Art in China.* Oxford: Oxford University Press, 1997. A useful survey of an immense field, with handy bibliographies to help find more specialized works.

Craven, Roy C. *Indian Art: A Concise History.* London: Thames and Hudson, 1997. As the title suggests, this practical book gives a broad overview of a huge subject, doing so with clarity and elegance— and many useful illustrations.

Girard-Gestan, M. et al., trans. J. A. Underwood. *Art of Southeast Asia.* New York: Harry N. Abrams, 1998. An up-to-date overview of all the cultures discussed in this chapter, with separate essays by experts.

Guth, Christine. *Art of Edo Japan: The Artist and the City, 1615–1868.* New York: Abrams, 1996. Beautifully illustrated, this account provides a social and cultural context for one of the most impressive periods of Japanese art.

Mitter, Partha. *Indian Art.* New York: Oxford University Press, 2001. A well-illustrated, comprehensive study of art and architecture.

Sickman, L., and A. C. Soper. *The Art and Architecture of China.* New Haven, CT: Yale University Press, 1992. Especially valuable for the material on architecture.

Spence, J. D. *The Chan's Great Continent: China in Western Minds.* New York: Norton, 1998. A wholly absorbing account, by one of the great masters of Chinese studies, of China's impact on Westerners from Marco Polo to Richard Nixon (and beyond).

Sullivan, M. *The Arts of China,* 4th ed. Berkeley: University of California Press, 1999. The most recent edition of perhaps the best single-volume introduction to its subject.

Weidner, Marsha, ed. *Flowering in the Shadows: Women in the History of Chinese and Japanese Painting.* Honolulu: University of Hawaii Press, 1990. A series of essays on various aspects of the treatment of women in Japanese and Chinese art—and life.

READING SELECTIONS

PREM CHAND
"THE SHROUD" (*Translated from Hindi*)

Prem Chand (1880–1936)—his real name was Dhanpat Ray Srivastav—was one of India's leading writers, in both Hindi and Urdu, during the first part of the twentieth century. He worked for many years as a schoolteacher and schools inspector, but in 1921, on the advice of Gandhi, Chand withdrew from government service to devote himself to Gandhi's Non-Cooperation Movement. In short stories and novels, he aimed to describe to the outside world the grim life that so many of India's poorest villagers led. His story, "The Shroud," translated from the Hindi, depicts the all-but-hopeless conditions that existed for millions of Indians over countless generations, and that, of course, still afflict many today. The fate of Madhava's wife shows that even in a society almost utterly bereft of material goods, the women suffer most. In a poignant touch, the author does not even give her a name.

I

Father and son were sitting silently at the door of their hut beside the embers of a fire. Inside, the son's young wife, Budhiya, was suffering the pangs of childbirth. Every now and then she gave such piercing cries that the hearts of both men seemed to stop beating. It was a winter night; all was silent and the whole village was plunged in darkness.

Gheesu said, "She may be dying. We've been out chasing around all day. You ought to go in now and see how she is."

Madhava answered peevishly, "If she has to die, then the sooner the better. What's there to see?"

"You're heartless. Such lack of consideration for the wife with whom you lived so pleasantly for a whole year!"

"I can't bear to watch her in pain and torment."

Theirs was a family of cobblers notorious throughout the village. Gheesu worked for a day, then rested for three days.

His son, Madhava, tired so quickly that he needed an hour for a smoke after every half hour of work. Therefore they could find little work anywhere. If they had no more than a handful of grain in the house, they refused to stir themselves. After a couple of days' fasting, Gheesu would climb a tree and break off some branches for firewood. Madhava would take it to the bazaar and sell it. As long as they had any of the proceeds in their pockets, both of them lazed about. When it came to the fasting point once more, they again collected firewood or looked for work.

There was no dearth of work in their peasant village; in fact, there were a hundred jobs for a hard-working man. But these two were called only in emergencies, when an employer had to be content with two people doing the work of one. If they had been ascetics, they would not have needed restraint or discipline to cultivate contentment and patience. It was part of their nature.

Their life was strange. They had no property at all in the house except a few mud pots. They covered their nakedness with a few tattered rags. With no worldly cares and anxieties, in spite of their burden of debts, they suffered abuse and beatings, but they were never sad. They were so destitute that people always lent them something or other, though there was never any hope of the debt being repaid. During the season for peas and potatoes, they habitually plundered somebody's field. Sometimes they uprooted sugar cane and made a meal out of it. Gheesu had passed his sixty years in this bohemian fashion, and Madhava, as became a good son, was treading in his father's footsteps. He was even adding to the glories of the ancestral name.

Gheesu's wife had died long ago; Madhava had married only a year ago. Since his wife had come to their house, she had tried to introduce some sort of order in the family. She managed to earn a handful of flour either by grinding corn for somebody or by mowing grass, and this filled the bellies of these two shameless creatures. Since she had come, they had grown even more indolent. They had even begun putting on airs. If somebody called them to work, they coolly asked for double wages. Now she was suffering the agony of a difficult birth, and the two seemed to be only waiting for her to die so that they could sleep undisturbed.

Gheesu dug out a stolen potato from the ashes, and proceeding to peel it, he said, "Just go and see how she is. Some ghost must have got hold of her; what else can it be? Perhaps a doctor could help, but here even the healer wants nothing less than a rupee."

Madhava was afraid that Gheesu would polish off most of the potatoes if he were to go inside. He said, "I'm afraid to go inside."

"What are you afraid of? I'm right here."

"Why don't you go in yourself, then, and see how things are?"

"When my wife died, I never left her side for three whole days. Your wife will feel shy of me. I've never even seen her face, and now you want me to see her naked body! Her clothes are probably all in disorder. If she were to see me, even the little relief of thrashing her arms and legs about would be denied her."

"I'm thinking what will happen if a child is born. We've nothing at all in the house—oil, candy, and the rest."

"We'll have everything, God willing! The same people who refuse us even a crust of bread today will send for us and offer us money tomorrow. Nine sons were born to me, and we never had anything in the house. But God helped us to pull through, anyhow."

In a society in which to condition of those who toiled honestly day and night was hardly better than theirs, while those who knew how to take advantage of the weaknesses of the peasants were flourishing and prosperous, the growth of an attitude of mind like this was nothing very strange. We may even conclude that Gheesu was far wiser than the honest people were, having cast lot with the ignoble tribe of idlers instead of joining the bunch of unthinking peasants. True, he had no finesse in observing the rules and policies that enrich nonproducers. Therefore, while the other members of this class ruled the roost in the village as its leaders and chief men, he was merely the object of the entire village's scorn. Still, he at least did not have to indulge in backbreaking toil day and night. Moreover, other people did not get rich at the expense of his innocence.

Both men dug the potatoes out of the ashes and consumed them while they were still scorching hot. As they had eaten nothing since the day before, they didn't have the patience to let them cool. They each burned their tongues several times. They gobbled at top speed, though their eyes watered at the effort.

Gheesu recalled at this moment the landowner's wedding party which he had attended twenty years ago. The satisfaction he had found in that feast was something worth remembering all his life, and the memory was still fresh in his mind. He said, "I can't forget that landowner's feast. I have never since had food to equal it. The bride's party had ordered enough wheat cakes to satisfy everyone. Every single person, small or great, was fed on those cakes, fried in the best butter. Every delicacy was provided—pickles, curds, four varieties of curry, chutney, sweets! How can I describe to you how wonderful that meal was? There were no limits. You could ask for anything you liked and have as much of it as you pleased. We ate so much that there was hardly any room left for a drop of water. Those who were serving went on supplying the guests with hot, round, and fragrant cakes. You said you didn't want them, you covered your leaf plate with your hands, but still they put them down before you. When everybody had rinsed his mouth and wiped his hands, they offered betel nut, too. But I had no thought of betel nut that day. I could hardly stand up. I went and collapsed on my blanket. Ah, but that landowner was generous that day!"

Madhava savored the wonder of these delicacies in his imagination and said, "These days we never have a feast like that."

"Who can afford such a feast now? That was a different age. Now everyone wants to economize. They don't spend either at weddings or funerals. Then what are they going to do with all the money plundered from the poor? There's a limit to piling up of money! They ought to go as easy on grabbing as they do on spending."

"You must have eaten at least twenty cakes?"

"More than twenty!"

"I would have eaten at least fifty!"

"I couldn't have eaten less than fifty. I was strong then. You aren't even half the size I was."

They drank some water after finishing the potatoes and lay down by the fire, their knees pulled up to their bellies, covering themselves with their loincloths. They were like two huge pythons curled up.

And Madhava's wife, Budhiya, was still moaning.

II

When Madhava entered the hut in the morning, his wife lay dead and cold. Flies swarmed over her face. Her eyes were fixed in a glassy stare. Her whole body was covered with dust. The child had died in the womb.

Madhava came rushing out to Gheesu. Each started wailing loudly and beating his breast. When the neighbors heard

this uproar, they came running and tried to console the bereaved in the time-honored fashion.

But there was not much time for weeping and wailing. They had to buy a shroud and wood for the funeral pyre. Money was as scarce in their house as meat in the nest of a kite!

Father and son went weeping to the landowner's house. He hated the very sight of these two, both of whom he had beaten on several occasions with his own hands for thieving and for failing to come to work after promising to. He asked, "What is it, Gheesu? Why are you weeping, you rogue? I never even see you now. It seems you do not wish to live in this village any more."

Gheesu touched the ground with his forehead; his eyes were filled with tears. He said, "Master, I am in very great trouble. Madhava's wife passed away last night. She was in agony the whole night long. We sat by her side through it all. We arranged for medicine and did all we could. But she has departed. Now there is no one to feed us even a crust of bread, sir! We are ruined. Our home has been devastated. I am your slave, master. Who is there except you to help us in arranging her last rites? We have spent all we had on her treatment. Her body can be removed only if you take pity on us. There is no one else I can turn to."

The landowner was a kindhearted person. But he knew that to show pity to Gheesu was wasted effort. He wanted to say, "Get out! You don't come at all when we send for you; but now that you're in trouble, you come bowing and scraping. Scoundrel!"

But this was no occasion for anger or reprimands. Annoyed as he was, he threw down two rupees. He uttered not a word of solace, however. He did not even glance in Gheesu's direction.

When the landowner had given two rupees, how could the shopkeepers and moneylenders of the village refuse to give anything? Gheesu knew well how to use the landowner's name in his favor. One man offered two annas; another gave four. Within an hour Gheesu had collected the respectable sum of five rupees. He got grain from one place and wood from another. At midday Gheesu and Madhava went to fetch cloth for a shroud from the bazaar. Neighbors began to cut bamboo and make other preparations.

The tenderhearted ones among the village women came to view the dead body and shed a few tears over Budhiya's unhappy fate.

III

When they reached the bazaar, Gheesu said, "We've got enough wood to burn her body; isn't that right, Madhava?"

Madhava said, "Yes, we have enough wood. Now we need a shroud."

"Then come, let us buy a cheap shroud."

"Yes, of course. It'll be dark before the body is removed. Who's going to see at night what sort of a shroud it is?"

"What a bad custom it is that one who gets hardly a stitch of cloth while living must have a new cloth for a shroud when dead."

"The shroud is, after all, burned with the body."

"Of course. Does anyone think it survives? Had we got these five rupees earlier, we could have given her some medicines and looked after her properly."

Each guessed the other's secret thoughts. They wandered about in the bazaar. They went to this cloth shop and that. They examined various kinds of cloth, silk and cotton, but approved of none. Gradually it became evening. Then, by some sort of heavenly guidance, they reached a liquor shop and went in, as though according to a prearranged plan. They stood there for a while, hesitating; then Gheesu approached the counter and said, "Sir, please give us a bottle, too."

They got something to nibble at and some fried fish, and then both sat down on the veranda of the liquor shop to drink peacefully.

After several tumblefuls downed in a great hurry, the liquor began taking effect.

Gheesu said, "A shroud would have been useless. It would have just got burned. It couldn't possibly go to heaven with her."

Madhava looked at the sky as though calling upon the gods to be witnesses to his innocence, and said, "It's just the custom. But why should people give thousands of rupees to Brahmans? Who can know whether it ever reaches our loved ones in heaven or not?"

"The rich have wealth to squander. They are welcome to do so. We haven't got anything to waste."

"But what will you say to people who ask where the shroud is?"

Gheesu laughed. "We'll tell them we lost the money somewhere. We looked for it everywhere, but found no trace of it. They won't believe us, but they'll have to give us money a second time."

Madhava also laughed at this unexpected good fortune. He said, "She was a good wife. She provides for us even after her death!"

More than half the bottle had been consumed. Gheesu sent for several pounds of cakes. Also pickles, liver, and chutney. There was a meat shop right in front of the liquor shop. Madhava rushed over and brought everything back in two leaf-covered bundles. He spent a whole rupee and a half on it. Now they had only a few small coins left.

The two were eating cakes with great righteousness, like lions feeding on game in the jungle. They feared neither explanations nor ill fame. They had got over such feelings years ago.

Gheesu spoke philosophically. "Our hearts are blessing her for this feast. That would be a virtuous deed in her favor."

Madhava bowed his head reverently and said, "Certainly that would be. O God, All-knowing One! Take her to heaven. We both bless her from our hearts. We are eating today as never before in our lives."

After a while a certain curiosity arose in Madhava's heart. "Father, will we also go to heaven someday?"

Gheesu gave no reply to this innocent query. He did not wish to spoil the joy of the present moment by thinking about the other world.

"If she asks us there why we gave her no shroud, then what will you say?"

"Nonsense!"

"She will certainly ask us."

"How do you know that she'll have not shroud? Do you think I'm such a fool? Have I learned nothing in all my sixty years on earth? She'll have a shroud and a better one than we could have given her."

Madhava was skeptical. He asked, "Who will give it to her? You spent the money, but it's me she'll call to account. It was I who took on the responsibility, when I married her."

Gheesu got angry and said, "I tell you she'll have her shroud. Why don't you listen to me?"

"Then tell me who will give it?"

"The same people who gave it last time. Only this time, we won't be given any cash."

As darkness grew and the splendor of the stars increased, the liquor shop, too, hummed with greater gaiety. One customer sang, another talked big, a third embraced his companions, and another put his cup to the lips of a friend.

There was intoxication in the very spirit of the place and in the air surrounding it. Many grew drunk here just on a couple of drops. They found the atmosphere even more intoxicating than the liquor. The vicissitudes of life drew them here where they forgot for a time whether they were alive or dead, or didn't care which.

And these two—father and son—continued to sip happily. All eyes were focused on them. How lucky they were! They had a whole bottle between them.

After they had eaten their fill, Madhava gave the remaining cakes to a beggar who stood looking hungrily at them. He experienced for the first time in his life the joy, pride, and glory of giving something.

Gheesu said, "Take it, eat your fill, and bless us! She whose earnings these are has died. But your blessings will certainly reach her. Let each hair on your body bless her. This money she earned the hard way."

Madhava again looked up at the sky and said, "She will go to heaven, Father! She will be the queen of heaven."

Gheesu stood up, and as though swimming on waves of elation, said, "Yes, son! She will go to heaven. She never troubled or oppressed anyone. Even in dying, she fulfilled the most heartfelt desire of our lives. If she is not to go to heaven, who then should go there? The fat ones who plunder the poor, then bathe in the Ganges and offer incense in temples to wash away their sins?"

This mood of reverence soon passed. Fickleness is the special virtue of intoxication. They now struck a note of grief and despair.

Madhava: "But Father, the poor thing suffered hell in this life. How painfully she died!"

He began to weep again, covering his eyes with his hands. Gheesu consoled him. "Why do you weep, son? You should be happy that she has found her release from this mortal bondage. She has been liberated from her sorrows. She was very fortunate in breaking through the bonds of Maya so early."

Then they both stood up and started singing:

O Maya, deceitful one, Goddess of Illusion,
Cast not your beguiling eyes at us.

The eyes of all the other drunkards were focused on this pair as they sang merrily, full of their own joy of intoxication. Then they began to dance. They jumped and leaped; they fell down and rolled their eyes. They gesticulated and dramatized their emotions. And in the end they sank down dead drunk.

WU CH'ENG-EN
from MONKEY, Chapter XV

In this episode from Wu Ch'eng-en's long tale, describing the journey of the Buddhist priest Tripitaka and his companion Monkey to India, Tripitaka loses his horse to a greedy dragon. When the priest, in tearful despair, turns for help to various deities (who symbolize administrators in China's labyrinthine bureaucracy), they only make things more complicated, and it is left to Monkey—who has little patience or respect for the various Bodhisattvas and other spirits—to remedy the situation.

It was mid-winter, a fierce north wind was blowing and icicles hung everywhere. Their way took them up precipitous cliffs and across ridge after ridge of jagged mountain. Presently Tripitaka heard the roaring of a torrent and asked Monkey what this river might be. 'I remember,' said Monkey, 'that there is a river near here called the Eagle Grief Stream.' A moment later they came suddenly to the river side, and Tripitaka reined in his horse. They were looking

down at the river, when suddenly there was a swirling sound and a dragon appeared in mid-stream. Churning the waters, it made straight for the shore, clambered up the bank and had almost reached them, when Monkey dragged Tripitaka down from the horse and turning his back to the river, hastily threw down the luggage and carried the Master up the bank. The dragon did not pursue them, but swallowed the horse, harness and all, and then plunged once more into the stream. Meanwhile Monkey had set down Tripitaka upon a high mound, and gone back to recover the horse and luggage. The luggage was there, but the horse had disappeared. He brought up the luggage to where Tripitaka was sitting.

'The dragon has made off,' he said. 'The only trouble is that the horse has taken fright and bolted.'

'How are we to find it?' asked Tripitaka.

'Just wait while I go and have a look,' said Monkey. He sprang straight up into the sky, and shading his fiery eyes with his hand he peered down in every direction. But nowhere was the least sign of the horse. He lowered his cloud-trapeze.

'I can't see it anywhere,' he said. 'There is only one thing that can have happened to it. It has been eaten by the dragon.'

'Now Monkey, what can you be thinking of?' said Tripitaka. 'It would have to have a big mouth indeed to swallow a large horse, harness and all. It is much more likely that it bolted and is hidden by a fold of the hill. You had better have another look'

'Master, you underrate my power,' said Monkey. 'My sight is so good that in daylight I can see everything that happens a thousand leagues around. Within a thousand leagues a gnat cannot move its wings without my seeing it. How could I fail to see a horse?'

'Well, suppose it has been eaten,' said Tripitaka, 'how am I to travel? It's a great deal too far to walk.' And as he spoke his tears began to fall like rain.

'Don't make such an object of yourself,' shouted Monkey, infuriated by this exhibition of despair. 'Just sit here, while I go and look for the wretch and make him give us back the horse.'

'You can't do anything unless he comes out of the water,' said Tripitaka, 'and if he does it will be me that he will eat this time.'

'You're impossible, impossible,' thundered Monkey, angrier than ever. 'You say you need the horse to ride, and yet you won't let me go and recover it. At this rate, you'll sit here staring at the luggage forever.'

He was still storming, when a voice spoke out of the sky, saying, 'Monkey, do not be angry. Priest of T'ang, do not weep. We divinities have been sent by Kuan-yin to protect you in your quest.' Tripitaka at once did obeisance.

'Which divinities are you?' cried Monkey. 'Tell me your names, and I'll tick you off on the roll.'

'Here present are Lu Ting and Lu Chia,' they said, 'the Guardians of the Five Points, the Four Sentinels, and the Eighteen Protectors of Monasteries. We attend upon you in rotation.'

'And which of you are on duty this morning?' asked Monkey.

'Lu Chia, one Sentinel and the Protectors are on duty,' they said, 'and the Golden-headed Guardian is always somewhere about, night and day.'

'Those who aren't on duty can retire,' said Monkey. 'But Lu Ting, the Sentinel of the day, and all the Guardians had better stay and look after the Master, while I go to the river and look for that dragon, and see if I can get him to return the horse.'

Tripitaka, feeling somewhat reassured, sat down on the bank, begging Monkey to be careful. 'Don't you worry about me!' said Monkey.

Dear Monkey! He tightened the belt of his brocade jacket, hitched up his tiger-skin, grasped his iron cudgel, and going straight down to the water's edge called in a loud voice, 'Cursed fish, give me back my horse!' The dragon way lying quietly at the bottom of the river, digesting the white horse. But hearing someone cursing him and demanding his prey, he fell into a great rage, and leapt up through the waves crying, 'Who is it that dares make such a hullabaloo outside my premises?'

'Stand your ground,' hissed Monkey, 'and give me back my horse.' He brandished hid cudgel and struck at the dragon's head. The dragon advanced upon him with open jaws and threatening claws. It was a valiant fight that those two had on the banks of the river. To and fro they went, fighting for a long while, hither and thither, round and round. At last the dragon's strength began to fail, he could hold out no longer, and with a rapid twist of the tail he fled from the encounter and disappeared in the river. Monkey, standing on the bank, cursed and taunted him unceasingly, but he turned a deaf ear. Monkey saw nothing for it but to go back and report to Tripitaka.

'Master,' he said, 'I taunted him till he came out and fought many bouts, and in the end he took fright and ran away. He is now at the bottom of the river and won't come out.'

'We are still not sure whether he did swallow the horse,' said Tripitaka.

'How can you say such a thing?' said Monkey. 'If he hadn't eaten it, why should he have come out and answered my challenge?'

'The other day when you dealt with that tiger,' said Tripitaka, 'you mentioned that you could also subdue dragons. I don't understand why you are having such difficulties with this dragon today.'

To such a taunt as this no one could be more sensitive than Monkey. 'Not another word!' he cried, stung to the quick. 'I'll soon show you which is master!'

He strode to the stream-side, and used a magic which stirred up the clear waters of the river till they became as turbulent as the waves of the Yellow River. The dragon soon became very uncomfortable as he lay at the bottom of the stream. 'Misfortunes never come singly,' he thought to himself. 'Hardly a year has passed since I barely escaped with my life from the Tribunal of Heaven and was condemned to this exile; and now I have fallen foul of this cursed monster, who seems determined to do me injury.' The more he thought, the angrier he became. At last, determined not to give in, he leapt up through the waves and gnashing his teeth he snarled, 'What monster are you, and where do you come from, that you dare affront me in this fashion?'

'Never mind where I come from or don't come from,' said Monkey. 'Just give me back my horse, or you shall pay for it with your life.'

'Your horse,' said the dragon, 'is inside me. How am I to give it back to you? And anyhow, if I don't, what can you do to me?'

'Have a look at this cudgel,' said Monkey. 'If you don't give me back the horse you shall pay for it with your life.'

Again they fought upon the bank, and after several rounds the dragon could hold out no longer, made one great wriggle, and changing itself into a water-snake, disappeared into the long grass. Beating the grass with his cudgel, Monkey pranced wildly about, trying to track it down, but all in vain. At last, fuming with impatience, he uttered a loud OM,

as a secret summons to the spirits of the locality. In a moment they were kneeling before him.

'Hold out your shanks,' said Monkey, 'and I'll give you each five strokes with the cudgel just to relieve my feelings.'

'Great Sage,' they besought him, 'pray give us a chance to put our case to you. We had no idea that you had been released from your penance, or we should have come to meet you before. We humbly beg you to forgive us.'

'Very well then,' said Monkey. 'You shan't be beaten. But answer me this. Where does this dragon come from, who lives in the Eagle Grief River? Why did he swallow my Master's white horse?'

'Great Sage,' they said, 'in old days you had no Master, and indeed refused obedience to any power in Heaven or Earth. What do you mean by your Master's horse?'

'After I got into trouble about that affair in Heaven,' said Monkey, 'I had to do penance for five hundred years. But now I have been taken in hand by the Bodhisattva Kuan-yin and put in charge of a priest who is going to India to fetch Scriptures. I was travelling with him as a disciple, when we lost my Master's horse.'

'If you want to catch this dragon, surely your best plan would be to get the Bodhisattva to come to deal with it,' they said. 'There used not to be any dragon here, and it is she who sent it.'

They all went and told Tripitaka of this plan. 'How long shall you be?' he asked. 'Shan't I be dead of cold or starvation before you come back?' While he spoke, the voice of the Golden-headed Guardian was heard saying from the sky, 'None of you need move a step. *I* will go and ask the Bodhisattva.'

'Much obliged,' said Monkey. 'Pray go at once.'

The Guardian soared up through the clouds and made straight for the Southern Ocean. Monkey told the local deities to look after the Master, and the Sentinels to supply food. Then he went back to the banks of the river.

'What have you come for?' asked the Bodhisattva, when the Golden-headed Guardian was brought to her where she sat in her bamboo-grove.

'The priest of T'ang,' said he, 'has lost his horse at the Eagle Grief River. It was swallowed by a dragon, and the Great Sage sent me for your help.'

'That dragon,' said Kuan-yin, 'is a son of the Dragon King of the Western Ocean. By his carelessness he set fire to the magic pearls in the palace and they were destroyed. His father accused him of subversive intents, and the Tribunal of Heaven condemned him to death. I saw the Jade Emperor about it, and asked that the sentence might be commuted if the dragon consented to carry the priest of T'ang on his journey to India. I cannot understand how he came to swallow the horse. I'll come and look into it.' She got down from her lotus seat, left her fairy cave, and riding on a beam of magic light crossed the Southern Sea. When she came near the River of Eagle Grief, she looked down and saw Monkey on the bank uttering ferocious curses. She sent the Guardian to announce her arrival. Monkey at once sprang into the air and shouted at her, 'A fine "Teacher of the Seven Buddhas", a fine "Founder of the Faith of Mercy" you are, to plot in this way against us!'

'You impudent stableman, you half-witted red-bottom,' said the Bodhisattva. 'After all the trouble I have taken to find someone to fetch scriptures, and tell him to redeem you, instead of thanking me you make a scene like this!'

'You've played a fine trick on me,' said Monkey. 'You might in decency, when you let me out, have allowed me to go round and amuse myself as I pleased. But you gave me a dressing down and told me I was to spend all my time and energy in looking after this T'ang priest. Very well! But why

did you give him a cap that he coaxed me into putting on, and now I can't get it off, and whenever he says some spell or other I have frightful pains in the head?'

'Oh Monkey,' laughed Kuan-yin, 'if you were not controlled in some such way as this, there would be no doing anything with you. Before long we should have you at all your old tricks again.'

'It's no good trying to put the blame on me,' said Monkey. 'How comes it that you put this dragon here, after he had been condemned by the Courts, and let him eat my Master's horse? It was you who put it in his way to continue his villainies here below. You ought to be ashamed of yourself!'

'I specially asked the Jade Emperor,' said Kuan-yin, 'to let this dragon be stationed here, so that he might be used to carry the master on his way to India. No ordinary Chinese horse would be able to carry him all that way.'

'Well, now he is frightened of me and is hiding,' said Monkey, 'so what is to be done?'

Kuan-yin called the Golden-headed Guardian and said to him, 'Go to the edge of the river and cry "Third son of the Dragon King, come out! The Bodhisattva is here." He'll come out all right.' The dragon leapt up through the waves and immediately assumed human form.

'Don't you know that this is the Scripture-seeker's disciple?' Kuan-yin said, pointing at Monkey.

'Bodhisattva,' said the young dragon, 'I've been having a fight with him. I was hungry yesterday and ate his horse. He never once mentioned anything about "Scripture-seeking".'

'You never asked my name,' said Monkey, 'so why should I tell you?'

'Didn't I ask you what monster you were and where you came from?' asked the dragon. 'And didn't you shout at me "Never mind where I came from or didn't come from, but just give me back my horse"? You never so much as mentioned the word T'ang.'

'Monkey is fonder of showing off his own powers than mentioning his connection with other people,' said Kuan-yin. 'But in future if anyone questions him, he must be sure to say that he is seeking Scriptures. Then there will be no more trouble.'

The Bodhisattva then went to the dragon and removed the jewel of wisdom from under his chin. Then she took her willow-spray and sprinkled him all over with sweet dew, and blowing upon him with magic breath cried 'Change!' Whereupon the dragon immediately changed into the exact image of the lost horse. She then solemnly called upon the once-dragon to turn from his evil ways, and promised that when his task was ended he should be given a golden body and gain illumination. The young dragon humbled himself and promised faithfully to do as he was bid. Then she turned to go, but Monkey grabbed at her, crying, 'This is not good enough! The way to the west is very bad going, and it would be difficult enough in any case to get an earthly priest over all those precipices and crags. But if we are going to have encounters like this all the time, I shall have hard work keeping alive at all, let alone any thought of achieving salvation. I'm not going on!'

'That's odd,' said the Bodhisattva, 'because in the old days you used to be very keen on obtaining illumination. I am surprised that, having escaped from the punishment imposed upon you by Heaven, you should be so unwilling to take a little trouble. When you get into difficulties you have only to call upon Earth, and Earth will perform its miracles. If need be, I will come myself to succour you. And, by the

way, come here! I am going to endow you with one more power.' She took the willow leaves from her willow-spray, and dropping them down Monkey's back cried 'Change.' At once they changed into three magic hairs. 'These,' she said, 'will get you out of any trouble, however menacing.'

Monkey thanked the Bodhisattva, who now set out for the Southern Heaven, and taking the horse by the forelock he led it to Tripitaka, saying, 'Master, here's a horse anyway!'

'It's in much better condition than the old one,' said Tripitaka. 'However did you manage to find it?'

'What have you been doing all the while? Dreaming?' said Monkey. 'The Golden-headed Guardian sent for Kuan-yin, who changed the dragon into the exact image of our white horse. The only thing it lacks is harness.'

'Where is the Bodhisattva?' asked Tripitaka, very much surprised. 'I should like to thank her.'

'You're too late,' said Monkey. 'By this time she is already crossing the Southern Ocean.'

However Tripitaka burned incense and bowed towards the south. Then he helped Monkey to put together the luggage, and they set out. 'It's not going to be easy to ride a horse without saddle and reins,' said Tripitaka. 'I'd better find a boat to get across the river, and see if I can't get some harness on the other side.'

'That's not a very practical suggestion,' said Monkey. 'What chance is there of finding a boat in this wild, desolate place? The horse has lived here for some time and must know his way through the waters. Just sit tight on his back and let him carry you across.' They had got to the river bank, Tripitaka astride the horse and Monkey carrying the luggage, when an old fisherman appeared upstream, punting a crazy old raft. Monkey waved to him, crying, 'We have come from the east to fetch scriptures. My Master does not know how to get across, and would like you to ferry him.' The old man punted rapidly towards them, and Monkey told Tripitaka to dismount. He then helped him on board, and embarked the horse and luggage. The old man punted them swiftly across to the far side, where Tripitaka told Monkey to look in the pack for some Chinese money to give to the old fisherman. But the old man pushed off again at once, saying he did not want money. Tripitaka felt very uncomfortable and could only press together his palms in token of gratitude. 'Don't you worry about him,' said Monkey. 'Didn't you see who he really is? This is the river divinity who failed to come and meet us. I was on the point of giving him a good hiding, which he richly deserved. The fact that I let him off is payment enough. No wonder he hadn't the face to take your cash.' Tripitaka was not at all sure whether to believe this story or not. He got astride the horse once more, and followed Monkey along the road to the west. And if you do not know where they got to, you must listen to what is told in the next chapter.

Excerpt from *Monkey* by Wu Cheng-En, translated by Arthur Waley, Chapter XV, pp. 158–166, Allen & Unwin, © 1942 by permission of The Arthur Waley Estate.

BASHO

SELECTED HAIKU

Basho, the greatest master of the haiku, was born in Kyoto, and spent much of his youth in the local aristocratic circles. In 1667, at age twenty-three, Basho moved to Tokyo, and later left that city to

*settle in a recluse's hut in the countryside. Outside the hut there grew a banana tree (*basho* in Japanese), and he took the word as his name. His haiku chiefly date from the final years of his life, during which he followed the example of Chinese poets like Li Po, and traveled widely in order to experience the wonders of nature. His aim was* karumi *(lightness of touch), and the concision of his verses reflects the influence of Zen Buddhism.*

The order in which the following selection appears is random; Basho expected each haiku to be self-sufficient.

In my new robe
this morning—
someone else

Spring rain—
under trees
a crystal stream.

Now cat's done
Mewing, bedroom's
touched by moonlight.

Do not forget the plum,
blooming
in the thicket.

Drizzly June—
long hair, face
sickly white.

Wake, butterfly—
it's late, we've miles
to go together.

Violets—
how precious on
a mountain path.

Bright moon: I
stroll around the pond—
hey, dawn has come.

Noon doze,
wall cool against
my feet.

Snowy morning—
one crow
after another.

Come, see real
flowers
of this painful world.

Friends part
forever—wild geese
lost in cloud.

Year's end, all
corners of this
floating world, swept.

	GENERAL EVENTS	LITERATURE & PHILOSOPHY	ART
STONE AGE	First occupation of site of Great Zimbabwe		
B.C.E. C.E.			
300	**300 c.e. – 1075** Kingdom of Ghana Ghana emerges as a trading center between Africa and the Mediterranean, exporting gold and other goods		
1000	Height of Ghana's success; at this time it is the world's largest gold producer Introduction of new food crops in Nigeria **1075** Defeat of Ghana by Muslim Berbers		More sophisticated metal-working tools make larger communities possible
1300	**1300 – 1500** Kingdom of Benin Benin Kingdom flourishes under the hereditary rule of the Oba, trading in pepper and ivory Great Zimbabwe serves as base for a trading empire extending from the Near East, Persia, and China		Bronze plaques adorn the Oba's central palace
1500	Beginning of European colonization and the slave trade	Before the 20th century, most African story-telling was done by word of mouth **1500** Religious verse brought by Muslim traders is paraphrased in Swahili; over time, the Swahili-Arabic script becomes a new poetic tradition	
1700	**1787? – 1828** Life of the legendary Zulu King Shaka, who organized weak Zulu warriors into a formidable fighting force	Oral poet Somali Raage Ugaas becomes popular for his wisdom and piety Saiyid Abdallah (c. 1720 – 1810) writes "Self-Examination," a long poem using the decline of great Arab trading cities on the East African coast as a symbol of the inevitability of death	
1800	Mass deportation of male Benin population by Arab and European slave-traders **1895** Ghana falls under French rule	**c. 1805** Qamaan Bulhan becomes well-known for his philosophical and reflective verses, which in some cases have now become proverbial expressions	
1900	Shona people now occupy site of Great Zimbabwe	**1907** Lesotho native Thomas Mofolo (1875? – 1948) writes *Traveler of the East* in his native language, Sesotho, becoming the first African novelist **1912** Mofolo writes *Chaka,* his most celebrated book, but the missionary-run press that published his previous works refuse to publish it **1925** *Chaka* becomes an instant best-seller and is widely translated **1929** Senegalese poet writing in French, Leopold Senghor (1906 – 1989) creates a literary movement known as "negritude," which celebrates the unique traditions of African art **1930** Africa's most acclaimed 20th-century writer, Chinua Achebe, is born	As African art-works begin to circulate among Western collectors, African artistic styles begin to influence the work of Western artists like Pablo Picasso
1955	**1960** Nigeria receives independence from the British **1967** Igbo people of eastern Nigeria secede to form the Republic of Biafra; Chinua Achebe becomes Minister of Information in the new state	**1958** Chinua Achebe writes his first novel, *Things Fall Apart,* in English **1960** Nigerian writer Wole Soyinka becomes president of Senegal, retiring voluntarily in 1980 Achebe publishes *No Longer at Ease*	Contemporary African art continues to examine the conflict between Western and traditional culture
1970 TO PRESENT	**1970** Igbo breakaway is crushed by the Nigerian government; Achebe stays under a general amnesty for rebels	**1986** Wole Soyinka becomes the first African to receive a Nobel Prize for literature	

Most dates are approximate

Benin artists also create ancestral altars representing the power of Oba

1300 Rulers of Great Zimbabwe erect huge stone buildings surrounded by massive walls

1990 Traditional artforms and rituals involving masks and head dresses continue to play a crucial role in African communities

CHAPTER 20

THE PEOPLES AND CULTURES OF AFRICA

A study of the humanities as they developed in Africa requires a special approach. In the first place, the sheer size of Africa—three times as big as the continental United States and Alaska—and the variety of climates and landforms prevented the formation of a single unified culture. Unlike India or China, Africa was never united under a central government; it is therefore impossible to generalize about developments there. Like the Americas, technology and the ability to write did not develop at the same speed as in Europe and Asia, and we have no consistent written records before the nineteenth century. Further confusion was created by the arrival of Muslim and European traders in the sixteenth century and the subsequent centuries of generally brutal colonization. To reconstruct the earliest civilizations on African soil, we must rely on archaeological remains and written accounts by the first outsiders to visit the early African kingdoms. The general picture is that of a series of powerful and highly developed states.

RELIGION AND SOCIETY IN EARLY AFRICA

At first sight, African life seems to have been divided by its size into a wide variety of differing peoples and cultures. It is often observed that today more than one thousand languages are spoken in sub-Saharan Africa. Yet most of these are related to four or five basic tongues, suggesting that beneath the apparent diversity there lies a common cultural inheritance. Other factors bear this out. One important characteristic many Africans share is their attitude toward their environment and living creatures. Although a single common African religion never existed, most African peoples developed a variety of **animist beliefs.** These took forms specific to individual regions, but all basically aimed to understand the world and human life through the workings of nature, using rituals and ceremonies to deal with illness, death, and natural disasters. For many groups, the focus of their specific cult was a particular animal—which became sacred—and could not therefore be killed by members of the group. Because, in the absence of written texts, the accumulation of religious practices and beliefs had to be memorized and passed on by word of mouth, the elderly became revered, and a tradition of ancestor worship developed. This in turn laid emphasis on the family and, more broadly, the village community. Within the community certain extended families, or kinship groups, served specific functions: hunters, farmers, traders, and so on. Thus, religion and social structure reinforced one another and allowed for the slow evolution of increasingly powerful kingdoms.

THREE EARLY AFRICAN KINGDOMS: GHANA, BENIN, AND ZIMBABWE

One of the earliest states to develop was Ghana, in West Africa. **Caravan routes** crossing the Sahara linked the region to Mediterranean cities, first by horse and oxen and then, after C.E. 300, by camel. Shortly after, the city of Ghana, on the upper river Niger, began to export gold, animal hides, pepper, ivory, and slaves in exchange for salt, cloth, pottery, and other manufactured goods. Ghana grew increasingly wealthy and, at the height of its success (around 1000), was probably the world's largest gold producer. According to an Arab traveler who visited Ghana in 1065, the army numbered two hundred thousand, of whom forty thousand were armed with bows and arrows. This formidable fighting force was defeated a decade later by a nomadic army of Muslim **Berbers.** The Berbers moved north after a few years to attack Morocco, but Ghana never fully recovered (in part because the gold mines were beginning to peter out), and by 1300, the great kingdom was only a memory.

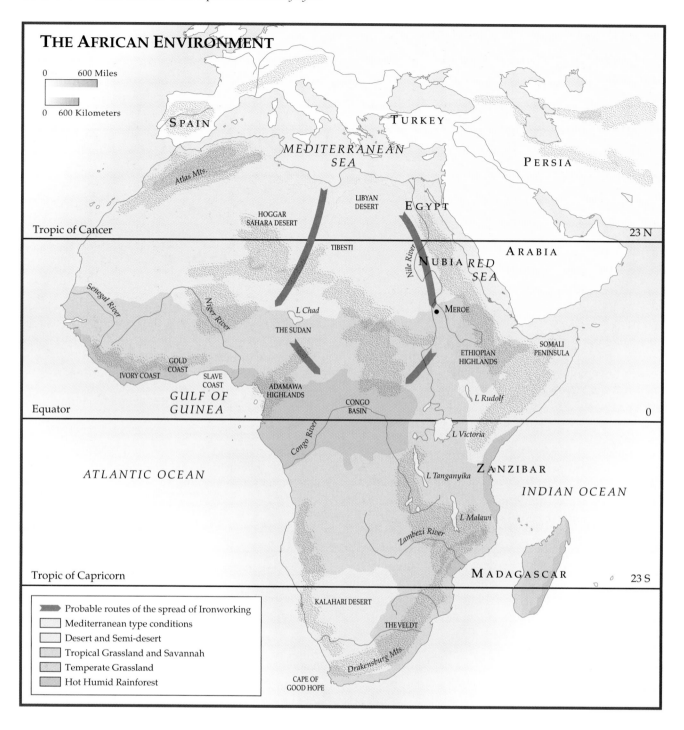

THE AFRICAN ENVIRONMENT

Probable routes of the spread of Ironworking
Mediterranean type conditions
Desert and Semi-desert
Tropical Grassland and Savannah
Temperate Grassland
Hot Humid Rainforest

During the time of Ghana's slow decline, the kingdom of Benin was beginning to grow in what is now modern-day Nigeria (ancient Benin should not be confused with the modern African state of Benin). The period around 1000 saw the introduction of new food crops from East Asia and more sophisticated methods of metalworking, making larger communities possible. The kingdom of Benin flourished between the fourteenth and sixteenth centuries, trading widely in pepper and ivory. Its eventual decline was caused by the massive deportation of its male population in the nineteenth century by Arab and European slave traders. The kingdom was ruled by a hereditary male absolute monarch with the title of **Oba,** who had at his disposal a powerful army and an effective central government.

The Oba's central palace was adorned with a series of bronze plaques, showing the life of the court and military exploits. On one of these, we see an Oba flanked by the royal bodyguard. The Oba wears a high crown and a ceremonial cape, and is brandishing a

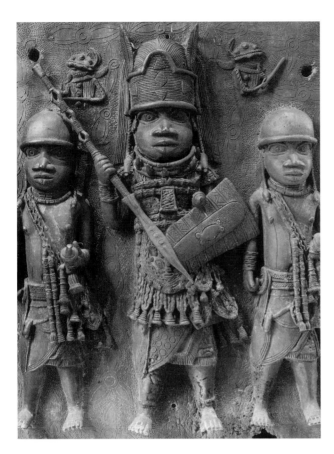

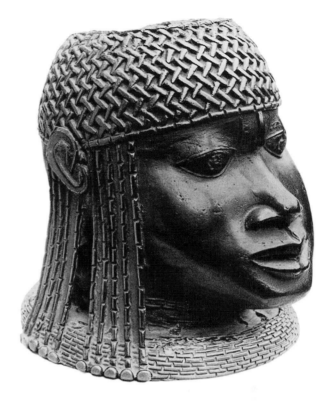

■ **20.1** Bronze frieze from Benin, Nigeria, showing an Oba (ruler) with his warriors, fifteenth to sixteenth century. 18½″ × 14½″. Peabody Museum, Harvard University. By means of a complex method of casting the bronze, the artist has made the figure of the Oba stand out virtually in the round, while the two soldiers are more recessed in the background, which is decorated with further details.

■ **20.2** Portrait of a royal woman, from the palace at Benin, Nigeria. Bronze, sixteenth century, height 7⅛″. Fogg Art Museum, Harvard University. The stylized beauty of the headgear and the hair, as well as the treatment of the ear, are curiously reminiscent of Greek sculpture of the Archaic age (compare Figures 2.10 and 2.12)—art that was completely unknown even in the West at this time.

spear. The soldiers, smaller in stature to indicate their lesser importance, stand quietly by [**Fig. 20.1**]. Among the sculptures discovered in the palace is a small portrait of a royal woman with necklace and braided hair, which offers insight into the lavish life at the Benin court. At the same time, the beauty of line and balance between decoration and naturalism give some idea of how much we have lost with the disappearance of so much African art [**Fig. 20.2**].

Another bronze from Benin throws light on religious practices at court. It comes on an **ikegobo,** or royal shrine, at which the Oba would have offered up sacrifices, either for favors received from the gods or in the hope of receiving future ones. The Oba appears both on the side and on the lid, again dominating the accompanying attendants. On the lid, two meek leopards crouch humbly at his feet. Even the creatures of the wild acknowledge the supreme power of their master, while other animals range around the base [**Fig. 20.3**].

The greatest ancient kingdom in South Africa was Zimbabwe. **Bushmen** paintings and tools show that

the earliest people to occupy the site settled there in the Stone Age. Around 1300, its rulers ordered the erection of huge stone buildings surrounded by massive walls; the complex is now known as Great Zimbabwe [**Fig. 20.4**]. Finds in the ruins include beads and pottery from the Near East, Persia, and even China, suggesting that the complex served as the base for a trading empire that must have been active well before the arrival of the Europeans, some two centuries later.

Attempts to understand the function of Great Zimbabwe's constructions are largely based on accounts of Portuguese traders who visited the site after its original inhabitants had abandoned it. The main building seems to have been a royal residence, with other structures perhaps for nobles, and a great open ceremonial court. It has been calculated that at the height of its power, the complex may have served as the center for a population of some eighteen thousand persons, with the ruling class living inside and the remainder in less permanent structures on the surrounding land.

Portuguese documents describe Great Zimbabwe as "the capital of the god-kings called Monomotapa." In the sixteenth century, Europeans used this name for

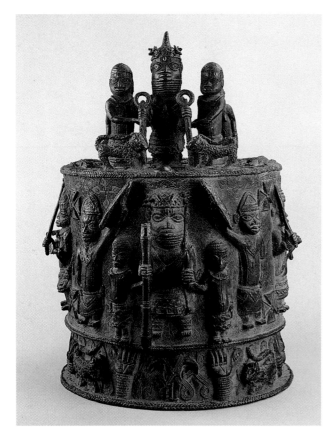

■ **20.3** Altar to the Hand and Arm, from Benin, Nigeria, c. seventeenth–eighteenth century. Bronze, 1′5½″ (19 cm) high. British Museum, London. Note the large size of the Oba's head, both on the main body of the altar and on the lid: one of the standard terms used to praise the ruler was "great head," symbol of his power.

■ **20.4** Tower and outer wall, Great Zimbabwe, fifteenth century. Granite. The surrounding walls probably enclosed a royal residence, with private living quarters and an open area for ceremonial assemblies. Some of the larger towers may have been used to store grain.

two **Shona** rulers: Mutota and Matope. The original inhabitants may well have been ancestors of the Shona people, who are now among the groups living in modern Zimbabwe. Part of Shona beliefs is the idea that ancestral spirits take the form of birds, often eagles. In one of the enclosed structures, perhaps an ancestral shrine, archaeologists discovered a large soapstone block crowned by a bird, with a crocodile carved onto the stone's lower surface. Below the bird is a row of circles which, in later Shona art, are called "eyes of the crocodile" [FIG. 20.5].

All three kingdoms flourished long before the Europeans entered Africa's interior. From the sixteenth century, with the beginning of the age of European colonization and the slave trade that accompanied it, Europeans began to settle in coastal regions, which served as bases for exploring and exploiting Africa's extraordinary natural resources. Islamic missionaries had carried their religion southward across the Sahara desert centuries earlier. Now the arrival of the Europeans brought Christianity and, under the influence of both religions, traditional patterns of ritual and ancestor worship began to die out.

AFRICAN LITERATURE

Although very little written African literature existed before the twentieth century, there was a rich tradition of storytelling, often in verse. Much of this was passed down by word of mouth, in the same way as the earliest works of Western literature—Homer's *Iliad* and *Odyssey*—and a little has been preserved, written down by later generations using either the Arabic or Western alphabet. Somalia had a rich poetic tradition. Raage Ugaas (eighteenth century), of the Somali Ogaden clan, was popular for his wisdom and piety, whereas another Somali oral poet, Qamaan Bulhan (probably mid-nineteenth century) was well-known for his philosophical and reflective verses, some of which have become proverbial expressions.

One area that did develop an earlier written tradition was the coastal region of East Africa, where **Swahili** (an African language strongly influenced by Arabic) was and still is spoken. Beginning in the sixteenth century, Muslim traders brought with them to the coastal trading centers didactic and religious verse that was paraphrased in Swahili, with the Swahili ver-

sion written between the lines of the Arabic text. Over time, poets used this Swahili-Arabic script to compose their own works, either recording traditional songs or creating new ones. Saiyid Abdallah (c. 1720–1810) was born on the island of Lamu, now part of present-day Kenya. In his long poem *Self-examination,* he uses the decline of the great Arab trading cities on the East African coast, increasingly overshadowed during Abdallah's time by the new European colonial centers, as a symbol of the inevitability of death.

Over time, as African writers began to use the Western alphabet, they also adopted Western languages, normally the one spoken by their colonial occupiers. The modern state of Senegal, which once formed part of the eleventh-century kingdom of Ghana, fell under French rule in 1895. As a young boy, Leopold Senghor (1906–1989) was sent to a Catholic mission school where he learned French and Latin. In due course he won a scholarship to study in Paris, where Senghor became part of a group of talented black writers, some African, some West Indian, and some, including Langston Hughes, American. Overwhelmed by the squalor of the city of Paris and the arrogance of its people—the conquerors of his country—Senghor found strength in his "blackness." He later talked of discovering Africa in France and feeling his "pagan sap which prances and dances."

Together with his fellow black African exiles, he created a literary movement known as **negritude.** Senghor defined *negritude* as "the sum total of the civilization of the African world. It is not racialism, it is culture." Negritude's contribution to universal civilization, he believed, lay in Africa's uniqueness: the song styles and rhythms of its oral literature and poetry, but also its social values of traditionalism, earthiness, and the importance of community. In his own poems, Senghor often used woman as a symbol for Mother Africa, his version of Mother Earth. Not all African writers were convinced by Senghor's philosophy. One Senegalese contemporary described it as "mystification" that ignored the class struggle, elitist, and out of touch with the masses. Many younger African critics have attacked negritude as a compromise with Neo-Colonialism, a refusal to complete the decolonization of the African mind. The Nigerian writer Wole Soyinka (who in 1986 was the first African to receive the Nobel Prize for literature) has dismissed negritude by observing that

■ **20.5** Bird with crocodile image on stone monolith, from Great Zimbabwe, fifteenth century. Soapstone. Bird image 1′2½″ (14 cm) high. Great Zimbabwe Site Museum, Zimbabwe. Found in an area associated with a shrine dedicated to the ancestors of the ruler's first wife, the bird may represent her family. The crocodile stretching up the left-hand side of the base is perhaps a symbol of her male ancestors, while the circles below the bird may stand for her female ancestors.

"tigers do not contemplate their 'tigritude' but just act naturally by pouncing." Senghor went on to a career in politics, building on negritude to form a variety of African socialism, neither capitalist nor Marxist. Becoming president of Senegal in 1960, he retired in 1980, the first African president to do so by his own choice. Whatever the lasting value of his aesthetic theories, his influence on twentieth-century African history is undeniable. One of his fellow countrymen called him "the myth that is endlessly discussed."

Other important African writers used their own language, rather than that of the colonizers. The first African novelist, Thomas Mofolo (1875?–1948), was born in Lesotho, a landlocked kingdom in the middle of South Africa, upon which it has always depended economically. While he was teaching in South Africa and Lesotho, Mofolo's passion for storytelling encouraged friends to urge him to begin writing. In 1906, he published *Traveler of the East,* writing in the Sesotho language. The book is generally considered both the first novel by an African and the first written in an African language. In his early work, Mofolo sought to combine Christian elements with traditional tales and poems. By the time he came to write his most important and successful novel, *Chaka* (1912), he used African religion as the overriding influence in his characters' lives. The book describes the career of **Zulu** King Shaka (1787?–1828), an actual historical figure who organized the hitherto weak Zulu warriors into a formidable fighting force. The real king was notorious for his cruelty and paranoia. In Mofolo's story, however, Chaka begins as genuinely heroic and courageous. The tragic hero then declines into tyranny and eventual insanity when, in an African version of Faust's pact with the devil, he sells his soul into sorcery. The missionary press, which had published Mofolo's earlier books, refused to publish it, and it did not appear in print until 1925. *Chaka* became an instant best-seller and has been widely translated.

The most widely read and acclaimed African novelist of the twentieth century is probably Chinua Achebe, born in Nigeria in 1930; his family belonged to the **Igbo** people of eastern Nigeria. When Nigeria became independent in 1960, the country (an artificial creation of the British) began to divide. In 1967, the Igbo seceded to form the Republic of Biafra, and Achebe, a passionate supporter of the Igbo, became Minister of Information in the new state. The Igbo breakaway was crushed in 1970, and the central Nigerian government seized control again. Achebe, overwhelmed by the death of many of his closest friends and the defeat of his people, chose to remain in Nigeria under the terms of the general amnesty for the rebels, and the war became a constantly recurring subject in much of his poetry.

The central theme of Achebe's work is the conflict between two worlds: Western technology and values, and traditional African society. In most of his novels, the chief character is torn by these opposing forces and is often destroyed in the process. His first book, *Things Fall Apart* (1958), forewarns us by its title (a quotation from W. B. Yeats's poem, "The Second Coming") that its story is tragic. When the British arrive in a traditional Igbo society, they undermine the values that have sustained it, and one of the community's most respected leaders is driven to suicide, as "things fall apart." Although the disaster is implicit from the beginning, Achebe's cool, laconic prose style distances the storyteller from his tale.

In his next novel, *No Longer at Ease* (1960), conflict becomes internalized. Its chief character, Obi Okonkwo, has been sent by his community to England for his education, and on his return takes an uneasy position among the corrupt minor British bureaucrats governing local affairs. As the story unfolds, Achebe paints a bitter, if ironic, picture of the colonial ruling classes, the bewilderment of the Africans, and the disastrous effect of both forces on the innocent young man in the middle. Obi's plight is made even more poignant by the impact on him of two powerful aspects of Western culture: Christianity and Romantic love.

Achebe wrote his novels in English and, as in the case of Senghor, many of his fellow African writers have reproached him for writing in a colonial language. Achebe has always argued, however, that only Western languages can carry the message to those who most need to hear it. Furthermore, by using European languages, Africans can prove that their work can stand alongside Western literature with honor. Above all, throughout his long career, Achebe has always believed that the retelling of the African experience is crucial. In one of his novels, an elder says: "It is the story that saves our progeny from blundering like blind beggars into the spikes of the cactus fence. The story is our escort; without it, we are blind."

TRADITIONAL AFRICAN ART IN THE MODERN PERIOD

In order to appreciate traditional African art, it is necessary to bear in mind its cultural context. Unlike most modern Western artists, African artists generally have not produced works as aesthetic objects to be looked at, but rather to fulfill a precise function in society and religion. Until the commercialization of recent times, the notion of a museum or gallery was alien to African art. Also, far from following Western ideas of "inspiration" or progress, African art is firmly rooted in tradition. The identity of the individual creator is far less important than the authenticity of the object and, as a result, we know very few names of African artists. Whether it exalts the secular power of rulers or the spiritual force of the spirit world—and often the two overlap—the sculpture or mask must evoke age-old

▪ VOICES OF THEIR TIMES

An Arab and a European Visit Africa

This account of the Ghanaian capital (probably Kumbi Saleh) comes from the travel account of al-Bakri, an Arab geographer:

> Ghana consists of two towns lying in a plain. One of these towns is inhabited by Muslims. It is large and possesses twelve mosques. . . . The town in which the king lives is six miles from the Muslim one and bears the name Al Gaba. The land between the two towns is covered with houses. The houses of the inhabitants are made of stone and acacia wood. The king has a palace and a number of dome-shaped dwellings, the whole surrounded by an enclosure like the defensive wall of a city. . . . The king adorns himself like a woman, wearing necklaces and bracelets, and when he sits before the people he puts on a high cap decorated with gold and wrapped in turbans of fine cotton.

Cited in E. Jefferson Murphy, *History of African Civilization* (New York: Crowell, 1972), p. 110.

The following description of the capital of Benin was written by a Dutch trader in the late seventeenth century, long after the city's heyday:

> The town is enclosed on one side by a wall ten-feet high, made of a double palisade of trees, with stakes in between interlaced in the form of a cross, thickly lined with earth. On the other side a marsh, fringed with bushes, which stretches from one end of the wall to the other, serves as a natural rampart to the town. There are several gates, eight- or nine-feet high, and five-feet wide. . . . The king's palace . . . is a collection of buildings which occupy as much space as the town of Haarlem, and which is enclosed within walls. There are numerous apartments for the king's ministers and fine galleries most of which are as big as those on the Exchange at Amsterdam.

Cited in Murphy, op. cit., p. 172.

memories and associations. At the same time, African artists are as open to the influences of changing times and the world around them as are Western or Asian artists.

The conflict between Achebe's Igbo tradition and the newly arrived Western forces, which leads to tragedy in his novels, is made visible in a pair of clay figures produced by an Igbo artist for a shrine known as a **mbari house** [**Fig. 20.6**]. The Igbo people used to construct houses made of **adobe** (sundried mudbrick) in honor of their deities, which were then filled with sculptures and paintings: these mbari houses were never repaired but were allowed to crumble into dust, before a new one was built. Seated in a mbari house, the two figures seen here represent the thunder god, Amadioha, and his wife. The god, symbol of worldly power, wears the clothing of the forces of Western colonialism, including sunhat, gun, and even necktie. His wife, as if representing Senghor's "Mother Africa," has a traditional hairstyle and body paint. To further enrich the visual impact of the pair, the "Western-style" thunder god is also carrying a traditional spear and has tattoo markings on his face, and both figures have "white" skin.

The same complexity of influences can be seen on many of the houses constructed by the Dogon people of the modern state of Mali—the geographical and political states of modern Africa are the result, for the most part, of Western colonization, and their borders do not conform to original settlement patterns. The example illustrated shows a **togu na,** or "men's house

▪ **20.6** Mbari thunder god (Amadioha) in modern dress with wife, Igbo. Umgote Orishaeze, Nigeria. Clay. Height 15½". Photographed 1966. Note the incongruity of the dress, hats, and hairstyles of the two figures. Their long bodies and necks and large heads are intended to make them seem more imposing and dominating.

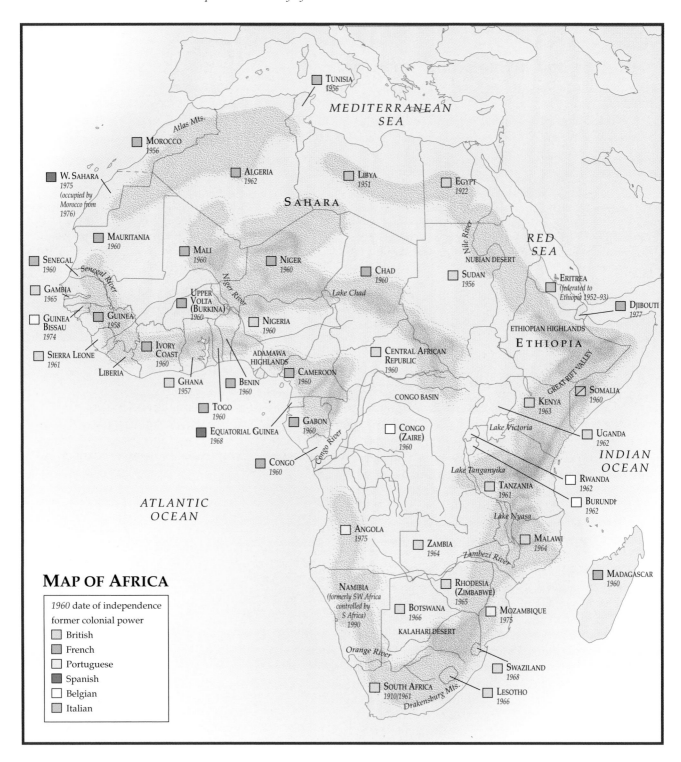

MAP OF AFRICA

1960 date of independence
former colonial power
- British
- French
- Portuguese
- Spanish
- Belgian
- Italian

TUNISIA 1956

MEDITERRANEAN SEA

Atlas Mts.

MOROCCO 1956

W. SAHARA 1975 (occupied by Morocco from 1976)

ALGERIA 1962

LIBYA 1951

EGYPT 1922

SAHARA

Nile River

NUBIAN DESERT

RED SEA

MAURITANIA 1960

SENEGAL 1960

Senegal River

GAMBIA 1965

GUINEA BISSAU 1974

GUINEA 1958

SIERRA LEONE 1961

LIBERIA

MALI 1960

UPPER VOLTA (BURKINA) 1960

Niger River

NIGER 1960

NIGERIA 1960

CHAD 1960

Lake Chad

SUDAN 1956

ERITREA (federated to Ethiopia 1952–93)

DJIBOUTI 1977

ETHIOPIAN HIGHLANDS

ETHIOPIA

IVORY COAST 1960

GHANA 1957

TOGO 1960

BENIN 1960

ADAMAWA HIGHLANDS

CAMEROON 1960

CENTRAL AFRICAN REPUBLIC 1960

CONGO BASIN

GREAT RIFT VALLEY

SOMALIA 1960

KENYA 1963

EQUATORIAL GUINEA 1968

GABON 1960

CONGO 1960

Congo River

CONGO (ZAIRE) 1960

Lake Victoria

UGANDA 1962

INDIAN OCEAN

Lake Tanganyika

RWANDA 1962

BURUNDI 1962

ATLANTIC OCEAN

TANZANIA 1961

Lake Nyasa

ANGOLA 1975

ZAMBIA 1964

MALAWI 1964

Zambezi River

MADAGASCAR 1960

NAMIBIA (formerly SW Africa controlled by S Africa) 1990

RHODESIA (ZIMBABWE) 1965

BOTSWANA 1966

MOZAMBIQUE 1975

KALAHARI DESERT

Orange River

SWAZILAND 1968

SOUTH AFRICA 1910/1961

LESOTHO 1966

Drakensburg Mts.

of words," which served for the male assemblies debating the affairs of their community [**FIG. 20.7**]. The central unpainted post dates probably to the nineteenth century. It bears the figure of a woman, probably a female ancestor. The other posts, added over time to replace earlier ones, show the growing exposure to external—mainly Western—influences, including a Western-style realistic sun, moon, star, and writing.

Many traditional African works of art celebrate the renewal of life and, simultaneously, its fragility. When women of the Luluwa people of what is now the Democratic Republic of the Congo want a child but are unable to conceive one, they traditionally seek help from their ancestors by turning to a **healer.** The healer initiates them into a fertility cult, which aims to prevent miscarriage and safeguard newborn infants by

▪ **20.7** Togu na (men's "house of words"). Dogon, Mali. Wood and pigment. Photographed in 1989. With the coming of Western influence, the traditional tribal art, produced by anonymous artists, has given way to works signed and dated by specific groups and individuals. Note on the blue second post from the right the signature: 3 GROUPE 89.

reincarnating a female ancestor in the form of a wooden image known as a **maternity figure** [**Fig. 20.8**]. The statuettes have two short pegs, one attached to each foot, which are inserted into a vessel containing medicine; a hole is drilled into the top of the head in which the healer inserts special herbs to cure infertility because, according to Luluwa beliefs, the natural cavities of the skull are associated with divine insight into past and future experience.

The statue illustrated here is unusually large and elaborately carved, suggesting that it was made for a woman of high rank. The inward contemplation of the expression, accentuated by the large eyelids and downward gaze, conveys the Luluwa view of women as mediators between nature and the world of the spirit. As is often the case in African culture, the same basic idea emerges elsewhere with a different artistic style. The Yoruba people, whose culture developed in the region now made up of western Nigeria and the Republic of Benin, also revered the spiritual role of the mother and often symbolized it by using the moon as an emblem of the eternal feminine.

A painted wooden Yoruba mask takes the form of a woman's face. It was used in a special ritual dedicated to "the mothers," whose power is at its greatest at night [**Fig. 20.9**]. Masks play a crucial role in the rituals of many different African peoples, providing a means of transforming humans into animals or spirits, blurring age and gender distinctions, and invoking supernatural forces. In most cases, the mask represents an ideal type, such as a young woman capable of bearing many children [**Fig. 20.10**], seen here as used in a ritual

dance of the Baga Sitemu in modern Guinea. On rare occasions, a mask is carved to capture the appearance of an individual. A photograph (taken in 1971) shows Moya Yanso together with her stepson, holding a mask carved around 1913 to represent her in her youthful beauty [**Fig. 20.11**].

THE IMPACT OF AFRICAN CULTURE ON THE WEST

Throughout the nineteenth century, as Western nations continued to colonize Africa, a growing number of African artworks began to circulate among Western collectors. One result was to create increasing interest in the study of anthropology, as scholars began to try to understand and distinguish among the various cultures. By the turn of the century, however, African artistic styles were directly influencing Western art. Pablo Picasso, one of the towering figures of twentieth-century art, returned throughout his long career to the African masks he had seen at a Paris exhibition and which he began to collect. One of the first of his works to show their effect on his painting is illustrated at the beginning of the next chapter (see Figure 21.1), the painting known as *Les Demoiselles d'Avignon*. Sixty years later, commissioned to produce a monumental sculpture for the city of Chicago, Picasso had a huge copy made of one of his small cubist sculptures from that period, a work inspired by the same source [**Fig. 20.12**].

■ **20.9** Mask, Yoruba, from Republic of Benin. Paint on wood. Height 14½″ (37 cm). The purpose of such masks was to disguise the individual wearing it, who thus became symbolic of a category; in this case the mask represents one of the "mothers," female spirits watching over the community.

■ **20.8** Maternity figure from Luluwa, Democratic Republic of the Congo. Mid- to late nineteenth century. Wood, 1⅜″ × 3⅜″ × 3½″ (28.9 × 8.6 × 8.2 cm). The Art Institute of Chicago, Wirt D. Walker Endowment fund. Note the peg under the foot, used to insert the figure into the pot containing the "magical" herbs. As in the case of the Benin Oba (Figure 20.3) and the Igbo thunder god and his wife (Figure 20.6), the maternity figure's neck and head are enlarged.

Perhaps an even more direct link between African culture and modern Western culture is in music. As Chapter 21 describes in detail, jazz derives ultimately from the music of the African ancestors of African Americans. Yet jazz only partially represents Africa's musical legacy, as the growing interest in world music continues to show.

SUMMARY

The development of culture in Africa was largely conditioned by climate and the different varieties of environment. The absence before modern times of a consistent written record means that our picture of early societies there is based largely on archaeological evi-

■ **20.10** Female headdress (D'amba dance), Baga Sitemu, Guinea. Photographed in 1990. Note that in this ritual dance, intended to promote fertility, the dancer has her head and face completely covered and wears the anonymous face as a headdress. Attached to it are large, pendulous breasts representing abundant milk.

■ **20.11** Ghagba portrait mask of Moya Yanso and stepson, Kouame Ndri. Kami village, Baule, Ivory Coast. Mask carved around 1913, photographed in 1971. Unlike the previous two illustrations, the mask seen here was intended to represent an individual, sitting beside it in the photograph. Yet even in this case, the mask represents the idealized beauty of a young woman, not the specific appearance of a particular person.

■ **20.12** Pablo Picasso. Chicago Civic Center Sculpture. Welded steel. Height 65′9″ (20.9 m), 1966. Civic Center Plaza, Chicago. The mask, here reduced to its essentials, has the same prominent nose as the standing figure to the right in Picasso's *Les Demoiselles d'Avignon* (see Figure 21.1).

dence and the historical accounts of the first Muslim and Western travelers.

Religion and Society in Early Africa Although African culture was never unified, certain characteristics were shared by many early African societies. Religious beliefs were generally animist, using the world of nature to explain to individuals their own lives. Successive generations passed on traditional beliefs by word of mouth, and the elders in a family or group therefore acquired a special status. Within each society, particular families or kin-groups undertook specific tasks.

Three Early Kingdoms: Ghana, Benin, Zimbabwe Of the many powerful and sophisticated kingdoms that developed in Africa before the age of colonization, Ghana was outstanding for its wealth and exported large quantities of gold. Its period of greatest richness occurred around 1000. Both Benin (in West Africa) and Zimbabwe (in South Africa) began to grow around 1300. We can document life in Benin by means of the bronze plaques used to decorate the royal buildings. They reveal a society ruled by a hereditary king and a religion that emphasized the cult of ancestor worship. Zimbabwe was chiefly notable for its massive stone buildings and for its trade with Asia long before the Europeans established trade links there.

African Literature The earliest literary tradition in Africa was oral, although some of the Muslim traders in East Africa introduced Arabic script. One of the results was the development of Swahili, an African language influenced by Arabic. In the early twentieth century, African writers were faced with the choice of whether to write in their own language or that of their colonizers. Leopold Senghor (of Senegal) wrote in French but was a leading influence in the literary movement known as "negritude," which emphasized the specifically African contribution to world culture. The first African novelist, Thomas Mofolo, wrote in the language of his birthplace: Lesotho. The Nigerian Chinua Achebe writes in English; his books explore

the impact of Western colonialism on African culture and lifestyles.

Traditional African Arts in the Modern Period The same contrast between Western culture and traditional African artistic styles recurs in the visual arts. Most African artists created works for secular rulers or ritual purposes. Recurrent symbols included animals and natural phenomena such as the moon. Masks played an important role as a means of transforming or concealing identity.

The Impact of African Culture on the West The discovery of African art by Western artists in the late nineteenth century and the development of jazz in the early twentieth century are two important illustrations of African influence on Western culture.

KEY TERMS

Adobe Sundried mudbrick

Animism Belief that the world is governed by the workings of nature

Berbers North African tribes, all speaking the Berber language although culturally separate, and mostly Muslim

Bushmen A people of South Africa, living around the Kalahari Desert, noted for their vivid painting

Caravan routes Trade routes, often through rough terrain (e.g., the Sahara Desert), used by groups of merchants traveling together for reasons of safety

Healer A person with special spiritual powers, often related to fertility

Ikegobo Royal altar used by the **Oba** (ruler) of Benin

Maternity figure Small statue representing a female ancestor of a pregnant woman, to watch over the birth, prevent miscarriage, and protect the newborn child

Negritude Term created by Leopold Senghor to summarize the African contribution to world culture

Oba The hereditary male absolute ruler of the ancient kingdom of Benin

Shona One of the peoples now living in modern Zimbabwe, who may be the descendants of the inhabitants of the ancient kingdom of Zimbabwe

Swahili An African language strongly influenced by Arabic, spoken by many of the inhabitants of East Africa

Togu na "Men's House of Words," used by the Dogon people for meetings of the male community assembly

Zulu Inhabitants of the northeast region of Natal Province, South Africa. Most are traditionally farmers and cattle-raisers.

PRONUNCIATION GUIDE

Achebe:	a-CHAY-BAY
Biafra:	Be-AF-ra
Lesotho:	Less-OWE-thow
Lulawa:	Loo-LAR-wa
Mofolo:	Mo-FOE-low
Oba:	OWE-ba
Senghor:	Sun-GORE
Shona:	SHOW-na
Swahili:	Swa-HEE-li
Yoruba:	Yo-ROO-ba
Zimbabwe:	Zim-BAB-wi

EXERCISES

1. Which aspects of their culture did African slaves bring with them to the United States? How have these transplanted forms been changed or modified?
2. Compare the effects of Islam and Christianity on African art and religion.
3. The question of which language to write in has been a major issue for twentieth-century African writers. What are the arguments for and against the use of Western languages?
4. Masks play an important role in African art and ritual. How does their use compare to that in Western culture? How have other cultures used masks?
5. For most of their history, African poets and storytellers depended on transmission of their compositions by word of mouth. What other cultures have used similar methods?

YOUR RESOURCES

- **ExploringHumanities CD-ROM**
 - Interactive Map: Africa before 1800, Modern Africa
- **Website http://art.wadsworth.com/cunningham**
 - Chapter 20 Quiz
 - Links

FURTHER READING

Blier, S. P. *The Royal Arts of Africa.* New York: Abrams, 1998. Lavishly illustrated; an excellent survey.

Brockman, N. C. *An African Biographical Dictionary.* Santa Barbara, CA: ABC Clio, 1994. An extremely useful reference work that provides a brief introduction to more than five hundred prominent sub-Saharan Africans from all periods of history.

Connah, Graham. *African Civilizations,* 2nd. ed. Cambridge: Cambridge University Press, 2001. A very useful survey of the enormous range of peoples and cultures in Africa. Well worth reading and also handy for reference.

Dewey, William J. *Legacies of Stone: Zimbabwe Past and Present.* Tervuren, Belgium: Royal Museum for Central Africa, 1997. An account of some of the most impressive monuments of Africa's past, which places them in a contemporary context.

Enwezor, Okwui, ed. *The Short Century: Independence and Liberation Movements in Africa, 1945–1994.*

New York: Prestel, 2001. A series of essays providing different perspectives on African history in the second half of the 20th century.

Garlake, Peter. *Early Art and Architecture of Africa.* Oxford: Oxford University Press, 2001. A comprehensive survey of the first civilizations in Africa, with useful illustrations and a good bibliography.

Kasfir, Sidney L. *Contemporary African Art.* London: Thames and Hudson, 1999. A well-illustrated examination of the latest developments in the art of the continent.

LaGamma, A. *Art and Oracle: African Art and Divination.* New York: Metropolitan Museum of Art, 2000. An introduction to the relationship between traditional African religion and art, with a valuable introductory essay by John Pemberton III.

Phillips, Tom, ed. *Africa: The Art of a Continent.* New York: Prestel, 1995. A series of essays that range widely over the diversity of African art.

Vogel, Susan M. *Baule: African Art, Western Eyes.* New Haven, CT: Yale University Press, 1997. A detailed study of the Baule people of central Ivory Coast, which throws interesting light on the interplay between African and Western culture.

READING SELECTIONS

CHINUA ACHEBE

from NO LONGER AT EASE, *Chapter One*

Chinua Achebe's novel No Longer at Ease *takes its title from a verse by T. S. Eliot in his poem "The Journey of the Magi":*

> *We returned to our places, these Kingdoms,*
> *But no longer at ease here, in the old dispensation,*
> *With an alien people clutching their gods.*
> *I should be glad of another death.*

The hero of the story, Obi Okonkwo, returns from his schooling in England, having been chosen by his village for education abroad, to find himself very far from at ease. No longer able to relate to the society in which he grew up and out of place in the alien and corrupt world of the colonial rulers for whom he works, he finds himself out of place wherever he turns. The first chapter of the novel, reproduced here, describes the consequences of this alienation: He is arrested and tried for accepting a small bribe. The rest of the book explores the forces that led to his apparently self-destructive act, including an affair with Clara, an African young woman whom he meets in London. In his sympathetic depiction of Obi, Achebe spares neither the petty world of the colonialists nor the African society from which Obi comes. Chapter One includes a particularly ironic depiction of the collision between African traditional religion and Christianity, lending additional dimension to Achebe's choice of quotation from T. S. Eliot.

Excerpt from "The Journey of the Magi" in *Collected Poems 1909–1962* by T. S. Eliot, copyright 1936 by Harcourt, Inc., copyright © 1964, 1963 by T. S. Eliot, reprinted by permission of the publisher and Faber & Faber, Ltd.

For three or four weeks Obi Okonkwo had been steeling himself against this moment. And when he walked into the dock that morning he thought he was fully prepared. He wore a smart palm-beach suit and appeared unruffled and indifferent. The proceeding seemed to be of little interest to him. Except for one brief moment at the very beginning when one of the counsel had got in to trouble with the judge.

"This court begins at nine o'clock. Why are you late?"

Whenever Mr. Justice William Galloway, Judge of the High Court of Lagos and the Southern Cameroons, looked at a victim he fixed him with his gaze as a collector fixes his insect with formalin. He lowered his head like a charging ram and looked over his gold-rimmed spectacles at the lawyer.

"I am sorry, Your Honor," the man stammered. "My car broke down on the way."

The judge continued to look at him for a long time. Then he said very abruptly:

"All right, Mr. Adeyemi. I accept your excuse. But I must say I'm getting sick and tired of these constant excuses about the problems of locomotion."

There was suppressed laughter at the bar. Obi Okonkwo smiled a wan and ashy smile and lost interest again.

Every available space in the courtroom was taken up. There were almost as many people standing as sitting. The case had been the talk of Lagos for a number of weeks and on this last day anyone who could possibly leave his job was there to hear the judgment. Some civil servants paid as much as ten shillings and sixpence to obtain a doctor's certificate of illness for the day.

Obi's listlessness did not show any signs of decreasing even when the judge began to sum up. It was only when he said: "I cannot comprehend how a young man of your education and brilliant promise could have done this" that a sudden and marked change occurred. Treacherous tears came into Obi's eyes. He brought out a white handkerchief and rubbed his face. But he did it as people do when they wipe sweat. He even tried to smile and belie the tears. A smile would have been quite logical. All that stuff about education and promise and betrayal had not taken him unawares. He had expected it and rehearsed this very scene a hundred times until it had become as familiar as a friend.

In fact, some weeks ago when the trial first began, Mr. Green, his boss, who was one of the Crown witnesses, had also said something about a young man of great promise. And Obi had remained completely unmoved. Mercifully he had recently lost his mother, and Clara had gone out of his life. The two events following closely on each other had dulled his sensibility and left him a different man, able to look words like *education* and *promise* squarely in the face. But now when the supreme moment came he was betrayed by treacherous tears.

Mr. Green had been playing tennis since five o'clock. It was most unusual. As a rule his work took up so much of his time that he rarely played. His normal exercise was a short walk in the evenings. But today he had played with a friend who worked for the British Council. After the game they retired to the club bar. Mr. Green had a light-yellow sweater over his white shirt, and a white towel hung from his neck. There were many other Europeans in the bar, some half-sitting on the high stools and some standing in groups of twos and threes drinking cold beer, orange squash or gin and tonic.

"I cannot understand why he did it," said the British Council man thoughtfully. He was drawing lines of water with his finger on the back of his mist-covered glass of ice-cold beer.

"I can," said Mr. Green simply. "What I can't understand is why people like you refuse to face facts." Mr. Green was famous for speaking his mind. He wiped his red face with the white towel on his neck. "The African is corrupt through and through." The British Council man looked about him furtively, more from instinct than necessity, for although the club was now open to them technically, few Africans went to it. On this particular occasion there was none, except of course the stewards who served unobtrusively. It was quite

possible to go in, drink, sign a check, talk to friends and leave again without noticing these stewards in their white uniforms. If everything went right you did not see them.

"They are all corrupt," repeated Mr. Green. "I'm all for equality and all that. I for one would hate to live in South Africa. But equality won't alter facts."

"What facts?" asked the British Council man, who was relatively new to the country. There was a lull in the general conversation, as many people were now listening to Mr. Green without appearing to do so.

"The fact that over countless centuries the African has been the victim of the worst climate in the world and of every imaginable disease. Hardly his fault. But he has been sapped mentally and physically. We have brought him Western education. But what use is it to him? He is . . ." He was interrupted by the arrival of another friend.

"Hello, Peter. Hello, Bill."

"Hello."

"Hello."

"May I join you?"

"Certainly."

"Most certainly. What are you drinking? Beer? Right. Steward. One beef for this master."

"What kind, sir?"

"Heineken."

"Yes, sir."

"We were talking about this young man who took a bribe."

"Oh, yes."

Somewhere on the Lagos mainland the Umuofia Progressive Union was holding an emergency meeting. Umuofia is an Ibo village in Eastern Nigeria and the hometown of Obi Okonkwo. It is not a particularly big village, but its inhabitants call it a town. They are very proud of its past when it was the terror of their neighbors, before the white man came and leveled everybody down. Those Umuofians (that is the name they call themselves) who leave their home town to find work in towns all over Nigeria regard themselves as sojourners. They return to Umuofia every two years or so to spend their leave. When they have saved up enough money they ask their relations at home to find them a wife, or they build a "zinc" house on their family land. No matter where they are in Nigeria, they start a local branch of the Umuofia Progressive Union.

In recent weeks the Union had met several times over Obi Okonkwo's case. At the first meeting, a handful of people had expressed the view that there was no reason why the Union should worry itself over the troubles of a prodigal son who had shown great disrespect to it only a little while ago.

"We paid eight hundred pounds to train him in England," said one of them. "But instead of being grateful he insults us because of a useless girl. And now we are being called together again to find more money for him. What does he do with his big salary? My own opinion is that we have already done too much for him."

This view, although accepted as largely true, was not taken very seriously. For, as the President pointed out, a kinsman in trouble had to be saved, not blamed; anger against a brother was felt in the flesh, not in the bone. And so the Union decided to pay for the services of a lawyer from their funds.

But this morning the case was lost. That was why another emergency meeting had been convened. Many people had already arrived at the house of the President on Moloney Street, and were talking excitedly about the judgment.

"I knew it was a bad case," said the man who had opposed the Union's intervention from the start. "We are just throwing money away. What do our people say? He that fights a ne'er-do-well has nothing to show for it except a head covered in earth and grime."

But this man had no following. The men of Umuofia were prepared to fight to the last. They had no illusions about Obi. He was, without doubt, a very foolish and self-willed young man. But this was not the time to go into that. The fox must be chased away first, after that the hen might be warned against wandering into the bush.

When the time for warning came the men of Umuofia could be trusted to give it in full measure, pressed down and flowing over. The President said it was a thing of shame for a man in the senior service to go to prison for twenty pounds. He repeated twenty pounds, spitting it out: "I am against people reaping where they have not sown. But we have a saying that if you want to eat a toad you should look for a fat and juicy one."

"It is all lack of experience," said another man. "He should not have accepted the money himself. What others do is tell you to go and hand it to their houseboy. Obi tried to do what everyone does without finding out how it was done." He told the proverb of the house rat who went swimming with his friend the lizard and died from cold, for while the lizard's scales kept him dry the rat's hairy body remained wet.

The President, in due course, looked at his pocket watch and announced that it was time to declare the meeting open. Everybody stood up and he said a short prayer. Then he presented three kola nuts to the meeting. The oldest man present broke one of them, saying another kind of prayer while he did it. "He that brings kola nuts brings life," he said. "We do not seek to hurt any man, but if any man seeks to hurt us may he break his neck." The congregation answered *Amen.* "We are strangers in this land. If good comes to it may we have our share." *Amen.* "But if bad comes let it go to the owners of the land who know what gods should be appeased." *Amen.* "Many towns have four or five or even ten of their sons in European posts in this city. Umuofia has only one. And now our enemies say that even that one is too many for us. But our ancestors will not agree to such a thing." *Amen.* "An only palm fruit does not get lost in the fire." *Amen.*

Obi Okonkwo was indeed an only palm-fruit. His full name was Obiajulu—"the mind at last is at rest"; the mind being his father's of course, who his wife having borne him four daughters before Obi, was naturally becoming a little anxious. Being a Christian convert—in fact a catechist—he could not marry a second wife. But he was not the kind of man who carried his sorrow on his face. In particular, he would not let the heathen know that he was unhappy. He had called his fourth daughter Nwanyidinma—"a girl is also good." But his voice did not carry conviction.

The old man who broke the kola nuts in Lagos and called Obi Okonkwo an only palm-fruit was not, however, thinking of Okonkwo's family. He was thinking of the ancient and warlike village of Umuofia. Six or seven years ago Umuofians abroad had formed their Union with the aim of collecting money to send some of their brighter young men to study in England. They taxed themselves mercilessly. The first scholarship under this scheme was awarded to Obi Okonkwo five years ago, almost to the day. Although they called it a scholarship it was to be repaid. In Obi's case it was worth eight hundred pounds, to be repaid within four years of his return. They wanted him to read law so that when he returned he would handle all their land cases against their neighbors. But when he got to England he read English, his self-will was not new. The Union was angry but in the end they left him alone. Although he would not be a lawyer, he would get a "European post" in the civil service.

The selection of the first candidate had not presented any difficulty to the Union. Obi was an obvious choice. At the

age of twelve or thirteen he had passed his Standard Six examination at the top of the whole province. Then he had won a scholarship to one of the best secondary schools in Eastern Nigeria. At the end of five years he passed the Cambridge School Certificate with distinction in all eight subjects. He was in fact a village celebrity, and his name was regularly invoked at the mission school where he had once been a pupil. (No one mentioned nowadays that he once brought shame to the school by writing a letter to Adolf Hitler during the war. The headmaster at the time had pointed out, almost in tears, that he was a disgrace to the British Empire, and that if he had been older he would surely have been sent to jail for the rest of his miserable life. He was only eleven then, and so got off with six strokes of the cane on his buttocks.)

Obi's going to England caused a big stir in Umuofia. A few days before his departure to Lagos his parents called a prayer meeting at their home. The Reverend Samuel Ikedi of St. Mark's Anglican Church, Umuofia, was chairman. He said the occasion was the fulfillment of the prophecy:

The people which sat in darkness
Saw a great light,
And to them which sat in the region and shadow of death
To them did light spring up.

He spoke for over half an hour. Then he asked that someone should lead them in prayer. Mary at once took up the challenge before most people had had time to stand up, let alone shut their eyes. Mary was one of the most zealous Christians in Umuofia and a good friend of Obi's mother, Hannah Okonkwo. Although Mary lived a long way from the church—three miles or more—she never missed the early morning prayer which the pastor conducted at cockcrow. In the heart of the wet season, or the cold harmattan, Mary was sure to be there. Sometimes she came as much as an hour before time. She would blow out her hurricane lamp to save kerosene and go to sleep on the long mud seats.

"Oh, God of Abraham, God of Isaac and God of Jacob," she burst forth, "the Beginning and the End. Without you we can do nothing. The great river is not big enough for you to wash your hands in. You have the yam and you have the knife; we cannot eat unless you cut us a piece. We are like ants in your sight. We are like little children who only wash their stomach when they bathe, leaving their back dry . . ." She went on and on reeling off proverb after proverb and painting picture after picture. Finally, she got round to the subject of the gathering and dealt with it as fully as it deserved, giving among other things, the life history of her friend's son who was about to go to the place where learning finally came to an end. When she was done, people blinked and rubbed their eyes to get used to the evening light once more.

They sat on long wooden forms which had been borrowed from the school. The chairman had a little table before him. On one side sat Obi in his school blazer and white trousers.

Two stalwarts emerged from the kitchen area, half bent with the gigantic iron pot of rice which they carried between them. Another pot followed. Two young women then brought in a simmering pot of stew hot from the fire. Kegs of palm wine followed, and a pile of plates and spoons which the church stocked for the use of its members at marriages, births, deaths, and other occasions such as this.

Mr. Isaac Okonkwo made a short speech placing "this small kola" before his guests. By Umuofia standards he was well-to-do. He had been a catechist of the Church Missionary Society for twenty-five years and then retired on a pension of twenty-five pounds a year. He had been the very first man to build a "zinc" house in Umuofia. It was therefore not unexpected that he would prepare a feast. But no one had imagined anything on this scale, not even from Okonkwo,

who was famous for his openhandedness which sometimes bordered on improvidence. Whenever his wife remonstrated against his thriftlessness he replied that a man who lived on the banks of the Niger should not wash his hands with spittle—a favorite saying of his father's. It was odd that he should have rejected everything about his father except this one proverb. Perhaps he had long forgotten that his father often used it.

At the end of the feast the pastor made another long speech. He thanked Okonkwo for giving them a feast greater than many a wedding feast these days.

Mr. Ikedi had come to Umuofia from a township, and was able to tell the gathering how wedding feasts had been steadily declining in the towns since the invention of invitation cards. Many of his hearers whistled in unbelief when he told them that a man could not go to his neighbor's wedding unless he was given one of these papers on which they wrote R.S.V.P.—Rice and Stew Very Plenty—which was invariably an overstatement.

Then he turned to the young man on his right. "In times past," he told him, "Umuofia would have required of you to fight in her wars and bring home human heads. But those were days of darkness from which we have been delivered by the blood of the Lamb of God. Today we send you to bring knowledge. Remember that the fear of the Lord is the beginning of wisdom. I have heard of young men from other towns who went to the white man's country, but instead of facing their studies they went after the sweet things of the flesh. Some of them even married white women." The crowd murmured its strong disapproval of such behavior. "A man who does that is lost to his people. He is like rain wasted in the forest. I would have suggested getting you a wife before you leave. But the time is too short now. Anyway, I know that we have no fear where you are concerned. We are sending you to learn book. Enjoyment can wait. Do not be in a hurry to rush into the pleasures of the world like the young antelope who danced herself lame when the main dance was yet to come."

He thanked Okonkwo again, and the guests for answering his call. "If you had not answered his call, our brother would have become like the king in the Holy Book who called a wedding feast."

As soon as he had finished speaking, Mary raised a song which the women had learnt at their prayer meeting.

Leave me not behind Jesus, wait for me
When I am going to the farm.
Leave me not behind Jesus, wait for me
When I am going to the market.
Leave me not behind Jesus, wait for me
When I am eating my food.
Leave me not behind Jesus, wait for me
When I am having my bath.
Leave me not behind Jesus, wait for me
When he is going to the White Man's Country.
Leave him not behind Jesus, wait for him.

The gathering ended with the singing of "Praise God from whom all blessings flow." The guests then said their farewells to Obi, many of them repeating all the advice that he had already been given. They shook hands with him and as they did so they pressed their presents into his palm, to buy a pencil with, or an exercise book or a loaf of bread for the journey, a shilling there and a penny there—substantial presents in a village where money was so rare, where men and women toiled from year to year, to wrest a meager living from an unwilling and exhausted soil.

From *No Longer at Ease* by Chinua Achebe, pp. 1–13. Reprinted by permission of Harcourt Education.

GENERAL EVENTS	LITERATURE & PHILOSOPHY	ART

EDWARDIAN AGE IN ENGLAND

1901

1900–1905 Einstein researches the theory of relativity

1900–1905 Freud formulates basic ideas of psychoanalysis; *The Interpretation of Dreams* (1900)

1907 African sculpture fascinates artists in Paris: Picasso, *Les Demoiselles d'Avignon;* Retrospective of Cézanne's work in Paris; Picasso and Braque begin cubist experiments: Braque, *Violin and Palette* (1909–1910); Picasso, *Daniel-Henry Kahnweiler* (1910)

1908–1915 Marinetti publishes futurist manifestos

1909–1915 Italian futurists glorify technological progress

1910

THE CALM AND THE "GREAT WAR"

1910 Death of Edward VII of England

1910 Death of Tolstoy

1910 Roger Fry's First Post-Impressionist Exhibition scandalizes London; Kandinsky, *Concerning the Spiritual in Art*

1910–1941 British Bloomsbury Group around Virginia and Leonard Woolf rejects Edwardian mentality

c. 1911 German expressionism flourishes

1912–1914 Mondrian in Paris influenced by cubists; *Color Planes in Oval* (1913–1914)

1913 Carl Jung breaks with Freud

1913 New York Armory Show brings avant-garde art to attention of American public

1914 World War I begins; European colonialism wanes

1915 End of futurist movement; Severini, *Armored Train in Action*

1915–1916 Dada movement founded Café Voltaire in Zurich; Dada manifesto by Tristan Tzara (1918)

1915–1916 Dada artists begin assault on traditional concepts of art; Duchamp, *L.H.O.O.Q.* (1919)

1917 Cocteau, scenario for ballet *Parade;* Wilfred Owen, "Dulce et Decorum Est;" Leonard Woolf begins Hogarth Press

1917 Picasso designs *Parade* set

1917 Bolshevik Revolution ends tsarist rule in Russia

1918

BETWEEN THE WORLD WARS

1918 World War I ends; women granted right to vote in Great Britain

1919 Yeats, "The Second Coming"

1921 Picasso, *Three Musicians*

1921–1931 Klee teaches at Bauhaus; Kandinsky appointed professor in 1922

1920 Women granted right to vote in United States

1922 Alienation and cultural despair themes in postwar literature: T. S. Eliot, *The Waste Land;* Joyce, *Ulysses.* Sinclair Lewis satirizes American middle class in *Babbitt*

1922 Fascists come to power in Italy after Mussolini's march on Rome

1923–1924 Chagall, *The Green Violinist*

1924 Surrealism begins; Buñuel and Dalí collaborate on films *Un Chien Andalou* (1929), *L'Âge d'Or* (1930)

1927 Lindbergh's solo flight across Atlantic

1924 Freudian theory and dadaism foster surrealism; Breton, *First Surrealist Manifesto;* Freudian themes appear in American drama; O'Neill, *Desire Under the Elms* (1924)

1928 First sound movie produced

1925 Eisenstein completes influential film *Potemkin*

1929 Great Depression begins in Europe and America

c. 1925 Black cultural regeneration, "Harlem Renaissance," in Northern U.S. cities

1926 Kandinsky, *Several Circles, No. 323;* Klee, *Around the Fish*

1933 Nazis come to power in Germany under Hitler; first refugees leave country

1925 Eliot, *The Hollow Men;* Kafka, *The Trial*

1927 Rouault, *This will be the last time, little Father!* (*Miserere* series)

1926 Kafka, *The Castle*

1928 Magritte, *Man with a Newspaper*

1936–1939 Spanish Civil War; Guernica bombed (1937)

1929 V. Woolf, *A Room of One's Own*

1930 Cocteau film, *Blood of a Poet*

1930 Freud, *Civilization and Its Discontents*

1931 Dalí, *The Persistence of Memory*

1932 Huxley warns against unrestrained growth of technology in *Brave New World*

1934 Douglas, *Aspects of Negro Life*

1939 Germany invades Poland; World War II begins

1935 Evans, *Share Cropper's Family*

1937 Picasso, *Guernica*

1939

WORLD WAR II

1939 First commercial TV

1939 Death of Freud; Auden, *In Memory of Sigmund Freud*

1937 Kahlo, *Self-Portrait Dedicated to Leon Trotsky*

1941 United States enters war

1939 Tamayo, *Women of Tehuantepec*

1945

1945 World War II ends

1945 Orwell, *Animal Farm*

1949 Orwell, *1984*

1944–1946 Eisenstein, *Ivan the Terrible,* Parts I and II

Most dates are approximate

ARCHITECTURE	MUSIC

c. 1900 Jazz originates among Black musicians of New Orleans

1903 First recording of Joplin's *Maple Street Rag*

1909 Wright, Robie House, Chicago

c. 1910 Peak and decline of ragtime music; jazz becomes fully developed

1911 Piano rag composer Scott Joplin completes opera *Treemonisha*

1913 Stravinsky's *The Rite of Spring* first performed in Paris

1917 Satie composes score for ballet *Parade*

Avant-garde composers come under influence of jazz and ragtime: Stravinsky, *L'Histoire du Soldat* (1918), Hindemith, *Klaviersuite* (1922)

1916 Death of futurist architect Antonio Sant'Elia in World War I

1919 Bauhaus design school founded at Weimar; Bauhaus ideas find wide acclaim in architecture and many industrial fields

1919–1920 Russian constructivist sculptor and visionary architect Tatlin builds model for *Monument to the Third International*

c. 1920 Chicago becomes jazz center; in New York's Harlem, Cotton Club provides showcase for jazz performers

1920s Josephine Baker and other American performers bring jazz and blues to Paris

1923 Schoenberg perfects twelve-tone technique (serialism)

1924 Gershwin, *Rhapsody in Blue*

1926 Gershwin, *Concerto in F Major* for piano

1928 First recording of Armstrong's *West End Blues*

1930 Weill, *The Threepenny Opera*, text by Bertolt Brecht

1935–1940 WPA photographers active

1936 Riefenstahl, *Triumph of the Will*, film glorifying Nazis

1937 Picasso paints *Guernica* in protest against war; Dalí uses Freudian symbolism in *Inventions of the Monsters*

1938 Eisenstein film *Alexander Nevsky*, score by Prokofiev; Riefenstahl, *Olympia*

late 1930s Bauhaus architects Gropius and van der Rohe flee Nazi Germany for United States

1935 Gershwin's *Porgy and Bess*, first widely successful American opera

1943 Duke Ellington's symphonic suite *Black, Brown, and Beige* premieres at Carnegie Hall

1945 Stravinsky, *Symphony in Three Movements*

CHAPTER 21

BETWEEN THE WORLD WARS

THE GREAT WAR (WORLD WAR I) AND ITS SIGNIFICANCE

The armed conflict that raged throughout Europe from 1914 until 1918 put to rest forever the notion that war was a heroic rite of passage conferring nobility and glory. The use of technology—especially poison gas, tanks, and planes—made possible slaughter on a scale hitherto only imagined by storytellers. The sheer numbers of soldiers killed in the major battles of World War I continue to stagger the imagination. By the end of the war the Germans had lost three and a half million men and the Allies five million.

The sociopolitical consequences of the Great War were monumental. The geopolitical face of Europe was considerably altered. The October Revolution of 1917 led by V. I. Lenin toppled the tsarist regime and produced a communist government in Russia; it was a direct result of Russia's humiliation in the war. The punitive attitude of the Allies and the stricken state of Germany's postwar economy provided the seedbed from which Hitler's National Socialist movement (Nazism) sprang. Postwar turmoil led to Mussolini's ascendancy in Italy. England had lost many of its best young men in the war; those who survived leaned toward either frivolity or pacifism.

Culturally, World War I sounded the death knell for the world of settled values. The battle carnage and the senseless destruction—in no small part the result of callous and incompetent military leadership—made a mockery of patriotic slogans, appeals to class, and the metaphysical unity of nations. One result of this disillusionment was a spirit of frivolity, but another was bitterness and cynicism about anything connected with military glory. A whole school of poets, many of whom did not survive the war, vented their hatred and disgust with this first modern war. English poets like Rupert Brooke (1887–1915) and Wilfred Owen (1893–1918) both died in the war, but not before penning powerful poems about the stupidity, the carnage, and the waste of the battles.

The political upheavals and cultural tremors of the immediate postwar period coincided with a technological revolution in transportation and communications. After World War I, radio came into its own. It is difficult to comprehend what this information linkup meant for people who were previously isolated by lack of access to the larger world of information and culture. Similarly, the mass production of the automobile, made possible by the assembly-line techniques of Henry Ford in the United States, provided mobility to many who a generation before were confined to an urban neighborhood or a rural village. The widespread popularity of the cinema gave new forms of entertainment and instruction to those who were already accustomed to the voices of the radio coming into their homes each evening.

LITERARY MODERNISM

At the end of World War I, the Irish poet William Butler Yeats (1865–1939), profoundly moved by unrest in his own country (particularly the Easter Rebellion of 1916) and the rising militarism on the Continent, wrote one of the most extraordinarily beautiful and prophetic poems of modern times, "The Second Coming." The title of the poem is deeply ironic because it refers not to the glorious promised return of the Savior but to an event the poet only hints at in an ominous manner. A line from that poem with its prescient look into the future is as strikingly relevant for our times as it was for Yeats:

> Things fall apart; the centre cannot hold;
> Mere anarchy is loosed upon the world,
> The blood-dimmed tide is loosed, and everywhere
> The ceremony of innocence is drowned;

The best lack all conviction, while the worst
Are full of passionate intensity.

Source: Reprinted with permission of Scribner, a division of Simon & Schuster Adult Publishing Group, from *The Collected Poems of W. B. Yeats, Volume 1, The Poems,* Revised, edited by Richard J. Finneran. Copyright © 1924 by Macmillan Publishing Company, copyright renewed © 1952 by Bertha Georgie Yeats.

T. S. Eliot and James Joyce

The year 1922 was a turning point for literary modernism. In that year T. S. Eliot (1888–1965), an **expatriate** American living in England, published his poem *The Waste Land* and James Joyce (1882–1941), an expatriate Irish writer living on the Continent, published his novel *Ulysses*. In their respective works, Eliot and Joyce reflect some of the primary characteristics of what is called the *modernist temper* in literature. There is fragmentation of line and image, the abandonment of traditional forms, an overwhelming sense of alienation and human homelessness (both authors were self-imposed exiles), an ambivalence about the traditional culture, an intense desire to find some anchor in a past that seems to be escaping, a blurring of the distinction between reality "out there" and the world of subjective experience, and, finally, a straining and pushing of language to provide new meanings for a world they see as exhausted.

Both Eliot and Joyce reflect the conviction that, in Yeats's phrase, "the centre cannot hold." For Joyce, only art would give people a new worldview that would provide meaning. Eliot felt that if culture was to survive, one had to recover a sense of cultural continuity through a linkage of the artistic and religious tradition of the past. That perceived need for past cultural links helps explain why Eliot's poems are filled with allusions to works of art and literature as well as fragments from Christian rituals.

The gradual shift from cultural despair in *The Waste Land* can be traced in Eliot's later poems beginning with "The Hollow Men" (1925) and "Ash Wednesday" (1930) and culminating in *Four Quartets,* which were completed in the early forties. The *Quartets* were Eliot's mature affirmation of his Christian faith as a bulwark against the ravages of modernist culture. To read *The Waste Land* and the *Four Quartets* in tandem is to see one way in which a sensitive mind moved from chaos to stability in the period between the wars.

Before World War I, Joyce had already published his collection of short stories under the title *Dubliners* (1912) and his *Portrait of the Artist as a Young Man* (1916). The former was a series of linked short stories in which persons come to some spiritual insight (which Joyce called an **epiphany**), while the latter was a thinly disguised autobiographical memoir of his own youth before he left for the Continent in self-imposed exile

after his graduation from college. With the 1922 publication of *Ulysses,* Joyce was recognized as a powerful innovator in literature. In 1939, two years before his death, Joyce published the dauntingly difficult *Finnegans Wake.* Joyce once said that *Ulysses* was a book of the day (it takes place in one day) while *Finnegans Wake* was a haunting dream book of the night.

Joyce's blend of myth and personal story, his many-layered puns and linguistic allusions, his fascination with stream of consciousness, his sense of the artist alienated from his roots, and his credo of the artist as maker of the world have all made him one of the watershed influences on literature in the twentieth century.

Franz Kafka

Perhaps the quintessential modernist in literature is the Czech writer Franz Kafka (1883–1924). A German-speaking Jew born and raised in Prague, Kafka was by heritage alienated from both the majority language of his city and its predominant religion. An obscure clerk for a major insurance company in Prague, he published virtually nothing during his lifetime. He ordered that his works be destroyed after his death, but a friend did not accede to his wish. What we have from Kafka's pen is so unique that it has contributed the adjective *Kafkaesque* to our language. A Kafkaesque experience is one in which a person feels trapped by forces that seem simultaneously ridiculous, threatening, incomprehensible, and dangerous.

This is precisely the tone of Kafka's fiction. In Kafka's *The Trial* (1925), Joseph K. (note the near-anonymity of the name) is arrested for a crime that is never named by a court authority that is not part of the usual system of justice. At the end of the novel, the hero (if he can be called that) is executed in a vacant lot by two seedy functionaries of the court. In *The Castle* (1926), a land surveyor known merely as K., hired by the lord of a castle overlooking a remote village, attempts in vain to approach the castle, to communicate with its lord, to learn of his duties. In time, he would be satisfied just to know if there actually is a lord who has hired him.

No critic has successfully uncovered the meaning of these novels—if in fact they should be called novels. Kafka's work might better be called extended parables that suggest, but do not explicate, a terrible sense of human guilt, a feeling of loss, and an air of oppression and muted violence.

Virginia Woolf

Virginia Woolf (1882–1941) is one of the most important writers in the period of literary modernism. Novels like *Mrs. Dalloway* (1925), *To the Lighthouse* (1927), and *The Waves* (1931) have been justly praised for their keen

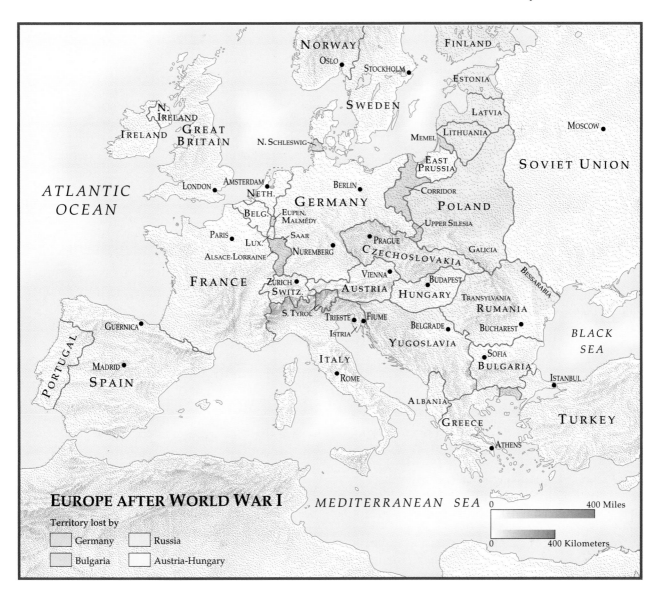

NORWAY
OSLO
STOCKHOLM
FINLAND
ESTONIA
SWEDEN
LATVIA
N. IRELAND
GREAT BRITAIN
IRELAND
N. SCHLESWIG
MEMEL
LITHUANIA
MOSCOW
SOVIET UNION
ATLANTIC OCEAN
LONDON
AMSTERDAM
NETH.
BERLIN
EAST PRUSSIA
CORRIDOR
POLAND
BELG.
GERMANY
EUPEN, MALMÉDY
UPPER SILESIA
PARIS
LUX.
SAAR
ALSACE-LORRAINE
NUREMBERG
PRAGUE
CZECHOSLOVAKIA
GALICIA
FRANCE
ZURICH
SWITZ.
VIENNA
BUDAPEST
BESSARABIA
AUSTRIA
HUNGARY
TRANSYLVANIA
RUMANIA
S. TYROL
TRIESTE
FIUME
ISTRIA
BELGRADE
BUCHAREST
BLACK SEA
GUERNICA
YUGOSLAVIA
SOFIA
BULGARIA
ISTANBUL
PORTUGAL
MADRID
SPAIN
ITALY
ROME
ALBANIA
GREECE
TURKEY
ATHENS

EUROPE AFTER WORLD WAR I

MEDITERRANEAN SEA

0 400 Miles

0 400 Kilometers

Territory lost by
- Germany
- Russia
- Bulgaria
- Austria-Hungary

sense of narrative, sophisticated awareness of time shifts, and profound feeling for the textures of modern life.

Woolf's reputation would be secure if she had only been known for her novels, but she was also an accomplished critic, a founder (with her husband Leonard Woolf) of the esteemed Hogarth Press, and a member of an intellectual circle in London known as the Bloomsbury Group. That informal circle of friends was at the cutting edge of some of the most important cultural activities of the period. Lytton Strachey, the biographer, was a member, as was John Maynard Keynes, the influential economist. The group also included the art critics Roger Fry and Clive Bell, who championed the new art coming from France. The Bloomsbury Group also had close contacts with mathematician-philosopher Bertrand Russell and poet T. S. Eliot.

Two small books, written by Woolf as polemical pieces, are of special contemporary interest. *A Room of One's Own* (1929) and *Three Guineas* (1938) were passionate but keenly argued polemics against the discrimination of women in public intellectual life. Woolf argued that English letters had failed to provide the world with a tradition of great women writers not because women lacked talent but because social structures never provided them with a room of their own; that is, the social and economic aid to be free to write and think or the encouragement to find outlets for their work. Woolf, a brilliant and intellectually restless woman, passionately resented the kind of society that had barred her from full access to English university life and entry to the professions. Her books were early salvos in the coming battle for women's rights. Woolf is rightly seen as one of the keenest thinkers of the modern feminist movement whose authority was enhanced by the position she held as a world-class writer and critic.

VOICES OF THEIR TIMES

Virginia Woolf

Then Joyce is dead: Joyce about a fortnight younger than I am. I remember Miss Weaver, in wool gloves, bringing Ulysses in typescript to our teatable at Hogarth House . . . One day Catherine [sic] Mansfield came, and I had it out. She began to read, ridiculing: then suddenly said: But there's something in this: a scene that should figure I suppose in the history of literature . . . Then I remember Tom [T. S. Eliot] saying: how could anyone write again after the immense prodigy of that last chapter?

We were in London on Monday. I went to London Bridge. I looked at the river; very misty; some tufts of smoke, perhaps from burning houses. There was another fire on Saturday. Then I saw a cliff of wall, eaten out, at one corner; a great corner all smashed: a bank; the monument erect; tried to get a bus; but such a block I dismounted; and the second bus advised me to walk. A complete jam of traffic; for streets were being blown up. So by Tube to the Temple; and there wandered in the desolate ruins of my old squares: gashed, dismantled; the old red bricks all white powder, something like a builder's yard. Grey dirt and broken windows. Sightseers; all that completeness ravished and demolished.

An abridged entry in Virginia Woolf's diary for January 15, 1941, describing the results of the German bombing of London. Shortly after writing this entry Virginia Woolf committed suicide.

THE REVOLUTION IN ART: CUBISM

Between 1908 and 1914, two young artists—Frenchman Georges Braque (1882–1963) and expatriate Spaniard Pablo Ruiz Picasso (1881–1973)—began a series of artistic experiments in Paris that revolutionized the direction of Western painting. For nearly five hundred years, painting in the West had attempted a reconstruction on canvas of a real or ideal world "out there" by the use of three-dimensional perspective and the rules of geometry. This artistic tradition, rooted in the ideas of the Italian Renaissance, created the expectation that when one looked at a painting one would see the immediate figures more clearly and proportionally larger while the background figures and the background in general would be smaller and less clearly defined. After all, it was reasoned, that is how the eye sees the real world. Braque and Picasso challenged that view as radically as Einstein, a decade before, had challenged all of the Classical assumptions we had made about the physical world around us.

To Braque and Picasso, paint on an essentially two-dimensional and flat canvas represented a challenge: How could one be faithful to a medium that by its very nature was not three-dimensional while still portraying objects that by their very nature *are* three-dimensional? Part of their answer came from a study of Paul Cézanne's many paintings of Mont Sainte-Victoire executed the century before. Cézanne saw and emphasized the geometric characteristics of nature; his representations of the mountain broke it down into a series of geometrical planes. With the example of Cézanne and their own native genius,

Braque and Picasso began a series of paintings to put this new way of "seeing" into practice. These experiments in painting began an era called *analytical Cubism* because the artists were most concerned with exploring the geometric qualities of objects seen without reference to linear perspective.

Picasso's *Les Demoiselles d'Avignon* [**FIG. 21.1**], painted in 1907, is regarded as a landmark of twentieth-century painting. Using the traditional motif of a group of bathers (the title of the painting is a sly joke; it alludes to a brothel on Avignon Street in Barcelona), Picasso moves from poses that echo Classical sculpture on the left to increasingly fragmented and distorted figures on the right. His acquaintance with African art prompted him to repaint the faces that same year to reflect his delight with the highly angular and "primitive" African masks he had seen at a Paris exhibition. The importance of this work rests in its violently defiant move away from both the Classical perspective of Renaissance art and the experiments of Cézanne in the preceding century. It heralds the Cubism with which both Picasso and Braque became identified the following year.

A look at representative paintings by Braque and Picasso will help clarify the aim of the Cubists. In *Violin and Palette* [**FIG. 21.2**], Braque depicts a violin so that the viewer sees at once the front, the sides, and the bottom of the instrument while they appear simultaneously on a single flat plane. The ordinary depth of the violin has disappeared. The violin is recognizable, but the older notion of the violin as appearing "real" has been replaced by the artist's vision of the violin as a problem to be solved according to his vision and through his analysis.

■ **21.1** Pablo Picasso. *Les Demoiselles d'Avignon,* Paris (begun May, reworked July 1907). Oil on canvas, 8′ × 7′8″ (243.9 × 233.7 cm). Collection, The Museum of Modern Art, New York (acquired through the Lillie P. Bliss Bequest). Note the increasing distortion of the faces as one's eyes move from left to right.

In Picasso's portrait of Daniel-Henry Kahnweiler [**Fig. 21.3**], the entire picture plane has become a geometric grid in which the traditional portrait form has been broken into separate cubelike shapes and scattered without reference to traditional proportion. The viewer must reconstruct the portrait from the various positions on the cubist grid. Within the picture one detects here a face, there a clasped hand, and a table

with a bottle on it. The intense preoccupation with line and form in this work can be noted by a close examination of the tiled surface facets that provide the painting with its artistic unity.

In the postwar period, the impact of Cubism on the artistic imagination was profound and widespread. Picasso moved away from the technically refined yet somewhat abstractly intellectual style of analytic Cubism

■ **21.2** Georges Braque. *Violin and Palette*, 1909–1910. Oil on canvas, 36⅛″ × 16⅛″ (92 × 43 cm). Guggenheim Museum, The Solomon R. Guggenheim Foundation, New York (PN 54.1412). The Cubist strategy of breaking up planes can be seen clearly by visually attempting to reconstruct the normal shape of the violin.

■ **21.3** Pablo Picasso. *Daniel-Henry Kahnweiler*, 1910. Oil on canvas, 39⅜″ × 28⅝″ (100.6 × 72.8 cm). Art Institute of Chicago (Gift of Mrs. Gilbert W. Chapman in memory of Charles B. Goodspeed, 1948.561). Note the intensely two-dimensional plane of the painting.

to what has been called *synthetic Cubism*. In *Three Musicians* [**FIG. 21.4**], he still employs the flat planes and two-dimensional **linearity** of Cubism, as the geometric masks of the three figures and the way they are lined up clearly show, but their color, vivacity, playfulness, and expressiveness somehow make us forget that they are worked out in terms of geometry. These post-war paintings seem more humane, alive, and less intellectually abstract.

The visual revolution of Cubism stimulated other artists to use the Cubist insight in a variety of ways. Only a close historical analysis could chart the many ways in which Cubism made its mark on subsequent art, but a sampling shows both the richness and diversity of art in the West after the Great War. The Dutch painter Piet Mondrian (1872–1944), after visits to Paris where he saw Cubist work, abandoned his earlier naturalistic works for paintings like *Color Planes in Oval* [**FIG. 21.5**], a work whose main focus is on line and square highlighted by color.

The influence of Cubism was not confined to a desire for simplified line and color, even though such a trend has continued to the present in *Minimalist* and Hardedge art. The *Green Violinist* [**FIG. 21.6**] by Marc Chagall (1889–1985) combines Cubist touches (in the figure of the violinist) with the artist's penchant for dreamy scenes evoking memories of Jewish village life in Eastern Europe. The extraordinary Mexican painter Rufino Tamayo (1899–1991), who deeply understood

▪ **21.4** Pablo Picasso. *Three Musicians.* Fontainebleau, summer 1921. Oil on canvas, 6'7″ × 7'3¾″ (2.7 × 2.23 m). Collection, The Museum of Modern Art, New York (Gift of Mrs. Simon Guggenheim Fund). Another, more decorative, version of this painting done in the same year hangs in The Philadelphia Museum of Art.

his own culture, came under Cubist influence during his long career. His brilliant *Women of Tehuantepec* [**FIG. 21.7**] reflected a subtle Cubist composition in its layered background while reflecting the lush colors of the baskets and fruits that frame the two Indian women who stand stocially slightly off center.

Although Cubism was the most radical departure in modern art, it was not the only major art trend that overarched the period of the Great War. German painters continued to paint works in the Expressionist style of the early years of the century. Perhaps the most accomplished exponent of Expressionism was Wassily Kandinsky (1866–1944), who was also one of the few

painters of his time who attempted to state his theories of art in writing. Kandinsky's *Concerning the Spiritual in Art* (1910) argued his conviction that the inner, mystical core of a human being is the truest source of great art. That attitude, together with Kandinsky's conviction that the physical sciences were undermining confidence in the solidity of the world as we see it, led him closer to color abstraction and further away from any form of representation. By 1926, Kandinsky was attempting to express the infinity and formlessness of the world (indeed, the cosmos) in paintings like *Several Circles* [**FIG. 21.8**] without appeal to any representative figures or sense of narration (nonobjective art).

■ **21.5** Piet Mondrian. *Color Planes in Oval,* 1913–1914. Oil on canvas, 42⅜″ × 31″ (108 × 79 cm). Collection, The Museum of Modern Art, New York (purchase). Color experiments of this kind would exert an enormous influence on clothing design and the graphic arts in subsequent decades.

■ **21.6** Marc Chagall. *Green Violinist,* 1923–1924. Oil on canvas, 6′8″ × 3′6¼″ (1.98 × 1.09 m). Guggenheim Museum, The Solomon R. Guggenheim Foundation, New York. This highly complex work blends Cubist, primitive, and dreamlike characteristics. Chagall's work blends memories of his Russian past and Jewish mysticism in a highly formal manner.

■ **21.7** Rufino Tamayo. *Women of Tehuantepec,* 1939. Oil on canvas, 33⅞″ × 57⅛″. Albright-Knox Art Gallery, Buffalo, New York. Notice the Cubist treatment of facial features and body shapes as tubular and geometric.

VALUES

Disillusionment

The period between the two world wars has often been characterized as a time of disillusionment. The horrendous slaughter of World War I, the brief spasm of economic prosperity followed by the worldwide Depression, the lack of trust in governments, and the questioning of traditional culture created a culture seeking ways to fill the moral vacancy of the times. Responses ranged from a new hedonism reflected in the excesses of the Jazz Age to a renewed search for some kind of a center for culture in the works of the modernist writers.

The most dangerous reaction to this disillusioned spirit was the rise of the total state. From Lenin's Russia, Hitler's Germany, and Mussolini's Italy arose a totalitarianism that saw the state as the total center of power that would guide everything from economics and social policy to the arena of culture, arts, and propaganda. The distinction between public and private life was erased by the total state.

One great lesson that can be learned from the rise of modern totalitarianism is the vigor with which the total state repressed all cultural alternatives to its own vision of reality. The suppression of free speech, independent media, toleration for the arts, the space for independent social groups or churches or civic organizations was total in the Soviet Union, Germany, and Italy. The vigorous antifascist novelist Ignazio Silone once wrote that what the state feared more than anything else was one person scrawling "NO" on a wall in the public square.

■ **21.8** Wassily Kandinsky. *Several Circles,* 1926. Oil on canvas, 4′7⅛″ (1.4 m) square. Guggenheim Museum, The Solomon R. Guggenheim Foundation, New York.

FREUD, THE UNCONSCIOUS, AND SURREALISM

In 1900, on the threshold of the century, Viennese physician Sigmund Freud (1856–1939) published *The Interpretation of Dreams,* one of the most influential works of modern times. In it, Freud argued that deep in the unconscious, which Freud called the *id,* were chaotic emotional forces of life and love (called *libido* or *Eros*) and death and violence (called *Thanatos*). These unconscious forces, often at war with each other, are kept in check by the *ego,* which is the more conscious self, and the *superego,* which is the formally received training of parental control and social reinforcements. Human life is shaped largely by the struggle between the ego and superego to prevent the deeply submerged drives of the *unconscious* from emerging. One way to penetrate the murky realm of the human unconscious, according to Freud, was via dreams. In the life of sleep and dreams, the ego and superego are more vulnerable in their repressive activities. "The dream," Freud wrote, "is the royal road to the unconscious." To put it simply, Freud turned the modern mind inward to explore those hidden depths of the human personality where the most primitive and dynamic forces of life dwell. Freudian **psychoanalysis** is not only a therapeutic technique to help anxious patients but also a descriptive philosophy that proposes to account for both human behavior and culture in general.

After the Great War, Freud's ideas were readily accessible to large numbers of European intellectuals. His emphasis on nonrational elements in human behavior exercised a wide influence on those who had been horrified by the carnage of the war. One group was particularly anxious to use Freud's theories about the dream world of the unconscious as a basis for a new aesthetics. The result was the movement known as *Surrealism.*

Surrealism was both a literary and an artistic movement, gathered around the journal *Littérature,* edited in Paris by the French critic André Breton. In 1924, Breton published his first *Manifesto of Surrealism,* which paid explicit homage to Freud's ideas on the subjective world of the dream and the unconscious. "Surrealism," Breton declared, "is based on the belief in the superior

reality of certain forms of association hitherto neglected, in the omnipotence of the dream, and in the disinterested play of thought."

The painters first associated with Surrealism are familiar to every museumgoer: Jean Arp, Giorgio de Chirico, Max Ernst, Paul Klee, Joan Miró, Pablo Picasso. The Spanish artist Salvador Dalí (1904–1989), who joined the movement in its latter period, however, was to become almost synonymous with Surrealism. His *The Persistence of Memory* [**Fig. 21.9**] is perhaps the most famous Surrealist painting. Its dreamlike quality comes from the juxtaposition of almost photographic realism with a sense of infinite quiet space and objects that seem unwilling to obey the laws of physics. The soft watches seem to melt in their plasticity. This juxtaposition of solidity and lack of solidity contributes to the "surreal" tone of the painting.

Although Frida Kahlo (1907–1954) was not a self-described surrealist, those in that circle claimed her as one of their own. In her 1937 *Self-Portrait Dedicated to Leon Trotsky* [**Fig. 21.10**], the artist depicts herself in her native Mexican dress framed by eerily white drawn-back curtains. Kahlo, who frequently painted her own portrait, made a profound study of the self, so that the viewer is invited to penetrate behind the mask of her persona to grasp the deep meaning of her life behind the mask of her direct gaze.

Another surrealist, René Magritte (1898–1967), was no less a draftsman but was less concerned with the dark side of the unconscious. His work, done with scrupulous attention to realistic detail, calls into question our assumptions about the reality of our world. In his *Man with a Newspaper* [**Fig. 21.11**], even the title of the painting misleads because the man, like a figure in a single frame of a motion picture, disappears quickly.

Film was a major influence on Magritte's development, as it was on other Surrealists. The motion-picture camera could be used to make images that corresponded closely with surreal intentions. Figures could dissolve, blend into other figures, be elongated, or slowly disappear. Some of the first artists associated with Surrealism—like the American Man Ray—experimented with both still photography and moving pictures. Dalí collaborated with his compatriot film

■ **21.9** Salvador Dalí. *The Persistence of Memory,* 1931. Oil on canvas, 9½″ × 13″ (24.1 × 33 cm). Collection, The Museum of Modern Art, New York (Given anonymously).

director Luis Buñuel to produce two famous Surrealistic films: *Un Chien Andalou* (1929) and *L'Âge d'Or* (1930). The French poet Jean Cocteau also produced a famous Surrealistic film in 1931: *Blood of a Poet.*

One artist deserves a separate mention; although his association with the surrealist movement was important, it does not adequately define his originality. The Swiss painter Paul Klee (1879–1940) had been influenced by most of the major art movements of his day. He knew the work of Picasso in Paris; he exhibited for a time with Der Blaue Reiter in Germany; after the war he taught at the famous design school in Germany called the Bauhaus. Finally, Klee showed his work at the first Surrealist exhibition of art in Paris. It was characteristic of Klee's talent that he could absorb elements of Cubist formalism, Expressionist colorism, and the fantasy of the Surrealists without being merely a derivative painter. He was, in fact, one of the most original and imaginative artists of the first half of the twentieth century. A painting like his 1926 *Around the Fish* [**Fig. 21.12**] is typical. The cylindrical forms hint at Cubism, but the floating shapes, some enigmatic, and the brilliant coloring evoke the dreamlike world of the surreal.

We have already noted that Freud's pioneering research into the nature of the unconscious profoundly impressed those writers associated with André Breton. Other writers more fully explored the implications of Freud and his followers throughout the twentieth century in fiction, poetry, drama, and criticism. The great American dramatist Eugene O'Neill (1888–1953) restated basic Freudian themes of love and hate between children and parents (the *Oedipus* and *Electra* complexes) in plays like *Desire under the Elms* and *Mourning Becomes Electra.* Other writers of world repute like Franz Kafka and the American novelist William Harrison Faulkner (1897–1962) may not have directly depended on Freud's writings, but their works are more accessible when we understand that they are dealing with similar issues and problems.

■ **21.11** René Magritte. *Man with a Newspaper,* 1928. Oil on canvas, 45½″ × 32″ (116 × 81 cm). Tate Gallery, London (reproduced by courtesy of the Trustees). Magritte's power to invoke solitude is evident in this picture.

■ **21.12** Paul Klee. *Around the Fish*, 1926. Oil on canvas, 18⅜″ × 25⅛″ (47 × 64 cm). Collection, The Museum of Modern Art, New York (Abby Aldrich Rockefeller Fund). The figures in the painting seem to float freely in an indeterminate space.

THE AGE OF JAZZ

Jazz is a peculiarly American contribution to Western culture, born out of the unique experience of Americans of African heritage. The matrix out of which jazz was born is an imperfectly documented history of a process that includes, among other elements: (1) certain intonations, rhythmic patterns (such as love of repetition), and melodic lines that come ultimately from the African ancestors of African Americans; (2) the tradition of the spirituals, Christian hymns sung both in the slave culture of the South and in the free churches of Blacks after the Civil War; (3) the ineffable music of the blues, developed in the Deep South with its characteristic *blue note* (the lowering by a half-step of a note in the melodic line), which produces a sound that is difficult to describe but instantly recognized; and (4) adaptations of certain European songs, especially French quadrilles and polkas, into a slightly different style of music that became known as *ragtime*.

 For an example of ragtime, play Scott Joplin's *Maple Leaf Rag* on track 19 on the Listening CD.

The blues existed mainly as an oral tradition in the Deep South in the nineteenth century, with one singer passing down songs to another. It became a popular public art form in city life from the 1920s onward. Musicians like W. C. Handy (the "grandfather of the blues") and singers like Mamie Smith, Ethel Waters, and Ma Rainey were immensely popular in the 1920s. Their popularity brought the blues style to the larger, mainly Anglo audiences in the period between the wars even though, as scholars generally agree, the blues were a quintessentially African American contribution to art.

Jazz made its first organized appearance in New Orleans around the turn of the century. The musicians, who were all African Americans, performed without written music and were self-taught. They formed bands and played in the streets and in the cabarets of the city. By the end of World War I, many of these musicians had migrated north to Chicago—which, in the early 1920s, was the center of jazz music. From there, jazz spread to Harlem in New York City and to other urban centers on both coasts.

The influence of Black jazz (and its Anglo counterpart) on American culture is difficult to overestimate. In fact, the period directly after World War I has been

called The Jazz Age, borrowing from an F. Scott Fitzgerald title. Some of the musicians of that era have permanent niches in American culture: the great blues singer Bessie Smith (1895–1937) and the trumpeter Louis ("Satchmo") Armstrong (1900–1971), along with such rediscovered masters as Eubie Blake (1883–1983) and Alberta Hunter (1895–1984), who made hit records in the 1920s and was still an active singer and recording artist into the 1980s. Jazz figures who reach down into contemporary culture would include such classic masters as Duke Ellington (1899–1974), Count Basie (1904–1984), and Lionel Hampton (1913–1994).

 To hear *West End Blues by* Louis Armstrong and his Hot Five, play track 20 on the Listening CD.

The popularity of jazz, a peculiarly Black musical idiom, was soon appropriated by the predominantly **Anglo culture** in America, so that often Anglo jazz bands and the mass media (the first talking motion picture in this country starred a white actor, Al Jolson, singing in blackface in *The Jazz Singer*) overshadowed the unheralded Black musicians of the time. Only more recently have serious and systematic attempts been made to recover early jazz recordings (because written music is largely nonexistent) and to bring out of retirement or obscurity the now-old blues singers who are the most authentic exponents of this art form.

Jazz as a musical and cultural phenomenon was not limited to the United States in the period after World War I. Jazz had a tremendous following in Paris in the 1920s, where one of the genuine celebrities was the Black American singer and dancer Josephine Baker [FIG. 21.13].

Just as Pablo Picasso had assimilated African sculptural styles in his painting, so serious musicians on the Continent began to understand the possibilities of this African American music for their own explorations in modern music. As early as 1913, Igor Stravinsky (1882–1971) utilized the syncopated rhythms of jazz in his path-breaking ballet *The Rite of Spring.* His *L'Histoire du soldat* (1918) incorporates a "ragtime" piece that he composed based only on sheet music copies he had seen of such music. Other avant-garde composers in Europe also came under the influence of jazz. Paul Hindemith's (1895–1963) *Klaviersuite* (1922) shows the clear influence of jazz. Kurt Weill's (1900–1950) *Dreigroschenoper* (*Threepenny Opera*) (1928), with a libretto by Bertolt Brecht, shows a deep acquaintance with jazz, demonstrated notably in the song "Mack the Knife."

By the 1930s, the influence of jazz in the United States had moved into the cultural consciousness of the country at large. Jazz was now commonly referred to as *swing,* and swing bands toured the country and were featured in films. The bands of Duke Ellington and Count Basie were well-known even though their

■ **21.13** Josephine Baker.

members, while on tour, had to put up with the indignities of racial segregation: They often played in hotels and clubs which they would have been unable to patronize. By the late 1930s, there was even a renewed interest in the older roots of jazz. In 1938, for example, Carnegie Hall in New York City was the site of the "Spirituals to Swing" concert, which presented a range of musicians from old-time New Orleans–style jazz performers to such avant-garde performers as Lester Young.

Many of the musicians of the swing era were extremely talented and quite able to cross musical boundaries. The great clarinetist Benny Goodman recorded Mozart's *Clarinet Quintet* with the Budapest String Quartet in 1939, the year he commissioned a composition from classical composer Bela Bartok (1881–1945). The African American jazz musician Fats Waller, in that same year, wrote his *London Suite,* his impressionistic tribute to that city.

Such crossovers were the exception rather than the rule, but they do underscore the rich musical tradition of the jazz movement. In the post–World War II era, a new experiment in avant-garde music—*new wave*—and cool jazz would give the performers the opportunity to extend the definition and range of jazz to where it would intersect with other forms of avant-garde music. This is evidenced by the musical careers of the late Charlie ("Bird") Parker (1920–1955) and the late Miles Davis (1926–1991).

George Gershwin

The most persistent effort to transpose jazz into the idiom of symphonic and operatic music was that made by the American composer George Gershwin (1898–1937). In large symphonic works like *Rhapsody in Blue* (1924) and *Concerto in F* (1926) for piano and orchestra, Gershwin utilized such jazz characteristics as blue notes, syncopation, and *riffs* (seemingly improvised variations) on a basic theme along with the more classically disciplined form for large orchestral music.

It is certainly appropriate, perhaps inevitable, that the first widely successful American opera should have a jazz background. George Gershwin's *Porgy and Bess* (1935) incorporated jazz and other African American musical material such as the "shouting" spirituals of the Carolina coastal black churches into a libretto written by the Southern novelist DuBose Heyward and Gershwin's brother, Ira. *Porgy and Bess* was not an immediate success in New York, but later revivals in the 1940s and after World War II established its reputation. In 1952, it had a full week's run at the La Scala opera house in Milan; in 1976, the Houston Opera mounted a full production, with earlier deletions restored, that was seen subsequently at the Metropolitan Opera in New York. It now ranks as a classic. Some of its most famous songs (such as "Summertime" and "It Ain't Necessarily So") have become standards.

 To hear *Summertime* from *Porgy and Bess,* go to track 21 on the Listening CD.

Being Anglo, Gershwin had easier access to the world stage than did many of the African Americans in the first half of the twentieth century. Only in the past few decades has a fine composer like Scott Joplin (1868–1917), for example, achieved any wide recognition in this country. The great blues singer Bessie Smith died after an automobile accident in the South because of delays in finding a hospital that would treat blacks. Many other singers and instrumentalists have remained in obscurity all their lives, although some—artists like the late Louis Armstrong—were so extraordinarily gifted that not even the hostile and segregated culture of the times could repress their talent.

Duke Ellington

One African American who managed to emerge decisively from the confines of black nightclubs into international fame was Edward Kennedy ("Duke") Ellington (1899–1974). Ellington gained fame at the Cotton Club in Harlem in the 1920s both for his virtuoso orchestral skills and for his prolific output as a composer. He was not only a successful writer of such popular musical pieces as "Take the A Train" and "Mood Indigo," but also a true original in his attempt to extend the musical idiom of jazz into a larger arena. After World War II, Ellington produced many works for symphonic settings. His symphonic **suite** *Black, Brown, and Beige* had its first hearing at Carnegie Hall in 1943. This work was followed by others—the titles of which alone indicate the ambition of his musical interests: *Shakespearean Suite* (1957), *Nutcracker Suite* (1960), *Peer Gynt Suite* (1962), and his ballet *The River* (1970), which he wrote for the dance company of Alvin Ailey, a notable African American choreographer.

 To hear Duke Ellington's *Take the A Train,* play track 22 on the Listening CD.

THE HARLEM RENAISSANCE

Jazz is an American or, more specifically, a distinctively African American contribution to world culture. It was not the only cultural movement among African Americans in the period between the wars. In the section of New York City known as Harlem, there was a concentration of African American writers, artists, intellectuals, and musicians who produced such a conspicuous body of specifically African American work that they are known collectively as the *Harlem Renaissance.* There were explorers of African American culture like Zora Neale Hurston, James Weldon Johnson, and Alain Locke; poets like Countee Cullen, Helene Johnson, Langston Hughes, and Claude McKay; artists like Hale Woodruff, Sargent Johnson, Augusta Savage, Romare Bearden, and the famous muralist and painter, Aaron Douglas [**FIG. 21.14**].

When one reads the poetry and fiction produced during the 1920s and 1930s by the Harlem Renaissance writers, it is easy to detect abiding themes of the African American experience: the ancestral roots of Africa; the quest for dignity in a culture of racism; a debate over the degree to which African American values should be part of—as opposed to distinct from—the majority culture; and the role of the church in life.

Behind most of these questions was the one posed at the beginning of the century by the African American intellectual W. E. B. DuBois (1868–1963): What self-identity does an African American affirm who must hold in balance his identity as being African, his place in American life, and the racism he endures? Those issues burn at the heart of what the Harlem Renaissance debated.

BALLET: COLLABORATION IN ART

In the period between the world wars, one form of culture where the genius of the various arts most easily

■ **21.14** Aaron Douglas. *Aspects of Negro Life,* 1934. Mural at the Harlem Branch of the New York Public Library. Arts and Artifacts Division, Schomburg Center for Research in Black Culture. The New York Public Library. Astor, Lenox and Tilden Foundations.

fused was the ballet. The most creative experiments took place in Paris through the collaboration of a cosmopolitan and talented group of artists.

The driving force behind ballet in this period in Paris was Serge Diaghilev (1872–1929), a Russian-born impresario who founded a dance company called the Ballet Russe, which opened its first artistic season in 1909. Diaghilev brought from Russia two of the most famous dancers of the first half of the century: Vaslav Nijinsky (1890–1950) and Anna Pavlova (1881–1931).

Diaghilev had a particular genius for recruiting artists to produce works for his ballet. Over the years, the Ballet Russe danced to the commissioned music of Igor Stravinsky, Maurice Ravel, Serge Prokofiev, Claude Debussy, Erik Satie, and Darius Milhaud. In that same period, sets, costumes, and stage curtains were commissioned from such artists as Pablo Picasso, Georges Rouault, Naum Gabo, Giorgio de Chirico, and Jean Cocteau.

Diaghilev produced a one-act dance called *Parade* (1917) in Paris. This short piece (revived in 1981 at the Metropolitan Opera with sets by the English painter David Hockney) is an excellent example of the level of artistic collaboration Diaghilev could obtain. The story of the interaction of street performers and men going off to war was by the poet Jean Cocteau (1891–1963); the avant-garde composer Erik Satie (1866–1925) contributed a score replete with street sounds, whistles, horns, and other accoutrements of urban life. Pablo Picasso designed the curtain drop, the sets, and the costumes [**Fig. 21.15**]. *Parade* had much to say about musicians, players, and street performers, so the production was ready-made for Picasso's well-known interest in these kinds of people.

The collaborative effort of these important figures was a fertile source of artistic inspiration. Picasso had a great love for such work and returned to it on several other occasions. He designed the sets for *Pulcinella* (1920), which had music by Igor Stravinsky. He designed sets for a balletic interpretation of Euripides' tragedy *Antigone* done from a translation of the play from the Greek into French by Jean Cocteau. In 1924, he also executed designs for a ballet that had original music written by Erik Satie, called *Mercury.*

Ballet, like opera, is an art form that lends itself to artistic integration. To enjoy ballet, one must see the disciplined dancers in an appropriate setting, hear the musical score that at once interprets and guides the movements of the dancers, and follow the narrative or "book" of the action. It is no wonder that an organizational genius like Diaghilev would seek out and nurture the efforts of the most creative artists of his era.

ART AS ESCAPE: DADA

A group of artists, writers, and musicians who gathered around the tables of the Café Voltaire in Zurich in 1915 founded a movement to protest what they considered the madness of the war and its senseless slaughter. They decided to fight the "scientific" and "rational" warmakers and politicians with nonsense language, ugly dissonant music, and a totally irreverent and iconoclastic attitude toward the great masterpieces of past culture. It was called *Dada,* a nonsense word of disputed origin that could be a diminutive of *father* or the word for *yes* or a child's word for *hobbyhorse.* One of its poets, Tristan Tzara, wrote a Dada manifesto in 1918 that called for, among other things, a destruction of good manners, the abolition of logic, the destruction of

■ **21.15** Pablo Picasso. Curtain for the ballet *Parade*. Paris, 1917. Tempera on cloth, 34′9″ × 56′¾″ (10.6 × 17.3 m). Musée National d'Art Moderne, Centre Georges Pompidou, Paris. Many critics agree that both the music and the choreography of the ballet were overwhelmed by Picasso's brilliant sets.

memory, forgetfulness with respect to the future, and the elevation of the spontaneous to the highest good.

One of the most representative and creative of the Dada artists was Marcel Duchamp (1887–1968), who after 1915 was associated with an avant-garde art gallery in New York founded by the American photographers Alfred Stieglitz (1864–1946) and Edward Steichen (1879–1973). Duchamp was a restless innovator who originated two ideas in sculpture that became part of the common vocabulary of modern art: *mobiles* (sculptures with moving parts) and *ready-mades* (sculptures constructed from preexisting fabricated material originally intended for other purposes). Besides these important innovations, Duchamp has also gained notoriety for his whimsically irreverent attitude toward art, illustrated by his gesture of exhibiting a urinal at an art show as well as his humorous but lacerating spoofs of high culture, the most "Dada" of which is *L.H.O.O.Q.*—his famous defacement of the *Mona Lisa* [**FIG. 21.16**].

The Dadaists could not maintain the constant energy of their anarchy, so it was inevitable that they would move individually in other directions. Dada was a movement symptomatic of the crisis of the times, a reaction to chaos but no adequate answer to it. It is no small irony that while the Dada theater group performed in Zurich's Voltaire cabaret in 1916, there lived

across the street an obscure Russian political activist in exile from his native land. He would also respond to the chaos of the time but in a far different way. His name was V. I. Lenin.

ART AS PROTEST: *GUERNICA*

The late Protestant theologian Paul Tillich once called Picasso's *Guernica* [**FIG. 21.17**] the great Protestant painting. He said this not because Picasso was religious (which he was not) but because of the quality and depth of Picasso's protest against inhumanity. The title of the painting comes from the name of a small Basque town that was saturation-bombed by Germany's Condor Legion in the service of Franco's fascist rebel forces during the Spanish Civil War. Picasso completed the huge canvas in two months—May and June 1937—so that he could exhibit it at the Paris World's Fair that year.

The genesis and development of *Guernica* have been intensely studied in order to "unlock" its symbolism, but it would be safe to begin with Picasso's particular images. Many of these images recur repeatedly in his work to convey Picasso's sense of horror at the destruc-

tion of war together with his muted affirmation of hope in the face of the horror. His iconography is reinforced by its somber palette: gradations of black, brown, and white.

The complexity of images in *Guernica* at first glance seems chaotic, but prolonged viewing reveals a dense and ordered rhythm. Starting at the left with the bull—Picasso's symbol of brute force, of Spain, and at times of the artist himself—we see beneath the animal a woman with the broken body of a child. The echo of the Pietà theme is obvious. In the lower center and to the right is a dismembered figure, in the Cubist style, over whom rears up a "screaming" horse. At the top right of the work are Picasso's only hints of hope in the face of such evil: a small open window above a supplicant figure and an emerging figure holding a lamp. Over the center is an *oculus* ("eye") in which a lamp burns and casts off light.

As a social document the importance of *Guernica* cannot be overestimated. The German bombing of the little town was an experiment in a new style of warfare, a style that would be refined into a deadly technique in World War II. In *Guernica,* Picasso innovatively combines various stylistic techniques that were employed on the eve of World War I—Expressionistic distortion and Cubist abstraction—to protest a technological development that became commonplace in the next war. In this sense, *Guernica* is a pivotal document—it straddles two cataclysmic struggles in the century. *Guernica*'s cry of outrage provides an important observation about human culture. The painting reminds us that at its best the human imagination calls up the most primordial symbols of our collective experience (the woman and child, the horse and bull, the symbol of light) and invests them with new power and expressiveness fit for the demands of the age.

■ **21.16** Marcel Duchamp. *L.H.O.O.Q.,* 1919. Rectified ready-made. Pencil on colored reproduction of Leonardo da Vinci's *Mona Lisa,* 7¾″ × 4⅞″ (20 × 12 cm). Private Collection. The French pronunciation of the letters under the picture sounds like an off-color expression.

■ **21.17** Pablo Picasso. *Guernica,* 1937. Oil on canvas, 11′5½″ × 25′5¼″ (3.49 × 7.77 m). *Centro de Arte Reina Sofía, Madrid, Spain.* This monumental painting was on extended loan in New York until after the death of General Francisco Franco, when Picasso agreed to its return to his native Spain.

ART AS PROPAGANDA: FILM

The first motion pictures are attributed to the French Lumière Brothers (1895) and the American Panopticon and Vitascope developed in New York the year after. By the time of World War I, a vast movie industry was already turning out short silent films for an eager audience. Sound technology was added to films in 1927. But already longer films with lavish productions were being produced. During the period of World War I, people began to understand the power of film to educate, persuade, and shape public opinion. This development came at a time when totalitarian government arose, with its insatiable desire to propagandize.

Propaganda is the diffusion of a point of view with the intention to persuade and convince. We usually think of it in political terms. Throughout history, propagandists have used books, art, and music to spread their ideas. Inventions in the early part of the twentieth century, however, added immeasurably to the propagandist's weapons.

Besides radio, the other medium that most successfully blended propaganda with attempts at some artistic vision in the first half of the twentieth century was film. Two acknowledged masters of the use of film for propaganda need to be singled out because they set such a standard of excellence that, at least through their finest work, propaganda became high art.

Sergei Eisenstein (1898–1948) remains not only the greatest filmmaker the Soviet Union has produced but one of the most influential artists in the history of the cinema as well. A dedicated supporter of the Russian Revolution, Eisenstein fully appreciated Lenin's observation that the cinema would become the foremost cultural weapon in winning over the proletariat to the Revolution. From his early film *Strike!* (1925) to his last work, *Ivan the Terrible, Part I* (1944) and *Part II* (1946), Eisenstein was conscious of the class struggle, the needs of the working class, and the inevitable advance of socialism in history—themes dear to the official line of Stalin's USSR. Despite this orthodox line, Eisenstein was never an ideological hack. His films were meticulously thought out and he brought to bear his own considerable culture and learning to make films of high art. His *Alexander Nevsky* (1938) had an impressive musical score by Serge Prokofiev, and the two men worked closely to integrate musical and visual concepts. His vast *Ivan the Terrible* was deeply indebted to a study of El Greco's paintings; Eisenstein was struck by the cinematic possibilities in that artist's striking canvases.

Eisenstein's most influential film, *Potemkin* (finished at the close of 1925), is the story of the 1905 naval mutiny on the battleship *Potemkin* and the subsequent riot in Odessa that was crushed by the tsarist police. The communists saw in that historical incident a major foreshadowing of the **October Revolution** of 1917, which brought the Bolsheviks to power.

The scene in *Potemkin* of the crowd cheering the mutineers on a broad flight of stairs in Odessa and the subsequent charge of the police is a classic sequence in film history. In that sequence, Eisenstein uses the device of *montage* (the sharp juxtaposition of shots by film cutting and editing) with such power that the scene became a benchmark for subsequent filmmakers. His close-ups were meant to convey a whole scene quickly: A shot of a wounded woman cuts to a close-up of a clenched hand that slowly opens, telling the story of death in a moment. A crazily moving baby carriage is a macabre metaphor for the entire crowd in panic and flight. Shattered eyeglasses and blood pouring from an eye [**FIG. 21.18**] become a terrible shorthand statement of police violence.

For sheer explicit propaganda, one must turn to two documentary films made in Nazi Germany in the 1930s by the popular film actress and director Leni Riefenstahl (1902–2003). Her first great film was a documentary of the 1934 Nazi Congress in Nuremberg called *Triumph of the Will* (1936). Designed to glorify the Nazi Party and to impress the rest of the world, the film made ample use of the great masses of party stalwarts who gathered for their rally. That documentary allowed the young filmmaker to show the party congress as a highly stylized and ritualistic celebration of the Nazi virtues of discipline, order, congregated might, and the racial superiority of the Teutonic elite of the party members.

Riefenstahl's other great film, and arguably her masterwork, was a long documentary made at the Berlin Olympics of 1936 and issued in 1938 under the title *Olympia*. Riefenstahl used five camera technicians and thirty-eight assistants as well as footage shot by news agency photographers to make her film. The completed documentary, divided into two parts, pays tribute to the Olympic spirit of ancient Greece, develops a long section on the carrying of the Olympic torch to Berlin, records the homage to Hitler and the Nazi Party, and shows most of the major athletic competitions.

As a film, *Olympia* is matchless in its imaginative use of the camera to catch the beauty of sport [**FIG. 21.19**]. The vexing question is to what degree the film is political beyond the obvious homage paid to the German Third Reich, which sponsored the Olympics in 1936. Many critics note its elitist attitude to justify their contention that it is propaganda, albeit of a very high and subtle quality. Athletes are depicted as superior beings who act beyond the range of ordinary mortals. They give all and seem almost demigods. The film praises the heroic, the conquest, the struggle. It praises the ritualized discipline of the crowds and lovingly seeks out examples of the adoring Berlin masses surrounding the party leaders.

■ **21.19** Leni Riefenstahl. Still shot from the diving sequence of *Olympia*, 1938. This still shows the uniquely original camera angles Riefenstahl used. Such angles became a model for documentary filmmakers.

PHOTOGRAPHY

Photography is a nineteenth-century invention, as we have seen. During the nineteenth century, photography had a complex technological evolution as photographers sought ways to make cameras and photographic equipment more mobile. As this mobility increased, photography developed several specialties: portraiture, landscapes, documentation, and reportage. Most important and more basic, photography gave to the world

■ **21.18** Sergei Eisenstein. Still from the Odessa steps sequence of the film *Potemkin*, 1925. Museum of Modern Art, Film Stills Archives, New York. This close-up is a classic shot in the history of film. The single image represents the horror of the entire scene.

what no other visual medium could: immediacy. Before the advent of photography, field artists transcribed events in sketches and then transferred those drawings onto etching plates for reproduction in newspapers and magazines. With the photograph, people could "see" events as they were actually happening. The idea that "a picture is worth a thousand words" has become a tired cliché, but it is difficult for us today to comprehend the impact the first photographs of war must have made when traveling photographers sent back to England pictures of dying soldiers in the Crimean War of the 1850s or when the American public first saw the pictures made by Mathew Brady (1823–1896) and his assistants of death and devastation during the Civil War in the 1860s.

Further technical advances, like the small portable Kodak camera invented by the American George Eastman in the late nineteenth century and 35mm cameras (including the famous Leica) invented in the early twentieth century in Germany, contributed to the advance of photography in the twentieth century. In the period after World War I, there was an intense interest in photography as a new instrument for art. Man Ray (1890–1976), an American artist living in Paris, experimented with darkroom manipulations to produce what he called *rayograms*.

László Moholy-Nagy (1895–1946) taught a wide range of techniques in photography while he was an instructor at the influential Bauhaus school of design in Germany. When the school was closed by the Nazis, Moholy-Nagy came to the United States in 1933, where he continued to be a great influence on the development of American photography. A group of American photographers loosely connected with what was called the "f/64 Group" included pioneer photographers who are now recognized as authentic geniuses of the medium: Edward Weston (1886–1958), Ansel Adams (1902–1984), and Imogen Cunningham (1883–1975). We have already noted the influence of Alfred Stieglitz on the avant-garde art of New York. These photographers, and others like them, emphasized direct, crisp, and nonmanipulative pictures that set the standard for much of modern photography.

In the United States, the most powerful pictures between the world wars that were produced for social purposes were those photographs made to show the terrible economic deprivations of the Great Depression of the 1930s. In the mid-1930s, the Farm Security

Administration of the United States Department of Agriculture commissioned photographers to record the life of America's rural poor. The resulting portfolios of these pictures taken by such photographers as Dorothea Lange, Arthur Rothstein, and Walker Evans have become classics of their kind. In 1941, the Pulitzer Prize–winning writer James Agee wrote a prose commentary on some of the photographs of Walker Evans. The photos of Evans and the text of James Agee were published together under the title *Let Us Now Praise Famous Men* [**FIG. 21.20**]. Along with John Steinbeck's novel *The Grapes of Wrath* (turned into an Academy Award–winning film), Agee's book is one of the most moving documents of the Great Depression, as well as a model of how word and picture can be brought together into an artistic whole for both social and aesthetic purposes.

ART AS PROPHECY: FROM FUTURISM TO *BRAVE NEW WORLD*

Great art always has a thrust to the future. This chapter began with the observation of William Butler Yeats that "the centre cannot hold"—a prescient observation, as the aftermath of World War I was to show.

Not all artists were either so pessimistic or so prophetic as Yeats. A small group of painters, sculptors, architects, and intellectuals in Italy looked to the future with hope and to the past with contempt. Known as

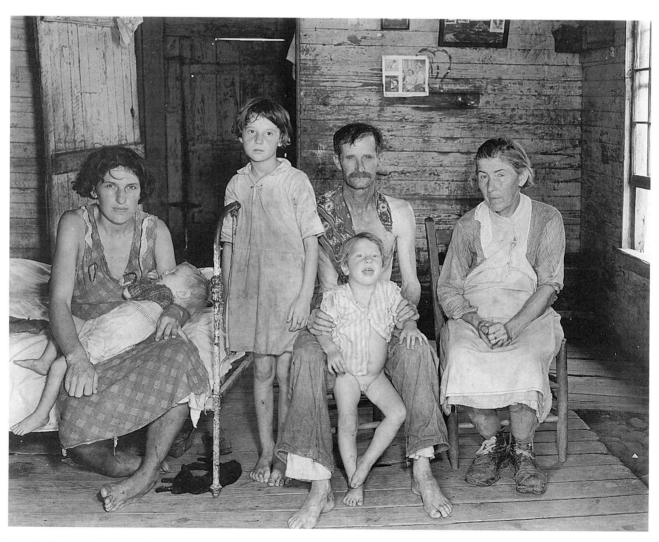

■ **21.20** Walker Evans. *Share Cropper's Family,* Alabama, 1935. Black and white. Photograph. The Museum of Modern Art, New York. Gift of the Farm Security Administration. Evans and James Agee often visited this family. Agee wrote about the family in *Let Us Now Praise Famous Men.* With Bud Fields, a one-mule tenant farmer, age fifty-nine, are his second wife, Ivy (mid-twenties), their daughter (twenty months), Ivy's daughter by an earlier common-law marriage (eight), their son (three), and Ivy's mother (early fifties).

the *Futurists,* they exalted the values of industrial civilization and the power of urban accomplishment, and (with equal intensity) despised the artistic culture of the past. The theorist of the movement was a Milanese poet and writer, Filippo Tommaso Marinetti (1876–1944), who issued a long series of Futurist manifestos between 1908 and 1915.

In the few years during which Futurism flourished, its followers produced significant paintings, sculptures, and ideas about city planning and urban architecture. World War I was to end their posturing; the sculptor Umberto Boccioni and the futurist architect Antonio Sant'Elia both died in 1916, victims of the war. Some of the futurists, including Marinetti, true to their fascination with power, war, destruction, and the exaltation of might, were increasingly used as apologists for the emerging fascist movement in Italy. Thus a painting like Gino Severini's *Armored Train in Action* [**Fig. 21.21**] proved prophetic in ways not quite appreciated in 1915.

The Futurist romance with industrial culture and the idea of technological "progress" was not shared by all artists of the twentieth century. We have already noted that T. S. Eliot pronounced his world a wasteland. The American novelist Sinclair Lewis (1885–1951) viciously satirized American complacency in the postwar period. His novel *Babbitt* (1922) was a scathing indictment of the middle-class love for the concept of "a chicken in every pot and two cars in every garage." His philistine hero, George Babbitt, became synonymous with a mindless materialism in love with gadgets, comfort, and simplistic midwestern values.

By contrast, the English novelist Aldous Leonard Huxley (1894–1963) saw the unrestrained growth of technology as an inevitable tool of totalitarian control over individuals and society. His 1932 novel *Brave New*

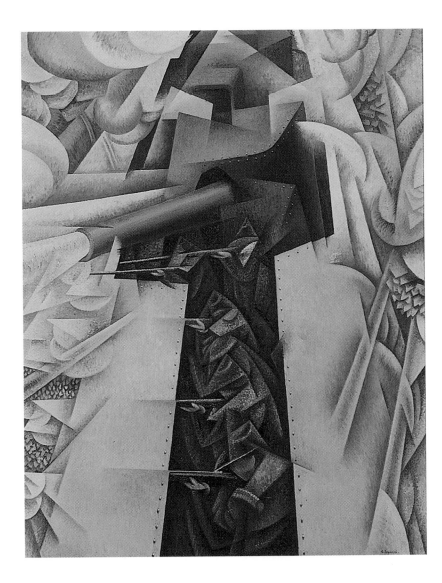

■ **21.21** Gino Severini. *Armored Train in Action,* 1915. Oil on canvas, 45⅜″ × 34⅞″ (115.8 × 88.5 cm). The Museum of Modern Art, New York (gift of Richard S. Zeisler). The influence of Cubism in the composition is obvious.

World was a harbinger of a whole literature of prophetic warning about future dangers. The two most famous prophetic works of the post–World War II era are *Animal Farm* (1945) and *1984* (1949), both by the English writer George Orwell, the pen name used by Eric Arthur Blair (1903–1950).

Huxley's *Brave New World* is set in the far distant future—600 A.F. (After [Henry] Ford, who had been deified as the founder of industrial society because he developed the assembly line). In this society, babies are born and raised in state hatcheries according to the needs of the state. They are produced in five classes (from Alpha to Epsilon) so that the exact numbers of needed intellectuals (Alphas) and menials (Epsilons) are produced. The goal of society is expressed in three words: Community/Identity/Stability. All sensory experience is supplied either by machines or a pleasure-drug called *soma*. Individuality, family relationships, creativity, and a host of other "unmanageable" human qualities have been eradicated from society either by coercion or programming.

Toward the end of the novel there is a climactic conversation between John Savage, a boy from the wilds of New Mexico raised outside the control of society, and Mustapha Mond, one of the controllers of the "brave new world" of the future. Patiently, Mustapha Mond explains to the uncivilized young man the reasons why certain repressions are inevitable and necessary in the society of the future. The reader sees rather clearly how aware Huxley is that the great humanistic achievements of the past—literature, art, religion—are threatening forces to any totalitarian society and as such are logical targets for a "scientifically" constructed society. His explanations now have a prescient and somber reality to us in the light of what we know about the real totalitarian societies of our own time.

SUMMARY

What made World War I so catastrophic was the advanced technologies used in the service of death. The old military charge against an enemy became obsolete with the invention of the machine gun just as the use of poison gas (not outlawed until after the war) made a mockery of military exercises of strategy. The result was an appalling slaughter of youth on a scale unparalleled in human history.

In the period between the wars, the memory of that slaughter shook intellectuals to the core. Their response was predictable enough: protest or pacifism or a total distrust of the powers of rationality to cope with human evil. The reaction to the Great War ranged, in short, from T. S. Eliot's combination of pessimism and faith to the playful nonsense of the Dada artists and the inner retreat of the Surrealists.

The technological advances that had made the war so terrible also gave promise of new forms of communication that would advance the arts radically into new and different fields. The widespread development of radio networks, the transition of the film from the silent screen to the "talkies," the increased mobility brought about by the automobile, and the advances in photography would not only produce new art forms but also provide their availability to larger audiences.

Coupled with these advances were some profound shifts in social status. People were leaving rural areas in great numbers for the factories of the cities of America and Europe. The old social stratification of the classes was beginning to break down in Europe. The economic dislocations brought on by the war created urban poverty in Europe and, after a giddy decade of prosperity in the 1920s, the Depression years in the United States. In response to these social and economic dislocations, new political movements seemed attractive and compelling. Hitler's National Socialist party rose against the background of Germany's defeat, as did Mussolini's fascists. The period between the wars also saw the consolidation of communist power in Russia and the rise of the totalitarian state under Stalin.

Finally, we should note other fundamental (and radical) ideas that were beginning to gain notice. Einsteinian physics were changing the picture of the world in which we lived because it contained the seeds of the atomic era. Sigmund Freud's ideas were also radically reshaping our notions of the interior landscape of the human soul.

All of these forces—political, technological, scientific, social, and artistic—shaped a culture that in its richness (and sadness) we call the Western world between the two great wars.

KEY TERMS

Anglo culture Common description of the majority culture of native English speakers in the United States, Canada, and the United Kingdom.

Epiphany Literally: a "showing forth." Frequently used as a term for a sudden illumination, intuition, or insight.

Expatriate Literally: "out of one's country." Used for those individuals or communities who live outside of their homeland for extended periods.

Linearity Used as a description for art that emphasizes the geometrical quality of drawing as opposed to melding, blurring, or otherwise lessening the division of descriptive spaces within an art work.

October Revolution Common way of designating the overthrow of the Tsars and the emergence of Marxist government in Russia in 1917. By extension: any radical overthrow of the established political order.

Psychoanalysis The various schools of psychological therapy, and the theoretical underpinnings of those schools, that ultimately derive from the ideas of Sigmund Freud.

Suite In music: an instrumental composition of several parts exhibiting movements of a different character. In ballet, adaptation of a longer orchestral work for purposes of dance.

PRONUNCIATION GUIDE

Braque:	BRAK
Breton:	Bre-TAN
Buñuel:	Boon-WELL
Chagall:	Sha-GAL
Diaghilev:	DIAG-i-leff
Duchamp:	Dew-SHAWM
Guernica:	GHER-nee-ka
Kafka:	KAF-ka
Mustapha Mond:	MUS-taw-fa MOND
Nijinsky:	Nidge-IN-ski
Riefenstahl:	REEF-in-stall
Stravinsky:	Stra-VIN-ski

EXERCISES

1. Look carefully at a Cubist painting. Can you analyze the precise manner in which a Picasso or a Braque tries to get us to see in a new and unaccustomed way?
2. Some people have called Kafka a Surrealist writer. Is that an apt description of his writing? Why or why not? Is "dreamlike" ("nightmarish") an apt way to think of his writing?
3. Jazz is still a much-respected art form today. Give a description of what you understand as jazz and distinguish it from rock music.
4. Discuss ways in which photography and film are used for propaganda currently.

YOUR RESOURCES

- **ExploringHumanities CD-ROM**
 - Reading Selections: T.S. Eliot, selected works; Stein, *Three Lives*
- **Website http://art.wadsworth.com/cunningham**
 - Chapter 21 Quiz
 - Links
- **Audio CD**
 - Joplin: *Maple Leaf Rag*
 - Armstrong: *West End Blues*
 - Gershwin: *Summertime*, from *Porgy and Bess*
 - Ellington: *Take the A Train*

FURTHER READING

Anderson, H., and Bearden, R. *A History of African American Artists from 1792 to the Present.* New York: Pantheon, 1983. Especially good on the Harlem Renaissance.

Bell, Q. *Virginia Woolf: A Biography.* New York: Harcourt, 1972. A standard biography, written by Woolf's nephew; very readable.

Douglas, A. *Terrible Honesty: Mongrel Manhattan in the 1920s.* New York: Farrar, Straus & Giroux, 1995. A brilliant intellectual and cultural history.

Fussell, P. *The Great War and Modern Memory.* New York: Oxford University Press, 1976. A classic study of the cultural impact of World War I.

Gay, P. *Freud: A Life for Our Time.* New York: Norton, 1988. Quite good on the spread of Freudian ideas in the twentieth century.

Hughes, R. *The Shock of the New.* New York: Knopf, 1981. Lavishly illustrated history of modern art derived from the television series of the same name.

Richardson, J. *Pablo Picasso* (Vol. 1). New York: Knopf, 1991. See commentary below.

Richardson, J. *Pablo Picasso* (Vol. 2). New York: Knopf, 1996. A definitive biography; brilliant for the cultural background of the period leading up to the *Demoiselles*.

Watson, Peter. *The Modern Mind: An Intellectual History of the Twentieth Century.* New York: Harper-Collins, 2001. A rapid survey that is highly readable.

READING SELECTIONS

T. S. ELIOT
THE HOLLOW MEN

This poem tracks two basic themes that run through all of Eliot's poetry: the alienation of modern people as a result of a loss of traditional values and the response of faith as an affirmation of some deep center that anchors human life in such a time of cultural decay.

> *"Mistah Kurtz—he dead."*
> *"A penny for the Old Guy."*

I

> We are the hollow men
> We are the stuffed men
> Leaning together
> Headpiece filled with straw. Alas!
> Our dried voices, when
> We whisper together
> Are quiet and meaningless
> As wind in dry grass
> Or rats' feet over broken glass
> In our dry cellar 10
> Shape without form, shade without color,
> Paralyzed force, gesture without motion;
> Those who have crossed
> With direct eyes, to death's other Kingdom
> Remember us—if at all—not as lost
> Violent souls, but only
> As the hollow men
> The stuffed men.

II

> Eyes I dare not meet in dreams
> In death's dream kingdom 20
> These do not appear:

There, the eyes are
Sunlight on a broken column
There, is a tree swinging
And voices are
In the wind's singing
More distant and more solemn
Than a fading star.
Let me be no nearer
In death's dream kingdom 30
Let me also wear
Such deliberate disguises
Rat's coat, crowskin, crossed staves
In a field
Behaving as the wind behaves
No nearer—
Not that final meeting
In the twilight kingdom.

III

This is the dead land
This is cactus land
Here the stone images
Are raised, here they receive
The supplication of a dead man's hand 40
Under the twinkle of a fading star.
Is it like this
In death's other kingdom
Waking alone
At the hour when we are
Trembling with tenderness
Lips that would kiss
Form prayers to broken stone.

IV

The eyes are not here
There are no eyes here
In this valley of dying stars
In this hollow valley
This broken jaw of our lost kingdoms.

In this last of meeting places
We grope together
And avoid speech
Gathered on this beach of the tumid river.

Sightless, unless
The eyes reappear 60
As the perpetual star
Multifoliate rose
Of death's twilight kingdom
The hope only
Of empty men.

V

Here we go round the prickly pear
Prickly pear prickly pear
Here we go round the prickly pear
At five o'clock in the morning.

Between the idea 70
And the reality
Between the motion
And the act
Falls the shadow
 For Thine is the Kingdom

Between the conception
And the creation
Between the emotion
And the response

Falls the Shadow
 Life is very long

Between the desire
And the spasm
Between the potency
And the existence
Between the essence
And the descent
Falls the Shadow 90
 For Thine is the Kingdom

For Thine is
Life is
For Thine is the
This is the way the world ends
This is the way the world ends
This is the way the world ends
Not with a bang but a whimper.

POEMS: LANGSTON HUGHES AND COUNTEE CULLEN

Langston Hughes (1902–1967) was the premier poet of the Harlem Renaissance. His poem "I, Too, Sing America" is a cry against racial discrimination and, at the same time, an affirmation of Black Pride. "The Negro Speaks of Rivers," by contrast, is a poem filled with memory both racial and historical. Countee Cullen (1903–1946) was a powerful voice cut off by an early death. His "Heritage" is a powerful blend of African roots and American experience.

COUNTEE CULLEN

Heritage

What is Africa to me:
Copper sun or scarlet sea,
Jungle star or jungle track,
Strong bronzed men, or regal black
Women from whose loins I sprang
When the birds of Eden sang?
One three centuries removed
From the scenes his fathers loved,
Spicy grove, cinnamon tree,
What is Africa to me?

So I lie, who all day long
Want no sound except the song
Sung by wild barbaric birds
Goading massive jungle herds,
Juggernauts of flesh that pass
Trampling tall defiant grass
Where young forest lovers lie,
Plighting troth beneath the sky.
So I lie, who always hear,
Though I cram against my ear
Both my thumbs, and keep them there,
Great drums throbbing through the air.
So I lie, whose fount of pride,
Dear distress, and joy allied,
Is my somber flesh and skin,
With the dark blood dammed within
Like great pulsing tides of wine
That, I fear, must burst the fine
Channels of the chafing net
Where they surge and foam and fret.
Africa? A book one thumbs
Listlessly, till slumber comes.

Unremembered are her bats
Circling through the night, her cats
Crouching in the river reeds,
Stalking gentle flesh that feeds
By the river brink; no more
Does the bugle-throated roar
Cry that monarch claws have leapt
From the scabbards where they slept.

Silver snakes that once a year
Doff the lovely coats you wear,
Seek no covert in your fear
Lest a mortal eye should see;
What's your nakedness to me?
Here no leprous flowers rear
Fierce corollas in the air;
Here no bodies sleek and wet,
Dripping mingled rain and sweat,
Tread the savage measures of
Jungle boys and girls in love.
What is last year's snow to me,
Last year's anything? The tree
Budding yearly must forget
How its past arose or set—
Bough and blossom, flower, fruit,
Even what shy bird with mute
Wonder at her travail there,
Meekly labored in its hair.
One three centuries removed
From the scenes his fathers loved,
Spice grove, cinnamon tree,
What is Africa to me?

So I lie, who find no peace
Night or day, no slight release
From the unremittant beat
Made by cruel padded feet
Walking through my body's street.
Up and down they go, and back,
Treading out a jungle track.
So I lie, who never quite
Safely sleep from rain at night—
I can never rest at all
When the rain begins to fall;
Like a soul gone mad with pain
I must match its weird refrain;
Ever must I twist and squirm,
Writhing like a baited worm,
While its primal measures drip
Through my body, crying, "Strip!
Doff this new exuberance.
Come and dance the Lover's Dance!"
In an old remembered way
Rain works on me night and day.

Quaint, outlandish heathen gods
Black men fashion out of rods,
Clay, and brittle bits of stone,
In a likeness like their own,
My conversion came high-priced;
I belong to Jesus Christ,
Preacher of humility;
Heathen gods are naught to me.

Father, Son, and Holy Ghost,
So I make an idle boast;
Jesus of the twice-turned cheek,
Lamb of God, although I speak
With my mouth thus, in my heart
Do I play a double part.
Ever at Thy glowing altar

Must my heart grow sick and falter,
Wishing He I served were black,
Thinking then it would not lack
Precedent of pain to guide it,
Let who would or might deride it;
Surely then this flesh would know
Yours had borne a kindred woe.
Lord, I fashion dark gods, too,
Daring even to give You
Dark despairing features where,
Crowned with dark rebellious hair,
Patience wavers just so much as
Mortal grief compels, while touches
Quick and hot, of anger, rise
To smitten cheek and weary eyes.
Lord, forgive me if my need
Sometimes shapes a human creed.
All day long and all night through,
One thing only must I do:
Quench my pride and cool my blood,
Lest I perish in the flood.
Lest a hidden ember set
Timber that I thought was wet
Burning like the driest flax,
Melting like the merest wax,
Lest the grave restore its dead.
Not yet has my heart or head
In the least way realized
They and I are civilized.

"Heritage" by Countee Cullen from *Color*. Published by Arno Press and *New York Times*, 1969. Copyright 1925 by Harper & Brothers, copyright renewed 1953 by Ida M. Cullen. Reprinted by permission of GRM Associates, Inc.

LANGSTON HUGHES

I, Too, Sing America

I, too, sing America
I am the darker brother.
They send me to eat in the kitchen
When company comes,
But I laugh,
And eat well,
And grow strong.

Tomorrow,
I'll be at the table
When company comes.
Nobody'll dare
Say to me,
"Eat in the kitchen,"
Then.

Besides,
They'll see how beautiful I am
And be ashamed—

I, too, am America.

LANGSTON HUGHES

The Negro Speaks of Rivers

I've known rivers:
I've known rivers ancient as the world and older than the
 flow of human blood in human veins.
My soul has grown deep like the rivers.

I bathed in the Euphrates when dawns were young.
I built my hut near the Congo and it lulled me to sleep.
I looked upon the Nile and raised the pyramids above it.

I heard the singing of the Mississippi when Abe Lincoln
 went down to New Orleans, and I've seen its
 muddy bosom turn all golden in the sunset.

I've known rivers:
Ancient, dusky rivers.

My soul has grown deep like rivers.

"I Too Sing America" and "The Negro Speaks of Rivers" by Langston
Hughes from *The Collected Poems of Langston Hughes.* Copyright © 1994 by
the Estate of Langston Hughes. Used by permission of Alfred A. Knopf, a
division of Random House, Inc.

HELENE JOHNSON
BOTTLED (1907)

Published in Countee Cullen's Caroling Dusk *(1927), this bitter
poem against stereotyping uses racial epithets like "darky" and
"shine" to drive home its point.*

Upstairs on the third floor
Of the 135th Street library
In Harlem, I saw a little
Bottle of sand, brown sand
Just like the kids make pies
Out of down at the beach.
But the label said: "This Sand was taken from the Sahara
 desert."
Imagine that! The Sahara desert!
Some bozo's been all the way to Africa to get some sand.

And yesterday on Seventh Avenue
I saw a darky dressed fit to kill
In yellow gloves and swallow tail coat
And swirling a cane. And everyone
Was laughing at him. Me too,
At first, till I saw his face
When he stopped to hear a
Organ grinder grind out some jazz.
Boy! You should a seen that darky's face!
It just shone. Gee, he was happy!
And he began to dance. No
Charleston or Black Bottom for him.
No sir. He danced just as dignified
And slow. No, not slow either.
Dignified and *proud!* You couldn't
Call it slow, not with all the
Cuttin' up he did. You would a died to see him.

The crowd kept yellin' but he didn't hear,
Just kept on dancin' and twirlin' that cane
And yellin' out loud every once in a while.
I know the crowd thought he was coo-coo,
But say, I was where I could see his face,
And somehow, I could see him dancin' in a jungle,
A real honest-to-cripe-jungle, and he wouldn't have on
 them
Trick clothes—those yaller shoes and yaller gloves
And swallow tail coat. He wouldn't have on nothing.
And he wouldn't be carrying no cane.
He'd be carrying a spear with a sharp fine point
Like the bayonets we had "over there."
And the end of it would be dipped in some kind of
Hoo-doo poison. And he'd be dancin' black and naked
 and gleaming.
And he's have rings in his ears and on his nose
And bracelets and necklaces of elephants' teeth.
Gee, I bet he'd be beautiful then all right.
No one could laugh at him then, I bet.
Say! that man that took that sand from the Sahara desert
And put it in a little bottle on a shelf in the library,

That's what they done to this shine, ain't it? Bottled him.
Trick shoes, trick coat, trick cane, trick everything—all
 glass—
But inside—
Gee, that poor shine!

"Bottled" by Helene Johnson (1907) in *Caroling Dusk* by Countee Cullen.
Copyright 1927 by Harper & Brothers; copyright renewed 1955 by Ida M.
Cullen. Reprinted by permission of GRM Associates, Inc., Agents for the
Estate of Ida M. Cullen.

JAMES JOYCE
from the opening of ULYSSES

*The great novel of modernism opens with echoes of Catholic reli-
gious services and an introduction of Stephen Dedalus who bears
an "absurd name," which is more Greek than Irish. Dedalus had
previously appeared in* Portrait of the Artist as a Young Man
*and represents the experiences of Joyce himself as he grew up in
turn-of-the-century Dublin.*

*To get some sense of Joyce's style and technique one must read
carefully and slowly as he weaves together conversation, allusions
to the city of Dublin, fragments of songs, recollections of family
life, and the theme of searching in this great retelling of the ancient
myth of Ulysses.*

Stately, plump Buck Mulligan came from the stairhead, bear-
ing a bowl of lather on which a mirror and a razor lay
crossed. A yellow dressing gown, ungirdled, was sustained
gently behind him by the mild morning air. He held the
bowl aloft and intoned:
 —*Introibo ad altare Dei.*
 Halted, he peered down the dark winding stairs and
called up coarsely:
 —Come up, Kinch. Come up, you fearful jesuit.
 Solemnly he came forward and mounted the round gun-
rest. He faced about and blessed gravely thrice the tower,
the surrounding country and the awaking mountains. Then,
catching sight of Stephen Dedalus, he bent toward him and
made rapid crosses in the air, gurgling in this throat and
shaking his head. Stephen Dedalus, displeased and sleepy,
leaned his arms on the top of the staircase and looked coldly
at the shaking gurgling face that blessed him, equine in its
length, and at the light untonsured hair, grained and hued
like pale oak.
 Buck Mulligan peeped an instant under the mirror and
then covered the bowl smartly.
 —Back to barracks, he said sternly.
 He added in a preacher's tone:
 —For this. O dearly beloved, is the genuine Christine:
body and soul and blood and ouns. Slow music, please. Shut
your eyes, gents. One moment. A little trouble about those
white corpuscles. Silence, all.
 He peered sideways up and gave a long low whistle of
call, then paused awhile in rapt attention, his even white
teeth glistening here and there with gold points. Chrysosto-
mos. Two strong shrill whistles answered through the calm.
 —Thanks, old chap, he cried briskly. That will do nicely.
Switch off the current, will you?
 He skipped off the gunrest and looked gravely at his
watcher, gathering about his legs the loose folds of his
gown. The plump shadowed face and sullen oval jowl re-
called a prelate, patron of arts in the Middle Ages. A pleas-
ant smile broke quietly over his lips.
 —The mockery of it, he said gaily. Your absurd name, an
ancient Greek.
 He pointed his finger in friendly jest and went over to
the parapet, laughing to himself. Stephen Dedalus stepped
up, followed him wearily halfway and sat down on the edge

of the gunrest, watching him still as he propped his mirror on the parapet, dipped the brush in the bowl and lathered cheeks and neck.

Buck Mulligan's gay voice went on.

—My name is absurd too: Malachi Mulligan, two dactyls. But it has a Hellenic ring, hasn't it? Tripping and sunny like the buck himself. We must go to Athens. Will you come if I can get the aunt to fork out twenty quid?

He laid the brush aside and, laughing with delight, cried:

—Will he come? The jejune jesuit.

Ceasing, he began to shave with care.

—Tell me, Mulligan, Stephen said quietly.

—Yes, my love?

—How long is Haines going to stay in this tower?

Buck Mulligan showed a shaven cheek over his right shoulder.

—God, isn't he dreadful? he said frankly. A ponderous Saxon. He thinks you're not a gentleman. God, these bloody English. Bursting with money and indigestion. Because he comes from Oxford. You know, Dedalus, you have the real Oxford manner. He can't make you out. O, my name for you is the best: Kinch, the knifeblade.

He shaved warily over his chin.

—He was raving all night about a black panther, Stephen said. Where is his guncase?

—A woeful lunatic, Mulligan said. Were you in a funk?

—I was, Stephen said with energy and growing fear. Out here in the dark with a man I don't know raving and moaning to himself about shooting a black panther. You saved men from drowning. I'm not a hero, however. If he stays on here I am off.

Buck Mulligan frowned at the lather on his razorblade. He hopped down from his perch and began to search his trouser pockets hastily.

—Scutter, he cried thickly.

He came over to the gunrest and, thrusting a hand into Stephen's upper pocket, said:

—Lend us a loan of your noserag to wipe my razor.

Stephen suffered him to pull out and hold up on show by its corner a dirty crumpled handkerchief. Buck Mulligan wiped the razorblade neatly. Then, gazing over the handkerchief, he said:

—The bard's noserag. A new art color for our Irish poets: snotgreen. You can almost taste it, can't you?

He mounted to the parapet again and gazed out over Dublin bay, his fair oakpale hair stirring slightly.

—God, he said quietly; Isn't the sea what Algy calls it: a gray sweet mother? The snotgreen sea. The scrotumtightening sea. *Epi oinopa ponton.* Ah, Dedalus, the Greeks. I must teach you. You must read them in the original. *Thalatta! Thalatta!* She is our great sweet mother. Come and look.

Stephen stood up and went over to the parapet. Leaning on it he looked down on the water and on the mailboat clearing the harbor mouth of Kingstown.

—Our mighty mother, Buck Mulligan said.

He turned abruptly his great searching eyes from the sea to Stephen's face.

—The aunt thinks you killed your mother, he said. That's why she won't let me have anything to do with you.

—Someone killed her, Stephen said gloomily.

—You could have knelt down, damn it, Kinch, when your dying mother asked you, Buck Mulligan said. I'm hyperborean as much as you. But to think of your mother begging you with her last breath to kneel down and pray for her. And you refused. There is something sinister in you. . .

He broke off and lathered again lightly his farther cheek. A tolerant smile curled his lips.

—But a lovely mummer, he murmured to himself. Kinch, the loveliest mummer of them all.

He shaved evenly and with care, in silence, seriously.

Stephen, an elbow rested on the jagged granite, leaned his palm against his brow and gazed at the fraying edge of his shiny black coatsleeve. Pain, that was not yet the pain of love, fretted his heart. Silently, in a dream she had come to him after her death, her wasted body within its loose brown graveclothes giving off an odor of wax and rosewood, her breath, that had bent upon him, mute, reproachful, a faint odor of wetted ashes. Across the threadbare cuffedge he saw the sea hailed as a great sweet mother by the wellfed voice beside him. The ring of bay and skyline held a dull green mass of liquid. A bowl of white china had stood beside her deathbed holding the green sluggish bile which she had torn up from her rotting liver by fits of loud groaning vomiting.

Buck Mulligan wiped again his razorblade.

—Ah, poor dogsbody, he said in a kind voice. I must give you a shirt and a few noserags. How are the secondhand breeks?

—They fit well enough, Stephen answered.

Buck Mulligan attacked the hollow beneath his underlip.

—The mockery of it, he said contentedly, secondleg they should be. God knows what poxy bowsy left them off. I have a lovely pair with a hair stripe, gray. You'll look spiffing in them. I'm not joking, Kinch. You look damn well when you're dressed.

—Thanks, Stephen said. I can't wear them if they are gray.

—He can't wear them, Buck Mulligan told his face in the mirror. Etiquette is etiquette. He kills his mother but he can't wear gray trousers.

He folded his razor neatly and with stroking palps of fingers felt the smooth skin.

Stephen turned his gaze from the sea and to the plump face with its smokeblue mobile eyes.

—That fellow I was with in the Ship last night, said Buck Mulligan, says you have g. p. i. He's up in Dottyville with Conolly Norman. General paralysis of the insane.

He swept the mirror a half circle in the air to flash the tidings abroad in sunlight now radiant on the sea. His curling shaven lips laughed and the edges of his white glittering teeth. Laughter seized all his strong wellknit trunk.

—Look at yourself, he said, you dreadful bard.

Stephen bent forward and peered at the mirror held out to him, cleft by a crooked crack, hair on end. As he and others see me. Who chose this face for me? This dogsbody to rid of vermin. It asks me too.

—I pinched it out of the skivvy's room, Buck Mulligan said. It does her all right. The aunt always keeps plainlooking servants for Malachi. Lead him not into temptation. And her name is Ursula.

Laughing again, he brought the mirror away from Stephen's peering eyes.

—The rage of Caliban at not seeing his face in a mirror, he said. If Wilde were only alive to see you.

Drawing back and pointing, Stephen said with bitterness:

—It is a symbol of Irish art. The cracked lookingglass of a servant.

Buck Mulligan suddenly linked his arm in Stephen's and walked with him round the tower, his razor and mirror clacking in the pocket where he had thrust them.

—It's not fair to tease you like that, Kinch, is it? he said kindly. God knows you have more spirit than any of them.

Parried again. He fears the lancet of my art as I fear that of his. The cold steelpen.

—Cracked lookingglass of a servant. Tell that to the oxy chap downstairs and touch him for a guinea. He's stinking with money and thinks you're not a gentleman. His old felow made his tin by selling jalap to Zulus or some bloody swindle or other. God, Kinch, if you and I could only work together we might do something for the island. Hellenize it.

Cranly's arm. His arm.

—And to think of your having to beg from these swine. I'm the only one that knows what you are. Why don't you trust me more? What have you up your nose against me? Is it Haines? If he makes any noise here I'll bring down Seymour and we'll give him a ragging worse than they gave Clive Kempthorpe.

Young shouts of moneyed voices in Clive Kempthorpe's rooms. Palefaces: they hold their ribs with laughter, one clasping another. O, I shall expire! Break the news to her gently, Aubrey! I shall die! With slit ribbons of his shirt whipping the air he hops and hobbles round the table, with trousers down at heels, chased by Ades of Magdalen with the tailor's shears. A scared calf's face gilded with marmalade. I don't want to be debagged! Don't you play the giddy ox with me!

Shouts from the open window startling evening in the quadrangle. A deaf gardener, aproned, masked with Matthew Arnold's face, pushes his mower on the sombre lawn watching narrowly the dancing motes of grasshalms.

To ourselves . . . new paganism . . . omphalos.

—Let him stay, Stephen said. There's nothing wrong with him except at night.

—Then what is it? Buck Mulligan asked impatiently. Cough it up. I'm quite frank with you. What have you against me now?

They halted, looking toward the blunt cape of Bray Head that lay on the water like the snout of a sleeping whale. Stephen freed his arm quietly.

—Do you wish me to tell you? he asked.

—Yes, what is it? Buck Mulligan answered. I don't remember anything.

He looked in Stephen's face as he spoke. A light wind passed his brow, fanning softly his fair uncombed hair and stirring silver points of anxiety in his eyes.

Stephen, depressed by his own voice, said:

—Do you remember the first day I went to your house after my mother's death?

Buck Mulligan frowned quickly and said:

—What? Where? I can't remember anything. I remember only ideas and sensations. Why? What happened in the name of God?

—You were making tea, Stephen said, and I went across the landing to get more hot water. Your mother and some visitor came out of the drawingroom. She asked you who was in your room.

—Yes? Buck Mulligan said. What did I say? I forget.

—You said, Stephen answered, O, *it's only Dedalus whose mother is beastly dead.*

A flush which made him seem younger and more engaging rose to Buck Mulligan's cheek.

—Did I say that? he asked. Well? What harm is that?

He shook his constraint from him nervously.

—And what is death, he asked, your mother's or yours or my own? You saw only your mother die. I see them pop off every day in the Mater and Richmond and cut up into tripes in the dissecting room. It's a beastly thing and nothing else. It simply doesn't matter. You wouldn't kneel down to pray for your mother on her deathbed when she asked you. Why? Because you have the cursed jesuit strain in you, only it's injected the wrong way. To me it's all a mockery and beastly. Her cerebral lobes are not functioning. She calls the doctor Sir Peter Teazle and picks buttercups off the quilt. Humor her till it's over. You crossed her last wish in death and yet you sulk with me because I don't whinge like some hired mute from Lalouette's. Absurd! I suppose I did say it. I didn't mean to offend the memory of your mother.

He had spoken himself into boldness. Stephen, shielding the gaping wounds which the words had left in his heart, said very coldly:

—I am not thinking of the offence to my mother.

—Of what, then? Buck Mulligan asked.

—Of the offence to me, Stephen answered.

Buck Mulligan swung around on his heel.

—O, an impossible person! he exclaimed.

He walked off quickly round the parapet. Stephen stood at his post, gazing over the calm sea towards the headland. Sea and headland now grew dim. Pulses were beating in his eyes, veiling their sight, and he felt the fever of his cheeks.

A voice within the tower called loudly:

—Are you up there, Mulligan?

—I'm coming, Buck Mulligan answered.

He turned toward Stephen and said:

—Look at the sea. What does it care about offences? Chuck Loyola, Kinch, and come on down. The Sassenach wants his morning rashers.

His head halted again for a moment at the top of the staircase, level with the roof.

—Don't mope over it all day, he said. I'm inconsequent. Give up the moody brooding.

His head vanished but the drone of his descending voice boomed out of the stairhead:

And no more turn aside and brood
Upon love's bitter mystery
For Fergus rules the brazen cars.

Woodshadows floated silently by through the morning peace from the stairhead seaward where he gazed. Inshore and farther out the mirror of water whitened, spurned by lightshod hurrying feet. White breast of the dim sea. The twining stresses, two by two. A hand plucking the harpstrings merging their twining chords. Wavewhite wedded words shimmering on the dim tide.

A cloud began to cover the sun slowly, shadowing the bay in deeper green. It lay behind him, a bowl of bitter waters. Fergus' song: I sang it alone in the house, holding down the long dark chords. Her door was open: she wanted to hear my music. Silent with awe and pity I went to her bedside. She was crying in her wretched bed. For those words, Stephen: love's bitter mystery.

Where now?

Her secrets: old feather fans, tasseled dancecards, powdered with musk, a gaud of amber beads in her locked drawer. A birdcage hung in the sunny window of her house when she was a girl. She heard old Royce sing in the pantomime of Turko the terrible and laughed with others when he sang:

I am the boy
That can enjoy
Invisibility.

Phantasmal mirth, folded away: muskperfumed.

And no more turn aside and brood

Folded away in the memory of nature with her toys. Memories beset his brooding brain. Her glass of water from the kitchen tap when she had approached the sacrament. A cored apple, filled with brown sugar, roasting for her at the hob on a dark autumn evening. Her shapely fingernails reddened by the blood of squashed lice from the children's shirts.

In a dream, silently, she had come to him, her wasted body within its loose graveclothes giving off an odor of wax and rosewood, her breath bent over him with mute secret words, a faint odor of wetted ashes.

Her glazing eyes, staring out of death, to shake and bend my soul. On me alone. The ghostcandle to light her agony. Ghostly light on the tortured face. Her hoarse loud breath rattling in horror, while all prayed on their knees. Her eyes

on me to strike me down. *Liliata rutilantium te confessorum turma circumdet: iubilantium te virginum chorus excipiat.*

Ghoul! Chewer of corpses!

No mother. Let me be and let me live.

—Kinch ahoy!

Buck Mulligan's voice sang from within the tower. It came nearer up the staircase, calling again. Stephen, still trembling at his soul's cry, heard warm running sunlight and in the air behind him friendly words.

—Dedalus, come down, like a good mosey. Breakfast is ready. Haines is apologizing for waking us last night. It's all right.

—I'm coming, Stephen said, turning.

—Do, for Jesus' sake, Buck Mulligan said. For my sake and for all our sakes.

His head disappeared and reappeared.

—I told him your symbol of Irish art. He says it's very clever. Touch him for a quid, will you? A guinea, I mean.

—I get paid this morning, Stephen said.

—The school kip? Buck Mulligan said. How much? Four quid? Lend us one.

—If you want it, Stephen said.

—Four shining sovereigns, Buck Mulligan cried with delight. We'll have a glorious drunk to astonish the druidy druids. For omnipotent sovereigns.

He flung up his hands and tramped down the stone stairs, singing out of tune with a Cockney accent:

O, won't we have a merry time
Drinking whisky, beer and wine,
On coronation,
Coronation day?
O, won't we have a merry time
On coronation day?

Warm sunshine merrying over the sea. The nickel shavingbowl shone, forgotten, on the parapet. Why should I bring it down? Or leave it there all day, forgotten friendship?

He went over to it, held it in his hands awhile, feeling its coolness, smelling the clammy slaver of the lather in which the brush was stuck. So I carried the boat of incense then at Clongowes. I am another now and yet the same. A servant too. A server of a servant.

In the gloomy domed livingroom of the tower Buck Mulligan's gowned form moved briskly about the hearth to and fro, hiding and revealing its yellow glow. Two shafts of soft daylight fell across the flagged floor from the high barbicans: and at the meeting of their rays a cloud of coalsmoke and fumes of fried grease floated, turning.

—We'll be choked, Buck Mulligan said. Haines, open that door, will you?

Stephen laid the shavingbowl on the locker. A tall figure rose from the hammock where it had been sitting, went to the doorway and pulled open the inner doors.

—Have you the key? a voice asked.

Dedalus has it, Buck Mulligan said. Janey Mack, I'm choked.

He howled without looking up from the fire:

—Kinch!

—It's in the lock, Stephen said, coming forward.

The key scraped round harshly twice and, when the heavy door had been set ajar, welcome light and bright air entered. Haines stood at the doorway, looking out. Stephen haled his upended valise to the table and sat down to wait. Buck Mulligan tossed the fry on to the dish beside him. Then he carried the dish and a large teapot over to the table, set them down heavily and sighed with relief.

—I'm melting, he said, as the candle remarked when . . . But hush. Not a word more on that subject. Kinch, wake up. Bread, butter, honey. Haines, come in. The grub is ready.

Bless us, O Lord, and these thy gifts. Where's the sugar? O, jay, there's no milk.

Stephen fetched the loaf and the pot of honey and the buttercooler from the locker. Buck Mulligan sat down in a sudden pet.

—What sort of a kip is this? he said. I told her to come after eight.

—We can drink it black, Stephen said. There's a lemon in the locker.

—O, damn you and your Paris fads, Buck Mulligan said. I want Sandycove milk.

Haines came in from the doorway and said quietly:

—That woman is coming up with the milk.

—The blessings of God on you, Buck Mulligan cried, jumping up from his chair. Sit down. Pour out the tea there. The sugar is in the bag. Here, I can't go fumbling at the damned eggs. He hacked through the fry on the dish and slapped it out on three plates, saying:

—*In nomine Patris et Filii et Spiritus Sancti.*

Haines sat down to pour out the tea.

—I'm giving you two lumps each, he said. But, I say, Mulligan, you do make strong tea, don't you?

Buck Mulligan, hewing thick slices from the loaf, said in an old woman's wheedling voice:

—When I makes tea I makes tea, as old mother Grogan said. And when I makes water I makes water.

—By Jove, it is tea, Haines said.

Buck Mulligan went on hewing and wheedling:

—*So I do, Mrs Cahill,* says she. *Begob, ma'am,* says Mrs Cahill, *God send you don't make them in the one pot.*

He lunged toward his messmates in turn a thick slice of bread, impaled on his knife.

—That's folk, he said very earnestly, for your book, Haines. Five lines of text and ten pages of notes about the folk and the fishgods of Dundrum. Printed by the weird sisters in the year of the big wind.

He turned to Stephen and asked in a fine puzzled voice, lifting his brows:

—Can you recall, brother, is mother Grogan's tea and water pot spoken of in the Mabinogion or is it in the Upanishads?

—I doubt it, said Stephen gravely.

—Do you now? Buck Mulligan said in the same tone. Your reasons, pray?

—I fancy, Stephen said as he ate, it did not exist in or out of the Mabinogion. Mother Grogan was, one imagines, a kinswoman of Mary Ann.

Buck Mulligan's face smiled with delight.

—Charming, he said in a finical sweet voice, showing his white teeth and blinking his eyes pleasantly. Do you think she was? Quite charming.

Then, suddenly overclouding all his features, he growled in a hoarsened rasping voice as he hewed again vigorously at the loaf:

—For old Mary Ann
She doesn't care a damn,
But, hising up her petticoats . . .

He crammed his mouth with fry and munched and droned.

The doorway was darkened by an entering form.

—The milk, sir.

—Come in, ma'am, Mulligan said. Kinch, get the jug.

An old woman came forward and stood by Stephen's elbow.

—That's a lovely morning, sir, she said. Glory be to God.

—To whom? Mulligan said, glancing at her. Ah, to be sure.

Stephen reached back and took the milkjug from the locker.

—The islanders, Mulligan said to Haines casually, speak frequently of the collector of prepuces.

—How much, sir? asked the old woman.

—A quart, Stephen said.

He watched her pour into the measure and thence into the jug rich white milk, not hers. Old shrunken paps. She poured again a measureful and a tilly. Old and secret she had entered from a morning world, maybe a messenger. She praised the goodness of the milk, pouring it out. Crouching by a patient cow at daybreak in the lush field, a witch on her toadstool, her wrinkled fingers quick at the squirting dugs. They lowed about her whom they knew, dewsilky cattle. Silk of the kine and poor old woman, names given her in old times. A wandering crone, lowly form of an immortal serving her conqueror and her gay betrayer, their common cuckquean, a messenger from the secret morning. To serve or to upbraid, whether he could not tell: but scorned to beg her favor.

—It is indeed, ma'am, Buck Mulligan said, pouring milk into their cups.

—Taste it, sir, she said.

He drank at her bidding.

—If we could only live on good food like that, he said to her somewhat loudly, we wouldn't have the country full of rotten teeth and rotten guts. Living in a bogswamp, eating cheap food and the streets paved with dust, horsedung and consumptives' spits.

—Are you a medical student, sir? the old woman asked.

—I am, ma'am, Buck Mulligan answered.

Stephen listened in scornful silence. She bows her old head to a voice that speaks to her loudly, her bonesetter, her medicineman; me she slights. To the voice that will shrive and oil for the grave all there is of her but her woman's unclean loins, of man's flesh made not in God's likeness, the serpent's prey. And to the loud voice that now bids her be silent with wondering unsteady eyes.

—Do you understand what he says? Stephen asked her.

—Is it French you are talking, sir? the old woman said to Haines.

Haines spoke to her again a longer speech, confidently.

—Irish, Buck Mulligan said. Is there Gaelic on you?

—I thought it was Irish, she said, by the sound of it. Are you from west, sir?

—I am an Englishman, Haines answered.

—He's English, Buck Mulligan said, and he thinks we ought to speak Irish in Ireland.

—Sure we ought to, the old woman said, and I'm ashamed I don't speak the language myself. I'm told it's a grand language by them that knows.

—Grand is no name for it, said Buck Mulligan. Wonderful entirely. Fill us out some more tea, Kinch. Would you like a cup, ma'am?

—No, thank you, sir, the old woman said, slipping the ring of the milkcan on her forearm and about to go.

Haines said to her:

—Have you your bill? We had better pay her, Mulligan, hadn't we?

Stephen filled the three cups.

—Bill, sir? she said, halting. Well, it's seven mornings a pint at twopence is seven twos is a shilling and twopence over and these three mornings a quart at fourpence is three quarts is a shilling and one and two is two and two, sir.

Buck Mulligan sighed and having filled his mouth with a crust thickly buttered on both sides, stretched forth his legs and began to search his trouser pockets.

—Pay up and look pleasant, Haines said to him smiling.

Stephen filled a third cup, a spoonful of tea coloring faintly the thick rich milk. Buck Mulligan brought up a florin, twisted it round in his fingers and cried:

—A miracle!

He passed it along the table toward the old woman, saying:

—Ask nothing more of me, sweet. All I can give you I give.

Stephen laid the coin in her uneager hand.

—We'll owe twopence, he said.

—Time enough, sir, she said, taking the coin. Time enough. Good morning, sir.

She curtseyed and went out, followed by Buck Mulligan's tender chant:

—*Heart of my heart, were it more,*
More would be laid at your feet.

He turned to Stephen and said:

—Seriously, Dedalus, I'm stony. Hurry out to your school kip and bring us back some money. Today the bards must drink and junket. Ireland expects that every man this day will do his duty.

—That reminds me, Haines said, rising, that I have to visit your national library today.

—Our swim first, Buck Mulligan said.

He turned to Stephen and asked blandly:

—Is this the day for your monthly wash, Kinch?

Then he said to Haines:

—The unclean bard makes a point of washing once a month.

—All Ireland is washed by the gulfstream, Stephen said as he let honey trickle over a slice of the loaf.

Haines from the corner where he was knotting easily a scarf about the loose collar of his tennis shirt spoke:

—I intend to make a collection of your sayings if you will let me.

Speaking to me. They wash and tub and scrub. Agenbite of inwit. Conscience. Yet here's a spot.

—That one about the cracked lookingglass of a servant being the symbol of Irish art is deuced good.

Buck Mulligan kicked Stephen's foot under the table and said with warmth of tone:

—Wait till you hear him on Hamlet, Haines.

—Well, I mean it, Haines said, still speaking to Stephen. I was just thinking of it when that poor old creature came in.

—Would I make money by it? Stephen asked.

Haines laughed and, as he took his soft gray hat from the holdfast of the hammock, said:

—I don't know, I'm sure.

He strolled out to the doorway. Buck Mulligan bent across to Stephen and said with coarse vigor:

—You put your hoof in it now. What did you say that for?

—Well? Stephen said. The problem is to get money. From whom? From the milkwoman or from him. It's a toss up, I think.

—I blow him out about you, Buck Mulligan said, and then you come along with your lousy leer and your gloomy jesuit jibes.

—I see little hope, Stephen said, from her or from him.

Buck Mulligan sighed tragically and laid his hand on Stephen's arm.

—From me, Kinch, he said.

In a suddenly changed tone he added:

—To tell you the God's truth I think you're right. Damn all else they are good for. Why don't you play them as I do? To hell with them all. Let us get out of the kip.

He stood up, gravely ungirdled and disrobed himself of his gown, saying resignedly:

—Mulligan is stripped of his garments.

He emptied his pockets on to the table.

—There's your snotrag, he said.

And putting on his stiff collar and rebellious tie, he spoke to them, chiding them, and to his dangling watchchain. His hands plunged and rummaged in his trunk while he called

for a clean handkerchief. Agenbite of inwit. God, we'll simply have to dress the character. I want puce gloves and green boots. Contradiction. Do I contradict myself? Very well then, I contradict myself. Mercurial Malachi. A limp black missile flew out of his talking hands.

—And there's your Latin quarter hat, he said.

Stephen picked it up and put it on. Haines called to them from the doorway:

—Are you coming, fellows?

—I'm ready, Buck Mulligan answered, going towards the door. Come out, Kinch. You have eaten all we left, I suppose. Resigned he passed out with grave words and gait, saying, wellnigh with sorrow:

—And going forth he met Butterly.

Stephen, taking his ashplant from its leaningplace, followed them out and, as they went down the ladder, pulled to the slow iron door and locked it. He put the huge key in his inner pocket.

At the foot of the ladder, Buck Mulligan asked:

—Did you bring the key?

—I have it, Stephen said, preceding them.

He walked on. Behind him he heard Buck Mulligan club with his heavy bathtowel the leader shoots of ferns or grasses.

—Down, sir. How dare you, sir? Haines asked.

—Do you pay rent for this tower?

—Twelve quid, Buck Mulligan said.

—To the secretary of state for war, Stephen added over his shoulder.

They halted while Haines surveyed the tower and said at last:

—Rather bleak in wintertime, I should say. Martello you call it?

—Billy Pitt had them built, Buck Mulligan said, when the French were on the sea. But ours is the *omphalos*.

—What is your idea of Hamlet? Haines asked Stephen.

—No, no, Buck Mulligan shouted in pain. I'm not equal to Thomas Aquinas and the fiftyfive reasons he has made to prop it up. Wait till I have a few pints in me first.

He turned to Stephen, saying as he pulled down neatly the peaks of his primrose waistcoat:

—You couldn't manage it under three pints, Kinch, could you?

—It has waited so long, Stephen said listlessly, it can wait longer.

—You pique my curiosity, Haines said amiably. Is it some paradox?

—Pooh! Buck Mulligan said. We have grown out of Wilde and paradoxes. It's quite simple. He proves by algebra that Hamlet's grandson is Shakespeare's grandfather and that he himself is the ghost of his own father.

—What? Haines said, beginning to point at Stephen. He himself?

Buck Mulligan slung his towel stolewise round his neck, and bending in loose laughter, said to Stephen's ear:

—O, shade of Kinch the elder! Japhet in search of a father!

—We're always tired in the morning, Stephen said to Haines. And it is rather long to tell.

Buck Mulligan, walking forward again, raised his hands.

—The sacred pint alone can unbind the tongue of Dedalus, he said.

—I mean to say, Haines explained to Stephen as they followed, this tower and these cliffs here remind me somehow of Elsinore. *That beetles o'er his base into the sea*, isn't it?

Buck Mulligan turned suddenly for an instant toward Stephen but did not speak. In the bright silent instant Stephen saw his own image in cheap dusty mourning between their gay attires.

—It's a wonderful tale, Haines said, bringing them to halt again.

Eyes, pale as the sea the wind had freshened, paler, firm and prudent. The seas' ruler, he gazed southward over the bay, empty save for the smokeplume of the mailboat, vague on the bright skyline, and a sail tacking by the Muglins.

—I read a theological interpretation of it somewhere, he said bemused. The Father and the Son idea. The Son striving to be atoned with the Father.

Buck Mulligan at once put on a blithe broadly smiling face. He looked at them, his wellshaped mouth open happily, his eyes, from which he had suddenly withdrawn all shrewd sense, blinking with mad gaiety. He moved a doll's head to and fro, the brims of his Panama hat quivering, and began to chant in a quiet happy foolish voice:

—*I'm the queerest young fellow that ever you heard.*
My mother's a jew, my father's a bird.
With Joseph the joiner I cannot agree,
So here's to disciples and Calvary.

He held up a forefinger of warning.

—*If anyone thinks that I amn't divine*
He'll get no free drinks when I'm making the wine
But have to drink water and wish it were plain
That I make when the wine becomes water again.

He tugged swiftly at Stephen's ashplant in farewell and, running forward to a brow of the cliff, fluttered his hands at his sides like fins or wings of one about to rise in the air, and chanted:

—*Goodbye, now, goodbye. Write down all I said*
And tell Tom, Dick and Harry I rose from the dead.
What's bred in the bone cannot fail me to fly
And Olivet's breezy . . . Goodbye, now, goodbye.

He capered before them down towards the fortyfoot hole, fluttering his winglike hands, leaping nimbly, Mercury's hat quivering in the fresh wind that bore back to them his brief birdlike cries.

Haines, who had been laughing guardedly, walked on beside Stephen and said:

—We oughtn't to laugh, I suppose. He's rather blasphemous. I'm not a believer myself, that is to say. Still his gaiety takes the harm out of it somehow, doesn't it? What did he call it? Joseph the Joiner?

—The ballad of Joking Jesus, Stephen answered.

—O, Haines said, you have heard it before?

—Three times a day, after meals, Stephen said drily.

—You're not a believer, are you? Haines asked. I mean, a believer in the narrow sense of the word. Creation from nothing and miracles and a personal God.

—There's only one sense of the word, it seems to me, Stephen said.

Haines stopped to take out a smooth silver case in which twinkled a green stone. He sprang it open with his thumb and offered it.

—Thank you, Stephen said, taking a cigarette.

Haines helped himself and snapped the case to. He put it back in his sidepocket and took from his waistcoatpocket a nickel tinderbox, sprang it open too, and having lit his cigarette, held the flaming spunk towards Stephen in the shell of his hands.

—Yes, of course, he said, as they went on again. Either you believe or you don't, isn't it? Personally I couldn't stomach that idea of a personal God. You don't stand for that, I suppose?

—You behold in me, Stephen said with grim displeasure, a horrible example of free thought.

He walked on, waiting to be spoken to, trailing his ashplant by his side. Its ferrule followed lightly on the path, squealing

at his heels. My familiar, after me, calling Steeeeeeeeeephen. A wavering line along the path. They will walk on it tonight, coming here in the dark. He wants that key. It is mine, I paid the rent. Now I eat his salt bread. Give him the key too. All. He will ask for it. That was in his eyes.

—After all, Haines began . . .

Stephen turned and saw that the cold gaze which had measured him was not all unkind.

—After all, I should think you are able to free yourself. You are your own master, it seems to me.

—I am the servant of two masters, Stephen said, an English and an Italian.

—Italian? Haines said.

A crazy queen, old and jealous. Kneel down before me.

—And a third, Stephen said, there is who wants me for odd jobs.

—Italian? Haines said again. What do you mean?

—The imperial British state, Stephen answered, his color rising, and the holy Roman catholic and apostolic church.

Haines detached from his underlip some fibers of tobacco before he spoke.

—I can quite understand that, he said calmly. An Irishman must think like that, I daresay. We feel in England that we have treated you rather unfairly. It seems history is to blame.

The proud potent titles clanged over Stephen's memory the triumph of their brazen bells: *et unam sanctam catholicam et apostolicam ecclesiam:* the slow growth and change of rite and dogma like his own rare thoughts, a chemistry of stars. Symbol of the apostles in the mass for pope Marcellus, the voices blended, singing alone loud in affirmation: and behind their chant the vigilant angel of the church militant disarmed and menaced her heresiarchs. A horde of heresies fleeing with mitres awry: Photius and the brood of mockers of whom Mulligan was one, and Arius, warring his life long upon the consubstantiality of the Son with the Father, and Valentine, spurning Christ's terrene body, and the subtle African heresiarch Sabellius who held that the Father was Himself His own Son. Words Mulligan had spoken a moment since in mockery to the stranger. Idle mockery. The void awaits surely all them that weave the wind: a menace, a disarming and a worsting from those embattled angels of the church, Michael's host, who defend her ever in the hour of conflict with their lances and their shields.

Hear, hear. Prolonged applause. *Zut! Nom de Dieu!*

—Of course I'm a Britisher, Haines' voice said, and I feel as one. I don't want to see my country fall into the hands of German jews either. That's our national problem, I'm afraid, just now.

Two men stood at the verge of the cliff, watching: businessman, boatman.

—She's making for Bullock harbor.

The boatman nodded toward the north of the bay with some disdain.

—There's five fathoms out there, he said. It'll be swept up that way when the tide comes in about one. It's nine days today.

The man that was drowned. A sail veering about the blank bay waiting for a swollen bundle to bog up, roll over to the sun a puffy face, salt white. Here I am.

They followed the winding path down to the creek. Buck Mulligan stood on a stone, in shirtsleeves, his unclipped tie rippling over his shoulder. A young man clinging to a spur of rock near him moved slowly frogwise his green legs in the deep jelly of the water.

—Is the brother with you, Malachi?

—Down in Westmeath. With the Bannons.

—Still there? I got a card from Bannon. Says he found a sweet young thing down there. Photo girl he calls her.

—Snapshot, eh? Brief exposure.

Buck Mulligan sat down to unlace his boots. An elderly man shot up near the spur of rock a blowing red face. He scrambled up by the stones, water glistening on his pate and on its garland of gray hair, water rilling over his chest and paunch and spilling jets out of his black sagging loincloth.

Buck Mulligan made way for him to scramble past and, glancing at Haines and Stephen, crossed himself piously with his thumbnail at brow and lips and breastbone.

—Seymour's back in town, the young man said, grasping again his spur of rock. Chucked medicine and going in for the army.

—Ah, go to God, Buck Mulligan said.

—Going over next week to stew. You know that red Carlisle girl, Lily?

—Yes.

—Spooning with him last night on the pier. The father is rotto with money.

—Is she up the pole?

—Better ask Seymour that.

—Seymour a bleeding officer, Buck Mulligan said.

He nodded to himself as he drew off his trousers and stood up, saying tritely:

—Redheaded women buck like goats.

He broke off in alarm, feeling his side under his flapping shirt.

—My twelfth rib is gone, he cried. I'm the *Uebermensch.* Toothless Kinch and I, the supermen.

He struggled out of his shirt and flung it behind him to where his clothes lay.

—Are you going in here, Malachi?

—Yes. Make room in the bed.

The young man shoved himself backward through the water and reached the middle of the creek in two long clean strokes. Haines sat down on a stone, smoking.

—Are you not coming in? Buck Mulligan asked.

—Later on, Haines said. Not on my breakfast.

Stephen turned away.

—I'm going, Mulligan, he said.

—Give us that key, Kinch, Buck Mulligan said, to keep my chemise flat.

Stephen handed him the key. Buck Mulligan laid it across his heaped clothes.

—And twopence, he said, for a pint. Throw it there.

Stephen threw two pennies on the soft heap. Dressing, undressing. Buck Mulligan erect, with joined hands before him, said solemnly:

—He who stealeth from the poor lendeth to the Lord. Thus spake Zarathustra.

His plump body plunged.

—We'll see you again, Haines said, turning as Stephen walked up the path and smiling at wild Irish.

Horn of a bull, hoof of a horse, smile of a Saxon.

—The Ship, Buck Mulligan cried. Half twelve.

—Good, Stephen said.

He walked along the upwardcurving path.

Liliata rutilantium.
Turma circumdet.
Iubilantium te virginum.

The priest's gray nimbus in a niche where he dressed discreetly. I will not sleep here tonight. Home also I cannot go.

A voice, sweettoned and sustained, called to him from the sea. Turning the curve he waved his hand. It called again. A sleek brown head, a seal's, far out on the water, round.

Usurper.

FRANZ KAFKA
from THE TRIAL

This parable, told to Joseph K. in a cathedral, is meant to be an enigma and a puzzle. As a parable it mirrors the confusion of the hero, who is pursued by the Court for crimes he cannot identify and for a guilt he recognizes but whose source he cannot name. Pay attention to the nightmarish quality of both the setting and the parable itself.

Before the Law

And K. certainly would not have noticed it had not a lighted lamp been fixed above it, the usual sign that a sermon was going to be preached. Was a sermon going to be delivered now? In the empty church? K. peered down at the small flight of steps which led upward to the pulpit, hugging the pillar as it went, so narrow that it looked like an ornamental addition to the pillar rather than a stairway for human beings. But at the foot of it, K. smiled in astonishment, there actually stood a priest ready to ascend, with his hand on the balustrade and his eyes fixed on K. The priest gave a little nod and K. crossed himself and bowed, as he ought to have done earlier. The priest swung himself lightly on to the stairway and mounted into the pulpit with short, quick steps. Was he really going to preach a sermon? Perhaps the verger was not such an imbecile after all and had been trying to urge K. toward the preacher, a highly necessary action in that deserted building. But somewhere or other there was an old woman before an image of the Madonna; she ought to be there too. And if it were going to be a sermon, why was it not introduced by the organ? But the organ remained silent, its tall pipes looming faintly in the darkness.

K. wondered whether this was not the time to remove himself quickly; if he did not go now he would have no chance of doing so during the sermon, he would have to stay as long as it lasted, he was already behindhand in the office and was no longer obliged to wait for the Italian; he looked at his watch, it was eleven o'clock. But was there really going to be a sermon? Could K. represent the congregation all by himself? What if he had been a stranger merely visiting the church? That was more or less his position. It was absurd to think that a sermon was going to be preached at eleven in the morning on a weekday, in such dreadful weather. The priest—he was beyond doubt a priest, a young man with a smooth, dark face—was obviously mounting the pulpit simply to turn out the lamp, which had been lit by mistake.

It was not so, however; the priest after examining the lamp screwed it higher instead, then turned slowly toward the balustrade and gripped the angular edge with both hands. He stood like that for a while, looking around him without moving his head. K. had retreated a good distance and was leaning his elbows on the foremost pew. Without knowing exactly where the verger was stationed, he was vaguely aware of the old man's bent back, peacefully at rest as if his task had been fulfilled. What stillness there was now in the Cathedral! Yet K. had to violate it, for he was not minded to stay; if it were this priest's duty to preach a sermon at a certain hour regardless of circumstances, let him do it, he could manage it without K.'s support, just as K.'s presence would certainly not contribute to its effectiveness. So he began slowly to move off, feeling his way along the pew on tiptoe until he was in the broad center aisle, where he advanced undisturbed except for the ringing noise that his lightest footstep made on the stone flags and the echoes that sounded from the vaulted roof faintly but continuously, in manifold and regular progression. K. felt a little forlorn as he advanced, a solitary figure between the rows of empty seats, perhaps with the priest's eyes following him; and the size of the Cathedral struck him as bordering on the limit of what human beings could bear. When he came to the seat where he had left the album he simply snatched the book up without stopping and took it with him. He had almost passed the last of the pews and was emerging into the open space between himself and the doorway when he heard the priest lifting up his voice. A resonant, well-trained voice. How it rolled through the expectant Cathedral! But it was no congregation the priest was addressing, the words were unambiguous and inescapable, he was calling out: "Joseph K.!"

K. paused and stared at the ground before him. For the moment he was still free, he could continue on his way and vanish through one of the small, dark, wooden doors that faced him at no great distance. It would simply indicate that he had not understood the call, or that he had understood it and did not care. But if he were to turn round he would be caught, for that would amount to an admission that he had understood it very well, that he was really the person addressed, and that he was ready to obey. Had the priest called his name a second time K. would certainly have gone on, but as everything remained silent, though he stood waiting for a long time, he could not help turning his head a little just to see what the priest was doing. The priest was standing calmly in the pulpit as before, yet it was obvious that he had observed K.'s turn of the head. It would have been like a childish game of hide-and-seek if K. had not turned right round to face him. He did so, and the priest beckoned him to come nearer. Since there was now no need for evasion, K. hurried back—he was both curious and eager to shorten the interview—with long flying strides toward the pulpit. At the first rows of seats he halted, but the priest seemed to think the distance still too great; he stretched out an arm and pointed with sharply bent forefinger to a spot immediately before the pulpit. K. followed this direction too; when he stood on the spot indicated he had to bend his head far back to see the priest at all. "You are Joseph K.," said the priest, lifting one hand from the balustrade in a vague gesture. "Yes," said K., thinking how frankly he used to give his name and what a burden it had recently become to him; nowadays people he had never seen before seemed to know his name. How pleasant it was to have to introduce oneself before being recognized! "You are an accused man," said the priest in a very low voice. "Yes," said K., "so I have been informed," "Then you are the man I seek," said the priest. "I am the prison chaplain." "Indeed," said K. "I had you summoned here," said the priest, "to have a talk with you." "I didn't know that," said K. "I came here to show an Italian round the Cathedral." "That is beside the point," said the priest. "What is that in your hand? Is it a prayer book?" "No," replied K., "it is an album of sights worth seeing in the town." "Lay it down," said the priest. K. threw it away so violently that it flew open and slid some way along the floor with disheveled leaves. "Do you know that your case is going badly?" asked the priest. "I have that idea myself," said K. "I've done what I could, but without any success so far. Of course, my petition isn't finished yet." "How do you think it will end?" asked the priest. "At first I thought it must turn out well," said K. "but now I frequently have my doubts. I don't know how it will end. Do you?" "No," said the priest, "but I fear it will end badly. You are held to be guilty. Your case will perhaps never get beyond a lower Court. Your guilt is supposed, for the present, at least, to have been proved." "But I am not guilty," said K.; "it's a mistake. And, if it comes to that, how can any man be called guilty? We are all simply men here, one as much as the other." "That is true," said the priest, "but that's how all

guilty men talk." "Are you prejudiced against me too?" asked K. "I have no prejudices against you," said the priest. "Thank you," said K.; "but all the others who are concerned in these proceedings are prejudiced against me. They are influencing outsiders too. My position is becoming more and more difficult." "You are misinterpreting the facts of the case," said the priest. "The verdict is not suddenly arrived at, the proceedings only gradually merge into the verdict." "So that's how it is," said K., letting his head sink. "What is the next step you propose to take in the matter?" asked the priest. "I'm going to get more help," said K., looking up again to see how the priest took his statement. "There are several possibilities I haven't explored yet." "You cast about too much for outside help," said the priest disapprovingly, "especially from women. Don't you see that it isn't the right kind of help?" "In some cases, even in many I could agree with you," said K., "but not always. Women have great influence. If I could move some women I know to join forces in working for me, I couldn't help winning through. Especially before this Court, which consists almost entirely of petticoat-hunters. Let the Examining Magistrate see a woman in the distance and he knocks down his desk and the defendant in his eagerness to get at her." The priest leaned over the balustrade, apparently feeling for the first time the oppressiveness of the canopy above his head. What fearful weather there must be outside! There was no longer even a murky daylight; black night had set in. All the stained glass in the great window could not illumine the darkness of the wall with one solitary glimmer of light. And at this very moment the verger began to put out the candles on the high altar, one after another. "Are you angry with me?" asked K. of the priest. "It may be that you don't know the nature of the Court you are serving." He got no answer. "These are only my personal experiences," said K. There was still no answer from above. "I wasn't trying to insult you," said K. And at that the priest shrieked from the pulpit: "Can't you see one pace before you?" It was an angry cry, but at the same time sounded like the unwary shriek of one who sees another fall and is startled out of his senses.

Both were now silent for a long time. In the prevailing darkness the priest certainly could not make out K.'s features, while K. saw him distinctly by the light of the small lamp. Why did he not come down from the pulpit? He had not preached a sermon, he had only given K. some information which would be likely to harm him rather than help him when he came to consider it. Yet the priest's good intentions seemed to K. beyond question, it was not impossible that they could come to some agreement if the man would only quit his pulpit, it was not impossible that K. could obtain decisive and acceptable counsel from him which might, for instance, point the way, not toward some influential manipulation of the case, but toward a circumvention of it, breaking away from it altogether, a mode of living completely outside the jurisdiction of the Court. This possibility must exist, K. had of late given much thought to it. And should the priest know of such a possibility, he might perhaps impart his knowledge if he were appealed to, although he himself belonged to the Court and as soon as he heard the Court impugned had forgotten his own gentle nature so far as to shout K. down.

"Won't you come down here?" said K. "You haven't got to preach a sermon. Come down beside me." "I can come down now," said the priest, perhaps repenting of his outburst. While he detached the lamp from its hook he said: "I had to speak to you first from a distance. Otherwise I am too easily influenced and tend to forget my duty."

K. waited for him at the foot of the steps. The priest stretched out his hand to K. while he was still on the way down from a higher level. "Have you a little time for me?"

asked K. "As much time as you need," said the priest, giving K. the small lamp to carry. Even close at hand he still wore a certain air of solemnity. "You are very good to me," said K. They paced side by side up and down the dusky aisle. "But you are an exception among those who belong to the Court. I have more trust in you than in any of the others, though I know many of them. With you I can speak openly." "Don't be deluded," said the priest. "How am I being deluded?" asked K. "You are deluding yourself about the Court," said the priest. "In the writings which preface the Law that particular delusion is described thus: before the Law stands a doorkeeper. To this doorkeeper there comes a man from the country who begs for admittance to the Law. But the doorkeeper says that he cannot admit the man at the moment. The man, on reflection, asks if he will be allowed, then, to enter later. 'It is possible,' answers the doorkeeper, 'but not at this moment.' Since the door leading into the Law stands open as usual and the doorkeeper steps to one side, the man bends down to peer through the entrance. When the doorkeeper sees that, he laughs and says: 'If you are so strongly tempted, try to get in without my permission. But note that I am powerful. And I am only the lowest doorkeeper. From hall to hall, keepers stand at every door, one more powerful than the other. And the sight of the third man is already more than even I can stand.' These are difficulties which the man from the country has not expected to meet, the Law, he thinks, should be accessible to every man and at all times, but when he looks more closely at the doorkeeper in his furred robe, with his huge pointed nose and long thin Tartar beard, he decides that he had better wait until he gets permission to enter. The doorkeeper gives him a stool and lets him sit down at the side of the door. There he sits waiting for days and years. He makes many attempts to be allowed in and wearies the doorkeeper with his importunity. The doorkeeper often engages him in brief conversation, asking him about his home and about other matters, but the questions are put quite impersonally, as great men put questions, and always conclude with the statement that the man cannot be allowed to enter yet. The man, who has equipped himself with many things for his journey, parts with all he has, however valuable, in the hope of bribing the doorkeeper. The doorkeeper accepts it all, saying, however, as he takes each gift: 'I take this only to keep you from feeling that you have left something undone.' During all these long years the man watches the doorkeeper almost incessantly. He forgets about the other doorkeepers, and this one seems to him the only barrier between himself and the Law. In the first years he curses his evil fate aloud; later, as he grows old, he only mutters to himself. He grows childish, and since in his prolonged study of the doorkeeper he has learned to know even the fleas in his fur collar, he begs the very fleas to help him and to persuade the doorkeeper to change his mind. Finally his eyes grow dim and he does not know whether the world is really darkening around him or whether his eyes are only deceiving him. But in the darkness he can now perceive a radiance that streams inextinguishably from the door of the Law. Now his life is drawing to a close. Before he dies, all that he has experienced during the whole time of his sojourn condenses in his mind into one question, which he has never yet put to the doorkeeper. He beckons the doorkeeper, since he can no longer raise his stiffening body. The doorkeeper has to bend far down to hear him, for the difference in size between them has increased very much to the man's disadvantage. 'What do you want to know now?' asks the doorkeeper, 'you are insatiable.' 'Everyone strives to attain the Law,' answers the man, 'how does it come about, then, that in all these years no one has come seeking admittance but me?' The doorkeeper perceives that the man is nearing his end and his

hearing is failing, so he bellows in his ear: 'No one but you could gain admittance through this door, since this door was intended for you. I am now going to shut it.'"

"So the doorkeeper deceived the man," said K. immediately, strongly attracted by the story. "Don't be too hasty," said the priest, "don't take over someone else's opinion without testing it. I have told you the story in the very words of the scriptures. There's no mention of deception in it." "But it's clear enough," said K., "and your first interpretation of it was quite right. The doorkeeper gave the message of salvation to the man only when it could no longer help him." "He was not asked the question any earlier," said the priest, "and you must consider, too, that he was only a doorkeeper, and as such fulfilled his duty." "What makes you think he fulfilled his duty?" asked K. "He didn't fulfill it. His duty might have been to keep all strangers away, but this man, for whom the door was intended, should have been let in." "You have not enough respect for the written word and you are altering the story," said the priest. "The story contains two important statements made by the doorkeeper about admission to the Law, one at the beginning, the other at the end. The first statement is: that he cannot admit the man at the moment, and the other is: that this door was intended only for the man. If there were a contradiction between the two, you would be right and the doorkeeper would have deceived the man. But there is no contradiction. The first statement, on the contrary, even implies the second. One could almost say that in suggesting to the man the possibility of future admittance the doorkeeper is exceeding his duty. At that time his apparent duty is only to refuse admittance and indeed many commentators are surprised that the suggestion should be made at all, since the doorkeeper appears to be a precisian with a stern regard for duty. He does not once leave his post during these many years, and he does not shut the door until the very last minute; he is conscious of the importance of his office, for he says: 'I am powerful'; he is respectful to his superiors, for he says: 'I am only the lowest doorkeeper'; he is not garrulous, for during all these years he puts only what are called 'impersonal questions'; he is not to be bribed, for he says in accepting a gift: 'I take this only to keep you from feeling that you have left something undone'; where his duty is concerned he is to be moved neither by pity nor rage, for we are told that the man 'wearied the doorkeeper with his importunity'; and finally even his external appearance hints at a pedantic character, the large, pointed nose and the long, thin, black, Tartar beard. Could one imagine a more faithful doorkeeper? Yet the doorkeeper has other elements in his character which are likely to advantage anyone seeking admittance and which make it comprehensible enough that he should somewhat exceed his duty in suggesting the possibility of future admittance. For it cannot be denied that he is a little simple-minded and consequently a little conceited. Take the statements he makes about his power and the power of the other doorkeepers and their dreadful aspect which even he cannot bear to see—I hold that these statements may be true enough, but that the way in which he brings them out shows that his perceptions are confused by simpleness of mind and conceit. The commentators note in this connection: 'This right perception of any matter and a misunderstanding of the same matter do not wholly exclude each other.' One must at any rate assume that such simpleness and conceit, however sparingly manifest, are likely to weaken his defense of the door; they are breaches in the character of the doorkeeper. To this must be added the fact that the doorkeeper seems to be a friendly creature by nature, he is by no means always on his official dignity. In the very first moments he allows himself the jest of inviting the man to enter in spite of the strictly maintained veto against entry; then he does not, for instance, send the man away, but gives him, as we are told, a stool and lets him sit down beside the door. The patience with which he endures the man's appeals during so many years, the brief conversations, the acceptance of the gifts, the politeness with which he allows the man to curse loudly in his presence the fate for which he himself is responsible—all this lets us deduce certain feelings of pity. Not every doorkeeper would have acted thus. And finally, in answer to a gesture of the man's he bends down to give him the chance of putting a last question. Nothing but mild impatience—the doorkeeper knows that this is the end of it all—is discernible in the words: 'You are insatiable.' Some push this mode of interpretation even further and hold that these words express a kind of friendly admiration, though not without a hint of condescension. At any rate the figure of the doorkeeper can be said to come out very differently from what you fancied." "You have studied the story more exactly and for a longer time than I have," said K. They were both silent for a little while. Then K. said: "So you think the man was not deceived?" "Don't misunderstand me," said the priest, "I am only showing you the various opinions concerning that point. You must not pay too much attention to them. The scriptures are unalterable and the comments often enough merely express the commentators' despair. In this case there even exists an interpretation which claims that the deluded person is really the doorkeeper." "That's a far-fetched interpretation," said K. "On what is it based?" "It is based," answered the priest, "on the simple-mindedness of the doorkeeper. The argument is that he does not know the Law from inside, he knows only the way that leads to it, where he patrols up and down. His ideas of the interior are assumed to be childish, and it is supposed that he himself is afraid of the other guardians whom he holds up as bogies before the man. Indeed, he fears them more than the man does, since the man is determined to enter after hearing about the dreadful guardians of the interior, while the doorkeeper has no desire to enter, at least not so far as we are told. Others again say that he must have been in the interior already, since he is after all engaged in the service of the Law and can only have been appointed from inside. This is countered by arguing that he may have been appointed by a voice calling from the interior, and that anyhow he cannot have been far inside, since the aspect of the third doorkeeper is more than he can endure. Moreover, no indication is given that during all these years he ever made any remarks showing a knowledge of the interior, except for the one remark about the doorkeepers. He may have been forbidden to do so, but there is no mention of that either. On these grounds the conclusion is reached that he knows nothing about the aspect and significance of the interior, so that he is in a state of delusion. But he is deceived also about his relation to the man from the country, for he is inferior to the man and does not know it. He treats the man instead as his own subordinate, as can be recognized from many details that must be still fresh in your mind. But, according to this view of the story, it is just as clearly indicated that he is really subordinated to the man. In the first place, a bondman is always subject to a free man. Now the man from the country is really free, he can go where he likes, it is only the Law that is closed to him, and access to the Law is forbidden him only by one individual, the doorkeeper. When he sits down on the stool by the side of the door and stays there for the rest of his life, he does it of his own free will; in the story there is no mention of any compulsion. But the doorkeeper is bound to his post by his very office, he does not dare go out into the country, nor apparently may he go into the interior of the Law, even should he wish to. Besides, although he is in the service of the Law, his service is confined to this one entrance; that is

to say, he serves only this man for whom alone the entrance is intended. On that ground too he is inferior to the man. One must assume that for many years, for as long as it takes a man to grow up to the prime of life, his service was in a sense an empty formality, since he had to wait for a man to come, that is to say someone in the prime of life, and so he had to wait a long time before the purpose of his service could be fulfilled, and, moreover, had to wait on the man's pleasure, for the man came of his own free will. But the termination of his service also depends on the man's term of life, so that to the very end he is subject to the man. And it is emphasized throughout that the doorkeeper apparently realizes nothing of all this. That is not in itself remarkable, since according to this interpretation the doorkeeper is deceived in a much more important issue, affecting his very office. At the end, for example, he says regarding the entrance to the Law: 'I am now going to shut it,' but at the beginning of the story we are told that the door leading into the Law always stands open, and if it always stands open, that is to say at all times, without reference to the life or death of the man, then the doorkeeper cannot close it. There is some difference of opinion about the motive behind the doorkeeper's statement, whether he said he was going to close the door merely for the sake of giving an answer, or to emphasize his devotion to duty, or to bring the man into a state of grief and regret in his last moments. But there is no lack of agreement that the doorkeeper will not be able to shut the door. Many indeed profess to find that he is subordinate to the man even in knowledge, toward the end, at least, for the man sees the radiance that issues from the door of the Law while the doorkeeper in his official position must stand with his back to the door, nor does he say anything to show that he has perceived the change." "That is well argued," said K., after repeating to himself in a low voice several passages from the priest's exposition. "It is well argued, and I am inclined to agree that the doorkeeper is deceived. But that has not made me abandon my former opinion, since both conclusions are to some extent compatible. Whether the doorkeeper is clearsighted or deceived does not dispose of the matter. I said the man is deceived. If the doorkeeper is clearsighted, one might have doubts about that, but if the doorkeeper himself is deceived, then his deception must of necessity be communicated to the man. That makes the doorkeeper not, indeed, a deceiver, but a creature so simple-minded that he ought to be dismissed at once from his office. You mustn't forget that the doorkeeper's deceptions do himself no harm but do infinite harm to the man." "There are objections to that," said the priest. "Many aver that the story confers no right on anyone to pass judgment on the doorkeeper. Whatever he may seem to us, he is yet a servant of the Law; that is, he belongs to the Law and as such is beyond human judgment. In that case one must not believe that the doorkeeper is subordinate to the man. Bound as he is by his service, even only at the door of the Law, he is incomparably greater than anyone at large in the world. The man is only seeking the Law, the doorkeeper is already attached to it. It is the Law that has placed him at his post; to doubt his dignity is to doubt the Law itself." "I don't agree with that point of view," said K., shaking his head, "for if one accepts it, one must accept as true everything the doorkeeper says. But you yourself have sufficiently proved how impossible it is to do that." "No," said the priest, "it is not necessary to accept everything as true, one must only accept it as necessary." "A melancholy conclusion," said K. "It turns lying into a universal principle."

K. said that with finality, but it was not his final judgment. He was too tired to survey all the conclusions arising from the story, and the trains of thought into which it was leading him were unfamiliar, dealing with impalpabilities better suited to a theme for discussion among Court officials

than for him. The simple story had lost its clear outline, he wanted to put it out of his mind, and the priest, who now showed great delicacy of feeling, suffered him to do so and accepted his comment in silence, although undoubtedly he did not agree with it.

They paced up and down for a while in silence, K. walking close beside the priest, ignorant of his whereabouts. The lamp in his hand had long since gone out. The silver image of some saint once glimmered into sight immediately before him, by the sheen of its own silver, and was instantaneously lost in the darkness again. To keep himself from being utterly dependent on the priest, K. asked: "Aren't we near the main doorway now?" "No," said the priest, "we're a long way from it. Do you want to leave already?" Although at that moment K. had not been thinking of leaving, he answered at once: "Of course, I must go. I'm the Chief Clerk of a Bank, they're waiting for me, I only came here to show a business friend from abroad round the Cathedral." "Well," said the priest, reaching out his hand to K., "then go." "But I can't find my way alone in this darkness," said K. "Turn left to the wall," said the priest, "then follow the wall without leaving it and you'll come to a door." The priest had already taken a step or two away from him, but K. cried out in a loud voice, "Please wait a moment." "I am waiting," said the priest. "Don't you want anything more from me?" asked K. "No," said the priest. "You were so friendly to me for a time," said K., "and explained so much to me, and now you let me go as if you cared nothing about me." "But you have to leave now," said the priest. "Well, yes," said K., "you must see that I can't help it." "You must first see who I am," said the priest. "You are the prison chaplain," said K., groping his way nearer to the priest again; his immediate return to the Bank was not so necessary as he had made out, he could quite well stay longer. "That means I belong to the Court," said the priest. "So why should I want anything from you? The Court wants nothing from you. It receives you when you come and it dismisses you when you go."

"Before the Law" translated by Willa & Edwin Muir, from *Franz Kafka: The Complete Stories* by Franz Kafka, edited by Nahum N. Glatzer, copyright 1946, 1947, 1948, 1949, 1954, 1958, 1971 by Schocken Books. Used by permission of Schocken Books, a division of Random House, Inc.

ALDOUS HUXLEY
from BRAVE NEW WORLD

Written at a time when totalitarian powers were gaining strength in Europe, this passage is an incisive meditation on the power of language and art to undermine the authority of the state. Art, the totalitarian mind argues, provides an alternative way of seeing things and that, in a totalitarian society, is an unthinkable danger.

Chapter 16

The room into which the three were ushered was the Controller's study.

"His fordship will be down in a moment." The Gamma butler left them to themselves.

Helmholtz laughed aloud.

"It's more like a caffeine-solution party than a trial," he said, and let himself fall into the most luxurious of the pneumatic armchairs. "Cheer up, Bernard," he added, catching sight of his friend's green unhappy face. But Bernard would not be cheered; without answering, without even looking at Helmholtz, he went and sat down on the most uncomfortable chair in the room, carefully chosen in the obscure hope of somehow deprecating the wrath of the higher powers.

The Savage meanwhile wandered restlessly round the room, peering with a vague superficial inquisitiveness at the books in the shelves, at the soundtrack rolls and the reading

machine bobbins in their numbered pigeon-holes. On the table under the window lay a massive volume bound in limp black leather-surrogate, and stamped with large golden T's. He picked it up and opened it. MY LIFE AND WORK, BY OUR FORD. The book had been published at Detroit by the Society for the Propagation of Fordian Knowledge. Idly he turned the pages, read a sentence here, a paragraph there, and had just come to the conclusion that the book didn't interest him, when the door opened, and the Resident World Controller for Western Europe walked briskly into the room.

Mustapha Mond shook hands with all three of them; but it was to the Savage that he addressed himself. "So you don't much like civilization, Mr. Savage," he said.

The Savage looked at him. He had been prepared to lie, to bluster, to remain sullenly unresponsive; but, reassured by the good-humored intelligence of the Controller's face, he decided to tell the truth, straightforwardly. "No." He shook his head.

Bernard started and looked horrified. What would the Controller think? To be labeled as the friend of a man who said that he didn't like civilization—said it openly and, of all people, to the Controller—it was terrible. "But, John," he began. A look from Mustapha Mond reduced him to an abject silence.

"Of course," the Savage went on to admit, "there are some very nice things. All that music in the air, for instance . . ."

"Sometimes a thousand twangling instruments will hum about my ears and sometimes voices."

The Savage's face lit up with a sudden pleasure. "Have you read it too?" he asked. "I thought nobody knew about that book here, in England."

"Almost nobody. I'm one of the very few. It's prohibited, you see. But as I make the laws here, I can also break them. With impunity, Mr. Marx," he added, turning to Bernard. "Which I'm afraid you *can't* do."

Bernard sank into a yet more hopeless misery.

"But why is it prohibited?" asked the Savage. In the excitement of meeting a man who had read Shakespeare he had momentarily forgotten everything else.

The Controller shrugged his shoulders. "Because it's old; that's the chief reason. We haven't any use for old things here."

"Even when they're beautiful?"

"Particularly when they're beautiful. Beauty's attractive, and we don't want people to be attracted by old things. We want them to like the new ones."

"But the new ones are so stupid and horrible. Those plays, where there's nothing but helicopters flying about and you *feel* the people kissing." He made a grimace. "Goats and monkeys!" Only in Othello's words could he find an adequate vehicle for his contempt and hatred.

"Nice tame animals, anyhow," the Controller murmured parenthetically.

"Why don't you let them see *Othello* instead?"

"I've told you; it's old. Besides, they couldn't understand it."

Yes, that was true. He remembered how Helmholtz had laughed at *Romeo and Juliet.* "Well then," he said, after a pause, "something new that's like *Othello,* and that they could understand."

"That's what we've all been wanting to write," said Helmholtz, breaking a long silence.

"And it's what you never will write," said the Controller. "Because, if it were really like *Othello* nobody could understand it, however new it might be. And if it were new, it couldn't possibly be like *Othello.*"

"Why not?"

"Yes, why not?" Helmholtz repeated. He too was forgetting the unpleasant realities of the situation. Green with anxiety and apprehension, only Bernard remembered them; the others ignored him. "Why not?"

"Because our world is not the same as Othello's world. You can't make flivvers without steel—and you can't make tragedies without social instability. The world's stable now. People are happy; they get what they want, and they never want what they can't get. They're well off; they're safe; they're never ill; they're not afraid of death; they're blissfully ignorant of passion and old age; they're plagued with no mothers or fathers; they've got no wives, or children, or lovers to feel strongly about; they're so conditioned that they practically can't help behaving as they ought to behave. And if anything should go wrong, there's *soma.* Which you go and chuck out of the window in the name of liberty, Mr. Savage. *Liberty!*" He laughed. "Expecting Deltas to know what liberty is! And now expecting them to understand *Othello!* My good boy!"

The Savage was silent for a little. "All the same," he insisted obstinately, "*Othello's* good, *Othello's* better than those feelies."

"Of course it is," the Controller agreed. "But that's the price we have to pay for stability. You've got to choose between happiness and what people used to call high art. We've sacrificed the high art. We have the feelies and the scent organ instead."

"But they don't mean anything."

"They mean themselves; they mean a lot of agreeable sensations to the audience."

"But they're . . . they're told by an idiot."

The Controller laughed. "You're not being very polite to your friend, Mr. Watson. One of our most distinguished Emotional Engineers . . ."

"But he's right," said Helmholtz gloomily. "Because it *is* idiotic. Writing when there's nothing to say . . ."

"Precisely. But that requires the most enormous ingenuity. You're making flivvers out of the absolute minimum of steel—works of art out of practically nothing but pure sensation."

The Savage shook his head. "It all seems to me quite horrible."

"Of course it does. Actual happiness always looks pretty squalid in comparison with the over-compensations for misery. And, of course, stability isn't nearly so spectacular as instability. And being contented has none of the glamour of a good fight against misfortune, none of the picturesqueness of a struggle with temptation, or a fatal overthrow by passion or doubt. Happiness is never grand."

"I suppose not," said the Savage after a silence. "But need it be quite so bad as those twins?" He passed his hand over his eyes as though he were trying to wipe away the remembered image of those long rows of identical midgets at the assembling tables, those queued-up twin-herds at the entrance to the Brentford monorail station, those human maggots swarming round Linda's bed of death, the endlessly repeated face of his assailants. He looked at his bandaged left hand and shuddered. "Horrible!"

"But how useful! I see you don't like our Bokanovsky Groups; but, I assure you, they're the foundation on which everything else is built. They're the gyroscope that stabilizes the rocket plane of state on its unswerving course." The deep voice thrillingly vibrated; the gesticulating hand implied all space and the onrush of the irresistible machine. Mustapha Mond's oratory was almost up to synthetic standards.

"I was wondering," said the Savage, "why you had them at all—seeing that you can get whatever you want out of those bottles. Why don't you make everybody an Alpha Double Plus while you're about it?"

Mustapha Mond laughed. "Because we have no wish to have our throats cut," he answered. "We believe in happiness

and stability. A society of Alphas couldn't fail to be unstable and miserable. Imagine a factory staffed by Alphas—that is to say by separate and unrelated individuals of good heredity and conditioned so as to be capable (within limits) of making a free choice and assuming responsibilities. Imagine it!" he repeated.

The Savage tried to imagine it, not very successfully.

"It's an absurdity. An Alpha-decanted, Alpha-conditioned man would go mad if he had to do Epsilon Semi-Moron work—go mad, or start smashing things up. Alphas can be completely socialized—but only on condition that you make them do Alpha work. Only an Epsilon can be expected to make Epsilon sacrifices, for the good reason that for him they aren't sacrifices; they're the line of least resistance. His conditioning has laid down rails along which he's got to run. He can't help himself; he's foredoomed. Even after decanting, he's still inside a bottle—an invisible bottle of infantile and embryonic fixations. Each one of us, of course," the Controller meditatively continued, "goes through life inside a bottle. But if we happen to be Alphas, our bottles are, relatively speaking, enormous. We should suffer acutely if we were confined in a narrower space.

You cannot pour upper-caste champagne-surrogate into lower-caste bottles. It's obvious theoretically. But it has also been proved in actual practice. The result of the Cyprus experiment was convincing."

"What was that?" asked the Savage.

Mustapha Mond smiled. "Well, you can call it an experiment in rebottling if you like. It began in A.F. 473. The Controllers had the island of Cyprus cleared of all its existing inhabitants and recolonized with a specially prepared batch of twenty-two thousand Alphas. All agricultural and industrial equipment was handed over to them and they were left to manage their own affairs. The result exactly fulfilled all the theoretical predictions. The land wasn't properly worked; there were strikes in all the factories; the laws were set at naught, orders disobeyed; all the people detailed for a spell of low-grade work were perpetually intriguing for high-grade jobs, and all the people with high-grade jobs were counter-intriguing at all costs to stay where they were. Within six years they were having a first class civil war. When nineteen out of the twenty-two thousand had been killed, the survivors unanimously petitioned the World Controllers to resume the government of the island. Which they did. And that was the end of the only society of Alphas that the world has ever seen."

The Savage sighed, profoundly.

"The optimum population," said Mustapha Mond, "is modeled on the iceberg—eight-ninths below the water line, one-ninth above."

"And they're happy below the water line?"

"Happier than above it. Happier than your friend here, for example." He pointed.

"In spite of that awful work?"

"Awful? *They* don't find it so. On the contrary, they like it. It's light, it's childishly simple. No strain on the mind or the muscles. Seven and a half hours of mild, unexhausting labor, and then the *soma* ration and games and unrestricted copulation and the feelies. What more can they ask for? True," he added, "they might ask for shorter hours. And of course we could give them shorter hours. Technically, it would be perfectly simple to reduce all lower-caste working hours to three or four a day. But would they be any the happier for that? No, they wouldn't. The experiment was tried, more than a century and a half ago. The whole of Ireland was put on to the four-hour day. What was the result? Unrest and a large increase in the consumption of *soma;* that was all. Those three and a half hours of extra leisure were so far from being a source of happiness, that people felt constrained to take a holiday from them. The Inventions Office is stuffed with plans for labor-saving processes. Thousands of them." Mustapha Mond made a lavish gesture. "And why don't we put them into execution? For the sake of the laborers; it would be sheer cruelty to afflict them with excessive leisure. It's the same with agriculture. We could synthesize every morsel of food, if we wanted to. But we don't. We prefer to keep a third of the population on the land. For their own sakes—because it takes *longer* to get food out of the land than out of a factory. Besides, we have our stability to think of. We don't want to change. Every change is a menace to stability. That's another reason why we're so chary of applying new inventions. Every discovery in pure science is potentially subversive; even science must sometimes be treated as a possible enemy. Yes, even science."

Science? The Savage frowned. He knew the word. But what it exactly signified he could not say. Shakespeare and the old men of the pueblo had never mentioned science, and from Linda he had only gathered the vaguest hints: science was something you made helicopters with, something that caused you to laugh at the Corn Dances, something that prevented you from being wrinkled and losing your teeth. He made a desperate effort to take the Controller's meaning.

"Yes," Mustapha Mond was saying, "that's another item in the cost of stability. It isn't only art that's incompatible with happiness; it's also science. Science is dangerous; we have to keep it most carefully chained and muzzled."

"What?" said Helmholtz, in astonishment. "But we're always saying that science is everything. It's a hypnopædic platitude."

"Three times a week between thirteen and seventeen," put in Bernard.

"And all the science propaganda we do at the College . . ."

"Yes, but what sort of science?" asked Mustapha Mond sarcastically. "You've had no scientific training, so you can't judge. I was a pretty good physicist in my time. Too good—good enough to realize that all our science is just a cookery book, with an orthodox theory of cooking that nobody's allowed to question, and a list of recipes that mustn't be added to except by special permission from the head cook. I'm the head cook now. But I was an inquisitive young scullion once. I started doing a bit of cooking on my own. Unorthodox cooking, illicit cooking. A bit of real science, in fact." He was silent.

"What happened?" asked Helmholtz Watson.

The Controller sighed. "Very nearly what's going to happen to you young men. I was on the point of being sent to an island."

The words galvanized Bernard into a violent and unseemly activity. "Send *me* to an island?" He jumped up, ran across the room, and stood gesticulating in front of the Controller. "You can't send *me.* I haven't done anything. It was the others, I swear it was the others." He pointed accusingly to Helmholtz and the Savage. "Oh, please don't send me to Iceland. I promise I'll do what I ought to do. Give me another chance. Please give me another chance." The tears began to flow. "I tell you, it's their fault," he sobbed. "And not to Iceland. Oh please, your fordship, please . . ." And in a paroxysm of abjection he threw himself on his knees before the Controller. Mustapha Mond tried to make him get up; but Bernard persisted in his groveling; the stream of words poured out inexhaustibly. In the end the Controller had to ring for his fourth secretary.

"Bring three men," he ordered, "and take Mr. Marx into a bedroom. Give him a good *soma* vaporization and then put him to bed and leave him."

The fourth secretary went out and returned with three green-uniformed twin footmen. Still shouting and sobbing, Bernard was carried out.

"One would think he was going to have his throat cut," said the Controller, as the door closed. "Whereas, if he had the smallest sense, he'd understand that his punishment is really a reward. He's being sent to an island. That's to say, he's being sent to a place where he'll meet the most interesting set of men and women to be found anywhere in the world. All the people who, for one reason or another, have got too self-consciously individual to fit into community-life. All the people who aren't satisfied with orthodoxy, who've got independent ideas of their own. Every one, in a word, who's any one. I almost envy you, Mr. Watson."

Helmholtz laughed. "Then why aren't you on an island yourself?"

"Because, finally, I preferred this," the Controller answered. "I was given the choice: to be sent to an island, where I could have got on with my pure science, or to be taken on to the Controllers' Council with the prospect of succeeding in due course to an actual Controllership. I chose this and let the science go." After a little silence, "Sometimes," he added, "I rather regret the science. Happiness is a hard master—particularly other people's happiness. A much harder master, if one isn't conditioned to accept it unquestioningly, than truth." He sighed, fell silent again, then continued in a brisker tone. "Well, duty's duty. One can't consult one's own preferences. I'm interested in truth, I like science. But truth's a menace, science is a public danger. As dangerous as it's been beneficent. It has given us the stablest equilibrium in history. China's was hopelessly insecure by comparison; even the primitive matriarchies weren't steadier than we are. Thanks, I repeat, to science. But we can't allow science to undo its own good work. That's why we so carefully limit the scope of its researches—that's why I almost got sent to an island. We don't allow it to deal with any but the most immediate problems of the moment. All other inquiries are most sedulously discouraged. It's curious," he went on after a little pause, "to read what people in the time of Our Ford used to write about scientific progress. They seemed to have imagined that it could be allowed to go on indefinitely, regardless of everything else. Knowledge was the highest good, truth the supreme value; all the rest was secondary and subordinate. True, ideas were beginning to change even then. Our Ford himself did a great deal to shift the emphasis from truth and beauty to comfort and happiness. Mass production demanded the shift. Universal happiness keeps the wheels steadily turning; truth and beauty can't. And, of course, whenever the masses seized political power, then it was happiness rather than truth and beauty that mattered. Still, in spite of everything, unrestricted scientific research was still permitted. People still went on talking about truth and beauty as though they were the sovereign goods. Right up to the time of the Nine Years' War. *That* made them change their tune all right. What's the point of truth or beauty or knowledge when the anthrax bombs are popping all around you? That was when science first began to be controlled—after the Nine Years' War. People were ready to have even their appetites controlled then. Anything for a quiet life. We've gone on controlling ever since. It hasn't been very good for truth, of course. But it's been very good for happiness. One can't have something for nothing. Happiness has got to be paid for. You're paying for it, Mr. Watson—paying because you happen to be too much interested in beauty. I was too much interested in truth; I paid too."

"But *you* didn't go to an island," said the Savage, breaking a long silence.

The Controller smiled. "That's how I paid. By choosing to serve happiness. Other people's—not mine. It's lucky," he added, after a pause, "that there are such a lot of islands in the world. I don't know what we should do without them. Put you all in the lethal chamber, I suppose. By the way, Mr.

Watson, would you like a tropical climate? The Marquesas, for example; or Samoa? Or something rather more bracing?"

Helmholtz rose from his pneumatic chair. "I should like a thoroughly bad climate," he answered. "I believe one would write better if the climate were bad. If there were a lot of wind and storms, for example . . ."

The Controller nodded his approbation. "I like your spirit, Mr. Watson. I like it very much indeed. As much as I officially disapprove of it." He smiled. "What about the Falkland Islands?"

"Yes, I think that will do," Helmholtz answered. "And now, if you don't mind, I'll go and see how poor Bernard's getting on."

Chapter 17

"Art, science—you seem to have paid a fairly high price for your happiness," said the Savage, when they were alone. "Anything else?"

"Well, religion, of course," replied the Controller. "There used to be something called God—before the Nine Years' War. But I was forgetting; you know all about God, I suppose."

"Well . . ." The Savage hesitated. He would have liked to say something about solitude, about night, about the mesa lying pale under the moon, about the precipice, the plunge into shadowy darkness, about death. He would have liked to speak; but there were no words. Not even in Shakespeare.

The Controller, meanwhile, had crossed to the other side of the room and was unlocking a large safe let into the wall between the bookshelves. The heavy door swung open. Rummaging in the darkness within, "It's a subject," he said, "that has always had a great interest for me." He pulled out a thick black volume. "You've never read this, for example."

The Savage took it. *"The Holy Bible, containing the Old and New Testaments,"* he read aloud from the title-page.

"Nor this." It was a small book and had lost its cover. *"The Imitation of Christ."*

"Nor this." He handed out another volume.

"The Varieties of Religious Experience. By William James."

"And I've got plenty more," Mustapha Mond continued, resuming his seat. "A whole collection of pornographic old books. God in the safe and Ford on the shelves." He pointed with a laugh to his avowed library—to the shelves of books, the racks full of reading-machine bobbins and sound-track rolls.

"But if you know about God, why don't you tell them?" asked the Savage indignantly. "Why don't you give them these books about God?"

"For the same reason as we don't give them *Othello*: they're old; they're about God hundreds of years ago. Not about God now."

"But God doesn't change."

"Men do, though."

"What difference does that make?"

"All the difference in the world," said Mustapha Mond. He got up again and walked to the safe. "There was a man called Cardinal Newman," he said. "A cardinal," he exclaimed parenthetically, "was a kind of Arch-Community-Songster."

"'I Pandulph, of fair Milan, cardinal.' I've read about them in Shakespeare."

"Of course you have. Well, as I was saying, there was a man called Cardinal Newman. Ah, here's the book." He pulled it out. "And while I'm about it I'll take this one too. It's by a man called Maine de Biran. He was a philosopher, if you know what that was."

"A man who dreams of fewer things than there are in heaven and earth," said the Savage promptly.

"Quite so. I'll read you one of the things he *did* dream of in a moment. Meanwhile, listen to what this old Arch-Community-Songster said." He opened the book at the place

marked by a slip of paper and began to read. "We are not our own any more than what we possess is our own. We did not make ourselves, we cannot be supreme over ourselves. We are not our own masters. We are God's property. Is it not our happiness thus to view the matter? Is it any happiness or any comfort, to consider that we *are* our own? It may be thought so by the young and prosperous. These may think it a great thing to have everything, as they suppose, their own way—to depend on no one—to have to think of nothing out of sight, to be without the irksomeness of continual acknowledgment, continual prayer, continual reference of what they do to the will of another. But as time goes on, they, as all men, will find that independence was not made for man—that it is an unnatural state—will do for a while, but will not carry us on safely to the end . . .'" Mustapha Mond paused, put down the first book and, picking up the other, turned over the pages. "Take this, for example," he said, and in his deep voice once more began to read: "'A man grows old; he feels in himself that radical sense of weakness, of listlessness, of discomfort, which accompanies the advance of age; and, feeling thus, imagines himself merely sick, lulling his fears with the notion that this distressing condition is due to some particular cause, from which, as from an illness, he hopes to recover. Vain imaginings! That sickness is old age; and a horrible disease it is. They say that it is the fear of death and of what comes after death that makes men turn to religion as they advance in years. But my own experience has given me the conviction that, quite apart from any such terrors or imaginings, the religious sentiment tends to develop as we grow older; to develop because, as the passions grow calm, as the fancy and sensibilities are less excited and less excitable, our reason becomes less troubled in its working, less obscured by the images, desires and distractions, in which it used to be absorbed; whereupon God emerges as from behind a cloud; our soul feels, sees, turns towards the source of all light; turns naturally and inevitably; for now that all that gave to the world of sensations its life and charm has begun to leak away from us, now that phenomenal existence is no more bolstered up by impressions from within or from without, we feel the need to lean on something that abides, something that will never play us false—a reality, an absolute and everlasting truth. Yes, we inevitably turn to God; for this religious sentiment is of its nature so pure, so delightful to the soul that experiences it, that it makes up to us for all our other losses.'" Mustapha Mond shut the book and leaned back in his chair. "One of the numerous things in heaven and earth that these philosophers didn't dream about was this" (he waved his hand), "us, the modern world. 'You can only be independent of God while you've got youth and prosperity; independence won't take you safely to the end.' Well, we've now got youth and prosperity right up to the end. What follows? Evidently, that we can be independent of God. 'The religious sentiment will compensate us for all our losses.' But there aren't any losses for us to compensate; religious sentiment is superfluous. And why should we go hunting for a substitute for youthful desires, when youthful desires never fail? A substitute for distractions, when we go on enjoying all the old fooleries to the very last? What need have we of repose when our minds and bodies continue to delight in activity? of consolation, when we have *soma*? of something immovable, when there is the social order?"

"Then you think there is no God?"

"No, I think there quite probably is one."

"Then why? . . ."

Mustapha Mond checked him. "But he manifests himself in different ways to different men. In premodern times he manifested himself as the being that's described in these books. Now . . ."

"How does he manifest himself now?" asked the Savage.

"Well, he manifests himself as an absence; as though he weren't there at all."

"That's your fault."

"Call it the fault of civilization. God isn't compatible with machinery and scientific medicine and universal happiness. You must make your choice. Our civilization has chosen machinery and medicine and happiness. That's why I have to keep these books locked up in the safe. They're smut. People would be shocked if . . ."

The Savage interrupted him. "But isn't it *natural* to feel there's a God?"

"You might as well ask if it's natural to do up one's trousers with zippers," said the Controller sarcastically. "You remind me of another of those old fellows called Bradley. He defined philosophy as the finding of bad reason for what one believes by instinct. As if one believed anything by instinct! One believes things because one has been conditioned to believe them. Finding bad reasons for what one believes for other bad reasons—that's philosophy. People believe in God because they've been conditioned to believe in God."

"But all the same," insisted the Savage, "it is natural to believe in God when you're alone—quite alone, in the night, thinking about death . . ."

"But people never are alone now," said Mustapha Mond. "We make them hate solitude; and we arrange their lives so that it's almost impossible for them ever to have it."

The Savage nodded gloomily. At Malpais he had suffered because they had shut him out from the communal activities of the pueblo, in civilized London he was suffering because he could never escape from those communal activities, never be quietly alone.

"Do you remember that bit in *King Lear*?" said the Savage at last. "'The gods are just and of our pleasant vices make instruments to plague us; the dark and vicious place where thee he got cost him his eyes,' and Edmund answers—you remember, he's wounded, he's dying—'Thou hast spoken right; 'tis true. The wheel has come full circle; I am here.' What about that now? Doesn't there seem to be a God managing things, punishing, rewarding?"

"Well, does there?" questioned the Controller in his turn. "You can indulge in any number of pleasant vices with a freemartin and run no risks of having your eyes put out by your son's mistress. 'The wheel has come full circle; I am here.' But where would Edmund be nowadays? Sitting in a pneumatic chair, with his arm around a girl's waist, sucking away at his sex-hormone chewing-gum and looking at the feelies. The gods are just. No doubt. But their code of law is dictated, in the last resort, by the people who organize society; Providence takes its cue from men."

"Are you sure?" asked the Savage. "Are you quite sure that the Edmund in that pneumatic chair hasn't been just as heavily punished as the Edmund who's wounded and bleeding to death? The gods are just. Haven't they used his pleasant vices as an instrument to degrade him?"

"Degrade him from what position? As a happy, hardworking, goods-consuming citizen he's perfect. Of course, if you choose some other standard than ours, then perhaps you might say he was degraded. But you've got to stick to one set of postulates. You can't play Electro-magnetic Golf according to the rules of Centrifugal Bumble-puppy."

"But value dwells not in particular will," said the Savage. "It holds his estimate and dignity as well wherein 'tis precious of itself as in the prizer."

"Come, come," protested Mustapha Mond, "that's going rather far isn't it?"

"If you allowed yourselves to think of God, you wouldn't allow yourselves to be degraded by pleasant vices. You'd

have reason for bearing things patiently, for doing things with courage. I've seen it with the Indians."

"I'm sure you have," said Mustapha Mond. "But then we aren't Indians. There isn't any need for a civilized man to bear anything that's seriously unpleasant. And as for doing things—Ford forbid that he should get the idea into his head. It would upset the whole social order if men started doing things on their own."

"What about self-denial, then? If you had a God, you'd have a reason for self-denial."

"But industrial civilization is only possible when there's no self-denial. Self-indulgence up to the very limits imposed by hygiene and economics. Otherwise the wheels stop turning."

"You'd have a reason for chastity!" said the Savage, blushing a little as he spoke the words.

"But chastity means passion, chastity means neurasthenia. And passion and neurasthenia mean instability. And instability means the end of civilization. You can't have a lasting civilization without plenty of pleasant vices."

"But God's the reason for everything noble and fine and heroic. If you had a God . . ."

"My dear young friend," said Mustapha Mond, "civilization has absolutely no need of nobility or heroism. These things are symptoms of political inefficiency. In a properly organized society like ours, nobody has any opportunities for being noble or heroic. Conditions have got to be thoroughly unstable before the occasion can arise. Where there are wars, where there are divided allegiances, where there are temptations to be resisted, objects of love to be fought for or defended—there, obviously, nobility and heroism have some sense. But there aren't any wars nowadays. The greatest care is taken to prevent you from loving any one too much. There's no such thing as a divided allegiance; you're so conditioned that you can't help doing what you ought to do. And what you ought to do is on the whole so pleasant, so many of the natural impulses are allowed free play, that there really aren't any temptations to resist. And if ever, by some unlucky chance, anything unpleasant should somehow happen, why, there's always *soma* to give you a holiday from the facts. And there's always *soma* to calm your anger, to reconcile you to your enemies, to make you patient and long-suffering. In the past you could only accomplish these things by making a great effort and after years of hard moral training. Now, you swallow two or three half-gram tablets, and there you are. Anybody can be virtuous now. You can carry at least half your morality about in a bottle. Christianity without tears—that's what *soma* is."

"But the tears are necessary. Don't you remember what Othello said? 'If after every tempest came such calms, may the winds blow till they have wakened death.' There's a story one of the old Indians used to tell us, about the Girl of Mátaski. The young men who wanted to marry her had to do a morning's hoeing in her garden. It seemed easy; but there were flies and mosquitoes, magic ones. Most of the young men simply couldn't stand the biting and stinging. But the one that could—he got the girl."

"Charming! But in civilized countries," said the Controller, "you can have girls without hoeing for them; and there aren't any flies or mosquitoes to sting you. We got rid of them centuries ago."

The Savage nodded, frowning. "You got rid of them. Yes, that's just like you. Getting rid of everything unpleasant instead of learning to put up with it. Whether 'tis better in the mind to suffer the slings and arrows of outrageous fortune, or to take arms against a sea of troubles and by opposing end them . . . But you don't do either. Neither suffer nor oppose. You just abolish the slings and arrows. It's too easy."

He was suddenly silent, thinking of his mother. In her room on the thirty-seventh floor, Linda had floated in a sea of singing lights and perfumed caresses—floated away, out of space, out of time, out of the prison of her memories, her habits, her aged and bloated body. And Tomakin, ex-director of Hatcheries and Conditioning, Tomakin was still on holiday—from humiliation and pain, in a world where he could not hear those words, that derisive laughter, could not see that hideous face, feel those moist and flabby arms round his neck, in a beautiful world . . .

"What you need," the Savage went on, "is something *with* tears for a change. Nothing costs enough here."

("Twelve and a half million dollars." Henry Foster had protested when the Savage told him that. "Twelve and a half million—that's what the new Conditioning Center cost. Not a cent less.")

"Exposing what is mortal and unsure to all that fortune, death and danger dare, even for an egg-shell. Isn't there something in that?" he asked, looking up at Mustapha Mond. "Quite apart from God—though of course God would be a reason for it. Isn't there something in living dangerously?"

"There's a great deal in it," the Controller replied. "Men and women must have their adrenals stimulated from time to time."

"What?" questioned the Savage, uncomprehending.

"It's one of the conditions of perfect health. That's why we've made the V.P.S. treatments compulsory."

"V.P.S.?"

"Violent Passion Surrogate. Regularly once a month. We flood the whole system with adrenin. It's the complete physiological equivalent of fear and rage. All the tonic effects of murdering Desdemona and being murdered by Othello, without any of the inconveniences."

"But I like the inconveniences."

"We don't," said the Controller. "We prefer to do things comfortably."

"But I don't want comfort. I want God, I want poetry, I want real danger, I want freedom, I want goodness. I want sin."

"In fact," said Mustapha Mond, "you're claiming the right to be unhappy."

"All right then," said the Savage defiantly, "I'm claiming the right to be unhappy."

"Not to mention the right to grow old and ugly and impotent; the right to have syphilis and cancer; the right to have too little to eat; the right to be lousy; the right to live in constant apprehension of what may happen tomorrow; the right to catch typhoid; the right to be tortured by unspeakable pains of every kind."

There was a long silence.

"I claim them all," said the Savage at last.

Mustapha Mond shrugged his shoulders. "You're welcome," he said.

From *Brave New World* by Aldous Huxley, copyright 1932, 1960 by Aldous Huxley. Reprinted by permission of HarperCollins Publishers, Inc.

	GENERAL EVENTS	LITERATURE & PHILOSOPHY	ART

THE ATOMIC ERA

WORLD WAR II AND AFTERMATH

1939

1939 World War II begins; start of commercial television

1941 Japanese attack Pearl Harbor

1945 First atomic bombs used in warfare against Japan; World War II ends; Nazi extermination of Jews becomes widely known

1946 First meeting of UN General Assembly in London

1948 Israel becomes independent state; Berlin airlift marks beginning of "cold war"

1949 China becomes communist under leadership of Mao Zedong

1946 Orwell, *1984;* Sartre, *Existentialism as a Humanism*

Existentialist philosophy influences writers and dramatists: Camus, *The Stranger* (1942); Beckett, *Waiting for Godot* (1953)

1949 Miller's *Death of a Salesman* given Pulitzer Prize for Drama; Faulkner awarded Nobel Prize for Literature

late 1930s Refugee artists Hoffman, Albers, Grosz bring ideas to North America

1939 Moore, *Reclining Figure*

1942 Hopper, *Nighthawks;* Peggy Guggenheim exhibits European art at New York Gallery

1942–1953 Cornell, *Object Roses des Vents*

1943 Pollock's first exhibition

c. 1945 New York becomes international art center; New York School includes abstract expressionism, color-field painting

1948 Pollock, *Number 1*

1949 Shahn, *Death of a Miner*

THE BEAT GENERATION

1950

1950 Korean War begins; FCC approves first commercial transmission of color TV

1952 U.S. explodes first hydrogen bomb

1954 School segregation outlawed by Supreme Court

1955 Civil Rights Movement starts in South

1957 First earth satellite launched by USSR

1950 Sociologist Riesman writes *The Lonely Crowd*

1951 Langston Hughes, "Harlem," "Theme for English B"

1950s Alienation and anxiety become major themes of "Beat" writers Kerouac and Ginsberg

1951 Frankenthaler begins stained canvases: *The Bay* (1963)

1950s Rauschenberg experiments with "combine" paintings and, with Cage, "happenings"

1953–1954 Motherwell, *Elegy to the Spanish Republic #34*

c. 1955 Reaction to abstract expressionism results in "Pop" art; Johns, *Flag* (1954–1955); Warhol, *Soupcans*

1956 Bergman film *Wild Strawberries*

1957–1960 Nevelson, *Sky Cathedral— Moon Garden + One*

1959 Rauschenberg, *Monogram;* Gottlieb, *Thrust;* Calder, *Big Red*

1960s Rothko panels for Houston Chapel, opened 1971

THE YOUTH MOVEMENT

1960

1961 East Germans erect Berlin Wall; Soviets put first person in space

1962 First American orbits earth in space; transatlantic transmission of television signal via earth satellite

1963 President John F. Kennedy assassinated

1964 Massive buildup of American troops in Vietnam; Cultural Revolution in Communist China

1966 Founding of National Organization for Women in U.S.

1968 Assassination of Martin Luther King Jr. and Robert F. Kennedy; youth movement at apex

1969 First walk on moon

1960 Wiesel, *Night,* memoir of Nazi concentration camps
1961 Heller, *Catch-22,* satire on absurdity of war
1963 Flannery O'Connor, "Revelation"
1964 Stoppard, *Rosencrantz and Guildenstern Are Dead*
1970 Solzhenitsyn awarded Nobel Prize for Literature; Toffler, *Future Shock;* Nikki Giovanni, "Ego Tripping"
1971 Plath, *The Bell Jar,* published posthumously
1973 Pynchon, *Gravity's Rainbow*

1963 Smith, *Cubi I:* Manzù, Doors of Saint Peter's

1964 Kubrick, film *Dr. Strangelove*

1964–1966 Segal, *The Diner;* Kienholz, *The State Hospital*

1964 Bearden, *The Prevalence of Ritual: Baptism*

1966 Oldenburg, *Soft Toilet*

1970s Resurgence of realism; incorporation of technology in art: videotapes, computers, lasers

1974 Kelly, *Grey Panels 2*

1976–1977 Pearlstein, *Two Female Models on Eames Chair and Stool*

1976–1978 Leslie, *7 A.M. News*

1976–1982 Abakanowicz, *Backs*

1976 Rothenberg, *Cabin Fever*

CONTEMPORARY TRAJECTORIES

1975

1975 American withdrawal from Vietnam

1977 New Chinese government allows art previously banned

1981 First space shuttle flight

1989 Berlin Wall breached

1991 Soviet Union dissolved at the end of 1991

1981 Picasso's *Guernica* "returned" to Spain; Kiefer, *Innerraum;* Bartlett, *Two Boats*

1987 Lacy's *Little Egypt Condo, New York City*

1995 Nam June Paik, *Electronic Super Highway*

2000

2001 Twin Towers Disaster

Most dates are approximate

2000 Whitehead, *Holocaust Memorial*

2004 Plensa, *Crown Fountain*

THE CONTEMPORARY CONTOUR

ARCHITECTURE	MUSIC

late 1930s Bauhaus architects Gropius and van der Rohe flee Nazi Germany for United States

1943 Wright designs Guggenheim Museum, New York

1945 Britten composes opera *Peter Grimes*

c. 1947 Buckminster Fuller develops geodesic dome

1948 Structuralist Boulez composes *Second Piano Sonata;* LP recordings become commercially available

1952 Le Corbusier, *L'Unité d'Habitation,* Marseille

1950s Beginnings of electronic music; first use of synthesizer

Reinforced concrete technology results in building as sculpture: Nervi and Vitellozzi, *Palazzetto dello Sport,* Rome (1956–1957)

1952 Boulez, *Structures;* Cage experiments with aleatoric music: *4'3"*

1955–1956 Stockhausen, *Song of the Boys*

1956–1958 van der Rohe and Johnson, Seagram Building, New York

1958 Cage, *Concert for Piano and Orchestra*

1959 Guggenheim Museum completed

1959–1972 Utzon, Opera House, Sydney

1960 Niemeyer completes government buildings at Brasilia

1960 Penderecki, *Threnody for the Victims of Hiroshima*

1962 Saarinen, TWA Flight Center, New York

1962 Britten, *War Requiem;* Shostakovich, *Symphony No. 13,* text from poems by Yevtushenko

1965 Stockhausen, *Mixtur*

1970 Soleri begins utopian city Arconsanti in Arizona

c. 1965 Baez, Seeger, Dylan entertain with protest songs; height of rock music and Beatles; Lennon, *Yesterday;* eclectic music of Zappa and Mothers of Invention

1977 Piano and Rogers, Pompidou Center, Paris

1971 Shostakovich, *Symphony No. 15*

1978 Pei, East Wing of National Gallery of Art, Washington, DC

1973 Stockhausen, *Stop;* Britten, opera *Death in Venice*

1988 Kohn, Pederson, Fox, Seattle Building

1991 Venturi and Brown, Seattle Art Museum

1978 Penderecki, opera *Paradise Lost*

1994 Gehry, American Center, Paris

1983 Reich's *The Desert Music*

1997 Getty Center, Los Angeles

2000 Tate Modern, London

CHAPTER 22

THE CONTEMPORARY CONTOUR

TOWARD A GLOBAL CULTURE

Now that we have entered the twenty-first century and the new millennium has begun, the events that happened after 1945 seem to recede into distant history. It is difficult to remember what has happened to our culture in the three generations since the end of World War II. Events that occurred in the past more than four decades ago are still perhaps too close to know whether they have permanently changed us as a people. Was the moon landing of 1969 really a watershed in our consciousness as humans? Did the "American Century," so proudly forecast by commentators at the end of World War II, end? Has the revolution in communications already radically changed the way we learn things? Is the age of microtechnology, new forms of communication, and the computer age going to bring in a new, wonderful era or an anti-utopia?

The decades following World War II were rightly called The Atomic Age. Developed largely by refugee scientists during that war, atomic weaponry loomed like an ominous shadow over all international tensions and potentially belligerent situations. It is not merely a question of nuclear bombs being bigger or more deadly weapons, although they are surely that. Nuclear weapons can have long-term and little-understood consequences for both nature and the individuals who might survive the first blast. Today, with a precariously balanced peace between superpowers, the real fear of nuclear weapons is their possible use by rogue nations or terrorist groups.

First, because modern warfare was so far beyond the power of the postwar human intellect to imagine, artists turned to satire as a way of expressing their fear and hatred of it. Novels like Joseph Heller's *Catch-22* (1961) and Thomas Pynchon's *Gravity's Rainbow* (1973) sketched out war in terms of insanity, irrationality, and the blackest of humor, while Stanley Kubrick's brilliant movie *Dr. Strangelove* (1964) mounted a scathing attack on those who speak coolly about "megadeaths" and "mutual assured destruction" (MAD in military jargon). Any attempt at mere realism, these artists seemed to say, pales into triviality.

Second, at the end of World War II, the United States emerged both as a leading economic power in the world and as the leader of the "free world" in its struggle against communism. This preeminence explains both the high standard of living in the West and the resentment of those who did not share it. Only recently have we understood that economic supremacy does not permit a nation to live free from outside forces. The energy crises, the need for raw materials, the quest for labor, and the search for new markets today bind many nations together in a delicate economic and social network of political relationships. The United States depends on other countries; the shifting patterns of economic relationships between North America, Europe, the Third World, Japan, and the oil producers are all reminders of how fragile that network really is. That is why we can speak of a global economy. With the collapse of communism in Eastern Europe, new patterns of culture slowly began to emerge, as the vigor of the Pacific Rim nations attest. We do not know exactly how the New World Order will operate. What we do know is that our lives are not insulated: Our stereos are assembled in Malaysia; our vegetables may come from Mexico; our blue jeans are sewn in Bangladesh; and our sneakers manufactured in Romania.

The material satisfactions of Western life also spawned other kinds of dissatisfaction. While we may be the best-fed, best-housed, and best-clothed citizens in history, the hunger for individual and social meaning remains a constant in our lives. For instance, many movements in this country—for civil rights, the rights of women, minority recognition—are signs of that human restlessness that will not be satisfied by bread alone. These movements are not peculiar to North America, as democratic movements in other parts of the world so readily attest.

The incredible achievements of modern society have exacted their price. Sigmund Freud shrewdly pointed out in *Civilization and Its Discontents* (1929) that the price of advanced culture is a certain repression of the individual together with the need of that individual to conform to the larger will of the community. North

Americans have always been sensitive to the constraints of the state, because their history began as a revolt against statist domination.

The Western world tends to view repression in terms more social than political. The complexity of the technological management of modern life has led many to complain that we are becoming mere numbers or ciphers under the indifferent control of data-banks and computers. Such warnings began as early as George Orwell's political novel *1984* (1946), written right after World War II; progressed through David Riesman's sociological tract of the 1950s, *The Lonely Crowd;* to the futurist predictions of Alvin Toffler's *Future Shock* in the 1970s. Now, in the new millennium, many more such analyses are sure to appear.

Art, of course, reflects not only the materials of its age but also its hopes and anxieties. The art, literature, and music of contemporary times attempt to diagnose our ills, protest our injustices, and offer alternative visions of what life might become. On exceptional occasions, the voice of the artist can sum up a cultural condition in a way such that change can come. Who would have believed that an obscure convict, buried in the vast prison complex of the Siberian wasteland, would raise his voice against injustice and repression to change radically the way a whole society is understood? But that is exactly what Alexsandr Solzhenitsyn did with respect to the ominous character of a now-collapsed Soviet communism. The same may be said of Nelson Mandela, who went from being a political prisoner to becoming the first African president of South Africa.

The true artist can finally articulate a vision of what humanity can trust. In the midst of alienation, the artist can bring community and in the midst of ugliness, beauty. The artist, in short, acts not only as a voice of protest but also as a voice of hope. The American novelist William Harrison Faulkner (1897–1962) spent a lifetime chronicling the violence, decay, injustice, poverty, and lost dreams of the American South. His novels are difficult to read, because they reflect the modernist sense of dislocated place and fragmented time. His most famous novel, *The Sound and the Fury* (1929), was notorious for its depiction of defective children, incestuous relationships, loutish drunkenness, and violence. In that sense it reflects the bleak landscape of the modern literary imagination. Yet Faulkner insisted that beneath the horror of modern life was a strong residue of human hope and goodness. Faulkner reaffirmed it resoundingly in his acceptance speech when he was awarded the Nobel Prize for Literature in 1949: "I believe that man will not merely endure; he will prevail."

Two generations later, in 1993, the African American woman of letters and novelist Toni Morrison would accept that same prize with a ringing act of faith in the power of language to aid our common humanity as well as a powerful description of how much the evil powers of the world fear the depths of true language.

In the rapidly shifting contours of our contemporary world, we might reflect on the ways in which artists have participated in the restructuring of societies. Many of those who struggled for human rights in the former Soviet Union and the Eastern bloc were poets, novelists, filmmakers, musicians, and playwrights. The redefinition of the status of women or others who suffer minority status in our own country expresses their plight in everything from films to poetry. The "subversive" quality of popular music is not only a part of our culture but has become a worldwide phenomenon. The role of artists in the changing of society is very much a part of the fabric of this chapter; history teaches that this relationship will also be true now in the new millennium.

EXISTENTIALISM

The philosophy that most persistently gripped the intellectual imagination of the Western world in the immediate postwar period was *existentialism*. Existentialism is more an attitude than a single philosophical system. Its direct ancestry can be traced to the nineteenth-century Danish theologian and religious thinker Søren Aabye Kierkegaard (1813–1855), who set out its main emphases. Kierkegaard strongly reacted against the great abstract philosophical systems developed by such philosophers as Georg Wilhelm Hegel (1770–1831) in favor of an intense study of the individual person in his or her actual existing situation in the world. Kierkegaard emphasized the single individual ("the crowd is untruth") who exists in a specific set of circumstances at a particular time in history with a specific consciousness. Philosophers like Hegel, Kierkegaard once noted ironically, answer every question about the universe except "Who am I?," "What am I doing here?," and "Where am I going?"

This radically subjective self-examination was carried on throughout the twentieth century by philosophers like Friedrich Nietzsche and novelists like Fyodor Dostoyevsky, who are regarded as forerunners of modern existentialist philosophy (see **TABLE 22.1**). In the twentieth century, writers like Franz Kafka, the German poet Rainer Maria Rilke, the Spanish critic Miguel de Unamuno, and, above all, the German philosopher Martin Heidegger gave sharper focus to the existentialist creed. The postwar writer who best articulated existentialism both as a philosophy and a lifestyle, however, was the French writer and philosopher Jean-Paul Sartre (1905–1980).

Sartre believed it the task of the modern thinker to take seriously the implications of atheism. If there is no God, Sartre insisted, then there is no blueprint for

TABLE 22.1 *Some Writers in the Existentialist Tradition*

Fyodor Dostoyevsky (1821–1881)—Russian
Søren Kierkegaard (1813–1855)—Danish
Friedrich Nietzsche (1844–1900)—German
Miguel de Unamuno (1864–1936)—Spanish
Nicholas Berdyaev (1874–1948)—Russian
Rainer Maria Rilke (1875–1926)—Czech/German
Martin Buber (1878–1965)—Austrian/Israeli
Jacques Maritain (1882–1973)—French
Karl Jaspers (1883–1969)—German
Franz Kafka (1883–1924)—Czech/German
José Ortega y Gasset (1883–1955)—Spanish
Martin Heidegger (1889–1976)—German
Jean-Paul Sartre (1905–1980)—French
Albert Camus (1913–1960)—French

what a person should be and no ultimate significance to the universe. People are thrown into life, and their very aloneness forces them to make decisions about who they are and what they shall become. "People are condemned to be free," Sartre wrote. Existentialism was an attempt to help people understand their place in an absurd world, their obligation to face up to their freedom, and the kinds of ethics available to individuals in a world bereft of absolutes.

Sartre began his mature career just as Germany was beginning its hostilities in the late 1930s. After being a prisoner of war in Germany, Sartre lived in occupied France, where he was active in the French Resistance, especially as a writer for the newspaper *Combat*. Sartre as well as novelist Albert Camus (1913–1960) and feminist writer Simone de Beauvoir (1908–1986) were the major voices demanding integrity in the face of the absurdities and horrors of war-torn Europe. Such an attitude might be considered a posture if it were not for the circumstances in which these existentialist writers worked.

The appeal of existentialism was its marriage of thought and action, its analysis of modern anxiety, and its willingness to express its ideas through the media of plays, novels, films, and newspaper polemics. After the close of the war in 1945, there was a veritable explosion of existentialist theater (Samuel Beckett, Harold Pinter, Jean Gênet, Eugène Ionesco) and existentialist fiction (Camus, Sartre, Beauvoir) in Europe. In the United States, existentialist themes were taken up eagerly by intellectuals and writers who were attracted to its emphasis on anxiety and alienation.

The so-called Beat writers of the 1950s embraced a rather vulgarized style of existentialism filtered through the mesh of jazz and the black experience. Beat writers such as the late Jack Kerouac, Gregory Corso, and Allan Ginsberg embraced the existentialist idea of alienation even though they rejected the austere tone of their European counterparts. Their sense of alienation was united with the idea of experience heightened by ecstasy either of a musical, sexual, or chemical origin.

The Beats, at least in that sense, were the progenitors of the 1960s hippies.

The existentialist ethic remained alive mainly through the novels of Albert Camus. In works like *The Stranger* (1942), *The Plague* (1947), and *The Fall* (1956), Camus, who disliked being called an existentialist, continued to impress his readers with heroes who fought the ultimate **absurdity** of the world with lucidity and dedication and without illusion.

Today, existentialism is mainly an historical moment in the postwar culture of Europe and America. Its importance, however, resides in its capacity to formulate some of the most important ideas of modernity: the absence of religious faith, the continuous search for meaning, the dignity of the individual, the concern for human subjectivity.

PAINTING SINCE 1945

Art critic Barbara Rose wrote that the history of world art in the second half of the twentieth century bore an unmistakable American stamp. It is hard to quarrel with that historical judgment since in the 1940s the United States, and more specifically New York, became the center of new impulses in art, much the way Paris had been in the first half of the twentieth century. At the end of that century, however, it was also clear that American supremacy may well have been diluted as art took on an international and transnational character.

Part of this geographical shift from Paris to New York can be explained by the pressures of World War II. Numerous artists and intellectuals fled the **totalitarian** regimes of Europe to settle in America. Refugee artist-teachers like Hans Hofmann (1880–1966), Josef Albers (1888–1976), and George Grosz (1893–1959) brought European ideas to a new generation of American painters. The American patron and art collector Peggy Guggenheim, who was then married to the Surrealist painter Max Ernst, fled her European home when war broke out to return to New York City, where at her Art of This Century gallery she exhibited such European painters as Braque, Léger, Arp, Brancusi, Picasso, Severini, and Miró. She quickly became a patron of the American painters who eventually led the American avant-garde movement. Peggy Guggenheim's support of this group in New York was crucial to the Americanization of modern art.

History nevertheless rarely records total and immediate shifts in artistic styles. Thus, while a revolution was taking place in American art and, for that matter, in world art, some excellent artists continued to work in an older tradition relatively untouched by this revolution. Edward Hopper (1882–1967), for instance, continued to produce paintings that explored his interest in light and his sensitivity to the problems of human isolation and loneliness. His *Nighthawks* [**FIG. 21.1**] is an

■ **22.1** Edward Hopper. *Nighthawks,* 1942. Oil on canvas, 2′6" × 4′8¹¹⁄₁₆". The Art Institute of Chicago, Chicago (Friends of American Art Collection).

example of Hopper's twin concerns. Ben Shahn (1898–1969) never lost the social passion that had motivated his work all through the 1930s. His *Death of a Miner* [Fig. 22.2] is both a tribute to and an outcry against the death of a workingman in a senseless accident.

Another painter who remained untouched by the postwar American revolution in painting was Georgia O'Keeffe (1887–1986), who had her first show in New York in 1916 at the galleries of Alfred Stieglitz, the photographer she married in 1924. Her early

■ **22.2** Ben Shahn. *Death of a Miner,* 1949. Tempera on muslin treated with gesso on panel, 27″ × 48″ (68.5 × 1.22 cm). Metropolitan Museum of Art, New York (Arthur Hoppock Hearn Fund, 1950). Copyright 1997 Estate of Ben Shahn/Licensed by VAGA, New York, NY.

VOICES OF THEIR TIMES

Georgia O'Keeffe

I have picked bones where I have found them—Have picked up sea shells and rocks and pieces of wood where there were sea shells and rocks and pieces of wood that I liked.

When I found beautiful white bones in the desert I picked them up and took them home too.

I have used these things to say what is to me the wideness and the wonder of the world as I live in it.

A pelvis bone has always been useful in any animal that has it—quite as useful as a head I suppose. For years in the country the pelvis bones lay about the house indoors and out—always underfoot—seen and not seen as such things can be—seen in many different ways. . . .

I was the sort of child that ate around the raisin on the cookie and ate around the hole in the doughnut saving either the raisin or the hole for the last and best.

So probably—not having changed much—when I started painting the pelvis bones I was most interested in the holes in the bones—what I saw through them—particularly the blue from holding them up to the sun against the sky as one is apt to do when one seems to have more sky than earth in one's world—

They were most wonderful against the Blue—the Blue that will be there as it is now after all men's destruction is finished.

I have tried to paint the Bones and the Blue.

A catalogue statement of Georgia O'Keeffe about her desert paintings, 1944. Reprinted by permission of the Georgia O'Keeffe Foundation.

paintings, like *Poppy* [**FIG. 22.3**], show both a masterful sense of color and scale and a precise sense of line. She belonged to the early strain of American modernism but continued in her own style. O'Keeffe has been recognized not only as a major artist in her own right but also as the focus for serious discussion about a feminist **aesthetic** in art contemporaneously.

Abstract Expressionism

The artists discussed in the last section have a secure reputation in the history of art, but the abstract Expressionists gave art in the period after 1945 its "unmistakable American stamp." The term *abstract Expressionism* is useful because it alludes to two characteristics funda-

mental to the work of these artists: It was devoid of recognizable content (and thus abstract), and it used color, line, and shape to express interior states of subjective aesthetic experience. *Action painting* and *New York School* are two other terms used to classify these painters.

The acknowledged leader of the abstract Expressionists was the Wyoming-born painter Jackson Pollock (1912–1956), who had his first one-man show at Peggy Guggenheim's gallery in 1943. Pollock's early work was characterized by an interest in primitive symbolism, deriving from the artist's long encounter with the psychology of Carl Jung. By the early 1940s, under the influence of the Surrealists and their technique of automatic creation—in which the artist allows the unconscious rather than the conscious will

■ **22.3** Georgia O'Keeffe. *Poppy*, 1927. Oil on canvas, 30″ x 36″ (76 x 85 cm). Museum of Fine Arts, St. Petersburg, Florida. The artist took the common subject of flowers and, through her profound line and strong sense of color, turned them into mysterious, nearly abstract, shapes of feminine power.

to stimulate the act of creation—Pollock began to depart radically from traditional ways of painting.

At first Pollock discarded brush and palette for sticks, small mops, and sponges to apply paint in coarse, heavy gestures. Then he set aside instruments altogether and poured, dripped, and spattered paint directly on the canvas in nervous gestural lines rather than enclosed shapes. For his colors he mixed the expensive oils of the artists with the utilitarian enamels used by house painters. Perhaps most radically, instead of using an easel he rolled out on the floor of his studio large expanses of canvas and applied paint in his unusual manner as he walked around and on them. The dimensions of the finished painting were fixed when Pollock decided to cut out from this canvas a particular area and then attach it to the traditional wooden support or stretcher. The result of these unorthodox procedures was huge paintings composed of intricate patterns of dribbles, drops, and lines—webs of color vibrant in their complexity [**FIG. 22.4**]. The energy-filled nets of paint extended to the limits of the stretched canvas and by implication beyond, seeming to have no beginning or end and hence attracting the stylistic label *"overall"* painting. Neither did these colors and lines suggest the illusion of space receding in

planes behind the surface of the picture, although they did create a sense of continuous rhythmic movement.

Other painters of the New York School in the 1940s and 1950s were more interested in the potentialities of large fields of color and abstract symbol systems, often with obvious psychological meanings. Adolph Gottlieb (1903–1974) painted a series of "bursts" in the 1950s in which a luminous sunlike **color field** hung over a primordial exploding mass [**FIG. 22.5**]. Robert Motherwell (1915–1991) executed hundreds of paintings in which huge primitive black shapes are in the foreground of subtle, broken color fields [**FIG. 22.6**]. Mark Rothko (1903–1970) experimented restlessly with floating color forms of the most subtle variation and hue. In the 1960s, Rothko painted a series of panels for a chapel in Houston [**FIG. 22.7**] in which he attempted with some success to use color variations alone to evoke a sensibility of mystical awareness of transcendence.

What did these artists have in common? Their energy and originality make it difficult to be categorical, although some generalizations are possible. They all continued the modernist tendency to break with the older conventions of art. As the Cubists turned away from traditional perspective, so the abstract Expressionists turned away from recognizable content to focus on

■ **22.4** Jackson Pollock. *Number 1,* 1948. Oil and enamel on unprimed canvas, 5'8" × 8'8" (1.7 × 2.6 m). Collection, Museum of Modern Art, New York (purchase). The theoretical basis for such random painting can be traced to the Freudian idea of free association and the Surrealist adaptation of that technique for art called *psychic automatism.*

▪ **22.5** Adolph Gottlieb. *Thrust,* 1959. Oil on canvas, 9′ × 7′6″ (2.74 × 2.29 m). Metropolitan Museum of Art, New York (George A. Hearn Fund, 1959). Copyright 1997 Adolph and Esther Gottlieb Foundation/Licensed by VAGA, New York, NY. Gottlieb's art is partly inspired by a year he spent in Arizona studying the Native American tradition of pictographs. The paintings also have a strong sexual undercurrent.

the implications of color and line. Second, they were expressionists, which is to say that they were concerned with the ability of their paintings to express not what they saw but what they felt and what they hoped to communicate to others. As one critic has put it, in an age when organized religion could no longer compel people with the power of revelation, these artists wished to express their sense of ultimate meaning and their thirst for the infinite. "Instead of making cathedrals out of Christ, Man, or 'Life,'" painter Barnett Newman wrote, "we are making them out of ourselves, out of our own feeling."

The desire to expand the possibilities of pure color detached from any recognizable imagery has been carried on and extended by a second generation of color-field painters, the most notable of whom is Helen Frankenthaler (b. 1928). Around 1951, Frankenthaler began to saturate unprimed canvases with poured paint so that the figure (the paint) merged into the ground (the canvas) of the work. By staining the canvas, she carried Pollock's action painting one step farther, emphasizing the pure liquidity of paint and the color that derives from it. Frankenthaler uses the thinnest of paints to take advantage of the light contrast between the paint and the unstained canvas (unlike Pollock she does not paint all over her ground). The result has been paintings with the subtlety of watercolors but distinctively and inescapably different [**Fig. 22.8**]. Her younger contemporary, Elizabeth Murray (b. 1940) still finds energy in abstract art. She paints large abstract canvases

▪ **22.6** Robert Motherwell. *Elegy to the Spanish Republic #34,* 1953–1954. Oil on canvas, 80″ × 100″ (203.2 × 254 cm). Albright-Knox Art Gallery, Buffalo, NY (gift of Seymour H. Knox, 1957). Copyright 1997 Dedalus Foundation/Licensed by VAGA, New York, NY. The title of the painting was inspired by the poetry of Federico García Lorca, but no direct literary reference should be seen in the painting. Motherwell insists that the "painter communes with himself."

■ **22.7** The Rothko Chapel, consecrated 1971, Houston, Texas. North, northeast, and east wall paintings. Oil on canvas (1965–1966). Chapel design by Philip Johnson. Murals by Mark Rothko. This ecumenical chapel contains fourteen panels finished several years before the artist's death. Rothko desired that the panels' brooding simplicity be a focus for the personal meditations of each viewer. He said he sought to create, between the chapel's entrance and its apse, the tension between doom and promise.

but experiments with more than one canvas and uses a firmer control over her paint, as is apparent in her work *Open Book* [**FIG. 22.9**].

The Return to Representation

It was inevitable that some artists would break with abstract Expressionism and return to a consideration of the object. This reaction began in the mid-1950s with painters like Jasper Johns (b. 1930), whose *Flag* series [**FIG. 22.10**] heralded a new appreciation of objects. Furthermore, Johns's art focused on objects taken from the mundane world. Johns went on to paint and sculpt targets, toothbrushes, beer cans, and even his own artist's brushes. This shift signaled a whimsical and ironic rejection of highly emotive, content-free, and intellectualized abstract art.

■ **22.8** Helen Frankenthaler. *The Bay,* 1963. Acrylic resin on canvas, 6′8¼″ × 6′9¼″ (2.02 × 2.08 m). Detroit Institute of Arts (gift of Dr. Hilbert and Mrs. H. Delawter). Frankenthaler's work gains its almost watercolor luminosity by her practice of thinning her paints to the consistency of washes.

■ **22.9** Elizabeth Murray. *Open Book*. Whitney Museum of American Art, New York.

Robert Rauschenberg (b. 1925) was another artist who helped define the sensibility emerging as a counterforce to abstract Expressionism in the 1950s. Rauschenberg studied at Black Mountain College, an experimental school in North Carolina, under the tutelage of the refugee Bauhaus painter Josef Albers. A more important influence from his Black Mountain days was the avant-garde musician and composer John Cage (1912–1992), who encouraged experiments combining music, drama, dance, art, and other media into coherent artistic wholes, which were called *Happenings*. Rauschenberg began to experiment with what he called **combine paintings** that utilized painting combined with any number of assembled objects in a manner that had deep roots in the avant-garde. By 1959, he was doing large-scale works like his *Monogram* [**Fig. 22.11**], which combined an assortment of elements (including a stuffed goat!) in an outrageous yet delightful collage.

The third artist who emerged in the late 1950s, Andy Warhol (1930–1987), became notorious for his paintings of soup cans, soap boxes, cola bottles, and the other throwaway detritus of our society. This made his name synonymous with *Pop art,* a term first used in England to describe the art of popular culture. The long-range judgment on Warhol as a serious artist may be harsh, but he understood one thing quite well: Taste today is largely shaped by the incessant pressure of advertising, mass media, pulp writing, and the transient culture of fads. Warhol, who began his career as a commercial illustrator, exploited that fact relentlessly.

Over the years, Warhol increasingly turned his attention away from painting and toward printmaking,

■ **22.10** Jasper Johns. *Flag,* 1954. Encaustic, oil, and collage on fabric mounted on plywood, 3′6¼″ × 5′⅝″ (1.07 × 1.54 m). Museum of Modern Art, New York (gift of Philip Johnson in honor of Alfred Barr Jr.). Copyright 1997 Jasper Johns/ Licensed by VAGA, New York, NY. The rather banal subject should not detract from Johns's phenomenal technique. Encaustic is painting done with molten colored wax.

videotapes, movies, and Polaroid® photography. His subjects tended to be the celebrities of film and the social world. Whether his art is a prophetic judgment on our culture or a subtle manipulation of it is difficult to answer because Warhol could be bafflingly indirect. His lightly retouched silkscreen prints of entertainment celebrities [**FIG. 22.12**] seem banal and of little permanent value, but that may be exactly what he wished to express.

Painting from the 1970s is difficult to categorize. Some artists continued to explore color-field painting with great verve. Others, such as Ellsworth Kelly, Kenneth Noland, and Frank Stella, explored more formal elements with carefully drawn "hard edges," primary colors, and geometrically precise compositions. They were almost ascetic in their use of line and color, as "minimalist" works of an artist like Ellsworth Kelly show [**FIG. 22.13**].

Another group of painters went back totally to the recognizable object painted in a manner so realistic that critics called them *Photorealists*. Less glossy than the Photorealists but almost Classical in their fine draftsmanship are the erotically charged nudes of Philip Pearlstein, who takes a position somewhere between the fragmented world of Cubism and the slick glossiness of popular magazines. His *Two Female Models on*

■ **22.12** Andy Warhol. *Mick Jagger*, 1975. Synthetic polymer paint and silkscreen ink on canvas, 40" (102 cm) square. The Andy Warhol Foundation for the Visual Arts. Warhol incorporated into high art the world of the media, money, and fashion. Until his death in 1987, he incarnated the notion of the artist as celebrity figure with his explorations in video, film, photography, magazine publishing, graphics, and painting.

■ **22.13** Ellsworth Kelly. *Grey Panels 2,* 1974. Oil on canvas (two panels), 92" × 102" (233.6 × 304.8 cm). Leo Castelli Gallery, New York. By comparing this work to Frankenthaler's (Figure 22.8), one can see the different approaches to color in the post-abstract Expressionist period.

■ **22.14** Philip Pearlstein. *Two Female Models on Eames Chair and Stool,* 1976–1977. Oil on canvas, 60" × 72". Private Collection, New York. Compare Pearlstein's nudes to those of the Renaissance tradition represented by an artist like Titian to get a feeling for the modern temper.

Eames Chair and Stool [**Fig. 22.14**] is a serious and unsentimental study of the female figure.

For Alfred Leslie (b. 1927), the past can still be a teacher for the modern painter. In a work like *7 A.M. News* [**Fig. 22.15**], Leslie combines an eye for contemporary reality and the use of *chiaroscuro,* a technique he consciously borrows directly from the seventeenth-century painter Caravaggio. With Leslie we have come, as it were, full circle from the abstract Expressionist break with tradition to a contemporary painter who consciously looks back to seventeenth-century masters for formal inspiration.

One can say that two intellectual trends seem to have emerged in American painting in this period. One strain, abstract Expressionism and its various off-spring, is heavily indebted to the modernist intellectual tradition, with its many roots in psychological theories of Jung and Freud and the existentialist vocabulary of anxiety and alienation. By contrast, the work of painters like Johns, Warhol, Rauschenberg, and others is far more closely linked to the vast world of popular culture in postindustrial America. Its material, its symbols, and its intentions reflect the values of consumer culture more than the 1940s work of the New York School. Pop art, largely free from the brooding metaphysics of the abstract Expressionists, can be seen—perhaps simultaneously—as a celebration and a challenge to middle-class values.

One sees that same blend of "isms" and references to popular culture in the work of African American artists. Romare Bearden (1914–1988) produced work that absorbed collage, Cubism, and tendencies to abstraction

■ **22.15** Alfred Leslie. *7 A.M. News,* 1976–1978. Oil on canvas, 7′ × 5′ (2.13 × 1.52 m). Oil and Steel Gallery, Long Island. Copyright Alfred Leslie. Leslie uses the technique of *chiaroscuro* in conscious homage to baroque masters like Caravaggio and Rembrandt.

in order to make a body of art that was distinctively his own. His painting *The Prevalence of Ritual: Baptism* [**Fig. 22.16**] celebrates a traditional religious ritual with references to Africa done in a Cubist style. By contrast, the painter Jean Lacy (b. 1932) utilizes mixed media in the work *Little Egypt Condo, New York City* to celebrate her racial heritage and, at the same time, rejoice in the energy of city life [**Fig. 22.17**].

Painting in the late 1970s and 1980s went in many directions. Critics are agreed on one point: no pre-dominant "ism" defines contemporary art. The profusion of styles apparent on that day's art scene testifies to either a vigorous eclecticism or a sense of confusion. Older painters like Frank Stella still pushed the limits of abstract art [**Fig. 22.18**], whereas Susan Rothenberg's canvases reflected a concern with the texture of painting, in which recognizable figures emerged like risen ghosts [**Fig. 22.19**]. The same polarity of styles can be seen by contrasting the sunny optimism of the English-born David Hockney (now living

■ **22.16** Romare Bearden. *The Prevalence of Ritual: Baptism,* 1964. Collage on board, 9″ × 12″ (23 × 30 cm). The Hirshhorn Museum and Sculpture Garden, Smithsonian Institution. Washington, D.C. (Gift of Joseph H. Hirshhorn, 1966). Copyright 1997 Romare Bearden Foundation/Licensed by VAGA, New York, NY.

■ **22.17** Jean Lacy. *Little Egypt Condo, New York City,* 1987. Mixed media on museum board, 10½″ × 13½″ (26.6 × 33.5 cm). Dallas Museum of Arts, gift of the Dallas Chapter of LINKS, Inc.

■ **22.18** Frank Stella. *Shoubeegi (Indian Birds),* 1978. Mixed media on metal relief, 94″ × 120″ × 32½″ (238.8 × 304.8 × 82.6 cm). Private Collection (courtesy of Leo Castelli Gallery, New York). Stella has been the foremost and most persistent defender of abstract art on the American scene today.

■ **22.19** Susan Rothenberg. *Cabin Fever,* 1976. Acrylic and tempera on canvas, 67″ × 84″ (170.2 × 213.4 cm) Collection of the Modern Art Museum of Fort Worth, Fort Worth, Texas, Museum Purchase, Sid W. Richardson Foundation Endowment Fund and an Anonymous Donor.

in California) [**FIG. 2.20**] with the brooding work of the German Expressionist painter Anselm Kiefer [**FIG. 22.21**]. These artists worked in a time when "older masters" like Johns, Rauschenberg, and others still pushed the limits of their original insights and flights of imagination.

A new generation of artists like the Native American painter Jaune Quick-to-See Smith (born 1940) incorporates images, words, scribbles, and drips in works such as *Indian, Indio, Indigenous* to affirm both her own identity and her protest against racism in general and the mistreatment of Native Americans specifically [**FIG. 22.22**].

CONTEMPORARY SCULPTURE

Sculpture since 1945 shows both continuities and radical experimentation. The Italian sculptor Giacomo Manzù (1908–1990) still worked with traditional forms of bronze-casting to produce works like the doors of Saint Peter's [**FIG. 22.23**] commissioned by the Vatican in the 1950s and cast in the 1960s. Although his style is modern, the overall concept and nature of the commission hark back to the Italian Renaissance and earlier.

Much of contemporary sculpture has utilized newer metals (stainless steel or rolled steel, for instance) and welding techniques to allow some freedom from the inherent density of cast bronze, the traditional metal of the sculptor. David Smith (1906–1965) used his skills as a one-time auto-body assembler to produce simple and elegant metal sculptures that reflected his not-inconsiderable technical skills with metal as well as his refined sense of aesthetic balance. In works such as *Cubi I* [**FIG. 22.24**], Smith used stainless steel to produce a geometrically balanced work of solidity that conveys a sense of airy lightness.

Alexander Calder (1898–1976) used his early training as a mechanical engineer to combine the weightiness of metal with the grace of movement. Mobiles such as *Big Red* [**FIG. 22.25**] are constructed of painted sheet metal and wire; these constructions move because they are so delicately balanced that they respond to even the slightest currents of air. Calder once said that people think monuments "come out of the ground, never out of the ceiling"; his mobiles were meant to demonstrate just the opposite.

Other contemporary sculptors expanded the notion of assembling disparate materials into a coherent artistic whole. Employing far-from-traditional materials, these artists utilized a variety of found and manufactured articles of the most amazing variety to create organic artistic wholes. Louise Nevelson (1900–1988), for example, used pieces of wood, many of which had been lathed or turned for commercial uses, to assemble

■ **22.20** David Hockney. *Self-Portrait, July 1986,* 1986. Homemade print executed on color office copy machine, two panels, 22″ × 8½″ (55.9 × 21.6 cm). Collection of the artist. This work was done by running the page through commercial copying machines to get the various colors of the finished portrait.

large-scale structures that seemed at the same time to function as walls closing off space and as containers to hold the items that made up her compositions [**Fig. 22.26**]. Joseph Cornell (1903–1972), early influenced by both Surrealism and Dada, constructed small boxes that he filled with inexpensive trinkets, maps, bottles, tops, stones, and other trivia. In contrast to the larger brooding, almost totemic spirit of Nevelson, Cornell's painstakingly organized boxes [**Fig. 22.27**] allude to a private world of fantasy.

The sculptural interest in *Assemblage* has been carried a step farther by such artists as George Segal (1924–2000) and Edward Kienholz (1927–1994). Their works re-create entire tableaux into which realistically sculptured figures are placed. Segal, once a painting student of Hans Hofmann in New York, liked to cast human figures in plaster of Paris and then set them in particular but familiar settings [**Fig. 22.28**]. The starkness of the lone white figures evokes a mood of isolation and loneliness not unlike that of the paintings of Edward

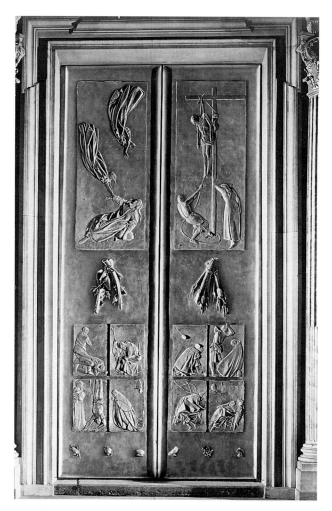

■ **22.21** Anselm Kiefer. *Innenraum,* 1981. Oil, paper, and canvas, 111′ × 122′ (34.45 × 37.2 m). Stedelijk Museum, Amsterdam. Kiefer's monumental paintings have echoes of past masters combined with a brooding sense of Germany's own past, mythic and historical.

■ **22.22** Juane Quick-to-See Smith. *Indian, Indio, Indigenous,* 1992. Oil and mixed media on canvas, 60″ × 100″ (152.4 × 254 cm). Washington, D.C., National Museum of Women in the Arts.

■ **22.23** Giacomo Manzù. Doors of Saint Peter's, 1963. Cast bronze, 24′3″ × 11′9″ (7.4 × 3.6 m). Vatican City, Rome. These doors are on the extreme left of the portico of the basilica. (Opposite is the entrance opened only for Holy Year celebrations, every quarter-century.)

■ **22.25** Alexander Calder. *Big Red,* 1959. Painted sheet metal and steel wire, 6′2″ × 9′6″ (1.9 × 2.9 m). Whitney Museum of American Art, New York (purchased with funds from the Friends of the Whitney Museum of American Art).

■ **22.24** David Smith. *Cubi I,* 1963. Stainless steel, height 10′4″ (3.15 m). Detroit Institute of Arts (Founders Society Purchase Fund). Copyright 1997 Estate of David Smith/Licensed by VAGA, New York, NY. Critics recognize Smith as one of the most important sculptors of the twentieth century. Smith took this photograph at his studio in Bolton Landing, New York.

■ **22.26** Louise Nevelson. *Sky Cathedral—Moon Garden + One,* 1957–1960. Painted wood, 9′1″ × 10′10″ × 19″ (2.77 × 3.3 × .48 m). Pace Gallery, Milly and Arnold Glimcher Collection. This detail shows the intricate and complex nature of Nevelson's work. At her death in 1988, she was considered one of the most accomplished sculptors in the world.

■ **22.27** Joseph Cornell. *Object Roses des Vents,* 1942–1953. Wooden box with twenty-one compasses set in a wooden tray resting on Plexiglas-topped-and-partitioned section, divided into seventeen compartments containing small miscellaneous objects and three-part hinged lid covered inside with parts of maps of New Guinea and Australia, $2\frac{5}{8}'' \times 21\frac{1}{4}'' \times 10\frac{3}{8}''$ (6.7 \times 53.9 \times 26.4 cm). Museum of Modern Art, New York (Mr. and Mrs. Gerald Murphy Fund).

Hopper. Kienholz was far better prepared to invest his works with strong social comment. His *State Hospital* [**FIG. 22.29**] is a strong, critical indictment of the institutional neglect of the mentally ill. The chained figure at the bottom of the tableau "dreams" of his own self-image (note the cartoonlike bubble) on the top bunk. In the original version of this powerful piece, goldfish were swimming in the plastic-enclosed faces of the two figures.

Both Segal and Kienholz have certain ties to Pop art, but neither artist works within its whimsical or humorous vein. Claes Oldenburg (b. 1929), however, is one of the more humorously outrageous and inventively intelligent artists working today. He has proposed (and, in many cases, executed) monumental outdoor sculptures depicting teddy bears, ice-cream bars, lipsticks, and baseball bats. From the 1960s on, Oldenburg experimented with sculptures that turn normally rigid objects into "soft" or "collapsing" versions made from vinyl or canvas and stuffed with kapok. A piece

■ **22.28** George Segal. *The Diner,* 1964–1966. Plaster, wood, chrome, formica, masonite, fluorescent lights, $8'6'' \times 9' \times 7'3''$ (2.59 \times 2.75 \times 2.14 m). Walker Art Center, Minneapolis (gift of the T. B. Walker Foundation, 1966). Copyright 1997 George Segal/Licensed by VAGA, New York, NY. More recently, Segal experimented with colored plasters and large cast bronze outdoor pieces.

■ **22.29** Edward Kienholz. *The State Hospital.* Detail, 1966. Mixed media, $8' \times 12' \times 10'$ (2.44 \times 3.66 \times 3.05 m). Moderna Museet, Stockholm. Kienholz's work provokes such violent reactions that in 1966 some works were threatened with removal from a one-person show he had in Los Angeles.

⌂ VALUES

Liberation

If we understand *liberation* in the deep social sense as freedom *to* realize one's full human potential as well as freedom *from* oppressive structures, we would then have to say that the desire for, and realization of, liberating freedom is one of the hallmarks of modern world culture. This was especially true in the second half of the twentieth century.

Liberation has come both for millions from the totalitarian regimes of fascism, Nazism, and Marxism as well as freedom from the colonial powers in areas as diverse as India and Africa. These liberation movements have their mirror image in the struggle for civil rights for people of color, for women, for exploited social minorities, as well as struggles to end poverty, hunger, and the exploitation of children.

What energizes these quite different movements for freedom and liberation? A partial answer is to be found in the power of mass communication to let people know that they are victims of oppression. There is also the power of certain fundamental ideas derived, in the West, from Greek philosophical thought and biblical prophetism, which crystallized in the Enlightenment that held forth the promise of the right to "life, liberty, and the pursuit of happiness."

The struggle for social and political liberation has involved many communities, with some spokespersons standing out both because of their personal bravery and the power of their convictions. We think immediately of Mohandas Gandhi in India; Martin Luther King Jr. in the United States; Desmond Tutu and Nelson Mandela in Africa; Lech Walesa and Vaclav Havel in Eastern Europe, as well as the many unnamed persons who put their lives on the line to live free.

like his *Soft Toilet* [**FIG. 22.30**] is simultaneously humorous and mocking. It echoes Pop art and recalls the oozing edges so characteristic of Surrealism.

Overarching these decades of sculptural development is the work of the British sculptor Henry Moore (1898–1986). Moore's work, which extends back into the 1920s, is a powerful amalgam of the monumental tradition of Western sculpture deriving from Renaissance masters like Michelangelo and his love for the forms coming from the early cultures of Africa, Mexico, and pre-Colombian Latin America. From these two sources, Moore worked out hauntingly beautiful works—some on a massive scale—that speak of the most primordial realities of art.

Moore's *Reclining Figure* [**FIG. 22.31**] is a complex work that illustrates many of the sculptor's mature interests. The outline is obviously that of a woman in a rather abstract form. There is also the hint of bonelike structure, a favorite motif in Moore's abstract sculpture, and holes pierce the figure. The holes, Moore once said, reminded him of caves and openings in hillsides with their hint of mystery, and critics have also noted their obvious sexual connotations. The figure reclines after the fashion of Etruscan and Mexican burial figures. In a single work, Moore hints at three primordial forces in the universal human experience: life (the female figure), death (the bonelike configurations), and sexuality (the holes). It is a sculpture contemporary in style but timeless in its message.

Most of the sculpture just discussed was made for a gallery or a collector. Thanks to increased government and corporate patronage in recent decades, it is possible for an average citizen to view outdoor sculpture as part of the urban environment. A walk in the downtown area of Chicago, for example, provides a chance to see monumental works of Picasso, Chagall, Bertoia, Calder, and Oldenburg. The fact that the federal government had set aside a certain percentage of its building budget for works of art to enhance public buildings has been an impetus for wider diffusion of modern art and sculpture. In one sense, the government, the large foundations, and the corporations have supplanted the church and the aristocracy as patrons for monumental art in our time.

One of the most moving public outdoor works is the Vietnam Veterans Memorial [**FIG. 22.32**] in Washington, D.C. The work's designer was a young architecture student at Yale University, Maya Ying Lin. Two polished black granite walls, each more than two hundred feet in length, converge in a V-shape. Fifty-five thousand names of dead service personnel killed in Vietnam are inscribed on the walls; the polished surface acts as a mirror for those who visit what has become one of the most popular pilgrimage spots in the nation's capital.

In the 1980s, sculpture demonstrated a variety not unlike that of contemporary painting. The Bulgarian-born Christo and his wife, Jeanne-Claude, sought out

large natural sites to drape with various fabrics for temporary alteration of our perception of familiar places [**Fig. 22.33**]. Part of Christo's strategy was to mobilize large numbers of volunteers to actually create the work he had so carefully planned. By contrast, the haunting work of Magdalena Abakanowicz uses basic fibers to make pieces that have fearful references to twentieth-century human disasters [**Fig. 22.34**]. The American sculptor Duane Hanson (d. 1996) took advantage of new materials like polyvinyl to create hyper-realistic visions of ordinary people in ordinary experiences [**Fig. 22.35**]. All of these sculptors have drawn on the most advanced contributions of material science and technology while meditating on problems of the human condition as old as art itself.

The American painter Jennifer Bartlett (b. 1941) has more recently moved into sculpture, taking some of the iconic symbols from her painting and turning them into sculptures like her *Two Boats* [**Fig. 22.36**], done as part of a commission for the Volvo Corporation in Sweden. By contrast, Mary Frank (b. 1932) has stepped into the world of ceramics to use terra-cotta to create large-scale sculptures of women that reflect a haunting beauty and an almost primitive power [**Fig. 22.37**]. One sculptor (if that is the word!) who has fully explored the potentialities of our media culture is the Korean-born Nam June Paik, whose assemblage titled *Electronic Superhighway* pays homage to what is surely one of the most revolutionary elements of contemporary culture [**Fig. 22.38**].

The British artist Rachel Whiteread (born 1963) created a large concrete sculpture of the interior of a library that once was in the Judenplatz in Vienna as part of a larger Holocaust memorial. The spare façade with its striated panels represents the lost books destroyed by the Nazis and, by extension, the attempted destruction of Jewry itself [**Fig. 22.39**].

■ **22.30** Claes Oldenburg. *Soft Toilet*, 1966. Vinyl filled with kapok painted with liquitex, and wood. Height 4′4″ (1.27 m). Whitney Museum of Modern Art, New York (50th Anniversary Gift of Mr. and Mrs. Victor M. Ganzi). Oldenburg's humor derives from the well-known device of taking the expected and rendering it in an unexpected self-parodying form.

■ **22.31** Henry Moore. *Reclining Figure,* 1939. Elm wood. 3′1″ × 6′7″ × 2′6″. Detroit Institute of Arts, Detroit. Founders Society purchase with funds from the Dexter M. Ferry Jr. Trustee Corporation.

■ **22.32** Maya Ying Lin. *Vietnam Veterans Memorial*, 1982. Black granite. Length: 492′. The Mall, Washington, D.C.

■ **22.33** Christo and Jeanne-Claude. *Valley Curtain, Rifle, Colorado. 1970–1972.* One hundred forty-two thousand square feet of woven nylon fabric; 11,000 pounds of steel cables. Spans 1250′ (381 m), height 365′ to 182′ (111 to 56 m). Project direction: Jan van der Marck. Since that project, Christo and Jeanne-Claude realized projects include *24½-mile Running Fence, Sonoma and Marin Counties, California, 1972–1976, Surrounded Islands, Biscayne Bay, Greater Miami, Florida, 1980–1983, The Pont Neuf Wrapped, Paris, 1975–1985,* and *The Umbrellas, Japan–USA, 1984–1991, Wrapped Reichstag, Berlin, 1971–1995, Wrapped Trees, Fondation Beyeler and Berower Park, Riehen, Switzerland, 1997–1998,* and *Gates, Central Park, New York City, 1979–2005.*

■ **22.34** Magdalena Abakanowicz. *Backs,* 1976–1982. (80 pieces) Burlap and resin, each approx. 27¼″ × 22″ × 26″ (69 × 56 × 66 cm). Each unique. Courtesy, Marlborough Gallery, New York. Copyright 1996 Magdalena Abakanowicz, *Backs,* 1976–1980/Licensed by VAGA, New York, NY. These figures speak of human degradation, the horrors of war and servitude, and inhumanity. Abakanowicz has pushed fiber arts to new and profound directions beyond the mere designation of "craft art."

■ **22.35** Duane Hanson. *The Dockman,* 1979. Polyvinyl, polychromed in oil, life-size. Collection Belger Cartage Service, Inc. Compare this work to George Segal's casts in Figure 22.28.

■ **22.36** Jennifer Bartlett. *Two Boats,* 1984. Cor-ten steel. Volvo Corporate Headquarters, Göteborg, Sweden.

■ **22.37** Mary Frank. *Chant,* 1984. Ceramic, 40″ × 60″ × 38″ (102 × 152.4 × 96.5 cm). Collection of Virginia Museum of Fine Arts, Richmond, Virginia.

ARCHITECTURE

The most influential American architect of the twentieth century was Frank Lloyd Wright (1869–1959), who was a disciple of Louis Sullivan (1856–1924). Sullivan had built the first skyscrapers in the United States in the last decade of the nineteenth century. Like Sullivan, Wright championed an architecture that produced buildings designed for their specific function with an eye focused on the natural environment in which the building was to be placed and with a sensi-

tivity to what the building should "say." "Form follows function" was Sullivan's famous aphorism for this belief. For Wright and his disciples, there was something ludicrous about designing a post office to look like a Greek temple and then building it in the center of a Midwestern American city. Wright wanted an *organic* architecture—an architecture that grows out of its location rather than being superimposed on it.

For decades Wright designed private homes, college campuses, industrial buildings, and churches that reflected this basic philosophy. In the postwar period, Wright finished his celebrated Solomon R. Guggen-

■ **22.38** Nam June Paik. *Electronic Superhighway,* 1995. Multiple television monitors (313 TVs—US/24 TVs—Alaska/1 TV—Hawaii). Laser disk images, neon, and audio, 15′ × 32′ × 4′ (4.6 × 9.8 × 1.2 m). Holly Solomon Gallery, New York.

■ **22.39** Rachel Whiteread, Holocaust Memorial, Vienna, Austria, 2000.

heim Museum [**Fig. 22.40**] in New York City from plans he had made in 1943. This building, one of Wright's true masterpieces, is a capsule summary of his architectural ideals. Wright was interested in the flow of space rather than its obstruction ("Democracy needs something basically better than a box"), so the

■ **22.40** Frank Lloyd Wright. Solomon R. Guggenheim Museum, 1957–1959. Reinforced concrete, diameter at ground level approx. 100′ (30.48 m), at roof level 128′ (39 m), height of dome 92′ (28 m). The Solomon R. Guggenheim Foundation, New York. One of the most discussed American buildings of the twentieth century, it is hard to realize that it sits in the midst of New York's Fifth Avenue buildings. A new rectangular addition now stands behind the museum.

Guggenheim Museum's interior is designed to eliminate as many corners and angles as possible. The interior is essentially one very large room with an immensely airy central space. Rising from the floor in a continuous flow for six stories is a long, simple spiraling ramp cantilevered off the supporting walls. A museumgoer can walk down the ramp and view an exhibition without ever encountering a wall or partition. The viewing of the art is a continuous unwinding experience. Thus the *function* of the museum (to show art) is accomplished by the *form* of the building.

The exterior of the Guggenheim Museum vividly demonstrates the possibilities inherent in the new building materials that became available in that century. By the use of reinforced or ferroconcrete, one could model or sculpt a building easily. The Guggenheim Museum, with its soft curves and cylindrical forms, seems to rise up from its base. The undulating lines stand in sharp contrast to the boxy angles and corners of most of the buildings found in New York City. By using such a design, made to fit a rather restricted urban space, the Guggenheim almost takes on the quality of sculpture.

The sculptural possibilities of reinforced and prestressed concrete gave other architects the means to "model" buildings in dramatically attractive ways. The Italian engineer and architect Pier Luigi Nervi (1891–1979) demonstrated the creative use of concrete in a series of buildings he designed with Annibale Vitellozi for the 1960 Olympic Games in Rome [**FIG. 22.41**]. Eero Saarinen (1910–1961) showed in the TWA Flight Center at Kennedy International Airport in New York City [**FIG. 22.42**] that a building can become almost pure sculpture; Saarinen's wing motif is peculiarly appropriate for an airport terminal. That architects have not exhausted the potentialities of this modeled architecture seems clear from the Opera House complex in Sydney, Australia [**FIG. 22.43**]. Here the Danish architect Jörn Utzon utilized Saarinen's wing motif, but it is no slavish copy because Utzon gives it a new and dramatic emphasis.

The influential French architect Le Corbusier (1887–1965; born Charles Édouard Jeanneret-Gris) did not share Wright's enthusiasm for "organic" architecture. Le Corbusier saw architecture as a human achievement that should stand in counterpoint to the world of nature. During his long career, Le Corbusier designed and oversaw the construction of both individual buildings and more ambitious habitations ranging from apartment complexes to an entire city. One of his most important contributions to architecture is his series of Unités d'Habitation in Marseille (1952) and Nantes [**FIG. 22.44**]. These complexes were attempts to make large housing units into livable modules that would not only provide living space but would also be sufficiently self-contained to incorporate shopping, recreation, and walking areas.

Le Corbusier used basic forms (simple squares, rectangles) for the complexes and set them on pylons to both give more space beneath the buildings and break up their rather blocky look. Many of these buildings would be set in green park areas situated to capture something of the natural world and the sun. The basic building material is concrete and steel (often the concrete was not finished or polished because Le Corbusier liked the rough texture of the material). Less-inspired architects have utilized these same concepts for public housing with indifferent success—as visits to the peripheries of most urban centers will attest. Time has been a harsh judge of Le Corbusier's vision of human living space, which is now judged to be soulless and deadening.

Le Corbusier's influence in North America has been mainly derivative. Two other European architects,

■ **22.41** Pier Luigi Nervi and Annibale Vitellozi. Palazzetto dello Sport, Rome, 1956–1957. The walls beneath the dome are of glass. The Y-shaped ferroconcrete columns are reminiscent of caryatids; their outstretched "arms" support the dome.

■ **22.42** Eero Saarinen. Trans World Flight Center, Kennedy International Airport, New York, 1962. The building brilliantly shows the sculptural possibilities of concrete. With the demise of TWA, the flight center is temporarily closed after a short period as an exhibit space.

■ **22.43** Jörn Utzon. Opera House, Sydney, Australia, 1959–1972. Reinforced concrete. Height of highest shell 200′ (60.96 m). The building juts dramatically into Sydney's harbor. Structural technology was pushed to the limit by the construction of the shells, which are both roof and walls. The openings between the shells are closed with two layers of amber-tinted glass to reduce outside noise and to open up views to people in the lobbies of the buildings.

however, have had an immense impact on American architecture. Walter Gropius (1883–1969) and Ludwig Miës van der Rohe (1896–1969) came to this country in the late 1930s, refugees from Nazi Germany. Both men had long been associated with the German school of design, the Bauhaus.

Van der Rohe's Seagram Building [**Fig. 22.45**] in New York City, designed with Philip Johnson (1906–1991), beautifully illustrates the intent of Bauhaus design. It is a severely chaste building of glass and anodized bronze set on stainless steel pylons placed on a wide granite platform. The uncluttered plaza (broken only by pools) contrasts nicely with the essentially monolithic glass building that rises up from it. The lines of the building are austere in their simplicity, while the materials are few and well chosen, which results in an integration of the whole. It illustrates the "modern" principle of the Bauhaus that simplicity of

■ **22.44** Le Corbusier. L'Unité d'Habitation, Marseille, France, 1947–1952. Length 550′ (167.64 m), height 184′ (56.08 m), width 79′ (24.08 m). The individual balconies have colored panels to break up the stark, rough concrete exterior. Imitation of this style resulted in much soulless public housing in the large cities of the world.

■ **22.45** Ludwig Miës van der Rohe and Philip Johnson. Seagram Building, New York, 1956–1958. Height 512′ (156.2 m). Compare the cleanly severe lines of this building to those of the more ornate buildings in the background.

design results in an aesthetically harmonic whole—"less is more" according to the slogan of this art.

The Seagram Building now seems rather ordinary to us, given the unending procession of glass-and-steel buildings found in most large city centers. That many of these buildings are derivative cannot be denied; that they may result in sterile jungles of glass and metal is likewise a fact. Imitation does not always flatter the vision of the artist, but excesses do not invalidate the original goal of the Bauhaus designers. They were committed to crispness of design and the imaginative use of material. In the hands of a master architect that idea is still valid, as the stunning East Wing addition to the National Gallery of Art in Washington, D.C., clearly demonstrates [**FIG. 22.46**]. This building, designed by I. M. Pei (b. 1917), utilizes pink granite and glass within the limits of a rather rigid geometric design to create a building that is monumental in scale without loss of lightness or crispness of design.

One can profitably contrast the chaste exterior East Wing of Washington's National Gallery with the Georges Pompidou National Center for Arts and Culture in Paris [**FIG. 22.47**], designed by Renzo Piano and Richard Rogers. The Pompidou Center was opened in 1977 as a complex of art, musical research, industrial design, and public archives. The architects eschewed the clean lines of Classical sculpture, covering the exterior with brightly colored heating ducts, elevators, escalators, and building supports. It has been a highly controversial building since its inception, but Parisians (and visitors) have found it a beautiful and intriguing place. Whether its industrial style will endure is open to question, but for now its garishness and nervous energy have made it a cultural mecca for visitors to Paris. It may in time even rival that other monument once despised by Parisians and now practically a symbol for the city: the Eiffel Tower.

Since the 1970s, several architects, including Philip Johnson and Robert Venturi, have moved beyond the standard modern design of large buildings to reshape them with decorative elements and more broken lines; this break from the severe lines of modernist taste has come to be called *postmodernism* in architecture. The country now has many such buildings, but one, a skyscraper in Seattle, Washington, well illustrates the postmodern sensibility [**FIG. 22.48**]. The designer, William Pederson, retains the severe lines and the ample use of glass characteristic of most modern business buildings, but he breaks up those lines with a bowed center of the building that stands in contrast to the classical sides. The higher floors break up the design of the lower floors and, in an almost postmodern signature, he caps the building with a half-arch students will remember seeing on the façades of Renaissance and baroque buildings but whose ultimate inspiration is the Roman half-arch. One architectural critic has said that this building sums up what is best in innovative skyscraper

▪ **22.46** I. M. Pei. East Wing of the National Gallery of Art, c. 1992, Washington, D.C., opened 1978. Pei combined a modernist look with a classical one that prevents the edifice from clashing with the older buildings on the mall leading to the Capitol.

design today. Its sense of color (the stone is a pinkish granite), its homage to Classical decorative motifs, and its advance on Bauhaus severity (without a firm rejection of it)—all summarize what is known as the post-modern in architecture.

The Seattle Art Museum (1991), designed by the husband-and-wife team of Robert Venturi and Denise Scott Brown, has many of the same postmodern characteristics with its bold use of color and modification of traditional architectural motifs to provide a startling new vision, which is an advance beyond the modernist ideal [**Fig. 22.49**].

A far more radical and "destabilizing" example of postmodern architecture is the innovative work of the Los Angeles–based architect, Frank Gehry (b. 1929), whose recently opened (1994) American Center in Paris [**Fig. 22.50**], done in Parisian limestone, is an energetically eccentric work of angles and sweeping lines.

▪ **22.47** Renzo Piano and Richard Rogers. Georges Pompidou National Center for Arts and Culture, Paris, 1977. In the recent past this center has taken on a lively bohemian air; nearby streets are lined with galleries and adjoining squares are dotted with street performers and musicians.

■ **22.48** Kohn, Pederson, Fox. 1201 Third Avenue in Seattle, Washington, 1988. The postmodern character of the building may be seen clearly by contrasting this building with the two office towers to the right and left in the photograph.

■ **22.49** Robert Venturi and Denise Scott Brown. Seattle Art Museum (interior corridor), Seattle, Washington, 1991. Note the almost Asian-looking arches and the perspectival view enhanced by the hidden lighting.

■ **22.50** Frank Gehry. American Center in Paris, 1994.

We should take note of two other museums opened in the 1990s as examples of creative architectural thinking. The Tate Modern, across the river Thames from Saint Paul's Cathedral in London, is a fine example of how to engage in urban renewal creatively. The museum, housed in what was once a power station, was designed by two Swiss architects—Jacques Herzog and Pierre de Meuron—who turned a massive industrial plant into a severe museum with spacious galleries, including the stunning room where the main dynamo was once housed [**Fig. 22.51**]. By contrast, the Getty Center (opened in 1997) in the Santa Monica Mountains outside Los Angeles is a stunning complex of six buildings faced with sixteen thousand tons of travertine stone quarried in Italy. The architect, Richard Meier, joined forces with the noted environmental artist Robert Irwin to create a multileveled building complex with Irwin's central garden as a unifying centerpiece [**Fig. 22.52**].

Finally, the new Millennium Park in Chicago is a complex of open spaces, monuments, and artistic venues, which includes the Crown Fountain designed by the Barcelona-born (1955) Spanish artist, Jaume Plensa. It features a reflecting pool with various patterns of cascading waterfalls from a pair of fifty-foot-tall glass block towers that project, thanks to embedded video screens, the faces of one thousand Chicagoans [**Fig. 22.53**].

■ **22.51** The Tate Modern, 1906–2000, London.

SOME TRENDS IN CONTEMPORARY LITERATURE

By the end of World War II, literary figures who had defined the modernist temper—like T. S. Eliot, James Joyce, Thomas Mann, Ezra Pound—were either dead or had already published their best work. Their passionate

■ **22.52** Richard Meier. Getty Center, Los Angeles, 1997.

■ **22.53** Jaume Plensa. Crown Fountain, Millennium Park, Chicago, 2004.

search for meaning in an alienated world, however, still inspired the work of others. The great modernist themes received attention by other voices in other media. The Swedish filmmaker Ingmar Bergman (b. 1918) began a series of classic films starting with his black-and-white *Wild Strawberries* in 1956, which explored the loss of religious faith and the demands of modern despair. The enigmatic Irish playwright (who lived in France and wrote in French and English) Samuel Beckett produced plays like *Waiting for Godot* (1952), absurdist literature that explores a world beyond logic, decency, and the certainty of language.

Waiting for Godot, for all its apparent simplicity, is maddeningly difficult to interpret. Two characters, Vladimir and Estragon, wait at an unnamed and barren crossroads for Godot. Their patient wait is interrupted by antic encounters with two other characters. In the two acts, each representing one day, a young boy announces that Godot will arrive the next day. At the end of the play, Vladimir and Estragon decide to wait for Godot, although they toy momentarily with the idea of splitting up or committing suicide if Godot does not come to save them.

The language of *Godot* is laced with biblical allusions and religious puns. Is Godot God and does the play illuminate the nature of an absurd world without final significance? Beckett does not say and critics do not agree, although they are in accord with the judgment that *Waiting for Godot* is a classic—if cryptic—statement about language, human relations, and the ultimate significance of the world.

Gradually, as the war receded in time, other voices relating the horrors of the war experience began to be heard. The most compelling atrocity of the war period, the extermination of six million Jews and countless other dissidents or enemies in the Nazi concentration camps, has resulted in many attempts to tell the world that story. The most significant voice of the survivors of the event is the European-born Elie Wiesel (b. 1928), a survivor of the camps. Wiesel describes himself as a "teller of tales." He feels a duty, beyond the normal duty of art, to keep alive the memory of the near-extermination of his people. Wiesel's autobiographical memoir and arguably his greatest work, *Night* (1960), recounts his own years in the camps. It is a terribly moving book with its juxtaposition of a

young boy's fervent faith with the demonic powers of the camp.

In the United States, an entirely new generation of writers defined the nature of the American experience. Arthur Miller's play *Death of a Salesman* (1949) explored the failure of the American Dream in the person of its tragic hero, Willie Loman, an ordinary man defeated by life. J. D. Salinger's *The Catcher in the Rye* (1951) documented the bewildering coming of age of an American adolescent in so compelling a manner that it was, for a time, a cult book for the young. Southern writers like Eudora Welty, William Styron, Walker Percy, and Flannery O'Connor continued the meditations of William Faulkner about an area of the United States that has tasted defeat in a way no other region has. Poets like Wallace Stevens, Theodore Roethke, William Carlos Williams, and Marianne Moore continued to celebrate the beauties and terrors of both nature and people.

We have already noted that existentialism was well suited to the postwar mood. One aspect of existentialism's ethos was its insistence on protest and human dissatisfaction. That element of existential protest has been very much a part of the postwar scene. The civil rights movement of the late 1950s and early 1960s became a paradigm for other protests, such as those against the Vietnam War; in favor of the rights of women; and for the rights of the dispossessed, underprivileged, or the victims of discrimination. The literature of protest has been an integral part of this cry for human rights.

First and foremost, one can trace the African Americans' struggle for dignity and full equality through the literature they produced, especially in the period after World War I. The great pioneers were those writers who are grouped loosely under the name Harlem Renaissance (discussed in Chapter 21). By refusing the stereotype of Negro, they crafted an eloquent literature demanding humanity and unqualified justice. The work of these writers presaged the powerful torrent of African American fiction chronicling racial injustice in America. Two novels in particular, Richard Wright's *Native Son* (1940) and Ralph Ellison's *Invisible Man* (1952), have taken on the character of American classics. Younger writers followed, most notably James Baldwin, whose *Go Tell It on the Mountain* (1953) fused vivid memories of black Harlem, jazz, and the intense religion of the black church into a searing portrait of growing up black in America. Alice Walker explored her Southern roots in the explosively powerful *The Color Purple* (1982).

For many of the younger black writers in America, the theme of black pride has been linked with the consciousness of being a woman. Nikki Giovanni (b. 1936) produced a body of poetry celebrating both her sense of "blackness" and her pride in her femininity. Her poetry has been a poetic blend of black history and female consciousness done in an American mode.

Similarly, Maya Angelou has become an enormously important voice for the African American community, as has Gwendolyn Brooks, whose ties go back to the writers of the Harlem Renaissance.

The rightful claims of women have been advanced currently by an activist spirit that seeks equality of women and men, free from any sexual discrimination. The battle for women's rights began in the nineteenth century. It was fought again in the drive for women's suffrage in the first part of the twentieth century and continues today in the feminist movement. The cultural oppression of women has been a major concern of the great women writers of our time. Writers like Doris Lessing, Margaret Atwood, Adrienne Rich, Maxine Kumin, and others continue to explore feminine consciousness in great depth and from differing angles of vision.

Two twentieth-century poets deserve particular mention, because both of them dealt so clearly with the dissatisfaction of women. Sylvia Plath (1932–1963) and Anne Sexton (1928–1974) used the imagery of traditional sexual roles to complain about the restraints of their position. Ironically enough, the precociously talented Sylvia Plath and Anne Sexton knew each other briefly when they studied poetry together. Sylvia Plath not only produced an important body of poetry but also a largely autobiographical novel, *The Bell Jar* (1962), describing most of her short and unhappy life. Anne Sexton, by contrast, wrote only poetry. Both, alas, died by their own hands after tortured lives of emotional upheavals.

A Note on the Postmodern

In the past generation some literary critics have been insisting, with varying degrees of acceptance, that much of contemporary literature has moved beyond the modernist preoccupation with alienation, myth, fragmentation of time, and the interior states of the self. The most debated questions now are: What exactly has followed modernism (by definition it is postmodern)? Does it have a shaping spirit? Who are its most significant practitioners? The latter question seems to be the easiest to answer. Many critics would mention the following among those who are setting and defining the postmodernist literary agenda: Italo Calvino in Italy; Jorge Luis Borges in Argentina; Gabriel García Márquez in Colombia; and a strong group of American writers that includes Donald Barthelme, Robert Coover, John Barth, Stanley Elkin, Thomas Pynchon, Renata Adler, Susan Sontag, and Kurt Vonnegut Jr. Borges is perhaps the writer most influential in shaping the postmodern sensibility.

This list of writers represents far-ranging and diverse sensibilities. What do they hold in common that permits them to be considered representative postmodernists? Some critics see the postmodernists as those who push

the modernist worldview to its extreme limit. Postmodernist writing, these critics say, is less concerned with traditional plot lines, more antirational, more private in its vision, more concerned in making the work a private world of meanings and significations. This is hardly a satisfactory definition because it merely defines the postmodern as more of the same. It does *not* define, it merely extends the definition. Postmodernism is a form of literary art in the process of birth. It must build on what modernism has accomplished, but it must also find its own voice.

It is impossible to create art today as if Cubism or abstract Expressionism had never existed, just as it is impossible to compose music as if Stravinsky had never lived. Furthermore, we cannot live life (or even look at it) as if relativity, atomic weapons, and Freudian explorations of the unconscious were not part of our intellectual and social climate. If art is to become part of the human enterprise, it must surely reflect its past without being a prisoner of it. In fact, most of the great achievements in the arts have done precisely that; they have mastered the tradition and then extended it. The terrain of modernism has been fairly well mapped; it is time to move on. But in which direction?

MUSIC SINCE 1945

Avant-Garde Developments

Since World War II, many avant-garde composers have been moving toward greater and greater complexity of musical organization, coupled with an increasing use of new kinds of sound. At the same time, other musicians, disturbed by their colleagues' obsessive concern for order, have tried to introduce an element of chance—even chaos—into the creation of a work of music. Both the "structuralists" and the advocates of random music have attracted followers, and only time will tell which approach will prove more fruitful.

Before considering the nature of these two schools in detail, some general observations are in order. It must be admitted that advanced contemporary music presents a tough challenge to the patience, sympathy, and ears of many sincere music lovers. Unlike the visual arts and literature, modern music seems, at least superficially, to have made virtually a complete break with past traditions. Furthermore, much of it seems remote from our actual experience. Developments in painting or architecture are visible around us in one form or another on a daily basis, and modern writers deal with problems that affect us in our own lives. Many creative musicians, however, have withdrawn to the scientific laboratory, where they construct their pieces with the aid of machines and in accordance with mathematical principles. It is hardly surprising that the results may at first seem sterile.

Yet it is well worth making an effort to understand and enjoy the latest developments in music. Concentration and an open mind will remove many of the barriers. So will persistence. Music lovers who listen twenty times to a recording of a Chopin waltz or a Mahler symphony for every one time they listen to a work by Boulez or Stockhausen can hardly expect to make much progress in understanding a new and admittedly difficult idiom. Much of today's music may well not survive the test of time, but it is equally probable that some pieces will become classics in this twenty-first century. By discriminative listening we can play our own part in judging which music is worthless and which will be of permanent value.

The principle of precise musical organization had already become important in twentieth-century music with the serialism of Arnold Schönberg. Schönberg's ordering of pitch (the melodic and harmonic element of music) in rigidly maintained twelve-tone rows has been extended by recent composers to other elements. Pierre Boulez (b. 1925), for example, constructed rows of twelve-note durations (the length of time each note sounds), twelve levels of volume, and twelve ways of striking the keys for works like his *Second Piano Sonata* (1948) and *Structures* for two pianos (1952). In this music, every element (pitch, length of notes, volume, and attack) is totally ordered and controlled by the composer in accordance with his predetermined rows, because none of the twelve components of each row can be repeated until after the other eleven.

The effect of this "total control" is to eliminate any sense of traditional melody, harmony, or counterpoint along with the emotions they evoke. Instead the composer aims to create a pure and abstract "structure" that deliberately avoids any kind of subjective emotional expression.

There remains, however, one element in these piano works that even Boulez cannot totally control: the human element. All of the composer's instructions, however precise, have to be interpreted and executed by a performer, and as long as composers depend on performers to interpret their works, they cannot avoid a measure of subjectivity. Different pianists will inevitably produce different results, and even the same pianist will not produce an identical performance on every occasion.

In order to solve this problem, some composers in the 1950s began to turn to *electronic music,* the sounds of which are produced not by conventional musical instruments but by an electronic oscillator, a machine that produces pure sound waves. A composer can order the sounds by means of a computer and then transfer these to recording tape for playback. In the past few years, the process of manipulating electronic sound has been simplified by the invention of the *synthesizer* (an electronic instrument that can produce just about any kind of sound effect). In combination with a computer, machines like the Moog synthesizer can be used

for either original electronic works or creating electronic versions of traditional music, as in the popular "Switched-on Bach" recordings of the 1960s.

From its earliest days, electronic music has alarmed many listeners by its apparent lack of humanity. The whistles, clicks, and hisses that characterize it may be eerily appropriate to the mysteries of the Space Age but have little to do with *traditional* musical expression. Composers of electronic music have had considerable difficulty in inventing formal structures for organizing the vast range of sounds available to them. In addition, there still exists no universally agreed-on system of writing down electronic compositions, most of which exist only on tape. It is probably significant that even Karlheinz Stockhausen (b. 1928), one of the leading figures in electronic music, has tended to combine electronic sounds with conventional musical instruments [**Fig. 22.54**]. His *Mixtur* (1965), for example, is written for five orchestras, electronic equipment, and loudspeakers. During performance, the sounds produced by the orchestral instruments are electronically altered and simultaneously mixed with the instrumental sound and prerecorded tape. In this way an element of live participation has been reintroduced.

For all its radical innovations, however, *Mixtur* at least maintains the basic premise of music in the Western tradition: that composers can communicate with their listeners by predetermining ("composing") their works according to an intellectual set of rules. The laws of baroque counterpoint, classical sonata form, or Stockhausen's ordering and altering of sound patterns all represent systems that have enabled composers to plan and create musical works. One of the most revolutionary of all recent developments, however, has been the invention of *aleatoric* music. The name is derived from the Latin word *alea* (a dice game) and is applied to music in which an important role is played by the element of chance.

One of the leading exponents of this genre of music is the American composer John Cage (1912–1992), who had been much influenced by Zen philosophy. Adopting the Zen attitude that one must go beyond logic in life, Cage argued that music should reflect the random chaos of the world around us and so does not seek to impose order on it. His *Concert for Piano and Orchestra* (1958) has a piano part consisting of eighty-four different "sound events," some, all, or none of which are to be played in any random order. The orchestral accompaniment consists of separate pages of music, some, all, or none of which can be played by any (or no) instrument, in any order and combination. Clearly, every performance of the *Concert* is going to be a unique event, largely dependent on pure chance for its actual sound. In other pieces, Cage instructed the performers to determine the sequence of events by even more random methods, including the tossing of coins.

Works like these are more interesting for the questions they ask about the nature of music than for any

■ **22.54** From Karlheinz Stockhausen. *nr. 11 Refrain,* 1961. Universal Editions, Ltd., London. Used by permission. This portion of the score was reproduced in the composer's own work, *Test on Electronic and Instrumental Music.* The system of musical notation that Stockhausen devised for this piece is as revolutionary as the music itself; it is explained in a preface to the score.

intrinsic value of their own. Cage partly reacted against what he regarded as the excessive organization and rigidity of composers like Boulez and Stockhausen, but at the same time he also raised some important considerations. What is the function of the artist in the modern world? What is the relationship between creator and performer? And what part, if any, should the listeners play in the creation of a piece of music? Need it always be a passive part? If Cage's own answers to questions such as these may not satisfy everyone, he had at least posed the problems in an intriguing form.

The New Minimalists

A very different solution to the search for a musical style has been proposed by a younger generation of American composers. Steve Reich (b. 1936) is one of the first musicians to build lengthy pieces out of the multiple repetition of simple chords and rhythms. Critics sometimes assume that the purpose of these repetitions is to achieve a hypnotic effect by inducing a kind of state of trance. Reich stated that his aim is, in fact, the reverse: a state of heightened concentration.

In *The Desert Music,* a composition for chorus and instruments completed in 1983, Reich's choice of texts

is helpful to an understanding of his music. The work's central section consists of a setting of words by the American poet William Carlos Williams (1883–1963):

It is a principle of music
to repeat the theme. Repeat
and repeat again,
as the pace mounts. The
theme is difficult
but no more difficult
than the facts to be
resolved.

Source: By William Carlos Williams from *Collected Poems 1939–1962*, Volume II, copyright 1953 by William Carlos Williams. Reprinted by permission of New Directions Publishing Corp.

The piece begins with the pulsing of a series of broken chords, which is sustained in a variety of ways, chiefly by tuned mallets. This pulsation, together with a wordless choral vocalization, gives the work a rhythmical complexity and richness of sound that is at times reminiscent of some African or Balinese music.

The works of Philip Glass (b. 1937) are even more openly influenced by non-Western music. Glass studied the Indian tabla drums for a time; he is also interested in West African music and has worked with Ravi Shankar, the great Indian sitar virtuoso. Many of Glass's compositions are based on combinations of rhythmical structures derived from classical Indian music. They are built up into repeating modules, the effect of which has been likened by unsympathetic listeners to a needle stuck in a record groove.

Length plays an important part in Glass's operas, for which he has collaborated with the American dramatist Robert Wilson. Wilson, like Glass, is interested in "apparent motionlessness and endless durations during which dreams are dreamed and significant matters are understood." Together they have produced three massive stage works in the years between 1975 and 1985: *Einstein on the Beach, Satyagraha,* and *Akhnaten.* The performances involve a team of collaborators that includes directors, designers, and choreographers; the results have the quality of a theatrical "happening." Although a description of the works makes them sound remote and difficult, performances of them have been extremely successful. Even New York's Metropolitan Opera House, not famous for an adventurous nature in selecting repertory, was sold out for two performances of *Einstein on the Beach.* Clearly, whatever its theoretical origins, the music of Glass reaches a wide public.

Traditional Approaches to Modern Music

Not all composers have abandoned the traditional means of musical expression. Musicians like Benjamin Britten (1913–1976) and Dmitri Shostakovich (1906–1975) demonstrated that an innovative approach to the traditional elements of melody, harmony, and rhythm can still produce exciting and moving results, and neither can be accused of losing touch with the modern world. Britten's *War Requiem* (1962) is an eloquent plea for an end to the violence of contemporary life, whereas Shostakovich's entire musical output reflects his uneasy relationship with Soviet authority. His *Symphony No. 13* (1962) includes settings of poems by the Russian poet Yevtushenko on anti-Semitism in Russia and earned him unpopularity in Soviet artistic and political circles.

Both Britten and Shostakovich did not hesitate to write recognizable "tunes" in their music. In his last symphony, *No. 15* (1971), Shostakovich even quoted themes from Rossini's *William Tell Overture* (the familiar "Lone Ranger" theme) and from Wagner. The work is at the same time easy to listen to and deeply serious. Like much of Shostakovich's music, it is concerned with the nature of death (a subject also explored in his *Symphony No. 14*). Throughout its four movements, Shostakovich's sense of rhythm is much in evidence, as is his feeling for orchestral color, in which he demonstrates that the resources of a traditional symphony orchestra are far from exhausted. The final mysterious dying close of *Symphony No. 15* is especially striking in its use of familiar ingredients—repeating rhythmic patterns, simple melodic phrases—to achieve an unusual effect.

If Shostakovich demonstrated that a musical form as old-fashioned as the symphony can still be used to create masterpieces, Britten did the same for opera. His first great success, *Peter Grimes* (1945), employed traditional operatic devices like arias, trios, and choruses to depict the tragic fate of its hero, a man whose alienation from society leads to his persecution at the hands of his fellow citizens. In other works, Britten followed the example of many of his illustrious predecessors in turning to earlier literary masterpieces for inspiration. *A Midsummer Night's Dream* (1960) is a setting of Shakespeare's play, while *Death in Venice* (1973) is based on the story by Thomas Mann. In all of his operas, Britten writes music that is easy to listen to (and, equally important, not impossible to sing), but he never condescends to his audience. Each work deals with a recognizable area of human experience and presents it in a valid musical and dramatic form. It is always dangerous to predict the verdict of posterity, but from today's vantage point the music of Britten seems to have as good a chance as any of surviving in this new century.

Popular (Pop) Music

No discussion of music since 1945 would be complete without mentioning pop music, the worldwide appeal

of which is a social fact of our times. Much of pop music is American in origin, although its ancestry is deeply rooted in the larger Western musical tradition. Its development both in this country and abroad is so complex as to be outside the scope of this book. One cannot adequately describe in a few pages the character of folk music, rhythm and blues, country and western, and the various shades of rock, much less sketch out their tangled interrelationships.

A single example demonstrates this complexity. During the 1960s, protest singers like Joan Baez, Pete Seeger, and Bob Dylan had in their standard repertoire a song called "This Land Is Your Land." The song had been written by Woody Guthrie as an American leftist reaction to the sentiments expressed in Irving Berlin's "God Bless America." Guthrie had adapted an old mountain ballad sung by the Carter Family, who had been a formative part of country and western music at the Grand Ole Opry since the late 1920s. The Carters played and sang mountain music that was a complex blending of old English balladry, Scottish drills, some black music, and the hymn tradition of the mountain churches.

The worldwide appeal of pop music must be recognized. The numbers in themselves are staggering. Between 1965 and 1973, nearly twelve hundred different recorded versions of The Beatles' song "Yesterday" (written by Paul McCartney and John Lennon) were available. By 1977, the Beatles had sold more than one hundred million record albums and the same number of singles. Elvis Presley had sold more than eighty million singles at the time of his death in 1977; today, some years after his death, all his major albums remain in stock in record stores. Bootleg tapes and cassettes are prized in those places of the world where political and social oppression are facts of life.

The best of popular music, both folk and rock, is sophisticated and elegant. Classic rock albums of The Beatles like *Revolver* reflect influences from the blues, ballads, the music of India, jazz harmonies, and some baroque orchestrations. The talented (and outrageous) Frank Zappa and the Mothers of Invention dedicated their 1960s album *Freak Out* to "Charles Mingus, Pierre Boulez, Anton Webern, Igor Stravinsky, Willie Dixon, Guitar Slim, Edgar Varèse, and Muddy Waters." Zappa's experiments with mixing rock and classical music were deemed serious enough for the celebrated conductor Zubin Mehta and the Los Angeles Philharmonic to have attempted some joint concerts. The popular folksinger Judy Collins's most successful album of the 1960s—*Wildflowers*—was orchestrated and arranged by Joshua Rifkin, a classical composer who was once on the music faculty of Princeton University. The crossbreeding of folk, rock, and classical modes of music continues with increasing interest in the use of electronics and advanced amplification systems.

The folk and rock music of the 1960s saw itself in the vanguard of social change and turmoil. Rock music was inextricably entwined with the youth culture. In fact, popular music provided one of the most patent examples of the so-called Generation Gap. If The Beatles upset the older generation with their sunny irreverence, their coded language about drugs, and their open sexuality, groups like The Rolling Stones were regarded by many as a clear menace to society. With their hard-driving music, their aggressive style of life, their sensuality, and their barely concealed flirtation with violence and nihilism, the Stones were seen by many as a living metaphor for the anarchy of the turbulent 1960s. It was hardly reassuring for parents to see their young bring home a Stones album titled *Their Satanic Majesties Request* inside the cover of which is an apocalyptic collage of Hieronymus Bosch, Ingres, Mughal Indian miniatures, and pop photography. Neither were many consoled when the violence of the music was translated into actual violence as rock stars like Jimi Hendrix, Janis Joplin, Phil Ochs, and Jim Morrison destroyed themselves with alcohol or drugs. Contemporary concerns with the social consequences of everything from heavy metal to rap music must be seen against the background of criticism of popular music that goes far back into our past.

Whatever the long-range judgment of history may be, pop music in its variegated forms is as much an indicator of our present culture as the novels of Dickens were of the nineteenth century. It partakes of both brash commercial hype and genuine social statement. The record album of a major rock group today represents the complex interaction of advanced technology, big business, and high-powered marketing techniques as well as the music itself. Likewise, a rock concert is no mere live presentation of music to an audience; it is a multimedia "happening" in which the plastic arts, dramatic staging, sophisticated lighting and amplification, and a medley of other visual and aural aids are blended to create an artistic whole with the music. Beyond (or under) this glitter, notoriety, and hype, however, is a music arising from real issues and expressing real feelings. New wave punk rock and heavy metal music, for instance, reflected the alienation of the working-class youth of Great Britain in the 1970s and 1980s. The rise of rap music, born in the African American experience, has grown into a cultural phenomenon that crosses racial and ethnic boundaries.

Finally, pop music is not a phenomenon of the moment alone. Its roots are in the tribulations of urban African Americans, the traditionalism of rural Anglos, the protest of activists, and the hopes and aspirations of the common people, causes with a lengthy history in the United States yet still alive today. Pop music, then, is both a social document of our era and a record of our past.

The best pop music hymns the joy of love, the anxiety of modern life, the yearning for ecstasy, and the damnation of institutionalized corruption. Rock music

in particular creates and offers the possibility of ecstasy. For those who dwell in the urban wastelands of post-technological America or the stultifying structures of post-Stalinist Eastern Europe, the vibrant beat and incessant sound of rock music must be a welcome, if temporary, refuge from the bleakness of life.

Now in the twenty-first century, the popular music scene shows two new trends that coincide with some of the themes we have noted in this chapter. First, advances in communication technology have not only spawned the music video (in which the visual arts, drama, and music can be joined in a single art experience) but—with the easy access of cable television linkups—it is now also possible to air transcontinental performances (like the famous Live Aid show of 1985) in which rock concerts take on a simultaneous character and showcase the international idiom of rock music. This communication revolution has taken a further step with the easy access of the Internet.

Second, and closely allied to the first trend, there has been a powerful cross-fertilization of music brought about through easy communication. Rock music, with its old roots in American forms of music, has now expanded to absorb everything from Caribbean and Latin American music to the music of West Africa and Eastern Europe. If there is any truth in the thesis of the global culture, it is most easily seen, in its infant stages, in the world of popular music.

SUMMARY

This chapter deals with Western culture after the time of World War II. In the postwar period, with Europe in shambles and the Far East still asleep, we confidently felt that the twentieth was the American century; many people, not always admiringly, spoke of the "Coca-Colazation" of the world. From the vantage point of the beginning of the twenty-first century, we see that, however powerful the United States may be, there now exist other countervailing powers, as the economic power of Japan readily demonstrates.

This postwar period also saw some dramatic shifts in the arts. The modernist temper that prevailed both in literature and in the arts had its inevitable reaction. The power of the New York School of painting (abstract expressionism/color-field painting/minimalism) has been challenged by new art forces, mainly from Europe, that emphasize once again the picture plane and the expressive power of emotion. In literature, the modernist temper exemplified in writers like Eliot, Woolf, and others gave way to a postmodern sensibility represented in writers who are from Latin America, Japan, and Europe. Increasing attention is being paid to the writers from both Eastern Europe and Africa.

Out of the human rights movement of the past decades has arisen a determined effort to affirm the place of women in the world of the arts both by retrieving their overlooked work from the past and by careful attention to those at work today. Similarly, individuals of color—both male and female—have come to the attention of large audiences as the arts democratize. Contemporary debates over the core humanities requirements in universities (Should they restrict themselves to the old "classics" or should they represent many voices and many cultures?) simply reflect the pressures of the culture, which is no longer sure of its older assumptions.

No consensus exists on a humanistic worldview. The postwar power of existentialism sprang both from its philosophical ideas and from its adaptability to the arts, especially the literary arts. Although the writings of Albert Camus are still read and the plays of Beckett and Ionesco are still performed, these now reflect a settled place in the literary canon, with no new single idea providing the power to energize the arts as a whole.

It may well be that the key word to describe the contemporary situation is *pluralism:* a diversity of influences, ideas, and movements spawned by an age of instant communication and ever-growing technology. The notion of a global culture argues for a common culture growing out of mutual links. There is some evidence of commonality, but it must be said that in other areas there are regional differences and even antagonisms. What we seem to be seeing in an age when more people than ever before buy books, see films, watch television, listen to tapes and CDs, go to plays and concerts, and use the Internet is a situation the Greek philosophers wrote about millennia ago—the curious puzzle about the relationship of unity and diversity in the observable world: We are one, but we are also many.

KEY TERMS

Absurdity Term adopted by existentialists to describe the ultimate meaninglessness of human existence

Aesthetic Descriptive adjective used (sometimes negatively) to characterize certain artworks as more interested in beauty than content. Also used as a shorthand way of speaking about a certain philosophical standard for the making of art (e.g., the Surrealist aesthetic).

Color field That form of painting that is characterized by its focus on color as the very description of a painting.

Combine Term used to describe those works of art that add actual objects to the paintings, which frequently jut out from the canvas

Totalitarian Any political system that asserts total control over all aspects of public life and thought while disallowing any independent ideas to intervene

PRONUNCIATION GUIDE

Borges:	BOR-hays
Boulez:	Boo-lez
Camus:	Cam-OO
existentialism:	eggs-es-TEN-shall-ism
Godot:	go-DOUGH
Le Corbusier:	Luh Cor-BOO-see-ay
Miès van der Rohe:	MEESE van der ROW-eh
Rauschenberg:	RAU-shen-berg
Søren Kierkegaard:	SORE-en Keer-ke-gar
Shostakovich:	Shah-stah-KO-vich
Wiesel:	Vee-ZELL

EXERCISES

1. When we look at abstract Expressionist art, it is tempting to believe that "anyone could do that." But *can* "anyone" do it? How does one go about describing in writing the character of abstract art?

2. Look closely at a work by Alexander Calder. Would a Classical sculptor (Rodin, Michelangelo) have recognized Calder's work as "sculpture"? What makes it different? Why is it called *sculpture?*

3. After reading Sartre's essay on existentialism, ask yourself: Is this a philosophy that could serve as a guide to my life? Give the reasons for your answer.

4. Look carefully at your campus buildings. Does "form follow function"? Is "less more"? Can you detect the styles that influenced the campus architect?

5. A classic is said to have a "surplus of meaning"—it is so good that one can always go back and learn more from it. Are there compositions in popular music that are now "classics" in that sense? List five songs that still inspire musicians today.

6. Have the new forms of communication (especially television) made you less of a reader? How does reading differ from watching television? How does looking at art differ from looking at television? Listening to music? Has the Internet changed your life? Explain.

YOUR RESOURCES

- ▄ **ExploringHumanities CD-ROM**
- ▄ **Website http://art.wadsworth.com/cunningham**
 - • Chapter 22 Quiz
 - • Links

FURTHER READING

Armstong, T., et al. *200 Years of American Sculpture.* New York: Whitney Museum, 1976. This well-illustrated catalog has abundant bibliographies. A good first look at sculpture in this country from a historical perspective.

Broude, N., and M. Garrard. (Eds.). *The Power of Feminist Art.* New York: Abrams, 1990. A good survey of the 1960s and 1970s.

Cage, J. *Silence.* Cambridge: MIT Press, 1969. A manifesto from one of the leaders of the artistic avant-garde.

Cantor, N. F. *Twentieth-Century Culture: Modernism to Deconstruction.* New York: Peter Lang, 1988. A survey of critical theory in this century that includes developments after structuralism.

Docker, J. *Postmodernism and Popular Culture: A Cultural History.* New York: Cambridge University Press, 1994. An excellent but difficult interdisciplinary study.

Glass, P., and R. T. Jones. *Music by Philip Glass.* New York: Harper & Row, 1987. A good introduction to the minimalist spirit in music, with a discography.

Goldberger, P. *On the Rise: Architecture and Design in the Post Modern Age.* New York: Penguin, 1983. An excellent survey of contemporary trends by the *New York Times'* architecture critic.

Hilberg, R. *The Destruction of the European Jews.* Chicago, IL: Quadrangle, 1967. The standard history of the subject; essential background for reading Wiesel and other Holocaust authors.

Hughes, R. *Nothing If Not Critical: Selected Essays.* New York: Knopf, 1990. Readable cultural criticism by the author of *The Shock of the New.*

Kaufmann, W. (Ed.). *Existentialism from Dostoevsky to Sartre.* New York: New American Library, 1975. A standard anthology, although not everyone agrees that "revolt" is the prime category for understanding the movement.

Rose, B. *American Painting in the Twentieth Century.* New York: Rizzoli, 1986. Especially good on the New York School of art.

Rubin, W. *Pablo Picasso: A Retrospective.* New York: Museum of Modern Art, 1980. This profusely illustrated catalog sums up a good deal of the twentieth century with its scholarly concentration on the century's major figure in art.

Sandler, I. *The Triumph of American Painting.* New York: Praeger, 1970. Sandler is the best chronicler of the New York School of painting.

Yates, G. G. *What Women Want: The Idea of the Movement.* Cambridge, MA: Harvard University Press, 1975. A good introduction to the feminist movement considered historically.

READING SELECTIONS

JEAN-PAUL SARTRE
from EXISTENTIALISM AS A HUMANISM

Sartre's essay argues, basically, that humans are thrown into the world and must define who they are and what they want to be bereft of any divine purpose. We are and must judge how best to live; this is the stern optimism that Sartre demands of modern people.

It is to various reproaches that I shall endeavor to reply today; that is why I have [titled] this brief exposition, *Existentialism and Humanism*. Many may be surprised at the mention of humanism in this connection, but we shall try to see in what sense we understand it. In any case, we can begin by saying that existentialism, in our sense of the word, is a doctrine that does render human life possible; a doctrine, also, which affirms that every truth and every action imply both an environment and a human subjectivity. The essential charge laid against us is, of course, that of overemphasis upon the evil side of human life. I have lately been told of a lady who, whenever she lets slip a vulgar expression in a moment of nervousness, excuses herself by exclaiming, "I believe I am becoming an existentialist." So it appears that ugliness is being identified with existentialism. Those who appeal to the wisdom of the people—which is a sad wisdom—find ours sadder still. Indeed their excessive protests make me suspect that what is annoying them is not so much our pessimism, but, much more likely, our optimism. For at bottom, what is alarming in the doctrine that I am about to try to explain to you is—is it not? that it confronts man with a possibility of choice. To verify this, let us review the whole question upon the strictly philosophic level. What, then, is this that we call existentialism?

Most of those who are making use of this word would be highly confused if required to explain its meaning. For since it has become fashionable, people cheerfully declare that this musician or that painter is "existentialist." A columnist in Clartes signs himself "The Existentialist," and, indeed, the word is now so loosely applied to so many things that it no longer means anything at all. It would appear that, for the lack of any novel doctrine such as that of Surrealism, all those who are eager to join in the latest scandal or movement now seize upon this philosophy in which, however, they can find nothing to their purpose. For in truth this is of all teachings the least scandalous and the most austere: it is intended strictly for experts and philosophers. All the same, it can easily be defined.

The question is only complicated because there are two kinds of existentialists. There are, on the one hand, the Christian existentialists and on the other hand the existential atheists, among whom I place myself. What they have in common is simply the fact that they believe that existence comes before essence—or, if you will, that we must begin from the subjective.

What do we mean by saying that existence precedes essence? We mean that man first of all exists, encounters himself, surges up in the world—and defines himself afterwards. If man is as the existentialist sees him, as not definable, it is because to begin with he is nothing. He will not be anything until later, and then he will be what he makes of himself. Thus, there is no human nature, because there is no God to have a conception of it. Man simply is. Not that he is simply what he conceives himself to be, but he is what he wills, and as he conceives himself after already existing—as he wills to be after that leap toward existence. Man is nothing else but that which he makes of himself. That is the first principle of existentialism. And this is what people call its "subjectivity," using the word as a reproach against us. But what do we mean to say by this, but that man is of a greater dignity than a stone or a table? For we mean to say that man primarily exists—that man is, before all else, something which propels itself toward a future and is aware that it is doing so. Man is, indeed, a project which possesses a subjective life, instead of being a kind of moss, or a fungus, or a cauliflower. Before that projection of the self nothing exists; not even in the heaven of intelligence; man will only attain existence when he is what he proposes to be. Thus, the first effect of existentialism is that it puts every man in possession of himself as he is, and places the entire responsibility for his existence squarely upon his own shoulders. And when we say that man is responsible for himself, we do not mean that he is responsible only for his own individuality, but that he is responsible for all men.

The word *subjectivism* is to be understood in two senses, and our adversaries play upon only one of them. Subjectivism means, on the one hand, the freedom of the individual subject and, on the other, that man cannot pass beyond human subjectivity. It is the latter which is the deeper meaning of existentialism. When we say that man chooses himself, we do mean that every one of us must choose himself; but by that we also mean that in choosing for himself he chooses for all men. For in effect, of all the actions a man may take in order to create himself as he wills to be, there is not one which is not creative, at the same time, of an image of man such as he believes he ought to be. To choose between this or that is at the same time to affirm the value of that which is chosen, for we are unable ever to choose the worse. What we choose is always the better; and nothing can be better for us unless it is better for all. If moreover, existence precedes essence and we will to exist at the same time as we fashion our image, that image is valid for all and for the entire epoch in which we find ourselves. Our responsibility is thus much greater than we had supposed, for it concerns mankind as a whole. I am thus responsible for myself and for all men, and I am creating a certain image of man as I would have him be. "In fashioning myself I fashion man."

This may enable us to understand what is meant by such terms—perhaps a little grandiloquent—as anguish, abandonment, and despair. As you will soon see, it is very simple. First, what do we mean by anguish? The existentialist frankly states that man is in anguish. His meaning is as follows—When a man commits himself to anything, fully realizing that he is not only choosing what he will be, but is thereby at the same time a legislator deciding for the whole of mankind—in such a moment a man cannot escape from the sense of complete and profound responsibility. There are many, indeed, who show no such anxiety. But we affirm that they are merely disguising their anguish or are in flight from it. Certainly, many people think that in what they are doing they commit no one but themselves to anything; and if you ask them, "What would happen if everyone did so?" they shrug their shoulders and reply, "Everyone does not do so." But in truth, one ought always to ask oneself what would happen if everyone did as one is doing; nor can one escape from the disturbing thought except by a kind of self-deception. The man who lies in self-excuse, by saying "Everyone will not do it" must be ill at ease in his conscience for the act of lying implies the universal value which

it denies. By its very disguise his anguish reveals itself. This is the anguish that Kierkegaard called "the anguish of Abraham." You know the story: An angel commanded Abraham to sacrifice his son: and obedience was obligatory, if it really was an angel who had appeared and said, "Thou, Abraham, shalt sacrifice thy son." But anyone in such a case would wonder, first, whether it was indeed an angel and secondly, whether I am really Abraham. Where are the proofs?

I shall never find any proof whatever; there will be no sign to convince me of it. If a voice speaks to me, it is still I myself who must decide whether the voice is or is not that of an angel. If I regard a certain course of action as good, it is only I who choose to say that it is good and not bad. There is nothing to show that I am Abraham; nevertheless, I also am obliged at every instant to perform actions which are examples. Everything happens to every man as though the whole human race had its eyes fixed upon what he is doing and regulated its conduct accordingly. So every man ought to say, "Am I really a man who has the right to act in such a manner that humanity regulates itself by what I do?" If a man does not say that, he is dissembling his anguish. Clearly, the anguish with which we are concerned here is not one that could lead to quietism or inaction. It is anguish pure and simple, of the kind well known to all those who have borne responsibilities. Far from being a screen which could separate us from action, it is a condition of action itself.

And when we speak of "abandonment"—a favorite word of Heidegger—we only mean to say that God does not exist, and that it is necessary to draw the consequences of his absence right to the end. The existentialist is strongly opposed to a certain type of secular moralism which seeks to suppress God at the least possible expense. Toward 1880, when the French professors endeavored to formulate a secular morality, they said something like this:—God is a useless and costly hypothesis, so we will do without it. However, if we are to have morality, a society, and a law-abiding world, it is essential that certain values should be taken seriously; they must have an *a priori* existence ascribed to them. It must be considered obligatory *a priori* to be honest, not to lie, not to beat one's wife, to bring up children, and so forth; so we are going to do a little work on this subject, which will enable us to show that these values exist all the same, inscribed in an intelligible heaven although, of course, there is no God. In other words—and this is, I believe, the purport of all we in France call radicalism—nothing will be changed if God does not exist; we shall rediscover the same norms of honesty, progress, and humanity, and we shall have disposed of God as an out-of-date hypothesis which will die away quietly of itself.

The existentialist, on the contrary, finds it extremely embarrassing that God does not exist, for there disappears with Him all possibility of finding values in an intelligible heaven. There can no longer by any good *a priori* since there is no infinite and perfect consciousness to think it. It is nowhere written that "the good" exists, that one must be honest or must not lie, since we are now upon the plane where there are only men. Dostoyevski once wrote, "If God did not exist, everything would be permitted"; and that, for existentialism, is the starting point. Everything is indeed permitted if God does not exist, and man is in consequence forlorn, for he cannot find anything to depend upon either within or outside himself. He discovers forthwith that he is without excuse. For if indeed existence precedes essence, one will never be able to explain one's action by reference to a given and specific human nature; in other words, there is no determinism—man is free, man is freedom.

You are free, therefore choose—that is to say, invent. No rule of general morality can show you what you ought to do: no signs are vouchsafed in this world. That is what "abandonment" implies, that we ourselves decide our being. And with this abandonment goes anguish.

As for "despair" the meaning of this expression is extremely simple. It merely means that we limit ourselves to a reliance upon that which is within our wills, or within the sum of the probabilities which render our action feasible. Whenever one wills anything, there are always these elements of probability. If I am counting upon a visit from a friend, who may be coming by train or by tram, I presuppose that the train will arrive at the appointed time, or that the tram will not be derailed. I remain in the realm of possibilities; but one does not rely upon any possibilities beyond those that are strictly concerned in one's action, beyond the point at which the possibilities under consideration cease to affect my action. I ought to disinterest myself. For there is no God and no prevenient [antecedent; to come before] design which can adapt the world and all its possibilities to my will. When Descartes said, "Conquer yourself rather than the world," what he meant was, at bottom, the same—that we should act without hope.

In the light of all this, what people reproach us with is not, after all, our pessimism but the sternness of our optimism. If people condemn our works of fiction, in which we describe characters that are base, weak, cowardly, and sometimes even frankly evil, it is not only because those characters are base, weak, cowardly or evil. For suppose that, like Zola, we showed that the behavior of these characters was caused by their heredity, or by the action of their environment upon them, or by determining factors, psychic or organic. People would be reassured, they would say, "You see, that is what we are like, no one can do anything about it." But the existentialist, when he portrays a coward, shows him as responsible for his cowardice. The existentialist says that the coward makes himself cowardly, the hero makes himself heroic; and that there is always a possibility for the coward to give up cowardice and for the hero to stop being a hero. What counts is the total commitment, and it is not by a particular case or particular action that you are committed altogether.

We have now, I think, dealt with a certain number of the reproaches against existentialism. You have seen that it cannot be regarded as a philosophy of quietism since it defines man by his action; nor as a pessimistic description of man, for no doctrine is more optimistic, the density of man is placed within himself. Nor is it an attempt to discourage man from action since it tells him that there is no hope except in his action, and that the one thing which permits him to have life is the deed. Upon this level therefore, what we are considering is an ethic of action and self-commitment.

Man makes himself; he is not found ready-made; he makes himself by the choice of his morality, and he cannot but choose a morality, such is the pressure of circumstances upon him. We define man only in relation to his commitments; it is therefore absurd to reproach us for irresponsibility in our choice. And moreover, to say that we invent values means neither more nor less than this; that there is no sense in life *a priori*. Life is nothing until it is lived; but it is yours to make sense of, and the value of it is nothing else but the sense that you choose. Therefore, you can see that there is a possibility of creating a human community. I have been reproached for suggesting that existentialism is a form of humanism.

Man is all the time outside of himself: it is in projecting and losing himself beyond himself that he makes man to exist;

aims that he himself is able to exist. Since man is thus self-surpassing, and can grasp objects only in relation to his self-surpassing, he is himself the heart and center of his transcendence. There is no other universe except the human universe, the universe of human subjectivity. This relation of transcendence as constitutive of man (not in the sense that God is transcendent, but in the sense of self-surpassing) with subjectivity (in such a sense that man is not shut up in himself but forever present in a human universe)—it is this that we call existential humanism. This is humanism, because we remind man that there is no legislator but himself; that he himself, thus abandoned, must decide for himself; also because we show that it is not by turning back upon himself, but always by seeking, beyond himself, an aim which is one of liberation or of some particular realization, that man can realize himself as truly human.

ELIE WIESEL
from NIGHT, CHAPTER V

This selection, based on his own personal experiences, recounts life in a concentration camp as seen by a teenage boy. Reading, one begins to see why Wiesel calls camp life the "Kingdom of the Night."

The summer was coming to an end. The Jewish year was nearly over.

On the eve of Rosh Hashanah, the last day of that accursed year, the whole camp was electric with the tension which was in all our hearts. In spite of everything, this day was different from any other. The last day of the year. The word *last* rang very strangely. What if it were indeed the last day?

They gave us our evening meal, a very thick soup, but no one touched it. We wanted to wait until after the prayers. At the place of assembly, surrounded by the electrified barbed wire, thousands of silent Jews gathered, their faces stricken.

Night was falling. Other prisoners continued to crowd in, from every block, able suddenly to conquer time and space and submit both to their will.

"What are You, my God," I thought angrily, "compared to this afflicted crowd, proclaiming to You their faith, their anger, their revolt? What does Your greatness mean, Lord of the Universe, in the face of all this weakness, this decomposition, and this decay? Why do You still trouble their sick minds, their crippled bodies?"

Ten thousand men had come to attend the solemn service, heads of the blocks, Kapos, functionaries of death.

"Bless the Eternal. . . ."

The voice of the officiant [one who officiates at a religious ceremony] had just made itself heard. I thought at first it was the wind.

"Blessed be the Name of the Eternal!"

Thousands of voices repeated the benediction; thousands of men prostrated themselves like trees before a tempest.

"Blessed be the Name of the Eternal!"

Why, but why should I bless Him? In every fiber I rebelled. Because He had had thousands of children burned in His pits? Because He kept six crematories working night and day, on Sundays and feast days? Because in His great might He had created Auschwitz, Birkenau, Buna, and so many factories of death? How could I say to Him: "Blessed art Thou, Eternal, Master of the Universe, Who chose us from among the races to be tortured day and night, to see our fathers, our mothers, our brothers, end in the crematory? Praised be Thy Holy Name, Thou Who hast chosen us to be butchered on Thine altar?"

I heard the voice of the officiant rising up, powerful yet at the same time broken, amid the tears, the sobs, the sighs of the whole congregation:

"All the earth and the Universe are God's!"

He kept stopping every moment, as though he did not have the strength to find the meaning beneath the words. The melody choked in his throat.

And I, mystic that I had been, I thought:

"Yes, man is very strong, greater than God. When You were deceived by Adam and Eve, You drove them out of Paradise. When Noah's generation displeased You, You brought down the Flood. When Sodom no longer found favor in Your eyes, You made the sky rain down fire and sulfur. But these men here, whom You have betrayed, whom You have allowed to be tortured, butchered, gassed, burned, what do they do? They pray before You! They praise Your name!"

"All creation bears witness to the Greatness of God!"

Once, New Year's Day had dominated my life. I knew that my sins grieved the Eternal; I implored his forgiveness. Once, I had believed profoundly that upon one solitary deed of mine, one solitary prayer, depended the salvation of the world.

This day I had ceased to plead. I was no longer capable of lamentation. On the contrary, I felt very strong. I was the accuser, God the accused. My eyes were open and I was alone—terribly alone in a world without God and without man. Without love or mercy. I had ceased to be anything but ashes, yet I felt myself to be stronger than the Almighty, to whom my life had been tied for so long. I stood amid that praying congregation, observing it like a stranger.

The service ended with the Kaddish [prayer for the dead]. Everyone recited the Kaddish over his parents, over his children, over his brothers, and over himself.

We stayed for a long time at the assembly place. No one dared to drag himself away from this mirage. Then it was time to go to bed and slowly the prisoners made their way over to their blocks. I heard people wishing one another a Happy New Year!

I ran off to look for my father. And at the same time I was afraid of having to wish him a Happy New Year when I no longer believed in it.

He was standing near the wall, bowed down, his shoulders sagging as though beneath a heavy burden. I went up to him, took his hand and kissed it. A tear fell upon it. Whose was that tear? Mine? His? I said nothing. Nor did he. We had never understood one another so clearly.

The sound of the bell jolted us back to reality. We must go to bed. We came back from far away. I raised my eyes to look at my father's face leaning over mine, to try to discover a smile or something resembling one upon the aged, dried-up countenance. Nothing. Not the shadow of an expression. Beaten. Yom Kippur. The Day of Atonement.

Should we fast? The question was hotly debated. To fast would mean a surer, swifter death. We fasted here the whole year round. The whole year was Yom Kippur. But others said we should fast simply because it was dangerous to do so. We should show God that even here, in this enclosed hell, we were capable of singing His praises.

I did not fast, mainly to please my father, who had forbidden me to do so. But further, there was no longer any reason why I should fast. I no longer accepted God's silence.

As I swallowed my bowl of soup, I saw in the gesture an act of rebellion and protest against Him.

And I nibbled my crust of bread.

In the depths of my heart, I felt a great void.

The SS gave us a fine New Year's gift.

We had just come back from work. As soon as we had passed through the door of the camp, we sensed something different in the air. Roll call did not take so long as usual. The evening soup was given out with great speed and swallowed down at once in anguish.

I was no longer in the same block as my father. I had been transferred to another unit, the building one, where, twelve hours a day, I had to drag heavy blocks of stone about. The head of my new block was a German Jew, small of stature, with piercing eyes. He told us that evening that no one would be allowed to go out after the evening soup. And soon a terrible word was circulating—selection.

We knew what that meant. An SS man would examine us. Whenever he found a weak one, a *musulman* as we called them, he would write his number down: good for the crematory.

After soup, we gathered together between the beds. The veterans said:

"You're lucky to have been brought here so late. This camp is paradise today, compared with what is was like two years ago. Buna was a real hell then. There was no water, no blankets, less soup and bread. At night we slept almost naked, and it was below thirty degrees. The corpses were collected in hundreds every day. The work was hard. Today, this is a little paradise. The Kapos had orders to kill a certain number of prisoners every day. And every week—selection. A merciless selection.

. . . Yes, you're lucky."

"Stop it! Be quiet!" I begged. "You can tell your stories tomorrow or on some other day."

They burst out laughing. They were not veterans for nothing.

"Are you scared? So were we scared. And there was plenty to be scared of in those days."

The old men stayed in their corner, dumb, motionless, hunted. Some were praying.

An hour's delay. In an hour, we should know the verdict—death or a reprieve.

And my father. Suddenly I remembered him. How would he pass the selection? He had aged so much. . . .

The head of our block had never been outside concentration camps since 1933. He had already been through all the slaughterhouses, all the factories of death. At about nine o'clock, he took up his position in our midst:

"Achtung!"

There was instant silence.

"Listen carefully to what I am going to say." (For the first time, I heard his voice quiver.) "In a few moments the selection will begin. You must get completely undressed. Then one by one you go before the SS doctors. I hope you will all succeed in getting through. But you must help your own chances. Before you go into the next room, move about in some way so that you give yourselves a little color. Don't walk slowly, run! Run as if the devil were after you! Don't look at the SS. Run, straight in front of you!"

He broke off for a moment, then added:

"And, the essential thing, don't be afraid!"

Here was a piece of advice we should have liked very much to be able to follow.

I got undressed, leaving my clothes on the bed. There was no danger of anyone stealing them this evening.

Tibi and Yossi, who had changed their unit at the same time I had, came up to me and said:

"Let's keep together. We shall be stronger."

Yossi was murmuring something between his teeth. He must have been praying. I had never realized that Yossi was a believer. I had even always thought the reverse. Tibi was silent, very pale. All the prisoners in the block stood naked between the beds. This must be how one stands at the last judgment.

"They're coming!"

There were three SS officers standing round the notorious Dr. Mengele, who had received us at Birkenau. The head of the block, with an attempt at a smile, asked us:

"Ready?"

Yes, we were ready. So were the SS doctors. Dr. Mengele was holding a list in his hand: our numbers. He made a sign to the head of the block: "We can begin!" As if this were a game! The first to go by were the "officials" of the block: *Stubenaelteste*, Kapos, foreman, all in perfect physical condition of course! Then came the ordinary prisoners' turn. Dr. Mengele took stock of them from head to foot. Every now and then, he wrote a number down. One single thought filled my mind: not to let my number be taken; not to show my left arm.

There were only Tibi and Yossi in front of me. They passed. I had time to notice that Mengele had not written their numbers down. Someone pushed me. It was my turn. I ran without looking back. My head was spinning: you're too thin, you're weak, you're too thin, you're good for the furnace. . . . The race seemed interminable. I thought I had been running for years. . . . You're too thin, you're too weak. . . . At last I had arrived exhausted. When I regained my breath, I questioned Yossi and Tibi:

"Was I written down?"

"No," said Yossi. He added, smiling: "In any case, he couldn't have written you down, you were running too fast. . . ."

I began to laugh. I was glad. I would have liked to kiss him: At that moment, what did the others matter! I hadn't been written down.

Those whose number had been noted stood apart, abandoned by the whole world. Some were weeping in silence. The SS officers went away. The head of the block appeared, his face reflecting the general weariness.

"Everything went off all right. Don't worry. Nothing is going to happen to anyone. To anyone."

Again he tried to smile. A poor, emaciated, dried-up Jew questioned him avidly in a trembling voice:

"But . . . but, *Blockaelteste*, they did write me down!"

The head of the block let his anger break out. What! Did someone refuse to believe him!

"What's the matter now? Am I telling lies then? I tell you once and for all, nothing's going to happen to you! To anyone! You're wallowing in your own despair, you fool!"

The bell rang, a signal that the selection had been completed throughout the camp.

With all my might I began to run to Block 36. I met my father on the way. He came up to me:

"Well? So you passed?"

"Yes. And you?"

"Me too."

How we breathed again, now! My father had brought me a present—half a ration of bread obtained in exchange for a piece of rubber, found at the warehouse, which would do to sole a shoe.

The bell. Already we must separate, go to bed. Everything was regulated by the bell. It gave me orders, and I automatically obeyed them. I hated it. Whenever I dreamed of a better world, I could only imagine a universe with no bells.

Several days had elapsed. We no longer thought about the selection. We went to work as usual, loading heavy stones into railway wagons. Rations had become more meager: this was the only change.

We had risen before dawn, as on every day. We had received black coffee, the ration of bread. We were about to set out for the yard as usual. The head of the block arrived, running.

"Silence for a moment. I have a list of numbers here. I'm going to read them to you. Those whose numbers I call won't be going to work this morning; they'll stay behind in the camp."

And, in a soft voice, he read out about ten numbers. We had understood. These were numbers chosen at the selection. Dr. Mengele had not forgotten.

The head of the block went toward his room. Ten prisoners surrounded him, hanging onto his clothes:

"Save us! You promised. . . ! We want to go to the yard. We're strong enough to work. We're good workers. We can . . . we will. . . ."

He tried to calm them, to reassure them about their fate, to explain to them that the fact that they were staying behind in the camp did not mean much, had no tragic significance.

"After all, I stay here myself every day," he added.

It was a somewhat feeble argument. He realized it, and without another word went and shut himself up in his room.

The bell had just rung.

"Form up!"

It scarcely mattered now that the work was hard. The essential thing was to be as far away as possible from the block, from the crucible of death, from the center of hell.

I saw my father running toward me. I became frightened all of a sudden.

"What's the matter?"

Out of breath, he could hardly open his mouth.

"Me, too . . . me, too . . . ! They told me to stay behind in the camp."

They had written down his number without his being aware of it.

"What will happen?" I asked in anguish.

But it was he who tried to reassure me.

"It isn't certain yet. There's still a chance of escape. They're going to do another selection today . . . a decisive selection."

I was silent.

He felt that his time was short. He spoke quickly. He would have liked to say so many things. His speech grew confused; his voice choked. He knew that I would have to go in a few moments. He would have to stay behind alone, so very alone.

"Look, take this knife," he said to me. "I don't need it any longer. It might be useful to you. And take this spoon as well. Don't sell them. Quickly! Go on. Take what I'm giving you!"

The inheritance.

"Don't talk like that, father." (I felt that I would break into sobs.) "I don't want you to say that. Keep the spoon and knife. You need them as much as I do. We shall see each other again this evening, after work."

He looked at me with his tired eyes, veiled with despair. He went on:

"I'm asking this of you. . . . Take them. Do as I ask, my son. We have no time. . . . Do as your father asks."

Our Kapo yelled that we should start.

The unit set out toward the camp gate. Left, right! I bit my lips. My father had stayed by the block, leaning against

the wall. Then he began to run, to catch up with us. Perhaps he had forgotten something he wanted to say to me. . . . But we were marching too quickly. . . . Left, right!

We were already at the gate. They counted us, to the din of military music. We were outside.

The whole day, I wandered about as if sleepwalking. Now and then Tibi and Yossi would throw me a brotherly word. The Kapo, too, tried to reassure me. He had given me easier work today. I felt sick at heart. How well they were treating me! Like an orphan! I thought: even now, my father is still helping me.

I did not know myself what I wanted—for the day to pass quickly or not. I was afraid of finding myself alone that night. How good it would be to die here!

At last we began the return journey. How I longed for orders to run!

The military march. The gate. The camp.

I ran to Block 36.

Were there still miracles on this earth? He was alive. He had escaped the second selection. He had been able to prove that he was still useful. . . . I gave him back his knife and spoon.

FLANNERY O'CONNOR
REVELATION

This short story by Flannery O'Connor has its deepest meaning in the title itself. The reader might well ask: What is revealed to Mrs. Turpin? Who is the agent of that revelation? How will she be different as she grasps the revelation? Pay particular attention to the closing paragraphs of the story.

The doctor's waiting room, which was very small, was almost full when the Turpins entered and Mrs. Turpin, who was very large, made it look even smaller by her presence. She stood looming at the head of the magazine table set in the center of it, a living demonstration that the room was inadequate and ridiculous. Her little bright black eyes took in all the patients as she sized up the seating situation. There was one vacant chair and a place on the sofa occupied by a blond child in a dirty blue romper who should have been told to move over and make room for the lady. He was five or six, but Mrs. Turpin saw at once that no one was going to tell him to move over. He was slumped down in the seat, his arms idle at his sides and his eyes idle in his head; his nose ran unchecked.

Mrs. Turpin put a firm hand on Claud's shoulder and said in a voice that included anyone who wanted to listen, "Claud, you sit in that chair there," and gave him a push down into the vacant one. Claud was florid and bald and sturdy, somewhat shorter than Mrs. Turpin, but he sat down as if he were accustomed to doing what she told him to.

Mrs. Turpin remained standing. The only man in the room besides Claud was a lean stringy old fellow with a rusty hand spread out on each knee, whose eyes were closed as if he were asleep or dead or pretending to be so as not to get up and offer her his seat. Her gaze settled agreeably on a well-dressed gray-haired lady whose eyes met hers and whose expression said: if that child belonged to me, he would have some manners and move over—there's plenty of room there for you and him too.

Claud looked up with a sigh and made as if to rise.

"Sit down," Mrs. Turpin said. "You know you're not supposed to stand on that leg. He has an ulcer on his leg," she explained.

Claud lifted his foot onto the magazine table and rolled his trouser leg up to reveal a purple swelling on a plump marble-white calf.

"My!" the pleasant lady said. "How did you do that?"

"A cow kicked him," Mrs. Turpin said.

"Goodness!" said the lady.

Claud rolled his trouser leg down.

"Maybe the little boy would move over," the lady suggested, but the child did not stir.

"Somebody will be leaving in a minute," Mrs. Turpin said. She could not understand why a doctor—with as much money as they made charging five dollars a day to just stick their head in the hospital door and look at you—couldn't afford a decent-sized waiting room. This one was hardly bigger than a garage. The table was cluttered with limp-looking magazines and at one end of it there was a big green glass ash tray full of cigarette butts and cotton wads with little blood spots on them. If she had had anything to do with the running of the place, that would have been emptied every so often. There were no chairs against the wall at the head of the room. It had a rectangular-shaped panel in it that permitted a view of the office where the nurse came and went and the secretary listened to the radio. A plastic fern in a gold pot sat in the opening and trailed its fronds down almost to the floor. The radio was softly playing gospel music.

Just then the inner door opened and a nurse with the highest stack of yellow hair Mrs. Turpin had ever seen put her face in the crack and called for the next patient. The woman sitting beside Claud grasped the two arms of her chair and hoisted herself up; she pulled her dress free from her legs and lumbered through the door where the nurse had disappeared.

Mrs. Turpin eased into the vacant chair, which held her tight as a corset. "I wish I could reduce," she said, and rolled her eyes and gave a comic sigh.

"Oh, *you* aren't fat," the stylish lady said.

"Ooooo I am too," Mrs. Turpin said. "Claud he eats all he wants to and never weighs over one hundred and seventy-five pounds, but me I just look at something good to eat and I gain some weight," and her stomach and shoulders shook with laughter. "You can eat all you want to, can't you, Claud?" she asked, turning to him.

Claud only grinned.

"Well, as long as you have such a good disposition," the stylish lady said, "I don't think it makes a bit of difference what size you are. You just can't beat a good disposition."

Next to her was a fat girl of eighteen or nineteen, scowling into a thick blue book which Mrs. Turpin saw was [titled] *Human Development*. The girl raised her head and directed her scowl at Mrs. Turpin as if she did not like her looks. She appeared annoyed that anyone should speak while she tried to read. The poor girl's face was blue with acne and Mrs. Turpin thought how pitiful it was to have a face like that at that age. She gave the girl a friendly smile but the girl only scowled the harder. Mrs. Turpin herself was fat but she had always had good skin, and, though she was forty-seven years old, there was not a wrinkle in her face except around her eyes from laughing too much.

Next to the ugly girl was the child, still in exactly the same position, and next to him was a thin leathery old woman in a cotton print dress. She and Claud had three sacks of chicken feed in their pump house that was in the same print. She had seen from the first that the child belonged with the old woman. She could tell by the way they sat—kind of vacant and white-trashy, as if they would sit there until Doomsday if nobody called and told them to get up. And at right angles but next to the well-dressed pleasant lady was a lank-faced woman who was certainly the child's mother. She had on a yellow sweat shirt and wine-colored slacks, both gritty-looking, and the rims of her lips were stained with snuff. Her dirty yellow hair was tied behind with a little piece of red paper ribbon. Worse than niggers any day, Mrs. Turpin thought.

The gospel hymn playing was, "When I looked up and He looked down," and Mrs. Turpin, who knew it, supplied the last line mentally, "And wona these days I know I'll we-eara crown."

Without appearing to, Mrs. Turpin always noticed people's feet. The well-dressed lady had on red and gray suede shoes to match her dress. Mrs. Turpin had on her good black patent leather pumps. The ugly girl had on Girl Scout shoes and heavy socks. The old woman had on tennis shoes and the white-trashy mother had on what appeared to be bedroom slippers, black straw with gold braid threaded through them—exactly what you would have expected her to have on.

Sometimes at night when she couldn't go to sleep, Mrs. Turpin would occupy herself with the question of who she would have chosen to be if she couldn't have been herself. If Jesus had said to her before he made her, "There's only two places available for you. You can either be a nigger or white-trash," what would she have said? "Please, Jesus, please," she would have said, "just let me wait until there's another place available," and he would have said, "No, you have to go right now and I have only those two places so make up your mind." She would have wiggled and squirmed and begged and pleaded but it would have been no use and finally she would have said, "All right, make me a nigger then—but that don't mean a trashy one." And he would have made her a neat clean respectable Negro woman, herself but black.

Next to the child's mother was a red-headed youngish woman, reading one of the magazines and working a piece of chewing gum, hell for leather, as Claud would say. Mrs. Turpin could not see the woman's feet. She was not white-trash, just common. Sometimes Mrs. Turpin occupied herself at night naming the classes of people. On the bottom of the heap were most colored people, not the kind she would have been if she had been one, but most of them; then next to them—not above, just away from—were the white-trash; then above them were the home-owners, and above them the home-and-land owners, to which she and Claud belonged. Above she and Claud were people with a lot of money and much bigger houses and much more land. But here the complexity of it would begin to bear in on her, for some of the people with a lot of money were common and ought to be below she and Claud and some of the people who had good blood had lost their money and had to rent and then there were colored people who owned their homes and land as well. There was a colored dentist in town who had two red Lincolns and a swimming pool and a farm with registered white-face cattle on it. Usually by the time she had fallen asleep all the classes of people were moiling and roiling around in her head, and she would dream they were all crammed in together in a box car, being ridden off to be put in a gas oven.

"That's a beautiful clock," she said and nodded to her right. It was a big wall clock, the face encased in a brass sunburst.

"Yes, it's very pretty," the stylish lady said agreeably. "And right on the dot too," she added, glancing at her watch.

The ugly girl beside her cast an eye upward at the clock, smirked, then looked directly at Mrs. Turpin and smirked again. Then she returned her eyes to her book. She was obviously the lady's daughter because, although they didn't look anything alike as to disposition, they both had the same shape of face and the same blue eyes. On the lady they sparkled pleasantly but in the girl's seared face they appeared alternately to smolder and to blaze.

What if Jesus had said, "All right, you can be white-trash or a nigger or ugly"!

Mrs. Turpin felt an awful pity for the girl, though she thought it was one thing to be ugly and another to act ugly.

The woman with the snuff-stained lips turned around in her chair and looked up at the clock. Then she turned back and appeared to look a little to the side of Mrs. Turpin. There was a cast in one of her eyes. "You want to know wher you can get you one of themther clocks?" she asked in a loud voice.

"No, I already have a nice clock," Mrs. Turpin said. Once somebody like her got a leg in the conversation, she would be all over it.

"You can get you one with green stamps," the woman said. "That's most likely wher he got hisn. Save you up enough, you can get you most anythang. I got me some joo'ry."

Ought to have got you a wash rag and some soap, Mrs. Turpin thought.

"I get contour sheets with mine," the pleasant lady said.

The daughter slammed her book shut. She looked straight in front of her, directly through Mrs. Turpin and on through the yellow curtain and the plate glass window which made the wall behind her. The girl's eyes seemed lit all of a sudden with a peculiar light, an unnatural light like night road signs give. Mrs. Turpin turned her head to see if there was anything going on outside that she should see, but she could not see anything. Figures passing cast only a pale shadow through the curtain. There was no reason the girl should single her out for her ugly looks.

"Miss Finley," the nurse said, cracking the door. The gum-chewing woman got up and passed in front of her and Claud and went into the office. She had on red high-heeled shoes.

Directly across the table, the ugly girl's eyes were fixed on Mrs. Turpin as if she had some very special reason for disliking her.

"This is wonderful weather, isn't it?" the girl's mother said.

"It's good weather for cotton if you can get the niggers to pick it," Mrs. Turpin said, "but niggers don't want to pick cotton any more. You can't get the white folks to pick it and now you can't get the niggers—because they got to be right up there with the white folks."

"They gonna *try* anyways," the white-trash woman said, leaning forward.

"Do you have one of the cotton-picking machines?" the pleasant lady asked.

"No," Mrs. Turpin said, "they leave half the cotton in the field. We don't have much cotton anyway. If you want to make it farming now, you have to have a little of everything. We got a couple of acres of cotton and a few hogs and chickens and just enough white-face that Claud can look after them himself."

"One thang I don't want," the white-trash woman said, wiping her mouth with the back of her hand. "Hogs. Nasty stinking things, a-gruntin and a-rootin all over the place."

Mrs. Turpin gave her the merest edge of her attention. "Our hogs are not dirty and they don't stink," she said. "They're cleaner than some children I've seen. Their feet never touch the ground. We have a pig-parlor—that's where you raise them on concrete," she explained to the pleasant lady, "and Claud scoots them down with the hose every afternoon and washes off the floor." Cleaner by far than that child right there, she thought. Poor nasty little thing. He had not moved except to put the thumb of his dirty hand into his mouth.

The woman turned her face away from Mrs. Turpin. "I know I wouldn't scoot down no hog with no hose," she said to the wall.

You wouldn't have no hog to scoot down, Mrs. Turpin said to herself.

"A-gruntin and a-rootin and a-groanin," the woman muttered.

"We got a little of everything," Mrs. Turpin said to the pleasant lady. "It's no use in having more than you can handle yourself with help like it is. We found enough niggers to pick our cotton this year but Claud he has to go after them and take them home again in the evening. They can't walk that half a mile. No they can't. I tell you," she said and laughed merrily, "I sure am tired of buttering up niggers, but you got to love em if you want em to work for you. When they come in the morning, I run out and I say, 'Hi yawl this morning?' and when Claud drives them off to the field I just wave to beat the band and they just wave back." And she waved her hand rapidly to illustrate.

"Like you read out of the same book," the lady said, showing she understood perfectly.

"Child, yes," Mrs. Turpin said. "And when they come in from the field, I run out with a bucket of icewater. That's the way it's going to be from now on," she said. "You may as well face it."

"One thang I know," the white-trash woman said. "Two thangs I ain't going to do: love no niggers or scoot down no hog with no hose." And she let out a bark of contempt.

The look that Mrs. Turpin and the pleasant lady exchanged indicated they both understood that you had to *have* certain things before you could *know* certain things. But every time Mrs. Turpin exchanged a look with the lady, she was aware that the ugly girl's peculiar eyes were still on her, and she had trouble bringing her attention back to the conversation.

"When you got something," she said, "you got to look after it." And when you ain't got a thing but breath and britches, she added to herself, you can afford to come to town every morning and just sit on the Court House coping and spit.

A grotesque revolving shadow passed across the curtain behind her and was thrown palely on the opposite wall. Then a bicycle clattered down against the outside of the building. The door opened and a colored boy glided in with a tray from the drugstore. It had two large red and white paper cups on it with tops on them. He was a tall, very black boy in discolored white pants and a green nylon shirt. He was chewing gum slowly, as if to music. He set the tray down in the office opening next to the fern and stuck his head through to look for the secretary. She was not in there. He rested his arms on the ledge and waited, his narrow bottom stuck out, swaying to the left and right. He raised a hand over his head and scratched the base of his skull.

"You see that button there, boy?" Mrs. Turpin said. "You can punch that and she'll come. She's probably in the back somewhere."

"Is that right?" the boy said agreeably, as if he had never seen the button before. He leaned to the right and put his finger on it. "She sometime out," he said and twisted around to face his audience, his elbows behind him on the counter. The nurse appeared and he twisted back again. She handed him a dollar and he rooted in his pocket and made the change and counted it out to her. She gave him fifteen cents for a tip and he went out with the empty tray. The heavy door swung to slowly and closed at length with the sound of suction. For a moment no one spoke.

"They ought to send all them niggers back to Africa," the white-trash woman said. "That's wher they come from in the first place."

"Oh, I couldn't do without my good colored friends," the pleasant lady said.

"There's a heap of things worse than a nigger," Mrs. Turpin agreed. "It's all kinds of them just like it's all kinds of us."

"Yes, and it takes all kinds to make the world go round," the lady said in her musical voice.

As she said it, the raw-complexioned girl snapped her teeth together. Her lower lip turned downwards and inside out, revealing the pale pink inside of her mouth. After a second it rolled back up. It was the ugliest face Mrs. Turpin had ever seen anyone make and for a moment she was certain that the girl had made it at her. She was looking at her as if she had known and disliked her all her life—all of Mrs. Turpin's life, it seemed too, not just all the girl's life. Why, girl, I don't even know you, Mrs. Turpin said silently.

She forced her attention back to the discussion. "It wouldn't be practical to send them back to Africa," she said. "They wouldn't want to go. They got it too good here."

"Wouldn't be what they wanted—if I had anythang to do with it," the woman said.

"It wouldn't be a way in the world you could get all the niggers back over there," Mrs. Turpin said. "They'd be hiding out and lying down and turning sick on you and wailing and hollering and raring and pitching. It wouldn't be a way in the world to get them over there."

"They got over here," the trashy woman said. "Get back like they got over."

"It wasn't so many of them then," Mrs. Turpin explained.

The woman looked at Mrs. Turpin as if here was an idiot indeed but Mrs. Turpin was not bothered by the look, considering where it came from.

"Nooo," she said, "they're going to stay here where they can go to New York and marry white folks and improve their color. That's what they all want to do, every one of them, improve their color."

"You know what comes of that, don't you?" Claud asked.

"No, Claud, what?" Mrs. Turpin said.

Claud's eyes twinkled. "White-faced niggers," he said with never a smile.

Everybody in the office laughed except the white-trash and the ugly girl. The girl gripped the book in her lap with white fingers. The trashy woman looked around her from face to face as if she thought they were all idiots. The old woman in the feed sack dress continued to gaze expressionless across the floor at the high-top shoes of the man opposite her, the one who had been pretending to be asleep when the Turpins came in. He was laughing heartily, his hands still spread out on his knees. The child had fallen to the side and was lying now almost face down in the old woman's lap.

While they recovered from their laughter, the nasal chorus on the radio kept the room from silence.

"You go to blank blank
and I'll go to mine
But we'll all blank along
To-geth-ther,
And wall along the blank
We'll hep eachother out
Smile-ling in any kind of
Weath-ther!"

Mrs. Turpin didn't catch every word but she caught enough to agree with the spirit of the song and it turned her thoughts sober. To help anybody out that needed it was her philosophy of life. She never spared herself when she found somebody in need, whether they were white or black, trash or decent. And of all she had to be thankful for, she was most thankful that this was so. If Jesus had said, "You can be high society and have all the money you want and be thin and svelte-like, but you can't be a good woman with it," she would have had to say, "Well don't make me that then. Make me a good woman and it don't matter what else, how fat or how ugly or how poor!" Her heart rose. He had not made her a nigger or white-trash or ugly! He had made her herself and given her a little of everything. Jesus, thank you! she said. Thank you thank you thank you! Whenever she counted her blessings she felt as buoyant as if she weighed one hundred and twenty-five pounds instead of one hundred and eighty.

"What's wrong with your little boy?" the pleasant lady asked the white-trashy woman.

"He has a ulcer," the woman said proudly. "He ain't give me a minute's peace since he was born. Him and her are just alike," she said, nodding at the old woman, who was running her leathery fingers through the child's pale hair. "Look like I can't get nothing down them two but Co' Cola and candy."

That's all you try to get down em, Mrs. Turpin said to herself. Too lazy to light the fire. There was nothing you could tell her about people like them that she didn't know already. And it was not just that they didn't have anything. Because if you gave them everything, in two weeks it would all be broken or filthy or they would have chopped it up for lightwood. She knew all this from her own experience. Help them you must, but help them you couldn't.

All at once the ugly girl turned her lips inside out again. Her eyes fixed like two drills on Mrs. Turpin. This time there was no mistaking that there was something urgent behind them.

Girl, Mrs. Turpin exclaimed silently, I haven't done a thing to you! The girl might be confusing her with somebody else. There was no need to sit by and let herself be intimidated. "You must be in college," she said boldly, looking directly at the girl. "I see you reading a book there."

The girl continued to stare and pointedly did not answer.

Her mother blushed at this rudeness. "The lady asked you a question, Mary Grace," she said under her breath.

"I have ears," Mary Grace said.

The poor mother blushed again. "Mary Grace goes to Wellesley College," she explained. She twisted one of the buttons on her dress. "In Massachusetts," she added with a grimace. "And in the summer she just keeps right on studying. Just reads all the time, a real book worm. She's done real well at Wellesley; she's taking English and Math and History and Psychology and Social Studies," she rattled on, "and I think it's too much. I think she ought to get out and have fun."

The girl looked as if she would like to hurl them all through the plate glass window.

"Way up north," Mrs. Turpin murmured and thought, well, it hasn't done much for her manners.

"I'd almost rather to have him sick," the white-trash woman said, wrenching the attention back to herself. "He's so mean when he ain't. Look like some children just take natural to meanness. It's some gets bad when they get sick but he was the opposite. Took sick and turned good. He don't give me no trouble now. It's me waitin to see the doctor," she said.

If I was going to send anybody back to Africa, Mrs. Turpin thought, it would be your kind, woman. "Yes, indeed," she said aloud, but looking up at the ceiling, "it's a heap of things worse than a nigger." And dirtier than a hog, she added to herself.

"I think people with bad dispositions are more to be pitied than anyone on earth," the pleasant lady said in a voice that was decidedly thin.

"I thank the Lord he has blessed me with a good one," Mrs. Turpin said. "The day has never dawned that I couldn't find something to laugh at."

"Not since she married me anyways," Claud said with a comical straight face.

Everybody laughed except the girl and the white-trash.

Mrs. Turpin's stomach shook. "He's such a caution," she said, "that I can't help but laugh at him."

The girl made a loud ugly noise through her teeth.

Her mother's mouth grew thin and tight. "I think the worst thing in the world," she said, "is an ungrateful person. To have everything and not appreciate it. I know a girl," she said, "who has parents who would give her anything, a little brother who loves her dearly, who is getting a good education, who wears the best clothes, but who can never say a kind word to anyone, who never smiles, who just criticizes and complains all day long."

"Is she too old to paddle?" Claud asked.

The girl's face was almost purple.

"Yes," the lady said, "I'm afraid there's nothing to do but leave her to her folly. Some day she'll wake up and it'll be too late."

"It never hurt anyone to smile," Mrs. Turpin said. "It just makes you feel better all over."

"Of course," the lady said sadly, "but there are just some people you can't tell anything to. They can't take criticism."

"If it's one thing I am," Mrs. Turpin said with feeling, "it's grateful. When I think who all I could have been besides myself and what all I got, a little of everything, and a good disposition besides, I just feel like shouting, 'Thank you, Jesus, for making everything the way it is!' It could have been different!" For one thing, somebody else could have got Claud. At the thought of this, she was flooded with gratitude and a terrible pang of joy ran through her. "Oh thank you, Jesus, Jesus, thank you!" she cried aloud.

The book struck her directly over her left eye. It struck almost at the same instant that she realized the girl was about to hurl it. Before she could utter a sound, the raw face came crashing across the table toward her, howling. The girl's fingers sank like clamps into the soft flesh of her neck. She heard the mother cry out and Claud shout, "Whoa!" There was an instant when she was certain that she was about to be in an earthquake.

All at once her vision narrowed and she saw everything as if it were happening in a small room far away, or as if she were looking at it through the wrong end of a telescope. Claud's face crumpled and fell out of sight. The nurse ran in, then out, then in again. Then the gangling figure of the doctor rushed out of the inner door. Magazines flew this way and that as the table turned over. The girl fell with a thud and Mrs. Turpin's vision suddenly reversed itself and she saw everything large instead of small. The eyes of the white-trashy woman were staring hugely at the floor. There the girl, held down on one side by the nurse and on the other by her mother, was wrenching and turning in their grasp. The doctor was kneeling astride her, trying to hold her arm down. He managed after a second to sink a long needle into it.

Mrs. Turpin felt entirely hollow except for her heart which swung from side to side as if it were agitated in a great empty drum of flesh.

"Somebody that's not busy call for the ambulance," the doctor said in the off-hand voice young doctors adopt for terrible occasions.

Mrs. Turpin could not have moved a finger. The old man who had been sitting next to her skipped nimbly into the office and made the call, for the secretary still seemed to be gone.

"Claud!" Mrs. Turpin called.

He was not in his chair. She knew she must jump up and find him but she felt like some one trying to catch a train in a dream, when everything moves in slow motion and the faster you try to run the slower you go.

"Here I am," a suffocated voice, very unlike Claud's, said.

He was doubled up in the corner on the floor, pale as paper, holding his leg. She wanted to get up and go to him but she could not move. Instead, her gaze was drawn slowly downward to the churning face on the floor, which she could see over the doctor's shoulder.

The girl's eyes stopped rolling and focused on her. They seemed a much lighter blue than before, as if a door that had been tightly closed behind them was now open to admit light and air.

Mrs. Turpin's head cleared and her power of motion returned. She leaned forward until she was looking directly into the fierce brilliant eyes. There was no doubt in her mind that the girl did know her, knew her in some intense and personal way, beyond the time and place and condition. "What you got to say to me?" she asked hoarsely and held her breath, waiting, as for a revelation.

The girl raised her head. Her gaze locked with Mrs. Turpin's. "Go back to hell where you came from, you old wart hog," she whispered. Her voice was low but clear. Her eyes burned for a moment as if she saw with pleasure that her message had struck its target.

Mrs. Turpin sank back in her chair.

After a moment the girl's eyes closed and she turned her head wearily to the side.

The doctor rose and handed the nurse the empty syringe. He leaned over and put both hands for a moment on the mother's shoulders, which were shaking. She was sitting on the floor, her lips pressed together, holding Mary Grace's hand in her lap. The girl's fingers were gripped like a baby's around her thumb. "Go on to the hospital," he said, "I'll call and make the arrangements."

"Now let's see that neck," he said in a jovial voice to Mrs. Turpin. He began to inspect her neck with his first two fingers. Two little moon-shaped lines like pink fish bones were indented over her windpipe. There was the beginning of an angry red swelling above her eye. His fingers passed over this also.

"Lea' me be," she said thickly and shook him off. "See about Claud. She kicked him."

"I'll see about him in a minute," he said and felt her pulse. He was a thin gray-haired man, given to pleasantries. "Go home and have yourself a vacation the rest of the day," he said and patted her on the shoulder.

Quit your pattin me, Mrs. Turpin growled to herself.

"And put an ice pack over that eye," he said. Then he went and squatted down beside Claud and looked at his leg. After a moment he pulled him up and Claud limped after him into the office.

Until the ambulance came, the only sounds in the room were the tremulous moans of the girl's mother, who continued to sit on the floor. The white-trash woman did not take her eyes off the girl. Mrs. Turpin looked straight ahead at nothing. Presently the ambulance drew up, a long dark shadow, behind the curtain. The attendants came in and set the stretcher down beside the girl and lifted her expertly onto it and carried her out. The nurse helped the mother gather up her things. The shadow of the ambulance moved silently away and the nurse came back in the office.

"That ther girl is going to be a lunatic, ain't she?" the white-trash woman asked the nurse, but the nurse kept on to the back and never answered her.

"Yes, she's going to be a lunatic," the white-trash woman said to the rest of them.

"Po' critter," the old woman murmured. The child's face was still in her lap. His eyes looked idly out over her knees. He had not moved during the disturbance except to draw one leg up under him.

"I thank Gawd," the white-trash woman said fervently, "I ain't a lunatic."

Claud came limping out and the Turpins went home.

As their pick-up truck turned into their own dirt road and made the crest of the hill, Mrs. Turpin gripped the window ledge and looked out suspiciously. The land sloped gracefully down through a field dotted with lavender weeds and at the start of the rise their small yellow frame house, with its little flower beds spread out around it like a fancy apron, sat primly in its accustomed place between two giant hickory trees. She would not have been startled to see a burnt wound between two blackened chimneys.

Neither of them felt like eating so they put on their house clothes and lowered the shade in the bedroom and lay down, Claud with his leg on a pillow and herself with a damp washcloth over her eye. The instant she was flat on her back, the image of a razor-backed hog with warts on its face and horns coming out behind its ears snorted into her head. She moaned, a low quiet moan.

"I am not," she said tearfully, "a wart hog. From hell." But the denial had no force. The girl's eyes and her words, even the tone of her voice, low but clear, directed only to her, brooked no repudiation. She had been singled out for the message, though there was trash in the room to whom it might justly have been applied. The full force of this fact struck her only now. There was a woman there who was neglecting her own child but she had been overlooked. The message had been given to Ruby Turpin, a respectable, hard-working, church-going woman. The tears dried. Her eyes began to burn instead with wrath.

She rose on her elbow and the washcloth fell into her hand. Claud was lying on his back, snoring. She wanted to tell him what the girl had said. At the same time, she did not wish to put the image of herself as a wart hog from hell into his mind.

"Hey, Claud," she muttered and pushed his shoulder.

Claud opened one pale baby blue eye.

She looked into it warily. He did not think about anything. He just went his way.

"Wha, whasit?" he said and closed the eye again.

"Nothing," she said. "Does your leg pain you?"

"Hurts like hell," Claud said.

"It'll quit derreckly," she said and lay back down. In a moment Claud was snoring again. For the rest of the afternoon they lay there. Claud slept. She scowled at the ceiling. Occa-sionally she raised her fist and made a small stabbing motion over her chest as if she was defending her innocence to invisible guests who were like the comforters of Job, reasonable-seeming but wrong.

About five-thirty Claud stirred. "Got to go after those niggers," he sighed, not moving.

She was looking straight up as if there were unintelligible handwriting on the ceiling. The protuberance over her eye had turned a greenish-blue. "Listen here," she said.

"What?"

"Kiss me."

Claud leaned over and kissed her loudly on the mouth. He pinched her side and their hands interlocked. Her expression of ferocious concentration did not change. Claud got up, groaning and growling, and limped off. She continued to study the ceiling.

She did not get up until she heard the pick-up truck coming back with the Negroes. Then she rose and thrust her feet in her brown oxfords, which she did not bother to lace, and stumped out onto the back porch and got her red plastic bucket. She emptied a tray of ice cubes into it and filled it half full of water and went out into the back yard. Every afternoon after Claud brought the hands in, one of the boys helped him put out hay and the rest waited in the back of the truck until he was ready to take them home. The truck was parked in the shade under one of the hickory trees.

"Hi yawl this evening?" Mrs. Turpin asked grimly, appearing with the bucket and the dipper. There were three women and a boy in the truck.

"Us doin nicely," the oldest woman said. "Hi you doin?" and her gaze stuck immediately on the dark lump on Mrs. Turpin's forehead. "You done fell down, ain't you?" she asked in a solicitous voice. The old woman was dark and almost toothless. She had an old felt hat of Claud's set back on her head. The other two women were younger and lighter and they both had new bright green sunhats. One of them had hers on her head; the other had taken hers off and the boy was grinning beneath it.

Mrs. Turpin set the bucket down on the floor of the truck. "Yawl hep yourselves," she said. She looked around to make sure Claud had gone. "No, I didn't fall down," she said, folding her arms. "It was something worse than that."

"Ain't nothin bad happen to you!" the old woman said. She said it as if they all knew that Mrs. Turpin was protected in some special way by Divine Providence. "You just had you a little fall."

"We were in town at the doctor's office for where the cow kicked Mr. Turpin," Mrs. Turpin said in a flat tone that indicated they could leave off their foolishness. "And there was this girl there. A big fat girl with her face all broke out. I could look at that girl and tell she was peculiar but I couldn't tell how. And me and her mama was just talking and going along and all of a sudden WHAM! She throws this big book she was reading at me and . . ."

"Naw!" the old woman cried out.

"And then she jumps over the table and commences to choke me."

"Naw!" they all exclaimed, "naw!"

"Hi come she do that?" the old woman asked. "What ail her?"

Mrs. Turpin only glared in front of her.

"Somethin ail her," the old woman said.

"They carried her off in an ambulance," Mrs. Turpin continued, "but before she went she was rolling on the floor and they were trying to hold her down to give her a shot and she said something to me." She paused. "You know what she said to me?"

"What she say?" they asked.

"She said," Mrs. Turpin began, and stopped, her face very dark and heavy. The sun was getting whiter and whiter, blanching the sky overhead so that the leaves of the hickory tree were black in the face of it. She could not bring forth the words. "Something real ugly," she muttered.

"She sho shouldn't said nothin ugly to you," the old woman said. "You so sweet. You the sweetest lady I know."

"She pretty too," the one with the hat on said.

"And stout," the other one said. "I never knowed no sweeter white lady."

"That's the truth befo' Jesus," the old woman said. "Amen! You des as sweet and pretty as you can be."

Mrs. Turpin knew exactly how much Negro flattery was worth and it added to her rage. "She said," she began again and finished this time with a fierce rush of breath, "that I was an old wart hog from hell."

There was an astounded silence.

"Where she at?" the youngest woman cried in a piercing voice.

"Lemme see her. I'll kill her!"

"I'll kill her with you!" the other one cried.

"She b'long in the sylum," the old woman said emphatically. "You the sweetest white lady I know."

"She pretty too," the other two said. "Stout as she can be and sweet. Jesus satisfied with her!"

"Deed he is," the old woman declared.

Idiots! Mrs. Turpin growled to herself. You could never say anything intelligent to a nigger. You could talk at them but not with them. "Yawl ain't drunk your water," she said shortly. "Leave the bucket in the truck when you're finished with it. I got more to do than just stand around and pass the time of day," and she moved off and into the house.

She stood for a moment in the middle of the kitchen. The dark protuberance over her eye looked like a miniature tornado cloud which might any moment sweep across the horizon of her brow. Her lower lip protruded dangerously. She squared her massive shoulders. Then she marched into the front of the house and out the side door and started down the road to the pig parlor. She had the look of a woman going single-handed, weaponless, into battle.

The sun was a deep yellow now like a harvest moon and was riding westward very fast over the far tree line as if it meant to reach the hogs before she did. The road was rutted and she kicked several good-sized stones out of her path as she strode along. The pig parlor was on a little knoll at the end of a lane that ran off from the side of the barn. It was a square of concrete as large as a small room, with a board fence about four feet high around it. The concrete floor sloped slightly so that the hog wash could drain off into a trench where it was carried to the field for fertilizer. Claud was standing on the outside, on the edge of the concrete, hanging onto the top board, hosing down the floor inside. The hose was connected to the faucet of a water trough nearby.

Mrs. Turpin climbed up beside him and glowered down at the hogs inside. There were seven long-snouted bristly shoats in it—tan with liver-colored spots—and an old sow a few weeks off from farrowing. She was lying on her side grunting. The shoats were running about shaking themselves like idiot children, their little slit pig eyes searching the floor for anything left. She had read that pigs were the most intelligent animal. She doubted it. They were supposed to be smarter than dogs. There had even been a pig astronaut. He had performed his assignment perfectly but died of a heart attack afterwards because they left him in his electric suit, sitting upright throughout his examination when naturally a hog should be on all fours.

A-gruntin and a-rootin and a-groanin.

"Gimme that hose," she said, yanking it away from Claud. "Go on and carry them niggers home and then get off that leg."

"You look like you might have swallowed a mad dog," Claud observed, but he got down and limped off. He paid no attention to her humors.

Until he was out of earshot, Mrs. Turpin stood on the side of the pen, holding the hose and pointing the stream of water at the hind quarters of any shoat that looked as if it might try to lie down. When he had had time to get over the hill, she turned her head slightly and her wrathful eyes scanned the path. He was nowhere in sight. She turned back again and seemed to gather herself up. Her shoulders rose and she drew in her breath.

"What do you send me a message like that for?" she said in a low fierce voice, barely above a whisper but with the force of a shout in its concentrated fury. "How am I a hog and me both? How am I saved and from hell too?" Her free fist was knotted and with the other she gripped the hose, blindly pointing the stream of water in and out of the eye of the old sow whose outraged squeal she did not hear.

The pig parlor commanded a view of the back pasture where their twenty beef cows were gathered around the hay-bales Claud and the boy had put out. The freshly cut pasture sloped down to the highway. Across it was their cotton field and beyond that a dark green dusty wood which they owned as well. The sun was behind the wood, very red, looking over the paling of trees like a farmer inspecting his own hogs.

"Why me?" she rumbled. "It's no trash around here, black or white, that I haven't given to. And break my back to the bone every day working. And do for the church."

She appeared to be the right size woman to command the arena before her. "How am I a hog?" she demanded. "Exactly how am I like them?" and she jabbed the stream of water at the shoats. "There was plenty of trash there. It didn't have to be me.

"If you like trash better, go get yourself some trash then," she railed. "You could have made me trash. Or a nigger. If trash is what you wanted why didn't you make me trash?" She shook her fist with the hose in it and a watery snake appeared momentarily in the air. "I could quit working and take it easy and be filthy," she growled. "Lounge about the sidewalks all day drinking root beer. Dip snuff and spit in every puddle and have it all over my face. I could be nasty.

"Or you could have made me a nigger. It's too late for me to be a nigger," she said with deep sarcasm, "but I could act like one. Lay down in the middle of the road and stop traffic. Roll on the ground."

In the deepening light everything was taking on a mysterious hue. The pasture was growing a peculiar glassy green and the streak of highway had turned lavender. She braced herself for a final assault and this time her voice rolled out over the pasture. "Go on," she yelled, "call me a hog! Call me a hog again. From hell. Call me a wart hog from hell. Put that bottom rail on top. There'll still be a top and bottom!"

A garbled echo returned to her.

A final surge of fury shook her and she roared, "Who do you think you are?"

The color of everything, field and crimson sky, burned for a moment with a transparent intensity. The question carried over the pasture and across the highway and the cotton field and returned to her clearly like an answer from beyond the wood.

She opened her mouth but no sound came out of it.

A tiny truck, Claud's, appeared on the highway, heading rapidly out of sight. Its gears scraped thinly. It looked like a child's toy. At any moment a bigger truck might smash into it and scatter Claud's and the niggers' brains all over the road.

Mrs. Turpin stood there, her gaze fixed on the highway, all her muscles rigid, until in five or six minutes the truck reappeared, returning. She waited until it had had time to turn into their own road. Then like a monumental statue coming to life, she bent her head slowly and gazed, as if through the very heart of mystery, down into the pig parlor at the hogs. They had settled all in one corner around the old sow who was grunting softly. A red glow suffused them. They appeared to pant with a secret life.

Until the sun slipped finally behind the tree line, Mrs. Turpin remained there with her gaze bent to them as if she were absorbing some abysmal life-giving knowledge. At last she lifted her head. There was only a purple streak in the sky, cutting through a field of crimson and leading, like an extension of the highway, into the descending dusk. She raised her hands from the side of the pen in a gesture hieratic and profound. A visionary light settled in her eyes. She saw the streak as a vast swinging bridge extending upward from the earth through a field of living fire. Upon it a vast horde of souls were rumbling toward heaven. There were whole companies of white-trash, clean for the first time in their lives, and bands of black niggers in white robes, and battalions of freaks and lunatics shouting and clapping and leaping like frogs. And bringing up the end of the procession was a tribe of people whom she recognized at once as those who, like herself and Claud, had always had a little of everything and the God-given wit to use it right. She leaned forward to observe them closer. They were marching behind the others with great dignity, accountable as they had always been for good order and common sense and respectable behavior. They alone were on key. Yet she could see by their shocked and altered faces that even their virtues were being burned away. She lowered her hands and gripped the rail of the hog pen, her eyes small but fixed unblinkingly on what lay ahead. In a moment the vision faded but she remained where she was, immobile.

At length she got down and turned off the faucet and made her slow way on the darkening path to the house. In the woods around her the invisible cricket choruses had struck up, but what she heard were the voices of the souls climbing upward into the starry field and shouting hallelujah.

THREE WOMEN POETS

Gwendolyn Brooks (b. 1917) was the first African American woman to win a Pulitzer Prize (in 1949). Her poetry in the past has focused on black pride and the concerns of oppression. The Emmett Till of the poem was a black child, murdered in Mississippi in the early 1960s.

Sylvia Plath (1932–1963) was one of the finest of the "confessional" poets; her poem "Lady Lazarus" reflects themes that would eventually drive her to suicide: a sense of loss; a haunting fascination with death; and strangely mixed feelings about men in her life.

Adrienne Rich (b. 1929) is one of the most accomplished poets of our time. Her recent concerns have been with feminism. "Diving into the Wreck" shows Rich at her greatest powers as a skin-diving expedition takes on a mystical and mythical dimension.

GWENDOLYN BROOKS
THE LAST QUATRAIN OF THE BALLAD OF EMMETT TILL

after the murder,
after the burial

Emmett's mother is a pretty-faced thing;
the tint of pulled taffy.
She sits in a red room,
drinking black coffee.
She kisses her killed boy.
And she is sorry.
Chaos in windy grays
through a red prairie. 10
1960

SYLVIA PLATH
LADY LAZARUS

I have done it again.
One year in every ten
I manage it——

A sort of walking miracle, my skin
Bright as a Nazi lampshade,
My right foot

A paperweight,
My face a featureless, fine
Jew linen.

Peel off the napkin 10
O my enemy.
Do I terrify?——

The nose, the eye pits, the full set of teeth?
The sour breath
Will vanish in a day.

Soon, soon the flesh
The grave cave ate will be
At home on me.

And I a smiling woman.
I am only thirty. 20
And like the cat I have nine times to die.

This is Number Three.
What a trash
To annihilate each decade.

What a million filaments.
The peanut-crunching crowd
Shoves in to see

Them unwrap me hand and foot——
The big strip tease.
Gentlemen, ladies, 30

These are my hands,
My knees.
I may be skin and bone,

Nevertheless, I am the same, identical woman.
The first time it happened I was ten.
It was an accident.

The second time I meant
To last it out and not come back at all.
I rocked shut

As a seashell. 40
They had to call and call
And pick the worms off me like sticky pearls.

Dying
Is an art, like everything else.
I do it exceptionally well.

I do it so it feels like hell.
I do it so it feels real.
I guess you could say I've a call.

It's easy enough to do it in a cell
It's easy enough to do it and stay put. 50
It's the theatrical

Comeback in broad day
To the same place, the same face, the same brute
Amused shout:

"A miracle!"
That knocks me out.
There is a charge

For the eyeing of my scars, there is a charge
For the hearing of my heart——
It really goes. 60

And there is a charge, a very large charge,
For a word or a touch
Or a bit of blood

Or a piece of my hair or my clothes.
So, so, Herr Doktor.
So, Herr Enemy.

I am your opus,
I am your valuable,
The pure gold baby

That melts to a shriek. 70
I turn and burn.
Do not think I underestimate your great concern.

Ash, ash——
You poke and stir.
Flesh, bone, there is nothing there——

A cake of soap,
A wedding ring,
A gold filling.

Herr God, Herr Lucifer,
Beware
Beware. 80

Out of the ash
I rise with my red hair
And I eat men like air.

"Lady Lazarus" from *Ariel* by Sylvia Plath. Copyright © 1963 by Ted Hughes. Reprinted by permission of HarperCollins Publishers, Inc., and Faber & Faber, Ltd.

ADRIENNE RICH
DIVING INTO THE WRECK

First having read the book of myths,
and loaded the camera,
and checked the edge of the knife-blade,
I put on
the body-armor of black rubber
the absurd flippers
the grave and awkward mask.
I am having to do this
not like Cousteau with his
assiduous team 10
aboard the sun-flooded schooner
but here alone.

There is a ladder.
The ladder is always there
hanging innocently
close to the side of the schooner.
We know what it is for,
we who have used it.
Otherwise
it's a piece of maritime floss 20
some sundry equipment.

I go down.
Rung after rung and still
the oxygen immerses me
the blue light
the clear atoms
of our human air.
I go down.
My flippers cripple me,
I crawl like an insect down the ladder 30
and there is no one
to tell me when the ocean
will begin.

First the air is blue and then
it is bluer and then green and then
black I am blacking out and yet
my mask is powerful
it pumps my blood with power
the sea is another story
the sea is not a question of power 40
I have to learn alone
to turn my body without force
in the deep element.

And now: it is easy to forget
what I came for
among so many who have always
lived here
swaying their crenellated fans
between the reefs
and besides 50
you breathe differently down here.

I came to explore the wreck.
The words are purposes.
The words are maps.
I came to see the damage that was done
and the treasures that prevail.
I stroke the beam of my lamp
slowly along the flank
of something more permanent
than fish or weed 60

the thing I came for:
the wreck and not the story of the wreck

the thing itself and not the myth
the drowned face always staring
toward the sun
the evidence of damage
worn by salt and sway into this threadbare beauty
the ribs of the disaster
curving their assertion
among the tentative haunters. 70

This is the place.
And I am here, the mermaid whose dark hair
streams black, the merman in his armored body
We circle silently
about the wreck
we dive into the hold.
I am she: I am he

whose drowned face sleeps with open eyes
whose breasts still bear the stress
whose silver, copper, vermeil cargo lies 80
obscurely inside barrels
half-wedged and left to rot
we are the half-destroyed instruments
that once held to a course
the water-eaten log
the fouled compass

We are, I am, you are
by cowardice or courage
the one who find our way
back to this scene 90
carrying a knife, a camera
a book of myths
in which
our names do not appear.

TONI MORRISON

This is the speech that Toni Morrison gave in Stockholm on December 7, 1993, on the occasion of her reception of the Nobel Prize for literature. The first African American woman to be so honored, Morrison stresses the universal value of literature in her address.

MEMBERS OF THE SWEDISH ACADEMY, LADIES AND GENTLEMEN: Narrative has never been merely entertainment for me. It is, I believe, one of the principal ways in which we absorb knowledge. I hope you will understand, then, why I begin these remarks with the opening phrase of what must be the oldest sentence in the world, and the earliest one we remember from childhood: "Once upon a time . . ."

"Once upon a time there was an old woman. Blind but wise." Or was it an old man? A guru, perhaps. Or a *griot* soothing restless children. I have heard this story, or one exactly like it, in the lore of several cultures.

"Once upon a time there was an old woman. Blind. Wise."

In the version I know the woman is the daughter of slaves, black, American, and lives alone in a small house outside of town. Her reputation for wisdom is without peer and without question. Among her people she is both the law and its transgression. The honor she is paid and the awe in which she is held reach beyond her neighborhood to places far away; to the city where the intelligence of rural prophets is the source of much amusement.

One day the woman is visited by some young people who seem to be bent on disproving her clairvoyance and showing her up for the fraud they believe she is. Their plan is simple: they enter her house and ask the one question the answer to which rides solely on her difference from them, a difference they regard as a profound disability: her blindness. They stand before her, and one of them says, "Old woman, I hold in my hand a bird. Tell me whether it is living or dead."

She does not answer, and the question is repeated. "Is the bird I am holding living or dead?"

Still she does not answer. She is blind and cannot see her visitors, let alone what is in their hands. She does not know their color, gender or homeland. She only knows their motive.

The old woman's silence is so long, the young people have trouble holding their laughter.

Finally she speaks, and her voice is soft but stern. "I don't know," she says. "I don't know whether the bird you are holding is dead or alive, but what I do know is that it is in your hands. It is in your hands."

Her answer can be taken to mean: if it is dead, you have either found it that way or you have killed it. If it is alive, you can still kill it. Whether it is to stay alive is your decision. Whatever the case, it is your responsibility.

For parading their power and her helplessness, the young visitors are reprimanded, told they are responsible not only for the act of mockery but also for the small bundle of life sacrificed to achieve its aims. The blind woman shifts attention away from assertions of power to the instrument through which that power is exercised.

Speculation on what (other than its own frail body) that bird in the hand might signify has always been attractive to me, but especially so now, thinking as I have been about the work I do that has brought me to this company. So I choose to read the bird as language and the woman as a practiced writer. She is worried about how the language she dreams in, given to her at birth, is handled, put into service, even withheld from her for certain nefarious purposes. Being a writer, she thinks of language partly as a system, partly as a living thing over which one has control, but mostly as agency—as an act with consequences. So the question the children put to her, "Is it living or dead?," is not unreal, because she thinks of language as susceptible to death, erasure; certainly imperiled and salvageable only by an effort of the will. She believes that if the bird in the hands of her visitors is dead, the custodians are responsible for the corpse. For her a dead language is not only one no longer spoken or written, it is unyielding language content to admire its own paralysis. Like statist language, censored and censoring. Ruthless in its policing duties, it has no desire or purpose other than to maintain the free range of its own narcotic narcissism, its own exclusivity and dominance. However, moribund, it is not without effect, for it actively thwarts the intellect, stalls conscience, suppresses human potential. Unreceptive to interrogation, it cannot form or tolerate new ideas, shape other thoughts, tell another story, fill baffling silences. Official language smithered to sanction ignorance and preserve privilege is a suit of armor, polished to shocking glitter, a husk from which the knight departed long ago. Yet there it is; dumb, predatory, sentimental. Exciting reverence in schoolchildren, providing shelter for despots, summoning false memories of stability, harmony among the public.

She is convinced that when language dies, out of carelessness, disuse, indifference, and absence of esteem, or

killed by fiat, not only she herself but all users and makers are accountable for its demise. In her country children have bitten their tongues off and use bullets instead to iterate the void of speechlessness, of disabled and disabling language, or language adults have abandoned altogether as a device for grappling with meaning, providing guidance, or expressing love. But she knows tongue-suicide is not only the choice of children. It is common among the infantile heads of state and power merchants whose evacuated language leaves them with no access to what is left of their human instincts, for they speak only to those who obey, or in order to force obedience.

The systematic looting of language can be recognized by the tendency of its users to forgo its nuanced, complex, midwifery properties, replacing them with menace and subjugation. Oppressive language does more than represent violence; it is violence, does more than represent the limits of knowledge; it limits knowledge. Whether it is obscuring state language or the faux language of mindless media; whether it is the proud but calcified language of the academy or the commodity-driven language of science; whether it is the malign language of law-without-ethics, or language designed for the estrangement of minorities, hiding its racist plunder in its literary cheek—it must be rejected, altered and exposed. It is the language that drinks blood, laps vulnerabilities, tucks its fascist boots under crinolines of respectability and patriotism as it moves relentlessly toward the bottom line and the bottomed-out mind. Sexist language, racist language, theistic language—all are typical of the policing languages of mastery, and cannot, do not, permit new knowledge or encourage the mutual exchange of ideas.

The old woman is keenly aware that no intellectual mercenary or insatiable dictator, no paid-for politician or demagogue, no counterfeit journalist would be persuaded by her thoughts. There is and will be rousing language to keep citizens armed and arming; slaughtered and slaughtering in the malls, courthouses, post offices, playgrounds, bedrooms and boulevards; stirring, memorializing language to mask the pity and waste of needless death. There will be more diplomatic language to countenance rape, torture, assassination. There is and will be more seductive, mutant language designed to throttle women, to pack their throats like pâté-producing geese with their own unsayable, transgressive words; there will be more of the language of surveillance disguised as research; of politics and history calculated to render the suffering of millions mute; language glamorized to thrill the dissatisfied and bereft into assaulting their neighbors; arrogant pseudo-empirical language crafted to lock creative people into cages of inferiority and hopelessness.

Underneath the eloquence, the glamour, the scholarly associations, however stirring or seductive, the heart of such language is languishing, or perhaps not beating at all—if the bird is already dead.

She has thought about what could have been the intellectual history of any discipline if it had not insisted upon, or been forced into, the waste of time and life that rationalizations for and representations of dominance required—lethal discourses of exclusion blocking access to cognition for both the excluder and the excluded.

The conventional wisdom of the Tower of Babel story is that the collapse was a misfortune. That it was the distraction or the weight of many languages that precipitated the tower's failed architecture. That one monolithic language would have expedited the building, and heaven would have been reached. Whose heaven, she wonders? And what kind? Perhaps the achievement of Paradise was premature, a little hasty if no one could take the time to understand other languages, other views, other narratives. Had they, the heaven

they imagined might have been found at their feet. Complicated, demanding, yes, but a view of heaven as life; not heaven as post-life.

She would not want to leave her young visitors with the impression that language should be forced to stay alive merely to be. The vitality of language lies in its ability to limn the actual, imagined and possible lives of its speakers, readers, writers. Although its poise is sometimes in displacing experience, it is not a substitute for it. It arcs toward the place where meaning may lie. When a President of the United States thought about the graveyard his country had become, and said, "The world will little note nor long remember what we say here. But it will never forget what they did here," his simple words were exhilarating in their life-sustaining properties because they refused to encapsulate the reality of 600, dead men in a cataclysmic race war. Refusing to monumentalize, disdaining the "final word," the precise "summing up," acknowledging their "poor power to add or detract," his words signal deference to the uncapturability of the life it mourns. It is the deference that moves her, that recognition that language can never live up to life once and for all. Nor should it. Language can never "pin down" slavery, genocide, war. Nor should it yearn for the arrogance to be able to do so. Its force, its felicity, is in its reach toward the ineffable.

Be it grand or slender, burrowing, blasting or refusing to sanctify; whether it laughs out loud or is a cry without an alphabet, the choice word or the chosen silence, unmolested language surges toward knowledge, not its destruction. But who does not know of literature banned because it is interrogative; discredited because it is critical; erased because alternate? And how many are outraged by the thought of a self-ravaged tongue?

Word-work is sublime, she thinks, because it is generative; it makes meaning that secures our difference, our human difference—the way in which we are like no other life.

We die. That may be the meaning of life. But we *do* language. That may be the measure of our lives.

"Once upon a time . . ." Visitors ask an old woman a question. Who are they, these children? What did they make of that encounter? What did they hear in those final words: "The bird is in your hands"? A sentence that gestures toward possibility, or one that drops a latch? Perhaps what the children heard was, "It is not my problem. I am old, female, black, blind. What wisdom I have now is in knowing I cannot help you. The future of language is yours."

They stand there. Suppose nothing was in their hands. Suppose the visit was only a ruse, a trick to get to be spoken to, taken seriously as they have not been before. A chance to interrupt, to violate the adult world, its miasma of discourse about them. Urgent questions are at stake, including the one they have asked: "Is the bird we hold living or dead?" Perhaps the question meant: "Could someone tell us what is life? What is death?" No trick at all; no silliness. A straightforward question worthy of the attention of a wise one. An old one. And if the old and wise who have lived life and faced death cannot describe either, who can?

But she does not; she keeps her secret, her good opinion of herself, her gnomic pronouncements, her art without commitment. She keeps her distance, enforces it and retreats into the singularity of isolation, in sophisticated, privileged space.

Nothing, no word follows her declaration of transfer. That silence is deep, deeper than the meaning available in the words she has spoken. It shivers, this silence, and the children, annoyed, fill it with language invented on the spot.

"Is there no speech," they ask her, "no words you can give us that help us break through your dossier of failures?

through the education you have just given us that is no education at all because we are paying close attention to what you have done as well as to what you have said? to the barrier you have erected between generosity and wisdom?

"We have no bird in our hands, living or dead. We have only you and our important question. Is the nothing in our hands something you could not bear to contemplate, to even guess? Don't you remember being young, when language was magic without meaning? When what you could say, could not mean? When the invisible was what imagination strove to see? When questions and demands for answers burned so brightly you trembled with fury at not knowing?

"Do we have to begin consciousness with battle, heroes and heroines, like you have already fought and lost, leaving us with nothing in our hands except what you have imagined is there? Your answer is artful, but its artfulness embarrasses us and ought to embarrass you.º Your answer is indecent in its self-congratulation. A made-for-television script that makes no sense if there is nothing in our hands.

"Why didn't you reach out, touch us with your soft fingers, delay the sound bite, the lesson, until you knew who we were? Did you so despise our trick, our modus operandi, that you could not see that we were baffled about how to get your attention? We are young. Unripe. We have heard all our short lives that we have to be responsible. What could that possibly mean in the catastrophe this world has become; where, as a poet said, 'nothing needs to be exposed since it is already barefaced'? Our inheritance is an affront. You want us to have your old, blank eyes and see only cruelty and mediocrity. Do you think we are stupid enough to perjure ourselves again and again with the fiction of nationhood? How dare you talk to us of duty when we stand waist deep in the toxin of your past?

"You trivialize us and trivialize the bird that is not in our hands. Is there no context for our lives? No song, no literature, no poem full of vitamins, no history connected to experience that you can pass along to help us start strong? You are an adult. The old one, the wise one. Stop thinking about saving face. Think of our lives and tell us your particularized world. Make up a story. Narrative is radical, creating us at the very moment it is being created. We will not blame you if your reach exceeds your grasp; if love so ignites your words that they go down in flames and nothing is left but their scald. Or if, with the reticence of a surgeon's hands, your words suture only the places where blood might flow.

We know you can never do it properly—once and for all. Passion is never enough; neither is skill. But try. For our sake and yours forget your name in the street; tell us what the world has been to you in the dark places and in the light. Don't tell us what to believe, what to fear. Show us belief's wide skirt and the stitch that unravels fear's caul. You, old woman, blessed with blindness, can speak the language that tells us what only language can: how to see without pictures. Language alone protects us from the scariness of things with no names. Language alone is meditation.

"Tell us what it is to be a woman so that we may know what it is to be a man. What moves at the margin. What it is to have no home in this place. To be set adrift from the one you knew. What it is to live at the edge of towns that cannot bear your company.

"Tell us about ships turned away from shorelines at Easter, placenta in a field. Tell us about a wagonload of slaves, how they sang so softly their breath was indistinguishable from the falling snow. How they knew from the hunch of the nearest shoulder that the next stop would be their last. How, with hands prayered in their sex, they thought of heat, then sun. Lifting their faces as though it was there for the taking. Turning as though there for the taking. They stop at an inn. The driver and his mate go in with the lamp, leaving them humming in the dark. The horse's void steams into the snow beneath its hooves and the hiss and melt are the envy of the freezing slaves.

"The inn door opens: a girl and a boy step away from its light. They climb into the wagon bed. The boy will have a gun in three years, but now he carries a lamp and a jug of warm cider. They pass it from mouth to mouth. The girl offers bread, pieces of meat and something more: a glance into the eyes of the one she serves. One helping for each man, two for each woman. And a look. They look back. The next stop will be their last. But not this one. This one is warmed."

It's quiet again when the children finish speaking, until the woman breaks into the silence.

"Finally," she says. "I trust you now. I trust you with the bird that is not in your hands because you have truly caught it. Look. How lovely it is, this thing we have done—together."

Nobel Prize acceptance speech given by Toni Morrison in Stockholm on December 7, 1993. Reprinted by permission of International Creative Management, Inc. Copyright © 1993 Toni Morrison.

GLOSSARY

Terms italicized within the definitions are themselves defined within the Glossary.

a capella Music sung without instrumental accompaniment.

abacus (1) Square block forming part of a Doric capital. (2) A computing device using movable counters.

absurdity Term adopted by existentialists to describe the ultimate meaninglessness of human existence.

academy Derived from Akademeia, the name of the garden where Plato taught his students; the term came to be applied to official (generally conservative) teaching establishments.

accompaniment The musical background to a melody.

acoustics The science of the nature and character of sound.

acropolis Literally, the high point of a Greek city, frequently serving as refuge in time of war. The best known is the Acropolis of Athens.

acrylic A clear plastic used to make paints and as a casting material in sculpture.

adagio The Italian word for "very slow"; used by composers to indicate the speed at which music should be played.

adobe Sundried mudbrick.

aesthetic Descriptive adjective used (sometimes negatively) to characterize certain artworks as more interested in beauty than content. Also used as a shorthand way of speaking about a certain philosophical standard for the making of art (e.g., the Surrealist aesthetic).

agora In ancient Greek cities, the open marketplace, often used for public meetings.

ahimsa The Buddhist teaching of nonviolence.

aisle In church *architecture*, the long open spaces parallel to the *nave*.

aleatory music Music made in a random way after the composer sets out the elements of the musical piece.

allegory In art, a genre where fictional characters symbolically represent another level of Truth.

allegro The Italian word for "fast," used to indicate the speed at which a piece of music should be played.

altar In ancient religion, a table at which offerings were made or victims sacrificed. In Christian churches, a raised structure at which the sacrament of the Eucharist is consecrated, forming the center of the ritual.

altarpiece A painted or sculptured *panel* placed above and behind an altar to inspire religious devotion.

alto The lowest range of the female voice, also called *contralto*.

ambulatory Covered walkway around the *apse* of a church.

amphora Greek wine jar.

Anabaptists Radical Reformers who insisted on adult baptism even for those who had been baptized in infancy (the word means "those baptized again").

Anglo culture Common description of the majority culture of native English speakers in the United States, Canada, and the United Kingdom.

animism Belief that the world is governed by the workings of nature.

anthem A musical composition written for choir (sometimes with solo voices added), the text of which is in English.

anthropomorphism The endowing of nonhuman objects or forces with human characteristics.

antiphony Music in which two or more *voices* alternate with one another.

antithesis See *synthesis*.

apse Eastern end of a church, generally semicircular, in which the *altar* is housed.

Ara Pacis The Altar of Peace, chief monument of Augustan sculpture.

arabesque Decorative feature using highly complex interlaced lines (sometimes of fruits or foliage); the word derives from Islamic decorative arts.

architecture The art and science of designing and constructing buildings for human use.

architrave The lowest division of an *entablature*, or the lowest of three bands forming the upper part of a Doric temple.

archivault The molding that frames an arch.

aria A solo song in an *opera*, *oratorio*, or *cantata*, which often gives the singer a chance to display technical skill.

aria Song for a solo voice in an *opera*, an *oratorio*, or a *cantata*.

Arians A dissident branch of early Christianity, which did not accept Jesus Christ as equal to the Father; name for the Alexandrian priest Arius.

Ars Nova Latin for "the New Art." Describes the more complex new music of the fourteenth century, marked by richer harmonies and elaborate rhythmic devices.

Aryans A people who invaded India c. 1,500 B.C.E.

assemblage The making of a sculpture or other three-dimensional art piece from a variety of materials. Compare *collage*, *montage*.

atelier A workshop.

atman The personal manifestation, within each individual, of *Brahman*.

atomists Presocratic philosophers who believed that matter consisted of atoms, small indivisible particles.

atonality Music that lacks a traditional harmonic (or tonal) center.

atrium An open court in a Roman house or in front of a church.

augmentation In music, the process of slowing down a melody or musical phrase by increasing (generally doubling) the length of its notes.

aulos Greek double-reed musical instrument, similar to the modern oboe but consisting of two pipes.

autocracy Political rule by one person of unlimited power.

avant-garde French for advance-guard. Term used to describe artists using innovative or experimental techniques.

avatar Descent of Hindu deity to earth; incarnation.

axis An imaginary line around which the elements of a painting, sculpture or building are organized; the direction and focus of these elements establishes the axis.

ayres Simple English songs written for one singer and accompaniment.

ballad A narrative poem or song with simple stanzas and a refrain which is usually repeated at the end of each stanza.

ballades, ballate Songs or ballads, often written for a single voice with accompanying instruments.

ballet A dance performance, often involving a narrative or plot sequence, usually accompanied by music.

band A musical performance group made up of *woodwind, brass,* and *percussion,* but no *strings.*

baritone The male singing voice of medium *register,* between *bass* and *tenor.*

barrel vault A series of arches forming a tunnel (or "barrel").

basilica Originally a large hall used in Roman times for public meetings, law courts, etc.; later applied to a specific type of early Christian church.

bas-relief Low relief; see *relief (low).*

bass The lowest range of the male voice.

beat The unit for measuring time and *meter* in music.

bel canto Italian for "beautiful singing"; term applied to a school of early nineteenth-century opera.

belle époque French for "beautiful age." Used to describe the growing prosperity of the late nineteenth century.

berbers North African tribes, all speaking the Berber language although culturally separate, and mostly Muslim.

bhakti Act of devotion to a god or the gods in general.

binary form A two-part musical form in which the second part is different from the first, and both parts are usually repeated.

bitonality A musical technique involving the simultaneous performance of two melodies in different *tonalities.*

black-figure Athenian vase-painting technique whereby the outline of a figure was painted in solid black, and the details were produced by cutting away the paint with a fine point. Compare *red-figure.*

blank verse Unrhymed verse often used in English *epic* and dramatic poetry. Its meter is *iambic pentameter.* Compare *heroic couplet.*

Blaue Reiter, Brücke Two of the schools of German Expressionist painting.

blue note A flattened third or seventh note in a *chord,* characteristic of jazz and blues.

bodhisattva A Buddhist saint.

boule The directing council of the Athenian Assembly.

Brahman According to Hindu belief, the underlying reality of the world.

brass instruments The French horn, trumpet, trombone, and tuba, all of which have metal mouthpieces and bodies.

Bronze Age The period during which bronze (an alloy of copper and tin) was the chief material for tools and weapons. It began in Europe around 3,000 B.C.E. and ended around 1,000 B.C.E. with the introduction of iron.

Buddha Literally, "The Enlightened One." Title of Siddhartha Gautama.

burin Sharp-pointed steel instrument used for incising the lines for an *engraving.*

Bushmen A people of South Africa, living around the Kalahari Desert, noted for their vivid painting.

buttress An exterior architectural support.

cadenza In music, a free or improvised passage, usually inserted toward the end of a *movement* or *aria,* intended to display the performer's technical skill.

caliph An Arabic term for leader or ruler.

calligraphy Literally, fine handwriting; the cultivating of writing as an art form.

cameo carving Small sculptures on shell or stone in which figures in relief are set off from the background of the shell or stone.

campanile In Italy the bell tower of a church, often standing next to but separate from the church building.

canon From the Greek meaning a "rule" or "standard." In *architecture* it is a standard of proportion. In literature it is the authentic list of an author's works. In music it is the melodic line sung by overlapping voices in strict *imitation.* In religious terms it represents the authentic books in the Bible or the authoritative prayer of the Eucharist in the Mass or the authoritative law of the church promulgated by ecclesiastical authority.

cantata Italian for a piece of music that is sung rather than played and may contain short *oratorios,* alternating *arias,* and *recitatives.* An instrumental piece is known as a *sonata.*

canto Literally, a "song"—used to describe part of the *Commedia* by Dante Alighieri.

cantor One who leads singing in synagogue or church services.

cantus firmus Latin for "fixed song," a system of structuring a *polyphonic* composition around a preselected melody by adding new melodies above and/or below. The technique was used by medieval and Renaissance composers.

cantus Early term for singing as opposed to *musica,* which meant the ordering of tones and intervals.

canzone Song, generally with a more literary text than a ballad.

canzoniere The Italian word for a songbook.

capital The head, or crowning part, of a column, taking the weight of the *entablature.*

capitularies Official letters with legal and administrative stipulations sent out under the imperial seal.

caravan routes Trade routes, often through rough terrain (e.g., the Sahara Desert), used by groups of merchants traveling together for reasons of safety.

cartoon (1) A full-scale preparatory drawing for a picture, generally a large one such as a wall painting. (2) A humorous drawing.

caryatids Female statues used instead of columns to support a roof, as on the South Porch of the Erechtheum.

cast A molded replica made by a process whereby plaster, wax, clay, or metal is poured in liquid form into a mold. When the material has hardened the mold is removed, leaving a replica of the original from which the mold was taken.

caste system Hindu system of organizing class distinctions.

catacomb An underground cemetery.

catharsis According to Aristotle, the "cleansing of the soul" experienced by a person who has undergone a tragic series of events.

cathedra The bishop's throne. From that word comes the word *cathedral,* i.e., a church where a bishop officiates.

cathedral The church of the bishop named for the seat or chair (*cathedra*) from which he preached and taught.

cella Inner shrine of a Greek or Roman temple.

ceramics Objects made of baked clay, such as vases and other forms of pottery, tiles, and small sculptures.

chamber music Music written for small groups.

chancel The part of a church that is east of the *nave* and includes the *choir* and *sanctuary.*

chanson Popular French song.

chant A single line of melody in free rhythm and unaccompanied. The term is most frequently used for liturgical music such as Gregorian or Ambrosian chant.

chapel A small space within a church or a secular building such as a palace or castle, containing an *altar* consecrated for ritual use.

chevet The eastern (*altar*) end of a church.

chiaroscuro In painting, extreme contrasts between dark and light.

China The name of the country, which became used to describe its most famous export.

choir The part of a church *chancel* between *nave* and *sanctuary* where the monks sing the Office; a group of singers.

chorale prelude Piece of instrumental music that uses a familiar *hymn* or sacred song as the basis of an improvisation.

chorale variation Piece of instrumental music consisting of a set of variations on a familiar hymn or sacred song.

chorale A simple *hymn* tune sung either in unison or harmonized.

chord Any combination of three or more notes sounded together.

chorus The collective body that interacts with the individual actors in a Greek *tragedy* (e.g., the People of Thebes) and comments on the main action. The term came to be used, like *choir,* for a group of singers.

Christ Anointed One—Greek title (from Hebrew *messiah*) meaning "anointed."

cithara Greek musical instrument: seven-stringed *lyre.*

classical Generally applied to the civilizations of Greece and Rome; more specifically to Greek art and culture in the fifth and fourth centuries B.C.E. Later imitations of classical styles are called neoclassical. Classical is also often used as a broad definition of excellence: a "classic" can date to any period.

clavecin French for "harpsichord."

clef French for "key." In written music the term denotes the sign placed at the beginning of the *staff* to indicate the range of notes it contains.

clerestory A row of windows in a wall above an adjoining roof.

cloister Technically, the covered interior walkways in a *monastery,* but more broadly, the interior of a monastery that was generally off-limits to laypeople.

coda The Italian word for "tail"; the concluding section of a *sonata form movement* summing up the previous material.

codex Book with bound pages of parchment used instead of scrolls.

coffer In *architecture,* a recessed panel in a ceiling.

collage A composition produced by pasting together disparate objects such as train tickets, newspaper clippings, or textiles. Compare *assemblage, montage.*

colonnade A row of columns.

color field That form of painting that is characterized by its focus on color as the very description of a painting.

combine Term used to describe those works of art that add actual objects to the paintings, which frequently jut out from the canvas.

comedy An amusing and light-hearted play or narrative intended to provoke laughter on the part of the spectator; or a work with a happy ending.

composer The writer of a piece of music.

composition Generally, the arrangement or organization of the elements that make up a work of art. More specifically, a piece of music.

concerto grosso A composition for *orchestra,* generally in three *movements*: fast-slow-fast; it is designed to display the orchestra as a whole.

concerto A piece of music for one or more solo instruments and *orchestra,* usually with three contrasting *movements.*

concetto Italian for "concept." In Renaissance and Baroque art, the idea that undergirds an artistic ensemble.

consul One of two Roman officials elected annually to serve as the highest state magistrates in the Republic.

contralto See *alto.*

contrapposto In sculpture, placing a human figure so that one part (e.g., the shoulder) is turned in a direction opposite to another part (e.g., the hip and leg).

cori spezzati Italian for "split choirs." The use of two or more choirs for a musical performance.

Corinthian An order of *architecture* that was popular in Rome, marked by elaborately decorated *capitals* bearing acanthus leaves. Compare *Doric, Ionic.*

cornice Top part of a Greek temple, projecting over the rest of the building.

counterpoint Two or more distinct melodic lines sung or played at the same time.

couplet Two lines of a poem in which the last words of each line typically rhyme.

courtier A person who is attached to a royal court and who is trained to act appropriately.

crescendo In music, a gradual increase in volume.

cruciform Arranged or shaped like a cross.

crypt A *vaulted* chamber, completely or partially underground, which usually contains a *chapel.* It is found in a church under the *choir.*

cult A system of religious belief and its followers.

cuneiform A system of writing, common in the ancient Near East, using characters made up of wedge shapes. Compare *hieroglyphics.*

curia The body of tribunals and assemblies through which the pope governed the church.

da capo Italian for "from the beginning." In a musical performance, return to and repetition of the beginning section.

daguerreotype Early system of photography in which the image is produced on a silver-coated plate.

daimyo A Japanese war lord.

decrescendo In music, a gradual decrease in volume.

design The overall conception or scheme of a work of art. In the visual arts, the organization of a work's *composition* based on the arrangement of lines or contrast between light and dark.

deuterocanonical The books accepted in the Jewish translation of the bible into Greek known as the *Septuagint.*

development The central section of a *sonata form movement,* in which a composer changes and combines the themes stated in the opening *exposition.*

dialectics A logical process of arriving at the truth by putting in juxtaposition contrary propositions; a term often used in medieval philosophy and theology, and also in the writings of Hegel and Marx.

diatonic The seven notes of a major or minor *scale,* corresponding to the piano's white *keys* in an *octave.*

diminuendo In music, a gradual decrease in volume.

diminution The speeding up of a musical phrase by decreasing (usually halving) the length of the notes.

diptych Painting made up of two panels.

dithyramb Choral hymn sung in honor of the god Dionysus, often wild and violent in character. Later, any violent song, speech, or writing. Compare *paean.*

dome Circular *vault* made up of a series of arches intersecting each other around a central *axis.*

dominant The fifth note of a *diatonic scale.*

Dorian Mode of Greek music expressing powerful, at times warlike feelings.

Doric One of the Greek orders of *architecture,* simple and austere in style. Compare *Corinthian, Ionic.*

dramatis personae Latin for characters in a play.

Dualists Presocratic philosophers who believed in the existence of two worlds: one real, the other ideal.

duomo Italian word for "cathedral."

dynamics In music, the various levels of loudness and softness of sound, together with their increase and decrease.

Ecclesia The Athenian Assembly.

echinus Convex disc forming part of a *Doric capital.*

elevation In *architecture,* a drawing of the side of a building which does not show perspective.

Empfindsamkeit The German word for "sensitiveness." In music, the term was used to describe the emotional music popular in the mid-eighteenth century.

encaustic A painting technique using molten wax colored by pigments.

engraving (1) The art of producing a depressed design on a wood or metal block by cutting it in with a tool. (2) The impression or image made from such a wood or metal block by ink that fills the design. Compare *burin, etching, woodcut.* (3) Process of incising lines on a copper plate, which is then printed to produce an impression (itself also known as an engraving).

enlightened despots Eighteenth-century rulers who, while

retaining full powers, sought the welfare of their subjects.

ensemble In opera, a scene in which several characters sing simultaneously.

entablature (1) In architecture, the upper part of a wall supported by a column or pillar. (2) The part of a Greek or Roman temple above the columns, normally consisting of *architrave, frieze,* and *cornice.*

entasis The process whereby a *Doric* column is thickest at a point one-third from the base and then tapers to the top.

epic A long narrative poem celebrating the exploits of a heroic character.

Epicurean A follower of the Greek philosopher Epicurus, who held that pleasure was the chief aim in life.

Epicureanism A philosophy, originally Greek, holding that the correct goal and principle of human actions should be pleasure.

epiphany Literally, a "showing forth." Frequently used as a term for a sudden illumination, intuition, or insight.

epithet Adjective used to describe the special characteristics of a person or object.

essay A short literary work, generally in prose, dealing with a specific topic.

etching (1) The art of producing a depressed design on a metal plate by cutting lines through a wax coating and then applying corrosive acid that removes the metal under the lines. (2) The impression or image made from such a plate by ink that fills the design. Compare *engraving, woodcut.*

ethos (1) Term used by Plato to describe an individual's moral character. (2) Greek word meaning "character." In general, that which distinguishes a particular work of art and gives it character. More specifically, a term used by the Greeks to describe the moral and ethical character that they ascribed to music.

evangelist One of the authors of the four *gospels* in the Bible: Matthew, Mark, Luke, and John.

exemplum Moral tale.

exodus Literally, "a going out." Term used for the Israelites going out of Egypt and the name of the biblical book which describes that going out.

expatriate Literally, "out of one's country." Used for those individuals or communities who live outside of their homeland for extended periods.

exposition The opening section of a *sonata form movement,* setting out its main themes.

Expressionism Early twentieth-century style of painting, popular in Germany, which aimed to use color and theme to express the growing social and political tensions of the times.

fabliaux Fables, often obscene.

façade The front of a building.

Fauvism Early twentieth-century style of painting in France, using violent extremes of color and form.

ferroconcrete A modern building material consisting of concrete and steel reinforcing rods or mesh.

fetes galantes In the eighteenth century, elegant festivals or parties, held outdoors.

feudal The highly structured social organization typical of the early Middle Ages based on a pyramidal model with the lord at the top and gradations down to the serfs, who were bound to the land.

finale In music, the final section of a large instrumental composition or of the act of an *opera.*

flagellants Persons who whip themselves out of religious devotion.

flat A symbol (♭) used in music to signify that the note it precedes should be lowered by one half-step.

flute Architectural term for the vertical grooves on Greek (and later) columns generally.

flying arch External curved *buttresses* of a Gothic church characteristic of that style.

foot In poetry, the unit for measuring *meter.*

foreshortening The artistic technique whereby a sense of depth and three-dimensionality is obtained by the use of receding lines.

form The arrangement of the general structure of a work of art.

forte Italian for "loud."

forum Originally any open space available for public use. The Forum Romanum (Roman Forum), at the foot of the Capitoline and Palatine Hills, became the center of Roman political, economic, social, and religious life for more than a thousand years.

fourth A musical interval used to build up the Greek modes.

fresco Painting done on fresh coats of plaster.

friar A member of one of the religious orders of begging brothers founded in the Middle Ages.

frieze Middle band of painted or carved decoration that forms the upper part of a Doric temple.

fugue A *polyphonic* composition, generally for two to four voices (vocal or instrumental), in which the same themes are repeated and combined in *counterpoint.*

galleria (In a Baroque Palace) Formal reception hall.

gallery A long, narrow room or corridor, such as the spaces above the *aisles* of a church.

gandharan Indian Buddhist sculpture influenced by Greek models.

gargoyle Extravagant animal carving, symbolizing the flight of demons, used on gothic churches to serve as drains.

genre A type or category of art. In the visual arts, the depiction of scenes from everyday life.

Gesamtkunstwerk German term invented by Wagner meaning "complete art work" to describe his combination of music, poetry,

the visual arts, and movement in a single work.

glaze In oil painting, a transparent layer of paint laid over a dried painted canvas. In *ceramics*, a thin coating of clay fused to the piece by firing in a kiln.

Gnadenaltar The German word for "Mercy Altar," generally found in *pilgrimage churches* in southern Germany and Austria.

goliardic verse Term used to describe medieval student poetry and songs.

gospel "Good News"—the Anglo-Saxon word that means both Christian preaching and the four biblical accounts of the life of Jesus in the New Testament, ascribed to Matthew, Mark, Luke, and John. Compare *evangelist*.

gouache An opaque watercolor medium.

graphic Description and demonstration by visual means.

Great Schism Division in the Church, with two rival popes.

Greek cross A cross with arms of equal length.

Gregorian chant The *monophonic* unaccompanied song of the church *liturgy*, where the notes are correlated with the syllables of the text being sung. Called *plainsong*. Compare *melisma, neum, trope*.

ground A coating applied to a surface to prepare it for painting.

ground, groundlings The part of an Elizabethan theater where the spectators stood. These poorer members of the audience became known as the *groundlings*. The ground was sometimes called the *pit*.

guild Medieval associations of artisans or tradesmen; precursors of modern trade unions.

guilloche A decorative band made up of interlocking lines of design.

hadith Islamic law/traditions outside of the *Qu'ran*.

haiku Japanese verse form consisting of three lines of five, seven, and five syllables.

haj The Islamic pilgrimage to Mecca.

hamartia Literally, Greek for "missing the mark," "failure," or "error." Term used by Aristotle to describe the character flaw in otherwise noble people that causes their tragic fate.

happening In art, a multimedia event performed with audience participation so as to create a single artistic expression.

harmony Used by the Greeks to describe certain musical scales; in modern usage, the relationships existing between simultaneously sounding notes and *chord* progressions.

harpsichord Keyboard instrument, the forerunner of the modern piano.

healer A person with special spiritual powers, often related to fertility.

hedonism The philosophical theory that material pleasure is the principal good in life.

hegira Muhammad's flight from Mecca to Medina; marks the beginning of the Islamic religion.

heroic couplet The *meter* generally employed in *epic* poetry, consisting of pairs of rhyming *iambic pentameter* lines. Compare *blank verse*.

hierarchy A system of ordering people or things which places them in higher and lower ranks.

hieroglyphics A system of writing in which the characters consist of realistic or stylized pictures of actual objects, animals, or human beings (whole or part). The Egyptian hieroglyphic script is the best known, but by no means the only one. Compare *cuneiform*.

high relief See *relief (high)*.

Hinayana One of the two main strains of Chinese Buddhism, more ascetic than the other, *Mahayana*.

hippodrome A race course for horses and chariots. Compare *spina*.

Homo Erectus First direct ancestors of modern humans.

Homo Sapiens Evolved form of Homo Erectus, first humans.

homophony Music in which a single melody is supported by a harmonious accompaniment. Compare *monophonic*.

horarium The daily schedule in a *monastery* or a church community; a term derived from the Latin word for an hour (*hora*).

Hua-Pen Chinese short stories.

hubris The Greek word for "insolence;" excessive—and therefore self-destructive—pride and ambition.

humanist In the Renaissance, someone trained in the humane letters of the ancient classics and employed to use those skills. More generally, one who studies the humanities as opposed to the sciences.

hymn A religious song intended to give praise and adoration.

iambic pentameter Describes the *meter* of poetry written in lines consisting of five groups (pentameter) of two syllables each, the second syllable stressed more than the first (iambic *foot*).

icon Greek word for "image." Panel paintings used in the Orthodox church as representations of divine realities.

iconoclasm Literally "image breaking"—movement in Christian East that militated against the use of icons in worship and devotion.

iconography The set of symbols and allusions that gives meaning to a complex work of art.

ideal The depiction of people, objects, and scenes according to an idealized, preconceived model.

idol An image of a deity that serves as the object of worship.

ikegobo Royal altar used by the *Oba* (ruler) of Benin.

image The representation of a human or nonhuman subject, or of an event.

imitation In music, the restatement of a melodic idea in different voice parts of a *contrapuntal* composition.

impasto Paint laid on in thick textures.

improvisation In musical performance, the spontaneous invention of music for voice or instrument.

incising Cutting into a surface with a sharp instrument.

index List of forbidden books that was issued by the Catholic Church.

induction A system of reasoning that starts from a specific case and tries to use it to establish a general theory.

indulgences Forgiveness of sins in return for prayer, good works, and/or money.

intercolumniation The horizontal distance between the central points of adjacent columns in a Greek or Roman temple.

intermezzo The Italian word for "interlude." Originally used to describe a short musical piece between two longer ones, or between two acts of an *opera,* it became used by some Romantic composers to describe a short independent composition.

interval Musical term for the difference in *pitch* between two musical notes.

inversion See *serialism.*

Ionic One of the Greek orders of *architecture,* elaborate and graceful in style. Compare *Doric, Corinthian.*

Iron Age The period beginning in Europe around 1,000 B.C.E. during which iron was the chief material used for tools and weapons.

isorhythm System of musical composition whereby one voice in a polyphonic work is given a single, repeating rhythm.

isorhythmic Polyphonic music in which the various sections are unified by repeated rhythmic patterns, but the melodies are varied.

italic The type face *like this* designed during the Renaissance that was based on a form of handwriting often used in manuscript copying.

Ius Civile Rome's Code of Civil Law, first organized under Julius Caesar.

jamb Upright piece of a window or a door frame, often decorated in medieval churches.

jazz Form of American music first developed in the Black community in the early twentieth century, consisting of improvisation on a melodic theme.

jongleur In French, a wandering minstrel. A professional musician, actor, or mime who went from place to place, offering entertainment.

Kabuki Japanese drama, aimed at a wider public than *No* drama, and often based on real-life incidents.

kantor Music director of a church choir (and often of a school attached to the church).

karma For Buddhists, their destiny as determined by their actions.

kettle drums A kind of drum that can be tuned to a specific *pitch* (note); known in Italian as *timpani.*

key (1) The tonal center around which a composer bases a musical work. (2) The mechanism by which a keyboard instrument (piano, organ, etc.) or wind instrument (clarinet, bassoon, etc.) is made to sound.

keystone Central stone of an arch.

kore Draped standing female figure, common in Archaic sculpture.

kouros Nude standing male figure, common in Archaic sculpture.

lancet A pointed window frame of a medieval Gothic cathedral.

landscape In the visual arts, the depiction of scenery in nature.

Latin cross A cross with the vertical arm longer than the horizontal arm.

legato Italian for "tied." In music, the performance of notes in a smooth line. The opposite, with notes detached, is called *staccato.*

legend Stories meant to be read aloud; often used for stories about the saints in medieval literature.

leitmotiv German for "leading motif." A system devised by Wagner whereby a melodic idea

represents a character, an object, or an idea.

lekythos Small Greek vase for oil or perfume, often used during funeral ceremonies.

libretto Italian for "little book." In music, the text or words of an *opera, oratorio,* or other musical work involving text.

lieder The German word for "songs," generally used to describe songs set to a German text.

light-wells Vertical shafts running down through Minoan Palace complexes, to light the lower stories.

line engraving A type of *engraving* in which the image is made by scored lines of varying width.

linear perspective A system of *perspective* in which all parallel lines converge at a single *vanishing point.*

linearity Used as a description for art that emphasizes the geometrical quality of drawing as opposed to melding, blurring, or otherwise lessening the division of descriptive spaces within an artwork.

lintel The piece that spans two upright posts.

lithography A method of producing a print from a slab of stone on which an image has been drawn with a grease crayon or waxy liquid.

liturgy The official public worship of the Christian church.

logarithm Table of numbers that simplifies mathematical calculation by substituting addition and subtraction for multiplication and division.

loggia A roofed-over gallery of a building, open on one or more sides, often with arches.

low relief See *relief (low).*

Luminism School of landscape painting that developed in mid-nineteenth-century America.

lunette Semicircular space in wall for window or decoration.

lyre Small stringed instrument used in Greek and Roman music. Compare *cithara.*

lyric (1) Words or verses written to be set to music. (2) Description of

a work of art that is poetic, personal, even ecstatic in spirit.

Madonna Italian for "My Lady." Used for the Virgin Mary.

madrigal *Polyphonic* song for three or more voices, with verses set to the same music and a refrain set to different music.

Mahayana The other main strain of Chinese Buddhism, more worldly (and therefore more acceptable to Confucians) than *Hinayana*.

mandorla Almond-shaped light area surrounding a sacred personage in a work of art.

manuscript Literally (from the Latin), text written by hand. The way of book production before the invention of printing.

Mass The most sacred rite of the Catholic *liturgy*.

materialism Belief that nothing exists except material things.

maternity figure Small statue representing a female ancestor of a pregnant woman, to watch over the birth, prevent miscarriage, and protect the newborn child.

matroneum Gallery for women in churches, especially churches in the Byzantine tradition.

mausoleum Burial chapel or shrine.

mazurka A Polish folk-dance in fast triple time.

meander Maze pattern, used frequently in geometric pottery decoration and Greek geometric art.

meiji Literally, "enlightened government." The period beginning in 1868 during which feudalism was abolished and a strong central government established.

melisma In *Gregorian chant,* an intricate chain of notes sung on one syllable. Compare *trope*.

messiah See *Christ* above.

metaphysical Term used (confusingly) to describe a group of seventeenth-century English poets.

meter A systematically arranged and measured rhythm in poetry or music.

metopes Rectangular panels often decorated with sculpture which alternated with *triglyphs* in a *Doric frieze*.

michrab A recessed space or wall design in a mosque to indicate direction of Mecca for Islamic worshippers.

minaret Tower of a mosque, from where the call to prayer is chanted.

Minbar A pulpit in an Islamic mosque.

minnesingers German medieval musicians of the aristocratic class who composed songs of love and chivalry. Compare *troubadors*.

minuet A French seventeenth-century dance, the rhythm of which came to be used in the third movement of eighteenth-century *sonatas* and *symphonies*.

mobile A sculpture so constructed that its parts move either by mechanical or natural means.

modes (1) The scales that formed the basis of the Greek system of music. (2) In ancient and medieval music an arrangement of notes forming a scale which, by the character of intervals, determines the nature of the composition. Compare *tetrachord*. (3) In modern music one of the two classes, major or minor, into which musical scales are divided.

modulation In music, movement from one *key* to another.

monastery A place where monks live in communal style for spiritual purposes.

monochrome A single color, or variations on a single color.

monody A *monophonic* vocal piece of music. See *recitative*.

monophonic From the Greek meaning "one voice." Describes music consisting of a single melodic line. Compare *polyphonic*.

monotheism Religious belief that affirms that there is only one God, as opposed to polytheism, which accepts many gods, or henotheism, which admits that there are many gods but only one is to be worshiped.

montage (1) In the cinema, the art of conveying an idea and/or mood by the rapid juxtaposition of different images and camera angles. (2) In art, the kind of work made from pictures or parts of pictures already produced and now forming a new composition. Compare *assemblage, collage*.

mosaic Floor or wall decoration consisting of small pieces of stone, ceramic, shell, or glass set into plaster or cement.

mosque Islamic house of worship.

motet (1) Musical composition, developed in the thirteenth century, in which words (French "mots") were added to fragments of *Gregorian chant*. (2) Sixteenth-century composition: four- or five-voiced sacred work, generally based on a Latin text.

movement A self-contained section of a *symphony, concerto,* or other extended composition made up of several separate *movements*; the classical symphony had four.

mughal The Persian word for "Mongol." It is used to describe the period of Muslim rule in India.

mullion A slender divider of light panels on a window.

mural Wall painting or *mosaics* attached to a wall.

Musica Ficta The art of performing music by departing from the written notes and introducing embellishments.

myth Story or *legend* whose origin is unknown; myths often help to explain a cultural tradition or cast light on a historical event.

narthex The porch or vestibule of a church.

natural selection According to Charles Darwin, the process of evolution by which some variations of each species die out, while others survive.

natural In music, the sign (\natural) which cancels any previously indicated *sharp* (\sharp) or *flat* (\flat).

nave From the Latin meaning "ship." The central space of a church.

neanderthal Early stage in the development of the human species, lasting from before 100,000 B.C.E. to around 35,000 B.C.E.; they were the first to bury their dead with offerings in graves.

Negritude Term created by Leopold Senghor to summarize the African contribution to world culture; a literary movement in twentieth century Black Africa based on African culture.

Neolithic The Late Stone Age, when agricultural skills had been developed but stone was still the principal material for tools and weapons. It began in the Near East around 8,000 B.C.E. and in Europe around 6,000 B.C.E.

Neo-Platonism Philosophical movement ultimately derived from the work of Plato and his followers, which emphasized the drive toward the ideal as the goal of transcending mere material reality.

neum The basic symbol used in the notation of *Gregorian chant.*

niche A hollow recess or indentation in a wall to hold a statue or other object.

nirvana The extinction of individual suffering and absorption into the Buddhist supreme spirit.

no (or **Noh**) Traditional Japanese drama, generally based on stories passed down from generation to generation, involving acting, song, dance, and mime.

nocturne Short, dreamy piece of music, generally for solo piano. Invented by the Irish composer John Field, it was popularized by Chopin.

notation The system of writing out music in symbols that can be reproduced in performance.

oba The hereditary male absolute ruler of the ancient kingdom of Benin.

obelisk A rectangular shaft of stone that tapers to a pyramidal point.

obi Title of ruler of the medieval African kingdom of Benin (modern Nigeria).

octave (1) Modern musical unit deriving from Pythagorean ideas about harmony. (2) The *interval* from one note to the next with the same *pitch*; e.g., from C to the C above or below.

October Revolution Common way of designating the overthrow of the Tsars and the emergence of Marxist government in Russia in 1917. By extension, any radical overthrow of the established, political order.

Oculus Regular Latin word for "eye." A circular eye-like window or opening, technically used to describe the empty round hole at the top of the dome of the *Pantheon.*

ode A lyric poem, usually exalted and emotional in character.

oil painting Painting in a medium made up of powdered colors bound together with oil, generally linseed.

opera A dramatic performance in which the text is sung to the accompaniment of an *orchestra* rather than spoken.

Opus Dei Latin for "work of God." Used to describe the choral offices of monks, which are sung during the hours of the day.

opus Latin for "work." Used for chronological lists of composers' works.

oral composition The composition and transmission of works of literature by word of mouth, as in the case of the Homeric epics.

oratorio Sacred drama or extended musical *composition* for solo singers, *chorus,* and *orchestra* that is performed without action, scenery, or costume, generally in a church or concert hall.

orchestra (1) In Greek theaters, the circular space in front of the stage in which the *chorus* moves. (2) A group of instrumentalists who come together to perform musical *compositions.*

order (1) In *classical architecture* a specific form of column and *entablature;* see *Doric, Ionic,* and *Corinthian.* (2) More generally, the

arrangement imposed on the various elements in a work of art.

organum An early form of *polyphonic* music in which one or more melody lines were sung along with the song line of *plainsong.* Compare *Gregorian chant.*

Orientalizing Early pottery decoration, popular at Corinth, using motifs from Eastern art.

orthodoxy Greek term meaning both correct belief and correct worship. It later became the generic name for Eastern Christianity which broke from Rome.

outcasts The lowest category of the caste system: the so-called untouchables.

overture An instrumental *composition* played as an introduction to a *ballet, opera,* or *oratorio.*

paean Song consisting of a solemn invocation to the gods, either praying for help or giving thanks for help already received. Later generally applied to any song of praise or triumph. Compare *dithyramb.*

Paleolithic The Old Stone Age, during which Homo Erectus appeared and manufactured tools for the first time. It began around two and a half million years ago.

palette (1) The tray on which a painter mixes colors. (2) The range and combination of colors typical of a particular painter.

palio Bareback horse-race run in Siena twice a year.

panel A rigid, flat support, generally square or rectangular, for a painting; the most common material is wood.

pantheon The collected gods. By extension, a temple to them. In modern usage a public building containing the tombs or memorials of famous people.

pantocrator From the Greek meaning "one who rules or dominates all." Used for those figures of God and/or Christ found in the *apses* of Byzantine churches.

parable A story told to point up a philosophical or religious truth.

parallelism A literary device, common in the psalms, of either repeating or imaging one line of poetry with another that uses different words but expresses the same thought.

Parthenos Literally "virgin." The attribute of Athena used to name her temple, the Parthenon.

pastel (1) Dry sticks of colored chalk that leave a soft, powdery hue when rubbed on paper. (2) A drawing made by these colored chalks.

pathos That aspect of a work of art that evokes sympathy or pity.

patricians The Roman upper classes.

patron A person or institution who supplies the financial and moral backing for artistic or literary projects.

pediment Long extended triangle at the top of each end of a Greek temple, often filled with sculpture.

pendentives Triangular architectural devices used to support a dome of a structure; the dome may rest directly on the pendentives. Compare *squinches*.

percussion instruments Musical instruments that are struck or shaken to produce a sound, e.g., drums, tambourine, cymbals.

peripatetic Greek for "walking around." Specifically applied to followers of the philosopher Aristotle.

peristyle An arcade (usually of columns) around the outside of a building. The term is often used of temple *architecture*.

perpendicular Style of English architecture, which emphasized the vertical lines of the inside of a building.

perspective A technique in the visual arts for producing on a flat or shallow surface the effect of three dimensions and deep space.

philosophy Study of the nature and ultimate significance of the human experience.

Phrygian Mode of Greek music expressing passion and sensuality.

piano Italian for "soft."

piazza The Italian word for a city square or market place.

picaresque novel Novel telling a story involving a rogue or adventurer.

pietá Term used to describe depictions of Mary holding the dead Christ in her arms.

pietra serena Italian for "serene stone." A characteristic building stone often used in Italy.

pilaster In *architecture* a pillar in *relief.*

pilgrimage church A church designated as a pilgrimage destination as opposed to a church (e.g., Chartres) that was a pilgrimage destination but was also a cathedral.

pillow-book Japanese literary form consisting of a diary describing the day's events, often of an erotic nature.

pit See *ground*.

pitch In music the relative highness or lowness of a note as established by the frequency of vibrations occurring per second within it.

pizzicato Italian for "plucked." An instruction to performers on *string* instruments to pluck instead of bow their strings.

plainsong See *Gregorian chant*.

plan An architectural drawing showing in two dimensions the arrangement of space in a building.

plebeians The Roman lower classes.

podium A base, platform, or pedestal for a building, statue, or monument.

polis The Greek word for "city"; used to designate the Greek self-governing city-state.

polonaise A stately Polish processional dance, frequently performed at weddings and public ceremonies.

polychrome Literally "many colors," used to describe sculpture/ceramics that are painted. Compare *monochrome*.

polyphonic From the Greek meaning "many voices." Music involving several melodic lines or "voices," which interweave into a single whole. Compare *monophonic*.

portal A door, usually of a church or cathedral.

portico A porch with a roof supported by columns.

Post-Impressionism General term for varying styles of painting, mainly in France, which developed after the Impressionist movement.

prelude In music, originally a short opening section of a longer piece (it was used in this way by Bach). Composers in the Romantic era also used it to describe a short independent piece.

Presocratics Greek philosophers before the time of Socrates.

presto Italian for "fast."

program music Instrumental music that imitates sound effects or illustrates a story or program.

prophet In Hebrew and Christian tradition, one who speaks authoritatively for another (God). In a secondary meaning, it is one who speaks about the future with authority.

proportion The relation of one part to another, and each part to the whole, in respect of size, whether of height, width, length, or depth.

prosody The art of setting words to music.

prototype An original model or form on which later works are based.

psalter Another name for the Book of Psalms from the Bible.

psychoanalysis The various schools of psychological therapy, and the theoretical underpinnings of those schools, that ultimately derive from the ideas of Sigmund Freud.

puja An act of prayer in the home, generally in front of a small *altar*.

pyramid Form of Egyptian *architecture*, generally (although not exclusively) used for the tombs of royalty and aristocracy.

pyramidal arrangement The manner of articulating artworks,

common in the Renaissance, in which minor figures form the base and the central figure the apex of the artwork.

Pythagoreanism Moral and intellectual teachings of Pythagoras.

Qur'an The sacred scriptures of Islam.

Rajput Rulers of local Indian kingdoms following the fall of the Gupta Empire.

Ramadan The month in the Muslim (lunar) calendar in which fasting from before dawn to sundown is stipulated.

Ramapithecus Earliest known form of hominid (human-like creature).

realism A nineteenth-century style in the visual arts in which people, objects, and events were depicted in a manner that aimed to be true to life. In film, the style of Neorealism developed in the post–World War II period according to similar principles.

recapitulation The third section of a *sonata form* movement which restates the themes heard in the first section, the *exposition*.

recitative The free declaration of a vocal line, halfway between singing and ordinary speech, with only a simple instrumental accompaniment for support. The inventors of *opera,* who thought they were reviving ancient Greek *tragedy,* used the Greek term: *monody.*

red-figure Style of Athenian vase-painting whereby red figures are painted on a black background and adding details with a brush. Compare *black-figure.*

register In music, the range of notes within the capacity of a human voice or an instrument.

relics Parts of a body or material (clothing, personal objects) associated with a saint.

relief (high) Sculptures carved out of a block of stone so deeply that they seem to stand independently.

relief (low) Sculptures carved out of the surface of a block of stone.

reliquary A small casket or shrine in which sacred *relics* are kept.

requiem A *Mass* for the dead.

retrograde inversion See *serialism.*

revelation Divine self-disclosure to humans.

rondo A musical form in which one main theme recurs in alternation with various other themes. The form was often used in the last *movement* of a *sonata* or *symphony.*

row See *serialism.*

Samurai Japanese professional warrior.

Samurai-dokoro Office held by Japanese emperor, giving him command over all Japan's professional warriors.

sanctuary In religion, a sacred place. The part of a church where the altar is placed.

Sangha A Buddhist *monastery* or the Buddhist monastic life in general.

Sanskrit Language spoken by the *Aryans.*

sarcophagus A burial container for a human body typically made from some form of stone (usually limestone) and often ornamented both on the lid and the side panels. From the Greek words for flesh (*sarx*) and to consume (*phagein*)

satire The use of ridicule and sarcasm to expose and discourage what the author considers folly or even more serious shortcomings; popular in eighteenth-century literature.

Satyagraha Nonviolent civil disobedience; a form of protest against British rule in India devised by Mohandas Gandhi.

Satyr Play The lighthearted play that followed the tragic *trilogy* of plays in performances at the Festival of Dionysus at Athens.

satyr Greek mythological figure usually shown with an animal's ears and tail.

scale (1) In music, a succession of notes arranged in ascending or descending order. (2) More generally, the relative or proportional size of an object or image.

scherzo The Italian word for "joke." Beethoven first employed the term for the third, more lighthearted *movement* of his *symphonies,* and composers continued to use it either to describe a similar movement in a symphony or for an independent piece.

score The written form of a piece of music in which all the parts are shown.

scriptorium The monastic room used by monks for the copying and illumination of *manuscripts* and their study.

section An architectural drawing showing the side of a building.

secular Not sacred; relating to the worldly.

Semitic A group of early Mesopotamian peoples who spoke variations of the same language.

Septuagint Greek translation of the Old Testament made two centuries before the Common Era.

sequence In music, the repetition of a melodic phrase at different *pitches.*

serenade A type of instrumental *composition* originally performed in the eighteenth century as background music for public occasions.

serial music A type of twentieth-century musical *composition* in which various components (notes, rhythms, dynamics, etc.) are organized into a fixed series.

serialism, Twelve-tone technique A system of musical composition invented by Schönberg, based on an arrangement of the twelve notes of the chromatic scale, which remains fixed during a piece of music. In strict serialism, the only variations of this *row* or *series* permitted are *inversion* (the row turned upside down), *retrograde* (the row turned backward), and *retrograde inversion* (the backwards version of the row turned upside down).

series See *serialism.*

Seven Liberal Arts The basic classic set of courses typically constituting education up to the university level made up of grammar, rhetoric, and dialects (the trivium) and arithmetic, geometry, music, and astronomy (the quadrivium).

Shari'a The code of law that covers religious, civil, and criminal law. It is the law of the land in several Muslim countries.

sharp In music, a sign (♯) which raises the note it precedes by one half-step.

Shintoism Native Japanese religion, combining reverence for nature spirits and worship of the emperor and his ancestors.

Shogun Official title of the Japanese emperor.

Shona One of the peoples now living in modern Zimbabwe, who may be the descendants of the inhabitants of the ancient kingdom of Zimbabwe.

silhouette The definition of a form by its outline.

skolion Greek drinking song, generally sung at banquets.

soliloquy Speech made by characters in a play who utter their thoughts aloud, without addressing them to any other character.

sonata In the seventeenth century, a short instrumental piece. Over time, the term came to be used for an instrumental piece in several *movements.*

sonata form, sonata allegro form A musical form evolved during the eighteenth century that became the basis of the first movement (and sometimes also the last) of a *sonata;* it employs *exposition, development,* and *recapitulation* as its major divisions.

sonnet Short poem of fourteen lines, either eight lines (octave) and six lines (sextet) or three quatrains of four lines and an ending couplet. Often attributed to Petrarch, the form—keeping the basic fourteen lines—was modi-

fied by such poets as Spenser, Shakespeare, and Milton.

Sophists Traveling professional "philosophers" who taught their pupils, among other things, how to win arguments and debates.

soprano The highest *register* of the female voice.

spandrel A triangular space above a window in a *barrel vault* ceiling, or the space between two arches in an arcade.

spina A monument at the center of a stadium or *hippodrome,* usually in the form of a triangular *obelisk.*

Sprechstimme A device invented by Schoenberg whereby a singer "speaks" musical notes rather than singing them in traditional style.

squinches Either columns or *lintels* used in corners of a room to carry the weight of a superimposed mass. Their use resembles that of *pendentives.*

staccato See *legato.*

staff The five horizontal lines, with four spaces between, on which musical notation is written.

stele Upright stone slab decorated with relief carvings, frequently used as a grave marker.

still life A painting of objects such as fruit, flowers, dishes, etc., arranged to form a pleasing *composition.*

stoa A roofed *colonnade,* generally found in ancient Greek open markets, to provide space for shops and shelter.

Stoicism A philosophy, originally Greek, which believed that the world is governed by Reason, and that Divine Providence watched over the virtuous.

stretcher A wooden or metal frame on which a painter's canvas is stretched.

string instruments The violin, viola, violoncello (or cello), and double bass. All of these have strings that produce sound when stroked with a bow or plucked.

string quartet A performing group consisting of two violins, viola, and cello; a *composition* in *sonata form* written for such a group.

studium/studia An ancient name for the place where a community of scholars taught and wrote; lecture halls for professors either in monasteries or civil establishments.

stupa A large Buddhist shrine, often in the form of a tower or mound.

Sturm und Drang German for "Storm and Stress." A late-eighteenth-century German literary school that rejected Neo-Classicism and emphasized emotions and protest against established authority.

style galant A style of elegant, lighthearted music popular in France in the early eighteenth century.

stylobate The upper step on which the columns of a Greek temple stand.

suite In music, an instrumental composition of several parts exhibiting *movements* of a different character sometimes with a linkage in *key* or theme between the movements. In ballet, adaptation of a longer orchestral work for purposes of dance.

summa The summation of a body of learning, particularly in the fields of philosophy and theology.

Sûra The name for a chapter in the *Qur'an*

Swahili An African language strongly influenced by Arabic, spoken by many of the inhabitants of East Africa.

syllogism A form of argumentation in which a conclusion is drawn from a major premise by the use of a minor premise: All men are mortal/Socrates is a man/Therefore Socrates is mortal.

symmetry An arrangement in which various elements are so arranged as to parallel one another on either side of an *axis.*

symphonic poem, tone poem A piece of *program music* that tells a story in sound; a one-movement orchestral work meant to illustrate a nonmusical object like a poem, painting, or view of nature.

symphony A musical work in several self-contained *movements,*

written for full orchestra; essentially a *sonata* for *orchestra.*

syncopation In music, the accentuation of a beat that is normally weak or unaccented.

synthesis A philosophical theory developed by Hegel, which aimed to achieve a balance between *thesis,* the world of humans, which he called "pure, infinite being," and *antithesis,* the world of nature.

synthesizer An electronic instrument for the production and control of sound that can be used for the making of music.

tabernacle A container for a sacred object; a receptacle on the altar of a Catholic church to contain the Eucharist.

Talmud The authoritative collection of ancient Jewish learning.

tambour The drum that supports the cupola of a church.

Tao (The way) The central teaching of Taoism, whose followers aimed to follow their own "way" or nature.

tempera A painting technique using coloring mixed with egg yolk, glue, or casein.

tempo The Italian word for "time": the speed, indicated by the composer, at which a piece of music should be performed.

tenor The highest range of the male voice. In medieval *organum,* it is the voice that holds the melody of the *plainsong.*

tercet A three-line stanza of a poem.

ternary form A musical form composed of three separate sections, with the second in contrast to the first and third, and the third a modified repeat of the first.

terra cotta Italian meaning "baked earth." Baked clay used for *ceramics.* Also sometimes refers to the reddish-brown color of baked clay.

tesserae The small colored cubes of colored stone that make up a *mosaic.*

testament Another word for covenant.

tetrachord A unit of four musical notes. A combination of two tetrachords, eight consecutive notes, formed a mode.

theme In music, a short melody or a self-contained musical phrase which a composer can vary and develop.

thesis Academic proposition that seeks to prove the truth of a statement; see *synthesis.*

tholos Term in Greek *architecture* for a round building.

timbre The particular quality of sound produced by a voice or instrument.

timpani See *kettle drums.*

toccata An instrumental composition combining extreme technical complexity and dramatic expression.

toga Civil dress of male Roman citizens, made of a single piece of material draped to cover the whole person except for the head and right arm.

Togu na "Men's House of Words," used by the Dogon people for meetings of the male community assembly.

tonality The characteristic of most music written between the seventeenth and twentieth centuries to be anchored around a fixed *key* and *mode* (i.e., major or minor), from which it can move but to which it eventually returns.

tonic The first and principal note of a *key,* serving as a point of departure and return.

Torah Hebrew word meaning "instruction" or "law." Also the name of the First five books of the Old Testament: Genesis, Exodus, Leviticus, Numbers, and Deuteronomy.

totalitarian Any political system that asserts total control over all aspects of public life and thought while disallowing any independent ideas to intervene.

trade fairs Periodic gatherings of merchants for buying, trading, and selling. In the Middle Ages these fairs coincided with major reli-

gious holidays and were held roughly four times a year.

tragedy A serious drama in which the principal character is often brought to disaster by his/her *hamartia,* or tragic flaw.

Transcendentalists An American literary school of the nineteenth century that emphasized the transcendental unity of humans and nature.

transept In a cruciform church, the entire part set at right angles to the *nave.*

treble In music, the higher voices, whose music is written on a *staff* marked by a treble *clef.*

trecento Italian for Three Hundred; generally used to refer to the 1300s, i.e., the fourteenth century.

tribune Representative of the *plebeians,* who could intervene with state officials on their behalf.

Triglyph Panel carved into three vertical bands, alternating with *metopes* on a *Doric frieze.*

trilogy A series of three tragic plays, either related or on separate themes, performed at the Athenian Festival of Dionysus.

triptych Painting consisting of three separate panels. A painting with two panels is called a *diptych;* one with several panels is a polyptych.

trompe l'oeil From the French meaning "to fool the eye." A painting technique by which the viewer seems to see real subjects or objects instead of their artistic representation.

trope In *Gregorian chant,* words added to a long *melisma.*

troubadors Aristocratic southern French musicians of the Middle Ages who composed *secular* songs with themes of love and chivalry; called trouvères in northern France. Compare *minnesingers.*

trumeau A supporting pillar for a church *portal,* common in medieval churches.

tuba Long bronze trumpet used on public occasions and in battle.

twelve-tone technique A *serial* method of *composition* devised by

Schönberg in the early twentieth century. Works in this style are based on a tone row consisting of an arbitrary arrangement of the twelve notes of the *octave.* See *serialism.*

tympanum The space, usually decorated, above a *portal,* between a *lintel* and an *arch.*

typeface The carved pieces of letters used by printers to assemble a page for printing. The type varied according to design (e.g., *Italic* or roman).

Übermensch Term invented by Nietzsche to describe a "superior human."

uncanonical Any form or idea that violates the agreed-on rule (*canon*) of the authentic or the generally accepted.

unison The sound that occurs when two or more voices or instruments simultaneously produce the same note or melody at the same *pitch.*

universitas A guild or cooperative body. The academic *universitas* is the ancestor of the present-day university.

Urdu New language, based on Hindi, Arabic, and Persian, created during the reign of Akbar.

value (1) In music, the length of a note. (2) In painting, the property of a color that makes it seem light or dark.

vanishing point In *perspective,* the point at which receding lines seem to converge and vanish.

vault A roof composed of arches of masonry or cement construction.

virginal Early keyboard instrument, sometimes called a spinet, which was a predecessor of the harpsichord. It was small enough to be placed on a table.

virtuoso A person who exhibits great technical ability, especially in music. As an adjective, it describes a musical performance that exhibits, or a music composition that demands, great technical ability.

vivace Italian for "lively" or "vivacious."

volute Spiral design of an *Ionic capital.*

votive chapel A small church built as fulfillment of a vow or a promise most usually dedicated to the Virgin Mary or one of the saints.

votive An offering made to a deity either in support of a request or in gratitude for the fulfillment of an earlier prayer.

voussoirs Wedge-shaped blocks in an arch.

Vulgate The Latin Bible translated by Saint Jerome in the fourth century, which was the normative text for the Western (Catholic) Church until modern times.

waltz A dance in triple rhythm.

woodcut A work produced by cutting away parts of a wooden block, which is then inked and printed. Compare *engraving, etching, lithograph.*

woodwind instruments The flute, oboe, English horn, clarinet, bass clarinet, bassoon, contrabassoon, and saxophone. All of these are pipes perforated by holes in their sides which produce musical sound when the columns of air within them are vibrated by blowing on a mouthpiece.

ziggurat Sumerian religious structure made of bricks built to form terraces.

Zulu Inhabitants of the northeast region of Natal Province, South Africa. Most are traditionally farmers and cattle-raisers.

Page numbers in italics refer to illustrations, photo illustrations, or tables.

PHOTO CREDITS

Literary Credits

This page constitutes an extension of the copyright page. We have made every effort to trace the ownership of all copyrighted material and to secure permission from copyright holders. In the event of any question arising as to the use of any material, we will be pleased to make the necessary corrections in future printings. Thanks are due to the following authors, publishers, and agents for permission to use the material indicated.

CHAPTER 12. 30-34: Excerpt by Laura Cerreta from *Her Immaculate Hand: Selected Works by and about the Women Humanists of Quattrocento Italy,* by Margaret L. King and Albert Rabil (Eds.), Second Revised Edition. © 1997 Pegasus Press, Asheville, NC 28803. Used with permission. **34-36:** From "The Prince" by Niccolo Machiavelli in *Niccolo Machiavelli: The Chief Works and Others,* Volume 1, translated by Allan Gilbert, © 1965. All rights reserved. Reprinted by permission of Duke University Press. **36-41:** "The Praise of Folly" by Desiderius Erasmus from *The Essential Erasmus,* translated by John P. Dolan. Copyright © 1964 by John P. Dolan. Used by permission of Dutton Signet, a division of Penguin Putnam, Inc.

CHAPTER 13. 66-70: "On Women" from *The Book of the Courtier* by Baldesar Castiglione, translated by George Bull (Penguin Classics, 1967). Copyright © George Bull, 1967. Reprinted by permission of the publisher Penguin Books, Ltd. **70-73:** From *The Autobiography of Benvenuto Cellini,* translated by George Bull (Penguin Classics, 1956). Copyright © George Bull, 1956. Reprinted by permission of Penguin Books, Ltd.

CHAPTER 14. 80: Letter by Katherine Zell reprinted from *Women of the Reformation in Germany and Italy* by Roland H. Bainton, © 1971 by Augusburg Fortress Press. **107-111:** From *The Complete Works of Montaigne: Essays, Travel Journal, Letters,* translated by Donald M. Frame. Copyright © 1958 by the Board of Trustees of the Leland Stanford Junior University. All rights reserved. Used with permission of Stanford University Press, www.sup.org. **111-112:** From *Martin Luther's Basic Theological Writings,* edited by Timothy L. Lull, copyright © 1989 Augsburg Fortress. Used by permission of Augsburg Fortress.

CHAPTER 15. 177: From *Born Under Saturn* by Giambattista Passeri, translated by Rudolf & Margot Wittkower, © 1963 by Rudolf & Margot Wittkower. Used by permission of Random House, Inc. **201-205:** Tartuffe by Moliere, English translation copyright © 1963, 1962, 1961 and renewed 1991, 1990 and 1989 by Richard Wilbur, reprinted by permission of Harcourt, Inc. **205-210:** From *The Adventures of Don Quixote* by Miguel de Cervantes Saavedra, translated by J. M. Cohen, © 1950 by J. M. Cohen. Published by Penguin Books, Ltd. Reproduced by permission of Penguin Books, Ltd. **210-217:** "The Argument" from *John Milton: Paradise Lost* by Flannagan, © 1993 Roy Flannagan.

CHAPTER 16. 254-256: "Emile" by Jean Jacques Rousseau from *Introduction to Contemporary Civilization in the West,* Volume 1, Third Edition, translated by Barbara Foxley. Copyright 1960 Columbia University Press. Reprinted by

permission. **256-267:** From *Candide and Other Writings* by Voltaire, edited by Haskell M. Block, copyright © 1956 and renewed 1984 by Random House, Inc. Used by permission of Random House, Inc.

CHAPTER 17. 322-323: Reprinted by permission of the publishers and the Trustees of Amherst College from *The Poems of Emily Dickinson,* Thomas H. Johnson, editor, Cambridge, MA: The Belknap Press of Harvard University Press. Copyright 1951, 1955, 1979 by the President and Fellows of Harvard College.

CHAPTER 18. 348: Letter of Gustav Mahler to his Wife from *Letters of Composers* by G. Norman and M. L. Shrifte. **359-362:** From Act III of "A Doll's House" by Henrik Ibsen, translated by Eva Le Gallienne in *Six Plays by Henrik Ibsen,* © 1957 Eva Le Gallienne. Reprinted by permission of International Creative Management, Inc.

CHAPTER 19. 375: From *Emperor of China* by Jonathan D. Spence, copyright © 1974 by Jonathan D. Spence. Used by permission of Alfred A. Knopf, a division of Random House, Inc. **388-390:** Excerpt from *Monkey* by Wu Cheng-En, translated by Arthur Waley, chapter XV, p. 158-166, Allen & Unwin, © 1942 by permission of The Arthur Waley Estate. **391:** From *On Love and Barley: Haiku of Basho,* translated by Lucien Stryk (Penguin Classics, 1985). Copyright © Lucien Stryk, 1985. Reproduced by permission of Penguin Books, Ltd.

CHAPTER 20. 407: Excerpt from "The Journey of the Magi" in *Collected Poems 1909-1962* by T. S. Eliot, copyright 1936 by Harcourt, Inc., copyright © 1964, 1963 by T. S. Eliot, reprinted by permission of the publisher. **407-409:** From *No Longer at Ease* by Chinua Achebe, p. 1-15. Reprinted by permission of Harcourt Education.

CHAPTER 21. 413-414: Reprinted with the permission of Scribner, a Division of Simon & Schuster Adult Publishing Group, from *The Collected Poems of W. B. Yates, Volume I: The Poems,* Revised, edited by Richard J. Finneran. Copyright © 1924 by Macmillan Publishing Company; copyright renewed © 1952 by Bertha Georgie Yeats. **435-436:** "The Hollow Men" from *Collected Poems 1909-1962* by T. S. Eliot. Copyright 1936 by Harcourt, Inc., copyright © 1964, 1963 by T. S. Eliot, reprinted by permission of the publisher. **436-437:** "Heritage" by Countee Cullen from *Color.* Published by Arno Press and New York Times, 1969. Copyright 1925 by Harper & Brothers, copyright renewed 1953 by Ida M. Cullen. Reprinted by permission of GRM Associates, Inc. **437-438:** "I Too Sing America" and "The Negro Speaks of Rivers" by Langston Hughes

from *The Collected Poems of Langston Hughes.* Copyright © 1994 by the Estate of Langston Hughes. Used by permission of Alfred A. Knopf, a division of Random House, Inc. **438:** "Bottled" by Helene Johnson (1907) in *Caroling Dusk* by Countee Cullen. Copyright 1927 by Harper & Brothers; copyright renewed 1955 by Ida M. Cullen. Reprinted by permission of GRM Associates, Inc., Agents for the Estate of Ida M. Cullens. **438-445:** Reproduced with the permission of the Estate of James Joyce; © copyright Estate of James Joyce. **445-448:** "Before the Law" translated by Willa and Edwin Muir, from *Franz Kafka: The Complete Stories* by Franz Kafka, edited by Nahum N. Glatzer, copyright 1946, 1947, 1948, 1949, 1954, 1958, 1971 Schocken Books. Used by permission of Schocken Books, a division of Random House, Inc. **448-453:** From *Brave New World* by Aldous Huxley, copyright 1932, 1960 by Aldous Huxley. Reprinted by permission of HarperCollins Publishers, Inc.

CHAPTER 22. 461: Reprinted by permission of the Georgia O'Keeffe Foundation. **490:** By William Carlos Williams from *Collected Poems 1939-1962,* Volume II, copyright 1953 by William Carlos Williams. Reprinted by permission of New Directions Publishing Corp. **494-496:** From "Existentiaslism as a Humanism" in *Essays in Existentialism* by Jean-Paul Sartre, ed. Wade Basking. Copyright © 1965. All rights reserved. Reprinted by permission of Kensington Publishing Corp. www.kensingtonbooks.com **496-498:** Excerpt from *Night* by Elie Wiesel, translated by Stella Rodway. Copyright © 1960 by MacGibbon & Kee. Copyright renewed © 1988 by The Collins Publishing Group. Reprinted by permission of Hill and Wang, a division of Farrar, Straus and Giroux, LLC. **498-505:** "Revelation" from *The Complete Stories* by Flannery O'Connor. Copyright © 1971 by the Estate of Mary Flannery O'Connor. Reprinted by permission of Farrar, Straus and Giroux, LLC. **505:** "Lady Lazarus" from *Ariel* by Sylvia Plath. Copyright © 1963 by Ted Hughes. Reprinted by permission of HarperCollins Publishers, Inc. **506:** "The Last Quatrain of the Ballad of Emmett Till" from *Blacks* by Gwendolyn Brooks. Copyright © 1978 by Gwendolyn Brooks. Reprinted by consent of Brooks Permissions. **507-508:** "Diving into the Wreck," copyright © 2002 by Adrienne Rich. Copyright © 1973 by W. W. Norton & Comapny, Inc., from *The Fact of a Doorframe: Selected Poems 1950-2001* by Adrienne Rich. Used by permission of W. W. Norton & Company, Inc. **508-510:** Nobel Prize acceptance speech given by Toni Morrison in Stockholm on December 7, 1993. Reprinted by permission of International Creative Management, Inc. Copyright © 1993 Toni Morrison.